History of Art
for Young People

History of Art
for Young People

H. W. Janson & Anthony F. Janson ❙ Sixth Edition

Harry N. Abrams, Inc., Publishers

Director of Textbook Publishing: Julia Moore

Editor: Margaret Donovan
Editorial Assistant: Julia Chmaj
Design and Production: Inkwell Publishing Solutions
Photo Editors: Barbara Lyons, Diana Gongora
Production Consultant: Shun Yamamoto

Library of Congress Cataloging-in-Publication Data

Janson, H. W. (Horst Woldemar), 1913–1982
 History of art for young people/ H. W. Janson and Anthony F. Janson — 6th ed.
 p. cm.
 Includes bibliographical references and index.
 ISBN 0-8109-4150-3 (hc)
 1. Art–History. I. Janson, Anthony F. II. Title.

 N5300 .J29 2002
 70–dc21 2002019771

This book is published by Prentice Hall/Abrams under the title *A Basic History of Art*

The original edition of *History of Art for Young People* was written by H. W. Janson
with Samuel Cauman

Printed and bound in Japan
10 9 8 7 6 5 4 3 2 1

Harry N. Abrams, Inc.
100 Fifth Avenue
New York, N.Y. 10011
www.abramsbooks.com

Abrams is a subsidiary of

LA MARTINIÈRE
G R O U P E

Pages 2 and 3: Details, Vasily Kandinsky. *Improvisation "Klamm."* 1914.
Oil on canvas, 43¼ x 43¼" (110 x 110 cm). Städtische Galerie im
Lenbachhaus, Munich. ©2002 Artists Rights Society (ARS), New York/ADAGP,
Paris. On part-opener pages 34–37: details of fig. 7-18; pages 146–49: details
of fig. 10-16; pages 264–67: details of fig. 17-7; pages 452–55: details of fig. 26-2

CONTENTS IN BRIEF

CONTENTS

PREFACE AND ACKNOWLEDGMENTS

Previous editions of this book have often acted as testing grounds for ideas that were later included in the larger Janson's *History of Art*. For a change, the roles are reversed. The present version incorporates numerous changes, both major and minor, that have already appeared in its sibling. The main ones are to be found in the discussions of ancient art, the history of architecture, and Romanticism. The book has been heavily rewritten and thoroughly reedited to improve readability.

There is, however, one important exception to the above rule, and that is the treatment of Italian art between 1520 and 1600. I have revived the concept of Late Renaissance and completely revised the section on painting to take into account the impact of the Reformation and Counter-Reformation. I have also adjusted some of my thoughts about Mannerist architecture. I am well aware that these changes may prove controversial. The decision to resurrect a period term that is often considered out of date is purely a matter of convenience, since the previous label "Mannerism and Other Tendencies" is both cumbersome and confusing. In reassessing religious painting in Italy during this period, I have tried to avoid the mistake of earlier art historians who saw everything after 1545 as an expression of the Counter-Reformation. Not only is the notion simplistic, but it also ignores the fact that the key developments had already taken place. My emphasis is therefore on the formative quarter-century that precedes the Council of Trent. I have taken advantage of the most recent scholarship on the Reformation and the early Catholic reform movement, which permits—even demands—a reassessment of the religious paintings of Rosso, Pontormo, Savoldo, and Correggio, as well as such later artists as Tintoretto. I am indebted to David Lyle Jeffrey and James McGowan, who read this section and made many valuable suggestions. Jim was also very helpful in pointing me to the most valuable new scholarship.

I have undertaken these changes in the same spirit of adventure that has motivated previous revisions of this book. Art history is a vast field. Even the narrow segment of Western art is too large and unwieldy to master single-handedly. But therein lies the charm. There is always something new to investigate and to reexamine with fresh eyes. Sometimes it is small, such as reinterpreting Soufflot's Pantheon and Labrouste's Bibliothèque Ste-Geneviève. At other times, it involves entire periods, as is the case with the Late Renaissance. The pleasure of discovery is endless for those who choose to roam outside their narrow specialties and explore the enormous riches that the art of mankind offers.

I want to thank my editors, Margaret Donovan and Julia Moore, for their tireless efforts in ensuring that both the text and design were the best possible under difficult conditions. They also wrote the many sidebars that enhance each chapter and add a wealth of interesting information that could not possibly be accommodated within the regular text. In addition, Julia provided clearheaded guidance and added a very helpful "Primer of Art History" at the beginning of the book to introduce the reader to the main terminology and concepts of the field. I am also grateful to Julia Chmaj, whose conscientiousness, intelligence, and hard work contributed enormously to many aspects of the book.

I am dedicating this book to my doctors, Robert Aaronson and Frank Snyder, with eternal gratitude for saving my life from two rare diseases that nearly killed me. Without them, the work would never have been finished. In medicine, as in scholarship, there is still no substitute for the inquiring mind that refuses to settle for snap judgments or to let go of a problem, no matter how difficult, but stubbornly continues to research and think about it until the correct answer has been found. My thanks, too, to Dr. Snyder's physician's assistants, Mellisa Bitto and Jeannie Benfield, who helped see me through this extremely difficult period, and finally to Dr. Frank Stevens and Dr. Michael McGarrity.

AFJ, 2002

A PRIMER OF ART HISTORY

The Introduction to this book, which begins on page 17, has been written by H. W. Janson and Anthony F. Janson over a period of 40 years. Although presented in the form of a deceptively simple narrative, the Introduction is actually a gathering of eloquent short essays, some exploring questions that are among the most meaningful one could ask. These questions have many different possible answers and, wisely, the Jansons ask us to try to answer them for ourselves, authentically: What is art? What is essential to the creation of art? What makes a visual artist different from other people? Why does an artist make art? Does it matter whether anyone besides the artist sees and experiences the things an artist creates? To make their points, the authors introduce us to some great works of art that embody ideas they hope we will recognize and appreciate.

This little Primer of Art History does not ask profound questions. Its purposes are to be a road map to the field of art history and to offer some specific road signs that the beginner will find useful in journeying with art from prehistory to the present.

The oldest surviving expressions of human culture, in fact, are sculpture and painting. Almost 90,000 years ago, human beings began fashioning beads—evidence of symbolic thinking—and shaping specialized tools. They probably had developed spoken languages more than 30,000 years ago, when they were painting subtly expressive images of animals on the walls of caves in southern Europe. They most likely danced and sang, too. But the actual evidence we have of our distant ancestors is their art, images fashioned out of real stuff. So when you study art, you engage with real objects of human experience. As the Introduction makes clear, however, art objects are not ordinary, born-of-necessity objects, but things created to satisfy uniquely human aspirations and longings.

Art history is a relatively new field of study—compared, for example, to the traditional study of literature. In the United States, art history began to flourish as an academic discipline and as a college and university curriculum only in the twentieth century, and mostly after World War II. (Technology played a part in art history's late start, because until printing technologies could reproduce images cheaply enough to circulate widely, it was very difficult for one person to see, remember, and compare physical objects—to say nothing of publishing illustrated books and articles about art.)

Men and women who devote their lives to the study of art are called art historians. Most art historians have advanced degrees and are passionate about art and ideas. But not all art historians approach the subject the same way. Some concentrate on the way art objects look, noting and savoring visual elements—such as line, color, shape, mass—and the materials and techniques the artist used to create a work of art, then analyzing how these were brought together to achieve a certain appearance and have a certain effect. The visual elements are referred to

as formal elements, and the term *formalism* denotes art history that emphasizes the art object per se, comparatively independent of other, not-art influences. It has been said—although far too simplistically—that a formalist looks no further than to other artworks to find the answers to why something looks the way it does and what the artist meant by it.

Art historians who factor what was happening at the time and place of an artwork's creation to explain why a work looks the way it does are practicing *contextualism* and are known as contextualist art historians. They explore questions like: What do we know about the artist? Who had political and economic power at the time? Who paid for artworks, and what were the motives of these people, known as patrons? What ideas were circulating in educated circles at the time? Today, most art history, including the book you have in your hands, is a fusion of formalism and contextualism. A number of more specialized approaches, all fairly recent and all derived from other humanistic disciplines, have smaller numbers of adherents. These include Structuralism and Deconstructivism, as well as Freudian, Marxist, and feminist art history.

Like all fields of inquiry, art history has undergone some fundamental changes. For a long time, art history was confined to the so-called fine arts of painting, sculpture, and architecture. Drawing and the graphic arts—works printed on paper—were also included. Stained glass and decorated (illuminated) manuscripts were regarded as painting, and so qualified as fine art. Photography was admitted to the field of study a few decades ago. More recently, art historians have expanded the definition of art to include works in many mediums (*mediums*, not *media*, is the art historian's preferred plural; *medium* is the material the artist uses to make the artwork). Woven textiles and other fiber arts, metalworking and silver- and goldsmithery, ceramics, glass, beadwork, and mixed mediums are now in art history's basket. Modern and contemporary art, especially, has forced open the borders. Happenings, one-time performed creations staged by artists in the 1960s, earth art, video art, computer art, installations, and even clips of documentary TV shows selected by an artist and declared to be art are now securely acknowledged to be forms of art-making.

The basic orientation of art is either visual or spatial. Visual, or pictorial, art has its own grammar and syntax. Architecture's vocabulary is spatial. Art history uses words to describe what is visual, but we should understand that words are weak translations of the nonverbal visual experience, which is directly perceived from eye to mind. (Much of the great power of images lies in that fact.) Words help us organize our perceptions, but words are a secondhand way to reexperience art. And a work of art is an artist's interpretation of the chosen subject, not the subject itself.

Both two-dimensional art (paintings and works of graphic art, for example) and three-dimensional sculpture rely on descriptors such as *representational*, *realistic*, *abstract*, and *nonobjective* that categorize a work's visual orientation to the subject. *Representational* art has subject matter that is recognizable from the natural world. *Realistic* art shows a high degree of imitation of the actual object or subject. *Abstract* art simplifies and alters the appearance of actual forms

Vertical perspective

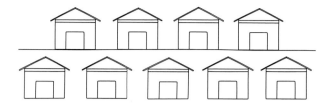

In vertical perspective, objects in the lower zone or zones are to be understood as closer than objects in the upper zone or zones.

Overlapping perspective

Overlapping perspective relies on our experience that forms partly obscured behind other forms are further distant from us.

One-point perspective

vanishing point

horizon line

picture plane

One-point linear perspective has all angles receding to a single point on a real or imaginary horizon, the so-called vanishing point. This diagram is drawn on an angle to better show the picture plane. The picture space is the illusionary space behind the plane.

Two-point perspective

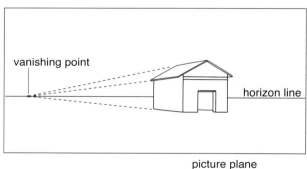

vanishing point vanishing point

horizon line

Two-point perspective has lines receding to two different vanishing points on the horizon line.

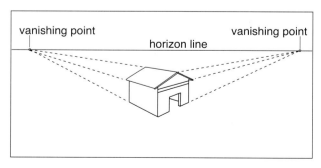

(they can still be recognizable) for various purposes, often to suggest an essence or universality. Most masks from Africa are abstract. *Nonobjective* art deals with forms that lack any reference to the natural world. Also referred to as *nonrepresentational* or *nonfigurative*, it relies solely on the interplay of formal visual elements. Much modern art is nonobjective.

What are the formal elements? Again, they include line, shape, mass, and color, and also texture and composition. *Line* can be drawn as a line, defining outlines and contours of forms and delineating shapes. Line imparts direction and movement, even when it is not a continuous mark. Implied lines, which our eyes seek out and our brains mentally connect, can be pictorially as effective as an actual, continuous line.

Shape is a two-dimensional form, an area on a flat plane. *Mass* is three-dimensional, occupying a volume of space. Sculpture that is freestanding is mass. So is architecture. But you experience architecture by moving around, into, and through it, not merely around it, as you have to do with sculpture.

Artists working in two-dimensional arts are challenged with representing three dimensions on a flat plane. The flat surface, called the *picture plane*, is the field on which the artist builds the illusion of space and three-dimensionality. *Picture space* is a term for what is created in that illusion. Artists have devised many pictorial strategies for suggesting space and objects in space, among them vertical stacking of forms, the overlapping of forms, and the illusion of distance by gradation of color from intense to pale, often bluish hues (*atmospheric* or *aerial perspective*). Since the Italian Renaissance in the fifteenth century, the Western tradition has settled on *scientific*, or *linear*,

perspective as the most satisfactory. It is based on two observations. One is that forms look smaller the further away they are, and the other is that parallel lines (such as railroad tracks) appear to converge and vanish at the point in the distance where sky meets earth. Scientific perspective assumes the artist's (and viewer's) fixed position and one or more vanishing points on a horizon line.

Another way artists suggest three-dimensionality is with the depiction of light. It is, after all, light that allows us to perceive forms. In the dark, form is invisible. By manipulating the range from light to dark, called the value scale, artists can define forms by suggesting shadow, and they can tell us where the light source is. Texture and color, also activated by light, are the two other most important formal elements. *Texture* can refer to the actual surface quality of a work of art or architecture or to the surface that the artist has simulated.

Full understanding of color lies in the realm of physics. *Color* is the effect on our brains of light waves of differing wavelengths reflected off objects. The source light is white light, which is a combination of all colors. Objects reflect and transmit particular parts of white light, giving the optical impression of having a particular color. It is helpful to understand the meaning of three color-related terms when you are reading about art. They are *hue, value,* and *intensity*. *Hue* refers to the essential color. The visible colors of a rainbow are the so-called spectral hues of red, orange, yellow, green, blue-violet, and violet. In the case of a rainbow, when the white light of the sun passes through drops of water in the air, the raindrops become like a crystal prism that separates wavelengths of light into the spectral hues.

Value, as we have just said, refers to the degree of lightness or darkness of a color. Two additional terms are sometimes used when describing value. One is *tint,* a color lighter than the hue's normal value, and the other is *shade,* a color darker than normal. Thus, apple green is a tint of pure green, and forest green is a shade. Finally, there is the term *intensity* (also called *saturation* or *chroma*). Intensity is the degree of a hue's purity. The closer a color is to the original rainbow-spectrum hue, the higher its intensity and the brighter its appearance.

The way the artist puts the formal elements together is called *composition*. Composition, whether of a painting, a sculpture, or even in a work of architecture, is distinctive from artist to artist and from culture to culture. Composition is one of the most closely studied attributes of an artwork, especially in formalist art history, because composition is one of the most important ingredients of style in a work of art.

Style describes the combination of distinguishing characteristics that imprint a work of art as the creation of a certain artist, or time, or place. As the Jansons say so eloquently

Value is manipulated to indicate the source of light falling on the vase and to create shadows that confirm the location and, to an extent, the intensity of the light source. The treatment of light across the surface indicates that the texture of this vase is smooth.

in their Introduction, "To art historians the study of styles is of central importance. It not only enables them to find out, by means of careful analysis and comparison, when, where, and often by whom a given work was produced, but it also leads them to understand the artist's intention as expressed through the style of the work."

What else reveals intention? *Subject matter*—the topic of an artwork, so to speak—is an obvious clue to intention. Of itself, however, subject matter is neutral. The way the artist handles the subject is infinitely variable and is not neutral. Subject matter does not need to be pictorially recognizable. An artist intending to create an expression of grief, for example, has many choices, from making a realistic portrayal of a person grieving the death of a loved one, to a totally nonobjective, subjective evocation of the emotional state of grief. The subject matter will be the same. The appearance, or form, will be utterly different.

Form is what we see in a work of art, what is visible. It is indisputable. What we interpret from the form is called *content*—the message or meaning of the work. The content of the realistic and the nonrepresentational images of grief just cited will vary for every single viewer, not just because the forms are different but because every person brings a different set of experiences, emotional makeup, cultural conditioning, and kinds of knowledge to his or her experience with the artwork. Content is always richer for what we bring to it, including knowing the time and place of its creation, possessing an understanding of its style, and having a notion of what the artist intended to say. The more looking skills we acquire, the more seeing we do. The more seeing we do, the larger our capacity for experiencing the human condition—and its reflection in art—fully and deeply.

Julia Moore

INTRODUCTION

Art and the Artist

"What is art?" Few questions provoke such heated debate and provide so few satisfactory answers. If we cannot come to any definitive conclusions, there is still quite a lot we can say. *Art* is first of all a *word,* one that acknowledges both the idea and the fact of art. Without the word, we might well ask whether art exists in the first place. The term, after all, is not found in the vocabulary of every society. Yet art is *made* everywhere. Art, therefore, is also an object, but not just any kind of object. Art is an *aesthetic object.* It is meant to be looked at and appreciated for its intrinsic value. Its special qualities set art apart, so that it is often placed away from everyday life, in museums, churches, or caves. What do we mean by *aesthetic*? By definition, the aesthetic is "that which concerns the beautiful." Of course, not all art is beautiful to our eyes, but it is art nonetheless.

People the world over make much the same fundamental judgments. Our brains and nervous systems are the same, because, according to recent theory, we all descend from one woman in Africa who lived about a quarter-million years ago. Taste, however, is conditioned by culture, which is so varied that it is impossible to reduce art to any one set of laws. It would seem, therefore, that absolute qualities in art must elude us, and that we cannot escape viewing works of art in the context of time and circumstance, whether past or present.

IMAGINATION

We all dream. That is imagination at work. To imagine means simply to make an image—a picture—in our minds. Human beings are not the only creatures who have imagination. Even animals dream. There is, however, a profound difference between human and animal imagination. Humans are the only creatures who can tell one another about imagination in stories or pictures. The imagination is one of our most mysterious facets. It can be regarded as the connector between the conscious and the subconscious, where most of our brain activity takes place. It is the very glue that holds our personality, intellect, and spirituality together. Because the imagination responds to all three, it acts in lawful, if unpredictable, ways that are determined by the psyche and the mind.

The imagination is important, as it allows us to conceive of all kinds of possibilities in the future and to understand the past in a way that has real survival value. It is a fundamental part of our make-up, though we share it with other creatures. By contrast, the urge to make art is unique to us. It separates us from all other creatures across an unbridgeable evolutionary gap. The ability to make art must have been acquired relatively recently in the course of

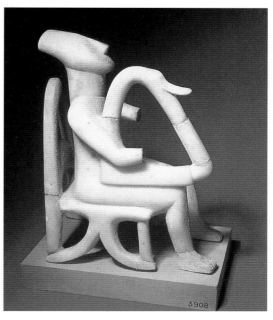

1 *Harpist,* so-called *Orpheus,* from Amorgos in the Cyclades. Latter part of the 3rd millennium B.C. Marble, height 8½" (21.6 cm). National Archaeological Museum, Athens

evolution. Human creatures have been walking upright on Earth for some 4.4 million years, but the oldest prehistoric art that we know of was made only about 35,000 years ago. It was undoubtedly the culmination of a long development no longer traceable, since the record of the earliest art is lost to us.

Who were the first artists? In all likelihood, they were shamans, individuals believed to have divine powers of inspiration and the ability to enter the underworld of the subconscious in a deathlike trance, but, unlike ordinary mortals, able to return to the realm of the living. Just such a figure seems to be represented by our *Harpist* (fig. 1) from about four thousand years ago. A work of unprecedented complexity for its time, it was carved by a remarkably gifted artist who makes us feel the visionary rapture of a poet as he sings his legend. With the rare ability to penetrate the unknown and to express

it through art, the artist-shaman seemed to gain control over the forces hidden in human beings and nature. Even today the artist remains a magician whose work can mystify and move us—an embarrassing fact to many of us, who do not readily relinquish our rational control.

Art plays a special role in human personality. Like science and religion, it fulfills a universal urge to comprehend ourselves and the universe. This function makes art especially significant and, hence, worthy of our attention. Art has the power to reach the core of our being, which recognizes itself in the creative act. For that reason, art represents its creators' deepest understanding and highest aspirations. At the same time, artists often act as the articulators of shared beliefs and values, which they express through an ongoing tradition to us, their audience.

CREATIVITY

What do we mean by *making*? If we concentrate on the visual arts, we might say that a work of art must be a tangible thing shaped by human hands. This definition at least eliminates the confusion of treating as works of art such natural phenomena as flowers, seashells, or sunsets. It is a far from sufficient definition, to be sure, since human beings make many things other than works of art. Still, it will serve as a starting point. Now let us look at the striking *Bull's Head* by Pablo Picasso (fig. 2), which seems to consist of nothing but the seat and handlebars of an old bicycle. How meaningful is our definition here? Of course, the materials Picasso used are fabricated, but it would be absurd to insist that he must share the credit with the manufacturer, since the seat and handlebars in themselves are not works of art.

While we feel a certain jolt when we first recognize the ingredients of this visual pun, we also sense that it was a stroke of genius to put them together in this unique way, and we cannot very well deny that it is a work of art. Nevertheless, the actual handiwork of mounting the seat on the handlebars is ridiculously simple. What is far from simple is the leap of the imagination by which Picasso recognized a bull's head in these unlikely objects. The leap of the imagination is

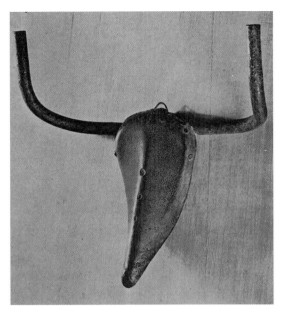

2 Pablo Picasso. *Bull's Head.* 1943. Bronze cast bicycle parts, height 16⅛" (41 cm). Galerie Louise Leiris, Paris

sometimes experienced as a flash of inspiration, but only rarely does a new idea emerge full blown like Athena from the head of Zeus. Instead, it is usually preceded by a long gestation period in which all the hard work is done without finding the key to the solution to the problem. At the critical point, the imagination makes connections between seemingly unrelated parts and recombines them.

Our *Bull's Head* is, of course, an ideally simple case, involving only one major connection and a manual act in response to it. Ordinarily, artists do not work with ready-made parts but with materials that have little or no shape of their own. The creative process generally consists of a long series of leaps of the imagination and the artist's attempts to give them form by shaping the material accordingly. In this way, by a constant flow of impulses back and forth between the mind and the partly shaped material, the artist gradually defines more and more of the image, until at last all of it has been given visible form. Needless to say, artistic creation is too subtle and intimate an experience to permit an exact step-by-step

description. Only artists can observe it fully, but they are so absorbed by it that they have great difficulty explaining it to us.

The creative process has been likened to birth, a metaphor that comes closer to the truth than would a description cast in terms of a transfer or projection of the image from the artist's mind. The making of a work of art is both joyous and painful, and full of surprises. We have, moreover, ample testimony that artists themselves tend to look upon their creations as living things. Perhaps that is why creativity was once a concept reserved for God, as the only one who could give material form to an idea. Indeed, the artist's labors are much like the Creation told in the Bible.

This divine ability was not realized until Michelangelo, who described the anguish and glory of the creative experience when he spoke of "liberating the figure from the marble that imprisons it." We may translate this to mean that he started the process of carving a statue by trying to visualize a figure in the rough, rectilinear block as it came to him from the quarry. It seems fair to assume that at first Michelangelo did not see the figure any more clearly than one can see an unborn child inside the womb, but we may believe that he could see isolated "signs of life" within the marble. Once he started carving, every stroke of the chisel would commit him more and more to a specific conception of the figure hidden in the block, and the marble would permit him to free the figure whole only if his guess as to its shape was correct. Sometimes he did not guess well enough, and the stone refused to give up some essential part of its prisoner. Michelangelo, defeated, left the work unfinished, as he did with *Awakening Slave* (fig. 3, page 20), whose very gesture seems to record the vain struggle for liberation. Looking at the block, we may get some inkling of Michelangelo's difficulties here. But could he not have finished the statue in *some* fashion? Surely there is enough material left for that. He probably could have, but perhaps not in the way he wanted. In that case the defeat would have been even more stinging.

Clearly, then, the making of a work of art has little in common with what we ordinarily mean by "making." It is a strange and risky business in which the makers never quite know what they are making until it has actually been made; or, to put it another way, it is a game of find-and-seek in which the seekers are not fully sure what they are looking for until they have found it. In the case of the *Bull's Head,* it is the bold "finding" that impresses us most; in the *Awakening Slave,* the strenuous "seeking." To the nonartist, it seems hard to believe that this uncertainty, this need to take a chance, should be the essence of the artist's work. We all tend to think of "making" in terms of artisans or manufacturers who know exactly what they want to produce from the very outset. There is thus comparatively little risk, but also little adventure, in such handiwork, which as a consequence tends to become routine. Whereas the artisan attempts only what is known to be possible, the artist is always driven to attempt the impossible—or at least the improbable or unimaginable. No wonder the artist's way of working is so resistant to any set rules, while the craftsperson's encourages standardization and regularity. We acknowledge this difference when we speak of the artist as *creating* instead of merely *making* something. Thus, we must obviously be careful not to confuse the making of a work of art with manual skill or craftsmanship. Some works of art may demand a great deal of technical discipline; others do not. Even the most painstaking piece of craft does not deserve to be called a work of art unless it involves a leap of the imagination.

Needless to say, there have always been many more craftspeople than artists among us, since our need for the familiar and expected far exceeds our capacity to absorb the original but often deeply unsettling experiences we get from works of art. The urge to discover unknown realms, to achieve something original, may be felt by every one of us now and then. What sets the real artist apart is not so much the desire to *seek,* but that mysterious ability to *find,* which we call talent. We also speak of it as a "gift," implying that it is a sort of present from some higher power; or as "genius," a term which originally meant a higher power (a kind of "good demon") that inhabits and acts through the artist.

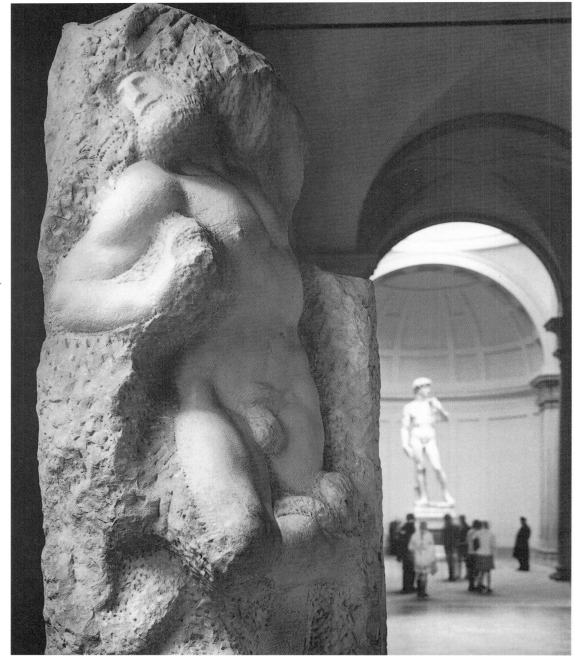

3 Michelangelo. *Awakening Slave* (foreground). 1506. Marble, height 8'11" (2.72 m). Galleria dell'Accademia, Florence

ORIGINALITY AND TRADITION

Originality, then, ultimately distinguishes art from craft. We may say, therefore, that it is the yardstick of artistic greatness or importance. Unfortunately, it is also very hard to define. The usual synonyms—uniqueness, novelty, freshness—do not help us very much, and the dictionaries tell us only that an original work must not be a copy. But no work of art can be entirely original. Each one is linked in a chain of relationships that arises somewhere out of the distant past and continues into the future. If it is true that "no man is an island," the same can be said of works of art. The sum total of these chains makes a web in which every work of art occupies

its own specific place. We call this web "tradition." Without tradition (the word means "that which has been handed down to us") no originality would be possible. It provides, as it were, the firm platform from which the artist makes a leap of the imagination. The place where he or she lands will in turn become part of the web and serve as a point of departure for further leaps. And for us, too, the fabric of tradition is equally essential. Whether we are aware of it or not, tradition is the framework within which we inevitably form our opinions of works of art and assess their degree of originality.

MEANING AND STYLE

Why do we create art? Surely one reason is an irresistible urge to adorn ourselves and to decorate the world around us. Both impulses are part of a larger desire, not to remake the world in our image but to recast ourselves and our environment in *ideal* form. Art is, however, much more than decoration, for it is laden with meaning, even if that content is sometimes slender or obscure. Art enables us to communicate our understanding in ways that cannot be expressed otherwise. Truly a painting (or any work of art) is worth a thousand words, not only in its descriptive value but also in its symbolic significance. In art, as in language, we are above all inventors of symbols that convey complex thoughts in new ways. However, we must think of art in terms not of everyday prose but of poetry, which is free to rearrange conventional vocabulary and syntax in order to convey new, often multiple, meanings and moods. A work of art likewise suggests much more than it states. It communicates partly by implying meanings through pose, facial expression, allegory, and the like. As in poetry, the value of art lies equally in what it says and how it says it.

But what is the *meaning* of art—its iconography? What is it trying to say? Artists often provide no clear explanation, since the work itself is the statement. Nonetheless, even the most private artistic statements can be understood on some level, even if only an intuitive one. The meaning, or content, of art is inseparable from its formal qualities, its *style*. The word *style* is derived from *stilus*, the

writing instrument of the ancient Romans. Originally, it referred to distinctive ways of writing: the shape of the letters as well as the choice of words. In the visual arts, *style* means the particular way in which the forms that make up any given work of art are chosen and fitted together. To art historians the study of styles is of central importance. It not only enables them to find out, by means of careful analysis and comparison, when, where, and often by whom a given work was produced, but it also leads them to understand the artist's intention as expressed through the style of the work. This intention depends on both the artist's personality and the context of time and place. Accordingly, we speak of "period styles." Thus art, like language, requires that we learn the style and outlook of a country, period, and artist if we are to understand it properly.

Nevertheless, our faith in the very existence of period styles has been severely shaken, even though we keep referring to them as a convenient way of discussing the past. They seem to be a matter of perspective: the more remote or alien the period, the more clear-cut the period style— and the more limited our knowledge and understanding. The nearer we come to the present, the more apt we are to see diversity rather than unity. Yet we cannot deny that works of art created at the same time and in the same place do have something in common. What they share is a social and cultural environment, which must have affected artist and patron alike to some degree. We have also come to realize, however, that these environmental factors often do not influence all the arts in the same way or to the same extent. Nor can artistic developments be fully understood as direct responses to such factors. Insofar as "art comes from art," its history is directed by the force of its own traditions, which tend to resist the pressure of external events or circumstances.

SELF-EXPRESSION AND AUDIENCE

Many of us are familiar with the Greek myth of the sculptor Pygmalion, who carved such a beautiful statue of the nymph Galatea that he actually fell in love with it and embraced her when Venus made his sculpture come to life. The birth of a work of art is indeed an intensely private experience,

so much so that many artists can work only when completely alone and refuse to show their unfinished pieces to anyone. Yet it must, as a final step, be shared with the public in order for the birth to be successful. Artists do not create merely for their own satisfaction, but want their work validated by others. In fact, the creative process is not complete until the work has found an audience. In the end, most works of art exist in order to be liked rather than to be debated.

Perhaps we can resolve this seeming paradox once we understand what artists mean by "public." They are concerned not with *the* public as a statistical entity but with their particular public, their audience. Quality rather than wide approval is what matters to them. The audience whose approval is so important to artists is often a limited and special one. Its members may be other artists as well as patrons, friends, critics, and interested beholders. The one quality they all have in common is an informed love of works of art, an attitude at once discriminating and enthusiastic that lends particular weight to their judgments. They are, in a word, experts, people whose authority rests on experience rather than theoretical knowledge. In reality, there is no sharp break, no difference in kind, between the expert and the public at large, only a difference in degree.

TASTES

Deciding what *is* art and rating a work of art are two separate problems. If we had an absolute method for distinguishing art from nonart, it would not necessarily enable us to measure quality. People tend to compound the two problems into one. Quite often when they ask, "Why is that art?" they mean, "Why is that *good* art?" Since the experts do not post exact rules, people are apt to fall back on the defense: "Well, I don't know anything about art, but I know what I like." It is a formidable roadblock, this stock phrase, in the path of understanding. Let us examine the roadblock and the various unspoken assumptions that buttress it.

Are there really people who know nothing about art? No, for art is so much a part of the fabric of human living that we encounter it all the time, even if our contacts with it are limited to magazine covers, advertising posters, war memorials, television, and the buildings where we live, work, and worship. The statement "I know what I like" may really mean "I like what I know (and I reject whatever fails to match the things I am familiar with)." Such likes are not in truth ours at all, for they have been imposed by habit and culture without any personal choice.

Why should so many of us cherish the illusion of having made a personal choice in art when in fact we have not? There is another unspoken assumption at work here: something must be wrong with a work of art if it takes an expert to appreciate it. But if experts appreciate art more than the uninformed, why should we not emulate them? The road to expertness is clear and wide, and it invites anyone with an open mind and a capacity to absorb new experiences. As our understanding grows, we find ourselves liking a great many more things than we had thought possible at the start. We gradually acquire the courage of our own convictions, until we are able to say, with some justice, that we know what we like.

Looking at Art

THE VISUAL ELEMENTS

We live in a sea of images conveying the culture and learning of modern civilization. Fostered by an unprecedented media explosion, this "visual background noise" has become so much a part of our daily lives that we take it for granted. In the process, we have become desensitized to art as well. Anyone can buy cheap paintings and reproductions to decorate a room, where they often hang virtually unnoticed, perhaps deservedly so. It is small wonder that we look at the art in museums with equal casualness. We pass rapidly from one object to another, sampling them like dishes in a smorgasbord. We may pause briefly before a famous masterpiece that we have been told we are supposed to admire, then ignore the gallery full of equally beautiful and important works around it. We will have seen the art but not really looked at it. Indeed, looking at great art is

not an easy task, for art rarely reveals its secrets readily. While the experience of a work can be immediately electrifying, we sometimes do not realize its impact until time has let it filter through the recesses of our imaginations. It even happens that something that at first repelled or confounded us emerges only many years later as one of the most important artistic events of our lives.

Understanding a work of art begins with a sensitive appreciation of its appearance. Art may be approached and appreciated for its purely visual elements: line, color, light, composition, form, and space. These may be shared by any work of art; their effects, however, vary widely according to medium (the physical materials of which the artwork is made) and technique, which together help determine the possibilities and limitations of what the artist can achieve. For that reason, our discussion is merged with an introduction to four major arts: graphic arts, painting, sculpture, and architecture. (The technical aspects of the major mediums are treated in separate sections within the main body of the text and in the glossary at the back of the book.) Just because line is discussed with drawing, however, does not mean that it is not equally important in painting and sculpture. And while form is introduced with sculpture, it is just as essential to painting, drawing, and architecture.

Visual analysis can help us appreciate the beauty of a masterpiece, but we must be careful not to trivialize it with a formulaic approach. Every aesthetic "law" advanced so far has proved of dubious value and usually gets in the way of our understanding. Even if a valid "law" were to be found—and none has yet been discovered—it would probably be so elementary as to prove useless in the face of art's complexity. We must also bear in mind that art appreciation is more than mere enjoyment of aesthetics. It is learning to understand the meaning (or iconography) of a work of art. Finally, let us remember that no work can be understood outside its historical context.

Line Line may be regarded as the most basic visual element. A majority of art is initially conceived in terms of contour lines, and their presence is often implied even when they are not actually used to describe form. Because children generally start out by scribbling, line is often considered the most rudimentary component of art, although as anyone knows who has watched a young child struggle to make a stick figure, drawing is by no means as easy as it seems. Line has traditionally been admired for its descriptive value, so that its expressive potential is easily overlooked, but line is capable of creating a broad range of effects.

Line drawings—as opposed to wash drawings and other works on paper that emphasize tone rather than contour—represent line in its purest form. The appreciation of drawings as works of art dates from the Renaissance, when the artist's creative genius first came to be valued and paper began to be made in quantity. Drawing style can be as personal as handwriting. In fact, the term *graphic art,* which designates drawings and prints, comes from the Greek word for writing, *graphos.* Collectors treasure drawings because they seem to reveal the artist's inspiration with unmatched freshness. Their role as records of artistic thought also makes drawings uniquely valuable to art historians, for they help in documenting the evolution of a work from its inception to the finished piece.

Artists themselves commonly treat drawings as a form of note-taking. Some of these notes are discarded as fruitless, while others are tucked away to form a storehouse of motifs and studies for later use. Once a basic idea is established, an artist may develop it into a more complete study. Michelangelo's study for the *Libyan Sibyl* (fig. 4) painted on the Sistine Chapel ceiling is a drawing of compelling beauty. For this sheet, he chose the softer medium of red chalk over the scratchy line of pen and ink that he used in rough sketches. His chalk approximates the texture of flesh and captures the play of light and dark over the nude form, giving the figure a greater sensuousness. The emphatic outline that defines each

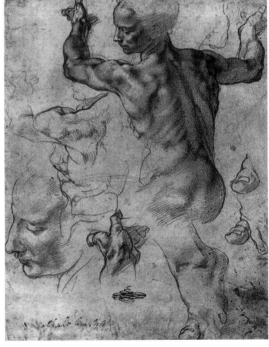

4 Michelangelo. Study for the *Libyan Sibyl.* c. 1511. Red chalk on paper, $11^3/_8$ x $8^3/_8$" (28.9 x 21.3 cm). The Metropolitan Museum of Art, New York

Purchase, Joseph Pulitzer Bequest, 1924

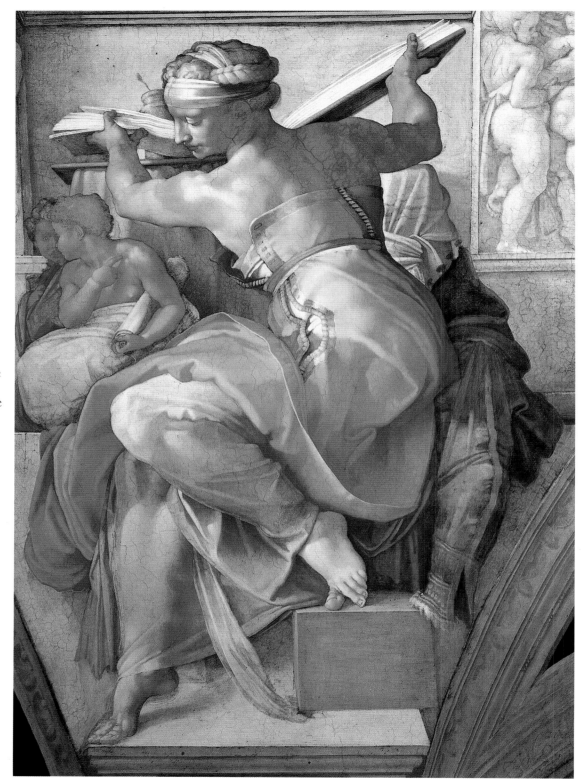

5 Michelangelo. *Libyan Sibyl*, detail of the Sistine ceiling. 1508–12. Fresco in the Sistine Chapel, the Vatican, Rome

part of the form is so fundamental to the conceptual genesis and design process in all of Michelangelo's paintings and drawings that ever since his time line has been closely associated with the "intellectual" side of art.

Like other artists of the time, Michelangelo based his female figures on male nudes drawn from life. To him, only the heroic male nude possessed the physical monumentality necessary to express the awesome power of figures such as this mythical prophetess. As in other similar sheets by Michelangelo, his focus here is on the torso; he studied the musculature at length before turning his attention to details such as the hand and toes. Since there is no sign of hesitation in the pose, we can be sure that the artist already had the conception firmly in mind; probably he established it in a preliminary drawing. Why did he go to so much trouble when the finished sibyl is mostly clothed and must be viewed from a considerable distance below? Evidently Michelangelo believed that only by describing the anatomy completely could he be certain that the figure would be convincing. In the final painting (fig. 5) the sibyl communicates a superhuman strength, lifting her massive book of prophecies with the greatest ease.

Color The world around us is alive with color. Whereas color is an adjunct element to graphics and sometimes sculpture, it is indispensable to virtually all forms of painting. This is true even of tonalism, which emphasizes dark, neutral hues such as gray and brown. Of all the visual elements, color is undoubtedly the most expressive, as well as the most recalcitrant. Perhaps for that reason, it has attracted the attention of numerous researchers and theorists since the mid-nineteenth century. We often read that red seems to advance, while blue recedes; or that the former is a violent or passionate color, the latter a sad one. Like a willful child, however, color in art refuses to be governed by any rules. They work only when the painter consciously applies them. Moreover, the emotional effects produced by the interaction of colors are often subtle and nearly impossible to translate into words.

Notwithstanding the large body of theory regard-

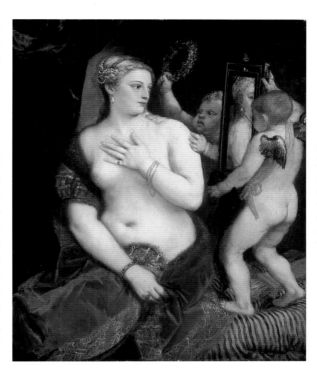

6 Titian. *Venus with a Mirror.* c. 1553–55. Oil on canvas, 49 x 41¹/₂" (124.5 x 105.5 cm). National Gallery of Art, Washington, D.C.

Andrew W. Mellon Collection

ing its place in art, color is so potent that it does not need a system to work its magic. Its role rests primarily on its sensuous and emotive appeal, in contrast to the more cerebral quality generally associated with line. The merits of line versus color have been the subject of an ongoing debate that first arose between partisans of Michelangelo and of Titian, his great contemporary in Venice. Titian himself was a fine draftsman and absorbed the influence of Michelangelo. He nevertheless stands at the head of the coloristic tradition that descends through Rubens and Van Gogh to the Abstract Expressionists of the twentieth century. *Venus with a Mirror* (fig. 6), executed around 1553–55, at the height of Titian's maturity, shows the painterly application of rich color that is characteristic of his style. Although he presumably worked out the essential features of the composition in a preliminary drawing, it has not survived. Nor evidently did he transfer the design onto the canvas but worked directly on it; this particular canvas was reused, for there is a completely different portrait of a man and woman underneath. By varying the consistency of his paints, the artist was able to capture the texture of Venus's flesh with uncanny

accuracy, while distinguishing it clearly from that of the two putti holding the mirror and the drapery that both reveals and enhances her charms by offering a coloristic and sensuous contrast to the goddess's creamy skin. To convey these tactile qualities, Titian built up the surface of the painting in thin coats, known as glazes. The interaction between these layers produces unrivaled richness and complexity of color; the medium is so filmy as to become nearly translucent in places. In fact, the man's coat was used for the velvet cloak around Venus's hips, with very few changes.

The painting became the prototype of all later variants from the artist's studio. More important, it is the first image since antiquity to treat the theme of a beautiful woman admiring herself in a mirror without the medieval moral overtones of Vanitas, which emphasizes the brevity of beauty and the inevitability of old age and death in order to exhort the viewer to think instead of spiritual values. The motif of a young woman contemplating her beauty was to have a long life (see, for example, *The Toilet of Venus* by the French Baroque artist Simon Vouet, fig. 19-4), extending through the twentieth century.

The greatest example of this subject in modern times is Picasso's *Girl Before a Mirror* (fig. 7). From

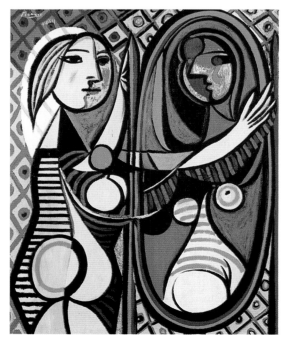

7 Pablo Picasso. *Girl before a Mirror.* 1932. Oil on canvas, 64 x 51¼" (1.63 x 1.3 m). The Museum of Modern Art, New York

Gift of Mrs. Simon Guggenheim

the heavy outlines, it is apparent that the artist must have originally conceived the picture in terms of form; yet visually it makes no sense in black and white. Picasso has treated his shapes much like the flat, enclosed panes of a stained-glass window within a striking decorative pattern. Rarely, however, has the theme been depicted with such disturbing overtones. Picasso's girl is anything but serene. On the contrary, her face is divided into two parts, one with a somber expression, the other with a masklike appearance whose color suggests passionate feeling. She reaches out to touch the image in the mirror with a gesture of longing and apprehension. Now, we all feel a jolt when we unexpectedly see ourselves in a mirror, which often gives back a reflection that upsets our self-conception. Picasso here suggests this visionary truth in several ways. Much as a real mirror introduces changes of its own and does not merely give back the simple truth, so this one alters the way the girl looks, revealing a deeper reality—a sea of conflicting emotions signified above all by the color scheme of her reflection. Framed by strong blue, purple, and green hues, her features stare back at her with fiery intensity. Clearly discernible is a tear on her cheek. But it is the masterstroke of the green spot, shining like a beacon in the middle of her forehead, that conveys the anguish of the girl's confrontation with her inner self. Picasso was no doubt aware of the theory that red and green are complementary colors which intensify each other. However, this "law" can hardly have dictated his choice of green to stand for the girl's psyche. That was surely determined as a matter of pictorial and expressive necessity.

Light Except for modern light installations such as laser displays, art is concerned with reflected light effects rather than with radiant light. Artists have several ways of representing radiant light. Divine light, for example, is sometimes indicated by golden rays, at other times by a halo or aura. A candle or torch may be depicted as the source of light in a dark interior or night scene. The most common method is not to show radiant light directly but to suggest its presence through a change in the value of reflected light from dark

8 Caravaggio. *David with the Head of Goliath.* 1607 or 1609/10. Oil on canvas, 49¼ x 39⅜" (125.1 x 100 cm). Galleria Borghese, Rome

to light. Sharp contrast (known as *chiaroscuro,* the Italian word for "light-dark") is identified with the Baroque artist Caravaggio, who made it the cornerstone of his style. In *David with the Head of Goliath* (fig. 8), he employed it to heighten the drama. An intense raking light from an unseen source at the left is used to model forms and create textures. The selective highlighting endows the life-size figure of David and the gruesome head with a startling presence. Light here serves as a device to create the convincing illusion that David is standing before us. The pictorial space, with its indeterminate depth, becomes continuous with ours, despite the fact that the frame cuts off the figure. Thus, the foreshortened arm with Goliath's head seems to extend out to the viewer from the dark background. For all its obvious theatricality, the painting is surprisingly muted: David seems to contemplate Goliath with a mixture of sadness and pity. According to contemporary sources, the severed head is a self-portrait, but although we may doubt the identification, this disturbing image communicates a tragic vision that was soon fulfilled. Not long after the *David* was painted, Caravaggio killed a man in a duel, which forced him to spend the rest of his short life on the run.

Composition All art requires order. Otherwise its message would emerge as visually garbled. To accomplish this, the artist must control space within the framework of a unified composition. Moreover, pictorial space must work across the picture plane, as well as behind it. Since the Early Renaissance, viewers have become accustomed to experiencing paintings as windows onto separate illusionistic realities. The Renaissance invention of one-point perspective (also called scientific or linear perspective) provided a geometric system for the convincing representation of architectural and open-air settings. By having the orthogonals (shown as diagonal lines) converge at a vanishing point on the horizon, the artist was able to gain command over every aspect of composition, including the rate of recession and placement of figures.

Artists usually dispense with aids such as perspective and rely on their own eyes. This does not mean that they merely transcribe optical reality. *Blowing Bubbles* by the French painter Jean-Baptiste-Siméon Chardin (fig. 9) depends in good measure on the satisfying composition for its success. The motif had been popular in earlier Dutch genre scenes, where bubbles symbolized life's brevity and, hence, the vanity of all earthly things. This meaning still resonates in Chardin's picture, however simple it at first appears. But much of its interest also lies in the sense of enchantment imparted by the children's rapt attention to the moment. We know from a contemporary source that Chardin painted the youth "carefully from life and . . . tried hard to give him an ingenuous air." The results are anything but artless, however. The triangular shape of the boy leaning on the

9 Jean-Baptiste-Siméon Chardin. *Blowing Bubbles.* c. 1745. Oil on canvas, 36⅝ x 29⅜" (93 x 74.6 cm). The National Gallery of Art, Washington, D.C.

Gift of Mrs. John Simpson

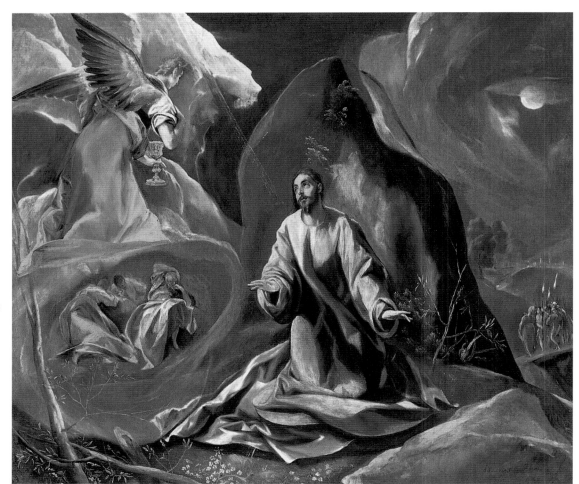

10 El Greco. *The Agony in the Garden.* 1597–1600. Oil on canvas, 40¼ x 44¾" (102.2 x 113.7 cm). The Toledo Museum of Art, Ohio

Gift of Edward Drummond Libbey

ledge gives stability to the painting, which helps suspend the fleeting instant in time. To fill out the composition, the artist includes the toddler peering intently over the ledge at the bubble, which is about the same size as his head. Chardin has carefully thought out every aspect of his arrangement. The honeysuckle in the upper left-hand corner, for example, echoes the contour of the adolescent's back, while the two straws are virtually parallel to each other. Even the crack in the stone ledge has a purpose: to draw attention to the glass of soap by setting it slightly apart.

Often artists paint not what they see but what they imagine. Pictorial space, however, need not conform to either conceptual or visual reality. El Greco's *Agony in the Garden* (fig. 10) uses contradictory, irrational space to help conjure up a mystical vision that represents a spiritual reality. Christ, isolated against a large rock that echoes his

shape, is comforted by the angel bearing a golden cup, symbol of the Passion. The angel appears to kneel on a mysterious oval cloud, which envelops the sleeping disciples. In the distance to the right we see Judas and the soldiers coming to arrest the Lord. The composition is balanced by two giant clouds on either side. The entire landscape resounds with Christ's agitation, represented by the sweep of supernatural forces. The elongated forms, eerie moonlight, and expressive colors—all hallmarks of El Greco's style—help heighten our sense of identification with Christ's suffering.

Form Every two-dimensional shape that we encounter in art is the counterpart to a three-dimensional form. There is nevertheless a vast difference between drawing or painting forms and sculpting them. The one transcribes, the other embodies them, as it were. They require fundamentally

11 *Hermes Leading Iphigeneia to Hades.* Lower column drum from the Temple of Artemis, Ephesus. c. 340 B.C. Marble, height 5'11" (1.8 m). The British Museum, London

different talents and attitudes toward material as well as subject matter. Although numerous artists have been competent in both painting and sculpture, only a handful have managed to bridge the gap between them with complete success.

Sculpture is categorized according to whether it is carved or modeled and whether it is a relief or freestanding. Relief remains tied to the background, from which it only partially emerges, in contrast to freestanding sculpture, which is fully liberated from it. A further distinction is made between low (*bas*) relief and high relief, depending on how much the carving projects. However, since scale as well as depth must be taken into account, there is no single guideline, so that a third category, middle relief, is sometimes cited.

Low reliefs often share characteristics with painting. In Egypt, where low-relief carving attained unsurpassed subtlety, many reliefs were originally painted and included elaborate settings. High reliefs largely preclude this kind of pictorialism. The figures on a column drum from a Greek temple (fig. 11) are so detached from the background that the addition of landscape or archi-

tecture elements would have been both unnecessary and unconvincing. The neutral setting, moreover, is in keeping with the mythological subject, which occurs in an indeterminate time and place. In compensation, the sculptor has treated the limited free space atmospherically, although the figures nonetheless remain imprisoned in stone.

Freestanding sculpture—that is, sculpture that is carved or modeled fully in the round—is generally made by either of two methods. One is carving. It is a subtractive process that starts with a solid block, usually stone, which is highly resistant to the sculptor's chisel. The brittleness of stone and the difficulty of cutting it tend to result in the compact, "closed" forms evident, for example, in Michelangelo's *Awakening Slave* (see fig. 3). Modeling is the very opposite of carving. It is an additive process using soft materials such as plaster, clay, or wax. Since these materials are not very durable, they are usually cast in a more lasting medium: anything that can be poured, including molten metal, cement, even plastic. Modeling encourages "open" forms created with the aid of metal armatures to support their extension into space. This technique and the development of lightweight hollow-bronze casting enabled the Greeks to experiment with daring poses in monumental sculpture before attempting them in marble. In contrast to the figure of Hermes on the column drum (see fig. 11), the bronze *Standing Youth* (fig. 12) is free to move about, which lends him a lifelike presence that is further enhanced by his dancing pose. His inlaid eyes and soft patina, accentuated by oxidation and corrosion (he was found in the Aegean Sea off the coast of Marathon), make him even more credible in a way that marble statues, with their seemingly cold and smooth finish, rarely equal, despite their more natural color.

12 Praxiteles (attributed to). *Standing Youth,* found in the sea off Marathon. c. 350–325 B.C. Bronze, height 51" (129.5 cm). National Archaeological Museum, Athens

Space Architecture is the principal means of organizing space. Of all the arts, it is also the most practical. The parameters of architecture are defined by utilitarian function and structural system, but there is almost always an aesthetic component as well, even when it consists of nothing more than a decorative veneer. A building proclaims the architect's concerns by the way in which these elements are woven into a coherent program.

Architecture becomes memorable only when it expresses a transcendent vision, whether personal, social, or spiritual. Such buildings are almost always important public places that require the marshaling of significant resources and serve the purpose of bringing people together to share goals, pursuits, and values. An extreme case is the Solomon R. Guggenheim Museum in New York by Frank Lloyd Wright. Scorned when it was erected in the late 1950s, it is a brilliant, if idiosyncratic, creation by one of the most original architectural minds of the century. The sculptural exterior (fig. 13) announces that this is a museum, for it is self-consciously a work of art in its own right. As a piece of design, the Guggenheim Museum is remarkably willful. In shape it is as defiantly individual as the architect himself and refuses to conform to the boxlike apartments around it. From the outside, the structure looks like a gigantic snail, reflecting Wright's interest in organic shapes. The office area forming the "head" (to the left in our photograph) is connected by a narrow passageway to the "shell" containing the main body of the museum.

The outside gives us some idea of what to expect inside (fig. 14), yet nothing quite prepares us for the extraordinary sensation of light and air in the main hall after we have been ushered through the unassuming entrance. The radical design makes it clear that Wright had completely rethought the purpose of an art museum. The exhibition area is a kind of inverted dome with a huge glass-covered eye at the top. The vast, fluid space creates an atmosphere of quiet harmony while actively shaping our experience by determining how art shall be displayed. After taking an elevator to the top of the building, we begin a leisurely descent down the gently sloping ramp. The continuous spiral provides for uninterrupted viewing, conducive to studying art. At the same time, the narrow confines of the galleries prevent us from becoming passive observers by forcing us into a direct confrontation with the works of art. Sculpture takes on a heightened physical presence which demands that we look at it. Even paintings acquire a new prominence by protruding slightly from the curved walls, instead of receding into them.

13 Frank Lloyd Wright. Solomon R. Guggenheim Museum, New York. 1956–59

14 Interior, Solomon R. Guggenheim Museum

Viewing exhibitions at the Guggenheim is like being conducted through a predetermined stream of consciousness, where everything merges into a total unity. Whether one agrees with this approach or not, the building testifies to the strength of Wright's vision by precluding any other way of seeing the art.

MEANING

Art has been called a visual dialogue, for though the object itself is mute, it expresses its creator's intention just as surely as if the artist were speaking to us. For there to be a dialogue, however, our active participation is required. Although we cannot literally talk with a work of art, we can learn how to respond to it and question it in order to try to fathom its meaning, despite what are sometimes enormous cultural barriers. Finding the right answers usually involves asking the right questions. Even if we aren't sure which questions to ask, we can always start with, "What would happen if the artist had done it another way?" And when we are through, we must question our explanation according to the same test of adequate proof that applies to any investigation: have we taken into account *all* the available evidence, and arranged it in a logical and coherent way? There is, alas, no step-by-step method to guide us, but this does not mean the process is entirely mysterious. We can illustrate it by looking at some examples together. The demonstration will help us gain courage to try the same analysis the next time we enter a museum.

The great Dutch painter Jan Vermeer has been called the Sphinx of Delft, and with good reason, for all his paintings have a degree of mystery. In *Woman Holding a Balance* (fig. 15, page 32), a young woman, richly dressed in the at-home wear of the day and with strings of pearls and gold coins spread out on the table before her, is contemplating a balance in her hand. The canvas is painted entirely in gradations of cool, neutral tones, except for a bit of the red dress visible beneath her jacket. The soft light from the partly open window is concentrated on her face and the cap framing it. Other beads of light reflect from the pearls and her right hand. The serene atmosphere is sustained throughout the stable composition. Vermeer places us at an intimate distance within the rela-

tively shallow space, which has been molded around the figure. The underlying grid of horizontals and verticals is modulated by the gentle curves of the woman's form and the heap of blue drapery, as well as by the oblique angles of the mirror. The design is so perfect that we cannot move a single element without upsetting the delicate balance.

The composition is controlled in part by perspective. The vanishing point of the diagonals formed by the top of the mirror and the right side of the table lies at the juncture of the woman's little finger and the picture frame. If we look carefully at the bottom of the frame, we see that it is actually lower on the right than on the left, where it lies just below her hand. The effect is so carefully calculated that the artist must have wanted to guide our eye to the painting in the background. Though difficult to read at first, it depicts Christ at the Last Judgment, when every soul is weighed. The parallel of this subject to the woman's activity tells us that, contrary to our initial impression, this cannot be simply a scene of everyday life. The painting, then, is testimony to the artist's faith, for he was a Catholic living in Protestant Holland, where his religion was officially banned, although worship in private houses was tolerated.

The meaning is nevertheless far from clear. Because Vermeer treated forms as beads of light, it was assumed until recently that the balance holds items of jewelry and that the woman is weighing the worthlessness of earthly possessions in the face of death; hence, the painting was generally called *The Pearl Weigher* or *The Gold Weigher.* If we look closely, however, we can see that the pans contain nothing. This is confirmed by infrared photography, which also reveals that Vermeer changed the position of the balance: to make the composition more harmonious, he placed it parallel to the picture plane instead of allowing it to recede into space.

What, then, is she doing? If she is weighing temporal against spiritual values, it can be only in a symbolic sense, because nothing about her or the setting betrays a sense of conflict. What accounts for this inner peace? Perhaps it is self-knowledge, symbolized here by the mirror. It may also be the promise of salvation through her faith. In *Woman Holding a Balance,* as in Caravaggio's *Calling of St. Matthew*

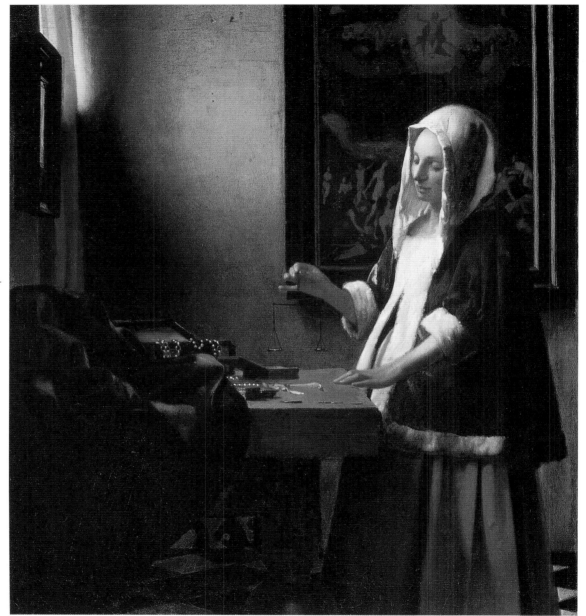

15 Jan Vermeer. *Woman Holding a Balance.* c. 1664. Oil on canvas, 16¾ x 15" (42.5 x 38.1 cm). The National Gallery of Art, Washington, D.C.

(see fig. 17-1), light might therefore serve not only to illuminate the scene but also to represent religious revelation. In the end, we cannot be sure, because Vermeer's approach to his subject proves as subtle as his pictorial treatment. He avoids any anecdote or symbolism that might limit us to a single interpretation. There can be no doubt, however, about his fascination with light. Vermeer's mastery of light's expressive qualities elevates his concern for the reality of appearance to the level of poetry and subsumes its visual and symbolic possibilities. Here, then, we have found the real "meaning" of Vermeer's art.

The ambiguity in *Woman Holding a Balance* serves to heighten our interest and pleasure, while the carefully organized composition expresses the artist's underlying concept with singular clarity. But what are we to do when a work deliberately seems

devoid of ostensible meaning? Modern artists can pose a gap between their intentions and the viewer's understanding. The gap is, however, often more apparent than real, for the meaning is usually intelligible to the imagination at some level. Still, we feel we must comprehend intellectually what we perceive intuitively. We can partially solve the personal code in Jasper Johns's *Target with Four Faces* (fig. 16) by treating it somewhat like a rebus. Where did he begin? Surely with the target, which stands alone as an object, unlike the long box at the top, particularly when its hinged door is closed. Why a target in the first place? The size, texture, and colors inform us that this is not to be interpreted as a real target. The design is nevertheless attractive in its own right, and Johns must have chosen it for that reason. When the wooden door is up, the assemblage is transformed from a neutral into a loaded image, bringing out the nascent connotations of the target. Johns has used the same plaster cast four times, which lends the faces a curious anonymity. He then cut them off at the eyes, "the windows of the soul," rendering them even more enigmatic. Finally, he crammed them into their compartments, so that they seem to press urgently out toward us. The results are disquieting, aesthetically as well as expressively.

Something so disturbing cannot be without significance. We may be reminded of prisoners trying to look out from small cell windows, or perhaps "blindfolded" targets of execution. Whatever our impression, the claustrophobic image radiates an aura of menacing danger. Unlike Picasso's joining of a bicycle seat and handlebars to form a bull's head, *Target with Four Faces* combines two disparate components in an open conflict that we cannot reconcile, no matter how hard we try. The intrusion of this ominous meaning creates an extraordinary tension with the dispassionate investigation of the target's formal qualities.

How can one be certain? After all, this is merely our personal interpretation, so we turn to the critics for help. We find them divided about the meaning of *Target with Four Faces*, although they agree it must have one. Johns, on the other hand, has insisted that there is none! Whom are we to believe, the critics or the artist himself? The more we think

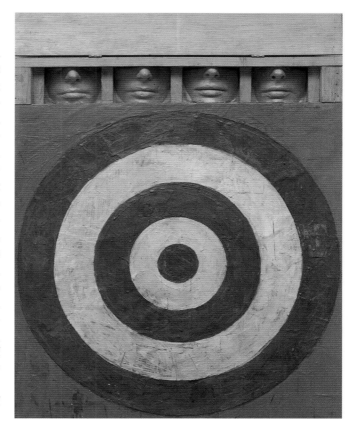

16 Jasper Johns. *Target with Four Faces*. 1955. Assemblage: encaustic on newspaper and cloth over canvas, 26 x 26" (66 x 66 cm), surmounted by four tinted plaster faces in wood box with hinged front. Box, closed 3³/₄ x 26 x 3¹/₂" (9.5 x 66 x 8.9 cm); overall dimensions with box open, 33⁵/₈ x 26 x 3" (85.4 x 66 x 7.6 cm). The Museum of Modern Art, New York
Gift of Mr. and Mrs. Robert C. Scull

about it, the more likely it seems that both sides may be right. Artists are not always aware of why they have made a work. That does not mean there were no reasons, only that they were unconscious ones. Under these circumstances, critics may well know artists' minds better than the artists do and may therefore explain their creations more clearly. We can now understand that to Johns his leap of imagination in *Target with Four Faces* remains as mysterious as it first seemed to us. Our account reconciles the artist's aesthetic concerns and the critics' search for meaning, and while we realize that no ultimate solution is possible, we have arrived at a satisfactory explanation by looking and thinking for ourselves.

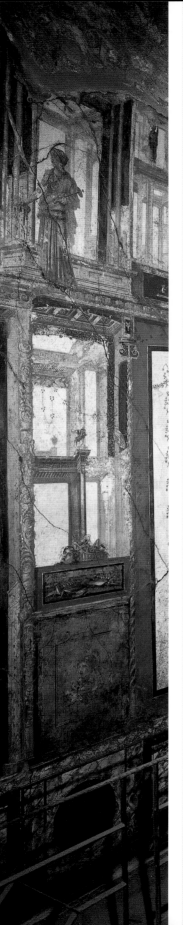

PART 1

THE ANCIENT WORLD

Art history is more than a stream of art objects created over time. It is closely tied to history itself, that is, the recorded evidence of human events. We must therefore consider the *concept* of history. History, we are often told, began with the invention of writing by the "historic" civilizations of Mesopotamia and Egypt some 5,000 years ago. Without writing, the growth we have known would have been impossible. However, the development of writing seems to have taken place over a period of several hundred years—roughly between 3300 and 3000 B.C., with Mesopotamia in the lead—after the new societies were past their first stage. Thus "history" was well under way by the time writing could be used to record events.

The invention of writing serves as a landmark, for the lack of written records is one of the key differences between prehistoric and historic societies. But as soon as we ask why this is so, we face some intriguing problems. First of all, how valid is the distinction between "prehistoric" and "historic"? Does it merely reflect a difference in our *knowledge* of the past?

(Thanks to the invention of writing, we know a great deal more about history than about prehistory.) Or was there a real change in the way things happened, and in the kinds of things that happened, after "history" began? Obviously, prehistory was far from uneventful. Yet the events of this period, decisive though they were, seem slow-paced and gradual when measured against the events of the last 5,000 years. The beginning of "history," then, means a sudden increase in the speed of events, a shift from low gear to high gear, as it were. It also means a change in the *kinds* of events. Historic societies literally make history. They not only bring forth "great individuals and great deeds" (one definition of history) by demanding human effort on a large scale, but they make these achievements *memorable*. And for an event to be memorable, it must be more than "worth remembering." It must also occur quickly enough to be grasped by human memory, not spread over many centuries. Taken together, memorable events have caused the ever-quickening pace of change during the past five millenniums, which begin with what we call the ancient world.

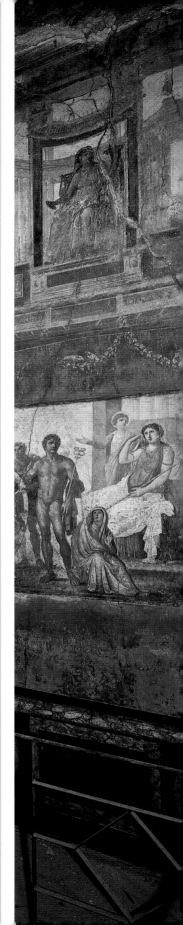

This period was preceded by a vast prehistoric era of which we know almost nothing until the last Ice Age in Europe began to recede, from about 40,000 to 8000 B.C. (There had been at least three previous ice ages, alternating with periods of subtropical warmth, at intervals of about 25,000 years.) At the time, the climate between the Alps and Scandinavia resembled that of present-day Siberia or Alaska. Huge herds of reindeer and other large plant-eating animals roamed the plains and valleys, preyed upon by the ancestors of today's lions and tigers, as well as by our own ancestors. These people liked to live in caves or in the shelter of overhanging rocks. Many such sites have been found, mostly in Spain and in southern France. This phase of prehistory is known as the Old Stone Age, or Paleolithic era, because tools were made only from stone. Its way of life was adapted almost perfectly to the special conditions of the waning Ice Age, and it could not survive beyond them.

The Old Stone Age came to a close with what is termed the Neolithic Revolution, which ushered in the New Stone Age. And a revolution it was indeed, even though it was a period of transition that extended over several thousand years during the Mesolithic Age. It began in the "fertile crescent" of the Near East (an area covering what is now Turkey, Iraq, Iran, Jordan, Israel, Lebanon, and Syria) sometime about 12,000–8000 B.C., with the first successful attempts to domesticate animals and food grains. The Neolithic came later to Europe but then spread much more rapidly.

The cultivation of regular food sources was one of the most decisive achievements in human history. People in Paleolithic societies had led the unsettled life of the hunter and food-gatherer, reaping wherever nature sowed. They were at the mercy of forces that they could neither understand nor control. But having learned how to ensure a food supply through their own efforts, they settled down in permanent villages. A new discipline and order entered their lives. There is, then, a very basic difference between the Neolithic and the Paleolithic, despite the fact that at first both still depended on stone for tools and weapons. The new way of life brought forth a number of new crafts and inventions long before the appearance of metals. Among them were pottery, weaving, and spinning, as well as basic methods of construction in wood, brick, and stone. When metallurgy in the form of copper finally appeared in southeastern Europe around 4500 B.C., at the beginning of the so-called Eneolithic era, it was as a direct outgrowth of the technology gained from pottery. Thus it did not in itself constitute a major advance; nor, surprisingly enough, did it have an immediate impact.

The Neolithic Revolution placed us on a level at which we might well have remained indefinitely. The forces of nature would never again challenge men and women as they had Paleolithic peoples. In a few places, however, the balance between humans and nature was upset by a new threat, one posed not by nature but by people themselves. Evidence of that threat can be seen in the earliest Neolithic fortifications, built almost 9,000 years ago in the Near East. What was the source of the human conflict that made these defenses necessary? Competition for grazing land among groups of herders or for arable soil among farming communities? The basic cause, we suspect, was that the Neolithic Revolution had been too successful. It had allowed population groups to grow beyond the available food supply. This situation might have been resolved in a number of ways. Constant warfare could have reduced the population. Or the people could have united in larger and more disciplined social units for the sake of group

efforts—such as building fortifications—that no loosely organized society could achieve on its own.

We do not know the outcome of the struggle in the region. (Future excavations may tell us how far the urbanizing process extended.) But about 3,000 years later, similar conflicts, on a larger scale, arose in the Nile Valley and again in the plains of the Tigris and Euphrates rivers. The pressures that forced the people in these regions to abandon Neolithic village life may well have been the same. These conflicts created enough pressure to produce the first civilizations. To be civilized, after all, means to live as a citizen, a town dweller. (The word *civilization* derives from the Latin term for city, *civilis*.) These new societies were organized into much larger units—cities and city-states—that were far more complex and efficient than had ever existed before. First in Mesopotamia and Egypt, somewhat later in neighboring areas, and in the Indus Valley and along the Yellow River in China, people would henceforth live in a more dynamic world. Their ability to survive was challenged not by the forces of nature but by human forces: by tensions and conflicts arising either within society or as the result of competition between societies. Efforts to cope with such forces have proved to be a far greater challenge than the earlier struggle with nature. The problems and pressures faced by historic societies thus are very different from those faced by peoples in the Paleolithic and Neolithic eras.

These momentous changes also spurred the development of new technologies in what we term the Bronze Age and the Iron Age, which, like the Neolithic, are stages, not distinct eras. People first began to cast bronze, an alloy of copper and tin, in the Middle East around 3500 B.C., at the same time that the earliest cities arose in Egypt and Mesopotamia. The smelting and forging of iron were invented about 2000–1500 B.C. by the Hittites, an Indo-European–speaking people who settled in Cappadocia (today's east central Turkey), a high plateau with abundant copper and iron ore. Indeed, it was the competition for mineral resources that helped create the conflicts that beset civilizations everywhere.

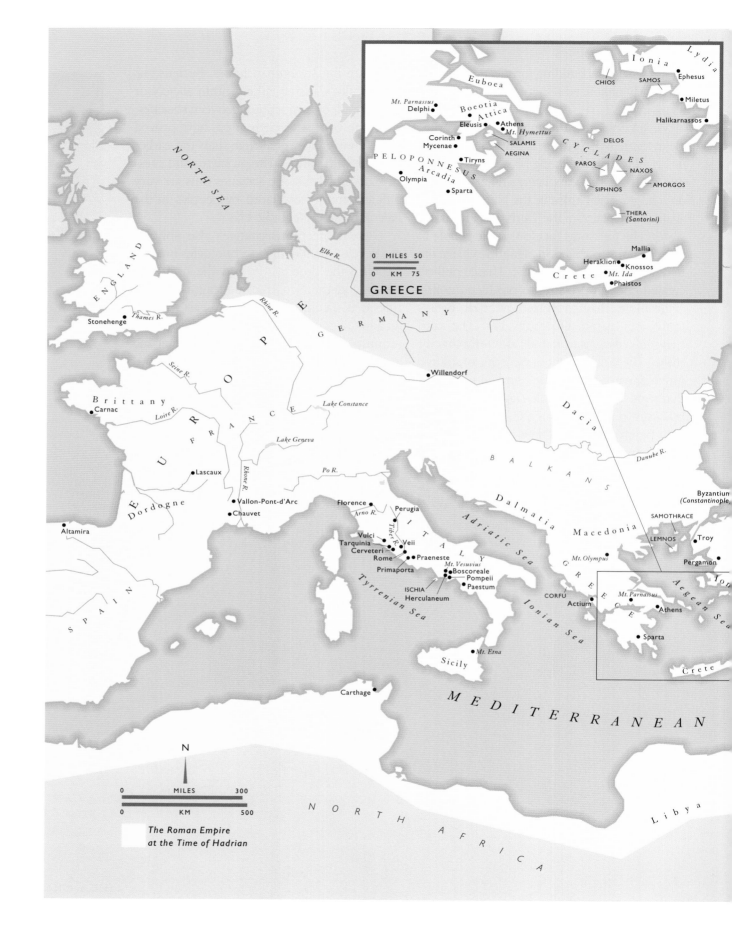

NORTH SEA

Mt. Parnassus
Delphi
Euboea
Boeotia
Attica
Eleusis
Athens
Mt. Hymettus
Corinth
Mycenae
SALAMIS
Tiryns
AEGINA
PELOPONNESUS
Arcadia
Olympia
Sparta

I o n i a
L y d i a
CHIOS
SAMOS
Ephesus
Miletus
Halikarnassos
DELOS
C Y C L A D E S
PAROS
NAXOS
SIPHNOS
AMORGOS

THERA
(Santorini)

Mallia
Heraklion
Knossos
C r e t e
Mt. Ida
Phaistos

0 MILES 50
0 KM 75

GREECE

Elbe R.

ENGLAND

Stonehenge *Thames R.*

Rhine R.

G E R M A N Y

Willendorf

E U R O P E

B r i t t a n y
Carnac

Seine R.

F R A N C E

Loire R.

Lake Constance

Lake Geneva

D a c i a

B A L K A N S

Danube R.

Dordogne

U

R

Lascaux

Rhone R.

Po R.

D a l m a t i a

Byzantium
(Constantinople)

SAMOTHRACE

LEMNOS

Vallon-Pont-d'Arc
Chauvet

Altamira

Florence

Arno R.

Perugia

I T A L Y

Vulci Veii
Tarquinia
Cerveteri
Rome Praeneste
Primaporta
Mt. Vesuvius
Boscoreale
ISCHIA Pompeii
Herculaneum Paestum

Tiber R.

T y r r h e n i a n S e a

S P A I N

A d r i a t i c S e a

M a c e d o n i a

Mt. Olympus

G
R
E
E
C
E

Mt. Parnassus
Athens

Troy

Pergamon

Aegean Sea

I o n

Sparta

CORFU
Actium

I o n i a n S e a

C r e t e

Sicily *Mt. Etna*

Carthage

M E D I T E R R A N E A N

N

0 MILES 300
0 KM 500

☐ The Roman Empire
at the Time of Hadrian

N O R T H A F R I C A

L i b y a

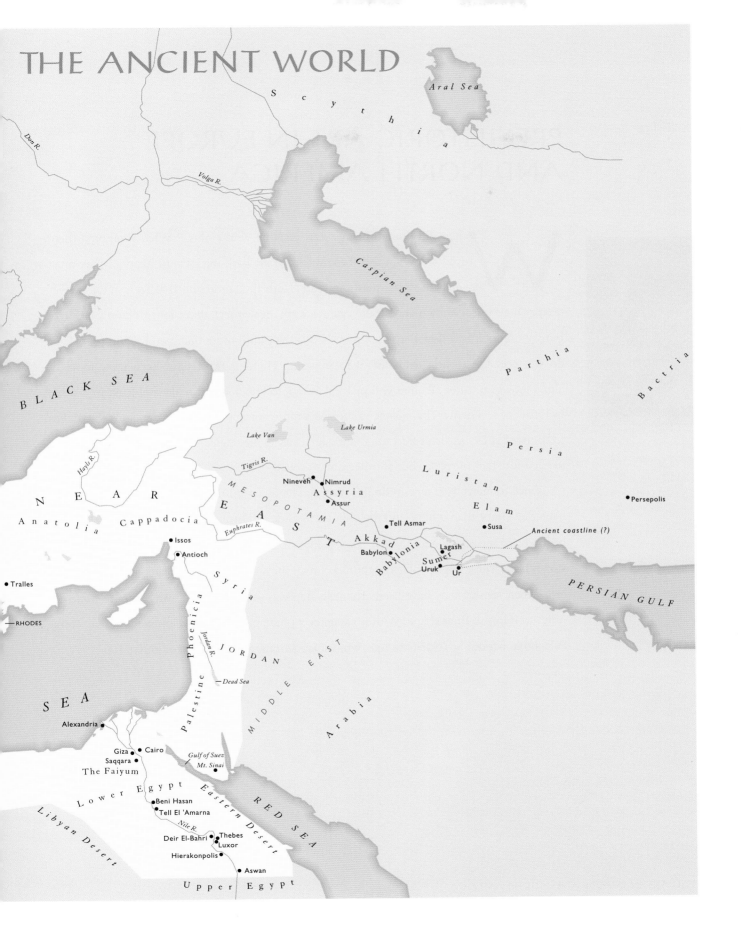

THE ANCIENT WORLD

Scythia

Aral Sea

Don R.

Volga R.

Caspian Sea

BLACK SEA

Parthia

Bactria

Persia

Halys R.

Lake Van *Lake Urmia*

NEAR

Luristan

• Persepolis

Anatolia *Cappadocia*

MESOPOTAMIA

Nineveh • • Nimrud
Assyria
• Assur

Elam

• Tell Asmar

• Susa

Ancient coastline (?)

E A S T

Euphrates R.

Akkad Babylonia
Babylon • Lagash •
Sumer
Babylonia Uruk • • Ur

PERSIAN GULF

• Issos

• Antioch

Syria

• Tralles

— RHODES

Phoenicia

Jordan R.

JORDAN

MIDDLE EAST

SEA

Palestine

— *Dead Sea*

Alexandria •

Arabia

Giza • • Cairo
Saqqara •
The Faiyum

Gulf of Suez
/ *Mt. Sinai*

Lower Egypt

Eastern Desert

RED SEA

• Beni Hasan
• Tell El 'Amarna
Nile R.
Deir El-Bahri • • Thebes
• Luxor
Hierakonpolis

Libyan Desert

• Aswan

Upper Egypt

CHAPTER 1

PREHISTORIC ART IN EUROPE AND NORTH AMERICA

When did human beings start creating works of art? What prompted them to do so? What did these works of art look like? Every history of art must begin with these questions—and with the admission that we cannot answer them. Our earliest known ancestors began to walk on two feet about four million years ago, but we do not know how they used their hands. Not until more than two million years later do we meet the earliest evidence of toolmaking. Humans must have been *using* tools all along, however. After all, apes will pick up a stick to knock down a piece of fruit, or a stone to throw at an enemy. The *making* of tools is a more complex matter. It demands the ability to think of sticks as "fruit knockers" and stones as "bone crackers," not only when they are needed for such purposes but at other times as well.

Once humans were able to do this, they gradually found that some sticks and stones had a handier shape than others, and they put them aside for future use as tools because they had begun to connect *form* and *function*. The sticks, of course, have not survived, but a few of the stones have. These large pebbles or chunks of rock show the marks of repeated use for the same task, whatever that may have been. The next step was to try chipping away at these stones in order to improve their shape. With it we enter a phase of human development known as the Paleolithic period, or Old Stone Age, which lasted from about 40,000 to 8000 B.C.

The Old Stone Age

CAVE ART

Chauvet The most striking works of Paleolithic art are the images of animals found on the rock surfaces of caves. In the Chauvet cave in southeastern France, we meet the earliest paintings known to us, which date from more than 30,000 years ago. Ferocious lions, panthers, rhinoceroses, bears, reindeer, and mammoths are depicted with extraordinary vividness, along with bulls, horses, birds, and occasionally humans. These paintings already show an assurance and refinement far removed from any humble beginnings. What a vivid, lifelike image is the depiction of horses seen in figure 1-1! We are amazed not only by the keen observation and the forceful outlines but also by the power and expressiveness of these creatures. It is highly unlikely that images such as this came into being in a single, sudden burst. They must have been preceded by thousands of years of development about which we know nothing at all.

Lascaux On the basis of differences among tools and other remains, scholars have divided later "cavemen" into several groups, each named after a specific site. Among these, the so-called AURIGNACIANS and MAGDALENIANS stand out for the gifted artists they produced and for the important role art must have played in their lives. One of the major sites is at Lascaux, in the Dordogne region of France (fig. 1-2). As at Chauvet, bison, deer, horses, and cattle race across walls and

1-1 Cave paintings, Chauvet cave, Vallon-Pont-d'Arc, Ardèche gorge, France. c. 28,000 B.C.

The earliest Upper Paleolithic artists date to the AURIGNACIAN period and are best known for carved female statuettes such as the *Woman of Willendorf* (see fig. 1-3); some 130 of these have been found over a vast area from France to Siberia. The zenith of prehistoric art was reached during the MAGDALENIAN era, the last period of the Upper Paleolithic. Its masterpieces are the magnificent cave paintings of animals in the Périgord region of France, in the Pyrenees Mountains, and at Altamira in Spain.

1-2 Cave paintings, Lascaux, Dordogne, France. c. 15,000–10,000 B.C.

This 30,000-year-old image of an owl in the Chauvet cave was made by pressing a flat-ended tool of some kind into the soft limestone surface of the cave wall, a process called **incising**. Most prehistoric incising produced chiseled lines that are narrower than those of this owl, but the process is the same.

ceiling. Some of them are outlined in black, others are filled in with bright earth colors, but all show the same uncanny sense of life. The style in both caves is essentially the same despite a gap of thousands of years—evidence of the stability of Paleolithic culture. Gone, however, are the fiercest beasts.

How did this amazing art survive intact over so many thousands of years? The question can be answered easily enough. The pictures never appear near the mouth of a cave, where they would be open to easy view and destruction. They are found only in dark recesses, as far from the entrance as possible. Some can be reached only by crawling on hands and knees. Often the path is so complex that one would soon be lost without an expert guide. In fact, the cave at Lascaux was discovered by chance in 1940 by some boys whose dog had fallen into a hole that led to the underground chamber.

What purpose did these images serve? Because they were hidden away in order to protect them from intruders, they must have been considered important. There can be little doubt that they were made as part of a ritual. But of what kind? The standard explanation is that they are a form of hunting magic. According to this theory, in "killing" the image of an animal (by throwing stones at it), people of the Old Stone Age thought they had killed its vital spirit. This later evolved into fertility magic, carried out deep in the bowels of the earth. But how are we to account for the presence at Chauvet of large meat-eaters too dangerous to be hunted? Perhaps at first cavemen took on the identity of lions and bears to aid in the hunt. Although it cannot be disproved, this proposal is not completely satisfying, for it fails to explain many curious features of cave art.

There is growing agreement that cave paintings must embody a very early form of religion. If so, the creatures found in them have a spiritual meaning that makes them the distant ancestors of the animal divinities and their half-human, half-animal cousins we shall meet throughout the Near East and the Aegean. Indeed, how else are we to account for these later deities? Such an approach accords with animism—the belief that

nature is filled with spirits—which was found the world over in the ethnographic societies that survived intact until recently.

Cave art is also important as the earliest example of a long tradition found in civilizations everywhere: the urge to decorate walls and ceilings with **incised**, painted, or carved images that have a spiritual meaning. Because they were not constructed, caves such as Lascaux do not qualify as architecture (see below). Yet they served the same function as a church or temple. In that sense, they are the forerunners of the religious architecture featured throughout this book.

How did cave painting originate? In many cases the shape of an animal seems to have been suggested by the natural formation of the rock: its body coincided with a bump, or its contour followed a vein or crack. We all know how our imagination sometimes makes us see many sorts of images in clouds or blots. At first, Stone Age artists may have merely reinforced the outlines of such images with a charred stick. It is tempting to think that those who were very good at finding such images were given a special status as artist-shamans. Then they were able to perfect their image-hunting until they learned how to make images with little or no help from chance formations.

PORTABLE OBJECTS

Apart from large-scale cave art, the people of the Upper Paleolithic also produced small, hand-sized drawings and carvings in bone, horn, or stone, skillfully cut with flint tools. Some of these carvings suggest that they, too, may have stemmed from the perception of a chance resemblance. Earlier Stone Age people were content to collect pebbles in whose natural shape they saw some special quality. Echoes of this approach can sometimes be felt in later pieces. The so-called *Woman of Willendorf* (fig. 1-3), one of many such female figurines, has a roundness that recalls an egg-shaped "sacred pebble." Her navel, the central point of the design, is a natural cavity in the stone. Judging from the spiritual beliefs of the "preliterate" societies of modern times, scholars have often seen such carvings as fertility figures.

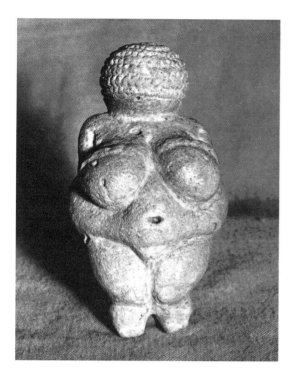

1-3 *Woman of Willendorf,* from Austria. c. 25,000–20,000 B.C. Limestone, height 4³/₈" (11.1 cm). Naturhistorischesmuseum, Vienna

Although the idea is tempting, we cannot be sure that such beliefs existed in the Old Stone Age.

The New Stone Age

NEOLITHIC EUROPE

The art of the Old Stone Age in Europe as we know it represents the highest achievement of a culture that began to decline soon afterward. The change is marked by the rise of fired-clay pottery, which first appeared in the Near East about 5000 B.C. and eventually spread to Europe during the Mesolithic era, the transitional period between the last Ice Age and the Neolithic Age. Pottery, being breakable but durable, has survived in large numbers of fragments, known as shards. Because the earliest shards uncovered by archaeologists are so scattered, it is unclear whether pottery making at first arose independently in several places or was transmitted through direct contact.

Over time, the patterns of distribution become clearer, with different forms that make it possible to chart successive changes in culture. A great variety of clay vessels covered with abstract patterns have been found, along with stone tools of ever-greater technical refinement and beauty. But none of these items can be compared to the painting and sculpture of the Paleolithic Age.

Figurines There may be a vast chapter in the development of art that is largely lost because Neolithic artists worked mainly in wood or other impermanent materials. The shift from hunting to husbandry that occurred at this time must have been accompanied by profound changes in the people's view of themselves and the world—changes that were no doubt reflected in their art. Unfortunately, the tangible evidence of Neolithic settlements tells us very little about the spiritual life of the New Stone Age. Baked clay figurines, however, sometimes provide a tantalizing hint of Neolithic religious beliefs. The earliest European examples, produced in the Balkans under Near Eastern influence, still remind us of the *Woman of Willendorf* (see fig. 1-3). But one dating to about 3000 B.C. (fig. 1-4) has, despite the massive legs, an almost girlish figure, which lends her a surprisingly modern appearance. With arms and head raised in a gesture of worship, our statuette radiates a very human charm that is as irresistible now as the day she was made.

Menhirs, Dolmens, and Cromlechs Long after the introduction of bronze about the middle of the third millennium B.C., a sparse population in central and northern Europe continued to lead a simple tribal life in small village communities. Hence, there is no clear distinction from the Neolithic. Neolithic and Bronze Age Europe never reached the level of social organization necessary to produce the masonry construction found in New Stone Age sites in the Near East. Instead we find monumental stone structures of a different kind, first in France and Scandinavia and then in England. These structures are termed megalithic because they are made of huge blocks or boulders used either singly or placed upon each other

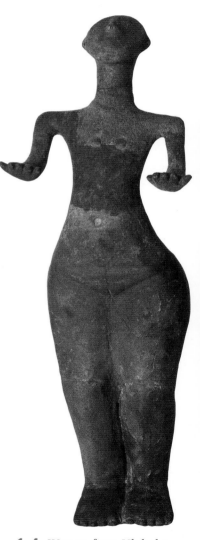

1-4 *Woman,* from Hluboké Masuvky, Moravia, Czech Republic. c. 3000 B.C. Clay, height 13" (33 cm). Vildomec Collection, Brno

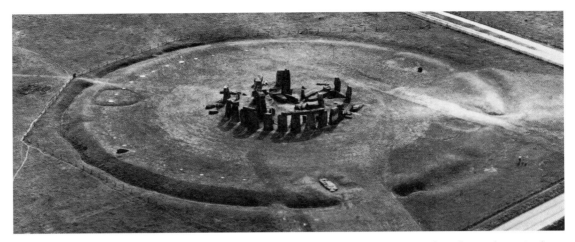

1-5 Stonehenge, Salisbury Plain, Wiltshire, England. c. 2000 B.C. Diameter of circle 97' (29.57 m)

menhirs

dolmen

Generally undressed or rough-hewn stones, MENHIRS are often found on hilltops from southern France to Scotland and are particularly common in Brittany, in northwestern France. DOLMENS, the simplest form of megalithic tomb, have several large upright stones supporting a single massive capstone. About 50,000 of these survive from Spain to Sweden. Scholars have long debated how the 30- to 40-ton capstones were placed atop the standing stones.

without mortar. Even today these monuments, built about 4500–1500 B.C., have a superhuman air about them, as if they were the work of a race of giants.

The simplest are MENHIRS: upright slabs that served as grave markers. Sometimes they were arranged in rows, as at Carnac in northern France. Carnac features another type as well, known as DOLMENS. Originally underground, these are tombs resembling "houses of the dead." Finally, there are the so-called cromlechs, found only in the British Isles, which were the settings of religious rites. The huge effort required to construct them could be compelled only by religious faith—a faith that almost literally demanded the moving of mountains.

The last and most famous of the cromlechs is Stonehenge in southern England (figs. 1-5, 1-6). What we see today is the result of several distinct building campaigns, beginning in the New Stone Age and continuing into the early Bronze Age. During the first phase, from roughly 3500 to 2900 B.C., a nearly continuous circle (henge) was dug into the chalk ground. A silted ditch was added about 3300–2140 B.C., then the avenue down to the Avon River sometime from 2580 to 1890 B.C. The sandstone (sarsen) circle of evenly spaced trilithons, each consisting of two uprights

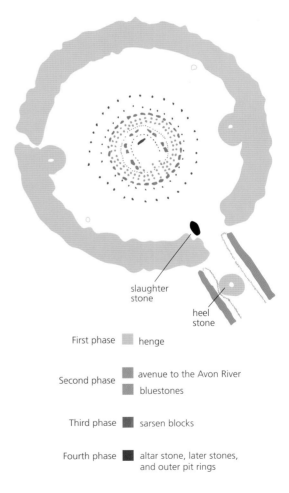

slaughter stone

heel stone

First phase — henge

Second phase — avenue to the Avon River, bluestones

Third phase — sarsen blocks

Fourth phase — altar stone, later stones, and outer pit rings

1-6 Diagram of original arrangement of stones at Stonehenge (after original drawing by Richard Tobias)

(posts) and a horizontal slab (**lintel**), was erected during the early Bronze Age Wessex culture, between 2850 and 2200 B.C. These immense stones were evidently dragged from Marlborough Downs, some 20 miles away—a feat as awesome as raising them. But it is far from clear whether the inner bluestone circle and horseshoe, which date from several hundred years later (2480–1940 B.C.), were deposited by glaciers or carried by carts and rafts from the Preseli Mountains in Wales some 200 miles to the west. During the final phase, from 2030 to 1520 B.C., this arrangement was echoed in two similarly marked circles and a smaller horseshoe that enclose an altarlike stone at the center.

Why was Stonehenge built in the first place? The widely held belief that the so-called Heel Stone was positioned so that the sun would rise directly above it on the day of the summer solstice (when the sun is farthest from the equator) has long been shown to be incorrect. It appears that Stonehenge was originally aligned with the major and minor northern moonrises. Only later did the structure become oriented toward the sun: the Heel Stone and fallen "Slaughter Stone," along with other stones and the axis of the causeway, were rearranged in the direction of the midsummer sunrise.

Each of Stonehenge's building phases was linked to broader changes during the Neolithic and Bronze ages. Burial mounds, called barrows, and henges from as early as 3500 B.C. that have been found in Scandinavia and northern Britain reflect the changeover to a settled, agrarian way of life; that they continued to be built until about 2000 B.C. testifies to a relatively stable Neolithic culture. However, the people who created the Wessex culture probably crossed the English Channel from Brittany in northwestern France, where megalithic horseshoes constructed along astronomical axes are far more common than in England. They brought with them Bronze Age technologies and ideas that must have seemed revolutionary to the local population, who initially put up a stiff resistance. At Stonehenge and elsewhere in southern England, these newcomers imposed their own traditions on established prac-

tices. In addition to erecting even larger cromlechs, they buried their leaders in barrows lined with boulders, making them, in effect, underground dolmens. Some of these tombs even have a rudimentary form of vaulting known as **corbeling**, which is also found in Mycenaean "beehive" tombs (see fig. 4-5), as well as in certain Etruscan tombs (see chapter 6). Stonehenge was eventually abandoned about 1100 B.C. as part of another change that occurred during the late Bronze Age: the preference for cremation over burials for the dead.

By definition, menhirs and dolmens are monuments. Not only are they large, but they commemorate the dead. Whether they and cromlechs should be termed architecture is also a matter of definition. We tend to think of architecture in terms of enclosed interiors, but we also have landscape architects, who design gardens, parks, and playgrounds. Open-air theaters and sports stadiums are likewise thought of as architecture. To the ancient Greeks, who coined the term, *architecture* meant something higher (*archi*) than the usual construction or building, much as an archbishop ranks above a bishop. Architecture differed from practical, everyday building in scale, order, permanence, and purpose. A Greek would have viewed Carnac and Stonehenge as architecture, since nature has been rearranged to serve as settings for human activities and to express shared beliefs. We, too, will be able to accept them as architecture once we understand that it is not necessary to *enclose* space in order to define it. If architecture is "the art of shaping space to human needs and aspirations," then Carnac and Stonehenge more than meet the test.

NEOLITHIC NORTH AMERICA

The "earth art" of the prehistoric Indians of North America, the so-called Mound Builders, may be compared to the megalithic monuments of Europe in terms of effort. These mounds vary greatly in shape and purpose as well as in date, ranging from about 2000 B.C. to the time of the Europeans' arrival in the late fifteenth century. Of particular interest are the "effigy mounds" in the shape of animals, presumably the totems of the

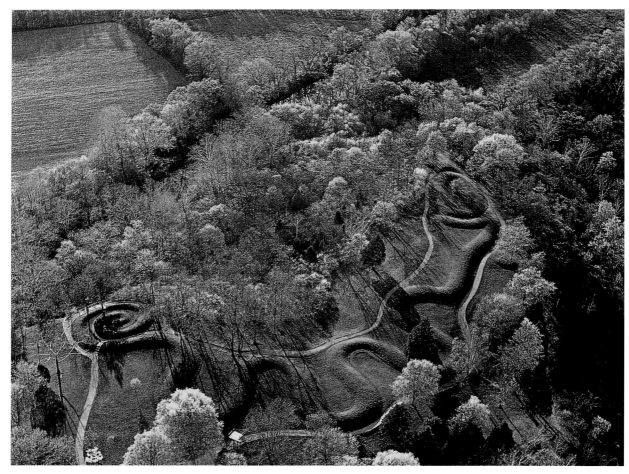

1-7 Great Serpent Mound, Adams County, Ohio. c. 1070 A.D. Length 1,400' (426.72 m)

tribes that produced them. The most spectacular is the Great Serpent Mound (fig. 1-7), a snake some 1,400 feet long that slithers along the crest of a ridge by a small river in southern Ohio. The huge head, its center marked by a heap of stones that may once have been an altar, occupies the highest point. It appears that the natural formation of the terrain inspired this extraordinary work of landscape architecture, as mysterious and moving in its way as Stonehenge.

EGYPTIAN ART

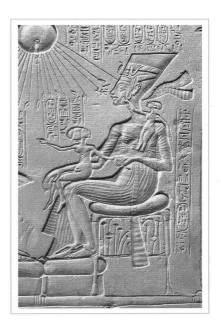

Egyptian civilization has long been considered the most rigid and conservative ever. Plato said that Egyptian art had not changed in 10,000 years. Perhaps "enduring" and "continuous" are better terms for it, although at first glance all Egyptian art between 3000 and 500 B.C. does have a certain sameness. The basic pattern of Egyptian institutions, beliefs, and artistic ideas was formed during the first few centuries of that vast time span and was maintained until the end. Over the years, however, this pattern went through ever more severe crises that threatened its survival. Had it been as inflexible as supposed, Egyptian civilization would have collapsed long before it finally did. Egyptian art alternates between conservatism and innovation, but is rarely static. Moreover, its greatest achievements had a decisive influence on Greek and Roman art. Thus we still feel ourselves linked to the Egypt of 5,000 years ago by a continuous tradition.

SPEAKING OF

king, kingship, kingdom, dynasty, and *pharaoh*

Egyptian *kings* were believed to combine divine and mortal qualities and thus to be quasi-divine. *Kingship* passed from father to son or to near kin. *Dynasties* were groupings of kings linked by kinship and were first devised in the early third century B.C. by the priest Manetho, who designated clusters of dynasties into *kingdoms* and "Intermediate Periods." Three main kingdoms—the Old, Middle, and New—comprise clusters through the Twentieth Dynasty. Manetho recognized 30 dynasties to 343 B.C., after which ancient Egypt continued another 350 years until the division of the Roman Empire in 395 A.D. The word *pharaoh* has been used synonymously with *king* by modern writers. It derives from the Egyptian term for "royal palace" and was employed by the Egyptians to mean "king" only beginning in the Eighteenth Dynasty.

The Old Kingdom

DYNASTIES

The history of Egypt is divided into dynasties of rulers, in agreement with ancient Egyptian practice. It begins with the First Dynasty, shortly before 3000 B.C. (The dates of the earliest rulers are difficult to translate precisely into our calendar; the dating system used in this book is that of the French Egyptologist Nicolas Grimal.) The transition from prehistory to the First Dynasty is called the Predynastic period. The next major period, known as the Old Kingdom, lasted from about 2700 B.C. until about 2190 B.C., the end of the Sixth Dynasty. This method of counting historic time by dynasties conveys both the strong Egyptian sense of continuity and the prime importance of the pharaoh (king), who was not only the supreme ruler but also a god. The pharaoh transcended all people, for his kingship was not a privilege derived from a superhuman source but was absolute, divine. This belief was the key feature of Egyptian civilization and largely shaped the character of Egyptian art. We do not know the exact steps by which the early pharaohs established their claim to divinity, but we know their historic achievements. They molded the Nile Valley from the First Cataract (falls) at Aswan to the Delta into a single state and increased its fertility by regulating the river waters through dams and canals.

TOMBS AND RELIGION

Of these vast public works nothing remains today, and very little has survived of ancient Egyptian palaces and cities. Our knowledge of early Egyptian civilization rests almost entirely on tombs and their contents. The survival of these structures is no accident, since they were built to last forever. Yet we must not make the mistake of concluding that the Egyptians viewed life on this earth mainly as a road to the grave. Their cult of the dead is a link with the Neolithic past, but the meaning they gave it was new. The dark fear of the spirits of the dead that dominates primitive ancestor cults seems entirely absent. Instead, the Egyptian attitude was that people must provide for their own happy afterlives. They therefore equipped their tombs as replicas of their daily environment for their spirits (kas) to enjoy. In order to make sure that the ka had both a home and a body to dwell in, tombs usually included a statue of the individual in case the mummified corpse was destroyed.

There is a blurring of the line between life and death in this practice, which was perhaps the main reason behind these mock households. People could look forward to active, happy lives without being haunted by fear of the great unknown, since they knew that their kas would enjoy the same pleasures as they did by providing for them in advance. In a sense, the Egyptian tomb was an investment in peace of mind. Such, at least, is the impression one gains of Old Kingdom tombs. Later, this concept of death was altered by a tendency to subdivide the spirit or soul into two or more separate identities, as well as by the introduction of the weighing of souls. Only then do we find expressions of the fear of death.

SCULPTURE

Palette of King Narmer During the Predynastic period, Egypt was still learning the use of bronze tools. The country was presumably governed by local rulers who barely outranked tribal chiefs. From these territories emerged two rival kingdoms: UPPER EGYPT, to the south, with its capital at Naqada near Thebes, and LOWER EGYPT near the Nile Delta, which empties into the Mediterranean. The struggle between them ended when the Upper Egyptian kings conquered Lower Egypt and combined the two realms.

One of these kings was Narmer, who appears on the ceremonial slate palette in figures 2-1 and 2-2. In many ways, the Narmer palette can be claimed as the oldest historical work of art we know. Not only is it the earliest surviving image of a historical personage identified by name, but its character is no longer primitive. In fact, it already shows most of the features of late Egyptian art. The Narmer palette evidently celebrates a victory over Lower Egypt. (Note the different crowns worn by the king.) However, its meaning is largely ceremonial.

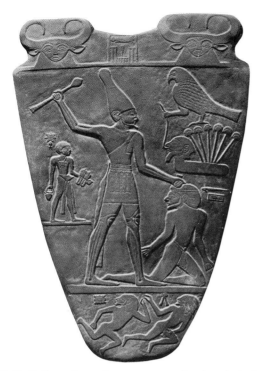
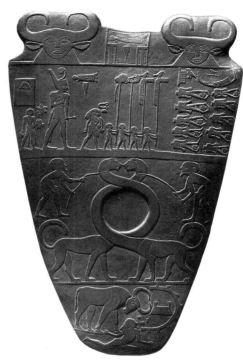

2-1, 2-2 *Palette of King Narmer* (both sides), from Hierakonpolis. c. 3150–3125 B.C. Slate, height 25" (63.5 cm). Egyptian Museum, Cairo

Egypt had already been unified under earlier kings, so that the traditional identification of Narmer with King Menes, the founder of the First Dynasty, is unlikely.

Let us first "read" the scenes on both sides. (The fact that we are able to do so is another sign that we have left prehistoric art behind.) The meaning of these **reliefs** (sculpture in which the image stands out from a flat background) is made explicit by **hieroglyphic** labels. (HIERO-GLYPH means sacred pictorial writing.) This system of writing was of very recent origin. The earliest examples we know of, which were found in the tomb of King Scorpion some 300 miles south of Cairo, date from about 3300–3200 B.C. The meaning is also made clear by symbols that convey precise messages and—most important—through the rational orderliness of the design.

In figure 2-1, Narmer, seen wearing the white crown of Upper Egypt, has seized a fallen enemy by the hair and is about to slay him with his mace. Two more defeated enemies are placed in the bottom compartment. (The small rectangular shape next to the man on the left stands for a fortified town or citadel.) Facing the king in the upper right we see a complex bit of picture writing: a falcon standing above a clump of papyrus plants holds a tether attached to a human head that "grows" from the same soil as the plants. This image repeats the main scene on a symbolic level. The head and papyrus plant stand for Lower Egypt, while the victorious falcon is Horus, the local god of Upper Egypt. The parallel is plain. Horus and Narmer are the same: both are gods triumphing over human foes. Narmer's gesture must therefore not be seen as representing a real fight. The enemy is helpless from the start, and the slaying is a ritual rather than a physical act. We know it is ritual because Narmer has taken off his sandals (the court official behind him carries them in his left hand), a sign that he is standing on holy ground. (The

Before Egypt was united by King Menes about 3200 B.C., there were two kingdoms, that of UPPER EGYPT (the Nile Valley southward from Memphis to Aswan) and that of LOWER EGYPT (the Nile Delta north from Memphis to the Mediterranean Sea).

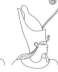

white crown Upper Egypt | red crown Lower Egypt | double crown unified Egypt

HIEROGLYPHS were used in two ways: as ideographs and as phonetic signs.

 In this Twelfth Dynasty amulet, the stylized papyrus clump on the left is an ideograph for "around" or "behind." amulet The *ankh* in the center is a symbol for life, and the *sa* on the right is a symbol of protection. The basket (*nebet*) means variously "all," "lord," or "master." Thus, this ideographic amulet is read as "All life and protection are around [the master, king, lord]."

 The phonetic reading of this hieroglyph is, from top to bottom: *sha* (for the stand of lotus), *ba* (Egyptian for "ram"), *ka* (upraised arms meaning "spirit" or "soul"). Because the cartouche signs are enclosed by the lozenge-form rope, called a cartouche, we know that this hieroglyph means "King Shabaka."

 Steadied by a worker, pioneering American Egyptologist James Henry Breasted copies a hieroglyphic inscription at Wadi Halfa, January 1906.

Most figures were represented like the long-haired woman: eyes and shoulders seen frontally and everything else rendered in profile. Figures that are drawn more naturalistically—like the short-haired woman—are always of commoners and slaves.

same notion is found again in the Old Testament, apparently as the result of Egyptian influence, when the Lord commands Moses to remove his shoes before he appears to him in the burning bush.)

On the other side of the palette (fig. 2-2), the king is again depicted barefoot, now wearing the red crown of Lower Egypt and followed by the sandal carrier. He walks behind a group of standard-bearers to inspect the beheaded bodies of prisoners. The bottom compartment depicts the victory on a symbolic level. The pharaoh is represented as a strong bull trampling an enemy and knocking down a citadel. (A bull's tail hanging down from Narmer's belt, shown in both images, became part of the pharaoh's ceremonial garb for the next 3,000 years.) Only the center section does not convey a clear meaning. The intertwined snake-necked lions and their two attendants have no identifying features. However, similar beasts are found in "protoliterate" Mesopotamian cylinder seals of about 3300–3200 B.C., an art form that was soon adopted in Egypt as well (see chapter 3). There they combine the lioness attribute of the mother goddess with the copulating snakes that signify the god of fecundity. They thus form a fertility symbol that unites the female and male principles in nature. Here they perhaps refer to the union of Upper and Lower Egypt. Whatever their meaning on Narmer's palette, their presence is evidence of contact between the two civilizations at an early and critical stage of their development. In any case, they do not reappear in Egyptian art.

The Narmer palette has a clear inner logic that is readily apparent. What strikes us first is its strong sense of order. The surface is divided into horizontal bands, or registers. Each figure stands on a line, or strip, denoting the ground. The only exceptions are the attendants of the long-necked beasts, whose role seems mainly ornamental; the hieroglyphic signs, which belong to a different level of reality; and the dead enemies, which are seen from above, instead of from the side. The modern way of depicting a scene as it would appear to a single viewer at a single moment is as alien to Egyptian artists as it was to those of the Neolithic era. They strive

for clarity, not illusion, and therefore pick the most characteristic view in each case.

But they impose a strict rule on themselves. When the angle of vision changes, it must be by 90 degrees, as if sighting along the edges of a cube. Hence, only three views are possible: full face, strict profile, and vertically from above. Any other position is embarrassing. (Note the rubber-like figures of the fallen enemies at the bottom of figure 2-1.) Moreover, the standing human figure does not have a single main profile. Instead, it has two different profiles, which must be combined for the sake of clarity. The method of doing this (which was to survive unchanged for 2,500 years) is shown in the large figure of Narmer in figure 2-1: eye and shoulders in frontal view, head and legs in profile. This formula was worked out so as to show the pharaoh (and all those who move in the aura of his divinity) in the most complete way possible. And since the scenes depict solemn and, as it were, timeless rituals, our artist did not have to concern himself with the fact that this method of depicting the human body made movement or action almost impossible. In fact, the frozen quality of the image seems well suited to the divine nature of the pharaoh. Mere mortals act; he simply is.

Whenever any movement requiring some sort of effort or strain must be depicted, the Egyptian artist abandons the combined view, for such activities are always performed by underlings whose dignity does not have to be preserved. Thus in our palette the two animal trainers and the four men carrying standards are shown in strict profile, except for the eyes. The composite view seems to have been created specifically by artists working for the royal court to convey the majesty of the divine king. It never lost its sacred flavor, even in later times, when it had to serve other purposes as well.

Tomb of Ti The style used to depict Narmer in the ceremonial palette was soon adopted for tombs in the Old Kingdom. The hippopotamus hunt in figure 2-3, from the offering chambers of the architectural overseer Ti at Saqqara, is of special interest because of its landscape setting.

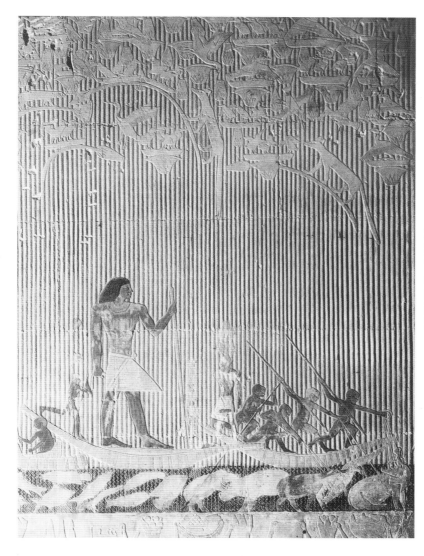

2-3 *Ti Watching a Hippopotamus Hunt,* Tomb of Ti, Saqqara. c. 2510–2460 B.C. Painted limestone relief, height approx. 45" (114.3 cm)

The background is a papyrus thicket. The stems form a regular design that erupts in the top zone into an agitated scene of nesting birds menaced by small animals. The water in the bottom zone, marked by a zigzag pattern, is equally crowded with struggling hippopotamuses and fish. All these, as well as the hunters in the first boat, are carefully observed and full of action. Only Ti himself, standing in the second boat, is immobile, as if he belonged to a different world. His pose is that of funerary portrait reliefs and statues (compare fig. 2-4). He towers above the other men since he is more important than they.

Ti's size also lifts him out of the context of the hunt. He does not direct it; he simply observes. His passive role is typical of the representations of the deceased in all such scenes from the Old Kingdom. It seems to be a way of conveying that the body is dead but the spirit is alive and aware of the pleasures of this world, although the man can no longer participate in them directly. We should also note that these scenes of daily life do not represent the dead man's favorite pastimes. If they did, he would be looking back, and such nostalgia is quite alien to the spirit of Old Kingdom tombs. It has been shown, in fact,

that these scenes form a seasonal cycle, a sort of perpetual calendar of recurring human activities for the spirit of the deceased to watch year in and year out.

The hunt may have symbolic meaning as well. Osiris, the mythical founder of Egypt, was associated with the Nile and the underworld as the god of fertility, death, and resurrection. In ancient tradition, he was murdered and dismembered by his brother Seth, who sealed him in a casket that was cast into the Nile. Seth scattered his remains after the casket was retrieved by Osiris's consort, Isis. She eventually recovered his parts and reassembled them into the first mummy, from which she conceived her son, Horus. Horus avenged his father's death by besting Seth in a series of contests lasting 80 years. As a result, Osiris became lord of the underworld, Horus the ruler of the living, and Seth the god of chaos and evil who governed the deserts. The hippopotamus was often viewed as an animal of evil and chaos that destroyed crops, and thus as the embodiment of Seth. In turn, the deceased may be likened to Osiris. Moreover, the papyrus thicket was where Isis hid Horus to protect him from Seth, so that it was seen as a place of rebirth, much like the tomb itself. Finally, the boat traditionally carried the ka through its eternal journey in the afterlife.

Scenes of daily life offered artists a welcome opportunity to widen their powers of observation. We often find astounding bits of realism in the description of plants and animals. Note, for example, the hippopotamus in the lower right-hand corner turning its head in fear and anger to face its attackers. Such a sympathetic portrayal is as delightful as it is unexpected in Old Kingdom art. Even more remarkable is the variety of poses among the hunters, which breaks the rules observed in the figure of Ti. Eventually even the deceased will abandon his passive, timeless stance to participate in scenes of daily life (see fig. 2-12).

Portraits The "cubic" approach to the human form can be observed most strikingly in Egyptian **sculpture in the round**, such as the splendid

2-4 *Menkaure and His Wife, Queen Khamerernebty,* from Giza. c. 2515 B.C. Slate (graywacke), height 54½" (138.4 cm). Museum of Fine Arts, Boston

Harvard University–Museum of Fine Arts Expedition

group of the king Menkaure and his queen, Khamerernebty (fig. 2-4). After marking the surfaces of the rectangular block with a grid, the artist drew the front, top, and side views of the statue on the block, then worked inward until these views met. This approach also encouraged the development of systematic proportions. In fact, the CANON of forms can be readily deduced, so standardized did it become, although it varied somewhat over time. Only in this way

The Egyptian CANON of proportions for two-dimensional works basically divided the standing human figure into 18 units, the seated figure into 14. Artists achieved precision through the use of a system of drawn grids, which were later removed. Three-dimensional works also followed a canon, largely based on qualities inherent in the stone blocks from which they were carved.

could the artist have achieved figures of such overpowering three-dimensional firmness and immobility—magnificent vessels for the ka to inhabit. Both have the left foot placed forward, yet there is no hint of a forward movement. These are idealized portraits; a similar but much smaller group, showing Menkaure between two goddesses, hardly differs in appearance.

The pair allows us to compare male and female beauty as interpreted by one of the finest Old Kingdom sculptors. The artist knew not only how to contrast the structure of the two bodies but also how to emphasize the soft, swelling form of the queen through a thin, close-fitting gown. Like other Old Kingdom statues, the group originally must have been vividly colored and thus strikingly lifelike in appearance. Unfortunately, such coloring has survived completely intact in only a few instances. According to the standard convention of Egyptian art, the king would have had a darker body color than the queen. Their eyes, too, would have been painted, and perhaps inlaid with shining quartz, to make them look as alive as possible and to emphasize the individuality of the faces.

ARCHITECTURE

When we speak of the Egyptians' attitude toward death and afterlife, we do not mean that of the average Egyptian. We are referring to the outlook of the small aristocratic caste clustered around the royal court. The tombs of this class of high officials, who were often relatives of the royal family, are usually found near the pharaohs'. Their shape and contents reflect, or are related to, the tombs of the kings. We still have a great deal to learn about the origin and significance of Egyptian tombs, but the concept of afterlife we find in the so-called private tombs initially seems to have applied only to the privileged few because of their association with the pharaohs. Ordinary mortals could look forward only to a shadowy afterlife in the underground realm of the dead. As early as the Fourth Dynasty, wealthy individuals built tombs in imitation of royal examples, complete with paintings and reliefs, cut into the bedrock near Giza. However, the standard form of these tombs was the **mastaba** (the word comes from the Arabic for "bench" because of their shape): a squarish mound faced with brick or stone built above the burial chamber, which was deep underground and linked to the mound by a shaft. A chapel for offerings to the ka and a secret cubicle for the statue of the deceased were inside the mastaba (see fig. 2-8).

Pyramids Royal mastabas became quite large as early as the First Dynasty, and their exteriors sometimes resembled that of a royal palace. During the Third Dynasty, they developed into step pyramids. The best known (and probably the first) is that of King Djoser (fig. 2-5, page 54; see also fig. 2-8), which was built over a traditional mastaba in a series of expanding layers. The pyramid itself, unlike later ones, is a solid structure with underground burial chambers. Its function was not so much funereal as memorial and religious: it declares the pharaoh's supreme power and divine status. The height and shape suggest Mesopotamian **ziggurats** (see fig. 3-1). The step pyramid, too, was perhaps intended to bridge the gap with the heavens by serving as the "stairway" and "jumping-off" point for Djoser to ascend to the heavens and fulfill his cosmological role as a god.

Pyramids were not isolated structures in the middle of the desert but rather were part of vast funerary districts, with temples and other buildings that were the scene of great religious celebrations during the pharaoh's lifetime as well as after. The funerary district around the Step Pyramid of Djoser is both the earliest and the first built entirely of stone, which had been used sparingly before that time. Enough of it has survived for us to see why its creator, Imhotep, came to be revered as the founder of Egyptian culture. He was both vizier (overseer) to the king and high priest of the sun-god Ra. Imhotep is the first artist whose name has been recorded in history, as well as the first in a long line of Egyptian architects that are known to us.

Imhotep's achievement is impressive not only for its scale but also for its unity, which embodies the concept of the pharaoh to perfection. The funerary district proclaims Djoser king

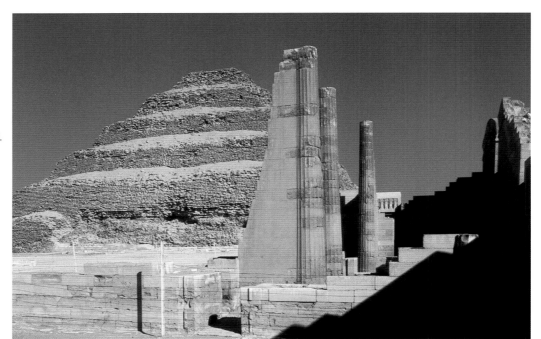

2-5 Imhotep. Step Pyramid of King Djoser, Saqqara. c. 2681–2662 B.C.

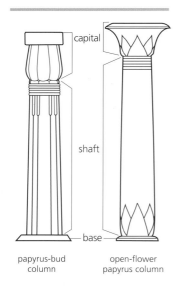

papyrus-bud column open-flower papyrus column

The Egyptians devised **columns** of three parts—base, shaft, and capital—the same parts found in two of the three main Greek Classical orders, which were to come later. The papyrus, both open and closed, was a favorite motif of Egyptian capitals. The shafts of columns were frequently decorated with brightly painted hieroglyphic writing in shallow or sunken relief.

of both Upper and Lower Egypt, in that there are two of everything, including a north and a south palace and a second tomb. The large courtyard was used for ritual purposes during the pharaoh's coronation, which was to be reenacted there as part of the Sed festival to celebrate his jubilee 30 years later. (Djoser's reign lasted only 19 years.) Imhotep must have had a remarkable intellect as well as outstanding ability—he was renowned as an astronomer and later deified as a healer. In this regard he set a precedent for the great architects who followed in his footsteps. Even today architects address the important ideas and issues of their time.

Columns Egyptian architecture had begun with structures made of mud bricks, wood, reeds, and other light materials. Although Imhotep used cut-stone masonry, his architectural forms reflected shapes and devices developed for these less enduring materials. Thus, we find **columns** of several kinds—always **engaged** (set into the wall rather than **freestanding**)—which echo the bundles of reeds or the wooden supports that used to be set into mud-brick walls in order to strengthen them. But the very fact that they no longer had their original function made it possible for Imhotep and his fellow architects to

make them serve a new, expressive purpose. The idea that architectural forms can express anything may seem hard to grasp at first. We tend to assume that unless these forms have a clear-cut structural role, such as supporting or enclosing, they are mere decoration. But the slender, tapered, fluted columns in figure 2-5, or the papyrus-shaped half-columns in figure 2-6, do not simply decorate the walls to which they are attached. They interpret them and give them life. Their proportions, the feeling of strength and resilience they convey, their spacing, the degree to which they project—all share in this task.

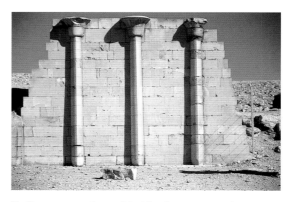

2-6 Papyrus-shaped half-columns, North Palace, funerary district of King Djoser, Saqqara

We shall learn more about the expressive role of columns when we discuss Greek architecture, which took over the Egyptian stone column and developed it further. For the time being, let us note another factor that may enter into their design: announcing the symbolic purpose of the building. The papyrus half-columns in figure 2-6 are linked with Lower Egypt (compare the papyrus plants in fig. 2-3); hence they appear in the North Palace of Djoser's funerary district. The South Palace has columns of a different shape, which is linked with Upper Egypt.

Giza Djoser's successors adapted the step pyramid to the smooth-sided shape that is familiar to us, a process that took several generations. The development of the pyramid reaches its climax during the Fourth Dynasty in the three **monumental** Great Pyramids at Giza (fig. 2-7). All of these originally had an outer casing of carefully **dressed stone**, which has disappeared except near the top of the Pyramid of Khafre. The top of each was also covered with a thin layer of gold. The three differ slightly from one another in scale, as well as in some details, but the basic features are shown in the section of

Khufu's pyramid (fig. 2-8, page 56). The burial chamber is near the center of the structure rather than below ground, as in the Step Pyramid of Djoser. This placement was a vain attempt to safeguard the chamber from robbers.

The pyramid evidently was identified with the pharaoh's "father," Ra, and perhaps served as the final resting place of the sun. According to a recent theory, the three pyramids at Giza are arranged in the same formation as the stars in the constellation Orion, which was identified with the god Osiris. One of the so-called "air shafts" in the king's chamber of the Pyramid of Khufu pointed to the polar stars in the north, which are always visible; in ancient times the other lined up with Orion, which could be seen in the southern sky after an absence of some two months (the position of Orion has since changed). The shaft thus served as a kind of "escape hatch" that allowed the pharaoh to take his place as a star in the cosmos. Another hidden shaft in the queen's chamber was aligned with the star of Isis (Sirius). It seems to have been used in the ritual of fertilization and rebirth described in the Egyptian Book of the Dead. The proposal, although controversial, is tantalizing, for it helps to explain

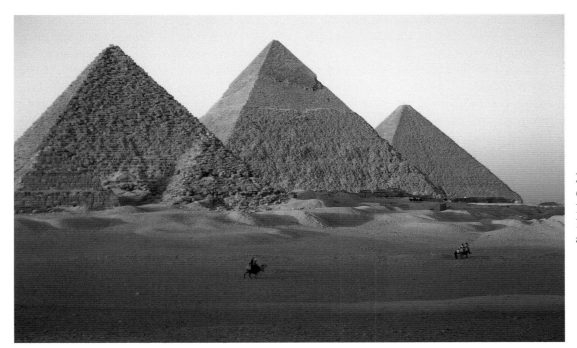

2-7 The Great Pyramids, Giza: (from left to right) of Menkaure (c. 2533–2515 B.C.), Khafre (c. 2570–2544 B.C.), and Khufu (c. 2601–2528 B.C.)

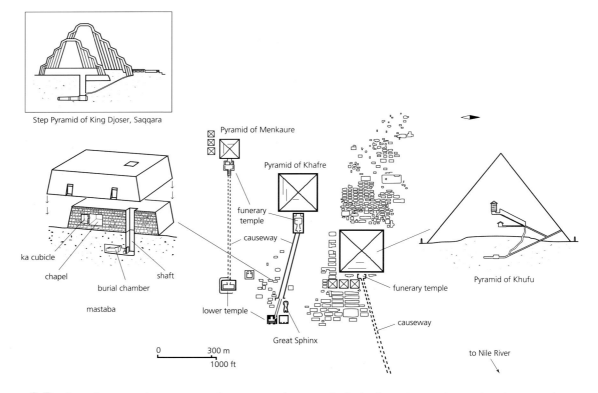

Step Pyramid of King Djoser, Saqqara

Pyramid of Menkaure

Pyramid of Khafre

Pyramid of Khufu

funerary
temple

causeway

ka cubicle

chapel shaft

burial chamber

mastaba

lower temple

funerary temple

causeway

Great Sphinx

to Nile River

0 300 m
1000 ft

2-8 Plan of necropolis at Giza with sections of Pyramid of Khufu and mastaba, and with inset of Step Pyramid of Djoser at Saqqara

many puzzling features of the pyramids in terms of Egyptian cosmology, which equated the pharaoh with Horus.

Clustered about the three Great Pyramids are several smaller ones and a large number of mastabas for members of the royal family and high officials (see fig. 2-8). The unified funerary district of Djoser has given way to a simpler arrangement. Adjoining each of the Great Pyramids to the east is a mortuary temple, where the pharaoh's body was brought for embalming and last rites. From there a causeway leads to a second temple at a lower level, in the Nile Valley, about a third of a mile away. This arrangement represents the final step in the evolution of kingship in Egypt. It links the pharaoh to the eternal cosmic order by connecting him, in both physical and ritual terms, to the Nile River, whose annual cycles give life to Egypt and dictate its rhythm to this very day.

Next to the valley temple of the Pyramid of Khafre stands the Great Sphinx, which was carved from the live rock (fig. 2-9). (*Sphinx* is an ancient Greek word for "strangler"; it was probably derived from the Egyptian *shesep ankh,* meaning "living image.") It is an even more impressive symbol of divine kingship than the pyramids themselves. The royal head rising from the body of the lion reaches a height of 65 feet. Damage inflicted during Islamic times has obscured the details of the face, and parts of the topmost section of the head are missing. Despite its location the Great Sphinx bears, in all probability, the features not of Khafre but of Khufu. The statue can be regarded as a colossal guardian figure in the guise of the lion-god Ruty. (Lions became associated with the pharaoh, perhaps through hunting, as early as the Predynastic period, when they were still plentiful. The sphinx in its original form was a griffin and destroyer of the enemy.) Its awesome majesty is

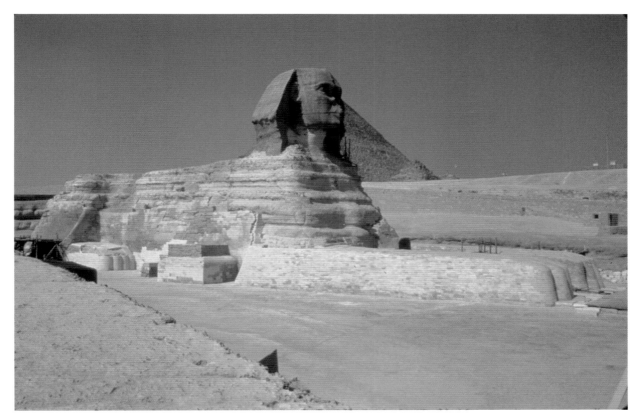

2-9 The Great Sphinx, Giza. c. 2570–2544 B.C. Sandstone, height 65' (19.81 m)

such that the Great Sphinx could be considered an image of the sun-god a thousand years later, when the lion became the personification of Ra. It acquired this connection through its nearness to the temple of the solar deity Harmakhis, which lies just before it.

The pyramids of Giza mark the high point of pharaonic power. After the end of the Fourth Dynasty, less than two centuries later, pyramids on such a scale were never attempted again in the Old Kingdom, although more modest ones continued to be built. The world has always marveled at the sheer size of the Great Pyramids as well as at the technical accomplishment they represent. To design and build them required both considerable skill and a grasp of geometry. Egyptian mathematics seems to have been based on practical problem-solving rather than abstract numbers. Despite this limitation, which precluded the development of the formulas that underlie higher mathematics, it was possible to calculate the volume of a pyramid, for example, by using a complex sequence of steps to arrive at the correct answer. The ingenious methods used to construct the pyramids are even more remarkable given the simple tools and measuring devices available to the builders. Much of the work was done with stone tools, such as chisels and axes, although some metal ones were also used.

The pyramids have come to be seen as symbols of slave labor, with thousands of men forced by cruel masters to work at their construction. Such a picture may not be entirely just. Records show that much of the labor was paid for and that shelter, clothing, and food (part of it in mead, a form of beer) were often furnished. It may be closer to the truth to view these monuments as vast public works that provided a livelihood for a good part of the population. At the same time, criminals, prisoners of war, and others were forced to work on the pyramids. Even under the best conditions, the labor was hard and dangerous.

The Middle Kingdom

After the collapse of centralized pharaonic power at the end of the Sixth Dynasty, Egypt entered a period of political disturbances and ill fortune that was to last almost 700 years. During most of this time, power was in the hands of local or regional overlords, who revived the old rivalry between Upper and Lower Egypt. Many dynasties followed one another in rapid succession. Only two, the Eleventh and Twelfth, which make up the Middle Kingdom (c. 2040–1674 B.C.), are worthy of note. During this period a series of able rulers, beginning with Mentuhotep II, the king who reunited Egypt about 2052 B.C., managed to reassert themselves against the provincial nobility. However, the authority of the Middle Kingdom pharaohs tended to be personal rather than institutional. The spell of divine kingship, having once been broken, never regained its old effectiveness. Soon after the close of the Twelfth Dynasty the weakened country was taken over by the Hyksos (the term essentially meant "foreign ruler"), a group of western Asiatic peoples of somewhat mysterious origin who had evidently been living in Egypt for some time. They seized the Delta area and ruled it for 150 years until their defeat by King Ahmose of Thebes about 1552 B.C.

TOMB DECORATIONS

The unsettled times gave rise to a great deal of experimentation by Egyptian artists, even though they continued to look back to the Old Kingdom. A relaxation of the rules can be seen in Middle Kingdom painting and relief sculpture, which often depart from convention. This loosening is most evident in the decoration of the tombs of local princes at Beni Hasan. Because they were carved into the living rock, these tombs have survived better than most Middle Kingdom monuments. The **mural** *Feeding the Oryxes* (fig. 2-10) comes from one of these rock-cut tombs, that of Khnumhotep. (As the emblem of the prince's domain, the oryx antelope seems to have been a sort of honored pet in his household.) According to the standards of Old Kingdom art, all the figures

2-10 *Feeding the Oryxes.* Detail of a wall painting at the Tomb of Khnumhotep, Beni Hasan. c. 1928–1895 B.C.

ought to share the same **groundline**. If not, the second oryx and its attendant ought to be placed above the first (a system known as vertical recession). Instead, the painter employs a secondary groundline only slightly higher than the primary one. As a result the two groups are related in a way that is similar to normal appearances. This interest in spatial effects can also be seen in the awkward but bold **foreshortening** of the shoulders of the two attendants. If we cover up the hieroglyphic signs, which emphasize the flatness of the wall, we can "read" the depth with surprising ease.

The New Kingdom

The 500 years after the Hyksos were expelled, which make up the Eighteenth, Nineteenth, and Twentieth dynasties, represent the third and final flowering of Egypt. Once again united under strong kings, the country extended its frontiers far to the east, into Palestine and Syria; hence this period is known as the Empire as well as the New Kingdom. Its art covers a wide range of styles and quality, from rigid conservatism to brilliant inventiveness, massive ostentation to delicate refinement. These different strands are interwoven into fabric so complex that, as with the art of imperial Rome 1,500 years later, it is difficult to come up with a representative sampling of New Kingdom art that adequately conveys its flavor and variety.

HATSHEPSUT

The climactic period of the New Kingdom extended from about 1500 B.C. to the end of the reign of Ramesses III in 1145 B.C. During this era tremendous architectural projects, centering on the region of Thebes, were carried out. The return of prosperity and stability was first marked by the revival of Middle Kingdom architectural forms to signify royal power. Thus the funerary temple of Queen HATSHEPSUT (fig. 2-11), built by her vizier Senenmut about 1478–1458 B.C. against the rocky cliffs of Deir el-Bahri, imitates Mentuhotep II's funerary temple of more than 500 years earlier (seen to the left in our illustration), which now lies in ruins. Hatshepshut's is, however, very much larger. (A third temple, built somewhat later by her nephew, Tuthmosis III, was sandwiched between them and was not unearthed until 1961.) The worshiper is led toward the holy of holies—a small chamber driven deep into the rock—through three large courts on ascending levels, which are linked by ramps flanked by long **colonnades**. Together they form a processional road similar to those at Giza, but with the mountain instead of a pyramid at the end. The ramps

and colonnades echo the shape of the cliff. This magnificent union of architecture and nature makes Hatshepsut's temple the rival of any of the Old Kingdom monuments.

The temple complex was dedicated to Amun and several other deities. During the New Kingdom, divine kingship was asserted by claiming the god Amun as the father of the reigning monarch. By fusing his identity with that of the sun-god Ra, Amun became the supreme deity, ruling the lesser gods much as the pharaoh dominated the provincial nobility.

AKHENATEN

Over time the priests of Amun grew into a caste of such wealth and power that they posed a threat to royal authority. The pharaoh could maintain his position only with their consent. Amenhotep IV, the most remarkable figure of the Eighteenth Dynasty, tried to defeat them by proclaiming his faith in a single god, the sun-disk Aten, whose cult had been promoted by his father, Amenhotep III. He changed his name to Akhenaten ("Effective for the Aten"), closed the Amun temples, and moved the capital to central Egypt, near

HATSHEPSUT (ruled c. 1478–1458 B.C.) acted as regent for Tuthmosis III until she crowned herself pharaoh. Frequently dressing as a man and referred to as such in official records, she sent military expeditions to Nubia and Syria-Palestine. Her reign is best remembered for the high quality of its art and architecture. In addition to Deir el-Bahri, her building projects include the so-called Red Chapel at Karnak and the Speos Artemidos, a rock-cut temple at Beni Hasan.

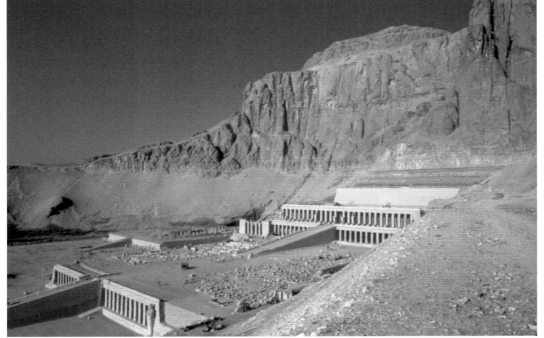

2-11 Temple of Queen Hatshepsut, Deir el-Bahri. c. 1478–1458 B.C.

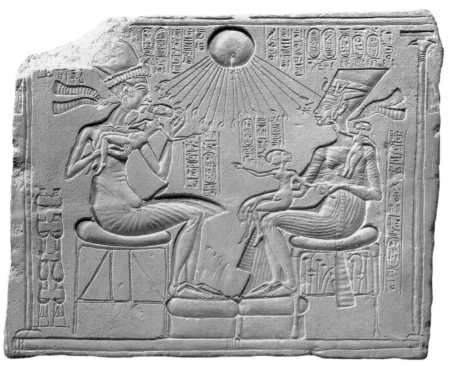

2-12 *Akhenaten and His Family.* c. 1355 B.C. Limestone, 12³/₄ x 15¹/₄" (32.5 x 38.7 cm). Staatliche Museen zu Berlin, Ägyptisches Museum

the modern Tell el'Amarna. However, his attempt to place himself at the head of a new faith did not outlast his reign (1348–1336/5 B.C.).

Of the great projects built by Akhenaten hardly anything remains above ground. He must have been a revolutionary not only in his religious beliefs but in his artistic tastes as well. Through his choice of masters, he fostered a new style. Known as the Amarna style, it can be seen at its best in a sunken relief portrait of Akhenaten and his family (fig. 2-12). The intimate domestic scene suggests that the relief was meant to serve as a shrine in a private household. The life-giving rays of the sun help to unify the composition and identify the royal couple as the living counterparts of Aten. Despite their very human qualities, their divine status is proclaimed by the new ideal, with its oddly haggard features and overemphatic outlines.

At first glance, the treatment of the royal family seems like a brutal caricature. In actual fact, the scene is remarkably skillful in its execution. The sculptor separates the complex overlapping planes

with surprising ease. What distinguishes the Amarna style is not greater realism so much as a new sense of form that seeks to unfreeze the traditional immobility of Egyptian art. Not only the contours but the shapes, too, seem more pliable, nearly antigeometric. That this was a conscious choice, not merely an exaggeration of their anatomy, can be seen in the way the features of Akhenaten's queen, Nefertiti, have been subtly altered to resemble his (compare fig. 2-13). The same must be true of the egg-shaped skulls of the three princesses, one of them still an infant. These express the theme of life and creativity, and are not simply a genetic oddity. The seemingly playful gestures, so appealing to modern eyes, are intended to ward off evil spirits and protect the household from harm. The informal, tender poses nonetheless defy all conventions of pharaonic dignity and bespeak a new view of humanity.

Despite its unique qualities, the Amarna revolution was partly an outgrowth of developments earlier in the Eighteenth Dynasty. The process was already highly evolved under Akhenaten's father, Amenhotep III. Indeed, the new ideal can already be seen emerging in certain portraits of Hatshepsut. The famous bust of Nefertiti (fig. 2-13) does not abandon that style. Rather, it relaxes the forms for the sake of a more elegant effect, reminding us that her name means "the beautiful one is come." Its perfection comes from a command of geometry that is at once precise—the face is completely symmetrical—and wonderfully subtle. Strangely enough, the bust remained unfinished (the left eye lacks the inlay of the right). It was left behind with a nearly identical head in the workshop of the royal sculptor Thutmose when he moved from Amarna to Memphis after Akhenaten's death.

Thutmose, like Imhotep before him, must have been a great genius—court records call him the "king's favorite and master of the works"—one who could give visible form to the pharaoh's ideas. He is not the first Egyptian artist known to us by name, but he is the first we can identify with a personal style. Thutmose was the last of several sculptors in succession who were mainly responsible for the Amarna style. This union of a

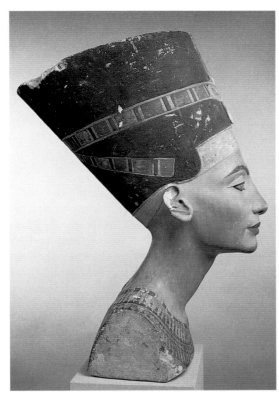

2-13 *Queen Nefertiti.* c. 1348–1336/5 B.C. Limestone, height 19" (48.3 cm). Staatliche Museen zu Berlin, Ägyptisches Museum

powerful patron and a sympathetic artist is rare. We shall not see it again until Periklean Greece (see pages 98–99).

TUTANKHAMEN

Akhenaten's successor, Smenkhkara, died soon after becoming pharaoh. The throne then passed to Tutankhamen, who was only about nine or ten years old at the time. Tutankhamen, who may have been Akhenaten's nephew, was married to his daughter Ankhesenpaaten; he died at the age of 18, perhaps of tuberculosis. (There is no solid evidence to support the popular conspiracy theories that he was murdered.) He owes his fame entirely to the fact that his is the only pharaonic tomb that has been found in our times with most of its contents intact. The immense value of the objects makes it easy to understand why grave robbing has been practiced in Egypt ever since the

Old Kingdom. Tutankhamen's gold coffin alone weighs 250 pounds. Even more impressive is the exquisite workmanship of the coffin cover (fig. 2-14, page 62), with its rich play of colored inlays against the polished gold surfaces.

RAMESSES II

The old religion was restored by Tutankhamen and his successor, the aged Ay, Akhenaten's uncle, who seems to have served as his vizier and perhaps married his widow to preserve the throne. The process was completed under Horemheb, who had been head of the army under Tutankhamen and became the last king of the Eighteenth Dynasty. The rulers of the New Kingdom devoted an ever-greater share of their architectural energies to building huge temples of Amun. The cult's center was Thebes, which included Karnak and Luxor on the east bank of the Nile and Deir el-Bahri on the west bank. Beyond lay the Valley of the Kings to the north and the Valley of the Queens to the south. Vast temple complexes at Karnak and Luxor that had been begun during the Middle Kingdom were greatly enlarged during the Nineteenth Dynasty.

At Luxor, Amenhotep III had replaced an earlier temple with a huge new one. It was completed by Ramesses II, the greatest of the New Kingdom pharaohs, who built on an unprecedented scale. The complex (fig. 2-15, page 63) is typical of later Egyptian temples. The **facade** (the side that faces a public way, at the far left in our illustration) consists of two massive walls, with sloping sides, that flank the entrance. This gateway, or **pylon**, leads to a series of courts and pillared halls. Beyond it is the temple itself, a series of symmetrically arranged halls and chapels. They shield the holy of holies, a square room with four columns containing a colossal statue of Amun. The temple was regarded as the actual house of the god. The cult statue, as his manifestation, was bathed, anointed, clothed, and fed by priests in elaborate daily rituals.

The entire complex was enclosed by high walls that shut off the outside world. Except for the pylon, such a structure is designed to be seen from within. Ordinary worshipers were confined to the courts

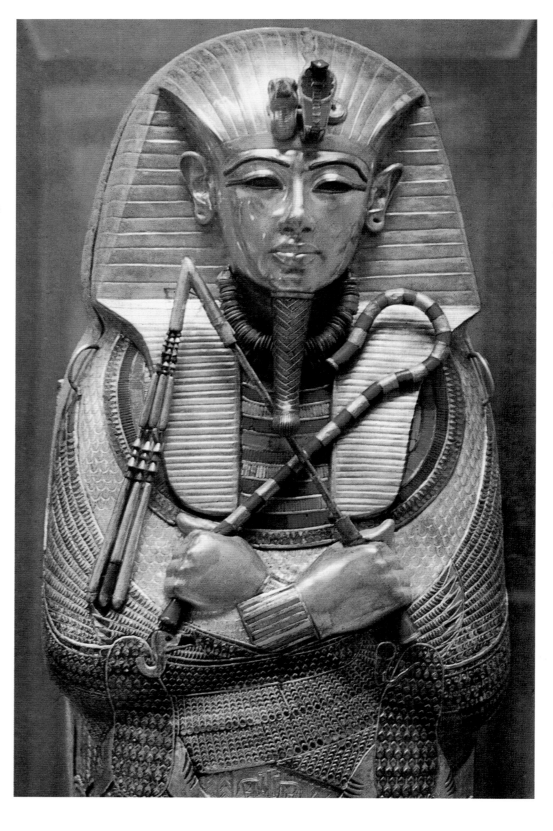

2-14 Cover of the coffin of Tutankhamen. c. 1327 B.C. Gold inlaid with enamel and semiprecious stones, height 72" (182.9 cm). Egyptian Museum, Cairo

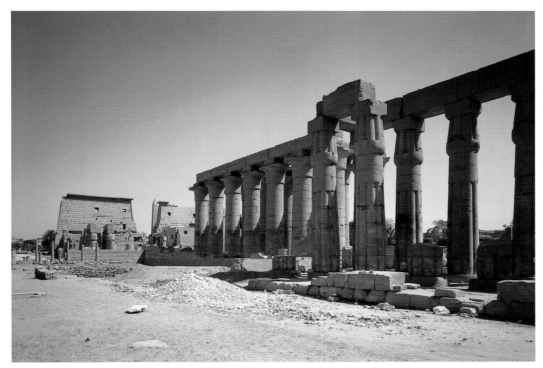

2-15 Court and pylon of Ramesses II and colonnade and court of Amenhotep III, temple complex of Amun-Mut-Khonsu, Luxor. c. 1279–1212 B.C.

and could but marvel at the forest of columns that screened the dark recesses of the sanctuary. The columns had to be closely spaced, for they supported the stone **lintels**, or horizontal members, of the ceiling, which were necessarily short to keep them from breaking under their own weight. Yet the architect has consciously exploited this condition by making the columns far heavier than they need be. The viewer feels almost crushed by their sheer mass. The effect is certainly impressive, but it is also rather coarse when measured against earlier masterpieces of Egyptian architecture. We need only compare the papyrus columns of the colonnade of Amenhotep III with their remote ancestors in Djoser's North Palace (see fig. 2-6) in order to see how little of the genius of Imhotep has survived at Luxor.

As an expression of pharaonic power the temples at Luxor and Karnak are without equal—perhaps justifiably, for the Ramesside period, as the Nineteenth and Twentieth dynasties are known, represents the height of Egyptian power. Nevertheless, the artistic degeneration anticipates the decline of Egypt itself. About 1076 B.C., barely 70 years after the end of the reign of Ramesses III, the country began a long period of decay. The priests gained more and more power, until the cult of Amun took control during the Twenty-first Dynasty. Egyptian civilization ended in a welter of esoteric religious doctrines.

The last phase of ancient Egypt belongs to the Greeks and the Romans. The country was conquered in 323 B.C. by Alexander the Great, who founded the city of Alexandria before his death later that year. His general Ptolemy (died 284 B.C.) became king, beginning a dynasty that lasted until Cleopatra's son by the Roman emperor Julius Caesar, Ptolemy XIV, was put to death by Augustus in 30 B.C. Alexandria became the leading center of learning in the Graeco-Roman world, but late Egyptian art, although no less skillful, is a strange mixture of stale conventions and foreign influences. It was not until the Christian era that Egyptian art flourished briefly once again in the encaustic portraits on Coptic mummy cases (see fig. 7-19).

A simple space-spanning construction device is the post-and-lintel combination. The wider the distance spanned (and the less the "give" of the spanning material), the closer the uprights (posts) have to be. Egyptians used stone columns for posts; the weight of the rigid stone lintels forced the builders to place the columns close together.

3

ANCIENT NEAR EASTERN ART

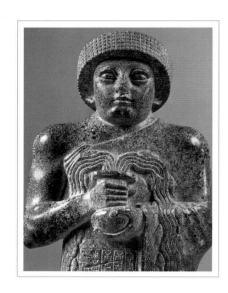

I t is an astonishing fact that civilization emerged in several places at about the same time. Between 3500 and 3000 B.C., when Egypt was being united under pharaonic rule, another great civilization arose in Mesopotamia, the "land between the rivers." Indeed, the latter may well claim to have developed first. And for close to 3,000 years these two regions retained their distinct characters, even though they had contact with each other from the beginning and their destinies were interwoven in many ways. The pressures that forced the people of both regions to abandon Neolithic village life may well have been the same.

Today Mesopotamia is a largely arid plain, but there is written evidence that at the dawn of civilization it was covered with lush vegetation. Unlike that of the Nile, the valley of the Tigris and Euphrates rivers is not a narrow, fertile strip protected by deserts on either side. Instead, it is a wide, shallow trough crisscrossed by the two rivers and their tributaries. With few natural defenses, it is easily entered from any direction.

Thus the facts of geography tended to discourage the idea of uniting the entire area under a single head. Rulers who had this ambition did not appear, so far as we know, until about a thousand years after the beginning of Mesopotamian civilization, and they succeeded in carrying it out only for brief periods and at the cost of almost continuous warfare. As a result, the history of ancient Mesopotamia has no underlying theme of the sort that divine kingship provides for Egypt. It is a mix of local rivalries, foreign incursions, and the sudden upsurge and collapse of military power. Against this background, the continuity of the region's cultural traditions is remarkable. This common heritage was largely created by the founders of Mesopotamian civilization, whom we call Sumerians, after Sumer, the region in which they lived, near the junction of the Tigris and Euphrates rivers.

Sumerian Art

The origin of the Sumerians remains obscure. Their language is not related to any other known tongue. Sometime before 4000 B.C., they came to southern MESOPOTAMIA from Iran. There, within the next thousand years, they founded a number of city-states. They also developed a distinctive form of writing in CUNEIFORM (wedge-shaped) characters on clay tablets. This phase, which corresponds to the Predynastic period in Egypt, is called "protoliterate"; it leads to the early dynastic period, from about 3000 to 2340 B.C. (The chronology used here is by J. A. Brinkman.)

Archaeological Conditions The first evidence of Bronze Age culture is seen in Sumer about 4000 B.C. Unfortunately, the archaeological remains of Sumerian civilization are scanty compared with those of ancient Egypt. Because there was no stone for building, the Sumerians used mud brick and wood, so that almost nothing is left of their structures but the foundations. Nor did they share the Egyptians' concern with the afterlife, although some rich tombs from the early dynastic period, in the shape of vaulted chambers below ground, have been found in the city of Ur. Our knowledge of Sumerian civilization thus depends largely on chance fragments, including vast numbers of inscribed clay tablets, brought to light by excavation. Yet we have learned enough to form a general picture of this vigorous, inventive, and disciplined people.

Religion Each Sumerian city-state had its own local god, who was regarded as its "king" and owner. It also had a human ruler—the steward of the "king"—who led the people in serving the deity; in effect, he was a priest-king. The local god, in return, was expected to speak for the people of the city-state among the other gods, who controlled the forces of nature, such as wind and weather, water, fertility, and the heavenly bodies. The idea of divine ownership was not a pious fiction. The god was believed to own not only the territory of the city-state but also the labor of the population and its products. All these were subject to his commands, which were transmitted to the people by his human steward, the ruler. The result was a system that has been dubbed "theocratic socialism," a planned society administered from the temple. The temple controlled the pooling of labor and resources for communal projects such as the building of dikes and irrigation ditches, and it collected and distributed much of the harvest. Detailed written records were required to carry out so many duties. Hence it is no surprise that early Sumerian texts deal largely with economic and administrative rather than religious matters, although writing was a priestly privilege.

ARCHITECTURE

The role of the temple as the center of both spiritual and physical life can be seen in the layout of Sumerian cities. The houses were clustered about a sacred area that was a vast architectural complex containing not only shrines but workshops, storehouses, and scribes' quarters as well. In their midst, on a raised platform, stood the temple of the local god. Perhaps reflecting the Sumerians' origin in the mountainous north, these platforms, known as **ziggurats**, soon reached considerable heights. They can be compared to the pyramids of Egypt in the immense effort required to build them and in their effect as landmarks that tower above the plain.

The most famous ziggurat, the biblical Tower of Babel, has been destroyed, but a much earlier example, built shortly before 3000 B.C. (and thus several centuries before the first pyramids), survives at Warka, the site of the Sumerian city of Uruk (called Erech in the Bible). The mound, 40 feet high, has sloping sides reinforced by brick masonry. Stairs and ramps lead up to the platform on which stands the sanctuary, called the "White Temple" because of its whitewashed brick exterior (figs. 3-1, 3-2, page 66). Its heavy walls, with regularly spaced projections and recesses, are well enough preserved to suggest the original appearance of the structure. The main room, or the **cella**, where sacrifices were made before the statue of the god, is a narrow hall that runs the length of the temple and is flanked by smaller chambers. Its main entrance is on the southwest

Apparently independent of one another, the earliest civilizations arose in four places, beginning after 4000 B.C. Egyptian civilization is found in the northeast corner of the continent of Africa, nourished by the Nile River. MESOPOTAMIA is the area encompassed by present-day Iraq, Iran, eastern Turkey, and the deserts of Syria, drained by the Tigris and Euphrates rivers. In roughly what is Pakistan today, drained by the Indus River, were the Indus Valley civilizations, and in west-central China, civilizations arose along the Yellow River.

CUNEIFORM characters were made by pressing an edge (not the end) of a stylus into damp clay. The stylus, usually fashioned from a reed, was shaped on both ends. One end was a wedge form; the other end was either pointed, rounded, or flat-tipped. The pointed end was used to draw lines and make punch marks. The tablets were sun-dried or baked.

This c. 1750 B.C. Babylonian deed of sale graphically shows the impressions made by the stylus in the soft clay.

Department of Western Asiatic Antiquities, No. 33236. The British Museum, London

3-1 Remains of the "White Temple" on its ziggurat, Uruk (Warka), Iraq. c. 3500–3000 B.C.

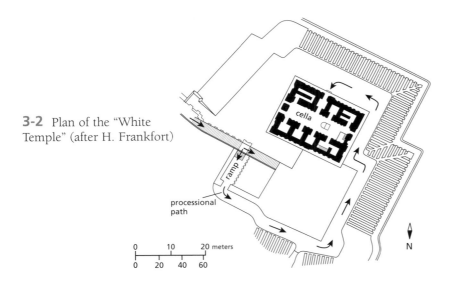

3-2 Plan of the "White Temple" (after H. Frankfort)

side, rather than on the side facing the stairs or on one of the narrow sides of the temple, as one might expect. To understand why this is the case, we must view the ziggurat and temple as a whole. The entire complex is planned in such a way that the worshiper, starting at the bottom of the stairs on the east side, is forced to go around as many corners as possible before reaching the cella. In other words, the path is a sort of angular spiral.

This "bent-axis approach" is a basic feature of Mesopotamian religious architecture, in contrast to the straight, single axis of Egyptian temples (see fig. 2-15). During the following 2,500 years, it was elaborated into ever-taller ziggurats rising in multiple stages. These were generally erected by the priest-king in his role as royal builder. What was the inspiration behind these structures? Certainly not the kind of pride attributed

to the builders of the Tower of Babel in the Old Testament. Rather, they reflect the belief that mountaintops are the dwelling places of the gods. The Sumerians felt they could provide a fitting home for a god only by creating their own artificial mountains.

SCULPTURE

The image of the god to whom the White Temple was dedicated—probably Anu, the god of the sky—is lost, but excavations of other temples have yielded stone statuary. A group of figures from Tell Asmar, in modern Iraq (fig. 3-3), shows the geometric and expressive aspects of sculpture from the early dynastic period. The entire group must have stood in the cella of a temple, contemporary with the pyramid of King Djoser, dedicated to Abu, the god of vegetation. Although the two tallest figures have been considered to be representations of Abu and a mother goddess, it is likely that all are **votive** statues of priests and worshipers. Despite the difference in size, all but the kneeling figure to the lower right have the same pose of humble worship. The priests and worshipers communicated with the god through their eyes. The enormous eyes of these figures convey the sense of awe the Sumerians felt before the often terrifying gods they worshiped. Their stare is emphasized by colored inlays, which are still in place.

The concept of representation had a very direct meaning for the Sumerians: the gods were believed to be present in their images, and the statues of the worshipers served as stand-ins for the persons they portrayed, offering prayers or transmitting messages to the god. Yet none of them shows any attempt to achieve a real likeness. The bodies as well as the faces are highly simplified so as not to distract attention from the eyes, "the windows of the soul." If Egyptian sculpture was based on the cube, Sumerian forms

MAJOR CIVILIZATIONS IN THE ANCIENT NEAR EAST	
c. 4000–2340 B.C.	Sumerian
c. 1792–1595 B.C.	Babylonian
c. 1000–612 B.C.	Assyrian
c. 612–539 B.C.	Neo-Babylonian
c. 559–331 B.C.	Persian

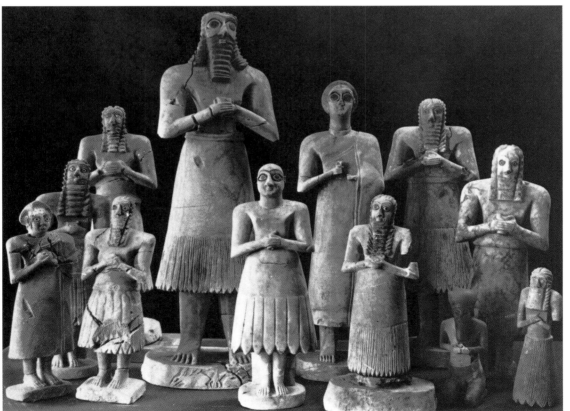

3-3 Statues, from the Abu Temple, Tell Asmar, Iraq. c. 2700–2500 B.C. Marble, height of tallest figure approx. 30" (76.2 cm). Iraq Museum, Baghdad, and The Oriental Institute Museum of The University of Chicago

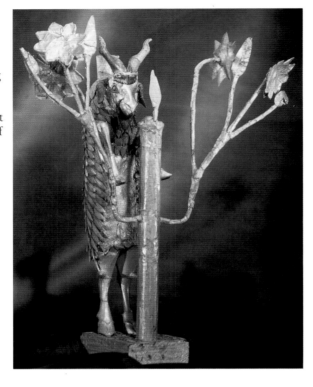

3-4 *Ram and Tree.* Offering stand from Ur (Muqaiyir), Iraq. c. 2600 B.C. Wood, gold, and lapis lazuli, height 20" (50.8 cm). University of Pennsylvania Museum, Philadelphia

The FABLE is a very old literary form in which animals play human characters. Fables may be in verse or in narrative, but either way they are moralizing allegorical commentaries on human behavior and are often highly satirical. The two greatest fabulists are thought to be AESOP, a semilegendary Greek said by Herodotus to have lived in the sixth century B.C., and JEAN DE LA FONTAINE, a seventeenth-century French writer of 12 books containing 230 fables, many of which derive from Aesop's. The word *fabulous*, meaning "of an astonishing or exaggerated nature," derives from *fable*.

were derived from the cone and cylinder. Arms and legs have the roundness of pipes, and the long skirts are as smoothly curved as if they had been turned on a lathe. This preference for round forms may have stemmed in part from the shape of the blocks supplied from afar, since suitable material was in short supply. However, it appears even in later times, when Mesopotamian sculpture displayed a far greater variety of shapes.

The simplification of the Tell Asmar statues is characteristic of the carver, who works by cutting forms out of a solid block. A far more realistic style is found in Sumerian sculpture that was made not by subtraction but by addition; such works are either **modeled** in soft materials for **casting** in bronze or put together from varied substances such as wood, gold leaf, and lapis lazuli. Some **assemblages** of the latter kind, roughly contemporary with the Tell Asmar figures, have been found in the tombs at Ur mentioned earlier. They include the fascinating object shown in figure 3-4, an offering stand in the shape of a ram

rearing up against a flowering tree. The marvelously alive animal has an almost demonic quality as it gazes from between the branches of the symbolic tree. And well it might, for it is sacred to the god Tammuz and thus embodies the male principle in nature. Here the awesome power of Mesopotamian gods and goddesses is given forceful visual expression.

Such an association of animals with deities is a carryover from prehistoric times (see page 42). We find it not only in Mesopotamia but in Egypt as well (compare the falcon of Horus in fig. 2-1). What distinguishes the sacred animals of the Sumerians is the active part they play in mythology. Much of this lore has not come down to us in written form, but we catch glimpses of it in pictorial representations such as those on an inlaid panel from a harp (fig. 3-5) that was recovered together with the offering stand at Ur. The hero embracing two human-headed bulls in the top compartment was such a popular subject that its design has become a rigidly symmetrical, decorative formula. The other sections, however, show animals performing human tasks in surprisingly lively fashion. The wolf and the lion carry food and drink to an unseen banquet, while the ass, bear, and deer provide music. (The bull-headed harp is the same type as the instrument to which our panel was attached.) At the bottom, a scorpion-man and a goat carry objects they have taken from a large vessel.

The artist who created these scenes was far less constrained by rules than Egyptian artists were. Even though these figures, too, are placed on **groundlines**, there is no fear of overlapping forms or **foreshortened** shoulders. We must be careful not to mistake the intent. What strikes us as delightfully humorous was most likely meant to be viewed seriously. If only we knew the context! The animals, which probably descend from tribal totems or worshipers wearing masks, presumably represent deities engaged in familiar human activities. Yet we may view them as the earliest known ancestors of the animal FABLE that flourished in the West from AESOP to LA FONTAINE. The ass with the harp and the hero between two animals survived as fixed images;

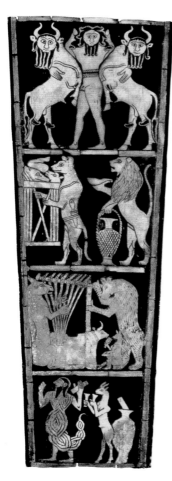

3-5 Inlay panel from the soundbox of a harp, from Ur (Muqaiyir), Iraq. c. 2600 B.C. Shell and bitumen, 12¼ x 4½" (31.1 x 11.3 cm). University of Pennsylvania Museum, Philadelphia

we meet them again almost 4,000 years later in medieval sculpture.

UR

Toward the end of the early dynastic period, the theocratic socialism of the Sumerian city-states began to decay. The local "stewards of the god" became ruling kings. The more ambitious tried to enlarge their domains by conquering their neighbors. At the same time, the Semitic-speaking inhabitants of northern Mesopotamia drifted south in ever-larger waves, until they outnumbered the Sumerian peoples in many places. Although these newer arrivals adopted many features of Sumerian civilization, they were less bound to the tradition of the city-state. Sargon of Akkad (his name means "true king," even though he usurped the throne of the northern city of Kish before founding Akkad) openly proclaimed his ambition to rule the entire earth. Sargon succeeded in conquering Sumer, as well as northern Syria and Elam, about 2334 B.C. He also combined the Sumerian and Akkadian gods and goddesses in a new pantheon. His goal was to unite the country and break down the traditional link between cities and their local gods. The rule of the Akkadian kings came to an end when tribesmen from the northeast descended into the Mesopotamian plain and gained control of it for more than half a century. They were driven out in 2112 B.C. by king Urnammu of Ur (the modern Muqaiyir), who reestablished a united realm that was to last a hundred years.

During the period of foreign dominance, Lagash (the modern Telloh), one of the lesser Sumerian city-states, managed to remain independent. Its ruler, Gudea, who lived at about the same time as Urnammu, took care to reserve the title of king for Lagash's city-god, Ningursu, and to promote his cult by an ambitious rebuilding of his temple. Nothing remains of the temple, but Gudea had numerous statues of himself placed in the shrines of Lagash. (Some 20 examples, all of the same general type, have been found so far.) However devoted he was to the Sumerian city-state, Gudea seems to have inherited the sense of personal importance of the Akkadian kings, although he prided himself on his relations with the gods rather than on his secular power.

The statue of Gudea in figure 3-6 tells us much about how he viewed himself. It was dedicated to Geshtinanna, the goddess of poetry and the interpreter of dreams, for it was in a dream that Ningursu ordered Gudea to build a temple when the Tigris failed to rise.

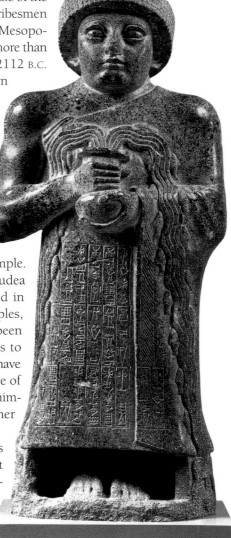

3-6 *Gudea,* from Lagash (Telloh), Iraq. c. 2120 B.C. Diorite, height 29" (73.7 cm). Musée du Louvre, Paris

The king was actively involved in the building of the ziggurat. He not only laid out the temple according to the design revealed to him by Enki, the god of building, but also helped make and carry the mud bricks. (A second statue shows him seated with the **ground plan** on his lap.) The process had to be followed scrupulously to ensure the sanctity of the ziggurat, or else the god would be displeased. We can be sure that Gudea's effort was rewarded, as the statue was an offering to Geshtinanna for her role in helping to end the drought. He is holding a vase from which flow two streams of life-giving water that represent the Tigris and Euphrates rivers. This attribute, which was reserved for water goddesses and female votive figures, may also allude to the king's role in providing irrigation canals as well as attesting to his benevolent rule.

Because the statue conforms to the same general type as others from Gudea, we may speak of a canon of forms for the first time in Mesopotamian art. (*Canon* means "rule"; see page 108.) Such consistency was probably inspired by Egyptian sculpture, which was based on set proportions. Moreover, the statue is carved of diorite, a hard stone favored by the Egyptians, and has been worked to a high finish that invites a play of light upon the features. The figure nevertheless contrasts with Egyptian statues such as that in figure 2-4. The Sumerian carver has rounded off all the corners to emphasize the cylindrical quality of the forms, although the fleshy roundness is far removed from the geometric simplicity of the Tell Asmar statues. Equally characteristic is the muscular tension in Gudea's bare arm and shoulder, compared with the passive, relaxed limbs of Egyptian sculpture.

BABYLON

The late third and the early second millennium B.C. was a time of turmoil in Mesopotamia. It gave rise to the city-states of Isin and Larsa, which rivaled Ur. Central power collapsed about 2025 B.C., when the governor of Isin refused to send aid to Ur during a famine. In 2004 Sumer fell to the Elamites from the east; a century later the Amorites from the northwest conquered several cities.

Order was restored in 1792 B.C, when Babylon assumed the role formerly played by Akkad and Ur. Hammurabi (ruled 1792–1750 B.C.), the founder of the Babylonian dynasty, is by far the greatest figure of the age. Combining military prowess with a deep respect for Sumerian tradition, he saw himself as "the favorite shepherd" of the sun-god Shamash, whose mission was "to cause justice to prevail in the land." Under him and his successors, Babylon became the cultural center of Sumer. The city was to retain this prestige for more than a thousand years after its political power had waned.

Hammurabi's greatest achievement is his LAW CODE. Justly famous as one of the earliest uniform written bodies of law, it is amazingly rational and humane. This code was engraved on a tall diorite **stela**, or stone slab, that has at its top a scene showing Hammurabi meeting Shamash (fig. 3-7). (Note the rays coming from the sun-god's shoulders.) The god holds the ring and rod of kingship, which here probably stand for justice as well. The ruler's right arm is raised almost in a speaking gesture, as if he were reporting his work to the divine king. The image conforms to a type of "introduction scene" in Mesopotamian art: an individual, his hand raised in prayer, is led by a goddess before a seated deity who bestows his blessing or, if it be an enthroned king, his office. Hammurabi is, then, a supplicant, but in this case he appears without the benefit—or need—of a divine intercessor. Hence, his relationship to the god is unusually direct.

Although the scene from the stela bearing the Law Code of Hammurabi was carved four centuries after the Gudea statues, it is closely related in both style and technique. The relief here is so high that the two figures almost give the impression of statues sliced in half. As a result, the sculptor has been able to render the eyes in the round, so that Hammurabi and Shamash gaze at each other with an immediacy that is unique in works of this kind. The figures recall the statues from Tell Asmar (see fig. 3-3), whose enormous eyes indicate an attempt to establish the same rapport between humans and gods in an earlier phase of Sumerian civilization.

The LAW CODE of Hammurabi contains 282 articles set down in 3,600 lines of cuneiform writing. Enforced throughout the empire, it purported "to destroy the wicked and the evil, that the strong may not oppress the weak." It specifies penalties for crimes (including fines, beatings, maimings, and executions), as well as laws relating to family life, such as those covering divorce. The well-known phrase "an eye for an eye, a tooth for a tooth" is a quotation from the code.

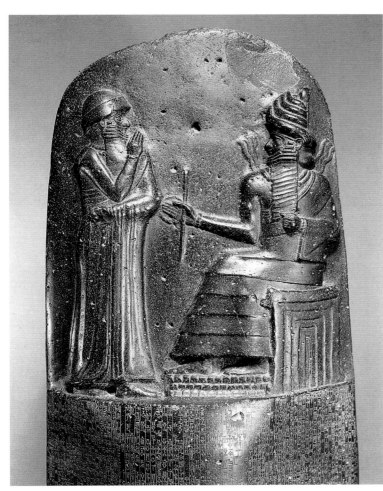

3-7 Upper part of stela inscribed with the Law Code of Hammurabi, from Susa (Shush), Iran. c. 1760 B.C. Diorite, height of stela approx. 7' (2.13 m); height of relief 28" (71.1 cm). Musée du Louvre, Paris

ASSYRIA

Babylon was overthrown in 1595 B.C. by the Hittites, an INDO-EUROPEAN tribe that had probably entered Turkey from southern Russia in the late third millennium B.C. and settled on the rocky plateau of Anatolia. The Hittite empire reached its height between 1400 and 1200 B.C., extending over most of Turkey and Syria. Its greatest king, Suppiluliuma I (ruled c. 1380/40–c. 1320 B.C.), was directly involved with the Egyptian pharaohs Akhenaten and Tutankhamen (see pages 59–61).

About 1360 B.C., the Hittites attacked the Mitannians, a people of Hurrian stock who had entered eastern Turkey around the same time as the Hittites. The Mitannians had formed a kingdom in the northern parts of Syria and northern Mesopotamia, including the city-state of Assur. They were allies of the Egyptians, who could send no effective aid because of the internal crisis provoked by the religious reforms of Akhenaten. Hence the Mitannians were defeated. Meanwhile, Babylon was taken over by the Kassites from the northwest, who traded with the Amarna pharaohs during the mid-fourteenth century B.C. They in turn were toppled by the Elamite king Shutruk-Nahhunte I about 1157 B.C., approximately the same time that the Medes and Persians began entering western Iran. However, a second Kassite dynasty quickly seized power and rose to great heights under Nebuchadnezzar I (ruled 1125–1104 B.C.). It has been argued that there is no such thing as a true Kassite style, but despite a debt to the art of Ur and Babylon, this dynasty established a revised canon of forms and new standard of skill that were taken over with very little change in the reliefs of the Assyrians, who conquered southern Mesopotamia soon thereafter.

Assur, located on the upper course of the Tigris, had regained its independence with the defeat of the Mitannians by the Hittites. Under a series of able rulers, beginning with Ashur-buballit (ruled 1363–1328? B.C.), who also had contact with the Amarna kings, the Assyrian empire gradually expanded. In time it covered not only Mesopotamia proper but the surrounding regions as well. At the height of its power, from

INDO-EUROPEAN describes the world's largest language group, or linguistic family. It takes its name from the area where the original language arose sometime before 2000 B.C.—that encompassed by Europe and India and the lands in between. The term denotes only a linguistic group, not ethnic or cultural divisions. Not all peoples living in this area speak an Indo-European language. Vocabulary and grammar structure are the common elements. The subfamilies include Anatolian, Baltic, Celtic, Germanic (which contains English), Greek, Indo-Iranian, Italic, Slavic, and several other smaller language groups.

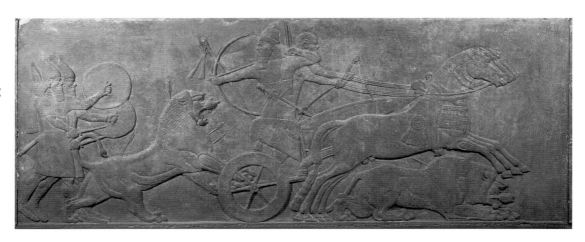

3-8 *Ashurnasirpal II Killing Lions,* from the Palace of Ashurnasirpal II, Calah (Nimrud), Iraq. c. 850 B.C. Limestone, 3'3" x 8'4" (1 x 2.54 m). The British Museum, London

The MEDES were a fierce people of the ancient kingdom of Media, located in today's western Iran (originally meaning "Land of the Aryans") and southern Azerbaijan. They kept no records and spoke an Indo-European language akin to ancient Persian.

The HANGING GARDENS of Babylon were classified by the ancients as one of the Seven Wonders of the World. The others were the Pyramid of Khufu at Giza (see fig. 2-7), the Mausoleum at Halikarnassos, the Colossus of Rhodes, the Artemision (Temple of Artemis) at Ephesus, the *Olympian Zeus* by Pheidias, and the Pharos (lighthouse) at Alexandria.

about 1000 to 612 B.C., the empire stretched from the Sinai Peninsula to Armenia. Even Lower Egypt was successfully invaded about 670 B.C.

The Assyrians, it has been said, were to the Sumerians what the Romans were to the Greeks. Assyrian civilization drew on the achievements of the south but adapted them to fit its own distinct character. The temples and ziggurats they built were based on Sumerian models, while the palaces of their kings grew to unprecedented size and magnificence. Although the Assyrians, like the Sumerians, built in brick, they liked to line gateways and the lower walls of interiors with reliefs of limestone (which was easier to obtain in northern Mesopotamia). These panels were devoted to glorifying the power of the king, either by detailed depictions of his military conquests or by showing the sovereign as the killer of lions. Both types of scenes derive from Egyptian art, but the Assyrian sculptor had to develop new techniques to cope with the demands of pictorial storytelling.

As in Egypt, the royal lion hunts were more like ritual combats than actual hunts: the animals were released from cages into a square formed by troops with shields. (At a much earlier time, lion hunting had been an important duty of Mesopotamian rulers as the "shepherds" of the communal flocks.) The Assyrian sculptor rises to his greatest heights in depictions of such scenes. In figure 3-8, the lion attacking the royal chariot from the rear is clearly the hero of the scene. Of magnificent strength and courage, the wounded animal seems to embody all the dramatic emotion of combat. The dying lion on the right is equally impressive in its agony—so different from the way the Egyptian artist had interpreted a hunted hippopotamus (see fig. 2-3).

THE NEO-BABYLONIANS

The Assyrian empire came to an end in 612 B.C., when Nineveh fell to the MEDES and Babylonians. Under the Chaldean dynasty the ancient city had a final brief flowering between 612 and 539 B.C., before it was conquered by the Persians. The best known of these Neo-Babylonian rulers was Nebuchadnezzar II (ruled 604–c. 561 B.C.), the builder of the Tower of Babel and the famous HANGING GARDENS.

Whereas the Assyrians had employed carved stone slabs to decorate their structures, the Neo-Babylonians (who were farther removed from the sources of such slabs) substituted baked and **glazed** brick. This technique, too, had been developed in Assyria. Now, however, it was used on a far greater scale, both for surface ornament and for reliefs. Its distinctive effect is evident in the Ishtar Gate of Nebuchadnezzar's sacred precinct in Babylon, which has been rebuilt from the thousands of glazed bricks that covered its surface (fig. 3-9). The procession of bulls, dragons, and other animals of molded brick within a framework of vividly colored ornamental bands has a grace and gaiety that remind us again of that special genius of ancient Mesopotamian art for the portrayal of animals.

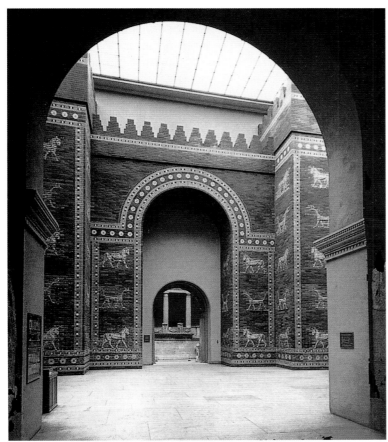

3-9 Ishtar Gate (restored), from Babylon, Iraq. c. 575 B.C. Glazed brick. Staatliche Museen zu Berlin, Preussischer Kulturbesitz, Vorderasiatisches Museum

Persian Art

Persia, the mountain-fringed high plateau to the east of Mesopotamia, takes its name from the people who occupied Babylon in 538 B.C. (see the discussion of the Achaemenids below). Today the country is called Iran, its older and more suitable name. Iran has been inhabited since prehistoric times and seems to have been a gateway for migrating tribes from the Asiatic steppes to the north as well as from India to the east. The new arrivals would settle down for a while, dominating or mingling with the local population, until the next wave of immigrants forced them to move on—to Mesopotamia, Asia Minor (roughly, Asian Turkey), or southern Russia.

ANIMAL STYLE

Not much is known about the movements of these nomadic tribes; the information we have is vague and uncertain. Since such peoples left no permanent structures or records, we can trace their wanderings only by careful study of the articles they buried with their dead. These objects, made of wood, bone, or metal, are a distinct kind of portable art called nomad's gear. They include weapons, bridles, buckles, and other articles of adornment, as well as cups, bowls, and the like. Found over a vast area, from Siberia to Central Europe, from Iran to Scandinavia, such articles have in common not only their ornamental design but also a set of forms known as the **animal style**. This style's main feature, as the name suggests, is the decorative use of animal motifs in abstract and imaginative ways.

One of the sources of the animal style appears to be ancient Iran, where it suddenly reappeared in the tenth to seventh centuries B.C. Although the exact origin and date of most objects are by no means certain, the remains of the gold belt in figure 3-10 are probably from Ziwiye in the northwestern part of the country, which was ruled in the seventh century B.C. by the Manneans. Here the animal style is at its finest—and most puzzling. The kneeling ibex is a descendant of those on prehistoric pottery from western Iran. But what are we to make of the other creatures? The stag, which is not native to the region, is a motif transported from the steppes of Central Asia by the Scythians. The alternating rows of ibexes and stags are enclosed in a pattern of

3-10 Fragment of a belt, probably from Ziwiye. 7th century B.C. Gold sheet, width 6½" (16.5 cm). The British Museum, London

abstract lion heads; this pattern was native to Urartu (the biblical Ararat) in eastern Turkey, which was conquered by Sargon II of Assyria in 714 B.C. Similar belts of bronze have also been found in Urartian tombs.

The SCYTHIANS belonged to a group of nomadic Indo-European tribes, including the Medes and the Persians, that began to filter into Iran soon after 1000 B.C. The animal style of the Scythians merged with that of the Luristan region in western Iran during the late eighth century B.C. These tribes, however, were makers of bronze. Although goldsmithing was of ancient origin and widely diffused, it was probably the Phoenicians who translated the animal style into gold. (A pectoral, or breastplate, from the same hoard as our belt depicts Phoenician deities in a similar fashion.) These seafaring traders, originally from Canaan, began ranging throughout the Mediterranean sea after the fall of Mycenae about 1200 B.C.

The seventh century B.C. was a time of intense contact between East and West. The cultural exchange gave rise to the Orientalizing style in Greece (see pages 87–90), which in turn contributed new motifs to the Near East. The Phoenicians played a key role in this process. They were superb craftsmen in various metals, including gold, who made use of motifs derived from their travels. About 800 B.C. they settled on nearby Cyprus, which soon became a center of silver- and gold-smithing and which was equally open to diverse influences. Whether Phoenician (as seems likely) or Cypriot, the artist who created our gold belt has brought together the elements of the animal style into a masterful design and fashioned it with impressive skill.

THE ACHAEMENIDS

The Near East long remained a vast melting pot. During the middle of the sixth century B.C., however, the entire region came under the sway of the Persians. After overthrowing Astyages, king of the Medes, Cyrus the Great (ruled 550–530/29 B.C.) conquered Babylon in 538 B.C. Along with the title "king of Babylon," he assumed the ambitions of the Assyrian rulers. The empire Cyrus founded continued to expand under his successors. Egypt

as well as Asia Minor fell to them, while Greece escaped by a narrow margin. At its height, under Darius I (ruled 521–486 B.C.) and his son Xerxes (ruled 485–465 B.C.), the Persian empire was far larger than the Egyptian and Assyrian empires combined. This huge domain endured for two centuries, and during most of its life it was ruled both efficiently and humanely. For an obscure tribe of nomads to have achieved all this is little short of a miracle. Within a single generation, the Persians not only learned how to administer an empire but also developed a highly original monumental art to express the grandeur of their rule.

Despite their genius for adaptation, the Persians retained their own religious beliefs, which were drawn from the prophecies of ZOROASTER. This faith was based on the dualism of Good and Evil, embodied in Ahuramazda (Light) and Ahriman (Darkness). Since the cult of Ahuramazda centered on fire altars in the open air, the Persians had no religious architecture. Their palaces, on the other hand, were huge and impressive. The most ambitious of these, at Persepolis, was begun by Darius I in 518 B.C. Assyrian traditions are the strongest single element throughout the vast complex, which consisted of a great number of rooms, halls, and courts on a raised platform. Yet they do not determine the character of the building, for they have been combined with influences from every corner of the empire to create a new, uniquely Persian style.

Columns are used on a grand scale at Persepolis. The Audience Hall of Darius and Xerxes, a room 250 feet square, had a wooden ceiling supported by 36 columns 40 feet tall, a few of which are still standing (fig. 3-11). Such a massing of columns suggests Egyptian architecture (compare fig. 2-15), and Egyptian influence can indeed be seen in the ornamental detail of the bases and capitals. However, the slender, fluted shaft of the Persepolis columns is derived from the Ionian Greeks in Asia Minor, who are known to have sent artists to the Persian court. The double stairway leading up to the Audience Hall is decorated with long rows of marching figures in low relief. Their repetitive, ceremonial character emphasizes a subservience to the architectural setting that is

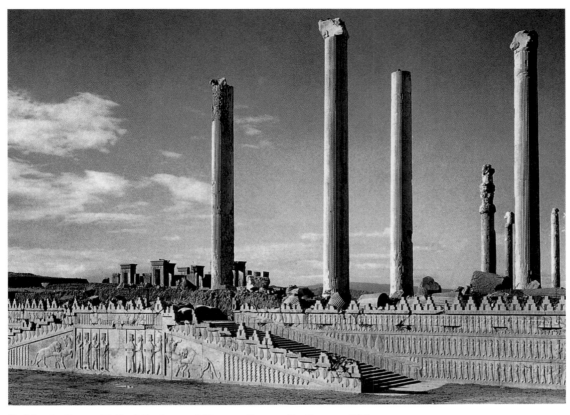

3-11 Audience Hall of Darius and Xerxes, Persepolis, Iran. c. 500 B.C.

typical of all Persian sculpture. Yet even here, we discover that the Assyrian-Babylonian heritage has been enriched by innovations stemming from the Ionian Greeks, who had created such figures in the course of the sixth century B.C. Hence the style of the Persian carvings is a softer, more refined echo of the Mesopotamian tradition. Although Persian art under the Achaemenids was a remarkable marriage of diverse elements, it lacked a capacity for growth. The style that developed under Darius I about 500 B.C. continued without major change until the end of the empire. The Persians, it seems, could not move beyond their preoccupation with decorative effects regardless of scale, a carryover from their nomadic past.

Mesopotamia, like Egypt, eventually became part of the Greek and Roman world, although it retained aspects of its ancient culture. The Achaemenids were toppled by Alexander the Great (356–323 B.C.) in 331 B.C. After his death eight years later, his realm was divided among his generals. Seleucis (ruled 305–281 B.C.) received much of the Near East, aside from Egypt, which was given to Ptolemy (see page 63). The Seleucids were succeeded by the Parthians, who gained control over the region in 238 B.C. The Parthians were fierce fighters who fended off the Romans until the time of Trajan in the second century A.D. Although their power later declined, it was not until 224 A.D. that Artabanus V, the last Parthian king, was overthrown by one of his governors, Ardashir (died 240 A.D.). Ardashir founded the Sassanian dynasty, which endured until it fell to the Arabs in 651 A.D. His son, Shapur I (ruled 240–272 A.D.), proved as ambitious as Darius had been and greatly expanded the empire. He even succeeded in defeating the Roman emperors Gordian III (ruled 238–244 A.D.) and Valerian (ruled 253–260 A.D.).

AEGEAN ART

I f we sail from the Nile Delta northwestward across the Mediterranean, our first glimpse of Europe will be the eastern tip of Crete. To the north we find a scattered group of small islands, the Cyclades. A little farther on is the mainland of Greece, facing the coast of Asia Minor across the Aegean Sea. To archaeologists, *Aegean* is not just a geographical term. They use it to refer to the civilizations that flourished in this area during the third and second millenniums B.C., before the development of Greek civilization proper. There were three closely related yet distinct cultures: Minoan (after the legendary King Minos), on the isle of Crete; Cycladic, on the Cyclades; and Helladic, on the Greek mainland, which includes Mycenae. Each has in turn been divided into three phases: Early, Middle, and Late, which correspond, very roughly, to the Old, Middle, and New Kingdoms in Egypt. Their greatest artistic achievements date from the latter part of the Middle phase and from the Late phase.

Aegean civilization was long known only from two epic poems by Homer and from Greek legends centering on Crete. The earliest excavations (by Heinrich Schliemann during the 1870s in Asia Minor and Greece and by Sir Arthur Evans in Crete shortly before 1900) were undertaken to find out whether these tales had a factual basis. Since then, a great deal of fascinating material has been brought to light—far more than written sources would lead us to expect. But even now, the lack of written records makes our knowledge of Aegean civilization much more limited than our knowledge of Egypt or the ancient Near East.

In Crete a system of writing was developed about 2000 B.C. A late form of this Minoan script, called Linear B, which was in use about six centuries later both in Crete and on the

Greek mainland, was deciphered in the early 1950s. The language of Linear B is Greek, yet this apparently was not the language for which Minoan script was used before the fifteenth century B.C. Hence, being able to read Linear B does not help us to understand earlier Minoan inscriptions. Moreover, most Linear B texts are inventories and records. They do reveal something about the history, religion, and political organization of the people who wrote them, but we still have little of the background knowledge required for an understanding of Aegean art.

Although the forms of Aegean art are linked to Egypt and the Near East on the one hand and to later Greek art on the other, they are no mere transition between these worlds. They have a haunting beauty of their own that belongs to neither. Among the many remarkable qualities of Aegean art are its freshness and spontaneity, which make us forget how little we know of its meaning.

Cycladic Art

After about 2800 B.C. the people of the Cycladic Islands often buried their dead with marble sculptures of a peculiarly impressive kind. Almost all of them represent a nude female figure with arms folded across the chest. They also share a distinctive form, which at first glance recalls the angular, abstract qualities of Paleolithic and Neolithic sculpture. Generally they possess a flat, wedge-shaped body, a strong, columnar neck, a tilted oval shield of a face, and a long, ridgelike nose. (Other features were painted in.) Within this narrowly defined and stable type, however, the Cycladic figures show wide variations in scale and form that lend them a surprising individuality. The best of these figures, such as that in figure 4-1, represent a late, highly developed phase dating to about 2500–2400 B.C.

Our example has a disciplined refinement utterly beyond the range of Paleolithic or Neolithic art. The longer we study this piece, the more we become aware of its elegance and sophistica-

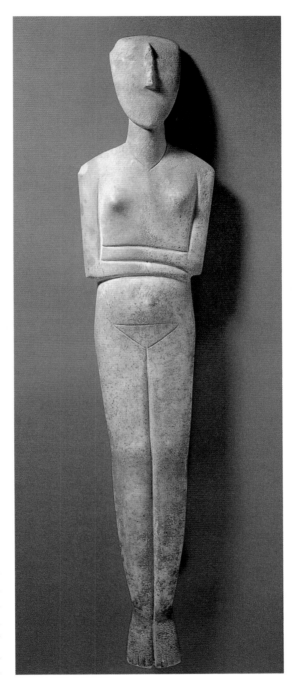

4-1 Figure, from Amorgos, Cyclades. c. 2500 B.C. Marble, height 30" (76.3 cm). Ashmolean Museum, Oxford

tion. What an extraordinary feeling for the organic structure of the body is shown in the delicate curves of the outline and in the hints of roundness at the knees and abdomen! Even if we discount its deceptively modern look, the figure is a bold departure from anything we have ever seen before. There is no lack of female figures in earlier periods, but almost all of them are descended from the heavy-bodied type of the Old Stone Age (see fig. 1-3, for example). In fact, the earliest Cycladic figurines, too, were of the same kind.

We do not know what led Cycladic sculptors to adopt the "girlish" ideal of figure 4-1. The transformation may have been related to a change in religious beliefs and practices. Perhaps there was a shift away from the mother and fertility goddess known to us from Asia Minor and the ancient Near East, whose ancestry reaches back to the Old Stone Age. The largest Cycladic figures were probably cult statues to a female divinity who may have been identified with the sun in the great cycle of life and death. The smaller ones might have been displayed in household shrines or even used as votive offerings. Although their meaning is far from clear, their purpose was not simply funereal. Rather, they were important objects that were included in graves with other items from everyday life. There they served as either presents for the deity or provisions for the afterlife. Rarely were they freestanding. Although most have been found in a reclining position, they may also have been propped upright during their normal use.

Be that as it may, the Cycladic sculptors of the third millennium B.C. produced the oldest large-scale figures of the female nude we know. In fact, for many hundreds of years they were the only ones to do so. In Greek art, we find very few nude female statues until the middle of the fourth century B.C., when Praxiteles and others began to create cult images of the nude Aphrodite (see fig. 5-22). It can hardly be by chance that the most famous of these Venuses were made for sanctuaries located on the Aegean Islands or the coast of Asia Minor, the region where the Cycladic idols had flourished.

MAJOR CIVILIZATIONS IN THE AEGEAN	
c. 2800–1600 B.C.	Cycladic
c. 3000–1450 B.C.	Minoan
c. 1600–1100 B.C.	Mycenaean

Minoan Art

Minoan civilization is by far the richest, as well as the strangest, of the Aegean world. What sets it apart, not only from those of Egypt and the Near East but also from the classical civilization of Greece, is its lack of continuity. The different phases appear and disappear so abruptly that they must have been caused by sudden violent changes affecting the entire island. They seem to be due to archaeological accidents as well as historical forces. Yet Minoan art, which is gay, even playful, and full of rhythmic motion, conveys no hint of such threats.

The first of these abrupt shifts occurred about 2000 B.C. Until that time, during the thousand years of the Early Minoan era, the Cretans had not advanced much beyond the Neolithic level of village life, although they do seem to have engaged in some trade that brought them into contact with Egypt. Then they created not only their own system of writing but also an urban civilization, centering on several great palaces. At least three palaces were built in short order at Knossos, Phaistos, and Mallia. Little is left of this sudden spurt of large-scale building. The three early palaces were all destroyed at the same time, about 1700 B.C., evidently by an earthquake. After a short interval, new and even larger structures were built on the same sites, only to be demolished by another earthquake about 1450 B.C. After that, Phaistos and Mallia were abandoned, but the palace at Knossos was occupied by the Mycenaeans, who took over the island almost immediately.

Minoan civilization therefore has a complicated chronology. Archaeologists divide the era that concerns us into the Old Palace period, comprising Middle Minoan I and Middle Minoan II, which together lasted from 2000 B.C. until about 1700 B.C., and the New Palace period, including Middle Minoan III, Late Minoan IA, and Late Minoan IB, which ended around 1450 B.C. (The dates of these internal divisions, which are constantly being debated, need not concern us here.) The eruption of the volcano on the island of Thera (the modern Santorini) occurred during the New Palace period, at the end of Late Minoan IA. It did little damage

to Crete, however, and ushered in the Late Minoan IB period, which marked the peak of Minoan civilization.

ARCHITECTURE

The "new" palaces are our main source of information about Minoan architecture. The one at Knossos, called the Palace of MINOS, was the most ambitious. It covered a large area and contained so many rooms that it survived in Greek legend as the LABYRINTH of the MINOTAUR. The palace has been carefully excavated and partly restored. There was no striving for a unified effect, and the exterior was modest compared with those of Assyrian and Persian palaces (see fig. 3-11). The individual units are rather small and the ceilings low (fig. 4-2), so that even those parts of the structure that were several stories high could not have seemed very tall.

Nevertheless, the numerous **porticoes** (roofed entranceways), staircases, and air shafts must have given the palace an open, airy look. Some of the interiors, with richly decorated walls, still retain their elegant appearance. The masonry construction is excellent, but the columns were always of wood. Although none of the columns has survived, their form is known from paintings and sculptures. They had a smooth **shaft** tapering downward and were topped by a wide, cushion-shaped **capital**. About the origins of this type of column, which in some contexts could also serve as a religious symbol, or about its possible links with Egyptian architecture, we can say nothing at all.

Who were the rulers that built these palaces? We do not know their names or deeds, except for the legendary Minos, but the archaeological evidence suggests that they were not warriors. No fortifications have been found anywhere in Minoan Crete, and military subjects are almost unknown in Minoan art. Nor is there any hint that they were sacred kings like those of Egypt or Mesopotamia, although they may have presided at religious festivals and their palaces certainly were centers of religious life. However, the only parts that can be identified as places of

The legendary MINOS was the son of Zeus and Europa and the husband of Pasiphaë, who bore the Minotaur as a punishment after her husband had disobeyed the god Poseidon. Greek historians, including Thucydides, also speak of a King Minos as the strongest, most prosperous ruler in the Mediterranean and the first to control the area with a powerful navy.

In Greek myth, the LABYRINTH was a maze of rooms beneath the palace of King Minos at Knossos, on the island of Crete. So complex was it that one could not enter it without getting lost. Within the Labyrinth lived the MINOTAUR, half-man and half-bull, who ate human flesh. After losing a war with Crete, Athens was compelled to send 14 young men and women to Crete each year to feed the monster. The Athenian prince Theseus put an end to the sacrifices by killing the Minotaur and escaping from the Labyrinth with the help of the Cretan princess Ariadne.

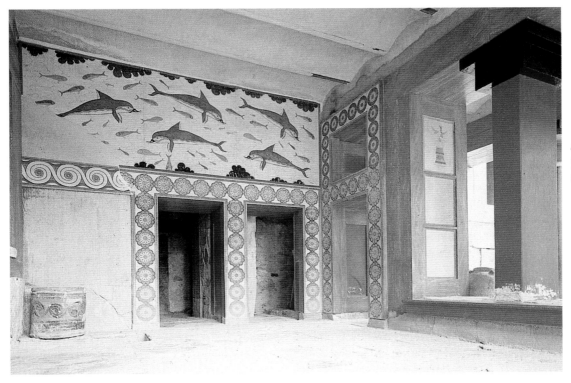

4-2 The Queen's Megaron, Palace of Minos, Knossos, Crete. c. 1700–1300 B.C.

worship are small chapels, which suggests that religious ceremonies took place out of doors or at outlying shrines.

The most important room in the palace was the megaron. This long hall typically had a hearth at the center and a roof supported by four columns. It was entered through a porch and vestibule. The many storerooms, workshops, and "offices" at Knossos indicate that the palace was not only a royal residence but also a center of administration and commerce. Shipping and trade were a major part of Minoan economic life, to judge from elaborate harbor constructions and from Cretan export articles found in Egypt and elsewhere. Perhaps, then, the king should be viewed as the head of a merchant aristocracy. Just how much power he had and how far it extended are still unclear.

SCULPTURE

The religious life of Minoan Crete centered on certain sacred places, such as caves or groves. Its chief deity (or deities?) was female, akin to the mother and fertility goddesses we have met before. Since the Minoans had no temples, we are not surprised to find that they lacked large cult statues. Several statuettes of about 1650 B.C. from Knossos must represent the goddess, although the costumes endow them with a secular, "fashionable" air. One of them (fig. 4-3) shows her with a snake in each hand and a headdress topped by a feline creature. Snakes are associated with earth deities and male fertility in many ancient religions, just as the bared breasts of this statuette suggest fecundity. The style of the *Snake Goddess* statuette hints at a source that may very possibly be foreign: the voluptuous bosom, the conical quality of the figure, and the large eyes and arched eyebrows suggest a kinship—indirect, perhaps through Asia Minor—with Mesopotamian art (compare fig. 3-3).

PAINTING

After the earlier palaces were destroyed, there was an explosive increase in wealth and a remarkable outpouring of creative energy that produced most of what we have in Minoan art and architecture. The most surprising achievement of this

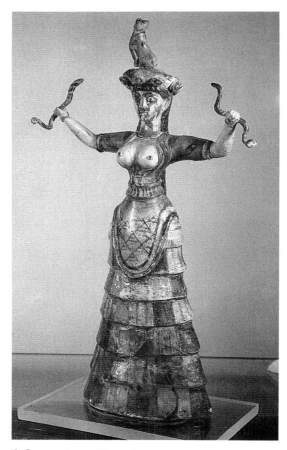

4-3 *"Snake Goddess,"* from the palace complex, Knossos. c. 1650 B.C. Faience, height 11⅝" (29.5 cm). Archaeological Museum, Iraklion, Crete

sudden flowering is mural painting. Unfortunately, the murals that covered the walls of the new palaces have survived mainly in fragments; we rarely have a complete composition left, let alone the design of an entire wall. Marine life (as seen in the fish-and-dolphin fresco in figure 4-2) was a favorite subject of Minoan painting after 1600 B.C. The floating world of Minoan wall painting was an imaginative creation so rich and original that its influence can be felt throughout Minoan art during the era of the new palaces. Instead of permanence and stability we find a passion for rhythmic movement, and the forms themselves have an oddly weightless quality. They seem to float, or sway, in a world without

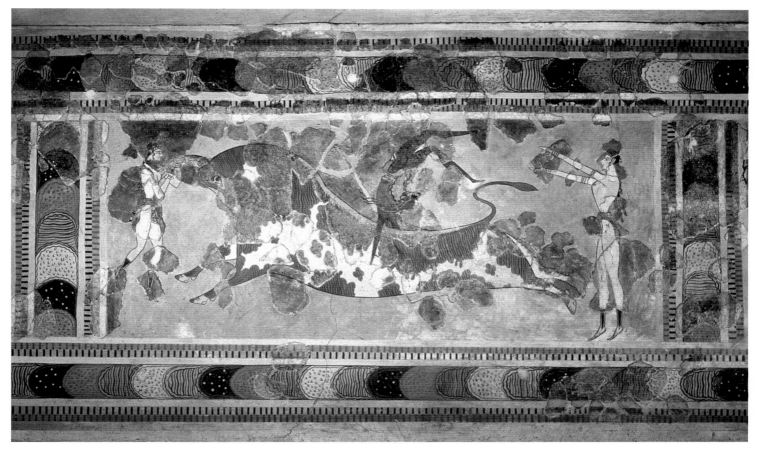

4-4 *"The Toreador Fresco,"* from the palace complex, Knossos. Original c. 1500 B.C.; restored. Height including upper border approx. 24¹/₂" (62.3 cm). Archaeological Museum, Iraklion, Crete

gravity. It is as if the scenes took place underwater, even though a great many show animals and birds among luxuriant vegetation.

We sense this quality even in *"The Toreador Fresco,"* the most dynamic Minoan mural recovered so far (fig. 4-4). (The darker patches are the original fragments on which the restoration is based.) The conventional title should not mislead us. What we see here is not a bullfight but a ritual game in which the performers vault over the back of the animal. Two of the slim-waisted athletes are girls, distinguished (as in Egyptian art) mainly by their lighter skin color. The bull was a sacred animal to the Minoans, and bull-vaulting occupied an important place in their religious life. There are

echoes of such scenes in the Greek legend of the youths and maidens sacrificed to the Minotaur, a half-animal, half-human creature. The three figures probably show different phases of the same action. But if we try to "read" the fresco as a description of what went on during these performances, we find it strangely ambiguous. This does not mean that the Minoan artist was lacking in skill. It would be absurd to find fault for failing to achieve what was never intended in the first place. Fluid, effortless movement clearly was more important than precision or drama. The painting idealizes the ritual, stressing its harmonious, playful aspect to the point that the performers behave like dolphins frolicking in the sea.

corbel arch

corbel vault

In Greek legend, ATREUS was the father of Menelaus (the husband of Helen, whose abduction caused the Trojan War) and Agamemnon, the leader of the Greek armies that besieged Troy. Through Agamemnon (often addressed as "Son of Atreus" in Homer's *Iliad*), Atreus became the ancestor of the royal family of Mycenae.

The TROJAN WAR was a half-legendary conflict fought between a number of the Greek city-states and Troy, a city on the coast of Asia Minor (modern Turkey). Homer's epic poem the *ILIAD* describes events that took place during the last year of the war, while the *ODYSSEY* recounts the ten-year homeward voyage of one of the Greek generals, Odysseos (Roman Ulysses), after the conflict. These poems—part history and part myth—developed gradually within the oral tradition of Greek poetry for centuries before there was a written Greek language and were passed down from one generation of poets to another. Recent archaeological discoveries have confirmed the accuracy of many of the details of Homer's narrative.

Mycenaean Art

Along the southeastern shores of the Greek mainland there were during Late Helladic times (c. 1600–1100 B.C.) a number of settlements that corresponded in many ways to those of Minoan Crete. They, too, for example, were grouped around palaces. Their inhabitants have come to be called Mycenaeans, after Mycenae, the most important of the settlements. Since the works of art unearthed there by excavation often showed a strikingly Minoan character, the Mycenaeans were at first thought to have come from Crete. It is now agreed that they were the descendants of the earliest Greek clans, who had entered the country sometime after 2000 B.C.

For some 400 years, these people had led a pastoral life in their new homeland. Their modest tombs contained only simple pottery and a few bronze weapons. Toward 1600 B.C., however, they suddenly began to bury their dead in deep-shaft graves. A little later, the burials were in conical stone chambers, known as beehive tombs. This trend reached its height about 1300 B.C. in structures such as the one shown in figure 4-5. Such tombs were built of concentric layers of precisely cut stone blocks that taper inward toward the highest point. (This method of spanning space is called **corbeling**.) The discoverer of this tomb thought it far too ambitious to have been used for that purpose and gave it the misleading name the Treasury of ATREUS. Burial places as elaborate as this can be matched only in Egypt during the same period.

The great monuments of Mycenaean architecture were all built between 1400 B.C., when Linear B script began to appear, and 1200 B.C. Apart from such details as decorative motifs or the shape of the columns, Mycenaean architecture owes little to the Minoan tradition. The palaces were hilltop fortresses surrounded by defensive walls of huge stone blocks. This type of construction, unknown in Crete, was similar to Hittite fortifications. The Lioness Gate at Mycenae (fig. 4-6) is the most impressive remnant of these massive ramparts, which inspired such awe in the Greeks of later times that they were regarded as the work of the Cyclopes, a mythical race of one-

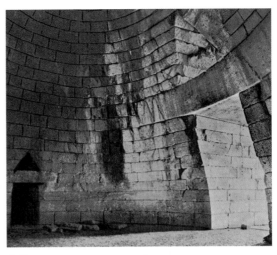

4-5 Interior, "Treasury of Atreus," Mycenae. c. 1300–1250 B.C.

eyed giants. Even the Treasury of Atreus, although built of smaller and more precisely shaped blocks, has a Cyclopean **lintel** (see fig. 4-5).

The stone relief over the doorway of the Lioness Gate is another departure from the Minoan tradition. The two lionesses flanking a symbolic Minoan column have a grim, **heraldic** majesty. Their function as guardians of the gate, their tense, muscular bodies, and their symmetrical design again suggest an influence from the Near East. We may at this point recall Homer's *ILIAD* and *ODYSSEY*, which recount the events of the TROJAN WAR and its aftermath, which brought the Mycenaeans to Asia Minor soon after 1200 B.C. It seems likely, however, that the Mycenaeans began to cross the Aegean, for trade or war, much earlier than that.

Mycenae in the sixteenth century B.C. thus presents a strange picture. What appears to be an Egyptian influence on burial customs is combined with a strong artistic influence from Crete and with an extraordinary material wealth, seen in the lavish use of gold in objects found in tombs. What we need is a triangular explanation that involves the Mycenaeans with Crete as well as Egypt about a century before the destruction of the new palaces. Such a theory—fascinating and imaginative, if hard to confirm in detail—runs as

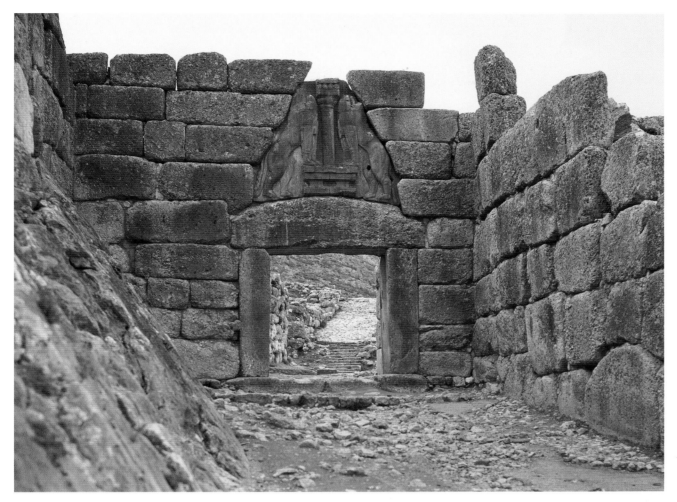

4-6 The Lioness Gate, Mycenae. 1250 B.C.

follows: between 1700 and 1580 B.C., the Egyptians were trying to rid themselves of the Hyksos, who had seized the Nile Delta (see page 58). They gained the aid of warriors from Mycenae, who returned home laden with gold (of which Egypt alone had an ample supply) and deeply impressed with Egyptian funerary customs. The Minoans, who were famous as sailors, ferried the Mycenaeans back and forth, so that they, too, had a new and closer contact with Egypt. This may help to explain their sudden prosperity about 1600 B.C. It may also account for the rapid development of naturalistic wall painting at that time. In fact, such a theory is supported by the discovery of a large group of Minoan-style paintings in Egypt. In any event, the close relations between Crete and Mycenae, once established, were to last a long time.

CHAPTER 5

GREEK ART

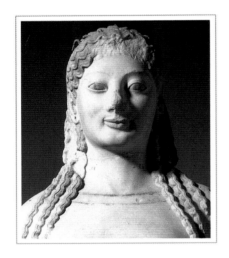

Because of the vast gaps in time and culture from the present, the works of art discussed so far seem alien, no matter how fascinating they may be. Greek architecture, sculpture, and painting, by contrast, are immediately recognizable as the direct ancestors of Western civilization, although we shall find that they owe a great deal to their predecessors. A Greek temple reminds us at a glance of the bank around the corner, a Greek statue brings to mind countless other statues that we have seen somewhere, and a Greek coin makes us want to reach for the small change in our own pockets. By the same token, the tradition linking us with the ancient Greeks can be a handicap as well as an advantage in looking at Greek art. Sometimes the contribution of original works is obscured by our familiarity with later imitations.

Another complication in the study of Greek art arises from the fact that we have three separate, and sometimes conflicting, sources of information on the subject. There are, first of all, the monuments themselves, a reliable but often inadequate source. Then we have Roman copies that tell us something about important works which would otherwise be lost to us entirely. These copies, however, pose a problem. Some are of such high quality that we cannot be sure that they really are copies. Others make us wonder how closely they follow their model—especially if we have several copies, all slightly different, of the same lost original.

Finally, there are the literary sources. The Greeks were the first people in history to write at length about their own artists, and their accounts were eagerly collected by the Romans, who handed them down to us. From them we learn what the Greeks themselves considered their

most important achievements in architecture, sculpture, and painting. This written testimony has helped us to identify some celebrated artists and monuments, but much of it deals with works of which no visible trace remains today, while other works, which do survive and which strike us as among the greatest masterpieces of their time, are not mentioned at all. To reconcile the literary evidence with that of the copies and the original works, and to weave these strands into a coherent picture of the development of Greek art, is a difficult task, despite the enormous amount of work that has been done since the beginnings of archaeological scholarship some 250 years ago.

Who were the Greeks? We have met some of them before, such as the Mycenaeans, who came to Greece about 2000 B.C. Other Greek-speaking tribes entered the peninsula from the north toward 1100 B.C. These newcomers absorbed the Mycenaeans and gradually spread to the Aegean Islands and Asia Minor. During the following centuries they created what we now call Greek civilization. We do not know how many separate tribal units there were at first, but three main groups, who settled mainland Greece, the coast of Asia Minor, and the Aegean Islands, stand out. They are the Aeolians, who took over the north; the Dorians, who inhabited the south, including the Cycladic Islands; and the Ionians, who colonized Attica, Euboea, most of the Aegean Islands, and the central coast of nearby Asia Minor. In the eighth century B.C., the Greeks also spread westward, founding important settlements in Sicily and southern Italy.

Despite a strong sense of kinship based on language and common beliefs, which were expressed in such traditions as the four great Panhellenic (all-Greek) festivals, the Greeks remained divided into small city-states. This pattern may be an echo of age-old tribal loyalties, an inheritance from the Mycenaeans, or a response to the geography of Greece, whose mountain ranges, narrow valleys, and jagged coastline would have made political unification difficult. Perhaps all of these factors worked together. In any event, the intense rivalry of these states undoubtedly spurred the growth of ideas and institutions.

Our own thinking about government uses many terms of Greek origin that reflect the evolution of the city-state. They include *monarchy* (from *monarches,* sole ruler), *aristocracy* (from *aristokratia,* rule of the best), *tyranny* (from *tyrannos,* despot), *oligarchy* (from *oligoi,* a small ruling elite), *democracy* (from *demos,* the people, and *kratos,* sovereignty), and, most important, *politics* (derived from *polites,* the citizen of the *polis,* or city-state). In the end, however, the Greeks paid dearly for their inability to broaden the concept of the state beyond the local limits of the *polis.* They engaged in constant warfare involving shifting alliances and banded together only when threatened by their common enemy, the Persians. The latter first invaded Greece in 490 B.C. under Darius I, only to be repulsed at the Battle of Marathon by a much smaller contingent of Athenians. They invaded again ten years later under Darius's son, Xerxes I, who was defeated in a series of famous battles at Thermopylae, Salamis, and Plataea in 480–479 B.C. After less than a half-century of peace, Athens and Sparta resumed their rivalry in the Peloponnesian War (431–404 B.C.), which ruined Athens and left Greece so weak that it was easily defeated by Philip II of Macedon and his son, Alexander the Great, in the late fourth century B.C.

Painting

GEOMETRIC STYLE

The formative phase of Greek civilization covers about 400 years, from about 1100 to 700 B.C. We know very little about the first three centuries of this period, but after about 800 B.C. the Greeks rapidly emerge into the full light of history. The earliest specific dates that have come down to us are from that time. The main ones are the founding of the OLYMPIAN GAMES in 776 B.C., the starting point of Greek chronology, as well as slightly later dates for the founding of various cities. Also during that time the oldest Greek style in the fine arts, the so-called Geometric, developed. We know it only from painted

From earliest recorded history, sport and fitness were highly valued in Greek civilization. The OLYMPIAN GAMES, forerunner to the modern Olympic games, were held every four years, beginning in 776 B.C., and functioned as a combined athletic and religious event. Held in honor of the Olympian god Zeus, they took place at the main sanctuary dedicated to him, which was at Olympia. The athletic contests, which were strictly for men, were discus and javelin throwing, running, jumping, wrestling, and boxing. Success brought great honor to the victor and his community.

amphora

krater

hydria

lekythos

oinochoe

kylix

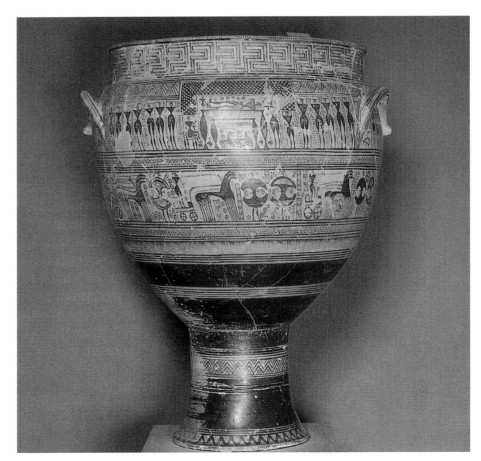

5-1 *Dipylon Vase,* from the Dipylon cemetery, Athens. 8th century B.C. Height 40½" (102.9 cm). The Metropolitan Museum of Art, New York

Rogers Fund, 1914

pottery and small-scale sculpture. (Monumental architecture and sculpture in stone did not appear until the seventh century B.C.) The two forms are closely related. The pottery was often adorned with the same kinds of figures found in sculpture, which was made of clay or bronze. These early bronzes leave little doubt that the Greeks learned the technique of **casting** from the Mycenaeans.

Greek potters soon developed a considerable variety of shapes. Each type was well adapted to its function, which was reflected in its form. As a result, each shape presented unique challenges to painters, and some became specialists at decorating certain types of vases. However, the larger pots generally attracted the best artists because they provided more generous fields to work on. Since both the making and the decorating of vases were complex processes, these were usually separate professions, but the finest painters were sometimes potters as well.

At first the pottery was decorated only with **abstract** designs: triangles, checkers, concentric circles. Toward 800 B.C. human and animal figures began to appear within the geometric framework. In the most mature examples these figures formed elaborate scenes. The one shown here (fig. 5-1), from the Dipylon cemetery near the double gate at the northwestern corner of Athens, belongs to a group of very large vases that served as grave monuments. Its bottom has holes through which

liquid offerings could filter down to the dead below. On the body of the vase we see the deceased lying in state, flanked by figures with their arms raised in a gesture of mourning. Below is a funeral procession of chariots and warriors on foot.

The most remarkable thing about this vase is that it does not refer to an afterlife. Its purpose is to commemorate the dead. Here lies a worthy man, it tells us, who was mourned by many and had a splendid funeral. Did the Greeks, then, have no concept of a hereafter? They did, but to them the realm of the dead was a colorless, ill-defined region where the souls, or "shades," led a feeble and passive existence without making any demands upon the living. When the warrior Odysseos conjures up the shade of Achilles in Homer's *Odyssey*, all the dead hero can do is mourn his own death: "Speak not conciliatorily of death, Odysseos. I'd rather serve on earth the poorest man . . . than lord it over all the wasted dead." Although the Greeks marked and tended their graves, and even poured liquid offerings over them, they did so in a spirit of pious remembrance, rather than to satisfy the needs of the deceased. Clearly, they had refused to adopt the elaborate burial customs of the Mycenaeans (see page 82). Nor is the Geometric style an outgrowth of the Mycenaean tradition. It is a fresh, in some ways primitive, start. Yet it also owes a great deal to Near Eastern art: the repertory of forms can be traced back to prehistoric Mesopotamian pottery, although how they survived to be transmitted to the Greeks is not known.

Given the limited repertory of shapes, the artist who painted our vase has achieved a remarkably varied effect. The width, density, and spacing of the bands are subtly related to the structure of the vessel. Interest in representation is limited, however. The figures or groups, repeated at regular intervals, are little more than another kind of ornament. They form part of the same overall pattern, so that their size varies according to the area to be filled. Organic and geometric elements still coexist in the same field, and often it is hard to distinguish between them. Lozenges indicate legs, whether of a man, a chair, or a bier. Circles with dots may or may not be human heads. The chevrons, boxed triangles, and other forms between the figures may be decorative or descriptive—we cannot tell.

Geometric pottery has been found not only in Greece but in Italy and the Near East as well. This wide distribution is a clear sign that Greek traders were established throughout the eastern Mediterranean in the eighth century B.C. What is more, they had already adapted the Phoenician alphabet to their own use, as we know from inscriptions on these same vases. The greatest Greek achievements of this era, however, are the two Homeric epics, the *Iliad* and the *Odyssey*. The scenes on Geometric vases barely hint at the narrative power of these poems. If our knowledge of eighth-century Greece were based on the visual arts alone, we would think of it as a far simpler and more provincial society than the literary evidence suggests.

There is a paradox here. Perhaps at this time Greek civilization was so language-minded that painting and sculpture played a less important role than they would in later centuries. In that event, the Geometric style may have been something of an anachronism, a conservative tradition about to burst at the seams. Representation and narrative demand greater scope than the style could provide. The dam finally burst toward 725 B.C., when Greek art entered another phase, which we call the Orientalizing style, and new forms came flooding in.

ORIENTALIZING STYLE

As its name implies, the new style reflects influences from Egypt and the Near East. Spurred by increasing trade with these regions, Greek art absorbed a host of oriental motifs and ideas between about 725 and 650 B.C., and was profoundly transformed in the process. It would be difficult to overestimate the impact of these influences. Whereas earlier Greek art is Aegean in flavor, the Orientalizing phase has a new monumentality and variety. Its wild exuberance reflects the efforts of painters and sculptors to master the new forms that came in waves, like immigrants from afar. The later development of Greek art is unthinkable without this vital period of experimentation.

Some of the subjects and motifs that we think

MAJOR PERIODS OF GREEK ART	
c. 900–725 B.C.	Geometric
c. 725–650 B.C.	Orientalizing
c. 650–480 B.C.	Archaic
c. 480–400 B.C.	Classical
c. 400–325 B.C.	Late Classical
c. 320–330 B.C.	Hellenistic

of as typically Greek were, in fact, derived from Mesopotamia and Egypt, where they had a long history reaching back to the dawn of Near Eastern civilization. Another major source was Syrian art of the previous 150 years, when the region was ruled by the Aramaeans; the result was a crude but vigorous blend of Hittite and Assyrian art. The Greeks were active at the port of Al Mina, at the mouth of the Orontes River in northern Syria. So were the Etruscans and Phoenicians, who also played an intermediary role as both artists and traders (see page 74). It was the merging of these influences with Aegean tendencies and the distinctive Greek cast of mind that soon gave rise to what we think of as Greek art proper.

The change becomes evident if we compare the large **amphora** (a vase for storing wine or oil) from Eleusis (fig. 5-2) with the *Dipylon Vase* of a hundred years earlier (see fig. 5-1). Geometric ornament has not disappeared from this vase altogether, but now it is confined to the foot, handles, and lip. New, curvilinear motifs—such as spirals, interlacing bands, palmettes, and rosettes—appear everywhere. On the shoulder of the vessel is a frieze of fighting animals, derived from Near Eastern art. The major areas, however, are given over to narrative, which now dominates the vase.

The Greek myths and legends (see box, page 89) were a vast source of subjects for narrative painting. These tales, many of which can be traced back to the Akkadians (see page 69), were the result of mixing local Doric and Ionic deities and heroes into the pantheon of Olympian gods and Homeric sagas. They also represent a comprehensive attempt to understand the world. The Greek interest in heroes and deities helps to explain the appeal of oriental lions and monsters to the Greek imagination. These terrifying creatures embodied the unknown forces faced by the hero. This fascination can be seen on the Eleusis amphora. The figures have gained so much in size and descriptive precision that the decorative patterns scattered among them can no longer interfere with their actions. Ornament of any sort now belongs to a separate and lesser realm clearly distinguished from that of representation.

Used almost continuously throughout Western art, the Greek vocabulary of ornamental motifs is vast, highly adaptable, and very durable.

spirals made of
interlacing bands

palmette

rosette

acanthus

meander

egg-and-dart

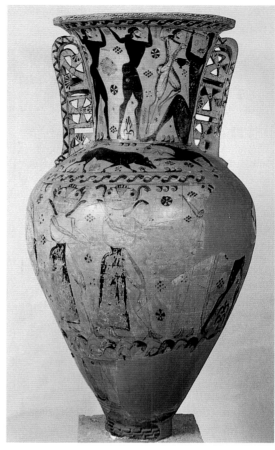

5-2 *The Blinding of Polyphemos and Gorgons,* on a Proto-Attic amphora. c. 675–650 B.C. Height 56" (142.2 cm). Archaeological Museum, Eleusis

The neck of the Eleusis amphora shows the blinding of the one-eyed Cyclops Polyphemos, a son of Poseidon, by Odysseos and his companions, whom the giant had imprisoned. The story, recounted in the *Odyssey* but undoubtedly known from other retellings, is portrayed with memorable directness and dramatic force. If these men lack the beauty we expect of epic heroes in later art, their movements have an expressive vigor that makes them seem thoroughly alive. The slaying of another monstrous creature is depicted on the body of the vase, which has, however, been so badly damaged that only two figures have survived

The Greek Gods and Goddesses

All early civilizations and preliterate cultures had creation myths to explain the origin of the universe and humanity's place in it. Over time, these myths evolved into complex cycles that represent a comprehensive attempt to understand the world. The Greek stories of the gods and heroes—the myths and legends—were the result of combining local Doric and Ionic deities and folktales with the pantheon of Olympian gods. These tales had been brought to Greece from the ancient Near East through successive waves of immigration. The gods and goddesses, though immortal, were very human in behavior. They quarreled, and had children with each other's spouses and often with mortals as well. They were sometimes threatened and even overthrown by their own children. The principal Greek gods and goddesses, with their Roman counterparts in parentheses, are given below.

ZEUS (Jupiter), god of sky and weather, was the king of the Olympian deities. His parents were KRONOS and RHEA. It had been prophesied that one of Kronos's children would overthrow him, and he had thus taken the precaution of eating his children as soon as they were born. After Zeus's birth, Rhea hid him so that he would not suffer the same fate as his siblings. Zeus later tricked Kronos into disgorging his other children, who then overthrew their father with the help of the earth goddess, GAEA. Gaea was both the mother and wife of the sky god, URANUS, and the wife of PONTUS, god of the sea. She was also the mother of the Cyclopes, who forged the weapons of the Olympians, as well as the TITANS and Hundred-Handed Ones. The descendants of the Titans included ATLAS (who was credited with holding up the earth), HECATE (an underworld goddess), SELENE (goddess of the moon), HELIOS (a god of the sun), and PROMETHEUS (a demigod, who gave humanity the gift of fire and was severely punished for doing so). After the defeat of Kronos, Zeus divided the universe by lot with his brothers POSEIDON (Neptune), who ruled the sea, and HADES (Pluto), who became lord of the underworld.

Zeus fathered ARES (Mars, the god of war), HEPHAESTUS (Vulcan, the god of armor and the forge), and HEBE (the goddess of youth) with his queen, HERA (Juno), goddess of marriage and fruitfulness, who was both his wife and sister. He also had numerous children through his love affairs with other goddesses and with mortal women. Chief among his children was ATHENA (Minerva), goddess of war. She was born of the liaison between Metis and Zeus, who swallowed her alive because, like his own father, he was told he would be toppled by one of his offspring. Athena later emerged fully armed from the head of Zeus. Although a female counterpart to the war god Ares, Athena was also the goddess of peace, a protector of heroes, a patron of arts and crafts (especially spinning and weaving), and, later, of wisdom. She became the patron goddess of Athens, an honor she won in a contest with Poseidon. Her gift to the city was an olive tree, which she caused to sprout on the Akropolis (Poseidon had offered a useless saltwater spring). Zeus sired other goddesses. The most important of them was APHRODITE (Venus), the goddess of love, beauty, and fertility. She became the wife of Hephaestus and a lover of Ares, by whom she bore HARMONIA, EROS, and ANTEROS. Aphrodite was also the mother of HERMAPHRODITUS (with Hermes), PRIAPUS (with Dionysos), and AENEAS (with the Trojan prince Anchises). ARTEMIS (Diana), who with her twin brother, APOLLO, was born of Leto and Zeus, was the virgin goddess of the hunt. She was also sometimes considered a moon goddess with Selene and Hecate.

Zeus begat other major gods as well. HERMES (Mercury), son of Maia, was the messenger of the gods, conductor of souls to Hades, and the god of travelers and commerce. He was sometimes credited with inventing the lyre and the shepherd's flute. The main god of civilization (including art, music, poetry, law, and philosophy) was the sun-god Apollo (Helios), who was also the god of prophecy and medicine, flocks and herds. Apollo was opposite in temperament to DIONYSOS (Bacchus), the son of Zeus and either PERSEPHONE (Proserpina), queen of the underworld, or the mortal Semele. Dionysos was raised on Mount Nyssa, where he invented wine making. His followers, the half-man, half-goat satyrs (the oldest of whom was Silenus, the tutor of Dionysos) and their female companions, the nymphs and humans who were known as maenads (bacchantes), were given to orgiastic excess. However, there was another, more temperate side to Dionysos's character. As the god of fertility, he was also a god of vegetation, as well as of peace, hospitality, and the civilized arts.

intact. They are GORGONS, sisters of the snake-haired MEDUSA, whom PERSEUS (partly seen fleeing to the right) killed with the aid of the gods. Even here we notice an interest in the articulation of the body that goes far beyond the limits of the Geometric style.

ARCHAIC STYLE

The Orientalizing phase of Greek art was a period of transition, in contrast to the stable Geometric style. Once the new elements from the East had been assimilated, another style emerged, as well defined as the Geometric but much greater in range: the **Archaic**, which lasted from the later seventh century to about 480 B.C., the time of the famous Greek victories over the Persians. During the Archaic period, we see the unfolding of the artistic genius of Greece, not only in vase painting but also in architecture and sculpture. While Archaic art lacks the balance and sense of perfection of the Classical style of the later fifth century, it has such freshness that many people consider it the most vital phase of Greek art.

Black-Figure Style Archaic vases are generally a good deal smaller than their predecessors, since pottery vessels no longer served as grave monuments (which were now made of stone). Their painted decoration, however, shows a far greater emphasis on pictorial subjects. Scenes from mythology, legend, and everyday life appear in endless variety, and the artistic level is often very high, especially among Athenian vases. After the middle of the sixth century, many of the finest vases bear the signatures of the artists who made them. This shows not only that potters, as well as painters, took pride in their work but also that they could become famous for their personal style. Some of the Archaic vase painters have so distinctive a style that their artistic "handwriting" can be recognized even without a signature. Archaic vase painting thus introduces us to the first clearly defined personalities in the history of art. (Signatures occur in Archaic sculpture and architecture as well, but they have not helped us to identify the personalities of individual masters.)

Archaic Greek painting was, of course, not confined to vases. There were murals and panels, too. Almost nothing has survived of them, but since all Archaic painting was essentially drawing filled in with solid, flat color, murals could not have looked very different from vase pictures. According to the literary sources, Greek wall painting did not come into its own until about 475–450 B.C., after the Persian wars. During this period artists gradually discovered how to model figures and objects and how to create a sense of spatial depth. From that time on, vase painting became a lesser art, since depth and modeling were beyond its limited technical means; by the end of the fifth century its decline was obvious. Thus the great age of vase painting was the Archaic era. Until about 475 B.C., the best vase painters enjoyed as much prestige as other artists. Whether or not their work directly reflects the lost wall paintings, it deserves to be viewed as a major achievement.

The difference between Orientalizing and Archaic vase painting is one of artistic discipline. In the amphora from Eleusis (see fig. 5-2), the figures are shown partly as solid silhouettes, partly in outline, or as a combination of both. Toward the end of the seventh century, vase painters in the Athens region adopted the **black-figure** style, in which the entire design is silhouetted in black against the reddish clay. Internal details are scratched in with a needle; white and purple may be added on top of the black to make certain areas stand out. This technique favors a decorative, two-dimensional effect.

Herakles killing the Nemean lion, on an amphora attributed to the painter Psiax (fig. 5-3), is the direct outgrowth of the forceful Orientalizing style of the blinding of Polyphemos in the Eleusis amphora. It reminds us of the hero on the soundbox of the harp from Ur (see fig. 3-5). Both show a man facing unknown forces in the form of terrifying creatures. The lion also serves to underscore the hero's might and courage against demonic powers. The scene on Psiax's amphora is all grimness and violence. The two heavy bodies are locked in combat, so that they almost grow together into a single unit. Lines and colors have

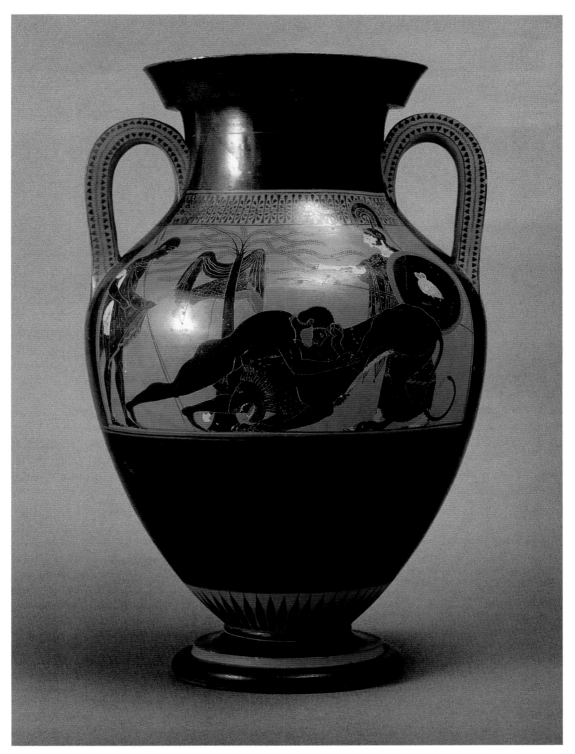

5-3 Psiax. *Herakles Strangling the Nemean Lion,* on an Attic black-figured amphora from Vulci, Italy. c. 525 B.C. Height 19 ½" (49.5 cm). Museo Civico dell'Età Cristiana, Brescia

been added with utmost economy in order to avoid breaking up the massive expanse of black. Yet both figures show such a wealth of anatomical knowledge and skillful foreshortening that they give an illusion of existing in the round. (Note the way the abdomen and shoulders of Herakles are rendered.) Only in such details as the eye of Herakles do we still find the traditional combination of front and profile views.

Red-Figure Style Psiax must have felt that the silhouettelike black-figure technique made foreshortening unduly difficult, for in some of his vases he tried the reverse procedure, leaving the figures red and filling in the background. This **red-figure** technique gradually replaced the older method toward 500 B.C. Its advantages can be seen in figure 5-4, a **krater** for mixing wine of about 510 B.C. by Euphronios showing Herakles wrestling the giant Antaios. The details have been applied by squeezing a bladder rather like a pastry tube, or by freely drawing them with the brush, rather than incised. As a result, the picture depends far less on the profile view than before. Instead, the artist uses the internal lines to show boldly foreshortened and overlapping limbs, precise details of costume (note the pleated dresses of the women), and intense facial expressions. He is so fascinated by these new effects that he has made the figures as large as possible. They almost seem to burst from the field of the vase!

The heightened naturalism made possible by red-figure vase painting allowed the artist to explore a new world of feeling as well. Euphronios takes care to show even subtle differences in appearance between Herakles and Antaios in order to make clear the distinction in their character, which the Greeks called *ethos*. By contrast, the outcome is never in doubt in Psiax's amphora, as can be seen from the composition and from the gesture of Athena, goddess of heroes. And whereas Psiax's lion roars in rage, Euphronios makes us feel the suffering, not just the pain, of the shaggy Antaios, who clearly will lose out to the neatly coiffed Herakles. He also depicts the fear of the mortal women on either side, who support the combatants but cannot

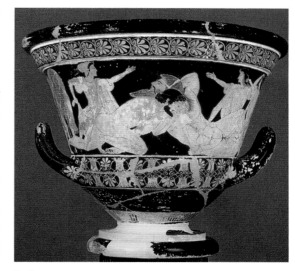

5-4 Euphronios. *Herakles Wrestling Antaios,* on an Attic red-figured krater. c. 510 B.C. Height 19" (48 cm). Musée du Louvre, Paris

protect them. Thus for the first time we see sympathy for the vanquished as victim.

The Symposium The vases we have just discussed were associated with wine. Obviously they were not meant for everyday use. (Unadorned vases served that purpose.) Decorated vases were reserved for major occasions, the most important of which was the symposium (*symposion*), an exclusive drinking party for men. The participants reclined on couches around the edges of a room; in the middle was a large mixing bowl, overseen by a master of ceremonies, who filled the drinkers' cups. Music, poetry, storytelling, and word games accompanied the festivities. The event often ended in lovemaking, which is frequently depicted on drinking cups. There was also a serious side to symposia, as described by Plato and Xenophon, which centered on debates about politics, ethics, and morality. This aspect is reflected in the gradual change in attitude toward myth and legend seen on the Greek vases we have surveyed.

CLASSICAL STYLE

According to literary sources, Greek painters of the Classical period, which began about 480 B.C.,

achieved a great breakthrough in mastering **illusionistic** space. Unfortunately, the only Greek murals to come to light are to be found in several Macedonian tombs, including that of Philip II, at Vergina, of about 340–330 B.C., that were discovered in 1976. By its very nature, vase painting could echo the new concept of **pictorial space** only in elementary fashion. From the mid-fifth century on, the impact of monumental painting gradually transformed vase painting as a whole into a satellite practical art that tried to reproduce large-scale compositions in a kind of shorthand dictated by its own limited technique and by the fact that vessels were made in large volume and sold cheaply.

Painting reached its peak in the fourth century B.C., when it was recognized as one of the liberal arts. During this time, numerous rival schools emerged as panel painting replaced wall painting. Among the leading artists mentioned by the Roman writer PLINY THE ELDER are Zeuxis of Herakleia, a master of texture, and Parrhasios of Ephesos, who "first gave proportion to painting . . . and was supreme in painting contour lines, which is the most subtle aspect of painting." Pliny also mentions Apelles

of Kos, Alexander the Great's favorite artist and the most famous painter of his day, celebrated for his grace, and Nikomachos of Athens, renowned for his rapid brush. Not a single panel painting survives to verify these claims.

We can, however, get some idea of what Greek wall painting looked like from Roman copies and imitations, although their relation is problematic (see page 142). According to Pliny, at the end of the fourth century B.C. Philoxenos of Eretria painted the victory of ALEXANDER THE GREAT over King Darius III at Issos in Asia Minor. The same subject—or another battle in Alexander's war against the Persians—is shown in an exceptionally large and technically masterful floor **mosaic** from a Pompeian house of about 100 B.C. (fig. 5-5). The scene depicts Darius and the fleeing Persians on the right, and, in the badly damaged left-hand portion, the figure of Alexander.

While there is no special reason to link this mosaic with Pliny's account (several others are recorded), we can hardly doubt that it is an excellent copy of a Hellenistic painting from the late fourth century B.C. The picture follows the four-color scheme (yellow, red, black, and white)

There were two Plinys: PLINY THE ELDER (23/24–79 A.D.) and his nephew and adopted son, Pliny the Younger (c. 61–c. 112). Pliny the Elder was a renowned equestrian and served several Roman emperors as a military officer. In midlife, he took up writing. Of the 31 books mentioned by Pliny the Younger, only the encyclopedic *Historia Naturalis* (*Natural History*) survives. Pliny the Younger's literary distinction is in his letters, including one that poignantly describes watching his uncle from a boat as he suffocated to death on the shore of the Roman seaside resort of Pompeii while it was being consumed by volcanic mud and steam from Mount Vesuvius.

Philip II (382–336 B.C.), king of Macedon—modern Macedonia—was a military genius who, by the time of his assassination, had conquered most of the Greek world. His son, ALEXANDER THE GREAT (356–323 B.C.), was already an accomplished general at the age of 18 and succeeded his father two years later. Within ten years he conquered various Persian and Near Eastern peoples as he created an empire that reached from the west across Mesopotamia to the Indus Valley. He encouraged Greek culture in the peoples he ruled, while not suppressing local beliefs or traditions. After surviving staggering military perils, he died suddenly in the city of Babylon when he was just 33.

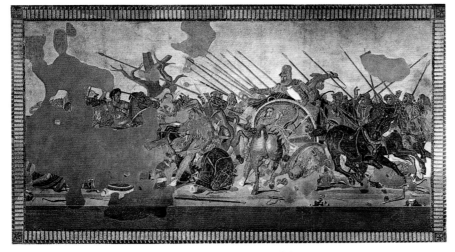

5-5 *The Battle of Issos* or *The Battle of Alexander and the Persians*. c. 100 B.C. Mosaic copy from Pompeii of a Hellenistic painting of c. 315 B.C. 8'11" x 16'9 1/2" (2.78 x 5.12 m). Museo Archeològico Nazionale, Naples

The early Greeks interpreted the meaning of events in terms of fate and human character rather than as accidents of history, in which they had little interest before about 500 B.C. The main focus in their writings was on explaining why the legendary heroes of the past seemed incomparably greater than people of their own day. Some of these heroes were historical figures, but all were believed to be descendants of the gods, who often had children with mortals. Such a lineage helped to explain the hero's extraordinary power. This power (called *arete* by the Greeks) could, in excess, lead to overweening pride (*hubris*) and to moral error (*hamartia*). The tragic results of *hamartia* were the subject of many Greek plays, especially those by Sophocles. The Greek ideal became moderation in all things, personified by Apollo, the god of art and civilization. *Arete* came to be identified over time with personal and civic virtues, such as modesty and piety.

The greatest of all Greek heroes was HERAKLES (Hercules to the Romans). The son of Zeus and the princess Alkmene, he became the only mortal ever to ascend to Mount Olympus upon his death. His greatest exploits were the 12 Labors. Undertaken over 12 years at the command of King Eurystheus in Tiryns, they were acts of atonement for killing his wife and children after he was driven mad by Hera (the wife of Zeus) for his excesses.

that is known to have been widely used at that time. Moreover, there can be little doubt that the mosaic was created by a Greek, as this technique originated in Hellenistic times and remained a specialty of Greek artists to the end. The crowding, the air of frantic excitement, the powerfully modeled and foreshortened forms, and the precise shadows make the scene far more complicated and dramatic than any other work of Greek art from the period. And for the first time it shows something that actually happened, without the symbolic overtones of *Herakles Strangling the Nemean Lion* (see fig. 5-3).

Temples

ORDERS

Since Roman times, the Greek achievement in architecture has been identified with the three Classical **orders**: Doric, Ionic, and Corinthian. Actually, there are only two, for the Corinthian is a variant of the Ionic. (The dentils, or toothlike blocks, of the Corinthian order are sometimes found in the Doric and Ionic orders as well.) The Doric, so named because its home is a region of the Greek mainland, may well be the basic order. It is older and more sharply defined than the Ionic, which developed on the Aegean Islands and the coast of Asia Minor.

What do we mean by an architectural "order"? By common agreement, the term is used only for Greek architecture (and its descendants); and rightly so, for none of the other architectural systems known to us produced anything like it. Perhaps the simplest way to make this point is to note that there is no such thing as "the Egyptian temple" or "the Gothic church." The individual buildings, however much they may have in common, are so varied that we cannot say that they represent a type. But "the Doric temple" is a real entity that forms in our minds as we study the monuments themselves.

We must be careful, of course, not to think of this abstraction as an ideal that permits us to measure the degree of perfection of any given Doric temple. It simply means that the elements of which a Doric temple is composed are extraordinarily constant in kind, in number, and in their relation to one another. As a result, Doric temples all belong to the same easily recognized family, just as kouros statues do (see below). And like kouros statues, the Doric temples show an internal

consistency that gives them a unique quality of organic unity. Nor is the similarity a coincidence. According to the Roman architect Vitruvius, no doubt basing himself on Greek sources, "Without symmetry and proportion there can be no principles in the design of any temple; that is, if there is no precise relation between its members, as in the case of a well-shaped man."

In the end, the greatest achievement of Greek architecture was much more than just beautiful buildings. Greek temples are governed by a structural logic that makes them look stable because of the precise arrangement of their parts. The Greeks tried to regulate their temples in accordance with nature's harmony by constructing them of measured units that were so proportioned that they would all be in perfect agreement. ("Perfect" was as significant an idea to the Greeks as "forever" was to the Egyptians.) Now architects could create organic unities, not by copying nature, not by divine inspiration, but by design. Thus, their temples seem to be almost alive. They achieved this triumph chiefly by expressing the structural forces active in the buildings themselves. In the Classical period, expressions of force and counterforce in both Doric and Ionic temples were proportioned so exactly that their opposition produced the effect of a perfect balancing of forces and a harmonizing of sizes and shapes. This is the real reason why, in so many periods of Western history, the orders have been considered the only true basis for beautiful architecture. They are so perfect that they could not be surpassed, only equaled.

TEMPLE PLANS

The **ground plans** of Greek temples are not directly linked to the orders, which concern only the **elevation**, or view of one exterior side seen straight on. (A third type of architectural drawing is the **section**.) They may vary according to the size of the building or regional preferences, but their basic features are so much alike that it is useful to study them from a generalized "typical" plan (fig. 5-6). The nucleus is the **cella**, or naos (the room in which the image of the deity

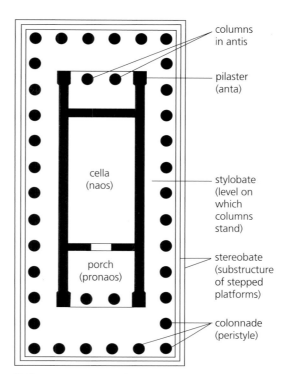

5-6 Ground plan of a typical Greek peripteral temple

is placed), and the porch (pronaos) with its two columns (columns in antis) flanked by **pilasters** (antae). Often we find a second porch added behind the cella, to make the design more symmetrical. In larger temples, the central unit is surrounded by a **colonnade**, called the **peristyle**, and the structure is then described as peripteral. The peristyle consists of six to eight columns at front and back, and usually 12 to 14 along the sides (the corner columns are counted twice). The very largest temples of Ionian Greece may even have a double colonnade. In most Greek temples the entrance faces east, toward the rising sun. This orientation reaches back to Stonehenge (see fig. 1-6) and is continued in Christian basilicas (see page 156), which also face east but were entered from the west.

DORIC ORDER

The term **Doric order** refers to the standard parts, and their sequence, found on the exterior of any

A plan, or **ground plan,** depicts a building as if sliced horizontally about three feet above the ground, usually showing solid parts in a darker tone than openings (doors and windows) and open spaces. Lines may indicate changes of level, such as steps. This plan shows a Doric temple.

An **elevation** shows one exterior side seen straight on, with the parts drawn to scale. This elevation is of the main entrance end of the Doric temple seen in the plan above.

A **section** reveals the inside of a structure as if sliced clean through.

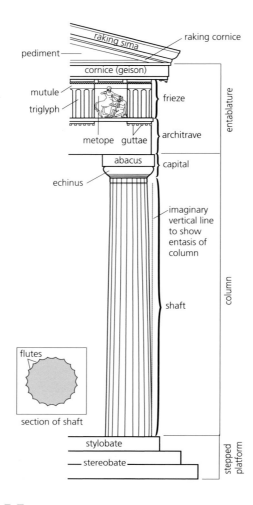

5-7 Doric order

Doric temple. The diagram in figure 5-7 shows the order in detail, along with the names of all its parts. To the nonspecialist, the detailed terminology of Greek architecture may seem something of a nuisance. Yet many of these terms have become part of our general architectural vocabulary. They remind us that analytical thinking, in architecture as in countless other fields, began with the Greeks.

Let us first look at the three main divisions: the stepped platform (consisting of the stylobate and stereobate), the column, and the **entablature**. The **Doric column** consists of the **shaft**, marked by 20 shallow vertical grooves known as **flutes**, and the **capital**, which is made up of the flaring,

cushionlike **echinus** and a square tablet called the **abacus**. These bear a strict ratio to each other, though the proportions became taller over time. The entablature, which includes all the horizontal elements that rest on the columns, is the most complex of the three major units. It is subdivided into the **architrave** (a row of stone blocks directly supported by the columns); the **frieze**, made up of grooved **triglyphs** and flat or sculpted **metopes**; and a projecting horizontal **cornice**, or geison, which may include a gutter (sima). The architrave in turn supports the triangular **pediment** and the roof elements (raking cornice and raking sima).

The entire structure is built of stone blocks fitted together without mortar. Naturally, these blocks had to be shaped with great precision to achieve smooth joints. Where necessary, they were fastened together with metal dowels or clamps. Columns, with very rare exceptions, were composed of sections, called **drums**. The shaft was fluted after the entire column was assembled and in position. The roof was made of terra-cotta tiles supported by wooden rafters, and wooden beams were used for the ceiling, so the threat of fire was constant.

How did the Doric order originate? What factors shaped it? These questions can be answered only in part, for we have hardly any remains from the time when the system was being formed. The earliest stone temples were probably built north of Mycenae near Corinth, the leading cultural center of Greece during the late seventh century B.C. From there the idea spread across the isthmus that connects the Peloponnesus to the mainland and up the coast to Delphi and Corfu, then rapidly throughout the Hellenic world. The importance of this architectural revolution can be seen in the fact that soon thereafter the first Greek architects become known to us by name. Nor is it a coincidence that they began to write treatises on architecture—the first we know of. The oldest temples that have come down to us show that the main features of the Doric order were already well established soon after 600 B.C. But how they developed, individually and in combination, and why they coalesced

into a system so quickly, remains a puzzle to which we have few reliable clues.

The early Greek builders in stone seem to have drawn upon three sources of inspiration: Egypt, Mycenae, and pre-Archaic Greek architecture in wood and mud brick. Of the three, Mycenae is the most obvious, although probably not the most important. The central unit of the Greek temple, the cella and porch, is clearly derived from the megaron, either through tradition or by way of revival. There is something oddly symbolic about the fact that the Mycenaean royal hall should have been converted into the dwelling place of the Greek gods. The entire Mycenaean era had become part of Greek mythology, as attested by the Homeric epics, and the walls of the Mycenaean fortresses were thought to be the work of mythical giants, the Cyclopes. The awe the Greeks felt toward these remains also helps us to understand the link between the Lioness Gate relief at Mycenae (see fig. 4-6) and the sculptured pediments on Doric temples. Finally, the flaring, cushionlike capital of the Minoan-Mycenaean column is much closer to the Doric echinus and abacus than is any Egyptian capital. The shaft of the Doric column, on the other hand, tapers upward, not downward as does the Minoan-Mycenaean column, and this points to Egyptian influence.

Perhaps we will recall with some surprise the fluted columns (or rather half-columns) in the funerary district of Djoser at Saqqara (see fig. 2-6). They look like the Doric shaft, but they are more than 2,000 years earlier. Moreover, the very notion that temples ought to be built of stone, and that they should have large numbers of columns, must have come from Egypt. It is true, of course, that the Egyptian temple is designed to be seen from the inside, while the Greek temple is arranged so that the exterior matters most. (People were allowed to see the cult statue in the dimly lit cella, but most religious rites took place at altars set up outdoors, with the temple facade as a backdrop.) A peripteral temple might be viewed as the columned court of an Egyptian sanctuary turned inside out. The Greeks must have gained many of their stonecutting and masonry techniques from the Egyptians. Also from Egypt came their knowledge of architectural ornament and the geometry needed to lay out temples and to fit the parts together. Yet we cannot say just how they went about all this, or exactly what they took over, technically and artistically, although there can be little doubt that they owed more to the Egyptians than to the Minoans or the Mycenaeans.

We must consider a third factor: To what extent was the Doric order a reflection of wooden structures? At the very start, Doric architects certainly imitated in stone some features of wooden temples, if only because these features were deemed necessary in order to identify a building as a temple. Thus the triglyphs were derived from the ends of ceiling beams decorated with three grooves and secured with wooden pegs. The shape of these pegs is echoed in the **guttae**. Metopes evolved out of the boards that filled in the gaps between the triglyphs to guard against the weather. Likewise, **mutules** (flat projecting blocks) reflect the rafter ends of wooden roofs. When Greek architects made them part of the Doric order, however, they did not do so from mere force of habit. The wooden forms had by now been so thoroughly transformed that they were an organic part of the stone structure.

Paestum We can see the evolution of temples in two examples located near the southern Italian town of Paestum, where a Greek colony flourished during the Archaic period (fig. 5-8, page 98). They are both dedicated to the goddess Hera, wife of Zeus; however, the Temple of Hera II (foreground) was built almost a century after the Temple of Hera I (the so-called "Basilica"). (The former was previously thought to be a Temple of Poseidon because Paestum was once named for the Greek god of the sea.) Both temples are Doric, but there are striking differences in their proportions. The Temple of Hera I seems low and sprawling—and not just because so much of the entablature is missing—while the Temple of Hera II looks tall and compact. Part of the difference is psychological and is produced by the outline of the columns. Those in the Temple of Hera I are more strongly curved and are tapered to a relatively narrow top. This swelling effect,

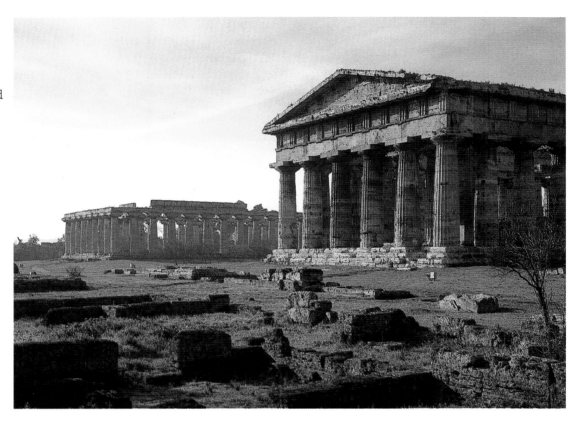

5-8 The Temple of Hera I, c. 550 B.C., and the Temple of Hera II, c. 460 B.C., Paestum, Italy

The preeminent leader of Classical Greece was the Athenian PERIKLES (c. 495–429 B.C.; Romanized to Pericles). During his 33-year rule, from 462 to 429 B.C., Athens became the center of a wealthy empire, a highly progressive democratic society, and an astonishingly vibrant hub of art and architecture.

known as **entasis**, makes one feel that the columns bulge with the strain of supporting the superstructure and that the slender tops, although aided by the widely flaring, cushionlike capitals, are just barely up to the task. The sense of strain has been explained on the grounds that Archaic architects were not fully familiar with their new materials and engineering procedures. Such a view, however, judges the building by the standards of later temples and overlooks the expressive vitality of the building—the vitality we also sense in a living body.

In the Temple of Hera II the exaggerated curvatures have been modified. This change, combined with a closer spacing of the columns, literally as well as expressively brings the stresses between supports and weight into more harmonious balance. Perhaps because the architect took fewer risks, the building is better preserved than the "Basilica." Its air of self-contained repose parallels developments in the field of Greek sculpture.

The Parthenon In 480 B.C., shortly before their defeat by the Greeks, the Persians destroyed the temple and statues on the Akropolis (literally, "highest part of the city"), the sacred hill above Athens, which had been a fortified site since Mycenaean times. The rebuilding of the Akropolis under the leadership of PERIKLES during the later fifth century, when Athens was at the height of its power, was the most ambitious enterprise in the history of Greek architecture. This achievement is all the more surprising in light of the fact that, by today's standards, Athens was only a modest city, never with more than about 50,000 inhabitants. The Akropolis nevertheless represents the artistic climax of Greek art. Individually and collectively, these structures exemplify the Classical phase of Greek art in full maturity. The inspiration for such a complex can only have come from Egypt. So must Perikles' idea of treating it as a vast public-works project, for which he spared no expense.

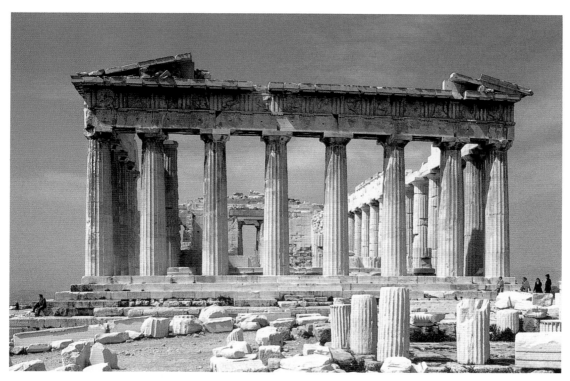

5-9 Iktinos, Kallikrates, and Karpion. The Parthenon (view of the west facade), Akropolis, Athens. 448–432 B.C.

The greatest temple, and the only one to be completed before the Peloponnesian War began in 431 B.C., is the Parthenon (fig. 5-9), dedicated to the virgin goddess Athena, the patron deity in whose honor Athens was named. Inside was a large cult statue of Athena by Pheidias (see below). The architects Iktinos, Kallikrates, and Karpion erected it in 448–432 B.C., an amazingly brief span of time for a project of this size. Built of gleaming white marble on the most prominent site along the southern flank of the Akropolis, it dominates the entire city and the surrounding countryside, a brilliant landmark against the backdrop of mountains to the north.

To meet the huge expense of building the largest and most lavish temple on the Greek mainland, Perikles used funds that had been collected from states allied with Athens for mutual defense against the Persians. He may have felt that the danger was no longer real and that Athens, the chief victim and victor of the Persian wars in 480–479 B.C., was justified in using the money to rebuild what the Persians had destroyed. His act weakened Athens's position, however, and contributed to the disastrous outcome of the Peloponnesian War. (Thucydides, who wrote a history of the war, reproached him for adorning the city "like a harlot with precious stones, statues, and temples costing a thousand talents.")

As the perfect embodiment of Classical Doric architecture, the Parthenon makes an instructive contrast with the Temple of Hera II at Paestum (see fig. 5-8, right). Despite its greater size, the Parthenon seems far less massive. Instead, it creates an impression of festive, balanced grace within the austere scheme of the Doric order. This effect has been achieved by lightening and readjusting the proportions. The entablature is lower in relation to its width and to the height of the columns, and the cornice projects less. The proportions were determined by the fact that, as a matter of convenience as well as economic necessity, the architects

reused numerous column drums from the unfinished first Parthenon, which had been burned by the Persians. The columns themselves are much more slender, their tapering and entasis less pronounced, and the capitals are smaller and less flaring; yet the spacing of the columns is wider. We might say that the load carried by the Parthenon columns has decreased, and as a result the supports can fulfill their task with a new sense of ease.

These and other intentional departures from the strict geometric regularity of the design are features of the Classical Doric style that can be seen in the Parthenon better than anywhere else. For example, the stepped platform and the entablature are not absolutely straight but are slightly curved, so that the center is a bit higher than the ends. Similarly, the columns lean inward; the space between the corner column and its neighbors is smaller than the standard interval adopted for the colonnade as a whole; and every capital of the colonnade is slightly distorted to fit the curving architrave. Such adjustments were made for aesthetic reasons. They give us visual reassurance that the points of greatest stress are supported and are provided with a counterstress as well.

These refinements nevertheless fail to account fully for the Parthenon's remarkable persuasiveness, which has never been surpassed. The Roman architect VITRUVIUS records that Iktinos based his design on carefully considered proportions. The ratio of spacing between the columns to their lower diameter (9:4) was used throughout the building. But accurate measurements reveal them to be anything but simple or rigid. There are many subtle adjustments, which give the temple its surprisingly organic quality. In this respect the Parthenon's design closely parallels the underlying principles of Classical sculpture (see pages 105–9). Indeed, with its sculpture in place the Parthenon must have seemed animated with the same inner life that informs the pediment figures, such as the *Three Goddesses* (see fig. 5-20).

The Propylaea Soon after the completion of the Parthenon, Perikles commissioned another costly project. This was the monumental entry gate at the western end of the Akropolis, called the Propylaea (fig. 5-10, left and center). It was begun in 437 B.C. under the architect Mnesikles, who completed the main part in five years; the remainder had to be abandoned because of the Peloponnesian War. Again, the entire structure was built of marble and included refinements similar to those of the Parthenon. It is fascinating to see how the elements of a Doric temple have been adapted to a totally different task, on an irregular and steeply rising site. Mnesikles' design not only fits the difficult terrain but transforms it from a rough passage among rocks into a splendid entrance to the sacred precinct.

IONIC ORDER
Next to the Propylaea is the elegant little Temple of Athena Nike (fig. 5-10, right), which was probably built between 427 and 424 B.C. from a design prepared 20 years earlier by Kallikrates. It has the slenderer proportions and the scroll capitals of the **Ionic order**. Not much is known about the previous history of this order, which first appeared about a half-century after the Doric. Of the huge Ionic temples that were erected in Archaic times—the Temple of Hera, built around 575 B.C. by Theodoros of Samos according to Vitruvius, and the Temple of Artemis at Ephesus, designed some 15 years later by Chersiphon and his son Metagenes—little has survived except the plans. They are the earliest dipteral (double-colonnaded) temples that we know of. Athens, with its strong Aegean orientation, had been open to the eastern Greek style of building from the mid-fifth century on. In fact, the finest surviving examples of the Ionic order are on the Akropolis. In pre-Classical times, however, the only Ionic structures on the Greek mainland had been the small treasuries built by eastern Greek states at Delphi in their regional styles. Thus, when Athenian architects first used the Ionic order, about 450 B.C., they thought of it as suitable only for small temples with simple plans.

The Ionic style seems to have been fairly fluid, with strong links to the Near East (see fig. 3-11). It did not become an order in the strict sense until the Classical period. Even then it remained more flexible than the Doric order. Its most striking

During his lifetime, Marcus VITRUVIUS Pollio (active 46–27 B.C.) was an architect for the Roman emperor Hadrian. His lasting fame, however, rests on the fact that his ten-book treatise on classical architecture, *De architectura,* is the only such work to survive from antiquity. It was based heavily on Greek architectural treatises and is thus our most important source of information about Greek architecture. From the fifteenth century to the present, architects have pored over the rough translations of Vitruvius's books to learn about classical principles of proportion, orders, and other matters of theory and practice—often interpreting them with wide latitude.

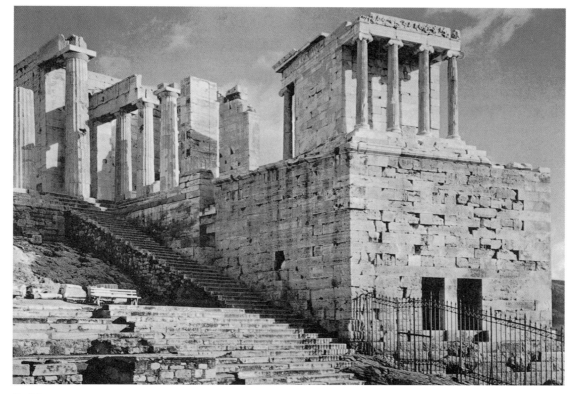

5-10 Mnesikles. The Propylaea, 437–432 B.C. (left and center), with the Temple of Athena Nike, 427–424 B.C. (right). Akropolis (view from the west), Athens

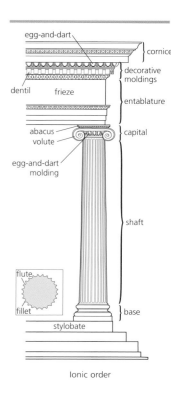

Ionic order

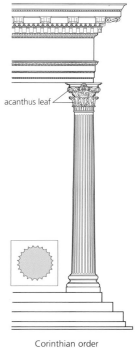

Corinthian order

The third major classical order, the Corinthian, is the most elaborate and elongated. The acanthus-leaf motif is distinctive of the Corinthian capital.

features are the continuous frieze, which lacks the alternating triglyphs and metopes of the Doric order, and the **Ionic column**, which differs from the Doric not only in body but also in spirit. The Ionic column rests on an ornate base of its own, perhaps used at first to protect the bottom from rain. The shaft is more slender, and there is less tapering and entasis. The capital shows a large double scroll, or **volute**, below the abacus, which projects strongly beyond the width of the shaft.

When we turn from a diagram to an actual building, it becomes clear that the Ionic column is very different in character from the Doric column. How shall we define it? The Ionic column is lighter and more graceful. It lacks the muscular quality of its mainland cousin. Instead, it evokes a growing plant, something like a formalized palm tree. This vegetal analogy is not sheer fancy, for we have early ancestors, or relatives, of the Ionic capital that bear it out. If we were to pursue these plantlike columns back to their point of origin, we would

find ourselves at Saqqara. There we see not only "proto-Doric" supports but also the papyrus half-columns of figure 2-6, with their flaring capitals. It may well be that the form of the Ionic column, too, had its source in Egypt. But instead of reaching Greece by sea, as we suppose the proto-Doric column did, it traveled a slow and tortuous path by land through Syria and Asia Minor.

Sculpture

The new motifs that distinguish the Orientalizing style from the Geometric in vase painting—fighting animals, winged monsters, scenes of combat—had reached Greece mainly through ivory carvings and metalwork imported from Phoenicia or Syria. Such objects, reflecting Mesopotamian as well as Egyptian influences, have been found in sufficient numbers on Greek soil to establish the

connection. However, they do not help us to explain the rise of monumental architecture and sculpture in stone about 650 B.C. All the Greek sculpture we know from the Geometric period consists of simple clay or bronze figurines of animals and warriors only a few inches in size. Why, we wonder, did the Greeks suddenly develop a taste for monumental art? It must have come from Egyptian sculpture that could be studied only on the spot. We know that small colonies of Greeks existed in Egypt at the time. How did their artists master stone carving so quickly? The oldest surviving Greek stone sculpture and architecture show that the Egyptian tradition had already been absorbed and Hellenized, although the link with Egypt is still clearly visible.

ARCHAIC STYLE

Let us compare a very early Greek statue of a nude youth of about 600 B.C., called a **kouros** (fig. 5-11), with the Egyptian statue of Menkaure (see fig. 2-4). The similarities are certainly striking. We note the block-conscious, cubic character of both; the slim, broad-shouldered silhouette of the figures; the position of their arms; their clenched fists; the way they stand with the left leg forward; the emphatic rendering of the kneecaps. The formalized, wiglike treatment of the hair is a further point of resemblance. And, like Egyptian sculpture, the figure of the youth was originally painted, as were all Greek statues. Judged by Egyptian standards, the kouros seems somewhat primitive: rigid, oversimplified, awkward, and less close to nature.

But the Greek statue also has virtues that cannot be measured in Egyptian terms. First of all, it is truly **freestanding**. In fact, it is the earliest large stone image of the human form in the entire history of art of which this can be said. Egyptian carvers had never dared to liberate such figures completely from the stone. The statues remain immersed in it to some degree, so that the empty spaces between the forms always remain partly filled. There are never any holes in Egyptian stone figures. The Greek sculptor, in contrast, does not mind holes in the least. The arms are separated from the torso and the legs from each other, unless they are encased in a skirt, and the carver goes to great

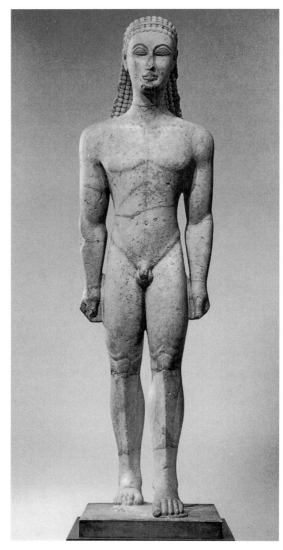

5-11 *Kouros (Standing Youth).* c. 600 B.C. Marble, height 6'1½" (1.88 m). The Metropolitan Museum of Art, New York

Fletcher Fund, 1932

lengths to cut away all the rest of the stone. (The only exceptions are the tiny bridges between the fists and the thighs.) Apparently the Greeks felt that a statue ought to consist only of stone that has representational meaning within an organic whole. The stone must be transformed; it cannot be allowed to remain inert or neutral.

This is not a question of technique but of artistic intention. The liberation of the figure gives our kouros a spirit quite different from that of Egyptian statues. While the latter seem becalmed by a spell that has released them from every strain for all time to come, the Greek image is tense and full of hidden life. The direct stare of his huge eyes offers the most telling contrast to the gentle, faraway gaze of the Egyptian figures.

The **kore**, as the Greek female statue type is called, shows more variations than the kouros. A clothed figure by definition, it poses a different problem: how to relate body and drapery. It is also likely to reflect changing habits or local differences of dress. The kore in figure 5-12 was carved almost a century after our kouros. She, too, is blocklike, with a strongly accented waist. The heavy cloth of her outer garment, called a peplos, forms a distinct, separate layer over the body, covering but not concealing the solidly rounded shapes beneath. Compared with the rigid wig of the kouros, the treatment of the hair, which falls over the shoulders in soft, curly strands, is more organic. Most noteworthy of all is the full, round face with its enchanting expression, often called the Archaic smile.

Whom do these figures represent? The general names of *kore* ("maiden") and *kouros* ("youth") are noncommittal terms that gloss over the difficulty of identifying them further. Nor can we explain why the kouros is always nude while the kore is clothed—although in art, as in life, public nudity was acceptable for males, but not for females. Whatever the reason, both types were produced in large numbers throughout the Archaic era, and their general outlines remained constant, paralleling the consistency we have noted in Doric temple architecture. Some are inscribed with the names of artists ("So-and-so made me") or with dedications to various deities. The latter, then, were votive offerings (the left hand of our kore originally was extended forward, proffering a gift of some sort). But in most cases we do not know whether they represent the donor, the deity, or a divinely favored person such as a victor in athletic games. Other figures were placed on graves, yet they represent the deceased only in a broad (and

completely impersonal) sense. This lack of differentiation seems part of the essential character of the figures. They are neither gods nor mortals but something in between, an ideal of physical perfection and vitality shared by mortal and immortal alike, just as the heroes of the Homeric epics dwell in the realms of both history and mythology.

Architectural Sculpture It is a striking feature of Greek temples and other religious buildings that they were designed with sculpture in mind almost as soon as they began to be built of stone (see pages 96–97). Indeed, early Greek architects such as Theodoros of Samos were often sculptors. Thus to a Greek, a temple would have seemed "undressed" without sculpture, which was usually designed at the same time as the structure itself. Architecture and sculpture became so closely linked that Greek architecture is highly sculptural and has the same organic quality as the figures that populate it. The sculpture, in turn, plays an important role in helping to articulate the structure and bring it to life.

In this way, the Greeks fell heir to the age-old tradition of architectural sculpture. The Egyptians had been covering walls and columns with reliefs since the Old Kingdom, but these carvings were so shallow (for example, fig. 2-3) that they did not break the continuity of the surface and had no weight or volume of their own. They were related to their architectural setting only in the same limited sense as wall paintings (with which they were, in practice, interchangeable). This is also true of the reliefs on Assyrian, Babylonian, and Persian buildings (for example, figs. 3-8 and 3-11).

In the Near East, however, there was another kind of architectural sculpture, which seems to have begun with the Hittites: the guardian monsters protruding from the blocks that framed the gateways of fortresses and palaces. This tradition must have inspired, perhaps indirectly, the carving over the Lioness Gate at Mycenae (see fig. 4-6). We must nevertheless note one important feature that distinguishes the Mycenaean guardian figures from

5-12 *Kore in Dorian Peplos.* c. 530 B.C. Marble, height 48" (122 cm). Akropolis Museum, Athens

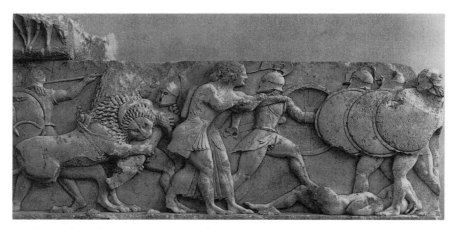

5-13 *Battle of the Gods and Giants,* from the north frieze of the Treasury of the Siphnians, Delphi. c. 530 B.C. Marble, height 26" (66 cm). Archaeological Museum, Delphi

their predecessors. Although they are carved in high relief on a huge slab, the slab is thin and light compared to the enormous Cyclopean blocks around it. In building the gate, the Mycenaean architect left an empty triangular space above the lintel, for fear that the weight of the wall above would crush it. That space was then filled with the lightweight relief panel. Here we have a new kind of architectural sculpture: a work integrated with the structure yet also a separate entity rather than a modified wall surface or block.

The Greeks followed the Mycenaean example. In their temples, stone sculpture is confined to the pediment, between the ceiling and the sloping sides of the roof, and to the zone immediately below it (the metopes in Doric temples and the frieze in Ionic architecture). Otherwise there were not many places that the Greeks deemed suitable for architectural sculpture. They might put freestanding figures (often of terra-cotta) above the ends and the center of the pediment to break the severity of its outline. The Ionians would also sometimes support the roof of a porch with female statues (called **caryatids**) instead of columns, an idea evidently derived from Syria.

The Greeks retained the narrative wealth of Egyptian reliefs. The *Battle of the Gods and Giants* (fig. 5-13), part of a frieze from the TREASURY OF THE SIPHNIANS at DELPHI, is executed in very high relief, with deep undercutting. At the far left, two lions (who pull the chariot of the mother goddess Cybele) are tearing apart an anguished giant. In front of them, Apollo and Artemis advance together, shooting their arrows. A dead giant, stripped of his armor, lies at their feet, while three others enter from the right. The sculptor has taken full advantage of the spatial possibilities offered by working in high relief. The projecting ledge at the bottom of the frieze is used as a stage on which figures can be placed in depth. The arms and legs of those nearest the viewer are carved completely in the round. In the second and third layers, the forms become shallower, yet even those farthest removed from us do not merge with the background. The result is a condensed but convincing space that permits a more dramatic relationship between the figures than we have ever seen before in narrative reliefs. Compared with older examples (such as figs. 2-3 and 3-8), Archaic art has indeed conquered a new dimension here, not only in the physical but also in the expressive sense.

Meanwhile, in pedimental sculpture, relief was quickly abandoned altogether. Instead, we find statues placed side by side in complex dramatic sequences designed to fit the triangular frame. The most ambitious groups of this kind in Archaic art were the pediments of the Temple of

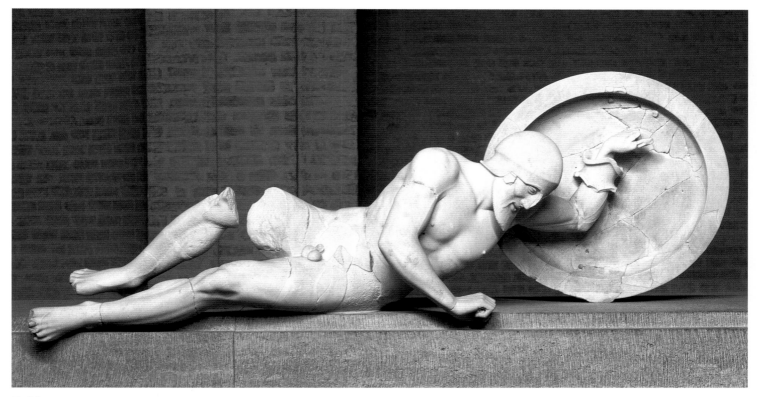

5-14 *Dying Warrior,* from the east pediment of the Temple of Aphaia, Aegina. c. 490 B.C. Marble, length 6' (1.83 m). Staatliche Antikensammlungen und Glyptothek, Munich

Aphaia at Aegina. The original east pediment was evidently destroyed by the Persians when they took the island in 490 B.C. The present one was commissioned after their defeat at the Battle of Salamis ten years later. It shows the first sack of Troy by Herakles, who had completed his 12 Labors, and Telamon, king of Salamis, who had fled Aegina after he and Peleus killed their half-brother. The subject attests to the important role played by the heroes of Aegina in this battle and the second siege of Troy (recounted in the *Iliad* and depicted on the west pediment)—and, by extension, at Salamis, where their navy helped win the day. This elevation of the historical cycle to a universal plane through allegory was typical of the Greek mentality.

The east pediment brings us to the final stage in the evolution of Archaic sculpture. The figures were found in pieces on the ground. Among the most impressive is the fallen warrior from the left-hand corner (fig. 5-14), whose lean, muscular body seems marvelously functional and organic. That in itself, however, does not explain his great beauty, much as we may admire the artist's command of the human form in action. What really moves us is his nobility of spirit in the agony of dying. This man, we sense, is suffering—or carrying out—what fate has decreed. This sense of extraordinary dignity and resolve is communicated to us in the very feel of the magnificently firm shapes of which he is composed.

CLASSICAL STYLE

Sometimes things that seem simple are the hardest ones to achieve. Greek sculptors of the late Archaic period were skilled at representing battle scenes full of struggling, running figures in reliefs. To introduce the same freedom of

made before the Greeks discovered the secret to making a figure stand "at ease." The *Kritios Boy* (fig. 5-15), named after the Athenian sculptor to whom it has been attributed, is the first known statue that "stands" in the full sense of the term. Just as in military drill, this is simply a matter of allowing the weight of the body to shift to one leg from equal distribution on both legs (as is the case with the kouros, even though one foot is in front of the other). The resulting stance—called ***contrapposto*** (or counterpoise)—brings about all kinds of subtle curvatures: the bending of the "free" knee results in a slight swiveling of the pelvis, a compensating curvature of the spine, and an adjusting tilt of the shoulders.

Like the refined details of the Parthenon, these variations have nothing to do with the statue's ability to stand erect. Rather, they serve to enhance its lifelike impression. In repose, it will still seem capable of movement; in motion, of maintaining its stability. The entire figure seems so alive that the Archaic smile, the "sign of life," is no longer needed. It has given way to a pensive expression characteristic of the early phase of Classical sculpture (or, as it is often called, the Severe style). Once the Greek statue was free to move, as it were, it became free to think, not merely to act. The two—movement and thought—are inseparable aspects of Greek Classicism. The forms, moreover, have a new naturalism and harmonious proportion that together provided the basis for the strong idealization characteristic of all subsequent Greek art.

Contrapposto was a very basic discovery. Only by learning how to represent the body at rest could the Greek sculptor gain the freedom to show it in motion. Is there not plenty of motion in Archaic art? There is indeed, but it is somewhat mechanical. We read it from the poses without really feeling it. Once the concept of *contrapposto* had been established, the problem of showing large, freestanding statues in motion no longer presented serious difficulties. Such figures are the most important achievement of the early phase of Classicism. The finest one of this kind (fig. 5-16) was recovered from the sea near the coast of Greece: a magnificent nude bronze Zeus, almost seven feet tall, in the act of hurling his thunderbolt. Here,

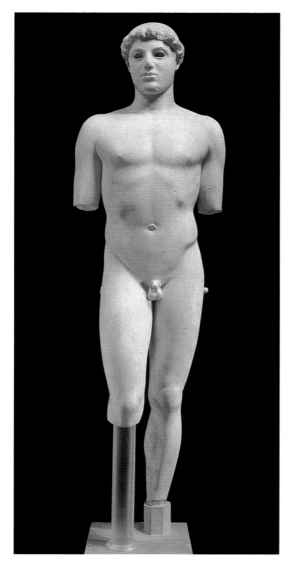

5-15 *Kritios Boy.* c. 480 B.C. Marble, height 46" (116.7 cm). Akropolis Museum, Athens

movement into freestanding statues was a far greater challenge. Not only did it run counter to an age-old tradition that denied mobility to these figures, but also the "unfreezing" had to be done in such a way as to safeguard their all-around balance and self-sufficiency.

Early Greek statues have an unintentional military air, as if they are soldiers standing at attention. It took more than a century after our kouros was

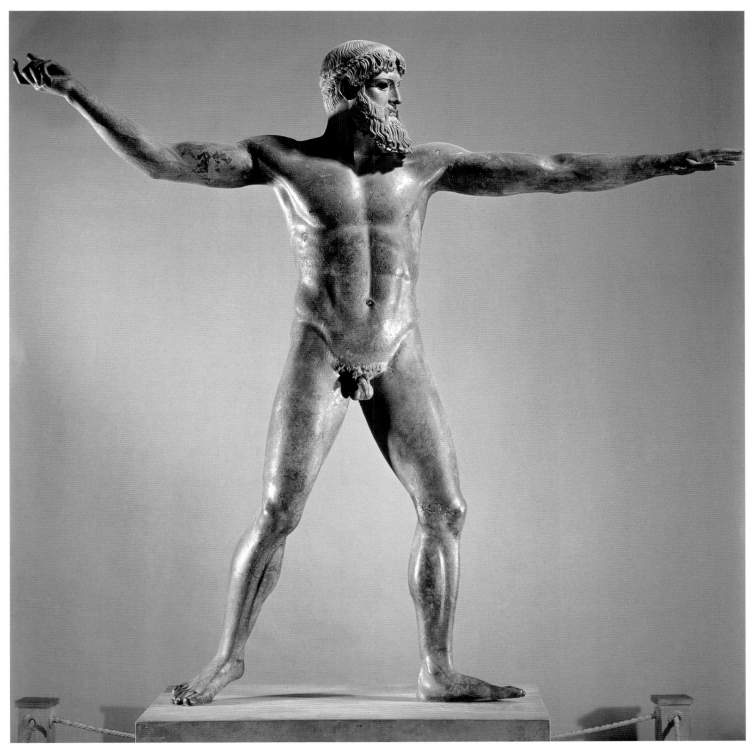

5-16 *Zeus.* C. 460–450 B.C. Bronze, height 6'10" (2.08 m). National Archaeological Museum, Athens

KANON (canon) in ancient Greek meant "rule" or "measure." In art history, *the canon* has come to mean the large body of art-works that, taken together, have been proclaimed as definitive of the Western tradition. (This book is centered on that canon.) The term also means a norm or ideal ratio of proportions, usually based on a unit of measure. It is in this sense that the Greeks originally called Polykleitos's *Doryphoros* the *Kanon*. (However, the Egyptian canons of proportion for the human body were not the same as the Greek canon; see page 52.) *Canon* means different things in the fields of music, religion, and law, in the Catholic Church, and in cultural fields that parallel art history, such as literature.

stability in the midst of action becomes outright grandeur. The pose is that of an athlete, yet it is not so much the arrested moment in a continuous motion as an awe-inspiring gesture that reveals the power of the god. Thus, hurling a weapon here becomes a divine attribute rather than an act aimed at a specific foe in the heat of battle.

Within half a century, the new articulation of the body that appears in the *Kritios Boy* was to reach its full development in the mature Classical style of the Periklean era. The most famous kouros statue of that time, the *Doryphoros* (*Spear Bearer*) by

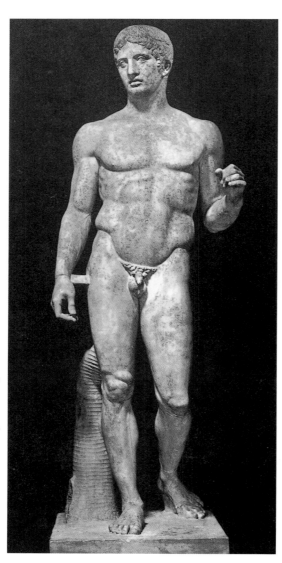

5-17 *Doryphoros* (*Spear Bearer*). Roman copy after an original of c. 450–440 B.C. by Polykleitos. Marble, height 6'6" (2 m). Museo Archeològico Nazionale, Naples

Polykleitos (fig. 5-17), is known to us only through Roman copies, which must convey little of the beauty of the original. Still, it is instructive to compare this work with the *Kritios Boy*. Everything is a harmony of complementary opposites. The *contrapposto* is now much more emphatic. The "working" left arm is balanced by the "engaged" right leg in the forward position, and the relaxed right arm by the "free" left leg. The differentiation between the halves of the body can be seen in every muscle. The turn of the head, barely hinted at in the *Kritios Boy*, is now pronounced. This studied poise, the precise anatomical details, and above all the harmonious proportions of the figure made the *Doryphoros* renowned as the embodiment of the Classical ideal of beauty. The ideal here must be understood in a dual sense: as a perfect model and as a prototype. According to one ancient writer, the statue was known simply as the *KANON* ("rule" or "measure").

The *Doryphoros* was more than an exercise in abstract geometry. It embodied not only *symmetria* (proportion, structure), but also *rhythmos* (composition, movement). Both were basic aspects of Greek aesthetics, derived from music and dance (see box, pages 110–11). A faith in ratio can be found throughout Greek philosophy beginning with the Pythagoreans, who believed that the harmony of the universe, like musical harmony, could be expressed in mathematical terms. The Greeks were not the first to explore proportions, of course; the Egyptians had done so earlier. But the Greeks were more systematic in their study, thanks to their passion for abstract numbers. They were able to devise the algebraic formulas required for solving complex problems, something that was beyond the grasp of the Egyptians, who remained wedded to a practical approach (see page 57). There is considerable evidence that East Greeks living in Anatolia, along the coast of modern Turkey, gained their theoretical bent from Mesopotamia. Once they had acquired this taste for mathematics, the Greeks never lost it. Plato, too, made numbers the basis of his doctrine of ideal forms and acknowledged that the concept of beauty was commonly based on proportion, though he seems to have had little use for art.

Polykleitos's faith in numbers also had a moral dimension often found in Classical Greek philosophy, including that of Plato. Contemplation of harmonious proportions was equated with contemplation of the good. To the Greeks, pose and expression reflected character and feeling, which revealed the inner person and, with it, *arete* (excellence or virtue). Thus the lowered gaze of the *Doryphoros* may be seen as denoting modesty, a chief virtue to the Classical Greeks. Rather than being opposed to naturalism, this moral dimension was linked to a more careful treatment of form. Classical Greek sculpture appeals to both the mind and the eye, so that human and divine beauty become one. No wonder that its figures of victorious athletes have sometimes been mistaken for gods!

Architectural Sculpture The conquest of movement in a freestanding statue exerted a liberating influence on pedimental sculpture as well, endowing it with a new spaciousness, fluidity, and balance. The greatest sculptural ensemble of the Severe style is the pair of pediments of the Temple of Zeus at Olympia, which was paid for with booty from the victory of Elis over its neighbor Pisa in 470 B.C. The figures were carved about 460 B.C., perhaps by Ageladas of Argos, and have been reassembled in the local museum. In the west pediment, the more mature of the two, we see the victory of the LAPITHS over the CENTAURS (fig. 5-18). At the center of the composition stands Apollo. His commanding figure is part of the drama and yet above it. The outstretched right arm and the strong turn of the head show his active role. He wills the victory but, as befits a god, does not physically help to achieve it. Still, there is a tenseness in this powerful body that makes its outward calm even more impressive.

The forms themselves are massive and simple, with soft contours and undulating surfaces. To the left of Apollo, we see another achievement of the Severe style in the Centaur king, Eurytion, who has seized Hippodamia, the bride of the Lapiths' king. No Archaic artist would have known how to combine the two into a group so compact, so full of interlocking movements. Strenuous action had already been investigated, of course, in pedimental sculpture of the late Archaic period (see fig. 5-14). Here, however, the passionate struggle is expressed not only through action and gesture but through the emotions mirrored in the face of the Centaur, whose pain and desperate effort contrast vividly with the stoic calm on the face of the young woman.

The pediment makes a clear moral distinction in the contrast between the bestial Centaurs and the humans, who share Apollo's nobility. Thus it is Apollo, as the god of music and poetry, who is the real hero. In general, the pediment stands for the victory of humanity's rational and moral sides over its animal nature. It thus celebrates the triumph of Greek civilization over barbarianism as

The mythical story of the LAPITHS' fight with the CENTAURS is recounted in Homer's *Iliad* and *Odyssey*. Centaurs were the offspring of Ixion, king of the Lapiths, and a phantom of Hera, whom he had tried to seduce while in Olympos. Since they were half-brothers of the Lapiths, the Centaurs were invited to the wedding of the Lapith king Peirithoös and Hippodamia. Half-man, half-horse creatures who were lustful and crazy for wine, the Centaurs became drunk and attempted to violate the bride and the female guests. They got into a brawl with the Lapiths, who subdued them with the aid of Peirithoös's friend Theseus. To the Greek mind, their defeat was a metaphoric lesson on the need for the rational side of human nature to prevail over the irrational side. Centaurs appear in other myths, including an attack on Herakles.

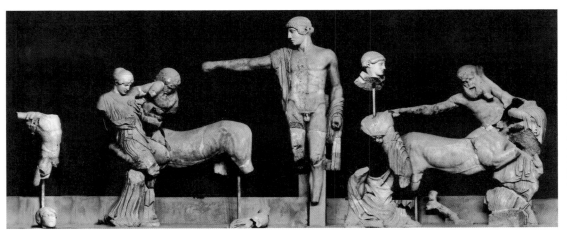

5-18 *Battle of the Lapiths and Centaurs,* from the west pediment of the Temple of Zeus, Olympia. c. 460 B.C. Marble, slightly over-life-size. Archaeological Museum, Olympia

Although the earliest surviving evidence of Greek culture can be dated to the eighth century B.C., these fragmentary remains show such sophistication that they must have been preceded by at least 400 years of development now lost to us. In the eighth century, we find the oldest remnants of Greek sculpture, painting, and architecture, the beginnings of Greek philosophy, and above all, the *Iliad* and the *Odyssey,* the two great epic poems attributed to the legendary poet HOMER (see page 82).

Music was of great importance in ancient Greece. The word itself derives from the Muses, the personifications and inspirations of the nine branches of art and learning. Thus, an educated person was a "musical" person. Greek music was organized in a system of five basic modes that were the forerunners of today's scales. Each mode had certain rhythms, meters, and melodies associated with it that lent it a distinctive character (*ethos*) but that can only be guessed at, since all that remains of Greek music are some 51, mostly late, fragments, supplemented by a small but crucial body of theory.

Early Greek vocal music was accompanied by lyres (harps) having but a few strings or by a primitive form of the *aulos*, an oboelike instrument that was always played in pairs. Like other poets of his time, Homer would have chanted his verses to the accompaniment of a lyre (hence, "lyric" poetry). Indeed, all Greek poems, like dances, were set to music, and the unity of word and music was to be a constant feature of Greek poetry. The lyric poets SAPPHO (early sixth century B.C.) and ANACREON (c. 570–c. 485 B.C.) both sang their words, as did the noted composer of odes (that is, poetry meant to be sung by a chorus), PINDAR (518?–c. 438 B.C.).

Instrumental music gradually became independent of singing. The first pipers' contest (*agones*) was won by Sakada of Argos at the Phrygian games in 586 B.C.; a contest for the players of the kithara (a lyrelike instrument) was added 28 years later. As a result, music gradually developed ever more novel, complex forms. It also underwent a change in character toward the ecstatic, serpentine music still found in the Near East today. By the mid-fifth century B.C., the emphasis on virtuosity inevitably influenced vocal music as well. Pindar, for example, emphasized the intricacy and variety of his music. Eventually, this increasing complexity made it essential to unify the scales into a coherent system.

Music and philosophy were closely linked, thanks in part to the philosopher and mathematician PYTHAGORAS (c. 582–c. 507 B.C.), who is generally credited with discovering that an octave is exactly one half the length of the next octave lower on a lyre string. This and other discoveries in the field of mathematics provided the basis for the aesthetic system based on harmonious proportion expounded by the philosopher PLATO (427?–347 B.C.). Moreover, beauty was regarded by Plato and his successor, Aristotle, the teacher of Alexander the Great, as having inherent ethical associations and educative functions. This concept, too, was rooted in music. It was first suggested in the 440s by Damon, Perikles' teacher, who spelled out a comprehensive theory of modes according to their expressive effect and impact on character. While it was challenged by the Epicurean philosophers in particular, the concept of musical ethos reached its height in the fifth century A.D. with the astronomer Ptolemy, whose system of cosmic proportions was founded very much on his belief in the "tuning" of the soul.

In the theater, Greek tragedy (literally, "goat song") combined not only words and music but dance as well, reflecting its origins in the ecstatic songs, known as dithyrambs, performed for the god Dionysos. At first, tragic dramas were improvised, but in the early sixth century B.C. the poet ARION of Corinth—the city that also claimed to have invented comedy—began to set down his verses in literary form. In 534 B.C., the Athenians reorganized the Dionysian festival and held the first drama contest, which was won by THESPIS (whose name survives in the term *thespian,* meaning "actor").

Our understanding of Greek tragedy is largely formed by the *Poetics* of ARISTOTLE (384–322 B.C.). To his inquisitive mind, everything became the subject of systematic philosophical thought. Aristotle's argument proceeds from the belief that tragedy is the highest form of drama and that *Oedipus Rex* by SOPHOCLES (c. 496–406 B.C.) is its greatest representative. His theory is based on the complex idea of imitation—in his words, "not of men but of life, an action"—which is conveyed by plot, words, song, costumes, and scenery. Plot is the very soul of tragedy, for through it is revealed the moral character of the protagonist, who experiences a reversal in fortunes brought about by error (*hamartia*) rather than evil intent. To be successful, the plot must have unity of action and preferably take place within one day. Comedy was represented by the bawdy satyr play, the distant ancestor of modern burlesque theater, which was apparently invented by Pratinas in the late sixth century B.C. The only surviving examples are EURIPIDES' *Cyclops* and a fragment from *The Trackers* by Sophocles, which are parodies of tragic dramas. Entirely different in character and perhaps origin are the comic plays of ARISTOPHANES (c. 448–c. 388 B.C.), which are commentaries on the contemporary scene: society, politics, war, literature—nothing was too sacred for his irreverent satire. Later Greek comedy, of which nothing remains, centered on the daily life of the middle class.

a whole—and the victory over the Persians in particular. (It may also have served as a gentle reminder to visitors at the Olympian games to behave in a dignified manner.)

The pedimental figures we have seen thus far, although technically carved in the round, are not freestanding. Rather, they are a kind of superrelief, designed to be seen against a background and from one direction only. By contrast, the *Dying Niobid* (fig. 5-19), a work of the 440s, is so three-dimensional and self-contained that we would hardly suspect she was carved for the pediment of a Doric temple. According to legend, Niobe had humiliated the mother of Apollo and Artemis by boasting of her seven sons and seven daughters. In revenge, the two gods killed all of Niobe's children. Our Niobid ("child of Niobe") has been shot in the back while running. Her strength broken, she sinks to the ground while trying to extract the fatal arrow. The violent movement of her arms has made her garment slip off. Her nudity is thus a dramatic device rather than a necessary part of the story.

The *Niobid* is the earliest known large female nude in Greek art. The artist's main goal was to display a beautiful female body in the kind of strenuous action that previously had been reserved for the male nude. Still, we must not misread the intent. It was not a detached interest in the physical aspect of the event alone but the desire to unite motion and emotion and thus to make the beholder experience the suffering of this victim of a cruel fate. In the *Niobid*, human feeling is for the first time expressed as eloquently in the features as in the rest of the figure. A glance at the wounded warrior from Aegina (see fig. 5-14) will show us how differently the agony of death had been conceived only half a century before. What separates the *Niobid* from the world of Archaic art is summed up in the Greek word *pathos*. *Pathos* means suffering, but particularly suffering conveyed with nobility and restraint, so that it touches rather

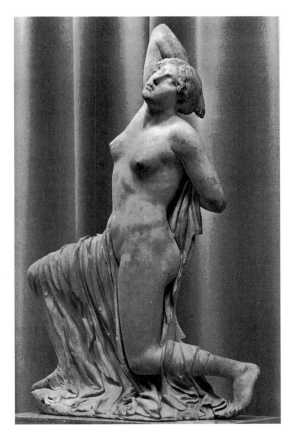

5-19 *Dying Niobid*. C. 450–440 B.C. Marble, height 59" (1.50 m). Museo delle Terme, Rome

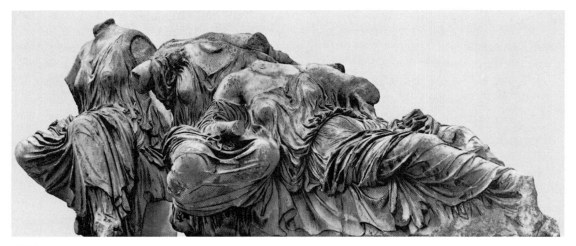

5-20 *Three Goddesses,* from the east pediment of the Parthenon. c. 438–432 B.C. Marble, over-life-size. The British Museum, London

than horrifies us. Late Archaic art may approach it now and then, yet the full force of pathos can be felt only in Classical works such as the *Dying Niobid.*

The largest, as well as the finest, group of Classical sculptures that has come down to us consists of the remains of the marble decoration of the Parthenon. Unfortunately, many of these works are in battered and fragmentary condition. Much of the sculpture was removed between 1801 and 1803 by Lord Elgin; these works, known as the Elgin Marbles, are today housed in the British Museum. The centers of both pediments are gone, and of the figures in the corners only those from the east pediment are well enough preserved to convey something of the quality of the whole. They represent various deities, most in sitting or reclining poses, witnessing the birth of Athena from the head of Zeus (fig. 5-20). (The west pediment portrayed the struggle of Athena and Poseidon for Athens.)

Here we marvel at the ease of movement even in repose. There is neither violence nor pathos in them—indeed, no specific action of any kind, only a deeply felt poetry of being. We find it in the soft fullness of the three goddesses, enveloped in thin drapery that seems to share the qualities of a liquid as it flows around the forms underneath.

Although all are seated or half-reclining, the turning of the bodies under the folds of their costumes makes them seem anything but static. Indeed, the "wet" drapery unites them in one continuous action, so that they seem to be in the process of arising. The figures are so freely conceived in depth that they create their own space. In fact, we find it hard to imagine them "shelved" upon the pediment. Evidently so did the sculptors who achieved such lifelike figures: the sculptural decoration of later buildings tended to be placed in areas where the figures would seem less boxed in and be more readily visible.

The Parthenon sculptures have long been associated with the name of Pheidias, who, according to the Greek biographer Plutarch, was the chief overseer of all the artistic projects sponsored by Perikles. Pheidias was famous for the huge ivory-and-gold statue of Athena that he made for the cella of the Parthenon, an equally large bronze sculpture of Athena that stood on the Akropolis facing the Propylaea, and another colossal figure for the Temple of Zeus at Olympia. None of these works survives, and small-scale copies made in later times cannot convey the artist's style. The admiration they aroused may have been due to their size, the cost of the materials, and the aura of religious awe surrounding them.

Pheidias may have been simply a very able supervisor, but more likely he was a genius, comparable to the Egyptian architect Imhotep (see page 54), who could give powerful expression to the ideas of his patron.

The Parthenon sculptures undoubtedly involved a large number of masters, since the two pediments and frieze were executed in less than ten years (c. 440–432 B.C.). The term *Pheidian style* is nevertheless convenient, for it conveys an ideal that was not merely artistic but extended to life itself: it denotes a distinctive attitude in which the gods are aware of, yet aloof from, human affairs as they fulfill their cosmic roles. This outlook came to be widely shared among Greek philosophers, especially in the fourth century B.C.

FOURTH-CENTURY SCULPTURE

The "Pheidian" style, so harmonious in both feeling and form, did not long survive the defeat of Athens by Sparta in the Peloponnesian War. Building and sculpture continued in the same tradition for another three centuries, but without the subtleties of the Classical age. Unfortunately, there is no single word, like *Archaic* or *Classical*, that we can use to designate this third and final phase in the development of Greek art, which lasted from about 400 to the first century B.C. The 75-year span between the end of the Peloponnesian War and the rise of Alexander the Great used to be called *Late Classical*. The remaining two centuries and a half were labeled *Hellenistic*, a term that was meant to convey the spread of Greek civilization southeastward to Asia Minor and Mesopotamia, Egypt, and the borders of India. It was natural to expect that the conquests of Alexander between 333 and 323 B.C. would bring about an artistic revolution. However, the history of style is not always in tune with political history. Although the center of Greek thought shifted to Alexandria, the city founded by Alexander in Egypt shortly before his death, there was no decisive break in the tradition of Greek art at the end of the fourth century. The art of the Hellenistic era is the direct outgrowth of developments that occurred not at the time of Alexander but during the preceding 50 years.

Here, then, is our dilemma: "Hellenistic" is a concept so closely linked with the political and cultural effects of Alexander's conquests that we cannot extend it backward to the early fourth century. This difficulty holds true even though there is wide agreement that the art of the years 400 to 325 B.C. can be understood far better if we view it as pre-Hellenistic rather than as Late Classical. But until the right word is found and becomes widely accepted, we shall have to make do with the existing terms, always keeping in mind the continuity of the third phase that we are about to examine.

The contrast between Classical and Late Classical art is strikingly demonstrated by the only project of the fourth century that corresponds to the Parthenon in size and ambition. It is not a temple but a huge tomb erected about 360 B.C. at Halikarnassos in Asia Minor by Mausolos, ruler of the area, from whose name comes the term *mausoleum*, used for outsized funerary monuments. The structure itself has been destroyed, but its dimensions and appearance can be reconstructed on the basis of ancient descriptions and the remaining fragments, which include a good deal of sculpture. There were two long friezes showing Greeks battling Persians and Greeks fighting AMAZONS. According to Pliny, the sculpture on each of the four sides of the monument was done by a different master, chosen from among the best of the time. Bryaxis did the north side, Timotheos the south, Leochares the west, and Skopas, the most famous, the main one on the east.

Skopas's dynamic style has been recognized in some parts of the Amazon frieze, such as the portion in figure 5-21 (page 114). The Parthenon style can still be felt here, but its harmony and rhythmic flow have been replaced by an un-Classical violence, physical as well as emotional, which is conveyed through strained movements and passionate expressions. (Deep-set eyes are a hallmark of Skopas's style.) His sweeping, impulsive gestures require a lot of elbow room. What the composition lacks in continuity, it more than makes up for in bold innovation (note, for instance, the Amazon seated backward on her horse) and heightened expressiveness. In a sense, Skopas turned back as

The AMAZONS, a mythical nation of powerful women warriors, were said to live somewhere in Asia Minor. In legend, they repeatedly engaged the Greeks in battle but always lost to them. From very early, these battles were popular subjects in Greek art and are seen from the seventh century B.C. on through the Hellenistic era.

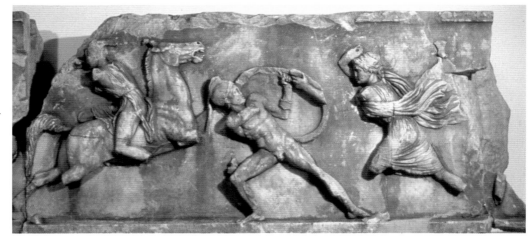

5-21 Skopas (?). *Battle of the Greeks and Amazons,* from the east frieze of the Mausoleum, Halikarnassos. 359–351 B.C. Marble, height 35" (88.9 cm). The British Museum, London

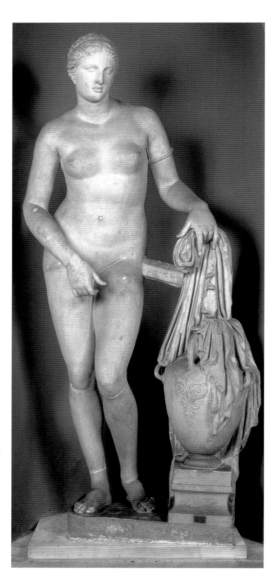

5-22 *Knidian Aphrodite.* Roman copy after an original of c. 340–330 B.C. by Praxiteles. Marble, height 6'8" (2 m). Musei Vaticani, Museo Pio Clementino, Gabinetto delle Maschere, Città del Vaticano, Rome

well—to the scenes of violent action so popular in the Archaic period. We recognize the ancestor of this scene in the Siphnian *Battle of the Gods and Giants* (see fig. 5-13).

In most instances, unfortunately, the best-known works of the Greek sculptors of the fifth and fourth centuries B.C. have been lost. Indeed, we do not have a single undisputed original work by any of the famous sculptors of Greece—only copies are preserved. Such is the case with Praxiteles' most famous statue, an Aphrodite of about 340–330 B.C. (fig. 5-22). This work was purchased by the island of Knidos, while a clothed version was acquired, so Pliny tells us, by the people of Kos. The *Knidian Aphrodite* achieved such fame that she is often referred to in ancient literature as a synonym for perfection. (According to one account, Alexander the Great's mistress, Phryne, posed for the statue.) She was to have countless descendants in Hellenistic and Roman art. To what extent her fame was based on her beauty is difficult to say, for the statue is known to us only through Roman copies that can be no more than pale reflections of the original. Her reputation rested at least as much on the fact that she was (so far as we know) the first completely nude monumental cult statue of a goddess in Greek art. She was placed in an open-air shrine in such a way that the viewer "discovered" her in the midst of bathing; yet through her pose and expression she maintains a modesty so chaste that it could not fail to disarm even the sternest critic.

HELLENISTIC STYLE

We know very little about the development of Greek sculpture during the first hundred years of the Hellenistic era. Even after that, we have few fixed points of reference. No more than a small fraction of the many works that have survived can be firmly identified as to date and place of origin. Moreover, Greek sculpture was now being produced throughout such a vast territory that the interplay of local and international currents must have formed a complex pattern, of which we can trace only isolated strands. Hellenistic sculpture is nevertheless quite different from that of the Classical era. It generally has a more pronounced realism and expressiveness, as well as a greater experimentation with drapery and pose, which often shows considerable twisting. These changes should be seen as a valid, even necessary, attempt to extend the subject matter and dynamic range of Greek art in accordance with a new outlook.

This new, more human conception is found in the sculpture groups dedicated by Attalos I of Pergamon (a city in northwestern Asia Minor) between about 240 and 200 B.C. These works celebrated his victories over the CELTS, who repeatedly raided the Greek states from Galatia, the area around present-day Ankara, until Attalos forced them to settle down. The famous *Dying Trumpeter* (fig. 5-23), though often considered a Roman copy, is of such high quality that it may well be the original statue by Epigonos of Pergamon mentioned in Pliny's *Natural History*. The sculptor must have known the Celts well, for the ethnic type is carefully rendered in the facial structure and in the bristly shock of hair. The torque around the neck is another Celtic feature. Otherwise, the trumpeter shares the heroic nudity of Greek warriors, such as those on the Aegina pediments (see fig. 5-14). Although his agony seems much more realistic in comparison, it still has a great deal of dignity and pathos. Clearly, the Celts were considered worthy foes. "They knew how to die, barbarians though they were," is the idea conveyed by the statue. Yet we also sense something else, an animal quality that had never before been part of Greek images of men. Death, as we witness it here, is a very concrete physical process. No longer able to move his legs, the trumpeter puts all his waning strength into his arms, as if to prevent a tremendous invisible weight from crushing him against the ground.

Several decades later, we find a second sculptural style flourishing at Pergamon. About 180 B.C., Eumenes II, the son and successor of Attalos I, had an enormous altar built on a hill above the city to commemorate the victory of Rome and her

Eventually ranging over a wide territory, the CELTS were first found in the second millennium B.C. in southwestern Germany and eastern France, called Gaul by the Romans. They spoke Indo-European dialects, were skilled in the art of smelting iron, and used their iron weapons to raid and conquer other peoples in Europe and Asia Minor well into the fourth century B.C., when they were displaced in much of Europe by Germanic peoples. Clearly, they dominated Iron Age culture in Europe. The Greeks noted that Celtic warriors were tall, light-skinned, and well muscled.

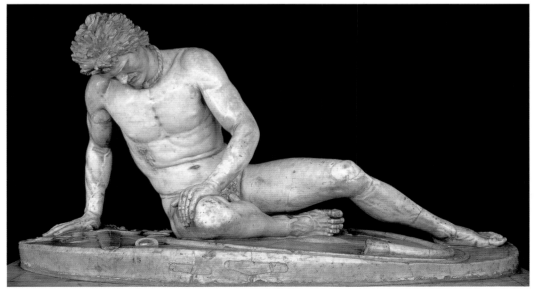

5-23 Epigonos of Pergamon (?). *Dying Trumpeter.* Perhaps a Roman copy after a bronze original of c. 230–220 B.C., from Pergamon, Turkey. Marble, life-size. Museo Capitolino, Rome

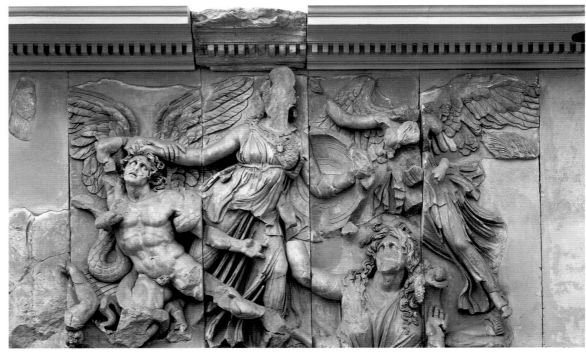

5-24 *Athena and Alkyoneos,* from the east side of the Great Frieze of the Great Pergamon Altar. c. 180 B.C. Marble, height 7'6" (2.29 m). Staatliche Museen zu Berlin, Antikensammlung

allies over Antiochos the Great of Syria eight years before (a victory that had given him much of the Seleucid empire). A large part of the sculptural decoration has been recovered by excavation, and the entire west front of the altar has been reconstructed in Berlin. Its boldest feature is the frieze covering the base, which is 400 feet long and over 7 feet tall (fig. 5-24). The huge figures, cut so deep that they seem almost detached from the background, have the scale and weight of pedimental statues, but they have been freed from the confining triangular frame and placed in a frieze. This unique blend of two traditions brings the development of Greek architectural sculpture to a thundering climax. The carving of the frieze, though not very subtle, has tremendous dramatic force. The muscular bodies rush at each other, and the high relief creates strong accents of light and dark. The beating wings and windblown garments are almost overwhelming in their dynamism. A writhing movement pervades the entire design, down to the last lock of hair, linking the figures in a single continuous rhythm. This sense of unity restrains the violence of the struggle and keeps it—but just

barely—from exploding its architectural frame.

The subject, the battle of the gods and giants, is a traditional one for Ionic friezes. (We saw it before on the Siphnian Treasury, fig. 5-13.) Yet at Pergamon, it has a novel significance. It promotes Pergamon as a new Athens—the patron goddess of both cities was Athena, who has a prominent place in the great frieze. Moreover, it almost surely incorporates a cosmological program, whose meaning, however, is disputed. Finally, the victory of the gods is meant to symbolize Eumenes' own victories. Such translations of history into mythology had been common in Greek art for a long time (see page 109). But to place Eumenes in analogy with the gods themselves implies an exaltation of the ruler that is oriental rather than Greek.

Equally dramatic is the great victory monument *Nike of Samothrace* (fig. 5-25). This sculpture probably commemorates the naval victory of Eudamos of Rhodes over Antiochos the Great in 190 B.C. The style is Rhodian, and the statue may well have been carved by the island's leading sculptor, Pythokritos. The goddess has just descended to the prow of a ship. Her great wings

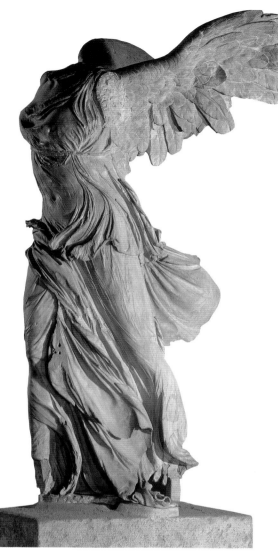

5-25 Pythokritos of Rhodes (?). *Nike of Samothrace.* c. 190 B.C. Marble, height 8' (2.44 m). Musée du Louvre, Paris

spread wide, she is still partly airborne by the powerful head wind against which she advances. The invisible force of onrushing air here becomes a tangible reality. It not only balances the forward movement of the figure but also shapes every fold of the wonderfully animated drapery. As a result,

there is an active relationship between the statue and the space around it such as we have never seen before. By comparison, all earlier examples of active drapery seem inert. This is true even of the three goddesses from the Parthenon (see fig. 5-20), whose wet drapery responds not to the atmosphere around it but to an inner impulse that is independent of motion. Nor shall we see its like again for a long time to come. The *Nike of Samothrace* deserves her fame as the greatest masterpiece of Hellenistic sculpture.

Individual likenesses were unknown in Classical art, which sought a timeless ideal. In the mid-fourth century, portraiture became a major branch of Greek sculpture, and it continued to flourish in Hellenistic times. Its achievements, however, are known to us only indirectly, for the most part through Roman copies. One of the few originals is a vivid bronze head from Delos, a work of the early first century B.C. (fig. 5-26). It was not made as a bust but rather, in accordance with Greek custom, was part of a full-length statue. The man's identity is not known. Whoever he was, we get an intensely private view of him that captures the character of the age, for his likeness has been fused with a distinctive Hellenistic type (compare the face of Alkyoneos in figure 5-24). The fluid modeling of the somewhat flabby features, the uncertain mouth, and the unhappy eyes under furrowed brows reveal an individual beset by doubts and fears—a very human, unheroic personality. There are echoes of pathos in these features, but it is a pathos translated into psychological terms. People who felt such inner turmoil had certainly existed earlier in the Greek world, just as they do today. Yet it is significant that their complex character could be conveyed in art only when Greek independence was about to come to an end, culturally as well as politically, under Rome.

5-26 Portrait head, from Delos. c. 80 B.C. Bronze, height 12¾" (32.4 cm). National Archaeological Museum, Athens

ETRUSCAN ART

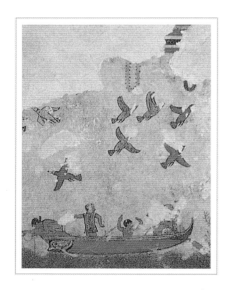

The Italian peninsula did not emerge into the light of history until fairly late. The Bronze Age, which dawned first in Mesopotamia about 3500 B.C., came to an end in the Italian peninsula only around 1000 B.C. At that time the Villanovans established an early Iron Age culture near Bologna that had strong ties to central Europe. They were succeeded by the Etruscans in the eighth century B.C., at about the time the Greeks first began to settle along the southern shores of Italy and in Sicily. Interestingly, the Classical Greek historian Herodotus believed that the Etruscans (*Tyrrhenoi* to the Greeks) had left their homeland of Lydia in Asia Minor about 1200 B.C. According to him, they had settled in the area between Florence and Rome, called Rasenna by the Etruscans and Etruria by the Romans, now known as Tuscany. Herodotus's claim was already disputed in Roman times by the Greek historian Dionysius of Halicarnassus. It is likely that the Etruscans were actually descended through the Villanovans from the Bronze Age peoples who had occupied central Italy since about 3000 B.C.

In any case, the Etruscans had strong cultural links both with Asia Minor and the ancient Near East. Yet they also show many traits that are not found anywhere else. The sudden

flowering of Etruscan civilization resulted in large part from the influx of Greek culture. For example, the Etruscans borrowed their alphabet from the Greeks toward the end of the eighth century. Nevertheless, their language is unlike any other. The only Etruscan writings that have come down to us are brief funerary inscriptions and a few somewhat longer texts relating to religious ritual. However, Roman authors, notably the emperor Claudius, tell us that a rich Etruscan literature once existed. In fact, we would know almost nothing about the Etruscans at first hand were it not for their tombs. They were not disturbed when the Romans destroyed or rebuilt Etruscan cities, and as a result they have survived intact until modern times.

In the seventh and sixth centuries B.C. the Etruscans reached the height of their power. Their cities rivaled those of the Greeks; their fleet dominated the western Mediterranean and protected a vast commercial empire that competed with the Greeks and Phoenicians; and their territory extended as far as Naples in the south and the lower Po Valley in the north. But the Etruscans, like the Greeks, never formed a unified nation. They were no more than a loose federation of individual city-states that were given to quarreling among themselves and were slow to unite against a common enemy. The Etruscan fleet was defeated by the navy of its archrival, Syracuse, in 474 B.C. And during the later fifth and fourth centuries B.C., one Etruscan city after another fell to the Romans. By 270 B.C., all of them had lost their independence, although many continued to prosper, if we are to judge by the richness of their tombs during the period of political decline.

The flowering of Etruscan civilization coincides with the Archaic age in Greece. During this period, especially near the end of the sixth and early in the fifth century B.C., Etruscan art showed its greatest vigor. Greek Archaic influence displaced the Orientalizing tendencies. (Many of the finest Greek vases have been found in Etruscan tombs of that time.) But Etruscan artists did not simply imitate their Hellenic models. Working in a very different cultural setting, they retained their own clear-cut identity.

Tombs and Their Decoration

EARLY FUNERARY BELIEFS

One might expect the Etruscan CULT OF THE DEAD to have waned under Greek influence. On the contrary, Etruscan tombs and their equipment grew more elaborate as the skills of the sculptor and painter increased. The deceased could be shown full-length, reclining on the lids of sarcophagi shaped like couches, as if they were participants in a festive event similar to the Greek symposium (see page 92). The Etruscans, however, made such feasts into family affairs instead of restricting them to men. (When women do appear in Greek banquet scenes, it is on red-figured pots with amorous subjects.) The example in figure 6-1 shows a husband and wife side by side, an Archaic smile on their lips,

The earliest Italian burials were modest, but about 700 B.C. Etruscan tombs began to be built in stone, to imitate the interiors of dwellings, and to be covered by great conical mounds of earth. Cinerary urns, which had formerly been simple pottery vessels, gradually took on human shape (right). The frequent depictions of funerary meals in Etruscan art as well as the gold and other precious objects found in the tombs are evidence of a CULT OF THE DEAD.

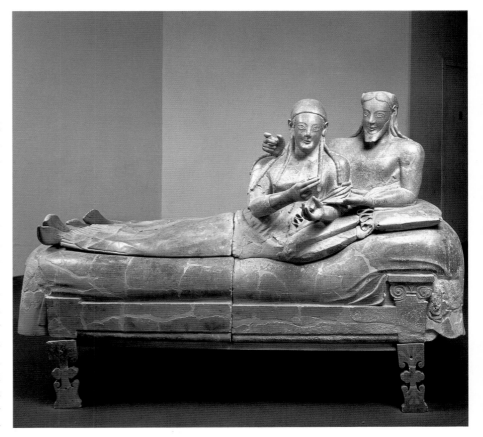

6-1 Sarcophagus, from Cerveteri. c. 520 B.C. Terra-cotta, length 6'7" (2 m). Museo Nazionale di Villa Giulia, Rome

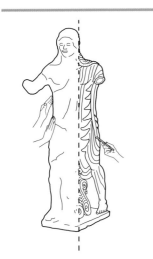

so that they seem gay and majestic at the same time. His right hand may have held an egg, his left a drinking cup; hers perhaps held a perfume vase and a piece of fruit. The entire work is of **terracotta** and was once painted in bright colors. The rounded forms reveal the Etruscan sculptor's preference for **modeling** in soft materials, in contrast to the Greek love of stone carving. There is less formal discipline here but an extraordinary directness and vivacity that are characteristic of Etruscan art.

We do not know exactly what ideas the Archaic Etruscans held about the afterlife. Effigies such as our reclining couple, which for the first time in history show the deceased as alive and enjoying themselves, suggest that they regarded the tomb as a home not only for the body but also for the soul. (In contrast, the Egyptians thought that the soul roamed freely; their funerary sculpture therefore was "inanimate.") How else are we to understand the purpose of the wonderfully rich array of murals in these tombs? Since nothing of the sort has survived in Greek territory, they are uniquely important not only as an Etruscan achievement but also as a possible reflection of Greek wall painting.

The Tomb of Hunting and Fishing Perhaps the most remarkable murals are found in the Tomb of Hunting and Fishing at Tarquinia of about 520 B.C. Figure 6-2 shows a marine panorama at one end of the low chamber. In this vast expanse of water and sky, the fishermen seem to play only an incidental part. One wonders if any Greek Archaic artist knew how to place human figures in a natural setting as effectively as the Etruscan painter did. Could the mural have been inspired by Egyptian scenes of hunting in the marshes, such as the one in figure 2-3? They seem the most likely precedent for our subject. If so, the Etruscan artist has brought the scene to life, just as the reclining couple in figure 6-1 has been brought to life compared with Egyptian funerary statues.

The free, rhythmic movement of birds and dolphins also reminds us of Minoan painting of a thousand years earlier (see fig. 4-2). So far as we know, the Minoans were the only people before the Etruscans to paint murals devoted solely to landscape. This apparent debt to earlier Egyptian and Minoan art amid the obvious Greek influences may have come about because of the Etruscan navy, which roamed throughout the Mediterranean, including Egypt—where, we recall, Minoan-style frescoes could also be seen (see page 83).

Despite the air of enchantment, the scene has ominous overtones. The giant hunter with a slingshot, from whom the birds flee in all directions, is very likely a demon of death. This dualism is continued in the niche above: we see a couple on a couch enjoying a last meal. It was in Syria that the funerary feast probably originated. (By contrast, paintings of the final supper found at the entrances to Egyptian tombs show only the deceased seated at a table.) Thus the purpose of the mural is essentially commemorative, ushering the deceased into the next life.

The man and woman in the mural are flanked by a musician and servants, one of whom is drawing wine from a large mixing bowl, or krater, while another is making wreaths. From the Greeks, the Etruscans adopted the cult of DIONYSOS, whom they called Fufluns or Pachies (from Bacchus, his other Greek name; see box, page 89). Besides being the god of wine, he was the god of vegetation and hence of death and resurrection, like Osiris. In this context, for example, the couple may be seen as counterparts to Bacchus and Ariadne (known as Ariatha to the Etruscans), who were symbols of regeneration.

LATER FUNERARY BELIEFS

During the fifth century, the Etruscan view of the hereafter must have become a good deal more complex and less festive. We notice the change immediately if we compare the group in figure 6-3 (page 122), a cinerary container made of soft local stone soon after 400 B.C., with its predecessor in figure 6-1. The woman now sits at the foot of the couch, but she is not the wife of the young man. Her wings show that she is the demon of death, and the scroll in her left hand records the fate of the deceased. The young man is pointing to it as if to say, "Behold, my time has come." The thoughtful,

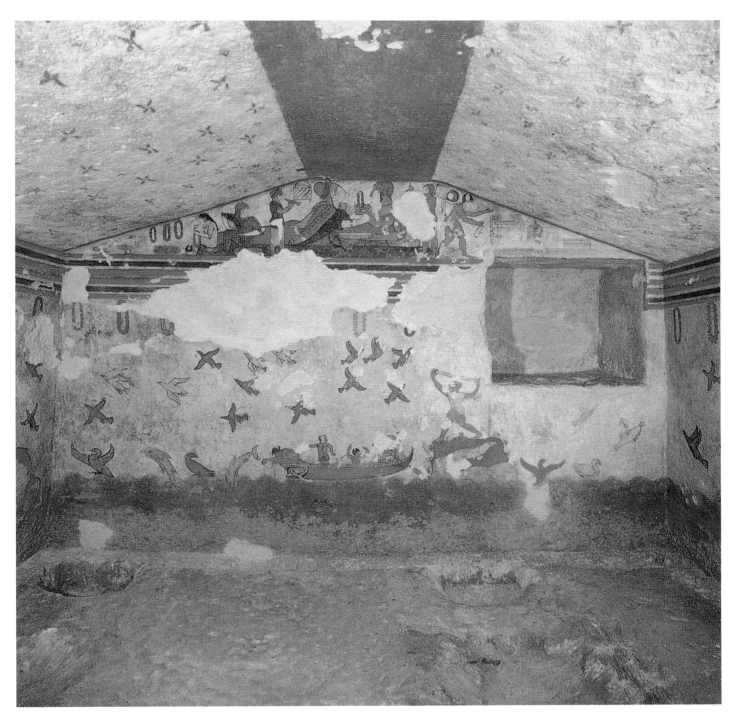

6-2 Tomb of Hunting and Fishing, Tarquinia, Italy. c. 520 B.C.

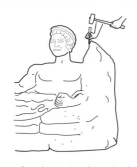

Carved sculpture is subtractive in the sense that the sculptor begins with a block of material, such as stone, that is larger than the finished sculpture and carves away what is not needed for the form of the final piece.

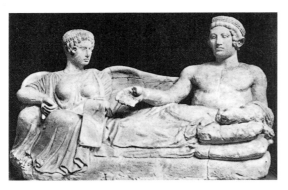

6-3 *Youth and Demon of Death.* Cinerary container. Early 4th century B.C. Stone, length 47" (119.4 cm). Museo Archeològico Nazionale, Florence

melancholy air of the two **carved** figures may be due, to some extent, to the influence of Classical Greek art, which pervades the style of this group. A new mood of uncertainty and regret is felt. Human destiny is in the hands of inexorable supernatural forces. Death is now the great divide rather than a continuation, albeit on a different plane, of life on earth. In later tombs, the demons of death gain an even more fearful aspect. Other, more terrifying demons enter the scene. Often they are shown battling against benevolent spirits for possession of the soul of the deceased—a prefiguration of the Last Judgment in medieval art (see fig. 10-13).

Temples

Only the stone foundations of Etruscan temples have survived, since the buildings themselves were built of wood. Apparently the Etruscans, although they were masters of masonry construction, rejected the use of stone in temple architecture for religious reasons. The design of their sanctuaries bears a general resemblance to Greek temples (compare fig. 5-8). Nevertheless, they have several distinctive features, some of which were later adopted by the Romans. The entire structure (fig. 6-4) rests on a tall base, or podium, that is no wider than the cella and has steps only on the south side. The steps lead to a

deep porch, supported by two rows of four columns each, and to the cella beyond. Because Etruscan religion was dominated by a triad of gods who were the predecessors of the Roman Juno, Jupiter, and Minerva, the cella is generally subdivided into three compartments. The shape of Etruscan temples, then, must have been squat and squarish compared to the graceful lines of Greek sanctuaries and was more closely linked with domestic architecture.

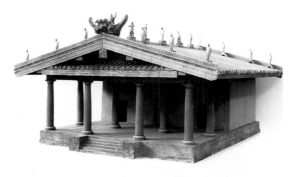

6-4 Reconstruction of an Etruscan temple, as described by Vitruvius. Museo delle Antichità Etrusche e Italiche, Università di Roma

Sculpture

Apollo **from Veii** The Etruscan temple provided no place for stone sculpture. The decoration usually consisted of terra-cotta plaques that covered the architrave and the edges of the roof. Only after 400 B.C. do we occasionally find large-scale terra-cotta groups designed to fill the pediment above the porch. We know, however, of one earlier attempt—and an astonishingly bold one—to find a place for monumental sculpture on the exterior of an Etruscan temple. The so-called Temple of Apollo at Veii, not far north of Rome, was a structure of the standard type. However, it had four life-size terra-cotta statues on the ridge of its roof (similar examples appear in the reconstruction model, fig. 6-4). They formed a dramatic group of the sort we might expect in Greek

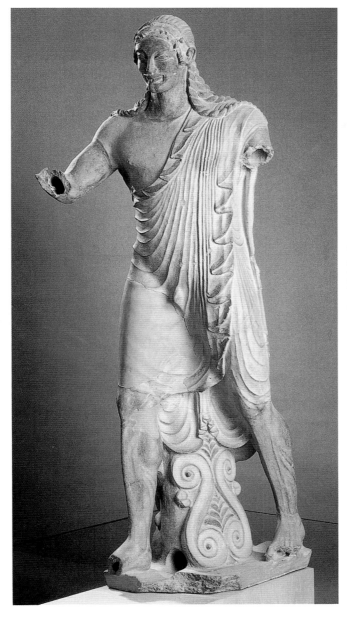

6-5 *Apollo,* from Veii. c. 510 B.C. Terra-cotta, height 5'9" (1.75 m). Museo Nazionale di Villa Giulia, Rome

pedimental sculpture: the contest of Hercules and Apollo for the sacred hind (female deer), in the presence of other deities.

The best preserved of these figures is the *Apollo* (fig. 6-5), acknowledged to be the masterpiece of Etruscan Archaic sculpture. His massive body, revealed beneath the ornamental striations of the drapery; the sinewy, muscular legs; the hurried, purposeful stride—all these possess an expressive force that has no counterpart in freestanding Greek statues of the same date.

She-Wolf That Veii was a sculptural center at the end of the sixth century seems to be confirmed by the Roman tradition that the last of the Etruscan rulers of the city called on a master from Veii to make the terra-cotta image of Jupiter for the temple on the Capitoline Hill. This image has been

Cast-metal sculpture was tradition-ally made by the lost-wax process.

First, a core of clay is shaped into the basic form of the intended metal sculpture. The clay core is covered with a layer of wax about the thickness of the final sculpture. The details of the sculpture are care-fully carved in the wax. A heavy outer layer of clay is applied over the wax and secured to the inner core with metal pegs. Then the mold is heated enough to melt the wax, which runs out. The space left by the "lost wax" is filled with molten metal, usually bronze. The outer and inner molds are broken, leaving a shell of metal that is the metal sculpture. The sculptor fin-ishes the piece by chiseling and polishing details.

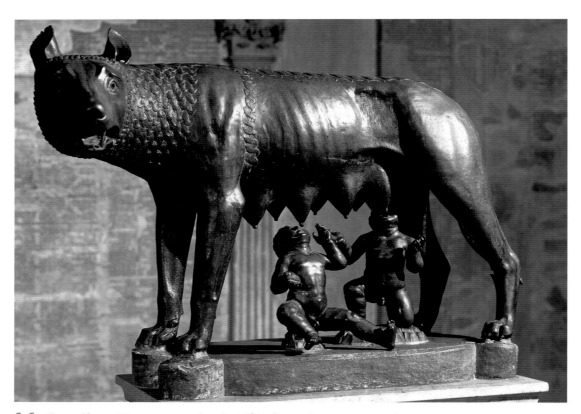

6-6 *She-Wolf.* c. 500 B.C. Bronze, height 33¹/₂" (85 cm). Museo Capitolino, Rome

lost, but an even more famous one, **cast** in bronze, is still in existence (fig. 6-6). According to a myth promulgated by Virgil, Livy, and others during the time of Augustus to legitimize his reign, Rome was founded in 753 B.C. by Romulus and Remus. These two brothers, descendants of refugees from Troy in Asia Minor, were said to have been nour-ished by a she-wolf after being abandoned. (The two babes beneath the wolf were added during the Renaissance.) The she-wolf has strong links with Etruscan mythology, in which wolves seem to have played an important part from early times. The wonderful ferocity of expression and the phys-ical power of the body and legs have the same awesome quality sensed in the *Apollo* from Veii.

The Architecture of Cities

According to Roman writers, the Etruscans were masters of architectural engineering, town plan-ning, and surveying. There is little doubt that the Romans learned a good deal from them. Roman temples certainly retained many Etruscan features. In town planning and surveying, too, the Etruscans have a good claim to priority over the Greeks. The Etruscans must also have taught the Romans how to build fortifications, bridges, drainage systems, and aqueducts. It is nevertheless difficult to say how much the Etruscans contributed to Roman archi-tecture, since hardly anything of Etruscan or early Roman architecture is still standing.

7

ROMAN ART

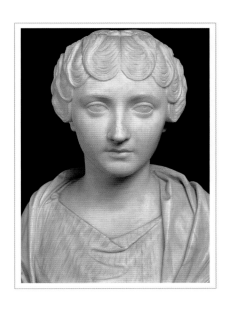

Roman civilization is far more accessible to us than any other of the ancient world. We know a great deal about its history, thanks to its vast literary legacy, from poetry and philosophy to inscriptions recording everyday events. The Romans also built vast numbers of monuments throughout their empire. Yet there are few questions more difficult to answer than "What is Roman art?" The Roman genius, so clearly recognizable in everything else, is much harder to distinguish when we ask whether there was a characteristic Roman style in the fine arts.

Why is this so? The most obvious reason is the Romans' admiration for Greek art. They imported originals by the thousands and had them copied in even greater numbers. In addition, their own works were clearly based on Greek sources, and many of their artists, from Republican times (510–27 B.C.) to the end of the empire (27 B.C.– 395 A.D.), were of Greek origin. Actually, the Greek names of these artists do not mean much: most of them, it seems, were fully Romanized.

Roman authors tell us a good deal about the development of Greek art as it was described in Greek writings on the subject. They also discuss Roman art during the early days of the Republic, of which not a trace survives today. However, they show little concern with the art of their own time. And, except for Vitruvius, whose treatise on architecture is of great importance for later eras (see page 100), the Romans never developed a rich literature on the history and theory of art such as had existed among the Greeks.

Yet the fact remains that, as a whole, Roman art does look distinctly different from Greek art. Rome, after all, was not simply an outgrowth of Greece. It was ruled by Etruscan kings

Rome arose on the east bank of the Tiber River from a cluster of hilly settlements of several early Italic peoples, including the Etruscans. By 510 B.C., united Romans overthrew the "foreign" rule of the Tarquins, an Etruscan royal house, and established the ROMAN REPUBLIC. Under generations of elected leaders (not kings), the Roman Republic extended its direct and indirect dominion throughout the Mediterranean basin, including North Africa, much of Asia Minor, and Europe to the North Sea. From Sulla (ruled 82–79 B.C.) through at least Julius Caesar, Rome was actually ruled by dictators, even though it was nominally a republic.

The Roman Empire dates from 27 B.C., when Octavian was named emperor (*imperator*, meaning "commander") and received the honorary name Augustus ("revered"). The Roman Empire reached its greatest geographical extent, which was almost the entire known Western world, under Emperor Trajan (ruled 98–117), then declined gradually. In 395 A.D., the empire split into Eastern and Western dominions. From then on, the Western Empire rapidly weakened until its fall in 476, when the last Roman emperor was deposed by a Germanic king.

The FORUM was a square or rectangular market-and-meeting place in the heart of cities and towns built under Etruscan and Roman rule. The first Roman forum was laid out in a marshy valley between two of Rome's seven hills: the Palatine and the CAPITOLINE (Capitol). The Capitoline was the highest of the hills and was the religious center of the city from earliest times.

for about a century until 510 B.C., when the ROMAN REPUBLIC was established. The Etruscan kings threw the first defensive wall around the seven hills, drained the swampy plain of the FORUM, and built the original temple on the CAPITOLINE HILL, thus making a city out of what had been little more than a group of villages consisting of rude huts. Equally important, they provided Rome with its early institutions and introduced the latest techniques of warfare, thereby establishing the foundations for its future greatness. These Etruscan influences, as well as native traditions, made Roman civilization quite distinct from that of the Greeks.

From the very start Roman society proved astonishingly tolerant of non-Roman traditions. Roman civilization and art thus acquired not only the Greek and Etruscan heritage but, to a lesser extent, that of Egypt and the Near East as well. All this made for a complex and open society that was uniform and diverse at the same time. Under such conditions, we cannot expect Roman art to show a consistent style, such as we found in Egypt, or the clear-cut evolution that distinguishes the art of Greece. Its development consists of a set of tendencies that may exist side by side, even within a single monument, none of which is dominant. The "Roman-ness" of Roman art must be found in this complex pattern rather than in a single, consistent quality of form—and that is precisely its strength.

Architecture

While the originality of Roman sculpture and painting has been questioned, there is no such doubt about Roman architecture, which is a creative feat of extraordinary importance. From the very start, its growth reflected a distinctly Roman way of public and private life. Greek models, although much admired, could not accommodate the sheer numbers of people in large public buildings required by the empire. And when it came to supplying citizens with everything they needed, from water to entertainment on a grand scale,

new forms had to be invented, and cheaper materials and quicker methods had to be used.

We cannot imagine the growth of Rome without the **arch** and the **vault** systems derived from it: the **barrel vault** (a half-cylinder); the **groin vault** (two barrel vaults that intersect at right angles); and the **dome**. True arches are constructed of wedge-shaped blocks, called **voussoirs**, each pointing toward the center of the semicircular opening. Such an arch is strong and self-sustaining, in contrast to the "false" arch made up of horizontal courses of masonry or brickwork (like the opening above the lintel of the Lioness Gate at Mycenae, fig. 4-6). The true arch, as well as its extension, the barrel vault, had been discovered in Egypt as early as about 2700 B.C. But the Egyptians had used it mainly in underground tombs and in utilitarian buildings, never in temples. Apparently they did not think it was suited to monumental architecture. In Mesopotamia the true arch was used for city gates and perhaps elsewhere as well, but to what extent we cannot determine for lack of preserved examples. The Greeks knew the principle of the true arch from the fifth century on, but they confined its use to underground structures or simple gateways and refused to combine it with the architectural orders.

No less vital to Roman architecture was concrete, a mixture of mortar and gravel with rubble (small pieces of building stone and brick). Concrete construction had been invented in the Near East more than a thousand years earlier, but the Romans made it their chief building technique. The advantages of concrete are obvious: it is strong, cheap, and adaptable. Concrete made possible the vast architectural works that are the chief reminders of "the grandeur that was Rome." The Romans hid the unattractive concrete surface by adding a facing of brick, stone, or marble, or by covering it with smooth plaster. Today this decorative skin has disappeared from most Roman buildings, thus leaving the concrete core exposed and depriving these ruins of the appeal that those of Greece have for us.

Sanctuary of Fortuna Primigenia Roman buildings characteristically speak to us through their

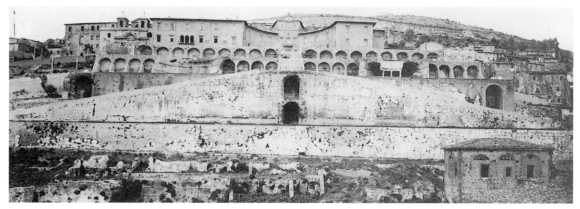

7-1 Sanctuary of Fortuna Primigenia, Praeneste (Palestrina). Early 1st century B.C.

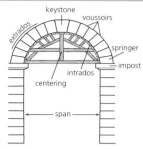

massive size and bold conception. The oldest monument in which these qualities are fully seen is the Sanctuary of Fortuna Primigenia at Palestrina, in the foothills of the Apennines east of Rome (fig. 7-1), dating from the early first century B.C. Here, in what was once an important Etruscan stronghold, a strange cult had been established since early times, dedicated to Fortuna (Fate) as a mother deity and combined with a famous oracle, a person through whom the deity was believed to have spoken.

The site originally had a series of ramps leading up to a broad colonnaded terrace. At the top of the entire structure was a great colonnaded court. (The present semicircular building is of a much later date.) The first terrace was marked by semicircular recesses, the second by arched openings framed by engaged columns and architraves. The openings were covered by barrel vaults, another typical feature of Roman architecture. Except for one niche having the original columns and entablature on the lower terrace (center right), all the surfaces now visible are of concrete. Indeed, it is hard to imagine how such a huge complex could have been constructed otherwise.

What makes the sanctuary at Palestrina so imposing, however, is not merely its scale but the superb way it fits the site. An entire hillside, comparable to the Akropolis of Athens in its commanding position, has been transformed. The architectural forms seem to grow out of the rock,

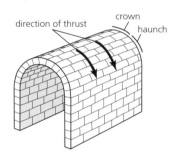

as if human beings had simply completed a design laid out by nature itself. Such a molding of open spaces had never been possible, or even desired, in the Classical Greek world. The only comparable projects are found in Egypt (see the Temple of Queen Hatshepsut, fig. 2-11). Nor did it express the spirit of the Roman Republic. Significantly, the Palestrina sanctuary dates from the time of Sulla, whose dictatorship (82–79 B.C.) marked the transition from Republican government to the one-man rule of Julius Caesar and the emperors who followed him. Because Sulla had won a great victory against his enemies in the civil war at Palestrina, it is tempting to assume that he personally ordered the complex built, both as an offering to Fortuna and as a monument to his own fame.

The Colosseum The arch and vault, as we saw at Palestrina, were an essential part of Roman monumental architecture. They testify not only to the high caliber of Roman engineering but also to the sense of order and permanence that inspired these efforts. It is these qualities, one may argue, that underlie all Roman architecture and define its unique character. They impress us again in the Colosseum, the huge amphitheater for gladiatorial games in the center of Rome (fig. 7-2, page 128).

Completed in 80 A.D., the Colosseum is, in terms of sheer mass, one of the largest single buildings anywhere: it could hold more than 50,000 spectators. The concrete core, with its miles of stairways

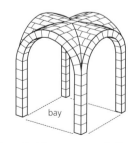

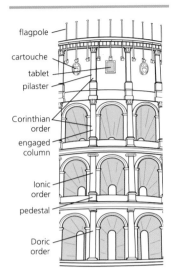

flagpole

cartouche

tablet

pilaster

Corinthian
order

engaged
column

Ionic
order

pedestal

Doric
order

The first three levels of the Colosseum facade have engaged columns flanking the open ends of barrel vaults. The highest level is decorated with pilasters, between which cartouches and tablets with inscriptions once hung.

Public bathing facilities existed in other ancient civilizations, but none compared with those built by the Romans. Their *THERMAE* ranged from the great imperial baths in the capital to smaller local examples. Each had a *frigidarium* (cold bath), *tepidarium* (warm bath), and *caldarium* (hot bath), as well as a *natatio* (swimming pool) and small "plunge baths." The imperial baths built by Caracalla and Diocletian were massive complexes with richly decorated interiors.

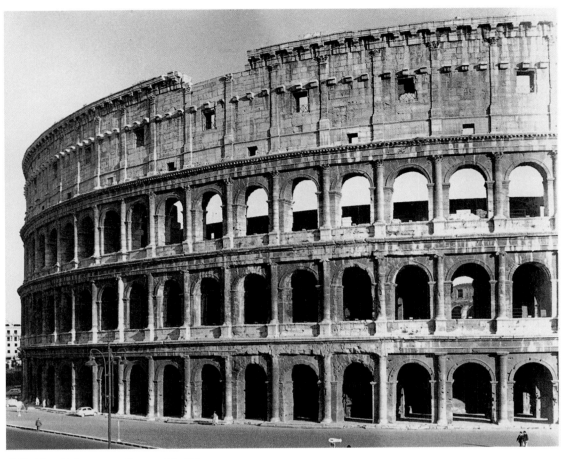

7-2 The Colosseum, Rome. 72–80 A.D.

and barrel- and groin-vaulted corridors, is an outstanding feat of engineering, designed to ensure the smooth flow of traffic to and from the arena. The exterior, dignified and monumental, reflects the interior of the structure but clothes and accentuates it in cut stone. There is a fine balance between vertical and horizontal elements in the framework of engaged columns and entablatures that contains the endless series of arches. The three Classical orders are superimposed according to their "weight": Doric, the oldest and most severe, on the ground floor, followed by Ionic and Corinthian. The lightening of the proportions, however, is barely noticeable, for the Roman versions of the orders are almost alike. Structurally they have become ghosts, yet they still serve an aesthetic function. It is through them

that this enormous facade is related to the human scale.

The Pantheon Arches, vaults, and concrete permitted the Romans to create huge, uninterrupted interior spaces for the first time in the history of architecture. The potential of all three was explored especially in the great baths, or *THERMAE,* which were major centers of social life in imperial Rome. The experience gained there could then be applied to more traditional types of buildings, sometimes with revolutionary results.

Perhaps the most striking example of this process is the famous **Pantheon** in Rome (fig. 7-3). This large round temple of the early second century A.D. is one of the best preserved, as well as the most

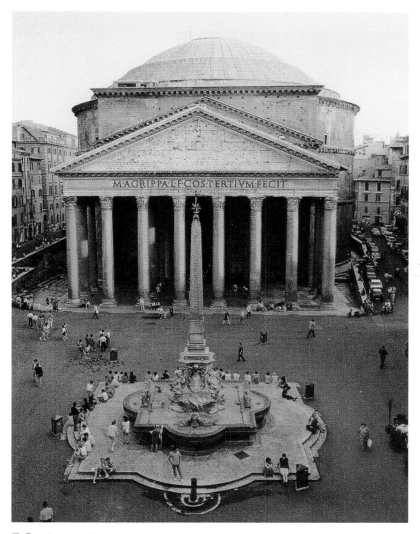

7-3 The Pantheon, Rome. 118–25 A.D.

impressive, of any Roman structure. As its name suggests, the Pantheon was dedicated to all the gods—more precisely, to the seven planetary gods. There had been round temples long before this time, but they are so different from the Pantheon that it could not have been derived from them. In fact, this solemn and splendid structure grew directly from the baths of a century earlier. On the outside, the cella of the Pantheon appears as a plain cylindrical **drum**, surmounted by a gently curved dome. The entrance is emphasized by a deep porch. (The inscription refers to Marcus Agrippa, who built the first temple on the site toward the end of the first century B.C.) The junction of these two elements seems rather abrupt, but we no longer see the building raised high on a podium as it was meant to be seen. Today the level of the surrounding streets is a good deal higher than it was in antiquity. Moreover, the porch was part of a rectangular, colonnaded forecourt, which must have had the effect of detaching it from the rotunda.

The heavy plainness of the exterior wall suggests that the architects did not have an easy time with the problem of supporting the huge dome. Nothing on the outside, however, gives any hint of the interior. Indeed, its airiness and elegance are completely different from what the severe exterior would lead us to expect. The impact of the interior—awe-inspiring and harmonious

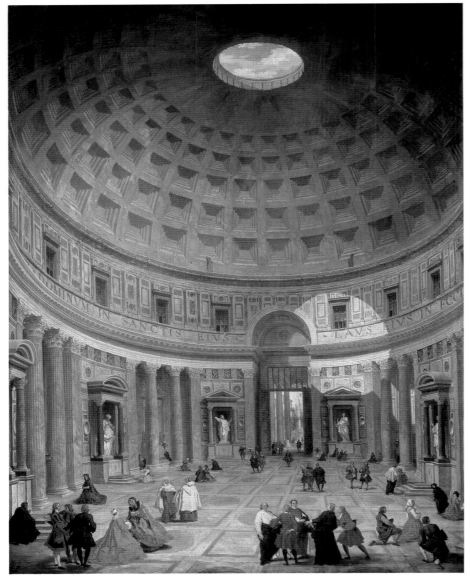

7-4 Giovanni Paolo Pannini. *The Interior of the Pantheon.* c. 1740. Oil on canvas, 50½ x 39" (128.2 x 99.1 cm). National Gallery of Art, Washington, D.C.

Samuel H. Kress Collection

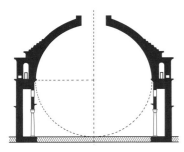

7-5 Section of the Pantheon

base and the interior. The dome and drum are likewise of equal heights, so that all the proportions are in exact balance (fig. 7-5). The weight of the dome is concentrated on the eight solid sections of wall. (The sculptures of the seven planetary gods date from the Baroque era.) Between the walls are seven niches, screened by columns that give the effect of an open space behind the supports. We thus feel that the walls are less thick and the dome much lighter than they actually are. The columns, the colored marble paneling of the wall surfaces, and the floor remain largely as they were in Roman times. However, the coffers were originally gilded (overlaid with a thin layer of gold). It is likely that this golden canopy represented the Dome of Heaven.

Basilica of Constantine The Basilica of Constantine (it was actually begun by Constantine's predecessor, Maxentius) is an even more direct example of how *thermae* were transformed in new types of buildings. **Basilicas**, long halls used for a variety of civic purposes, had first been developed in Hellenistic Greece toward the end of the third century B.C. (In ancient Greek, *basilica* meant "royal house," from *basileus*, "king.") They never conformed to a single type but varied from region to region. Roman basilicas, whose origins can be traced back to 184 B.C., eventually became a standard feature of every major town. One of their chief functions was to provide a dignified setting for the courts of law that dispensed justice in the name of the emperor. These basilicas had wooden ceilings instead of masonry vaults, for reasons of convenience and tradition rather than necessity. Thus they were often destroyed by fire. The Basilica of Constantine, by contrast, was derived from the main halls of the public baths built by two earlier emperors, Caracalla and Diocletian. However, it is built on an even grander scale and must have been the largest roofed interior in all of Rome. Today only the north **aisle**, consisting of three huge barrel-vaulted compartments, is still standing (fig. 7-6).

The Basilica of Constantine was entered through the **narthex** at the east end (fig. 7-7). At the opposite end was a semicircular niche, called an **apse**,

at the same time—is impossible to convey in photographs. Even the painting in figure 7-4 fails to do it justice.

The dome is a true hemisphere of ingenious design. The interlocking ribs form a structural cage that permits the use of relatively lightweight **coffers** (recessed panels) arranged in five rings. The height from the floor to the oculus (eye) is 143 feet, which is also the diameter of the dome's

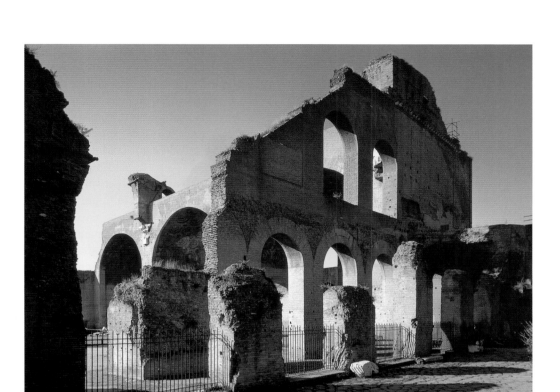

7-6 The Basilica of Constantine, Rome. c. 307–20 A.D.

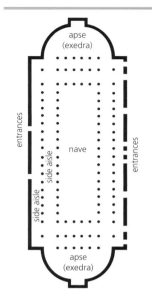

There was no standard form for the Roman **basilica**. This basilica plan shows two apses, or exedrae; most have only one apse.

where the colossal statue of Constantine was found (see fig. 7-13). Perhaps to make room for his cult statue, Constantine modified the building by adding a second entrance to the south and a second apse opposite it where he could sit as emperor. The center space, or **nave**, was covered by three groin vaults and rose a good deal higher than the aisles. Since a groin vault, like a canopy, has its weight and thrust concentrated at the four corners, the upper walls of the nave could be pierced by large windows (called the **clerestory**). As a result, the interior of the basilica must have had a light and airy quality despite its enormous size.

The Basilica of Constantine was a daring attempt to create a new, vaulted type. Despite its obvious advantages, the type seems to have met with little favor. Perhaps people felt that it lacked dignity because of its resemblance to the public baths. Whatever the reason, the Christian basilicas of the fourth century (see fig. 8-2) were modeled on the older,

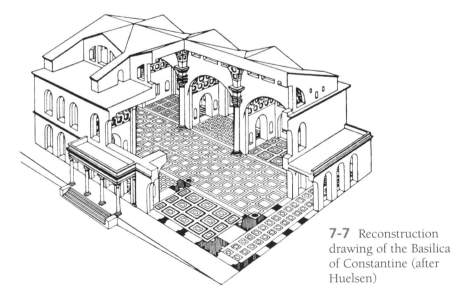

7-7 Reconstruction drawing of the Basilica of Constantine (after Huelsen)

wooden-roofed type. Not until 700 years later did vaulted basilican churches become common in western Europe.

Sculpture

The question "Is there such a thing as a Roman style?" has centered largely on sculpture, and for good reason. Even if we discount the importing and copying of Greek originals, the reputation of the Romans as imitators seems to be borne out by large numbers of works that are probably based on Greek models. While the Roman demand for sculpture was tremendous, much of it may be attributed to a taste for antiquities and for sumptuous interior decoration. On the other hand, there can be no doubt that some kinds of sculpture had important functions in ancient Rome. These works represent the living sculptural tradition. We shall concern ourselves here with two aspects of Roman sculpture that are rooted in Roman society: portraiture and narrative relief.

PORTRAITS

We know from literary accounts that great political or military leaders were honored by having their statues put on public display. This custom began in early Republican times and was to continue until the end of the empire a thousand years later. It may have been derived from the Greek tradition of placing votive statues of athletes and other important individuals in the precincts of the Akropolis and such sanctuaries as Delphi and Olympia (see fig. 5-15). Unfortunately, the first 400 years of this Roman tradition are a closed book. Not a single Roman portrait has come to light that can be securely dated before the first century B.C. How were those early statues related to Etruscan or Greek sculpture? Did they have any specifically Roman qualities? Were they individual likenesses, or were their subjects identified only by pose, costume, attributes, and inscriptions?

It appears that a clearly Roman portrait style was not achieved until the time of Sulla, when Roman architecture, too, came of age. It arose from an ancient custom. Upon the death of the male head of the family, a wax image was made of his face, which was then preserved in a special shrine or family altar. At funerals, these ancestral images were carried in the procession. The patrician (aristocratic) families of Rome clung tenaciously to this kind of ancestor worship well into imperial times. The desire to have these perishable wax likenesses reproduced in marble may have come about because the patricians felt that their traditional position of leadership was threatened and wanted to make a greater public display of their ancestors in order to stress their ancient lineage.

Ancestor Portraits Such display is certainly the purpose of the statue in figure 7-8. It shows an unknown Roman holding two busts of his ancestors, presumably his father and grandfather. The impressive heads of the two ancestors are copies of the lost originals. (Differences in style and in the shape of the bust indicate that the original of the head on the left is about 30 years older than that of the one on the right.) The somber face

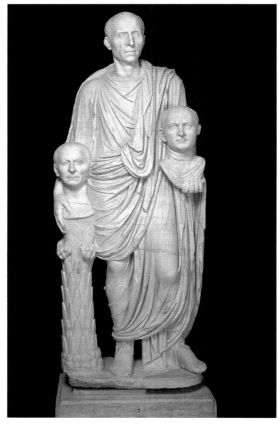

7-8 *A Roman Patrician with Busts of His Ancestors.* Late 1st century B.C. Marble, life-size. Museo Capitolino, Rome

and grave demeanor of this dutiful Roman are strangely affecting and indeed seem to project a spirit of patriarchal dignity that was probably not present in the original wax portraits. Thus the process of translating ancestor portraits into marble not only made the images permanent but monumentalized them in the spiritual sense as well.

What mattered, however, was the face itself, not the style of the artist who recorded it. For that reason, these portraits have a serious, prosaic quality. The word *uninspired* suggests itself—not as a criticism but as a way to describe the attitude of the Roman artist in contrast to that of Greek or even Etruscan portraitists. That seriousness was a positive value becomes clear when we compare the right-hand ancestral head in our group with the Hellenistic portrait from Delos in figure 5-26. It would be hard to imagine a greater contrast. Both are persuasive likenesses, yet they seem worlds apart. Whereas the Hellenistic head impresses us with its grasp of the sitter's psychology, the Roman bust may strike us at first glance as no more than a detailed record of the face's topography, in which the sitter's character appears only incidentally. And yet this is not really the case. The features are true to life, no doubt, but the carver has emphasized them selectively to bring out a specifically Roman personality: stern, rugged, devoted to duty. It is a father image of frightening authority, and the facial details are like individual biographical data that distinguish it from others.

Augustus of Primaporta As we approach the reign of the emperor AUGUSTUS (27 B.C.–14 A.D.), we find a new trend in Roman portraiture, which reaches its climax in the images of Augustus himself. At first glance, we may not be certain whether his statue from Primaporta (fig. 7-9) represents a god or a human being. This doubt is entirely appropriate, for the figure is meant to be both. Here we meet a concept familiar to us from Egypt and the ancient Near East: the divine ruler. It had entered the Greek world in the fourth century B.C. Alexander the Great adopted it, as did his successors, who modeled themselves after him. They, in turn, transmitted it to Julius Caesar and the Roman emperors, who at first encouraged the worship of themselves only in the eastern provinces, where belief in a divine ruler was a tradition.

The idea of giving the emperor divine stature to enhance his authority soon became official policy. While Augustus did not carry it as far as later emperors, the Primaporta statue clearly shows him enveloped in an air of divinity. (He also was the chief priest of the state religion.) Still, despite its heroic, idealized body, which is clearly derived from the *Doryphoros* of Polykleitos (see fig. 5-17), the sculpture has an unmistakably Roman flavor. The costume, including the rich allegorical program on the breastplate, has a concreteness of surface texture that conveys the actual touch of cloth, metal, and leather. The head is idealized, or better yet "Hellenized." Small details are omitted, and the focus on the eyes gives it something of an "inspired" look. Even so, the face is a definite, individual likeness, as we know from many other portraits of Augustus. All Romans would have recognized it immediately, for they knew it from coins and countless other representations.

Although it was found in the villa of Augustus's wife, Livia, the Primaporta statue may be a later copy of a lost original. The bare feet indicate that he has been deified, so the sculpture was perhaps made after his death. Myth and reality are blended in order to glorify the emperor. The little Cupid on a dolphin serves both to support the heavy marble figure and to remind viewers of the claim that the Julian family was descended from Venus. The breastplate illustrates Augustus's victory over the Parthians in 39–38 B.C., which avenged a Roman defeat at their hands nearly 15 years earlier. Characteristically, however, the event is shown as an allegory. The presence of gods and goddesses raises it to cosmic significance, while the symbolic aspects of the work proclaim that this triumph, which Augustus viewed as pivotal, began an era of peace and plenty.

Equestrian Monuments Augustus still conformed to age-old Roman custom by being clean-shaven. His successors, in contrast, adopted the Greek fashion of wearing beards as an outward

7-9 *Augustus of Primaporta.* c. 20 A.D. Roman copy of a Roman original of c. 15 B.C. Marble, height 6'8" (2.03 m). Musei Vaticani, Braccio Nuovo, Rome

AUGUSTUS (63 B.C.–14 A.D.), the first Roman emperor, was the grandson of Julius Caesar's sister. He became sole ruler after defeating Marc Antony at the Battle of Actium in 31 B.C. During his long reign, he returned Rome to constitutional rule, instituted tax reforms, built roads, and supported the arts. Abroad, his aims were to maintain the borders set by Caesar. Augustus was awarded the title *Pater Patriae* (Father of His Country) by the grateful citizens of the empire.

sign of admiration for the Hellenic heritage. It is not surprising, therefore, to find a strong classicistic trend, often of a peculiarly cool, formal sort, in the sculpture of the second century A.D., especially during the reigns of Hadrian and MARCUS AURE-LIUS, both of them private men deeply interested in Greek philosophy. We can sense this quality in the famous equestrian bronze statue of Marcus Aurelius (fig. 7-10), which is notable not only as the sole survivor from antiquity of this class of monument but also as one of the few Roman statues that remained on public view throughout the Middle Ages. Such images, showing the mounted emperor as the all-conquering lord of the earth, had been an established tradition ever since Julius Caesar permitted an equestrian statue of himself to be erected in the forum that he built. Marcus Aurelius, too, was meant to be seen as ever-victorious. According to medieval accounts, a small figure of a bound barbarian chieftain once crouched beneath the horse's right front leg. The powerful and spirited horse expresses this martial spirit. But the emperor himself is a model of Stoic calm. Without weapons or armor, Marcus Aurelius appears as a bringer of peace rather than a military hero, for this is how he saw himself and his reign.

Portrait Heads A portrait of Marcus Aurelius's wife, Faustina the Younger (fig. 7-11), is cast in the same classical mold as those of her husband. Although it is a clear likeness, her features have been subtly idealized in accordance with Greek sculpture, right down to the coiffure (compare the head of the *Dying Niobid*, fig. 5-19). In this way, the bust acclaims Faustina as a model of Roman womanhood. Roman empresses served as a model for other women and often determined matters of taste in fashion. Besides bearing him two sons, Faustina accompanied the emperor on his military campaigns, which earned her the title Mother of the Camps. Her life embodied the feminine virtues that were important to the Romans, for which her husband later consecrated her a goddess (*diva*): devotion to home and family, affection, respect, and piety, as well as beauty, grace, fertility, and chastity. The tunic and cloak worn by Faustina are signs of modesty befitting a Roman matron.

The reign of Marcus Aurelius was the calm before the storm. A period of chaos was ushered in by his decadent son Commodus, who was finally murdered in 192 A.D. The reforms of the short-lived Severan dynasty (193–235 A.D.) gave way to almost constant crisis, which plagued the Roman Empire for the remainder of the third century. Barbarians threatened the frontiers while internal conflicts undermined the authority of the

7-10 *Equestrian Statue of Marcus Aurelius.* 161–80 A.D. Bronze, over-life-size. Piazza del Campidoglio, Rome

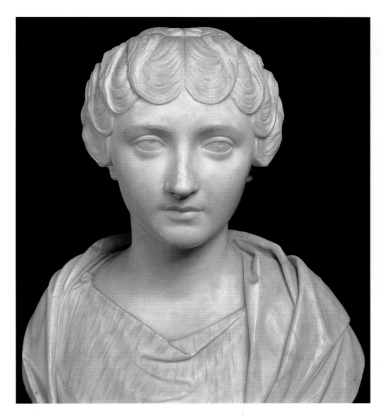

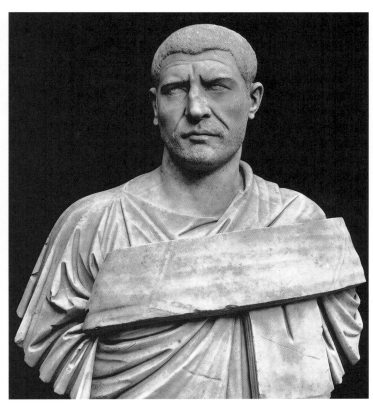

7-11 *Faustina the Younger.* c. 147–48 A.D. Marble, height 23⅝" (60 cm). Museo Capitolino, Rome

7-12 *Philippus the Arab.* 244–49 A.D. Marble, life-size. Musei Vaticani, Braccio Nuovo, Città del Vaticano, Rome

emperor. Retaining the throne became a matter of naked force, succession by murder a regular habit. The "soldier emperors," mercenaries from the outlying provinces of the realm, followed one another at brief intervals. The portraits of some of these men, such as Philippus the Arab (fig. 7-12), who reigned from 244 to 249 A.D., are among the most powerful likenesses in all of art. Their realism is as exact as that of Republican portraiture, but its aim is expressive rather than documentary. All the dark passions of the human mind—fear, suspicion, cruelty—are revealed here, with a directness that is almost unbelievable. The face of Philippus mirrors all the violence of the time. Yet it also moves us to pity. There is a psychological nakedness about it that recalls a brute creature, cornered and doomed. Clearly, the agony of the Roman world was not only physical but spiritual.

The portrait of Philippus reminds us of the head from Delos (see fig. 5-26). Let us note, however, the new means by which it achieves its impact. We are struck, first of all, by the way expression centers on the eyes, which seem to gaze at some unseen threat. The engraved outline of the iris and the hollowed-out pupils, devices that do not appear in earlier portraits, serve to fix the direction of the glance. The hair, too, is rendered in un-Classical fashion as a close-fitting, textured cap. The beard has been replaced by a stubble that results from roughing up the surfaces of the jaw and mouth with short chisel strokes.

We enter a different world with the head of Constantine the Great, the first Christian emperor and reorganizer of the Roman state (fig. 7-13, page 136). Its face is not a true portrait. In fact, the head is one of several fragments of the huge statue

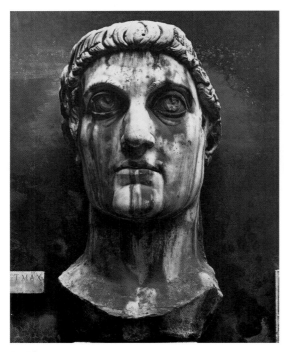

7-13 *Constantine the Great.* Early 4th century A.D. Marble, height 8' (2.44 m). Palazzo dei Conservatori, Rome

so out of proportion to the scale of ordinary people that we feel crushed by its size. It was clearly intended to give the viewer the impression of being in the presence of some unimaginable power. The portrait seems superhuman, not only because of its enormous size but even more so perhaps as an image of imperial majesty. This impression is reinforced by the massive, immobile features, particularly the huge eyes that stare out with hypnotic intensity. All in all, the colossal head conveys little of Constantine's appearance, but it tells us a great deal about his view of himself and his exalted office.

RELIEFS

Imperial art was not confined to portraiture. The emperors also commemorated their achievements in narrative reliefs on MONUMENTAL ALTARS, TRIUMPHAL ARCHES, and columns. Similar scenes are familiar to us from the ancient Near East (see figs. 3-7 and 3-8) but not from Greece. Historical events—that is, events which occurred only once, at a specific time and place—had not been shown in Classical Greek sculpture. If a victory over the Persians was to be commemorated, for instance, it had to be portrayed as a mythical event outside any space-time context: a combat of Lapiths and Centaurs or Greeks and Amazons (see figs. 5-18 and 5-21). This attitude persisted in Hellenistic times, although not quite as absolutely. When the kings of Pergamon celebrated their victories over the Celts, the latter were represented faithfully (see fig. 5-23), but in typical poses of defeat rather than in the framework of a particular battle.

Greek painters, on the other hand, had shown historical subjects such as the Battle of Salamis as early as the mid-fifth century B.C., although we do not know how specific these pictures were in detail. As we have seen, the mosaic from Pompeii showing the Battle of Issos (see fig. 5-5) probably reflects a famous Hellenistic painting of about 315 B.C. depicting the defeat of the Persian king Darius by Alexander the Great. Historic events had been portrayed in Rome, too, from the third century B.C. on. A victorious military leader would have his deeds painted on panels that were carried in his triumphal procession or shown in public

from the apse of Constantine's basilica (see fig. 7-6). Unlike the *Augustus of Primaporta* (see fig. 7-9) and other full-length imperial portraits, which generally show the ruler standing, this one probably depicted him seated nude in the manner of Jupiter, with a mantle draped across his legs, in imitation of Pheidias's cult statue of Zeus at Olympia (see page 112). It is probably the large statue mentioned by Bishop Eusebius, Constantine's friend and biographer, that held a cross-scepter, called a *labarum*, in its right hand. After Constantine's conversion in 312, this imperial device, originally a Roman military standard, became a Christian symbol through the addition of the Chi Rho insignia within a wreath. (Chi and rho are the first two letters of Christ's name in Greek.) Thus the colossal statue represented Constantine as a Christian ruler of the world, although the surviving hand points straight up. (The other hand most likely held an orb.) At the same time, it served as a cult statue to the emperor himself.

The head alone is eight feet tall. Everything is

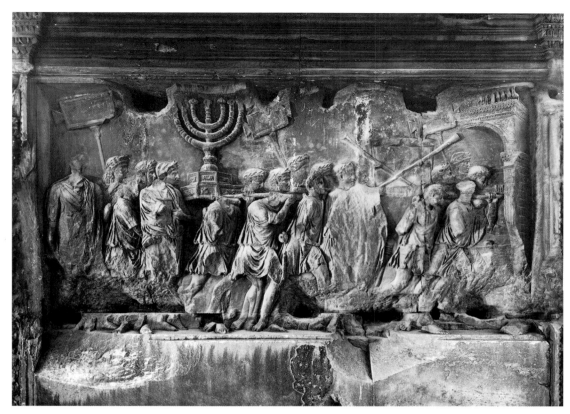

7-14 *Spoils from the Temple in Jerusalem.* Relief in passageway, Arch of Titus, Rome. 81 A.D. Marble, height 7'10" (2.39 m)

places. These pictures seem to have had the fleeting nature of posters advertising the hero's achievements; none has survived. Sometime during the late years of the Republic, such images began to take on a more monumental and permanent form. They were no longer painted, but carved and attached to structures intended to last indefinitely. They proved a ready tool for glorifying imperial rule, and the emperors used them on a large scale.

Arch of Titus Roman relief carving reached its greatest development in the two large narrative panels on the triumphal arch erected in 81 A.D. to commemorate the victories of the emperor Titus. One of them (fig. 7-14) shows part of the procession celebrating the conquest of Jerusalem. The booty includes a seven-branched menorah (candlestick) and other sacred objects. The movement of a crowd of figures in depth is conveyed with

striking success, despite the damaged surface. On the right, the procession turns away from us and disappears through a triumphal arch, which is placed obliquely to the background plane so that only the nearer half actually emerges from the background—a radical but effective compositional device. The sculptor's main concern was to display this set image, rather than to keep the procession moving. Once we try to read the figures and objects in terms of real space, we become aware of how contradictory the spatial relationships are.

Column of Trajan The conflict between the narrative or symbolic purposes of imperial art and the desire for realistic treatment of space becomes fully evident in the Column of Trajan. The column was erected between 106 and 113 A.D. to celebrate that emperor's victorious campaigns against the Dacians (the inhabitants of what is now Romania).

Freestanding columns had been used as commemorative monuments from Hellenistic times on; their source may have been the obelisks of Egypt. The Column of Trajan is distinguished not only by its great height (125 feet, including the base) but also by the continuous spiral band of relief (fig. 7-15), which recounts in epic breadth the history of the Dacian wars. The column was crowned by a statue of the emperor (destroyed in the Middle Ages), and the base served as a burial chamber for his ashes. The design is often credited to Apollodorus of Damascus, who served as Trajan's military architect during the wars.

If we could unwind the relief band on the column, it would be 656 feet long, two-thirds the combined length of the friezes of the Mausoleum at Halikarnassos. In terms of the number of figures and the density of the narrative, however, our relief is by far the most ambitious **frieze** composition up to that time. It is also the most frustrating, for viewers must "run around in circles like a circus horse" (as one scholar put it) if they want to follow the narrative. Moreover, details above the fourth or fifth turn can hardly be seen without binoculars. One wonders for whose benefit this elaborate pictorial account was intended. In Roman times, the monument formed the center of a small court flanked by libraries at least two stories tall within the Forum of Trajan, but even that arrangement does not answer our question.

At any rate, the spiral frieze on the Column of Trajan was a new and demanding framework for historic narrative, which imposed a number of difficult conditions upon the sculptor. Since there could be no inscriptions, the pictorial account had to be as clear as possible. The spatial setting of each episode therefore had to be worked out with great care. Visual continuity had to be preserved without destroying the coherence of each scene. And the carving had to be much shallower than in reliefs such as those on the Arch of Titus. Otherwise, the shadows cast by the projecting parts would make the scenes unreadable from below.

The artist has solved these problems with great success, but at a price. Landscape and architecture become "stage sets," and the ground on which the figures stand is tilted upward. These devices had already been used in Assyrian narrative reliefs. Here they appear once more, against the tradition of **foreshortening** and **perspective** space. Perhaps we are judging the Roman artist too harshly. Despite the testimony of literary sources that Greek Classical painters made great strides in treating illusionistic space (see pages 92–93), there is no direct evidence that they did so on the scale found here. Seen in this light, the Roman conquest of landscape and architectural space is a striking achievement, whatever its shortcomings. This method of pictorial description was to become dominant in another 200 years, at the dawn of medieval art. In this respect, the relief band on the Column of Trajan foretells both the end of one era and the beginning of the next.

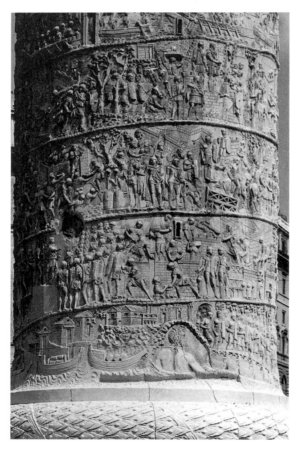

7-15 Lower portion of the Column of Trajan, Rome. 106–13 A.D. Marble, height of relief band approx. 50" (127 cm)

Painting

We know infinitely less about Roman painting than we do about Roman architecture or sculpture. Almost all the surviving works are wall paintings, and most of these come from Pompeii, Herculaneum, and other towns buried by the eruption of Mount Vesuvius in 79 A.D., or from Rome and its environs. Their dates cover a span of less than 200 years, from the end of the second century B.C. to the late first century A.D. After that time Roman painting seems to have declined. And since we have only a few Greek wall paintings in Macedonian tombs from Alexander's time, it is far more difficult to single out the Roman element in painting than in sculpture or architecture.

ROMAN ILLUSIONISM

Based partly on Vitruvius's discussion, four phases of Roman wall painting have been distinguished. However, the differences among them are not always clear, and there seems to have been a great deal of overlap in their sequence. The earliest phase, known from a few examples dating to the late second century B.C., must have been widespread in the Hellenistic world, since examples of it have also been found in the eastern Mediterranean. Unfortunately, it is not very informative for us, as it consists entirely of the imitation of colored marble paneling. About 100 B.C., this so-called First Style began to be displaced by a far more ambitious style that sought to open up the flat surface of the wall by means of architectural perspectives and "window effects," including landscapes and figures.

The architectural vistas typical of the Second Style are represented by the FRESCOES in figure 7-18 (see page 141). Our artist is clearly a master of modeling and surface textures. The forms framing each vista—the richly decorated columns, moldings, and garlands—have an extraordinary degree of three-dimensionality. They set off the views of buildings, which are flooded with light to convey a sense of open space. But we quickly realize that the painter has no systematic grasp of spatial depth; the perspective is haphazard and inconsistent within itself. We were never intended to enter this architectural maze. Like a promised land, it remains forever beyond us.

Odyssey Landscapes When landscape takes the place of architectural vistas, foreshortening becomes less important. Now the virtues of the Roman painter's approach outweigh its drawbacks. This advantage can be seen most clearly in the Odyssey Landscapes, a continuous stretch of landscape subdivided into eight compartments by a framework of pilasters. Each section illustrates an adventure of Odysseus (Ulysses). Vitruvius tells us that such cycles were common. However, the narrative has large gaps, which suggests that the scenes have been taken from a larger cycle. In the adventure with the Laestrygonians (fig. 7-16, page 140), the bluish tones create a feeling of light-filled space that envelops all the forms in this warm Mediterranean fairyland, including the figures, which seem to play a minor role. Only upon reflection do we realize how frail the illusion of consistency is. If we tried to map this landscape, we would find it just as ambiguous as the architectural perspective discussed above. Its unity is not structural but poetic.

Villa of the Mysteries The great cycle of murals in one of the rooms in the Villa of the Mysteries just outside Pompeii (fig. 7-17, page 140) dates from the latter part of the first century B.C., when the Second Style was at its height. So far as the treatment of the wall surface is concerned, it has been conceived in terms of rhythmic continuity and arm's-length depth. The frieze nevertheless has a grandeur and coherence that are nearly unique in Roman painting. The figures have been placed on a narrow ledge of green against a regular pattern of red panels separated by strips of black, so as to create a kind of running stage on which they perform their strange ritual. Who are they, and what is the meaning of the cycle? Many details remain puzzling, but the frieze as a whole depicts various rites of the Dionysiac mysteries, a semisecret cult of very ancient origin that had been brought to Italy from Greece. The rituals are performed, perhaps as part of an initiation into womanhood or marriage, in the presence of Dionysus

SPEAKING OF

wall painting, mural,
and *fresco*

Wall painting is a very broad descriptive term for painting in any medium on a wall-like surface, from those on caves and rock-cut tombs to those on modern buildings. A *mural* is a painted image made on or attached to a particular wall, such as the painting cycle in the Villa of the Mysteries (see fig. 7-17). *FRESCO* is a specific wall-painting technique favored in Italy from Roman times through the eighteenth century. In true (*buon*) fresco, the artist paints with water-borne colored pigments directly on fresh, still-damp plaster, working in small sections and producing a stable, long-lasting image. Dry (*secco*) fresco, in which the pigments are painted on dry plaster, is far less durable than true fresco and has been used mostly for details.

7-16 *The Laestrygonians Hurling Rocks at the Fleet of Odysseus.* Wall painting from the Odyssey Landscapes series in a house on the Esquiline Hill, Rome. Late 1st century B.C. Biblioteca Apostolica Vaticana, Città del Vaticano, Rome

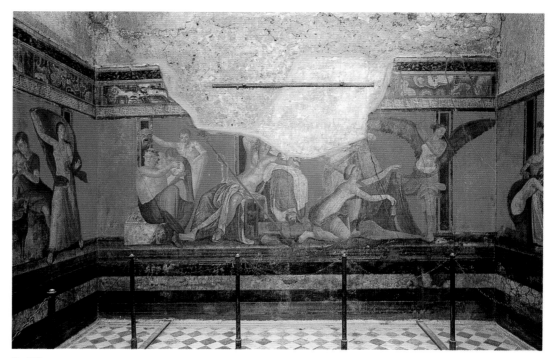

7-17 *Scenes of a Dionysiac Mystery Cult.* Mural frieze. c. 50 B.C. Villa of the Mysteries, Pompeii

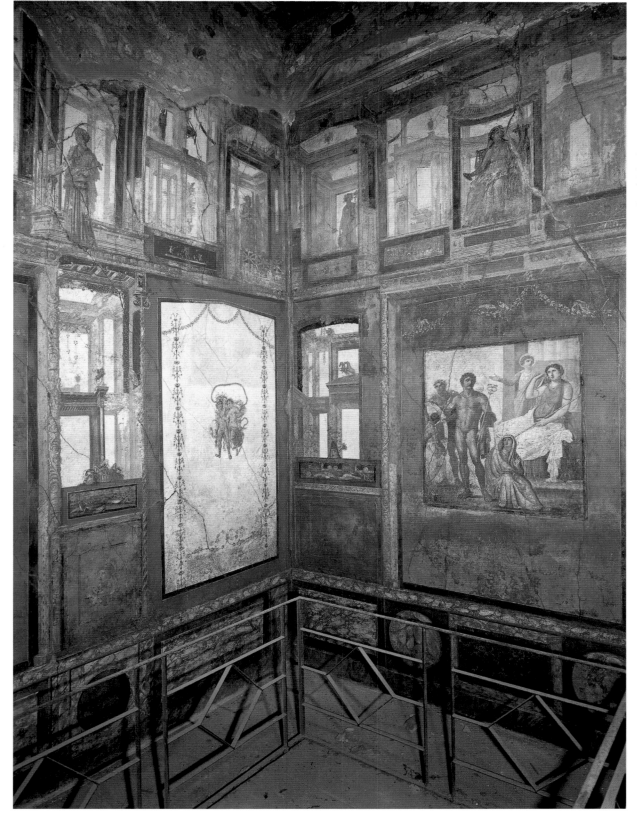

and Adriadne, with their train of SATYRS and SILENI. Thus human and mythical reality tend to merge into one. As a result all the figures have certain qualities in common: their dignity of bearing and expression, the firmness of body and drapery, and the rapt intensity with which they participate in the drama of the ritual.

Late Roman Painting The Third Style, from about 20 B.C. until at least the middle of the first century A.D., abandoned illusionism in favor of decorative surfaces with broad planes of intense color that were sometimes relieved by imitation panel paintings. By contrast, the Fourth Style, which prevailed at the time of the eruption of Mount Vesuvius in 79 A.D., was the most intricate of all. It united aspects of all three preceding styles to create an extravagant effect. The result is a somewhat disjointed compilation of **motifs** from various sources. The Ixion Room in the House of the Vettii at Pompeii (fig. 7-18, page 141) combines imitation marble paneling, framed mythological scenes that give the effect of panel pictures set into the wall, and fantastic architectural vistas seen through make-believe windows. This architecture has a strangely unreal and picturesque quality that is thought to reflect the architectural backdrops of the theaters of the time.

GREEK SOURCES

There is no doubt that Greek designs were copied and that Greek paintings as well as painters were imported. It is tempting to link Roman paintings with lost Greek works recorded by Pliny, Vitruvius, and others. *The Battle of Issos* (see fig. 5-5) is, however, one of the rare cases in which such a connection can be clearly demonstrated. For the most part, Roman painting appears to have been a specifically Roman development. Despite the fact that the characters' names are given in Greek, there is no reason to assume a Greek origin for the Odyssey Landscapes. Likewise the still-lifes that sometimes appear within the architectural schemes of the Fourth Style are distinctively Roman, even though **still-life** painting began in Greece and certain Classical Greek motifs were taken over by the Romans. Finally, the illusionistic

tendencies that gained the upper hand in Roman murals during the first century B.C. represent a dramatic breakthrough that had no precedent in Greek art so far as we know.

The issue is more complex when it comes to narrative painting. Although not a trace of it exists, we can hardly doubt that Greek painting continued to evolve after the Classical era. However, narrative painting underwent a decline in the late Hellenistic period, when earlier panels were highly prized by collectors, in the way "old master" paintings are today. It was revived, Pliny tells us, around the middle of the first century B.C. by Timomachus of Byzantium, who "restored its ancient dignity to the art of painting." This rebirth came around the same time as the frescoes in the Villa of the Mysteries, which provide a test case of what is Roman in Roman painting. Many of the poses and gestures are taken from Classical Greek art, yet they lack the self-conscious quality of Classicism. An artist of great vision has filled these forms with new life. He was the legitimate heir of the Greeks in the same sense that the finest Latin poets were legitimate heirs to the Greek poetic tradition.

Roman painting as a whole shows the same genius for adapting Greek examples to Roman needs as do sculpture and architecture. This is true even of seemingly reproductive or imitative works. The mythological panels that occur like islands in the Third and Fourth Styles sometimes give the impression of being copies after Hellenistic originals. Yet, in several cases, we possess more than one variant of the same composition derived ultimately from the same, presumably Greek, source. The differences between examples attest to how readily the original was copied and changed. Moreover, a closer look shows that such panels, too, evolved in ways that reflect the changing taste of Roman artists and their patrons. Figures were freely altered and rearranged, often in very different settings, suggesting that they could be found in pattern books. Thus, whatever their relation to the masterpieces of Greece that are lost to us forever, scenes such as Hermes overseeing the punishment of Ixion in figure 7-18 represent the eclectic Roman approach to painting, and it is likely that most were of recent vintage as well.

PORTRAITS

Portrait painting, according to Pliny, was an established custom in Republican Rome. It served the ancestor cult, as did the portrait busts discussed earlier (see pages 132–33). None of these panels has survived, and the few portraits found on the walls of Roman houses in Pompeii may derive from a different, Hellenistic tradition. The only coherent group of painted portraits that has come down to us is from the Faiyum district in Lower Egypt. The earliest of them seem to date from the second century A.D. We owe them to the survival (or revival) of the ancient Egyptian custom of attaching a portrait of the deceased to the wrapped, mummified body. Originally, these portraits had been sculpted, but in Roman times they were replaced by painted ones such as the very fine wooden panel that is shown in figure 7-19.

The amazing freshness of its colors is due to the fact that it was done in a very durable medium called **encaustic**, which uses pigments suspended in hot wax. The mixture can be opaque and creamy, like oil paint, or thin and translucent. At their best, these portraits have an immediacy and a sureness of touch that have rarely been surpassed, thanks to the need to work quickly before the hot wax set. Our dark-haired boy is as solid and lifelike as anyone might wish. The style of the picture—and it does have style, otherwise we could not tell it from a snapshot—becomes apparent only when we compare it with other Faiyum portraits. Since they were produced quickly and in large numbers, they tend to have many elements in common. These include the emphasis on the eyes, the placing of the highlights and shadows, and the angle from which the face is seen. Over time, these elements would stiffen into a fixed type, but here they provide a flexible mold within which to cast an individual likeness. In this happy case, the intent was only to recall the personality of a beloved child. This way of painting was revived four centuries later in the earliest Byzantine icons, which were considered "portraits" of the Madonna and Child, Christ, and the saints.

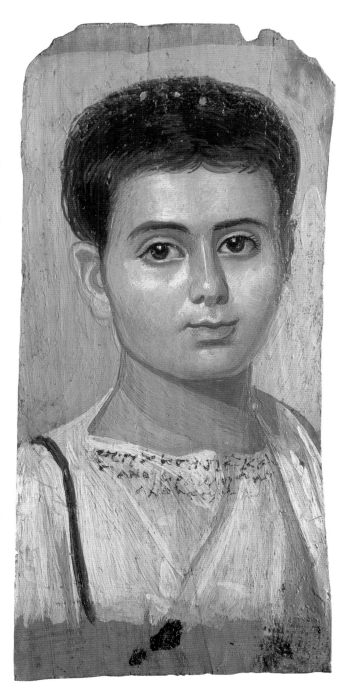

7-19 *Portrait of a Boy,* from the Faiyum (?), Lower Egypt. 2nd century A.D. Encaustic on panel, 15 3/8 x 7 1/2" (39.1 x 19.1 cm). The Metropolitan Museum of Art, New York

Gift of Edward S. Harkness, 1918

4000 B.C.–300 A.D.

Political History

4000–2000 B.C.
Sumerians settle in lower Mesopotamia
Early Dynastic period, Old Kingdom, Egypt (Dynasties 1–6), c. 3150–2190
Early dynastic period, Sumer, c. 4000–2340; Akkadian kings 2340–2180

2000–1000 B.C.
Middle Kingdom, Egypt, c. 2040–1674
Hammurabi founds Babylonian dynasty c. 1760
Flowering of Minoan civilization c. 1700–1450
New Kingdom, Egypt, c. 1552–1069

1000–500 B.C.
Jerusalem capital of Palestine; rule of David; of Solomon (died 926)
Assyrian Empire c. 1000–612
Persians conquer Babylon 539; Egypt 525
Romans revolt against Etruscans, set up Republic 510

Religion and Literature

4000–2000 B.C.
Pictographic writing, Sumer, c. 3500
Hieroglyphic writing, Egypt, c. 3100
Cuneiform writing, Sumer, c. 2900
Divine kingship of the pharaoh
Theocratic socialism in Sumer

2000–1000 B.C.
Code of Hammurabi c. 1760
Monotheism of Akhenaten (ruled 1348–1336/35)
Book of the Dead, first papyrus books, Dynasty 18

1000–500 B.C.
Hebrews accept monotheism
Phoenicians develop alphabetic writing c. 1000; Greeks adopt it c. 800
First Olympian games 776
Homer (active c. 750–700), *Iliad* and *Odyssey*
Zoroaster, Persian prophet (born c. 660)
Aeschylus, Greek playwright (525–456)

Science and Technology

4000–2000 B.C.
Wheeled carts, Sumer, c. 3500–3000
Sailboats used on Nile c. 3500
Potter's wheel, Sumer, c. 3250
First bronze tools and weapons, Sumer

2000–1000 B.C.
Bronze tools and weapons in Egypt
Canal built from Nile to Red Sea
Mathematics and astronomy flourish in Babylon under Hammurabi
Hyksos bring horses and wheeled vehicles to Egypt c. 1725

1000–500 B.C.
Coinage invented in Lydia (Asia Minor) c. 700–650; soon adopted by Greeks
Pythagoras, Greek philosopher (active c. 520)

Painting

2000–1000 B.C.
"The Toreador Fresco," Knossos, Crete (4-4)

4-4

1000–500 B.C.
Dipylon vase, Greece (5-1)
Black-figure amphora by Psiax, Greece (5-3)
Tomb of Hunting and Fishing, Tarquinia (6-2)

Sculpture

4000–2000 B.C.
Palette of King Narmer, Egypt (2-1, 2-2)
Statues from Abu Temple, Tell Asmar (3-3)
Offering stand and harp, Ur (3-4, 3-5)
Menkaure and Queen Khamerernebty, Egypt (2-4)
Female figure from Amorgos, Cycladic Islands (4-1)

2-4

2000–1000 B.C.
Stela of Hammurabi, Susa (3-7)
Head of Nefertiti, Egypt (2-13)
Coffin of Tutankhamun, Egypt (2-14)
Lioness Gate, Mycenae (4-6)

1000–500 B.C.
Lion-hunt relief, Nimrud (3-8)
Kouros, Greece (5-11)
Kore in Dorian Peplos, Greece (5-12)
North frieze from Treasury of the Siphnians, Delphi (5-13)
Apollo, Veii (6-5)

5-12

Architecture

4000–2000 B.C.
"White Temple" and ziggurat, Uruk (3-1, 3-2)
Step Pyramid and funerary district of Zoser, Saqqara, by Imhotep (2-5, 2-6)
Sphinx, Giza (2-9)
Pyramids at Giza (2-7)

2000–1000 B.C.
Stonehenge, England (1-5, 1-6)
Palace of Minos, Knossos, Crete (4-2)
Temple of Amun-Mut-Khonsu, Luxor (2-15)
"Treasury of Atreus," Mycenae (4-5)

1000–500 B.C.
Ishtar Gate, Babylon (3-9)
"Basilica," Paestum (5-8)

| 4000–2000 B.C. | 2000–1000 B.C. | 1000–500 B.C. |

500 B.C. –100 B.C.	100 B.C. –100 A.D.	100 A.D. –300 A.D.

Persian Wars in Greece 499–478
Periklean Age in Athens c. 460–429
Peloponnesian War, Sparta against Athens, 431–404
Alexander the Great (356–323) occupies Egypt 333; defeats Persians 331; conquers Near East
Rome dominates Asia Minor and Egypt, annexes Macedonia (and thereby Greece) 147

Julius Caesar dictator of Rome 49–44
Emperor Augustus (ruled 27 B.C.–14 A.D.)
Jewish rebellion against Rome 66–70; destruction of Jerusalem
Eruption of Mt. Vesuvius buries Pompeii, Herculaneum 79

Emperor Trajan (ruled 98–117) rules Roman Empire at its largest extent
Emperor Marcus Aurelius (ruled 161–80)
Shapur I (ruled 242–72), Sassanian king of Persia
Emperor Diocletian (ruled 284–305) divides Empire
Constanine the Great (ruled 324–37)

Sophocles, Greek playwright (496–406)
Euripides, Greek playwright (died 406)
Socrates, philosopher (died 399)
Plato, philosopher (427–347); founds Academy 386
Aristotle, philosopher (384–322)

Golden Age of Roman literature: Cicero, Catullus, Virgil, Horace, Ovid, Livy
Crucifixion of Jesus c. 30
Paul (died c. 65) spreads Christianity to Asia Minor and Greece

Persecution of Christians in Roman Empire 250–302
Christianity legalized by Edict of Milan 313; state religion 395
Augustine of Hippo (354–430), Jerome (c. 347–420)

Travels of Herodotus, Greek historian, c. 460–440
Hippokrates, Greek physician (born 469)
Books on geometry by Euclid (active c. 300–280)
Archimedes, physicist and inventor (287–212)
Invention of paper, China

Vitruvius's *De architectura*
Pliny the Elder (*Natural History*) dies in Pompeii 79
Seneca, Roman statesman

Ptolemy, Graeco-Egyptian geographer and astronomer (died 160)
Silk cultivation brought to eastern Mediterranean from China

Herakles Wrestling Antaios, red-figure krater, Greece (5-4)
The Battle of Issos, Pompeian copy of Greek original (5-5)

Odyssey Landscapes, Rome (7-16)
Villa of the Mysteries, Pompeii (7-17)
House of the Vettii, Pompeii (7-18)

Portrait of a Boy, Faiyum, Egypt (7-19)

7-19

5-26

She-Wolf, Rome (6-6)
East pediment, Temple of Aphaia, Aegina (5-14)
Kritios Boy, Greece (5-15)
Zeus, Greece (5-16)
East pediment, Parthenon, Athens (5-20)
East frieze, Mausoleum, Halikarnassos (5-21)
Cinerary container, Etruria (6-3)
Dying Trumpeter, Greece (5-23)
Nike of Samothrace, Greece (5-25)

Roman Patrician, Rome (7-8)
Portrait Head, Delos (5-26)
Arch of Titus, Rome (7-14)

Column of Trajan, Rome (7-15)
Equestrian statue of Marcus Aurelius, Rome (7-10)
Philippus the Arab, Rome (7-12)
Colossal statue of Constantine the Great, Rome (7-13)

5-14

Palace, Persepolis (3-11)
Temple of Poseidon, Paestum (5-8)
Temples on Akropolis, Athens: Parthenon (5-9); Propylaia and Temple of Athena Nike (5-10)

Colosseum, Rome (7-2)

Pantheon, Rome (7-4, 7-5)
Basilica of Constantine, Rome (7-6, 7-7)

7-6

PART 2

THE MIDDLE AGES

We tend to think of the great Western civilizations of the past in terms of the monuments that have come to symbolize them: the pyramids of Egypt, the ziggurats of Babylon, the Parthenon of Athens, the Colosseum of Rome. The Middle Ages would be represented by a Gothic cathedral—Notre-Dame in Paris or Chartres in France, perhaps, or Salisbury Cathedral in England. We have many to choose from, but whichever one we pick, it will be well north of the Alps (albeit in an area that was once part of the Roman Empire). And if we were to spill a bucket of water in front of the cathedral of our choice, this water would eventually make its way to the English Channel rather than to the Mediterranean Sea. Here, then, we have perhaps the most important single fact about the Middle Ages. The center of gravity of European civilization has shifted to what had been the northern boundaries of the Roman world. The Mediterranean, which for so many centuries bound together all the lands along its shores, has become a border zone.

How did this dramatic shift come about? In 323 A.D. Constantine the Great made a fateful decision, the consequences of which are still felt today. He resolved to move the capital of the Roman Empire to the Greek town of Byzantium, which came to be known as Constantinople and in modern times as Istanbul. Six years later, after a major building campaign, the transfer was officially completed. In taking this step, the emperor acknowledged the growing strategic and economic importance of the eastern provinces. The new capital also symbolized the new Christian basis of the Roman state, since it was in the heart of the most fully converted part of the empire. Constantine could hardly have foreseen that moving the seat of imperial power would split the empire. Less than 75 years later, in 395, the division of the realm into the Eastern and Western empires was complete. Eventually that separation led to a religious split as well.

By the end of the fifth century, the bishop of Rome, who derived his authority from St. Peter, regained independence from the emperor. He then reasserted his claim as the pope, the head of the Christian Church. This claim to supremacy, however, was soon disputed by his Eastern counterpart, the patriarch of Constantinople. Differences in doctrine began to emerge and eventually the division of Christendom into a Western, or Catholic, and an Eastern, or Orthodox, Church became all but final. The differences between them went very deep. Roman Catholicism maintained its independence from state authority and became an international institution, reflecting its character as the Universal Church. The Orthodox Church, on the other hand, was based on the union of spiritual and secular authority in the person of the emperor, who appointed the patriarch. It thus remained dependent on the power of the State, requiring a double allegiance from the faithful. This tradition did not die even with the fall of Constantinople to the Ottoman Turks. The czars of Russia claimed the mantle of the Byzantine emperors, Moscow became "the third Rome," and the Russian Orthodox Church was as closely tied to the State as the Byzantine church had been.

Under Justinian (ruled 527–65), the Eastern, or Byzantine, Empire reached new power and stability after riots in 532 nearly deposed him. In contrast, the Latin West soon fell prey to invading Germanic peoples: Visigoths, Vandals, Franks, Ostrogoths, and Lombards. By the end of the sixth century, the last vestige of centralized authority had disappeared, even though the emperors at Constantinople did not give up their claim to the western provinces. Yet these invaders, once they had settled in their new lands, accepted the framework of late Roman, Christian civilization, however imperfectly. The local kingdoms they founded—the Vandals in North Africa, the Visigoths in Spain, the Franks in Gaul, the Ostrogoths and

Lombards in Italy—were all Mediterranean-oriented, provincial states on the edges of the Byzantine Empire. They were subject to the pull of the empire's military, commercial, and cultural power. As late as 630, after the Byzantine armies had recovered Syria, Palestine, and Egypt from the Sassanid Persians, the reconquest of the western provinces remained a serious possibility as well. Ten years later, the chance had ceased to exist, for an unforeseen new force—Islam—had made itself felt in the East.

Under the banner of Islam, the Arabs overran the African and Near Eastern parts of the empire. By 732, a century after Muhammad's death, they had absorbed Spain and threatened to conquer southwestern France as well. In the eleventh century, the Turks occupied much of Asia Minor. Meanwhile the last Byzantine lands in the West (in southern Italy) fell to the Normans, from northwestern France. The Eastern Empire, with its domain reduced to the Balkan peninsula, including Greece, held on until 1453, when the Turks conquered Constantinople.

In the East, Islam created a new civilization stretching to the Indus Valley (now Pakistan). That civilization reached its highest point far more rapidly than did that of the medieval West. Baghdad, on the Tigris, was the most important city of Islam in the eighth century. Its splendor rivaled that of Byzantium. Islamic art, learning, and crafts were to have great influence on the European Middle Ages, from arabesque ornament, the manufacture of paper, and Arabic numerals to the transmission of Greek philosophy and science through the writings of Arab scholars. (The English language records this debt in words such as *algebra*.)

It would be difficult to exaggerate the impact of the rapid advance of Islam. The Byzantine Empire, deprived of its western Mediterranean bases, focused on keeping Islam at bay in the

East and retained only a precarious foothold in the West. The European shore of the western Mediterranean, from the Pyrenees to Naples, was exposed to Arabic raiders from North Africa and Spain. Western Europe was thus forced to develop its own resources—political, economic, and spiritual.

The process was slow and difficult, however. The early medieval world was in a state of constant turmoil and therefore presents a continually shifting picture. Not even the Frankish kingdom, which was ruled by the Merovingian dynasty from about 500 to 751 (when it was overthrown by the Carolingian king Pepin III) was able to impose lasting order. As the only international organization of any sort, Christianity was of critical importance in promoting a measure of stability. Yet it, too, was divided between the papacy, whose influence was limited, and the monastic orders that spread quickly throughout Europe but remained largely independent of the Church in Rome.

This rapid spread of Christianity, like that of Islam, cannot be explained simply in institutional terms, for the Church did not perfectly embody Christian ideals. Moreover, its success was hardly guaranteed. In fact, its position was often precarious under Constantine's Latin successors. Instead, Christianity must have been extremely persuasive, in spiritual as well as moral terms, to the masses of people who heard its message. There is no other way to explain the rapid conversion of northern Europe. (Heathen gods were as terrifying as those of the ancient Near East, reflecting the violent life of a warrior society.)

Church and State gradually discovered that they could not live without each other. What was needed, however, was an alliance between a strong secular power and a united church. This link was forged when the Catholic church, which had now gained the allegiance of the religious orders, broke its last ties with the East and turned for support to the Germanic north. There the leadership of Pepin III's son Charlemagne and his descendants—the Carolingian dynasty—made the Frankish kingdom into the leading power during the second half of the eighth century. Charlemagne usurped the territory of his brother, Carloman, from his heirs. He then conquered most of Europe from the North Sea to Spain and as far south as Lombardy. When Pope Leo III appealed to him for help in 799, Charlemagne went to Rome, where on Christmas Day 800, the pope gave him the title of Emperor of the West—something that Charlemagne had neither sought nor wanted.

In placing himself and all of Western Christianity under the protection of the king of the Franks and Lombards, Leo did not merely solemnize the new order of things. He also tried to assert his authority over the newly created Catholic emperor. He claimed that the emperor's legitimacy depended on the pope, based on the forged Donation of Constantine. (Before then it had been the other way around: the emperor in Constantinople had ratified the newly elected pope.) Charlemagne did not subordinate himself to the pope, but this dualism of spiritual and political authority, of Church and State, was to distinguish the West from both the Orthodox East and the Islamic South. Its outward symbol was the fact that although the emperor was crowned in Rome, he did not live there. Charlemagne built his capital at the center of his power, in Aachen, located in what is now Germany and close to France, Belgium, and the Netherlands.

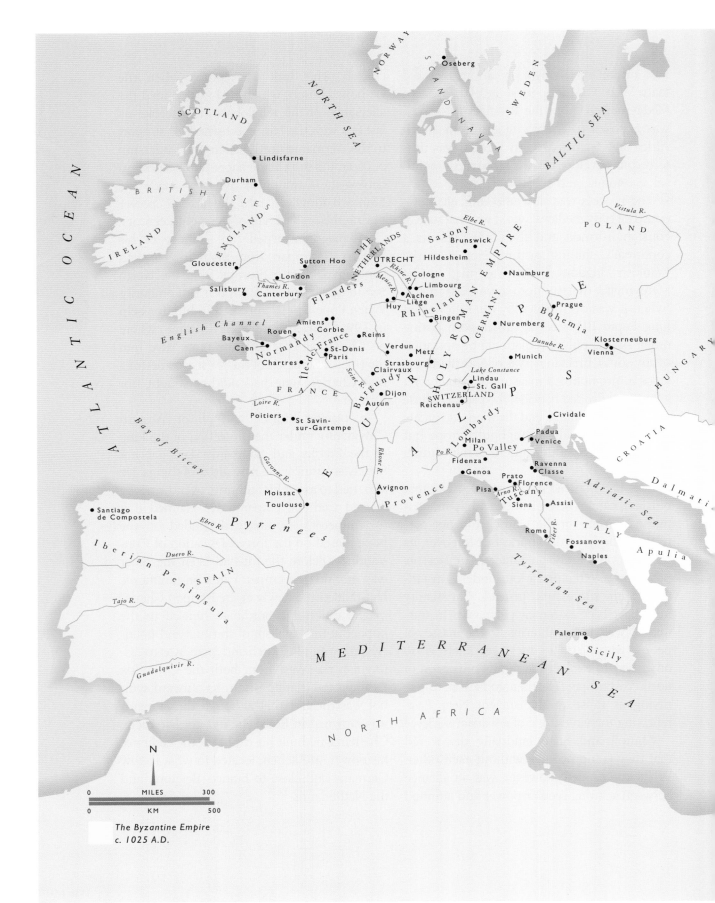

NORWAY

SWEDEN

• Oseberg

NORTH SEA

SCANDINAVIA

BALTIC SEA

SCOTLAND

ATLANTIC OCEAN

• Lindisfarne

BRITISH ISLES

• Durham

Vistula R.

POLAND

IRELAND

ENGLAND

Elbe R.

Saxony
• Brunswick

HOLY ROMAN EMPIRE

Gloucester •

• Sutton Hoo

• UTRECHT

Hildesheim •

E

• London
Salisbury • Thames R.
 Canterbury

THE NETHERLANDS

Rhine R.

Cologne •

Limbourg •

Naumburg •

Flanders

Meuse R.

Huy • Liège
 • Aachen

Rhineland

Bingen •

Prague •

Bohemia

GERMANY

Nuremberg •

English Channel

Amiens •

Corbie

Reims •

Verdun •

Danube R.

Klosterneuburg •

Bayeux •
Caen •

Rouen •

Normandy

St-Denis •

Paris •

Metz •

Vienna •

HUNGARY

Chartres •

Île-de-France

Strasbourg •

Munich •

Seine R.

Clairvaux •

Lake Constance

Lindau

St. Gall •

FRANCE

Burgundy

Dijon •

SWITZERLAND

Reichenau

A

L

P

S

Loire R.

Autun •

Poitiers •

• St Savin-
 sur-Gartempe

Po R.

Lombardy

Cividale •

Milan •

Padua •
Venice •

Po Valley

Garonne R.

Fidenza •

CROATIA

Moissac •

Rhône R.

Genoa •

Ravenna •
Classe

Adriatic Sea

Dalmatia

Toulouse •

Pisa •

Prato • Florence •

Arno R.

Tuscany

Siena •

Assisi •

Santiago
de Compostela •

Ebro R.

Pyrenees

Avignon •

Provence

ITALY

Iberian Peninsula

Duero R.

SPAIN

Rome •

Tiber R.

Fossanova •

Apulia

Tajo R.

Tyrrhenian Sea

Naples •

MEDITERRANEAN SEA

Palermo •

Sicily

Guadalquivir R.

Bay of Biscay

NORTH AFRICA

N

MILES
0 300

KM
0 500

The Byzantine Empire
c. 1025 A.D.

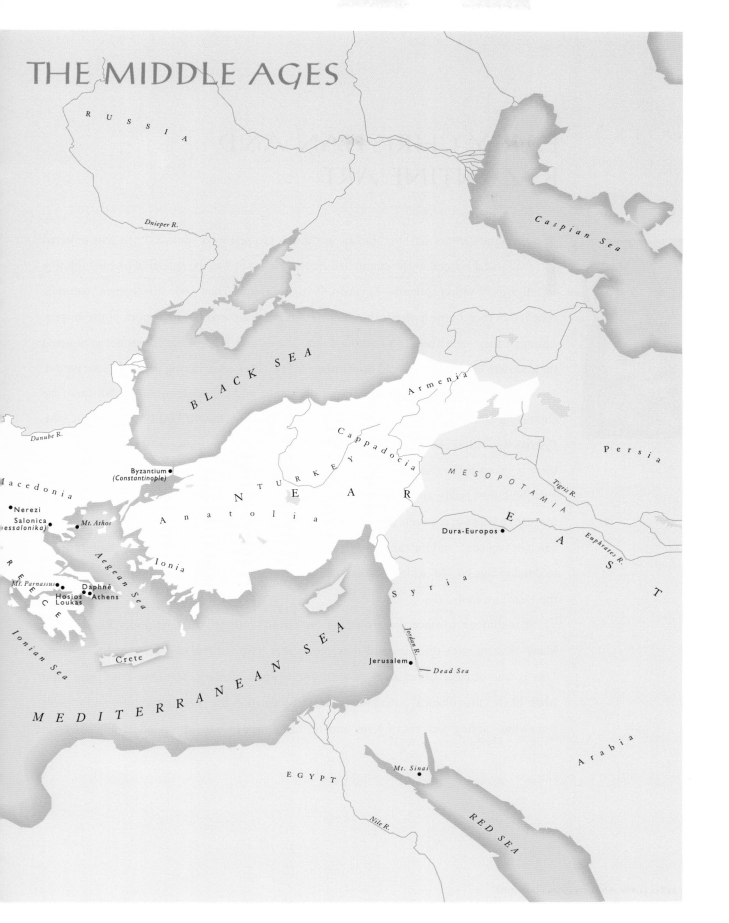

THE MIDDLE AGES

RUSSIA

Dnieper R.

Caspian Sea

BLACK SEA

Danube R.

Armenia

Cappadocia

Persia

MESOPOTAMIA

Macedonia

Byzantium
(Constantinople)

N TURKEY E A R

Tigris R.

Nerezi

Salonica
(Thessalonika)

Mt. Athos

Anatolia

Dura-Europos

E A S T

Euphrates R.

GREECE

Aegean Sea

Ionia

Mt. Parnassus

Daphnē

Hosios Athens
Loukas

Syria

Ionian Sea

Crete

Jordan R.

MEDITERRANEAN SEA

Jerusalem — Dead Sea

Arabia

EGYPT

Mt. Sinai

Nile R.

RED SEA

CHAPTER 8

EARLY CHRISTIAN AND BYZANTINE ART

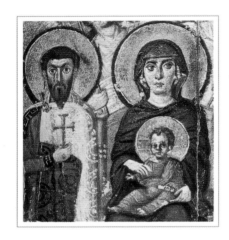

In the third century A.D. the Roman world was gripped by a spiritual crisis that reflected broad social turmoil as the empire fell apart. One result was the spread of oriental mystery religions of various origins—Egyptian, Persian, Semitic. Their early development naturally centered in their home territory, the southeastern provinces and border regions of the empire. Although they were based on traditions that had existed long before Alexander conquered these ancient lands, the cults had been influenced by Greek ideas during the Hellenistic period. In fact, they owed their appeal to a blend of oriental and Greek elements. At that time, the competing faiths in the Near East (including MITHRAISM, MANICHAEISM, GNOSTICISM, JUDAISM, CHRISTIANITY, and many more) tended to influence one another. As a result, all these religions had a number of things in common. Among these were a claim to both exclusivity and universality, an emphasis on revealed truth, the hope of salvation, a chief prophet or messiah, a belief in a cosmic struggle of good against evil, a ritual of purification or initiation (such as baptism), and the duty to seek converts among unbelievers. The last faith of this type to develop was ISLAM, which was founded in the seventh century and continues to dominate the Near East to this day.

It is difficult to trace the growth of the Graeco-oriental religions under Roman rule. Many of them were underground movements that have left few tangible remains or texts. This is true of early Christianity as well. The Gospels of Mark, Matthew, Luke, and John (their likely chronological order) were probably written in the later first century and present somewhat varying pictures of Jesus and his teachings. In part, these reflect differences in

doctrine between St. Peter, the first bishop of Rome, and St. Paul, the most important of the early converts and a tireless proselytizer. For the first three centuries after Christ, Christian congregations were reluctant to worship in public. Instead, their simple services took place in the houses of the wealthier members. At best, they made use of altars that were portable; there were few implements or vestments (special clothing worn by those who conducted the services). The new Christian faith spread first to the Greek-speaking communities, notably Alexandria, then eventually reached the Latin world by the end of the second century.

Even before it was declared a lawful religion in 261 by the emperor Gallienus, Christianity was rarely persecuted. It suffered chiefly under the tyrant Nero and under Diocletian. In 309 Galerius, who succeeded Diocletian, issued an edict of toleration. Still, the new faith had little standing until the conversion of Constantine the Great in 312, despite the fact that by then nearly one-third of Rome was Christian. Late in his life, according to Bishop Eusebius of Caesarea, the emperor recounted that on the eve of the battle against his rival Maxentius at the Milvian Bridge, over the Tiber River in Rome, there appeared in the sky the sign of the cross with the inscription, "In this sign, conquer." The next night, Christ came to Constantine in a dream with a sign (which must have been the CHI RHO monogram) and commanded him to copy it. He had the insignia inscribed on his helmet and on the military standards of his soldiers. After his victory, Constantine accepted the faith, if he had not done so already, although he was baptized only on his deathbed. The next year, 313, he and his fellow emperor, Licinius, issued the Edict of Milan, which proclaimed freedom of religion throughout the empire.

Although Constantine never made Christianity the official state religion, it enjoyed a special status under his rule. The emperor promoted it and helped shape its theology, partly in an effort to settle doctrinal disputes. Unlike the pagan emperors, Constantine could not be deified, but he did claim that his authority was granted by God. Thus he placed himself at the head of the Church as well as of the State. In doing so, he adapted an ancient tradition: the divine kingship of Egypt and the Near East. Although there is no doubt that Constantine's faith was sincere, he did set a pattern for future Christian rulers in that he employed religion for his own personal and imperial ends—for example, as means of continuing to promote the cult of the emperor.

Early Christian Art

We do not know when and where the first Christian works of art were produced. None of the surviving examples can be dated earlier than about 200 A.D. In fact, we know little about Christian art before the reign of Constantine the Great, because little remains from the third century. The painted decorations of the Roman CATACOMBS, the underground burial places of the Christians, are the only sizable body of material, but these are merely one of several kinds of Christian art that may have existed. Before that time, Rome was not the only center of faith. Older and larger Christian communities existed in the great cities of North Africa and the Near East, such as Alexandria and Antioch. They had probably developed separate artistic traditions of their own, but few traces of them survive, because the area where the development of the Graeco-oriental religions took place has seen so much war and destruction. There is enough evidence, however, to indicate that the new faiths also gave birth to a new style in art, and that this style blended Graeco-Roman and oriental elements.

CATACOMBS

The catacomb paintings tell us a good deal about the spirit of the communities that sponsored them, even though the lack of material from the eastern provinces of the empire makes it difficult to judge their role in the development of Christian art. The burial rite and the safeguarding of the tomb were of vital concern to the early Christians,

MITHRAISM, MANICHAEISM, and GNOSTICISM had as a common element a dualistic struggle between forces of good and evil. All three were mystery religions in the sense that all involved elaborate and secret initiations. All were monotheistic (one god) religions, as are JUDAISM and CHRISTIANITY.

ISLAM is practiced by Muslims. Islam has but one God, Allah, who revealed himself in the seventh century A.D. to a historical figure, the prophet Muhammad. (Muslims regard Old Testament prophets and Jesus as predecessors to Muhammad.) The Koran is the text of God's revelations to Muhammad. Because it forbids the representation of people and animals, Islamic art is highly decorative and incorporates much calligraphy into designs.

The CHI RHO sign, a monogram of Christ, is composed of the first two Greek letters of *Christos*: chi (x) and rho (p). It is also called the Chrismon or the Christogram.

Rome's vast network of CATACOMBS, dug into the tufa (porous rock) hills outside the city, preserves frescoes from about the third to the sixth century. Most of the epitaphs are in Greek rather than Latin—a reflection of the low social standing of the majority of early Christians. Among the Christian symbols found on the walls are anchors (symbolizing hope), fish (the Last Supper), doves (peace), the Good Shepherd (Christ), and depictions of Noah and Jonah.

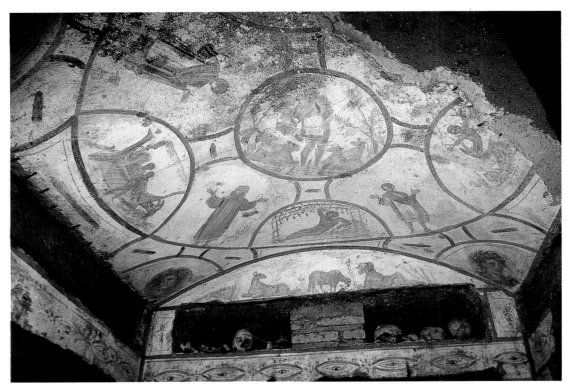

8-1 Painted ceiling, Catacomb of SS. Pietro e Marcellino, Rome. 4th century

whose faith rested on the hope of eternal life in heaven. In the painted ceiling in figure 8-1, the imagery clearly expresses this otherworldly outlook. The forms are still those of pre-Christian murals, and the division of the ceiling into compartments is a highly simplified echo of the architectural schemes that are found in Pompeian painting. The modeling of the figures, as well as the landscape settings, are also descended from Roman designs, although they have become debased by endless repetition. But the catacomb painter has little interest in the original meaning of the forms, which he has used to convey a new, symbolic content. Even the geometric framework shares in this task, for the great circle suggests the dome of heaven, inscribed with the Cross, the basic symbol of the faith. In the central medallion, or circle, we see a youthful shepherd, with a sheep on his shoulders, in a pose that can be traced back as far

as Greek Archaic art. He stands for Christ the Savior, the Good Shepherd who gives his life for his flock.

The semicircular compartments tell the story of Jonah. On the left he is cast from the ship, and on the right he emerges from the whale. At the bottom he is safe again on dry land, meditating upon the mercy of the Lord. This Old Testament miracle, often juxtaposed with those of the New Testament, enjoyed great favor in Early Christian art as proof of the Lord's power to rescue the faithful from the jaws of death. The standing figures with their hands raised in prayer (known as orants) may represent members of the Church. The entire scheme, however small in scale and unimpressive in execution it may seem, has a consistency and clarity that set it apart from its non-Christian ancestors. In the ceiling of the catacomb of SS. Pietro e Marcellino, we have at least the promise of a monumental new form.

Biblical, Church, and Celestial Beings

Much of Western art deals with biblical persons and celestial beings. Their names appear in titles of paintings and sculpture and in discussions of subject matter. The following is a brief guide to some of the most commonly encountered persons and beings in Christian art.

PATRIARCHS. Literally, heads of families, or rulers of tribes. The Old Testament patriarchs are Abraham, Isaac, Jacob, and Jacob's 12 sons. *Patriarch* may also refer to the bishops of the five chief bishoprics of Christendom: Alexandria, Antioch, Constantinople, Jerusalem, and Rome.

PROPHETS. In Christian art, *prophets* usually means the Old Testament figures whose writings were seen to foretell the coming of Christ. The so-called major prophets are Isaiah, Jeremiah, and Ezekiel. The minor prophets are Hosea, Joel, Amos, Obadiah, Jonah, Micah, Nahum, Habakkuk, Zephaniah, Haggai, Zechariah, and Malachi.

TRINITY. Central to Christian belief is the doctrine that One God exists in Three Persons: Father, Son (Jesus Christ), and Holy Spirit. The Holy Spirit is often represented as a dove.

HOLY FAMILY. The infant Jesus, his mother, Mary, and his foster father, Joseph, constitute the Holy Family. Sometimes Mary's mother, St. Anne, appears with them.

JOHN THE BAPTIST. The precursor of Jesus Christ, John is regarded by Christians as the last prophet before the coming of the Messiah, Jesus. John was an ascetic who baptized his disciples in the name of the coming Messiah; he recognized Jesus as that Messiah when he saw the Holy Spirit descend on Jesus when he came to John to be baptized.

EVANGELISTS. There are four: Matthew, John, Mark, and Luke—each an author of one of the Gospels. The first two were among Jesus' 12 apostles. The latter two wrote in the second half of the first century.

APOSTLES. The apostles are the 12 disciples Jesus asked to convert nations to his faith. They are Peter (Simon Peter), Andrew, James the Greater, John, Philip, Bartholomew, Matthew, Thomas, James the Less, Jude (or Thaddaeus), Simon the Canaanite, and Judas Iscariot. After Judas betrayed Jesus, his place was taken by Matthias. St. Paul (though not a disciple) is also considered an apostle.

DISCIPLES. See APOSTLES.

ANGELS and ARCHANGELS. Beings of a spiritual nature, angels are spoken of in the Old and New Testaments as having been created by God to be heavenly messengers between God and human beings, heaven and earth. Mentioned first by the apostle Paul, archangels, unlike angels, have names: Michael, Gabriel, and Raphael.

SAINTS. Persons are declared saints only after death. The pope acknowledges sainthood by canonization, a process based on meeting rigid criteria of authentic miracles and beatitude. He ordains a public cult of the new saint throughout the Catholic church. A similar process is followed in the Orthodox church.

MARTYRS. Originally, *martyrs* (witnesses) referred to all the apostles. Later, it signified those persecuted for their faith. Still later, the term was reserved for those who died in the name of Christ.

POPE. Meaning "father," the term refers to the bishop of Rome, the spiritual head of the Roman Catholic church. Today, the pope dwells in and heads an independent state, Vatican City, within the city of Rome. Throughout most of Christian history, the pope ruled a large territory that occupied much of central Italy. His chief attribute is a shepherd's staff; he dresses in white.

CARDINALS. Priests or higher religious officials chosen to help the pope administer the Church. They are of two types: those who live in Rome (the Curia) and those who remain in their dioceses. Together they constitute the Sacred College. One of their duties is to elect a pope after the death or removal of a sitting pope. They wear a red cassock (robe) and, depending on the occasion, one of three ceremonial hats.

DIOCESE. A territorial unit administered in the Western church by a BISHOP and in the Eastern church by a PATRIARCH. A cathedral is the diocesan church and the seat of the bishop.

BISHOPS and ARCHBISHOPS. A bishop is the highest order of minister in the Catholic church, with his administrative territory being the DIOCESE. Bishops are ordained by archbishops, who also have the authority to consecrate kings. They carry an elaborately curved staff that is called a crozier and, on ceremonial occasions, wear a three-pointed hat.

PRIESTS and PARISHES. Priests did not exist in the early Church, because only bishops were authorized to offer the Eucharist and receive confession. As the Church grew, church officials called presbyters (elders), or priests, were designated by bishops to perform the Eucharist and ablutions in smaller administrative units, called parishes.

ABBOTS and ABBESSES. Heads of large monasteries (abbeys) and convents (nunneries).

MONKS and NUNS. Men and women living in religious communities who have taken vows of poverty, chastity, and obedience to the rules of their orders.

ARCHITECTURE

Constantine's decision to make Christianity a favored religion of the Roman Empire had a profound impact on Christian art. Before then, the Church (*ecclesia*) was simply the congregation. (The Greek word *ekklesia* originally meant "the assembly of citizens.") Now, almost overnight, an impressive setting had to be created for the faith, so that the Church might be visible to all. To do so, however, involved rethinking the meaning of the Church itself. It now became identified with its expression in architecture, something that we take for granted but for which there had been no need before. To meet the challenge, Church leaders adapted existing types to new ends. Constantine devoted the full resources of his office to this task, and within a few years an astonishing number of large, imperially sponsored churches were built, not only in Rome but also in Constantinople, the Holy Land, and other important centers.

The most important structures were of a new type, now called the Early Christian basilica, which provided the basic model for the development of church architecture in western Europe. Although this type of building has features of an assembly hall, temple, and private house, it cannot be wholly explained in terms of its sources. The Early Christian basilica as we know it owes its essential character to the imperial basilicas built during the previous hundred years (see pages 130–31). The Roman basilica was not unique to Christianity, however. It had already been used by pagan cults and by Judaism. It was nevertheless a suitable model for Constantinian churches, since it combined the spacious interior needed to accommodate a large congregation with imperial associations that proclaimed the privileged status of Christianity. But a church had to be more than an assembly hall. In addition to serving as a meeting place for the faithful, it was the sacred House of God, literally the Heavenly Jerusalem. As such, it was the Christian successor to the temples of old. In order to express this function, the basilica had to be redesigned. The plan of the Early Christian basilica was given a new focus, the altar, which was placed in front of the semicircular apse at the eastern end of the **nave**. The entrances,

which in earlier basilicas had usually been on the flanks, were shifted to the western end. The Early Christian basilica was thus arranged along a single, longitudinal axis that is indebted to the layout of Greek temples, except that the latter faced eastward to greet the rising sun.

Unfortunately, none of the early Christian basilicas has survived in its original form. But a good deal is known about the greatest Constantinian church, Old St. Peter's in Rome (see the diagrams at the left). (It was torn down and replaced by the present church in the sixteenth and seventeenth centuries; see figs. 13-12 and 17-8). Old St. Peter's, begun as early as 319 and finished by 329, was built on the Vatican hill next to a pagan burial ground. It lies directly over the grave of St. Peter and thus served mainly as a **martyrium** of the apostle. (*Martyr* originally meant "witness" in Greek and only later came to denote someone willing to die for faith.) The basic plan follows the precedent set by the basilica of S. Giovanni in Laterano, Constantine's first major church, begun about 313 as the cathedral of the bishop of Rome. Old St. Peter's, which was covered by a wooden roof, had a long nave lit by clerestory windows and flanked by aisles. The apse was not at the east but at the west end of the church, which also included a **transept**, a separate compartment of space placed at right angles to the nave and aisles to form a cross. The plan also shows the entrance hall (**narthex**) and the colonnaded court (**atrium**).

S. Apollinare in Classe The sixth-century Church of S. Apollinare in Classe, near Ravenna (figs. 8-2, 8-3), is the best preserved of the Early Christian basilicas. (S. Apollinarus was the first bishop of Ravenna; Classe is the seaport of Ravenna, which originally was a naval station on the Adriatic.) Our view, taken from the west, shows the narthex but not the atrium, which was torn down long ago. The church is similar in plan to Old St. Peter's, except that it has single aisles and the transept was omitted, as it was in many early churches. (The round bell tower, or **campanile**, is a medieval addition.)

S. Apollinare in Classe shows another essential aspect of Early Christian religious architecture,

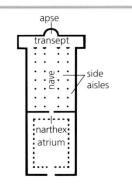

This plan for Old St. Peter's in Rome has two features not present in S. Apollinare in Classe (see fig. 8-2): a transept and an atrium forecourt.

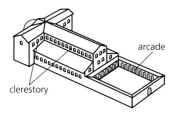

The oblique view shows clearly the rows of clerestory windows in the transept and nave and reveals the open arches (arcades) around the inside of the atrium.

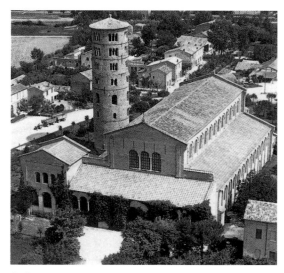

8-2 S. Apollinare in Classe, near Ravenna. 533–49

that is, the contrast between exterior and interior. The plain brick exterior is merely a shell, shaped to reflect the space it encloses—the opposite of the Classical temple. This antimonumental treatment of the exterior gives way to the utmost richness as we enter the church proper. Having left the everyday world behind, we find ourselves in a shimmering realm of light and color where precious marble surfaces and the brilliant glitter of **mosaics** evoke the spiritual splendor of the Kingdom of God. The steady rhythm of the nave **arcade** pulls us toward the great "triumphal" arch at the eastern end, which frames the altar and the vaulted apse beyond.

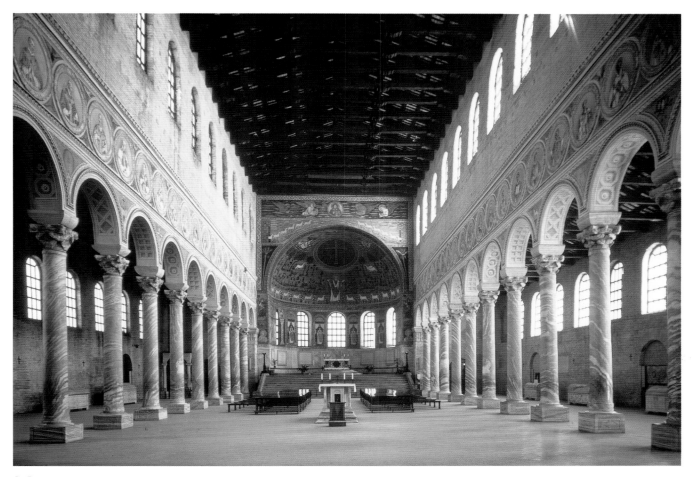

8-3 Interior (view toward the apse), S. Apollinare in Classe

MOSAICS

The rapid growth of Christian architecture on a large scale had a revolutionary effect on Early Christian art. All of a sudden, huge wall surfaces had to be covered with images worthy of their monumental framework. Who was equal to this challenge? Certainly not the humble artists who had decorated the catacombs. They were replaced by masters of greater ability, who were probably recruited by officials of the empire, as were the architects of the new basilicas. Unfortunately, very little of the decoration of fourth-century churches has survived, and so it is not possible to trace its history in any detail.

Out of this process emerged a great new art form, the Early Christian wall mosaic, which to a large extent replaced the older and cheaper medium of mural painting. Mosaics—designs composed of small pieces of colored material set in plaster—had been used by the Sumerians as early as the third millennium B.C. to decorate architectural surfaces. The Hellenistic Greeks and the Romans, using small cubes of marble called **tesserae**, had refined the technique to the point that it could copy paintings, as in *The Battle of Issos* (see fig. 5-5). But these were mostly floor mosaics, and the color scale, although rich in gradations, lacked brilliance, since it was limited to the various kinds of colored marble found in nature. The Romans also produced wall mosaics occasionally, but only for special purposes and on a limited scale.

The extensive and complex wall mosaics of Early Christian art are thus essentially without precedent. The same is true of their material. They consist of tesserae made of colored glass, which the Romans had known but never fully exploited. Glass tesserae offered colors, including gold, of a far greater range and intensity than marble tesserae, but they lacked the fine gradations in tone needed to imitate painted pictures. Moreover, the shiny (and slightly irregular) faces of glass tesserae act as tiny reflectors, so that the overall effect is that of a glittering, immaterial screen rather than of a solid, continuous surface. All these qualities made glass mosaic the ideal material for the new architectural aesthetic of

Early Christian basilicas. The brilliant color, the brightness of gold, the severe geometric order of the images in a mosaic cycle such as that of S. Apollinare in Classe—all fit the spirit of these interiors to perfection. One might say, in fact, that Early Christian and Byzantine churches demand mosaics the way Greek temples demand architectural sculpture.

Early Sources The challenge of inventing a body of Christian imagery produced an extraordinary creative outpouring, and by 500 A.D. the process was largely complete. It took less than two centuries to lay the foundation for a new artistic tradition—a remarkably short time indeed! The development of Christian imagery was interwoven with that of architecture. The earliest church decorations probably consisted of ornamental designs in marble, plaster, stucco, or even gold. Soon, however, great pictorial cycles of subjects selected from the Old and New Testaments were spread over the nave walls, the triumphal arch, and the apse; these were executed first in painting, then in mosaic. Much of the initial development seems to have occurred during the fifth century A.D.

These cycles must have drawn upon sources that reflected the whole range of Graeco-Roman painting as well as the art of other Christian centers. Paintings in an Orientalizing style may have decorated the walls of Christian places of worship in Syria and Palestine. (The earliest Christian congregations were formed by dissident members of the Jewish community.) Moreover, during the first or second century A.D., Alexandria, the home of a large, Hellenized Jewish colony, may have produced illustrations of the Old Testament in a style akin to that of Pompeian murals. We meet echoes of such scenes in Christian art later on, but we cannot be sure when or where they originated, or by what paths they entered the Christian tradition. The importance of Judaic sources for Early Christian art is hardly surprising: the new faith also incorporated many aspects of the Jewish service into its own liturgy. These included hymns, which later formed the basis of medieval chants.

MAJOR DATES IN THE EARLY CHRISTIAN AND BYZANTINE PERIODS

c. 1st–6th century	Early Christian period
330	Constantine relocates capital to Constantinople
395	Roman Empire permanently divided
526–726	Early Byzantine period
c. late 9th–11th century	Middle Byzantine period
1054	Christian Church split into Eastern (Orthodox) and Western (Catholic) churches
c. 12th–mid-15th century	Late Byzantine period
1453	Byzantine Empire ends when Turks capture Constantinople

Sta. Maria Maggiore Roman mural painting used illusionistic devices to suggest a reality beyond the surface of the wall. Early Christian mosaics also denied the flatness of the wall surface, but their goal was to achieve an "illusion of unreality," a luminous realm filled with celestial beings or symbols. In Early Christian narrative scenes we see the illusionistic tradition of ancient painting being transformed by new content.

The Parting of Lot and Abraham (fig. 8-4) is a scene from the oldest and most important surviving mosaic cycle of this kind. It was done about 432–40 in the church of Sta. Maria Maggiore in Rome. In the left half of the scene, Abraham, his son Isaac, and the rest of his family depart for the land of Canaan. On the right, Lot and his clan, including his two small daughters, turn toward the city of Sodom. The task of the artist who designed our panel is similar to that of the sculptors of the Column of Trajan (see fig. 7-15). They needed to condense complex actions into a form that could be read at a distance. In fact, many of the same "shorthand" devices are employed, such as the formulas for house, tree, and city, as well as the trick of showing a crowd of people as a "grape-cluster of heads."

In the Trajanic reliefs, these devices could be used only to the extent that they allowed the artist to re-create actual historical events. The mosaics in Sta. Maria Maggiore, by contrast, depict the history of salvation. They begin with Old Testament scenes along the nave (in this instance from Genesis 13) and end with the life of Jesus as the Messiah on the arch across the nave. The scheme is not only a historical cycle but a symbolic program that presents a higher reality— the Word of God. Hence the artist need not be concerned with the details of historical narrative. Glances and gestures are more important than movement or three-dimensional form. The symmetrical composition, with its gap in the center, makes clear the significance of this parting. The way of righteousness is represented by Abraham, the way of evil by the city of Sodom, which was destroyed by the Lord.

8-4 *The Parting of Lot and Abraham.* Mosaic in Sta. Maria Maggiore, Rome. c. 432–40

ROLL, BOOK, AND ILLUSTRATION

From what sources did the designers of mosaic cycles such as those at Sta. Maria Maggiore derive their compositions? They were certainly not the first to depict scenes from the Bible (see box, page 160) in extensive fashion. For certain subjects, they could have found models among the catacomb murals, but some prototypes may also have come from illustrated manuscripts. Because they were portable, manuscripts were assigned an important role in disseminating religious imagery. In some cases there is no doubt that manuscript illustrations served as models for wall paintings. In others it is clear that murals must have been derived ultimately from frescoes, especially when the similarities between two pictures point to a common source.

Because it was founded on the Word of God as revealed in Holy Writ, the early Christian Church must have sponsored the duplicating of the sacred text on a large scale. Every copy of it was handled with a reverence quite unlike the treatment of any book in Graeco-Roman civilization. But when did these copies become works of pictorial art as well? And what did the earliest Bible illustrations look like?

Because books are frail things, we have only indirect evidence of their history in the ancient world. It begins in Egypt with the discovery of a suitable material, paperlike but more brittle, derived from the papyrus plant (see page 51). Books of papyrus were made in the form of rolls throughout antiquity. Not until the second century B.C., in late Hellenistic times, did a better substance become available. This was parchment, or **vellum** (thin, bleached animal hide), which is far more durable than papyrus. It was strong enough to be creased without breaking and thus made possible the kind of bound book we know today, technically called a codex, which appeared sometime in the late first century A.D.

Between the second and fourth centuries A.D., the vellum codex gradually replaced the roll. This change must have had an important effect on book illustration. As long as the roll form prevailed, illustrations seem to have been mostly line drawings, since layers of pigment would soon have cracked and come off in the process of rolling and unrolling. Only the vellum codex permitted the use of rich colors, including gold. Hence, it would make book illustration—or, as we usually say, manuscript **illumination**—the small-scale counterpart of murals, mosaics, and panel pictures. There can be little doubt that the earliest illuminations, whether Christian, Jewish, or classical, were strongly influenced by the illusionism of Hellenistic-Roman painting of the sort we met at Pompeii. Some questions are still unanswered: When, where, and at what pace did book illumination develop? Were most early subjects biblical, mythological, or historical? How much of a carryover was there from roll to codex?

Versions of the Bible

The word *bible* is derived from the Greek word for "books," since it was originally a compilation of a number of sacred texts. Over time, the books of the Bible came to be regarded as a unit, and thus the Bible is now generally considered a single book.

There is considerable disagreement between Christians and Jews, and among various Christian and Jewish sects, over which books should be considered canonical—that is, accepted as legitimate parts of the biblical canon, the standard list of authentic texts. However, every version of the Bible includes the Hebrew TORAH, or the Law (also called the PENTATEUCH, or Books of Moses), as the first five books. Also universally accepted by both Jews and Christians are the books known as the Prophets (which include texts of Jewish history as well as prophecy). There are also a number of other books known simply as the Writings, which include history, poetry (the Psalms and the Song of Songs), prophecy, and even folktales, some universally accepted, some accepted by one group, and some accepted by virtually no one. Books of doubtful authenticity are known as APOCRYPHAL BOOKS, or simply Apocrypha, from a Greek word meaning "obscure." The Jewish Bible or Hebrew Canon—the books that are accepted as authentic Jewish scripture—was agreed upon by Jewish scholars sometime before the beginning of the Christian era.

The Christian Bible is divided into two major sections, the OLD TESTAMENT and the NEW TESTAMENT. The Old Testament contains many, but not all, of the Jewish scriptures, while the New Testament, originally written in Greek, is specifically Christian. It contains four GOSPELS—each written in the first century A.D. by one of the Early Christian missionaries known as the four EVANGELISTS, Mark, Matthew, Luke, and John. The Gospels tell, from slightly different points of view, the story of the life and teachings of Jesus of Nazareth. They are followed by the EPISTLES, letters written by Paul and a few other Christian missionaries to various congregations of the Church. The final book is the APOCALYPSE, by John the Divine, also called the Book of Revelation, which foretells the end of the world.

Jerome (342–420), the foremost scholar of the early Church, selected the books considered canonical for the Christian Bible from a large body of Early Christian writings. It was because of his energetic advocacy that the Church accepted the Hebrew scriptures as representing the Word of God as much as the Christian texts, and therefore worthy to be included in the Bible. Jerome then translated the books he had chosen from Hebrew and Greek into Latin, the spoken language of Italy in his time. This Latin translation of the Bible was—and is—known as the VULGATE because it was written in the vernacular (Latin *vulgaris*) language. The Vulgate remained the Church's primary text for the Bible for more than a thousand years. It was regarded with such reverence that in the fourteenth century, when early humanists first translated it into the vernacular languages of their time, they were sometimes suspected of heresy for doing so. The writings rejected for inclusion in the New Testament by Jerome are known as Christian Apocrypha. Although not canonical, some of these books, such as the Life of Mary and the Gospel of James, were nevertheless used by artists and playwrights during the Middle Ages as sources for stories to illustrate and dramatize.

Vienna Genesis The oldest illustrated Bible manuscripts discovered thus far appear to date from the early sixth century, except for one fragment of five leaves that is probably a hundred or so years earlier. They, too, contain echoes of the Hellenistic-Roman style, which has been adapted to religious narrative but often has a Near Eastern flavor. The most important example is the *Vienna Genesis* (fig. 8-5). This Greek translation of the first book of the Bible achieves a sumptuous effect not unlike that of the mosaics we have seen. It is written in silver (now turned black) on vellum and adorned with brilliantly colored **miniatures** (small color illustrations). Our page shows a number of scenes from the story of Jacob. (In the center foreground, for example, we see him wrestling with the angel,

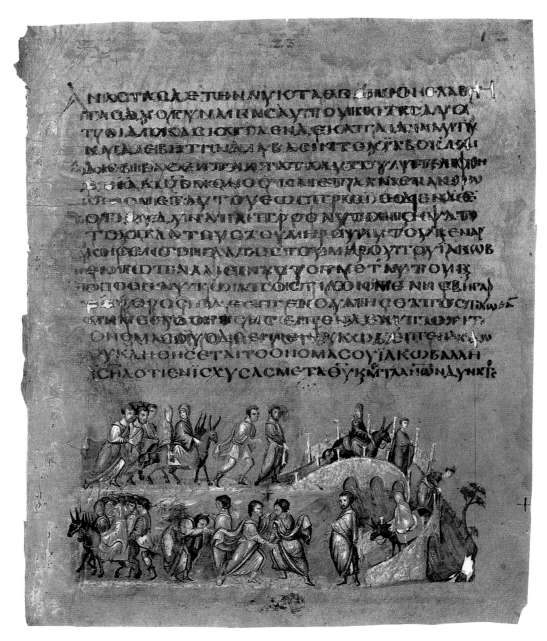

8-5 Page with *Jacob Wrestling the Angel,* from the *Vienna Genesis.* Early 6th century. Tempera and silver on dyed vellum, 13¼ x 9½" (33.7 x 24.1 cm). Österreichische Nationalbibliothek, Vienna

then receiving the angel's blessing.) The picture thus does not show a single event but a whole sequence. The scenes are strung out along a single U-shaped path, so that progression in space becomes progression in time. This method, known as continuous narration, has a history going back as far as ancient Egypt and Mesopotamia. Its appearance in miniatures such as that shown in figure 8-5 may reflect earlier illustrations made for books in roll form: our picture certainly does look like a frieze turned back upon itself.

For manuscript illustration, the continuous method makes the most economical use of space. The painter can pack a maximum of narrative content into the area at his disposal. Our artist seems to have thought of his picture as a running account to be read like lines of text rather than as a window that required a frame. The painted forms are placed directly on the purple background that holds the letters, making the entire page a unified field.

SCULPTURE

Compared with painting and architecture, sculpture was less significant in Early Christian art. The biblical prohibition of graven (carved) images in the Second Commandment was thought to apply particularly to large cult statues, the idols that were worshiped in pagan temples. To escape the taint of idolatry, therefore, religious sculpture had to avoid life-size representations of the human figure. It thus developed away from the spatial depth and massive scale of Graeco-Roman sculpture toward small-scale forms and lacelike surface decoration.

The earliest works of Christian sculpture are marble **sarcophagi**. These evolved from the pagan examples that replaced cinerary urns in Roman society toward the middle of the second century, when belief in an afterlife arose as part of a major change in the attitude toward death. From the middle of the third century on, these stone coffins were also made for the more important members of the Christian Church. Before the time of Constantine, they were decorated mainly with themes that are familiar from catacomb murals—the Good Shepherd, Jonah and the Whale, and so forth—but within a framework borrowed from pagan art. Not until a century later do we find a much broader range of subjects and forms.

Covenants Old and New

By convention, Western history is divided into two epochs separated by the birth of Jesus: B.C. (Before Christ) and A.D. (*Anno Domini*, "year of our Lord"), also called C.E. (Christian Era). To Christians, these periods correspond to the Old and New Testaments. Consequently they are also known as the Old Dispensation, which is the Covenant of the Ark, and the New Dispensation, the covenant represented by the cup of wine at the Last Supper, when Jesus said, "This is my blood of the new testament, which is shed for many." The Christian era is often termed the time of grace, or the *tempus gratia*, in contrast to the time of God's law as received by Moses, or the *tempus legem*.

The Covenant of the Ark bound the Israelites to worship Yahweh as their only god in exchange for being his chosen people. The ark consisted of the two tablets containing the Ten Commandments given to Moses on Mount Sinai; hence the Covenant of the Ark is also called the Covenant of Sinai. The ark resided at Shiloh in Canaan, the Promised Land, until it was brought by King David to Jerusalem, where it was later placed inside the tabernacle of the temple built by King Solomon. To many Christians, Jesus was the sacrificial lamb whose death atoned for the Jews' violation of the old covenant, which was therefore replaced by the new. To Muslims, Islam adds the Last Covenant, made between Muhammad and God, as revealed in the Koran.

Sarcophagus of Junius Bassus The finest Early Christian sarcophagus is the richly carved example made for Junius Bassus, a prefect of Rome who died in 359 (fig. 8-6). Its colonnaded front, divided into ten square compartments, shows a mixture of Old and New Testament scenes. In the upper row we see (left to right) the Sacrifice of Isaac, St. Peter Taken Prisoner, Christ Enthroned between Sts. Peter and Paul, and Christ before Pontius Pilate (two compartments). In the lower row are the Misery of Job, the Temptation of Adam and Eve, Christ's Entry into Jerusalem, Daniel in the Lions' Den, and St. Paul Led to His Martyrdom. The choice of scenes from Jesus' life, which may seem somewhat strange to the modern viewer, is characteristic of the Early Christian way of thinking, which stressed his divine rather than his human nature. Hence his suffering and death are merely hinted at.

Christ appears before Pilate as a youthful, long-haired philosopher expounding the true wisdom (note the scroll). The martyrdom of the two apostles is shown in the same discreet fashion. The two central scenes are also devoted to Jesus (see box, pages 164–65). Enthroned above Jupiter as the personification of the heavens, he dispenses the Law to Sts. Peter and Paul. Below, he enters Jerusalem as Conquering Savior. Adam and Eve, the original sinners, denote the burden of guilt redeemed by Christ. The Sacrifice of Isaac is an Old Testament prefiguration of Christ's death and resurrection. Job and Daniel carry the same message as Jonah in the catacomb painting (see fig. 8-1): they fortify the hope of salvation. The figures in their deeply recessed niches still recall the statuesque dignity of the Greek and Roman tradition. (Compare Eve to the *Knidian Aphrodite* of Praxiteles, fig. 5-22.) Yet beneath this classicism we sense a kinship to the Constantinian style in the large heads. The events and figures are no longer intended to tell their own story but to call to mind a symbolic meaning that unites them. Hence the passive air of scenes that would otherwise seem to call for dramatic action.

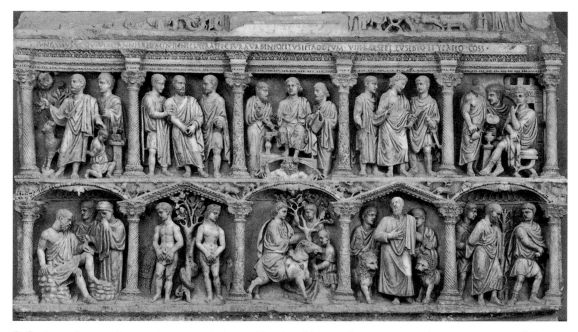

8-6 *Sarcophagus of Junius Bassus.* c. 359. Marble, 3'10¹/₂" x 8' (1.18 x 2.44 m). Museo Storico del Capitolino di San Pietro, Rome

Events in the life of Jesus, from his birth through his ascension to heaven, are traditionally grouped in cycles, each with numerous episodes. The scenes most frequently depicted in European art are presented here.

INCARNATION CYCLE and THE CHILDHOOD OF JESUS

These episodes concern Jesus' conception, birth, infancy, and youth.

ANNUNCIATION. The archangel Gabriel tells Mary that she will bear God's son. The Holy Spirit, shown usually as a dove, represents the Incarnation, the miraculous conception.

VISITATION. The pregnant Mary visits her older cousin Elizabeth, who is to bear John the Baptist and who is the first to recognize the divine nature of the baby Mary is carrying.

NATIVITY. At the birth of Jesus, the Holy Family—Mary, his foster father, Joseph, and the child—is usually depicted in a stable or, in Byzantine representations, in a cave.

ANNUNCIATION TO THE SHEPHERDS and ADORATION OF THE SHEPHERDS. An angel announces the birth of Jesus to shepherds in the field at night. The shepherds then go to the birthplace to pay homage to the child.

ADORATION OF THE MAGI. The Magi, wise men from the East (called the Three Kings in the Middle Ages), follow a bright star for 12 days until they find the Holy Family and present their gifts to Jesus.

PRESENTATION IN THE TEMPLE. Mary and Joseph take the baby Jesus to the Temple in Jerusalem, where Simeon, a devout man, and Anna, a prophetess, foresee Jesus' messianic (savior's) mission and martyr's death.

MASSACRE OF THE INNOCENTS and FLIGHT INTO EGYPT. King Herod orders all children under the age of two in and around Bethlehem to be killed in order to preclude his being murdered by a rival newborn king spoken of in a prophecy. The Holy Family flees to Egypt.

PUBLIC MINISTRY CYCLE

BAPTISM. John the Baptist baptizes Jesus in the Jordan River, recognizing Jesus' incarnation as the Son of God. This marks the beginning of Jesus' ministry.

CALLING OF MATTHEW. A tax collector, Matthew, becomes Jesus' first disciple (apostle) when Jesus calls to him, "Follow me."

JESUS WALKING ON THE WATER. During a storm, Jesus walks on the water of the Sea of Galilee to reach his apostles in a boat.

RAISING OF LAZARUS. Jesus brings his friend Lazarus back to life four days after Lazarus's death and burial.

DELIVERY OF THE KEYS TO PETER. Jesus names the apostle Peter his successor by giving him the keys to the Kingdom of Heaven.

TRANSFIGURATION. As Jesus' closest disciples watch, God transforms Jesus into a dazzling vision and proclaims him to be his own son.

CLEANSING THE TEMPLE. Enraged, Jesus clears the Temple in Jerusalem of money changers and animal traders.

PASSION CYCLE

The Passion (from *passio*, Latin for "suffering") cycle relates Jesus' death, resurrection from the dead, and ascension to heaven.

ENTRY INTO JERUSALEM. Welcomed by crowds as the Messiah, Jesus triumphantly rides an ass into the city of Jerusalem.

LAST SUPPER. At the Passover seder, Jesus tells his disciples of his impending death and lays the foundation for the Christian rite of the Eucharist: the taking of bread and wine in remembrance of Christ. (Strictly speaking, Jesus is called Jesus until he leaves his earthly physical form, after which he is called Christ.)

JESUS WASHING THE DISCIPLES' FEET. Following the Last Supper, Jesus washes the feet of his disciples to demonstrate humility.

AGONY IN THE GARDEN. In Gethsemane, the disciples sleep while Jesus wrestles with his mortal dread of suffering and dying.

BETRAYAL (ARREST). The disciple Judas Iscariot takes money to identify Jesus to Roman soldiers. Jesus is arrested.

DENIAL OF PETER. As Jesus predicted, Peter, waiting outside the high priest's palace, denies knowing Jesus three times as Jesus is being questioned by the high priest, Caiaphas.

JESUS BEFORE PILATE. Jesus is questioned by the Roman governor Pontius Pilate regarding whether he calls himself King of the Jews. Jesus does not answer. Pilate reluctantly condemns him.

FLAGELLATION (SCOURGING). Jesus is whipped by Roman soldiers.

JESUS CROWNED WITH THORNS (THE MOCKING OF CHRIST). Pilate's soldiers mock Jesus by dressing him in robes, crowning him with thorns, and calling him King of the Jews.

CARRYING OF THE CROSS (ROAD TO CALVARY). Jesus carries the wooden cross on which he will be executed from Pilate's house to the hill of Golgotha, "the place of the skull."

CRUCIFIXION. Jesus is nailed to the Cross by his hands and feet, and dies after great physical suffering.

DESCENT FROM THE CROSS (DEPOSITION). Jesus' followers lower his body from the Cross and wrap it for burial. Also present are the Virgin, the apostle John, and in some accounts Mary Magdalen.

LAMENTATION (PIETÀ or *VESPERBILD*). The grief-stricken followers gather around Jesus' body. In the Pietà, his body lies in the lap of the Virgin.

ENTOMBMENT. The Virgin and others place the wrapped body in a sarcophagus, or rock tomb.

DESCENT INTO LIMBO (HARROWING OF HELL or *ANASTASIS* in the Orthodox Church). Christ descends to hell, or limbo, to free deserving souls who have not heard the Christian message—the

Byzantine Art

It is the religious, even more than the political, separation of East and West that makes it impossible to discuss the development of Christian art in the Roman Empire under a single heading. *Early Christian* does not, strictly speaking, designate a style. It refers, rather, to any work of art produced by or for Christians during the time prior to the splitting off of the Orthodox Church—roughly, the first five centuries after Christ. *Byzantine*, on the other hand, designates not only the art of the eastern Roman Empire but a specific culture and a quality of style as well. Hence, the terms are by no means equivalents.

There is no clear-cut line between Early Christian and Byzantine art. It could be argued that a Byzantine style (that is, a style linked to the imperial court of Constantinople) can be seen in Early Christian art as early as the beginning of the fourth century, soon after the division of the empire. However, we have avoided making this distinction. East Roman and West Roman—or, as some scholars prefer to call them, Eastern and Western Christian—characteristics are difficult to separate before the sixth century. Until that time, both areas contributed to the development of Early Christian art, but as the West declined, the leadership tended to shift to the East. This process was completed during the reign of Justinian, who ruled the Eastern Empire from 527 to 565. Constantinople not only reasserted its political dominance but became the artistic capital as well. Justinian himself was a man of strongly Latin orientation, and he almost succeeded in reuniting the Constantinian domain. The monuments he sponsored have a grandeur that justifies the claim that his era was a golden age. In addition, they display an inner unity of style that links them more strongly with the future development of Byzantine art than with the art of the past.

The political and religious cleavage between East and West became an artistic cleavage as well. In western Europe, Celtic and Germanic peoples fell heir to the civilization of late antiquity, of which Early Christian art had been a part, and transformed it into that of the Middle Ages. The East, in contrast, experienced no such break. Late antiquity lived on in the Byzantine Empire, although the Greek and oriental elements came increasingly to the fore at the expense of the Roman heritage. A sense of tradition, of continuity with the past, was central to the development of Byzantine art.

EARLY BYZANTINE ART

The finest of the Early Byzantine monuments (526–726 A.D.) survive not in Constantinople, where much has been destroyed, but in the town of Ravenna in Italy. Ravenna had become the capital first of the West Roman emperors in 402 and then, at the end of the century, of Theodoric, king of the Ostrogoths, whose tastes were patterned after those of Constantinople, where he had spent a decade as a young man. Under Justinian, Ravenna became the main stronghold of Byzantine rule in Italy.

S. Vitale, Ravenna The most important church of that time, S. Vitale (figs. 8-7, 8-8), was begun by Bishop Ecclesius in 526, just before Theodoric's death. It was continued under Bishop Ursicinus and Bishop Victor, but built chiefly in 540–47 under Bishop Maximianus, who also consecrated S. Apollinare in Classe two years later. Dedicated to a minor figure whose body had been rediscovered at Bologna, S. Vitale functioned as a martyrium. The type of structure is derived mainly from Constantinople. Its plan shows only the barest remnants of the longitudinal axis of the Early Christian basilica. Toward the east is a cross-vaulted compartment for the altar, backed by an apse. On the other side is a narthex, whose odd, nonsymmetrical placement has never been fully explained. Otherwise the plan is octagonal with a domed central space that makes it a descendant of Roman baths. (The design of the Pantheon was derived from that source as well; see fig. 7-3.) However, the intervening development seems to have taken place in the East, where domed churches of various kinds had been built during the previous century.

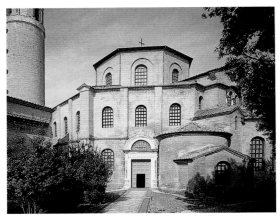

8-7 S. Vitale, Ravenna. 526–47

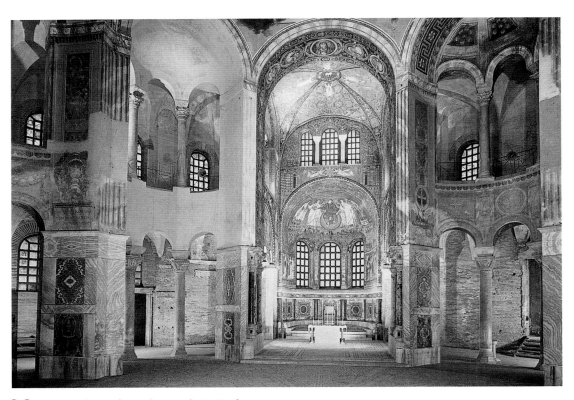

8-8 Interior (view from the apse), S. Vitale

When we recall S. Apollinare in Classe (see figs. 8-2 and 8-3), built at the same time on a straightforward basilican plan with funds from the same donor, we are struck by how different S. Vitale is. How did it happen that the East favored a type of church building so unlike the basilica? A number of reasons, practical, religious, and political, have been suggested. All of them may be relevant, but none is fully persuasive. After all, the design of the basilica had been backed by the authority of Constantine; yet it was never as popular in the East as it had been in the West since early imperial times. Moreover, it was Constantine who built the first **central-plan churches** in Constantinople, thereby helping to establish the preference for the type in the East. In any case, domed, central-plan churches were to dominate the world of Orthodox Christianity as thoroughly as the basilican plan dominated the architecture of the medieval West.

S. Vitale is notable for the richness of its spatial effect. The circular nave is ringed by an aisle, or **ambulatory**. Below the clerestory, this central space turns into a series of semicircular niches that penetrate into the aisle and thus link it to the nave in a new way. The aisle itself has a second story, known as the **gallery**, and these may have been reserved for women. A new economy in the construction of the vaulting permits large windows on every level of the church, and these flood the interior with light. The complexity of the interior of S. Vitale is fully matched by its lavish decoration.

S. Vitale's link with the Byzantine court can be seen in the two famous mosaics flanking the altar (figs. 8-9, 8-10, page 168). These depict Justinian and his empress, Theodora, accompanied by officials, the local clergy, and ladies-in-waiting, about to enter the church from the atrium at the beginning of the Byzantine liturgy (the Little Entrance). Although they did not attend the actual event, the royal couple are shown as present at the consecration of S. Vitale. The purpose is to demonstrate their authority over Church and State, as well as their support for Maximianus, who at first was unpopular with the citizens of Ravenna.

In these large panels, whose design was most likely a product of the imperial workshop, we find an ideal of beauty that is extraordinarily different from the squat, large-headed figures we have encountered in the art of the fourth and fifth centuries.

Despite a few glimpses of this new ideal in previous works (see figs. 8-1 and 8-14), only now do we see it complete. The figures are tall and slim, with tiny feet, small almond-shaped faces dominated by huge eyes, and bodies that seem to be capable only of ceremonial gestures and the display of magnificent costumes. There is no hint of movement or change. The dimensions of time and earthly space have given way to an eternal present in the golden setting of heaven. Hence the solemn, frontal images seem to belong to a celestial rather than a secular court. This union of political and spiritual authority reflects the "divine kingship" of the Byzantine emperor. Justinian and Theodora are portrayed as analogous to Christ and the Virgin. Justinian is flanked by 12 companions—the equivalent of the 12 apostles. (Six are soldiers, crowded behind a shield with the monogram of Christ.) The embroidery on the hem of Theodora's mantle shows the three Magi carrying their gifts to Mary and the newborn King. Its exact meaning is not clear: it may refer to the Eucharist, the Second Coming, or, more likely, the royal couple as donors of the church.

Justinian, Theodora, and the other main figures were surely meant to be individual likenesses. Their features are differentiated to some degree—especially those of Maximianus and Julianus Argentarius, the banker who underwrote the building. But the ideal has molded the faces as well as the bodies, so that they all resemble one another. We shall meet the same large, dark eyes under curved brows, the same small mouths and long, narrow noses countless times from now on in Byzantine art. As we turn from these mosaics to the interior space of S. Vitale (see fig. 8-8), we come to realize that it, too, shares the quality of dematerialized, soaring slenderness that endows the courtly figures with an air of mute exaltation.

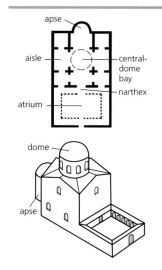

A **central-plan church** may be in the form of a square, as in this generalized plan of an Early Christian structure, a polygon, or a Greek cross, with its four "arms" intersecting at the crossing. The dome sits over the central bay.

The vertical axiality of central-plan buildings is distinctive. Otherwise, central-plan churches share elements with basilica-plan churches: narthex, nave, aisles, crossing (under the dome), and apse. Not every Early Christian and Byzantine church had an atrium.

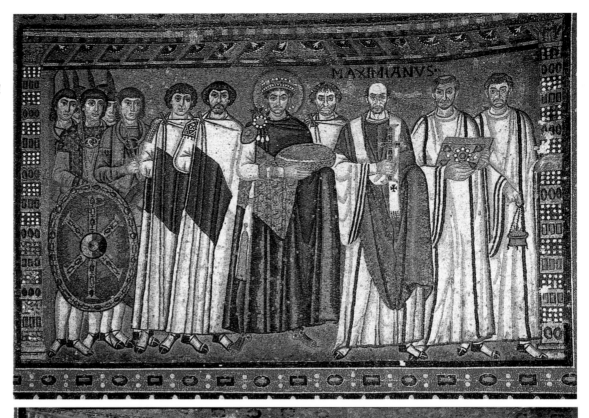

8-9 *Emperor Justinian and His Attendants.* Mosaic in S. Vitale. c. 547

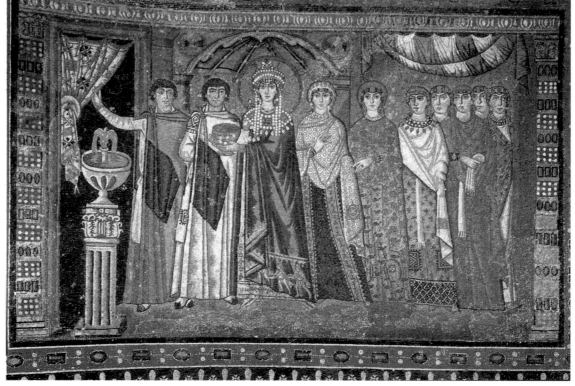

8-10 *Empress Theodora and Her Attendants.* Mosaic in S. Vitale. c. 547

Hagia Sophia, Istanbul Among the surviving monuments of Justinian's reign in Constantinople, the most important by far is Hagia Sophia (Church of Holy Wisdom). The architectural masterpiece of its era, Hagia Sophia is one of the great creative triumphs of any age (figs. 8-11, 8-12). The first church, begun by Constantine II and finished in 360, was destroyed during rioting in 404. Its replacement, built by Theodosius II within a decade, suffered the same fate in the riots of 532 that almost deposed Justinian, who immediately rebuilt it. Completed in only five years, Hagia Sophia achieved such fame that the names of the architects, too, were remembered: Anthemius of Tralles, an expert in geometry and the theory of statics and kinetics, and Isidorus of Miletus, who taught physics and wrote on vaulting techniques. The dome collapsed in the earthquake of 558, and a new, taller one was built in four years from a new design by Isidorus's nephew. After the Turkish conquest in 1453, the church became a mosque (the four minarets and extra buttresses were added then), and the mosaic decoration was largely hidden under whitewash. Some of the mosaics were uncovered in the twentieth century, after the building was turned into a museum.

The design of Hagia Sophia presents a unique combination of elements. It has the longitudinal axis of an Early Christian basilica, but the central feature of the nave is a vast, square space crowned by a huge dome. At either end are half-domes, so that the nave has the form of a great ellipse. Attached to the half-domes are semicircular niches with open arcades, similar to those in S. Vitale. One might say, then, that the domed central space of Hagia Sophia has been inserted between the two halves of a divided central-plan church. The dome rests on four arches that carry its weight to the large **piers** at the corners of the square. Thus the walls below the arches have no supporting function at all. The transition from the square formed by the arches to the circular rim of the dome is

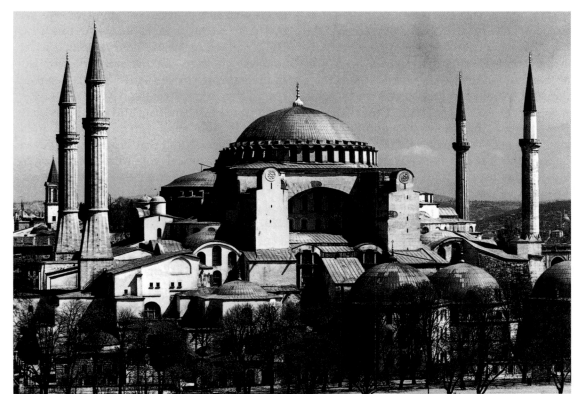

8-11 Anthemius of Tralles and Isidorus of Miletus. Hagia Sophia, Istanbul. 532–37

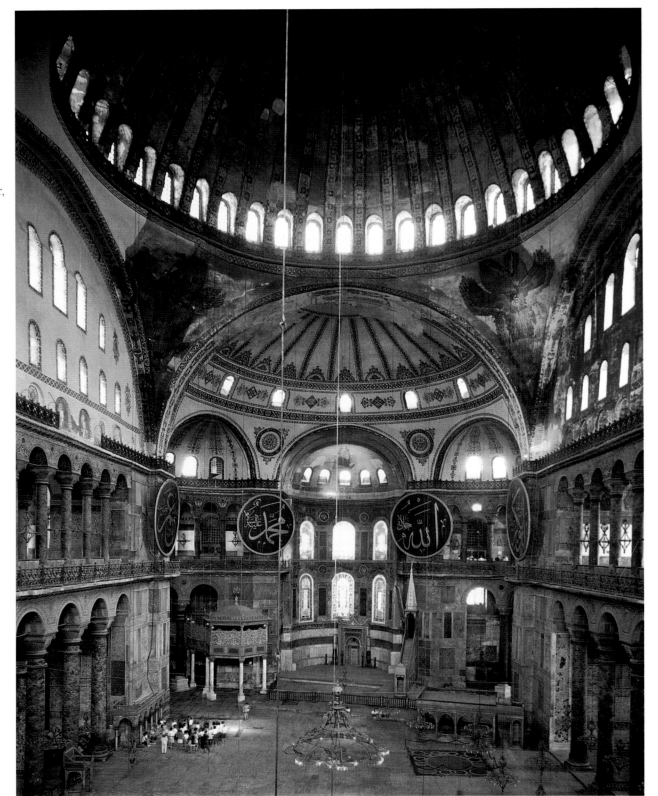

8-12 Interior,
Hagia Sophia

achieved by spherical triangles called **pendentives**. Hence we speak of the entire unit as a dome on pendentives. This device, along with a new technique for building domes using thin bricks embedded in mortar, permits the construction of taller, lighter, and more economical domes than the older method (seen in the Pantheon and S. Vitale) of placing the dome on a round or polygonal base. Where or when the dome on pendentives was invented we do not know. Hagia Sophia is the earliest case we have of its use on a monumental scale, and it had a lasting impact. It became a basic feature of Byzantine architecture and, somewhat later, of Western architecture as well.

There is, however, still another element that entered into the design of Hagia Sophia. The plan, the buttressing of the main piers, and the huge scale of the whole recall the Basilica of Constantine (see figs. 7-6 and 7-7), the most ambitious achievement of imperial Roman vaulted architecture and the greatest monument associated with a ruler for whom Justinian had particular admiration. Hagia Sophia thus unites East and West, past and future, in a single overpowering synthesis. Its massive exterior, firmly planted upon the earth like a great mound, rises by stages to a height of 184 feet—41 feet higher than the Pantheon—and therefore its dome, although its

diameter is somewhat smaller (112 feet), stands out far more boldly. The dome improves on the Pantheon's, to which it is obviously indebted: the thinnest of ribs radiate from an oculus, which has been closed in, while the extremely lightweight construction made it possible to dispense with the rings altogether and to insert a row of windows around the base.

Once we are inside, all sense of weight disappears, as if the material, solid aspects of the structure had been banished to the outside. Nothing remains but a space that inflates, like so many sails, the apsidal recesses, the pendentives, and the dome itself. Here the architectural aesthetic we saw taking shape in Early Christian architecture has achieved a new dimension. Even more than before, light plays a key role. The dome seems to float—"like the radiant heavens," according to a contemporary description—because it rests upon the closely spaced row of windows. The nave walls are pierced by so many openings that they have the transparency of lace curtains. The golden glitter of the mosaics must have completed the "illusion of unreality." Its purpose is clear. As Procopius, the court historian to Justinian, wrote: "Whenever one enters this church to pray, he understands at once that it is not by any human power or skill, but by the influence

Pendentives are the curved triangular sections of vaulting that arc up from the corners of a square area to form a rounded base from which a dome springs. Such a construction is called a "pendentive dome" or "dome on pendentives."

The Liturgy of the Mass

The central rite of many Christian churches is the EUCHARIST or COMMUNION service, a ritual meal that reenacts Jesus' Last Supper. In the Catholic church and in a few Protestant churches as well, this service is known as the MASS (from the Latin words *Ite, missa est*—"Go, [the congregation] is dismissed," at the end of the Latin service). The Mass was first codified by Pope Gregory the Great around 600 A.D.

Each Mass consists of the "ordinary"—those prayers and hymns that are the same in

all Masses—and the "proper," the parts that vary, depending on the occasion. In addition to a number of specific prayers, the "ordinary" consists of five hymns: the *Kyrie Eleison* (Greek for "Lord, have mercy on us"); the *Gloria in Excelsis* (Latin for "Glory in the highest"); *Credo* (Latin for "I believe," a statement of faith also called the Creed); the *Sanctus* (Latin for "Holy"); and the *Agnus Dei* (Latin for "Lamb of God"). A musical setting for these five hymns, also called a Mass, has been a major compositional form from 1400

up to the present day. Many of the greatest composers have written Masses, including Josquin des Prés, Bach, Haydn, Mozart, Beethoven, Verdi, Stravinsky, and Bernstein.

The "proper" of the Mass consists of prayers, two readings from the New Testament (one from the Epistles and one from the Gospels); a homily, or sermon, on these texts; and hymns, all chosen specifically for the day. There are also Masses for special occasions, such as the Requiem Mass for the dead and the Nuptial Mass for weddings.

of God, that this work has been so finely turned. And so his mind is lifted up toward God and exalted, feeling that He cannot be far away, but must especially love to dwell in this place that He has chosen."

Icons

In the late sixth century, ICONS began to compete with relics as objects of personal, then public, veneration. Icons are paintings of Christ, the Enthroned Madonna, or saints. From the beginning they were considered "portraits," and understandably so, for such pictures had developed in Early Christian times out of Graeco-Roman portrait panels. One of the chief arguments in their favor was the claim that Christ had appeared with the Virgin to St. Luke and permitted him to paint their portrait, and that other portraits of Christ

or of the Virgin had miraculously appeared on earth by divine command. These "true" sacred images were considered to have been the sources for the later, man-made ones. Little is known about their origins, for examples from before the Iconoclastic Controversy are extremely scarce (see below), but they no doubt developed in part from pagan icons, since both first appeared about 200 A.D.

Of the few early examples, the most revealing is the *Madonna and Child Enthroned between Saints and Angels* (fig. 8-13). Like late Roman murals (see pages 139–42), it is painted in several styles. Its link with Graeco-Roman portraiture is clear not only from the use of encaustic (which was not employed after the Iconoclastic Controversy) but also from the gradations of light and shade in the Virgin's face, which is similar in treatment to that of

As transportable panel paintings, Christian ICONS (from the Greek *eikon*, "image") could be venerated by the public on special occasions, carried in processions, and even brought into battle as a means of seeking divine protection. Among the most common subjects found on early icons are the Christ Pantokrater ("All-Sovereign"), the Theotokos ("God-Bearer," an image of the Virgin), and the Deesis ("Entreaty," Christ flanked by the Virgin and St. John the Baptist).

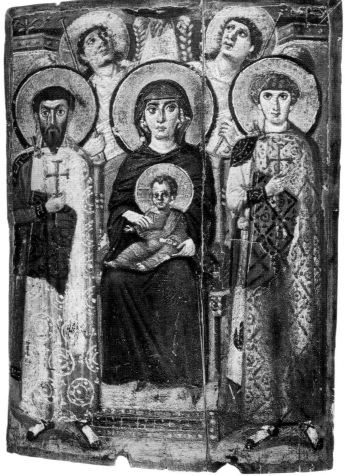

8-13 *Madonna and Child Enthroned between Saints and Angels.* Late 6th century. Encaustic on panel, 27 x 19³⁄₈" (68.6 x 49.2 cm). Monastery of St. Catherine, Mount Sinai, Egypt

the little boy in our Faiyum portrait (see fig. 7-19). She is flanked by two warrior saints, probably Theodore on the left and George (or Demetrios?) to the right, who recall the stiff figures that accompany Justinian in S. Vitale (see fig. 8-9). Typical of early icons, however, their heads are too massive for their doll-like bodies. Behind them are two angels who come closest to Roman art, although their lumpy features show that classicism is no longer a living tradition. Clearly these figures are quotations from different sources, so that the painting marks an early stage in the development of icons. Yet it is typical of the conservative icon tradition that the artist has tried to remain faithful to his sources, in order to preserve the likenesses of these holy figures.

This icon, though not impressive in itself, is worthy of our attention because it is the earliest representation we have of the Madonna and Child. The motif itself was probably taken from the cult of Isis, which was popular in Egypt at the time of the Faiyum portraits. The regal Christ Child probably evolved from images of the infant Dionysos. We note the stiff formality of the pose. To the Byzantines the Madonna was the regal mother, or bearer, of god (Theotokos), while Jesus is no mere infant but god in human form (Logos). Only later did she acquire the gentle maternal presence of the Virgin that is so familiar in Latin art (compare fig. 12-16).

Icons functioned as living images to instruct and inspire the worshiper. Because the actual figure—be it Christ, Mary, a saint, or an angel—was thought to reside in the image, as in antiquity, icons were believed able to work miracles and to intercede on behalf of the faithful. In describing an icon of the archangel Michael, the sixth-century poet Agathias writes: "The wax remarkably has represented the invisible.... The viewer can directly venerate the archangel [and] trembles as if in his actual presence. The eyes encourage deep thoughts; through art and its colors the innermost prayer of the viewer is passed to the image."

Classicism Classicizing tendencies seem to have recurred in Early Christian sculpture from the mid-fourth through the sixth century. Their causes have

been explained in various ways. During this period paganism still had many important followers, who may have fostered such revivals as a kind of rear-guard action. Recent converts (including Junius Bassus, who was not baptized until shortly before his death) often remained loyal to values of the past. Some Church leaders also sought to reconcile Christianity with the heritage of classical antiquity. They did so with good reason: early Christian theology depended a great deal on Greek and Roman philosophers, not only more recent thinkers such as Plotinus but also Plato, Aristotle, and their predecessors. The imperial courts, both East and West, remained aware of their links with pre-Christian times. They collected large numbers of original Greek works and Roman copies, so that they became centers for classicizing tendencies. Whatever its roots in any given case, classicism remained important during this time of transition.

Ivory Diptychs The lingering classical tradition is found especially in a category of objects whose artistic importance far exceeds their physical size: ivory panels and other small-scale reliefs in precious materials. Designed for private ownership and meant to be enjoyed at close range, they often mirror a collector's taste. Such a refined aesthetic sense is not found among the large works sponsored by Church or State. The ivory **diptych** in figure 8-14, made about 525–50 in the eastern Roman Empire, shows a classicism that has become an eloquent vehicle for Christian content. The majestic archangel is a descendant of the winged Victories of Graeco-Roman art, down to the rich drapery (see fig. 5-25). He may have been paired with a panel showing Justinian. (The Greek inscription above has the prayer, "Receive these gifts, and having learned the cause . . . ," which would probably have continued on the missing leaf with a plea to forgive the owner's sins.) The power the angel heralds is not of this world, nor does he inhabit an earthly space. The niche against which he appears has lost all three-dimensional reality. Its relationship to him is purely symbolic and ornamental, so that he seems to hover rather than to stand. (Notice the position of the feet on

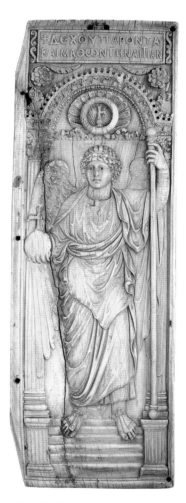

8-14 *The Archangel Michael.* Leaf of a diptych. c. 525–50. Ivory, 17 x 5½" (43.2 x 14 cm). The British Museum, London

the steps.) It is this disembodied quality, conveyed through harmonious forms, that makes his presence so compelling.

MIDDLE BYZANTINE ART

Iconoclastic Controversy After the age of Justinian, the development of Byzantine art, not only painting and sculpture but architecture as well, was disrupted by the Iconoclastic Controversy, which began with an edict promulgated by Leo III in 726 prohibiting religious images. The conflict raged for more than a hundred years between two hostile groups. The image-destroyers (Iconoclasts), led by the emperor and supported mainly in the eastern provinces, insisted on a literal interpretation of the biblical ban against graven images as leading to idolatry. They wanted to restrict religious art to abstract symbols and plant or animal forms. Their opponents, the Iconophiles, were led by the monks and centered in the western provinces, where the imperial edict was not very effective. Over time, the strongest argument in favor of retaining icons was that, because Christ and his image are inseparable, the honor given to the image is transferred to him.

The roots of the argument went very deep. On the plane of theology, they involved the basic issue of the relationship between the human and the divine in the person of Christ. Moreover, icons had come to replace the Eucharist as the focus of lay devotion because of the screen hung with icons that separated the altar from the worshipers in Orthodox churches. Socially and politically, the conflict was a power struggle between Church and State, which in theory were united in the figure of the emperor. It came during a low point in Byzantine power, when the empire had been greatly reduced in size by the rise of Islam. Iconoclasm seemed justified by Leo's victories over the Arabs, who were themselves iconoclasts. The controversy also caused an irreparable break between Catholicism and the Orthodox faith, although the two churches remained officially united until 1054, when the pope excommunicated the Eastern patriarch for heresy.

If Leo's edict had been enforced throughout the empire, it might well have dealt Byzantine religious art a fatal blow. It did succeed in greatly reducing the production of sacred images, but failed to wipe it out entirely. Hence there was a fairly rapid recovery after the victory of the Iconophiles in 843 under the empress Theodora. Spearheaded by Basil I the Macedonian, this restoration lasted from the late ninth to the eleventh century. We know little about how the Byzantine artistic tradition managed to survive from the early eighth to the mid-ninth century, but survive it did.

Mosaics Byzantine architecture never produced another structure to match the scale of Hagia Sophia. The churches built after the Iconoclastic Controversy were initially modest in size and monastic in spirit. Most were built for small groups of monks living in isolated areas, although later monasteries erected in Constantinople under imperial patronage were much larger and served social purposes by operating schools and hospitals.

The most important of these later churches was the Nea (New Church), completed by Basil I in Constantinople by 880, which established the basic character of Middle Byzantine architecture. It was at this time that Middle Byzantine imagery was also defined, in the mosaics of the Nea and the decorations Basil added to Constantine's Church of the Holy Apostles in Constantinople (both now destroyed). A logical order governs the distribution of subjects throughout the interiors of churches from this period, but with variations that reflect differences in individual buildings, local tastes, and the inclinations of donors. The subjects were organized approximately along the lines of the 12 Great Feasts of the Orthodox church, which celebrate major events from the lives of Jesus and Mary. Taken together, they illustrate the Orthodox belief in the Incarnation as the redemption of original sin and the triumph over death.

Byzantine art had managed somehow to preserve biblical subjects from Early Christian times. In the eleventh century their narrative and pictorial potential was thoroughly explored, along with a wider range of themes and feelings. The *Nativity* in the monastery of Hosios Loukas (fig. 8-15) is more complex than previous examples. Instead of focusing simply on the Virgin and Child, the

SPEAKING OF

iconoclasm

The term *iconoclasm* derives from two Greek words meaning "to break an image." It refers to a prohibition against the *religious* use of images—not all images per se. At the root of all iconoclastic movements is the fear that images will be worshiped.

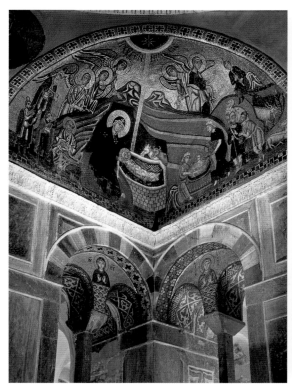

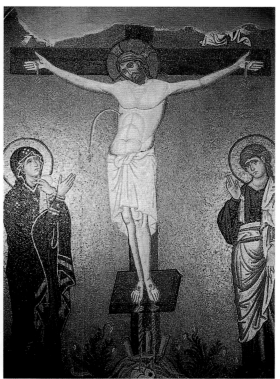

8-15 *Nativity.* Mosaic in Monastery of Hosios Loukas, Thessaly, Greece. c. 1030–40

8-16 *Crucifixion.* Mosaic in Monastery Church, Daphne, Greece. Early 12th century

mosaicist uses continuous narrative. The scene includes not only midwives bathing the newborn infant but also a host of angels, the Adoration of the Magi, and the Annunciation to the Shepherds. The great variety of poses and expressions lends a heightened sense of drama to the scene. Despite its schematic rendering, the mountainous landscape shows a new interest in illusionistic space as well.

After Basil I reopened the university in Constantinople, there was a revival of classical learning, literature, and art. Much of it occurred in the early tenth century under Constantine VII, who was emperor in name only for most of his life and consequently turned to classical scholarship and art. This renewed interest helps to explain the reappearance of Late Classical motifs in Middle Byzantine art. More often, however, classicism is merged with the spiritualized ideal of human beauty we saw in the art of Justinian's reign.

The *Crucifixion* mosaic in the Greek monastery church at Daphne (fig. 8-16) enjoys special fame. Its classical qualities are deeply felt, yet they are also completely Christian. There is no attempt to create a realistic spatial setting, but the composition has a balance and clarity that are truly monumental. Classical, too, is the heroic nudity of Christ, which emphasizes the Incarnation of the Logos (see page 173). The statuesque dignity of the figures makes them seem extraordinarily organic and graceful compared to those of the Justinian mosaics at S. Vitale (see figs. 8-9 and 8-10).

The most important aspect of these figures' classical heritage, however, is emotional rather than physical. The gestures and facial expressions convey a restrained and noble suffering of the kind we first met in Greek art of the fifth century B.C. (see pages 111–12). Early Christian art, which stressed the Savior's divine wisdom and power rather than his **Passion**, had been quite devoid of this quality. Hence, the Crucifixion was depicted

only rarely and without pathos, albeit with the same simplicity found here. We cannot say when and where this human interpretation of the Savior first appeared. But it seems to have developed in the wake of the Iconoclastic Controversy and reached its height during the Ducas and Comnene dynasties, which ruled Byzantium from the middle of the eleventh through the late twelfth century. There are, to be sure, a few earlier examples of it, but none of them appeals to the emotions of the viewer so powerfully as the Daphne *Crucifixion*. To have introduced this compassionate view of Christ into sacred art was perhaps the greatest achievement of Middle Byzantine art.

Murals The emphasis on human emotions reaches its climax in the paintings at the church of St. Panteleimon in Nerezi, Macedonia. Built by members of the Byzantine royal family, it was decorated by a team of artists from Constantinople. From the beginning of Byzantine art in the sixth century, mural painting had served as a less expensive alternative to mosaic, which was preferred whenever possible. The two were closely linked, however, since mosaics were laid out in paint on fresh plaster each day before the tesserae were added. Thus the best painters participated fully in the new style and, in some cases, introduced innovations of their own. The artist responsible

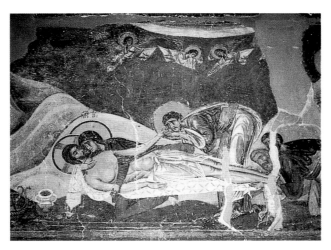

8-17 *Lamentation.* Fresco in the Church of St. Panteleimon, Nerezi, Republic of Macedonia. 1164

for the *Lamentation* (fig. 8-17) was a great master who expanded on the latest advances. The gentle sadness of the Daphne *Crucifixion* has been replaced by a grief of almost unbearable intensity. The style remains the same, but its expressive qualities have been emphasized by subtle adjustments in the proportions and features. The subject seems to have been invented recently, for it does not occur in earlier Byzantine art. Its origins, even more than those of the Daphne *Crucifixion*, lie in classical art. Yet nothing prepares us for the Virgin's anguish as she clasps her dead son or the deep sorrow of St. John holding Christ's lifeless hand. We have entered a new realm of religious feeling that was to be explored further in the West.

LATE BYZANTINE PAINTING

In 1204 Byzantium suffered an almost fatal defeat when the armies of the Fourth Crusade captured and sacked the city of Constantinople, instead of warring against the Turks. For more than 50 years, the core of the Eastern Empire remained in Western hands. Byzantium, however, survived this catastrophe. In 1261 it regained its independence under the Palaeologue dynasty, and the fourteenth century saw a last flowering of Byzantine painting, which came to an end with the Turkish conquest in 1453.

Icons The Crusades decisively changed the course of Byzantine art by bringing contact with the West. The impact can be seen in the *Madonna Enthroned* (fig. 8-18), which unites elements of both, so that its authorship has been much debated. Because of the veneration in which they were held, icons had to conform to strict rules, with fixed patterns repeated over and over again. As a result, most of them are noteworthy more for exacting craftsmanship than for artistic inventiveness. Although painted at the end of the thirteenth century, our example reflects a much earlier type. There are echoes of Middle Byzantine art in the graceful pose, the play of drapery folds, the tender melancholy of the Virgin's face. But these elements have become abstract, reflecting a new taste and style. The highlights on the drapery resemble sunbursts, in contrast to the soft shading

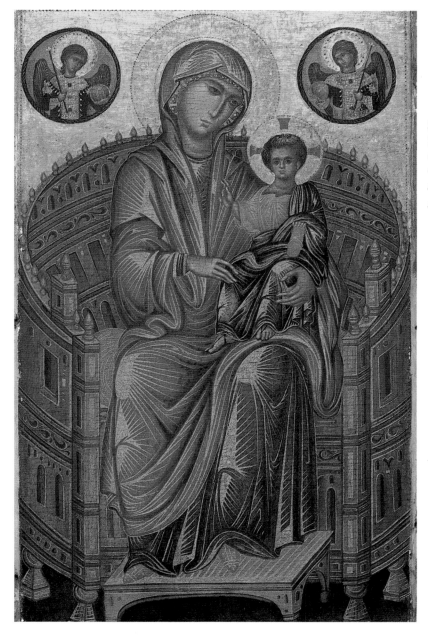

8-18 *Madonna Enthroned.* Late 13th century. Tempera on panel, 32⅛ x 19⅜" (81.6 x 49.3 cm). National Gallery of Art, Washington, D.C.

Andrew W. Mellon Collection

of hands and faces. The total effect is neither flat nor spatial but transparent: the shapes look as if they were lit from behind. Indeed, the gold background and highlights are so brilliant that even the shadows never seem wholly opaque. This all-pervading radiance, we will recall, first appears in Early Christian mosaics. Panels such as this may therefore be viewed as the aesthetic equivalent of mosaics, and not simply as the descendants of the panel-painting tradition. In fact, some of the most precious Byzantine icons are miniature mosaics attached to panels, and our artist may have been trained as a mosaicist rather than as a painter.

The style, then, is Late Byzantine—but with an Italian overlay, for example in the treatment of the faces, that is hard to explain. The elaborate

throne, which looks like a miniature replica of the Colosseum (see fig. 7-2), no longer functions as a three-dimensional object, despite the foreshortening. The panel must have been painted by a Byzantine artist, not simply a Westerner trained in that tradition. However, this master may have worked either for a Western patron or in a Byzantine center under European control. (Cyprus, then ruled by the French, has been suggested.) Our painter might even have visited Italy or been active there, perhaps in Rome or Tuscany, where a neo-Byzantine style was well established (see pages 245–47). Whatever position we adopt points to a profound shift in the relation between the two traditions: after 600 years of borrowing from Byzantium, Western art for the first time began to contribute something in return.

Mosaics and Murals The finest surviving cycles of Late Byzantine mosaics and murals are found in Istanbul's Kariye Camii, the former Church of the Savior in the Chora Monastery. (*Chora* means "land" or "place"; *Camii* denotes a mosque, although the site is now a museum.) They represent the climax of the humanism that emerged in Middle Byzantine art. Because of the empire's greatly reduced resources, murals often took the place of mosaics, but at Kariye Camii they exist on an even footing and may have been designed by the same artist.

Figure 8-19 shows the *Anastasis* (from a Greek term meaning both "to rise" and "to raise"), which is part of the frescoes in the mortuary chapel attached to Kariye Camii. The scene depicts the traditional Byzantine image of this subject, which Western Christians call Christ's Descent into Limbo, or the Harrowing of Hell, to rescue souls. Surrounded by a radiant **mandorla**, the Savior has vanquished Satan and battered down the gates of hell. (Note the bound Satan at his feet, in the midst of a profusion of hardware; the two kings to the left are David and Solomon.) What amazes us about the central group of Christ raising Adam and Eve from the dead is its dramatic force, a quality we would not expect from what we have seen of Byzantine art so far. Christ here moves with extraordinary physical energy, tearing Adam and Eve from their graves, so that they appear to fly through the air—a magnificently expressive image of divine triumph. Such dynamism had been unknown in the earlier Byzantine tradition. This style, which was related to slightly earlier developments in manuscript painting, was indeed revolutionary. Coming in the fourteenth century, it indicates that 800 years after Justinian, when the subject first appeared, Byzantine art still had all its creative powers.

The resurrection miracles depicted on either side of the *Anastasis* show the growing Byzantine fascination with storytelling. *The Raising of the Widow's Son,* on the left, uses a landscape style that had flourished in sixth-century secular mosaics and had been all but lost. The architectural illusionism in *The Raising of the Daughter of Jairus,* to the right, is familiar to us from Pompeian painting, which was recovered in manuscripts of the classical revival during the tenth century. More important than such details is the way the settings have been incorporated to complete these lively narratives. We shall not meet their equal in the West until the time of Duccio and Giotto, who were clearly influenced by Late Byzantine art.

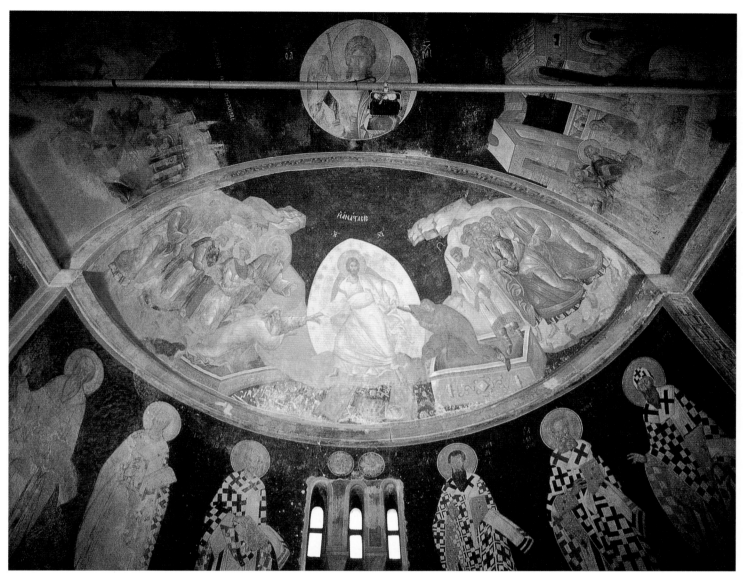

8-19 *Anastasis.* Fresco in Kariye Camii (Church of the Savior in Chora), Istanbul. c. 1310–20

9

EARLY MEDIEVAL ART

Once established, the labels used for historical periods are almost impossible to change, even though they may no longer be suitable. The humanists who coined the term *Middle Ages* thought of the entire thousand years from the fifth to the fifteenth century as an age of darkness: an empty interval between classical antiquity and its rebirth, the Renaissance in Europe. Since then, our view of this period has altered completely. We now think of it as a time of great cultural change and creative activity. During the 200 years between the death of Justinian and the reign of Charlemagne, the center of gravity of European civilization shifted northward from the Mediterranean Sea. At the same time, the economic, political, and spiritual framework of the Middle Ages began to take shape. These two centuries also gave rise to some important artistic achievements.

Celtic-Germanic Style

The first of these was the Celtic-Germanic style, which was a result of the widespread migrations that took place after the fall of the Roman Empire. The Celts, who had settled the area later known to the Romans as Gaul (southwestern Germany and eastern France) during the second millennium B.C., spread across much of Europe and into Asia Minor, where they battled the Greeks (see page 115). Pressed by neighboring Germanic peoples who originated in the Baltic region, they crossed the English Channel in the fourth century B.C. and colonized Britain and Ireland. There they were joined in the fifth century by the Angles and Saxons from today's Denmark and northern Germany. In 376 the Huns, who had advanced beyond the Black Sea from Central Asia, became a serious threat to Europe. They pushed the Germanic Visigoths westward into the Roman Empire from the Danube. Then under Attila (died 453) they invaded Gaul in 451 before attacking Rome a year later. These Germanic peoples from the east carried with them, in the form of nomads' gear, the ancient and widespread artistic tradition known as the animal style (see pages 73–74). We have seen an early example of it in the gold belt from Ziwiye (see fig. 3-10). The animal style, with its combination of abstract and organic shapes, of formal discipline and imaginative freedom, merged with the intricate ornamental metalwork of the Celts, which had previously been affected by it. Out of this union came Celtic-Germanic art.

An excellent example of this "heathen" style is the gold-and-enamel purse cover (fig. 9-1) from the SHIP BURIAL at Sutton Hoo of an East Anglian king (almost certainly Raedwald, who died about 625). On it are four pairs of symmetrical motifs. Each has its own distinctive character, an indication that the purse was assembled from different sources. One, the standing man between facing animals, has a very long history indeed. We first saw it in Mesopotamian art more than 3,200 years earlier (see fig. 3-5), and it is even older than that. The eagles pouncing on ducks bring to mind similar pairings of carnivore and victim in ancient bronzes. The design above them, at the center, is of more recent origin. It consists of fighting animals whose tails, legs, and jaws are elongated into bands that form a complex interweaving pattern. The fourth, on the top left and right, uses interlacing bands as an ornamental device. This motif occurs in Roman and Early Christian art, especially along the southern shore of the Mediterranean. However, the combination of these bands with the animal style, as shown here, seems to be an invention of Celtic-Germanic art, not much before the date of our purse cover.

SHIP BURIALS originated among the Scandinavians early in the first millennium A.D. The deceased was placed in the center of the ship and surrounded by grave goods (weapons, armor, and jewelry); the ship was then either buried intact beneath a mound of earth or burned before burial. Whether symbols of the soul's journey or of social status, ship burials such as those at Oseberg in Norway and Ladby in Denmark are valuable resources of material culture.

9-1 Purse cover, from the Sutton Hoo ship burial. 625–33. Gold with garnets and enamels, length 8" (20.3 cm). The British Museum, London

are some of the details, such as the teeth, gums, and nostrils. But the surface is covered with interlacing and geometric patterns derived from metalwork. Snarling monsters such as this used to rise from the prows of Viking ships, where they took on the character of mythical sea dragons.

9-2 Animal head, from the Oseberg ship burial. c. 825. Wood, height approx. 5" (12.7 cm). Institute for Art History and Classical Archaeology, University of Oslo

The chief medium of the animal style had been metalwork, in a variety of materials and techniques and sometimes of exquisitely refined craftsmanship. Such articles, small, durable, and eagerly sought after, account for the rapid diffusion of this idiom's repertory of forms. They spread not only geographically but also artistically: from metal into wood, stone, and even paint. We know from literary accounts that gold objects were plentiful. Since nothing else like it from the same period has been found elsewhere in England, it is far from clear whether the Sutton Hoo purse was made locally or, like "Scythian gold" (see page 74), was of foreign origin, as were most of the luxury goods found at the mound.

Ship burials like those at Sutton Hoo and nearby Snape first began in Scandinavia, where the animal style flourished longer than anywhere else and where most wooden items have been found. The splendid animal head of the early ninth century in figure 9-2 is the terminal, or decorated end, of a post recovered from a buried Viking ship at Oseberg in southern Norway. Like the motifs on the Sutton Hoo purse cover, it is a composite. The basic shape of the head is surprisingly realistic, as

Hiberno-Saxon Style

During the early Middle Ages, the Irish (Hibernians) were the spiritual and cultural leaders of western Europe. In fact, the period from 600 to 800 deserves to be called the Golden Age of Ireland. Unlike their English neighbors, the Irish had never been part of the Roman Empire. Thus the missionaries who carried the Gospel to them from England in the fifth century found a Celtic society that was barbarian by Roman standards. The Irish readily accepted Christianity, which brought them into contact with Mediterranean civilization. However, they adapted what they had received in a spirit of vigorous local independence.

Because it was essentially urban, the institutional framework of the Roman Church was poorly suited to the rural Irish way of life. Irish Christians preferred to follow the example of the desert saints of Egypt and the Near East, who had left the temptations of the city to seek spiritual perfection in the solitude of the wilderness, where groups of them founded the earliest monasteries (see box, pages 200–201). By the fifth century, monasticism had spread as far north as western Britain, but only in Ireland did the monks take over the leadership of the Church from the bishops.

Irish monasteries, unlike their Egyptian models, soon became centers of learning and the arts. They sent monks to preach to the heathens and to found monasteries not only in northern Britain but also on the European mainland, from present-day France to Austria. These Irish monks speeded the conversion of Scotland, northern France, the Netherlands, and Germany to Christianity. Further, they made the monastery a cultural center throughout the European countryside. The monasteries on the Continent were soon taken over by the

monks of the Benedictine order, who were advancing north from Italy during the seventh and eighth centuries. Even so, Irish influence would be felt within medieval civilization for several hundred years.

MANUSCRIPTS AND BOOK COVERS

In order to spread the Gospel, the Irish monasteries had to produce copies of the Bible and other Christian books in large numbers. Their SCRIPTORIA (writing workshops) also became artistic centers. A manuscript containing the Word of God was looked upon as a sacred object whose beauty should reflect the importance of its contents. Irish monks must have known Early Christian illuminated manuscripts, but here, too, they developed an independent tradition instead of simply copying their models. While pictures illustrating biblical events held little interest for them, they devoted much effort to abstract decoration. The finest of their manuscripts belong to the Hiberno-Saxon style—a Christian form that evolved from heathen Celtic-Germanic art and flourished in the monasteries founded by Irishmen in Saxon England.

Thanks to a later colophon (inscription), we know a great deal about the origin of the *Lindisfarne Gospels*, including the names of the translator and the scribe, who presumably painted the illuminations as well. The Cross page (fig. 9-3, page 184) is a creation of breathtaking complexity. Working with the precision of a jeweler, the miniaturist has poured into the geometric frame an animal interlace so dense and yet so full of movement that the fighting beasts on the Sutton Hoo purse cover seem simple in comparison. It is as if these biting and clawing monsters had been subdued by the power of the Cross. In order to achieve this effect, our artist has had to work within a severe discipline by exactly following the "rules of the game." These rules demand, for instance, that organic and geometric shapes must be kept separate. Within the animal compartments, every line must turn out to be part of an animal's body. There are other rules concerning symmetry, mirror-image effects, and repetitions of shapes and colors. Only by working these out by intense observation can

we enter into the spirit of this mazelike world.

What was the origin of this complex style? From the beginning, Celtic art had favored a form of organic abstraction based mainly on plant motifs. This vocabulary was greatly enlarged during the later fourth century B.C. by Etruscan and other Italian artisans working for Celtic patrons. Many of the new forms they used were derived from Classical Greece. The vegetal style spread rapidly throughout the Celtic realm, where it became thoroughly integrated with existing motifs. It was subjected to a strict control through the use of the compass, which continued to be employed in Britain long after it was abandoned on the Continent. Yet nothing in earlier Celtic art prepares us for the elaboration found in Hibernian manuscripts, despite the persistence of plantlike forms.

Of the images in Early Christian manuscripts, the Hiberno-Saxon illuminators retained only the symbols of the four evangelists, since they could be readily translated into their ornamental style. These symbols—the man (St. Matthew), the lion (St. Mark), the ox (St. Luke), and the eagle (St. John)—were derived from the Revelation of St. John the Divine and assigned to the evangelists by St. Augustine. However, Celtic and Germanic artists showed little interest in the human figure for a long time. The bronze plaque of the Crucifixion (fig. 9-4, page 185), probably made for a book cover, emphasizes flat patterns, even when dealing with the image of a man. Although the composition is Early Christian in origin, the artist has treated the human frame as a series of ornamental compartments. The figure of Jesus is disembodied in the most literal sense: the head, arms, and feet are all separate elements joined to a central pattern of whorls, zigzags, and interlacing bands. Most fascinating of all are the faces: they hardly differ from those found on Celtic bronzes of fully 1,200 years earlier! Clearly, there is a wide gulf between the Celtic-Germanic and the Mediterranean traditions, a gulf that the Irish artist who modeled the Crucifixion saw no need to bridge. The situation was much the same in the rest of Europe during the early Middle Ages. Even the French and the Lombards in northern Italy did not know what to do with human images.

The monks working in the medieval SCRIPTORIA were adept at all aspects of manuscript production, from parchment preparation to binding. At first, the copying and illumination of the texts probably were performed by the same individual, but later each of these tasks was executed by a specialist. The scriptorium itself could be a large room with benches and tables or a series of individual carrels.

Matthew, a man

Mark, a lion

Luke, an ox

John, an eagle

Each of the four evangelists has a symbol, or icon. Their identities were immediately recognizable by Christians until comparatively recent times—though their appearance varied greatly according to period. Often but not always the symbols were winged.

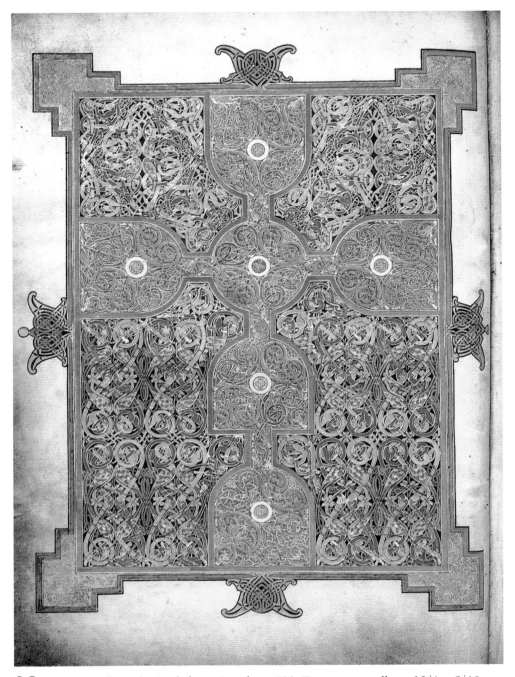

9-3 Cross page from the *Lindisfarne Gospels*. c. 700. Tempera on vellum, 13 ½ x 9 ¼"
(34.3 x 23.5 cm). The British Library, London

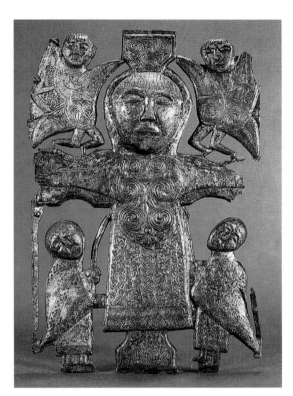

9-4 *Crucifixion.* Plaque from a book cover (?). 8th century. Bronze, height 8¼" (21 cm). National Museum of Ireland, Dublin

The problem was finally solved by Carolingian artists drawing on the Byzantine tradition, with its roots in classical art.

Carolingian Art

The cultural achievements of CHARLEMAGNE's reign have proved far more lasting than his empire, which began to fall apart even before his death in 814. Indeed, this very page is printed in letters whose shapes are derived from the script in Carolingian manuscripts. The fact that these letters are known today as "Roman" rather than Carolingian recalls another aspect of the cultural reforms sponsored by Charlemagne: the collecting and copying of ancient Roman literary texts. The oldest surviving texts of many classical Latin authors are found in Carolingian manuscripts, which, until not long ago, were mistakenly considered Roman. Hence their lettering, too, was called Roman.

This interest in preserving the classics was part of a larger reform program to improve the education of the court and the clergy. Charlemagne's goals were to improve the administration of his realm and the teaching of Christian truths. He summoned the best minds to his court, including Alcuin of York, the most learned scholar of the day, to restore ancient Roman learning and to establish a system of schools at every cathedral and monastery. The emperor, who could read but not write, took an active hand in this renewal, which went well beyond mere antiquarianism. He wanted to model his rule after the empire under Constantine and Justinian—not their pagan predecessors. To a great extent he succeeded. Thus the "Carolingian revival" may be termed the first, and in some ways most important, phase of a fusion of the Celtic-Germanic spirit with the heritage of the Mediterranean world.

ARCHITECTURE

The achievement of Charlemagne's famous Palace Chapel (fig. 9-5, page 186) is all the more spectacular when seen in this light. On his visits to Italy, beginning with his son Pepin's baptism by Pope Hadrian in 781, Charlemagne had become familiar with the monuments of the Constantinian era in Rome and with those of the reign of Justinian in Ravenna. He felt that his new capital at Aachen (the site was chosen for its mineral baths) must convey the majesty of empire through buildings of an equally imposing kind. To signify Charlemagne's position as a Christian ruler, his palace complex was modeled on the Lateran Palace in Rome, which had been given by Constantine to the pope. Charlemagne's palace included a basilica, the Royal Hall, which was linked to the Palace Chapel. The chapel itself was inspired in equal measure by the Lateran baptistery and S. Vitale (see figs. 8-7 and 8-8). To construct such a building on Northern soil was a difficult undertaking, which was supervised by Einhard, Charlemagne's trusted adviser and biographer. Columns and bronze gratings had to be imported

SPEAKING OF

master, masterwork, masterpiece, and *old master*

In the ten centuries since the title *master* was first awarded to men whose accomplishments met the highest standards set by their guilds, the term has become synonymous with excellence of conception and execution. In fact, the word *masterwork* originally denoted the piece of work that qualified a journeyman for the rank of master. Other *master*-based terms are now used without suggesting or limiting gender. For example, no English word has quite the same impact as *masterpiece* to mean something that is the best of its kind. And *old master* refers to the greatest artists or artworks, without limits on period, style, or whether the artist was a man or a woman.

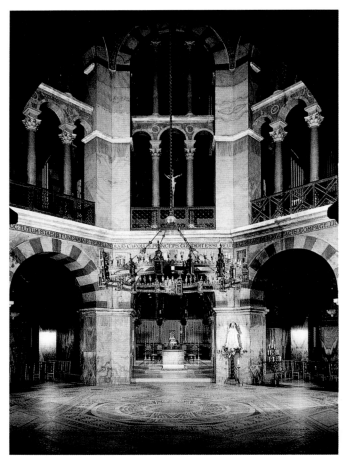

9-5 Odo of Metz. Interior, Palace Chapel of Charlemagne, Aachen. 792–805

from Italy, and expert stonemasons must have been hard to find.

The design is by Odo of Metz (probably the earliest architect north of the Alps known to us by name). It is by no means a mere echo of S. Vitale but a vigorous reinterpretation. The **piers** and vaults have an impressive massiveness, while the geometric clarity of the spatial units is very different from the fluid space of the earlier structure. These features, which are found in French buildings of the previous century, are a distinctly Northern variant of Roman architecture. Odo's scheme for the western entrance, now largely obscured by later additions and rebuilding, featured a monumental structure known as a **westwork** (from the German *Westwerk*). Although contemporary documents

say very little about its function, the westwork seems to have been used initially as a royal loge or chapel. However, it may have been employed for various other purposes as the need arose.

The best-preserved westwork from the Carolingian era is seen on the abbey church at Corvey (fig. 9-6), which was built in 873–85. Except for the upper stories, which date from about 1146, the westwork retains much of its original appearance. Even without these additions, it provided a suitably regal entrance. It is impressive not only because of its height but also because of its plain surfaces, which show the understated power of Carolingian architecture at its finest. The clear geometry and powerful masses of the **facade** have a wonderful simplicity that is continued inside the church. The east end, now much changed, is also important for anticipating the apses with radiating chapels and ambulatories found on Romanesque churches (compare fig. 10-1).

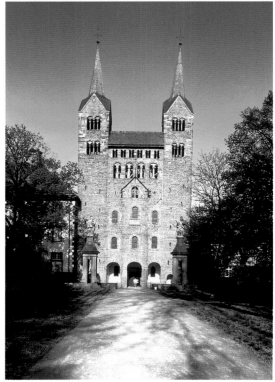

9-6 Facade, Abbey Church, Corvey, Westphalia, Germany. 873–85, with later additions

The word *architect* derives from the Greek term for "master builder" and was defined in its modern sense of "designer and theoretician" by the Roman writer Vitruvius during the first century B.C. During the Middle Ages, it came to have different meanings. In the course of the eighth century, the distinction between design and construction, theory and practice, became increasingly blurred. As a result, the term nearly disappeared in the North by the tenth century and was replaced by a new vocabulary, in part because the building trades were strictly separated under the guild system. When it was used, *architect* could apply not only to masons, carpenters, and even roofers but also to the person who commissioned or supervised a building.

In some instances, the abbot (leader) of a community of monks was the actual designer. Therefore, the design of churches became increasingly subordinate to liturgical (public worship) and practical considerations. The churches' actual appearance, however, was largely determined by an organic construction process. Roman architectural principles and construction techniques, such as the use of cement, had been largely forgotten and were recovered only through cautious experimentation by builders of inherently conservative persuasion. Thus, vaulting remained rudimentary and was limited to short spans, mainly the aisles, if it was used at all.

Not until about 1260 did Thomas Aquinas revive Aristotle's definition of *architect* as the person of intellect who leads or conducts, as opposed to the artisan who makes. Within a century the term was used to designate the artist in charge of a project by the humanist Petrarch, who thus acknowledged what had already become established practice in the city of Florence, where first the painter Giotto, then the sculptors Andrea Pisano and Francesco Talenti, were placed in charge of Florence Cathedral (see pages 230–31).

In the Middle Ages, the word *master* (Latin, *magister*) was a title conferred by a trade organization, or **guild**, on a member who had achieved the highest level of skill in the guild's profession or craft. In each city, trade guilds virtually controlled commercial life by establishing quality standards, setting prices, defining the limits of each guild's activity, and overseeing the admission of new members. The earliest guilds were formed in the eleventh century by merchants. Soon, however, craftsmen also organized themselves in similar professional societies, which continued to be powerful well into the sixteenth century. Most guilds admitted only men, but some, such as the painters' guild of Bruges, occasionally admitted women as well. Guild membership established a certain level of social status for townspeople, who were neither nobility, clerics (people in religious life), nor peasantry.

A boy would begin as an apprentice to a master in his chosen guild and after many years might advance to the rank of journeyman. In most guilds this meant that he was then a full member of the organization, capable of working without direction, and entitled to receive full wages for his work. Once he became a master, the highest rank, he could direct the work of apprentices and manage his own workshop, hiring journeymen to work with him.

In architecture, the master mason, who was sometimes called the master builder, generally designed the building, that is, acted in the role of architect. In church-building campaigns, there were teams of masons, carpenters (joiners), metalworkers, and glaziers (glassworkers) who labored under the direction of the master builder.

MANUSCRIPTS AND BOOK COVERS

The fine arts were an important part of Charlemagne's cultural program from the very start. We know from literary sources that Carolingian churches contained murals, mosaics, and relief sculpture, but these have disappeared almost entirely. Illuminated manuscripts, carved ivories, and goldsmiths' work, on the other hand, have survived in considerable numbers. They demonstrate the impact of the Carolingian revival even more strikingly than the architectural remains of the period. The former Imperial Treasury in Vienna contains a Gospel Book said to have been found in the tomb of Charlemagne and, in any case, closely linked with his court at Aachen. Looking at the picture of the evangelist Matthew from that manuscript (fig. 9-7, page 188), we can hardly believe that such a work could have been executed in northern Europe about the year 800. Were it not for the large golden **halo**, the *St. Matthew* might almost be mistaken for the portrait of a classical author. Whether Byzantine, Italian, or Frankish, the artist clearly knew the Roman tradition of painting, down to the acanthus ornament on the wide frame, which emphasizes the "window" treatment of the picture.

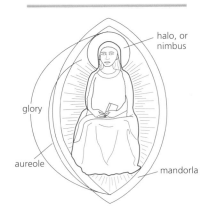

The **halo** (or nimbus) represents light radiating around the head of a saint or divinity. The aureole is light around the body, and the glory is all the light—both the halo and aureole. The mandorla is the almond-shaped form that encloses the image of a saint and is also symbolic of the radiant light of holiness.

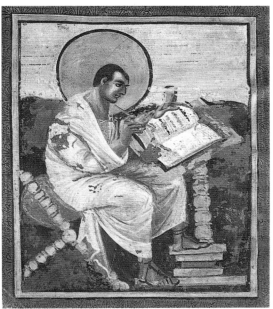

9-7 *St. Matthew,* from the *Gospel Book of Charlemagne.* c. 800–810. Ink and colors on vellum, 13 x 10" (33 x 25.4 cm). Kunsthistorisches Museum, Vienna

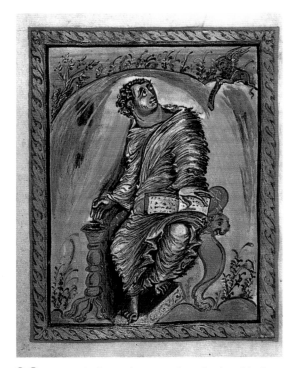

9-8 *St. Mark,* from the *Gospel Book of Archbishop Ebbo of Reims.* 816–35. Ink and colors on vellum, 10¼ x 8¼" (26 x 20.8 cm). Bibliothèque Municipale, Épernay, France

The *St. Matthew* represents the first and most conservative phase of the Carolingian revival. It is comparable to a copy of the text of a classical work of literature. More typical is a miniature of St. Mark painted some three decades later for the *Gospel Book of Archbishop Ebbo of Reims* (fig. 9-8), which shows the classical model translated into a Carolingian idiom. It must have been based on an evangelist's portrait of the same style as the *St. Matthew,* but now the picture is filled with a vibrant energy that sets everything into motion. The drapery swirls about the figure, the hills heave upward, and the vegetation seems to be tossed about by a whirlwind. Even the acanthus pattern on the frame has a flamelike character. While Matthew resembled a Roman author setting down his thoughts, Mark is here seized with the frenzy of divine inspiration, a vehicle for recording the Word of God. His gaze is fixed not upon his book but upon his symbol (the winged lion with a scroll), which transmits the sacred text. This dependence on the Word, so powerfully expressed here, characterizes the contrast between classical and medieval images of humanity. But the means of expression—the dynamism of line that distinguishes our miniature—recalls the passionate movement that we have previously seen in the ornamentation of Irish manuscripts (see fig. 9-3).

The style of the Reims school can still be felt in the reliefs on the front cover of the *Lindau Gospels* (fig. 9-9). This masterpiece of the goldsmith's art, made in the third quarter of the ninth century, shows how splendidly the Celtic-Germanic metalwork tradition was adapted to the Carolingian revival. The clusters of semiprecious stones are not mounted directly on the gold ground. Instead, they are raised on claw feet or arcaded turrets, so that the light can penetrate from beneath them to bring out their full brilliance. The crucified Jesus betrays no hint of pain or death. He seems to stand rather than to hang, his arms spread out in a solemn gesture. To endow him with the signs of human suffering was not yet conceivable for the Carolingian artists, even though the means were at hand, as we can see from the expressions of grief among the small figures found in the surrounding compartments.

9-9 Front cover of binding, *Lindau Gospels.* c. 870. Gold and jewels, 13³/₄ x 10¹/₂"
(34.9 x 26.7 cm). The Pierpont Morgan Library, New York

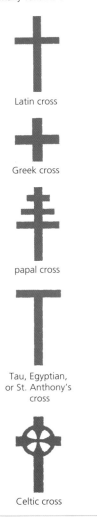

These five types of crosses are among those most often seen in Western art, though many variants exist.

Latin cross

Greek cross

papal cross

Tau, Egyptian, or St. Anthony's cross

Celtic cross

Ottonian Art

Upon the death of Charlemagne's son, Louis I, in 843, the empire built by Charlemagne was divided into three parts by his grandsons: Charles the Bald, the West Frankish king, who founded the French Carolingian dynasty; Louis the German, the East Frankish king, who ruled an area roughly that of today's Germany; and Lothair I, who inherited the middle kingdom and the title of Holy Roman Emperor. By dividing the king's domain among his heirs, the Carolingian dynasty made the same fatal mistake as its predecessors, the Merovingians. Charlemagne had tried to impose unified rule by placing his friends in positions of power throughout the realm, but they became increasingly independent over time. During the late ninth and early tenth centuries this loose arrangement gave way to the decentralized political and social system known today as feudalism, in France and Germany, where it had deep historical roots. Knights (originally cavalry officers) held fiefs, or feuds, as their land was called. In return, they gave military and other service to their lords, to whom they were linked through a complex system of personal bonds— termed vassalage—that extended all the way to the king. The land itself was worked by the large class of generally downtrodden peasants (serfs and esnes), who were utterly powerless.

The Carolingians finally became so weak that Continental Europe once again lay exposed. The Muslims attacked in the south. Slavs and Magyars advanced from the east, and Vikings from Scandinavia ravaged the north and west. The Vikings (the Norse ancestors of today's Danes and Norwegians) had been raiding Ireland and Britain by sea from the late eighth century on. Now they invaded northwestern France and occupied the area that ever since has been called Normandy. They soon adopted Christianity and Carolingian civilization, and their leaders were recognized as dukes nominally subject to the king of France. During the eleventh century, the Normans played a major role in shaping the political and cultural destiny of Europe. The duke of Normandy, William the Conqueror, became king of England following the invasion of 1066, while other Norman nobles expelled the Arabs from Sicily and the Byzantines from southern Italy and Sicily.

In Germany, the center of political power shifted north to Saxony after the death of the last Carolingian monarch in 911. Beginning with Henry I, the Saxon kings (919–1024) reestablished an effective central government. The greatest of them, Otto I, also revived the imperial ambitions of Charlemagne. After marrying the widow of a Lombard king, he extended his rule over most of Italy. In 962 he was crowned emperor by Pope John XII, at whose request he conquered Rome and whom he later deposed for conspiring against him. From then on the Holy Roman Empire was to be a German institution. Perhaps we ought to call it a German dream, for Otto's successors were unable to maintain their claim to sovereignty south of the Alps. Yet this claim had important effects, since it led the German emperors into centuries of conflict with the papacy and local Italian rulers. North and South thus were linked in a love-hate relationship whose echoes are still felt today.

SCULPTURE

During the Ottonian period, from the mid-tenth century to the beginning of the eleventh, Germany was the leading nation of Europe, artistically as well as politically. German achievements in both areas began as revivals of Carolingian traditions but soon developed original traits that reflected a new outlook. The change is brought home to us if we compare the Christ on the cover of the *Lindau Gospels* with the *Gero Crucifix* (fig. 9-10) in the Cathedral at Cologne. (It was carved for Archbishop Gero of that city.) The two works are separated by little more than a hundred years, but the contrast between them suggests a far greater span. In the *Gero Crucifix* we meet an image of the crucified Savior that is new to Western art. It is monumental in scale, carved in powerfully rounded forms, and filled with deep concern for the sufferings of the Lord. Particularly striking is the forward bulge of the heavy body, which makes the physical strain on the arms and shoulders seem almost unbearable. The face, with its deeply incised, angular features, has turned into a mask of agony, from which all life has fled.

9-10 *The Gero Crucifix.*
c. 975–1000. Wood, height
6'2" (1.88 m). Cologne
Cathedral

How did the Ottonian sculptor arrive at this bold conception? The *Gero Crucifix* was clearly influenced by Middle Byzantine art, which had created the compassionate view of Christ on the Cross (see fig. 8-16). Byzantine influence was strong in Germany at the time, for Otto II had married a Byzantine princess, thereby linking the two imperial courts. Yet, that source alone is not enough to explain the results. It remained for the Ottonian artist to translate the Byzantine image into large-scale sculptural terms and to replace its gentle pathos with the expressive realism that has been the main strength of German art ever since.

The size and intensity of the figure on the *Gero Crucifix* signal an important religious development at the time. The individual was given a greater role in salvation, not merely through baptism and celebration of the Eucharist but through a personal union with Christ and identification with his sacrifice. The result was a rift between theology and mysticism that was not reconciled until a century later by St. Anselm of Canterbury.

ARCHITECTURE

Judged in terms of surviving works, the most ambitious patron of architecture and art in the Ottonian age was Bernward, who became bishop of Hildesheim after having been court chaplain

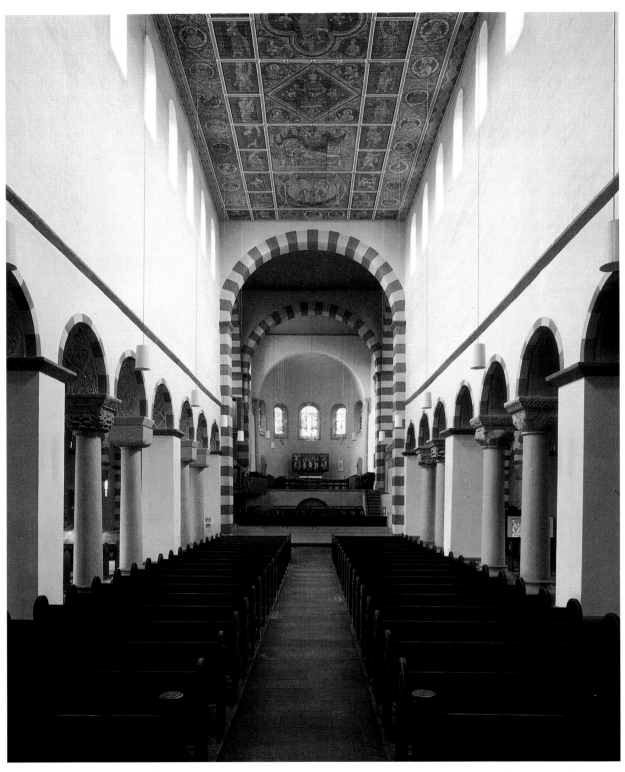

9-11 Interior, Hildesheim Cathedral (Abbey Church of St. Michael), 1001–33. View toward the apse, after restoration of 1950–60

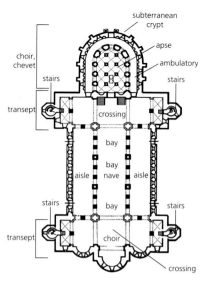

9-12 Reconstructed plan, Hildesheim Cathedral

and a tutor of Otto III during the regency of the empress Theophano. His chief monument is the Benedictine abbey church, St. Michael's (figs. 9-11, 9-12). The plan is remarkable for its symmetry. Not only are there two **choirs** and lateral entrances, there are also two identical transepts, each with a crossing tower and stair turrets. The supports of the nave arcade, instead of being uniform, consist of pairs of columns separated by square piers. This alternating system divides the arcade into three equal units, called **bays**, of three openings each. Moreover, the first and third units are correlated with the entrances, thus echoing the axis of the transepts. And since the aisles and nave are unusually wide in relation to their length, the architect's intention must have been to achieve a harmonious balance between the longitudinal and transverse axes throughout the structure.

The western choir, as reconstructed in our plan, is especially interesting. Its floor was raised above the level of the rest of the church to make room for a half-subterranean basement chapel, or **crypt**. The crypt (apparently a special sanctuary of St. Michael) could be entered both from the transept and from the west. It was roofed by **groin vaults** resting on two rows of columns, and its walls were pierced by arched openings that linked it with

the U-shaped corridor, or **ambulatory**, wrapped around it. This ambulatory must have been visible above ground, where it enriched the exterior of the choir, since there were windows in its outer wall. Such crypts with ambulatories, usually housing the venerated tomb of a saint, had been introduced into Western church architecture during Carolingian times. But the Bernwardian design stands out for its large scale and its careful integration with the rest of the building.

The exterior as well as the choirs of Bernward's church have been disfigured by rebuilding. However, the restoration of the interior of the nave (fig. 9-11), with its great expanse of wall space between arcade and clerestory, retains the majestic feeling of the original design. (The capitals of the columns date from the original structure, the Bernwardian western choir from the twelfth century, and the painted wooden ceiling from the thirteenth.)

METALWORK

We can gauge the importance Bernward himself attached to the crypt at St. Michael's from the fact that he commissioned a pair of richly sculptured bronze doors that were probably meant for the two entrances leading from the transept to the ambulatory. They were finished in 1015, the year the crypt was consecrated. According to his biographer, Thangmar of Heidelberg, Bernward excelled in the arts and crafts. The idea for the doors may have come to him as a result of his visit to Rome, where he could have seen ancient Roman (and perhaps Byzantine) bronze examples. Bernward's, however, differ from earlier ones: they are divided into broad horizontal fields rather than vertical panels, and each field contains a biblical scene in high relief. The subjects, taken from Genesis (left door) and the Life of Christ (right door), depict the origin and redemption of sin.

Our detail (fig. 9-13, page 194) shows Adam and Eve after the Fall. Below it, in inlaid letters notable for their classical Roman character, is part of the inscription, with the date and Bernward's name. The figures here have none of the monumental spirit of the *Gero Crucifix*. They seem far smaller than they actually are, so that

9-13 *Adam and Eve Reproached by the Lord,* from the Doors of Bishop Bernward, Hildesheim Cathedral. 1015. Bronze, approx. 23 x 43" (58.3 x 109.3 cm)

one might mistake them for a piece of goldsmith's work such as the *Lindau Gospels* cover (compare fig. 9-9). The composition must have been derived from an illuminated manuscript, since very similar scenes are found in medieval Bibles. Even the stylized bits of vegetation have a good deal of the twisting movement we recall from Irish miniatures. Yet this is no mere imitation. The story is conveyed with splendid directness and expressive force. The accusing finger of the Lord, seen against a great void of surface, is the focal point of the drama. It points to a cringing Adam, who passes the blame to his mate, while Eve, in turn, passes it to the serpent at her feet.

MANUSCRIPTS

The same intensity is found in Ottonian manuscript painting. Here Carolingian and Byzantine elements are blended into a new style of extraordinary scope and power. The most important center of manuscript illumination at that time was the Reichenau Monastery, located on an island in Lake Constance, on the borders of modern-day Germany and Switzerland. Perhaps its finest achievement—and one of the great masterpieces of medieval art—is the *Gospel Book of Otto III.*

The scene of Jesus washing the feet of St. Peter (fig. 9-14) contains strong echoes of ancient painting, transmitted through Byzantine art. (The subject is found at Hosios Loukas.) The soft pastel hues of the background recall the illusionism of Graeco-Roman landscapes (see fig. 7-16), and the architectural frame around Jesus is a late descendant of the kind of architectural perspectives we saw in the House of the Vettii (see fig. 7-18). The Ottonian artist has put these elements to a new use. What was once an architectural vista now becomes the Heavenly City, the House of the Lord filled with golden celestial space as against the atmospheric earthly space outside.

The figures have also been transformed. In ancient art, this composition had been used to depict a doctor treating a patient. Now St. Peter takes the place of the patient and Jesus that of the physician. (Jesus is still represented as a beardless young philosopher.) As a result, the emphasis has shifted from physical to spiritual action. This new kind of action is not only conveyed through glances and gestures, but also governs the scale of things. Jesus and St. Peter, the most animated figures, are larger than the rest, and Jesus' "active" arm is longer than his "passive" one. The eight apostles, who merely watch, have been compressed into a tiny space, so that we see little more than their eyes and hands. Even the fan-like Early Christian crowd from which this group is derived (see fig. 8-4) is less disembodied. The scene straddles two eras. On the one hand, the nearly perfect blend of Western and Byzantine elements represents the culmination of the early medieval manuscript tradition. On the other, the expressive distortions look forward to Romanesque art, which incorporated them in heightened form.

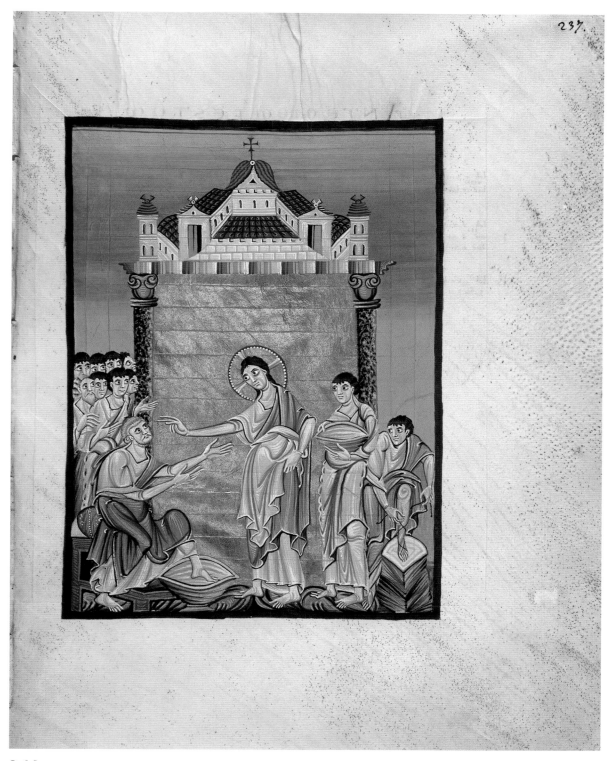

9-14 *Jesus Washing the Feet of Peter,* from the *Gospel Book of Otto III.* c. 1000. Tempera on vellum, 13 x 9³/₈" (33 x 23.8 cm). Staatsbibliothek, Munich

CHAPTER

10

ROMANESQUE ART

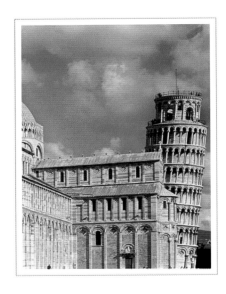

Up to this point, almost all of our chapter headings and subheadings might serve equally well for a general history of civilization. Some are based on technology (for example, the Old Stone Age), others on geography, ethnology, or religion. Whatever the source, they have been borrowed from other fields, even though in our context they also designate artistic styles. There are only two important exceptions: *Archaic* and *Classical* are mainly stylistic terms. They refer to qualities of form rather than to the setting in which these forms were created. Why don't we have more terms of this sort? We do, as we shall see, but only for the art of the past 900 years.

Those who first thought of viewing the history of art as an evolution of styles began with the belief that ancient art evolved toward a single climax: Greek art from the age of Perikles to that of Alexander the Great. This style they called *Classical* (that is, perfect). Everything that came before was labeled *Archaic*, to indicate that it was still old-fashioned and tradition-bound—it was not yet Classical but striving in the right direction. The style of post-Classical times, on the other hand, did not deserve a special term, since it had no positive qualities of its own—it was merely an echo or a decline of Classical art.

The early historians of medieval art followed a similar pattern. To them, the great climax was the Gothic style, from the thirteenth century to the fifteenth. For whatever was not yet Gothic they adopted the label *Romanesque,* which was first introduced in 1871. In doing so, they were thinking mainly of architecture. Pre-Gothic churches, they noted, were round-arched,

solid, and heavy, compared to the pointed arches and the soaring lightness of Gothic structures. It was rather like the ancient Roman style of building, and *Romanesque* was meant to convey just that quality.

The term is actually something of a misnomer. In one sense, all of medieval art before 1200 could be called Romanesque insofar as it shows any link with Roman tradition. Strictly speaking, however, it applies only to a small group of modest churches in northern Italy, southern France, and northern Spain. These structures do seem to be part of a revival about 950–1060 of the Early Christian style under Constantine and Justinian, although the effect is rather superficial. This "First Romanesque," as it is sometimes known, was too limited and provincial, however, to account for the Romanesque itself. The same decorative vocabulary, moreover, had already been used on Ottonian churches. What distinguishes the Romanesque proper is its amazing diversity and inventiveness, bespeaking a new spirit that is expressed most fully in monumental architecture.

Carolingian art, we will recall, was brought into being by Charlemagne and his circle, as part of a conscious revival. Even after his death it remained linked with his court. Ottonian art had a similarly narrow sponsorship. The Romanesque, in contrast, sprang up all over western Europe at about the same time. It consists of a large variety of regional styles, distinct yet closely related in many ways and without a central origin. In this respect, it resembles the art of the early Middle Ages rather than the Carolingian and Ottonian court styles that had preceded it. Its sources, however, include those styles, along with many other, less clearly traceable ones. Late Classical, Early Christian, and Byzantine elements can be found, as well as some Islamic influence and the Celtic-Germanic heritage.

What welded these components into a coherent style during the second half of the eleventh century was not any single force but a variety of factors that led to an upsurge of vitality throughout the West. The millennium came and went without the Apocalypse (described in the Book of Revelation of St. John the Divine) that many had predicted. Christianity had at last triumphed everywhere in Europe. The Vikings, still largely heathen in the ninth and tenth centuries when their raids terrorized the British Isles and the Continent, had entered the Catholic fold, not only in Normandy but in Scandinavia as well. In 1031 the Caliphate of Cordova had broken up into many small Muslim states, thus opening the way for the reconquest of the Iberian Peninsula, and the Magyars had settled down in Hungary.

There was a growing spirit of religious enthusiasm that could be seen in the greatly increased numbers of people making PILGRIMAGES to sacred sites and in the CRUSADES against the Muslims. Equally important was the reopening of Mediterranean trade routes by the navies of Venice, Genoa, Amalfi, Pisa, and Rimini. The revival of trade and travel linked Europe commercially and culturally, and urban life flourished as a result. The new pace of religious and secular life is vividly described in pilgrim guides of the time.

During the turmoil of the early Middle Ages, the towns of the West Roman Empire had shrunk greatly. (The population of Rome, about one million in 300 A.D., fell to less than 50,000 at one point.) Some cities were deserted altogether. From the eleventh century on, however, they began to regain their former importance. New towns sprang up everywhere. Like the cities, they gained their independence, thanks to a new middle class of artisans and merchants, which established itself between the peasantry and the landed nobility and became an important factor in medieval society.

In many ways, then, western Europe between 1050 and 1200 became a great deal more "Romanesque" than it had been since the sixth century. It recaptured some of the trade patterns, the urban quality, and the military strength of ancient imperial times. To be sure, there was no central political authority. Even the empire of Otto I did not extend much farther west than modern Germany does. But to some extent the central spiritual authority of the pope took its place as a unifying force. The monasteries of the Cistercians and Benedictines rivaled the wealth and power of secular rulers (see box, pages 200–201). Indeed, it was now the pope who sought to unite Europe into a single Christian realm. In 1095 Pope Urban II called for

Christian PILGRIMAGES began as early as the second century with journeys to Jerusalem. The pilgrim would travel to a sacred site to ask for help, to give thanks, or simply to express devotion. In medieval times, there were many pilgrimage destinations, the most popular being Rome, the Holy Land, and Santiago de Compostela in Spain. Geoffrey Chaucer's classic *The Canterbury Tales* is an account of a pilgrimage to the tomb of St. Thomas Becket.

Between 1095 and 1291, seven different armies were raised in Europe to undertake campaigns, called CRUSADES, to the Holy Land in the name of "freeing" Jerusalem from Muslim control. In fact, the Church's broad call was for war against all of its perceived opponents: political, heretical, and schismatic. In responding to the call, however, the nobles who volunteered themselves and their loyal soldiers believed they were accumulating merit by waging a "holy war" to reclaim the lands where Jesus had lived. The Crusades combined aspects of the pilgrimage as well, with Crusaders making stops at holy sites along the way from their homes to their various destinations in Syria, Palestine, and Egypt.

the First Crusade to liberate the Holy Land from Muslim rule and to aid the Byzantine emperor against the advancing Turks. The army of Crusaders was more powerful than anything a secular ruler could have raised for the purpose. The pope's authority was spiritual, not just temporal, as he tried to combat the heresies that grew throughout the Catholic realm. His claim of supremacy in dogma led to the final break (known as the Great Schism) with the Byzantine Orthodox church in 1054.

Architecture

The most striking difference between Romanesque architecture and that of the earlier Middle Ages is the amazing increase in building activity. An eleventh-century monk, Raoul Glaber, summed it up well when he exclaimed that the world was putting on a "white mantle of churches." These churches were not only more numerous than those of the early Middle Ages, they were also larger, more richly articulated, and more "Roman-looking." Their naves now had stone vaults instead of wooden roofs. Their exteriors, unlike those of previous churches, were decorated with both architectural ornament and sculpture. Romanesque monuments of the first importance are distributed over an area that might well have represented the world—the Catholic world, that is—to Raoul Glaber: from northern Spain to the Rhineland, from the Scottish-English border to central Italy. The richest examples, the greatest variety of regional types, and the most adventurous ideas are to be found in France. If we add to this group the buildings, since destroyed or disfigured, whose original designs are known through archaeological research, we have a wealth of architectural invention unmatched by any previous era.

SOUTHWESTERN FRANCE
We begin our survey of Romanesque churches with St-Sernin, in the southern French town of Toulouse (figs. 10-1–10-3). It is one of a group of great churches of the "pilgrimage type," so called because they were built along the roads leading to the pilgrimage center of Santiago de Compostela in northwestern Spain. The plan is much more complex and more fully integrated than those of earlier structures such as St. Michael's at Hildesheim (see fig. 9-12). It is an emphatic **Latin cross**, with the center of gravity at the eastern end. Clearly this church was designed not only to serve a monastic community but also, like Old St. Peter's in Rome (see diagram, page 156), to accommodate large crowds of lay worshipers in its long nave and transept.

The nave is flanked by two aisles on each side. The inner aisle continues around the arms of the transept and the apse. This ambulatory circuit is anchored to the two towers of the west facade, which was never completed as planned. The ambulatory, we will recall, had been a feature of the crypts of earlier churches such as St. Michael's. Now it is above ground, where it is linked with the aisles of the nave and transept. Chapels radiate from the apse and continue along the eastern face of the transept. (The apse, ambulatory, and apsidal chapels form a unit known as the pilgrimage **choir**.) The plan also shows that the aisles of St-Sernin are groin-vaulted throughout. Along with the features already noted, the use of vaulting imposes a high degree of regularity on the design. The aisles are made up of square bays, which serve as a basic module for the other dimensions. The nave and transept bays equal two such units, the **crossing** and the facade towers four units. The harmony conveyed by the repetition of these modules is perhaps the most notable feature of the pilgrimage church.

On the exterior, the interrelationship of elements is enhanced by the different roof levels, which set off the nave and transept against the inner and outer aisles, the apse, the ambulatory, and the radiating chapels. The effect is increased by the **buttresses**, which reinforce the walls between the windows to contain the outward **thrust** of the vaults. The windows and **portals** are further emphasized by decorative framing. The crossing tower was completed later, in Gothic times, and is taller than originally intended. The two facade towers, unfortunately, were never finished and remain stumps.

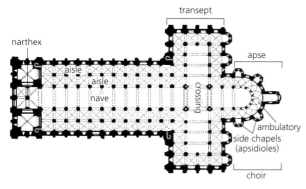

10-1 Plan of St-Sernin, Toulouse

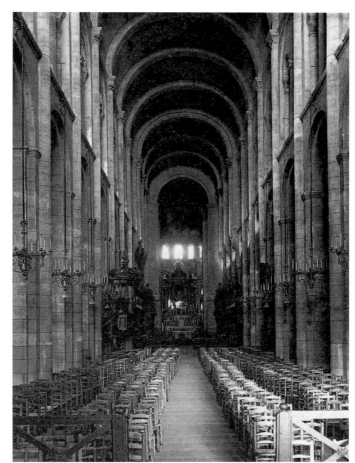

10-3 Nave and choir, St-Sernin

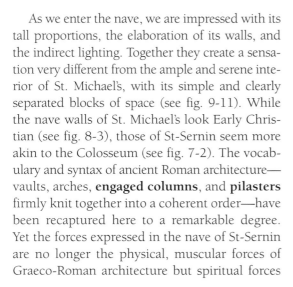

10-2 St-Sernin. c. 1070–1120

As we enter the nave, we are impressed with its tall proportions, the elaboration of its walls, and the indirect lighting. Together they create a sensation very different from the ample and serene interior of St. Michael's, with its simple and clearly separated blocks of space (see fig. 9-11). While the nave walls of St. Michael's look Early Christian (see fig. 8-3), those of St-Sernin seem more akin to the Colosseum (see fig. 7-2). The vocabulary and syntax of ancient Roman architecture—vaults, arches, **engaged columns**, and **pilasters** firmly knit together into a coherent order—have been recaptured here to a remarkable degree. Yet the forces expressed in the nave of St-Sernin are no longer the physical, muscular forces of Graeco-Roman architecture but spiritual forces of the kind we have seen governing the human body in Carolingian and Ottonian miniatures. To a Roman viewer, the half-columns running the entire height of the nave wall would appear just as unnaturally drawn out as the arm of Jesus in figure 9-14. The columns seem to be driven upward by some tremendous, unseen pressure, as if hastening to meet the transverse arches that subdivide the **barrel vault** of the nave. Their insistently repeated rhythm propels us toward the eastern end of the church, with its light-filled apse and ambulatory (now obscured by a huge altar of later date).

We do not mean to suggest that the architect set out to achieve this effect. Beauty and engineering were inseparable. Vaulting the nave to

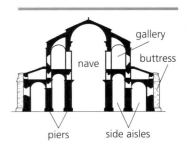

Seen in section, the physics of St-Sernin are quite apparent. The walls of the nave and the aisles transfer the weight downward through the piers and outward to the lowest side walls, where it is buttressed.

People of many times, places, and religious faiths have renounced the world and devoted themselves entirely to a spiritual way of life. Some have chosen to live alone as hermits, often in isolated places, where they have led harsh, ascetic existences. Others have come together in religious communities known as MONASTERIES to share their faith and religious observance. Hermits have been especially characteristic of Hinduism, while the monastic life has been more common in Buddhism. Among the Jews of the first century B.C., there were both hermits, or ANCHORITES (John the Baptist was one of these), and a kind of monasticism practiced by a sect known as the Essenes. Both forms are found in Christianity throughout most of its history as well. Their basis can be found in Scripture. On the one hand, Jesus urged his followers to give up all earthly possessions as the road to salvation. On the other, the book of Acts in the Bible records that the disciples came together in their faith after the Crucifixion.

The earliest monasticism practiced by Christians was the hermit's life. It was chosen by a number of pious men and women who lived alone in the Egyptian desert in the second and third centuries A.D. This way of life was to remain fundamental to the Eastern Church, especially in Syria.

But early on, communities emerged when colonies of disciples—both men and women—gathered around the most revered of the hermits, such as St. Anthony (fourth century), who achieved such fame as a holy man that he was pursued by people asking him to act as a divine intercessor on their behalf.

Monasteries soon came to assume great importance in early Christian life. (They included communities for women, which are often called convents or nunneries.) The earliest known monastery was founded by Pachomius along the Nile about 320 and blossomed into a community of nine monasteries and two nunneries by the time of his death a quarter-century later. Similar ones quickly followed in Syria, where monachism (monasticism) flourished until the 638 conquest by the Arabs. Syrian monasteries were for the most part sites along pilgrimage routes leading to the great monastery at Telanessa (present-day Qalᶜat Simᶜan), where Simeon Stylites (born 390) spent the last 30 years of his long life atop a tall column in almost ceaseless prayer.

Eastern monasticism was founded by Basil the Great (c. 330–379), bishop of Caesarea in Asia Minor. A remarkable man, he was the brother of Gregory of Nyssa and St. Macrina, successor to Eusebius as bishop of Caesarea. Along with his close friend Gregory Nazianzen, he was one of the four Fathers of the Greek Church. Basil's rule established the basic characteristics of Christian monasticism: poverty, chastity, and humility. It emphasized prayer, scriptural reading, and work, not only within the monastery but also for the good of laypeople in the world beyond its walls; as a result, monasticism now assumed a social role.

One of the oldest rules in the West is that of St. Augustine of Hippo (354–430). He spread monasticism to Africa, where it proved short-lived due to the Vandal conquests. Monasticism had been brought even earlier to France by St. Martin of Tours (c. 316–397) about the middle of the fourth century and to Ireland by St. Patrick (c. 385–461) in the fifth century. Ireland wholeheartedly adopted a harsh form of anchoritism during the sixth century. Monasticism was established in England by St. Augustine (died 604), first archbishop of Canterbury, who went there in 597 at the request of Pope Gregory the Great and enjoyed remarkable success in turning the country to Christianity.

The most important figure in Western monasticism was Benedict of Nursia (c. 480–c. 553), the founder of the abbey at Monte Cassino in southern

eliminate the fire hazard of a wooden roof was not only a practical aim, it also provided a challenge to make the House of the Lord grander. Since a vault becomes more difficult to sustain the farther it is from the ground, every resource had to be strained to make the nave as tall as possible. However, for safety's sake there is no **clerestory**. Instead, **galleries** were built over the inner aisles to abut the lateral pressure of the nave vault in the hope that enough light would filter through them into the central space. St-Sernin reminds us that architecture,

like politics, is "the art of the possible." Its success, here as elsewhere, is measured by the degree to which the architect has explored the limits of what seemed possible, both structurally and aesthetically, under those particular conditions.

BURGUNDY AND WESTERN FRANCE
The builders of St-Sernin would have been the first to admit that their answer to the problem of the nave vault was not the final one. The architects of Burgundy arrived at a more elegant

Italy. His rule, which was patterned after Basil's, divided the monk's day into periods of private prayer, communal ritual, and labor; it also required a moderate form of communal life, which was strictly governed. This was the beginning of the BENEDICTINE order, the first of the great monastic orders (or societies) of the Western church. The Benedictines thrived with the strong support of Gregory the Great, himself a former monk, who codified the Western liturgy and the forms of Gregorian chant.

Because of their organization and continuity, monasteries were considered ideal seats of learning and administration under the Frankish kings of the eighth century. They were supported even more strongly by Charlemagne and his heirs, who gave them land, money, and royal protection. As a result, they became rich and powerful, even exercising influence on international affairs. Monasteries and convents provided a place for the younger children of the nobility, and even talented members of the lower classes, to pursue challenging, creative, and useful lives as teachers, nurses, writers, and artists — opportunities that generally would have been closed to them in secular life (see box, page 212). Although they had considerable independence at first, the various orders eventually gave their loyalty to Gregory. They thereby became a major source of power for the papacy in return for its protection. Through these ties, Church and State over time became linked institutionally to their mutual benefit, thereby promoting greater stability.

Besides the Benedictines, the other important monastic orders of the West included the Cluniacs, the Cistercians, the Carthusians, the Franciscans, and the Dominicans. The CLUNIAC order (named after its original monastery at Cluny, in France) was founded as a renewal of the original Benedictine rule in 909 by Berno of Baume and 12 brethren on farmland donated by William of Aquitaine. It quickly emerged as the leading international force in Europe, thanks to its unique charter, which made it answerable only to the papacy, then at a low ebb in its power. The order also enjoyed close connections to the Ottonian rulers. Indeed, under the abbots Odilo (ruled 994–1049) and Hugh of Semur (ruled 1049–1109), its authority became so great that it could determine papal elections and influence imperial policy. It also called for Crusades and the reconquest of Spain.

Partly in reaction to the wealth and secular power of the Cluniac order and other church institutions, the CISTERCIAN order was founded in 1098 by Robert of Molesme as a return to the Benedictine rule. This order, headquartered at Cîteaux, reached its height under St. Bernard (1090–1153). His abbey in Clairvaux, settled with 12 brethren, overtook Cluny in population and power by the time of his death. Cistercian monasteries were deliberately located in remote places, where the monks would come into minimal contact with the outside world, and the rules of daily life were particularly strict. In keeping with this austerity, the order developed an architectural style known as Cistercian Gothic, recognizable by its geometric simplicity and lack of ornamentation (see pages 225 and 227–28).

The CARTHUSIAN order was founded by Bruno, an Italian monk, in 1084. Carthusians are in effect hermits, each monk or nun living alone in a separate cell, vowed to silence and devoted to prayer and meditation. The members of each house come together only for religious services and for communal meals several times a year. Because of the extreme austerity and piety of this order, several powerful dukes in the fourteenth and fifteenth centuries established Carthusian houses (charter-houses; French, *chartreuses*), so that the monks could pray perpetually for the souls of the dukes after they died. The most famous of these was the Chartreuse de Champmol, built in 1385 near Dijon, France, as the funerary church of Philip the Bold of Burgundy (see page 239) and his son John the Fearless.

Eventually the conflict between poverty and work led to the creation of two orders of wandering friars: the Franciscans and the Dominicans. Founded with the blessing of Pope Innocent III, to whom they swore obedience, both orders became arms of papal policy. They grew with astonishing rapidity until they became rivals, owing partly to their contrasting missions. The Franciscans were devoted to spiritual reform by living example, while the purpose of the Dominicans was to combat heresy. The FRANCISCAN order was founded in 1209 by St. Francis of Assisi (c. 1181–1226) as a preaching community. Francis, who was perhaps the most saintly character since Early Christian times, insisted on a life of complete poverty, not only for the members personally but for the order as a whole. The Poor Clares, established by Francis and his friend St. Clare (1194–1253) near Assisi, was an order of nuns that followed the ascetic life while ministering to the sick. It, too, underwent spectacular growth, especially in Spain, where it was sponsored by the royal house. Franciscan monks and nuns were originally MENDICANTS— that is, they begged for a living. This rule was revised in the fourteenth century.

The DOMINICAN order was established in 1220 by St. Dominic (c. 1170–1221), a Spanish monk who had been a member of the Cistercians. Besides preaching, the Dominicans devoted themselves to the study of theology. They were considered the most intellectual of the religious orders in the late Middle Ages and the Early Renaissance. While the Dominicans were well organized from the start, the Franciscan community did not become a formal order until a papal bull of 1230. It attained its greatest prominence under St. Bonaventure (1221–1274), who was, with the Dominican St. Thomas Aquinas (1225–1274), one of the great Doctors (theologians) of the Church. The two even taught together at the University of Paris during the early 1250s.

solution, which can be seen in the Cathedral of Autun (fig. 10-4). The cathedral was dedicated to Lazarus, the dead man revived by Christ and whose bones it came to house. It was begun by Bishop Étienne de Bage of the Cluniac order (see box, page 201) and was consecrated in 1132. Here the galleries are replaced by a **blind arcade** (called a **triforium**, since it often has three openings per bay) and a clerestory. This three-story elevation was made possible by the use of the pointed arch for the nave vault. The pointed arch probably reached France from Islamic architecture, where it had been used for some time. By eliminating the center part of the round arch, which responds the most to the pull of gravity, the two halves of a pointed arch brace each other. This type of arch thus exerts less outward pressure than the semicircular arch. It can therefore be made as steep as possible, and its walls can be pierced as well. (For reasons of harmony, the pointed arch also appears in the nave arcade, where it is not needed for further support.) The advances that grew out of this discovery were to make possible the soaring churches of the Gothic

period (see, for example, figs. 11-3 and 11-7). Like St-Sernin, Autun comes close to straining the limits of the possible. The upper part of the nave wall shows a slight outward lean under the pressure of the vault—a warning against any further attempts to increase the height of the clerestory or to enlarge the windows.

NORMANDY AND ENGLAND

The duchy of Normandy, farther north, had been ruled by a series of weak Carolingians before being ceded to the Danes by the aptly named Charles the Simple in 911. By the middle of the eleventh century, however, it had developed into the most dynamic force in Europe under the Capetian dynasty, which was established when Hugh Capet was elected king in 987 and which ruled France for almost 350 years. Although it came late, Christianity was strongly supported by the Norman dukes and barons, who were active in promoting monastic reform and who founded numerous abbeys. Thus Normandy soon became a cultural center of international importance. The architecture of southern France merged with local traditions to produce a new Norman school that evolved in an entirely different direction.

The westwork of St-Étienne (fig. 10-5), the abbey church founded at Caen by William the Conqueror a year or two after his invasion of England in 1066 (see pages 190 and 212), proclaims this an imperial church. Its closest ancestors are Carolingian churches built under royal patronage, such as Corvey (see fig. 9-6). Like its predecessors, it has a minimum of decoration. Four huge buttresses divide the front of the church into three vertical sections. The vertical thrust continues in the two towers, whose height would be impressive even without the tall Early Gothic helmets. St-Étienne is cool and composed: its refined proportions are meant to be appreciated by the mind rather than the eye.

The thinking that went into Norman architecture is responsible for the next great breakthrough in structural engineering, which took place in England, where William started to build as well. Durham Cathedral (fig. 10-6), begun in 1093, is

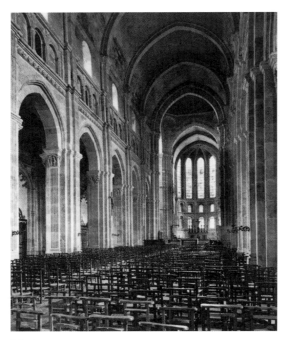

10-4 Nave wall, Autun Cathedral. c. 1120–32

separated by strong transverse arches, are oblong and groin-vaulted in such a way that the **ribs** form a double-X design. The vault thus is divided into seven sections rather than the usual four. Since the nave bays are twice as long as the aisle bays, the transverse arches occur only at the odd-numbered **piers** of the nave arcade. The piers therefore alternate in size. The larger ones are of compound shape (that is, bundles of column and pilaster **shafts** attached to a square or oblong core), while the others are cylindrical.

The easiest way to visualize the origin of this system is to imagine that the architect started out by designing a barrel-vaulted nave, with galleries over the aisles and without a clerestory, as at St-Sernin, but with the transverse arches spaced more widely. The realization suddenly dawned that putting groin vaults over the nave as well as the aisles would gain a semicircular area at the ends of each transverse vault which could be broken through to make a clerestory, because it had no essential supporting

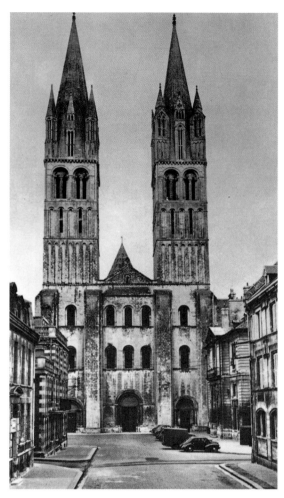

10-5 West facade, St-Étienne, Caen. Begun 1068

among the largest churches of medieval Europe. It has a nave one-third wider than St-Sernin's, and its overall length (400 feet) is also greater. The nave may have been designed to be vaulted from the start. The vault over its eastern end had been completed by 1107, a remarkably short time, and the rest of the nave was finished by 1130. This vault is of great interest. As the earliest systematic use of a ribbed groin vault over a three-story nave, it marks a basic advance beyond the solution we saw at Autun.

The aisles, which we can glimpse through the arcade, consist of the usual groin-vaulted compartments approaching a square. The bays of the nave,

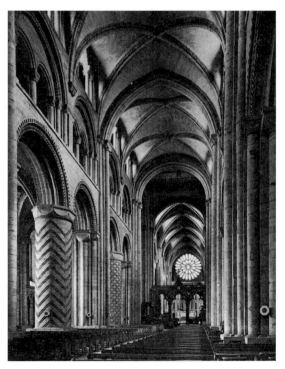

10-6 Nave (looking east), Durham Cathedral. 1093–1130

functions (fig. 10-7, left). Each nave bay is intersected by two transverse barrel vaults of oval shape, so that it contains a pair of Siamese-twin groin vaults that divide it into seven compartments. The outward thrust and weight of the whole vault are concentrated at six securely anchored points on the gallery level. The ribs were needed to provide a stable skeleton for the groin vault, so that the curved surfaces between them could be filled in with masonry of minimum thickness. Thus both weight and thrust were reduced. We do not know whether this ingenious scheme was actually invented at Durham, but it could not have been devised much earlier, for it is still in an experimental stage. While the transverse arches at the crossing are round, those to the west of it are slightly pointed, indicating an ongoing search for improvements.

This system had other advantages as well. From an aesthetic standpoint, the nave at Durham is among the finest in all Romanesque architecture. The wonderful sturdiness of the alternating piers makes a splendid contrast with the dramatically lit, sail-like surfaces of the vault. This lightweight, flexible system for covering broad expanses of great height with fireproof vaulting, while retaining the ample lighting of a clerestory, marks the culmination of the Romanesque and the dawn of the Gothic.

ITALY

We might have expected central Italy, which had been part of the heartland of the Roman Empire, to have produced the noblest Romanesque of them all, since surviving classical originals were close at hand. There were a number of factors that prevented this development. All of the rulers who sought to revive "the grandeur that was Rome," with themselves in the role of emperor, were in northern Europe. The spiritual authority of the pope, reinforced by large territorial holdings, made imperial ambitions in Italy difficult to achieve. New centers of prosperity and commerce, whether arising from seaborne trade or local industries, tended to consolidate a number of small principalities. They competed among themselves or aligned themselves from time to time with the pope or the German emperor if it seemed politically profitable. Lacking the urge to re-create the old empire, and having Early Christian buildings as readily accessible as classical Roman ones, the Tuscans were content to continue basically Early Christian forms. Yet they enlivened these structures with decorative features inspired by pagan architecture.

The most famous monument of the Tuscan Romanesque owes its fame to an accident. Because of poor foundations, the Leaning Tower of Pisa, designed by the sculptor Bonanno Pisano (active 1174–86), began to tilt even before it was completed. The tower is the **campanile** of Pisa Cathedral, which includes the church itself and the circular, domed baptistery to the west (fig. 10-8). This ensemble, built on an open site north of the city, reflects the wealth and pride of the city-republic of Pisa after its naval victory at Palermo in 1062.

Tuscany remained conscious of its classical heritage throughout the Middle Ages. If we compare Pisa Cathedral with S. Apollinare in Classe and St-Sernin in Toulouse (see figs. 8-2 and 10-2), we see that it is closely related to the latter in its scale and shape. However, the essential features are still much as we see them in S. Apollinare. The basic plan of Pisa Cathedral is that of an Early Christian basilica, but it has been transformed into a Latin cross by the addition of transept arms that resemble small basilicas with apses of their own. The crossing is marked by a dome.

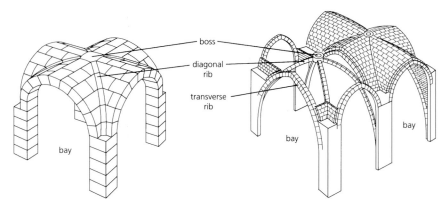

boss

diagonal rib

transverse rib

bay

bay

bay

10-7 Rib vaults (after Acland)

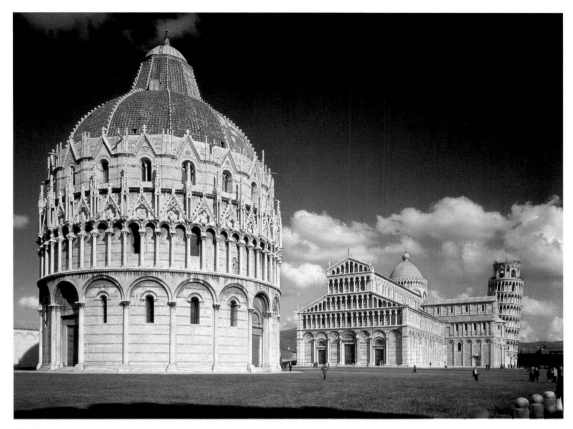

10-8 Pisa Baptistery, Cathedral, and Campanile (view from the west). 1053–1272

The only deliberate revival of the antique Roman style in Tuscan architecture was in the use of a multicolored marble "skin" on the exteriors of churches. Little of this is left in Rome because much of it was literally "lifted" to decorate later buildings. However, the interior of the Pantheon still gives us some idea of it (see fig. 7-4). We can recognize the desire to emulate such marble inlay in the baptistery opposite Florence Cathedral (fig. 10-9). The green-and-white marble paneling follows severe geometric lines, and the blind arcades are extraordinarily classical in proportion and detail. The entire building, in fact, has such a classical air that a few hundred years later, the Florentines believed it to have been originally a temple of Mars. Even today the debate over its date has not been settled completely. (Parts of the facade may actually date from the Early Renaissance.) We shall return to the Baptistery of S. Giovanni a number of times, since it was to be of great importance in the Renaissance.

10-9 Baptistery of S. Giovanni, Florence. c. 1060–1150

Sculpture

The revival of **monumental** stone sculpture is even more surprising than the architectural achievements of the Romanesque era. Neither Carolingian nor Ottonian art had shown any tendencies in this direction. Freestanding statues all but disappeared from Western art after the fifth century. Stone relief survived only in the form of architectural ornament or surface decoration, with the depth of the carving kept to a minimum. Thus the only continuous sculptural tradition in early medieval art was that of sculpture-in-miniature: small reliefs, and occasional statuettes, in metal or ivory. In works such as the bronze doors of Bishop Bernward (see fig. 9-13), Ottonian art had enlarged the scale of this tradition but not its spirit. Moreover, its truly large-scale sculptural efforts, such as the impressive *Gero Crucifix* (see fig. 9-10), were limited almost entirely to wood.

SOUTHWESTERN FRANCE

Fifty years later, the situation had changed dramatically. We do not know exactly when and where the revival of stone sculpture began, but the earliest surviving examples are found in southwestern France and northern Spain, along the pilgrimage roads leading to Santiago de Compostela. Thus, as in Romanesque architecture, the rapid development of stone sculpture shortly before 1100 coincides with the growth of religious fervor in the decades before the First Crusade. Architectural sculpture, especially on the exterior of a church, is meant to appeal to the lay worshiper rather than to the members of a closed monastic community.

St-Sernin at Toulouse contains several important examples probably carved about 1090, including the *Apostle* in figure 10-10. (This panel is now in the ambulatory; its original location is not certain, but it may have decorated the front of an altar.) Where have we seen its like before? The solidity of the forms has a strongly classical air, indicating that our artist must have had a close look at late Roman sculpture, of which there are numerous remains in southern France. But the solemn frontality of the figure and its placement in the architectural frame show that the design must be derived from a Byzantine source, probably an

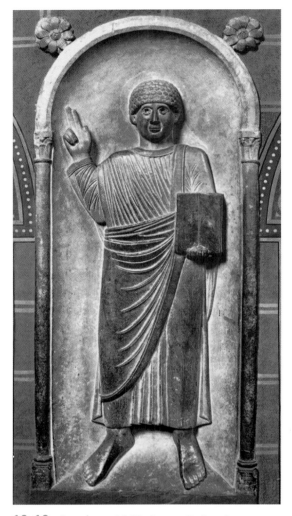

10-10 *Apostle*. c. 1090. Stone. St-Sernin, Toulouse

ivory panel descended from the Archangel Michael in figure 8-14. In enlarging such a miniature, the carver of our relief has also reinflated it. The niche is a real cavity, the hair a round, close-fitting cap, the body severe and blocklike. Our *Apostle* has, in fact, much the same dignity and directness as the sculpture of Archaic Greece.

The figure, which is somewhat more than half-life-size, was not meant to be viewed only at close range. Its impressive bulk and weight "carry" over a considerable distance. This emphasis on massive volume hints at what may have been the

main impulse behind the revival of large-scale sculpture. A stone-carved image, being tangible and three-dimensional, is far more "real" than a painted one. To the mind of a cleric steeped in abstract theology, this might seem irrelevant or even dangerous. For unsophisticated lay worshipers, however, any large sculpture had something of the quality of an idol, and it was this fact that gave it such great appeal.

Another important early center of Romanesque sculpture was the abbey at Moissac, farther north of Toulouse along the Garonne River. In figure 10-11 we see the magnificent **trumeau** (the center post supporting the lintel) and the western **jamb** (the side of the doorway) of the south portal. (Elements of a typical Romanesque portal are shown in figure 10-12.) Both have a scalloped profile—apparently a bit of Moorish influence. The shafts of the half-columns applied to the jambs and trumeau also follow this pattern, as if they had been squeezed from a giant pastry tube. Human and animal forms are treated with the same flexibility, so that the spidery prophet on the side of the trumeau seems perfectly adapted to his precarious perch. (Notice how he, too, has been fitted into the scalloped outline.) He even remains free to cross his legs in a dancelike movement and to turn his head toward the interior of the church as he unfurls his scroll.

But what of the crossed lions that form a symmetrical zigzag on the face of the trumeau—do they have a meaning? So far as we know, they simply "animate" the shaft, just as the interlacing beasts of Irish miniatures (from which they are descended) enliven the compartments they inhabit. In manuscript illumination, this tradition had never died out. Our sculpture has undoubtedly been influenced by it, just as the agitated movement of the prophet originated in miniature painting (see fig. 9-8). The crossed lions reflect another source as well. We can trace them through textiles to Persian metalwork (although not in this towerlike formation). They descend ultimately from the confronted animals of ancient Near Eastern art (see fig. 3-5). Yet we cannot fully account for their presence at Moissac in terms of their effectiveness as ornament alone. They belong to an extensive family

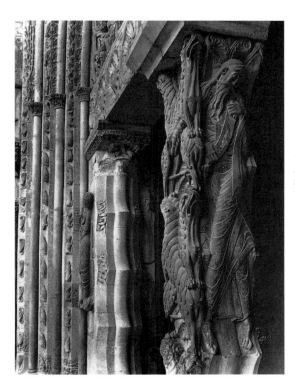

10-11 Portion of south portal, St-Pierre, Moissac. Early 12th century

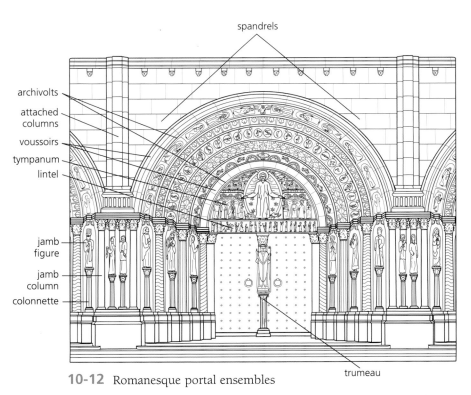

10-12 Romanesque portal ensembles

spandrels

archivolts

attached columns

voussoirs

tympanum

lintel

jamb figure

jamb column

colonnette

trumeau

of savage or monstrous creatures in Romanesque art that retain their demoniacal vitality even though they are forced, like our lions, to perform a supporting function. Their purpose is thus not only decorative but expressive as well. They embody dark forces that have been domesticated into guardian figures or banished to a position that holds them fixed for all eternity, however much they may snarl in protest.

The south portal at Moissac shows a richness of invention that St. Bernard of Clairvaux condemned in a letter of 1127 to Abbot William of St-Thierry concerning the sculpture of Cluny: "In the cloister under the eyes of the brethren who read there, what profit is there in those ridiculous monsters, in that marvelous and deformed beauty, in that beautiful deformity? . . . So many and so marvelous are the varieties of shapes on every hand, that we are even more tempted to read in the marble than in our books, and to spend the whole day wondering at these things rather than in meditating on the law of God." The pic-

torial representation of Christian themes was often justified by a famous saying, *"Quod legentibus scriptura, hoc idiotis . . . pictura."* Translated freely, it means that painting conveys the Word of God to the unlettered. Although he did not object specifically to the teaching role of art, St. Bernard had little use for church decoration. He would surely have disapproved of the Moissac portal's excesses, which were clearly meant to appeal to the eye—as his grudging admiration for the cloister at Cluny attests.

BURGUNDY

The **tympanum** (the **lunette** above the lintel) of the main portal of Romanesque churches usually holds a composition centering on the Enthroned Christ. Most often it shows the Apocalyptic Vision, or the Last Judgment, the most awesome scene in Christian art. At Autun Cathedral this subject has been visualized with extraordinary force by Giselbertus (fig. 10-13), who probably based his imagery on a contemporary account rather than

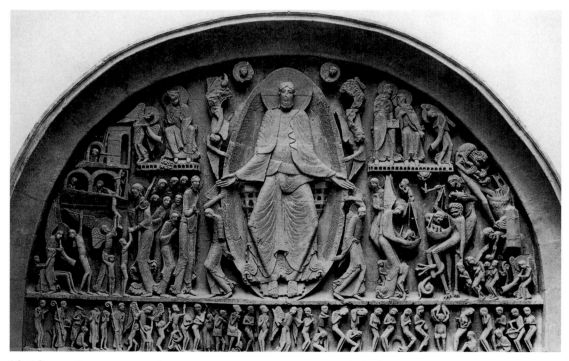

10-13 Giselbertus. *Last Judgment,* west tympanum, Autun Cathedral. c. 1130–35

on the Revelation of St. John the Divine. The apostles, at the viewer's left, observe the weighing of souls, shown at the right. Four angels in the corners sound the trumpets of the Apocalypse. At the bottom, the dead rise from their graves in fear and trembling; some are already beset by snakes or gripped by huge, clawlike hands. Above, their fate quite literally hangs in the balance, with devils yanking at one end of the scales and angels at the other. The saved souls cling like children to the angels for protection before their ascent to the Heavenly Jerusalem (far left), while the condemned, seized by grinning devils, are cast into the mouth of hell (far right). These devils betray the same nightmarish imagination we saw in the Romanesque animal world. Although human in general outline, they have birdlike legs, furry thighs, tails, pointed ears, and savage mouths. No visitor, having "read in the marble" here (to quote St. Bernard of Clairvaux), could fail to enter the church in a chastened spirit.

The emergence of distinct artistic personalities in the twelfth century is rarely acknowledged, perhaps because it contradicts the widespread notion that all medieval art is anonymous. Giselbertus is not the only or even the earliest case. He is one of several Romanesque sculptors who are known to us by name, and not by accident. Their highly individual styles made theirs the first names worthy of being recorded since Odo of Metz more than 300 years earlier.

THE MEUSE VALLEY

The revival of individuality also took place in the valley of the Meuse River, which runs from northeastern France into Belgium and Holland. This region had been the home of the classicizing Reims style in Carolingian times (see figs. 9-8 and 9-9), and an awareness of classical sources pervades its art (called Mosan) during the Romanesque period. Here again the revival of individuality is linked with the influence of ancient art, although this influence did not lead to works on a monumental scale.

Mosan Romanesque sculptors excelled in metalwork. The baptismal font of 1107–18 in Liège (fig. 10-14) was done by the earliest artist of the

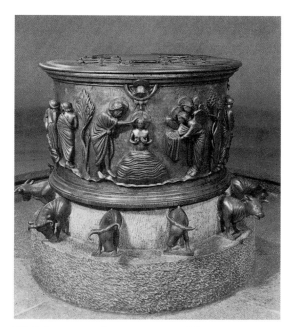

10-14 Renier of Huy. Baptismal font. 1107–18. Bronze, height 25" (63.5 cm). St-Barthélemy, Liège

region whose name we know: Renier of Huy. The vessel rests on 12 oxen (symbols of the 12 apostles), like Solomon's basin in the Temple at Jerusalem as described in the Bible. The reliefs make an instructive contrast with those of Bernward's doors (see fig. 9-13), since they are about the same height. Instead of the rough expressive power of the Ottonian panel, we find here a harmonious balance of design, a subtle control of the sculptured surfaces, and an understanding of organic structure that, in medieval terms, are amazingly classical. The figure seen from the back (beyond the tree on the left), with its graceful movement and Greek-looking drapery, might almost be taken for an ancient work.

ITALY

The French style quickly became international, but was modified through interaction with local tradition. We see this process in the work of Benedetto Antelami, the greatest sculptor of Italian Romanesque art. Unlike Giselbertus, Antelami was at heart a monumental sculptor, not a relief carver.

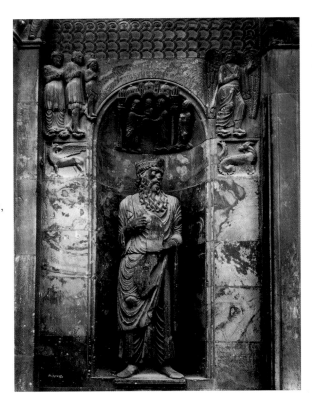

His *King David* (fig. 10-15), from the facade of Fidenza Cathedral in Lombardy, approaches the ideal of the self-sufficient statue more closely than any medieval work we have seen so far. The *Apostle* from St-Sernin is one of a series of figures, all of them fixed to their niches. Antelami's *David,* by contrast, stands physically free and even shows an attempt to recapture the classical *contrapposto*. To be sure, he would look awkward if placed on a pedestal in isolation; he demands the architectural framework for which he was made, but certainly to a far lesser extent than do other Romanesque statues. Nor is he subject to the group discipline of a series. His only companion is a second niche statue on the other side of the portal, which is likewise lost in thought. Such expressiveness, new to Romanesque sculpture, is characteristic of Antelami's work. We shall meet it again in the statues of Donatello. The *King David* is an extraordinary achievement, especially if we consider that less than a hundred years separate it from the beginnings of the sculptural revival.

Painting and Metalwork

Unlike architecture and sculpture, Romanesque painting shows no revolutionary developments that set it apart from Carolingian or Ottonian art. Nor does it look more "Roman" than Carolingian or Ottonian painting. This does not mean, however, that in the eleventh and twelfth centuries painting was any less important than it had been during the earlier Middle Ages. The lack of dramatic change merely emphasizes the greater continuity of the pictorial tradition, especially in manuscript illumination. Nevertheless, soon after the year 1000 we find the beginnings of a painting style that corresponds to—and often anticipates—the monumental qualities of Romanesque sculpture.

THE CHANNEL REGION

Although Romanesque painting, like architecture and sculpture, developed a wide variety of regional styles throughout western Europe, its greatest achievements emerged from the monastic scriptoria of northern France, Belgium, and southern England. The works produced in this area are so closely related in style that it is at times impossible to be sure on which side of the English Channel a given manuscript originated. Thus the style of the miniature of St. John (fig. 10-16) has been linked with both Cambrai, France, and Canterbury, England. Here the abstract linear draftsmanship of earlier medieval manuscripts (see fig. 9-8) has been influenced by Byzantine art, but without losing its energetic rhythm. (Note the ropelike loops of drapery, whose origin can be traced back to such works as the *Crucifixion* at Daphne in figure 8-16 and even further, to the ivory leaf in figure 8-14.) The controlled dynamics of every contour, both in the main figure and in the frame, unite the varied elements of the composition into a coherent whole. This quality of line betrays its ultimate source, the Celtic-Germanic heritage.

If we compare our miniature with the Cross page from the *Lindisfarne Gospels* (see fig. 9-3), we realize how much the interlacing patterns of the early Middle Ages have contributed to the design of the St. John page. The drapery folds and

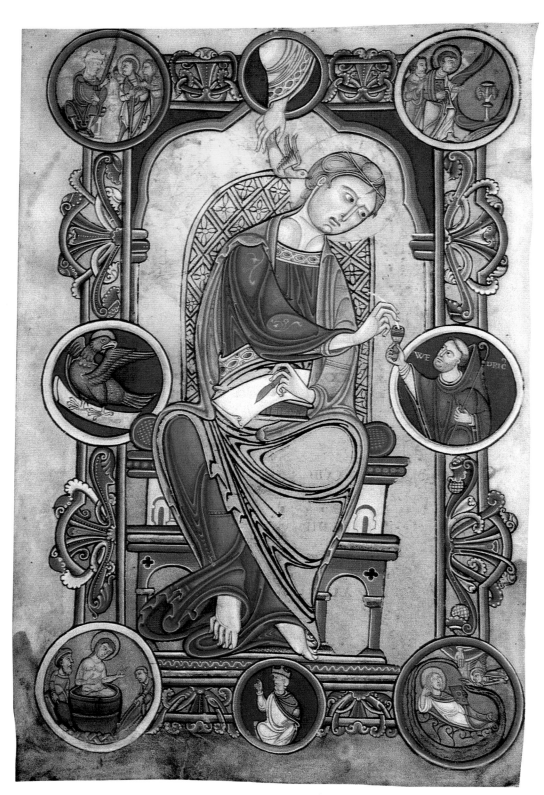

10-16 *St. John the Evangelist,* from the *Gospel Book of Abbot Wedricus.* c. 1147. Tempera on vellum, 14 x 9$\frac{1}{2}$" (35.5 x 24 cm). Société Archéologique et Historique, Avesnes-sur-Helpe, France

The late tenth through the twelfth century witnessed the unprecedented rise of women, first as patrons of art and then as artists. This remarkable development began with the Ottonian dynasty, which forged an alliance with the Church by placing members of the family in prominent positions. Thus Mathilde, Otto I's granddaughter, became abbess of the Holy Trinity convent at Essen in 974. Later, the sister, daughters, and granddaughter of Otto II also served as abbesses of major convents. Hardly less important, though not of royal blood, were Hrosvitha, canoness at the monastery of Gandersheim, who was the first woman dramatist we know of, and the two abbesses of Niedermünster, both named Uota. They paved the way for Herrad of Hohenberg (died 1195), author of *The Garden of Delights,* an encyclopedia of knowledge and history compiled for the education of her nuns.

"The Fountain of Life," detail from *Liber divinorum operum*, Vision 8, fol. 132r. 13th century. Tempera on vellum, $13^1/_8$ x $5^5/_8$" (33.3 x 14.4 cm). Biblioteca Statale di Lucca, Italy

Most remarkable of all was the Benedictine abbess Hildegard of Bingen (1098–1179). Among the most brilliant women in history, she corresponded with leaders throughout Europe. In addition to a musical drama in Latin, the *Ordo virtutum,* about the struggle between the forces of good and evil, she composed almost 80 vocal works that rank with the finest of the day. For her, musical harmony reflected the harmony of the universe.

She also wrote some 13 books on theology, medicine, and science. Hildegard is known above all for her books of visions, which made her one of the great spiritual voices of her day. Although one, *Scivias* (To Know the Ways of God), is now available only in facsimile (it was destroyed in 1945) and the other, *Liber divinorum operum* (The Book of Divine Works), in a later reproduction, it seems likely that the originals were executed under her direct supervision by nuns in her convent on the Rhine. It has also been argued that they were produced by monks at nearby monasteries.

That there were women artists from the twelfth century on is certain, although we know only a few of their names. In one instance, an initial in a manuscript includes a nun bearing a scroll inscribed, "Guda, the sinful woman, wrote and illuminated this book"; another book depicts Claricia, evidently a lay artist, swinging as carefree as any child from the letter *Q* she has decorated. Without these author portraits, we might never suspect the involvement of women illuminators.

WILLIAM THE CONQUEROR (c. 1028–1087), the illegitimate son of the duke of Normandy, most likely was promised the English throne by his cousin Edward the Confessor. William defeated the usurper Harold Godwin at the Battle of Hastings and was crowned king on Christmas Day 1066. By the time of the Domesday Book (1086), a survey of England ordered by William, the Anglo-Saxon rebellions had been completely crushed, and a new ruling class of Normans, Bretons, and Flemings had been established.

the clusters of floral ornament have an impulsive yet disciplined aliveness that echoes the intertwined, snakelike monsters of the animal style, even though the foliage is derived from the classical acanthus and the human figures are based on Carolingian and Byzantine models. The unity of the page is conveyed not only by the forms but by the content as well. St. John "inhabits" the frame in such a way that we could not remove him from it without cutting off his ink supply (offered by the donor of the manuscript, Abbot Wedricus), his source of inspiration (the dove of the Holy Spirit held in the hand of God), or his symbol (the eagle). The other medallions show various scenes taken from the saint's life.

The linearity and the simple, closed contours of this painting style lend themselves readily to changes in scale and to other mediums (murals, tapestries, **stained-glass** windows, sculptured reliefs). The *Bayeux Tapestry* is an embroidered frieze 230 feet long, illustrating WILLIAM THE CONQUEROR's invasion of England. In our detail (fig. 10-17) depicting the Battle of Hastings, the designer has integrated narrative and ornament with complete ease. The main scene is framed by two border strips. The upper tier with birds and animals is purely decorative, but the lower one is full of dead warriors and horses and thus forms part of the story.

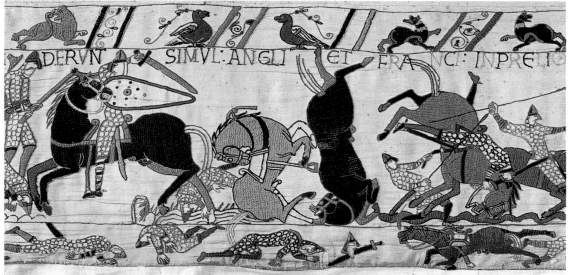

Although it does not use the pictorial devices of classical painting, such as foreshortening and overlapping (see fig. 5-5), the tapestry gives us a vivid and detailed account of warfare in the eleventh century. The massed forms of the Graeco-Roman scene are gone, replaced by a new kind of individualism that makes each figure a potential hero, whether by force or by cunning. (Note how the soldier who has fallen from the horse with its hind legs in the air is, in turn, toppling his foe by yanking at the saddle girth of his mount.)

SOUTHWESTERN FRANCE

The firm outlines and strong sense of pattern found in the English Channel region are equally characteristic of Romanesque wall painting in southwestern France. *The Building of the Tower of Babel* (fig. 10-18) is part of the most impressive surviving cycle, which appears on the nave vault of the church at St-Savin-sur-Gartempe. It is an intensely dramatic design, crowded with strenuous action. The Lord himself, on the far left, participates directly in the narrative as he addresses the

10-18 *The Building of the Tower of Babel.* Detail of painting on the nave vault, St-Savin-sur-Gartempe, France. Early 12th century

builders of the huge structure. He is counterbalanced, on the right, by the giant Nimrod, the leader of the enterprise, who frantically hands blocks of stone to the masons atop the tower, so that the entire scene becomes a great test of strength between God and human. The heavy, dark contours and the emphatic play of gestures make the composition easily readable from the floor below. Yet the same qualities occur in the illuminated manuscripts of the region, which can be equally monumental despite their small scale.

THE MEUSE VALLEY

Soon after the middle of the twelfth century, there was an important change in Romanesque painting on both sides of the English Channel under the influence of metalwork. That the new style should have originated in this way is not as strange as it might seem, for its essential qualities are sculptural rather than pictorial. Metalwork (which includes not only cast or **embossed** sculpture but also **engraving**, **enameling**, and goldsmithing) had been a highly developed art in the Meuse Valley area since Carolingian times. Its greatest practitioner after Renier of Huy was Nicholas of Verdun, in whose work the classicizing, three-dimensional style of draftsmanship reaches full maturity.

An ALTARPIECE at Klosterneuburg that Nicholas completed in 1181 for provost Wernher consists of numerous engraved and enameled plaques laid out side by side like a series of manuscript illuminations from the Old and New Testaments. Originally this work took the form of a pulpit, but after a fire in 1330 it was rearranged as a **triptych**. *The Crossing of the Red Sea* (fig. 10-19) has a sumptuousness that recalls, on a miniature scale, the glittering play of light across mosaics (compare fig. 8-4). Here we meet the pictorial counterpart of the classicism that we saw earlier in the baptismal font of Renier of Huy at Liège (see fig. 10-14). The lines have suddenly regained their ability to describe three-dimensional forms instead of abstract patterns. The figures, clothed in "wet" draperies familiar to us from Classical statues, have achieved such a

10-19 Nicholas of Verdun. *The Crossing of the Red Sea,* from the *Klosterneuburg Altarpiece.* 1181. Enamel on gold plaque, height 5¹/₂" (14 cm). Klosterneuburg Abbey, Austria

high degree of organic structure and freedom of movement that we tend to think of them as forerunners of Gothic art rather than as the final phase of the Romanesque. Whatever we choose to call it, the style of the *Klosterneuburg Altarpiece* had a profound impact on both painting and sculpture during the next 50 years (see figs. 11-19 and 11-20).

Equally revolutionary is the new expressiveness of the scene. All the figures, even the little dog perched on the bag carried by one of the men, are united through the exchange of glances and gestures within the tightly knit composition. Not since late Roman times have we seen such concentrated drama, although its intensity is unique to medieval art. Indeed, the astonishing humanity of Nicholas of Verdun's art is linked to an appreciation of the beauty of ancient works of art, as well as to a new regard for classical literature and mythology.

Altars are tables or sometimes low stones that are the focal point of religious worship, often the site of sacrificial rites. They have been found at most Neolithic sites and are virtually universal. The Christian altar traditionally is a narrow stone "table" that contains bone fragments of a martyr within it (Protestants do not have this requirement) and a prescribed set of liturgical objects used in the rite of Eucharist on the top surface (the mensa). The altar frontal (antependium) may be plain or decorated.

An ALTARPIECE is not an altar, but is placed behind or at the back of the altar table. Early altarpieces were wingless, with painted or carved images in the shrine section and more images in the predella zone below the shrine. Winged altarpieces were developed in the twelfth century. Wings allow the imagery to change according to the Church calendar.

GOTHIC ART

e tend to think of events as unfolding in time, yet we are not as aware of their unfolding in space. Thus we cannot define the Gothic era in terms of time alone—we must consider its changing surface area as well. At the start, about 1140, this area was small indeed. It included only the province known as the Île-de-France (Paris and vicinity), the royal domain of the French kings. A hundred years later, most of Europe had adopted the Gothic style, from Sicily to Iceland. Around 1450, the Gothic area began to shrink. (It no longer included Italy.) By about 1550, it had disappeared almost entirely.

The term *Gothic* was first coined for architecture, and it is in architecture that the characteristics of the style are most easily recognized, although we also speak of Gothic sculpture and painting. For a century—from about 1150 to 1250, during the Age of the Great Cathedrals—architecture played the dominant role. Gothic sculpture was at first severely architectural in spirit but became less and less so after 1200; its greatest achievements are between the years 1220 and 1420. Painting, in turn, reached a peak between 1300 and 1350 in central Italy. North of the Alps, it became the leading art form from about 1400 on. Thus, in surveying the Gothic era as a whole, we find a gradual shift of emphasis from architectural to pictorial qualities. Early Gothic sculpture and painting both reflect the discipline of their monumental setting, while Late Gothic architecture and sculpture strive for "picturesque" effects.

Overlying this broad pattern is another one: international diffusion as against regional independence. As we have seen, Gothic art originally spread from the Île-de-France to the rest of France and then all of Europe, where it came to be known as *opus modernum* or *opus francigenum* ("modern work" or "French work"). In the course of the thirteenth century, the new style gradually lost its imported flavor, and regional variety began to appear.

The first three of these terms are descriptive of styles, not time periods (the points of difference between them can be readily inferred from the text). *High Gothic* and *Classic High Gothic* creations can and do appear in the same place and at the same time, as do a number of other overlapping styles. *International Gothic* refers to the spread of French High Gothic–style sensibilities outward from the Île-de-France to all of Europe, and *International Style* describes the lyrical, courtly painting and sculpture that flourished about 1400 throughout Europe.

Toward the middle of the fourteenth century, there was a growing tendency for these regional styles to influence each other until an "International Gothic" style prevailed almost everywhere about 1400. Shortly thereafter, this unity broke apart. Italy, with Florence in the lead, created a radically new art, that of the Early Renaissance. North of the Alps, Flanders took the lead in the development of Late Gothic painting and sculpture. Finally, a century later the Italian Renaissance became the basis of another international style.

This development roughly parallels what happened in the political arena. Supported by shifting alliances with the papacy, the kings of France and England emerged as the leading powers at the expense of the Germans in the early thirteenth century, which was generally a time of peace and prosperity. Under these ideal conditions the new Franciscan and Dominican orders were established (see box, page 201), and Catholicism found its greatest intellect, St. Thomas Aquinas, since St. Augustine and St. Jerome some 850 years earlier. After 1290, however, the balance of power quickly broke down. Finally, in 1305 the French pope Clement V moved the papacy to Avignon, where it remained for more than 70 years during what the humanist Petrarch called "the Babylon Captivity of the Papacy."

Architecture

FRANCE

Abbey Church of St-Denis We can pinpoint the origin of the Gothic style with uncommon accuracy. It was born between 1137 and 1144 in the rebuilding by Abbot Suger of the royal Abbey Church of St-Denis, just outside the city of Paris. To understand how Gothic architecture arose at this particular spot, we must examine the relationship between St-Denis, Suger, and the French monarchy. The kings of France derived their authority from the Carolingian tradition, although they belonged to the Capetian line (see page 202). However, their power was eclipsed by that of the nobles, who, in theory, were their vassals. The only

area they ruled directly was the Île-de-France, and their authority was often challenged even there. Not until the early twelfth century did the royal power begin to expand. As chief adviser to Louis VI, Suger helped to shape this process. It was he who forged the alliance between the monarchy and the Church. This union brought the bishops of France (and the cities under their authority) to the king's side; the king, in turn, supported the papacy in its struggle against the German emperors.

Suger also engaged in "spiritual politics." By giving the monarchy religious significance and glorifying it as the strong right arm of justice, he sought to rally the nation behind the king. The abbey of St-Denis was a key element in his plan. The church, founded in the late eighth century, enjoyed a dual prestige: it was both the shrine of St-Denis, the Apostle of France and protector of the realm, and the chief memorial of the Carolingian dynasty. Both Charlemagne and his father, Pepin, had been consecrated as kings there. It was also the burial place of Charles Martel, Pepin, and Charles the Bald. Suger wanted to make the abbey the spiritual center of France, a pilgrimage church that would outshine all others and provide a focal point for religious as well as patriotic emotion. To achieve this goal, the old structure had to be enlarged and rebuilt. The great abbot himself wrote two accounts of the church and its rebuilding which tell us a great deal, although they are incomplete. Unfortunately, the west **facade** of the present church is badly mutilated, and the **choir** at the east end, which Suger saw as the most important part of the church, retains its original appearance only in the **ambulatory** (fig. 11-1).

The ambulatory and radiating chapels surrounding the **arcaded apse** are familiar elements from the Romanesque pilgrimage choir (compare fig. 10-1), but they have been integrated in a new way. Instead of being separate, the **chapels** are merged to form, in effect, a second ambulatory. Ribbed **groin vaulting** based on the pointed arch is used throughout. (In the Romanesque pilgrimage choir, only the ambulatory had been groin-vaulted.) As a result, the entire apse is held together by a new kind of geometric order. It consists of seven nearly identical wedge-shaped units fanning out from

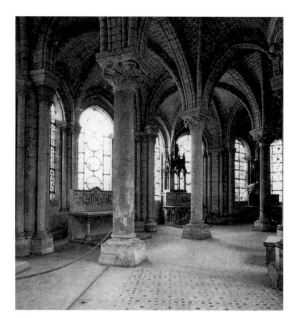

11-1 Ambulatory, Abbey Church of St-Denis, Paris. 1140–44

the center of the apse. (The central chapel, dedicated to the Virgin, and its neighbors on either side are slightly larger, presumably because of their greater importance.) We experience this double ambulatory not as a series of individual compartments but as a continuous (though articulated) space, whose shape is outlined for us by the network of slender **arches**, **ribs**, and **columns** that sustains the vaults.

What distinguishes this interior from earlier ones is its lightness, in both senses of the word. The architectural forms seem graceful, almost weightless, compared to the massive solidity of the Romanesque. In addition, the windows have been enlarged to the point that they are no longer openings cut into a wall—they themselves become translucent walls. What makes this abundance of light possible? The outward pressure of the vaults is contained by heavy **buttresses** jutting out between the chapels. (For the structural system of Gothic architecture, see fig. 11-5.) No wonder, then, that the interior appears so airy, since the heaviest parts of the structural skeleton are outside. The impression would be even more striking if we could see

all of Suger's choir, for the upper part of the apse, rising above the double ambulatory, had very large, tall windows. The effect, from the nave, must have been similar to that of the somewhat later choir of Notre-Dame in Paris (see fig. 11-3).

Suger and Gothic Architecture In describing Suger's choir, we have also described the essentials of Gothic architecture. Yet none of the elements that make up its design is really new. The pilgrimage choir plan, the pointed arch, and the ribbed groin vault can be found in regional schools of the French and Anglo-Norman Romanesque. However, they were never combined in the same building until St-Denis. Since the Île-de-France had not developed a Romanesque tradition of its own, Suger (as he himself tells us) had to bring together artisans from many different regions for his project. Yet we must not conclude that Gothic architecture was merely a synthesis of Romanesque traits. Otherwise, we would be hard-pressed to explain the new spirit that strikes us so forcibly at St-Denis: the emphasis on geometric planning and the quest for luminosity. Suger's account of the rebuilding of his church stresses both of these features as the highest values achieved in the new structure. "Harmony" (that is, the perfect relationship among parts in terms of mathematical proportions or ratios) is the source of all beauty, since it exemplifies the laws by which divine reason made the universe. Thus, it is suggested, the "miraculous" light that floods the choir through the "most sacred" windows becomes the Light Divine, a revelation of the spirit of God.

Suger was not a scholar but a man of action who was conventional in his thinking. He probably consulted the contemporary theologian Hugh of St-Victor, who was steeped in Dionysian thought (see box, page 218), especially for the most obscure part of his program at the west end of the church. This does not mean that Suger's own writings are simply a justification after the fact. On the contrary, he clearly knew his own mind. What, then, was he trying to achieve? For Suger, the material realm was the stepping-stone for spiritual contemplation. Thus the actual experience of dark, jewel-like light filtering through the stained-glass

In the first millennium of Christian thought, the symbolic interpretation of light and of numerical harmony underwent important development. The theological importance of these two concepts was due in part to the writings of a fifth-century Greek theologian who, during the entire Middle Ages, was believed to have been an Athenian disciple of St. Paul known as Dionysios the Areopagite. Dionysios's conversion to Christianity is recorded in the Acts of the Apostles (17:34). Because of this identification, the works of another fifth-century writer, called the Pseudo-Dionysios, also gained great authority. The power of the Pseudo-Dionysian writings—which emphasize an intimate union between the soul and God and offer Christians a spiritual path to attaining transcendent union with the divine—was highly influential in the Middle Ages. In Carolingian France, moreover, Dionysios, the disciple of Paul, came to be identified both with the author of the Pseudo-Dionysian texts and with St-Denis. The monks at the Abbey of St-Denis also blurred the identity of their patron saint with that of Jesus' "contemporary," perhaps to increase the abbey's prestige and power and bolster its royal association.

windows and disembodying the material world lies at the heart of Suger's mystical intent: to be transported to "some strange region of the universe which neither exists entirely in the slime of earth nor entirely in the purity of Heaven."

Suger and the Medieval Architect The success of the choir design at St-Denis is proved not only by its inherent qualities but also by its extraordinary impact. Every visitor, it seems, was overwhelmed by the achievement, and within a few decades the new style had spread far beyond the Île-de-France. The how and why of Suger's success are a good deal more difficult to explain. They involve a controversy we have met several times before—that of form versus function. To the advocates of the functionalist approach, Gothic architecture was the result of advances in engineering, which made it possible to build more efficient vaults, to concentrate their **thrust** at a few critical points, and thus to eliminate the solid walls of the Romanesque church. Suger, they argue, was fortunate in having an architect who understood the principles of ribbed groin vaulting better than anybody else at that time. If the abbot chose to interpret the resulting structure as symbolic of Dionysian theology, he was simply expressing his enthusiasm in the abstract language of the churchman; thus, his account does not help us to understand the origin of the new style.

As the integration of its parts suggests, the choir of St-Denis is more rationally planned and constructed than any Romanesque church. The pointed arch (which can be "stretched" to reach any desired height regardless of the width of its base) has become an integral part of the ribbed groin vault. As a result, these vaults are no longer restricted to square or near-square compartments. They have a new flexibility that allows them to cover areas of almost any shape (such as the trapezoids and pentagons of the ambulatory). The buttressing of the vaults, too, is more fully understood than before.

How could Suger's ideas have led to these technical advances unless he had been professionally trained as an architect? Actually, architectural training in the modern sense did not exist at the time, and in any event we know that Suger had no such background. Can the abbot then claim any credit for the style of what he so proudly calls "his" new church? Oddly enough, there is no contradiction here. As we have already noted (see box, page 187), the term *architect* had a very different meaning from the modern one, which derives from Greece and Rome by way of the Italian Renaissance. To the medieval mind, the overall leader of the project, not the master builder responsible for its construction, was the "architect." As Suger's account makes abundantly clear, he shared this view, which is why he remains so silent about his helper.

Perhaps this is a chicken-and-egg question. The function of a church, after all, is not merely to enclose a maximum of space with a minimum of material but also to convey the religious ideas that lie behind it. For the master who built the choir of St-Denis, the technical problems of vaulting must have been intertwined with such ideas, as well as

with issues of form—beauty, harmony, and the like. As a matter of fact, the design includes elements that express function without actually performing it, for example, the slender shafts (called **responds**) that seem to carry the weight of the vaults to the church floor.

In order to know what concepts to convey, the medieval architect needed the guidance of religious authority. At a minimum, such guidance might be a simple directive to follow some established model. In Suger's case, however, it amounted to a more active role. It seems that he began with one master builder at the west end but was disappointed with the result and had it torn down. This fact not only shows that Suger was actively involved in the design process but also confirms his position as the architect of St-Denis in the medieval sense. Suger's views, and not simply his design preferences, no doubt guided his choice of a second master of Norman background who would translate his ideas into the kind of structure he wanted. This great artist must have been singularly responsive to the abbot's objectives. Together, they created the Gothic style. We have seen this kind of close collaboration between patron and architect before: it occurred between Djoser and Imhotep, Perikles and Pheidias, just as it does today.

Constructing St-Denis Building St-Denis was an expensive and complex task that required the combined resources of Church and State. Suger used stone from quarries near Pontoise for the ambulatory columns and lumber from the forest of Yveline for the roof. Both had to be transported by land and river over great distances, a slow and costly process. The master builder probably employed several hundred stonemasons and two or three times that many laborers. He was aided by advances in technology spurred by warfare. Especially important were better cranes powered by windlasses or treadwheels that used counterweights and double pulleys for greater efficiency. These devices were easily put up and taken down, allowing for lighter scaffolding suspended from the wall instead of resting on the ground. Such developments made possible the construction techniques that were essential to building the new rib vaults.

Notre-Dame, Paris Despite the crucial importance of St-Denis, the future of Gothic architecture lay in the towns rather than in such rural monastic communities. There had been a vigorous revival of urban life, we will recall, since the early eleventh century. This movement continued at a rapid pace, and the growth of the cities was felt not only economically and politically but in countless other ways as well. Their bishops and clergy rose to new importance, and **cathedral** schools and universities took the place of monasteries as centers of learning. And the artistic efforts of the age culminated in the great cathedral churches.

Notre-Dame ("Our Lady," the Virgin Mary) at Paris, begun in 1163, reflects the main features of Suger's St-Denis more directly than does any other church (figs. 11-2–11-4, page 220). The plan (fig. 11-2), with its emphasis on the long axis, is extraordinarily compact and unified compared to that of the major Romanesque churches. The double ambulatory of the choir continues directly into the aisles, and the stubby transept barely exceeds the width of the facade. The six-part nave vaults over squarish bays, although not identical with the "Siamese-twin" groin vaulting in Durham Cathedral (see fig. 10-6), continue the kind of structural experimentation that was begun by the Norman Romanesque.

Inside (fig. 11-3) we find other echoes of the Norman Romanesque in the galleries above the inner aisles and the columns of the nave arcade. Here the pointed ribbed arches, pioneered in the western bays of the nave at Durham, are used throughout the building. Yet the large clerestory windows and the light and slender forms create the weightless effect that we associate with Gothic interiors and make the nave walls seem thin. The vertical emphasis of the interior is also Gothic. It depends less on the actual proportions of the nave—some Romanesque naves are equally tall relative to their width—than on the constant accenting of the verticals and the apparent ease with which the sense of height is attained. By contrast, Romanesque interiors (such as that in fig. 10-3) emphasize the great effort required in supporting the weight of the vaults.

In Notre-Dame, as in Suger's choir, the buttresses

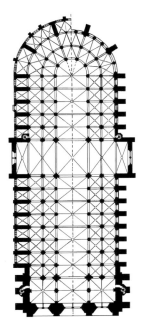

11-2 Plan of Notre-Dame, Paris. 1163–c. 1250

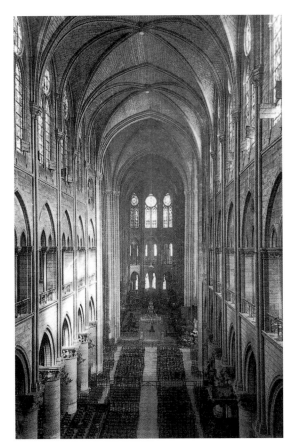

11-3 Nave and choir, Notre-Dame, Paris

11-4 Notre-Dame, Paris (view from the southeast)

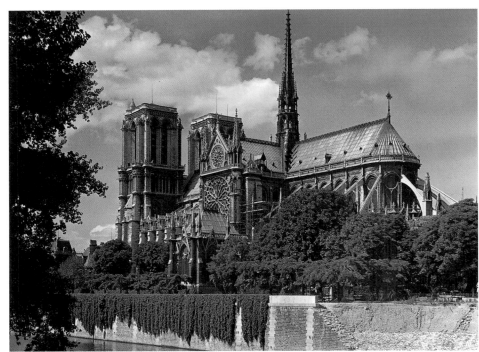

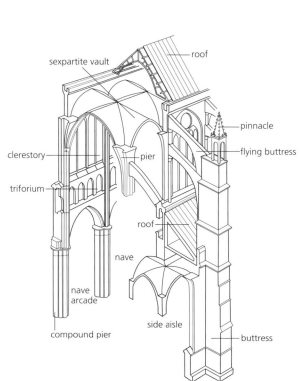

11-5 Axonometric projection of a High Gothic cathedral (after Acland)

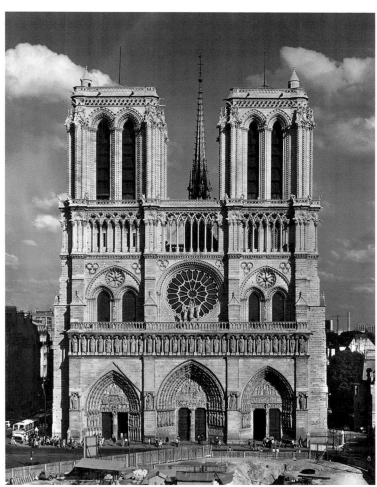

11-6 West facade, Notre-Dame, Paris

(the "heavy bones" of the structural skeleton) cannot be seen from the inside. (The plan shows them as massive blocks of masonry that stick out from the building like a row of teeth.) Above the aisles, these piers turn into **flying buttresses**—arched bridges that reach upward to the critical spots between the clerestory windows where the outward thrust of the nave vault is concentrated (fig. 11-4). This method of anchoring vaults, characteristic of Gothic architecture, certainly owed its origin to functional considerations (fig. 11-5). Yet even the flying buttress soon became aesthetically important. Its shape could express support (apart

from actually providing it) in a variety of ways, according to the designer's sense of style.

The most monumental aspect of the exterior of Notre-Dame is the west facade (fig. 11-6). It retains its original appearance, except for the sculpture, which was badly damaged during the French Revolution and is for the most part restored. The design reflects that of St-Denis, which was in turn derived from Norman Romanesque facades. If we compare Notre-Dame with St-Étienne at Caen (see fig. 10-5), we see that they share some basic features. These include the **pier buttresses** that reinforce the corners of the towers and divide the facade into

three main parts, the placing of the portals, and the three-story arrangement. The rich sculptural decoration, however, recalls the facades of southwestern France (see fig. 10-11) and the carved portals of Burgundy (see fig. 10-13).

Much more important are the qualities that distinguish Notre-Dame's facade from its Romanesque ancestors. Foremost among these is the way all the details have been integrated into a coherent whole. Here the meaning of Suger's emphasis on harmony, geometric order, and proportion becomes even more evident than in St-Denis itself. The same formal discipline can be seen in the sculpture, which no longer shows the spontaneous (and often uncontrolled) growth so typical of the Romanesque. Instead, it has been assigned a precise role within the architectural framework. At the same time, the cubic solidity of the facade of St-Étienne has been dissolved. Lacelike arcades and huge portals and windows break down the continuity of the wall surfaces, so that the total effect of Notre-Dame's facade is that of a weightless openwork screen.

How rapidly this tendency advanced during the first half of the thirteenth century can be seen by comparing the west front of Notre-Dame with the somewhat later facade of the south transept, visible in the center of figure 11-4. In the west facade, the **rose window** in the center is still deeply recessed. As a result, the stone **tracery** that subdivides the opening is clearly set off against the surrounding wall. On the transept, we can no longer distinguish the rose window from its frame, because a network of tracery covers the entire area.

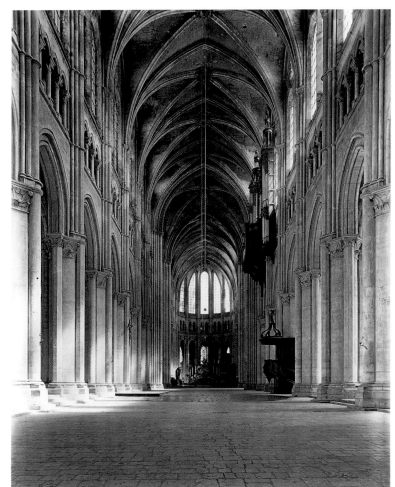

11-7 Nave and choir, Chartres Cathedral. 1145–1220

11-8 Triforium wall of the nave, Chartres Cathedral

Chartres Cathedral Toward 1145 the bishop of Chartres, who befriended Abbot Suger and shared his ideas, began to rebuild his cathedral in the new style with the help of the faithful. In 1194 a fire destroyed all but the west facade, which provided the main entrance, and the east crypt. A second rebuilding was begun that year, and as the result of a huge campaign it was largely complete within the astonishingly brief span of 26 years.

Designed one generation after the nave of Notre-Dame in Paris, the rebuilt nave (fig. 11-7) is the first masterpiece of the mature, or High Gothic, style. The openings of the pointed nave arcade are taller and narrower (see fig. 11-3) than in Early Gothic churches. They are joined to a clerestory of the same height by a short **triforium** screening the galleries, which have been reduced to a narrow wall. Responds have been added to the columnar supports to stress the continuity of the vertical lines and guide our eye upward to the quadripartite vaults, which appear as diaphanous webs stretched across the slender ribs. Because there are so few walls, the vast interior space appears at first to lack clear boundaries. It seems even larger because

of the sense of disembodied sound. The effect is so striking that it may well have been planned from the beginning with music in mind—both antiphonal choirs and large pipe organs, which had been in use for more than two centuries in some parts of Europe.

An alternating sequence of round and octagonal piers extends down the nave toward the apse, where the liturgy is performed. Beneath the apse is the crypt, which houses Chartres's most important possession: remnants of a robe said to have been worn by the Virgin Mary, to whom the cathedral is dedicated. The relic, which miraculously survived the great fire of 1194, drew pilgrims from all over Europe. To provide room for large numbers of visitors without disturbing worshipers, there is a wide aisle running the length of the nave and around the transept. It is joined at the choir by a second aisle, forming an ambulatory that connects the apsidal chapels.

Alone among all the major Gothic cathedrals, Chartres still retains most of its more than 180 original stained-glass windows. The magic of the jewel-like light from the clerestory is unforgettable to anyone who has experienced it (fig. 11-8). The windows admit far less light than one might expect. They act mainly as diffusing filters that change the quality of daylight, giving it the poetic and symbolic values so highly praised by Abbot Suger. The sensation of ethereal light dissolves the physical solidity of the church and, hence, the distinction between the temporal and the divine realms. The "miraculous light" creates the intensely mystical experience that lies at the heart of Gothic spirituality. (The aisles are darker because the stained-glass windows on the outer walls, though relatively large, are smaller and located at ground level, where they let in less light.)

The High Gothic style defined at Chartres reached its climax a generation later. Breathtaking height became the dominant aim, both technically and aesthetically. Skeletal construction was carried to its most precarious limits. The inner logic of the system forcefully manifested itself in the varied shapes of the vaults, taut and thin as membranes, and in the expanded window area, so that the entire wall above the nave arcade became a clerestory.

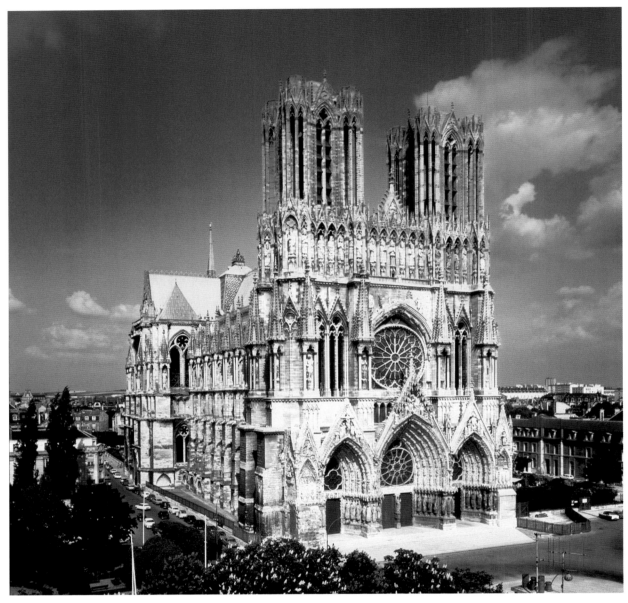

11-9 West facade, Reims Cathedral. c. 1225–99

Reims Cathedral The same emphasis on verticality and translucency can be traced in the development of the High Gothic facade. The most famous of these, at Reims Cathedral (fig. 11-9), makes an instructive contrast with the west facade of Notre-Dame in Paris, even though its basic design was conceived only about 30 years later. The two share many elements (as the coronation cathedral of the kings of France, Reims was closely linked to Paris), but in the later structure they have been reshaped into a very different ensemble. The portals, instead of being recessed, project forward as **gabled** porches, with windows in place of **tympanums** above the doorways. The gallery of royal statues, which in Paris forms a horizontal band between the first and second stories, has been raised until it merges with

the third-story arcade. Every detail except the rose window has become taller and narrower than before. Pinnacles everywhere accentuate the restless upward movement. The sculptural decoration, by far the most lavish of its kind (see fig. 11-21), no longer remains in clearly marked-off zones. It has now spread to so many new perches, not only on the facade but on the flanks as well, that the exterior begins to look like a dovecote for statues.

Secular Architecture Since our account of medieval architecture is mainly concerned with the development of style, we have confined our attention to religious structures, the most ambitious as well as the most representative efforts of the age. Secular building reflects the same general trends, but these are often obscured by the diversity of types, ranging from bridges and fortifications to royal palaces, from barns to town halls. Moreover, social, economic, and practical factors were more important here than in church design, so that the useful life of the buildings is apt to be much briefer and their chances of surviving lower. (Fortifications, for example, are often made obsolete by even minor advances in the technology of warfare.) As a result, our knowledge of secular structures of the pre-Gothic Middle Ages is fragmentary. Most of the surviving examples from Gothic times belong to the second half of the period. This fact, however, is significant in itself: nonreligious architecture, both private and public, became far more elaborate during the fourteenth and fifteenth centuries than it had been before.

The history of the Louvre in Paris provides a striking example. The original building, erected about 1200, followed the functional plan of the castles of that time. It consisted mainly of a stout tower (the donjon or keep) surrounded by a heavy wall. In the 1360s, King Charles V had a new one built as a royal residence. Although this second Louvre, too, has now disappeared, we know what it looked like from a miniature painted in the early fifteenth century (see fig. 11-40). There is still a defensive outer wall, but the structure behind it is much more like a palace than a fortress. Symmetrically laid out around a square court, it provided comfortable quarters for the royal household (note the countless chimneys), as well as lavishly decorated halls for state occasions.

International Gothic Architecture The High Gothic cathedrals of France represent a concentrated effort rarely seen before or since then. They are truly national monuments. Their huge cost was borne by donations collected all over the country and from all classes of society. They are the tangible expression of the merging of religious and patriotic fervor that had been the goal of Abbot Suger. By the middle of the thirteenth century, this wave of enthusiasm had passed its crest. Work on the vast structures begun during the first half now proceeded at a slower pace. New projects were fewer and generally far less ambitious. As a result, the highly organized teams of masons and sculptors that had formed at the sites of the great cathedrals during the preceding decades gradually broke up into smaller units.

The "royal French style of the Paris region" evoked an enthusiastic response abroad. Even more remarkable was its ability to adapt itself to a variety of local conditions. In fact, the Gothic monuments of England and Germany have become objects of intense national pride, and critics in both countries have claimed Gothic as a native style. A number of factors contributed to the rapid spread of Gothic art. Among these were the skill of French architects and stone carvers and the prestige of French centers of learning, such as the Cathedral School of Chartres and the University of Paris. Also important was the influence of the Cistercians, the reformed monastic order energized by St. Bernard of Clairvaux (see box, page 201). Still, one wonders whether any of these explanations really go to the heart of the matter. The basic reason for the spread of Gothic art seems to have been the persuasive power of the style itself. It kindled the imagination and aroused religious feeling even among people far removed from the cultural climate of the Île-de-France.

ENGLAND

Salisbury Cathedral That England was especially receptive to the new style is not surprising. Yet the English Gothic did not grow directly from the

Anglo-Norman Romanesque. Rather, it emerged from the Gothic of the Île-de-France, which was introduced in 1175 by the French architect who rebuilt the choir of Canterbury Cathedral, and from that of the Cistercians. Within less than 50 years, it developed a well-defined character of its own, known as the Early English style, which dominated the second quarter of the thirteenth century. Although there was a great deal of building activity during those decades, most of it consisted of additions to Anglo-Norman structures. Many English cathedrals had been begun about the same time as Durham (see fig. 10-6) but remained unfinished. They were now completed or enlarged. As a result, we find few churches that are designed in the Early English style throughout.

Among cathedrals, only Salisbury meets this requirement (fig. 11-10). We see immediately how different the exterior is from its counterparts in France—and how futile it would be to judge it by French Gothic standards. Compactness and verticality have given way to a long, low, sprawling look. (The crossing tower, which provides a dramatic unifying accent, was built a century later than the rest and is much taller than originally planned.) Since height is not the main goal, flying buttresses are used only as an afterthought. The west facade has become a screen wall, wider than the church itself and divided into horizontal bands of ornament and statuary, while the towers have shrunk to stubby turrets.

Gloucester Cathedral English Gothic rapidly developed toward a more pronounced verticality. The choir of Gloucester Cathedral (fig. 11-11) is a striking example of the English Late Gothic, also called the Perpendicular style. The name certainly fits, since we now find the dominant vertical accent that is absent in the Early English style. (Note the responds running in an unbroken line from the vault to the floor.) In this respect Perpendicular Gothic is much more akin to French sources, but it includes so many features we have come to know as English that it would look out of place on the Continent. The repetition of small uniform tracery panels recalls the bands of statuary

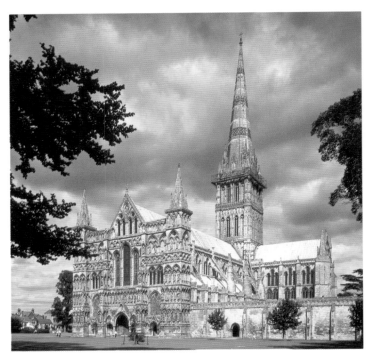

11-10 West facade, Salisbury Cathedral. 1220–70

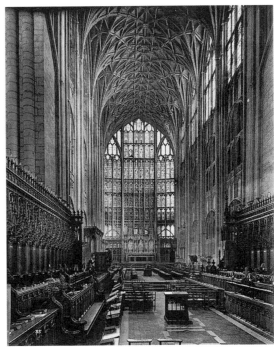

11-11 Choir, Gloucester Cathedral. 1332–57

on the west facade at Salisbury. The square end simulates the apses of earlier English churches, and the upward curve of the vault is as steep as in those buildings. The ribs of the vaults, on the other hand, have taken on a new role. They have been multiplied until they form an ornamental network that screens the boundaries between the bays and thus makes the entire vault look like one continuous surface. This effect, in turn, emphasizes the unity of the interior space. Such elaboration of the "classic" four-part vault is characteristic of the so-called Flamboyant style on the Continent as well (see page 361), but the English started it earlier and carried it to greater lengths.

GERMANY

Hall Churches In Germany, Gothic architecture took root a good deal more slowly than in England. Until the mid-thirteenth century, the Romanesque tradition, with its persistent Ottonian elements, remained dominant, despite the growing acceptance of Early Gothic features. From about 1250 on, however, the High Gothic of the Île-de-France had a strong impact on the Rhineland. Especially characteristic of German Gothic is the hall church, or *Hallenkirche*. Such churches, with aisles and nave of the same height, stem from Romanesque architecture. Although also found in France, the type was favored in Germany, where its artistic possibilities were explored fully. Heiligenkreuz (Holy Cross) in Schwäbish Gmünd (fig. 11-12) is one of many examples from central Germany. The space has a fluidity and expansiveness that enfold us as if we were standing under a huge canopy. There is no clear sense of direction to guide us. And the unbroken lines of the pillars, formed by bundles of shafts that diverge as they turn into lacy ribs covering the vaults, seem to echo the continuous movement that we feel in the space itself.

ITALY

Italian Gothic architecture stands apart from that of the rest of Europe. Judged by the standards of the Île-de-France, most of it hardly deserves to be called Gothic at all. Yet the Gothic in Italy produced beautiful and impressive structures that cannot be

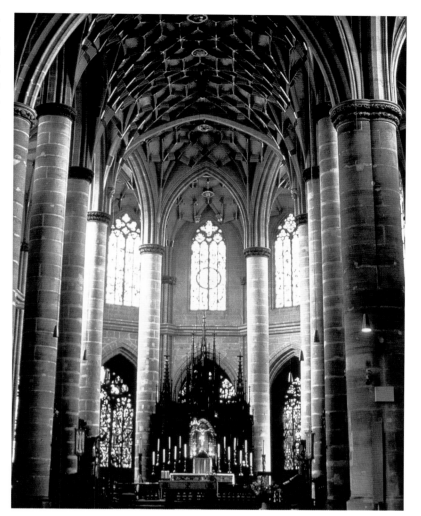

11-12 Choir, Heiligenkreuz, Schwäbish Gmünd, Germany. After 1351

viewed simply as continuations of the local Romanesque. We must be careful, therefore, to avoid too rigid a standard in approaching these monuments, lest we fail to do justice to their blend of Gothic qualities and Mediterranean tradition. It was the Cistercians, rather than the cathedral builders of the Île-de-France, who provided the chief models for Italian architects. As early as the end of the twelfth century, Cistercian abbeys sprang up in both northern and central Italy, their designs patterned directly after those of the order's French monasteries.

Abbey Church, Fossanova In keeping with St. Bernard's ideals, Cistercian abbey churches were of a distinctive, severe type. Decoration of any sort was held to a minimum, and a square choir took the place of apse, ambulatory, and radiating chapels. For that very reason, however, Cistercian architects put special emphasis on harmonious proportions and exact craftsmanship. Their "anti-Romanesque" outlook (see page 208) also led them to adopt certain basic features of the Gothic style, even though Cistercian churches remained strongly Romanesque in appearance. During the latter half of the twelfth century, as the reform movement gathered momentum, this austere Cistercian Gothic came to be known throughout western Europe.

One of the finest buildings is at Fossanova, some 60 miles south of Rome, which was consecrated in 1208 (fig. 11-13). Without knowing its location, we would be hard put to decide where to place it on a map—it might as well be Burgundian or English. The plain interior is in keeping with the ideal of austerity prescribed by St. Bernard. The finely proportioned interior resembles those of Cistercian abbeys of the French Romanesque and Gothic eras. The groin vaults, while based on the pointed arch, have no diagonal ribs. The windows are small, and the architectural detail retains a good deal of Romanesque solidity. Still, the flavor of the whole is unmistakably Gothic.

11-13 Nave and choir, Abbey Church of Fossanova, Italy. Consecrated 1208

Sta. Croce, Florence Churches such as the one at Fossanova made a deep impression upon the Franciscans, the monastic order founded by St. Francis of Assisi in the early thirteenth century (see box, page 201). As mendicant friars dedicated to poverty, simplicity, and humility, they were the spiritual kin of St. Bernard. The severe beauty of Cistercian Gothic must have seemed to express an ideal closely related to theirs. Thus, from the first, their churches reflected Cistercian influence and were pivotal in establishing Gothic architecture in Italy.

Sta. Croce in Florence, begun about a century after Fossanova, may well claim to be the greatest of all Franciscan structures (fig. 11-14). Reputed to be by the sculptor Arnolfo di Cambio (c. 1245–1310), it is also a masterpiece of Gothic architecture, even though it has wooden ceilings instead of groin vaults, except in the choir. There can be no doubt that this was a matter of deliberate choice, rather than of technical or economic necessity. The decision was made not simply on the basis of local practice. (Wooden ceilings had been a feature of the Tuscan Romanesque.) It may also have sprung from a desire to evoke the simplicity of Early Christian basilicas and to link Franciscan poverty with the traditions of the early Church. Since the wooden ceiling does not require buttresses,

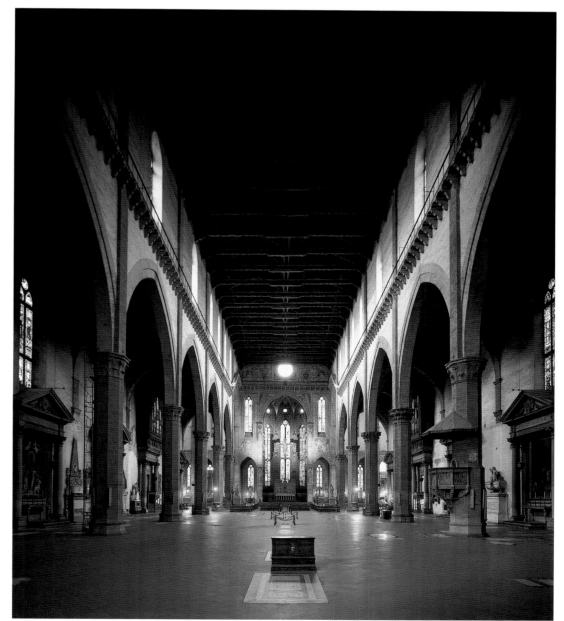

11-14 Nave and choir, Sta. Croce, Florence. Begun c. 1295

there are none. The walls thus provide continuous surfaces. Indeed, Sta. Croce owes part of its fame to its murals. (Some of these can be seen on the transept and apse in our illustration.)

Why, then, do we speak of Sta. Croce as Gothic? Surely the use of the pointed arch is not enough to justify the term. Yet the interior creates an effect fundamentally different from that of either Early Christian or Romanesque archi-

tecture. The nave walls have the weightless, "transparent" quality we saw in Northern Gothic churches, and the dramatic massing of windows at the eastern end conveys the dominant role of light as forcefully as Abbot Suger's choir at St-Denis. Judged in terms of its emotional impact, Sta. Croce is Gothic beyond doubt. It is also profoundly Franciscan—and Florentine—in its monumental simplicity.

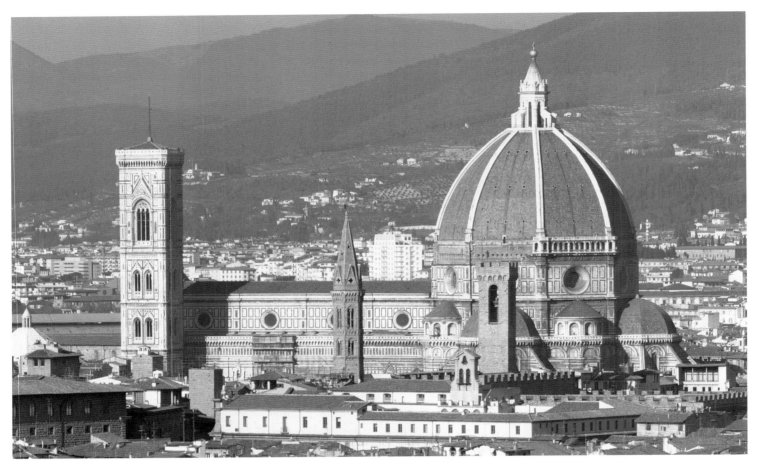

11-15 Florence Cathedral (Sta. Maria del Fiore). Begun by Arnolfo di Cambio, 1296; dome by Filippo Brunelleschi, 1420–36

Florence Cathedral At Sta. Croce the architect's main concern was an impressive interior. In contrast, Florence Cathedral was planned as a landmark to civic pride towering above the city (fig. 11-15). The original design, by Arnolfo di Cambio, dates from 1296, a little after Sta. Croce was begun, and is not known in detail. Although somewhat smaller than the present building, it probably had the same basic plan. The building as we know it is based largely on a design by Francesco Talenti (active 1325–69), who took over about 1343. The most striking feature is the octagonal dome with its subsidiary half-domes, a motif that can be traced to late Roman times. At first it may have been thought of as an oversize dome above the crossing of nave and transept, but it soon grew into a huge central pool of space that makes the nave look like an afterthought. The basic features of the dome were set by a committee of leading painters and sculptors in 1367. Because it posed enormous problems, however, the actual construction belongs to the early fifteenth century (see page 279).

Apart from the windows and the doorways, there is nothing Gothic about the exterior of Florence Cathedral. (Flying buttresses to sustain the nave vault may have been planned but proved unnecessary.) The solid walls, decorated with geometric marble inlays, are a perfect match for the Romanesque **Baptistery** nearby (see fig. 10-9). Typical of Italy, a separate campanile takes the place of the facade towers of northern Gothic

churches. It was begun by the great painter Giotto (see pages 247–51), who managed to finish only the first story, and continued by the sculptor Andrea Pisano (c. 1290–1348?), who was responsible for the niche zone. The rest is the work of Talenti, who completed it by about 1360.

Sculpture

FRANCE

Abbot Suger must have attached considerable importance to the sculptural decoration of St-Denis, although his story of the rebuilding of the church does not discuss it at length. The three portals of his west facade were far larger and more richly carved than those of Norman Romanesque churches. Unhappily, the trumeau figure of St-Denis and the jamb statue-columns were removed when the central portal was enlarged in 1770–71; worse still, the heads of the remaining figures were attacked by a mob during the French Revolution, and the metal doors melted down. As a result of these ravages and a series of clumsy restorations undertaken during the eighteenth and nineteenth centuries, we can gain only a general view of Suger's ideas about the role of sculpture within the total context of the structure he had envisioned.

Chartres Cathedral Suger's ideas paved the way for the splendid west portals of Chartres Cathedral (fig. 11-16), which were begun about 1145 under the influence of St-Denis, but were even more ambitious. They may well be the oldest full-fledged example of Early Gothic sculpture. Comparing them with a Romanesque portal (see fig. 10-12), we are impressed with a new sense of order. It is as if all the figures, conscious of their responsibility to the architectural framework, had suddenly come

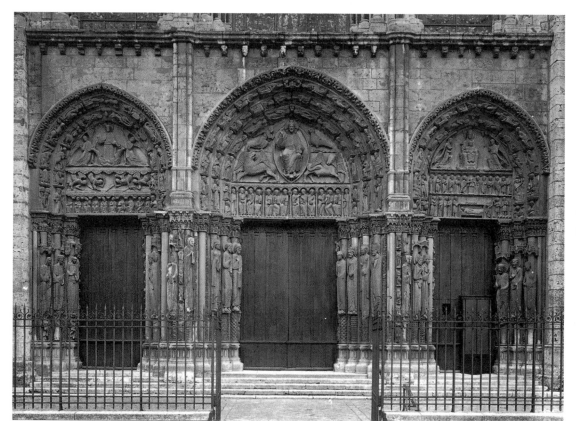

11-16 West portal, Chartres Cathedral. c. 1145–70

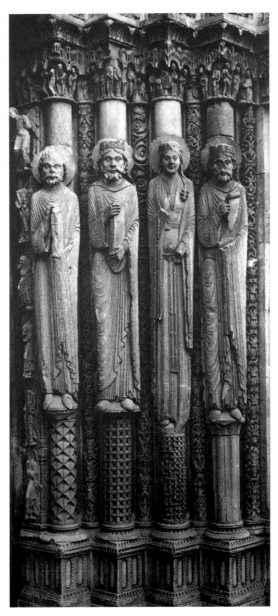

11-17 Jamb statues, west portal, Chartres Cathedral

to attention. The dense crowding and frantic movement of Romanesque sculpture have given way to symmetry and clarity. The figures on the lintels, **archivolts**, and tympanums are no longer entangled (see fig. 10-11) but stand out as separate entities. As a result, the design carries much further than that of previous portals.

Especially striking is the novel treatment of the jambs (fig. 11-17), which are lined with tall figures attached to columns. Such figures had occurred on the jambs or trumeaux of Romanesque portals, but they were reliefs carved into or protruding from the masonry of the doorway. The Chartres jamb figures, in contrast, are essentially statues, each with its own axis. They could, in theory at least, be detached from their supports. Here, then, we witness a development of truly revolutionary importance: the first step toward the reconquest of monumental sculpture in the round since the end of classical antiquity. (Only Benedetto Antelami, we will recall, had made such an attempt during the Romanesque era; see fig. 10-15.) Apparently this step could be taken only by borrowing the cylindrical shape of the column for the human figure, with the result that these statues seem more abstract than their Romanesque predecessors. Yet they will not retain their immobility and unnatural proportions for long. The very fact that they are round gives them a stronger presence than anything in Romanesque sculpture, and their heads show a gentle, human quality that bespeaks the fundamentally realistic trend of Gothic sculpture.

Realism is, of course, a relative term whose meaning varies according to circumstances. On the Chartres west portals, it appears to spring from a reaction against the fantastic and demoniacal aspects of Romanesque art. This response may be seen in the solemn spirit of the figures and their increased physical bulk (compare the Christ of the center tympanum with that at Autun, fig.10-13). It also appears in the discipline of the symbolic program underlying the entire scheme. While an understanding of the subtler aspects of this program requires a knowledge of the theology of the Chartres Cathedral School, its main elements can be readily understood.

The jamb statues form a continuous sequence linking all three portals. Together they represent the prophets, kings, and queens of the Bible. Their purpose is to acclaim the rulers of France as the spiritual descendants of Old Testament royalty and to stress the harmony of spiritual and secular rule, of priests (or bishops) and kings—ideals put forward by Abbot Suger. Christ himself is enthroned above the main doorway as Judge and Ruler of the universe.

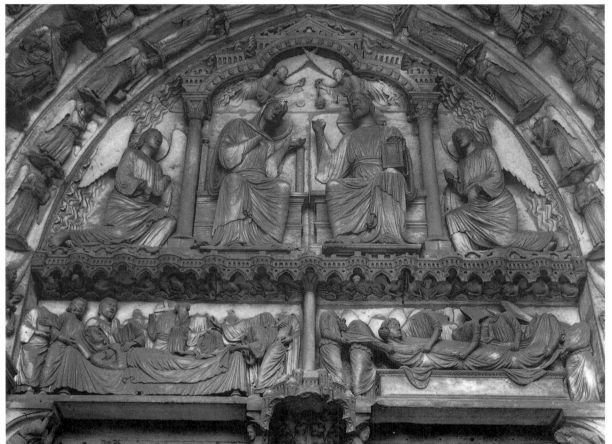

He is flanked by the symbols of the four evangelists, with the apostles below and the 24 elders of the Apocalypse in the outer two archivolts. The right-hand tympanum shows Christ's incarnation: the Birth, the Presentation in the Temple, and the Infant Christ on the lap of the Virgin, who also stands for the Church. In the outer two archivolts above are representations of the liberal arts as human wisdom paying homage to the divine wisdom of Christ. Finally, in the left-hand tympanum, we see the timeless Heavenly Christ (the Christ of the Ascension) framed by the ever-repeating cycle of the year: the signs of the zodiac and their earthly counterparts, the labors of the 12 months.

When Chartres Cathedral was rebuilt after the fire of 1194, the so-called Royal Portals of the west facade must have seemed small and old-fashioned in relation to the rest of the new structure. Perhaps

for that reason, the two transept facades each received three large portals preceded by deep porches. The north transept (fig. 11-18) is devoted to the Virgin. She had already appeared over the right portal of the west facade in her traditional guise as the Mother of God seated on the Throne of Divine Wisdom. Her new prominence reflects the growing importance of the cult of the Virgin, which had been actively promoted by the Church since the Romanesque period. The growth of Mariology, as it is known, was linked to a new emphasis on divine love, which was embraced by the faithful as part of the more human view that became increasingly popular during the Gothic era. The cult of the Virgin received special emphasis about 1204, when Chartres, which is dedicated to her, received the head of her mother, St. Anne, as a relic.

The north tympanum shows events associated

with the Feast of the Assumption (celebrated on August 15), when Mary was transported to heaven. They are the Death (Dormition), Assumption, and Coronation of the Virgin, which, along with the Annunciation, became the most frequently depicted subjects relating to her life. The presence of all three here is extraordinary. It identifies Mary with the Church as the Bride of Christ and the Gateway to Heaven, in addition to her traditional role as divine intercessor. More important, it stresses her equality with Christ. She becomes not only his companion (The Triumph of the Virgin) but also his queen! Unlike earlier representations, which rely on Byzantine examples, these are of Western invention. The figures have a monumentality never found before in medieval sculpture. Moreover, the treatment is so pictorial that the scenes are independent of the architectural setting into which they have been crammed.

Gothic Classicism The *Coronation of the Virgin* represents an early phase of High Gothic sculpture. The jamb statues of the transept portals at Chartres, such as the group shown in figure 11-19, show a similar evolution. By now, the interdependence of statue and column has begun to dissolve. The columns are quite literally put in the shade by the greater width of the figures, by the strongly projecting canopies, and by the elaborately carved bases of the statues.

In the three saints on the right, we still find echoes of the cylindrical shape of Early Gothic jamb statues, but even here the heads are no longer strictly in line with the central axis of the body. St. Theodore, the knight on the left, stands at ease, in a semblance of classical **contrapposto**. His feet rest on a horizontal platform, rather than on a sloping shelf as before, and the axis of his body, instead of being straight, describes a slight but perceptible S CURVE. Even more surprising is the abundance of precisely observed detail in the weapons and in the texture of the tunic and chain mail. Above all, there is the organic structure of the body. Not since imperial Roman times have we seen a figure as thoroughly alive as this. Yet the most impressive quality of the statue is not its realism,

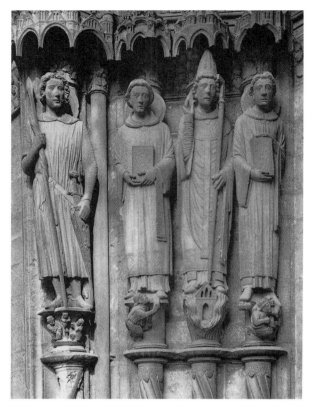

11-19 Jamb statues, south transept portal, Chartres Cathedral. c. 1215–20

but the serene, balanced image that this realism conveys. In this ideal portrait of the Christian soldier, the spirit of the Crusades has been expressed in its most elevated form.

The style of the *St. Theodore* could not have evolved directly from the elongated columnar statues of Chartres's west facade. It also incorporates another, equally important tradition: the classicism of the Meuse Valley, from Renier of Huy to Nicholas of Verdun (compare figs. 10-14 and 10-19). At the end of the twelfth century this trend, previously confined to metalwork and miniatures, also began to appear in monumental stone sculpture and transformed it from Early Gothic to Classic High Gothic.

Strasbourg Cathedral The link with Nicholas of Verdun is striking in the *Death of the Virgin* (fig.

The reverse S CURVE is slight, yet it animates the figure.

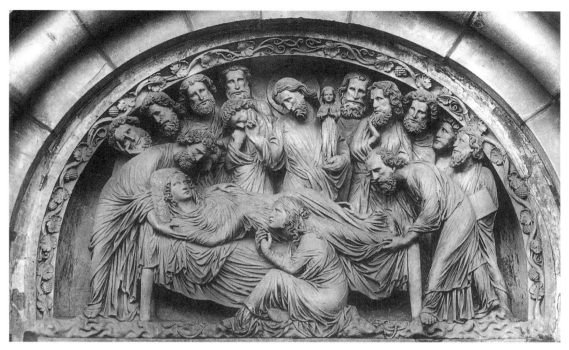

11-20 *Death of the Virgin,* tympanum of south transept portal, Strasbourg Cathedral. c. 1220

11-20), a tympanum at Strasbourg Cathedral slightly later than the Chartres north transept portals. Here the draperies, facial types, and movements and gestures have a classical flavor that recalls the work of Nicholas of Verdun (see fig. 10-19). What marks it as Gothic rather than Romanesque, however, is the deeply felt tenderness pervading the scene. We sense a bond of shared emotion among the figures, an ability to communicate by glance and gesture that surpasses even the *Klosterneuburg Altar*. This quality, too, has a long heritage reaching back to antiquity. It entered Byzantine art during the eleventh century as part of a renewed classicism (see figs. 8-16 and 8-17). Gothic expressiveness is unthinkable without such examples. But how much warmer and more eloquent it is at Strasbourg than at Chartres! What appears as merely one episode within the larger doctrinal statement of the earlier work now becomes the sole focus of attention. It serves as the vehicle for an outpouring of emotion that had never been seen in the art of western Christendom.

Reims Cathedral The climax of Gothic classicism is reached in some of the statues at Reims Cathedral. The most famous among them is the *Visitation* group (fig. 11-21, page 236, pair at right). To have a pair of jamb figures enact a narrative scene such as this would have been inconceivable in Early Gothic sculpture. The fact that they can do so now shows how far the column has receded into the background. Now the S curve, resulting from the pronounced *contrapposto,* is much more apparent than in the *St. Theodore.* It dominates the side view as well as the front view. The physical bulk of the body is further emphasized by horizontal folds pulled across the abdomen. The relationship of the two women shows the same warmth and sympathy we found in the Strasbourg tympanum, but their classicism is far more monumental. They make us wonder if the artist could have been inspired by large-scale Roman sculpture.

Because of the vast scale of the sculptural program at Reims, it was necessary to employ masters from other building sites. We therefore see several

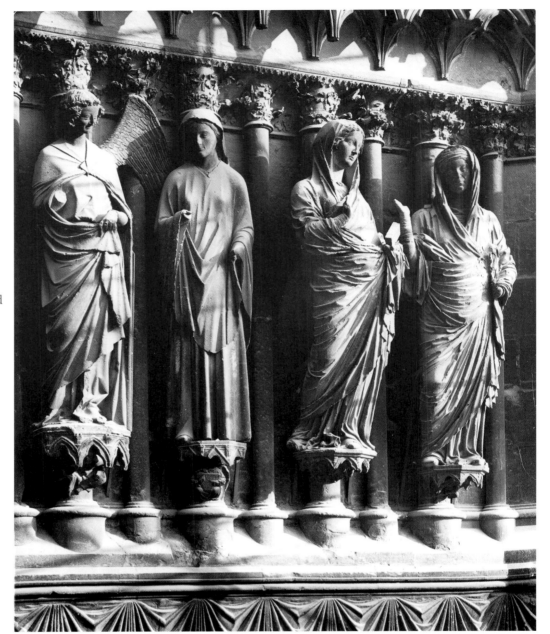

11-21 *Annunciation* and *Visitation*, west portal, Reims Cathedral. c. 1225–45

distinct styles among these figures. Two of them, both clearly different from the classicism of the *Visitation*, appear in the *Annunciation* group (fig. 11-21, left pair). The Virgin has a rigidly vertical body axis and straight, tubular folds meeting at sharp angles. This severe style was probably invented about 1220 by the sculptors of the west portals of Notre-Dame in Paris; from there it traveled to Reims. The angel, in contrast, is remarkably

graceful. We note the tiny, round face framed by curly locks, the emphatic smile, the strong S curve of the slender body, and the richly accented drapery. This "elegant style," created around 1240 by Parisian masters working for the royal court, spread far and wide during the following decades. In fact, it soon became the standard formula for High Gothic sculpture. We shall see its effect for many years to come, not only in France but abroad.

The Virgin of Paris A half-century later every trace of classicism has disappeared from Gothic sculpture. The human figure now becomes strangely abstract. Thus the famous *Virgin of Paris* (fig. 11-22) in Notre-Dame Cathedral consists largely of hollows,

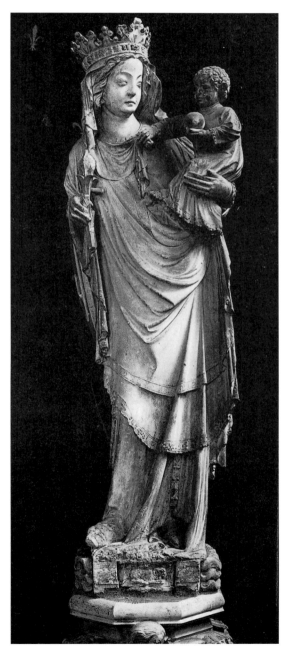

11-22 *The Virgin of Paris.* Early 14th century. Stone. Notre-Dame, Paris

and the projections have been reduced to the point where they are seen as lines rather than volumes. The statue is quite literally disembodied—its swaying stance no longer bears any relation to classical *contrapposto*. Compared to such unearthly grace, the angel of the Reims *Annunciation* seems solid and tangible indeed. Yet it contains the seed of the very qualities expressed so strikingly here.

When we look back over the century and a half that separates *The Virgin of Paris* from the Chartres west portals, we cannot help wondering what brought about this graceful manner. The new style was certainly encouraged by the royal court of France and thus had special authority. However, from about 1250 to 1400, these smoothly flowing, calligraphic lines came to dominate Gothic art not just in France but throughout Northern Europe. It is clear, moreover, that the style of *The Virgin of Paris* represents neither a return to the Romanesque nor a complete rejection of the earlier realistic trend.

Gothic realism had never been systematic. Rather, it had been a "realism of particulars," focused on specific details rather than on the overall structure of the visible world. This intimate kind of realism survives even within the formal framework of *The Virgin of Paris*. We see it in the Infant Christ, who appears here not as the Savior-in-miniature facing the viewer, but as a human child playing with his mother's veil. Our statue thus retains an emotional appeal that links it to the Strasbourg *Death of the Virgin* and to the Reims *Visitation*. It is this appeal, not realism or classicism as such, that is the essence of Gothic art.

GERMANY

The spread of the Gothic style in sculpture beyond the borders of France began only toward 1200—the style of the Chartres west portals had hardly any echoes abroad—but, once under way, it proceeded at an astonishingly rapid pace. England may well have led the way, as it did in evolving its own version of Gothic architecture. Unfortunately, so much English Gothic sculpture was destroyed during the Reformation that we can study its development only with difficulty. In Germany, the growth of Gothic sculpture can be traced more easily.

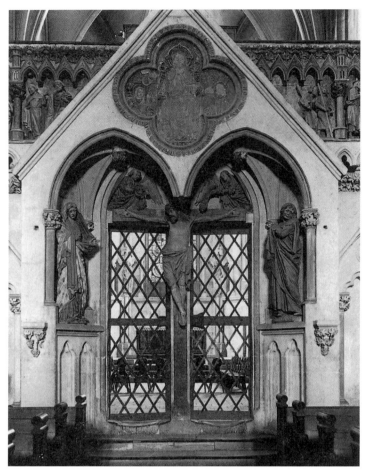

11-23 Naumburg Master. *Crucifixion,* on the choir screen, Naumburg Cathedral. c. 1240–50. Stone

The Naumburg Master These qualities are strikingly evident in the style of the Naumburg Master, an artist of real genius whose best-known work is the magnificent series of statues and reliefs made about 1240–50 for Naumburg Cathedral. The *Crucifixion* (fig. 11-23) forms the center of the **choir screen**; flanking it are statues of the Virgin and John the Baptist. Enclosed by a deep, gabled porch, the three figures frame the opening that links the nave with the sanctuary. Rather than placing the group above the screen, as was usual, our sculptor has brought the subject down to earth both physically and emotionally. The suffering of Christ thus becomes a human reality through the emphasis on the weight and volume of his body. Mary and John, pleading with the viewer, convey their grief more eloquently than ever before. The pathos of these figures is heroic and dramatic, as against the lyricism of the Strasbourg tympanum or the Reims *Visitation* (see figs. 11-20 and 11-21). If the classic High Gothic sculpture of France may be compared with Pheidias, the Naumburg Master might be termed the temperamental kin of Skopas (see pages 113–14).

The Pietà Gothic sculpture, as we have come to know it so far, reflects a desire to endow the traditional themes of Christian art with greater emotional appeal. Toward the end of the thirteenth century, this tendency gave rise to a new kind of religious image. Originally designed for private devotion, it is often referred to by the German term **Andachtsbild** (contemplation image), since Germany played a leading part in its development. The most widespread type was a representation of the Virgin grieving over the dead Christ. It is called a **Pietà** after an Italian word derived from the Latin *pietas*, the root word for both "pity" and "piety." No such scene occurs in the scriptural accounts of the Passion. The Pietà unites two iconic types, the Madonna and Child and the Crucifixion. (These images were often paired once they became familiar to Western Europeans after the conquest of Constantinople in 1204.) We do not know where or when the Pietà was invented, but it portrays one of the Seven Sorrows of the Virgin. It thus forms a tragic counterpart

From the 1220s on, German masters trained in the sculptural workshops of the French cathedrals brought the new style to their homeland, although German architecture at that time was still predominantly Romanesque. Even after the middle of the century, however, Germany did not produce the large statuary cycles that France did. As a result, German Gothic sculpture tended to be less closely linked with its architectural setting. In fact, the finest work of German sculptors was often done for the interiors of churches rather than for the exteriors. This independence, in turn, permitted a greater expressive freedom than the French models afforded.

to the motif of the Madonna and Child, one of her Seven Joys.

The *Roettgen Pietà* (fig. 11-24), named for the town it comes from, is carved of wood and vividly painted. Like most such groups, this large cult statue was meant to be placed on an altar. The style, like the subject, expresses the emotional fervor of lay religiosity, which emphasized a personal relationship with God as part of the tide of mysticism that swept fourteenth-century Europe. Realism here has become purely a means of expression to enhance the work's impact. The faces convey unbearable pain and grief; the wounds are exaggerated grotesquely; and the bodies and limbs have become puppetlike in their thinness and rigidity. The purpose of the work clearly is to arouse so overwhelming a sense of horror and pity that the faithful will share in Jesus' suffering and identify their own feelings with those of the grief-stricken Mother of God. The ultimate goal of this emotional bond is a spiritual transformation that comprehends the central mystery of God in human form through compassion (which means "to suffer with").

At a glance, our Pietà would seem to have little in common with *The Virgin of Paris* (see fig. 11-22), which dates from the same period. Yet they share a lean, "deflated" quality of form and a strong emotional appeal to the viewer. Both features characterize the art of Northern Europe from the late thirteenth century to the mid-fourteenth. Only after 1350 do we again find an interest in weight and volume, coupled with a renewed desire to explore tangible reality as part of a change in religious sensibility.

INTERNATIONAL STYLE SCULPTURE IN THE NORTH

Sluter The climax of the new trend toward realism came about 1400, during the period of the International Style (see pages 257–61). Its greatest representative was Claus Sluter, a sculptor of Netherlandish origin working at Dijon for the king's brother Philip the Bold, the duke of Burgundy. Much of Sluter's work belongs to a category that, for lack of a better term, we must label church furniture. It includes tombs, pulpits, and the like, which combine large-scale sculpture with a small-scale architectural setting. The most impressive of these is *The Moses Well* at the Carthusian monastery near Dijon known as the Chartreuse de Champmol (fig. 11-25, page 240). This symbolic well surrounded by statues of Old Testament prophets was at one time surmounted

11-24 *Roettgen Pietà.* Early 14th century. Wood, height 34¹⁄₂" (87.6 cm). Rheinisches Landesmuseum, Bonn

11-25 Claus Sluter. *The Moses Well.* 1395–1406. Stone, height of figures approx. 6' (1.88 m). Chartreuse de Champmol, Dijon

Moses seems to look forward to the Renaissance. Only when we look more closely do we realize that Sluter remains firmly tied to the Gothic.

What strikes us is the precise and masterful realism of every detail, from the particulars of the costume to the texture of the wrinkled skin. The head has all the individuality of a portrait. Nor is this impression misleading: Sluter left us two splendid examples in the heads of the duke and duchess of Burgundy on the Chartreuse portal. It is this attachment to the specific that distinguishes his realism from that of the thirteenth century.

ITALY

We have left a discussion of Italian Gothic sculpture to the last, for here, as in Gothic architecture, Italy stands apart from the rest of Europe. The earliest Gothic sculpture there was probably produced in the extreme south, in Apulia and Sicily. This region was ruled during the thirteenth century by the German emperor Frederick II, who employed Frenchmen and Germans along with native artists at his court. Few of the works Frederick sponsored have survived, but there is evidence that he favored a strongly classical style derived from the sculpture of the Chartres transept portals and the *Visitation* group at Reims (see figs. 11-19 and 11-21). This style not only provided a fitting visual language for a ruler who saw himself as the heir of the Caesars, it also blended easily with the classical tendencies in Italian Romanesque sculpture (see fig. 10-15).

Nicola Pisano Such was the background of Nicola Pisano (c. 1220/5–1284), who went to Tuscany from southern Italy about 1250, the year of Frederick II's death. Ten years later he completed the marble pulpit in the Baptistery of Pisa Cathedral. Pisano has been described as "the greatest— and in a sense the last—of medieval classicists." The classical flavor in reliefs such as the *Nativity* (fig. 11-26) is so strong that the Gothic elements are at first hard to detect, but they are there nonetheless. The most striking Gothic quality is the human feeling. The dense crowding of figures, however, has no counterpart in Northern Gothic sculpture. The panel also shows the Annunciation

by a crucifix. Heavy draped garments envelop the majestic Moses like an ample shell. The swelling forms seem to reach out into the surrounding space as if trying to capture as much of it as possible. (Note the outward curve of the scroll, which reads: "The children of Israel do not listen to me.") The effect must have been enhanced greatly by the **polychromy** added by the painter Jean Malouel, which has largely disappeared. At first glance,

and the shepherds in the fields receiving the glad tidings of the birth of Christ. The treatment of the relief as a shallow box filled almost to the bursting point with solid, convex shapes shows that Nicola Pisano must have been thoroughly familiar with Roman and Early Christian sarcophagi (compare fig. 8-6).

Giovanni Pisano Half a century later, Nicola's son Giovanni (1245/50–after 1314), who was an equally gifted sculptor, carved a marble pulpit for Pisa Cathedral. (It has two inscriptions by the artist praising his ability but bemoaning the hostility to his work.) This pulpit, too, includes a Nativity (fig. 11-27). Both panels have much in common, as we might expect, yet they also present a sharp—and instructive—contrast. Giovanni's slender, swaying figures, with their smoothly flowing draperies, recall neither classical antiquity nor the *Visitation* group at Reims. Instead, they reflect the elegant style of the royal court at Paris, which had become the standard Gothic formula during the later thirteenth century (compare fig. 11-21, left pair). And with this change came a new treatment of relief. To Giovanni Pisano, space is as important as form. The figures are no longer tightly packed together. They are now placed far enough apart to let us see the landscape setting, and each figure has its own pocket of space. Whereas Nicola's *Nativity* strikes us as a sequence of bulging, rounded masses, Giovanni's appears to be made up mainly of cavities and shadows. Giovanni Pisano, then, follows the same trend toward disembodiment that we saw north of the Alps around 1300, only he does so in a more limited way.

Tomb Sculpture Italian Gothic church facades generally did not attempt to rival those of the French cathedrals. The French Gothic portal, with its jamb statues and richly carved tympanum, never found favor in the south. Instead, we often find a survival of Romanesque traditions of architectural sculpture, such as statues in niches or small-scale reliefs on wall surfaces (see fig. 10-15). Italian Gothic sculpture excelled in the field that we have called church furniture—pulpits, screens, shrines, and tombs.

11-26 Nicola Pisano. *The Nativity*. Detail of pulpit, Baptistery, Pisa. 1259–60. Marble, 33$\frac{1}{2}$ x 44$\frac{1}{2}$" (85 x 113 cm)

11-27 Giovanni Pisano. *The Nativity*. Detail of pulpit, Pisa Cathedral. 1302–10. Marble, 34$\frac{3}{8}$ x 43" (87.2 x 109.2 cm)

The late thirteenth century saw the development of a new kind of tomb for leaders of the Catholic church. Its origins lie in French royal tombs, but the type spread quickly to Italy. There it was given definitive form by Arnolfo di Cambio (see page 230), who had been an assistant to Nicola Pisano. A characteristic example is the elaborate tomb by an unknown sculptor in the Bardi Chapel, Sta. Croce (see fig. 11-37, foreground), which, although somewhat later, is still very much in Arnolfo's style. With its large pinnacle and **trefoil** cutout, it is like a High Gothic portal in miniature. Thus the tomb is far closer to French architecture (compare fig. 11-9) than is the church itself (see fig. 11-14). Like others of its class, it is set inside a shallow niche, so that sculpture and architecture become one. Here the traditional carved effigy figure has been replaced by a painting of the deceased rising from the grave (see page 255).

INTERNATIONAL STYLE SCULPTURE IN THE SOUTH

Ghiberti During the later fourteenth century, Italy was especially open to artistic influences from across the Alps, not only in architecture but in sculpture as well. These crosscurrents gave rise to the International Style about 1400. The outstanding representative of this style in Italian sculpture was Lorenzo Ghiberti (c. 1381–1455), a Florentine who as a youth must have had close contact with French art. We first meet him in 1401–2, when he won a competition, later described in his *Commentaries,* for a pair of richly decorated bronze doors for the Baptistery of S. Giovanni in Florence (see fig. 10-9). (It took him more than two decades to complete these doors, which fill the north portal of the building.) Each of the competing artists had to submit a trial relief, in a Gothic **quatrefoil** frame, depicting the Sacrifice of Isaac. Ghiberti's panel (fig. 11-28) strikes us first of all with the perfection of its craftsmanship, which reflects his training as a goldsmith. The silky shimmer of the surfaces and the wealth of detail make it easy to understand why this entry was awarded the prize. If the composition seems somewhat lacking in dramatic force, that is characteristic of Ghiberti's calm, lyrical

11-28 Lorenzo Ghiberti. *The Sacrifice of Isaac.* 1401–2. Gilt bronze, 21 x 17" (53.3 x 43.2 cm). Museo Nazionale del Bargello, Florence

temper, which suited the taste of the period. Indeed, his figures, in their softly draped garments, have an air of courtly elegance even when they engage in acts of violence.

However much his work may owe to French influence, Ghiberti shows himself to be thoroughly Italian in one respect: his admiration for ancient sculpture, which can be seen in the beautiful nude torso of Isaac. Here he revives a tradition of classicism that had reached its highest point in Nicola Pisano but had gradually died out during the fourteenth century. But Ghiberti is also the heir of Giovanni Pisano. In Giovanni's *Nativity* panel (see fig. 11-27) we noted a new emphasis on the spatial setting. Ghiberti's trial relief carries this tendency a good deal further and achieves a far more natural sense of recession. For the first time since classical antiquity, we experience the background of the panel not as a flat surface but as empty space from which the sculpted forms emerge, so that the angel in the upper right-hand corner seems to hover in midair. This pictorial quality relates Ghiberti's work to the painting of the International Style, where we find a similar concern with spatial depth and

atmosphere (see pages 257–61). While not a revolutionary himself, he prepares the ground for the momentous changes that will take place in Florentine art during the second decade of the fifteenth century, at the beginning of the Early Renaissance.

Painting

FRANCE

Stained Glass Although Gothic architecture and sculpture began dramatically at St-Denis and at Chartres, Gothic painting developed at a rather slow pace in its early stages. The architectural style sponsored by Abbot Suger gave birth to a new conception of monumental sculpture almost at once, but it did not demand any radical change in painting. To be sure, Suger's account of the rebuilding of his church emphasizes the miraculous effect of STAINED-GLASS windows, with their "continuous light." Stained glass was thus an integral element of Gothic architecture from the very beginning. Yet the technique of stained-glass painting had already been perfected in Romanesque times, and the style of stained-glass designs (especially single figures) sometimes remained surprisingly Romanesque for nearly another hundred years. Nevertheless, the "many masters from different regions" whom Suger assembled to execute the choir windows at St-Denis faced a larger task and a more complex pictorial program than ever before.

During the next half-century, as Gothic structures became ever more skeletal and clerestory windows grew to huge size, stained glass displaced manuscript illumination as the leading form of painting. Since the production of stained glass was so closely linked with the great cathedral workshops, the designers were influenced more and more by architectural sculpture. The majestic *Notre Dame de la Belle Verrière* (fig. 11-29) at Chartres Cathedral is the finest early example of this process. The design—which still betrays its Byzantine ancestry (see fig. 8-14)—recalls the relief on the west portal of the church (see fig. 11-17) but lacks its sculptural qualities. Instead, the stained glass dissolves the group into a weightless mass that hovers effortlessly in indeterminate space.

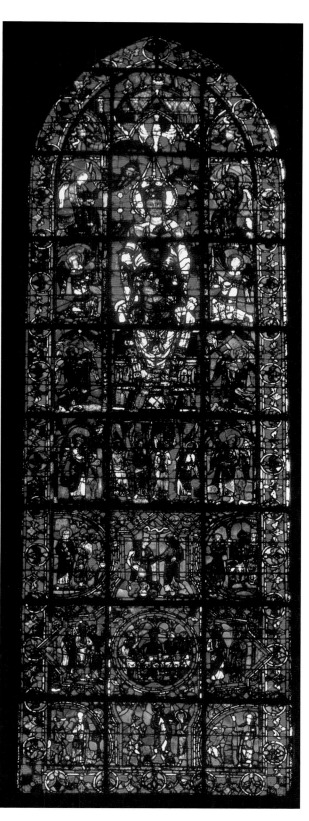

STAINED GLASS got its colors from being heated with different metal oxides.

The stained-glass artist first drew the design on a large, flat surface, then cut pieces of colored glass to match the drawn sections.

The individual pieces of glass were enclosed by channeled strips of lead.

The lead strips (cames) between the individual glass pieces were always an important part of the design.

11-29 *Notre Dame de la Belle Verrière*, Chartres Cathedral. c. 1170. Stained-glass window, height approx. 14' (4.27 m)

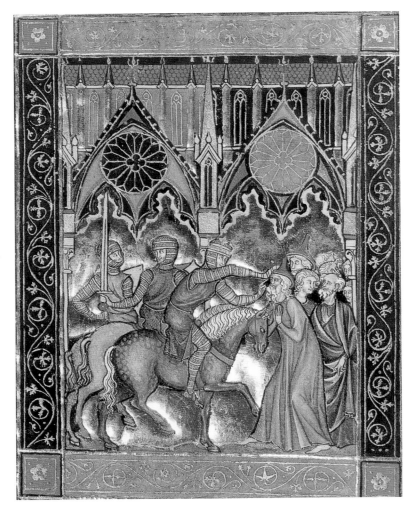

11-30 *Nahash the Ammonite Threatening the Jews at Jabesh,* from the *Psalter of St. Louis.* c. 1260. 5 x 3½" (12.7 x 8.9 cm). Bibliothèque Nationale, Paris

The window consists of hundreds of small pieces of tinted glass bound together by strips of lead. The maximum size of these pieces was limited by the primitive methods of medieval glass manufacture, so that the design could not simply be "painted on glass." Rather, the window was painted *with* glass. It was assembled in somewhat the same way as one would put together a mosaic or a jigsaw puzzle, out of odd-shaped fragments cut to fit the contours of the forms. Only the finer details, such as eyes, hair, and drapery folds, were added by painting—or drawing—in black or gray on the glass surfaces. This process encourages an abstract, ornamental style, which tends to resist any attempt to render three-dimensional effects.

Only in the hands of a great master could the maze of lead strips lead to such monumental figures.

The stained-glass workers who filled the windows of the great Gothic cathedrals also had to face difficulties arising from the enormous scale of their work. No Romanesque painter had ever been called upon to cover areas so vast or so firmly bound into an architectural framework. The task required a degree of orderly planning that had no precedent in medieval painting. Only architects and stonemasons knew how to deal with this problem, and it was their methods that the stained-glass workers borrowed in mapping out their own designs. As we recall from our discussion of the apse of St-Denis (see pages 216–17), Gothic architectural design

uses a system of geometric relationships to establish numerical harmony. The same rules could be used to control the design of stained-glass windows or even of an individual figure.

The period 1200–1250 might be termed the golden age of stained glass. After that, as architectural activity declined and the demand for stained glass began to slacken, manuscript illumination gradually regained its former position of leadership. By then, however, miniature painting had been thoroughly influenced by both stained glass and stone sculpture, the artistic pacemakers of the first half of the century.

Illuminated Manuscripts The change of style can be seen in figure 11-30, from a psalter done about 1260 for King Louis IX (St. Louis) of France. The scene illustrates I Samuel 11:2, in which Nahash the Ammonite threatens the Jews at Jabesh. We first notice the careful symmetry of the framework, with its flat, ornamented panels. Equally symmetrical is the architectural setting, which is remarkably similar to the choir screen by the Naumburg Master (see fig. 11-23). It also recalls the canopies above the heads of jamb statues (see fig. 11-19).

Against this two-dimensional background, the figures stand out in relief by their smooth and skillful modeling. But their sculptural quality stops short at the outer contours, which are defined by heavy, dark lines rather like the lead strips in stained-glass windows. The figures themselves show all the features of the elegant style originated about 20 years earlier by the sculptors of the royal court: graceful gestures, swaying poses, smiling faces, and neatly waved strands of hair (compare *The Virgin of Paris,* fig. 11-22). Our miniature thus exemplifies the subtle and refined taste that made the court art of Paris the standard for all Europe. Of the expressive energy of Romanesque painting, we find not a trace (see fig. 10-18).

ITALY

Italian painting at the end of the thirteenth century produced an outpouring of creative energy as spectacular, and as far-reaching in its impact on the future, as the rise of the Gothic cathedral in France. As we inquire into the conditions that made it possible, we find that it arose from the same "old-fashioned" attitudes we met in Italian Gothic architecture and sculpture.

Medieval Italy, although strongly influenced by Northern art from Carolingian times on, had maintained contact with Byzantine civilization. As a result, panel painting, mosaic, and murals—mediums that had never taken firm root north of the Alps—were kept alive on Italian soil, though barely. Indeed, a new wave of influences from Byzantine art, which enjoyed a resurgence during the thirteenth century, overwhelmed the Romanesque elements in Italian painting at the very time when stained glass became the dominant pictorial medium in France.

There is a certain irony in the fact that this neo-Byzantine style appeared soon after the conquest of Constantinople by the armies of the Fourth Crusade in 1204. (One thinks of the way Greek art had once captured the taste of the Romans.) Pisa, whose navy made it a power in the eastern Mediterranean, was the first to develop a school of painting based on this "Greek manner," as the Italians called it. In some cases it was transplanted by Byzantine artists who had fled Constantinople during the Crusades. Giorgio Vasari later wrote that in the mid-thirteenth century, "Some Greek painters were summoned to Florence by the government of the city for no other purpose than the revival of painting in their midst, since that art was not so much debased as altogether lost."

There may be more truth to this statement than is often acknowledged. Byzantine art had preserved Early Christian narrative scenes virtually intact. When transmitted to the West, this tradition led to an explosion of subjects and designs that had been essentially lost for nearly 700 years. Many of them, of course, had been available all along in the mosaics of Rome and Ravenna. There had also been successive waves of Byzantine influence throughout the early Middle Ages and the Romanesque period. Nevertheless, they lay dormant, so to speak, until interest in them was reawakened through closer relations with Constantinople, which enabled Italian painters to absorb Byzantine art far more thoroughly than ever before. During this same

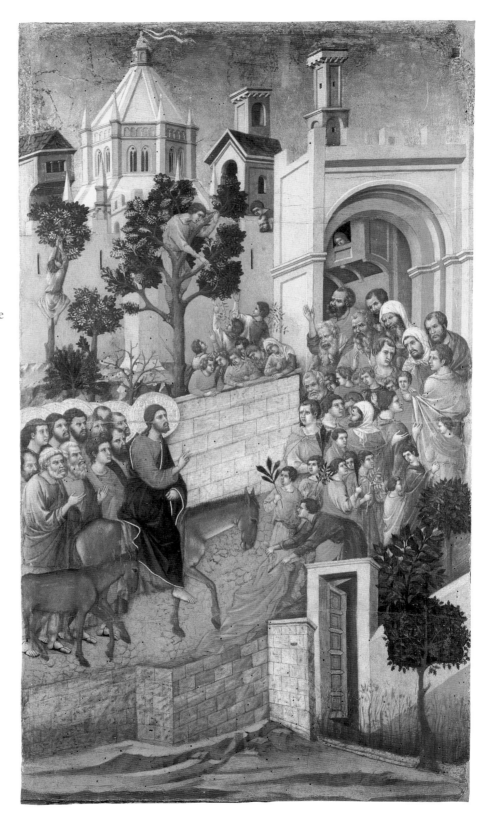

11-31 Duccio. *Christ Entering Jerusalem,* from the back of the *Maestà Altar.* 1308–11. Tempera on panel, 40 1/2 x 21 1/8" (103 x 53.7 cm). Museo dell'Opera del Duomo, Siena

period, we recall, Italian architects and sculptors took a different course: untouched by the Greek manner, they were assimilating the Gothic style. Eventually, toward 1300, Gothic influence spilled over into painting as well, and its interaction with the neo-Byzantine produced the revolutionary new style.

Duccio The most important painter in the Greek manner was Duccio (Duccio di Buoninsegna, c. 1255–before 1319), of Siena. The back of his great altarpiece for Siena Cathedral, the *Maestà* (Majesty), includes numerous small panels with scenes from the lives of Jesus and the Virgin. Among these, the most mature works of Duccio's career, is *Christ Entering Jerusalem* (fig. 11-31). The composition, which goes back to Early Christian times (see fig. 8-6), is based directly on a Byzantine example that was fully developed by the late tenth century. In Duccio's hands, the Greek manner has become unfrozen. The rigid, angular draperies have given way to an undulating softness. The abstract shading-in-reverse with lines of gold is kept to a minimum. The bodies, faces, and hands are beginning to swell with three-dimensional life. Clearly, the heritage of Hellenistic-Roman illusionism that had always been part of the Byzantine tradition, however submerged, is asserting itself once more. But there is also a half-hidden Gothic element here. We sense it in the fluency of the drapery, the appealing naturalness of the figures, and the tender glances by which they communicate with one another. The chief source of this Gothic influence must have been Giovanni Pisano (see page 241), who was in Siena from 1285 to 1295 as the sculptor-architect in charge of the cathedral facade.

Here, the cross-fertilization of Gothic and Byzantine elements has given rise to a development of fundamental importance: a new kind of picture space. In *Christ Entering Jerusalem*, the architecture has a space-creating function. Ancient painters and their Byzantine successors had been unable to achieve such a space. Their architectural settings always stay behind the figures, so that their indoor scenes tend to look as if they were taking place in an open-air theater, on a stage without a roof.

Duccio's figures, in contrast, inhabit a space that is created and defined by the architecture. Northern Gothic painters, too, had tried to produce architectural settings, but they could do so only by flattening them out completely (as in the *Psalter of St. Louis*, fig. 11-30).

Because they were trained in the Greek manner, the Italian painters of Duccio's generation learned enough of the devices of Hellenistic-Roman illusionism (see fig. 7-18) to let them render such a framework without draining it of three-dimensionality. Duccio, however, is not interested simply in space for its own sake. The architecture is used to integrate the figures within the drama more convincingly than ever before. The diagonal movement into depth is conveyed not by the figures, which have the same scale throughout, but by the walls on either side of the road leading to the city, by the gate that frames the welcoming crowd, and by the structures beyond. Whatever the shortcomings of Duccio's perspective, his architecture is able to contain and enclose. For that reason, it seems more understandable than similar views in ancient or Byzantine art (compare figs. 7-15 and 8-15).

Giotto In Giotto (Giotto di Bondone, 1267?–1336/7) we meet an artist of far bolder and more dramatic temper. Ten to 15 years younger than Duccio, Giotto was by instinct a wall painter rather than a panel painter. Thus he was less close to the Greek manner from the start, despite his probable apprenticeship under another painter in the Greek manner, Cimabue. The art of Giotto is so daringly original that its sources are far more difficult to trace than those of Duccio's style. Apart from his knowledge of the Greek manner, the young Giotto seems to have been familiar with the work of the neo-Byzantine masters of Rome. In Rome, too, Giotto must have become acquainted with Early Christian and ancient Roman mural painting. Classical sculpture likewise seems to have left an impression on him. More fundamental, however, was the influence of late medieval Italian sculptors, especially Nicola and Giovanni Pisano. It was through them that Giotto came in contact with Northern Gothic art. The latter remains the most important of all the elements that entered

SPEAKING OF

Italian artists' names

In many cases, the names by which we know the great Italian artists are not those given to them at birth. Sometimes the traditional name is actually a nickname, based either on the occupation of the artist's family (Ghirlandaio, "garland maker") or on more personal characteristics (Masaccio, "ugly Tom," or Fra Angelico, "angelic brother"). The artist's family birthplace can also be the source of the traditional name (Leonardo da Vinci, that is, Leonardo from Vinci).

into Giotto's style. Indeed, Northern works such as those in figure 11-20 and figure 11-23 are almost certainly the ultimate source of the emotional quality in his work.

Of Giotto's surviving murals, those in the Arena Chapel in Padua, painted in 1305–6, are the best preserved as well as the most characteristic. Devoted mainly to events from the life of Christ, they are arranged in three tiers of narrative scenes that culminate in a Last Judgment at the west end of the chapel. Giotto depicts many of the same subjects that we find on the reverse of Duccio's *Maestà,* including *Christ Entering Jerusalem* (fig. 11-32). But while Duccio has enriched the traditional scheme, spatially as well as narratively, Giotto simplifies it. The two versions have much in common, since both ultimately derive from Byzantine sources. Giotto's painting, however, suggests the example of Byzantine mosaics done on Italian soil during the twelfth century. The action proceeds parallel to the **picture plane**. Landscape, architecture, and figures have been reduced to a minimum. The austerity of Giotto's art is emphasized by the sober medium of **fresco** painting, with its limited range and intensity of tones. By contrast, Duccio's picture, which is executed in egg **tempera** on gold ground, has a jewel-like brilliance and sparkling colors. Yet Giotto's work has far more impact: it makes us feel so close to the event that we have a sense of being direct participants rather than distant observers.

How does the artist achieve this extraordinary effect? He does so, first of all, by having the entire scene take place in the foreground. Even more important, he presents it in such a way that the viewer's eye level falls within the lower half of the picture. Thus we can imagine ourselves standing on the same **ground plane** as the figures, even though we actually see them from well below. In contrast, Duccio makes us survey the scene from above in "bird's-eye" perspective. The effects of Giotto's choice of viewpoint are far-reaching. *Choice* implies conscious awareness—in this case, awareness of a relationship in space between the beholder and the picture. Duccio does not yet treat his picture space as continuous with the viewer's, and so we have the feeling of floating above the scene. With the notable exception of the Villa of the Mysteries (see fig. 7-17), ancient painting rarely tells us where we stand as Giotto does. Above all, he gives his forms such a strong three-dimensional reality that they seem as solid and tangible as sculpture in the round.

Giotto uses the figures, not the framework, to create the picture space. As a result, his space is more limited than Duccio's. Its depth extends no further than the combined volumes of the overlapping bodies in the picture—but within its limits it is much more persuasive. To Giotto's contemporaries, the tactile quality of his art must have seemed a near-miracle. It was this quality that made them praise him as equal, or even superior, to the greatest of the ancient painters. His forms looked so lifelike that they could be mistaken for reality itself. Equally significant are the stories linking Giotto with the claim that painting is superior to sculpture. This was not an idle boast, as it turned out, for Giotto does indeed mark the start of what might be called the era of painting in Western art. The symbolic turning point is the year 1334, when he was appointed head of the Florence Cathedral workshop, an honor that until then had been reserved for architects or sculptors.

Giotto's aim was not simply to transplant Gothic statuary into painting. By creating a radically new kind of picture space, he had also sharpened his awareness of the picture surface. When we look at a work by Duccio (or his ancient and medieval predecessors), we tend to do so in installments, as it were. Our glance travels from detail to detail until we have surveyed the entire area. Giotto, on the contrary, invites us to see the whole at one glance. His large, simple forms, the strong grouping of his figures, and the limited depth of his "stage" give his scenes an inner coherence never found before. Notice how dramatically the massed verticals of the "block" of apostles on the left are contrasted with the upward slope formed by the welcoming crowd on the right, and how Jesus, alone in the center, bridges the gulf between the two groups. The more we study the composition, the more we come to realize its majestic firmness and clarity. Thus the artist has rephrased the traditional pattern of Christ's Entry into Jerusalem to stress the solemnity of the event as the triumphal procession of the Prince of Peace.

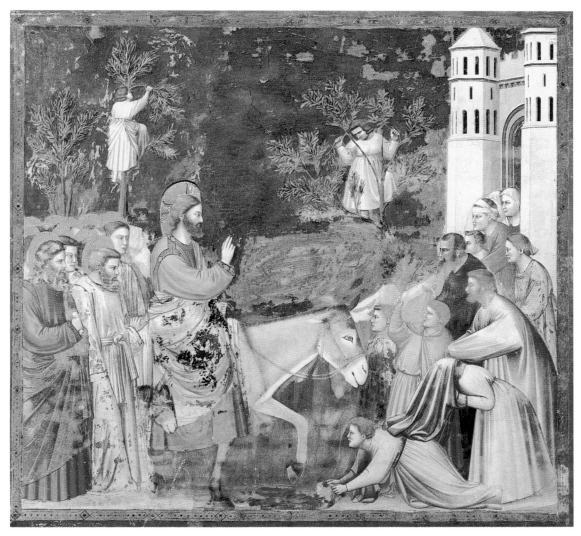

11-32 Giotto. *Christ Entering Jerusalem.* 1305–6. Fresco in the Arena (Scrovegni) Chapel, Padua

Giotto's achievement as a master of design does not fully emerge from any single work. Only if we examine a number of scenes from the Arena fresco cycle do we see how closely each composition is attuned to the emotional content of the subject. *The Lamentation* (fig. 11-33, page 250) was clearly inspired by a Byzantine example similar to the Nerezi fresco (see fig. 8-17), which was known in Italy early on. The differences, however, are as important as the similarities. In its muted expression this *Lamentation* is closer to the Gothic *Death of the Virgin* on Strasbourg Cathedral (see fig. 11-20) than it is to the anguish conveyed so vividly by the Byzantine painter. The tragic mood, found also in religious texts of the era, is brought home to us by the formal rhythm of the design as much as by the gestures and expressions of the participants. The low center of gravity and the hunched figures convey the somber quality of the scene and arouse our compassion

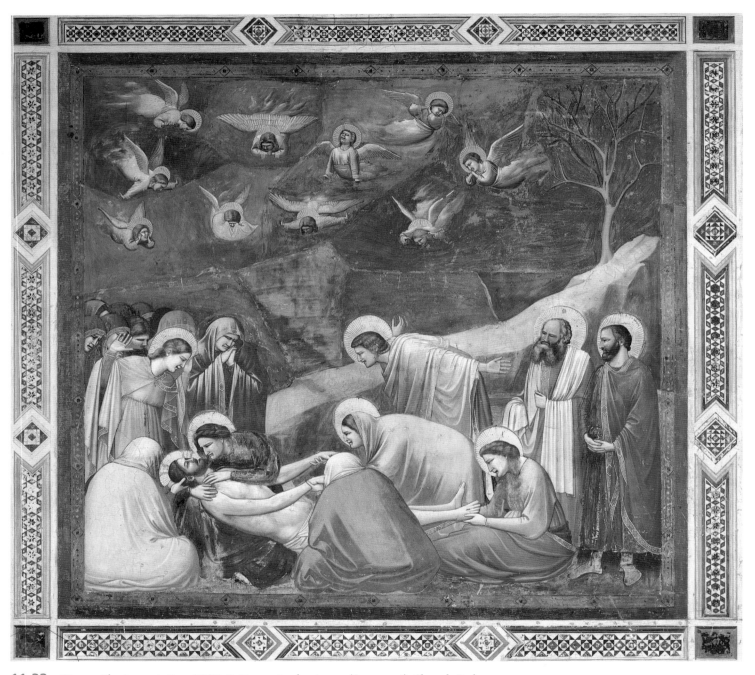

11-33 Giotto. *The Lamentation.* 1305–6. Fresco in the Arena (Scrovegni) Chapel, Padua

even before we have grasped the meaning of the event. With extraordinary boldness, Giotto sets off the frozen grief of the human mourners against the frantic movement of the weeping angels among the clouds. It is as if the figures on the ground were restrained by their obligation to maintain the stability of the composition, while the angels, small and weightless as birds, do not share this duty.

Once again the impact of the drama is heightened by the simple setting. The descending slope of the hill acts as a unifying element. At the same time, it directs our glance toward the heads of Christ and the Virgin, which are the focal point of the scene. Even the tree has a twin function. Its barrenness and isolation suggest that all of nature shares in the sorrow over the Savior's death. Yet it also carries a more precise symbolic message: it alludes (as does DANTE in a passage in *The Divine Comedy*) to the Tree of Knowledge, which the sin of Adam and Eve had caused to wither and which was to be restored to life through the sacrificial death of Christ.

Martini Few artists in the history of art equal Giotto as an innovator. His very greatness, however, tended to dwarf the next generation of Florentine painters. Their contemporaries in Siena were more fortunate in this respect, since Duccio never had the same overpowering impact. As a result, it was they, not the Florentines, who took the next decisive step in the development of Italian Gothic painting. Perhaps the most distinguished of Duccio's disciples was Simone Martini (c. 1284–1344), who spent the last years of his life in Avignon, the town in southern France that served as the residence of the popes during most of the fourteenth century.

The Road to Calvary (fig. 11-34, page 252), originally part of a small altar, was probably in Avignon about 1340, as it was commissioned by Philip the Bold of Burgundy for the Chartreuse de Champmol. In its sparkling colors, and especially in the architectural background, it still echoes the art of Duccio (compare fig. 11-31). However, the vigorous modeling of the figures, as well as their dramatic gestures and expressions, shows the influence of Giotto. While Simone Martini is little

concerned with spatial clarity, he is an acute observer. The sheer variety of costumes and physical types and the wealth of human activity provide a sense of down-to-earth reality very different from both the lyricism of Duccio and the grandeur of Giotto.

Pietro and Ambrogio Lorenzetti This closeness to everyday life can also be seen in the work of the brothers Pietro and Ambrogio Lorenzetti (both died 1348?). But it appears on a more monumental scale and is coupled with a keen interest in problems of space. The boldest spatial experiment is Pietro's *Birth of the Virgin* (fig. 11-35, page 253). In this triptych of 1342, the painted architecture has been related so closely to the real architecture of the frame that the two are seen as a single system. Moreover, the chamber where the birth takes place occupies two panels and continues unbroken behind the column that divides the center from the right wing. The left wing represents an anteroom which leads to a large and only partially seen space that suggests the interior of a Gothic church.

What Pietro Lorenzetti achieved here is the outcome of a development that began three decades earlier in the work of Duccio: the conquest of **pictorial space**. Only now, however, does the painting surface take on the quality of a transparent window *through* which—not *on* which—we perceive the same kind of space we know from daily experience. Duccio's work alone does not explain Pietro's astonishing breakthrough. His achievement became possible, rather, through a combination of the architectural picture space of Duccio and the sculptural picture space of Giotto.

The same approach enabled Ambrogio Lorenzetti to unfold a view of the entire town before our eyes in his frescoes of 1338–40 in the Siena city hall (fig. 11-36, page 254). We are struck by the distance that separates this precise "portrait" of Siena from Duccio's Jerusalem (see fig. 11-31). Ambrogio's mural is part of an allegorical program depicting the contrast of good and bad government. For example, the inscription under *Good Government* praises Justice and the many benefits that derive from her. To the right on the far wall we

DANTE (Dante Alighieri, 1265–1321), one of the greatest poets of all time, was the first major literary figure to write in the Italian language. His magnificent epic poem, *Commedia* (The Divine Comedy; the word *divine* was added in the sixteenth century), was written after he was exiled from Florence for political reasons in 1302. Dante's life and work were much admired in the nineteenth century, especially by Romantic artists and writers (see pages 524–25).

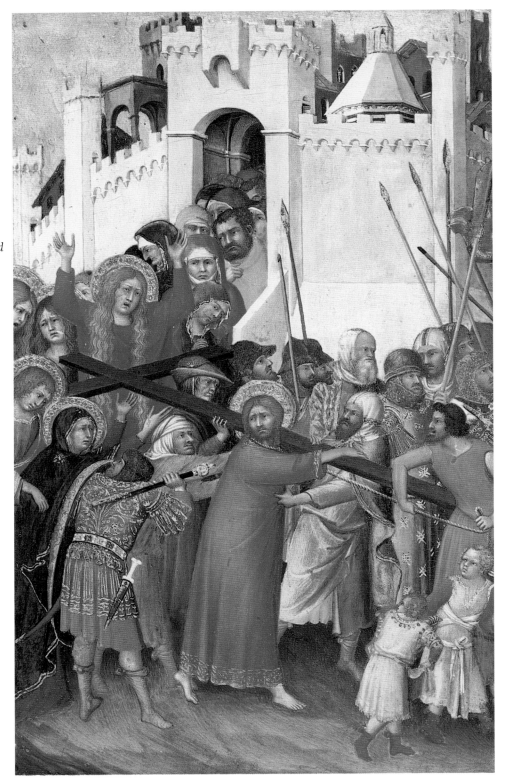

11-34 Simone Martini. *The Road to Calvary.* c. 1340. Tempera on panel, 9⁷/₈ x 6¹/₈" (25 x 15.5 cm). Musée du Louvre, Paris

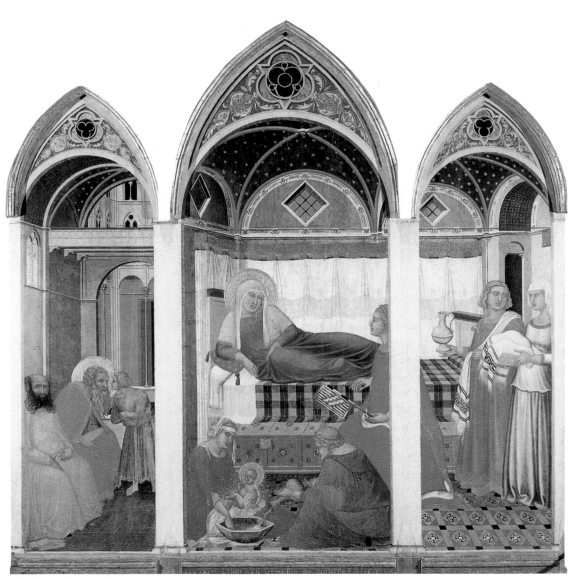

11-35 Pietro Lorenzetti. *Birth of the Virgin*. 1342. Tempera on panel, 6'1¹/₂" x 5'11¹/₂" (1.88 x 1.82 m). Museo dell'Opera del Duomo, Siena

11-36 Ambrogio Lorenzetti. *The Commune of Siena* (left), *Good Government in the City,* and portion of *Good Government in the Country* (right). 1338–40. Frescoes in the Sala della Pace, Palazzo Pubblico, Siena

see the Commune of Siena guided by Faith, Hope, and Charity and flanked by a host of other symbolic figures. To show the life of a well-ordered city-state, the artist had to fill the streets and houses of *Good Government in the City* with teeming activity. The bustling crowd gives the architectural vista its striking reality by introducing the human scale. On the right, outside the city walls, the other *Good Government* fresco provides a view of the Sienese countryside (not visible in figure 11-36), fringed by distant mountains—the first true landscape since ancient Roman times.

The Black Death The first four decades of the fourteenth century in Florence and Siena had been a period of political stability and economic expansion, as well as of great artistic achievement. In the 1340s both cities suffered a series of catastrophes whose echoes were to be felt for many years. Banks and merchants went bankrupt by the score, internal upheavals shook the government, and there were repeated crop failures. Then, in 1348, the epidemic of bubonic plague—the

Black Death—that spread throughout Europe wiped out more than half the population of the two cities (including, it seems, Pietro and Ambrogio Lorenzetti). Popular reactions to these events were mixed. Many people saw them as signs of divine wrath, warnings to a sinful humanity to forsake the pleasures of this earth. In such people the Black Death aroused a mood of otherworldly exaltation. To others, such as the merry company in BOCCACCIO's *Decameron,* the fear of death intensified the desire to enjoy life while there was still time. These conflicting attitudes were reflected in the theme of the Triumph of Death. With it came a new emphasis on elaborate tombs for the wealthy.

Maso di Banco, Taddeo Gaddi The artists who reached maturity around 1340 were not as innovative as the earlier painters we have discussed, but neither were they blind followers. At their best, they expressed the somber mood of the time with memorable intensity. The heritage of Giotto can be seen in the tombs made about this time for members of the Bardi family in Sta. Croce,

Giovanni BOCCACCIO (1313–1375) began his career as an author in Naples but moved in 1341 to Florence, where he became a friend of Petrarch. A diplomat and scholar of the "new learning," he wrote his classic, *The Decameron,* from 1348 to 1353. This collection of 100 witty and sometimes bawdy tales greatly influenced later writers such as Geoffrey Chaucer, William Shakespeare, and John Keats.

Florence, by two of his foremost pupils (fig. 11-37). The larger of the two, probably by Maso di Banco (active 1341–46), shows the dead man rising from his marble sarcophagus to receive a personal Last Judgment from the risen Christ. The scene, with its eerie landscape and majestic Jesus, retains some of Giotto's grandeur without being simply derivative (compare fig. 11-32). The ensemble is among the first to combine painting and sculpture. The result is a mixture of temporal and visionary reality that expresses the hope—indeed, the expectation—of salvation and life after death.

The same theme is repeated in the tomb to the right by Taddeo Gaddi (1295/1300–1366). The deceased is painted on the side of the sarcophagus receiving the body of Jesus above her own sepulchre. The message is clear: by bearing witness to the Entombment, she shall rise again, just as Christ did. This tomb, like the other, incorporates the image, widespread at the time, of Jesus as the Man of Sorrows, whose suffering redeems humanity's sins and offers the promise of eternal life. Despite the debt to Giotto's *Lamentation* (see fig. 11-33), Taddeo has begun to feel the influence of the Lorenzetti, which was soon seen in the work of Maso and other Florentine artists as well.

PAINTING NORTH OF THE ALPS

What happened to Gothic painting north of the Alps during the latter half of the fourteenth century was determined in large part by the influence of the great Italians. Sometimes this influence was transmitted by Italian artists who were active on Northern soil. An example is Simone Martini, who worked at the palace of the popes near Avignon.

One gateway of Italian influence was the city of Prague, the capital of Bohemia, thanks to Emperor Charles IV (1316–1378), the most remarkable ruler since Charlemagne. Charles received an excellent education in Paris at the French court of Charles IV, whose daughter he married and in whose honor he changed his name from Wenceslaus. He returned to Prague and in 1346 succeeded his father as king of Bohemia. As a result of Charles's alliance with Pope Clement VI, who resided at Avignon, Prague became an independent archbishopric. It was also through Clement's

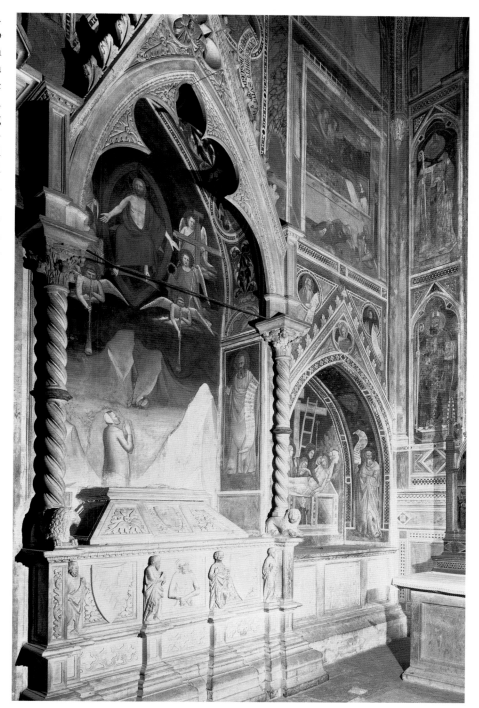

11-37 Maso di Banco (attributed to) (left) and Taddeo Gaddi (right). Tombs of members of the Bardi family. c. 1335–45 and c. 1335–41. Bardi di Vernio Chapel, Sta. Croce, Florence

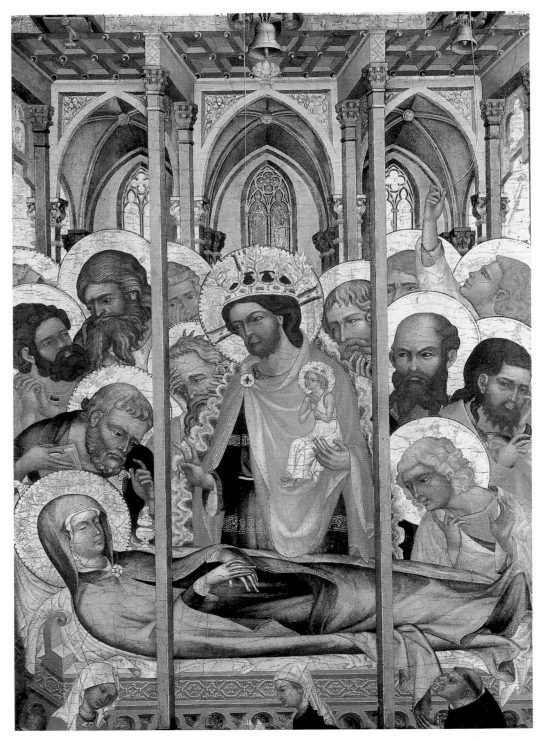

11-38 Bohemian Master. *Death of the Virgin.* 1355–60. Tempera on panel, 39³/₈ x 28"
(100 x 71 cm). Museum of Fine Arts, Boston

William Francis Warden Fund; Seth K. Sweetser Fund, The Henry C. and Martha B. Angell Collection, Juliana Cheney
Edwards Collection, Gift of Martin Brimmer, and Mrs. Frederick Frothingham; by exchange

intervention that Charles was named Holy Roman Emperor by the German Electors at Aachen in 1349. This title was confirmed by coronations in Milan and Rome six years later. In exchange, Charles later supported Pope Urban V's return to Rome in 1367—which lasted only three years, however.

Like Charlemagne before him, Charles wanted to make his capital a center of learning. In 1348 he established a university along the lines of that in Paris, which attracted many of the best minds from throughout Europe. He also became a patron of the arts and founded an artists' guild. Prague soon became a cultural center second only to Paris itself. Charles was also impressed most by the art he saw during his two visits to Italy. (He is known to have commissioned works by several Italian painters.) Thus the *Death of the Virgin* (fig. 11-38), done by a Bohemian master about 1355–60, brings to mind the works of the great Sienese painters. The carefully defined architectural interior shows its descent from such works as Pietro Lorenzetti's *Birth of the Virgin* (see fig. 11-35), but it lacks the spaciousness of its Italian models. Also Italian is the vigorous modeling of the heads and the overlapping of the figures, which reinforces the three-dimensional quality of the design but raises the awkward question of what to do with the halos. Finally, the rich color recalls that of Simone Martini (see fig. 11-34). Still, the Bohemian master's picture is not just an echo of Italian painting. The gestures and facial expressions convey an intensity of emotion that represents the finest heritage of Northern Gothic art. In this respect, our panel is far more akin to the *Death of the Virgin* at Strasbourg Cathedral (see fig. 11-20) than to any Italian work.

INTERNATIONAL STYLE PAINTING

Broederlam Around 1400 the merging of Northern and Italian traditions gave rise to a single dominant style throughout western Europe. This International Style was not confined to painting—we have used the same term for the sculpture of the period—but painters clearly were the major force in its development. Among the most important was Melchior Broederlam (active c. 1387–1409), a Fleming who worked for the court of the duke of Burgundy in Dijon, where he would

have known Simone Martini's *Road to Calvary* (see fig. 11-34). Figure 11-39 on page 258 shows the panels of a pair of shutters for an altar shrine that Broederlam painted in 1394–99 for the Chartreuse de Champmol. (The interior consists of an elaborately carved relief by Jacques de Baerze showing the Adoration of the Magi, the Crucifixion, and the Entombment.) Each wing is really two pictures within one frame. Landscape and architecture stand abruptly side by side, even though the artist has tried to suggest that the scene extends around the building.

Compared to paintings by Pietro and Ambrogio Lorenzetti, Broederlam's picture space seems naive in many ways. The architecture looks like a doll's house, although it is derived from Duccio (see fig. 11-31) and the Lorenzettis (see figs. 11-35 and 11-36), while the details of the landscape, which reminds us of the background in Ghiberti's trial relief (see fig. 11-28), are out of scale with the figures. Yet the panels convey a far stronger feeling of depth than we have found in any previous Northern work, thanks to the subtlety of the modeling. The softly rounded shapes and the dark, velvety shadows create a sense of light and air that more than makes up for any shortcomings of scale or perspective. This soft, pictorial quality is a hallmark of the International Style. It appears as well in the ample, loosely draped garments with their fluid, curvilinear patterns, which remind us of Sluter and Ghiberti (see figs. 11-25 and 11-28).

Broederlam's panels also show another feature of the International Style: its "realism of particulars." It is the same kind of realism we first saw in Gothic sculpture. In the left panel we find it in the carefully rendered foliage and flowers of the enclosed garden to the left, and in the contrast between the Gothic chamber and the Romanesque temple. We see it as well in the right panel: in the delightful donkey (obviously drawn from life) and in the rustic figure of St. Joseph, who looks and behaves like a simple peasant and thus helps to emphasize the delicate, aristocratic beauty of the Virgin. This painstaking detail gives Broederlam's work the flavor of an enlarged miniature rather than of a large-scale painting, even though the panels are more than five feet tall.

11-39 Melchior Broederlam. *Annunciation and Visitation; Presentation in the Temple and Flight into Egypt.* 1394–99. Tempera on panel, each 65 x 49¼" (167 x 125 cm). Musée des Beaux-Arts, Dijon

The expansion of subject matter during the period of the International Style was linked to a comparable growth in symbolism. In the left panel, for example, the lily signifies Mary's virginity, as does the enclosed garden next to her. The contrasting Romanesque and Gothic buildings stand for the Old and New Testaments respectively. This development paves the way for the elaboration of symbolic meaning that occurs 25 years later in works by Robert Campin and Jan van Eyck (see chapter 15).

The Limbourg Brothers Despite the growing importance of panel painting, book illumination remained the leading form of painting in Northern Europe during the International Style. Manuscript painting reached its height in the luxurious BOOK OF HOURS known as *Les Très Riches Heures du Duc de Berry* (The Very Rich Hours of the Duke of Berry). This volume was produced for the brother of the king of France, a man of far from admirable character but the

most lavish art patron of his day. The artists were Pol de Limbourg and his two brothers, Herman and Jean. (All three died in 1416, most likely of the plague.) These Flemings were introduced to the court by their uncle, Jean Malouel, the artist who had applied the polychromy to Sluter's *Moses Well* (see fig. 11-25). They must have visited Italy, for their work includes numerous motifs and whole compositions borrowed from the great masters of Tuscany.

The most remarkable pages of *Les Très Riches Heures* are those of the calendar, which depict the life of humanity and nature throughout the year. Such cycles, originally consisting of 12 single figures each performing an appropriate seasonal activity, were an established tradition in medieval art (see fig. 11-16, left). The Limbourg brothers, however, integrated these elements into a series of panoramas of human life in nature.

The illustration for the month of October (fig. 11-40) shows the sowing of winter grain. It is a

Developed in the fourteenth century, the BOOK OF HOURS was a prayer book for laypersons that contained psalms and devotional meditations chosen to suit the various seasons, months, days of the week, and hours of the day. Many of these small, portable books are masterpieces of luxurious illumination, especially those made for royal or aristocratic patrons.

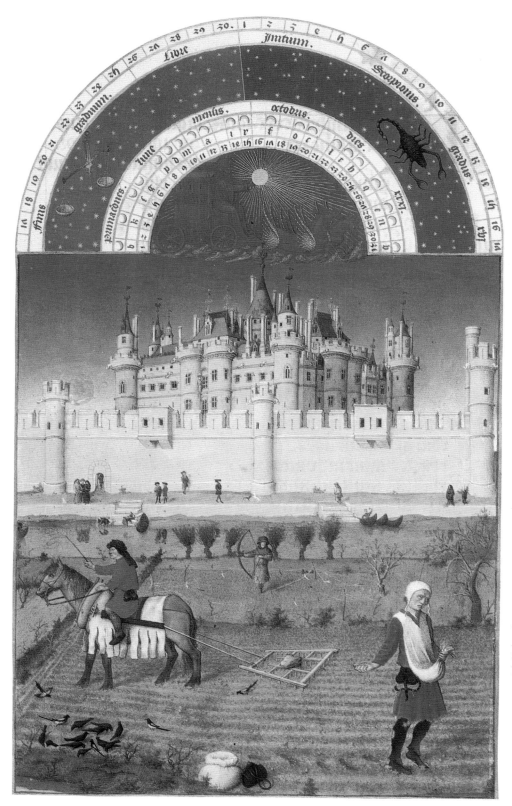

11-40 The Limbourg Brothers. *October,* from *Les Très Riches Heures du Duc de Berry.* 1413–16. 8 7/8 x 5 3/8" (22.5 x 13.7 cm). Musée Condé, Chantilly

bright, sunny day, and the figures—for the first time since classical antiquity—cast visible shadows on the ground. There is a wealth of realistic detail, such as the scarecrow in the middle distance and the footprints of the sower in the soil of the freshly plowed field. The sower is memorable in many ways. His tattered clothing, his unhappy air, go beyond mere description. Peasants were often caricatured in Gothic art, but the portrayal here is surprisingly sympathetic, as it is throughout this book of hours. The figure is meant to arouse our compassion for the miserable lot of the peasantry in contrast to the life of the aristocracy, symbolized by the castle on the far bank of the river. (The castle, we recall, is a "portrait" of the Gothic Louvre; see page 225.) Here, then, Gothic art transcends its "realism of particulars" to produce an encompassing vision of life that reflects the Limbourg brothers' knowledge of Italian art, as a glance at Ambrogio Lorenzetti's *Good Government* frescoes (see fig. 11-36) attests.

Gentile da Fabriano Italy was also affected by the International Style, although it gave more than it received. The altarpiece with the three Magi and their train (fig. 11-41) by Gentile da Fabriano (c. 1370–1427), the greatest Italian painter of the International Style, shows that he knew the work of the Limbourg brothers. The costumes here are as colorful, the draperies as ample and softly rounded, as in Northern painting. The Holy Family, on the left, seems almost in danger of being overwhelmed by the festive pageant pouring down from the hills in the distance. The foreground includes more than a dozen marvelously observed animals, not only the familiar ones but leopards, camels, and monkeys. (Such creatures were eagerly collected by the princes of the period, many of whom kept private zoos.) The oriental background of the Magi is emphasized by the Mongolian facial cast of some of their companions. It is not these exotic touches, however, that mark this as the work of an Italian master, but something else—a greater sense of weight, of physical substance, than we find in Northern painting of the International Style.

Despite his love of detail, Gentile clearly is not a manuscript illuminator but a painter used to working on a large scale. The panels decorating the base, or **predella**, of the altarpiece have a monumentality that belies their small size. Gentile was thoroughly familiar with Sienese art. Thus the *Flight into Egypt* in the center panel is indebted to Ambrogio Lorenzetti's frescoes in the Siena city hall (see fig. 11-36), while the *Presentation in the Temple* to the right is based on another scene by the same artist. Nevertheless, Gentile could achieve the delicate pictorial effects of a miniaturist when he wanted to. Although he was not the first artist to depict it, the night scene in the *Nativity* to the left, which was partly based on the vision received by the fourteenth-century Swedish princess St. Bridget in Bethlehem, has a remarkable poetic intimacy that shows the refinement which characterizes International Style art at its best.

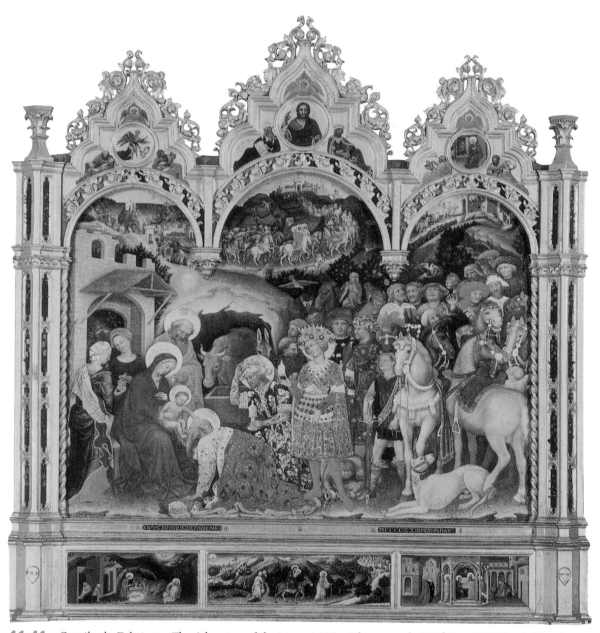

11-41 Gentile da Fabriano. *The Adoration of the Magi.* 1423. Oil on panel, 9'10⅛" x 9'3" (3 x 2.88 m). Galleria degli Uffizi, Florence

	400–700	700–900	900–1100
Political History	Roman Empire split into Eastern and Western branches 395 Rome sacked by Visigoths 410 Fall of the Western Roman Empire 476 "Golden Age" of Justinian 527–65 Muhammad (570–632) Byzantium loses Near Eastern and African provinces to Muslims (642–732)	Muslims invade Spain 711–18; defeated by Franks, Battle of Tours 732 Independent Muslim state established in Spain 756 Charlemagne (ruled 768–814) crowned Holy Roman Emperor 800 Alfred the Great (ruled 871–99?), Anglo-Saxon king of England	Otto I crowned Holy Roman Emperor 962 Otto II (ruled 973–83) defeated by Muslims in southern Italy Normans arrive in Italy 1016 William the Conqueror defeats Harold at Battle of Hastings 1066 Reconquest of Spain from Muslims begins 1085 First Crusade (1095–99) takes Jerusalem
Religion and Literature	Patrick (died c. 461) founds Church in Ireland 432 Split between Eastern and Western Churches begins 451 Isidore of Seville, encyclopedist (died 636) Koran 652	*Beowulf*, English epic, early 8th cent. Iconoclastic Controversy 726–843 Carolingian revival of Latin classics Earliest printed book, China, 868	Cluniac monastic order founded 910 Conversion of Russia to Orthodox Church c. 990 College of Cardinals formed to elect pope 1059 Cistercian order founded 1098 *Chanson de Roland*, French epic, c. 1098
Science and Technology	Papermaking introduced into Near East from China Stirrup introduced into western Europe c. 600	Earliest documented church organ, Aachen, 822 Horse collar adopted in western Europe, makes horses efficient draft animals	Earliest application of waterpower to industry Leif Ericsson sails to North America 1002
Painting	Catacomb of SS. Pietro e Marcellino, Rome (8-1) Mosaics, Sta. Maria Maggiore, Rome (8-4) *Vienna Genesis* (8-5) Mosaics, S. Apollinare in Classe and S. Vitale, Ravenna (8-3, 8-9, 8-10) *Lindisfarne Gospels* (9-3)	*Gospel Book of Charlemagne* (9-7) *Gospel Book of Archbishop Ebbo of Reims* (9-8) 8-10	*Gospel Book of Otto III* (9-14) Mosaics, Daphnē (8-16) *Bayeux Tapestry* (10-17)
Sculpture	*Sarcophagus of Junius Bassus*, Rome (8-6) *Archangel Michael*, diptych leaf (8-14) Sutton Hoo ship-burial treasure (9-1)	*Crucifixion* (plaque from a book cover?) (9-4) Oseberg ship burial (9-2) Crucifixion relief, cover of *Lindau Gospels* (9-9)	*Gero Crucifix*, Cologne Cathedral (9-10) Bronze doors of Bishop Bernward, Hildesheim (9-13) *Apostle*, St-Sernin, Toulouse (10-10) 9-10
Architecture	S. Vitale, Ravenna (8-7, 8-8) Hagia Sophia, Istanbul (8-11, 8-12) S. Apollinare in Classe, Ravenna (8-2, 8-3) 8-14	Palace Chapel of Charlemagne, Aachen (9-5)	St. Michael's, Hildesheim (9-11, 9-12) Pisa Cathedral complex (10-8) Baptistery, Florence (10-9) St-Étienne, Caen (10-5) St-Sernin, Toulouse (10-1–10-3) Durham Cathedral (10-6)

1100–1200	1200–1300	1300–1400

King Henry II founds Plantagenet line in England 1154
Frederick Barbarossa (ruled 1155–90) titles himself "Holy Roman Emperor," tries to dominate Italy

Fourth Crusade (1202–4) conquers Constantinople
Magna Carta limits power of English kings 1215
Louis IX (ruled 1226–70), king of France
Philip IV (ruled 1285–1314), king of France

Exile of papacy in Avignon 1309–76
Hundred Years' War between England and France begins 1337
Black Death throughout Europe 1347–50

Rise of universities (Bologna, Paris, Oxford); faculties of law, medicine, theology
Pierre Abélard, French philosopher and teacher (1079–1142)
Flowering of French vernacular literature (epics, fables, *chansons*); age of the troubadours

St. Dominic (1170–1221) founds Dominican order; Inquisition established to combat heresy
St. Francis of Assisi (died 1226)
St. Thomas Aquinas, Italian scholastic philosopher (died 1274)
Dante Alighieri, Italian poet (1265–1321)

John Wycliffe (died 1384) challenges Church doctrine; translates Bible into English
Petrarch, first humanist (1304–1374)
Canterbury Tales by Chaucer c. 1387
Decameron by Boccaccio 1387

Earliest manufacture of paper in Europe, by Muslims in Spain
Earliest use of magnetic compass for navigation
Earliest documented windmill in Europe 1180

Marco Polo travels to China and India c. 1275–93
Arabic (actually Indian) numerals introduced in Europe
First documented use of spinning wheel in Europe 1298

First large-scale production of paper in Italy and Germany
Large-scale production of gunpowder; earliest known use of cannon 1326
Earliest cast iron in Europe

9-14

Stained glass *Notre Dame de la Belle Verrière*, Chartres Cathedral (11-29)
Psalter of St. Louis (11-30)
Madonna Enthroned, icon (8-18)

11-9

Arena Chapel frescoes, Padua, by Giotto (11-32)
Maestà Altarpiece, Siena, by Duccio (11-31)
Good Government fresco, Palazzo Pubblico, Siena, by Ambrogio Lorenzetti (11-36)
Road to Calvary, by Simone Martini (11-34)
Birth of the Virgin triptych, Siena, by Pietro Lorenzetti (11-35)
Death of the Virgin, by Bohemian Master (11-38)
Altar wings, Dijon, by Melchior Broederlam (11-39)

South portal, St-Pierre, Moissac (10-11)
Baptismal font, St-Barthélemy, Liège, by Renier of Huy (10-14)
Last Judgment tympanum, Autun Cathedral, by Giselbertus (10-13)
West portals, Chartres Cathedral (11-16, 11-17)
Klosterneuburg Altarpiece, by Nicholas of Verdun (10-19)

West portal, Reims Cathedral (11-9)
Choir screen, Naumburg Cathedral (11-23)
Pulpit, Baptistery, Pisa, by Nicola Pisano (11-26)

Roettgen Pietà, Bonn (11-24)
Pulpit, Pisa Cathedral, by Giovanni Pisano (11-27)
Moses Well, Dijon, by Claus Sluter (11-25)

St-Denis, Paris (11-1)
Nôtre-Dame, Paris (11-2–11-4)
Chartres Cathedral (11-7, 11-8)
Reims Cathedral (11-9)

Salisbury Cathedral (11-10)
Sta. Croce, Florence (11-14)
Florence Cathedral (11-15)

Gloucester Cathedral (11-11)

11-24

1100–1200	1200–1300	1300–1400

THE RENAISSANCE THROUGH THE ROCOCO

In discussing the transition from classical antiquity to the Middle Ages, we were able to point to a great crisis—the rise of Islam—marking the separation between the two eras. No comparable event sets off the Middle Ages from the Renaissance. The fifteenth and sixteenth centuries, to be sure, witnessed far-reaching developments: the fall of Constantinople and the Turkish conquest of southeastern Europe; the journeys of exploration that led to the founding of overseas empires in the New World, Africa, and Asia, with the subsequent rivalry of Spain and England as the foremost colonial powers; and the deep spiritual crises of the Reformation and Counter-Reformation. But none of these events, however great their effects, can be said to have produced the new era. By the time they happened, the Renaissance was well under way. Even if we disregard the minority of scholars who would deny the existence of the period altogether, we are left with an extraordinary diversity of views on the Renaissance. Perhaps the only essential point on which most experts agree is that the Renaissance had begun when people realized they were no longer living in the Middle Ages.

This statement is not as simple-minded as it sounds. It brings out the undeniable fact that the Renaissance was the first period in history to be aware of its own existence and to coin a label for itself. Medieval people did not think they belonged to an age distinct from classical antiquity. The past, to them, consisted simply of "B.C." and "A.D.," the era "under the Law" (that is, of the Old Testament) and the era "of Grace" (that is, after the birth of Jesus). From their point of view, then, history was made in heaven rather than on earth. The Renaissance, by contrast, divided the past not according to the divine plan of salvation, but on the basis of human achievements. It saw classical antiquity as the era when civilization had reached the peak of its creative powers, an era brought to a sudden end by the barbarian invasions that destroyed the Roman Empire. During the thousand-year interval of "darkness" that followed, little was accomplished, but now, at last, this "time in-between" or "Middle Age" had been superseded by a revival of all those arts and sciences that had flourished in classical antiquity. The present, the "New Age," could thus be fittingly labeled a "rebirth"—*rinascita* in Italian (from the Latin *renascere,* "to be reborn"), *renaissance* in French and, by adoption, in English.

The origin of this revolutionary view of history can be traced back to the 1330s in the writings of the Italian poet Francesco Petrarca (1304–1374), the first of the great individuals who made the Renaissance. Petrarch, as we call him, thought of the new era mainly as a "revival of the classics," limited to the restoration of Latin and Greek to their former purity and the return to the original texts of ancient authors. During the next two centuries, this concept of the rebirth of antiquity grew to embrace almost the entire range of cultural endeavor, including the visual arts. The latter, in fact, came to play a particularly important part in shaping the Renaissance, for reasons that we shall explore later.

That the new historic orientation (to which, let us remember, we owe our concepts of the Renaissance, the Middle Ages, and classical antiquity) should have had its start in the mind of one man is itself a telling comment on the new era, although it was soon taken up by many others. Individualism—a new self-awareness and self-assurance—enabled Petrarch to proclaim, against all established authority, his own conviction that the "age of faith" was actually an era of darkness, while the "benighted pagans" of antiquity really represented the most enlightened stage of history. Such readiness to question traditional beliefs and practices was to become profoundly characteristic of the Renaissance as a whole. Humanism, to Petrarch, meant a belief in the importance of what we still call "the humanities" or "humane letters" (rather than divine letters, or the study of Scripture): the pursuit of learning in languages, literature, history, and philosophy for its own end, in a secular rather than a religious framework.

We must not assume, however, that Petrarch and his successors wanted to revive classical antiquity lock, stock, and barrel. By interposing the concept of "a thousand years of darkness" between themselves and the ancients, they acknowledged (unlike the medieval classicists) that the Graeco-Roman world was irretrievably dead. Its glories could be revived only in the mind, by nostalgic and admiring contemplation across the barrier of the "dark ages," by rediscovering the full greatness of ancient achievements in thought and art, and by endeavoring to compete with these achievements on an ideal plane.

The aim of the Renaissance was not to duplicate the works of antiquity but to equal and, if possible, to surpass them. In practice, this meant that the authority granted to the ancient models was far from unlimited. Writers strove to express themselves with Ciceronian eloquence and precision, but not necessarily in Latin. Architects continued to build the churches demanded by Christian ritual, but not to duplicate pagan temples. Rather, their churches were designed *all'antica,* "in the manner of the ancients," using an architectural vocabulary based on the study of classical structures. The humanists, however great their enthusiasm for classical philosophy, did not become neo-pagans but went to great lengths trying to reconcile the heritage of the ancient thinkers with Christianity.

The people of the Renaissance therefore found themselves in the position of the legendary sorcerer's apprentice, who set out to emulate his master's achievements and in the process released far greater energies than he had bargained for. But since their master was dead, rather than merely absent, they had to cope with these unfamiliar powers as best they could, until they became masters in their own right. This process of forced growth was replete with crises and tensions. The Renaissance must have been an uncomfortable, though intensely exciting, time to live in. Yet these very tensions, it seems, called forth an outpouring of creative energy such as the world had never before experienced. It is a fundamental paradox that the desire to return to

the classics, based on a rejection of the Middle Ages, brought to the new era not the rebirth of antiquity but the birth of modern civilization.

As we narrow our focus from the Renaissance as a whole to the Renaissance in the fine arts, we are faced with some questions that are still under debate. When did Renaissance art begin? Did it, like Gothic art, originate in a specific center or in several places at the same time? Should we think of it as one coherent style or as an attitude that might be embodied in more than one style? "Renaissance-consciousness," we know, was an Italian idea, and there can be no doubt that Italy was the leader in the development of Renaissance art, at least until the early sixteenth century. This fact does not necessarily mean, however, that the Renaissance was confined to the South.

So far as architecture and sculpture are concerned, modern scholarship agrees with the traditional view, first expressed more than 500 years ago, that the Renaissance began soon after 1400 in Florence. For painting, however, an even older tradition claims that the new era began with Giotto, who, as Boccaccio wrote about 1350, "restored to light this art which had been buried for many centuries." We cannot disregard such testimony. Yet if we accept it at face value, we must assume that the Renaissance in painting dawned about 1300, a full generation before Petrarch. Giotto himself certainly did not reject the past as an age of darkness. After all, the two chief sources of his own style were the Byzantine tradition and the influence of Northern Gothic. The artistic revolution he created from these elements does not inherently place him in a new era, since revolutionary changes had occurred in medieval art before. Nor is it fair to credit this revolution to him alone, disregarding Cimabue, Duccio, and the other great masters to whom he was linked. Petrarch was

well aware of the achievements of all these artists—he wrote admiringly of both Giotto and Simone Martini—but he never claimed that they had restored to light what had been buried during the centuries of darkness. And, in fact, such a thing was inherently impossible, because neither could have known classical painting.

How, then, do we account for Boccaccio's statement about Giotto? We must understand that Boccaccio (1313–1375), an ardent disciple of Petrarch, was chiefly concerned with advancing humanism in literature. In his defense of the status of poetry, he found it useful to draw analogies with painting. Had not the ancients themselves proclaimed that the two arts were alike, in Horace's famous dictum that art must conform to the example of poetry (*ut pictura poesis*)? Boccaccio thus cast Giotto in the role of "the Petrarch of painting," taking advantage of his already legendary fame. Boccaccio's view of Giotto as a Renaissance artist is, then, a bit of intellectual strategy, rather than a trustworthy reflection of Giotto's own attitude. Nevertheless, what he has to say interests us because he was the first to apply Petrarch's concept of "revival after the dark ages" to one of the visual arts, even though he did so somewhat prematurely.

Boccaccio's way of describing Giotto's achievement is also noteworthy. It was he who claimed that Giotto depicted every aspect of nature so truthfully that people often mistook his paintings for reality itself. Here he implies that the revival of antiquity means for painters an uncompromising realism. This, as we shall see, was to become a persistent theme in Renaissance thought, justifying the imitation of nature as part of the great movement "back to the classics" and tending to minimize the possible conflict between these two aims. After all, Classical Greek art was itself based on a synthesis of naturalism and ideal proportions.

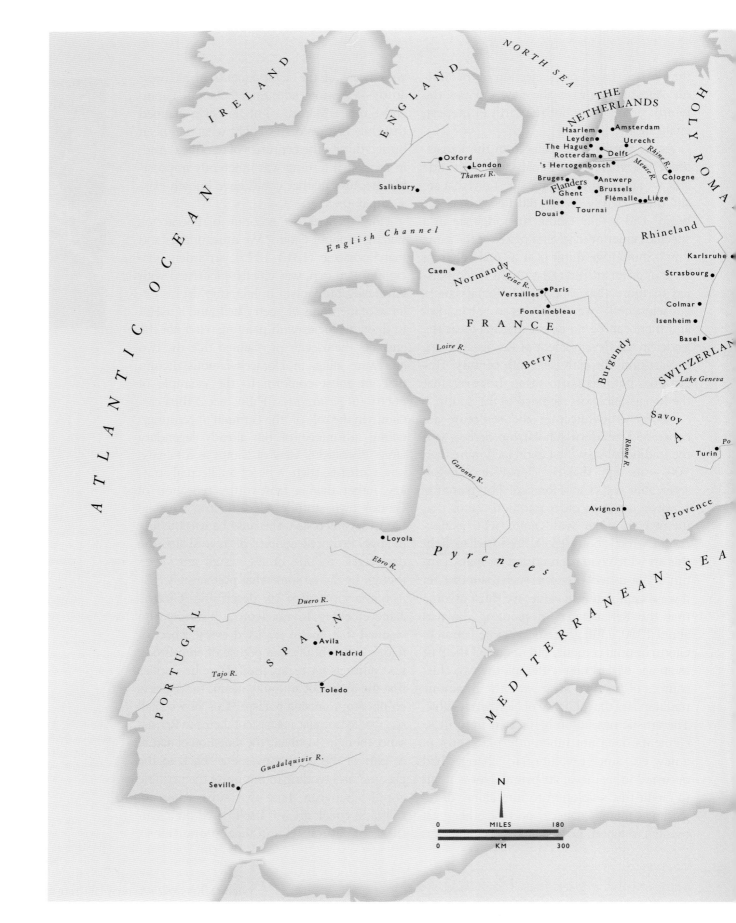

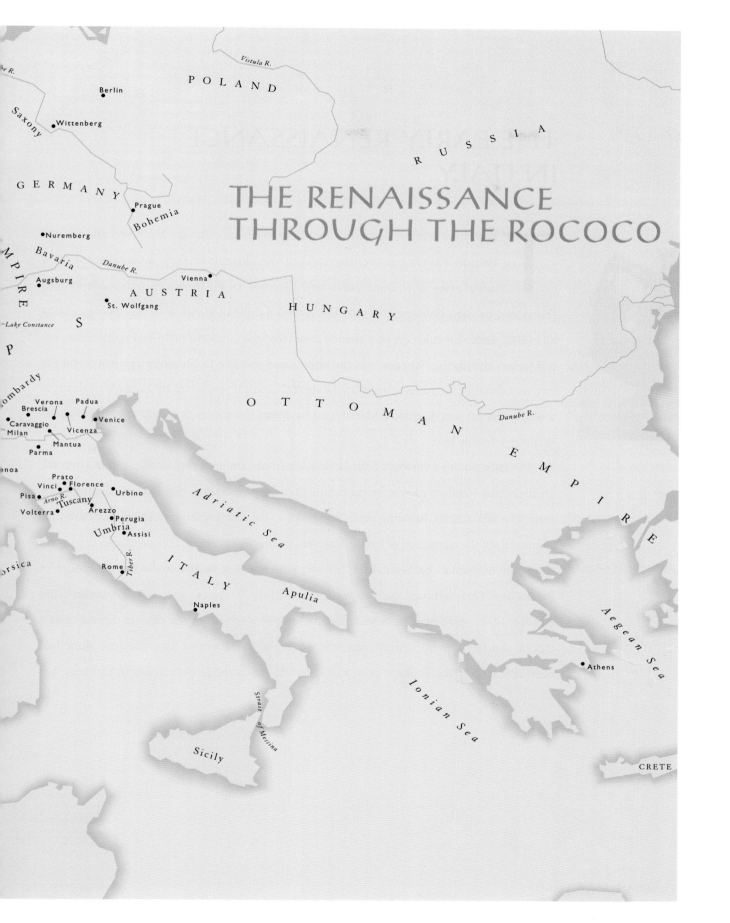

THE RENAISSANCE
THROUGH THE ROCOCO

POLAND

Vistula R.

Berlin

Saxony

Wittenberg

RUSSIA

GERMANY

Prague

Bohemia

Nuremberg

Bavaria

Danube R.

Augsburg

AUSTRIA

Vienna

St. Wolfgang

HUNGARY

Lake Constance

Lombardy

Verona Padua

Brescia

Caravaggio Venice

Milan Vicenza

Mantua

Parma

enoa

Prato

Vinci Florence

Pisa Urbino

Arno R. Tuscany

Volterra Arezzo

Perugia

Umbria Assisi

Corsica

Tiber R.

Rome

ITALY

OTTOMAN EMPIRE

Danube R.

Adriatic Sea

Apulia

Naples

Aegean Sea

Athens

Ionian Sea

Strait of Messina

Sicily

Crete

12

THE EARLY RENAISSANCE
IN ITALY

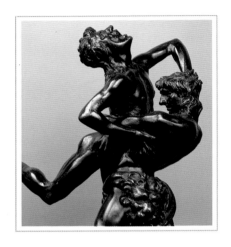

There are a number of reasons that help to explain why the Early Renaissance was born in Florence at the beginning of the fifteenth century, rather than in some other place or at some other time. Around 1400, Florence's independence was threatened by Gian Galeazzo Visconti, the powerful duke of Milan, who was trying to bring all of Italy under his rule. Visconti already controlled the Lombard plain and most of the central Italian city-states. Florence was the only major obstacle to his ambition. Just when the city was about to be overwhelmed by the duke's forces, it was saved by his sudden death in 1402; under his son, Giovanni Maria Visconti, Milan lost much of its power until his assassination a decade later.

Florence put up a vigorous defense on three fronts: military, diplomatic, and intellectual. Of these, the intellectual was by no means the least important. The duke was admired by some as a new Caesar, bringing peace and order to the country. In opposition, Florence proclaimed itself the champion of freedom against unchecked tyranny. This propaganda war was waged by humanists on both sides, but the Florentines gave by far the better account of themselves. Their writings, such as *Praise of the City of Florence* (1402–3) by Leonardo Bruni (see fig. 12-6), gave new focus to Petrarch's ideal of a rebirth of the classics. Speaking as a citizen of a free republic, Bruni asks why, among all the states of Italy, Florence alone had been able to defy the superior power of Milan. He finds the answer in her institutions, her

cultural achievements, her geographical situation, the spirit of her people, and her descent from the city-states of ancient Etruria. Florence, he concludes, has taken on the same role of political and intellectual leadership as Athens had during the Persian Wars.

The patriotic pride, the call to greatness that can be seen in this image of Florence as the "new Athens" must have aroused a deep response throughout the city. The Florentines embarked on an ambitious campaign to finish the great artistic works begun a century before at the time of Giotto. Following the competition of 1401–2 for the bronze doors of the Baptistery of S. Giovanni (see fig. 11-28), another major program continued the sculptural decoration of Florence Cathedral and other churches. At the same time, debate resumed over how to build the dome of the Cathedral, the largest and most difficult project of all. The artistic campaign, which lasted more than 30 years, gradually petered out after the completion of the dome in 1436. Its total cost was comparable to that of rebuilding the Akropolis in Athens. The huge investment was not a guarantee of artistic quality, but it provided an excellent opportunity for the emergence of creative talent and a new style worthy of the "new Athens."

From the start, the visual arts were viewed as central to the rebirth of the Florentine spirit. Throughout most of antiquity and the Middle Ages, they had been classed with the crafts, or "mechanical arts." It cannot be by chance that the first statement claiming a place for them among the liberal arts occurs about 1400 in the writings of the Florentine chronicler Filippo Villani; this position was solidified by Alberti's treatise on painting (see page 282). A century later, this idea was acknowledged throughout most of the Western world. What does it imply?

The liberal arts were defined by a tradition going back to Plato. They comprised the intellectual disciplines necessary for a "gentleman's" education: mathematics (including musical theory), dialectics (logical disputation), grammar, rhetoric (the art of persuasion), and philosophy. The fine arts were initially excluded because they were "handiwork" and lacked a theoretical basis. During

the early fourth century B.C., however, they were included in the liberal arts (see page 93). When Renaissance artists gained admission to the select group of humanists, they were viewed as people of ideas rather than mere manipulators of materials. Works of art came to be viewed more and more as the visible records of creative minds. This meant that they need not—indeed, should not—be judged only by the standards of craftsmanship. Soon anything that bore the imprint of a great master was eagerly collected: drawings, sketches, fragments, and unfinished pieces as well as finished works.

The outlook of artists changed as well. Now in the company of scholars and poets, they themselves often became learned and literary. They might write poems, autobiographies, or theoretical treatises. Another outgrowth of their new social status was that artists' personalities tended to develop in either of two contrasting ways. One was the person of the world, self-controlled, at ease in aristocratic society. The other was the solitary genius, secretive, subject to fits of melancholy, and likely to be in conflict with patrons. It is remarkable how quickly this modern view of art and artists took root in Early Renaissance Florence. But it was not accepted immediately everywhere, nor did it apply equally to all artists. England, for example, was slow to grant artists special status, and women in general were denied the training and opportunities available to men.

In addition to humanism and historical forces, individual genius played a decisive role in the birth of Renaissance art. It began with three men of exceptional ability—Filippo Brunelleschi, Donatello, and Masaccio. It is hardly a coincidence that these men knew one another. Moreover, they all faced the same task: to reconcile classical form with Christian content. Yet each approached this problem in a unique way. Thanks to them, Florentine art retained leadership of the movement during the first half of the fifteenth century, which we now think of as the heroic age of the Early Renaissance. To trace its beginnings, we must discuss sculpture first because the sculptors had earlier and more plentiful opportunities to meet the challenge of the "new Athens."

Sculpture

The artistic campaign began with the competition for the Baptistery doors, and for some time it consisted mainly of sculptural projects. Ghiberti's trial relief (see fig. 11-28) does not differ greatly from the International Gothic; nor do the doors themselves, even though it took another 20 years to complete them. Only in the torso of Isaac can Ghiberti's admiration for ancient art be linked with the classicism of the Florentine humanists. Similar examples can be found in other Florentine sculpture around 1400. But such instances, isolated and small in scale, merely recapture what Nicola Pisano had done a century before (see fig. 11-26).

Nanni di Banco A decade later this medieval classicism was surpassed by a somewhat younger artist, Nanni di Banco (c. 1384–1421). The four saints, called the *Quattro Coronati* (fig. 12-1), which he made about 1410–14 for one of the niches on the exterior of the church of Or San Michele, must be compared not with the work of Nicola Pisano but with the Reims *Visitation* (see fig. 11-21, right pair). The saints represent four Christian sculptors who were executed for not carving the statue of a pagan god ordered by the Roman emperor Diocletian, a story that was later merged with that of four martyrs who refused to worship in the god's temple. The figures in both groups are about life-size, yet Nanni's give the impression of being a good deal larger than those at Reims are. Their monumental quality was well beyond the range of medieval sculpture, even though Nanni depended less directly on ancient models. Only the heads of the second and third of the *Coronati* directly recall Roman sculpture—specifically, the portrait heads of the third century A.D. (see fig. 7-12). Nanni clearly was impressed by their realism and their agonized expressions. His ability to retain these qualities indicates a new attitude toward ancient art, one that unites classical form and content instead of separating them as medieval classicists had done.

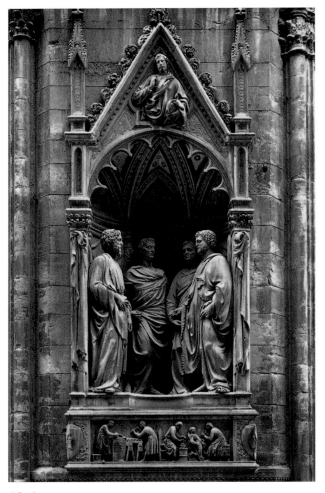

12-1 Nanni di Banco. *Four Saints (Quattro Coronati).* c. 1410–14. Marble, about life-size. Or San Michele, Florence

Donatello Early Renaissance art reestablished an attitude toward the human body similar to that of classical antiquity. Donatello (Donato de Betto di Bardi, 1386–1466), the greatest sculptor of his time, played a particularly important role in forming this new approach. Among the founders of the new style, he alone lived well past the middle of the century. (He was born only a few years after Nanni and outlived him by 45 years.) Together with Nanni, Donatello spent his early career working on commissions for Florence Cathedral and Or San Michele after completing his apprenticeship under Ghiberti. They often faced the same

artistic problems and influenced each other, although their personalities had little in common.

St. George Their different approaches can be seen by comparing Nanni's *Quattro Coronati* with Donatello's *St. George* (fig. 12-2). Both are located in Gothic niches, but Nanni's figures, like Antelami's *King David* (see fig. 10-15), cannot be divorced from the architectural setting. Instead, they still seem attached, like jamb statues, to the pilasters behind them. The figure of St. George, however, would lose none of its authority if it were removed from the niche. Perfectly balanced, it could stand by itself, like the statues of antiquity. Donatello has recaptured the full meaning of the classical **contrapposto,** the central achievement of Greek sculpture. Yet, unlike the *Coronati, St. George* is not at all classical in appearance—that is, ancient motifs are not quoted as they are in Nanni's figures. Perhaps "classic" is a better word for him. Donatello treats the human body as an articulated structure capable of movement. Although encased in armor, the saint's body and limbs are not rigid. His stance, with the weight placed on the forward leg, conveys his readiness for combat. (The right hand originally held a lance or sword.) The controlled energy of his body is reflected in his eyes, which seem to scan the horizon for the enemy. In his Early Renaissance version, St. George is portrayed as the Christian Soldier, spiritually akin to the *St. Theodore* at Chartres (see fig. 11-19), but now he is also the proud defender of the "new Athens."

Below *St. George's* niche is a relief panel showing the hero's best-known exploit, the slaying of a dragon. (The maiden on the right is the princess whom George had come to free.) Here Donatello devised a new kind of relief that is shallow (called *schiacciato,* "flattened-out") yet creates an illusion of infinite depth. This had been achieved to some degree in Greek and Roman reliefs, as well as by Ghiberti (compare with figs. 5-13, 7-15, and 11-28). In all these cases, however, the actual carved depth is roughly proportional to the apparent depth of the space represented. The forms in the front plane are in very high relief, while more distant ones become progressively lower, seemingly immersed in the

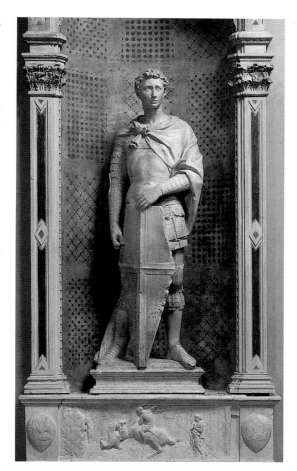

12-2 Donatello. *St. George* tabernacle, from Or San Michele, Florence. c. 1415–17. Marble, height of statue 6'10" (2.08 m). Museo Nazionale del Bargello, Florence

background. Donatello takes an entirely different approach. Behind the figures, the landscape consists of delicate surface modulations that cause the marble to catch light from varying angles. Every tiny ripple has a descriptive power that is much greater than its real depth. The sculptor's chisel, like a painter's brush, becomes a tool for creating shades of light and dark. Yet Donatello cannot have borrowed his effects from any landscape painting, for no painter at the time had achieved so unified and atmospheric a view of nature. In creating pictorial effects, sculptors remained far in advance of most painters until well past midcentury.

David Donatello had learned the technique of bronze sculpture as a youth by working under Ghiberti on the first Baptistery doors. By the 1420s, he began to rival his former teacher in that medium. His bronze *David* (fig. 12-3) is the first **freestanding** life-size nude statue since antiquity. In the Middle Ages it would have been condemned as an idol, and even in Donatello's day people must

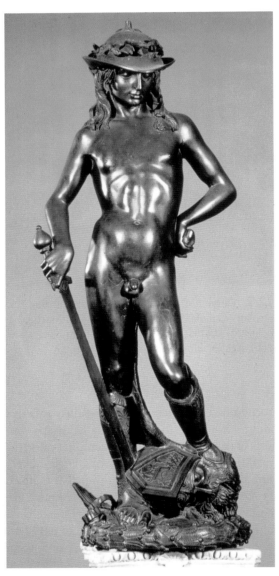

12-3 Donatello. *David.* c. 1425–30. Bronze, height 62½" (158.8 cm). Museo Nazionale del Bargello, Florence

have felt uneasy about it, because for many years it remained the only work of its kind. The statue evidently was meant for an open space. It probably stood on top of a column in the garden of Cosimo de' Medici, the most powerful figure in Florence, where it would have been visible from every side.

The key to the meaning of the statue is the helmet of Goliath, with its visor and wings. This form was derived from depictions of the Roman wind-god Zephyr, an evil figure who killed the young boy Hyacinth. We may assume that the helmet is a reference to the dukes of Milan, who were again warring against Florence in the mid-1420s. The statue thus is a patriotic public monument identifying DAVID—weak but favored by the Lord—with Florence, and GOLIATH with Milan. David's nudity may be a reference to the classical origin of Florence; his wreathed hat, the opposite of Goliath's helmet, perhaps represents peace versus war.

Donatello chose to model an adolescent boy, not a full-grown youth like the athletes of Greece, so that the figure lacks their swelling muscles. Nor is the torso articulated according to the classical pattern (compare figs. 5-15 and 5-17). Rather, it is softly sensuous. *David* resembles an ancient statue mainly in its *contrapposto*. If the figure has a classical appearance, the reason lies in its expression, not in its anatomy. The lowered gaze signifies humility, which triumphs over the sinful pride of Goliath. It was inspired by classical examples, which equate it with modesty and virtue (compare fig. 5-17). As in ancient statues, however, the body speaks to us more eloquently than the face, which by Donatello's standards strangely lacks individuality.

Gattamelata In 1443 Donatello was invited to Padua to produce his largest freestanding work in bronze: the equestrian monument of Gattamelata (fig. 12-4). This statue, which honors the recently deceased commander of the Venetian armies, is still in its original position on a tall pedestal near the facade of the church dedicated to St. Anthony of Padua. Like the mounted Marcus Aurelius in Rome (see fig. 7-10), the *Gattamelata* is impressive

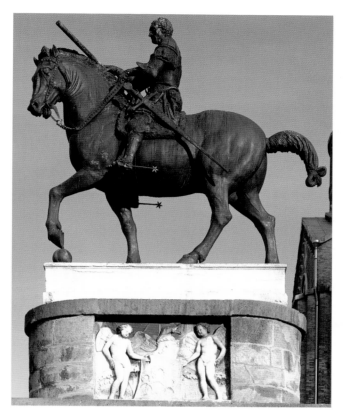

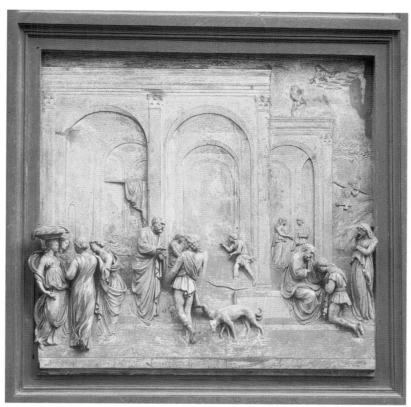

12-4 Donatello. *Equestrian Monument of Gattamelata.* 1445–50. Bronze, approx. 11 x 13' (3.35 x 3.96 m). Piazza del Santo, Padua

12-5 Lorenzo Ghiberti. *The Story of Jacob and Esau,* panel of the *"Gates of Paradise."* c. 1435. Gilt bronze, 31¼" (79.4 cm) square. Baptistery of S. Giovanni, Florence

in scale and reflects a sense of balance and dignity. The horse, a heavyset animal fit to carry a man in full armor, is so large that the rider must dominate it by authority rather than by force. But the *Gattamelata* is not the self-glorifying statue of a sovereign; it is a monument authorized by the Republic of Venice to commemorate a great soldier. Donatello therefore has united the ideal with the real. The armor combines modern construction with classical detail; the head is that of an individual, yet it displays a truly Roman nobility of character.

Ghiberti Donatello's only serious rival was his former teacher, Lorenzo Ghiberti. After the great success of his first doors for the Florence Baptistery, Ghiberti was commissioned to do a second

pair, which are so beautiful that they were soon dubbed the *"Gates of Paradise."* Each contains ten large reliefs in simple square frames, which create a larger field than the 28 small panels in quatrefoil frames of the earlier doors. The style reveals the influence of Donatello and other pioneers of the Early Renaissance. The only remnants of the Gothic are seen in the graceful classicism of the figures, which reminds us of the International Style.

The *"Gates of Paradise"* show the pictorialism found in many Renaissance reliefs. The hint of spatial depth we saw in *The Sacrifice of Isaac* (see fig. 11-28) has grown in *The Story of Jacob and Esau* (fig. 12-5) into a complete setting that goes back as far as the eye can reach. We can imagine the figures leaving the scene, for the deep space of

Scientific Perspective

Although it is not certain, Brunelleschi probably invented scientific, or linear, perspective. This system is a geometric procedure for projecting space onto a plane, analogous to the way the lens of a photographic camera projects a perspective image on the film. Its central feature is the vanishing point, toward which any set of parallel lines will seem to converge. If these lines are perpendicular to the picture plane, their **vanishing point** will be on the horizon, corresponding exactly to the position of the beholder's eye. Brunelleschi's discovery in itself was scientific rather than artistic, but it immediately became highly important to Early Renaissance artists because, unlike the perspective practices of the past, it was objective, precise, and rational. In fact, it soon became an argument for upgrading the fine arts into the liberal arts.

While empirical methods could also yield striking results, scientific perspective made it possible to represent three-dimensional space on a flat surface in such a way that all the distances remained measurable. This meant, in turn, that by reversing the procedure, a plan could be derived from the perspective picture of a building. On the other hand, the scientific implications of the new perspective demanded that it be consistently applied, a requirement that artists could not always live up to, for practical as well as aesthetic reasons. Since the method presupposes that the beholder's eye occupies a fixed point in space, a perspective picture automatically tells us where we must stand to see it properly. Thus, the artist who knows in advance that a work will be seen from above or below, rather than at ordinary eye level, ought to make its perspective construction correspond to these conditions. If, however, these are so abnormal that the entire design must be foreshortened to an extreme degree, the artist may disregard them and assume instead an ideal beholder, normally located. In 1435 Brunelleschi's discovery was formulated in *De pictura*, the first Renaissance treatise on painting, written by Leone Battista Alberti, who later became an important architect in his own right (see pages 282–83).

this relief does not require their presence. Ghiberti's spacious hall is a fine example of Early Renaissance architectural design. It is also an example of a picture space using Brunelleschi's **scientific perspective** (see box above), which assumes an ideal vantage point in which the viewer's eye is on a line perpendicular to the center of the panel. This new pictorial space allows Ghiberti to present his story in continuous narrative with unprecedented coherence, as if all seven episodes were taking place simultaneously (compare fig. 8-5).

Bernardo Rossellino After Donatello left for Padua in 1443, there was a shortage of marble sculptors in Florence. By the time he returned ten years later, this gap had been filled by a group of men, most still in their twenties, from the hill towns north and east of Florence that had long supplied the city with stonemasons and carvers. Taking advantage of the unusual opportunities open to them, the most gifted of these developed into artists of considerable importance. The oldest, Bernardo Rossellino (1409–1464), seems to have begun as a sculptor and architect in Arezzo. He came to Florence about 1436 but received no major commissions until eight years later, when he was asked to design the tomb of Leonardo Bruni (fig. 12-6). This great humanist and statesman had played a vital part in the city's affairs since the beginning of the century (see page 270). When he died in 1444, he received a grand funeral "in the manner of the ancients." His monument was probably ordered by the city government. Since Bruni had been born in Arezzo, his native town also wished to honor him and may have helped obtain the commission for Bernardo.

Although Bruni's is not the earliest Renaissance tomb, it is the first to express fully the spirit of the era. The references to antiquity contain many echoes of Bruni's funeral: the deceased lies on a bier supported by Roman eagles, his head wreathed in laurel and his right hand resting on a book (presumably his own *History of Florence*, rather than a prayer book). The monument is a fitting tribute to the man who, more than any other, had helped establish the historical perspective of the Florentine Early Renaissance. On the sarcophagus, two winged **genius** figures hold an inscription that is very different from those on medieval tombs. Instead of

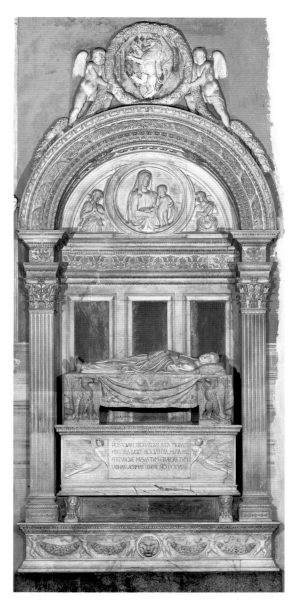

12-6 Bernardo Rossellino. Tomb of Leonardo Bruni. c. 1445–50. Marble, height to top of arch 20' (6.10 m). Sta. Croce, Florence

The monument may be viewed as an attempt to reconcile two contrasting attitudes toward death: the retrospective, commemorative outlook of the ancients and the Christian concern with afterlife and salvation. Bernardo's design, adapted from Gothic tombs (see fig. 11-37), is well suited to this task. Consequently, all the tombs, tabernacles, and reliefs of the Madonna produced in Florence between 1450 and 1480 owe much to it. The Bruni monument balances architecture and sculpture within a compact framework. The two pilasters supporting a round arch resting on a strongly accented architrave recall the work of Leone Battista Alberti, who employed this motif often (see fig. 12-11). While Bernardo may have used it for aesthetic reasons, he may also have meant it to symbolize the gateway between one life and the next. Perhaps he even wanted us to associate the motif with the Pantheon, the "temple of the immortals" for both pagans and Christians. (Once dedicated to all the gods of the Roman world, the Pantheon had been rededicated to all the martyrs when it had became a Christian church. In the High Renaissance the building was to house the tombs of another breed of immortals: famous artists such as Raphael.)

Pollaiuolo By 1450, the great civic art campaign had come to an end in Florence, and artists had to depend mainly on private commissions. This put the sculptors at a disadvantage because of the high cost of making their work. Since there were few commissions for monuments, they created pieces of moderate size and price, such as bronze statuettes. The collecting of sculpture, common in ancient times, had stopped during the Middle Ages. The taste of kings, feudal lords, and others who could afford to collect for their own pleasure ran to gems, jewelry, goldsmith's work, illuminated manuscripts, and precious fabrics. The habit resumed in fifteenth-century Italy as part of the "revival of antiquity." Humanists and artists first collected ancient sculpture, especially small bronzes, of which there were many. Before long, artists began to cater to the demand by creating portrait busts and small bronzes "in the manner of the ancients."

recording the name, rank, and age of the deceased and the date of his death, it refers only to his achievements: "At Leonardo's passing, history grieves, eloquence is mute, and it is said that the MUSES, Greek and Latin alike, cannot hold back their tears." The religious aspect of the tomb is confined to the lunette, where the Madonna is adored by angels.

Patron goddesses of intellectual and creative endeavors, the MUSES were nine mythical daughters of Zeus and the goddess of memory, Mnemosyne. They were Klio, history; Kalliope, epic poetry; Erato, love poetry; Euterpe, lyric poetry; Melpomene, tragedy; Polyhymnia, songs and poetry for the gods; Thalia, comedy; Terpsichore, choral songs and dance; and Urania, astronomy.

A fine example of this kind is *Hercules and Antaeus* (fig. 12-7) by Antonio del Pollaiuolo (1431–1498). Pollaiuolo's style was very different from that of the marble carvers discussed above. Trained as a goldsmith and metalworker, probably in the Ghiberti workshop, he was deeply impressed by the late styles of Donatello and Andrea del Castagno (see fig. 12-18), as well as by ancient art. From these sources, he developed the distinctive style that appears in our statuette.

Pollaiuolo was a painter and engraver as well as a bronze sculptor, and we know that about 1465 he did a closely related picture of HERCULES and ANTAEUS for the MEDICI, who also owned the statuette. (The painting has been lost, but the

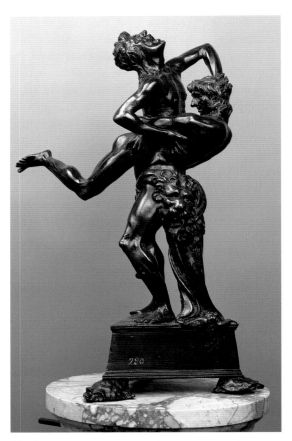

12-7 Antonio del Pollaiuolo. *Hercules and Antaeus.* c. 1475. Bronze, height with base 18" (45.8 cm). Museo Nazionale del Bargello, Florence

design is preserved in a smaller copy.) Here, for the first time, a sculptural group has been given the pictorial quality that could be seen in reliefs since the early years of the Renaissance. To create a freestanding group of two struggling figures, even on a small scale, was a daring idea. There is no precedent for this design among earlier statuary groups, ancient or Renaissance. Even bolder is the centrifugal force that can be felt in this composition. Limbs seem to move outward in every direction. We see the full complexity of their movements only when we view the statuette from all sides. Despite its violent action, the group is in perfect balance. To stress the central axis, Pollaiuolo in effect grafted the upper part of Antaeus onto the lower part of Hercules.

Verrocchio Although Pollaiuolo made two bronze tombs for St. Peter's in Rome during the late years of his career, he never had a chance to create a large-scale freestanding statue. For such works we must turn to Andrea del Verrocchio (1435–1488), the greatest sculptor of his day and the only one to share some of Donatello's range and ambition. A modeler as well as a carver—we have works of his in marble, terra-cotta, silver, and bronze—he combined elements from Rossellino and Pollaiuolo into a unique style. He was also a respected painter and the teacher of Leonardo da Vinci.

Like *Hercules and Antaeus* by Pollaiuolo, Verrocchio's *Doubting of Thomas* (fig. 12-8) is closely related to a painting: a Baptism of Christ, painted with the assistance of the young Leonardo. The result is a pictorialism unique in monumental sculpture of the Early Renaissance. In contrast to the *Quattro Coronati* of Nanni di Banco (see fig. 12-1), the subject is a narrative. Also, Verrocchio's group does not quite fit its niche on Or San Michele, for it replaced a figure by Donatello that had been moved. Hence the statues have no backs, so that they can fit in the shallow tabernacle, which acts as a foil rather than as a container.

Although the biblical text is inscribed on the drapery, the drama is conveyed by the eloquent poses and bold exchange of gestures between Christ and Thomas. It is heightened by the active

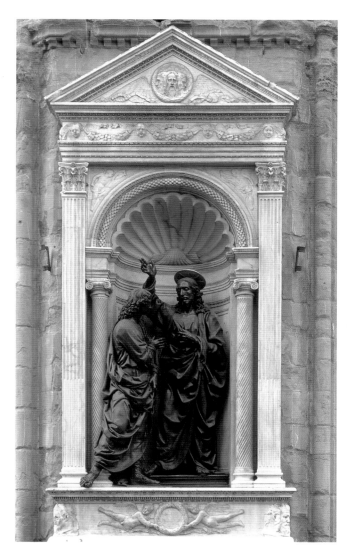

12-8 Andrea del Verrocchio. *The Doubting of Thomas*. 1465–83. Bronze, life-size. Or San Michele, Florence

Architecture

Brunelleschi Donatello did not create the Early Renaissance style in sculpture all by himself. The new architecture, in contrast, owed its existence to one person, Filippo Brunelleschi (1377–1446), who was arguably the central figure in Early Renaissance art. Ten years older than Donatello, he, too, had begun his career as a sculptor. After losing the competition for the first Baptistery doors, he certainly went to Rome with Donatello. There he studied ancient structures and seems to have been the first person to take exact measurements of them. His discovery of scientific perspective (see box, page 276) may have grown out of his search for an accurate way of recording their appearance. We do not know what else Brunelleschi did during this period, but between 1417 and 1419 he again competed with Ghiberti, this time for the job of building the Florence Cathedral dome (see fig. 11-15). The dome had been designed half a century earlier, so only details could be changed, but its vast size posed a difficult problem of construction. Brunelleschi's proposals, although contrary to traditional practice, so impressed the authorities that this time he won—thanks in part to a model he built with the help of Donatello and Nanni di Banco. Thus the dome may be viewed as the first work of postmedieval architecture, as an engineering feat if not for style.

Brunelleschi's main achievement was to build the dome in two separate shells. These make use of a skeletal system inspired by the coffered dome of the Pantheon (see fig. 7-4). The two are ingeniously linked so as to reinforce each other, rather than forming a solid mass. Because the weight of the structure was lightened, Brunelleschi could dispense with the massive and costly wooden trusswork required by the older method of construction. Instead of having building materials carried up on ramps to the required level, he designed hoisting machines. Although Brunelleschi was neither a

drapery, with its deep folds, which echo the contrasting states of mind. *The Doubting of Thomas* is of great importance in the history of sculpture. The work was admired for its great beauty, especially the head of Christ, which was to inspire Michelangelo. For Leonardo it served as a model of figures whose actions express the passions of the mind. Later it stimulated the sculpture of Bernini (compare fig. 17-14).

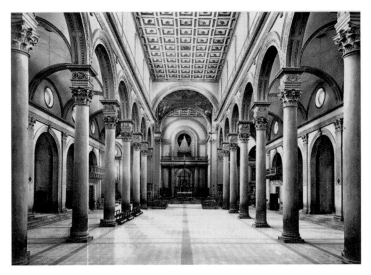

12-9 Filippo Brunelleschi. S. Lorenzo, Florence. 1421–69

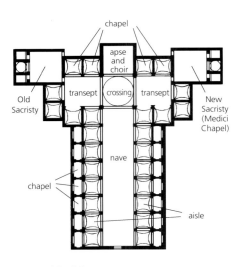

12-10 Plan of S. Lorenzo

man of letters nor a scientist, his entire scheme reflects a bold, analytical mind that was willing to discard traditional solutions if better ones could be devised. This approach is very different from that of the Gothic stonemason-architects.

In 1419, while he was working out the final plans for the dome, Brunelleschi received his first opportunity to create buildings entirely of his own design. It came from the head of the Medici family, one of the leading merchants and bankers of Florence, who commissioned him to add a **sacristy** to the Romanesque church of S. Lorenzo. His plans for this structure (which was to serve also as a burial chapel for the Medici) were so successful that he was asked to develop a new design for the entire church. The construction, begun in 1421, was often interrupted, so that the interior was not completed until 1469, more than 20 years after the architect's death. (The exterior remains unfinished to this day.) Nevertheless, the building in its present form is essentially what Brunelleschi had envisioned about 1420, and represents the first full statement of his architectural aims (figs. 12-9, 12-10).

At first glance, the plan may not seem very novel. Its general arrangement recalls that of Cistercian Gothic churches, while the unvaulted nave and transept link it to Sta. Croce (see fig. 11-14). What distinguishes it is a new emphasis on symmetry and regularity. The entire design consists of square units. Four large squares form the choir, the crossing, and the arms of the transept. Four more are combined into the nave. Other squares, one-fourth the size of the large ones, make up the aisles and the chapels attached to the transept. (The oblong chapels outside the aisles were not part of the original design but were added sometime after 1442.)

As we study the plan, we see that Brunelleschi must have decided to make the floor area of the choir equal to four of the small square units. The nave and transept thus would be twice as wide as the aisles or chapels. In other words, Brunelleschi conceived S. Lorenzo as a grouping of "space blocks," the larger ones being simple multiples of a standard unit. (He was not concerned with the thickness of the walls between these compartments, so that the transept arms are slightly longer than they are wide, and the length of the

nave is not four but four and one-half times its width.) Once we understand this, we realize how revolutionary he was. His clearly defined space compartments were a radical change from the Gothic architect's way of thinking. The difference is one of consistency. Despite Abbot Suger's emphasis on harmonious ratios, Gothic churches such as Notre-Dame in Paris (see fig. 11-2) never applied a systematic set of proportions throughout, even though groin-vaulting encouraged the development of uniform modules.

In the interior, static order has replaced the flowing spatial movement of Gothic examples. S. Lorenzo does not sweep us off our feet. It does not even draw us forward after we have entered; we are content to remain near the door. From there our view seems to take in the entire structure, almost as if we were looking at a demonstration of scientific perspective (compare fig. 12-5). The effect recalls the "old-fashioned" Tuscan Romanesque, such as the Baptistery of S. Giovanni in Florence (see fig. 10-9), as well as Early Christian basilicas. These monuments, to Brunelleschi, exemplified the church architecture of classical antiquity. (The Baptistery was even thought to have once been a classical temple.) They inspired his use of round arches and columns, rather than piers, in the nave arcade. Yet these earlier buildings lack the lightness and precise articulation of S. Lorenzo. Their columns are larger and more closely spaced, tending to screen off the aisles from the nave. Only the arcade of the Florentine Baptistery is as gracefully proportioned as that of S. Lorenzo, but it is a blind arcade, without any supporting function.

Clearly, then, Brunelleschi did not revive the architectural forms of the ancients out of mere enthusiasm. The very quality that attracted him to them—their inflexibility—must have seemed their chief drawback from the medieval point of view. Unlike a medieval column, a classical column is strictly defined; its details and proportions can be varied only within narrow limits. The classical round arch, unlike any other arch (horseshoe, pointed, and so forth), has only one possible shape, a semicircle. The classical architrave, profiles, and ornaments are all subject to similarly strict rules. This is not to say that classical forms are completely rigid. If they were, they could not have persisted to the fourth century A.D. But the discipline of the Greek orders, which can be felt even in the most original Roman buildings, demands regularity and discourages arbitrary departures from the norm.

Without such "standardized" forms, Brunelleschi would have been unable to define his "space blocks" so clearly. With remarkable logic, he emphasizes the edges or "seams" of the units without disrupting their rhythmic sequence. To take one noteworthy example, consider the vaulting of the aisles. The transverse arches rest on pilasters attached to the outer wall (corresponding to the columns of the nave arcade), but between arch and pilaster there is a continuous architrave linking all the bays. We would expect these bays to be covered by unribbed groin vaults. Instead, we find a new kind of vault whose curved surface is formed from the upper part of a hemispherical dome. (Its radius equals half the diagonal of the square compartment.) Avoiding the ribs and even the groins, Brunelleschi has created a "one-piece" vault, strikingly simple and regular, in which each bay is a distinct unit.

At this point we may ask: if the new architecture consists of separate elements added together, be they spaces, columns, or vaults, how do they relate to one another? What makes the interior of S. Lorenzo seem so fully integrated? There is indeed a principle that accounts for the balanced nature of the design. For Brunelleschi, the secret of good architecture was to give the "right" proportions—that is, proportional ratios expressed in simple whole numbers—to all the major measurements of a building. The ancients had possessed this secret, he believed, and he tried to discover it when he measured their monuments. What he found, and exactly how he applied it, we do not know for sure. He may have been the first to discover what would be stated a few decades later in Leone Battista Alberti's *Treatise on Architecture*: the mathematical ratios that determine musical harmony must also govern architecture, for they recur throughout the universe and thus are divine in origin.

vocabulary and *syntax*

The words *vocabulary* and *syntax* are often used in connection with architecture. *Vocabulary* refers to the individual parts of a structure, for example, the columns, arches, and arcades. *Syntax* is the arrangement of the parts in an orderly, often hierarchical disposition, thus paralleling the usage of the same term in grammar.

An ANTIQUARIAN is a person who studies the past, especially by searching out and interpreting original documents and artifacts. A DILETTANTE is essentially an enthusiast who is an amateur, someone for whom the pursuit of an interest, usually cultural, is not connected to his or her livelihood.

Similar ideas, derived from the theories of the Greek philosopher Pythagoras, had been current during the Middle Ages, but they had never before been expressed so directly and simply. When Gothic architects "borrowed" the ratios of musical theory, they did so far less consistently. But even Brunelleschi's faith in harmonious proportions did not tell him how to allot these ratios to the parts of any given building. It left him many alternatives, and his choice was necessarily subjective. We may say, in fact, that the main reason S. Lorenzo strikes us as the product of a great mind is the individual sense of proportion that can be found in every detail.

In the revival of classical forms, Renaissance architecture found a standard vocabulary. The theory of harmonious proportions gave it a syntax that had been mostly absent in medieval architecture. This relative lack of flexibility should be viewed as an advantage. To take our linguistic analogy further, we may draw a parallel between the "unclassical" flexibility of medieval architecture, expressed in numerous regional styles, and the equally "unclassical" attitude toward language that prevailed at the time, as found in its barbarized Latin and regional vernaculars, the ancestors of today's Western languages. The revival of Latin and Greek in the Renaissance did not stunt these languages. On the contrary, it made them much more stable, precise, and articulate, so that before long Latin lost its dominant position as the language of intellectual discourse. It is not by chance that we can read Renaissance literature in Italian, French, English, or German without much trouble, while texts of a century or two earlier can often be understood only by scholars. Similarly, the revival of classical forms and proportions enabled Brunelleschi to transform the architectural "vernacular" of his region into a stable, precise, and clear system. The principles on which his buildings were based soon spread to the rest of Italy and later to all of Northern Europe.

Alberti In architecture, the death of Brunelleschi in 1446 brought to the fore Leone Battista Alberti (1404–1472). Alberti's career, like Brunelleschi's, had been long delayed, although in other ways the two men were very different. Until he was 40, Alberti seems to have been interested in the fine arts only as an ANTIQUARIAN and theorist. He studied the monuments of ancient Rome, albeit casually at first, and wrote the first Renaissance treatises on sculpture and painting. He also began a third treatise, far more exhaustive than the others, on architecture—the first of its kind since Vitruvius's, on which it is modeled (see page 100). After about 1430, he was close to the leading artists of his day. (*On Painting* is dedicated to Brunelleschi and refers to "our dear friend" Donatello.) Alberti began to practice architecture as a DILETTANTE, but in time he became a professional of outstanding ability. Highly educated in classical literature and philosophy, he was both a humanist and a person of the world.

Alberti devoted much of his career to resolving a fundamental issue of Renaissance architecture: how to apply a classical system to the exterior of a nonclassical structure. Whether Brunelleschi ever coped with this problem is hard to say. In any case, most of Alberti's work for the Church consisted of remodeling projects, which hampered his goal of superimposing a classical temple front on the traditional basilican church facade. Only toward the end of his career did he achieve this seemingly impossible feat: in the majestic facade of S. Andrea at Mantua (fig. 12-11), his last work, designed in 1470 at the behest of Lodovico Gonzaga, duke of Mantua.

Alberti superimposed a **triumphal-arch** motif with a huge center niche upon a classical temple front and projected this combination onto the wall. The arch supported by pilasters is derived in turn from the doorway to the Pantheon (see fig. 7-3). These are clearly set off from their surroundings, and their flatness emphasizes the primacy of the wall surface. The pilasters are of two sizes. The smaller ones support the arch over the central niche, while the larger ones are linked with the unbroken architrave and the strongly outlined pediment. The latter form what is known as a **colossal order** (meaning that it is more than one story high). Extending across all three stories of the facade, it balances the horizontal and vertical elements of the design. So intent was Alberti on creating a

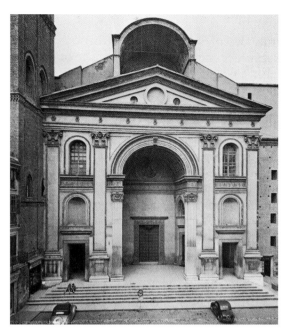

12-11 Leone Battista Alberti. S. Andrea, Mantua. Designed 1470

unified facade that he inscribed the entire design within a square, even though it is much lower than the nave of the church. (The effect of the west wall protruding above the pediment is more disturbing in photographs than at street level, where it can hardly be seen.) While the facade is distinct from the main body of the structure, it offers a "preview" of the interior, where the same colossal order, the same proportions, and the same triumphal-arch motif reappear on the walls of the nave.

Because it occupies the site of an older basilican church (note the Gothic campanile next to the facade), S. Andrea does not conform to the ideal shape of sacred buildings as defined in Alberti's *Treatise on Architecture*. There he explains that the plan of such structures should be either circular or derived from the circle (square, hexagon, octagon, and so forth). The justification is that the circle is the perfect, as well as the most natural, figure and therefore a direct image of divine reason. Alberti's ideal church must have such a harmonious design that it would be a revelation of God and would arouse pious contemplation in the worshiper. It should stand alone, above its surroundings.

Light should enter through openings placed high, for only the sky should be seen through them. The fact that such a structure was not well suited to Catholic ritual meant little to Alberti. A church, he believed, must embody "divine proportion," which could be attained only by the **central plan**.

This claim rests, of course, on Alberti's faith in the God-given validity of mathematical proportions. He took to heart Vitruvius's belief that architecture must employ the same principles of symmetry and proportion as a "well-shaped man." (In support of this rule, Vitruvius pointed out that a man with arms and legs outstretched fits into a circle or square.) How could Alberti reconcile his belief in the central plan with historical evidence? After all, the standard form of both ancient temples and Christian churches was longitudinal. But, he reasoned, the basilican church plan became traditional only because the early Christians worshiped in private Roman basilicas. Since pagan basilicas were associated with the dispensing of justice (which originates from God), he granted that their shape had some relationship to sacred architecture. However, since they could not rival the sublime beauty of the temple, their purpose must have been human rather than divine.

In speaking of temples, Alberti relied entirely on the Pantheon (see figs. 7-3 and 7-4) and other round structures that he mistook for temples. Moreover, he asked, had not the early Christians themselves acknowledged the sacred nature of these structures by converting them to their own use? Here he could point not only to the Pantheon itself (which had been used as a church ever since the early Middle Ages) but also the Baptistery in Florence (then thought to be a former temple of Mars).

Giuliano da Sangallo Toward the end of the century, after Alberti's treatise became widely known, the central-plan church gained wide acceptance. Between 1500 and 1525 it reigned supreme in High Renaissance architecture. It is no coincidence that Sta. Maria delle Carceri in Prato (fig. 12-12, page 284) was begun in 1485, the date of the first printed edition of the treatise. Its architect, Giuliano da Sangallo (c. 1443–1516), who was employed

as a military engineer, must have been an admirer of Brunelleschi, as we can tell from the vocabulary. The basic shape of his structure, however, conforms to Alberti's ideal. Except for the dome, the entire church would fit neatly inside a cube; its height (up to the **drum**) equals its length and width. By cutting into the corners of this cube, Giuliano has formed a Greek cross (a plan he preferred for its symbolic value). The arms are **barrel-vaulted,** and the dome rests on these vaults. Yet the drum does not quite touch the supporting arches, so that the dome seems to hover weightlessly, like the pendentive domes of Byzantine architecture (compare fig. 8-12). There can be no doubt that Giuliano wanted his dome to accord with the age-old tradition of the Dome of Heaven. The single round opening in the center and the 12 on the perimeter clearly refer to Christ and the apostles.

Painting

Masaccio Early Renaissance painting did not appear until the early 1420s. The new style was launched by a young genius named Masaccio (Tommaso di Giovanni di Simone Guidi, 1401–1428), who was only 21 years old at the time and who died just six years later. The fact that the Early Renaissance was already well established in sculpture and architecture made Masaccio's task easier than it would have been otherwise. The artist's achievement was quite remarkable nevertheless.

Trinity Masaccio's first mature work is a fresco of 1425 in Sta. Maria Novella (fig. 12-13) depicting the Holy Trinity in the company of the Virgin, St. John the Evangelist, and two donors who kneel on either side. The lowest section, which is linked with a tomb below, shows a skeleton lying on a sarcophagus. The inscription (in Italian) reads as follows: "What you are, I once was; what I am, you will become."

It seems hard to believe that only a few years before, Gentile da Fabriano had painted *The Adoration of the Magi* (see fig. 11-41). Masaccio's style completely abandons the lyrical grace of the International Gothic. Instead we seem to plunge into a new environment, one that brings to mind not the style of the recent past but the art of Giotto and his school, with its large scale, severe composition, and sculptural volume (compare figs. 11-32, 11-33, and 11-37). Masaccio's allegiance to Giotto was only a starting point, however. For Giotto, body and drapery form a single unit, as if both had the same substance. In contrast, Masaccio's

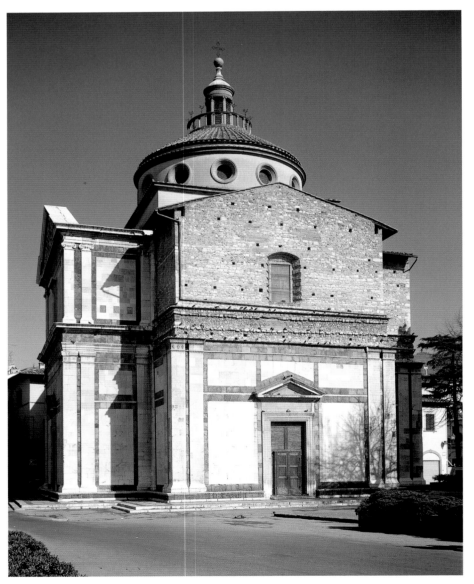

12-12 Giuliano da Sangallo. Sta. Maria delle Carceri, Prato. Begun 1485

figures, like Donatello's, are "clothed nudes," whose drapery falls like real fabric. The Christ still follows the example set by Duccio's *Maestà* altarpiece (see fig. 11-31), but the nearly sculptural treatment recalls an early *Crucifixion* by Brunelleschi that translates the same model into three dimensions. Like Donatello and Brunelleschi, Masaccio had a thorough knowledge of anatomy, not seen since Roman art. They may well have initiated the modern practice of dissecting cadavers to study the inner workings of the human body.

The up-to-date setting reveals the artist's understanding of Brunelleschi's new architecture and of scientific perspective. For the first time in history, we are given all the data needed to measure the depth of a painted interior, to draw its plan, and to duplicate the structure in three dimensions. It is, in short, the earliest example of a rational space in painting. This barrel-vaulted chamber is not a shallow niche, but a deep space in which the figures could move freely if they so wished. As in Ghiberti's relief panel *The Story of Jacob and Esau* (see fig. 12-5), the picture space is independent of the figures. They inhabit the space, but they do not create it. Take away the architecture and you take away the figures' space. We could go even further and say that scientific perspective depends on this particular kind of architecture, so different from the Gothic.

First we note that all the lines perpendicular to the picture plane converge toward a point below the foot of the Cross, on the platform that supports the kneeling donors. To see the fresco correctly, we must face this point, which is at normal eye level, somewhat more than five feet above the floor of the church. The figures within the chamber are five feet tall, slightly less than life-size, while the donors, who are closer to us, are fully life-size. The framework therefore is "life-size," too, since it is directly behind the donors. The distance between the pilasters equals the span of the barrel vault, seven feet. The circumference of the arc over this span is 11 feet. That arc is subdivided by eight square coffers and nine ridges, the coffers being one foot wide and the ridges four inches wide. If we apply these data to the length of the barrel vault (it consists of seven coffers, the nearest of which is hidden

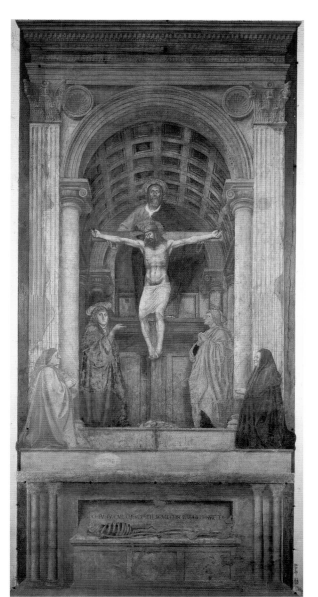

12-13 Masaccio. *The Holy Trinity with the Virgin, St. John, and Two Donors.* 1425. Fresco in Sta. Maria Novella, Florence

Plan of floor and ceiling derived from the painting

Masaccio's one-point scientific perspective creates a rational picture space—the illusion that the figures are standing in a coffered, barrel-vaulted niche just above our eye.

behind the entrance arch), we find that the vaulted area is nine feet deep.

We can now draw a complete floor and ceiling plan. However, the position of God the Father is puzzling at first. His arms support the Cross, close to the front plane, while his feet rest on a ledge attached to a wall. How far back is this surface?

If it is the rear wall of the chamber, God would seem to be exempt from the laws of perspective. But unless the artist made a gross error in his calculations, this cannot be so. Hence Masaccio must have intended to locate the ledge directly behind the Cross. The strong shadow that St. John casts on the wall beneath the ledge bears this out. What, then, is God standing on? It is likely that he is standing on the tomb of Christ, which is placed at a right angle to the wall and measures five and a half feet high by four feet wide and six or seven feet deep.

We realize, then, that *The Holy Trinity* is a restatement of the promise of eternal life in the Bardi chapel frescoes by Maso di Banco and Taddeo Gaddi (see fig. 11-37). But instead of combining painting with actual tomb sculpture, Masaccio has created an illusion that is far more convincing. This is so even though the niche is treated as a separate realm that the viewer, like the two donors, cannot enter. The rational pictorial space plays a key role in other ways as well. For Masaccio, as for Brunelleschi, it must have been a symbol of the universe ruled by divine reason. This attitude further explains the quiet atmosphere, the calm gesture of the Virgin as she points to the Cross, and the solemn grandeur of God the Father as he holds it effortlessly. The fervent hope of salvation portrayed in the Bardi chapel (note the prayerful poses of the deceased) is presented here as a certitude based on reason as well as faith. Such, indeed, was the purpose of Renaissance humanism, in which the artist now assumed a position comparable to that of a philosopher.

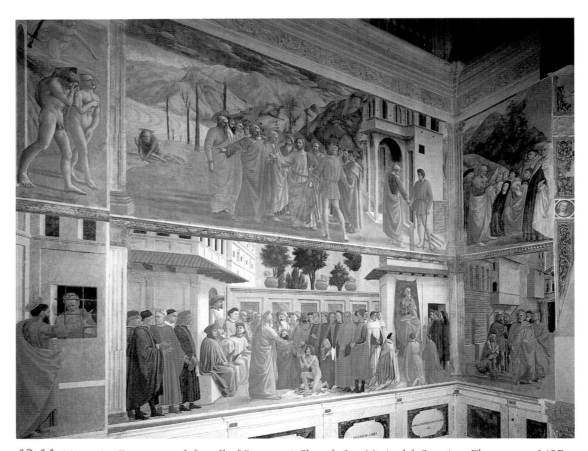

12-14 Masaccio. Frescoes on left wall of Brancacci Chapel, Sta. Maria del Carmine, Florence. c. 1427

Brancacci Chapel The largest group of Masaccio's works to come down to us are frescoes in the Brancacci Chapel in Sta. Maria del Carmine, Florence (fig. 12-14), which are devoted to the life of St. Peter. The most famous of them is *The Tribute Money*, located in the upper tier. It depicts the story in the Gospel of Matthew (17:24–27) as a continuous narrative. In the center, Christ instructs Peter to catch a fish, whose mouth will contain the tribute money for the tax collector. On the far left, in the distance, Peter takes the coin from the fish's mouth, and on the right he gives it to the tax collector. Since the lower edge of this scene is almost 14 feet above the floor of the chapel, the artist could not assume an ideal vantage point. Instead, we must imagine that we are looking directly at the central vanishing point, which is located behind the head of Christ. Oddly enough, this feat is so easy that we take note of it only if we stop to analyze it. But then, any pictorial illusion is an imaginary experience. No matter how eager we are to believe in a picture, we never mistake it for reality, just as we never confuse a statue with a living thing.

If we could see *The Tribute Money* from the top of a ladder, the illusion of reality would not improve very much, because it does not depend mainly on scientific perspective. Masaccio controls the flow of light (which comes from the right, where the window of the chapel is located) and also uses **atmospheric perspective** in the subtle tones of the landscape. We now recall Donatello's use of such a setting a decade earlier in his small relief of St. George (compare fig. 12-2).

The figures in *The Tribute Money*, even more than those in the *Trinity* fresco, display Masaccio's ability to merge the weight and volume of Giotto's figures with the new functional view of body and drapery. All stand in balanced *contrapposto*. Fine vertical lines scratched in the plaster establish the axis of each figure from the head to the heel of the engaged leg. In accord with this dignified approach, the figures seem rather static. The narrative is conveyed by intense glances and a few strong gestures, rather than by physical movement. But in *The Expulsion from Paradise*, just to the left, Masaccio proves that he can show the human body in motion. The tall, narrow format leaves little room

for a spatial setting. The gate of paradise is barely indicated, and in the background are a few shadowy, barren slopes. Yet the soft, atmospheric modeling, and especially the forward-moving angel, boldly foreshortened, convey a sense of unlimited space. Masaccio's grief-stricken Adam and Eve, though hardly dependent on ancient models, are striking representations of the beauty and power of the nude human form.

Fra Angelico Masaccio died too young (he was only 27) to be the founder of a school, and his style was too bold to be taken up immediately by his contemporaries. His slightly older contemporary, Fra Angelico (c. 1400–1455), was a friar who rose to a high position within his order. We sense his reverential attitude in the large *Deposition* (fig. 12-15, page 288), which was probably done for the same chapel as Gentile da Fabriano's *Adoration of the Magi* (see fig. 11-41). Fra Angelico took over the commission from Gentile's contemporary Lorenzo Monaco. Lorenzo was responsible for the paintings in the frame and the triangular pinnacles, but died before he could complete the altar. *The Deposition* may date anywhere from about 1435 to the early 1440s, for Fra Angelico, like Ghiberti, developed slowly, and his mature style underwent very little change.

This painting is an object of devotion. Fra Angelico retains Masaccio's dignity, directness, and spatial order. Thus Fra Angelico's dead Christ is the true heir of the monumental figure in Masaccio's *Trinity*. Yet Fra Angelico's art is something of a paradox. It combines Gothic piety with Renaissance grandeur in an atmosphere of calm contemplation. The setting spreads behind the figures like a tapestry. The landscape, with the town in the distance, harks back to the *Good Government* by Ambrogio Lorenzetti (see fig. 11-36). The artist also shows his awareness of the achievements of Northerners such as the Limbourg brothers (compare fig. 11-40): he evokes a brilliant sunlit day with striking success. Yet the scene does not seem at all Gothic. This light fills the landscape with a sense of wonderment at God's creation, an effect that is wholly Renaissance in spirit. We shall meet it again in the work of Giovanni Bellini, which it

SPEAKING OF

school, school of, and *follower of*

Art historians use the word *school* in several ways. Some master artists developed a following of people who worked in their presence, consciously emulating the style of the master. Similarly, artists who worked in the same time, place, and style sometimes are considered to be a school, such as those during the nineteenth century who painted at Barbizon. *School of* is used to identify an unknown artist clearly working under the influence of a major figure, and *follower of* suggests a second-generation artist whose work continues the style of the named master.

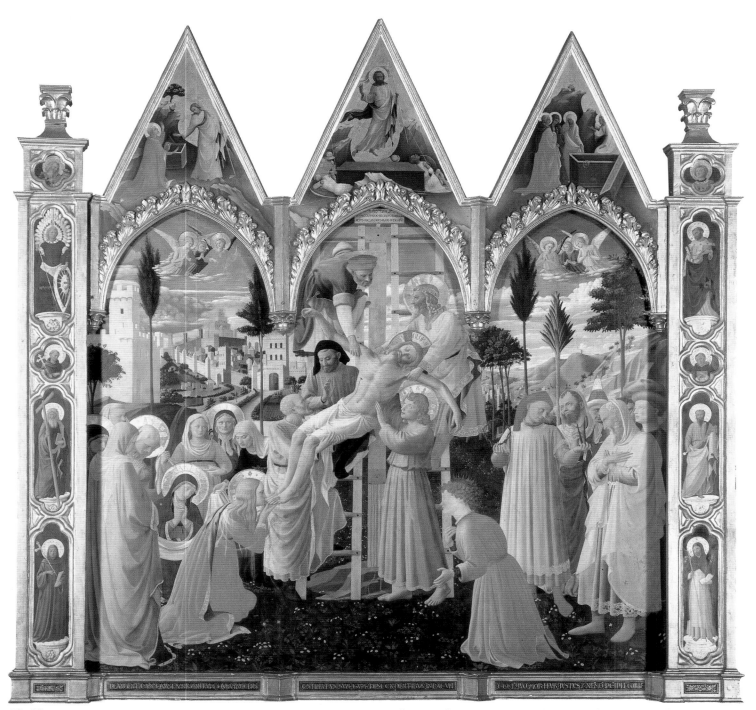

12-15 Fra Angelico. *The Deposition.* Probably early 1440s. Oil on panel, 9'1¼" x 9'4¼" (2.75 x 2.85 m). Museo di S. Marco, Florence

anticipates in another respect: the beautiful yet uninhabited city in the distance is surely the HEAVENLY JERUSALEM (see fig. 12-23). At the same time, the bright, enamel-like hues, though remnants of the International Style, look forward to the colorism of Domenico Veneziano.

Domenico Veneziano In 1439 Domenico Veneziano, a gifted painter from Venice, settled in Florence. We can only guess at his age, training, and previous work. (He was probably born about 1410 and died in 1461.) He must, however, have been in sympathy with the spirit of Early Renaissance art, for he quickly became an important artist in his new home. His *Madonna and Child with Saints* (fig. 12-16) is one of the earliest examples of a new kind of altar panel, called a *sacra conversazione* ("sacred conversation"). An enthroned Madonna is framed by architecture and flanked by saints, who may converse with her, with the beholder, or among themselves.

As a metaphor for the Christian heaven, the HEAVENLY JERUSALEM was seen as the counterpart to the earthly city of Jerusalem. It was the site where God dwelled and the place to which the saved would ascend on Judgment Day.

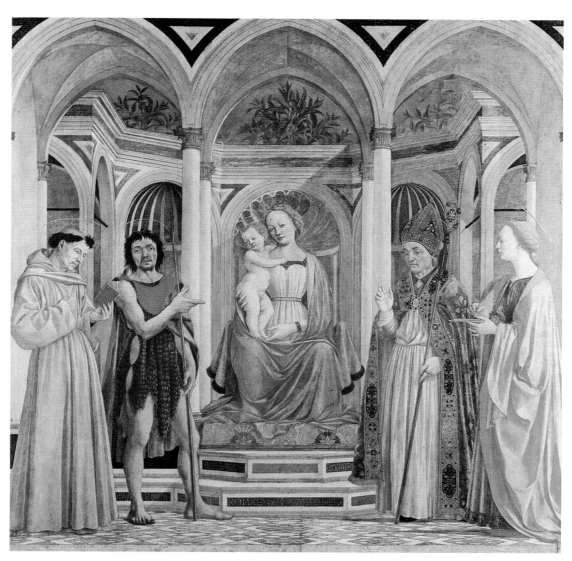

12-16 Domenico Veneziano. *Madonna and Child with Saints.* c. 1455. Oil on panel, 6'10" x 7' (2.08 x 2.13 m). Galleria degli Uffizi, Florence

Looking at Domenico's panel, we can understand the appeal of the *sacra conversazione*. The architecture and the space it defines are clear and tangible, yet elevated above the everyday world. The figures, while echoing the formality of their setting, are linked with each other by a fully human awareness. We are admitted to their presence, but they do not invite us to join them. Like spectators in a theater, we are not allowed "on stage."

The basic elements of our panel were already present in Masaccio's *Holy Trinity* fresco. Domenico must have studied it carefully, for his St. John looks at us while pointing toward the Madonna, repeating the glance and gesture of Masaccio's Virgin. Domenico's perspective setting is worthy of the earlier master, although the slender proportions and colored inlays of his architecture are more decorative. His figures, too, are as balanced and dignified as Masaccio's, but without the same weight and bulk. The slim, sinewy bodies of the male saints, with their highly individualized, expressive faces, show Donatello's influence.

Unlike Masaccio, Domenico treats color as an integral part of his work, and the *sacra conversazione* is as noteworthy for its palette as for its composition. The blond tonality—its harmony of pink, light green, and white set off by spots of red, blue, and yellow—reconciles the brightness of Gothic panel painting with perspective space and natural light. A *sacra conversazione* is usually an indoor scene, but this one takes place in a kind of **loggia** (a covered open-air arcade) with sunlight streaming in from the right, as we can tell from the cast shadow behind the Madonna. The surfaces reflect the light so strongly that even the shadowed areas glow with color. Masaccio had achieved a similar quality of light in one of his oil paintings, which Domenico surely knew. In this *sacra conversazione,* the technique has been applied to a more complex set of forms and merged with Domenico's exquisite color sense. The influence of its distinctive tonality can be seen throughout Florentine painting during the second half of the century.

Piero della Francesca When Domenico Veneziano settled in Florence, he had a young assistant from southeastern Tuscany named Piero della Francesca (c. 1420–1492). Piero became his most important disciple and one of the great artists of the Early Renaissance. Surprisingly, however, he left Florence after a few years, never to return. The Florentines seem to have viewed his work as provincial and old-fashioned, and from their point of view they were right. Piero's style, even more than Domenico's, reflected the aims of Masaccio. Piero retained his allegiance to the founder of Italian Renaissance painting throughout his long career, even while Florentine taste developed in a different direction in the years after 1450.

Piero's most impressive work is the fresco cycle in the choir of S. Francesco in Arezzo, painted from about 1452 to 1459. Its many scenes depict the legend of the True Cross (the story of the Cross used for Christ's crucifixion). The section in figure 12-17 shows the empress Helena, the mother of Constantine the Great, discovering the True Cross and the two crosses of the thieves who died beside Jesus. (All three had been hidden by enemies of the Faith.) On the left, they are being lifted out of the ground; on the right, the True Cross is identified by its power to bring a dead youth back to life.

Piero's link with Domenico is apparent in his colors. The tonality of this fresco, although less luminous than in Domenico's *sacra conversazione,* is similarly blond and evokes morning sunlight in much the same way. Since the light enters the scene at a low angle, in a direction almost parallel to the picture plane, it defines every shape and lends drama to the narrative. But Piero's figures have an austere grandeur that recalls Masaccio, or even Giotto, more than Domenico. These men and women seem to belong to a lost heroic race, beautiful and strong—and silent. Their inner life is conveyed by glances and gestures, not by facial expressions. They have a gravity that makes them seem akin to Greek sculpture of the Severe style (see figs. 5-16 and 5-18).

How did Piero arrive at these images? They were born of his passion for perspective. More than any other artist of his day, Piero believed in scientific perspective as the basis of painting. In a

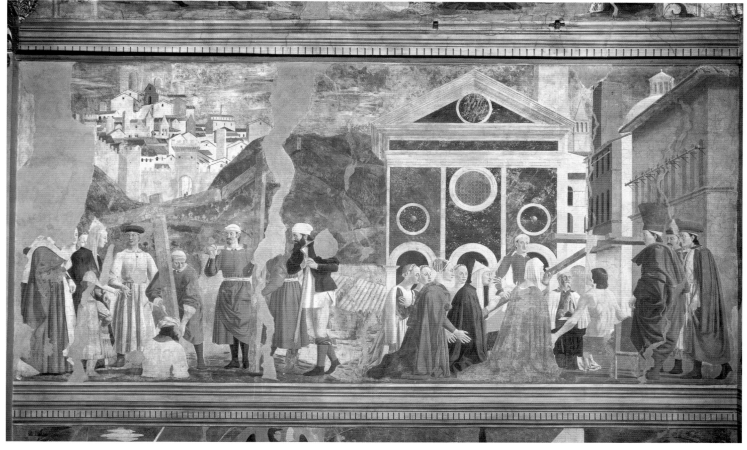

12-17 Piero della Francesca. *The Discovery and Proving of the True Cross.* c. 1455. Fresco in S. Francesco, Arezzo

mathematical treatise that was the first of its kind, he showed how it applied to stereometric (scientifically measured) bodies and architectural shapes, as well as to the human form. This mathematical outlook can be seen in all of his work. When he drew a head, an arm, or a piece of drapery, he saw them as variations or compounds of spheres, cylinders, cones, cubes, and pyramids. Thus he endowed the visible world with some of the clarity and permanence of stereometric bodies. Medieval artists, in contrast, built natural forms on geometric scaffolds (see fig. 11-29). We may regard Piero as the earliest ancestor of the abstract artists of our own time, for they, too, simplify natural forms. It is not surprising that Piero's fame is greater today than ever before.

Castagno The new direction in Florentine taste after 1450 can be seen in the remarkable *David* (fig. 12-18, page 292) executed by Andrea del Castagno (c. 1423–1457) shortly before his death. It is painted on a leather shield that was used only for display. Its owner probably wanted to convey an analogy between himself and the biblical hero, since David is here defiant as well as victorious. This dynamic linear style is far removed from Masaccio's. Solid volume and statuesque immobility have given way to graceful movement, conveyed by both the pose and the windblown hair and drapery. The modeling of the figure has been minimized. The forms are now defined mainly by their outlines, so that David seems to be in relief rather than in the round.

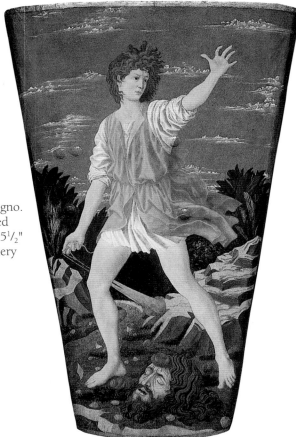

12-18 Andrea del Castagno. *David.* c. 1455–57. Painted leather on wood, height 45½" (115.8 cm). National Gallery of Art, Washington, D.C.

Widener Collection

Botticelli The dynamic linear style seen in *David* was to dominate the second half of the century. Its climax came in the final quarter of the century, in the art of Sandro Botticelli (1444/5–1510), who soon became the favorite painter of the Medici circle—the group of nobles, scholars, and poets surrounding Lorenzo the Magnificent, the head of the family and, for all practical purposes, the real ruler of the city. Botticelli painted *The Birth of Venus* (fig. 12-19), his most famous picture, for the young prince Lorenzo de' Medici. (It once hung in his summer villa.) The shallow modeling and the emphasis on outline produce an effect of low relief rather than of solid, three-dimensional shapes. We note, too, a lack of concern with deep space. The grove at the right, for example, functions as an ornamental screen. Bodies are elongated and drained of all weight; indeed, they seem

to float even when they touch the ground. All this seems to deny the basic values of the founders of Early Renaissance art, yet the picture does not look medieval. The bodies, however ethereal, remain voluptuous. They are genuine nudes, with full freedom of movement.

Botticelli's Venus is derived from a variant of the *Knidian Aphrodite* by Praxiteles (see fig. 5-22). The subject itself was inspired by the Homeric "Hymn to Aphrodite," which begins: "I shall sing of beautiful Aphrodite...who is obeyed by the flowery sea-girt land of Cyprus, whither soft Zephyr and the breeze wafted her in soft foam over the waves. Gently the golden-filleted Horae received her, and clad her in divine garments." Yet no single literary source accounts for the pictorial conception. It owes something as well to Ovid and the humanist poet Angelo Poliziano, who was, like Botticelli, a member of the Medici circle and may well have advised him on the painting, as he undoubtedly did on others.

Neoplatonism The subject of *The Birth of Venus* is clearly meant to be serious, even solemn. How could such images be justified in Christian terms without both the artist and his patron being accused of neopaganism? To answer this question we must consider the meaning of the picture as well as the use of classical subjects in Early Renaissance art.

During the Middle Ages, classical form had become divorced from classical subject matter. Artists could draw upon ancient poses, gestures, expressions, and types only by changing the identity of their sources. Philosophers became apostles, Orpheus turned into Adam, Hercules was now Samson. When medieval artists wanted to represent the pagan gods, they based their pictures on literary descriptions rather than visual models. This was the situation, by and large, until the mid-fifteenth century. Only with Pollaiuolo and with Mantegna in northern Italy (see below) does classical form begin to rejoin classical content. Pollaiuolo's lost paintings of the Labors of Hercules, made about 1465, mark the earliest case, so far as we know, of large-scale subjects from classical mythology depicted in a style inspired by ancient monuments.

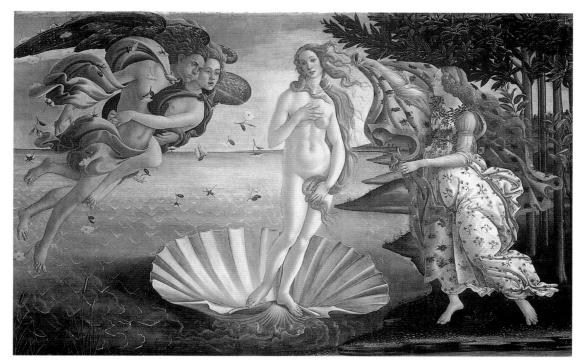

12-19 Sandro Botticelli. *The Birth of Venus.* c. 1480. Tempera on canvas, 5'8⅞" x 9'1⅞" (1.75 x 2.79 m). Galleria degli Uffizi, Florence

In the Middle Ages, classical myths had at times been interpreted as allegories of Christian ideas, however remote the analogies might be. Europa carried off by the bull, for instance, could be declared to signify the soul redeemed by Christ. But such weak analogies were a poor excuse for reinvesting the pagan gods with their ancient beauty and strength. To fuse the Christian faith with ancient mythology, rather than merely to relate them, required a stronger argument. This was provided by the Neoplatonic philosophers. The best known of them was Marsilio Ficino, who enjoyed great prestige during the late fifteenth century and after. Ficino, who was also a priest, based his thought as much on the mysticism of Plotinus as on the works of PLATO. He believed that the life of the universe, including human life, was linked to God by a spiritual circuit continuously ascending and descending, so that all revelation—whether from the Bible, Plato, or classical myths—was one. He also proclaimed that beauty, love, and beatitude, being phases of this same circuit, were one. Thus Neoplatonists could speak of both the "celestial Venus" (the nude Venus born of the sea, as in our picture) and the Virgin Mary as sources of "divine love" (meaning the recognition of divine beauty).

The celestial Venus, according to Ficino, dwells purely in the sphere of Mind. Her twin, the ordinary Venus, gives rise to "human love." Of her Ficino wrote to the Medici prince: "Venus . . . is a nymph of excellent comeliness, born of heaven and more than others beloved by God all highest. Her soul and mind are Love and Charity, her eyes Dignity and Magnanimity, the hands Liberality and Magnificence, the feet Comeliness and Modesty. The whole, then, is Temperance and Honesty, Charm and Splendor. Oh, what exquisite beauty!...a nymph of such nobility has been wholly given into your hands! If you were to unite with her in wedlock and claim her as yours she would make all

One of the most creative and influential philosophers of all time, PLATO (c. 428–c. 347 B.C.) was an aristocratic Athenian, a pupil of Socrates, and founder of the Academy, on the outskirts of Athens. (Aristotle was Plato's outstanding student.) Plato's writings are in the form of dialogues, and the ideas characterized as "Platonic thought" are those that rely on his theory of Forms, or Ideas. Expressed very simply, Plato distinguishes two levels of awareness: opinion—based on information received by the senses and experiences—and genuine knowledge, which is derived from reason and is universal and infallible. In Platonic thinking, the objects conceived by reason exist in a pure form in an Idea realm.

your years sweet." In both form and content, this passage follows odes to the Virgin composed by medieval Church fathers.

Once we know that Botticelli's picture has this quasi-religious meaning, it seems less surprising that the wind-god Zephyr and the breeze-goddess Aura on the left look so much like angels. It also makes sense that the **Hora** on the right, personifying Spring, who welcomes Venus ashore, recalls the relationship of St. John to the Savior in the Baptism of Christ (compare fig. 10-14). As baptism is a "rebirth in God," so the birth of Venus evokes the hope for "rebirth," from which the Renaissance takes its name. Thanks to the fluidity of Neoplatonic doctrine, the number of possible associations in our painting is endless. All of them, however, like the celestial Venus herself, "dwell in the sphere of Mind," and Botticelli's Venus would hardly be a fit vessel for them if she were less ethereal. Thus, rather than being merely decorative, the highly stylized treatment of the surface is what elevates the picture to allegory.

Neoplatonic philosophy and its expression in art were obviously too complex to become popular outside the select and highly educated circle of its devotees. In 1494 the suspicions of ordinary people were aroused by the friar Girolamo Savonarola, who attacked the "cult of paganism." He is usually portrayed unsympathetically as a book-burning firebrand whose sermons gained him a huge following. However, he was an ardent reformer and began a vigorous campaign against corruption not only within the Church but also in the city of Florence, which he briefly ruled after the Medici were expelled. Because of the many enemies he made in the city's ruling circle, Savonarola was unjustly burned at the stake as a heretic in 1498 at the urging of the corrupt Pope Alexander VI. Botticelli himself was perhaps a follower of Savonarola and reportedly burned a number of his own "pagan" pictures. In his last works, Botticelli returned to traditional religious themes but with no essential change in style. He seems to have stopped painting entirely after 1500, even though the apocalyptic destruction of the world predicted by Savonarola at the millennium-and-a-half was not fulfilled.

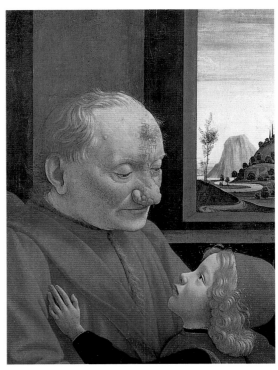

12-20 Domenico Ghirlandaio. *An Old Man and His Grandson.* c. 1480. Tempera and oil on panel, 24 1/8 x 18" (61.3 x 45.7 cm). Musée du Louvre, Paris

Ghirlandaio The fresco cycles of Domenico Ghirlandaio (1449–1494), a contemporary of Botticelli, contain so many portraits that they almost serve as family chronicles of the wealthy patricians who sponsored them. Among his most touching individual portraits is the panel *An Old Man and His Grandson* (fig. 12-20). The attention to surface texture and facial detail emphasizes the old man's nose, which has been disfigured by rosacea. Ghirlandaio has shown the tender relationship between the little boy and his grandfather with unique understanding. Psychologically, our panel plainly bespeaks its Italian origin.

Perugino Rome, long neglected during the papal exile in Avignon (see page 216), once more became a major artistic center in the later fifteenth century. As the papacy regained power on Italian soil, the popes began to beautify both the Vatican and the city, in the belief that the monuments of Christian

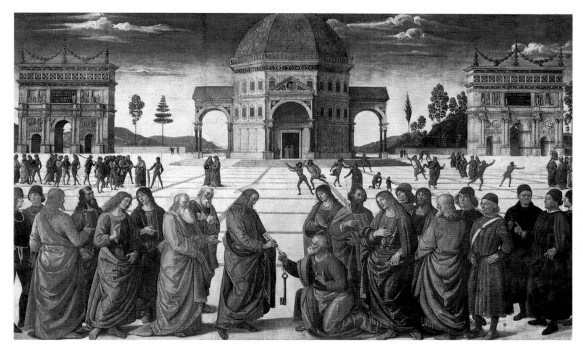

12-21 Pietro Perugino. *The Delivery of the Keys.* 1482. Fresco in the Sistine Chapel, the Vatican, Rome

Rome must outshine those of the pagan past. The most ambitious pictorial project of those years was the decoration of the walls of the recently completed Sistine Chapel for Pope Sixtus IV (see fig. 13-8). Begun around 1481–82, this large cycle consists of events from the life of Moses (left wall) and Christ (right wall), representing the old and new covenants (see box, page 162). The artists include most of the important painters of central Italy, among them Botticelli and Ghirlandaio. If the Sistine murals do not, on the whole, present their best work, it is because these mostly young artists had little experience in monumental fresco painting, for which there had been few opportunities since the 1450s.

There is, however, one notable exception: *The Delivery of the Keys* (fig. 12-21) by Pietro Perugino (c. 1450–1523) is this artist's finest achievement. Born near Perugia in Umbria (the region southeast of Tuscany), Perugino maintained close ties with Florence. Early in his career he was strongly influenced by Verrocchio, as can be seen in the statuesque balance and solidity of his figures (compare fig. 12-8). The symmetrical design conveys the importance of the subject. The authority of St. Peter as the first pope, as well as of all those who

followed him, rests on his having received the keys to the Kingdom of Heaven from Christ himself, in the same way that the Christian church in the background is built on the rock that is Peter. A number of Perugino's contemporaries, with highly individualized features, witness the solemn event.

Equally striking is the vast expanse of the background. To the left, in the middle distance, is the moment when Jesus says, "Render to Caesar what is Caesar's"; to the right, the stoning of Christ. The inscriptions on the two Roman triumphal arches (modeled on the Arch of Constantine in Rome) favorably compare Sixtus IV to Solomon, who built the Temple of Jerusalem, where the Ark of the Covenant was later housed. The pair of arches flank a domed structure representing the ideal church of Alberti's *Treatise on Architecture*. Also Albertian is the mathematically exact perspective, which lends the view its spatial clarity. (In order to simplify the scheme, however, the squares are far larger than those recommended by Alberti for such a piazza.)

This scene, so rational and intelligible in its construction, nevertheless achieves a stunning visionary effect. Despite its novel spatial qualities, Perugino's fresco in many respects continues the

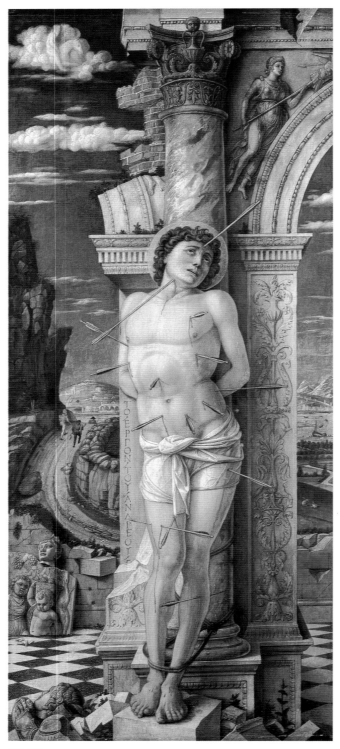

12-22 Andrea Mantegna. *St. Sebastian.* c. 1455–60. Tempera on panel, 26³/₄ x 11⁷/₈" (68 x 30.6 cm). Kunsthistorisches Museum, Vienna

tradition of Piero della Francesca, who spent much of his later life working for Umbrian clients, notably the duke of Urbino. Also from Urbino, shortly before 1500, Perugino received a pupil whose fame would soon outshine his own: Raphael.

Mantegna In northern Italy, the International Style in painting and sculpture lingered until mid-century, and architecture long retained a strongly Gothic flavor. As a result, there were hardly any major achievements in these fields. Between 1450 and 1500, however, a great painting tradition was born in Venice and its territories that was to flourish for the next three centuries. The Republic of Venice, although more oligarchic and oriented toward the East, had many ties with Florence. Hence it is not surprising that Venice, rather than Milan, became the center of Early Renaissance art in northern Italy.

Florentine masters had been carrying the new style to Venice and nearby Padua since the 1420s. Yet their presence had little effect until shortly before 1450. At that time, Andrea Mantegna (1431–1506) emerged as an independent master. He was trained by a minor Paduan painter, but his early career was shaped by his impressions of Florentine works and, we may assume, by contact with Donatello. Next to Masaccio, he is the most important painter of the Early Renaissance. He, too, was a young genius, able to carry out commissions of his own by age 17. In the next decade he reached artistic maturity, and during the next half-century (he died at the age of 75) he broadened the range of his art, without abandoning the style he had developed in the 1450s.

The *St. Sebastian* panel reproduced in figure 12-22 is set among classical ruins. (In the foreground, to the left of the saint, we also find the artist's signature in Greek.) Here Mantegna's devotion to the visible remains of antiquity, almost like an archaeologist's, shows his close association with the learned humanists at the University of Padua, who had the same devotion to ancient literature. No Florentine painter or sculptor of the time could have conveyed such an attitude to him. The saint looks more like a statue than a living body. The tense figure, muscular and firm, is derived from

Donatello. Mantegna was much concerned with light and color. We see an atmospheric landscape and a deep blue sky dotted with soft white clouds. The scene is bathed in warm late-afternoon sunlight, which creates a melancholy mood and makes the pathos of the dying saint even more poignant. The background shows the influence, direct or indirect, of the Van Eycks (compare fig. 15-2, left). And, in fact, some works of the great Flemish masters had reached Florence as well as Venice between 1430 and 1450. They created the interest in light-filled landscapes that became such an important part of Venetian painting.

Giovanni Bellini In the painting of Giovanni Bellini (c. 1431–1516), Mantegna's brother-in-law, we can trace the further impact of the Flemish tradition in the South. Bellini was slow to mature. His finest pictures, such as *St. Francis in Ecstasy* (fig. 12-23), date from the last decades of the century or even later. Bellini's contours are less brittle than Mantegna's, his colors softer and the light more glowing. He also shares the concern of the great Flemings for every detail and its symbolism. Unlike the Northerners, however, he can define the viewer's spatial relationship to the landscape. The rock formations of the foreground are

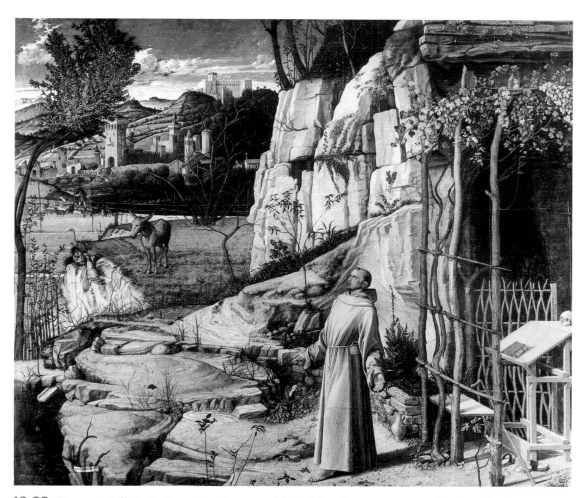

12-23 Giovanni Bellini. *St. Francis in Ecstasy.* c. 1485. Oil and tempera on panel, 49 x 55$\frac{7}{8}$" (124.5 x 141.9 cm). The Frick Collection, New York

clear and firm, like architecture rendered by scientific perspective.

The subject is unique. The scene is treated as the equivalent of Moses and the burning bush in the book of Exodus. When the patriarch of the Jews came to the mountain of God, an angel appeared to him in a flame of fire out of a bush that was not consumed and from which the Lord commanded him to remove his shoes, because he was on holy ground (see also page 353). It was then that God promised to deliver the Jews out of the hands of the Egyptians and into the land of milk and honey. Here, the saint has left his wooden pattens behind and looks up ecstatically to the sky.

The painting is often thought to show Francis receiving the stigmata (the wounds of Christ) on the Feast of the Holy Cross in 1224, when a crucified seraph appeared to him on Mount Alverna; however, the marks on his hands and feet are barely visible and have clearly healed. Instead, it most likely "illustrates" the Hymn of the Sun, which Francis composed the next year, after his annual fast at a hermitage near his hometown of Assisi. During that time he could not bear the sight of light and was plagued by mice. The monk finally emerged from his cell after the Lord assured him that he would enter the Kingdom of Heaven.

For Francis, "Brother Sun, who gives the day . . . and . . . is beautiful and radiant with great splendor" was a symbol of the Lord. What he sees, however, is not the sun itself, which is obscured by a cloud, but God revealed as the light divine. This miraculous light is so intense that it illuminates the entire scene. Even the lone tree at the left, a counterpart to the burning bush, bends in response to it, as if moved by a powerful, unseen force.

In the background is a magnificent expanse of Italian countryside. Yet this is no ordinary landscape. It represents the Heavenly Jerusalem, inspired by the Revelation of St. John the Divine. The city remains empty until Judgment Day, when it will receive the souls of the blessed. It lies across the river, separated from the everyday world by the bridge to the left. Behind looms Mount Zion, where the Lord dwells. How, then, shall we enter the gate to paradise, shown as a large tower? For Francis, the road to salvation lay in the ascetic life, symbolized by the cave, which also links him to St. Jerome, the first great hermit saint. The donkey stands for St. Francis, who referred to his body as Brother Ass, which must be disciplined. The other animals—the heron, bittern, and rabbit—are, like monks, solitary creatures in Christian lore.

The symbolism does not by itself explain the picture. More important is the treatment of the landscape. Francis is so small compared to the setting that he seems almost incidental. Yet his mystic rapture before the beauty of the visible world guides our own response to the view that is spread out before us, which is ample and intimate at the same time. Francis believed that the Lord had created nature for the benefit of humanity. Bellini clearly shares his reverence for the Lord's handiwork, as expressed in the Hymn of the Sun, which begins, "Be praised, my Lord, with all Your creatures."

THE HIGH RENAISSANCE IN ITALY

It used to be taken for granted that the High Renaissance followed the Early Renaissance as inevitably as night follows day. The great masters of the sixteenth century—Leonardo, Bramante, Michelangelo, Raphael, Giorgione, Titian—were thought to have shared the ideals of their predecessors, but to have expressed them so completely that their names became synonyms for perfection. They represented the climax, the classic phase, of Renaissance art, just as Pheidias had brought the art of ancient Greece to its highest point. This view could also explain why these two classic phases, although 2,000 years apart, were so short. If art is assumed to develop along the pattern of a ballistic curve, its highest point cannot last more than a moment.

Art historians have come to realize the drawbacks of this scheme. When we apply it literally, the High Renaissance becomes so brief that we wonder whether it happened at all. Moreover, it hardly helps our understanding of the Early Renaissance if we regard it as a "not-yet-perfect High Renaissance," any more than an Archaic Greek statue can be satisfactorily viewed from a Classical standpoint. Nor is it very useful to insist that the post-Classical phase, whether Hellenistic or "Late Renaissance," must be one of decline. The image of the ballistic curve has now been abandoned. As a result, we have gained a less assured, but also less arbitrary, estimate of what, for lack of another term, we still call the High Renaissance.

In some basic respects, the High Renaissance was indeed the culmination of the Early Renaissance. In others, however, it was a major departure. Certainly the tendency to view artists as geniuses, rather than simply as artisans, was never stronger than during the first half of the sixteenth century. Plato's concept of genius—the spirit that enters poets and causes

them to compose in a "divine frenzy"—had been broadened by Marsilio Ficino and his fellow Neoplatonists to include architects, sculptors, and painters. For Giorgio Vasari, geniuses were set apart by "grace," in the sense of both divine grace (a gift from God) and gracefulness (which reflected it). To him, this concept had moral and spiritual significance, inspired in part by Dante's *Inferno*. Building further on Petrarch's scheme of history (see page 266), Vasari saw the High Renaissance as superior even to antiquity, because it belonged to the era of Christian grace, which had not been revealed to the pagans (see box, page 162). Thus, in his *Lives of the Painters* (1550–68), he praises the "gracious," virtuous personalities of Michelangelo, Leonardo, and Raphael as a way of accounting for their talent. Grace also served to justify his assessment of Michelangelo as the greatest artist of all time. This view remains with us to this day, although Michelangelo's character was far from admirable in some respects.

What set these artists apart was the inspiration guiding their efforts, which was worthy of being called "divine," "immortal," and "creative." (Before 1500, creating, as distinct from making, was the privilege of God alone.) To Vasari, the painters and sculptors of the Early Renaissance, like those of the Late Gothic, had learned only to imitate nature. The geniuses of the High Renaissance, in contrast, had conquered nature by ennobling or transcending it. In actual fact, the High Renaissance remained thoroughly grounded in nature. Its achievement lay in the creation of a new classicism.

Faith in the divine origin of inspiration led artists to rely on subjective standards of truth and beauty. Whereas Early Renaissance artists felt bound by what they believed to be universal rules, such as the numerical ratios of musical harmony and the laws of scientific perspective, their High Renaissance successors were less concerned with rational order than with visual effectiveness. They evolved a new drama and a new rhetoric to engage the emotions of the beholder, whether sanctioned or not by classical precedent. Indeed, the works of the great masters of the High Renaissance soon became classics in their own right, with an authority equal to that of the most famous monuments of antiquity. At the same time, this cult of the genius had a profound effect on the artists themselves. It spurred them to ambitious goals and prompted their patrons to support those projects. Since these ambitions often went beyond what was humanly possible, they were apt to be limited by external as well as internal difficulties. Artists were thus left with a sense of having been defeated by malevolent fate.

Here we face a contradiction: if the creations of genius are viewed as unique by definition, they cannot be successfully imitated by lesser artists, however worthy they may seem of emulation. Unlike the founders of the Early Renaissance, the leading artists of the High Renaissance did not set the pace for a broadly based "period style" that could be practiced on every level of quality. The High Renaissance produced surprisingly few minor masters. It died with those who had created it, or even before. Of the six great personalities mentioned above, only Michelangelo and Titian lived beyond 1520.

Conditions after that date were less favorable to the High Renaissance style than those of the first two decades of the sixteenth century. Yet the High Renaissance might well have ended soon anyway. Its harmonious grandeur was an inherently unstable balance of conflicting elements. Only these components, not the balance itself, could be transmitted to the artists who reached maturity after 1520. In pointing out the limited and precarious nature of the High Renaissance, we do not mean to deny its tremendous impact upon later art. For most of the next 300 years, the great masters of the early sixteenth century loomed so large that the achievements of their predecessors seemed to belong to a forgotten era. Even when the art of the fourteenth and fifteenth centuries was finally rediscovered, people still saw the High Renaissance as the turning point and referred to all painters before Raphael as "the Primitives."

LEONARDO DA VINCI

One reason the High Renaissance deserves to be called a period is the fact that its key monuments were all produced between 1495 and 1520, despite the great differences in age of the artists who created

them. Bramante, the oldest, was born in 1444, Raphael in 1483, and Titian about 1488–90. Yet the distinction of being the earliest High Renaissance master belongs to Leonardo da Vinci (1452–1519). He was trained in Florence by Verrocchio. Conditions there must not have suited him, however. At the age of 30 Leonardo went to work for the duke of Milan, primarily as a military engineer and only secondarily as an architect, sculptor, and painter.

The Virgin of the Rocks Soon after arriving in Milan, Leonardo painted *The Virgin of the Rocks* (fig. 13-1). The figures emerge from the semi-darkness of the grotto, enveloped in a moist atmosphere that delicately veils their forms. This fine haze, called **sfumato**, is more pronounced than similar effects in Flemish and Venetian painting. It lends an unusual warmth and intimacy to the scene. It also creates a remote, dreamlike quality and makes the picture seem a poetic vision rather than an image of reality. In his NOTEBOOKS Leonardo had much to say about the relationship between art and literature. Called the *paragone,* it was rooted in Horace's statement that poetry is like painting (*ut pictura poesis*), which the High Renaissance reinterpreted to mean that painting ought to conform to poetry. The subject—the infant St. John adoring the Christ Child in the presence of the Virgin and an angel—is entirely new in art. The story of their meeting is one of the many legends that arose to satisfy curiosity about the "hidden" early life of Jesus, which is hardly mentioned in the Bible. (According to a similar legend, St. John, about whom equally little is known, spent his childhood in the wilderness; hence he is shown wearing a hair shirt.)

The treatment of the scene is mysterious in many ways. The secluded setting, the pool in front, and the carefully rendered plant life hint at levels of meaning that are hard to define. How are we to interpret the relationships among the four figures, expressed in their gestures? Protective, pointing, blessing, they convey with infinite tenderness the wonderment of St. John's recognition of Christ as the Savior. The gap between

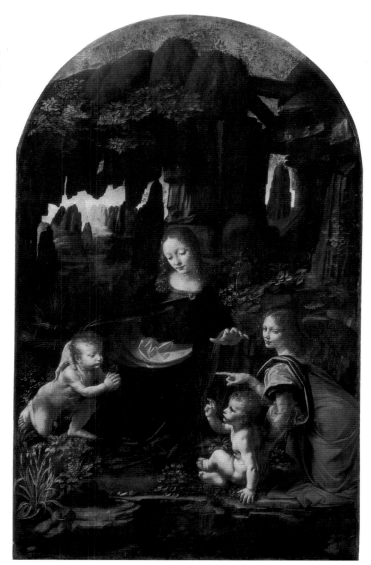

13-1 Leonardo da Vinci. *The Virgin of the Rocks.* c. 1485. Oil on panel transferred to canvas, 6'3" x 3'7½" (1.91 x 1.11 m). Musée du Louvre, Paris

these hands and St. John makes the exchange all the more telling. Although present in *The Doubting of Thomas* by Leonardo's teacher, Verrocchio (see fig. 12-8), the elegant gestures and refined features are the first example of that High Renaissance "grace" signifying a spiritual state of being.

The Last Supper Despite its originality, *The Virgin of the Rocks* does not yet differ clearly in

In the early 1490s, during his stay at the court of Ludovico Sforza in Milan, Leonardo made a meticulous record of his wide-ranging studies in more than 1,000 pages of NOTE-BOOKS, today preserved in 31 volumes. Written backward in mirror writing, the notebooks treat four main themes—painting, architecture, mechanics, and human anatomy—and reveal the range and depth of the artist's prodigious mind. Among the devices anticipated by Leonardo but not built until centuries later were flying machines (including the helicopter), bicycles, submarines, missile launchers, and parachutes.

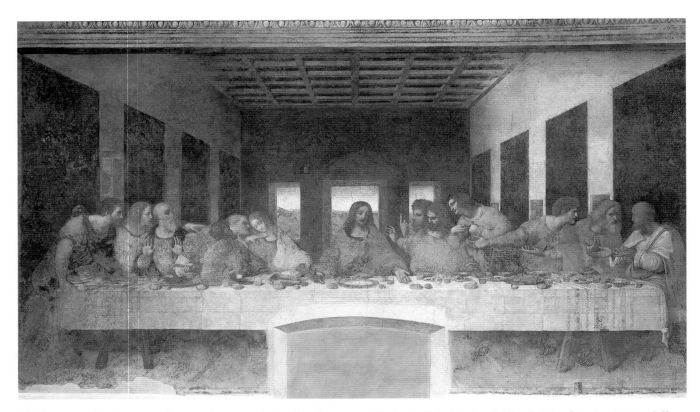

13-2 Leonardo da Vinci. *The Last Supper.* c. 1495–98. Tempera, 15'2" x 28'10" (4.62 x 8.79 m). Mural in Sta. Maria delle Grazie, Milan

conception from Early Renaissance art. Leonardo's *Last Supper,* of a dozen years later, was the first full statement of the ideals of High Renaissance painting (fig. 13-2). Unfortunately, the famous mural began to deteriorate a few years after its completion. The artist, dissatisfied with the limitations of the traditional fresco technique, experimented in an oil-tempera medium in plaster that did not adhere well to the wall. We thus need some effort to imagine its original splendor, even though the painting was recently restored. Yet what remains is more than sufficient to account for its tremendous impact. Viewing the composition as a whole, we are struck at once by its balanced stability. Only afterward do we realize that Leonardo achieved this balance by the reconciliation of competing, even conflicting, aims that no previous artist had attempted.

As we know from preparatory drawings, Leonardo began with the figure composition. Hence

the architecture had merely a supporting role from the start, so that it is the very opposite of the rational pictorial space of the Early Renaissance. His perspective is an ideal one. The painting, high up the refectory (dining hall) wall, assumes a vantage point some 15 feet above the floor and 30 feet back. This position is clearly impossible, yet we readily accept it. The central vanishing point, which governs our view of the interior, is located behind the head of Jesus in the exact middle of the picture and therefore becomes charged with symbolic significance. Equally plain is the symbolic function of the main opening in the back wall: it acts as the architectural equivalent of a halo. We thus tend to see the perspective framework of the scene almost entirely in relation to the figures, rather than as something preexisting. We can easily test how vital this relationship is by covering the upper third of the picture. The composition then takes on the character of a **frieze**;

the grouping of the apostles is less clear; and the calm triangular shape of Jesus becomes passive, instead of acting as a physical and spiritual force. At the same time, the perspective system helps to "lock" the composition in place, giving the scene an eternal quality without making it look static.

The Savior has presumably just spoken the fateful words, "One of you shall betray me." The disciples are asking, "Lord, is it I?" We see nothing that contradicts this interpretation. But to view the scene as just one moment in a psychological drama does not do justice to Leonardo's aims, which went well beyond a literal rendering of the biblical narrative. He crowded the disciples together on the far side of the table, in a space too small for so many people. He clearly wanted to condense his subject, both physically (by the compact, monumental grouping of the figures) and spiritually (by presenting many levels of meaning at one time). Thus Jesus' gesture is one of submission to the divine will, and of offering. It is a hint at his main act at the Last Supper, the institution of the **Eucharist**, in which bread and wine become his body and blood through **transubstantiation**.

The apostles do not simply react to Jesus' words. Each reveals his own personality, his own relationship to Christ. (Note that Judas is no longer segregated from the rest; his defiant profile sets him apart well enough.) Leonardo has carefully calculated each pose and expression so that the drama unfolds across the picture plane. The figures exemplify what the artist wrote in one of his notebooks, that the highest and most difficult aim of painting is to depict "the intention of man's soul" through gestures and movements of the limbs—a statement to be interpreted as referring not to momentary emotional states but to the inner life as a whole.

Mona Lisa In 1499 the duchy of Milan fell to the French, and Leonardo returned to Florence after brief trips to Mantua and Venice. He must have found the cultural climate there very different from what he remembered. The Medici had been expelled, and the city was briefly a republic again, until their return. For a while, Leonardo seems to have been active mainly as an engineer and surveyor.

Then in 1503 the city commissioned him to do a mural of some famous event from the history of Florence for the council chamber of the Palazzo Vecchio. He chose the Battle of Anghiari, but in 1506 he abandoned the commission and returned to Milan at the request of the French. The painting is known only through various copies of the cartoon (including one by Peter Paul Rubens), which survived for more than a century.

While working on the mural, Leonardo also painted the *Mona Lisa* (fig. 13-3). Here the sfumato

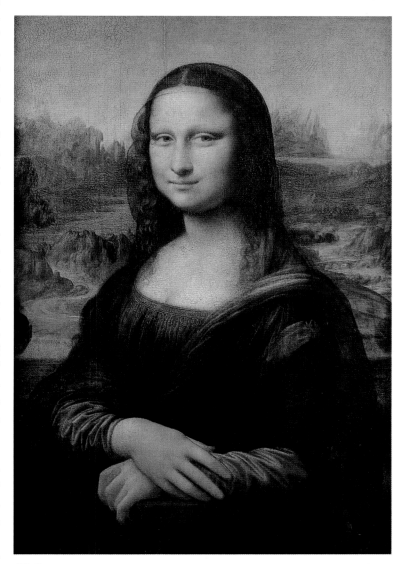

13-3 Leonardo da Vinci. *Mona Lisa*. c. 1503–5. Oil on panel, 30¼ x 21" (76.8 x 53.5 cm). Musée du Louvre, Paris

of *The Virgin of the Rocks* is so perfected that it seemed miraculous to the artist's contemporaries. The forms are built from layers of glazes so thin that the panel appears to glow with a gentle light from within. But the fame of the *Mona Lisa* comes not from this subtlety alone. Even more intriguing is the sitter's personality. Why, among all the smiling faces ever painted, has this one been singled out as "mysterious"? Perhaps the reason is that, as a portrait, the picture does not fit our expectations. The features are too individual for Leonardo to have simply depicted an ideal type, yet they are so idealized that they blur the sitter's character. Once again the artist has brought two opposites into harmonious balance. The smile also may be read in two ways: as the echo of a momentary mood and as a timeless, symbolic expression akin to the "Archaic smile" of the Greeks (see fig. 5-12).

The *Mona Lisa* seemingly embodies a maternal tenderness that was the essence of womanhood to Leonardo. Even the landscape, made up mainly of rocks and water, suggests elemental generative forces. Who was the sitter for this, the most famous portrait in the world? Her identity long remained a mystery, but we now know that she was the wife of a Florentine merchant and was born in 1479 and was dead before 1556. This is not the only painting of the *Mona Lisa*: Leonardo also painted a nude version that once belonged to the king of France.

Architecture Leonardo devoted himself more and more to his scientific interests. Art and science, we recall, were first united in Brunelleschi's discovery of systematic perspective. Leonardo's work is the climax of this trend. The artist, he believed, must know not only the rules of perspective but all the laws of nature. To him the eye was the perfect means of gaining such knowledge. The extraordinary range of his inquiries can be seen in the hundreds of drawings and notes that he hoped to turn into an encyclopedic set of treatises.

Contemporary sources show that Leonardo was esteemed as an architect. He seems, however, to have been less concerned with actual building than with problems of structure and design. For the most part, the many architectural projects

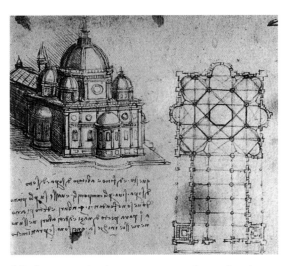

13-4 Leonardo da Vinci. *Project for a Church* (Ms. B). c. 1490. Pen drawing, $9^{1}/_{8}$ x $6^{3}/_{4}$" (23 x 17 cm). Bibliothèque de l'Arsenal, Paris

in his drawings were intended to remain on paper. Yet these sketches, especially those of his Milanese period, have great historical importance. In them we can trace the transition from the Early to the High Renaissance in architecture.

The domed, centrally planned churches of the type shown in figure 13-4 hold particular interest for us. The plan recalls one by Brunelleschi, but the relationship of the spatial units is more complex, while the exterior, with its cluster of domes, is more monumental than any Early Renaissance structure. In conception, this design stands halfway between the dome of Florence Cathedral and the most ambitious structure of the sixteenth century, the new basilica of St. Peter's in Rome (compare figs. 11-15, 13-5, and 13-6). It gives evidence, too, of Leonardo's close contact with the architect Donato Bramante (1444–1514).

BRAMANTE

St. Peter's Bramante arrived in Milan around 1479, several years before Leonardo. A native of Urbino, he began his career as a fresco painter. His earliest work as a professional architect suggests the influence of Leonardo's drawings. Since Leonardo was not a practicing architect but a military

engineer, it is likely that he benefited in turn from Bramante, as well as others who were active in Milan. After Milan fell to the French in 1499, Bramante went to Rome, where he spent several years in a study of ancient buildings that was to transform him as an architect. Thus it was in Rome, during the last 15 years of his life, that he created High Renaissance architecture.

Most of the great achievements that made Rome the center of Italian art belong to the decade 1503–13, the papacy of JULIUS II. While these projects testify to the pope's personal ambition, they were also essential to his goal of restoring papal authority over Christendom. Julius II decided to replace the old basilica of St. Peter's, which was in poor condition, with a church so magnificent that it would overshadow all the monuments of imperial Rome. The task was given to Bramante, who had quickly established himself as the foremost architect in the city. His original design of 1506 is known only from a plan (fig. 13-5) and from the medal commemorating the start of the building campaign (fig. 13-6), which shows the exterior in rather imprecise perspective. They are enough, however, to bear out the words Bramante reportedly used to define his aim: "I shall place the Pantheon on top of the Basilica of Constantine."

The goal thus was to surpass the two most famous structures of Roman antiquity by a Christian building of a grandeur never seen before. Nothing less would have satisfied the ambitious Julius II, who wanted to unite all Italy under his command and thereby gain a temporal power that matched his spiritual authority. Bramante's design is indeed magnificent. A huge hemispherical dome crowns the crossing of the barrel-vaulted arms of a Greek cross, with four lesser domes and tall corner towers at the angles. This plan fulfills all the demands laid down by Alberti for sacred architecture (see page 283). Yet it is strikingly different from anything envisioned by him (compare fig. 12-11). Based entirely on the circle and the square, it is so symmetrical that we cannot tell which apse was to hold the high altar. Bramante envisioned four identical facades dominated by severely classical forms: domes, half-domes, colonnades, pediments.

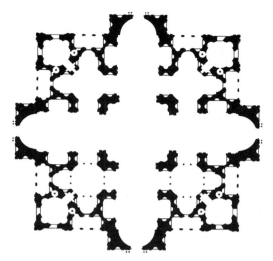

13-5 Donato Bramante. Original plan for St. Peter's, Rome. 1506 (after Geymuller)

13-6 Christofor Foppa Caradosso. Bronze medal showing Bramante's design for St. Peter's. 1506. The British Museum, London

Inside the church, however, the sculptured wall reigns supreme. The plan shows no continuous surfaces, only great, oddly shaped "islands" of masonry that have been well described by one critic as giant pieces of toast half-eaten by a voracious space. The actual size of these islands can be visualized only if we compare the measurements

of Bramante's church with those of earlier buildings. S. Lorenzo in Florence, for instance, has a length of 268 feet, less than half that of the new St. Peter's (550 feet). Bramante's reference to the Pantheon and the Basilica of Constantine was no idle boast. His plan dwarfs these monuments, as well as every Early Renaissance church. (Each arm of the Greek cross has about the same dimensions as the Basilica of Constantine.)

How did Bramante propose to build such an enormous structure? Cut stone and brick, the materials favored by medieval architects, would not do, for technical and economic reasons. Only concrete, as used by the Romans but largely forgotten during the Middle Ages, was strong and cheap enough (see page 126). By reviving this ancient technique, Bramante opened a new era in the history of architecture. Concrete permitted far more flexible designs than the building methods used by medieval masons. However, its possibilities were not exploited fully for some time.

MICHELANGELO

Nowhere is the concept of genius as divine inspiration—a superhuman power granted to a few individuals and acting through them—embodied more fully than in the life and work of Michelangelo (Michelangelo di Lodovico Buonarroti Simoni, (1475–1564). It was not only his admirers who viewed him in this light. He himself, steeped in Neoplatonist thought (see pages 292–94), accepted the idea of his genius as a living reality, although it seemed to him at times a curse rather than a blessing. What brings continuity to Michelangelo's long and stormy career is the sovereign power of his personality, his faith in the subjective rightness of everything he created. Conventions, standards, and traditions might be observed by lesser artists, but for him there was no higher authority than the dictates of his genius.

Unlike Leonardo, for whom painting was the noblest of the arts because it embraced every visible aspect of the world, Michelangelo was a sculptor to the core. More specifically, he was a carver of marble statues. Art, for him, was not a science but "the making of men," analogous (however imperfectly) to divine creation. Hence the limitations of

sculpture, which Leonardo condemned as mechanical, unimaginative, and dirty, were virtues in Michelangelo's eyes. Only the "liberation" of real, three-dimensional bodies from recalcitrant matter could satisfy his creative urge. Painting, for him, must imitate the roundness of sculptured forms: architecture, too, ought to share the organic qualities of the human figure.

Michelangelo's faith in the human image as the supreme vehicle of expression gave him a sense of kinship with Classical sculpture closer than that of any Renaissance artist. Among Italian masters, he admired Giotto, Masaccio, and Donatello more than the men he knew as a youth in Florence. Of his training little is known. He was apprenticed to Ghirlandaio and carefully studied Masaccio's frescoes in the Brancacci Chapel (see fig. 12-14). Soon he was taken under the wing of Lorenzo de' Medici, which enabled him to study the antique statues in the garden of one of the family's houses. The collection was overseen by Bertoldo di Giovanni (c. 1420–1491), a pupil of Donatello, who presumably taught Michelangelo the rudiments of sculpture.

The young artist's mind was decisively shaped by the cultural climate of Florence during the 1480s and 1490s, even though the troubled times led him to flee the city for Rome in 1496. Both the Neoplatonism of Marsilio Ficino and the religious reforms of Savonarola affected him profoundly. These conflicting influences reinforced the tensions in Michelangelo's personality, his violent changes of mood, his sense of being at odds with himself and with the world. Just as he conceived his statues as human bodies released from their marble prisons, so he saw the body as the earthly prison of the soul—noble perhaps, but a prison nonetheless. This dualism of body and spirit endows his figures with extraordinary pathos. Although outwardly calm, they seem stirred by an overwhelming psychic energy that finds no release in physical action.

David The unique qualities of Michelangelo's art emerge in his *David* (fig. 13-7), the earliest monumental statue of the High Renaissance. Commissioned in 1501 as the symbol of the Florentine republic, the huge figure was designed to

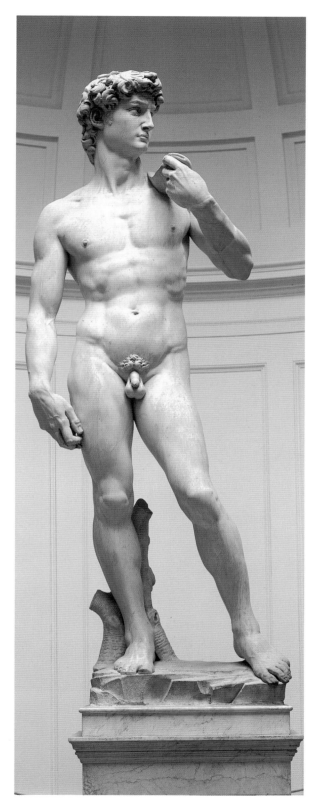

be placed high above the ground, on one of the buttresses of Florence Cathedral. A committee of civic leaders and artists decided instead to put it in front of the Palazzo Vecchio, the fortresslike palace of the Medici near the center of town.

We can well understand the decision. By omitting the head of Goliath, Michelangelo transforms his David from a victorious hero into the champion of a just cause. To Michelangelo, he embodied the virtue Fortitude, but here the figure has a civic rather than a moral significance. Vibrant with pent-up energy, he faces the world like Donatello's *St. George* (see fig. 12-2), although his nudity links him to the older master's bronze *David* as well (see fig. 12-3). The style of the sculpture proclaims an ideal very different from the wiry slenderness of Donatello's youths. Michelangelo had just spent several years in Rome, where he had been deeply impressed with the emotion-charged, muscular bodies of Hellenistic sculpture. Their heroic scale, their superhuman beauty and power, and the swelling volume of their forms became part of Michelangelo's own style and, through him, of Renaissance art in general.

Whereas his earlier work could sometimes be taken for ancient statues, in the *David* Michelangelo competes with antiquity on equal terms and replaces its authority with his own. This resolute individualism is partly indebted to Leonardo, who had recently returned to Florence. (As with all of Michelangelo's great peers, they soon became rivals.) So is the expressive attitude of the figure, which conveys the "intention of man's soul." In Hellenistic works (compare fig. 5-24) the body "acts out" the spirit's agony, while the *David*, at once calm and tense, shows the action-in-repose that is so characteristic of Michelangelo.

13-7 Michelangelo. *David.* 1501–4. Marble, height 13'5" (4.08 m). Galleria dell'Accademia, Florence

Sistine ceiling

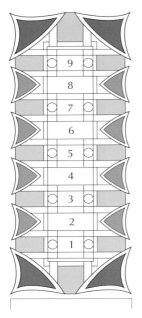

End wall with *Last Judgment*

Scenes from Genesis

1 *Division of Light from Darkness*
2 *Creation of Sun and Moon*
3 *Division of Heaven (Earth) from the Waters*
4 *Creation of Adam*
5 *Creation of Eve*
6 *The Fall* and *The Expulsion*
7 *Sacrifice of Noah*
8 *The Deluge*
9 *The Drunkenness of Noah*

Sibyls and prophets

Ancestors of Jesus Christ

Old Testament scenes

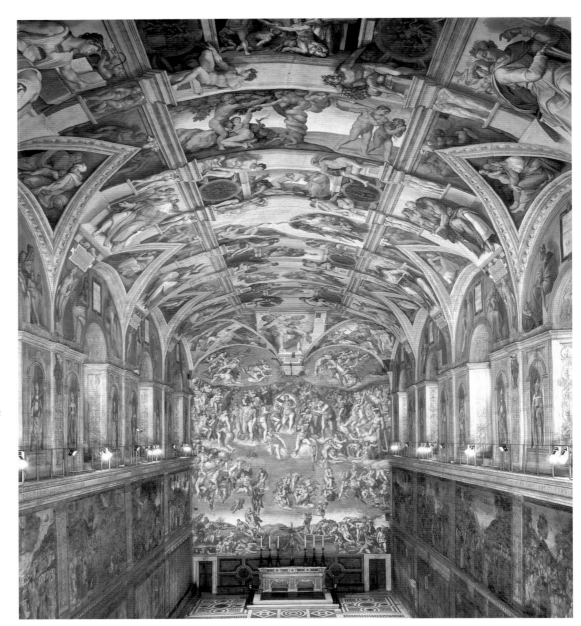

13-8 Interior of the Sistine Chapel, the Vatican, Rome. Ceiling frescoes by Michelangelo, 1508–12; *The Last Judgment,* on the end wall, by Michelangelo, 1534–41; scenes on the side walls by Perugino, Ghirlandaio, Botticelli, and others, 1481–82

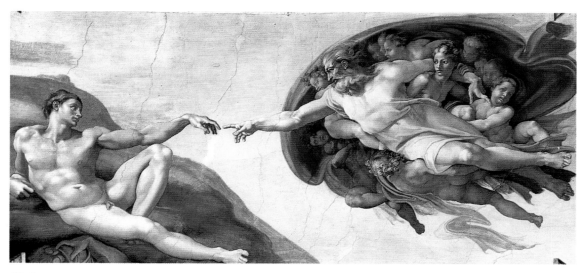

13-9 Michelangelo. *The Creation of Adam*. 1508–12. Detail of fresco on the ceiling of the Sistine Chapel

The Sistine Ceiling Soon after completing the *David*, Michelangelo was called to Rome by Julius II, for whom he designed an enormous tomb. After a few years, the pope changed his mind and set the reluctant artist to work instead on the ceiling fresco of the Sistine Chapel (fig. 13-8). Driven by his desire to resume work on the tomb, Michelangelo finished the ceiling in only four years, between 1508 and 1512. He produced a work of truly epochal importance—a huge organism with hundreds of figures distributed rhythmically within the painted architectural framework.

In the central area, subdivided by five pairs of girders, are nine scenes based on the Old Testament Book of Genesis, from the Creation of the World (at the far end of the chapel) to the Drunkenness of Noah. The theological scheme of these and other scenes, and the PROPHETS, SIBYLS, nude youths, medallions, and scenes in the **spandrels** that accompany them, have not been fully explained. We know, however, that they link early history and the coming of Jesus. What greater theme could Michelangelo wish than the creation, destruction, and salvation of humanity? It is unclear how much responsibility he had for the **program**, but the subject matter of the ceiling fits his cast of mind so perfectly that his own desires cannot have conflicted strongly with those of his patron.

The Creation of Adam (fig. 13-9) must have stirred Michelangelo's imagination most deeply. It shows not the physical molding of Adam's body but the passage of the divine spark—the soul—and thus achieves a dramatic juxtaposition unrivaled by any other artist. The dynamism of Michelangelo's design contrasts the earth-bound Adam, who has been likened to an awakening river-god (compare fig. 23-5), and the figure of God rushing through the sky. This relationship takes on even more meaning when we realize that Adam strains not only toward his Creator but also toward Eve, whom he sees, yet unborn, in the shelter of the Lord's left arm.

Michelangelo has long been regarded as a poor colorist, but the recent cleaning of the frescoes has revealed that he was in fact extraordinarily gifted in that respect. *The Creation of Adam* shows the bold, intense hues that characterize the whole ceiling. The range of his palette is astonishing. Contrary to what had been thought, the heroic figures have none of the quality of painted sculpture. Full of life, they act out their epic roles in illusionistic "windows" that puncture the architectural setting. Michelangelo does not simply color the areas within the contours. Rather, he builds up his forms from broad, vigorous brushstrokes in the tradition of Giotto and Masaccio.

The 12 biblical PROPHETS include Elijah, Ezekiel, Isaiah, and Jeremiah, as well as Anna, a prophetess. The four males are Old Testament prophets of Israel, whose actions and words are regarded as transmissions of the will of God. In disguised language, they foretold the coming of Jesus Christ. Anna recognized the Infant Jesus as the Lord at the Presentation in the Temple. SIBYLS, also numbering 12, were the pagan female counterparts to the prophets. They were believed to have prophetic gifts and to have existed since ancient times. By the Middle Ages, sibyls were credited with predicting the advent of Jesus Christ.

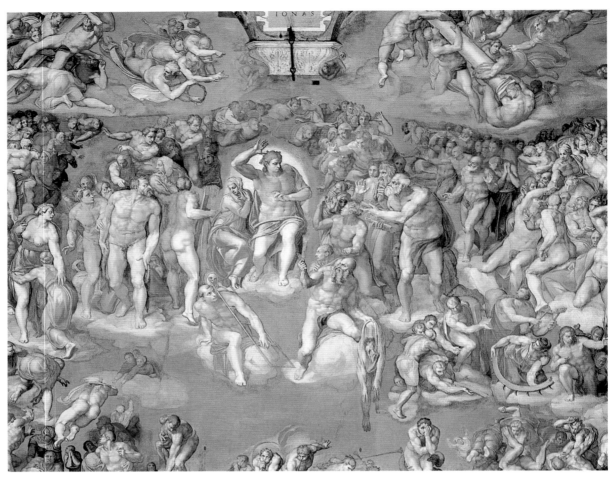

13-10 Michelangelo. *The Last Judgment.* 1534–41. Detail of fresco in the Sistine Chapel

The Last Judgment When Michelangelo returned to the Sistine Chapel in 1534, more than 20 years after completing the ceiling fresco, the Western world was undergoing the spiritual and political crisis of the Reformation (see pages 324–26). Michelangelo's religious beliefs had changed as well. We can see the new mood with shocking directness as we turn from the radiant vitality of the ceiling fresco to the somber vision of *The Last Judgment* (fig. 13-10), which illustrates Matthew 24:29–31. Here the agony has become essentially spiritual, as expressed through violent physical contortions within the turbulent atmosphere. The blessed and damned alike huddle together in tight clumps, pleading for mercy before a wrathful God.

The only trace of classicism is the Apollo-like figure of the Lord. Straddling a cloud just below him is the apostle Bartholomew, holding a human skin to represent his martyrdom by flaying. The face on that skin, however, is not the saint's but Michelangelo's own. In this grim self-portrait, so well hidden that it was recognized only in modern times, the artist has left his personal confession of guilt and unworthiness.

The Medici Chapel The time between the Sistine ceiling and *The Last Judgment* coincides with the papacies of Leo X (1513–21) and Clement VII (1523–34). Both were members of the Medici family and preferred to employ Michelangelo in

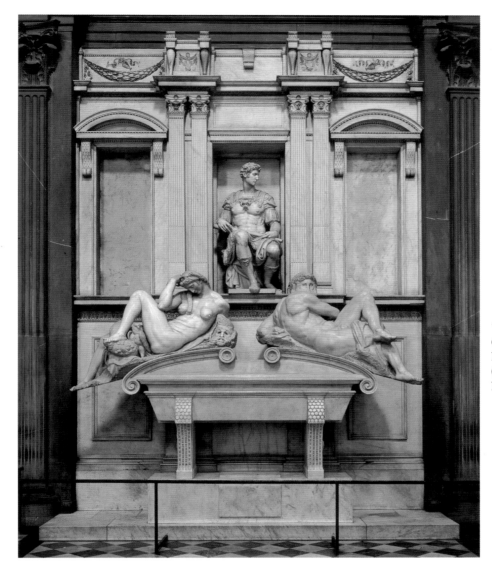

13-11 Michelangelo. Tomb of Giuliano de' Medici. 1524–34. Marble, height of central figure 71" (1.81 m). New Sacristy, S. Lorenzo, Florence

Florence. His activities centered on the Medici church of S. Lorenzo. A century after Brunelleschi's design for the sacristy (see page 280), Leo X decided to build a matching structure, the New Sacristy. It was to house the tombs of Lorenzo the Magnificent, Lorenzo's brother Giuliano, and two younger members of the family, also named Lorenzo and Giuliano. Michelangelo worked on the project for 14 years and managed to complete the architecture and two of the tombs, those for the lesser Lorenzo and Giuliano (fig. 13-11); these tombs are nearly mirror-images of each other. The New Sacristy was thus conceived as an architectural-sculptural ensemble. It is the only one of the artist's works in which the statues remain in the setting intended for them, although their exact placement is problematic. Michelangelo's plans for the Medici tombs underwent many changes while the work was under way. Other figures and reliefs were designed but never executed. The present state of the monuments can hardly be Michelangelo's desired solution, but the design process was halted when the artist left permanently for Rome in 1534.

The tomb of Giuliano remains an imposing

visual unit, although the niche is too narrow and shallow to accommodate the seated figure comfortably. The triangle of statues is held in place by a network of verticals and horizontals whose slender, sharp-edged forms heighten the roundness and weight of the sculpture. The design still shows some kinship with such Early Renaissance tombs as that of Leonardo Bruni (see fig. 12-6), but the differences are more important. There is no inscription, and the effigy has been replaced by two allegorical figures—Day on the right and Night on the left. What is the meaning of this group? Some lines penned on one of Michelangelo's drawings suggest an answer: "Day and Night speak, and say: We with our swift course have brought the Duke Giuliano to death. . . . It is only just that the Duke takes revenge [for] he has taken the light from us; and with his closed eyes has locked ours shut, which no longer shine on earth."

Giuliano, the ideal image of the prince, is in classical military garb and bears no resemblance to the deceased Medici. ("A thousand years from now, nobody will know what he looked like," Michelangelo is said to have remarked.) Originally the base of each tomb was to have included a pair of river-gods. The reclining figures, themselves derived from ancient river-gods (compare fig. 23-5), embody action-in-repose more dramatically than any other works by Michelangelo. They contrast sharply in mood. In the brooding menace of Day, whose face was left deliberately unfinished, and in the disturbed slumber of Night, the dualism of body and soul is expressed with unforgettable grandeur.

St. Peter's The construction of St. Peter's progressed so slowly that in 1514, when Bramante died, only the four crossing piers had actually been built. For the next three decades the campaign was carried on hesitantly by architects trained under Bramante, who modified his design in a number of ways. A new and decisive phase in the history of the church began only in 1546, when Michelangelo took over. Ironically, the two men had been such bitter enemies that Michelangelo left Rome in anger when the commission

for St. Peter's was given to Bramante; upon the latter's death, his friend Raphael (see below), another rival of Michelangelo, was put in charge of the project. Michelangelo replaced the architect Antonio da Sangallo the Younger (nephew of Giuliano da Sangallo; see pages 283–84), whose peculiar design for the church (known in a wooden model) would have completely recast Bramante's.

The present appearance of St. Peter's (fig. 13-12) was largely shaped by Michelangelo's ideas. He simplified Bramante's complex plan without changing its centralized character. He also redesigned the exterior. Unlike Bramante's many-layered elevation (see fig. 13-6), Michelangelo's uses a **colossal** order of pilasters to emphasize the compact body of the structure, thus setting off the dome more dramatically. We have encountered the colossal order before, on the facade of Alberti's S. Andrea (see fig. 12-11), but it was Michelangelo who welded it into a fully coherent system. The same desire for compactness and organic unity led him to simplify the interior. He brought the complex spatial sequences of Bramante's plan (see fig. 13-5) into one cross-and-square. He further defined the main axis by modifying the exterior of the eastern apse and adding a portico to it; this part of his design was never carried out. The dome, however, reflects Michelangelo's ideas in every important respect, although it was largely built after his death and has a steeper pitch.

Bramante had planned his dome as a stepped hemisphere above a narrow drum, which would have seemed to press down on the church. Michelangelo's plan, in contrast, has a powerful thrust that draws energy upward from the main body of the structure. This effect is created by the high drum, the strongly projecting buttresses accented by double columns, the ribs, the raised curve of the cupola, and the tall lantern. Michelangelo borrowed not only the double-shell construction but also the Gothic profile from the Florence Cathedral dome (see fig. 11-15), yet the effect is very different. The smooth planes of Brunelleschi's dome give no hint of the internal stresses. Michelangelo, however, gives a sculptured shape to these forces and relates it to the rest of the building. The impulse of the paired colossal pilasters below is taken up by the double

13-12 Michelangelo. St. Peter's (view from the west), Rome. 1546–64. Dome completed by Giacomo della Porta, 1590

columns of the drum, continues in the ribs, and culminates in the lantern. The logic of this design is so persuasive that almost all domes built between 1600 and 1900 were influenced by it.

Michelangelo's magnificent assurance in handling such projects as St. Peter's seems to belie his portrayal of himself as a limp skin in *The Last Judgment*. It is indeed difficult to reconcile these contrasting aspects of his personality. Perhaps toward the end of his life he found greater fulfillment in architecture than in shaping human bodies, for we have no finished sculpture from his hand after 1545, when he at last completed the Tomb of Julius II, albeit in heavily modified form. Much of his final two decades were devoted to poetry and drawings of a religious and Neoplatonic sort that are highly personal in content. The statues undertaken for his own purposes, including a Pietà intended for his tomb that he mutilated and partly reworked, show him groping for new forms, as if his earlier work had become meaningless to him.

Painter, architect, and historiographer GIORGIO VASARI (1511–1574) defined Italian Renaissance art with his publication in 1550 of the history of Italian art from Cimabue (c. 1240–1302?) through Michelangelo; in 1568 he published an expanded and corrected edition of the work. *The Lives of the Most Excellent Italian Architects, Painters, and Sculptors,* known as the *Lives,* gives a mass of anecdotal biographical information about Florentine artists and accords Florence most of the credit for the Renaissance. More significantly, Vasari's view that the goal of art should be the faithful imitation of nature expressed a value judgment favoring classical and Renaissance art that endured for centuries.

RAPHAEL

If Michelangelo exemplifies the solitary genius, then Raphael of Urbino (Raffaello Sanzio, 1483–1520) belongs to the opposite type: the artist as a man of the world. As a result, the two were natural antagonists. The contrast between them was as clear to their contemporaries as it is to us. Although each had his defenders, they enjoyed equal fame. Thanks to GIORGIO VASARI, Michelangelo's chief partisan, as well as to the authors of historical novels and fictionalized biographies, Michelangelo still fascinates people. Today Raphael is usually discussed only by historians of art, although his life, too, was the subject of a fanciful account. The younger artist's career seems too much a success story, his work too marked by effortless grace, to match the tragic heroism of Michelangelo. Raphael also appears to have been less of an innovator than Leonardo, Bramante, and Michelangelo, whose achievements were basic to his. Nevertheless, he is the central painter of the High Renaissance. Our conception of the entire style rests more on his work than on any other artist's. Raphael had a unique genius for synthesis that enabled him to merge the qualities of Leonardo and Michelangelo. Thus his art is lyric and dramatic, pictorially rich and sculpturally solid.

Stanza della Segnatura In 1508, at the time Michelangelo began to paint the Sistine ceiling, Julius II summoned Raphael from Florence at the suggestion of Bramante, who also came from Urbino. At first Raphael mined ideas he had developed under his teacher Perugino, but Rome transformed him as an artist, just as it had Bramante, and he underwent an astonishing growth. The results can be seen in the Stanza della Segnatura (Room of the Seal, fig. 13-13), the first in a series of rooms he was called on to decorate at the Vatican Palace. The Stanza housed Julius II's personal library; only later did the tribunal of the seal (segnatura), presided over by Pope Paul III, meet there to dispense canon and civil law.

Raphael's cycle of frescoes on its walls and ceiling refers to the four domains of learning: theology, philosophy, law, and the arts. The program is derived in part from the Franciscan St. Bonaventure,

who sought to reconcile reason and faith, and from St. Thomas Aquinas, the Dominican chiefly responsible for reviving Aristotelian philosophy (see box, page 201). The Stanza represents a summation of High Renaissance humanism, for it attempts to unify all understanding into one grand scheme. Raphael probably had a team of scholars and theologians as advisers; yet the design is his alone.

Of all the frescoes in the Stanza della Segnatura, *The School of Athens* (fig. 13-14, page 316), has long been acknowledged as Raphael's masterpiece and the perfect embodiment of the classical spirit of the High Renaissance. Its subject is "the Athenian school of thought," a group of famous Greek philosophers gathered around Plato and Aristotle, each in a characteristic pose or activity. Raphael must have already looked at the Sistine ceiling, then nearing completion. He owes to Michelangelo the expressive energy, physical power, and dramatic grouping of his figures. Yet Raphael has not simply borrowed Michelangelo's gestures and poses. He has absorbed them into his own style and thus given them a different meaning.

Body and spirit, action and emotion, are now balanced harmoniously, and all members of this great assembly play their roles with magnificent, purposeful clarity. The total conception of *The School of Athens* suggests the spirit of Leonardo's *Last Supper* (see fig. 13-2) rather than the Sistine ceiling. Raphael makes each philosopher reveal "the intention of his soul." He further distinguishes the relations among individuals and groups, and links them in a formal rhythm. (The artist worked out the poses in a series of drawings, many from life.) Also in the spirit of Leonardo is the symmetrical design, as well as the interdependence of the figures and their architectural setting.

Raphael's building is more central to the composition than the hall of *The Last Supper.* With its lofty dome, barrel vault, and colossal statuary, it is classical in spirit, yet Christian in meaning. The building is in the shape of a simplified Greek cross to suggest the harmony of pagan philosophy and Christian theology. Inspired by Bramante, who, as Vasari informs us, helped Raphael with the architecture, it seems like an advance view of the new

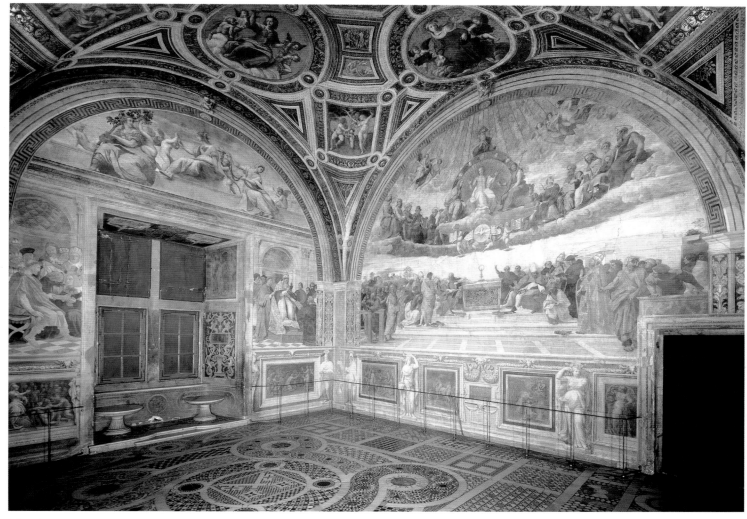

13-13 Stanza della Segnatura, with frescoes by Raphael. 1508–11. Vatican Palace, Rome

St. Peter's. (Raphael developed into a skilled architect in his own right and, as we have seen, succeeded Bramante at St. Peter's.) The dimensions and overall ground plan of the structure can be determined with considerable accuracy. This geometric precision, along with the spatial grandeur of the work as a whole, brings to a climax the tradition begun by Masaccio (see fig. 12-13). It was transmitted to Raphael by Perugino, who had inherited it from Piero della Francesca. What is new is the active role played by the architecture in creating narrative space. This innovation was of fundamental importance and had a profound impact on the course of painting far beyond the sixteenth century.

The identity of most of the figures is not certain, but we can be sure that many incorporate portraits of Raphael's friends and patrons. At center stage, Plato (whose face resembles Leonardo's) is holding his book of cosmology and numerology, *Timaeus,* which provided the basis for much of the Neoplatonism that came to pervade Christianity. To Plato's proper left (the "sinister," or inferior side) his pupil Aristotle grasps a volume

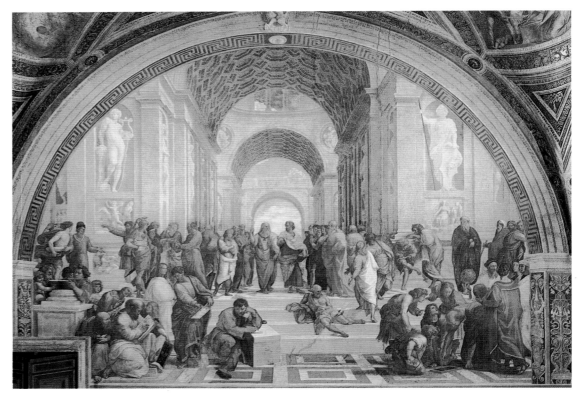

13-14 Raphael. *The School of Athens*. 1510–11. Fresco in Stanza della Segnatura, Vatican Palace, Rome

of his *Ethics,* which, like his science, is grounded in what is knowable in the material world. The tomes explain why one is pointing to the heavens, the other to the earth. Thus stand reconciled the two most important Greek philosophers, whose seemingly opposite approaches were deemed complementary by many Renaissance humanists.

To Plato's right (his "good" side) is his mentor, Socrates, in a purple robe, who was already viewed as a precursor of Jesus because he died for his beliefs (see fig. 21-2). Raphael borrowed the features of Bramante for the head of Euclid, seen drawing or measuring two overlapping triangles with a pair of compasses in the foreground to the lower right. The diagram must be a reference to the Star of David. It also forms the plan for the arrangement of the figures in the fresco. Seated on the other side is the bearded PYTHAGORAS, who believed in a rational universe based on harmonious propor-

tions, the foundation for much of Greek philosophy. He has his sets of numbers and harmonic ratios arranged on a pair of inverted tables that each achieve a total of the divine number ten. They refer in turn to the two tablets with the Ten Commandments held by Moses. Despite their rivalry, Raphael added Michelangelo at the last minute as HERACLITUS writing on the steps. Vasari also states that the figure wearing a black hat at the extreme right is a self-portrait of Raphael. The man next to him is probably his teacher, Perugino. The inclusion of so many artists among, as well as in the guise of, famous philosophers is testimony to their recently acquired—and hard-won—status as members of the learned community.

Galatea Raphael rarely set so splendid a stage again. To create pictorial space, he relied increasingly on the movement of human figures rather than

perspective vistas. In the *Galatea* of 1513 (fig. 13-15), the subject is again classical: the beautiful nymph GALATEA belongs to Greek mythology. Like the verse by Angelo Poliziano that inspired it, the painting celebrates the light-hearted, sensuous aspect of antiquity, in contrast to *The School of Athens*. While the latter presents an ideal view of the antique past, *Galatea* captures its pagan spirit as if it were a living force. The composition recalls Botticelli's *Birth of Venus* (see fig. 12-19), a picture Raphael knew from his Florentine days,

which shares a debt to Poliziano (see page 292). Yet the very resemblance emphasizes their profound differences. Raphael's statuesque, full-bodied figures suggest his careful study of ancient Roman sculpture. (He was later appointed superintendent of antiquities for all of Rome.) They take on a dynamic spiral movement from the vigorous *contrapposto* of Galatea. In Botticelli's picture, the movement is not generated by the figures but imposed on them by the decorative, linear design, so that it remains on the surface of the canvas.

In Greek mythology, the sea nymph GALATEA was vainly pursued by the ugly, one-eyed giant (Cyclopean) shepherd, Polyphemos. The Cyclops crushed Galatea's lover, Acis, by hurling stones, whereupon Galatea turned Acis's blood into a river.

13-15 Raphael. *Galatea*. 1513. Fresco in Villa Farnesina, Rome

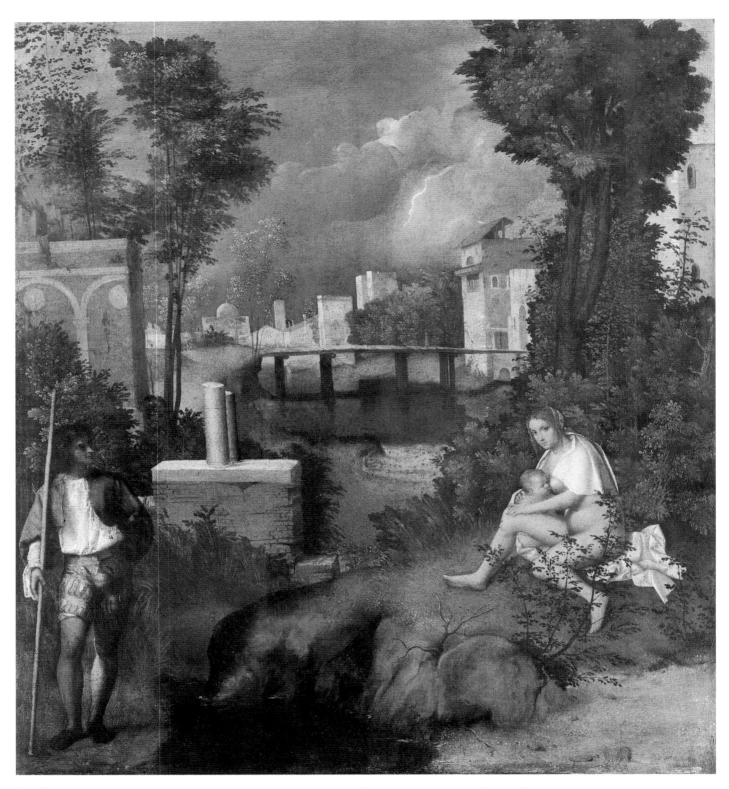

13-16 Giorgione. *The Tempest.* c. 1505. Oil on canvas, 31¼ x 28¾" (79.5 x 73 cm). Galleria dell'Accademia, Venice

GIORGIONE

The distinction between Early and High Renaissance art, so marked in Florence and Rome, is far less sharp in Venice. Giorgione (Giorgione da Castelfranco, 1478–1510), the first Venetian painter to belong to the new era, left the orbit of Giovanni Bellini only during the final years of his short career. Among his few mature works, *The Tempest* (fig. 13-16) is both the most unusual and the most enigmatic. There have been many attempts to explain this image. The most persuasive one is that the painting depicts Adam and Eve after the Fall. Their fate as decreed by God, whose voice is represented by the lightning bolt, is that man shall till the ground from which he was taken and that woman shall bring forth children in sorrow. Adam, dressed in Venetian costume, is seen resting from his labors. Eve, whose draped nudity signifies shame and carnal knowledge, suckles Cain, her firstborn son. In the distance is a bridge over the river surrounding the city of the Earthly Paradise, from which they have been expelled. Barely visible near the rock at river's edge is a snake, signifying the Temptation. The broken columns stand for death, the ultimate punishment of original sin.

The Tempest was probably commissioned by the merchant Gabriele Vendramin, one of Venice's greatest patrons of the arts, who owned the picture when it was first recorded in 1530. It certainly reflects the taste for humanist allegories in Venetian painting, whose subjects are often obscured, as here, by static poses and alien settings. The iconography does not tell us the whole story of *The Tempest,* however. It is the landscape, rather than Giorgione's figures, that interprets the scene for us. Belonging themselves to nature, Adam and Eve are passive victims of the thunderstorm that seems about to engulf them. The contrast to Bellini's *St. Francis in Ecstasy* (see fig. 12-23) is striking. Bellini's landscape is meant to be seen through the eyes of the saint, as a piece of God's creation. Despite its biblical subject, the mood in *The Tempest* is subtly, pervasively pagan. The scene is like an enchanted idyll, a dream of pastoral beauty soon to be swept away. In the past, only poets had captured this air of nostalgic reverie. Now, it entered the repertory of the artist.

Indeed, the painting is very similar in mood to *Arcadia* by Jacopo Sannazaro, a poem about unrequited love that was popular in Giorgione's day. Thus *The Tempest* initiates what was to become an important new tradition.

TITIAN

Giorgione died before he could fully explore the sensuous, lyrical world he had created in *The Tempest.* This task was taken up by Titian (Tiziano Vecellio, 1488/90–1576), who was influenced first by Bellini and then by Giorgione. An artist of incomparable ability, Titian was to dominate Venetian painting for the next half-century.

Bacchanal Titian's BACCHANAL of about 1518 (fig. 13-17, page 320) is frankly pagan, inspired by an ancient author's description of such a revel. The landscape, rich in contrasts of cool and warm tones, has all the poetry of Giorgione, but the figures are of another breed. Active and muscular, they move with a joyous freedom that recalls Raphael's *Galatea* (see fig. 13-15). By this time, many of Michelangelo's and Raphael's compositions had been engraved (see fig. 23-4), and from these reproductions Titian became familiar with the Roman High Renaissance. A number of the figures in his *Bacchanal* also reflect the influence of classical art. Titian's approach to antiquity, however, is very different from Raphael's. He visualizes the realm of classical myths as part of the natural world, inhabited not by animated statues but by beings of flesh and blood. The figures of the *Bacchanal* are idealized just enough to persuade us that they belong to a long-lost Golden Age. They invite us to share their blissful state in a way that makes the *Galatea* seem cold and remote by comparison.

Danaë Danaë (fig. 13-18, page 321), painted during a long stay in Rome in the middle of Titian's career, is a masterful display of the painterly use of sonorous color. (The scene, taken from a story in Ovid's *Metamorphoses,* depicts Jupiter in the guise of a gold shower seducing the young woman, who had been locked in a tower by her father to keep all suitors away.) The figure shows the

A BACCHANAL is a feast and celebration in honor of the Greek god of wine, known as Bacchus or Dionysos (see box, page 89).

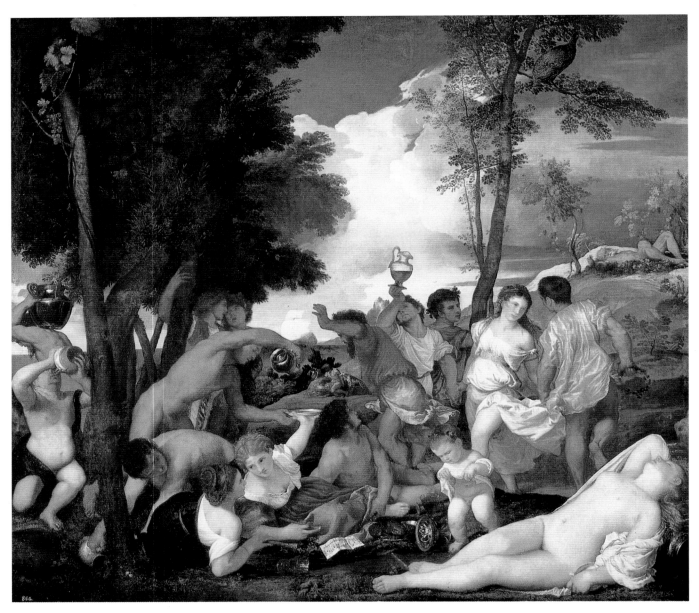

13-17 Titian. *Bacchanal*. c. 1518. Oil on canvas, 5'8⁷/₈" x 6'4" (1.75 x 1.93 m). Museo del Prado, Madrid

impact of Michelangelo's *Night* on the Tomb of Giuliano de' Medici (see fig. 13-11), which Titian probably knew from an engraving. After seeing the canvas in the artist's studio, Michelangelo is said to have praised Titian's coloring and style but criticized his design. We can readily understand Michelangelo's discomfort, for Titian has rephrased his sculpture in utterly sensuous terms. Michelangelo, we know, made detailed drawings for his figures. Titian, too, was a fine draftsman and was influenced by Michelangelo. But although he presumably worked out the essential features of his compositions in prelimi-nary drawings, none has survived. Nor, it seems, did he transfer the design onto the canvas. Instead, he worked directly on the surface and made adjustments as he went along.

Ever since Michelangelo and Titian, the merits of **line** versus **color**—of *disegno* and *colore*—have been the subject of intense debate. The role of color rests mainly on its sensuous and emotional appeal, in contrast to the more intellectual quality of line. Titian thus stands at the head of the coloristic tra-dition that descends through Rubens, Delacroix, and Van Gogh to the Expressionists of the twen-tieth century.

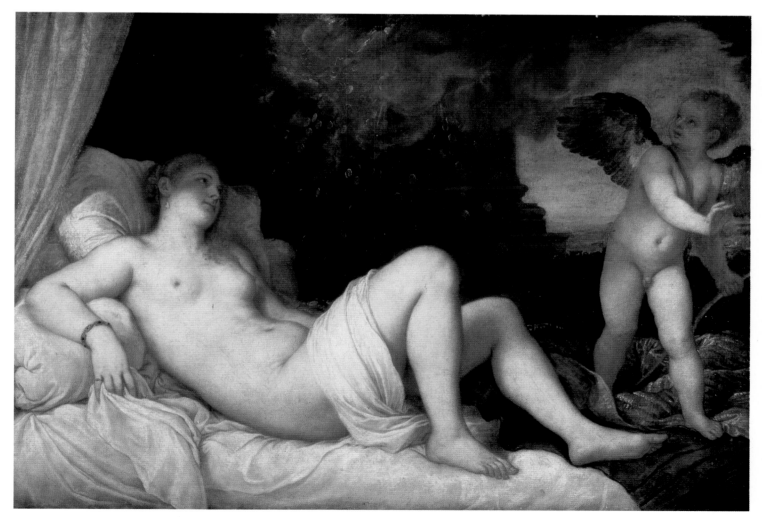

13-18 Titian. *Danaë*. c. 1544–46. Oil on canvas, 7$^{1}/_{4}$ x 67$^{3}/_{4}$" (120 x 172 cm). Museo e Gallerie Nazionale di Capodimonte, Naples

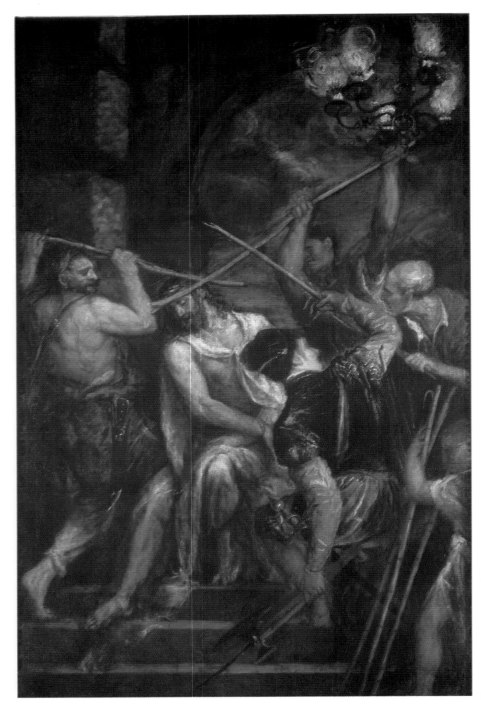

Late Works A change of pictorial technique is no mere surface phenomenon. It always indicates a change in the aim of the artist. This correspondence of form and technique is especially clear in *Christ Crowned with Thorns* (fig. 13-19), the most awesome work of Titian's old age. To what does this canvas owe its power? Surely not only to its large scale or dramatic composition, although these are contributing factors. (The painting is a variant of one the artist had made a quarter-century earlier that is less successful.) The answer lies in Titian's technique. The shapes emerging from the semidarkness now consist wholly of light and color. Despite the heavy **impasto**, the shimmering surfaces have lost every trace of material solidity and seem translucent, as if aglow from within. The violent action has been miraculously suspended. What lingers in our minds is the mood of serenity arising from deep religious feeling rather than the drama. As a result, we contemplate not Jesus' physical suffering but its purpose: the redemption and salvation of humanity. In this regard, the painting is the very opposite of a German **Andachtsbild**. In its ethereality, *Christ Crowned with Thorns* reflects a widespread visionary tendency that was shared by other late-sixteenth-century Venetian artists. We shall meet it again in the work of Tintoretto and El Greco.

13-19 Titian. *Christ Crowned with Thorns.* c. 1570. Oil on canvas, 9'2" x 6' (2.79 x 1.83 m). Alte Pinakothek, Munich

THE LATE RENAISSANCE
IN ITALY

rt historians have yet to agree on a name for the 80 years separating the High Renais-
sance from the Baroque. We have run into this difficulty before, in dealing with the
problem of Late Classical versus Hellenistic art. Any label implies that the period
has only a single style. This interval, however, was a time of crisis that gave rise to a number of
competing tendencies rather than a main ideal. In fact, there is no clear dividing line between
them, and we often find several trends in the work of a single artist, which adds to the com-
plexity of the age. Since there was no single style in the years 1520 to 1600, why should this
span be thought of as a period at all? What was its relation to the two eras that it separates? The
term *Late Renaissance,* which used to be common, is controversial. It implies a period of decline
from the peak attained by the High Renaissance and a transition to the great next phase, the
Baroque, that followed. Yet we have no truly satisfactory alternative. Until one is found, we
have chosen to retain *Late Renaissance* as a matter of convenience, but with the understanding
that it is the rich diversity that gives this epoch its peculiar flavor. We look in vain for an under-
lying unity, be it historical, social, cultural, or religious. The one common denominator we find
is a tidal wave of change on all fronts that reshaped Europe.

The great voyages of discovery that took place during the High Renaissance—Columbus's
landing in the New World in 1492, Amerigo Vespucci's exploration of South America seven
years later, and Magellan's voyage around the world beginning in 1519—had far-reaching
consequences. The most immediate effect was the rise of the major European colonial powers,
which vied with each other for commercial supremacy around the world. The Spanish, then

the Portuguese, quickly established themselves in the Americas; Mexico was conquered by Hernán Cortés in 1519–21, Peru by Francisco Pizarro during the next decade. By 1585 Sir Walter Raleigh had founded the first English settlement in North America; the French soon followed with outposts of their own. An unexpected effect was the explosion of knowledge as explorers brought back a host of natural and artistic wonders never before seen in Europe. Avid collectors formed *Kunst-und Wunderkammern* (literally, "art and wonder rooms") to display exotic treasures from every corner of the earth. As Europeans struggled to absorb the new discoveries into old categories of thought, the science inherited from ancient Greece and Rome was largely discarded by 1650 in favor of the new body of learning.

After 1500 the European order was reshaped by new rulers of extraordinary ambition, which was mirrored in the new imagery that appeared in court portraiture. Chief among them were Charles V of Spain, Francis I of France, and Henry VIII of England. Charles and Francis spent their reigns in nearly constant warfare against each other. At first the Spanish monarch had the edge. He even took Francis captive in 1525 at the Battle of Pavia and held him prisoner for several years. Eventually, however, Charles abdicated his throne in favor of his son, Philip II, when he was unable to gain a decisive victory over the French king. Yet the French advantage proved short-lived, and Spain emerged as the leading power in Europe after the Treaty of Cateau-Cambrésis in 1559.

Much of the conflict was played out in Italy, where Spain took over Naples and Sicily, and France laid claim to Milan. Spanish forces sacked Rome in 1527 and took Florence in 1530. The conflict inevitably came to involve the papacy, which formed the Holy League from leading Italian cities in order to protect its assets and those of the powerful families that occupied the Throne of St. Peter for most of the first half of the century: the Medicis from Florence and the Farneses of Rome. The struggle for power between France and Spain engaged Europe in constantly shifting alliances on both sides. They vied for the support of the princes and dukes of Germany, England, and Scotland, and

even the Turks, who became allies of the French for a while. As a result no side gained the upper hand for long, and treaties were made and broken in rapid succession.

The political upheavals and social unrest sweeping Europe ultimately became embroiled in the Reformation and Counter-Reformation, which gripped Europe after 1520. Yet religion played a relatively small and inconsistent part in this larger arena before 1560, despite intense sectarian wars at the local level. Catholics and Protestants regularly entered into unions based on self-interest, economic necessity, and the need to maintain a balance of power between France and Spain. Although they were sometimes passionate in their beliefs, rulers usually allied themselves with the Reformation or Counter-Reformation for dynastic reasons. Thus Henry VIII of England established the Church of England in 1534 so that he could divorce his queen in the hope of producing a male heir. Later Philip II of Spain embraced the Catholic cause to advance Hapsburg ambitions and cloaked his motives in the mantle of a crusade for the true faith.

The Protestant Reformation was launched in October 1517 by Martin Luther, a former Augustinian friar who had become professor of theology at the University of Wittenberg. At face value, the 95 theses he nailed to the Wittenberg Castle church door on All Saints' Eve were a broadside against the sale of indulgences promising redemption of sins. More fundamentally they were a wholesale attack on Catholic dogma, for Luther claimed that the Bible and natural reason were the sole bases of religious authority, and that the intervention of clerics and saints was unnecessary for salvation, which was freely given by God. Thus authority was transferred from the pope to the individual conscience of each Bible reader.

Freed from traditional doctrine, the Protestant movement rapidly developed splinter groups. Within a few years the Swiss pastor Huldreich Zwingli wanted to reduce religion to its essentials by preaching an even more radical fundamentalism. He denounced the arts as distractions and denied the validity of even the Eucharist as a rite, which led

to a split with Luther that was never healed. Within Zwingli's camp there were also rifts: the Anabaptists accepted only adult baptism. What divided the reformers above all were the twin issues of grace and free will in attaining faith and salvation. By the time Zwingli died at the hands of Catholic forces at the Battle of Kappel in 1531, the main elements of Protestant theology had nevertheless been defined. They were codified around midcentury by John Calvin of Geneva, who tried to mediate between Luther and Zwingli while adopting the puritanical beliefs of the Anabaptists.

The Catholic church soon launched a reform movement of its own, known today as the Counter-Reformation. It began more than a half-century before the Council of Trent in 1545, which marks its official onset. In fact, the Church had been in an almost constant state of reform since the middle of the thirteenth century. The roots of Catholic reform were complex, but several main causes can be defined. It was a reform of the Church not simply doctrinally or institutionally but also spiritually. By the end of the fifteenth century there was a growing urge among Christians throughout Europe for a more meaningful relationship with God. Much of it sprang from the rediscovery of the *Confessions* and other writings of St. Augustine of Hippo. In Italy this renewed emphasis on personal faith and good works was embodied in the exemplary life of St. Francis of Assisi, himself an ardent reader of St. Augustine. St. Augustine also inspired mystics from the fourteenth century on.

The Franciscans initiated a reform of their own in Italy by establishing the austere Capuchin order in 1529. This was but one of many orders that were founded before 1540, beginning with the Oratories of Divine Love in Genoa and Rome. The growing reform movement was spearheaded mainly by Venice and cities under its control: Verona and Brescia. Geography helped make northern Italy open to Reformation ideas. Venice had close trading relations with Germany, as did Brescia, while Milan had commercial ties to Switzerland just across the Alps, as did other major cities in northern Italy. The Tyrol was heavily German in both its language and culture. Soon after 1520

Reformation ideas began to spread rapidly throughout Italy, including Tuscany.

In Florence, Lucca, and other Tuscan cities, the origin of reform can be traced back to Savonarola (see page 294). His memory was kept alive by his many followers, including the Medicis themselves, and his reputation was restored by Pope Julius II, a bitter enemy of Pope Alexander VI, who had tried Savonarola for heresy. The papacy was rightly seen as the root of many of the Church's ills. Indeed, it was slow to respond to the challenges posed by Protestantism and the rising Catholic rebellion against abuses, such as the sale of indulgences. The ignorant, all-too-worldly clergy were an even deeper problem, as were the bishops, many of whom did not reside in their sees.

Pope Paul III, who had been elected in 1534 on the promise of convening a council to discuss the Church's problems, summoned the Council of Trent only after a decade on the throne of St. Peter. (Trent itself was a hotbed of Lutheran sentiments.) Predictably, the Council, which met at various times for nearly 20 years, reinforced the central position of the papacy and reasserted traditional dogma as it had been defined over the long history of the Church. Yet it was also in the forefront of genuine reform. After the inaugural meeting of the Council of Trent, held in 1545–47, the reform movement was spearheaded by the JESUIT order, representing the Church militant. However, the internal reforms were carried out mainly by Paul IV, who became pope in 1555, and by St. Carlo Borromeo, who initiated the model of reform five years later as bishop of Milan, where the Reformation had made considerable inroads.

Central to both the Reformation and Counter-Reformation was humanism. Humanistic scholarship insisted on a correct understanding of the original Greek and Hebrew sources of the Bible, and of the writings of the early Church fathers. Such efforts resonated with those seeking a more authentic spirituality unburdened by later doctrine. Humanists such as Gasparo Contarini, the cardinal of Venice, Pietro Bembo at the University of Padua, Desiderius Erasmus of Rotterdam, Philip Melancthon in Germany, and Thomas

The Society of Jesus, a religious order known as the JESUITS, was founded by St. Ignatius of Loyola (see page 398) in 1540 with the particular mission of defending and supporting the pope. Noted for their long and rigorous training, the Jesuits have distinguished themselves as missionaries—working in the seventeenth century, for instance, among the native peoples of North America—as educators (at such universities as Georgetown and Fordham), and as scholars.

More in England, to name only the best known, played vital roles in the Catholic and Protestant movements. The humanists at first had counted Luther and Zwingli among their number; many of them eventually turned against the Reformation because of its extreme views. In Spain mysticism and reform, which both arose around 1500, soon became allied. This tendency was to culminate in St. Theresa of Avila (see page 397), who was a vigorous reformer of nunneries.

Painting

MANNERISM IN FLORENCE AND ROME

Among the trends in art in the wake of the High Renaissance, Mannerism is the most significant, as well as the most problematic. The original meaning of the term was narrow and derogatory. It referred to a group of mid-sixteenth-century painters in Rome and Florence whose "artificial" style (*maniera*) was derived from certain aspects of the work of Raphael and Michelangelo. This phase has since been recognized as part of a wider movement that had begun about 1520. Keyed to a sophisticated taste, early Mannerism had appealed to a small circle of aristocratic patrons such as Cosimo I, the grand duke of Tuscany, and Francis I, the king of France. The style soon became international as a number of events—including the plague of 1522, the SACK OF ROME by Spanish forces in 1527, and the conquest of Florence three years later—drove many artists abroad, where most of the style's next phase developed.

This new phase, High Mannerism, was the assertion of a purely aesthetic ideal. Through formulaic abstraction, it became a style of utmost refinement that emphasized grace, variety, and virtuoso display at the expense of content, clarity, and unity. This taste for affected elegance and bizarre conceits appealed to a small but sophisticated audience. In a larger sense, however, Mannerism signaled a fundamental shift in Italian culture. In part it resulted from the High Renaissance quest for originality as a projection of the individual's character, which had given artists license to explore their imaginations freely. While this investigation of new modes was ultimately beneficial, the Mannerist style itself came to be regarded by many as decadent, and no wonder: given such subjective freedom, it produced extreme personalities who today seem the most "modern" of all sixteenth-century painters.

The formalism of High Mannerist art was part of a wider movement that placed inner vision, however private or fantastic, above the twin standards of nature and the ancients. Hence the definition of Mannerism has sometimes been expanded to include the later style of Michelangelo, who would acknowledge no artistic authority higher than his own genius. Mannerism is often viewed as a reaction against the ideal created by the High Renaissance as well. Except for a brief early phase, however, Mannerism did not consciously reject the tradition from which it stemmed. The subjectivity inherent in its aesthetic was unclassical, but it was not deliberately anticlassical, save for its most extreme forms. Even more important than Mannerism's anticlassicism is its insistent antinaturalism.

The relation of Mannerism to religious trends was equally ambiguous. Although a deep reverence is found in many works by the first generation of painters, the extreme worldliness of the second generation was inherently opposed to both the Reformation, with its stern morality, and the Counter-Reformation, which demanded strict adherence to doctrine. After midcentury there was nonetheless a "Counter-Mannerist" trend, centering on Bronzino and Vasari (see below), which adapted the vocabulary of Mannerism for Counter-Reformation ends. The result was an arid style geared solely to supporting the Church and its dogma. These "official" Counter-Reformation images were given a strong physical presence to convey their theological messages as clearly as possible.

The Counter-Reformation had a well-founded concern over the proliferation of images that were unsupported by the Bible or traditional doctrine. Worse still were images that might be deemed disrespectful or even sacrilegious. However, commentators were not always in agreement about

Rome and the papacy were caught up in the imperial rivalries among Francis I of France, Henry VIII of England, and Holy Roman Emperor Charles V. In 1526 Henry and Charles both laid claim to Italy. In the following year, Francis, Henry, and Pope Clement VII invaded Italy. Charles's forces prevailed, however, and the pope was taken captive. The six-month siege, marked by burning and looting, is referred to as the SACK OF ROME.

what was permissible. As the Catholic church sought to define itself against the Protestant Reformation, religious imagery nevertheless became increasingly standardized. Much of the reason can be found in the INQUISITION, a medieval institution that was revived in Italy in 1542 after a lapse of several hundred years and established separately in Spain in 1478 to enforce religious orthodoxy. Yet, these visual sermons also reflect a sincere response to Catholic reform. Indeed, the sculptor and architect Bartolomeo Ammanati renounced the nude statues he had produced early in his career. At the same time, however, the subjective freedom of Mannerism was valued for its visionary power as part of a larger shift in religious sentiment toward mysticism, especially in northern Italy.

Rosso The first signs of discord in the High Renaissance appear shortly before 1520 in Florence. Art had been left in the hands of a younger generation that could refine but not further develop the styles of the great masters who had spent their early careers there. Having absorbed the lessons of the leading artists at one remove, the first generation of Mannerists was free to apply High Renaissance formulas to a new style divorced from its previous content. While this early phase of Mannerism may be a reflection of the growing turmoil in Italy, its highly personal spirituality is almost certainly the legacy of Savonarola.

The first full expression of the new attitude is *The Descent from the Cross* (fig. 14-1, page 328) painted by Rosso Fiorentino (1495–1540), the most eccentric of the first-generation Mannerists. It was commissioned in 1521 by the Company of the Cross of the Day, a confraternity of flagellants, in the Tuscan city of Volterra. Although it looks back in part to Early Renaissance art, nothing has prepared us for the shocking impact of the spidery forms spread out against the dark sky. The figures are agitated yet rigid, as if frozen by a sudden icy blast. Even the draperies have brittle, sharp-edged planes. The acid colors and the light, brilliant but unreal, reinforce the nightmarish effect of the scene. Here is clearly a full-scale revolt against the classical balance of High Renaissance

art—a profoundly disquieting, willful, visionary style that indicates a deep inner anxiety. Amid the violent activity the limp, astonishingly serene figure of Christ appears to hover almost effortlessly. We are, then, meant to experience the painting on two levels: as something akin to an *Andachtsbild,* with its intense emotion, and as an object of devotion, like an icon. As such, it accords with Savonarola's urging of continuous, "inflamed" contemplation of the meaning of the crucified Christ and his role in the salvation of humanity. Thus this *Descent from the Cross* was especially appropriate to the religious order that commissioned it.

Pontormo Jacopo da Pontormo (1494–1556/7), a friend of Rosso, had an equally strange temperament. Introspective, headstrong, and shy, he worked only when and for whom he pleased. He would shut himself up in his quarters for weeks on end and refuse to see even his closest friends. His *Deposition* (fig. 14-2, page 329) is a reflection of his character. It contrasts sharply with Rosso's *Descent from the Cross* but is no less disturbing. Unlike Rosso's elongated forms, Pontormo's have a nearly classical beauty and sculptural solidity inspired by Michelangelo, who is known to have admired his art. Yet the figures are confined to a stage so claustrophobic as to cause acute discomfort in the viewer. The very implausibility of the image, however, makes it convincing in spiritual terms. Indeed, this visionary quality is essential to its meaning, which is conveyed by formal means alone.

We have entered a world of innermost contemplation in which every pictorial element responds to a purely subjective impulse. Everything is subordinate to the play of graceful rhythms created by the tightly interlocking forms. These patterns unify the surface and give the work a poignancy unlike any we have seen. Although they seem to act together, the mourners are lost in a grief too personal to share with one another—or us. In this hushed atmosphere, anguish is transformed into a lyrical expression of exquisite sensitivity. The entire scene is as haunted as Pontormo's self-portrait just to the right of the swooning Madonna. The artist, moodily gazing into space, seems to shrink from

The INQUISITION began as a papal judicial process in the twelfth century, was codified in 1231 with the institution of excommunication, and was formalized in 1542 by Pope Paul III as the Holy Office. In Spain in 1478, it independently became an instrument of the State and was not abolished until 1834. In all its forms, its purpose was to rid the Catholic church of heresy. At its fairest, the process was just and merciful; at its worst, the Inquisition was pure political terrorism.

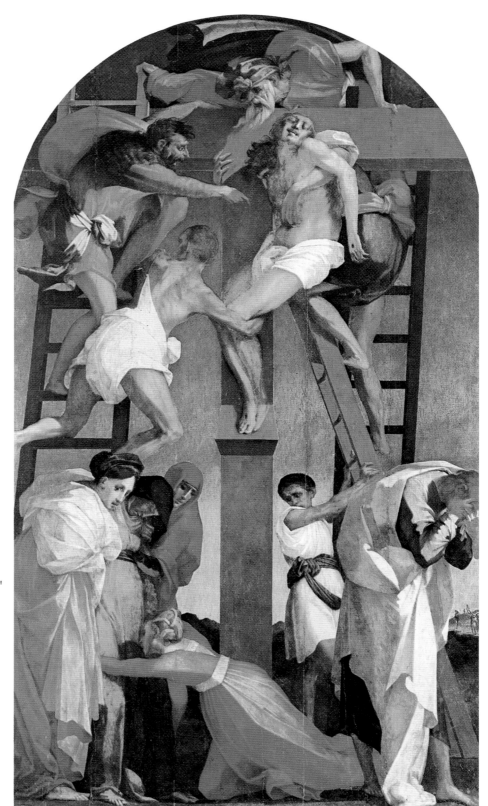

14-1 Rosso Fiorentino.
The Descent from the Cross.
1521. Oil on panel, 11' x 6'5½"
(3.35 x 1.97 m). Pinacoteca
Communale, Volterra

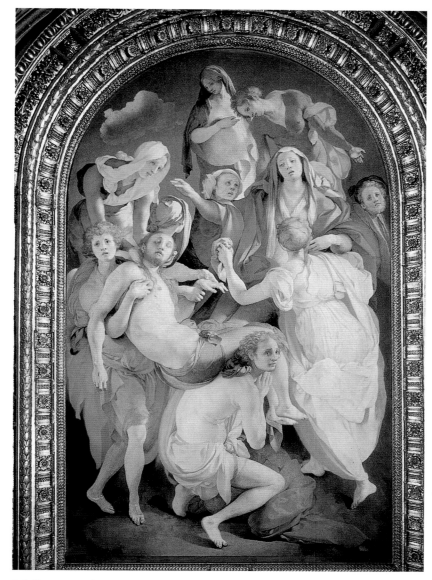

14-2 Jacopo da Pontormo. *The Deposition.* c. 1526–28. Oil on panel, 10'3" x 6'4" (3.12 x 1.93 m). Sta. Felicità, Florence

the outer world—as if scarred by the trauma of some half-remembered experience—and into one of his own invention.

Parmigianino The first phase of Mannerism was soon replaced by one less openly anticlassical, less charged with subjective emotion, but equally far removed from the confident, stable world of the High Renaissance. *The Madonna with the Long Neck* (fig. 14-3, page 330) reflects the strange imagination of Parmigianino (Girolamo Francesco Maria Mazzuoli, 1503–1540). Vasari informs us that the artist, as he neared the end of his brief career, was obsessed with alchemy and became "a bearded, long-haired, neglected, and almost savage or wild man." This, his most famous work, was painted

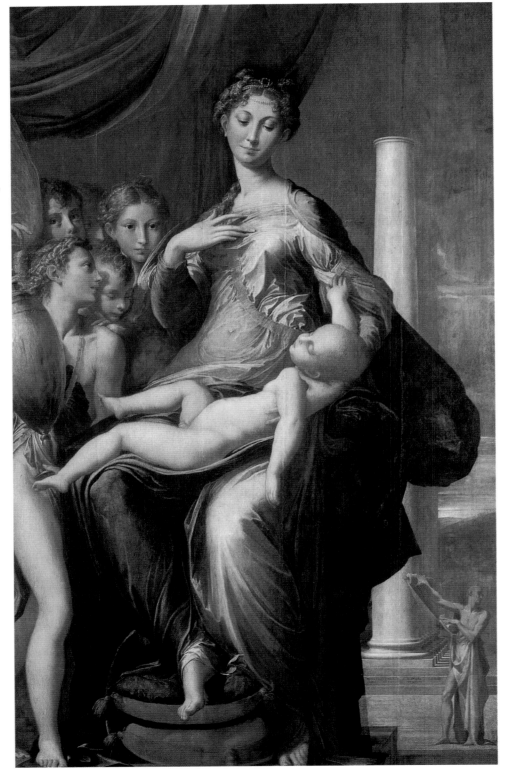

14-3 Parmigianino. *The Madonna with the Long Neck.* c. 1535. Oil on panel, 7'1" x 4'4" (2.16 x 1.32 m). Galleria degli Uffizi, Florence

after he had returned to his native Parma from a stay of several years in Rome. He had been deeply impressed with the rhythmic grace of Raphael's art, but here he has transformed the older artist's figures into a remarkable new breed.

The limbs, elongated and ivory-smooth, move with effortless languor and embody an ideal of beauty as remote from nature as any Byzantine figure. The pose of the Christ Child balanced precariously on the Madonna's lap echoes that of a Pietà (compare fig. 11-24), which shows that he is already aware of his mission to redeem original sin through his death. Although sometimes also found in Byzantine icons, this unusual device evidently is Parmigianino's own invention and helps to explain the setting, which is not as arbitrary as it may seem. The gigantic column, representing the gateway to heaven, is a symbol often associated with the Madonna. It refers both to eternal life and to the Immaculate Conception. It may also refer to the flagellation of Jesus during the Passion, thus reminding us of his sacrifice, which the tiny figure of a prophet foretells on his scroll. Visually the column serves to disrupt our perception of the pictorial space, which is strangely disjointed. Parmigianino seems determined to prevent us from judging anything in this picture by the standards of ordinary experience. Here we approach the "artificial" style for which the term *Mannerism* was coined. *The Madonna with the Long Neck* is a vision of unearthly perfection, with a cold elegance that is no less compelling than the violence in Rosso's *Descent*.

Bronzino High Mannerism is identified with the second generation of artists who surrounded Agnolo Bronzino and Giorgio Vasari. They transformed the styles of Rosso, Pontormo, and Parmigianino into one of cool perfection that filtered out the intensely individual outlooks of those artists. As a result, they produced few masterpieces. In their best works, however, formal beauty becomes the aesthetic counterpart to obscure, even perverse thought.

Nowhere is this better seen than in the *Allegory of Venus* (fig. 14-4) by Bronzino (1503–1572), Pontormo's favorite pupil. It was painted as a gift to Francis I of France from Cosimo I de' Medici. The central motif of Cupid embracing Venus was suggested by a lost *Triumph of Love* by Michelangelo that Pontormo and Bronzino are both known to have copied. As with so much else in High Mannerism, however, the source has been corrupted in content and treatment. Father Time

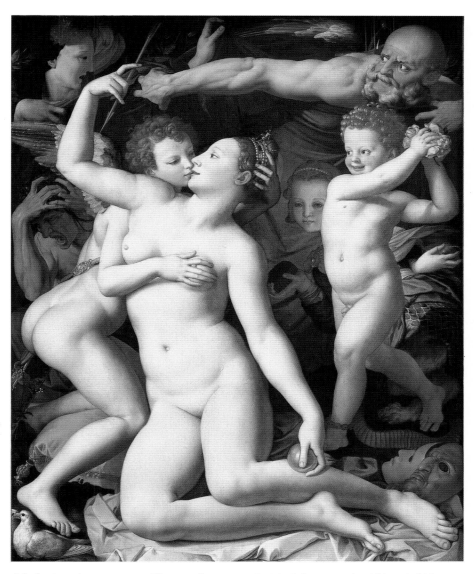

14-4 Agnolo Bronzino. *Allegory of Venus.* c. 1546. Oil on panel, 57½ x 45⅝" (146.1 x 116.2 cm). The National Gallery, London

tears back the curtain from Fraud in the upper left-hand corner to reveal Venus and Cupid in an incestuous embrace, much to the delight of Folly, who is armed with roses, and the dismay of Jealousy, who tears her hair, as Pleasure, half-woman and half-snake, offers a honeycomb. The moral is that folly blinds one to the jealousy and fraud of sensual love, which time reveals. The unmasking of this fraud revels in the lustfulness that it pretends to condemn. The painting is thus a corruption of the high-minded humanism in Botticelli's *Birth of Venus* (see fig. 12-19). With its extreme stylization, Bronzino's elegance proclaims a refined erotic ideal that reduces passion to a genteel exchange of serpentine gestures, so characteristic of High Mannerism, between figures as polished as marble.

Vasari Bronzino's figures are indebted to Michelangelo in their sculptural quality (compare the Venus to *Night* in fig. 13-11). Those in *Perseus and Andromeda* (fig. 14-5) by Giorgio Vasari (see page 300) owe more to Raphael. The debt is surprising,

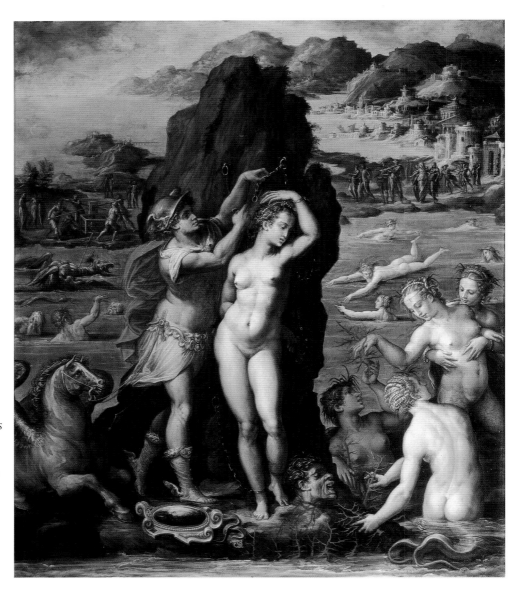

14-5 Giorgio Vasari. *Perseus and Andromeda.* 1570–72. Oil on slate, 45¹/₂ x 34" (115.6 x 86.4 cm). Studiolo, Palazzo Vecchio, Florence

as Vasari esteemed Michelangelo above all others. The painting, one of his last works, is a play on Raphael's *Galatea* (see fig. 13-15). It is part of Vasari's decorative scheme devoted to the Four Elements for the study of Francesco I de' Medici of Florence. (The program was devised by the humanist Vincenzo Borghini.) The artist has chosen to represent water with the story of coral, which according to legend was formed by the blood of the monster slain by PERSEUS when he rescued ANDROMEDA. The subject provided an excuse to show voluptuous nudes, but here the story has become an enchanting fantasy, in contrast to the lewdness typical of Mannerist imagery. In keeping with this playful treatment, the Nereids, light-hearted versions of Raphael's mythological creatures, frolic with bits of coral they have discovered in the sea. Vasari's painting became a classic in its own right. It spawned a host of imitations by minor artists in the waning years of Mannerism, and was revived by the Romantics.

NORTH ITALIAN REALISM

Although Mannerism spread to other cities, as a style it did not become dominant outside Florence and Rome. Elsewhere it competed with other tendencies. In Venice and the towns along the northern edge of the Lombard plain under its sway, there were a number of artists who worked in styles based on Titian's, but with a stronger interest in everyday reality. After 1560, however, Mannerism became thoroughly absorbed into North Italian realism.

Savoldo One of the earliest of these North Italian realists was Girolamo Savoldo (c. 1480–1550) from Brescia, near Venice. His *St. Matthew and the Angel* (fig. 14-6) must have been painted around the same time as Parmigianino's *Madonna with the Long Neck*. The *St. Matthew* represents a new approach to religious painting. Never before have we seen the sacred brought down to earth with such tangible immediacy. The style shows the influence of Titian, who would not, however, have placed the evangelist in such a humble domestic setting. The scene in the background shows the saint's environment to be lowly indeed and makes

14-6 Girolamo Savoldo. *St. Matthew and the Angel*. c. 1535. Oil on canvas, 36³/₄ x 49" (93.3 x 124.5 cm). The Metropolitan Museum of Art, New York

Marquand Fund, 1912

the presence of the angel doubly miraculous. This tendency to visualize sacred events among ramshackle buildings and simple people had been characteristic of Gothic painting, especially in the North, and Savoldo must have acquired it from that source.

The religious content, too, may have originated across the Alps. Even the poorest, the artist seems to say, may experience revelation directly, reflecting that hunger for personal religious experience which swept Europe. The picture reminds us that the Bible and natural reason were the twin pillars of authority to Martin Luther. Luther also argued that there was no need for the clergy, saints, or angels to act as intercessors on behalf of the faithful, but here the angel plays an essential role by dictating the gospel as the word of God to the unlettered apostle. The nocturnal lighting recalls such International Style pictures as the *Nativity* by Gentile da Fabriano (see fig. 11-41). But instead of divine radiance, Savoldo uses an ordinary oil lamp for his magic and intimate effect, so filled with sacred overtones, however disguised.

Savoldo labored in obscurity in his hometown. Around 1600, however, at the dawn of the Baroque, his direct realism became an important source for the revolutionary style of Caravaggio, another North

PERSEUS, the son of Zeus and the mortal Danaë, was greatly loved by the gods, who helped him slay Medusa, one of three hideous, snake-haired sisters known as the Gorgons. On his way home, Perseus encountered the Ethiopian princess ANDROMEDA, who was chained to a rock as a sacrifice to a sea monster. Poseidon had sent the beast to destroy Ethiopia because its queen, Cassiopeia, claimed her daughter was more beautiful than the sea nymphs, known as Nereids. Perseus killed the monster and later married Andromeda.

Italian who carried these ideas to Rome, where they were to influence artists throughout Europe.

Correggio Correggio (Antonio Allegri da Correggio, 1489/94–1534), an extraordinarily gifted North Italian painter, spent most of his brief career in Parma, which lies to the west along the Lombard plain. As a result, he absorbed a wide range of influences: first Leonardo and the Venetians, then Michelangelo and Raphael. But their ideal of classical balance did not attract him for long. Correggio's work applies North Italian realism with the imaginative freedom of the Mannerists. (Surprisingly, we do not find any hint of his fellow townsman Parmigianino in his style.) His largest work, the fresco of *The Assumption of the Virgin* in the dome of Parma Cathedral (fig. 14-7), is a masterpiece of illusionistic perspective. In transporting us into the heavens, it is the very opposite of Savoldo's painting. Correggio here initiates an entirely new kind of visionary representation in which heaven and earth are joined visually and spiritually. While not the first to execute an illusionistic dome painting—that honor belongs to

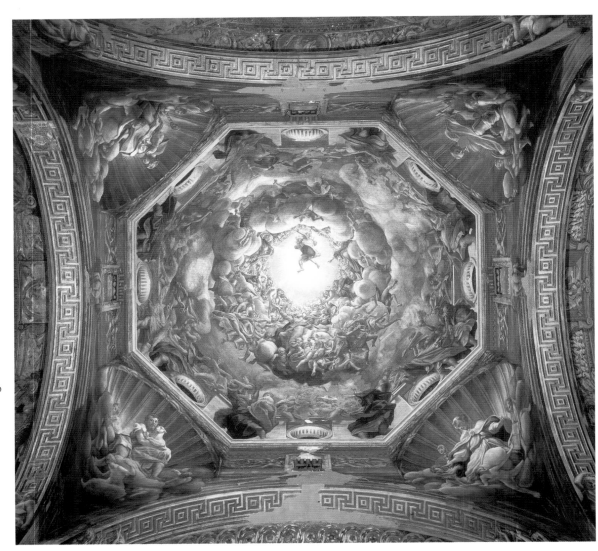

14-7 Correggio. *The Assumption of the Virgin.* c. 1525. Portion of fresco in the dome of Parma Cathedral

Mantegna, from whom he got the idea—he was the first to apply it to a religious subject. Also new are the figures themselves. They move with such exhilarating ease that the force of gravity seems not to exist for them, and they frankly delight in their weightless condition. These are healthy, energetic beings of flesh and blood, reflecting the influence of Titian, not the disembodied spirits so often found in earlier art.

There was little difference between spiritual and physical rapture for Correggio, who thereby established an important precedent for Baroque artists such as Gianlorenzo Bernini (see pages 396–99). We can see this relationship by comparing *The Assumption of the Virgin* with his *Jupiter and Io* (fig. 14-8), part of a series depicting the loves of the classical gods. The nymph IO, swooning in the embrace of a cloudlike JUPITER, is the direct kin of the jubilant angels in the fresco. The use of **sfumato**, combined with a Venetian sense of color and texture, produces a frank sensuality that far exceeds Titian's in his *Bacchanal* (see fig. 13-17).

Like Savoldo, Correggio had no immediate successors, nor did he have any lasting influence on the art of his century, but toward 1580 his work began to be appreciated by Federico Barrocci (1528?–1612) and Annibale Carracci (see pages 387–89). Like Savoldo's, it embodies so many features which later characterized the Baroque that his style has been labeled Proto-Baroque; such a term, however, hardly does justice to Correggio's highly individual qualities. For the next century and a half he was admired as the equal of Raphael and Michelangelo, while the Mannerists, so important before, were largely forgotten.

VENICE

Veronese In the work of Paolo Veronese (Paolo Caliari, 1528–1588), who was born and trained in Verona, North Italian realism takes on the splendor of a pageant. *Christ in the House of Levi* (fig. 14-9, page 336) avoids all reference to the supernatural. The symmetrical composition harks back to paintings by Leonardo and Raphael, while the festive mood of the scene reflects examples by Titian of the 1520s. At first glance the picture looks like a High Renaissance work born 50 years too late. Missing, however, is the ideal conception of humanity that underlies the High Renaissance. Veronese paints a sumptuous banquet, a true feast for the eyes, but not "the intention of man's soul."

We are not even sure which event from the life of Jesus he originally meant to depict. He gave the painting its present title only after he had been summoned by the religious tribunal of the

JUPITER is a Roman counterpart to the Greek god Zeus, who fell in love with IO. To disguise Io so that his wife, Hera (Juno in Roman mythology), would not be jealous, Zeus turned Io into a white heifer. Hera suspected Io's real identity and demanded the heifer as a gift from Jupiter. Correggio's painting shows the moment before Io was transformed—when Jupiter made himself into a cloud for an amorous visit.

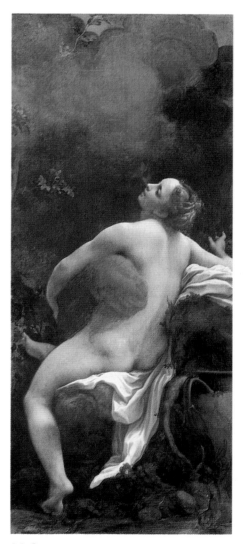

14-8 Correggio. *Jupiter and Io.* c. 1532. Oil on canvas, 64¹/₂ x 27³/₄" (163.8 x 70.5 cm). Kunsthistorisches Museum, Vienna

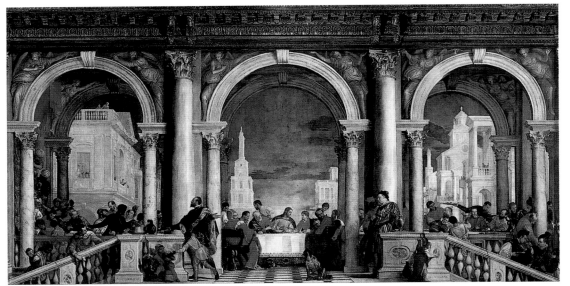

14-9 Paolo Veronese. *Christ in the House of Levi.* 1573. Oil on canvas, 18'2" x 42' (5.54 x 12.8 m). Galleria dell'Accademia, Venice

Inquisition on the charge of filling his picture with "buffoons, drunkards, Germans, dwarfs, and similar vulgarities" unsuited to its sacred character. The account of this trial shows that the tribunal thought the painting represented the Last Supper, but Veronese's testimony never made clear whether it was the Last Supper or the Supper in the House of Simon. To him this distinction made little difference. In the end, he settled on a convenient third title, *Christ in the House of Levi,* which permitted him to leave the offending incidents in place. He argued that they were no more objectionable than the nudity of Jesus and the Heavenly Host in Michelangelo's *Last Judgment.* Nevertheless, the tribunal failed to see the analogy, on the grounds that "in the *Last Judgment* it was not necessary to paint garments, and there is nothing in those figures that is not spiritual."

The Inquisition, of course, considered only the impropriety of Veronese's art, not its lack of spiritual depth. His refusal to admit the justice of the charge, his insistence on his right to include directly observed details, however "improper," and his indifference to the subject of the picture spring from an attitude so extroverted that it was not widely accepted until the nineteenth century. The painter's domain, Veronese seems to say, is the

entire visible world, and here he acknowledges no authority other than his senses. Although tame by Mannerist standards, the presentation is supremely theatrical, from the vast, stagelike space to the lavish costumes, which hardly differ from those in Venetian productions of the day. And just as it goes against the religious outlook of the day, the painting also violates the concept of decorum in contemporary dramatic theory.

Tintoretto Veronese and Jacopo Tintoretto (1518–1594) both found favor with the public. They certainly looked at each other's work, but the differences in their styles are readily apparent if we compare Veronese's *Christ in the House of Levi* to Tintoretto's *Last Supper* (fig. 14-10), his final and most spectacular major painting. Tintoretto reportedly wanted "to paint like Titian and to design like Michelangelo," but his relationship to those two masters, although real enough, was as peculiar as Parmigianino's was to Raphael. Tintoretto fully assimilated the influence of Mannerism into his personal style in order to heighten the visionary effects seen in Titian's late work (see fig. 13-19).

The Last Supper seems to deny in every possible way the classic values of Leonardo's version (see fig. 13-2), painted almost exactly a century

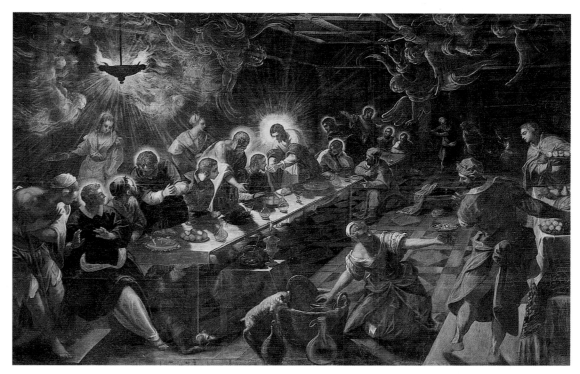

14-10 Jacopo Tintoretto. *The Last Supper.* 1592–94. Oil on canvas, 12' x 18'8" (3.66 x 5.69 m). S. Giorgio Maggiore, Venice

before, which still underlie Veronese's picture. Christ, to be sure, is at the center of the composition, but his small figure in the middle distance is distinguished mainly by the brilliant halo. Tintoretto barely hints at the human drama of Judas's betrayal, so important to Leonardo. Judas can be seen isolated on the near side of the table across from Christ, but his role is so insignificant that he could almost be mistaken for an attendant. The table is now placed at a sharp angle to the picture plane in exaggerated perspective. This arrangement was designed to relate the scene to the space of the **chancel** of the Benedictine monastery church S. Giorgio Maggiore in Venice. There it was seen on the wall by the friars as they knelt at the altar rail to receive Communion, so that it receded less sharply than when viewed head on.

Tintoretto has gone to great lengths to give the event an everyday setting, cluttering the scene with attendants, containers of food and drink, and domestic animals. There are also celestial attendants who converge upon Christ just as he offers his body and blood, in the form of bread and wine, to the disciples. The smoke from the blazing oil lamp miraculously turns into clouds of angels, blurring the distinction between the natural and the supernatural and turning the scene into a magnificently orchestrated vision. The artist's main concern has been to make visible the miracle of the Eucharist—the transubstantiation of earthly into divine food—in both real and symbolic terms. The central importance of this institution to Catholic doctrine was forcefully reasserted during the Counter-Reformation. The painting was especially appropriate for its location in S. Giorgio Maggiore, which played a prominent role in the early reform movement.

El Greco If we can call Tintoretto a Mannerist only with hesitation, there can be no such doubt

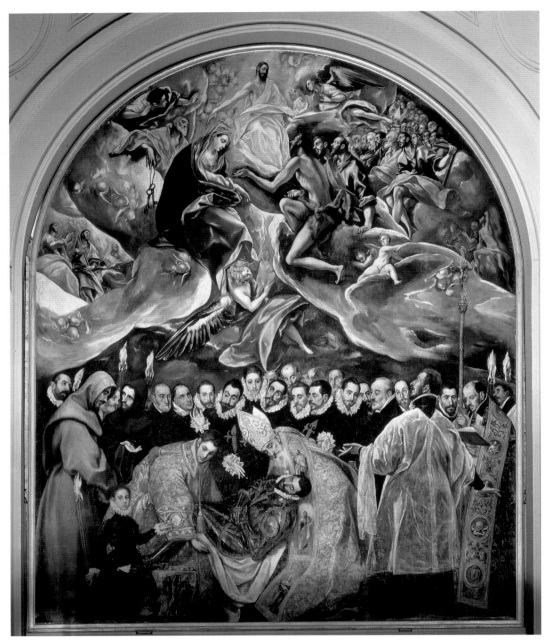

14-11 El Greco. *The Burial of Count Orgaz.* 1586. Oil on canvas, 16' x 11'10" (4.88 x 3.61 m). Sto. Tomé, Toledo, Spain

about Domenikos Theotocopoulos (1541–1614), called El Greco, even though his work, too, falls outside the mainstream of that tradition. He came from Crete, which was then under Venetian rule. There he must have been trained by an artist still working in the Byzantine tradition. (El Greco never forgot his Byzantine background. Until the very end of his career, he signed his pictures in

Greek.) Soon after 1560 he arrived in Venice and quickly absorbed the lessons of Titian, Tintoretto, and other artists. A decade later, in Rome, he came to know the art of Raphael, Michelangelo, and the Mannerists from central Italy. In 1576/7 El Greco went to Spain and settled in Toledo for the rest of his life. He became a member of the leading intellectual circles of the city, then a

major center of learning as well as the seat of Catholic reform in Spain. Although it provides the content of his work, Counter-Reformation theology does not account for the exalted emotionalism that informs his painting. The spiritual tenor of El Greco's mature work was primarily a response to mysticism, which was especially intense in Spain. Contemporary Spanish painting, however, was too provincial to affect him. His style had already been formed before he arrived in Toledo.

The largest and most splendid of El Greco's major commissions, and the only one for a public chapel, is *The Burial of Count Orgaz* (figs. 14-11, 14-12) in the church of Sto. Tomé. The program, which was given at the time of the commission, emphasizes the traditional role of good works in salvation and of the saints as intercessors with heaven. This huge canvas honors a medieval bene-

factor so pious that ST. STEPHEN and St. Augustine miraculously appeared at his funeral and lowered the body into its grave. The burial took place in 1323, but El Greco presents it as a contemporary event and even portrays many of the local nobility and clergy among the attendants. The dazzling display of color and texture in the armor and vestments could hardly have been surpassed by Titian himself. Above, the count's soul (a small, cloudlike figure like the angels in Tintoretto's *Last Supper*) is carried to heaven by an angel. The celestial assembly in the upper half of the picture is painted very differently from the group in the lower half: every form—clouds, limbs, draperies—takes part in the sweeping, flamelike movement toward the figure of Christ. The painting is close in its unearthly spirit and style to Rosso's *Descent from the Cross* (see fig. 14-1). Here, even more than in Tintoretto's art, the entire range of Mannerism fuses into a single ecstatic vision.

The full meaning of the work becomes clear only when we see it in its original setting. Like a huge window, it fills one entire wall of its chapel. The bottom of the canvas is six feet above the floor, and as the chapel is only about 18 feet deep, we must look sharply upward to see the upper half of the picture. The violent foreshortening is calculated to achieve an illusion of boundless space above, while the figures in the lower foreground appear as on a stage. (Their feet are cut off by the molding just below the picture.) The large stone plaque set into the wall also belongs to the ensemble. It represents the front of the sarcophagus into which the two saints lower the body of the count and therefore explains the action in the picture. The viewer, then, perceives three levels of reality. The first is the grave itself, supposedly set into the wall at eye level and closed by an actual stone slab; the second is the reenactment of the miraculous burial; and the third is the vision of celestial glory witnessed by some of the participants. El Greco's task here was similar to Masaccio's in his *Trinity* mural (see fig. 12-13). But whereas Masaccio constructed the illusion of reality through a rational pictorial space that appears continuous with ours, El Greco summons an apparition that remains separate from its architectural surroundings.

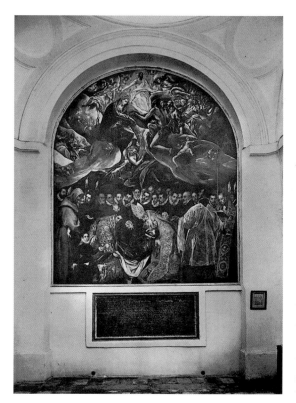

14-12 Chapel with *The Burial of Count Orgaz.* Sto. Tomé, Toledo, Spain

ST. STEPHEN is called the Protomartyr because, according to the New Testament, he was the first Christian martyr. Acts 6:8–15 recounts how he was accused of blasphemy for trying to win converts to the new religion. Stephen was condemned to death by stoning before he could finish speaking in his own defense.

El Greco has created a spiritual counterpart to his imagination. Every passage is alive with his peculiar religiosity, which is felt as a nervous exaltation occurring as the dreamlike vision is conjured up. This kind of mysticism is very similar in character to that found in the *Spiritual Exercises* of Ignatius of Loyola, the founder of the Jesuits, although his teachings are based on a long tradition that achieved a new popularity after 1490. St. Ignatius sought to make visions so real that they would seem to appear before the very eyes of the faithful. Such mysticism could be achieved only through strenuous devotion. That effort is mirrored in the intensity of El Greco's work, which fully retains a feeling of intense spiritual struggle.

Sculpture

Italian sculptors of the later sixteenth century failed to match the achievements of the painters. Perhaps Michelangelo's overpowering personality discouraged new talent in this field, but there was also a lack of major commissions outside of portraiture, as we can tell from the considerable number of small bronzes that were made during this period. In any case, the most interesting sculpture of this period was produced outside of Italy. After the death of Michelangelo in 1564, even the leading sculptor in Florence was a Northerner.

MANNERISM

Cellini The early phase of Mannerism, seen in the style of Rosso, has almost no sculptural counterpart, but the second, elegant stage appears in countless sculptures in Italy and abroad. The best-known representative of the style is Benvenuto Cellini (1500–1571), a Florentine goldsmith and sculptor who owes much of his fame to his colorful AUTOBIOGRAPHY. The gold saltcellar (fig. 14-13), made for Francis I of France while Cellini was working at Fontainebleau, is his only important work in precious metal that has survived. The piece displays the virtues and limitations of his art. The main function of this lavish object is clearly as a conversation piece. Because salt comes

14-13 Benvenuto Cellini. *Saltcellar of Francis I.* c. 1543. Gold with enamel, $10^{1/4}$ x $13^{1/8}$" (26 x 33.3 cm). Kunsthistorisches Museum, Vienna

from the sea and pepper from the land, the boat-shaped salt container is protected by Neptune. The pepper, in a tiny triumphal arch, is watched over by a personification of Earth, who, in another context, might be the god's consort, Amphitrite. On the base are figures representing the four seasons and the four parts of the day.

The saltcellar reflects the cosmic significance of the Medici tombs (compare fig. 13-11). But on this miniature scale Cellini's program turns into a playful fancy on the same order as Vasari's *Perseus and Andromeda* (see fig. 14-5). Cellini wants to impress us with his ingenuity and skill. Earth, he wrote, is "fashioned like a woman with all the beauty of form, the grace and charm, of which my art was capable." The allegorical significance of the design is simply a pretext for this display of virtuosity. For instance, when he tells us that Neptune and Earth each have a bent and a straight leg to signify mountains and plains, form is completely divorced from content. Despite his admiration for Michelangelo, Cellini creates elegant figures that are as elongated, smooth, and languid as Parmigianino's (see fig. 14-3).

Benvenuto Cellini's AUTOBIOGRAPHY, written between 1558 and 1567, is a valuable (if somewhat exaggerated) account of social, political, and ecclesiastical life, especially in sixteenth-century Florence, where Cellini lived from 1545 onward. It was first translated into English in 1960.

Primaticcio Parmigianino also influenced Francesco Primaticcio (1504–1570), Rosso's assistant and successor at the royal château of Fontainebleau. A man of many talents, Primaticcio designed the interior decoration of some of the main rooms, which combine painted scenes and a sculptured stucco framework. The section shown in figure 14-14 caters to the same aristocratic taste that admired the saltcellar of Cellini. The four maidens have no specific allegorical significance, although they recall the nudes of the Sistine ceiling (compare fig. 13-8). They seem to perform a task for which they are ill fitted: to reinforce the piers that sustain the ceiling. These willowy **caryatids** epitomize the studied nonchalance of second-phase Mannerism. The painting is nearly lost in the luxurious ornamentation. Executed by assistants from Primaticcio's design, it shows Apelles painting the abduction of Campaspe by Alexander the Great, who gave his favorite concubine to the artist when he fell in love with her. Such a heady mixture of violence and eroticism appealed greatly to the Mannerists. Yet the story had been interpreted as a gesture of uncommon respect and nobility by the Roman historian Pliny, which justified the subject.

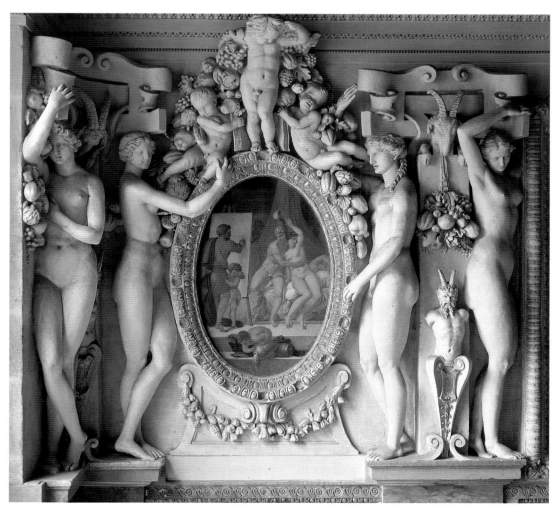

14-14 Francesco Primaticcio. *Stucco Figures*. c. 1541–45. Room of the Duchesse d'Estampes, Château of Fontainebleau, France

Giovanni Bologna Rosso, Primaticcio, Cellini, and the other Italians employed by Francis I at Fontainebleau made Mannerism the dominant style in sixteenth-century France. Their influence went far beyond the royal court. It reached Jean de Bologne (1529–1608), a gifted young sculptor from Douai in northern France, who went to Italy about 1555 for further training. He stayed and, under the Italianized name of Giovanni Bologna, became the most important sculptor in Florence during the last third of the century. His over-life-size marble group, *The Abduction of the Sabine Woman* (fig. 14-15), was especially admired and still has its place of honor near the Palazzo Vecchio.

The subject, drawn from the legends of ancient Rome, seems an odd choice for statuary. According to the story, the city's founders, an adventurous band of men from across the sea, tried in vain to find wives among their neighbors, the Sabines. Finally, they resorted to a trick. Having invited the entire Sabine tribe into Rome for a festival, they attacked them, took the women away by force, and thus ensured the future of their race. Actually, the artist designed the group with no specific subject in mind. It was meant to demonstrate his ability while he was a student at the Academy of Design, founded by Vasari in 1562 under the patronage of Cosimo I de' Medici. Bologna chose what seemed to him the most difficult feat: three contrasting figures united in a single action. When asked to identify the figures, the artist proposed Andromeda, but another member of the Academy, Raffaello Borhini, suggested *The Abduction of the Sabine Woman* as the most suitable title.

Here, then, is another artist who is noncommittal about subject matter, although his motive was different from Veronese's. Like Cellini, Bologna wished to display his virtuosity. His task was to carve in marble, on a massive scale, a sculptural composition that was to be seen from all sides. This had previously been attempted only in bronze and on a much smaller scale (see fig. 12-7).

14-15 Giovanni Bologna. *The Abduction of the Sabine Woman.* Completed 1583. Marble, height 13'6" (4.11 m). Loggia dei Lanzi, Florence

He has solved this formal problem brilliantly, but at the cost of removing his group from the world of human experience. These figures, spiraling upward as if confined inside a tall, narrow cylinder, perform their well-rehearsed exercise with ease. But, like much Hellenistic sculpture (compare fig. 5-24), they lack emotional meaning. We admire their discipline but find no trace of pathos.

Architecture

MANNERISM

The term *Mannerism* was first coined to describe painting. We have had no difficulty in applying it to sculpture. But can it be usefully extended to architecture as well? And if so, what qualities must we look for? These questions have proved difficult to answer. The reasons are all the more puzzling, because the important Mannerist architects were leading painters and sculptors. Yet today only a few buildings are generally considered to be Mannerist.

Romano The main example is the Palazzo del Te in Mantua by Giulio Romano (c. 1499–1566), Raphael's chief assistant. The courtyard facade (fig. 14-16) features unusually squat proportions and coarse **rustication**. The massive **keystones** of the windows have been "squeezed" up by the force of the triangular lintels. The effect is an absurd impossibility. There are no true arches except over the central doorway, which is surmounted by a pediment in violation of classical canon. Even more bizarre is how the **triglyph** midway between each pair of columns "slips" downward in defiance of all logic and accepted practice, thereby creating the sense that the frieze might collapse before our eyes.

The reliance on eccentric gestures that depart from Renaissance norms does not in itself define Mannerism as an architectural period style. What, then, are the qualities we must look for? Above all, form is divorced from content for the sake of surface effect. The emphasis is instead on picturesque devices, especially encrusted decoration,

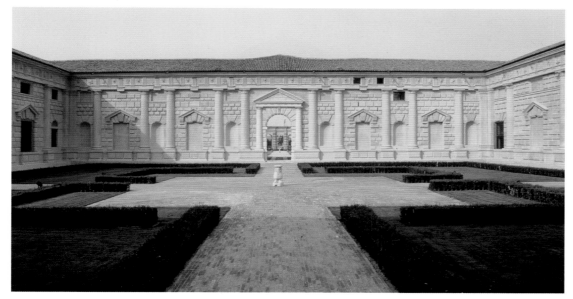

14-16 Giulio Romano.
Courtyard, Palazzo del Te,
Mantua. 1527–34

with the occasional distortion of form and novel, even illogical rearrangement of space. Thus Mannerist architecture lacks a consistent integration of elements.

CLASSICISM

Palladio Most later sixteenth-century architecture can hardly be called Mannerist at all. Andrea Palladio (1518–1580), next to Michelangelo the most important architect of the century, belongs to the tradition of the humanist and theoretician Leone Battista Alberti (see pages 282–83). Although Palladio's career centered on his native Vicenza, a town near Venice, his buildings and theoretical writings brought him international renown. Palladio believed that architecture had to be governed by reason and by certain rules that were exemplified by the buildings of the ancients. He thus shared Alberti's basic outlook and faith in the cosmic significance of numerical ratios. The two differed in how each related theory and practice, however. With Alberti, this relationship had been flexible, whereas Palladio believed quite literally in practicing what he preached. This view stemmed in part from the fact that he had begun his career as a stonemason and sculptor before entering the humanist circles of Count Giangiorgio Trissino of Vicenza at the age of 30. As a result, his treatise *THE FOUR BOOKS OF ARCHITECTURE* (1570) is more practical than Alberti's, which helps to explain its huge success, while his buildings are linked more directly with his theories. It has even been said that Palladio designed only what was, in his view, sanctioned by ancient precedent. Indeed, the usual term for both Palladio's work and theoretical attitude is *classicistic*. This term denotes a conscious striving for classic qualities, although the results are not necessarily classical in style.

Much of Palladio's architecture consists of town houses and country villas. The Villa Rotonda (fig. 14-17, page 344), one of Palladio's finest buildings, perfectly illustrates the meaning of his classicism. This country residence, built near Vicenza for Paolo Almerico, consists of a square block surmounted by a dome, with identical porches in the shape of temple fronts on all four sides. Alberti had defined the ideal church as a symmetrical, centralized design of this sort. Palladio adapted the same principles for the ideal country house. As he tells us in the second book of his treatise, his design takes advantage of the pleasing views offered in every direction by the site.

How could Palladio justify such a secular context for the solemn motif of the temple front?

Andrea Palladio's *Quatro libri dell'architettura* (*THE FOUR BOOKS OF ARCHITECTURE*) has influenced architects for more than four centuries. Thomas Jefferson, for instance, once referred to it as "the Bible," and the "Palladian" window is still a feature of today's homes. In spectacular detailed drawings, Palladio reconstructed the ruins of classical temples, shrines, basilicas, and arenas, so that they would serve as models for contemporary practitioners. He also presented his own designs for country houses (*ville*), town houses (*palazzi*), and a monastery (*convento*).

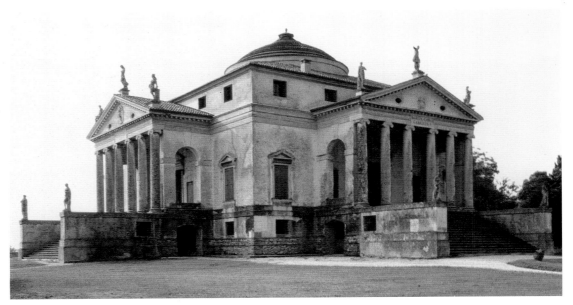

14-17 Andrea Palladio. Villa Rotonda, Vicenza. c. 1567–70

Like Alberti, he interpreted the historical evidence in a selective fashion. He was convinced, on the basis of Vitruvius and Pliny, that Roman private houses had porticoes like these. (Excavations have since proved him wrong.) But Palladio's use of the temple front here is not mere antiquarianism. He regarded this feature as both legitimate and essential for decorum—namely, appropriateness, beauty, harmony, and utility—befitting the houses of "great men." This concept, embedded in the social outlook of the later sixteenth century, was similar to that introduced in theater by Julius Caesar Scaliger and Lodovico Castelvetro. Beautifully correlated with the walls behind and the surrounding vistas, the porches of the Villa Rotonda give the structure an air of serene dignity and festive grace that is enhanced by Lorenzo Vicentino's sculptures.

RELIGIOUS ARCHITECTURE

Della Porta The problem of how to fit a classical facade onto a basilican church remained the greatest challenge faced by Italian architects. Alberti's compromise at S. Andrea in Mantua (see fig. 12-11) was too singular to provide a guideline for later architects. Palladio also had great difficulty solving this puzzle. The most widely accepted solution was the facade of Il Gesù (Jesus) in Rome by Giacomo della Porta (c. 1540–1602), who had assisted Michelangelo at St. Peter's and was still using his architectural vocabulary (fig. 14-18). Since it was the mother church of the Jesuits, its design must have been closely supervised so as to conform to the aims of that militant order. We may therefore view it as the architectural embodiment of the spirit of the Counter-Reformation. Indeed, the planning of the structure began in 1550, only five years after the Council of Trent was first convened (see page 325). Michelangelo himself once promised a design, but apparently never furnished it. The present plan by Giacomo Vignola (1507–1573), another former assistant of Michelangelo, was adopted in 1568.

Despite its originality, the facade of Il Gesù is not entirely new. The paired pilasters and broken **architrave** on the lower story are clearly derived from the colossal order on the exterior of St. Peter's (compare fig. 13-12), and small wonder: it was Della Porta who completed Michelangelo's dome. In the upper story the same pattern recurs on a somewhat smaller scale, with four instead of six pairs of supports. The difference in width is bridged by two scroll-shaped buttresses, which hide the roofline. This device, taken from the facade of S. Maria Novella in Florence by Alberti, forms a graceful transition to the large pediment

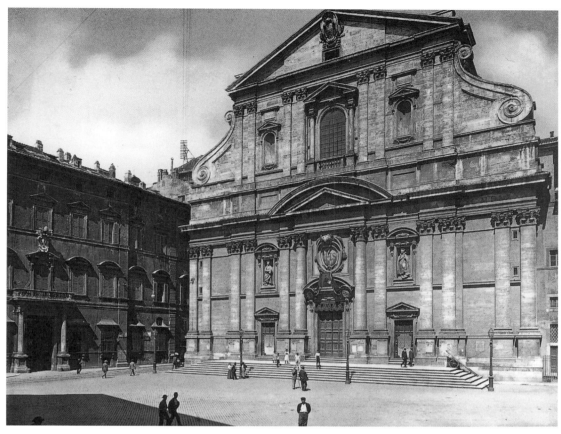

14-18 Giacomo della Porta. Facade of Il Gesù, Rome. c. 1575–84

crowning the facade, which retains the classic proportions of Renaissance architecture. (The height equals the width.)

What is fundamentally new here is the integration of all the parts into a single whole. Della Porta, freed from classicistic scruples by his allegiance to Michelangelo, gave the same vertical rhythm to both stories of the facade. This rhythm is obeyed by all the horizontal members. (Note the broken **entablature**.) In turn, the horizontal divisions determine the size of the vertical members; hence no colossal order. Equally important is the sculptural treatment of the facade, also inspired by Michelangelo, which places greater emphasis on the main portal. Its double frame—

two pediments resting on coupled pilasters and columns—projects beyond the rest of the facade and gives strong focus to the entire design. Not since Gothic architecture has the entrance to a church received such a dramatic concentration of features. The total effect is remarkably theatrical, in the best sense of the term.

What are we to call the style of Il Gesù? Obviously, it has little in common with Palladio. The label *Mannerist* will not serve us either. As we shall see, the design of Il Gesù became basic to Baroque architecture. As with the paintings of Savoldo and Correggio, we may call it Proto-Baroque, which suggests both its great importance for the future and its special place in relation to the past.

CHAPTER 15

"LATE GOTHIC" PAINTING, SCULPTURE, AND GRAPHIC ARTS

Many scholars treat fifteenth-century Northern painting as the counterpart of the Early Renaissance in Italy, and with good reason. It had an impact that went far beyond its own region. In Italy Flemish artists were admired as much as the leading Italian artists. To Italian eyes, their work was clearly postmedieval. Its intense realism had a marked influence on Early Renaissance painting. Should we, then, think of the Renaissance as a unified style? Or should we view it as an attitude that was embodied in several styles?

The Italians, as we have already seen, associated the exact imitation of nature in painting with a "return to the classics." When Boccaccio praised Giotto's imitation of nature, he could not know how many aspects of reality Giotto and his contemporaries had failed to investigate. These, we recall, were further explored later by the painters of the International Style, however tentatively. To go beyond Gothic realism required a second revolution, which began in Italy and in the Netherlands about 1420. We must think of two events, linked by a common aim—the conquest of the visible world—yet sharply divided in almost every other way.

The Italian, or Southern, revolution was more systematic. In the long run, it was also more fundamental, since it included architecture and sculpture as well as painting. There are still many unanswered questions about the Northern revolution and its relation to the Renaissance

as a whole. We do not yet know why the new style emerged in Flanders around 1420, in contrast to the Early Renaissance, which started in Florence under very specific circumstances. Italian Renaissance art, moreover, made very little impression north of the Alps during the fifteenth century. Not until the final decades did humanism become an important force in Northern thought, which it then changed decisively. Nor do we find an interest in the art of classical antiquity before that time. Rather, the artistic and cultural environment of Northern painters clearly remained rooted in the Gothic tradition.

We have, in fact, no satisfactory name for Northern fifteenth-century art as a whole. Whatever we choose to call the style, we shall find that it has some justification. For the sake of convenience, we shall use the label *Late Gothic*. The term hardly does justice to the special character of the new Flemish painting. No matter how cumbersome, it suggests the continuity with the worldview of the late Middle Ages. Netherlandish art, unlike the Italian Renaissance, did not entirely reject the International Style. Instead, Northern painters took it as their point of departure, so that the break with the past was less abrupt than in the South. Despite its great importance, their work may be seen as the final phase of Gothic painting. The term *Late Gothic* also reminds us that fifteenth-century architecture and sculpture outside Italy were an outgrowth of the Gothic.

Netherlandish Painting

Campin The first, and perhaps most decisive, phase of the pictorial revolution in FLANDERS can be seen in the work of an artist formerly known as the Master of Flémalle (after the fragments of a large altar from Flémalle), who was undoubtedly Robert Campin, the foremost painter of Tournai. We can trace his career in documents from 1406 to his death in 1444, although it declined after his conviction in 1428 for adultery, which was a criminal offense at that time. His finest work is the *Mérode Altarpiece* (fig. 15-1, page 348), which

he must have painted soon after 1425. If we compare it to the Franco-Flemish pictures of the International Style (see fig. 11-39), we see that it falls within the same tradition. Yet we also recognize in it a new pictorial experience.

Here, for the first time, we have the sense of actually looking through the surface of the panel into a world that has all the essential features of everyday reality: unlimited depth, stability, continuity, and completeness. The painters of the International Style, even at their most daring, had never aimed at such consistency, and their commitment to reality was far from absolute. Their pictures have the enchanting quality of fairy tales. The scale and relationship of things can be shifted at will, and fact and fancy mingle without conflict. Campin, in contrast, has tried to tell the truth, the whole truth, and nothing but the truth. To be sure, he does not yet do it with total ease. His objects, overly **foreshortened**, tend to jostle each other in space. But he defines every last detail of every object to make it as concrete as possible: its shape and size; its color, material, hardness, and surface textures; and its way of responding to light. The artist even distinguishes between the diffused light, which creates soft shadows and delicate gradations of brightness, and the direct light entering through the two round windows, which produces the twin shadows sharply outlined in the upper part of the center panel and the twin reflections on the brass vessel and candlestick.

The *Mérode Altarpiece* transports us from the aristocratic world of the International Style to the household of a Flemish burgher. Campin was no court painter but a townsperson who catered to the tastes of well-to-do fellow citizens such as the two donors piously kneeling outside the Virgin's chamber. This is the earliest Annunciation in panel painting that occurs in a fully equipped domestic interior. It is also the first to honor Joseph, the humble carpenter, by showing him at work next door.

This bold departure from tradition forced our artist to confront a problem that no one had faced before. He needed to transfer supernatural events from symbolic settings to an everyday environment without making them look either trivial or out of place. He met this challenge by the method

Originally a county (ruled by counts), FLANDERS was a cultural and political entity for many centuries (its original lands are now parts of Belgium, France, and the Netherlands). It was fought over and controlled by a succession of counts, dukes, and kings of France, Burgundy, and Flanders itself. Ghent and Bruges were two of its most important cities. Holland was a county to the north of Flanders, whose history parallels that of Flanders in being subject to outside rule for much of its history. Holland was absorbed into the Netherlands when it was officially formed as a kingdom in 1648. Belgium is a relatively modern entity, a kingdom created in 1839.

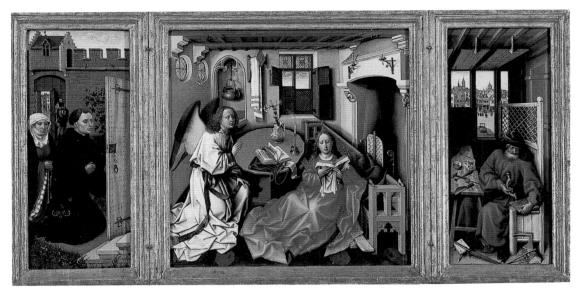

15-1 Robert Campin (Master of Flémalle). *Mérode Altarpiece.* c. 1425–30. Oil on panel, center 25³/₁₆ x 24⁷/₈" (64.1 x 63.2 cm); each wing approx. 25³/₈ x 10⁷/₈" (64.5 x 27.6 cm). The Metropolitan Museum of Art, New York

The Cloisters Collection, 1956

known as "disguised symbolism," which means that almost any detail within the picture, however casual, may carry a symbolic message. We saw its beginnings during the International Style in the *Annunciation* by Melchior Broederlam (see fig. 11-39), but his symbolism seems simple compared with the many hidden meanings in the *Mérode Altarpiece.*

The flowers, for example, are associated with the Virgin. In the left wing the roses denote her charity and the violets her humility, while in the center panel the lilies symbolize her chastity. The shiny water basin and the towel on its rack are not just household equipment. They are further attributes of Mary as the "vessel most clean" and the "well of living waters." Perhaps the most intriguing symbol of this sort is the candle next to the vase of lilies. It has been extinguished only moments before, as we can tell from the glowing wick and the curl of smoke. But why had it been lit in broad daylight, and what made the flame go out? Has the divine radiance of the Lord's presence overcome the material light? Or did the flame of the candle

itself represent the divine light, now extinguished to show that God has become human, that in Jesus "the Word was made flesh"?

Clearly, the entire range of medieval symbolism not only survives in our picture but has been expanded. It is nevertheless so completely immersed in the world of everyday appearances that we often wonder whether a given detail carries a symbolic meaning. Scholars long speculated, for instance, about the boxlike object on Joseph's workbench (and a similar one on the ledge outside the open window). Finally they were identified as mousetraps that convey a specific theological message. According to St. AUGUSTINE, God had to appear on earth in human form so as to fool Satan: "The Cross of the Lord was the devil's mousetrap."

Since it takes much scholarly ingenuity to explain this sort of iconography, we tend to think of the *Mérode Altarpiece* and similar pictures as puzzles. We can still enjoy them without knowing all their symbolism. But what about the patrons for whom these works were painted? Did they

understand the meaning of every detail? They would have had no trouble with the well-established symbols in our picture, such as the flowers, and they probably knew the significance of the water basin. The message of the extinguished candle and the mousetrap could not have been common knowledge even among the well educated, however.

These two symbols—and we can hardly doubt that they are symbols—appear for the first time in the *Mérode Altarpiece*. They must be unusual, too, for St. Joseph with the mousetrap has been found in only one other picture, and the freshly extinguished candle does not occur elsewhere, so far as we know. It seems that Campin introduced them into the visual arts, yet hardly any artists adopted them despite his great influence. If the candle and the mousetrap were difficult to understand even in the fifteenth century, why are they in our picture at all? Was the artist told to put them in by an exceptionally educated patron? This would be possible if it were the only case of its kind, but since there are many instances of equally subtle or obscure symbolism in "Late Gothic" painting, it seems more likely that the initiative came from the artists rather than from their patrons.

Campin either was a man of unusual learning or had contact with theologians or scholars who could supply him with references that suggested the symbolic meanings of things such as the extinguished candle and the mousetrap. In other words, the artist did not simply continue the symbolic tradition of medieval art within the framework of the new realistic style. He enlarged and enriched it by his own efforts. To him, even more than Broederlam, realism and symbolism were interrelated. We might say that Campin needed a growing symbolic repertory because it encouraged him to explore features of the visible world that had not been depicted before, such as a candle just after it has been blown out or the interior of a carpenter's shop, which provided the setting for the mousetraps. For him to paint everyday reality, he had to "sanctify" it with spiritual significance.

This reverence for the physical world as a mirror of divine truths helps us to understand why in the *Mérode* panels the smallest details are rendered with the same attention as the sacred figures. The disguised symbolism of Campin and later painters was not grafted onto the new realistic style. It was ingrained in the creative process. Their Italian contemporaries must have sensed this, for they praised both the realism and the "piety" of the Flemish masters.

Campin's distinctive **tonality** makes the *Mérode* Annunciation stand out from earlier panel paintings. The jewel-like brightness of the older works, their patterns of brilliant hues and lavish use of gold, have given way to a color scheme far less decorative but much more flexible and nuanced. The muted greens and the bluish or brownish grays show a new subtlety, and the scale of intermediate shades is smoother and has a wider range. These effects are essential to the realistic style of Campin. They were made possible by the use of oil.

Tempera and Oil Techniques The basic medium of medieval panel painting had been **tempera**, in which the finely ground pigments were mixed ("tempered") with diluted egg yolk to produce a tough, quick-drying coat of colors that cannot be blended smoothly. Oil, a viscous, slow-drying medium, could produce a vast variety of effects, from thin, translucent films (called **glazes**) to a thick layer of creamy, heavy-bodied paint (called **impasto**). The TONES could also yield the continuous scale of HUES necessary for rendering three-dimensional effects, including rich, velvety dark shades previously unknown. **Oil painting** offers a unique advantage over using egg tempera, **encaustic**, and **fresco**: oils give artists the unprecedented ability to change their minds almost at will. Without oil, the Flemish artists' conquest of visible reality would have been much more limited. Although oil was not unfamiliar to medieval artists, it was Campin and his contemporaries who discovered its artistic possibilities. Thus, from the technical point of view, too, they deserve to be called the founders of modern painting, for oil has been the painter's basic medium ever since.

Jan and Hubert van Eyck The full possibilities of oil were not discovered all at once, nor by any one artist. The great contribution was made by Jan van Eyck, a somewhat younger and much more famous

The vocabulary of color includes the terms *TONE, HUE, tint, shade,* and *intensity. Hue* refers to the name of a color—green, for example. *Tint* refers to a color resulting from the mixture of white with a given hue (light green), and *shade* is the hue darkened by the addition of black (dark green). *Intensity* is the degree of a hue's purity or saturation. *Tone* and *tonality* describe the impression given by a color or a range of colors, which can range from soft to garish.

artist who was long thought to have "invented" oil painting. We know a good deal about Jan's life and career. Born about 1390, he worked in Holland from 1422 to 1424, in Lille from 1425 to 1429, and thereafter in Bruges, where he died in 1441. Both a townsman and a court painter, he was highly esteemed by Duke Philip the Good of Burgundy, who occasionally sent him on diplomatic errands. After 1432, we can follow Jan's career through a number of signed and dated pictures. His older brother Hubert remains a shadowy figure, however. We know only that he died in 1426, as the inscription on the frame of an altarpiece tells us.

There are a number of "Eyckian" works that may have been painted by either or both of the two brothers. The most fascinating of these is a pair of panels showing the Crucifixion and the Last Judgment (fig. 15-2). Their date must be between 1420 and 1425. The style of these paintings has many qualities in common with that of the *Mérode Altarpiece*. These include a total devotion to the visible world, an unlimited depth of space, and angular drapery folds, which are less graceful but far more realistic than the unbroken loops of the International Style. At the same time, the individual forms are not absolutely tangible, like those of Campin, and seem less "sculptural." The sweeping sense of space is the result not so much of foreshortening as of subtle changes of light and color. If we look closely at the *Crucifixion* panel, we see a gradual decrease in the intensity of local colors, and in the contrast of light and dark, from the foreground figures to the far-off city of Jerusalem and the snowcapped peaks beyond. Everything tends toward a uniform bluish-gray, so that the farthest mountain range merges imperceptibly with the color of the sky.

This optical phenomenon is known as **atmospheric perspective**. The Van Eycks were the first to use it systematically, although the Limbourg brothers were aware of it (see fig. 11-40). The atmosphere is never wholly transparent. Even on the clearest day, the air between us and what we are looking at acts as a hazy screen that interferes with our ability to see distant shapes clearly. As we approach the limit of visibility, it swallows them

completely. Atmospheric perspective is more essential to our perception of deep space than scientific perspective, which records the decrease in the apparent size of objects as their distance from the viewer increases. It is effective not only in distant vistas. In the *Crucifixion* panel, even the foreground seems to be enveloped in a delicate haze that softens contours, shadows, and colors. Thus the entire scene has a continuity and harmony beyond the pictorial range of Campin.

How did the Van Eycks achieve this effect? It is difficult to determine their technical process, but there can be no doubt that they used the oil medium with extraordinary refinement. By alternating opaque and translucent layers of paint, they were able to give their pictures a soft, glowing color that has never been equaled, probably because it depends as much on their individual sensibilities as it does on their skillful craftsmanship.

Seen as a whole, the *Crucifixion* seems to lack drama, as if the scene were calmed by some magic spell. Only when we concentrate on the details do we become aware of the violent expressions in the faces of the crowd beneath the Cross, and the restrained but deeply touching grief of the Virgin Mary and her companions in the foreground. In the *Last Judgment* panel, this dual quality of the Eyckian style takes the form of two extremes. Above the horizon, all is order and calm symmetry; below it, on earth and in the realm of Satan, chaos prevails. The two states thus correspond to heaven and hell, contemplative bliss as against physical and emotional turbulence. The lower half, clearly, was the greater challenge to the artist's imaginative powers. The dead rising from their graves with frantic gestures of fear and hope, the damned being torn apart by monsters more terrifying than any we have seen before (compare fig. 10-13), all have the awesome reality of a nightmare. Yet it is "observed" with the same care as the natural world of the *Crucifixion* panel.

The Flemish cities of Tournai, Ghent, and Bruges, where the new style of painting flourished, rivaled those of Italy as centers of international banking and trade. Their foreign residents included many Italian businessmen. Jan van Eyck painted the portrait in figure 15-3 (page 352) to celebrate the

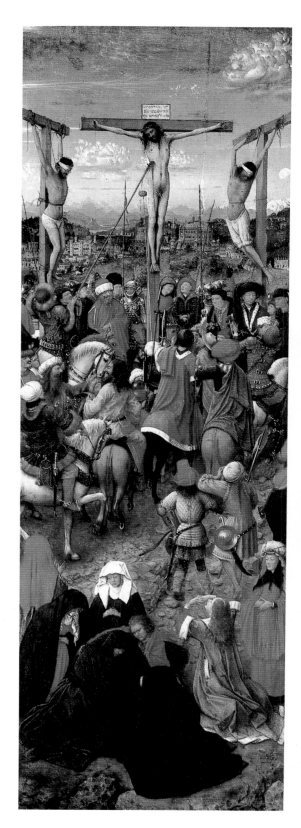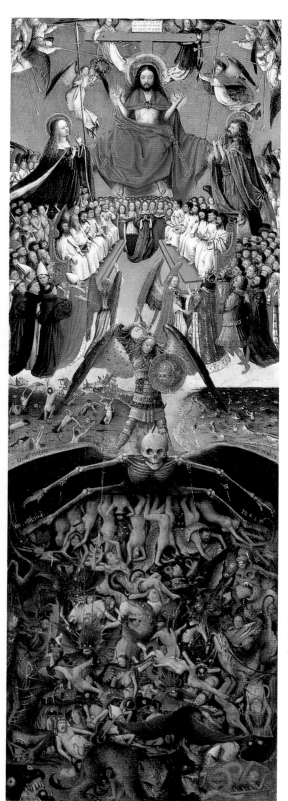

15-2 Hubert and/or Jan van Eyck. *The Crucifixion* and *The Last Judgment*. c. 1420–25. Tempera and oil on canvas, transferred from panel; each panel 22¼ x 7¾" (56.5 x 19.7 cm). The Metropolitan Museum of Art, New York

Fletcher Fund, 1933

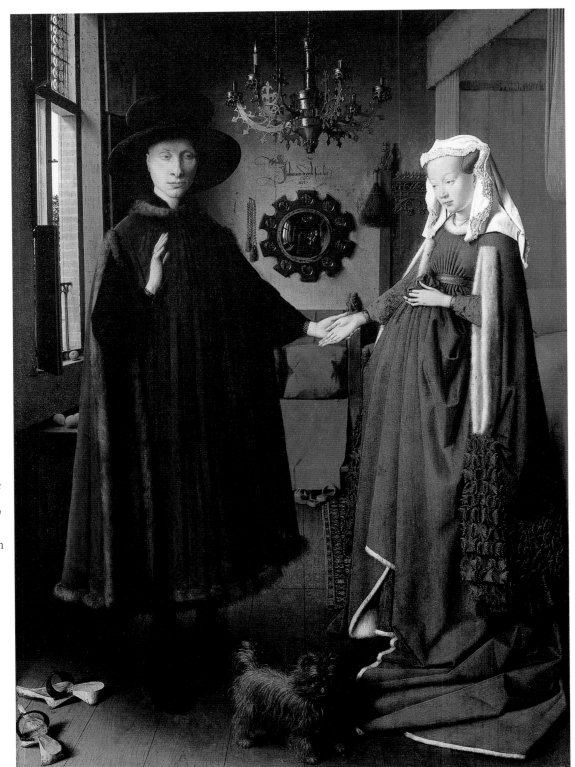

15-3 Jan van Eyck. *The Arnolfini Betrothal.* 1434. Oil on panel, 33 x 22½" (83.8 x 57.2 cm). The National Gallery, London

alliance of two families that were active in Bruges and Paris. It probably shows the betrothal of Giovanni Arnolfini and Giovanna Cenami in the main room of the bride's house, rather than an exchange of marriage vows in the privacy of the bridal chamber, as usually thought. The young couple touch hands as he raises his right hand in solemn oath. (In accordance with Northern custom, the actual wedding no doubt took place later in front of a church, when the young couple's right hands were joined in holy matrimony.) They seem to be quite alone, but in the mirror behind them is the reflection of two other people who have entered the room (fig. 15-4). One of them is presumably the bride's father, who by tradition gives her to the groom. The other must be the artist, since the words above the mirror, in florid lettering, tell us that "Johannes de eyck fuit hic" (Jan van Eyck was here) in the year 1434.

Jan's role, then, is that of a witness to the engagement, which also entailed a legal and financial contract between the two families. The picture claims to show exactly what he saw. Given its secular nature, we may wonder whether the picture is filled with the same sort of disguised symbolism as the *Mérode Altarpiece*. Or does the realism serve simply as an accurate record of the event and its domestic setting? The elaborate bed, the main piece of furniture in the well-appointed living room of the day, was used not for sleeping but for greeting new mothers and paying final respects to the dead. May it not also refer to the physical consummation of marriage? Have the couple taken off their shoes merely as a matter of custom, or to remind us that they are standing on "holy ground"? (For the origin of the theme, see page 49). By the same token, is the little dog a beloved pet, or an emblem of fidelity? (In Latin, *fides* is the root for the words *dog, fidelity,* and *betrothal.*) The other furnishings of the room pose similar questions. What is the role of the single candle in the chandelier, burning in broad daylight (compare page 348)? And is the convex mirror, whose frame is decorated with scenes from the Passion, not also a Vanitas symbol (see fig. 18-14)? Jan was so intrigued by its visual effects that he included it in two other paintings as well.

In the end, we are forced to conclude that here, too, the natural world contains the world of the spirit so completely that the two become one. As our detail of the mirror shows, the young couple are too far from the doorway to have removed their shoes simply out of habit. The mirror and its carved decorations convey a moral message: to think of spiritual values, not simply to enjoy the worldly pleasures represented by the luxurious interior. Nor can the placement of the dog directly below the mirror and squarely between the man and woman be simply a coincidence. As a sacrament, matrimony was holy and binding in a spiritual, not just a legal, sense. Yet, in questioning the traditional reading, we are reminded not to overinterpret the symbolic meaning of an image to the point where it would have been hopelessly obscure even to the artist's contemporaries.

Rogier van der Weyden In the work of Jan van Eyck, the exploration of the reality made visible by light and color reached a level that was not to be surpassed for another two centuries. Rogier van der Weyden (1399/1400–1464), the third great master of early Flemish painting, set himself a different but equally important task: to recapture the emotional drama and pathos of the Gothic past within the framework of the new

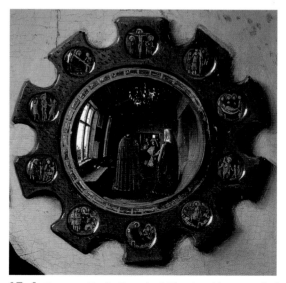

15-4 Jan van Eyck. Detail of *The Arnolfini Betrothal*

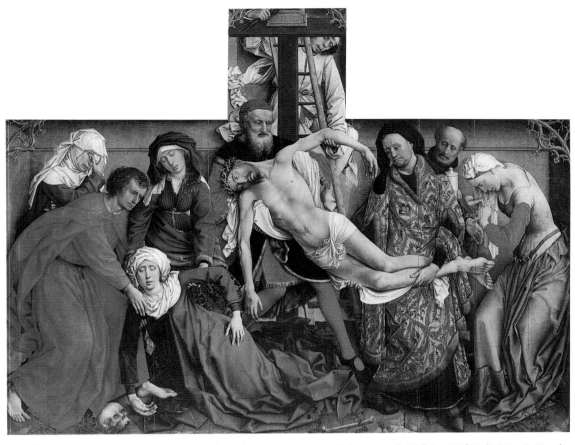

15-5 Rogier van der Weyden. *Descent from the Cross.* c. 1435. Oil on panel, 7'2⅝" x 8'7⅛" (2.20 x 2.62 m). Museo del Prado, Madrid

style. We see this greater expressive immediacy in his early masterpiece, *Descent from the Cross* (fig. 15-5), which dates from about 1435. Here the modeling is sculpturally precise, with angular drapery folds recalling those of Rogier's teacher, Robert Campin. The soft half-shadows and rich colors show his knowledge of Jan van Eyck, with whom he may also have been in contact. Yet Rogier is far more than a follower of the two older artists.

Whatever he owes to them (and it is clearly a great deal) he uses for his own purposes. The external event of lowering Jesus' body from the Cross concerns him less than the world of human feeling: "the inner desires and emotions…whether sorrow, anger, or gladness," in the words of an early

account. The visible world in turn becomes a means toward that same end. Rogier's art has been well described as "at once physically barer and spiritually richer than Jan van Eyck's." Judged for its expressive content, this *Descent* could well be called a *Lamentation*. The Virgin's swoon echoes the pose and expression of her son. So intense are her pain and grief that they inspire the same compassion in the viewer. Rogier has staged his scene in a shallow niche or shrine, not against a landscape. This bold device gives him a double advantage in heightening the effect of the tragic event. It focuses the viewer's attention on the foreground and allows the artist to mold the figures into a coherent group. It seems fitting that Rogier treats his figures as if they were colored statues, for the

source of these grief-stricken gestures and faces is in sculpture rather than in painting. The panel descends from the Strasbourg *Death of the Virgin* (see fig. 11-20), to which it is very similar in both composition and mood.

Truly "Late Gothic," Rogier's art never departs from the spirit of the Middle Ages. Yet visually it belongs just as clearly to the new era, so that the past is restated in contemporary terms. Thus Rogier was accessible to people who retained a medieval outlook. No wonder he set an example for countless other artists. When he died in 1464, after 30 years as the foremost painter of Brussels, his influence was supreme throughout Europe north of the Alps. Its impact continued to be felt almost everywhere outside Italy, in painting as well as sculpture, until the end of the fifteenth century.

Hugo van der Goes Few of the artists who followed Rogier van der Weyden escaped from his shadow. To them his paintings offered a choice between intense drama and delicate restraint. The vast majority chose the latter, and their work is marked by a fragile charm. The most dynamic of

Rogier's disciples was Hugo van der Goes (c. 1440–1482), an unhappy genius whose tragic end suggests an unstable personality. After a spectacular rise to fame in the cosmopolitan atmosphere of Bruges, he decided to enter a monastery as a lay brother in 1475, when he was about 35 years old. He continued to paint for some time, but increasing fits of depression drove him to the verge of suicide, and seven years later he was dead.

The huge altarpiece commissioned in 1475 by Tommaso Portinari, an agent of the Medicis in Bruges, is Van der Goes's most ambitious work (fig. 15-6). There is a tension between the artist's devotion to the natural world and his concern with the supernatural that suggests a nervous and restless personality. Hugo has rendered a wonderfully spacious and atmospheric landscape with a wealth of precise detail. Yet the difference in the size of the figures seems to contradict this realism. In the wings, the kneeling members of the Portinari family are dwarfed by their patron saints, whose gigantic size marks them as beings of a higher order. The latter figures are not meant to be "larger than life," however. They share the

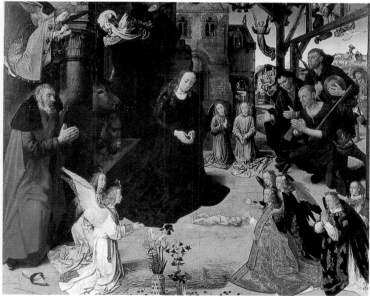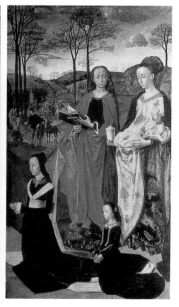

15-6 Hugo van der Goes. *Portinari Altarpiece* (open). c. 1476. Tempera and oil on panel, center 8'3¹/₂" x 10' (2.53 x 3.05 m); wings each 8'3¹/₂" x 4'7¹/₂" (2.53 x 1.41 m). Galleria degli Uffizi, Florence

same huge scale with Joseph, the Virgin Mary, and the shepherds of the Nativity in the center panel, whose height is normal in relation to the architecture and to the ox and ass. The angels are on the same scale as the donors, and thus appear abnormally small.

This change of scale stands outside the logic of everyday experience found in the setting that the artist has provided for his figures. Although it originated with Rogier van der Weyden and has a clear symbolic purpose, Hugo exploited this variation for expressive effect. There is another striking contrast between the hushed awe of the shepherds and the ritual solemnity of all the other figures. These field hands, gazing in breathless wonder at the newborn Child, react to the miracle of the Nativity with a wide-eyed directness new to Flemish art. They were especially admired by the Italian

painters who saw the work after Portinari brought it to Florence in 1483.

Bosch During the last quarter of the fifteenth century, there were no painters in Flanders comparable to Hugo van der Goes, and the most original artists appeared farther north, in Holland. One of these, Hieronymus Bosch, appeals to our interest in the world of fantasy. Little is known about him except that he came from a family of painters named Van Aken, spent his life in the provincial town of 's Hertogenbosch, and died, an old man, in 1516. His work, full of weird and seemingly irrational imagery, has proved difficult to interpret.

Bosch's most famous work, the TRIPTYCH known as *The Garden of Delights* (fig. 15-7), is the richest and most puzzling of all. Of the three

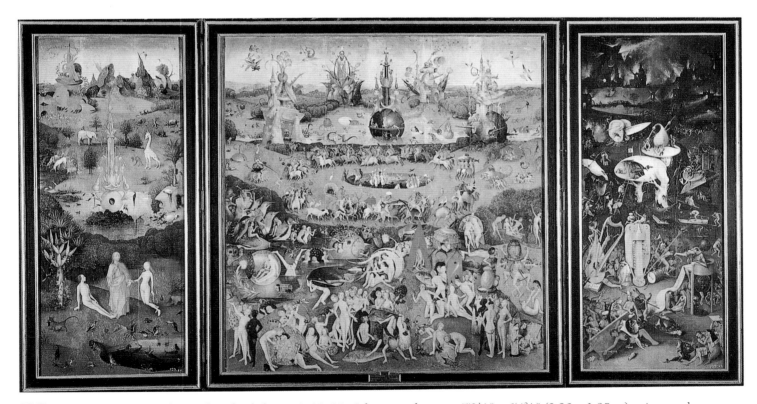

15-7 Hieronymus Bosch. *The Garden of Delights.* c. 1510–15. Oil on panel, center 7'2½" x 6'4¾" (2.20 x 1.95 m); wings each 7'2½" x 3'2" (2.20 m x 96.5 cm). Museo del Prado, Madrid

panels, only the left has a clearly recognizable subject. It is the Garden of Eden, where the Lord introduces Adam to the newly created Eve. The airy landscape is filled with animals, including such exotic creatures as an elephant and a giraffe, as well as sinister hybrid monsters. The right wing, a nightmarish scene of burning ruins and instruments of torture, surely represents hell. But what of the center panel? Here is a landscape much like that of the Garden of Eden, populated with countless nude men and women engaged in a variety of strange acts. In the center, they parade around a circular basin on the backs of all sorts of beasts. Many frolic in pools of water. Most of them are linked with huge birds, fruit, flowers, or marine animals. Only a few are openly engaged in lovemaking, but there can be no doubt that the birds, fruit, and the like are thinly disguised symbols of carnal desire. The delights in this "garden" are an unending repetition of the original sin of Adam and Eve, which dooms us in our life on earth to be prisoners of our appetites.

The picture's strange qualities stem in part from the fact that this is not a traditional altarpiece but a secular work. It was probably commissioned by Henry III of Nassau for his palace in Brussels, where it was hanging just after Bosch's death. (Henry would have been familiar with Bosch's work in 's Hertogenbosch, the royal summer residence.) Much of the imagery in *The Garden of Delights* derives from *The Romance of the Rose*. This allegorical poem on love, modeled loosely on Ovid's *Art of Love*, was begun around 1230–40 by Guillaume de Lorris (named for his hometown near Orléans) and greatly expanded around 1275 by Jean Chopinel, better known as Jean de Meung for his birthplace, also in the vicinity of Orléans. It remained the most popular literary work in France for nearly three centuries. Bosch may well have known the version by Jean Molinet toward the end of the fifteenth century, but others would also have been available to him. (It is most familiar to English-speaking peoples in Geoffrey Chaucer's translation of the late 1360s.)

There are many parallels between *The Garden of Delights* and *The Romance of the Rose*. The title of Bosch's painting actually comes from the garden where the lover conquers his lady, whose symbol is the rose. As in the picture, the central feature is a fountain, where Narcissus fell in love with his reflection, thus giving rise to natural, or earthly, love. De Lorris's original poem begins in the garden after THE FALL. It is cast as a sexual nightmare that is further interpreted in de Meung's commentary covering a wide range of subjects, such as the sins of the clergy, which are treated in other works by Bosch as well. Both painting and poem use irony to teach moral lessons by horrid example. The difference is that in *The Romance of the Rose*, earthly love may lead to a higher, spiritual love and thus to divine love and redemption. Nowhere, however, does Bosch even hint that salvation is possible. Corruption, on the animal level at least, was already found in the Garden of Eden before the Fall; hence we are all destined for hell, the Garden of Satan, with its grisly instruments of torture.

Bosch, then, has not simply illustrated *The Romance of the Rose* but interpreted it in highly personal terms, based in part on popular sayings of the day. We also know that the shapes of the fountains and many other forms were taken from treatises on ASTROLOGY and ALCHEMY, which Bosch would have known through his father-in-law, a well-to-do pharmacist. Astrology and alchemy united the HUMORS with the ZODIAC in a scheme of good and evil paralleling that of the poem. In the context of *The Garden of Delights* they represent earthly knowledge, which is the corruption of spiritual knowledge, just as earthly love is the sinful opposite of divine love.

Swiss and French Painting

After about 1430, the new realism of the Flemish masters began to spread into France and Germany. By the middle of the century, its influence prevailed everywhere in Northern Europe, from Spain to the Baltic. Among the countless artists (including many whose names are not known) who turned out provincial versions of Netherlandish painting, only a few were gifted enough to impress us with a distinctive personality.

Judeo-Christian belief holds that the first male and female, Adam and Eve, were originally immortal and lived in the Garden of Eden. When they consciously disobeyed one of the few rules God had laid down and ate a fruit from the Tree of the Knowledge of Good and Evil, they committed the original sin. For this, God forced them to leave the garden, imbued them with the sense of shame, and took back the gift of eternal life. These events are known as THE FALL.

ASTROLOGY is the art and science of foretelling events by observing and interpreting the movements of the sun, moon, planets, and stars. In the Middle Ages and until the sixteenth century, astrology was regarded very seriously. ALCHEMY is the supposed transformation of base metals into silver and gold; its practitioners, alchemists, relied on astrologists to advise them on the most propitious times to perform their mystical and secretive activities. The ZODIAC technically is a zone of the sky encompassing the major paths of the sun, moon, and planets. It is divided into 12 equal areas of 30 degrees, each named for a major constellation of stars. The interplay of the zodiacal sections is important to astrology. The four HUMORS—identified in ancient times as blood, phlegm, black bile, and yellow bile—were thought to determine health and temperament.

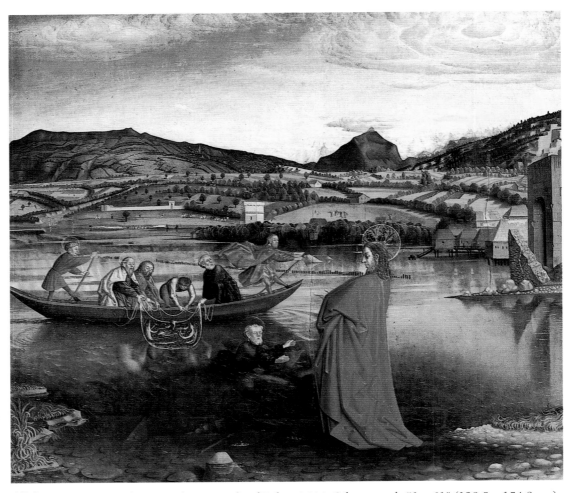

15-8 Conrad Witz. *The Miraculous Draught of Fishes.* 1444. Oil on panel, 51 x 61" (129.5 x 154.9 cm). Musée d'Art et d'Histoire, Geneva

Witz One of the earliest and most original of these masters was Conrad Witz of Basel (1400/10–1445/6). His altarpiece for Geneva Cathedral, painted in 1444, includes the panel shown in figure 15-8. To judge from the drapery, with its tubular folds and angular breaks, he must have had close contact with Campin. But it is the setting, rather than the figures, that attracts our interest, and here the influence of the Van Eycks seems dominant. Witz, however, did not simply follow these great masters. An explorer himself, he knew more about the optical appearances of water than any other painter of his time, as we can see from the bottom of the lake in the foreground. The landscape, too, is an original

contribution. Representing a specific part of the shore of Lake Geneva, it is among the earliest landscape "portraits" that have come down to us.

Fouquet In France, the leading painter was Jean Fouquet (c. 1420–1481) of Tours. As the result of a lengthy visit to Italy around 1445, soon after he had completed his training, Fouquet's work blends Flemish and Early Renaissance elements, although it remains basically Northern. *Étienne Chevalier and St. Stephen,* the left wing of the *Melun Diptych* (fig. 15-9), his most famous work, shows his mastery as a portraitist. The head of the saint seems no less individual than that of the donor. Italian

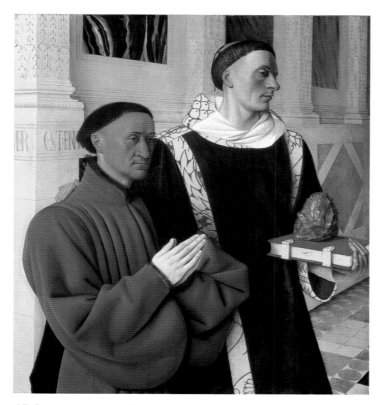

15-9 Jean Fouquet. *Étienne Chevalier and St. Stephen,* left wing of the *Melun Diptych.* c. 1450. Oil on panel, 36¹/₂ x 33¹/₂" (92.7 x 85 cm). Staatliche Museen zu Berlin, Gemäldegalerie

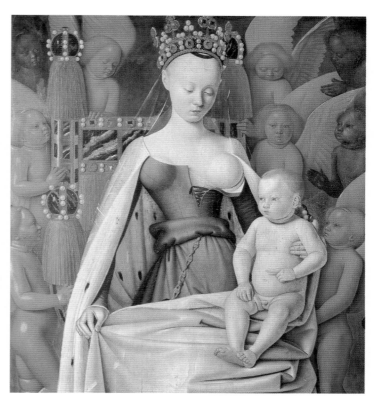

15-10 Jean Fouquet. *Madonna and Child,* right wing of the *Melun Diptych.* c. 1450. Oil on panel, 36⁵/₈ x 33¹/₂" (93 x 85 cm). Musée Royal des Beaux-Arts, Antwerp

influence can be seen in the style of the architecture and, less directly, in the statuesque solidity of the two figures. According to an old tradition, the Madonna in the right wing (fig. 15-10) is also a portrait: of Agnes Sorel, Charles VII's mistress. (Chevalier, the king's secretary and lord treasurer, served as executor of her estate upon her death in 1450, when our diptych may have been painted.) If so, it presents an idealized image of courtly beauty, as befits the Queen of Heaven, seen wearing a crown amid a choir of angels. (Her bared, ample breast signifies the lactating Mary who nurtures the infant Jesus.)

Here we see the beginnings of the tendency toward intellectual clarity and visual abstraction that were to become distinctive to French art. This emphasis even extends to the background. The treatment of space is very different in the two panels, not out of disregard for visual perspective but in order to distinguish between the temporal and spiritual realms. Thus each half of the diptych is a self-contained world. In turn, pictorial space for Fouquet exists independently of the viewer's "real" space.

"Late Gothic" Sculpture

If we had to describe fifteenth-century art north of the Alps in a single phrase, we might label it "the first century of panel painting." Panel painting was so dominant in the period between 1420 and 1500 that its standards apply to manuscript illumination, stained glass, and even sculpture. After the later thirteenth century, we will recall,

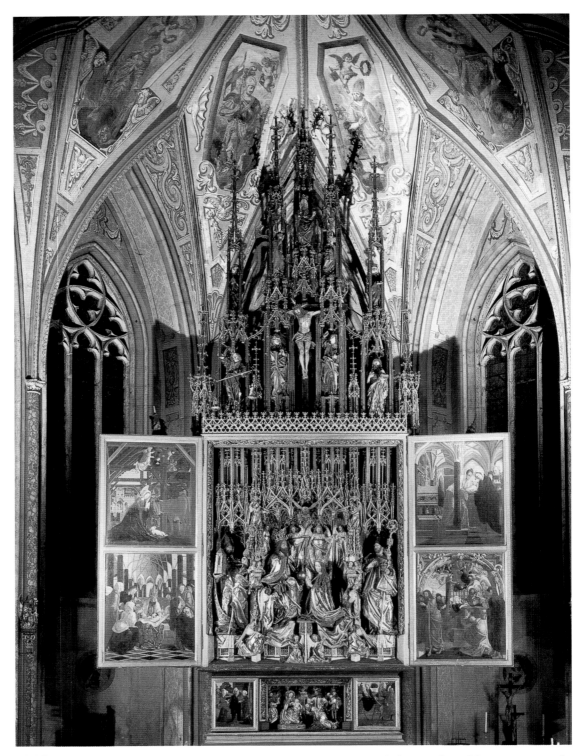

15-11 Michael Pacher. *St. Wolfgang Altarpiece.* 1471–81. Carved wood, figures about life-size; wings, oil on panel. Church of St. Wolfgang, Austria

the emphasis had shifted from architectural sculpture to the more intimate scale of devotional images, tombs, pulpits, and the like. Claus Sluter, whose art is so impressive in weight and volume (see fig. 11-25), had briefly recaptured the monumental spirit of the High Gothic. However, he had no real successors, although echoes of his style can be felt in French art for the next 50 years. It was the influence of Campin and Rogier van der Weyden that ended the International Style in the sculpture of Northern Europe. The carvers, who quite often were also painters, reproduced the style of these artists in stone or wood until about 1500.

Pacher The most important works of the "Late Gothic" carvers are wooden altar shrines, often large in size and intricate in detail. Such shrines were especially popular in the Germanic countries. One of the richest examples is the *St. Wolfgang Altarpiece* (fig. 15-11) by the Tyrolean sculptor and painter Michael Pacher (c. 1435–1498). Its lavishly gilt and colored forms make a dazzling spectacle as they emerge from the shadows under FLAMBOYANT canopies. We enjoy it, but in pictorial rather than sculptural terms. We have no sense of volume, either positive or negative. The figures and setting in the central panel, showing the Coronation of the Virgin, seem to melt into a pattern of twisting lines that permits only the heads to stand out as separate elements.

Surprisingly, when we turn to the paintings of scenes from the life of the Virgin on the interior of the wings, we enter a different realm, one that already commands the vocabulary of the Northern Renaissance. Here the artist provides a deep space in scientific perspective that takes the viewer's vantage point into account, so that the upper panels are represented slightly from below. The figures, strongly modeled by the clear light, seem far more "sculptural" than the carved ones, even though they are a good deal smaller. It is as if Pacher the sculptor felt unable to compete with Pacher the painter in rendering three-dimensional bodies and therefore chose to treat the Coronation of the Virgin in pictorial terms, by extracting the maximum of drama from contrasts of light and shade.

The Graphic Arts

PRINTING

We must now take note of another important event: the development of printmaking, which had a profound effect on Western civilization. Our earliest printed books in the modern sense were produced in the Rhineland soon after 1450. (It is not certain whether Johannes Gutenberg deserves the priority long claimed for him.) The new technique quickly spread all over Europe and developed into an industry, ushering in the era of increased literacy. Printed pictures had hardly less importance, for without them the printed book could not have replaced the work of the medieval scribe and illuminator so quickly and completely. The pictorial and the literary aspects of printing were, indeed, closely linked from the start.

The idea of printing pictorial designs from blocks of wood onto paper seems to have originated in Northern Europe at the very end of the fourteenth century. Many of the oldest surviving examples of such prints, called **woodcuts**, are German, others are Flemish, and some may be French, but all show the qualities of the International Style. The designs were probably furnished by painters or sculptors. The actual carving of the wood blocks, however, was done by specially trained artisans, who also produced wood blocks for textile prints. As a result, early woodcuts, such as the *St. Dorothy* in figure 15-12 (page 362), have a flat, ornamental pattern. Forms are defined by simple, heavy lines, and there is little concern for three-dimensional effects, as indicated by the absence of HATCHING or SHADING. Since the outlined shapes were meant to be filled in with color, these prints often recall stained glass (compare fig. 11- 29) more than the miniatures they replaced.

ENGRAVING

Whoever first thought of metal type for setting text probably had the aid of goldsmiths to work out the technical production problems. This is all the more likely since many goldsmiths had already entered the field of printmaking as engravers. The technique of **engraving**—of embellishing metal surfaces with incised pictures—was developed

The term *FLAMBOYANT style* is used to characterize the last phase of Gothic architecture in France, ranging from the late fourteenth to the early sixteenth century. The most common feature of the style is a sinuous tracery with flamelike shapes, but it is also characterized by wide arches, flattened arcades, and star-patterned rib vaults.

HATCHING and SHADING are two methods of creating dark areas and enhancing an illusion of three-dimensionality in drawings and prints. Individual hatch lines often taper from thin to thick. To intensify darkness, hatch lines may be superimposed at angles, which is called cross-hatching. Shading can be achieved through many means; it is the simple manipulation of light and dark areas to model an object.

hatching and cross-hatching

shading

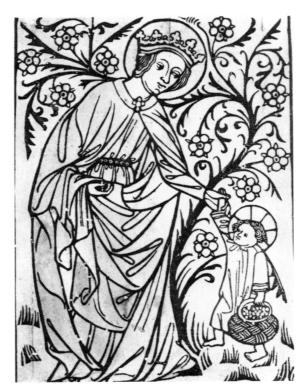

15-12 *St. Dorothy.* c. 1420. Woodcut, 10⅝ x 7½" (27 x 19.1 cm). Staatliche Graphische Sammlung, Munich

WOODCUT is a printmaking relief process: the image is created by carving away what is not to appear and inking only the "raised" lines and areas that remain. ENGRAVING, in contrast, is an intaglio process, and engravings are intaglio prints. The image is made by incising the metal plate, using a burin; ink is pushed into the shallow incised troughs left by the incising process. Prints are made by applying great pressure on dampened paper laid over the ink metal plate, which forces the ink from the crevices in the plate onto the surface of the paper.

burin

in classical antiquity and continued to be practiced throughout the Middle Ages (see figure 10-19, where the engraved lines are filled in with enamel). Thus, no new skill was required to engrave a plate that was to serve as the matrix for a paper print.

The idea of making an engraved print, or ENGRAVING, apparently came from the desire for an alternative to WOODCUTS. In a woodcut, lines left by gouging out the block are ridges; hence, the thinner they are, the more difficult to carve. In an engraving, lines are incised with a tool (called a **burin**) into a metal plate, usually copper, which is relatively soft and easy to work, so that they are much more refined and flexible.

Despite their appeal to modern eyes, fifteenth-century woodcuts were popular art, on a level that did not attract artists of great ability until shortly before 1500. A single wood block yielded thousands of copies, to be sold for a few pennies apiece, so that for the first time in history anyone could own pictures. From the first, however, engravings appealed to a smaller and more sophisticated public. The oldest examples we know, dating from about 1430, already show the influence of the great Flemish painters. Their forms are systematically modeled with fine hatched lines and often convincingly foreshortened. Nor do engravings share the anonymity of early woodcuts. Individual hands can be distinguished almost from the beginning, dates and initials appear soon after, and most of the important engravers of the last third of the fifteenth century are known to us by name. Although the early engravers were usually trained as goldsmiths, their prints are so closely linked to local painting styles that it is far easier to determine their place of origin than it is for woodcuts.

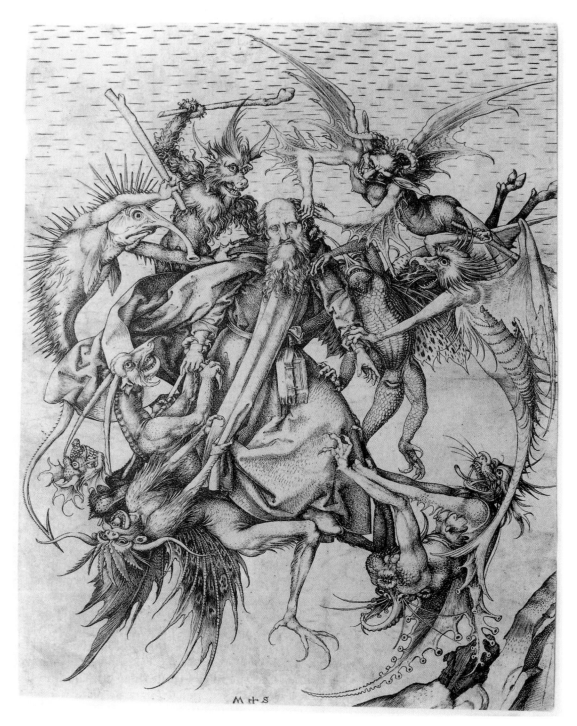

15-13 Martin Schongauer. *The Temptation of St. Anthony.* c. 1480–90. Engraving, $11\frac{1}{2}$ x $8\frac{5}{8}$" (29.2 x 21.8 cm). The Metropolitan Museum of Art, New York

Rogers Fund, 1920

Especially in the Upper Rhine region, we can trace a continuous tradition of fine engravers from the time of Conrad Witz to the end of the century.

Schongauer The finest of the Upper Rhenish engravers was Martin Schongauer (c. 1430–1491). He was the first printmaker whom we also know as a painter, and the first to gain international fame. Schongauer might be called the Rogier van der Weyden of engraving. After learning the goldsmith's craft in his father's shop, he must have spent considerable time in Flanders, for he shows a thorough knowledge of Rogier's art. His prints are filled with motifs and expressive devices that reveal a deep affinity to the great Fleming. Yet Schongauer was a highly original artist in his own right. His finest engravings have a complex design, spatial depth, and rich texture that make them equivalent to panel paintings. In fact, lesser artists often found inspiration in them for large-scale pictures. They were also copied by other printmakers.

The Temptation of St. Anthony (fig. 15-13, page 363), one of Schongauer's most famous works, masterfully combines intense expressiveness and formal precision, violent movement and ornamental stability. Schongauer was not surpassed by any later engraver in his range of tonal values, the rhythmic beauty of his engraved line, and his ability to render every conceivable kind of surface—spiky, scaly, leathery, furry—by varying the burin's attack upon the plate. Although he remained Late Gothic in spirit, Schongauer paved the way for Albrecht Dürer, who was to become the greatest representative of the Renaissance in the North (see pages 368–70). Indeed, Dürer hoped to become a member of Schongauer's workshop, but he did not arrive in Colmar until shortly after the older artist's death.

THE RENAISSANCE IN THE NORTH

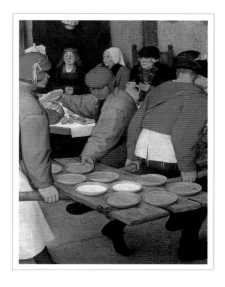

I talian forms and ideas, as we have seen, had little influence on fifteenth-century artists north of the Alps. Since the time of Robert Campin and the Van Eycks they had looked to Flanders, rather than to Tuscany, for leadership. This relative isolation ended suddenly toward the year 1500. As if a dam had burst, Italian influence flowed northward in an ever-wider stream, and Northern Renaissance art began to replace the "Late Gothic." *Northern Renaissance,* however, has a far less well defined meaning than *"Late Gothic,"* which at least refers to a single, clearly recognizable stylistic tradition. During the sixteenth century the variety of trends north of the Alps is even greater than in Italy. Nor does Italian influence provide a common denominator, for this influence is itself diverse: Early Renaissance, High Renaissance, and Mannerist, all are to be found in regional variants from Lombardy, Venice, Florence, and Rome. Its effects, too, vary greatly. They may be superficial or profound, direct or indirect, specific or general. The "Late Gothic" tradition remained very much alive, if no longer dominant. Its encounter with Italian art resulted in a conflict among styles that ended only when the Baroque emerged as an international movement in the early seventeenth century. Its course was decisively affected by the Reformation (see pages 324–26), which had a far greater impact on art north of the Alps than in Italy, but with mixed results. Still, we may speak for the first time of a Renaissance proper in the North. As in Italy, it was marked by an interest in humanism, albeit with equally varied consequences.

Germany

It was in Germany, the home of the Reformation, where the first major stylistic developments took place during the first quarter of the century. Between 1475 and 1500, it had produced such important artists as Michael Pacher and Martin Schongauer (see figs. 15-11 and 15-13), but they hardly prepare us for the extraordinary burst of creative energy that was to follow. This period was as brief and brilliant as the Italian High Renaissance. The range of its achievements can be measured by the contrasting personalities of its greatest artists: Matthias Grünewald and Albrecht Dürer. Both died in 1528, probably at about the same age, although we know only Dürer's birth date (1471). Dürer quickly became internationally famous, while Grünewald, who was born about 1470–80, remained so obscure that his real name, Mathis Gothart Nithart, was discovered only at the end of the nineteenth century.

Grünewald Grünewald's main work, the *Isenheim Altarpiece,* was long believed to be by Dürer. It was painted between about 1509/10 and 1515 for the monastery church of the Order of St. Anthony at Isenheim, in Alsace, not far from the former abbey that now houses it in the city of Colmar. This magnificent altarpiece is unique in Northern Renaissance art: it is fully the equal of the Sistine ceiling in its ambitious program and its ability to overwhelm us.

There are two sets of movable wings, which provide three stages, or "views." The first of these, when all the wings are closed, shows the Crucifixion in the center panel (fig. 16-1)—the most impressive ever painted. In one respect it is very medieval. Jesus' terrible agony and the desperate grief of the Virgin, St. John, and Mary Magdalen recall the older German **Andachtsbild** (see fig. 11-24). But the body on the Cross, with its twisted limbs, its many wounds, its streams of blood, is on a heroic scale that raises it beyond the human and thus reveals the two natures of Christ. The same message is conveyed by the flanking figures. The three historic witnesses on the left mourn Jesus' death as a man. John the Baptist, on the right,

calmly points to him as the Savior foretold in the Bible he holds. Even the background suggests this duality. Golgotha here is not a hill outside Jerusalem, but a mountain towering above lesser peaks. The *Crucifixion,* lifted from its familiar setting, becomes a lonely event silhouetted against a ghostly landscape and a blue-black sky. Darkness is over the land, in accordance with the Gospel, yet light bathes the foreground with the force of revelation. This union of time and eternity, of reality and symbolism, gives Grünewald's *Crucifixion* its awesome grandeur.

When the outer wings are opened, the mood of the *Isenheim Altarpiece* changes dramatically (fig. 16-2). All three scenes in this second view—the *Annunciation,* the *Madonna and Child with Angels,* and the *Resurrection*—celebrate events as jubilant as the *Crucifixion* is solemn. Most striking in comparison with "Late Gothic" painting is the sense of movement found throughout these panels. Everything twists and turns as if it had a life of its own. The angel of the *Annunciation* enters the room like a gust of wind that blows the Virgin backward, and the Risen Christ leaps from his grave with explosive force. This vibrant energy is matched by the ecstatic vision of heavenly glory in celebration of Jesus' birth, seen behind the Madonna and Child, who are the most tender and lyrical in all of Northern art.

In contrast to the brittle contours and angular drapery of "Late Gothic" art, Grünewald's forms are soft and fleshy. His light and color show a similar change. He employs the resources of Flemish art with extraordinary boldness and flexibility. The range of his color scale is matched only by the Venetians. Indeed, his use of colored light has no parallel at that time. Grünewald achieved unsurpassed miracles through light in the luminous angels of the *Madonna and Child,* the apparition of God the father and the heavenly host above the Madonna, and the rainbow-hued radiance of the spectacular Risen Christ.

How much did Grünewald owe to Italian art? Nothing at all, we are first tempted to say. Yet he must have learned from the Renaissance in more ways than one. His knowledge of perspective (note the low horizons) and the vigor of his

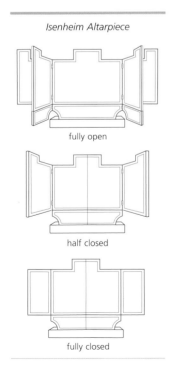

Isenheim Altarpiece

fully open

half closed

fully closed

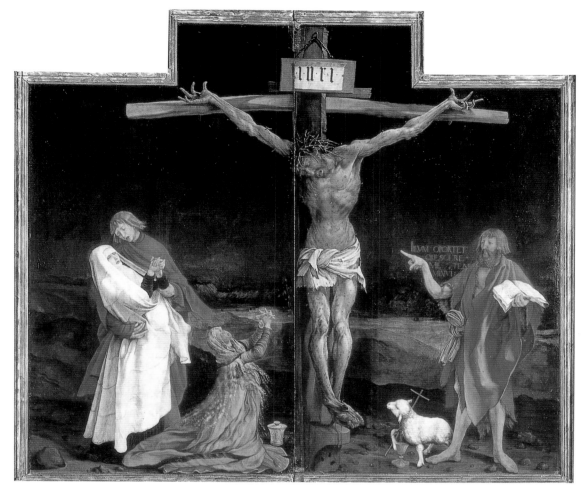

16-1 Matthias Grünewald. *The Crucifixion,* from the *Isenheim Altarpiece* (fully closed, central section). c. 1509/10–15. Oil on panel, 8'10" x 10'1" (2.69 x 3.07 m). Musée Unterlinden, Colmar, France

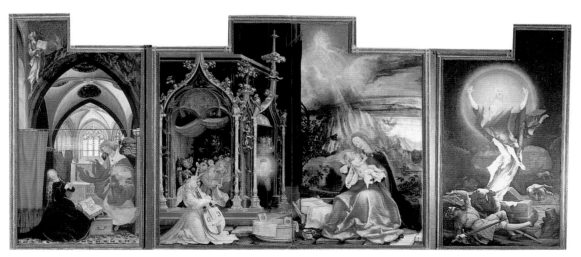

16-2 Matthias Grünewald. *The Annunciation, The Madonna and Child with Angels,* and *The Resurrection,* from the *Isenheim Altarpiece* (half closed). c. 1510–15. Oil on panel, each wing 8'10" x 4'8" (2.69 x 1.42 m); center panel 8'10" x 11'2½" (2.69 x 3.42 m)

figures cannot be explained by the "Late Gothic" tradition alone, and at times his pictures show architectural details of Southern origin.

Perhaps the most important effect of the Renaissance on him, however, was psychological. We know little about his career, but he apparently did not lead the settled life of an artisan-painter controlled by GUILD rules. Like Leonardo, he was also an architect, an engineer, something of a courtier, and an entrepreneur. Moreover, he worked for many different patrons and stayed nowhere for very long. He was in sympathy with Martin Luther even though as a painter he depended on Catholic patronage. In a word, Grünewald seems to have shared the free, individualistic spirit of Italian Renaissance artists. The daring of his pictorial vision likewise suggests that he relied on his own abilities. The Renaissance, then, had a liberating influence on him but did not change the basic cast of his imagination. Instead, it helped him to heighten the expressive aspects of the "Late Gothic" in a uniquely intense and individual style.

Dürer For Albrecht Dürer, the Renaissance held a richer meaning. Attracted to Italian art while still a young journeyman, he visited Venice in 1494/5 and returned to his native Nuremberg with a new view of the world and the artist's place in it. (He was to go again in 1505.) To him, the unbridled fantasy of Grünewald's art was "a wild, unpruned tree" (a phrase he used for painters who worked by rules of thumb, without theoretical foundations) that needed the discipline of the objective, rational standards of the Renaissance. Taking the Italian view that the fine arts belong among the liberal arts, he also adopted the ideal of the artist as a gentleman and humanistic scholar. By cultivating his artistic and intellectual interests, Dürer incorporated an unprecedented variety of subjects and techniques. And as the greatest printmaker of the time, he had a wide influence on sixteenth-century art through his woodcuts and engravings, which circulated widely in Europe.

Dürer was the first artist to be fascinated by his own image. In this respect he was more of a Renaissance personality than any Italian artist. His earliest

GUILDS were associations of people with a common interest or enterprise, such as a business, a profession, or a craft. In the European Middle Ages, two types of guilds succeeded one another as powerful civic and economic forces: the merchant guild and the craft guild. Both were critical in the rise of a prosperous middle class. The merchant guild arose in the eleventh century and virtually regulated commerce and trade. By the fourteenth century, the craft guild had taken its place as the chief commercial institution. Painters belonged to guilds, as did sculptors (carvers) and smiths.

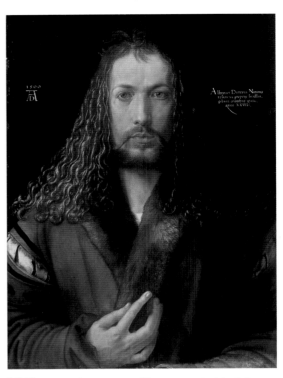

16-3 Albrecht Dürer. *Self-Portrait.* 1500. Oil on panel, 26¼ x 19¼" (66.7 x 49 cm). Alte Pinakothek, Munich

known work, a drawing made at 13, is a self-portrait, and he continued to produce images of himself throughout his career. Most impressive, and uniquely revealing, is the panel of 1500 (fig. 16-3). In pictorial terms, it belongs to the Flemish tradition, but the solemn pose and the idealization of the features have an authority that is beyond the range of ordinary portraits. The picture looks, in fact, like a secularized icon, for it is patterned after images of Christ. It reflects not so much Dürer's vanity as the seriousness with which he viewed his mission as an artistic reformer.

The didactic aspect of Dürer's art is clearest in the engraving *Adam and Eve* of 1504 (fig. 16-4). Here the biblical subject serves as a pretext for the display of two ideal nudes: Apollo and Venus in a Northern forest (compare figs. 5-18 and 5-22). No wonder they look somewhat out of place. Unlike the picturesque setting and the animals in it, Adam and Eve are not observed from life. Instead, they are constructed according to what

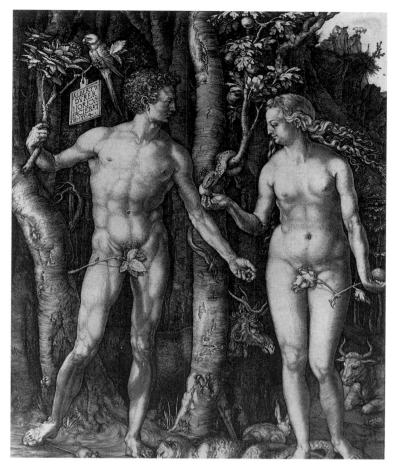

16-4 Albrecht Dürer. *Adam and Eve.* 1504. Engraving, $9^7/_8$ x $7^1/_2$" (25.2 x 19.1 cm). Los Angeles County Museum of Art

Art Museum Council Fund

Dürer believed to be perfect proportions. For the first time, both the form and the substance of the Italian Renaissance enter Northern art, but adapted to the unique cultural climate of Germany. That is why Dürer's ideal male and female figures, although very different from classical examples, were to become models in their own right to countless Northern artists.

The same approach, now applied to the body of a horse, is evident in *Knight, Death, and Devil* (fig. 16-5), one of the artist's finest prints. This time, however, there is no inconsistency. The knight on his mount, poised and confident as an equestrian statue (compare fig. 7-10), embodies an ideal that is both aesthetic and moral. He is the Christian Soldier, steadfast on the road of faith toward the Heavenly Jerusalem and undeterred by the hideous rider threatening to cut him off or the grotesque devil behind him. The dog, a symbol of fidelity, loyally follows its master

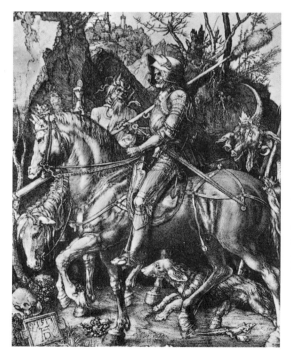

16-5 Albrecht Dürer. *Knight, Death, and Devil.* 1513. Engraving, $9^7/_8$ x $7^1/_2$" (25.2 x 19.1 cm). Museum of Fine Arts, Boston

Gift of Mrs. Horatio Greenough Curtis in memory of her husband

despite the lizards and skulls in their path. Italian Renaissance form, united with the heritage of "Late Gothic" symbolism (whether open or disguised), here takes on a new, characteristically Northern significance.

Dürer seems to have derived the subject of *Knight, Death, and Devil* from the *Manual of the Christian Knight* by Erasmus of Rotterdam, the greatest Northern humanist, whom he later met (see below). His own convictions were essentially those of Christian humanism. They made him an early and enthusiastic follower of Martin Luther, although, like Grünewald, he continued to work for Catholic patrons.

Cranach the Elder Most of Dürer's religious paintings were done before the onset of the Reformation, and his hope for a monumental art embodying the Protestant faith was not fulfilled. Other German painters, notably Lucas Cranach the Elder (1472–1553), tried to cast Luther's doctrines into visual form but created no viable tradition. On his way to Vienna around 1500, Cranach probably visited Dürer in Nuremberg. In any event, he fell under the influence of Dürer's work, which he turned to for inspiration throughout his career. In 1504 Cranach left Vienna for Wittenberg, then a center of humanist learning. There he became court painter to Frederick the Wise of Saxony, who also commissioned works by Dürer, as well as a close friend of Martin Luther, who became a godfather to one of his children. Like Grünewald and Dürer, Cranach relied on Catholic patronage. Some of his altars have a Protestant content but, ironically, they lack the fervor of those he painted before his conversion. Efforts to embody Luther's doctrines in art were doomed, since the spiritual leaders of the Reformation looked upon religious images with indifference or, more often, hostility—even though Luther himself seems to have tolerated them.

Cranach is best remembered today for his portraits and his delightfully incongruous mythological scenes. In *The Judgment of Paris* (fig. 16-6), nothing could be less classical than the three coy damsels, whose wriggly nakedness fits the Northern background better than does the nudity of Dürer's Adam and Eve. Cranach's PARIS is a German knight clad in the fashionable armor of the nobles at the court of Saxony, who were among the artist's patrons. The playful eroticism, small size, and precise, miniaturelike detail make the picture a collector's item, attuned to the tastes of a provincial aristocracy. Cranach's many portraits hardly differ from the doll-like creatures in *The Judgment of Paris.*

Cranach's main contribution lies in the handling of the landscape, which lends Dürer's naturalism an element of fantasy. (Note the crinkly vegetation.) Cranach had developed this manner soon after arriving in Vienna. It played a critical role in the formation of the Danube School, which culminated in the work of Albrecht Altdorfer (c. 1480–1538), a somewhat younger artist who spent most of his career in Bavaria.

Altdorfer Altdorfer's *Battle of Issus* (fig. 16-7, page 372) is as remote from the classical ideal as Cranach's *Judgment of Paris* but far more impressive. We could not possibly identify the subject, Alexander's victory over Darius, without the text on the tablet suspended in the sky and the inscriptions on the banners (they were probably written by the Regensburg court humanist Aventinus) and the label on Darius's fleeing chariot. The artist has tried to follow ancient descriptions of the actual number and kind of combatants in the battle. In doing so, he adopts a bird's-eye view, traditional in Northern landscapes (compare fig. 15-7), so that the two leaders are lost in the ant-like mass of their own armies. (Compare the depiction of the same subject in a Hellenistic mosaic, fig. 5-5.)

However, the soldiers' armor and the fortified town in the distance are unmistakably of the sixteenth century. The picture commemorates a battle that took place in 1529, the year this panel was painted. At that time the Turks tried unsuccessfully to invade Vienna after gaining control over much of eastern Europe. (They were to threaten the city repeatedly for another 250 years.) Neither the Hapsburg emperor Charles V nor Suleiman the Magnificent, the Turkish sultan, was present at this battle. Yet the painting acclaims

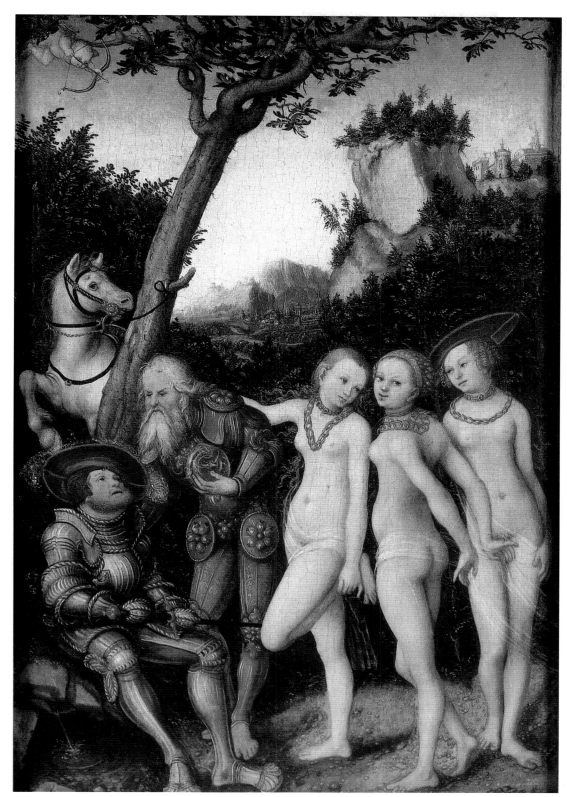

16-6 Lucas Cranach the Elder. *The Judgment of Paris.* 1530. Oil on panel, $13^1/_2$ x $9^1/_2$" (34.3 x 24.2 cm). Staatliche Kunsthalle, Karlsruhe, Germany

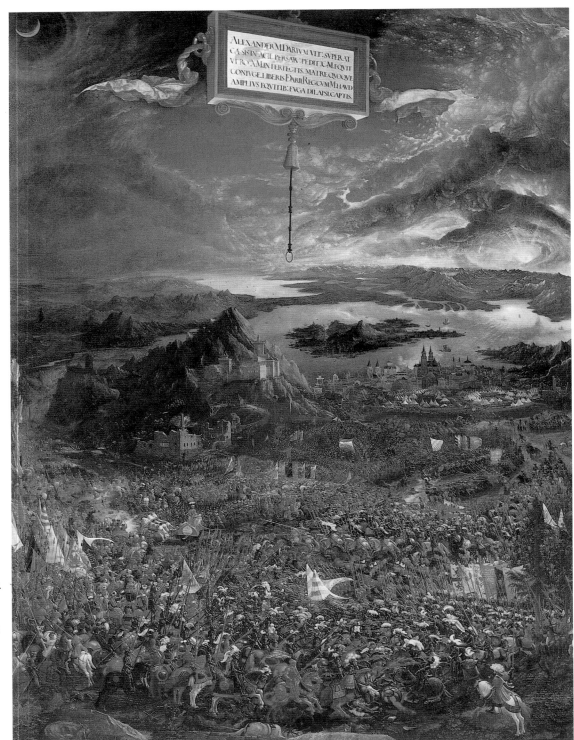

16-7 Albrecht Altdorfer. *The Battle of Issus.* 1529. Oil on panel, 62 x 47" (157.5 x 119.5 cm). Alte Pinakothek, Munich

Charles a new Alexander in his victory over Suleiman, who, like Darius, became the ruler of a vast empire.

To suggest its importance, Altdorfer treats the event as an allegory. The sun triumphantly breaks through the clouds of the spectacular sky and "defeats" the moon, which represents the Turkish Crescent. The celestial drama above a vast Alpine landscape, correlated with the human contest below, raises the scene to the cosmic level. This turbulent sky is strikingly similar to the vision of the Heavenly Host above the Virgin and Child in the *Isenheim Altarpiece* (see fig. 16-2) by Grünewald, who influenced Altdorfer earlier in his career. Altdorfer, too, was an architect and was thoroughly familiar with scientific perspective and with Italian Renaissance style. However, his paintings show the same "unruly" imagination as the work of the older painter. But Altdorfer is unlike Grünewald in treating the human figure with ironic intent by making it incidental to the setting. Tiny figures like the soldiers of *The Battle of Issus* also appear in his other late pictures, and he painted at least one landscape with no figures at all—the first "pure" landscape we know of since antiquity.

Holbein Gifted though they were, Cranach and Altdorfer both evaded the main challenge of the Renaissance so bravely faced, if not always mastered, by Dürer: the human image. Their miniaturelike style set the pace for dozens of lesser masters. Perhaps the rapid decline of German art after Dürer's death was due to lack of ambition among artists and patrons alike. The career of Hans Holbein the Younger (1497–1543), the one painter of whom this is not true, confirms the general rule. The son of an important artist, he was born and raised in Augsburg, a center of international commerce in southern Germany that was particularly open to Renaissance ideas, but he left at the age of 18 with his brother to seek work in Switzerland. Thanks in large part to the help of humanist patrons, he was well established in Basel by 1520 as a decorator, portraitist, and designer of woodcuts. Holbein took Dürer as his point of departure, but almost from the beginning his religious paintings and portraits

show a keen interest in the Italian Renaissance, especially the latest tendencies from Venice and Rome.

Holbein's likeness of ERASMUS of Rotterdam (fig. 16-8), painted soon after the famous author had settled in Basel, gives us a truly memorable image, at once intimate and monumental. This kind of profile view had been popular during the Early Renaissance and was adopted by Dürer late in his career. Here it is combined with a characteristically Northern emphasis on tangible reality to

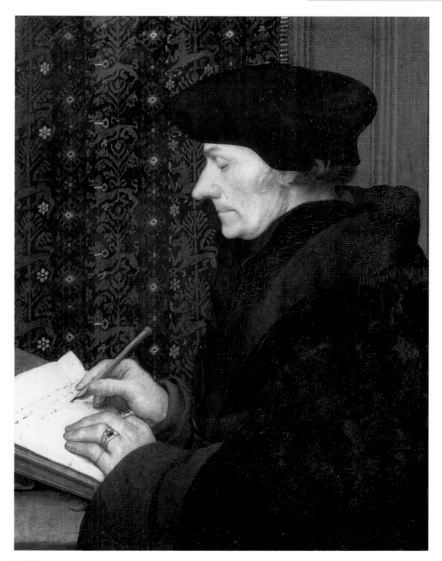

16-8 Hans Holbein the Younger. *Erasmus of Rotterdam*. c. 1523. Oil on panel, 16½ x 12½" (41.9 x 31.8 cm). Musée du Louvre, Paris

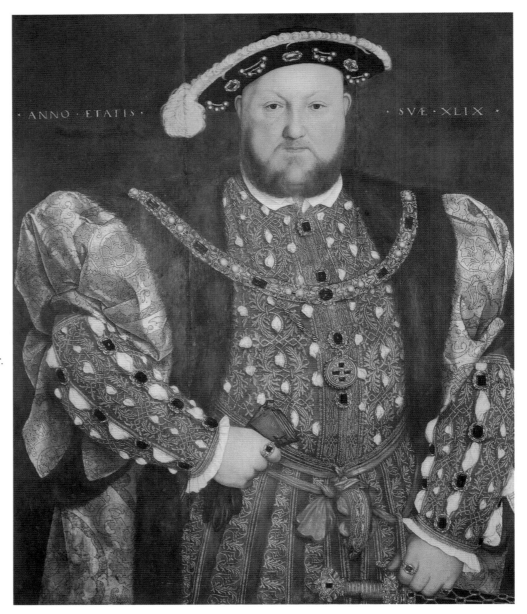

ANNO·ETATIS· **·SVÆ·XLIX·**

16-9 Hans Holbein the Younger. *Henry VIII.* 1540. Oil on panel, 32½ x 29" (82.6 x 73.7 cm). Palazzo Barberini, Galleria Nazionale d'Arte Antica, Rome

convey the sitter's personality in a way that is nonetheless in keeping with High Renaissance concepts. The very ideal of the scholar, this doctor of humane letters has a calm rationality that lends him an intellectual authority formerly reserved for Doctors of the Church. The similarity is intentional. Erasmus took as his model St. Jerome, who translated the Bible into Latin (the Vulgate). In his biography of the saint, Erasmus praises him as

"the best scholar, writer and expositor," who was "equally and completely at home in all literature, both sacred and profane" and "had the whole of Scripture by heart."

Holbein spent 1523–24 traveling in France, apparently with the intention of offering his services to Francis I. When he returned two years later, Basel was in the throes of the Reformation. Hoping that he would obtain commissions at the

court of HENRY VIII, Holbein then went to England. He brought with him the portrait of Erasmus as a gift to the humanist Thomas More, who became his first patron in London. (Erasmus, in a letter recommending him to More, wrote: "Here [in Basel] the arts are out in the cold.") Ironically, Henry had More beheaded in 1525 for refusing to consent to the Act of Supremacy, which made the king the head of the Church of England. When Holbein returned to Basel in 1528, he saw Protestant mobs destroying religious images as "idols"; reluctantly, he abandoned Catholicism. Despite the entreaties of the city council, he left for London four years later, and visited Basel only once more, in 1538, while traveling on the Continent as court painter to Henry VIII. The city council made a last attempt to keep Holbein at home, but he had become an artist of international fame to whom Basel now seemed provincial indeed.

Holbein's style, too, had gained an international flavor. His portrait of Henry VIII (fig. 16-9) has the rigid frontality of Dürer's self-portrait (see fig. 16-3), but its purpose is to convey the almost divine authority of the absolute ruler. The king's physical bulk creates an overpowering sense of his ruthless, commanding personality. The immobile pose, the air of unapproachability, and the precisely rendered costume and jewels show the impact of court portraits that Holbein could have seen on his travels. The type originated in Mannerist portraiture between 1525 and 1550, then spread quickly to other regions as the embodiment of a new aristocratic ideal. Although portraitists in France during the reign of Francis I, such as Jean Clouet (active 1516–40/41), were largely of Flemish origin, the French court was especially hospitable to Italian artists and influences, and imported large numbers of paintings by the leading Italian masters. (For Francis I as a patron of Italian Mannerists, see page 340.) Holbein's pictures molded British taste in aristocratic portraiture for decades, but he had no English disciples of real talent. The Elizabethan genius was more literary and musical than visual, and the English demand for portraits in the later sixteenth century continued to be filled largely by visiting foreign artists.

The Netherlands

The Netherlands in the sixteenth century had the most turbulent history of any country north of the Alps. When the Reformation began, it was part of the empire of the HAPSBURGS under Charles V, who was also king of Spain. Protestantism quickly gained strength in the Netherlands, and attempts to suppress it led to revolt against foreign rule. After a bloody struggle, the northern provinces (today's Holland) emerged at the end of the century as an independent state. The southern ones (roughly corresponding to modern Belgium) remained in Spanish hands.

The religious and political strife might have had catastrophic effects on the arts, but this, astonishingly, did not happen. The art of the period did not equal that of the fifteenth century in brilliance, nor did it produce any pioneers of the Northern Renaissance comparable to Dürer and Holbein. This region absorbed Italian elements more slowly than Germany, but more steadily and systematically, so that instead of a few isolated peaks we find a continuous range of achievement. Between 1550 and 1600, its most troubled time, the Netherlands produced all the major painters of Northern Europe, who in turn paved the way for the great Dutch and Flemish masters of the next century.

Two main concerns, sometimes separate, sometimes interwoven, characterize Netherlandish sixteenth-century painting: to assimilate Italian art from Raphael to Tintoretto (albeit in an often dry and academic manner) and to develop new genres that would supplement, and eventually replace, traditional religious subjects.

Gossaert When Flanders passed from Burgundy to Spain in 1482, Antwerp, with its deep harbor, replaced Ghent and Bruges as the political, commercial, and artistic capital of the Netherlands. Flemish artists spent the next quarter-century largely imitating earlier Netherlandish painting. Then, around 1507, we find two important new developments. *Antwerp Mannerism* is the misleading label applied to the school of largely anonymous painters which first arose in that city.

HENRY VIII (1491–1547) ascended to the throne in 1509 and for the next few years battled the French and the Scots. His 1521 book on the sacraments, written to refute Martin Luther, earned him the title Defender of the Faith. However, his efforts to divorce his wife, Catherine of Aragon, eventually resulted in a complete break with the Church and in Henry's being named head of the Church of England. In his last years, Henry married five more times; two of his wives were executed, he divorced one, one died, and one survived him.

One of Europe's oldest, most powerful, and eminently prominent royal families, the HAPSBURGS first became major players in 1273 with the election of Count Rudolf as German king and Holy Roman Emperor. Through marriages and political alliances, the family produced dukes and archdukes of Austria from the late twelfth century; kings of Hungary and Bohemia from 1526 to 1918; kings of Spain from 1516 to 1700; and emperors of Austria through the nineteenth century until 1918. Their power peaked in the mid-sixteenth century with Holy Roman Emperor Charles V.

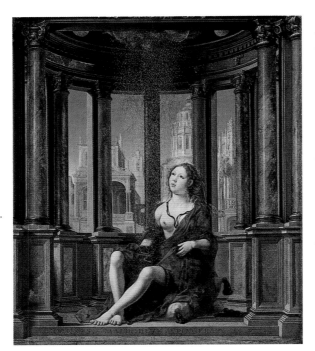

16-10 Jan Gossaert. *Danaë*. 1527. Oil on panel, 44½ x 37⅜" (113 x 95 cm). Alte Pinakothek, Munich

greater monumentality, his religious subjects were based on fifteenth-century Netherlandish art, and he often found it easier to assimilate Italian classicism through the intermediary of Dürer's prints.

Danaë (fig. 16-10), painted toward the end of Gossaert's career, is his most Italianate work. In true humanist fashion, Jupiter's seduction of the mortal is treated as a pagan equivalent of the Annunciation. (For the subject, see page 319.) Thus the picture may be seen as a chaste counterpart to Correggio's *Jupiter and Io* (see fig. 14-8). The god enters, disguised as a shower of gold analogous to the stream of light in the *Mérode Altarpiece* (see fig. 15-1). Despite her partial nudity, Danaë appears as modest as the Virgin in any Annunciation. Indeed, she hardly differs in type from Gossaert's paintings of the Madonna and Child, inspired equally by Van Eyck and Raphael. She even wears the blue robe traditional to Mary as Queen of Heaven. The scientific perspective of the architectural fantasy, compiled largely from Italian treatises such as that published by Sebastiano Serlio in 1545, marks a revolution. Never before have we seen such a systematic treatment of space in the Netherlands.

Still Life, Landscape, and Genre Later religious art in the Netherlands combined Antwerp Mannerism and Romanism to produce a distinctive strain of Northern Mannerism that lasted until the end of the century. After 1550, however, narrative painting was increasingly replaced by secular themes: landscape, **still life**, and **genre** (scenes of everyday life). The process was gradual—it began around 1500 and was not complete until a hundred years later—and was shaped less by the genius of individual artists than by the need to cater to popular taste as Church commissions became scarcer. Protestant iconoclastic zeal was particularly widespread in the Netherlands. Under Calvin's instruction, sculpture, frescoes, and stained glass gave way to clear windows and to whitewashed walls. Still life, landscape, and genre had been part of the Flemish tradition since Campin and the Van Eycks. In the *Mérode Altarpiece* (see fig. 15-1) we recall the objects grouped on the Virgin's table and the scene of Joseph in his

Their preference for elongated forms, decorative surfaces, and arbitrary space seems a return to "Late Gothic" tendencies, although the similarities are superficial. Actually, the style was not directly related either to the Renaissance or to Mannerism in Italy. Still, the term has some basis. It suggests the odd flavor of their work, for it was a "mannered" response to the "classics" by Jan van Eyck, Rogier van der Weyden, and their successors. At almost the same time, a second group of Netherlandish artists, the so-called Romanists, began to visit Italy in the wake of Albrecht Dürer and returned home with the latest tendencies. The preceding generation of Flemish painters had already shown a growing interest in Renaissance art and humanism, but none of them ventured below the Alps, so that they assimilated both at second hand.

The greatest of the Romanists, Jan Gossaert (c. 1478–1532; nicknamed Mabuse, for his hometown), was also the first to travel south. In 1508 he accompanied Philip of Burgundy to Italy, where the Renaissance and antiquity made a deep impression on him. He nevertheless viewed this experience through Northern eyes. Except for their

workshop. We may also think of the outdoor setting of the Van Eyck *Crucifixion* (see fig. 15-2). But these elements were subordinate to the devotional purpose of the whole and were often governed by the principle of disguised symbolism. Now they gained a new independence and grew in importance, until the religious subject could even be relegated to the background.

Patinir We see the beginnings of this approach in the paintings of Joachim Patinir (c. 1485–1524). *Landscape with St. Jerome Removing the Thorn from the Lion's Paw* (fig. 16-11) shows that he is the heir of Bosch in both his treatment of nature and his choice of subject, but without the strange demonic overtones of *The Garden of Delights* (see fig. 15-7). Although the landscape dominates the scene, the figures are central to both its composition and subject. The landscape has been constructed around the hermit in his cave, which could exist happily in another setting, whereas the picture would be incomplete without it.

The painting is an allegory of the pilgrimage of life. It contrasts the way of the world with the road to salvation through ascetic withdrawal. (Note the two pilgrims wending their way up the hill to the right, past the lion hunt, which they do not notice.) The church on the mountain represents the Heavenly Jerusalem, which can be reached only by passing through the hermit's cave (compare fig. 12-23). Like Bosch, Patinir is ambivalent toward his subject. The vista in the background, with its well-kept fields and its tidy villages, is enchanting in its own right. Yet, he seems to tell us, these temptations should not distract us from the path of righteousness.

Aertsen Pieter Aertsen (1508/9–1575) is remembered today mainly as a pioneer of still lifes. However, he seems to have first painted them as a sideline, until he saw many of his altarpieces destroyed by iconoclasts. *The Meat Stall* (fig. 16-12), done a few years before he moved from Antwerp to Amsterdam, seems at first glance to be a purely secular picture. The tiny, distant figures are almost blotted out by the food in the foreground. There seems little interest in selection or

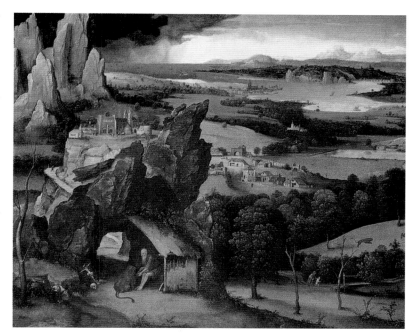

16-11 Joachim Patinir. *Landscape with St. Jerome Removing the Thorn from the Lion's Paw.* c. 1520. Oil on panel, 29¹⁄₈ x 35⁷⁄₈" (74 x 91 cm). Museo del Prado, Madrid

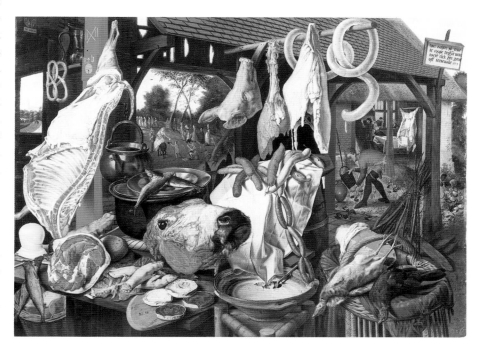

16-12 Pieter Aertsen. *The Meat Stall.* 1551. Oil on panel, 48³⁄₈ x 65³⁄₄" (122.9 x 167 cm). Uppsala University, Sweden, University Art Collections

formal arrangement. The objects, piled in heaps or strung from poles, are meant to overwhelm us with their sensuous reality. (The artist lived near the city's meat market.)

The still life so dominates the picture that it seems independent of the religious subject in the background. Yet the latter is not merely a pretext for the painting; it must be important to the scene's meaning. In the distance to the left we see the Virgin on the Flight into Egypt giving bread to the poor, who are ignored by the worshipers lined up for church. To the right is a tavern scene with the Prodigal Son, who will later repent his sins and return to his forgiving father. The stall has a variety of Christian symbols, many of them disguised, some of them obvious, such as the two pairs of crossed fish, which signify the Crucifixion.

The Northern Mannerists often relegated subject matter to a minor position within their compositions. This "inverted" perspective was a favorite device of Aertsen's younger contemporary Pieter Bruegel the Elder, who treated it with ironic purpose in his landscapes. Aertsen belonged to the same tradition. It was an outgrowth of Northern humanist literature, whose greatest representative was Erasmus of Rotterdam (see above). *The Meat Stall* is, then, a moralizing sermon on gluttony, charity, and faith, possibly relating to Lent, the time of fasting before Easter when meat and fish were traditionally forbidden. Not until around 1600 was this vision displaced as part of a larger change in worldview (see page 416). Only then did it no longer prove necessary to include religious or historical scenes in still lifes and landscapes.

Bruegel the Elder Pieter Bruegel the Elder (1525/30–1569), the only genius among these Netherlandish painters, explored landscape, peasant life, and MORAL ALLEGORY. Although his career was spent in Antwerp and Brussels, he may have been born near 's Hertogenbosch, the home of Hieronymus Bosch. Certainly Bosch's paintings impressed him deeply, and in many ways his work is just as puzzling. What were his religious convictions, his political sympathies? We know little about him, but his interest in folk customs and the daily life of humble people seems to have

sprung from a complex philosophical outlook. Bruegel was highly educated, the friend of humanists, who, with wealthy merchants, were his main clients, although he was also patronized by the Hapsburg court. He apparently never worked for the Church, and when he dealt with religious subjects he did so in a strangely ambiguous way.

Bruegel's attitude toward Italian art is also hard to define. A trip to the South in 1552–53 took him to Rome, Naples, and the Strait of Messina, but the famous monuments admired by other Northerners seem not to have interested him. He returned instead with a sheaf of magnificent landscape drawings, especially Alpine views. He was probably much impressed by landscape painting in Venice, above all its integration of figures and scenery and the progression in space from foreground to background (see figs. 13-16 and 13-17).

Out of this experience came the sweeping landscapes of Bruegel's mature style. *The Return of the Hunters* (fig. 16-13) is one of a set depicting the months. (He typically composed in series.) Such scenes, we recall, had begun with medieval calendar illustrations, and Bruegel's still shows its descent from *Les Très Riches Heures du Duc de Berry* (see fig. 11-40). Now, however, nature is more than a setting for human activities. It is the main subject of the picture. The seasonal tasks of men and women are incidental to the majestic annual cycle of death and rebirth that is the rhythm of the cosmos.

The *Peasant Wedding* (fig. 16-14) is Bruegel's most memorable scene of peasant life. These are stolid, crude folk, heavy-bodied and slow, yet their very clumsiness gives them a strange gravity that commands our respect. Painted in flat colors with little modeling and no cast shadows, the figures nonetheless have a weight and solidity that remind us of Giotto. Space is created in assured perspective, and the composition is as monumental and balanced as that of any Italian master. Why, we wonder, did Bruegel endow this commonplace ceremony with the solemnity of a biblical event? It is because he saw in the life of these rural people the natural condition of humanity. We know from his biographer, Karel van Mander (the "Netherlandish Vasari"), that Bruegel and his patron Hans

Allegory is used to convey symbolic meaning in literary and artistic mediums. Religious allegory uses extended metaphor, parable (a biblical metaphor, usually in narrative form in the New Testament), or fable to teach a lesson. Thus, MORAL ALLEGORY delivers a moral lesson in disguised form. Bruegel's work often makes use of this device.

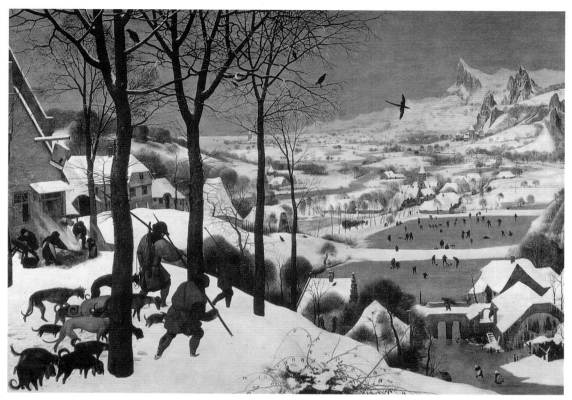

16-13 Pieter Bruegel the Elder. *The Return of the Hunters.* 1565. Oil on panel, 46$\frac{1}{2}$ x 63$\frac{3}{4}$" (118.1 x 161.9 cm). Kunsthistorisches Museum, Vienna

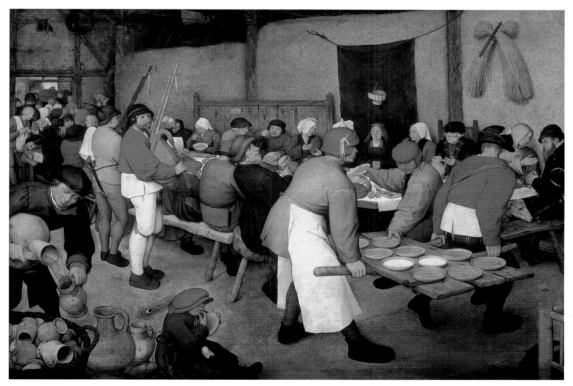

16-14 Pieter Bruegel the Elder. *Peasant Wedding.* c. 1565. Oil on panel, 44$\frac{7}{8}$ x 64$\frac{1}{8}$ " (114 x 162.9 cm). Kunsthistorisches Museum, Vienna

Franckert often disguised themselves as peasants and joined in their revelries, so that Bruegel could draw them from life. In his hands, they become types whose follies he knew at first hand, yet whose dignity ultimately remains intact. For him, Everyman occupies an important place in the scheme of things.

France

It took the Northern countries longer to absorb Italian forms in architecture and sculpture than in painting. France, however, was more closely linked with Italy than the rest. We will recall that it had conquered Milan in 1499. Earlier King Francis I had shown his admiration for Italian art by inviting Leonardo to Fontainebleau before luring several of the leading Mannerists—including Rosso, Primaticcio, and Cellini—to France (see pages 340–41). As a result, France began to assimilate Italian

art and architecture somewhat earlier than the other countries and was the first to achieve an integrated Renaissance style.

Lescot In 1546 Francis I decided to replace the Gothic royal castle, the Louvre (see fig. 11-40), with a new palace on the old site. The project had barely begun at the time of his death, but his architect, Pierre Lescot (c. 1515–1578), continued it under Henry II and quadrupled the size of the court. This enlarged scheme was not completed for more than a century. Lescot built only the southern half of the court's west side (fig. 16-15), which represents its "classic" phase. The term is well justified. Whereas earlier buildings were derived from the Early Renaissance, Lescot drew on the work of Bramante and his successors. Lescot's design is classic in another sense as well. It is the finest surviving example of Northern Renaissance architecture.

The details of Lescot's facade do indeed have a surprising classical purity, yet we would not think

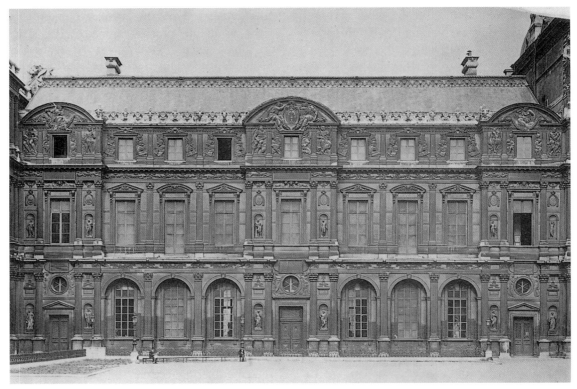

16-15 Pierre Lescot. Square Court of the Louvre, Paris. Begun 1546

it an Italian building. Its distinctive quality comes not from a superficial use of Renaissance forms but from a genuine synthesis of the traditional French CHÂTEAU with the Italian palazzo. The superimposed classical orders, the pedimented window frames, and the arcade on the ground floor are Italian. But the continuity of the facade is broken by three projecting pavilions that have taken the place of the château turrets. The high-pitched roof is also French. The vertical accents thus overcome the horizontal ones. (Note the broken architraves.) This effect is heightened by the tall, narrow windows, which descend from the Gothic. The solution devised by Lescot proved to be so satisfying that the need for a purer classicism was not felt until the completion of the Louvre 120 years later under Louis XIV (see fig. 19-5).

Goujon Equally un-Italian is the rich sculptural decoration covering almost the entire wall surface of the Louvre's third story. These reliefs, beautifully adapted to the architecture, are by Jean Goujon (c. 1510–1565?), the finest French sculptor of the mid-sixteenth century, with whom Lescot often collaborated. Unfortunately, they have been much restored. To get a more accurate idea of Goujon's style, we must turn to the relief panels from the Fontaine des Innocents (fig. 16-16). These are intact, but their architectural framework by Lescot is lost. The graceful figures recall the Mannerism of Cellini and, even more, Primaticcio's Fontainebleau decorations (see figs. 14-13 and 14-14). Like Lescot's architecture, however, they combine purely classical details with a slenderness that gives them a uniquely French air.

Counterpart to the English fortified castle, the French CHÂTEAU (plural, châteaux) was a securely fortified residence and stronghold for French nobility and large landholders in the late Middle Ages and Renaissance. In the sixteenth century, châteaux were less heavily fortified—a moat was usually enough—and were outfitted with gardens and decorative secondary structures.

16-16 Jean Goujon. *Nymphs,* from the Fontaine des Innocents, Paris (dismantled). 1548–49. Bas reliefs, each 6'4³/₄" x 2'4³/₄" (1.95 x .73 m). Musée du Louvre, Paris

CHAPTER 17

THE BAROQUE IN ITALY AND SPAIN

What is Baroque? Like *Mannerism,* the term was originally coined to disparage the style it designates. It meant "irregular, contorted, grotesque." Art historians remain divided over its definition. Should *Baroque* be used only for the dominant style of the seventeenth century, or should it include other tendencies, such as classicism, to which it bears a complex relationship? Should the time frame include the period 1700 to 1750, known as the Rococo? More important, is the Baroque distinct from both Renaissance and modern? Although a good case can be made for viewing the Baroque as the final phase of the Renaissance, we shall treat it as a distinct era. The approach we choose is perhaps less important than understanding the factors that must enter into our decision.

The Baroque cannot be easily classified. It was a time full of contradictions and paradoxes, not unlike the present, which is why we find it so fascinating. It has been claimed that the Baroque style expresses the spirit of the Counter-Reformation. However, by 1600 Catholicism had regained much of its former territory and Protestantism was on the defensive, so that neither side had the power to upset the new balance. In 1622 the heroes of the Counter-Reformation—Ignatius of Loyola, Francis Xavier (both Jesuits), Theresa of Avila, Filippo Neri, and Isidoro Agricola—were named saints. (Carlo Borromeo had already been made one in 1610.) This began a wave of canonizations that lasted through the mid-eighteenth century. In contrast to the piety and good deeds of these reformers, the new princes of the Church who supported the growth of Baroque art were known mainly for their lives of worldly splendor.

Another reason why we should avoid placing too much emphasis on the Baroque's ties to the Counter-Reformation is that, unlike Mannerism, the new style was not specifically

Italian, even though it was born in Rome during the final years of the sixteenth century. Nor was it confined to religious art. Baroque elements quickly entered the Protestant North, where they were applied primarily to secular subjects.

Equally problematic is the idea that Baroque is "the style of absolutism," reflecting the centralized state ruled by an autocrat of unlimited powers. Although absolutism reached its climax during the reign of Louis XIV in the later seventeenth century, it had been in the making since the 1520s (under Francis I in France, the Hapsburgs in Austria and Spain, Henry VIII in England, and the Medici dukes in Tuscany). Moreover, Baroque art flourished in bourgeois Holland no less than in the absolutist monarchies, and the style sponsored under Louis XIV was a notably subdued, classicistic kind of Baroque.

It is nevertheless tempting to see the turbulent history of the era reflected in Baroque art, where the tensions of the era often seem to erupt into open conflict. The seventeenth century was one of almost continuous warfare, which involved almost every European nation in a complex web of shifting alliances. The Thirty Years' War (1618–48) was fueled by the ambitions of the kings of France, who sought to dominate Europe, and by those of the Hapsburgs, who ruled not only Austria and Spain but also the Netherlands, Bohemia, and Hungary. Although fought largely in Germany, the war eventually engulfed nearly all of Europe. After the Treaty of Westphalia ended the war and formally granted their freedom, the United Provinces—as the independent Netherlands was known—entered into a series of battles with England and France that lasted until 1679. Yet, other than in Germany, which was left in ruins, there is little correlation between these rivalries and the art of the period. In fact, the seventeenth century has been called the Golden Age of painting in France, Holland, Flanders, and Spain. Moreover, these wars had practically no effect on Baroque imagery, although we can catch indirect glimpses of it in Dutch militia scenes, such as Rembrandt's *Night Watch* (see fig. 18-10).

It is also difficult to relate Baroque art to the science and philosophy of the period. A direct link did exist in the Early and High Renaissance, when an artist could also be a humanist and a scientist. During the seventeenth century, however, scientific and philosophical thought became too complex, abstract, and systematic for the artist to share. Gravitation and calculus could not stir the artist's imagination any more than René Descartes's famous motto *Cogito, ergo sum* (I think, therefore I am).

There is nevertheless a relationship between Baroque art and science which, though subtle, is essential to an understanding of the age. The complex metaphysics of the humanists, which gave everything religious meaning, was replaced by a new physics. The change began with Nicholas Copernicus, Johannes Kepler, and Galileo Galilei, and culminated in Descartes and Isaac Newton. Their cosmology broke the ties between sensory perception and science. By placing the sun, not the earth (and humanity), at the center of the universe, it contradicted what our eyes (and common sense) tell us: that the sun revolves around the earth. Scientists now defined underlying relationships in mathematical and geometrical terms as part of the simple, orderly system of mechanics. Not only was the seventeenth century's worldview fundamentally different from what had preceded it, but its understanding of visual reality was forever changed by the new science, thanks to advances in optical physics and physiology. Thus we may say that the Baroque literally saw with new eyes.

The attack on Renaissance science and philosophy, which could trace their origins (and authority) back to antiquity, also had the effect of displacing natural magic, a precursor of modern science that included both astrology and alchemy (see page 357). Unlike the new science, natural magic tried to control the world through prediction and manipulation; it did so by uncovering nature's "secrets" instead of her laws. Yet, because it was linked to religion and morality, it lived on in popular literature and folklore long afterward.

In the end, Baroque art was not simply the result of religious, political, or intellectual developments. Let us therefore think of it as one among

other basic features that distinguish the period: the strengthened Catholic faith, the absolutist state, and the new science. These factors are combined in volatile mixtures that give the Baroque its fascinating variety. Such diversity was well suited to express the expanding view of life. What ultimately unites this complex era is a reevaluation of humanity and its relation to the universe. Central to this image is the new psychology of the Baroque. Philosophers gave greater prominence to human passion, which encompassed a wider range of emotions and social levels than ever before. The scientific revolution leading up to Newton's unified mechanics responded to the same view, which presumes a more active role for people's ability to understand and affect the world around them. Remarkably, the Baroque remained an age of great religious faith, however divided it may have been in its loyalties. The interplay of passion, intellect, and spirituality may be seen as forming a dialogue that has never been truly resolved.

Painting in Italy

Around 1600 Rome became the fountainhead of the Baroque, as it had of the High Renaissance a century before, by attracting artists from other regions. The papacy patronized art on a large scale, with the aim of making Rome the most beautiful city of the Christian world "for the greater glory of God and the Church." This campaign had begun as early as 1585, but the artists then on hand were Late Mannerists with little talent. Nevertheless, it soon attracted ambitious young artists, especially from northern Italy. It was they who created the new style.

Caravaggio Foremost among them was a painter of genius, Michelangelo Merisi (1571–1610), called Caravaggio after his birthplace near Milan. His first important religious commission was for a series of three monumental canvases devoted to St. Matthew that he painted for the Contarelli chapel in S. Luigi dei Francesi from about 1599 to

1602. As decorations they perform the same function that fresco cycles had in the Renaissance. The main image, *The Calling of St. Matthew* (fig. 17-1), is remote from both Mannerism and the High Renaissance. Its only ancestor is the "North Italian realism" of artists such as Savoldo (see fig. 14-6). But Caravaggio's realism is of a new and radical kind. According to contemporary accounts, Caravaggio painted directly on the canvas, as had Titian, but he worked from the live model. He depicted the world he knew, so that his canvases are filled with ordinary people. Indeed, his pictures are surprisingly autobiographical at times.

Never have we seen a sacred subject depicted so entirely in terms of contemporary lowlife. Matthew, the tax gatherer, sits with some armed men (who must be his agents) in a common Roman tavern as two figures approach from the right. (The setting and costumes must have been very familiar to Caravaggio. He moved in a circle of young toughs in a working-class neighborhood and carried a sword himself. Highly argumentative, he was often in trouble and even killed a friend in a duel over a ball game, so that he fled to Naples and eventually Malta.) The arrivals are poor people whose bare feet and simple garments contrast strongly with the colorful costumes of Matthew and his companions.

For Caravaggio, however, naturalism is not an end in itself but a means of conveying profoundly religious content. Why do we sense a religious quality in this scene and not mistake it for an everyday event? The answer is that Caravaggio's North Italian realism is wedded to elements derived from his study of Renaissance art in Rome, which give the scene its surprising dignity. His style, in other words, is classical, without being classicizing. The composition, for example, is spread across the picture surface and its forms are sharply highlighted, much as in a relief (see fig. 7-14). What identifies one of the figures as Christ? It is surely not his halo, the only supernatural feature in the picture, which is an inconspicuous gold band that we might well overlook. Our eyes fasten instead upon his commanding gesture, borrowed from Michelangelo's *Creation of Adam* (see fig. 13-9), which "bridges" the gap between the two groups

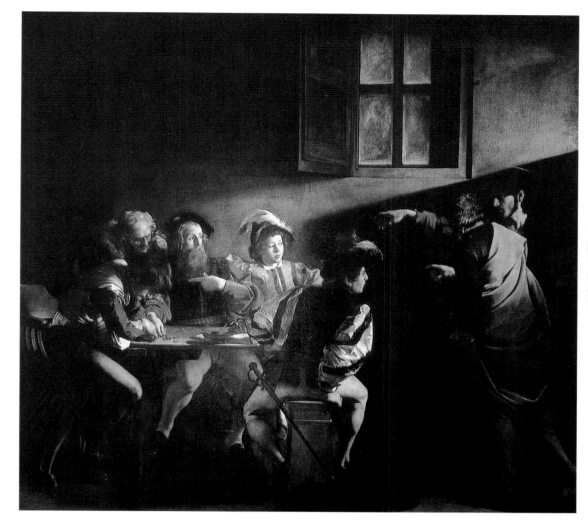

17-1 Caravaggio. *The Calling of St. Matthew.* c. 1599–1602. Oil on canvas, 11'1" x 11'5" (3.38 x 3.48 m). Contarelli Chapel, S. Luigi dei Francesi, Rome

and is echoed by Matthew, who points questioningly at himself.

Most decisive is the beam of sunlight above Jesus. It illuminates his face and hand in the gloomy interior, thus carrying his call across to Matthew. Without this light, so natural yet so charged with meaning, the picture would lose its power to make us aware of the divine presence. Caravaggio gives direct form to an attitude shared by certain saints of the Counter-Reformation: that the mysteries of faith are revealed not by speculation but through an inward experience that is open to all people. What separates the Baroque from the later Counter-Reformation is the externalization of the mystic vision, which appears to us complete, without any signs of the spiritual struggle that characterizes El Greco's art (see pages 337–40).

Caravaggio's paintings have a "lay Christianity" that appealed to Protestants no less than to Catholics. This quality made possible his strong, though indirect, influence on Rembrandt, the greatest religious artist of the Protestant North. In Italy, Caravaggio's work was praised by artists and connoisseurs, but the ordinary people for whom it was intended resented meeting their own kind in these paintings. They preferred religious imagery of a more idealized sort. Conservative critics, moreover, regarded Caravaggio as lacking

decorum—the propriety and reverence demanded of religious subjects. For these reasons, Caravaggism largely ran its course by 1630, when it was absorbed into other Baroque tendencies.

Ribera Caravaggio's style lived on only in Naples, then under Spanish rule. His main disciple in that city was the Spaniard Jusepe Ribera (1591–1652), who settled there after having learned Caravaggio's style in Rome and who in turn spawned a school of his own. Especially popular were Ribera's paintings of saints, prophets, and ancient beggar-philosophers. Their asceticism appealed strongly to the otherworldliness of Spanish Catholicism. Such pictures also reflected the learned humanism of the Spanish nobility, who were the artist's main patrons. Most of Ribera's figures are middle-aged or elderly men who possess the unique blend of inner strength and intensity seen in *St. Jerome and the Angel of Judgment* (fig. 17-2), his masterpiece in this vein. The fervent characterization owes its expressive force to both the dramatic composition, inspired by Caravaggio, and the raking light, which gives the figure a powerful presence by heightening the realism and emphasizing the vigorous surface textures.

Artemisia Gentileschi So far, we have not discussed a woman artist, although this does not mean that there were none. Pliny, for example, in his *Natural History* (book 35) documents the names and works of women artists in Greece and Rome, and there are records of women manuscript illuminators during the Middle Ages (see box, page 212). We must remember, however, that the vast majority of all artists remained anonymous until the late fourteenth century. As a result, it has been possible to identify only a few works by women before that time. Women began to emerge as distinct artistic personalities about 1550, but it was not until the Baroque era that they first became prominent in the arts. Because it was difficult for them to obtain instruction in figure drawing and anatomy, they were effectively barred from painting narrative subjects. Hence, until the middle of the nineteenth century, women artists were largely restricted to painting portraits, genre scenes, and still lifes. Even so, many had successful careers and often became the equals or superiors of the men in whose styles they were trained. The exceptions to this rule were certain Italian women born into artistic families, for whom painting came naturally. The most important of them was Artemisia Gentileschi (1593–c. 1653).

She was born in Rome, the daughter of Caravaggio's follower Orazio Gentileschi, and became one of the leading painters of her day. She took

17-2 Jusepe Ribera. *St. Jerome and the Angel of Judgment.* 1626. Oil on canvas, 8'7¹/₈" x 5'4¹/₂" (2.62 x 1.64 m). Museo e Gallerie Nazionali di Capodimonte, Naples

great pride in her work but found the way difficult for a woman artist. Her characteristic subjects are Bathsheba, the tragic object of King David's passion, and Judith, who saved her people by beheading the Assyrian general Holofernes. Both themes were popular during the Baroque era, which delighted in erotic and violent scenes. Artemisia's frequent depictions of these biblical heroines suggest an ambivalence toward men that was rooted in her turbulent life. (She was raped by her teacher, who was acquitted in a jury trial.)

While Gentileschi's early paintings of Judith take her father's and Caravaggio's work as their points of departure, our example (fig. 17-3) is a fully mature, independent work. The inner drama is hers alone, and it is no less powerful for its restraint. Rather than the beheading itself, the artist shows the instant after. Momentarily distracted, Judith gestures theatrically as her servant stuffs Holofernes's head into a sack. The object of their attention remains hidden from view, heightening the air of intrigue. The hushed, candlelit atmosphere creates a mood of mystery that conveys Judith's complex emotions with unsurpassed understanding. Gentileschi's rich palette was to have a strong influence on painting in Naples, where she settled in 1631.

Annibale Carracci The conservative wishes of everyday people in Italy were met by artists who were less radical, and less talented, than Caravaggio. They took their lead instead from Annibale Carracci (1560–1609), who also had recently arrived in Rome. Annibale came from Bologna, where in the 1580s he and two other members of his family had evolved an anti-Mannerist style based on North Italian realism and Venetian art. He was a reformer rather than a revolutionary. As with Caravaggio, who admired him, his experience of Roman classicism transformed his art. He, too, felt that art must return to nature, but his approach emphasized a revival of the classics, which to him meant the art of antiquity. Annibale also sought to emulate Raphael, Michelangelo, Titian, and Correggio. At his best, he was able to fuse these diverse elements, although their union always remained somewhat unstable.

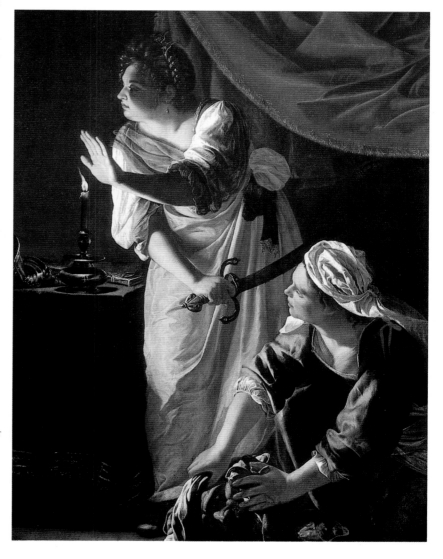

17-3 Artemisia Gentileschi. *Judith and Her Maidservant with the Head of Holofernes.* c. 1625. Oil on canvas, 72$\frac{1}{2}$ x 55$\frac{3}{4}$" (184.2 x 141.6 cm). The Detroit Institute of Arts

Gift of Leslie H. Green

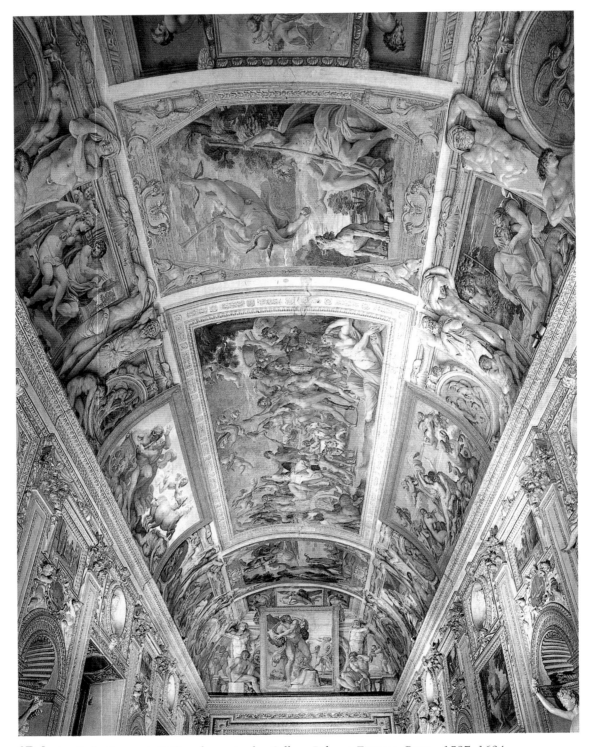

17-4 Annibale Carracci. Ceiling fresco in the Gallery, Palazzo Farnese, Rome. 1597–1604

Between 1597 and 1604 Annibale produced a vast ceiling fresco in the GALLERY of the Farnese Palace (fig. 17-4), his most ambitious work, which soon became so famous that it ranked behind only the murals of Michelangelo and Raphael. Commissioned to celebrate a wedding in the Farnese family, it wears its humanist subject, the Loves of the Classical Gods, lightly. The narrative scenes, like those of the Sistine ceiling, are surrounded by painted architecture, simulated sculpture, and nude youths. But the fresco does not rely solely on Michelangelo's masterpiece. The style of the main panels recalls Raphael's *Galatea* (see fig. 13-15), with a strong debt to Titian (compare the *Bacchanal*, fig. 13-17). The whole is held together by an illusionistic scheme that reflects Annibale's knowledge of Correggio (see fig. 14-7) and Veronese. Carefully foreshortened and lit from below (as we can judge from the shadows), the nude youths and the simulated sculpture and architecture appear real. Against this background the mythologies are presented as simulated easel pictures, a solution adopted from Raphael. Each of these levels of reality is handled with consummate skill, and the entire ceiling has an exuberance that sets it apart from both Mannerism and High Renaissance art.

Reni and Guercino To artists who were inspired by it, the Farnese Gallery seemed to offer two alternatives. Using the Raphaelesque style of the mythological panels, they could arrive at a deliberate, "official" classicism, or they could take their cue from the illusionism of the framework. The approach varied according to personal style and the specific site. Among the earliest examples of the first alternative is the ceiling fresco *Aurora* (fig. 17-5, page 390) by Guido Reni (1575–1642), which shows Apollo in his chariot (the Sun) led by Aurora (Dawn). Here grace becomes the pursuit of perfect beauty. The relieflike design would seem little more than a pallid reflection of High Renaissance art were it not for the glowing color and dramatic light, which give it an emotional force that the figures alone could never achieve. This style is called Baroque classicism to distinguish it from all earlier forms of classicism, no matter how much it may be indebted to them.

The *Aurora* ceiling (fig. 17-6, page 390) painted less than ten years later by Guercino (Giovanni Francesco Barbieri, 1591–1666) is the very opposite of Reni's. Here architectural perspective, combined with the pictorial illusionism of Correggio and the intense light and color of Titian, converts the entire surface into one limitless space, in which the figures sweep past as if driven by the winds. With this work, Guercino started what became a flood of similar visions characteristic of the High Baroque after 1630.

Cortona The most overpowering of these illusionistic ceilings is the fresco by Pietro da Cortona (1596–1669) in the great hall of the Barberini Palace in Rome (fig. 17-7, page 391). This enormous painting glorifies the reign of the Barberini pope, Urban VIII, in the form of a complex allegory. As in the Farnese Gallery, the ceiling area is subdivided by a painted framework that simulates architecture and sculpture, but beyond it we now see the unbounded sky, as in Guercino's *Aurora*. Clusters of figures, perched on clouds or soaring freely, swirl above as well as below this framework. They create a dual illusion: some figures appear to hover inside the hall, close to us, while others recede into the distance. The effect is very similar to that of a domed ceiling painted by Giovanni Lanfranco in Rome nearly a decade earlier, which was based directly on Correggio's *Assumption of the Virgin* (see fig. 14-7).

Cortona's frescoes were the focal point for the rift between the High Baroque and Baroque classicism that grew out of the Farnese ceiling. The classicists insisted that art serves a moral purpose and must observe the principles of clarity, unity, and decorum. And, supported by a tradition based on Horace's adage *ut pictura poesis* (see page 301), they maintained that painting should follow the example of tragic poetry in conveying meaning through a minimum of figures whose movements, gestures, and expressions can be easily read. Cortona, though not anticlassical, presented the case for art as epic poetry, with many actors and episodes that expand on the central theme and create a magnificent effect. He was also the first to argue that art has a sensuous appeal which exists as an end in itself.

A GALLERY is a long, rectangular space that usually functions as a passageway or corridor. From the Renaissance onward, galleries in palaces, public buildings, and stately houses would be heavily decorated, frequently with paintings and works of sculpture. From this practice, the word *gallery* came to mean an independent space devoted to the exhibition of works of art. In churches, a gallery is a low story above the nave, often arcaded.

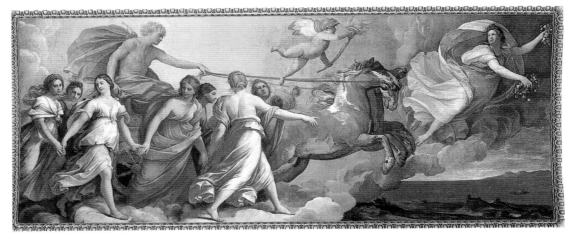

17-5 Guido Reni. *Aurora*. 1613. Ceiling fresco in the Casino Rospigliosi, Rome

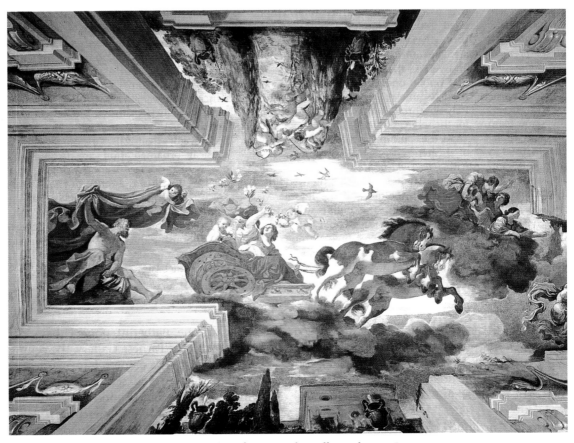

17-6 Guercino. *Aurora*. 1621–23. Ceiling fresco in the Villa Rudovisi, Rome

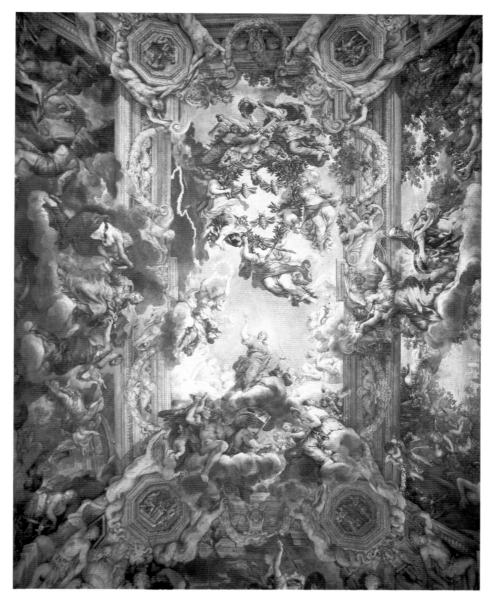

17-7 Pietro da Cortona. *The Glorification of the Reign of Urban VIII.* 1633–39. Portion of ceiling fresco in the Palazzo Barberini, Rome

Although it took place largely on a theoretical level, the debate over illusionistic ceiling painting involved more than opposing approaches to telling a story and expressing ideas in art. The issue lay at the very heart of the Baroque. Illusionism allowed artists to overcome the apparent contradictions of the era by fusing separate levels of reality into a pictorial unity of such overwhelming grandeur as to sweep aside any differences between them. Despite the intensity of the debate, in practice the two sides rarely came into conflict over easel paintings, where the differences between Cortona and Carracci's followers were not always so clear-cut. Surprisingly, Cortona found inspiration in classical art and Raphael throughout his career. Nevertheless, the leader of the reaction against what were

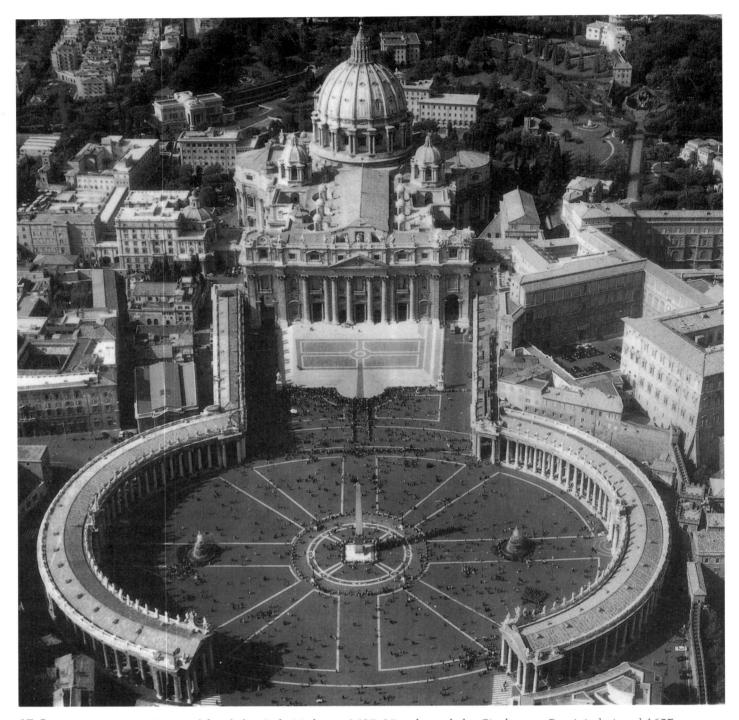

17-8 St. Peter's, Rome. Nave and facade by Carlo Maderno, 1607–15; colonnade by Gianlorenzo Bernini, designed 1657

regarded as the excesses of the High Baroque was neither a fresco painter, nor was he an Italian, but a French artist living in Rome: Nicolas Poussin (see pages 421–23), who moved in the same antiquarian circle as Cortona early on but drew very different lessons from it.

Architecture in Italy

Maderno The beginnings of the Baroque style in architecture cannot be defined as precisely as in painting. Carlo Maderno (1556–1629) was the most talented young architect to emerge in the vast ecclesiastical building program that got under way in Rome toward the end of the sixteenth century. In 1603 he was given the task of completing, at long last, the church of St. Peter's. Pope Clement VIII had decided to add a nave and narthex to the west end of Michelangelo's building (see fig. 13-12), thereby converting it into a basilica. The change of plan, which had already been proposed by Raphael in 1514, made it possible to link St. Peter's with the Vatican Palace, to the right of the church.

Maderno's design for the facade (fig. 17-8) follows the pattern established by Michelangelo for the exterior of the church. It consists of a **colossal order** supporting an **attic,** but with a dramatic emphasis on the portals. The effect can only be described as a crescendo that builds from the corners toward the center. The spacing of the supports becomes closer, the pilasters turn into columns, and the facade wall projects step-by-step. This quickened rhythm had been hinted at a generation earlier in Giacomo della Porta's facade of Il Gesù (see fig. 14-18). Maderno made it the dominant principle of his facade designs, not only for St. Peter's but for smaller churches as well. In the process, he replaced the traditional concept of the church facade as one continuous wall surface, which was not yet challenged by the facade of Il Gesù, with the "facade-in-depth," dynamically related to the open space before it. The possibilities of this new treatment were not to be exhausted until 150 years later.

Bernini After Maderno's death in 1629, Gianlorenzo Bernini (1598–1680) was appointed to succeed him at St. Peter's. Bernini considered himself Michelangelo's successor as both architect and sculptor. Thus he molded the open space in front of the facade into a magnificent oval piazza that is amazingly sculptural (see fig. 17-8). This "forecourt," which imposed a degree of unity on the sprawling Vatican complex, acts as an immense atrium framed by colonnades that Bernini himself likened to the motherly, all-embracing arms of the Church. The device itself is not new. It had been used at private villas designed by Jacopo Vignola for the Farneses in the 1550s; but these were, in effect, **belvederes** opening onto formal gardens. What is novel is the idea of placing it at the main entrance to a building. Also new is the huge scale. For sheer impressiveness, this integration of the building with such a grandiose setting can be compared only with the ancient Roman sanctuary at Palestrina (see fig. 7-1).

Borromini As a personality, Bernini represents a type we first met among the artists of the Early Renaissance, a self-assured person of the world. His greatest rival in architecture, Francesco Borromini (1599–1667), who also started out at St. Peter's as an assistant to Maderno and then to Bernini himself, was the opposite: a secretive and emotionally unstable genius who died by suicide. The Baroque heightened the tension between the two types. The contrast between the two masters would be evident from their works alone, even without the accounts by their contemporaries. Both exemplify the climax of Baroque architecture in Rome, yet Bernini's design for the colonnade of St. Peter's is dramatically simple and unified, while Borromini's structures are extravagantly complex. Whereas the surfaces of Bernini's interiors are extremely rich, Borromini's are surprisingly plain. They rely on the architect's phenomenal grasp of spatial geometry to achieve their spiritual effects. Bernini himself agreed with those who denounced Borromini for flagrantly disregarding the classical tradition, enshrined in Renaissance theory and practice, that architecture must reflect the proportions of the human body.

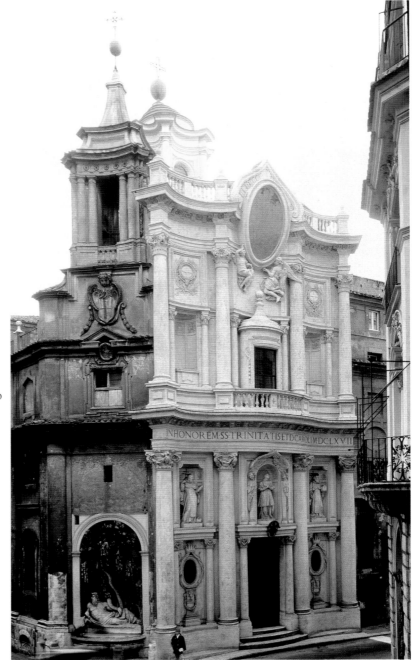

17-9 Francesco Borromini. Facade, S. Carlo alle Quattro Fontane, Rome. 1665–67

In Borromini's first major project, the church of S. Carlo alle Quattro Fontane (figs. 17-9, 17–10), it is the syntax, not the vocabulary, that is new and disquieting. The ceaseless play of concave and convex surfaces makes the entire structure seem elastic, as if pulled out of shape by pressures that no previous building could have withstood. The inside of the coffered dome, like the plan, looks "stretched": if the tension were relaxed, it would snap back to normal. On the facade, which was designed almost 30 years later, the pressures and counterpressures reach their maximum intensity.

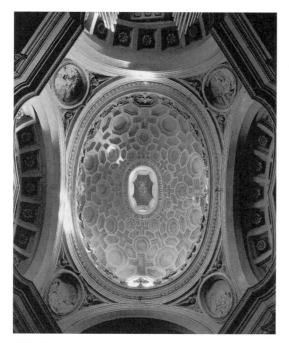

17-10 Dome, S. Carlo alle Quattro Fontane

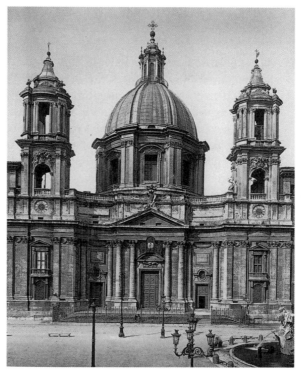

17-11 Francesco Borromini. Sta. Agnese in Piazza Navona, Rome. 1653–63

Borromini merges architecture and sculpture in a way that must have shocked Bernini. No such union had been attempted since Gothic art. S. Carlo alle Quattro Fontane established Borromini's fame. "Nothing similar," wrote the head of the religious order for which the church was built, "can be found anywhere in the world. This is attested by the foreigners who . . . try to procure copies of the plan. We have been asked for them by Germans, Flemings, Frenchmen, Italians, Spaniards, and even Indians."

A second project by Borromini is of special interest as a High Baroque critique of St. Peter's. There was one problem that Maderno had been unable to solve: Michelangelo's dome is gradually hidden by the new facade as we approach the church. Borromini designed the facade of Sta. Agnese in Piazza Navona (fig. 17-11) with this conflict in mind. Its lower part is adapted from the facade of St. Peter's, but it curves inward, so that the dome (a tall, slender version of Michelangelo's) functions as the upper part of the facade. The dramatic juxtaposition of concave and convex,

so characteristic of Borromini, is emphasized by the two towers, which form a monumental group with the dome. Such towers were also originally planned for St. Peter's by Bramante (see fig. 13-6) and also by Bernini, but they would have been freestanding. Once again Borromini joins Gothic and Renaissance features—the two-tower facade and the dome—into a remarkably "elastic" compound.

Guarini The new ideas introduced by Borromini were developed further not in Rome but in Turin, the capital of Savoy, which became the creative center of Baroque architecture in Italy toward the end of the seventeenth century. In 1666 Guarino Guarini (1624–1683), Borromini's most brilliant successor, was called to Turin as an engineer and mathematician by the duke. Guarini was a Theatine monk whose genius was grounded in philosophy and mathematics. His design for the dome of the Chapel of the Holy Shroud (fig. 17-12), a round structure attached to Turin Cathedral, consists of familiar Borrominian motifs, yet it ushers us into a

realm of pure illusion completely unlike anything by the earlier architect. The interior surface of the dome of S. Carlo alle Quattro Fontane, although dematerialized by light and a honeycomb of fanciful coffers, was still recognizable (see fig. 17-10). But here the surface has disappeared in a maze of ribs, inspired by Moorish architecture, which Guarini had studied while working in Messina, Sicily, during 1660–62. As a result, we find ourselves staring into a huge kaleidoscope. Above this seemingly endless funnel of space hovers the dove of the Holy Spirit within a 12-pointed star.

Guarini's dome retains the symbolic meaning of the Dome of Heaven (see figs. 7-3 and 12-12). However, the objective harmony of the Renaissance has become subjective, a compelling experience of the infinite. If Borromini's style at times suggests a fusion of Gothic and Renaissance, Guarini takes the next step. In his writings, he contrasts the "muscular" architecture of the ancients with the effect of Gothic churches, which appear to stand only by means of some kind of miracle, and he expresses equal admiration for both. This attitude corresponds exactly to his own practice. By using the most advanced mathematical techniques of his day, he achieved wonders even greater than those of the seemingly weightless Gothic structures. He thus helped to pave the way for Soufflot and the rationalist movement in the next century (see pages 469–70).

17-12 Guarino Guarini. Dome of the Chapel of the Holy Shroud, Turin Cathedral. 1668–94

Sculpture in Italy

Bernini We have already encountered Gianlorenzo Bernini as an architect. It is now time to consider him as a sculptor, although the two aspects are never far apart in his work. He was trained by his father, Pietro Bernini (1562–1629), a sculptor of considerable ability who worked in Florence, Naples, and Rome. Thus his work was a direct outgrowth of Mannerist sculpture in many ways, but these do not explain his revolutionary qualities.

As in the colonnade for St. Peter's (see fig. 17-8), we can often see a strong relationship between Bernini's sculpture and that of antiquity. If we compare Bernini's *David* (fig. 17-13) with Michelangelo's (see fig. 13-7) and ask which is closer to the Pergamon frieze (see fig. 5-24), our vote must go to Bernini. His figure shares with Hellenistic works that unison of body and spirit, of motion and emotion, which Michelangelo so consciously avoids. This does not mean that Michelangelo is more classical than Bernini. It shows, rather, that both the Baroque and the High Renaissance were inspired by different aspects of ancient art.

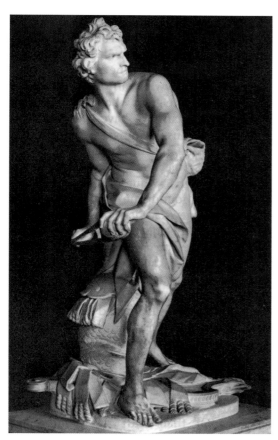

17-13 Gianlorenzo Bernini. *David*. 1623. Marble, life-size. Galleria Borghese, Rome

Bernini's *David* is in no sense an echo of Hellenistic art. What makes it Baroque is the implied presence of Goliath. Unlike earlier statues of David, including Donatello's (see fig. 12-3), Bernini's is conceived not as a self-contained figure but as half of a pair, his entire action focused on his adversary. Did Bernini, we wonder, plan a statue of Goliath to complete the group? He never did, nor did he need to. His David tells us clearly enough where he sees the enemy. Consequently, the space between David and his invisible opponent is charged with energy—it "belongs" to the statue.

The *David* shows us just what distinguishes Baroque sculpture from that of the two preceding centuries: its new, active relationship with the surrounding space. It rejects self-sufficiency in favor of the illusion of a presence or force implied by the action of the statue. Because they so often present an "invisible complement" (like the Goliath of Bernini's *David*), Baroque statues attempt pictorial effects that were traditionally outside the province of sculpture. Such a charging of space with energy is, in fact, a key feature of Baroque art. Caravaggio had achieved it in his *St. Matthew,* with the aid of a sharply focused beam of light. Indeed, Baroque art does not make a clear-cut distinction between sculpture and painting. The two may even be combined with architecture to form a compound illusion, like that of the stage.

Bernini had a passionate interest in the theater, and was an innovative scene designer. Thus he was at his best when he could merge architecture, sculpture, and painting. His masterpiece in this vein is the Cornaro Chapel in the church of Sta. Maria della Vittoria, containing the famous group called *The Ecstasy of St. Theresa* (fig. 17-14, page 398). THERESA OF AVILA, one of the great saints of the Counter-Reformation, had described how an angel pierced her heart with a flaming golden arrow: "The pain was so great that I screamed aloud; but at the same time I felt such infinite sweetness that I wished the pain to last forever. It was not physical but psychic pain, although it affected the body as well to some degree. It was the sweetest caressing of the soul by God."

Bernini has made this visionary experience as sensuously real as Correggio's *Jupiter and Io* (see fig. 14-8). In a different context, the angel could be Cupid, and the saint's ecstasy is palpable. The two figures on their floating cloud are lit from a hidden window above, so that they seem almost dematerialized. The viewer thus experiences them as visionary. The "invisible complement" here, less specific than David's but equally important, is the force that carries the figures toward heaven and causes the turbulence of their drapery. Its divine nature is suggested by the golden rays, which come from a source high above the altar. In an illusionistic fresco by Guidobaldo Abbatini on the vault of the chapel, the glory of the heavens is revealed as a dazzling burst of light from which tumble clouds of jubilant angels (fig. 17-15, page 398). This celestial "explosion" gives force to the

St. THERESA OF AVILA (1515–1582) inaugurated reforms in her own Carmelite order that had an immense influence on other congregations of religious women and on the Church as a whole. Her powerful writings include the *Life* (1562–65), a spiritual autobiography; *The Way of Perfection* (after 1565), a discussion of various devotional practices; and *Exclamations of the Soul to God* (1569), meditations that reflect her experiences of mystical union with God. In 1970 Theresa was named the first female Doctor of the Church.

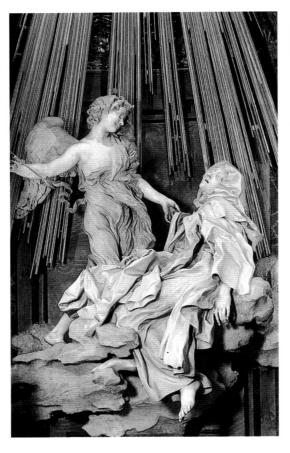

17-14 Gianlorenzo Bernini. *The Ecstasy of St. Theresa.* 1645–52. Marble, life-size. Cornaro Chapel, Sta. Maria della Vittoria, Rome

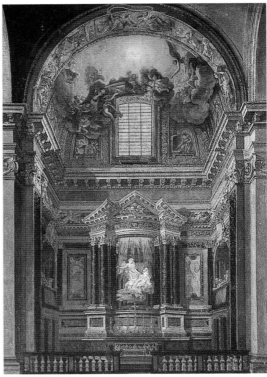

17-15 Anonymous. *The Cornaro Chapel.* 18th century. Oil on canvas, 66¼" x 47¼" (1.68 x 1.20 m). Staatliches Museum, Schwerin, Germany

Ignatius of Loyola (Iñigo de Oñez y Loyola, 1491–1556) was an influential Catholic teacher, founder of the Jesuit order (see page 325), and eventually a saint and patron of spiritual retreats. His *SPIRITUAL EXERCISES* is a manual for contemplation of the meaning of life as well as a source of pragmatic advice on how to live a spiritual life in the service and honor of God. It is used as a model for many Roman Catholic retreats and missions.

thrusts of the angel's arrow and makes the ecstasy of the saint believable.

To complete the illusion, Bernini even provides a built-in audience for his "stage." On the sides of the chapel are balconies resembling theater boxes that contain marble figures, depicting members of the Cornaro family, who also witness the vision. Their space and ours are the same and thus are part of everyday reality, while the saint's ecstasy, which is in a strongly framed niche, occupies a space that is real but beyond our reach.

It would be easy to dismiss *The Ecstasy of St. Theresa* as a theatrical display, but Bernini also was a devout Catholic who believed (as did Michelangelo) that he was inspired directly by God. Like the *SPIRITUAL EXERCISES* of Ignatius of Loyola, which Bernini practiced, his religious sculpture is intended to help the viewer identify with

miraculous events through a vivid appeal to the senses. Theatricality in the service of faith was basic to the Counter-Reformation, which often referred to the Church as sacred theater and the theater of human life.

Bernini was steeped in Renaissance humanism. Central to his sculpture is the role of gesture and expression in arousing emotion. While these devices were also important to the Renaissance (compare Leonardo), Bernini uses them with a freedom that seems anticlassical. However, he essentially followed the concept of decorum, and he planned his effects carefully, by varying them in accordance with his subject (see page 344). Unlike the Frenchman Nicolas Poussin (whom he respected, as he did Annibale Carracci), Bernini did this for the sake of expressive impact rather than conceptual clarity. The approaches of the

two artists were diametrically opposed as well. For Bernini, antique art served as no more than a point of departure for his own inventiveness, whereas for Poussin it served as a standard of comparison. It is nevertheless characteristic of the Baroque that Bernini's theories should be far more orthodox than his art. Thus he often sided with the classicists against his fellow High Baroque artists, especially Pietro da Cortona, who, like Raphael before him, also made an important contribution to architecture and was a rival in that sphere.

Algardi It is no less ironic that Cortona was the closest friend of the sculptor Alessandro Algardi (1596–1654), who is regarded as the leading classical sculptor of the Italian Baroque and the only serious rival to Bernini in ability. His main contribution is *The Meeting of Pope Leo I and Attila* (fig. 17-16), done while he replaced Bernini at St. Peter's during the papacy of Innocent X. It introduced a new kind of high relief that soon became widely popular. The scene depicts the defeat of the HUNS under ATTILA during a threatened attack on Rome in 452, a fateful event in the early history of Christianity, when its very survival was at stake. The subject revives one that is familiar to us from antiquity: the victory over barbarian forces (compare fig. 5-18). But now it is the Church, not civilization, that triumphs, and the victory is spiritual rather than military.

The commission was given for a sculpture because water condensation caused by the location in an old doorway of St. Peter's made a painting impossible. Never before had an Italian sculptor attempted such a large relief—it stands more than 28 feet high. The problems posed by translating a pictorial conception (it had been treated by Raphael in one of the Vatican Stanze) into a relief on this gigantic scale were formidable. If Algardi has not succeeded in resolving every detail, his achievement is stupendous nonetheless. By varying the depth of the carving, he nearly convinces us that the scene takes place in the same space as ours. The foreground figures are in such high relief that they seem detached from the background. To accentuate the effect, the stage on which they are standing projects several feet beyond its surround-

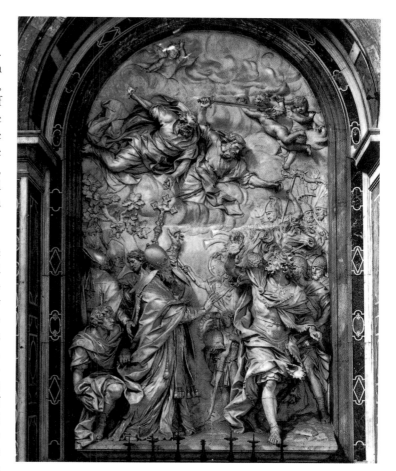

17-16 Alessandro Algardi. *The Meeting of Pope Leo I and Attila.* 1646. Marble, 28'1³/₄" x 16'2¹/₂" (8.58 x 4.94 m). St. Peter's, the Vatican, Rome

ing niche. Thus Attila seems to rush out toward us in fear and astonishment as he flees the vision of the two apostles defending the faith. The result is surprisingly persuasive in both visual and expressive terms.

Such illusionism is, of course, quintessentially Baroque. So is the intense drama, which is heightened by the twisting poses and theatrical gestures of the figures. Algardi was obviously touched by Bernini's genius. Strangely enough, the relief is partly a throwback to an Assumption of the Virgin of 1606–10 in Sta. Maria Maggiore by Bernini's father, Pietro. Only in his observance of the three traditional levels of relief carving (low, middle, and high, instead of continuously variable depth), his preference for frontal poses, and his restraint

The HUNS were a fierce nomadic people from the Asian steppes north of the Caspian Sea who repeatedly invaded deep into the Roman Empire in the fourth and fifth centuries, seriously weakening both the Western and Eastern empires. Under their greatest leader, ATTILA (died 453), they penetrated as far west as Gaul and were defeated there only in 451. The Huns' power rapidly waned after Attila's death.

in dealing with the violent action can Algardi be called a classicist, and then purely in a relative sense. Clearly, we must not draw the distinction between the High Baroque and Baroque classicism too sharply in sculpture any more than in painting.

Painting in Spain

During the sixteenth century, at the height of its political and economic power, Spain had produced great saints and writers, but no artists of the first rank. Nor did El Greco's presence stimulate native talent. The reason is that the Catholic church, the main source of patronage in Spain, was extremely conservative, while the Spanish court and most of the aristocracy preferred to employ foreign painters and held native artists in low esteem. Thus the main influences came from Italy and Flanders, which was ruled by Spain.

Zurbarán Seville was the home of the leading Spanish Baroque painters before 1640. Francisco de Zurbarán (1598–1664) stands out among them for his quiet intensity. His most important works were done for monastic orders and are filled with an ascetic piety that is uniquely Spanish. *St. Serapion* (fig. 17-17) shows an early member of the Mercedarians (Order of Mercy) who was brutally murdered by pirates in 1240 but canonized only a hundred years after this picture was painted. The canvas was placed as a devotional image in the funerary chapel of the order, which was originally dedicated to self-sacrifice.

The painting will remind us of Caravaggio. Zurbarán's saint is shown as a life-size three-quarter-length figure. The strong contrast between the white habit and the dark background gives the figure a heightened visual and expressive presence, so that the viewer contemplates the slain monk with a mixture of compassion and awe. Here pictorial and spiritual purity become one. The stillness creates a reverential mood that complements the stark realism. As a result, we identify with the strength of St. Serapion's faith rather than with his physical suffering. The absence of pathos is what makes this image deeply moving.

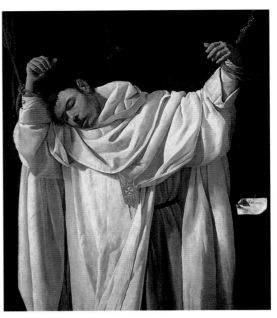

17-17 Francisco de Zurbarán. *St. Serapion*. 1628. Oil on canvas, 47½ x 41" (120.7 x 104.1 cm). Wadsworth Atheneum, Hartford, Connecticut

Ella Gallup Sumner and Mary Catlin Sumner Collection

Velázquez Diego Velázquez (1599–1660) painted in a Caravaggesque vein during his early years in Seville. His interests at that time centered on scenes of people eating and drinking rather than religious themes. In the late 1620s Velázquez was appointed court painter to Philip IV, whose reign from 1621 to 1665 was the great age of painting in Spain. Much of the credit must go to the duke of Olivares, who largely restored Spain's fortunes and supported an ambitious program of artistic patronage to proclaim the monarchy's greatness. Upon moving to Madrid, Velázquez quickly displaced the mediocre Florentines who had enjoyed the favor of Philip III and his minister, the duke of Lerma. A skilled courtier, the artist soon became a favorite of the king, whom he served as chamberlain. Velázquez spent the rest of his life in Madrid painting mainly portraits of the royal family.

During his visit to the Spanish court on a diplomatic mission in 1628, the Flemish painter Peter Paul Rubens (see pages 404–6) helped Velázquez to discover the beauty of the many

Titians in the king's collection, from which Velázquez developed a new fluency and richness. *The Maids of Honor* (fig. 17-18) shows his mature style at its fullest. Both a group portrait and a genre scene, it might be subtitled "the artist in his studio," for Velázquez depicts himself at work on a huge canvas. In the center is the Princess Margarita, who has just posed for him, among her playmates and maids of honor. The faces of her parents, the king and queen, appear in the mirror on the back wall. They have just stepped into the room, to see the scene exactly as we do. Through their presence the canvas celebrates Velázquez's position as royal painter and his knighthood in the Order of Santiago, whose red cross he proudly wears on his tunic.

The painting reveals Velázquez's fascination with light. The varieties of direct and reflected light in *The Maids of Honor* are almost limitless. The artist challenges us to match the mirror image against the paintings on the same wall, and against the "picture" of the man in the open doorway. Although the side lighting and strong contrasts of light and dark still suggest the

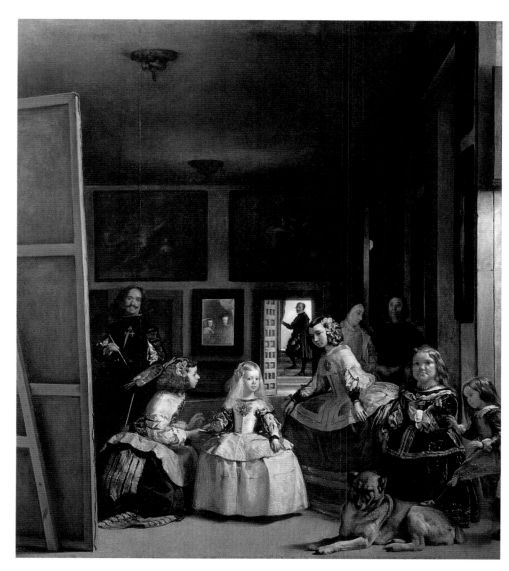

17-18 Diego Velázquez. *The Maids of Honor.* 1656. Oil on canvas, 10'5" x 9' (3.18 x 2.74 m). Museo del Prado, Madrid

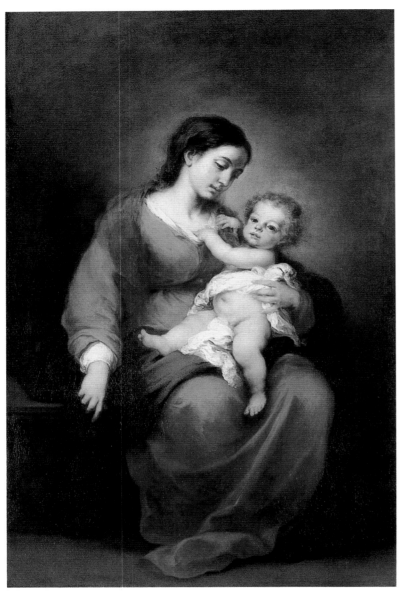

17-19 Bartolomé Esteban Murillo. *Virgin and Child.* c. 1675–80. Oil on canvas, 65¼ x 43" (165.7 x 109.2 cm). The Metropolitan Museum of Art, New York

Rogers Fund, 1943

influence of Caravaggio, Velázquez's technique is far more subtle, with delicate glazes setting off the impasto of the highlights. The glowing colors have a Venetian richness, but the brushwork is even freer and sketchier than Titian's. Velázquez explored the optical qualities of light more fully than any other painter of his time. His aim is to represent the movement of light itself and the infinite range of its effects on form and color. For Velázquez, as for Jan Vermeer in Holland (see page 418), light creates the visible world.

Murillo The work of Bartolomé Esteban Murillo (1617–1682), Zurbarán's successor as the leading painter in Seville, is the most cosmopolitan, as well as the most accessible, of any of the Spanish Baroque artists. For that reason, he had countless followers, whose pale imitations obscure his real achievement. He learned as much from Northern artists, including Rubens and Rembrandt, as he did from Italians such as Reni and Guercino. His *Virgin and Child* (fig. 17-19) unites these influences in an image that nevertheless retains an unmistakably Spanish character. The haunting expressiveness of the faces has a gentle pathos that is more emotionally appealing than Zurbarán's austere pietism. This human warmth reflects a basic change in religious outlook. It is also an attempt to inject new life into standard devotional images that had been reduced to formulas in the hands of lesser artists. The extraordinary sophistication of Murillo's brushwork and the subtlety of his color show the influence of Velázquez. There is a debt as well to the great Flemish Baroque painters Peter Paul Rubens and Anthony van Dyck.

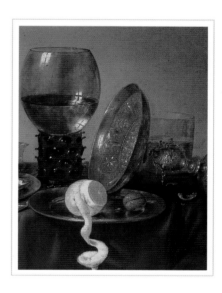

THE BAROQUE IN FLANDERS AND HOLLAND

I n 1581 the six northern provinces of the Netherlands, led by William the Silent of Nassau, declared their independence from Spain, capping a rebellion that had begun 15 years earlier against Catholicism and the attempt by Philip II to curtail local power. Spain soon recovered the southern Netherlands, called Flanders (now divided between France and Belgium). After a long struggle the United Provinces (today's Holland) gained their autonomy, which was recognized by the truce declared in 1609. Although hostilities broke out again in 1621, the freedom of the Dutch was never again seriously in doubt; it was finally ratified by the Treaty of Münster, which ended the Thirty Years' War in 1648.

The division of the Netherlands had very different consequences for the economy, social structure, culture, and religion of the north and the south. After being sacked by Spanish troops in 1576, Antwerp, the leading port of the southern Netherlands, lost half its population. The city gradually regained its position as Flanders's commercial and artistic capital, although Brussels was the seat of government. As part of the Treaty of Münster, however, the Scheldt River leading to Antwerp's harbor was closed to shipping, thereby crippling trade for the next two centuries. Because Flanders continued to be ruled by Spanish regents, who viewed themselves as the defenders of the true faith, its artists relied on commissions from Church and State, but the aristocracy and wealthy merchants were also important patrons.

Holland, in contrast, was proud of its hard-won freedom. While the cultural links with Flanders remained strong, several factors encouraged the quick development of Dutch artistic traditions. Unlike Flanders, where all artistic activity radiated from Antwerp, Holland had a number of local schools of painting. Besides Amsterdam, the commercial capital, there were

important artists in Haarlem, Utrecht, Leyden, Delft, and other towns. Thus Holland produced an almost bewildering variety of masters and styles.

The new nation was one of merchants, farmers, and seafarers, and its religion was Reformed Protestant, which was iconoclastic. Hence Dutch artists rarely had the large-scale commissions sponsored by State and Church that were available throughout the Catholic world. While city governments and civic bodies such as militias provided a certain amount of art patronage, their demands were limited. As a result, private collectors became the painter's chief source of support. This condition had already existed to some extent before (see page 376), but its full effect can be seen only after 1600. There was no shrinkage of output. On the contrary, the public developed such an appetite for pictures that the whole country became gripped by a kind of collectors' mania. During a visit to Holland in 1641, the English traveler John Evelyn noted in his diary that "it is an ordinary thing to find a common farmer lay out two or three thousand pounds in this commodity. Their houses are full of them, and they vend them at their fairs to very great gain."

The collectors' mania caused an outpouring of artistic talent that can only be compared to that of Early Renaissance Florence. Pictures became a commodity, and their trade followed the law of supply and demand. Many artists produced for the market rather than for individual patrons. They were lured into becoming painters by hopes of success that often failed to materialize, and even the greatest masters were sometimes hard-pressed. (It was not unusual for an artist to keep an inn or run a small business on the side.) Yet they survived—less secure, but freer.

Flanders

Rubens Although it was born in Rome, the Baroque style soon became international. The great Flemish painter Peter Paul Rubens (1577–1640) played a role of unique importance in this process. He finished what Dürer had started a hundred years

earlier: the breakdown of the artistic barriers between north and south. Rubens's father was a prominent Antwerp Protestant who fled to Germany to escape Spanish persecution during the war of independence (see page 375). The family returned to Antwerp after his death, when Peter Paul was ten years old, and the boy grew up a devout Catholic. Trained by local painters, Rubens became a master in 1598, but developed a personal style only when he went to Italy two years later.

During his eight years in the south, he absorbed the Italian tradition far more thoroughly than had any Northerner before him. He eagerly studied ancient sculpture, the masterpieces of the High Renaissance, and the work of Caravaggio and Annibale Carracci. In fact, Rubens competed on even terms with the best Italians of his day and could well have made his career in Italy. When he returned to Flanders in 1608 because of his mother's illness, he meant the visit to be brief. His plans changed when he received a special appointment as court painter to the Spanish regent, which allowed him to set up a workshop in Antwerp that was exempt from local taxes and guild regulations. Rubens had the best of both worlds. Like Jan van Eyck (see page 350), he was valued at court not only as an artist, but also as an adviser and emissary. Diplomatic errands gave him entry to the royal households of the major powers, where he received numerous commissions. Aided by a growing number of assistants, he was also free to carry out a huge volume of work for the city of Antwerp, for the Church, and for private patrons.

Rubens epitomized the Baroque ideal of the virtuoso for whom the entire universe is a stage. On the one hand, he was devoutly religious. On the other, he was a man of the world who succeeded in every arena by virtue of his character and ability. Rubens resolved the contradictions of the era through humanism, the union of faith and learning that was attacked by both the Reformation and the Counter-Reformation. In his paintings as well, Rubens reconciled seemingly incompatible forces. His enormous intellect and vitality enabled him to unite the natural and supernatural, reality and fantasy, learning and spirituality. Thus his epic canvases defined the scope and the style

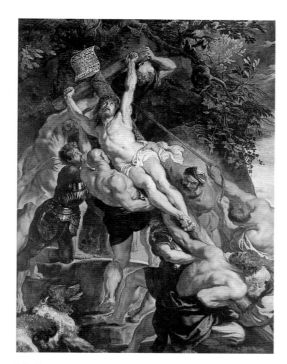

18-1 Peter Paul Rubens. *The Raising of the Cross.* 1609–10. Center panel of a triptych, oil on panel, 15'1" x 11'9⅝" (4.57 x 3.60 m). Antwerp Cathedral

18-2 Peter Paul Rubens. *Marie de' Medici, Queen of France, Landing in Marseilles.* 1622–23. Oil on panel, 25 x 19¾" (63.5 x 50.3 cm). Alte Pinakothek, Munich

of High Baroque painting. They possess a seemingly boundless energy and inventiveness, which, like his heroic nudes, express life at its fullest. The presentation of this heightened existence required the expanded arena that only Baroque theatricality could provide. Rubens's sense of drama was as highly developed as Bernini's. At the same time, he could be the most human of artists.

The Raising of the Cross (fig. 18-1), the first major altarpiece Rubens painted after his return to Antwerp, shows how much he was indebted to Italian art. The muscular figures, modeled to show their physical power and passionate feeling, recall those of the Sistine ceiling and the Farnese Gallery, while the lighting resembles Caravaggio's (see figs. 13-9, 17-1, and 17-4). The panel nevertheless owes much of its success to Rubens's ability to combine Italian influences with Netherlandish ideas, which he updated in the process. The painting is more heroic in scale and conception than any previous Northern work, yet it is unthinkable without Rogier

van der Weyden's *Descent from the Cross* (see fig. 15-5). Rubens is also a Flemish realist in such details as the foliage, the armor of the soldier, and the curly-haired dog in the foreground. These varied elements, integrated with total mastery, form a composition of tremendous dramatic force. The unstable pyramid of bodies, swaying precariously under the strain of the dramatic action, bursts the limits of the frame in a typically Baroque way, making the viewer feel like a participant in the action.

In the 1620s, Rubens's style reached its climax in his huge decorative schemes for churches and palaces. The most famous is the CYCLE in the Luxembourg Palace in Paris glorifying the career of Marie de' Medici, the widow of Henri IV and mother of Louis XIII. Our illustration shows the artist's oil sketch for one episode: the young queen landing in Marseilles (fig. 18-2). This is hardly an exciting subject, yet Rubens has turned it into a spectacle of unparalled splendor. As Marie

The term *CYCLE* refers to a number of scenes, usually painted, that illustrate a story or a series of episodes or events.

18-3 Peter Paul Rubens. *The Garden of Love.* c. 1638. Oil on canvas, 6'6" x 9'3¹/₂" (1.98 x 2.83 m). Museo del Prado, Madrid

de' Medici walks down the gangplank, Fame flies overhead sounding a triumphant blast on two trumpets. Neptune rises from the sea with his fish-tailed crew; having guarded the queen's journey, they rejoice at her arrival. Everything flows together here in swirling movement: heaven and earth, history and allegory. Even drawing and painting come together, for Rubens used oil sketches like this one to prepare his compositions. Unlike earlier artists, he preferred to design his pictures in terms of light and color from the start. (Most of his drawings are figure studies or portrait sketches.) This unified vision, which had been explored but never fully achieved by the great Venetians, was Rubens's most precious legacy to later painters.

Around 1630, the drama of Rubens's earlier work changed to a late style of lyrical tenderness inspired by Titian, whose work Rubens discovered anew in the royal palace while he visited Madrid in 1628. *The Garden of Love* (fig. 18-3) is as glowing a tribute to life's pleasures as Titian's *Bacchanal* (see fig. 13-17). But these fashionable couples belong to the present, not to a golden age of the past, although they are playfully assaulted by swarms of CUPIDS. The picture must have had special meaning for the artist, since he had just married a beautiful girl of 16. (His first wife died in 1626.) The Garden of Love had been a feature of Northern painting ever since the courtly style of the International Gothic. The early versions, however, were genre scenes showing groups of young lovers in a garden. By merging this tradition with Titian's classical mythologies, Rubens has created an enchanted realm where myth and reality become one.

Van Dyck Besides Rubens, only one Flemish Baroque artist won international stature. Anthony van Dyck (1599–1641) was that rarity among

painters, a child prodigy. Before he was 20 he had become Rubens's most valued assistant. But like Rubens, he developed his mature style only after a stay in Italy.

As a history painter, Van Dyck was at his best in lyrical scenes of mythological love. *Rinaldo and Armida* (fig. 18-4) is taken from Torquato Tasso's immensely popular poem *Jerusalem Freed* (1581) about the Crusades, which gave rise to a new courtly ideal throughout Europe and inspired numerous operas as well as paintings. Van Dyck shows the sorceress falling in love with the Christian knight she had intended to kill. The canvas reflects the conception of the English monarchy, for whom it was painted. Charles I, a Protestant, had married the Catholic Henrietta Maria, sister of his rival, the king of France. Charles found parallels in Tasso's epic. He saw himself as the virtuous ruler of a

18-4 Anthony van Dyck. *Rinaldo and Armida.* 1629. Oil on canvas, 7'9" x 7'6" (2.36 x 2.24 m). The Baltimore Museum of Art

The Jacob Epstein Collection

18-5 Anthony van Dyck. *Portrait of Charles I Hunting.* c. 1635. Oil on canvas, 8'11 1/8" x 6'11 1/2" (2.72 x 2.12 m). Musée du Louvre, Paris

peaceful realm much like the Fortunate Isle where Armida brought Rinaldo. (Ironically, Charles's reign ended in civil war, and he was beheaded in 1649.) The artist tells his story of ideal love in the pictorial language of Titian and Veronese, but with an expressiveness and opulence that would have been the envy of any Venetian painter. The picture was so successful that it helped Van Dyck gain appointment to the English court two years later.

Van Dyck's fame rests mainly on the portraits

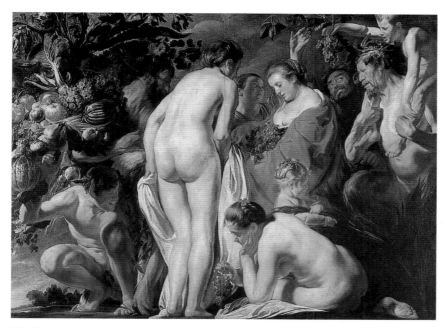

18-6 Jacob Jordaens. *Homage to Pomona (Allegory of Fruitfulness).* c. 1623. Oil on canvas, 5'10⅞" x 7'10⅞" (1.80 x 2.41 m). Musées Royaux d'Art et d'Histoire, Brussels

he painted in London between 1632 and 1641. *Portrait of Charles I Hunting* (fig. 18-5) shows the king standing near a horse and two grooms against a landscape backdrop. Representing the sovereign at ease, the painting might be called a "dismounted equestrian portrait." It is less rigid than a formal state portrait, but hardly less grand, for the king remains in full command of the state, symbolized by the horse. The fluid movement of the setting complements the self-conscious elegance of the king's pose. Van Dyck has brought the court portrait up to date, using Rubens and Titian as his points of departure. In the process, he created a new aristocratic portrait tradition that continued in England until the late eighteenth century and had considerable influence on the Continent as well.

Jordaens Jacob Jordaens (1593–1678) was the successor to Rubens and Van Dyck as the leading artist in Flanders. Although he was never a member of Rubens's studio, he turned to Rubens for inspiration throughout his career. His most character-istic subjects are mythological themes depicting the revels of NYMPHS and satyrs. Like his eating and drinking scenes, which illustrate popular sayings, they reveal him to be a close observer of people. The dwellers of the woods in *Homage to Pomona (Allegory of Fruitfulness)* (fig.18-6) inhabit an idyllic realm, untouched by human cares. The painterly execution shows a strong debt to Rubens, but the monumental figures lack Rubens's heroic vigor and instead possess a calm dignity.

Holland

Hals The Baroque style came to Holland from Antwerp through the work of Rubens, and from Rome through direct contact with Caravaggio and his followers, some of whom were Dutch. One of the first to profit from this experience was Frans Hals (1580/85–1666), the great portrait painter of Haarlem. He was born in Antwerp, and what little is known of his early work suggests the influence

NYMPHS were female divinities in Greek mythology who were identified with nature, natural objects, and sites. The Greeks had many classes of nymphs—most of them gentle and beautiful but some of them wild companions of satyrs—which numbered in the thousands.

POMONA was the goddess of fruit in Roman mythology. This wood nymph was so devoted to her gardens that she rejected many suitors. The god Vertumnus, in the guise of an ugly old woman, argued his merits to Pomona, but was not accepted by her until he appeared in his own radiant form.

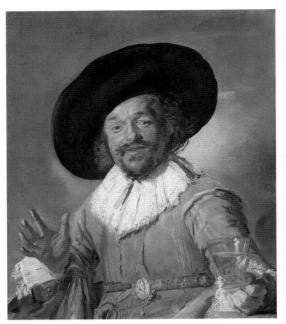

18-7 Frans Hals. *The Jolly Toper.* c. 1628–30. Oil on canvas, 31⁷⁄₈ x 26¹⁄₄" (81 x 66.6 cm). Rijksmuseum, Amsterdam

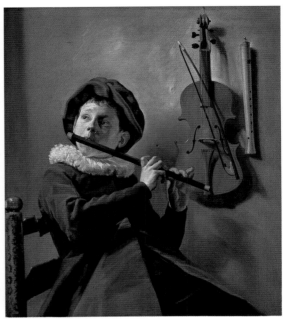

18-8 Judith Leyster. *Boy Playing a Flute.* 1630–35. Oil on canvas, 28³⁄₈ x 24³⁄₈" (72.1 x 61.9 cm). Nationalmuseum, Stockholm

of Rubens. His mature style, however, is seen in *The Jolly Toper* (fig. 18-7), which perhaps represents the sense of taste. The painting combines Rubens's robustness with a focus on the "dramatic moment" that must be derived from Caravaggesque painters in Utrecht. Everything here conveys complete spontaneity: the twinkling eyes and half-open mouth, the raised hand, the teetering wineglass, and—most important of all—the quick way of setting down the forms. Hals worked in dashing brushstrokes, each so clearly visible that we can almost count the total number of "touches." With this open, split-second technique, the completed picture has the immediacy of a sketch (compare our example by Rubens, fig. 18-2). The impression of a race against time is, of course, deceptive. Hals spent hours on this life-size canvas, but he maintains the illusion of having done it all in the wink of an eye.

Leyster Hals's virtuosity could not be readily imitated; hence he had few followers. The most important among them was Judith Leyster (1609–1660), who was responsible for a number of works that once passed as Hals's own. Like many women artists before modern times, her career was curtailed by motherhood. (She married a fellow student of Hals.) Leyster's *Boy Playing a Flute* (fig. 18-8) is her masterpiece. The rapt musician is a memorable expression of lyrical mood. To convey this spirit, Leyster explored the poetic quality of light with an intensity that anticipates the work of Jan Vermeer a generation later (see fig. 18-16).

Rembrandt Like Hals, Rembrandt van Rijn (1606–1669), the greatest genius of Dutch art, was influenced indirectly by Caravaggio through the Utrecht School. His earliest pictures, painted in his native Leyden, are small, sharply lit, and intensely realistic. Many deal with Old Testament subjects, a lifelong preference. They show both his greater realism and his new emotional attitude. Since the beginning of Christian art, episodes from the Old Testament had often been represented for the light they shed on Christian doctrine, rather than for their own sake. (The Sacrifice of Isaac, for example, "prefigured" the sacrificial death of Christ.) This perspective

not only limited the choice of subjects, it also colored their interpretation. Rembrandt, by contrast, viewed the stories of the Old Testament in much the same lay Christian spirit that governed Caravaggio's approach to the New Testament: as direct accounts of God's ways with his human creations.

How strongly these stories affected him is clear in *The Blinding of Samson* (fig. 18-9). Painted in the High Baroque style he developed in the 1630s after moving to Amsterdam, it shows Rembrandt as a master storyteller. The artist depicts the Old Testament world as full of oriental splendor and violence. The theatrical light pouring into the dark tent heightens the drama to the pitch of *The Raising of the Cross* by Rubens (see fig. 18-1), whose work Rembrandt sought to rival.

Rembrandt was at this time an avid collector of Near Eastern objects, which served as props in these pictures. He was now Amsterdam's most sought-after portrait painter, and a man of considerable wealth. His famous group portrait known as *The Night Watch* (fig. 18-10, page 412), painted in 1642, shows a military company assembling for the visit of Marie de' Medici to Amsterdam. Although its members had each contributed toward the cost of the huge canvas (originally it was much larger), Rembrandt did not give them equal weight. He wanted to avoid the mechanically regular designs of earlier group portraits—a problem only Hals had solved successfully. Instead, he made the picture a virtuoso performance filled with Baroque movement and lighting, which captures the excitement of the moment and gives the scene unprecedented drama. Some of the figures were plunged into shadow, while others were hidden by overlapping. Legend has it that the people whose portraits he

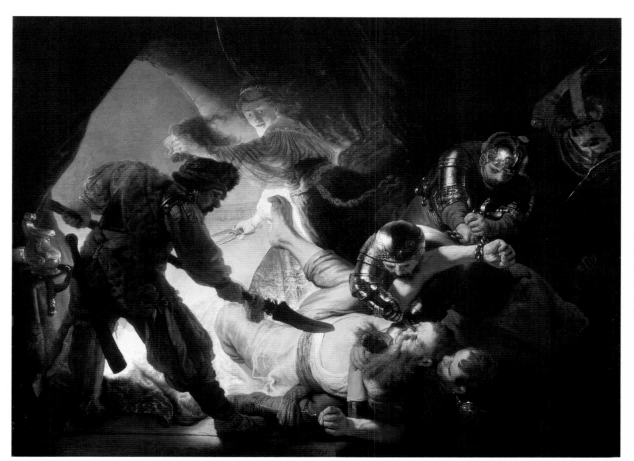

18-9 Rembrandt van Rijn. *The Blinding of Samson.* 1636. Oil on canvas, 7'9" x 9'11" (2.36 x 3.02 m). Städelsches Kunstinstitut, Frankfurt

had obscured were not satisfied with the painting, but there is no evidence for this claim. On the contrary, we know that the painting was much admired in its time.

Like Michelangelo and, later, Van Gogh, Rembrandt has been the subject (one might say, the victim) of many fictionalized biographies. In these, the artist's fall from public favor is usually explained by the "catastrophe" of *The Night Watch*. It is true that his prosperity petered out in the 1640s, as he was replaced by other, more fashionable artists, including some of his own pupils. Yet his fortunes declined less suddenly and completely than his romantic admirers would have us believe. A number

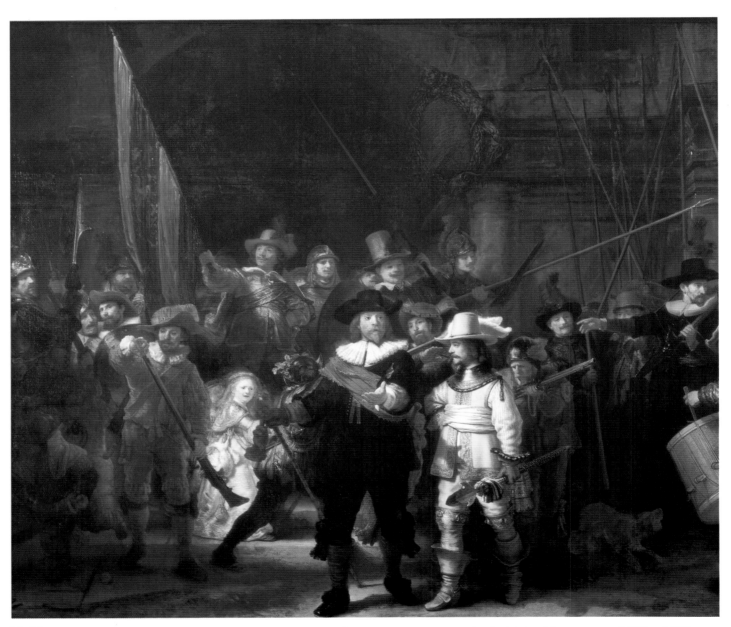

18-10 Rembrandt van Rijn. *The Night Watch (The Company of Captain Frans Banning Cocq)*. 1642. Oil on canvas, 12'2" x 14'7" (3.71 x 4.45 m). Rijksmuseum, Amsterdam

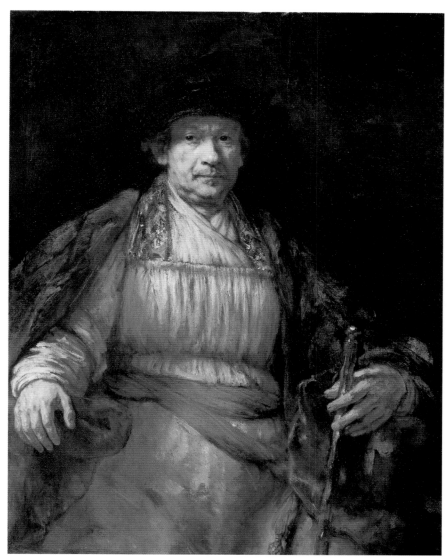

18-11 Rembrandt van Rijn. *Self-Portrait.* 1658. Oil on canvas, 52⅝ x 40⅞" (133.6 x 103.8 cm). The Frick Collection, New York

of important people in Amsterdam continued to be his friends and supporters, and he received some major public commissions in the 1650s and 1660s. Actually, his financial problems were due largely to poor management and his own stubbornness, which alienated his patrons. Still, the 1640s were a time of inner uncertainty and external troubles, especially his wife's death. Rembrandt's outlook changed profoundly. After about 1650, his style is marked by lyric subtlety and pictorial breadth. Some exotic trappings from the earlier years remain, but they no longer create an alien world.

In the many self-portraits Rembrandt painted over his long career, his view of himself reflects every stage of his inner development. It is experimental in the early Leyden years, theatrically disguised in the 1630s, and frank toward the end of his life. While our late example (fig. 18-11) is partially indebted to Titian's portraits, Rembrandt scrutinizes himself with a typically Northern candor. The bold pose and penetrating look bespeak a resigned but firm resolve in the face of adversity. This approach helps to account for the dignity we see in the religious scenes that play so large a part in Rembrandt's work in his later years.

Rembrandt's etchings, such as *Christ Preaching*

etching needle

drawing on a wax-coated etching plate

drypoint needles

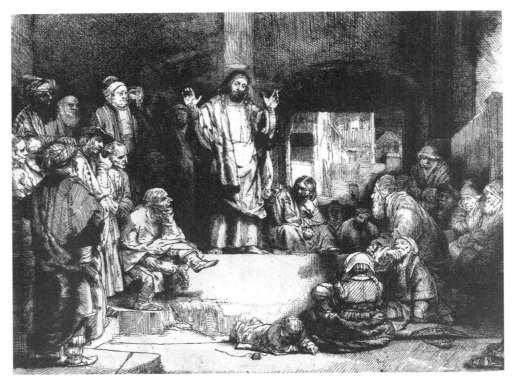

18-12 Rembrandt van Rijn. *Christ Preaching.* c. 1652. Etching, 6¹/₈ x 8¹/₈" (15.6 x 20.6 cm). The Metropolitan Museum of Art, New York

Bequest of Mrs. H. O. Havemeyer, 1929

(fig. 18-12), show this new depth of feeling. The sensuous beauty seen in *The Blinding of Samson* has given way to a humble world of bare feet and ragged clothes. The scene is full of the artist's compassion for the poor and outcast who make up Christ's audience. Rembrandt had a special sympathy for the Jews as heirs of the biblical past and as victims of persecution, and they were often his models. This print strongly suggests some corner in the Amsterdam ghetto and surely incorporates observations of life from the drawings he made throughout his career. Here, as in Caravaggio's *Calling of St. Matthew* (see fig. 17-1), it is the magic of light that endows the scene with spiritual significance.

Etching and Drypoint Rembrandt's importance as a GRAPHIC ARTIST is second only to Dürer's, although we get no more than a hint of this from our single example. Like other creative printmakers of the day, he preferred **etching,** often combined with **drypoint,** to the techniques of **woodcut** and **engraving,** which were employed mainly to reproduce other works. An etching is made by coating a copper plate with resin to make an acid-resistant "ground," through which the design is scratched with a needle, laying bare the metal surface underneath. The plate is then bathed in an acid that etches (or "bites") the lines into the copper. To scratch a design with a needle into the resinous ground is an easier task than to gouge it with the burin used in engraving (see page 362). Hence, an etched line is smoother and more flexible than an engraved line and preserves a sketchlike immediacy. As a result of its greater density of line, etching permits a wide tonal range, including velvety dark shades not possible in engraving or woodcut. Drypoint is made by scratching the design directly into the copper plate itself with a needle, which leaves a

raised burr (the metal displaced by the needle) along the shallow line, which carries the ink. Since the burr quickly breaks down, a drypoint plate yields far fewer prints than an etched plate.

LANDSCAPE, STILL-LIFE, AND GENRE PAINTERS

Rembrandt's religious pictures demand an insight that was beyond the capacity of all but a few collectors. Most art buyers in Holland preferred subjects within their own experience: landscapes, architectural views, **still lifes**, everyday scenes. These types, we recall, emerged in the latter half of the sixteenth century (see pages 376–77). As they became fully defined, artists began to specialize. The trend was not confined to Holland. We find it everywhere to some degree, but Dutch painting was its fountainhead, in both volume and variety.

Ruisdael The richest of the newly developed "specialties" was landscape, both as a portrayal of familiar views and as an imaginative vision of nature. Nature was enjoyed for its own sake, but it could also serve as a means of divine revelation through contemplation of God's work. In *The Jewish Cemetery* (fig. 18-13) by Jacob van Ruisdael (1628/29–1682), the greatest Dutch landscape painter, natural forces dominate the scene, which is imaginary except for the tombs, depicting a Jewish cemetery near Amsterdam. The thunderclouds passing over a wild, deserted mountain valley, the medieval ruin, the torrent that has forced its way between ancient graves, all create a mood of melancholy. Nothing endures on this earth, the artist tells us: time, wind, and water grind all to dust—trees and rocks as well as the works of human hands. Even the elaborate tombs

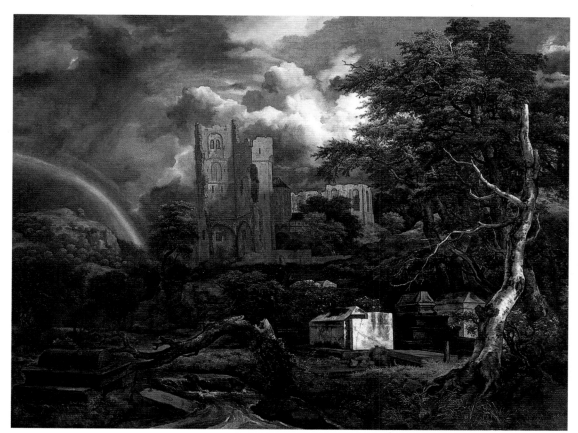

18-13 Jacob van Ruisdael. *The Jewish Cemetery.* 1655–60. Oil on canvas, 4'6" x 6'2½" (1.37 x 1.89 m). The Detroit Institute of Arts

Gift of Julius H. Haass in memory of his brother, Dr. Ernest W. Haass

offer no protection from the same forces that destroy the church built in God's glory. In the context of this extended allegory, the rainbow may be understood as a sign of the promise of redemption through faith. Ruisdael's vision of nature harks back to Giorgione's tragic vision (see fig. 13-16). *The Jewish Cemetery* inspires that awe on which the Romantics, 150 years later, based their concept of the Sublime. The difference is that for Ruisdael, God remains separate from his creation, instead of a part of it.

Heda Still lifes are meant above all to delight the senses, but even they can be tinged with a melancholy air. As a result of Holland's conversion to CALVINISM, these visual feasts became vehicles for teaching moral lessons. Most Dutch Baroque still lifes treat the theme of Vanitas (the vanity of all earthly things). Overtly or implicitly, they preach the virtue of temperance, frugality, and hard work by warning the viewer to contemplate the brevity of life, the inevitability of death, and the passing of all earthly pleasures. The medieval tradition of imbuing everyday objects with religious significance was absorbed into vernacular culture through EMBLEM BOOKS which, together with other forms of popular literature and prints, encompassed the Dutch

ethic in words and pictures. The stern Calvinist sensibility is exemplified by such homilies as "A fool and his money are soon parted" (a saying that goes all the way back to ancient Rome) and is illustrated by flowers, shells, and other exotic luxuries. The very presence in Vanitas still lifes of precious goods, scholarly books, and objects appealing to the senses suggests an ambivalent attitude toward their subject. Such symbols usually take on multiple meanings which, although no longer readily understood today, were widely recognized at the time. In their most elaborate form, these moral allegories become visual riddles that rely on the very learning they sometimes ridicule.

The **banquet** (or **breakfast**) **piece**, showing the remnants of a meal, had Vanitas connotations almost from the beginning. The message may lie in such symbols as death's-heads and extinguished candles, or be conveyed by less direct means. *Still Life* (fig. 18-14) by Willem Claesz. Heda (1594–1680) belongs to this widespread type. Food and drink are less emphasized here than luxury objects, such as crystal goblets and silver dishes, which are carefully chosen for their contrasting shapes, colors, and textures. How different this seems from the piled-up foods of Aertsen's *Meat Stall* (see fig. 16-12)! But virtuosity was not Heda's only aim. He reminds us that all is vanity. His "story," the human context of these grouped objects, is suggested by the broken glass, the half-peeled lemon, the overturned silver dish. The unstable composition, with its signs of a hasty departure, suggests transience. Whoever sat at this table was suddenly forced to leave the meal. The curtain that time has lowered on the scene, as it were, gives the objects a strange pathos. The disguised symbolism of "Late Gothic" painting lives on here in a new form.

Steen Genre scenes are as varied as landscapes and still lifes. They range from tavern brawls to refined domestic interiors. In *The Feast of St. Nicholas* (fig. 18-15) by Jan Steen (1625/6–1679), St. Nicholas has just paid his pre-Christmas visit to the household and left toys, candy, and cake for the children. The little girl and boy are delighted with their presents. She holds a doll of St. John the

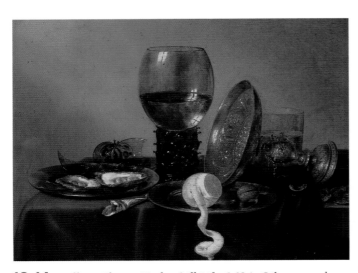

18-14 Willem Claesz. Heda. *Still Life*. 1634. Oil on panel, 16⅞ x 22⅞" (42.9 x 58.1 cm). Museum Boymans–van Beuningen, Rotterdam

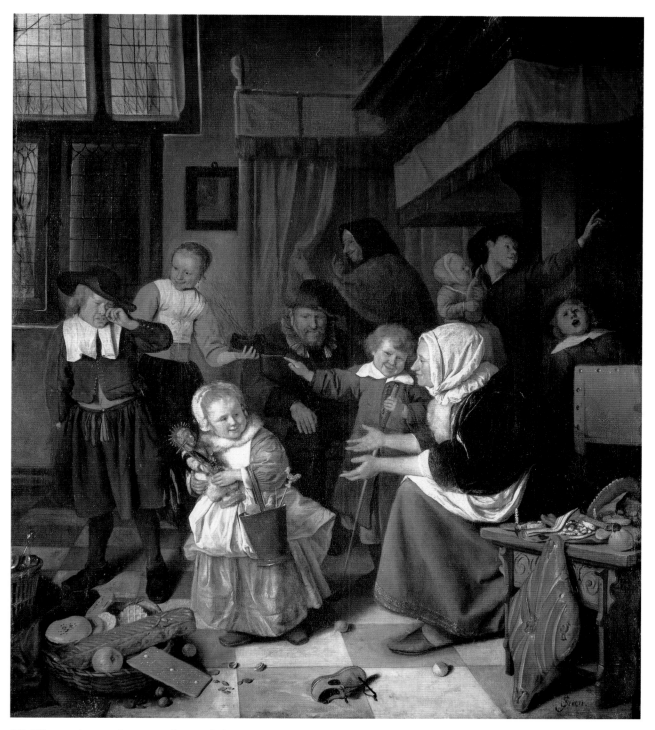

18-15 Jan Steen. *The Feast of St. Nicholas.* c. 1660–65. Oil on canvas, 32¹/₄ x 27³/₄" (81.9 x 70.5 cm). Rijksmuseum, Amsterdam

Baptist and a bucket filled with sweets, while he plays with a golf club and ball. Everybody is jolly except their brother, on the left, who has received only a birch rod (held by the maidservant) for caning naughty children. Soon his tears will turn to joy, however: his grandmother, in the background, beckons to the bed, where a toy is hidden.

Steen tells the story with relish, embroidering it with many delightful details. Of all the Dutch painters of daily life, he was the sharpest and the most good-humored observer. To supplement his earnings he kept an inn, which may explain his keen insight into human behavior. His sense of timing and his characterization often remind us of Frans Hals (compare fig. 18-7), while his storytelling stems from the tradition of Pieter Bruegel the Elder (compare fig. 16-14). Steen was also a gifted history painter, and although his pictures often contain parodies of well-known works by Italian artists, they usually convey a serious message as well. *The Feast of St. Nicholas,* for example, has such a content: the doll of St. John is meant as a reminder of the importance of spiritual matters over worldly possessions, no matter how delightful.

Vermeer In the genre scenes of Jan Vermeer (1632–1675), by contrast, there is hardly any narrative. Single figures, usually women, are seemingly engaged in everyday tasks. They exist in a timeless "still life" world. When there are two, as in *The Letter* (fig. 18-16), they do no more than exchange glances. The painting nonetheless does tell a story, but with unmatched subtlety. The "staged" entrance serves to establish our relation to the scene. We are more than bystanders: we become the bearer of the letter that has just been delivered to the young woman. Dressed in sumptuous clothing, she has been playing the lute, as if awaiting our visit. This instrument, filled with erotic meaning, tradition-ally signifies the harmony between lovers, who play each other's heartstrings. Are we, then, her lover? The amused expression of the maid suggests such an interest. Moreover, the lover in Dutch art and literature is often compared to a ship at sea, whose calm waters shown in the painting on the wall indicate smooth sailing. As usual with Vermeer, however, the picture refuses to yield a final answer, since the artist has depicted the moment before the letter is opened.

Vermeer, unlike earlier artists, perceives reality as a mosaic of colored surfaces—more accurately, he translates reality into a mosaic as he puts it on canvas. We see *The Letter* not only as a perspective "window," but as a "field" made up of smaller fields. Rectangles predominate, carefully aligned with the picture surface; there are no "holes," no undefined empty spaces. The interlocking shapes give Vermeer's work a uniquely modern quality. How did he acquire it? Although there is considerable documentary evidence relating to his life, we know very little about his training. Some of his works show the influence of Carel Fabritius (1622–1654), the most brilliant of Rembrandt's pupils. Others suggest his contact with the Utrecht School. But none of these sources really explains the origin of his style, which is so original that his genius was not recognized until about a century ago.

Vermeer's real interest centers on the role of light. The cool daylight that filters in from the left in *The Letter* is the only active element, working its miracles upon all the objects in its path. As we look at the painting, we feel as if a veil had been pulled from our eyes. The everyday world shines with jewel-like freshness, more beautiful than we have ever seen it before. No painter since Jan van Eyck saw as intensely as this. Nor shall we meet his equal again until the Rococo artist Chardin (see fig. 20-6).

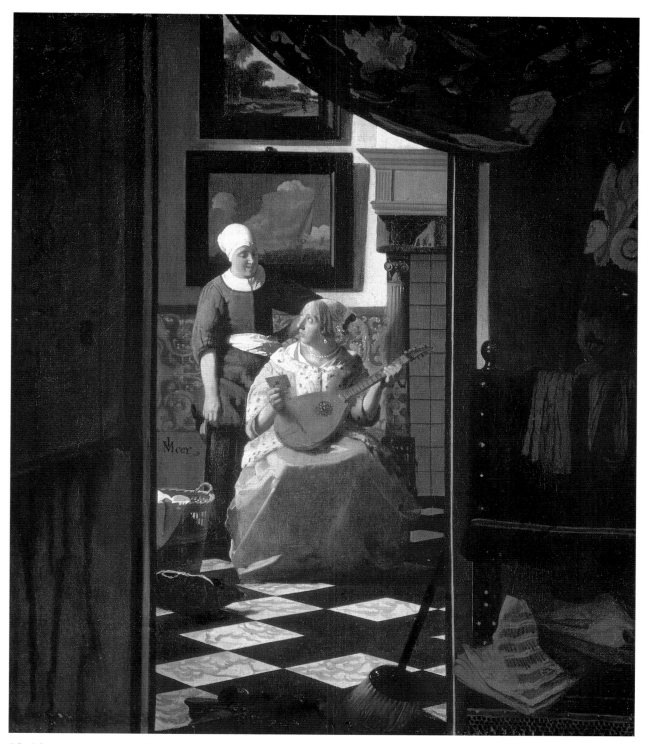

18-16 Jan Vermeer. *The Letter.* 1666. Oil on canvas, 17¼ x 15¼" (43.8 x 38.7 cm). Rijksmuseum, Amsterdam

CHAPTER 19

THE BAROQUE IN FRANCE AND ENGLAND

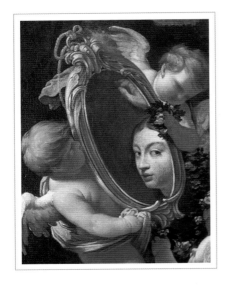

Under Henry IV (1553–1610), Louis XIII (1601–1643), and Louis XIV (1638–1715), France became the most powerful nation in Europe, both militarily and culturally. These monarchs were aided by a succession of extremely able ministers and advisers: the duc de Sully, Cardinal Richelieu, Cardinal Mazarin, and Jean-Baptiste Colbert. By the late seventeenth century, Paris was vying with Rome as the world capital of the major and minor arts. How did this change come about? Because of the Palace of Versailles and other vast projects glorifying the king of France, we are tempted to think of French art in the age of Louis XIV as the expression of absolute rule. This is true of the climactic phase of Louis's reign, from 1661 to 1685, but by that time seventeenth-century French art had already attained its distinctive style.

The French are reluctant to call this style Baroque. To them, it is the Style of Louis XIV. Often they also describe the art and literature of the period as classic. In this context, the word has three meanings. It is a synonym for "highest achievement," which implies that the Style of Louis XIV corresponds to the High Renaissance in Italy or the age of Perikles in ancient Greece. It also refers to the emulation of the forms and subject matter of classical antiquity. Finally, it suggests qualities of balance and restraint shared by ancient art and the Renaissance. The last two meanings describe what could more accurately be called classicism. Since the Style of Louis XIV reflects Italian Baroque art, however modified, we may label it "Baroque classicism."

This classicism was the official court style between 1661 and 1685, but its origin was primarily artistic, not political. Sixteenth-century architecture in France and, to a lesser

extent, sculpture were more closely linked with the Italian Renaissance than in any other Northern country. Painting, however, continued to be governed by the Mannerist style until after 1600. Classicism was also nourished by French humanism, with its intellectual heritage of reason and Stoic virtue, which reflected the values of the upper middle-class who gradually came to dominate cultural and political life. These factors slowed the spread of the Baroque in France and altered its interpretation. Rubens's Medici cycle (see fig. 18-2), for example, had no effect on French art until the very end of the century. In the 1620s, when he painted it, the young artists in France were still assimilating the early Baroque.

Painting in France

De La Tour Many of the early French Baroque painters were influenced by Caravaggio, although it is not clear how they absorbed his style. Most were minor artists toiling in the provinces, but a few developed highly original styles. The finest of them was Georges de La Tour (1593–1652), whose importance was recognized only in the nineteenth century. Although he spent his career in Lorraine in northeastern France, he was by no means a simple provincial artist. Besides being named a painter to the king, he received important commissions from the governor of Lorraine. He began his career painting picturesque genre figures, then turned to elaborate stock scenes from contemporary theater derived largely from Caravaggio's Northern followers.

Although the latter are well painted, de La Tour would arouse little interest were it not for his mature religious pictures, which possess both seriousness and grandeur. *Joseph the Carpenter* (fig. 19-1) might easily be mistaken for a genre scene, but its devotional spirit has the power of Caravaggio's *Calling of St. Matthew* (see fig. 17-1). De La Tour's intensity of vision lends each gesture and each expression its maximum significance within this spellbinding composition. The boy Jesus holds a candle, a favorite device of the artist, which lights

19-1 Georges de La Tour. *Joseph the Carpenter.* c. 1645. Oil on canvas, 51⅛ x 39¾" (130 x 100 cm). Musée du Louvre, Paris

the scene with intimacy and tenderness. De La Tour reduces his forms to a geometric simplicity that raises them above the everyday world, despite their apparent realism.

Poussin Why was de La Tour so quickly forgotten? The reason is simply that classicism was supreme in France after the 1640s. The clarity, balance, and restraint of de La Tour's art might be termed classical, especially when measured against other Caravagesque painters, but he was certainly not a classicist. The artist who did the most to bring about the rise of classicism was Nicolas Poussin (1593/4–1665), the greatest French painter of the century and the first French painter in history to win international fame. He nevertheless spent almost his entire career

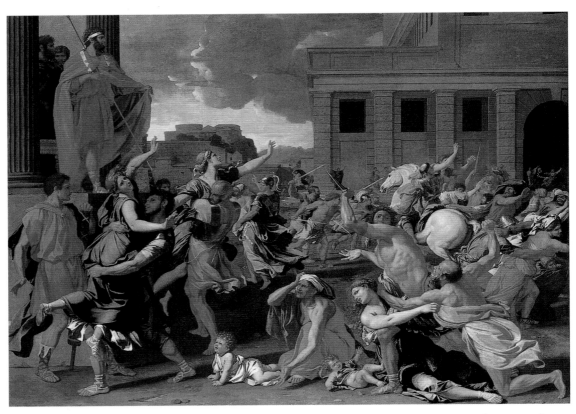

19-2 Nicolas Poussin. *The Abduction of the Sabine Women.* c. 1633–34. Oil on canvas, 5'7⅞" x 6'10⅝" (1.54 x 2.09 m). The Metropolitan Museum of Art, New York

in Rome. There he developed the style that was to become the model for French painters of the second half of the century.

At first Poussin was inspired by Titian's warm, rich colors and by his approach to classical mythology. Soon he fell under the spell of antiquity and Raphael. *The Abduction of the Sabine Women* (fig. 19-2) shows his allegiance to classicism. The painting exhibits the severe discipline of Poussin's intellectual style, which developed in response to what he regarded as the excesses of the High Baroque (see pages 391–93). The strongly modeled figures are "frozen in action," like statues. Many are, in fact, taken from Hellenistic sculpture, but the main group is derived from Giovanni Bologna's *Abduction of the Sabine Woman* (see fig. 14-15). Poussin has placed them before reconstructions of Roman architecture that he believed to be archaeologically

correct. The scene has a theatrical air, and with good reason. It was worked out by moving wax figurines around a miniature stagelike setting until it looked right to the artist. Emotion is abundantly displayed, but it is so lacking in spontaneity that it fails to touch us. The attitude reflected here is clearly Raphael's (see figs. 13-14 and 13-15). More accurately, it is Raphael as filtered through Annibale Carracci and his school (compare figs. 17-4 and 17-5). The Venetian qualities of his early career have been consciously suppressed.

Poussin now strikes us as an artist who knew his own mind only too well. This impression is confirmed by the numerous letters in which he stated his views to friends and patrons. The highest aim of painting, he believed, is to represent noble and serious human actions. This is true even in *The Abduction of the Sabine Women*, which depicts a subject that,

ironically, was admired as an act of patriotism ensuring the future of Rome. (According to the accounts of LIVY and PLUTARCH, the SABINES otherwise escaped unharmed, and the young women abducted as wives by the Romans later became peacemakers between the two sides.) To Poussin, such actions must be shown in a logical and orderly way—not as they really happened, but as they would have happened if nature were perfect. To this end, art must strive for the general and typical. In appealing to the mind rather than the senses, the painter should suppress such incidentals as color and instead stress form and composition. In a good picture, the viewer must be able to "read" the emotions of each figure and relate them to the story.

These ideas were not new. We recall Horace's motto *ut pictura poesis* and Leonardo's statement that the highest aim of painting is to depict "the intention of man's soul" (see pages 301 and 303). Before Poussin, however, no one made the analogy between painting and literature so closely, or put it into practice so single-mindedly. His method accounts for the cold rhetoric in *The Abduction of the Sabine Women*, which makes the picture seem so remote.

Claude Lorraine Like Poussin, the great French landscapist Claude Lorraine (1600–1682) spent almost his entire career in Rome. He explored the surrounding countryside, the Campagna, more thoroughly and affectionately than any Italian. Countless drawings made on the spot reveal his powers of observation. He also sketched in oils outdoors, the first artist known to have done so. Sketches, however, were only the raw material for his paintings. Claude's landscapes do not aim at topographic accuracy but evoke the poetic essence of a countryside filled with echoes of antiquity. In *A Pastoral Landscape* (fig. 19-3), the vista expands serenely and is imbued with the hazy, luminous

Titus Livius, called LIVY (59 B.C.– 17 A.D.), was a Roman historian whose *History of Rome* is a classic. He wrote 45 books, publishing them five at a time. The first ten books are semilegendary accounts of Rome's founding and early history; the rest are more factual, although colored by Livy's intention to show, through its history, that Rome was destined for greatness.

PLUTARCH (46?–120 A.D.), Greek essayist, moral philosopher, and biographer, is especially appreciated for his *Parallel Lives*. Composed of biographies of illustrious Greeks and Romans, the *Lives* are regarded as historically valid and were, in fact, the source that Shakespeare used for his Roman-history plays, among them *Antony and Cleopatra* and *Julius Caesar*.

Although the abduction of the SABINE women by early Roman followers of Romulus is regarded as legendary, the Sabines were in fact an Italic people who moved from the mountains east of the Tiber River and settled on the hills that became the early city of Rome (see page 126).

19-3 Claude Lorraine. *A Pastoral Landscape.* c. 1650. Oil on copper, 15½ x 21" (39.3 x 53.3 cm). Yale University Art Gallery, New Haven, Connecticut

Leo C. Hanna, Jr., Fund

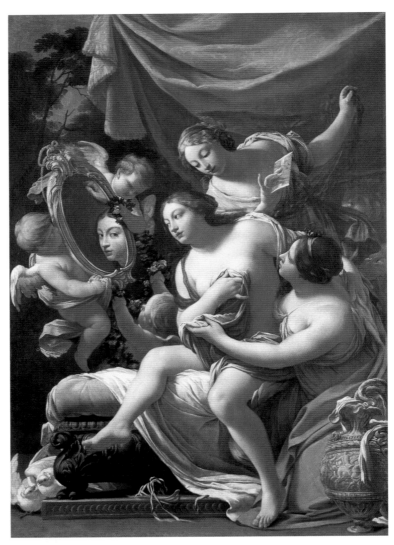

19-4 Simon Vouet. *The Toilet of Venus.*
c. 1640. Oil on canvas, 65 1/4 x 45"
(165.7 x 114.3 cm). The Carnegie
Museum of Art, Pittsburgh

Gift of Mrs. Horace Binney Hare

atmosphere of late afternoon to bring out the idyllic aspects of nature. An air of nostalgia hangs over the scene, of past experience enhanced by memory.

Vouet At an early age, Simon Vouet (1590–1649), too, went to Rome, where he became the leader of the French Caravaggesque painters. Unlike Poussin and Claude, who returned to France only briefly, he settled in Paris. There he quickly shed all traces of Caravaggio's manner and developed a colorful style based on Carracci's, which won such acclaim that Vouet was named First Painter to the king. He also brought with him

memories of the great North Italian precursors of the Baroque. *The Toilet of Venus* (fig. 19-4) depicts a subject popular in Venice from Titian to Veronese. Vouet's figure also recalls Correggio's Io (see fig. 14-8), but without her frank eroticism. Instead, she has been given an elegant sensuousness that is far removed from Poussin's disciplined art.

The Toilet of Venus was painted about 1640, toward the beginning of Poussin's ill-fated sojourn in Paris, where he had gone at the invitation of Louis XIII. He met with no more success than Bernini was to have 20 years later (see pages 426 and 431). After several years Poussin left, deeply

disillusioned by his experience at the court, whose taste and politics Vouet understood far better. In one sense, their rivalry was to continue long afterward. Vouet's decorative style was the basis for the Rococo, but it was Poussin's classicism that soon dominated art in France. The two traditions vied with each other through the Romantic era, alternating in succession without either gaining the upper hand for long.

THE ROYAL ACADEMY

When young Louis XIV took over the reins of government in 1661, Jean-Baptiste Colbert, his chief adviser, built the administrative apparatus to support the power of the ABSOLUTE MONARCH. In this system, aimed at subjecting the thoughts and actions of the entire nation to strict control from above, the visual arts had the task of glorifying the king. As in music and theater, which shared the same task, the official "royal style" was classicism. Centralized control over the visual arts was exerted by Colbert and by the artist Charles Lebrun (1619–1690), who became supervisor of all the king's artistic projects. As chief dispenser of royal art patronage, Lebrun had so much power that for all practical purposes he was the dictator of the arts in France. His authority extended beyond the power of the purse. It also included a new system of educating artists in the officially approved style.

Throughout antiquity and the Middle Ages, artists had been trained by apprenticeship, and this practice still prevailed in the Renaissance. As painting, sculpture, and architecture gained the status of liberal arts, artists wished to supplement their "mechanical" training with theoretical knowledge. For this purpose, art academies were founded, patterned on the academies of the humanists. (The name *academy* is derived from the Athenian grove, dedicated to the legendary hero Akademos—Academus in Latin—where Plato met with his disciples.) Art academies appeared first in Italy in the later sixteenth century as an outgrowth of literary academies. They seem to have been private associations of artists who met to draw from the model and discuss questions of art theory. These academies later became formal institutions that took over some functions from the guilds, but their teaching was limited and far from systematic.

This was the case as well with the Royal Academy of Painting and Sculpture in Paris, founded in 1648. But when Lebrun became its director in 1663, he established a rigid curriculum of instruction in practice and theory based on a system of rules. This set the pattern for all later academies, including the art schools of today. Much of this doctrine was derived from Poussin, with whom Lebrun had studied for several years in Rome, but it was carried to rationalist extremes. The Academy even devised a method for giving numerical grades to artists past and present in such categories as drawing, expression, and proportion. The ancients received the highest marks, of course, then came Raphael and his school, and Poussin. The Venetians, who "overemphasized" color, ranked low, the Flemish and Dutch even lower. Subjects were also classified, from "history" (that is, narrative subjects, be they classical, biblical, or mythological) at the top to still life at the bottom.

The political system that gives rise to an ABSOLUTE MONARCH is absolutism, in which full, unlimited, and unchecked power to rule a nation is in the hands of a single individual (an absolute monarch) or a group of rulers (oligarchs). Absolutism emerged in Europe near the end of the fifteenth century and is most clearly embodied by the reign of Louis XIV of France.

Architecture in France

The foundations of Baroque classicism in architecture were laid by a group of designers who form a continuous tradition with the sixteenth century that is unique in the history of architecture. The classicism introduced by Lescot at the Louvre (see fig. 16-15) reached its height around the middle of the sixteenth century. The central position was occupied by the Du Cerceau family, which worked on the Louvre and other royal projects through the middle of the seventeenth century. However, the first French architect of genius since Lescot was François Mansart (1598–1666). Apparently Mansart never visited Italy, but other French architects had already imported and adapted some aspects of the early Baroque. Chief among them was his rival, Jacques Lemercier (c. 1582–1654), whose works for Cardinal Richelieu, including the enlargement of the Square Court of the Louvre in 1624, are uninspired adaptations of earlier designs by Lescot and the Du Cerceaus. Mansart eventually lost out to Lemercier in church architecture

because of his difficult personality. Toward the end of his career, he was also supplanted in the field of hôtels and châteaux by the younger and more adaptable Louis Le Vau (1612–1670). Le Vau was part of a team, including Charles Lebrun and the landscape architect André Le Nôtre (1613–1700), who were called to the court by the king's minister Colbert in 1661 shortly before completing the château at Vaux-le-Vicomte outside Paris for the disgraced finance minister Nicolas Fouquet.

The Louvre The climactic phase of French Baroque classicism, which may be compared with the heroic classicism of Poussin and the playwright Pierre Corneille, began with the first great project Colbert directed, the completion of the Louvre. Work on the palace had proceeded intermittently for over a century, along the lines of Lescot's design (see fig. 16-15). What remained to be done was to close the Square Court on the east side with an impressive facade. Colbert, however, was dissatisfied with the proposals of French architects, including Mansart, who submitted various designs not long before his death. He therefore invited Bernini to Paris in the hope that the most famous master of the Roman Baroque would do for the French king what he had already done

for the Church. Bernini spent several months in Paris in 1665 and submitted three designs, all of them on a scale that would have dwarfed the existing palace. After much argument, Louis XIV rejected these plans and turned over the problem to a committee of three: Charles Lebrun, his court painter; Louis Le Vau, his court architect, who had already done much work on the Louvre; and Claude Perrault (1613–1688), who was an anatomist and student of ancient architecture, not a professional architect. All three were responsible for the structure that was actually built (fig. 19-5), although Perrault is rightly credited with the major share. Certainly his supporters and detractors thought so at the time, and he was often called upon to defend its design.

The center pavilion is based on a Roman temple front, and the wings look like the flanks of that temple folded outward. The temple theme required a single order of freestanding columns, but the Louvre had three stories. This problem was solved by treating the ground story as the **podium** of the temple and recessing the upper two behind the screen of the colonnade. The colonnade itself was controversial in its use of paired columns, even though they were not needed for support.

The east front of the Louvre signaled the victory of French classicism over the Italian Baroque as the royal style. It further proclaimed France the new Rome, both politically and culturally, by linking Louis XIV with the glory of the Caesars. The design combines grandeur and elegance in a way that fully justifies its fame. In some ways it suggests the mind of an archaeologist, but one who knew how to choose those features of classical architecture that would be compatible with the older parts of the palace. This antiquarian approach was Perrault's main contribution.

Perrault owed his position to his brother, Charles Perrault (1628–1703), who, as Colbert's Master of Buildings under Louis XIV, had helped to undermine Bernini during his stay at the French court. It is likely that Claude shared the views set forth some 20 years later in Charles's *Parallels between the Ancients and Moderns* (see page 454), which claimed "that Homer and Virgil made countless mistakes which the moderns no longer

19-5 Claude Perrault. East front of the Louvre, Paris. 1667–70

make [because] the ancients did not have all our rules." Thus the east front of the Louvre presents not simply a classical revival but a vigorous distillation of what Claude Perrault considered the eternal ideals of beauty, intended to surpass anything by the Romans themselves. Although it was attacked by strict classicists, this great example proved to be too pure and Perrault soon faded from favor.

The Palace of Versailles The king's largest enterprise was the Palace of Versailles, located 11 miles from the center of Paris. It was built by Louis XIV to prevent a repeat of the civil rebellion known as the Fronde, which occurred in 1648–53 during his minority, by forcing the aristocracy to live under royal control outside of Paris. Versailles was begun in 1669 by Le Vau, who designed the elevation of the garden front (fig. 19-6), but he died within a year. Under Jules Hardouin-Mansart (1646–

1708), a great-nephew and pupil of François Mansart (see above), the project was greatly expanded to accommodate the ever-growing royal household. The garden front, intended by Le Vau to be the main view of the palace, was stretched to an enormous length with no change in the architectural elements. As a result, his original facade design, a less severe variant of the east front of the Louvre, looks repetitious and out of scale. The whole center block contains a single room, the famous Galerie des Glaces (Hall of Mirrors). At either end are the Salon de la Guerre (War) and its counterpart, the Salon de la Paix (Peace).

Baroque features, although not officially acknowledged, reappeared inside the Palace of Versailles. This shift reflected the king's own taste. Louis XIV was interested less in architectural theory and monumental exteriors than in the lavish interiors that would make suitable settings for himself and his court. Thus the man to whom he really listened

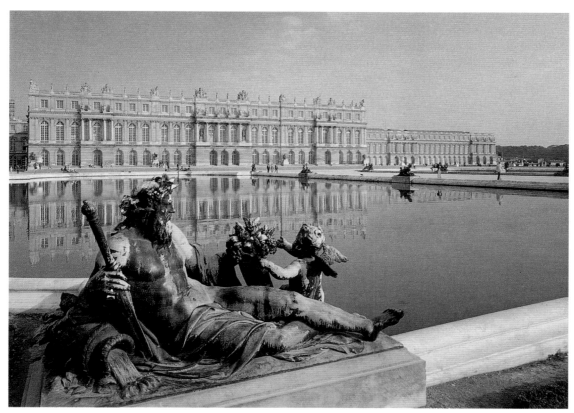

19-6 Louis Le Vau and Jules Hardouin-Mansart. Garden front of the center block of the Palace of Versailles. 1669–85

was not an architect but the painter Lebrun. Lebrun's goal was in itself Baroque: to subordinate all the arts to the glorification of Louis XIV. To achieve it, he drew freely on his memories of Rome. The great decorative schemes of the Baroque that he saw there must also have impressed him. They stood him in good stead 20 years later, both in the Louvre and at Versailles. Although a disciple of Poussin, he had studied first with Vouet and became a superb decorator. Lebrun employed architects, sculptors, painters, and decorators to create ensembles of unprecedented splendor. The Salon de la Guerre at Versailles (fig. 19-7) is close in many ways to the Cornaro Chapel (compare fig. 17-15), although Lebrun obviously emphasized surface decoration far more than did Bernini. As in so many Italian Baroque interiors, the separate components are less impressive than the effect of the whole.

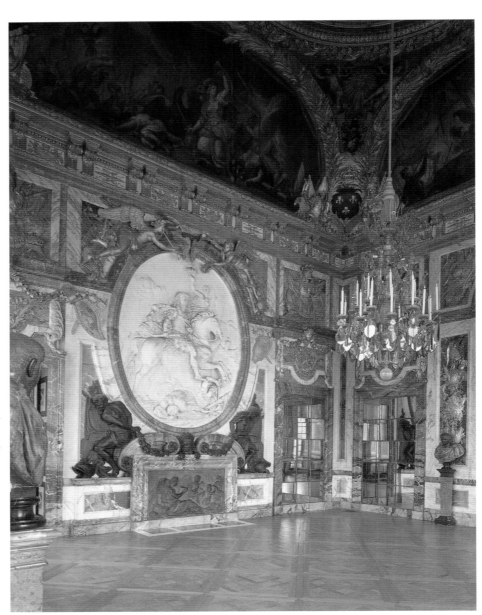

19-7 Jules Hardouin-Mansart, Charles Lebrun, and Antoine Coysevox. Salon de la Guerre, Palace of Versailles. Begun 1678

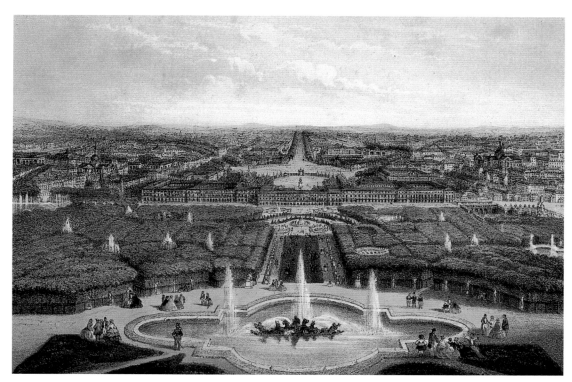

19-8 Charles Rivière. *Perspective View of the Château and Gardens of Versailles.* Lithograph after an 1860 photograph

Apart from the magnificent interior, the most impressive aspect of Versailles is the park extending west of the garden front for several miles (fig. 19-8). The design by Le Nôtre is so strictly correlated with the plan of the palace that it continues the architectural space. Like the interiors, these formal gardens, with their terraces, basins, clipped hedges, and statuary, were meant to provide a suitable setting for the king's appearances in public. They form a series of "outdoor rooms" for the splendid fêtes and spectacles that Louis XIV so enjoyed. The spirit of absolutism is even more striking in this geometric regularity imposed upon an entire countryside than it is in the palace itself. This kind of formal garden had its beginnings in Renaissance Florence but had never been used on the scale achieved by Le Nôtre at Versailles and elsewhere.

Hardouin-Mansart At Versailles, Hardouin-Mansart worked as a member of a team, constrained by the design of Le Vau. His own style can be better seen in the Church of the Invalides (figs. 19-9, 19-10, page 430), named after the institution for disabled soldiers of which it was a part. The building combines Italian Renaissance and Baroque features, but they have been interpreted in a distinctly French manner that stretches back to the middle of the sixteenth century. The Invalides may be seen as Hardouin-Mansart's comment on seventeenth-century churches in Paris by Lemercier, Mansart, and Le Vau. However, Hardouin-Mansart incorporated features found in his granduncle's design of 1665 for the Bourbon dynasty chapel at St-Denis. It may well be that the Invalides was intended to serve a similar purpose as Louis XIV's burial place.

In plan the Invalides consists of a Greek cross with four corner chapels. It is based (with various French intermediaries) on Michelangelo's plan for St. Peter's. The only Baroque element is the oval choir. The dome, too, reflects the influence of

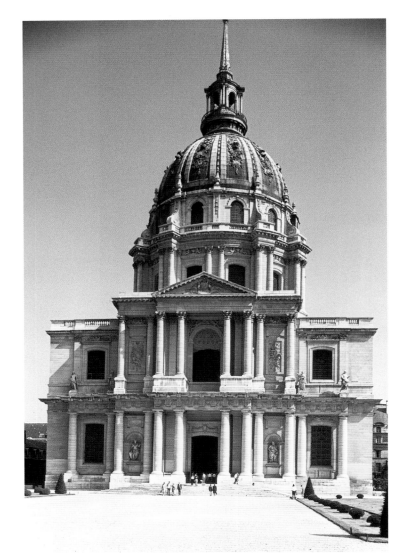

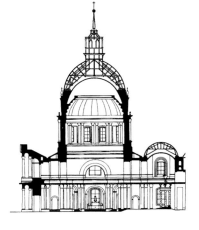

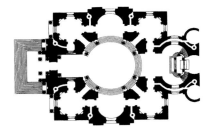

19-9 Jules Hardouin-Mansart. Church of the Invalides, Paris. 1680–91

19-10 Plan of the Church of the Invalides

Michelangelo (see fig. 13-12), but it consists of three shells, not the usual two, and the classicistic facade recalls the east front of the Louvre. Nevertheless, the exterior as a whole is unmistakably Baroque. It breaks forward repeatedly in the crescendo effect introduced by Maderno (see fig. 17-8). And, as in Borromini's Sta. Agnese in Piazza Navona (see fig. 17-11), the facade and dome are closely linked.

The dome itself is the most original, as well as the most Baroque, feature of Hardouin-Mansart's

design. Tall and slender, it rises in one continuous curve from the base of the drum to the spire atop the lantern. On the first drum rests a second, narrower drum. Its windows provide light for the painting inside the dome. The windows themselves are hidden behind a "pseudo-shell" with a large opening at the top, so that the vision of heavenly glory seems to be mysteriously illuminated and suspended in space. The bold "theatrical" lighting of the Invalides would do honor to any Italian Baroque architect.

Sculpture in France

Sculpture arrived at the official royal style in much the same way as architecture. While in Paris, Bernini carved a marble bust of Louis XIV. He was also commissioned to do an equestrian statue of the king, for which he made a terra-cotta model. However, the project shared the fate of Bernini's Louvre designs. Although he portrayed the king in classical military garb, the statue was rejected. Apparently the rearing horse, derived from Leonardo, was too dynamic to safeguard the dignity of Louis XIV. This decision was far-reaching. Equestrian statues of the king were later set up throughout France as symbols of royal authority. Bernini's design, had it succeeded, might have set the pattern for these monuments. Adopted instead was a timid variation on the equestrian portrait of Marcus Aurelius (see fig. 7-10) executed in the 1680s by François Girardon (1628–1715), which was destroyed during the French Revolution.

Coysevox Bernini's influence can nevertheless be felt in the work of Antoine Coysevox (1640–1720), one of the sculptors Lebrun employed at Versailles. The victorious Louis XIV in Coysevox's large stucco relief for the Salon de la Guerre (see fig. 19-7) retains the pose of Bernini's equestrian statue, although with a certain restraint. Coysevox is the first of a long line of distinguished French portrait sculptors. His terra-cotta portrait of Lebrun (fig. 19-11) repeats the general outlines of Bernini's bust of Louis XIV. The face, however, shows a realism and subtlety of characterization that are Coysevox's own.

Puget Coysevox approached the Baroque in sculpture as closely as Lebrun would permit. Pierre-Paul Puget (1620–1694), the most talented and most Baroque of seventeenth-century French sculptors, had no success at court until after Colbert's death, when Lebrun's power was on the decline. *Milo of Crotona* (fig. 19-12), Puget's finest statue, can be compared to Bernini's *David* (see fig. 17-13). Puget's composition is more contained than Bernini's, but the agony of the hero has such force that its impact is almost physical. The internal tension

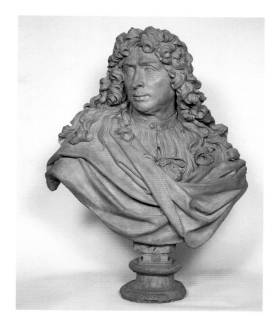

19-11 Antoine Coysevox. *Charles Lebrun.* 1676. Terra-cotta, height 26" (66 cm). The Wallace Collection, London

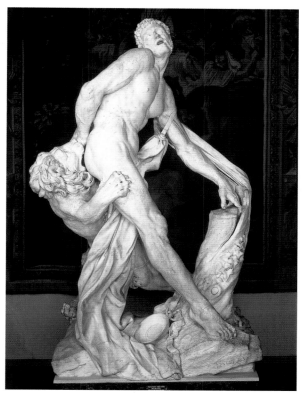

19-12 Pierre-Paul Puget. *Milo of Crotona.* 1671–83. Marble, height 8'10½" (2.71 m). Musée du Louvre, Paris

fills the statue with an intense life that also recalls Hellenistic sculpture (see fig. 5-24). That, one suspects, is what made it acceptable to Louis XIV.

England

The English made no significant contribution to Baroque painting and sculpture. They were content with feeble offshoots of Van Dyck's portraiture by imported artists such as the Dutch-born Peter Lely (1618–1680) and his German successor, Godfrey Kneller (1646–1723). The English achievement in architecture, however, was of genuine importance. This accomplishment is all the more surprising in light of the fact that the Late Gothic Perpendicular style (see fig. 11-11) proved extraordinarily durable in England, which did not produce any buildings of note until Elizabethan times.

Jones The first English architect of genius was Inigo Jones (1573–1652), who was also the leading English theatrical designer of the day. When he went to Italy about 1600 and again in 1613, he was influenced by the Baroque stage designs of Giulio Parigi; surprisingly, he returned a disciple of Palladio. In 1615 Jones was appointed Surveyor of the King's Works, a post he held until 1643. The Banqueting House he built at Whitehall Palace in London (fig. 19-13) for the masques and other entertainments he presented at the court conforms in every way to the principles in Palladio's treatise, although it does not copy any specific design. It is essentially a Vitruvian "basilica" (a double-cube with an **apse** for the king's throne) treated as a Palladian villa. Symmetrical and self-sufficient, it is more like a Renaissance palazzo than any other building north of the Alps designed at that time. Jones's spare style, supported by Palladio's authority as a theorist, stood as a beacon of classicist orthodoxy in England for 200 years.

Wren This classicism can be seen in some parts of St. Paul's Cathedral (fig. 19-14) by Sir Christopher Wren (1632–1723), who was the great English architect of the late seventeenth century. St. Paul's is in other ways an up-to-date Baroque design that reflects a thorough knowledge of the Italian and French architecture of the day. Wren came close to being a Baroque counterpart of the Renaissance artist-scientist. An intellectual prodigy, he first studied anatomy, then physics, mathematics, and astronomy, and was highly esteemed by Sir Isaac Newton. His serious interest in architecture did not begin until he was about 30. Yet it is typical of the Baroque as opposed to the Renaissance that there seems to be no direct link between his scientific and artistic ideas. It is hard to determine whether his technological knowledge affected the shape of his buildings.

If the GREAT LONDON FIRE OF 1666 had not destroyed the Gothic cathedral of St. Paul and many lesser churches, Wren might have remained an amateur architect. But after that catastrophe, he was named to the short-lived royal commission for rebuilding the city, and a few years later began his designs for St. Paul's. Wren favored **central-plan churches** and originally conceived St. Paul's in the shape of a Greek cross, based on Michelangelo's plan of St. Peter's, with a huge domed crossing. This idea was evidently inspired by a design by Inigo Jones, who had been involved with the restoration of the Gothic St. Paul's earlier in the century. Wren's proposal was nevertheless rejected by church authorities as "papist" in favor of a conventional basilica, which was deemed more suitable for a Protestant structure.

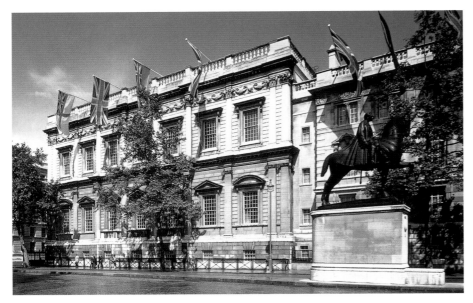

19-13 Inigo Jones. West front of the Banqueting House, Whitehall Palace, London. 1619–22

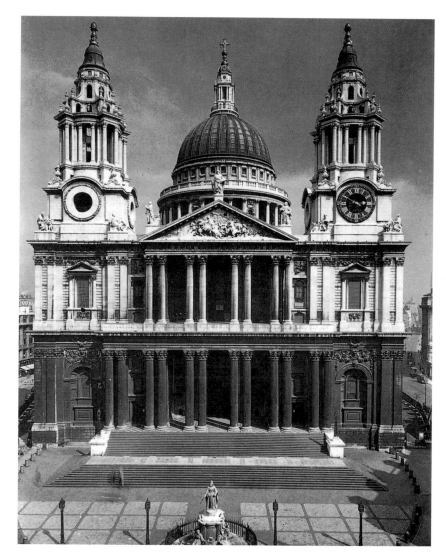

19-14 Sir Christopher Wren. Facade of St. Paul's Cathedral, London. 1675–1710

The tradition of Inigo Jones provided no more than a starting point for Wren. On his only trip abroad in 1665–66, Wren had visited Paris at the time of the dispute over the completion of the Louvre. He must have sided with Perrault, whose design for the east front is clearly reflected in the facade of St. Paul's. St. Paul's also bears a striking resemblance to Hardouin-Mansart's Church of the Invalides (see figs. 19-9 and 19-10), which inspired the tripartite construction of the dome. Despite his belief that Paris provided "the best school of architecture in Europe," Wren was affected by the Roman Baroque. He must have wanted the new St. Paul's to be the St. Peter's of the Church of England: soberer and not so large, but just as impressive. His dome, like that of St. Peter's, has a diameter as wide as the nave and aisles combined, but it rises high above the rest of the structure and dominates even our close view of the facade. Wren ingeniously hid the buttresses supporting the dome behind a thick wall, which further helps to brace them. The lantern and the upper part of the clock towers suggest that he knew Borromini's Sta. Agnese in Piazza Navona (see fig. 17-11), probably from drawings or engravings. The final result reflects not only the complex evolution of the design but also some needless changes made late in the construction by the commission overseeing it, which dismissed Wren in 1718.

20

THE ROCOCO

Much as the Baroque is often considered the final phase of the Renaissance, so the Rococo has been treated as the end of the Baroque: a long twilight, delicious but decadent, that was cleaned away by the Enlightenment and Neoclassicism. In France the Rococo is linked with Louis XV because it roughly corresponds to his life span (1710–1774). However, it cannot be identified with the State or the Church any more than can the Baroque, even though they continued to provide the main patronage. The essential characteristics of Rococo style were defined largely during the regency phase of 1715–23. Moreover, its first signs appeared as much as 50 years earlier, during the Late Baroque. Hence the view of the Rococo as the final phase of the Baroque is well founded. As the philosopher Voltaire (François-Marie Arouet) pointed out, the eighteenth century lived in debt to the past. In art Poussin and Rubens cast their long shadows over the period. The controversy between their partisans, in turn, goes back much further to the debate between the supporters of Michelangelo and of Titian over the merits of design versus color. In this sense, the Rococo, like the Baroque, still belongs to the Renaissance world.

There is nevertheless a fundamental difference between the Rococo and the Baroque. What is it? In a word, it is fantasy. If the Baroque presents theater on a grand scale, the Rococo stage is smaller and more intimate. At the same time, the Rococo is both more lighthearted and tender-minded, marked equally by playful whimsy and wistful nostalgia. Its artifice evokes an enchanted realm that presents a diversion from real life. Because the modern age is the product of the Enlightenment, the Rococo is still often criticized for its unabashed escapism and eroticism. To its credit, however, the Rococo celebrated the world of love and broadened the range of human emotion in art to include the family as a major theme.

France

The Rise of the Rococo After the death of Louis XIV in 1715, the administrative machine that Colbert had created ground to a stop (see page 425). The nobility, formerly attached to the court at Versailles, were now freer from royal control. Many of them chose not to return to their châteaux in the provinces but to live in Paris, where they built elegant town houses, known as hôtels. Hôtels had been used as city residences by the landed aristocracy since about 1350, but during the seventeenth century they developed into social centers. As state-sponsored building activity was declining, the field of "design for private living" took on new importance. These city sites were usually cramped and irregular, so that they offered few opportunities for impressive exteriors. Hence the layout and decor of the rooms became the architects' main concern. The hôtels demanded an intimate style of interior decoration that would give full scope to individual fancy, uninhibited by the classicistic rules seen at Versailles. To meet this need, French designers created the Rococo from Italian gardens and interiors. The name fits well: it was coined from *coquillage* and *rocaille* (echoing the Italian *barocco*), which meant the playful decoration of grottoes with irregular shells and stones.

THE DECORATIVE ARTS

It was in the DECORATIVE ARTS that the Rococo flourished first and foremost. We have not discussed the decorative arts until now, because their conservative nature tended to limit creativity except in a few unusual cases. The latter half of the seventeenth century was a time of change in French design. In the 1660s Colbert acquired the Gobelins manufactories (named after the brothers who founded them) for the Crown. He turned them into a royal workshop that supplied luxurious furnishings, including tapestries, to the court under the direction of Charles Lebrun. After 1688 the War of the League of Augsburg forced the Crown to economize. Reduced spending at the Gobelins gradually loosened central control of the decorative arts and opened the way to new stylistic developments. The situation paralleled the decline of the Academy's

dominance over the fine arts, which gave rise to the Rococo in painting.

This change does not explain the excellence of French decor, however. Crucial to its development was the importance assigned to designers. Their engravings established new standards of design that were expected to be followed by artisans, who thereby lost much of their independence. Let us note, too, the collaboration of architects, who became more involved in interior decoration. Along with sculptors, who often created the ornamentation, they helped to raise the decorative arts to the level of the fine arts, thus establishing a tradition that continued into modern times. The decorative and fine arts were most clearly joined in major furniture. French cabinetmakers known as *ébénistes* (after ebony, their preferred wood veneer) helped to bring about the revolution in interior decor by introducing new materials and techniques. Many of these upstarts came originally from Holland, Flanders, Germany, and even Italy.

The decorative arts occupied a unique position during the Rococo. Hôtel interiors were more than collections of objects. They were total environments put together with extraordinary care by discerning collectors and the talented architects, sculptors, decorators, and dealers who catered to their exacting taste. A room, like an item of furniture, could involve the services of a wide variety of artisans: cabinetmakers, wood-carvers, gold- and silversmiths, upholsterers, porcelain makers. All were dedicated to producing the ensemble, even though each craft was, by tradition, a separate specialty subject to strict regulations. Together they fueled the insatiable hunger for novelty that swept Europe.

Pineau Few of these rooms have survived intact. The vast majority have been destroyed, heavily altered, or dispersed. Even so, we can get a good idea of their appearance by the reconstruction of one such room from the Hôtel de Varengeville, Paris, designed about 1735 by Nicolas Pineau (1684–1754) for the duchesse de Villars (fig. 20-1, page 436). To create a sumptuous effect, the walls and ceiling are encrusted with ornamentation and the

SPEAKING OF

fine arts, minor arts, decorative arts, applied arts, and *crafts*

Throughout the history of most societies, aesthetic and practical intentions were not regarded as contradictory or incompatible. It was in the West in the late eighteenth century, led by the European academies and fueled by the intellectual environment of the Enlightenment, that *fine arts* (painting, sculpture, drawing, and architecture) were elevated at the expense of the so-called *minor arts,* which include ceramics, textiles and weaving, metalwork and gold- and silversmithery, furniture, glassware and stained glass, and enamel work. *Decorative arts* and *applied arts* have been used interchangeably with *minor arts* ever since. Another term, *crafts,* has been in and out of favor for a long time. Until the late Middle Ages in the West, crafts were art; they were art again in Rococo Europe and during the Arts and Crafts Movement at the turn of the twentieth century.

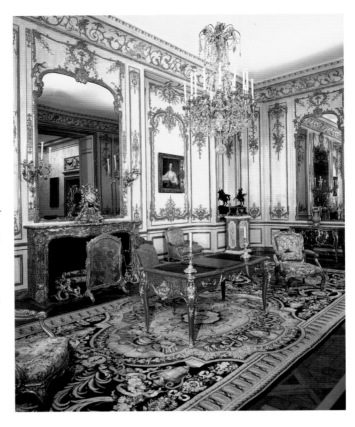

20-1 The Varengeville Room. From the Hôtel de Varengeville, 217, boulevard St-Germain, Paris. c. 1740. Chimneypiece wall at left, with *fleur-de-pêche* marble chimneypiece (not original to room). Original paneling probably commissioned from Nicolas Pineau. Carved, painted, and gilded oak, 18'3¾" x 40'6½" x 23'2½" (5.58 x 12.35 x 7.07 m). Photographed about 1995. The Metropolitan Museum of Art, New York

Purchase, Mr. and Mrs. Charles Wrightsman Gift, 1963

The Latin word GENIUS ("begetter") originally referred to the guardian spirit of the male head of a Roman household. It was later extended to peoples and places, as in the *genius populi Romani* ("genius of the Roman people"). In art and literature, the term came to be applied to figures personifying or embodying particular qualities, conditions, or attributes; it is generally capitalized when used this way. In modern times, *genius* most commonly denotes great intellectual or artistic talent or a person who possesses it.

elaborately carved furniture is embellished with gilt bronze. Everything swims in a sea of swirling patterns united by the most sophisticated sense of design and materials the world has ever known. Here there is no clear distinction between decoration and function in the clock on the mantel and the statuette in the corner. The painting, too, has been thoroughly integrated into the room.

SCULPTURE

Pigalle There were few monumental commissions for French sculptors in the eighteenth century. Rococo sculpture generally took the form of small groups in a "miniature Baroque" style, designed to adorn interiors and to be viewed at close range. Life-size statues were confined mainly to decorative figures of nymphs, goddesses, and the like, which are counterparts to the mythological creatures in the paintings of Boucher and his followers (see below). However, the Tomb of the Maréchal de Saxe (fig. 20-2) by Jean-Baptiste Pigalle (1714–1785), the most gifted sculptor of the era, recap-

tures some of the grandeur of the Baroque. The maréchal steps from a pyramid denoting immortality toward a casket held open for him by the figure of Death, as France tries in vain to intervene. He is mourned by the grief-stricken Hercules to the left, representing the French army, and, to the right, the weeping infant personifying the GENIUS of War, who extinguishes his torch before the fallen military standards. The strange menagerie to the left stands for the nations defeated by the maréchal in combat: Holland, England, and the Holy Roman Empire.

If the allegory strikes us as heavy-handed, there can be no denying the effectiveness of the presentation, which is among the most astonishing in all of sculpture. The poses show the classicism required for official French art, but the spirit of the whole is unmistakably Baroque. Pigalle has mounted a tableau worthy of Bernini, whose works he studied during several years in Rome as a young man. The restraint also suggests the example of Algardi (see pages 399–400). The pyramid is not

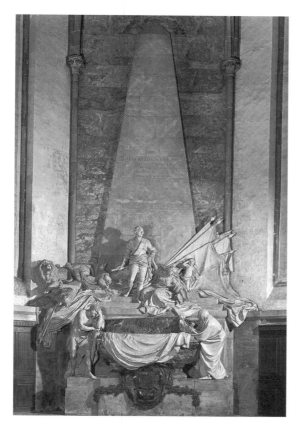

20-2 Jean-Baptiste Pigalle. Tomb of the Maréchal de Saxe. 1753–76. Marble. St-Thomas, Strasbourg, France

a three-dimensional structure but a low relief built against the wall of the church, while the steps leading up to it and the figures on them are in the round, like actors performing before a backdrop. We may therefore view the monument as a kind of theatrical performance in marble. The artist has even set it apart from its surroundings by creating an elevated "stage space" that projects forcefully outward.

PAINTING

"Poussinistes" versus "Rubénistes" It is hardly surprising that the strict system of the French Academy did not produce any major artists. Even Charles Lebrun, as we have seen, was far more Baroque in practice than we would expect from his classicistic theory. The rigidity of the official doctrine gave rise to a reaction that vented itself as soon as Lebrun's authority began to wane. Toward the end of the century, the members of the Academy formed two factions over the issue of drawing versus color: the "Poussinistes" against the "Rubénistes." The conservatives defended Poussin's view that drawing, which appealed to the mind, was superior to color, which appealed to the senses. The Rubénistes (many of whom were of Flemish descent) favored color, rather than drawing, as being more true to nature. They also pointed out that drawing, admittedly based on reason, appeals only to the expert few, whereas color appeals to everyone. This argument had important implications. It claimed that the layperson should be the judge of artistic values and challenged the Renaissance notion that painting, as a liberal art, could be appreciated only by the educated mind.

Watteau By the time Louis XIV died, the power of the Academy had long been overcome, and the influence of Rubens and the great Venetians was everywhere. The greatest of the Rubénistes was Jean-Antoine Watteau (1684–1721), the only painter of the Rococo who can be considered a genius without reservation. His paintings broke many academic rules, while his subjects did not conform to any established category. To make room for Watteau, the Academy invented the new category of *fêtes galantes* (elegant fêtes or entertainments). The term refers to the fact that his work mainly shows scenes of fashionable people or commedia dell'arte actors in parklike settings. His pictures often interweave theater and real life, so that no clear distinction can be made between the two.

A Pilgrimage to Cythera (fig. 20-3, page 438), painted as Watteau's reception piece for the Academy, is an evocation of love that includes elements of classical mythology. Accompanied by swarms of cupids, young couples have come to Cythera, the island of love, to pay homage to Venus, whose garlanded image appears on the far right. The action unfolds in the foreground from right to left, like a continuous narrative, which tells us that they are about to board the boat. Two lovers are still engaged in their amorous tryst;

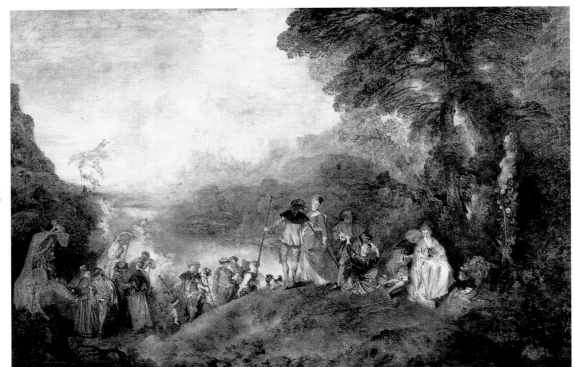

20-3 Jean-Antoine Watteau. *A Pilgrimage to Cythera.* 1717. Oil on canvas, 4'3" x 6'4$\frac{1}{2}$" (1.29 x 1.94 m). Musée du Louvre, Paris

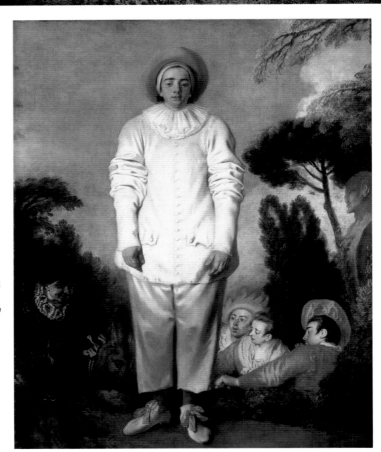

20-4 Jean-Antoine Watteau. *Gilles and Four Other Characters from the Commedia dell'Arte (Pierrot).* c. 1719. Oil on canvas, 6'1$\frac{1}{2}$" x 4'10$\frac{3}{8}$" (1.84 x 1.49 m). Musée du Louvre, Paris

behind them, another couple rises to follow a third pair down the hill as the reluctant young woman casts a longing look back at the goddess's sacred grove.

As a fashionable conversation piece, the scene recalls Rubens's *Garden of Love* (compare fig. 18-3), but Watteau has added a touch of poignancy that lends it a poetic subtlety reminiscent of Giorgione and Titian (see figs. 13-16 and 13-17). Watteau's figures lack the vitality of Rubens's. Slim and graceful, they move with the assurance of actors who play their roles so well that they touch us more than reality ever could. They recapture an earlier ideal of mannered elegance.

Many of Watteau's paintings center on the COMMEDIA DELL'ARTE. His treatment of this Italian theme is all the more remarkable because the commedia dell'arte was officially banned in France from 1697 until 1716. Shortly before his death Watteau painted perhaps his most moving work: *Pierrot* (fig. 20-4), traditionally known as *Gilles* after a similar stock character in the commedia dell'arte. It was probably done as a sign for a café owned by a friend who had retired from the stage after achieving fame in the racy role of the clown. The performance has ended, and the actor has stepped forward to face the audience. The other characters, all highly individualized, are thought to be likenesses of friends from the same circle.

Yet the painting is more than a portrait or an advertisement. Watteau approaches his subject with incomparable insight. Pierrot is life-size, so that he confronts us as a full human being, not simply as a stock character. In the process, Watteau transforms him into Everyman, with whom he evidently identified himself—a merger of identity basic to the commedia dell'arte. The face and pose have a poignancy that suggests a sense of alienation. Like the rest of the actors, except the doctor on the donkey who looks mischievously at us, he seems lost in his own thoughts. Still, it is difficult to define his mood, for the expression is as subtle as it is eloquent.

Boucher The work of Watteau signals the decisive shift in French art to the Rococo. Although

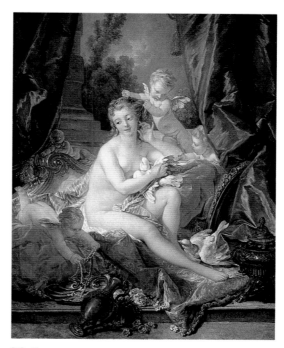

20-5 François Boucher. *The Toilet of Venus.* 1751. Oil on canvas, 43 x 33$\frac{1}{2}$" (109.2 x 85.1 cm). The Metropolitan Museum of Art, New York

Bequest of William K. Vanderbilt

the term originally applied to the decorative arts, it suits the playful character of French painting before 1765 equally well. By about 1720 even HISTORY PAINTING became intimate in scale and ebullient in style and subject. The finest painter in this vein was François Boucher (1703–1770), who epitomized the age of MADAME DE POMPADOUR, the mistress of Louis XV. *The Toilet of Venus* (fig. 20-5), which was painted for her private retreat, is full of silk and perfume. Compared with Vouet's sensuous goddess (see fig. 19-4), from which she is descended, Boucher's Venus has been transformed into a coquette of enchanting beauty. In this cosmetic never-never land, she is an eternally youthful goddess with the same rosy skin as the cherubs who attend her. If Watteau elevated human love to the level of mythology, Boucher raised playful eroticism to the realm of the divine. What Boucher lacks in the emotional depth of Watteau, he makes up for in his understanding of the fantasies that enrich people's lives.

The COMMEDIA DELL'ARTE arose in Italy in the late sixteenth century and soon became popular throughout Europe, especially in France. In age-old scenarios of love and intrigue, the commedia actors improvised dialogue and took the roles of stock characters, such as the innocent young girl, impoverished youth, or braggart captain. The comedic personages—clever servants who often outwitted authority figures—included the popular Harlequin and Pulcinella; their antics were the source of modern slapstick and burlesque comedy.

Paintings whose subjects are episodes from the Bible, mythology, or classical literature, treated by an artist in an intellectually or morally edifying way, comprise a genre called HISTORY PAINTING. Some academic artists, particularly in the late eighteenth and the early nineteenth century, believed that history painting was the highest form of art.

Jeanne-Antoinette Poisson (1721–1764), MADAME DE POMPADOUR, was Louis XV's mistress for nearly 20 years and the person who most influenced his political decisions. It is said that no important appointments were made without her consent.

Chardin The Rubénistes had cleared the way for a renewed interest in still-life and genre paintings by Dutch and Flemish masters. This revival was spurred by the presence of numerous artists from the Netherlands (and especially from Flanders), who settled in France in growing numbers after about 1550 but maintained ties to their native lands. Jean-Baptiste-Siméon Chardin (1699–1779) is the finest French painter in this vein. Yet he is far removed in spirit and style, if not in subject matter, from any Dutch or Flemish painter. His paintings act as moral lessons, not by conveying symbolic messages as Baroque art often does (see page 416) but by affirming the rightness of the existing social order and its values. To the rising middle class who were the artist's patrons, his genre scenes and kitchen still lifes proclaimed the virtues of hard work, frugality, honesty, and devotion to family.

Back from the Market (fig. 20-6) shows life in a Parisian middle-class household. Here we find such feeling for the beauty hidden in everyday life, and so clear a sense of spatial order, that we can compare him only to Vermeer (see fig. 18-16). However, Chardin's technique is quite unlike any Dutch artist's. His brushwork renders the light on colored surfaces with a creamy touch that is both analytical and lyrical. To reveal the inner nature of things, he summarizes forms, and subtly alters their appearance and texture, rather than describing them in detail. Chardin's genius discovered a hidden poetry in even the most humble objects and endowed them with timeless dignity. His many still lifes avoid the sensuous appeal of their Dutch predecessors. In *Back from the Market*, he treats the platter, bottles, and earthenware pot with a respect close to reverence. Beyond their shapes, colors, and textures, they are to him symbols of the life of common people.

Vigée-Lebrun It is from portraits that we can gain the clearest understanding of the French Rococo, for the transformation of the human image lies at the heart of the age. In portraits of the aristocracy, men were endowed with the illusion of character as an attribute of their noble birth. But the finest Rococo portraits were those of women, hardly a surprising fact in a society that idolized love and feminine beauty. Indeed, one of the finest artists in this vein was herself a beautiful woman: Marie-Louise-Élisabeth Vigée-Lebrun (1755–1842), who has left us a fascinating autobiography.

Throughout Vigée's long life she enjoyed great fame, which took her to every corner of Europe, including Russia, when she fled the FRENCH REVOLUTION. *The Duchesse de Polignac* (fig. 20-7), painted a few years after Vigée had become the portraitist for Queen MARIE-ANTOINETTE, demonstrates her great ability. The duchesse has the eternally youthful loveliness of Boucher's Venus (see fig. 20-5), made all the more persuasive by the artist's ravishing treatment of her clothing. At the same time, there is a sense of transience in the lyrical mood that exemplifies the Rococo's lighthearted theatricality. Interrupted in her singing, the duchesse becomes a real-life counterpart to the poetic creatures in Watteau's *Pilgrimage to Cythera* (see fig. 20-3). At the same time, she shares the delicate sentiment of the girl in Chardin's *Back from the Market*.

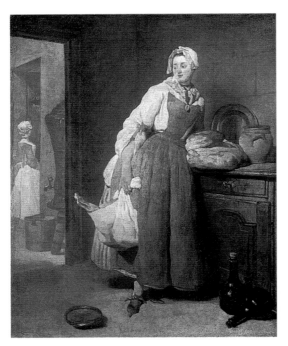

20-6 Jean-Baptiste-Siméon Chardin. *Back from the Market.* 1739. Oil on canvas, 18½ x 14¾" (47 x 37.5 cm). Musée du Louvre, Paris

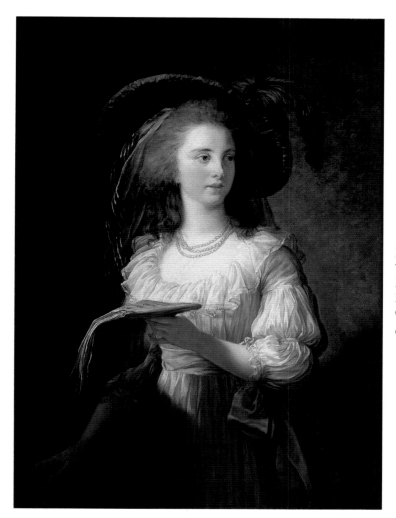

20-7 Marie-Louise-Élisabeth Vigée-Lebrun. *The Duchesse de Polignac.* 1783. Oil on canvas, 38¾ x 28" (98.4 x 71.1 cm). Collection Waddesdon Manor

© The National Trust

England

Across the English Channel, the Venetians were the dominant artists for more than a half-century (see page 447). However, the French Rococo had a major, though unacknowledged, effect. In fact, it helped to bring about the first school of English painting since the Middle Ages that had more than local importance.

Hogarth The earliest of these painters, William Hogarth (1697–1764), a natural-born satirist, began as an engraver and soon took up painting. Although he must have learned something about color and brushwork from Venetian and French examples, as well as Van Dyck, his work is so original that it has no real precedent. He made his mark in the 1730s with a new kind of picture, which he described as "modern moral subjects . . . similar to representations on the stage." It follows the vogue for sentimental comedies, such as those by Richard Steele, which sought to teach moral lessons through satire. In the same vein is John Gay's *Beggar's Opera* of 1728, a social and political satire that Hogarth illustrated in one of his paintings. Hogarth wished to be judged as a dramatist, he said, even though his "actors" could only "exhibit a dumb show." These pictures, and the prints he made from them for sale to the public, came in sets, with certain details repeated in each scene to unify the sequence. Hogarth's "morality plays" teach, by bad example, the solid middle-class virtues. They show a country girl who succumbs to the temptations of fashionable London; the evils of corrupt

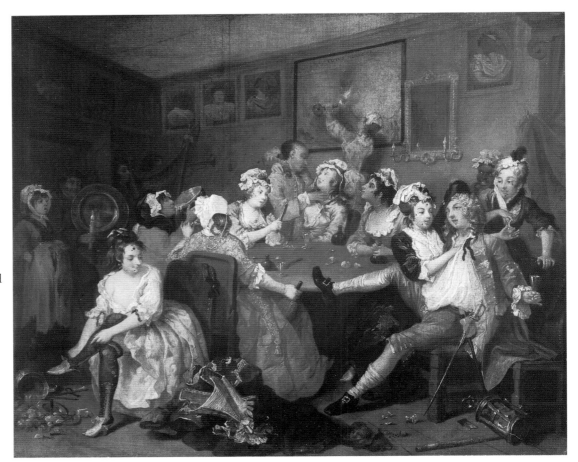

20-8 William Hogarth. *The Orgy,* Scene III of *The Rake's Progress.* c. 1734. Oil on canvas, 24½ x 29½" (62.2 x 74.9 cm). Sir John Soane's Museum, London

elections; and aristocratic rakes who live only for pleasure and marry wealthy women of lower status for their fortunes, which they soon dissipate. Hogarth is probably the first artist in history to become a social critic in his own right.

In *The Orgy* (fig. 20-8), from *The Rake's Progress,* the young wastrel is overindulging in wine and women. It is set in a famous London brothel, The Rose Tavern. The girl adjusting her shoe in the foreground is preparing for a vulgar dance involving the silver plate and candle behind her; to the left a chamber pot spills its contents over a chicken dish; and in the background a singer holds sheet music for a coarse song of the day. (The rogue is later arrested for debt, enters into a marriage of convenience, turns to gambling, goes to debtor's prison, and dies in an insane asylum.) The scene is so full of visual clues that a full account would take pages,

as well as constant references to other plates in the series. However literal-minded, the picture has great appeal. Hogarth combines some of Watteau's sparkle with Jan Steen's narrative gusto (compare figs. 20-3 and 18-15) and entertains us so well that we enjoy his sermon without being overwhelmed by its message.

Gainsborough Portraiture remained the only constant source of income for English painters. Hogarth was a pioneer in this field as well. The greatest master, however, was Thomas Gainsborough (1727–1788), who began by painting landscapes but ended as the favorite portraitist of British high society. He spent most of his career working in the provinces, first in his native Suffolk, then in the resort town of Bath. Toward the end of his career, Gainsborough moved to London, where

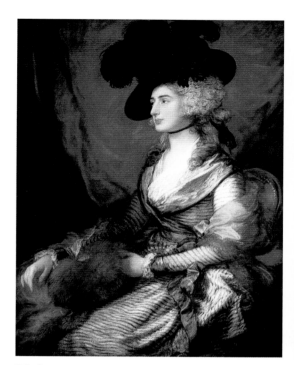

20-9 Thomas Gainsborough. *Mrs. Siddons.* 1785. Oil on canvas, 49½ x 39" (125.7 x 99.1 cm). The National Gallery, London

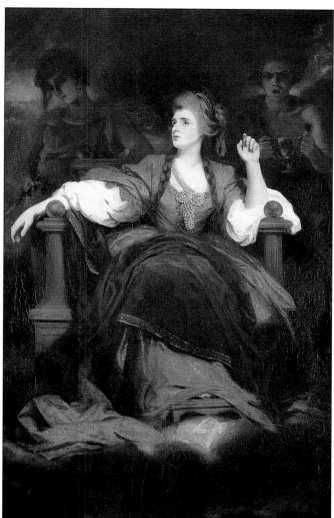

20-10 Sir Joshua Reynolds. *Mrs. Siddons as the Tragic Muse.* 1784. Oil on canvas, 7'9" x 4'9½" (2.36 x 1.46 m). Henry E. Huntington Library and Art Gallery, San Marino, California

his work underwent a major change. The splendid portrait of the famous actress Mrs. Siddons (fig. 20-9) has the virtues of the artist's late style: a cool elegance that translates Van Dyck's aristocratic poses into late-eighteenth-century terms, and a fluid, translucent technique reminiscent of Rubens's that renders the glamorous sitter, with her fashionable attire and coiffure, to ravishing effect.

Reynolds Gainsborough painted Mrs. Siddons to outdo his great rival on the London scene, Sir Joshua Reynolds (1723–1792), who had portrayed her as the Tragic Muse (fig. 20-10). A less able painter, Reynolds had to rely on pose and expression to suggest the aura of character that Gainsborough was able to convey through color and brushwork alone. Reynolds, who had been president of the Royal Academy since its founding in 1768, championed the academic approach to art, which he had acquired during two years in

Rome. In his *Discourses,* delivered at the Academy, he set forth what he considered necessary rules and theories. His views were essentially those of Lebrun, tempered by British common sense, and like Lebrun, he found it difficult to live up to his theories in practice. Although he preferred history painting in the grand style, most of his works are portraits ennobled by allegorical additions or disguises like those in his picture of Mrs. Siddons. His style owed a good deal more to the Venetians, the Flemish Baroque, and even Rembrandt (note the lighting in *Mrs. Siddons as the Tragic Muse*) than he was willing to admit, although he often recommended following the example of earlier masters.

Reynolds was generous enough to praise Gainsborough, whom he outlived by a few years and whose instinctive talent he must have envied. He eulogized him as one who saw with the eye of a painter rather than a poet, even if the compliment was left-handed. Gainsborough's paintings epitomized the Enlightenment philosopher David Hume's idea that painting must incorporate both nature and art. Gainsborough himself was a simple and unpretentious person, who exemplified Hume's "natural man," free of excessive pride or humility. Reynolds's approach, on the other hand, as stated in his *Discourses,* was based on Horace's saying *ut pictura poesis* (see page 301). His use of poses from the antique was intended to elevate the sitter from an individual to a universal type through association with the great art of the past and the noble ideals it embodied. This heroic model was closely related to the writings of the playwright Samuel Johnson and the practices of the actor David Garrick, both of whom were friends of Reynolds. (Garrick sat for portraits by Hogarth and Gainsborough as well as by Reynolds.) In this respect, Reynolds was the opposite of Gainsborough. Yet, for all the differences between them, the two artists had more in common, artistically and philosophically, than they cared to admit.

Reynolds and Gainsborough looked back to Van Dyck, while drawing different lessons from his example. Both emphasized in varying degrees the visual appeal and technical skill of their paintings. Moreover, their portraits of Mrs. Siddons are clearly related to the Rococo style of France—note their resemblance to Vigée's *Duchesse* (see fig. 20-7)—yet they remain distinctly English in character. Hume and Johnson were similarly linked by their skepticism. If anything, Johnson's writings, which inspired Reynolds, were more pessimistic than Hume's, which generally advocated a tolerant and humane ethical system.

Germany and Austria

The Rococo was a refinement in miniature of the curvilinear, "elastic" Baroque of Borromini and Guarini. Thus it could readily be united with architecture in Central Europe, where the Italian style had taken firm root. It is not surprising that the Italian style received such a warm response there. In Austria and southern Germany, ravaged by the Thirty Years' War, the number of new buildings remained small until near the end of the seventeenth century. The Baroque was an imported style, practiced mainly by visiting Italians. Not until the 1690s did native designers come to the fore. There followed a period of intense activity that lasted more than 50 years and gave rise to some of the most imaginative creations in the history of architecture. These monuments were built to glorify princes and prelates who generally deserve to be remembered only as lavish patrons of the arts. Rococo architecture in Central Europe is larger in scale and more exuberant than in France. Moreover, painting and sculpture are more closely linked with their settings. Palaces and churches are decorated with ceiling frescoes and sculpture unsuited to domestic interiors, however lavish, although they reflect the same taste that produced the Rococo French hôtels.

Fischer von Erlach Johann Fischer von Erlach (1656–1723), the first great architect of the Rococo in Central Europe, is a transitional figure closely linked to the Italian tradition. He had studied in Rome with Carlo Fontana (1634–1714), whose buildings embody the same compromise between the High Baroque and Baroque classicism found in Italian painting toward the end of the seventeenth century. Fischer von Erlach, however, was a genius who represents the decisive shift of the center of architecture from Italy to north of the Alps. His church of St. Charles Borromaeus in Vienna (fig. 20-11) combines the facade of Borromini's Sta. Agnese and the Pantheon portico (see figs. 17-11 and 7-3). Here we find a pair of huge columns, derived from the Column of Trajan (see fig. 7-15) and decorated with scenes from the life of the saint, instead of facade towers, which have become corner pavilions reminiscent of those on the Louvre court (compare fig. 16-15).

The church celebrates Fischer von Erlach's patron, the emperor Charles VI, as a Christian ruler. It reminds us that the Turks, who repeatedly menaced Austria and Hungary, had been

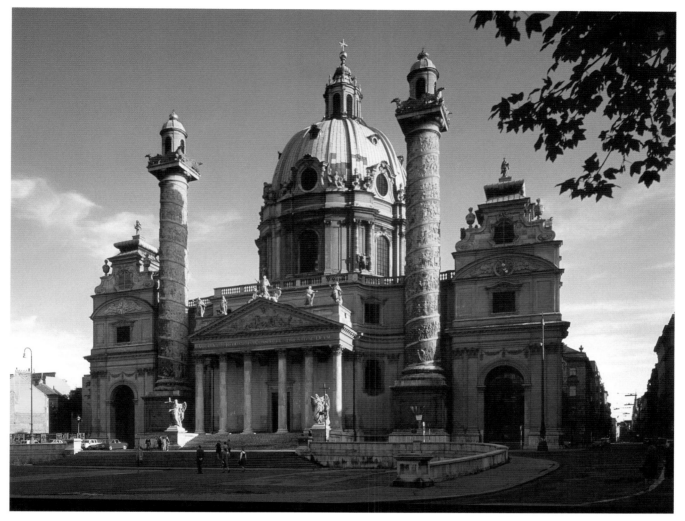

20-11 Johann Fischer von Erlach. Facade of St. Charles Borromaeus (Karlskirche), Vienna. 1716–37

defeated at the siege of Vienna only in 1683, thanks mainly to the intervention of John III of Poland, and that they remained a serious threat as late as 1718. With the inflexible elements of Roman imperial art embedded into the elastic curvatures of his church, Fischer von Erlach expresses, more boldly than any Italian architect of the time, the power of the Christian faith to transform the art of antiquity. Indeed, it was now Italy's turn to respond to the North. The Superga, a monastery church overlooking Turin that was begun only a year later by Filippo Juvarra (1678–1736), another pupil of

Fontana, was clearly influenced by Fischer von Erlach's design.

Neumann The next generation of architects favored lightness and elegance. Chief among them was Balthasar Neumann (1687–1753). Trained as a military engineer, he was named a surveyor for the Residenz (Episcopal Palace) in Würzburg after his return from a visit to Milan in 1720. The design is not wholly his. The basic plan was already established by Johann Maximilian von Welsch (1671–1745), and although Neumann greatly modified

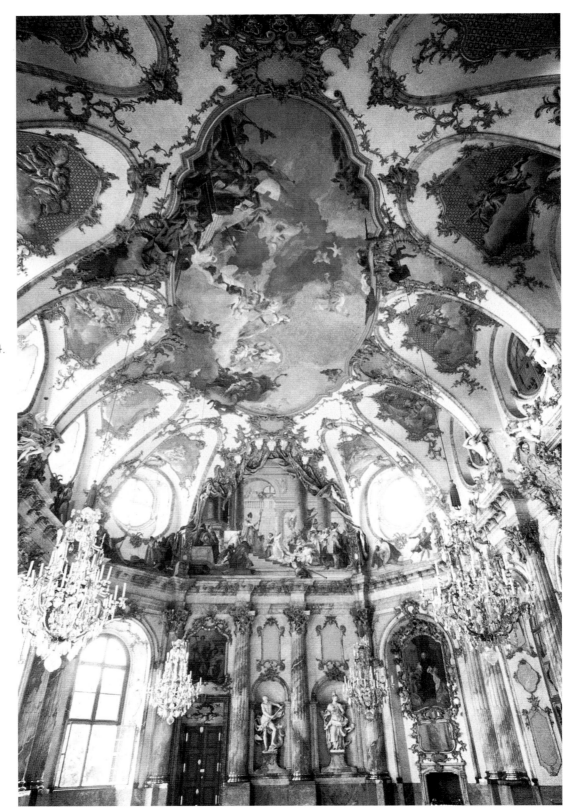

20-12 Balthasar Neumann. The Kaisersaal, Residenz, Würzburg, Germany. 1719–44. Frescoes by Giovanni Battista Tiepolo, 1751

it, he was required to consult the leading architects of Paris and Vienna in 1723. The final result is a skillful blend of the latest German, French, and Italian ideas. The breathtaking Kaisersaal (fig. 20-12) is a great oval hall decorated in the favorite color scheme of the mid-eighteenth century: white, gold, and pastel shades. The number and aesthetic role of structural members such as columns, pilasters, and architraves are now minimized. Windows and vault segments are framed by continuous, ribbon-like moldings, and the white surfaces are covered with irregular ornamental designs. These lacy, curling motifs, the hallmark of the French style (see fig. 20-1), are happily combined with German Rococo architecture. (The basic design recalls an early interior by Fischer von Erlach.) The abundant illumination, the play of curves and countercurves, and the weightless grace of the stucco sculpture give the Kaisersaal an airy lightness far removed from the Roman Baroque. The vaults and walls seem thin and pliable, like membranes easily punctured by the expansive power of space.

Italy

Just as the style of architecture invented in Italy achieved its climax north of the Alps, much of the Italian Rococo took place in other countries. The timid style of the Late Baroque in Italy was transformed during the first decade of the eighteenth century by the rise of the Rococo in Venice, which had been an artistic backwater for a hundred years. The Italian Rococo is distinguished from the Baroque by a revived appreciation of Veronese's colorism and pageantry, but with an airy sensibility that is new. The first artist to formulate this style was Sebastiano Ricci (1659–1734), who began his career as a stage painter and became an important artist only in midcareer. His skill at blending a Venetian painterly manner with High Baroque illusionism made Ricci and his later followers the leading decorative painters in Europe between 1710 and 1760. The Venetians were active in every major center throughout Europe, especially London and Madrid. They were not alone: many artists from Rome and other parts of Italy also worked abroad.

Tiepolo The last and most refined stage of Italian illusionistic ceiling decoration can be seen in the works of Giovanni Battista Tiepolo (1696–1770). In his command of light and color, his grace and masterful touch, and his power of invention, Tiepolo easily surpassed his fellow Venetians. These qualities made him famous far beyond his home territory. When Tiepolo painted the Würzburg frescoes (see fig. 20-12), his powers were at their height. The tissuelike ceiling so often gives way to illusionistic openings, both painted and sculpted, that we no longer feel it to be a spatial boundary. These openings do not, however, reveal avalanches of figures propelled by dramatic bursts of light, like those of Roman ceilings (compare fig. 17-7). Rather, we see blue sky and sunlit clouds, and an occasional winged creature soaring in this limitless expanse. Only along the edges of the ceiling are there solid clusters of figures.

At one end, replacing a window, is *The Marriage of Frederick Barbarossa*. As a public spectacle, it is as festive as *Christ in the House of Levi* (see fig. 14-9) by Veronese. The artist has followed Veronese's example by putting the event (which took place in the twelfth century) in a contemporary setting. Its allegorical fantasy is literally revealed by the carved putti opening a gilt-stucco curtain onto the wedding ceremony. The result is a display of theatrical illusionism worthy of Bernini. Unexpected in this lively procession is the element of classicism, which gives an air of noble restraint to the main figures in keeping with the solemnity of the occasion.

Tiepolo later became the last in the line of Italian artists who were invited to work at the Royal Palace in Madrid. There he encountered the German painter Anton Raphael Mengs, a champion of the classical revival whose presence signaled the end of the Rococo (see page 459).

Canaletto During the eighteenth century, landscape in Italy evolved a new form in keeping with the character of the Rococo: **veduta** (view) painting. Its beginnings can be traced back to the seventeenth century with the many foreigners, such as Claude Lorraine (see fig. 19-3), who specialized in depicting Rome's environs. After 1720,

20-13 Canaletto. *The Bucintoro at the Molo.* c. 1732. Oil on canvas, 30¹/₄ x 49¹/₂" (77 x 126 cm). The Royal Collection

© 1993 Her Majesty Queen Elizabeth II

however, it took on a specifically urban identity. The most famous of the vedutists was Canaletto (Giovanni Antonio Canal, 1697–1768) of Venice. His pictures were great favorites with the British, and he later became one of several Venetian artists to spend long sojourns in London. *The Bucintoro at the Molo* (fig. 20-13) was one of a series of paintings commissioned by Joseph Smith, an English entrepreneur living in Venice. It shows a favorite subject: the doge returning on his magnificent barge to the Piazza San Marco from the Lido (the city's island beach) on Ascension Day after celebrating the Marriage of the Sea. Canaletto has captured the festive air surrounding this great public celebration, which is presented as a brilliant theatrical display.

Canaletto's landscapes are, for the most part, topographically accurate. Yet he was not above tampering with the truth. While he usually made only slight adjustments for the sake of the composition, he would sometimes treat scenes with considerable freedom or create composite views. He may have used a mechanical or optical device (perhaps a **camera obscura**, a forerunner of the photographic camera) to render some of his views, although he was a skilled draftsman who hardly needed such aids. However, the liveliness and sparkle of his pictures, as well as his sure sense of composition, sprang in large part from his training as a scenographer. As in *The Bucintoro at the Molo,* he often included vignettes of daily life in Venice that lend a human interest to his scenes and make them fascinating cultural documents.

Piranesi Canaletto shared his background as a designer of stage sets with Ricci (see above) and with Giovanni Paolo Panini (1691–1765), his fellow vedutist in Rome who had a passion for classical antiquity (see fig. 7-4). They, in turn, are the forerunners of another Roman artist, Giovanni Battista Piranesi (1720–1778), whose *Prison Caprices* (fig. 20-14) are rooted in contemporary designs for theater and opera. Unlike the prints after Canaletto's paintings, these masterly etchings were conceived as original works of art from the beginning, so that they have a gripping power. In Piranesi's imagery, the play between reality and fantasy, so fundamental to the theatrical Rococo, has been transformed into a romanticized vision of despair as terrifying as any nightmare. His bold imagination appealed greatly to many artists of the next generation, on whom he exercised a decisive influence.

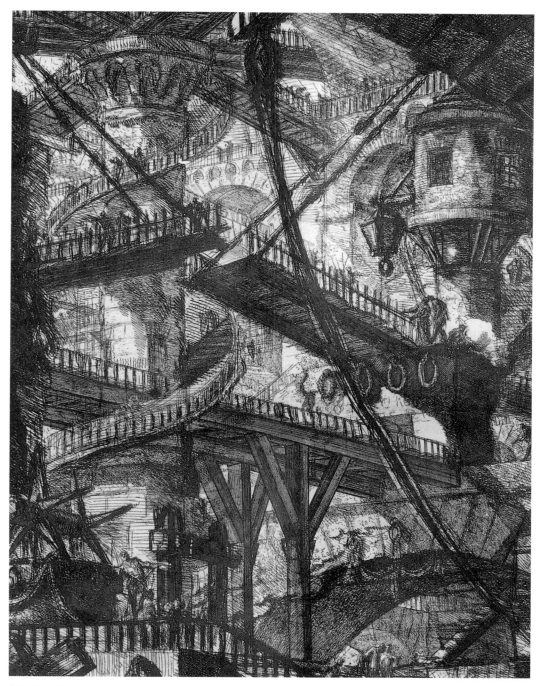

20-14 Giovanni Battista Piranesi. *Tower with Bridges,* from *Prison Caprices.* 1760–61. Etching, 21³/₄ x 16³/₈" (55.2 x 41.6 cm). The Metropolitan Museum of Art, New York

Rogers Fund

Political History

1400–1450
Great Papal Schism (since 1378) settled 1417; pope returns to Rome
Cosimo de' Medici leading citizen of Florence 1434–64

1450–1500
Hapsburg rule of Holy Roman Empire begins 1452
Constantinople falls to Turks 1453
Lorenzo de' Medici virtual ruler of Florence 1469–92
Ferdinand and Isabella unite Spain 1469
Spain and Portugal divide southern New World 1493–94
Charles VIII of France invades Italy 1494–99

1500–1550
Charles V of Spain elected Holy Roman Emperor 1519; Sack of Rome 1527
Hernando Cortés wins Aztec Empire in Mexico for Spain 1519; Francisco Pizarro conquers Peru 1532
Henry VIII of England (ruled 1509–47) founds Anglican Church 1534
Peace of Augsburg (1555) lets each German prince decide religion of his subjects

Religion and Literature

1400–1450
Leonardo Bruni (c. 1374–1444), *History of Florence*
Leone Battista Alberti (1404–1472), *On Architecture; On Painting*
Jan Hus, Czech reformer, burned at stake for heresy 1415; Joan of Arc burned at stake for heresy and sorcery 1431
Council of Florence attempts to reunite Catholic and Orthodox faiths 1439

1450–1500
Marsilio Ficino (1433–1499), Italian Neoplatonic philosopher
Pius II, humanist pope (ruled 1458–64)
Savonarola virtual ruler of Florence 1494; burned at stake for heresy 1498

1500–1550
Erasmus of Rotterdam's *Manual of a Christian Knight* 1503
Thomas More's *Utopia* 1516
Martin Luther (1483–1546) posts 95 Theses 1517; excommunicated 1521
Machiavelli's *Prince* 1532
Ignatius of Loyola founds Jesuit order 1534
John Calvin's *Institutes of the Christian Religion* 1536

Science and Technology

1400–1450
Prince Henry the Navigator of Portugal (1394–1460) promotes geographic exploration
Gutenberg credited with invention of printing with movable type 1446–50

1450–1500
Bartolomeu Diaz rounds Cape of Good Hope 1488
Christopher Columbus discovers America 1492
Vasco da Gama reaches India, returns to Lisbon 1497–99

1500–1550
Vasco de Balboa sights Pacific Ocean 1513
First circumnavigation of the globe, by Ferdinand Magellan and crew 1520–22
Copernicus (1473–1543) refutes geocentric view of universe

16-8

Painting

1400–1450
Hubert and/or Jan van Eyck, *Crucifixion and Last Judgment* (15-2)
Masaccio, *Holy Trinity* fresco (12-13)
Robert Campin, *Mérode Altarpiece* (15-1)
Jan van Eyck, *Arnolfini Betrothal* (15-3, 15-4)
Rogier van der Weyden, *Descent from the Cross* (15-5)

12-13

1450–1500
Piero della Francesca, Arezzo frescoes (12-17)
Mantegna, *St. Sebastian* (12-22)
Hugo van der Goes, *Portinari Altarpiece* (15-6)
Botticelli, *Birth of Venus* (12-19)
Ghirlandaio, *Old Man and His Grandson* (12-20)
Perugino, *Delivery of the Keys* (12-21)
Leonardo, *Virgin of the Rocks* (13-1)
Giovanni Bellini, *Saint Francis in Ecstasy* (12-23)
Leonardo, *Last Supper* (13-2)

1500–1550
Bosch, *Garden of Delights* (15-7)
Leonardo, *Mona Lisa* (13-3)
Giorgione, *The Tempest* (13-16)
Michelangelo, Sistine Chapel, Rome (13-8–13-10)
Grünewald, *Isenheim Altarpiece* (16-1, 16-2)
Raphael, *School of Athens* (13-14)
Dürer, *Knight, Death, and Devil* engraving (16-5)
Holbein, *Erasmus of Rotterdam* (16-8)
Pontormo, *Deposition* (14-2)
Altdorfer, *Battle of Issus* (16-7)
Parmigianino, *Madonna with the Long Neck* (14-3)

Sculpture

1400–1450
Donatello, *St. George* (12-2); *David* (12-3)
Ghiberti, "Gates of Paradise," Baptistery, Florence (12-5)
Donatello, Equestrian statue of Gattamelata, Padua (12-4)

1450–1500
Pollaiuolo, *Hercules and Antaeus* (12-7)
Verrocchio, *Doubting of Thomas* (12-8)

1500–1550
Michelangelo, *David* (13-7); Tomb of Giuliano de' Medici, Florence (13-11)
Cellini, Saltcellar of Francis I (14-13)

Architecture

1400–1450
Brunelleschi begins career as architect 1419; Florence Cathedral dome (11-15); S. Lorenzo, Florence (12-9, 12-10)

1450–1500
Alberti, S. Andrea, Mantua (12-11)
Giuliano da Sangallo, Sta. Maria delle Carceri, Prato (12-12)

12-12

1500–1550
Bramante, design for St. Peter's, Rome (13-5)
Michelangelo becomes architect of St. Peter's, Rome, 1546 (13-12)

| **1400–1450** | **1450–1500** | **1500–1550** |

Ivan the Terrible of Russia (ruled 1547–84)

Charles V retires 1556; son Philip II becomes king of Spain, Netherlands, New World

Elizabeth I of England (ruled 1558–1603)

Netherlands revolt against Spain 1586

Spanish Armada defeated by English 1588

Edict of Nantes establishes religious toleration in France 1598

Jamestown, Virginia, founded 1607; Plymouth, Massachusetts, 1620

Thirty Years' War 1618–48

Cardinal Richelieu consolidates power of Louis XIII, 1624–42

Charles I of England beheaded 1649; Commonwealth under Cromwell 1649–53; Charles II restores English monarchy 1660

Frederick William, the Great Elector (ruled 1640–88), establishes power of Prussia

Louis XIV absolute ruler of France (ruled 1661–1715)

Glorious Revolution against James II of England 1688; Bill of Rights

Peter the Great (ruled 1682–1725) westernizes Russia, defeats Sweden

Robert Walpole first prime minister of England 1721–42

Frederick the Great of Prussia defeats Austria 1740–45

Seven Years' War (1756–63): England and Prussia vs. Austria and France, called French and Indian War in America; French defeated in Battle of Quebec 1769

Catherine the Great (ruled 1762–96) extends Russian power to Black Sea

Montaigne (1533–1592), French essayist

Council of Trent for Catholic reform 1545–63

Giorgio Vasari's *Lives* 1564

William Shakespeare (1564–1616), English dramatist

Miguel de Cervantes's *Don Quixote* 1605–16

John Donne (1572–1631), English poet

King James Bible 1611

René Descartes (1596–1650), French mathematician and philosopher

Molière (1622–1673), French dramatist

Blaise Pascal (1623–1662), French scientist and philosopher

Spinoza (1632–1677), Dutch philosopher

John Milton's *Paradise Lost* 1667

John Bunyan's *Pilgrim's Progress* 1678

John Locke's *Essay Concerning Human Understanding* 1690

Daniel Defoe's *Robinson Crusoe* 1719

Jonathan Swift's *Gulliver's Travels* 1726

Wesley brothers found Methodism 1738

Voltaire (1698–1778), French author

Diderot's *Encyclopédie* 1751–72

Samuel Johnson's *Dictionary* 1755

Edmund Burke (1729–1797), English reformer

Jean-Jacques Rousseau (1712–1778), French philosopher and writer

Johannes Kepler establishes planetary system 1609–19

Galileo (1564–1642) invents telescope 1609; establishes scientific method

William Harvey describes circulation of the blood 1628

Isaac Newton (1642–1727), theory of gravity 1687

18-11

Carolus Linnaeus (1707–1778), Swedish botanist

James Watt patents steam engine 1769

Priestley discovers oxygen 1774

Coke-fed blast furnaces for iron smelting perfected c. 1760–75

Benjamin Franklin's experiments with electricity c. 1750

Bruegel, *Return of the Hunters* (16-13)

Titian, *Christ Crowned with Thorns* (13-19)

Veronese, *Christ in the House of Levi* (14-9)

El Greco, *Burial of Count Orgaz* (14-11)

Tintoretto, *Last Supper* (14-10)

Caravaggio, *Calling of Saint Matthew* (17-1)

Annibale Carracci, Farnese Gallery ceiling (17-4)

Rubens, *Marie de' Medici, Queen of France, Landing in Marseilles* (18-2)

Artemisia Gentileschi, *Judith and Her Maidservant with the Head of Holofernes* (17-3)

Hals, *Jolly Toper* (18-7)

Pietro da Cortona, Palazzo Barberini ceiling (17-7)

Van Dyck, *Portrait of Charles I Hunting* (18-5)

Rembrandt, *The Night Watch* (18-10)

Poussin, *Abduction of the Sabine Women* (19-2)

Lorraine, *Pastoral Landscape* (19-3)

Velázquez, *Maids of Honor* (17-18)

Rembrandt, *Self-Portrait* (18-11)

Vermeer, *The Letter* (18-16)

Watteau, *Pilgrimage to Cythera* (20-3)

Chardin, *Back from the Market* (20-6)

Hogarth, *Rake's Progress* (20-8)

Tiepolo, Würzburg ceiling fresco (20-12)

Boucher, *Toilet of Venus* (20-5)

Vigée-Lebrun, *Duchesse de Polignac* (20-7)

Reynolds, *Sarah Siddons as the Tragic Muse* (20-10)

Giovanni Bologna, *Abduction of the Sabine Woman*, Florence (14-15)

Bernini, *David* (17-13)

14-15

Bernini, Cornaro Chapel, Rome (17-14, 17-15)

Puget, *Milo of Crotona* (19-12)

Coysevox, *Charles Lebrun* (19-11)

19-12

20-11

Palladio, Villa Rotonda, Vicenza (14-17)

Della Porta, Facade of Il Gesù, Rome (14-18)

Maderno, Nave and facade of St. Peter's, Rome (17-8)

Bernini's colonnade, St. Peter's, Rome (17-8)

Borromini, S. Carlo alle Quattro Fontane, Rome (17-9, 17-10)

Perrault, East front of Louvre, Paris (19-5)

Hardouin-Mansart and Le Vau, Palace of Versailles (19-6); with Coysevox, Salon de la Guerre (19-7)

Fischer von Erlach, St. Charles Borromaeus, Vienna (20-11)

Neumann, Episcopal Palace, Würzburg (20-12)

Burlington and Kent, Chiswick House, London (21-10)

1550–1625

1625–1700

1700–1750

THE MODERN WORLD

Art history, according to the classical model of Johann Winckelmann, unfolds in an orderly progression in which one phase follows another as inevitably as night follows day. In addition, the concept of period style implies that the arts march in lockstep, sharing the same characteristics and developing according to the same inner necessity. The thoughtful reader will already suspect, however, that any attempt to synthesize the history of art and place it into a broader context must inevitably mask a welter of facts that do not conform to such a systematic model and may, indeed, call it into question. So far as the art of the distant past is concerned, we may indeed have little choice but to see it in larger terms, since so many facts have been erased that we cannot possibly hope to reconstruct a full and accurate historical record. Hence it is arguably the case that any reading is an artificial construct inherently open to question. As we approach the art of our times, these become more than theoretical issues. They take on a new urgency as we try, perhaps vainly, to understand modern civilization and how it came to be this way.

It is suggestive of the difficulties facing the historian that the period which began 250 years ago has not acquired a name of its own. Perhaps this does not strike us as peculiar at first. We are, after all, still in its midst. Considering how promptly the Renaissance coined a name for itself, however, we may well wonder why no key concept comparable to the

"rebirth of antiquity" has yet to emerge. It is tempting to call this "The Age of Revolution," for it has been characterized by rapid and violent change. It began with revolutions of two kinds: the Industrial Revolution, symbolized by the invention of the steam engine; and a political revolution, under the banner of democracy, inaugurated in America and France.

Both of these revolutions are still going on. Industrialization and democracy are so closely linked today that we tend to think of them as different aspects of one process, with effects more far-reaching than any basic shift since the Neolithic Revolution 10,000 years ago. Still, the twin revolutions are not the same. Both are founded on the idea of progress. But whereas progress in science and technology during the past two centuries has been more or less continuous and measurable, we can hardly make this claim for our pursuit of happiness, however we choose to define it. Here, then, is a fundamental conflict that continues to this very day.

If we nevertheless accept "The Age of Revolution" as a convenient name for the era as a whole, we must still make a distinction for the era since 1900. For lack of a better word, we shall call it modernity. It is a problematic term, *modernity*. What is it? When did it begin? These questions are not unlike those posed by the Renaissance, and so perhaps is the answer. No matter how many different opinions there may be about the nature of the beast—and scholars remain deeply divided over the issues—the modern era clearly began when people acquired "modern consciousness." Around 1900 the Western world became aware

that the character of the new age was defined by the machine, which brought with it a different sense of time and space, as well as the promise of a new kind of humanity and society.

It is difficult for us to appreciate from our vantage point just how radical the technological revolution seemed to people of the time, for it has since become commonplace and been outstripped by even more far-reaching changes. The advances that took place in science, mathematics, engineering, and psychology during the 1880s and 1890s laid the foundation for the Machine Age. The diesel and turbine engines, electric motor, tire, automobile, light bulb, phonograph, radio, box camera: all these were invented before 1900, and the airplane shortly thereafter. They forever transformed the quality of life—its very feel—but it was not until these changes had reached a "critical mass" in the opening years of the twentieth century that their sweeping magnitude was fully realized.

The word *modern* has its origins in the early medieval *modernus,* meaning that which is present, of our time, and, by extension, new or novel. In contrast, antiquity lacked a comparable expression, even though the word *modern* derives ultimately from the Latin *modo* (now). As this odd fact suggests, modernity is based on the Christian view of history as a break in time (before and after Christ), instead of on the concept of recurring cycles that had prevailed in Greece and Rome. It is to Petrarch that we owe the idea of history as a succession of periods, which he separated into eras of light, dark, and rebirth. For him, history was linear and progressive, permitting humanity to play an active part in shaping its outcome.

The end of the twelfth century witnessed the first dispute between disciples of ancient versus modern poetry; ever since, literature and criticism have taken the lead in framing the central issues of modernity. The controversy was revived in late-seventeenth-century France by Charles Perrault as the Quarrel of Ancients and Moderns. Throughout the debate, *modern* generally held negative connotations, for it was taken as the opposite of *classic,* whose original antonym in Latin was *vulgar.*

The nineteenth century gave birth to two conflicting views of modernity that have continued to compete with each other to this day: one based on scientific and material progress, which arose out of the Enlightenment, with its belief in reason and freedom, and is identified with the middle class; and a radical alternative regarding the bourgeoisie as the enemy of culture—in a word, philistines. Although its roots lie in eighteenth-century German thought, the second of these is a peculiarly Romantic notion, first formulated by the French writer Stendhal (Marie-Henri Beyle). Not only did he relate modernity specifically to Romanticism as a reaction against classicism, he regarded the Romantic as a warrior in the service of modernity—the forerunner of the avant-garde. But why should modernity need such a warrior in the first place? Because the times were slow to accept the new, which could therefore only be validated by the future, not the present.

It was nevertheless Charles Baudelaire who gave *modernity* its current meaning. "Modernity," he wrote, "is the transitory, the fugitive, the contingent, the half of art, of which the other half is the eternal and the immutable. . . ." Perceptively, he located the source of that beauty in urban existence (see page 511). Baudelaire had the distinction of being the first to use mechanical metaphors for beauty in place of the organic ones favored by the Romantics. He further denounced the material progress of modern civilization, thereby helping to create the schism between modernity and modernism. What is the difference between them? Paradoxically, modernism

looks to the future, whereas modernity is concerned with the present, which can stand in the way of progress. To artists, modernism is a trumpet call that both asserts their freedom to create in a new style and provides them with the mission to define the meaning of their times—and even to reshape society through their art. To be sure, artists have always responded to the changing world around them, but rarely have they risen to the challenge as they have under the banner of modernism, or with so fervent a sense of personal cause.

This is a role for which the term *avant-garde* (literally, "vanguard") is hardly sufficient. Although both arose as part of the decadent movement toward the end of the nineteenth century, the term *avant-garde,* like *modernism,* has a long history reaching back to the Middle Ages. The term originated in French warfare and was first applied to the arts in the sixteenth century, but began to acquire its modern definition only under the Romantics. The Socialist reformer the comte de Saint-Simon included artists along with scientists and industrialists in the elite group that would rule the ideal state, because as people of imagination they can foresee the future and therefore help to create it. As Baudelaire realized, however, there is an inherent contradiction between Romantic individualism and the discipline necessary for political action.

Despite the fact that they are closely linked, the avant-garde is by no means synonymous with—and is even antithetical to—modernism. We shall find that the two have held very different meanings for different artists—

and produced surprisingly different results in each of the visual arts. Both run counter to their times. But whereas modernism remains dedicated to a utopian vision of the future that stems from the Enlightenment, the avant-garde is bent solely on the destruction of bourgeois modernity. Judged by this standard, few of the twentieth-century's leading artists were members of a self-styled avant-garde.

Today, having cast off the framework of traditional authority which confined and sustained us before, we can act with a latitude both frightening and exhilarating. The consequences of this freedom to question all values are everywhere around us. Our knowledge about ourselves is now vastly greater, but this has not reassured us as we had hoped. In a world without fixed reference points, we search constantly for our own identity and for the meaning of human existence, individual and collective.

Because modern civilization lacks the cohesiveness of the past, it no longer proceeds by readily identifiable periods; nor are there clear period styles to be discerned in art or in any other form of culture. Instead, we find a continuity of another kind: movements and countermovements. Spreading like waves, these "isms" defy national, ethnic, and chronological boundaries. Never dominant anywhere for long, they compete or merge with each other in endlessly shifting patterns. Hence our account of modern art is guided more by movements than by countries. Only in this way can we hope to do justice to the fact that modern art, all regional differences notwithstanding, is as international as modern science.

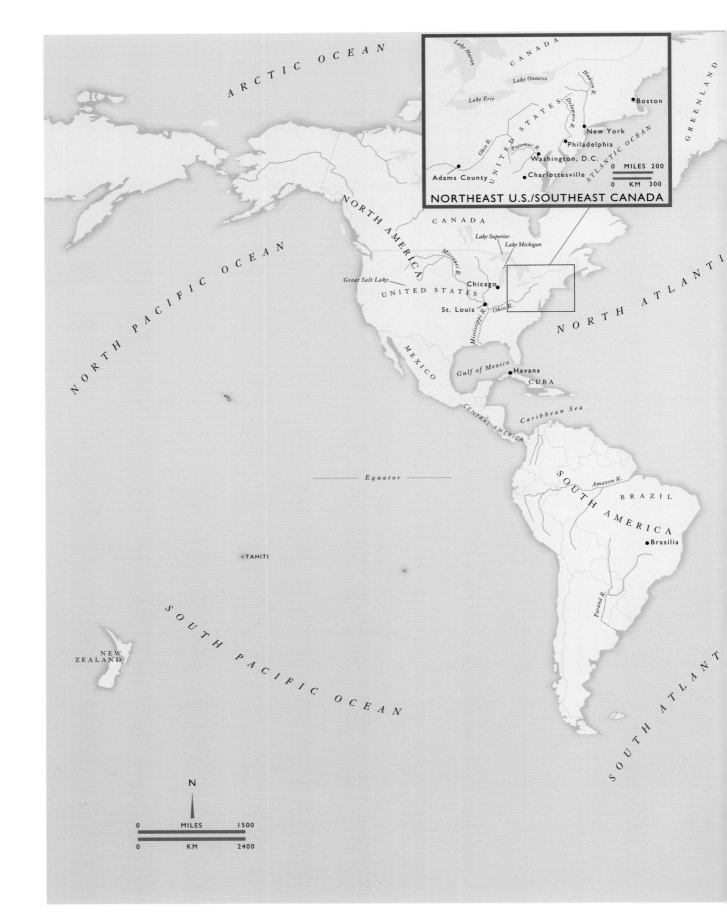

NORTHEAST U.S./SOUTHEAST CANADA

ARCTIC OCEAN

GREENLAND

NORTH AMERICA

NORTH PACIFIC OCEAN

CANADA

Lake Superior

Lake Michigan

Missouri R.

Great Salt Lake

Chicago

UNITED STATES

St. Louis

Ohio R.

Mississippi R.

MEXICO

Gulf of Mexico

Havana

CUBA

NORTH ATLANTIC

CENTRAL AMERICA

Caribbean Sea

Equator

Amazon R.

SOUTH AMERICA

BRAZIL

Brasília

Paraná R.

TAHITI

NEW ZEALAND

SOUTH PACIFIC OCEAN

SOUTH ATLANTIC

N

| 0 | MILES | 1500 |
| 0 | KM | 2400 |

Inset labels: Lake Huron, CANADA, Lake Ontario, Lake Erie, Hudson R., Boston, UNITED STATES, Ohio R., Delaware R., New York, Potomac R., Philadelphia, Washington, D.C., ATLANTIC OCEAN, Adams County, Charlottesville

| 0 | MILES | 200 |
| 0 | KM | 300 |

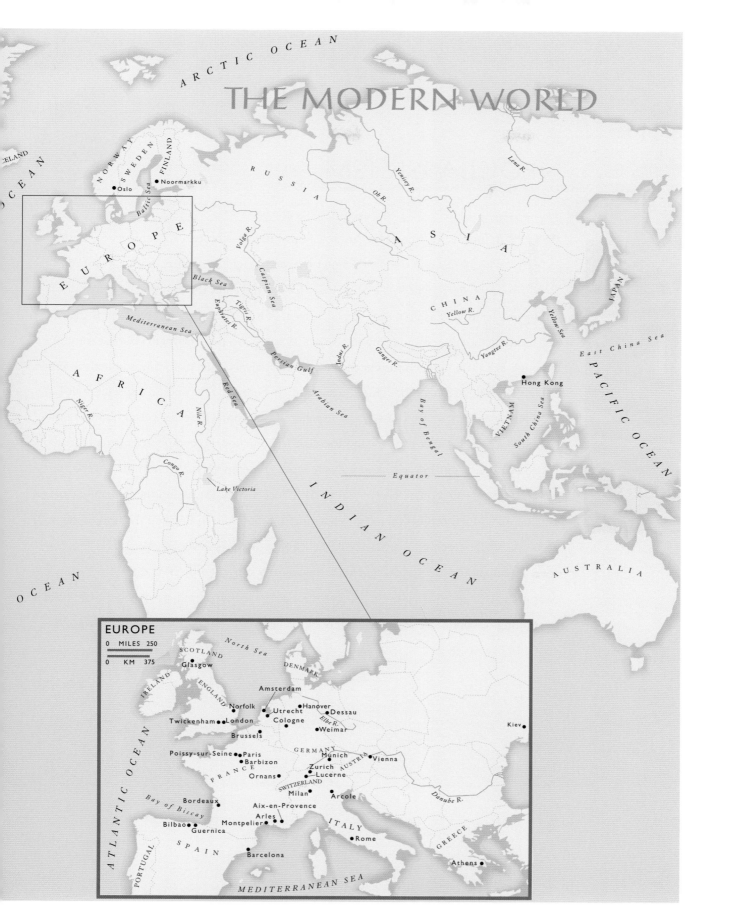

THE MODERN WORLD

ARCTIC OCEAN

OCEAN

ICELAND

NORWAY

SWEDEN

FINLAND

• Oslo

• Noormarkku

Baltic Sea

R U S S I A

Lena R.

Yenisey R.

Ob R.

Volga R.

A S I A

JAPAN

Black Sea

Caspian Sea

E U R O P E

Euphrates R.

Tigris R.

C H I N A

Yellow R.

Yellow Sea

Mediterranean Sea

Red Sea

Persian Gulf

Indus R.

Ganges R.

Yangtze R.

East China Sea

A F R I C A

Nile R.

Arabian Sea

Bay of Bengal

• Hong Kong

PACIFIC OCEAN

Niger R.

VIETNAM

South China Sea

Congo R.

• Lake Victoria

I N D I A N O C E A N

Equator

AUSTRALIA

OCEAN

EUROPE

0 MILES 250

0 KM 375

North Sea

SCOTLAND

• Glasgow

DENMARK

IRELAND

ENGLAND

• Amsterdam

• Norfolk

• Utrecht

• Hanover

• Dessau

Twickenham • • London

• Cologne

Elbe R.

• Kiev

• Brussels

• Weimar

GERMANY

Poissy-sur-Seine • • Paris

• Munich

• Barbizon

AUSTRIA

• Vienna

F R A N C E

• Ornans

• Zurich

• Lucerne

SWITZERLAND

• Milan

• Arcole

Bay of Biscay

• Bordeaux

Aix-en-Provence

• Arles

Danube R.

• Bilbao

• Montpelier

ITALY

GREECE

• Guernica

• Rome

ATLANTIC OCEAN

PORTUGAL

S P A I N

• Barcelona

Athens •

MEDITERRANEAN SEA

457

CHAPTER 21

NEOCLASSICISM

The history of Neoclassicism and Romanticism—the two movements to be dealt with in this and the next chapter—covers roughly a century, from about 1750 to 1850. Paradoxically, Neoclassicism has been seen as the opposite of Romanticism on the one hand, and as no more than one aspect of it on the other. The problem is that the two terms are not directly comparable. Neoclassicism was a new revival of classical antiquity, although it was no more consistent than earlier classicisms. Moreover, it was linked, at least initially, to Enlightenment thought. Romanticism, in contrast, refers not to a specific style but to an attitude that manifested itself in a number of ways, including classicism. Romanticism is therefore a far broader concept and thus harder to define. To complicate matters further, the Neoclassicists and early Romantics were exact contemporaries, who in turn overlapped the preceding generation of Rococo artists. The Neoclassicist David and the Romantic Goya, for example, were born within a few years of each other. And in England the leading representatives of the Rococo, Neoclassicism, and Romanticism—Reynolds, West, and Fuseli—shared many of the same ideas; nor were they always separated by clear differences in style or approach. Finally, Romanticism lasted far longer in sculpture and architecture than it did in painting: it continued well into the era of Realism and Impressionism, with vestiges lingering as late as 1900.

The Enlightenment

The modern era was born during the American Revolution of 1776 and the French Revolution of 1789. These political upheavals were preceded by a revolution of the mind that had begun half a century earlier. Its standard-bearers were those thinkers of the Enlightenment in England, France, and Germany—David Hume, Voltaire, Jean-Jacques Rousseau, Denis Diderot, and Heinrich Heine, to name only the most important—who proclaimed that human affairs ought to be ruled by reason and the common good rather than by tradition and established authority. In the arts, as in economics, politics, and religion, this rationalist movement turned against the prevailing practice: the ornate and aristocratic Rococo. In the mid-eighteenth century there was a widespread call for a return to reason, nature, and morality in art. Such terms proved highly problematic, because they eluded precise definition. Nevertheless, this demand in effect meant a return to the ancients. After all, had not the classical philosophers been the original "apostles of reason"?

The first to formulate this view was Johann Joachim Winckelmann (1717–1768), the German art historian and theorist who popularized the concept of the "noble simplicity and calm grandeur" of Greek art (in *Thoughts on the Imitation of Greek Works...*, published in 1755). His ideas deeply impressed two painters then living in Rome, the German Anton Raphael Mengs (1728–1779) and the Scotsman Gavin Hamilton (1723–1798). Both had strong antiquarian leanings but otherwise limited artistic ability. This shortcoming may explain why they accepted Winckelmann's doctrine so readily. Mengs's importance lies principally in his role as a proselytizer of the "Winckelmann program," since most of his paintings are weak paraphrases of Italian art. He left Rome in 1761 after painting his major work, a ceiling fresco of Parnassus inspired by Raphael's mural in the Stanza della Segnatura, and went to Spain, where he vied with the aging Tiepolo (see page 447).

It is a measure of Italy's decline that artistic leadership passed to the Northerners who gathered in Rome. The only Roman painter who could compete on even terms with the foreigners was Pompeo Batoni (1708–1787), a splendid technician who practiced an eclectic classicism but is remembered today chiefly for portraits of his English patrons. This vacuum helps to account for the astonishing success of Mengs and Hamilton. Toward the end of Batoni's career the Italian school was eclipsed once and for all by the FRENCH ACADEMY in Rome under Joseph-Marie Vien (1716–1809), its head from 1775 to 1781. To French artists, a return to the classics meant the style of Poussin and the "academic" theory of Lebrun, with a maximum of archaeological detail from the excavations of Pompeii and Herculaneum. Vien himself was a minor artist who reduced history painting to genre scenes of ancient life, but he was a gifted teacher. It was his pupils who were to establish French painting as the self-proclaimed guardian of the great tradition of Western art.

Painting

FRANCE

Greuze In France, the anti-Rococo trend in painting was at first a matter of content rather than style, which explains the sudden fame around 1760 of Jean-Baptiste Greuze (1725–1805). *The Village Bride* (fig. 21-1, page 460) is a scene of lower-class family life. What distinguishes it from earlier genre paintings (compare figs. 18-15 and 18-16) is its contrived, stagelike character, borrowed from Hogarth's "dumb show" narratives (see fig. 20-8). But Greuze had neither wit nor satire. His pictorial sermon illustrates the social gospel of Jean-Jacques ROUSSEAU: that the poor, in contrast to the immoral aristocracy, are full of "natural" virtue and honest sentiment. Everything is intended to remind us of this point, from the theatrical gestures and expressions of the actors to the smallest detail: one of the chicks gathered around the hen in the foreground has left the brood and sits alone on a saucer, like the bride who is about to leave her own "brood."

The Village Bride was acclaimed a masterpiece. The loudest praise came from Denis DIDEROT,

Strictly speaking, the FRENCH ACADEMY today is the Institut de France, a cluster of five learned societies brought together during the French Revolution. The original Académie Française began in secret around 1630 under King Louis XIII and was made official in 1635 at the urging of Louis's chief minister, the powerful Cardinal Richelieu (1585–1642). The Académie Royale de Peinture et de Sculpture (later, the Académie des Beaux-Arts), established in 1648 to encourage French fine artists and to maintain the aesthetic standards favored by those in power, is sometimes referred to by art historians as the French Academy.

One of the leading minds of the Enlightenment was the Swiss-born Frenchman Jean-Jacques ROUSSEAU (1712–1778), a brilliant philosopher (Enlightenment philosophers are called *philosophes*). Rousseau's ideas about "natural man" were published in 1754 in his *Discourse on the Origin and Bases of Inequality among Men.* He wrote two immensely influential works, *The Social Contract* and *Émile,* the latter of which provoked a long banishment from France.

A genius in many fields, including natural science, and a novelist, dramatist, poet, and art critic, Denis DIDEROT (1713–1784) is still best known as the compiler and editor of the great French *Encyclopédie* (1751–80), a staggering 28-volume compendium of the natural and physical sciences, law, and what would today be called political science. Fellow *philosophe* Jean-Jacques Rousseau was a contributor to the *Encyclopédie.*

21-1 Jean-Baptiste Greuze. *The Village Bride*. 1761. Oil on canvas, 36 x 46½" (91.4 x 118.1 cm). Musée du Louvre, Paris

that apostle of reason and nature. Here at last was a painter with a social mission who appealed to the viewer's moral understanding, instead of merely giving pleasure like Boucher with his frivolous works (see fig. 20-5)! In his first flush of enthusiasm, Diderot accepted the narrative of Greuze's pictures as "noble and serious human action" in Poussin's sense. Diderot's extravagant praise of Greuze is understandable. *The Village Bride* is a pictorial counterpart to his own melodramas, which attempted to add domestic tragedy and the comedy of virtue to the accepted classifications of theater.

David Greuze was less successful at painting historical subjects, and Diderot modified his views later, when a far more gifted and rigorous "Neo-Poussiniste" appeared on the scene: Jacques-Louis David (1748–1825). A disciple of Vien, David had developed his Neoclassical style in Rome during the years 1775–81. Upon his return to France, he quickly established himself as the leading Neoclassical painter. He overshadowed all others by far, so that our conception of the movement is based largely on his work. In *The Death of Socrates* (fig. 21-2) of 1787, David seems more "Poussiniste" than Poussin himself (compare fig. 19-2). The composition unfolds parallel to the picture plane like a relief, and the figures are as solid and immobile as statues. David has added one unexpected element. The lighting, which is sharply focused and casts precise shadows, is derived from Caravaggio. So is the firmly realistic detail. (Note the hands and feet, the furniture, the texture of the stone surfaces.) As a result, the

21-2 Jacques-Louis David. *The Death of Socrates.* 1787. Oil on canvas, 51 x 77¼" (129.5 x 196.2 cm). The Metropolitan Museum of Art, New York

Wolfe Fund, 1931. Catherine Lorillard Wolfe Collection

picture has a lifelike quality that is astonishing in such a doctrinaire statement of the new style. The very harshness of the design suggests that David was passionately involved in the issues of his age, artistic as well as political. Refusing to compromise his principles, Socrates was convicted of a trumped-up charge of teaching heresy and sentenced to death. He is shown about to drink poison hemlock from the cup. Thus he becomes not only an example of ancient virtue, but also the founder of the "religion of Reason." Here he is a Christ-like figure amid his 12 disciples, although fewer people were actually present at his death and his wife is omitted from the scene.

David took an active part in the French Revolution, and for some years he had controlling power over the artistic affairs of the nation. During this time he painted his greatest picture, *The Death of Marat* (fig. 21-3). David's deep emotion has made a great work from a subject that would have embarrassed any lesser artist, for Marat, one of the political leaders of the Revolution, had been murdered in his bathtub. A painful skin condition required immersion, and he did his work there, with a wooden board serving as his desk. One day a young woman named Charlotte Corday burst in with a personal petition,

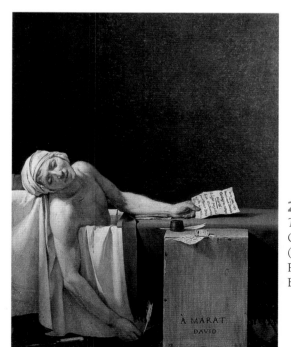

21-3 Jacques-Louis David. *The Death of Marat.* 1793. Oil on canvas, 65 x 50½" (165.1 x 128.3 cm). Musées Royaux des Beaux-Arts de Belgique, Brussels

then plunged a knife into his chest while he read it. David has composed the scene with a stark directness that is awe-inspiring. In this canvas, which was planned as a public memorial to the martyred hero,

classical art coincides with devotional image and historical account. However, classical art could offer little specific guidance here, even though the slain figure probably derives from an antique source, and the artist has drawn on the Caravaggesque tradition of religious art far more than in *The Death of Socrates*. It is no accident that his *Marat* reminds us so strongly of Zurbarán's *St. Serapion* (see fig. 17-17).

ENGLAND

West The leading role of artists such as Gavin Hamilton in formulating Neoclassicism was a result of England's enthusiasm for classical antiquity since the early years of the century. This appreciation was political, philosophic, and literary. Because it was motivated by a new nationalism, this admiration soon turned into a demand that England become "the principal seat of the arts" as well. In 1748 King George III established the ROYAL ACADEMY OF ARTS as a way of encouraging painting, sculpture, and architecture in Great Britain. (It is still under the patronage of the Crown.)

Among its founders was Benjamin West (1738–1820), who succeeded Sir Joshua Reynolds as its president. Largely self-taught, West went to Rome from Pennsylvania in 1760 and caused a sensation, since no American painter had appeared in Europe before. He relished his role of frontiersman. On being shown a famous Greek statue he reportedly exclaimed, "How like a Mohawk warrior!" He also quickly absorbed the lessons of Neoclassicism, so that he was in command of the most up-to-date style when he left a few years later. West stopped in London for what was intended to be a brief stay on his way home, but decided to remain there. He enjoyed phenomenal success and became the most important history painter in England. His career was thus European rather than American, but he always took pride in his New World background.

The Death of General Wolfe (fig. 21-4), West's most famous work, is the first painting to immortalize the martyrdom of a secular hero. It represents an incident that had aroused considerable feeling in London. Wolfe's death in 1759 occurred

R.A. after an artist's name or signature indicates membership in the ROYAL ACADEMY OF ARTS. Conservative by nature, the Academy sponsors a large annual show of works by members and nonmembers.

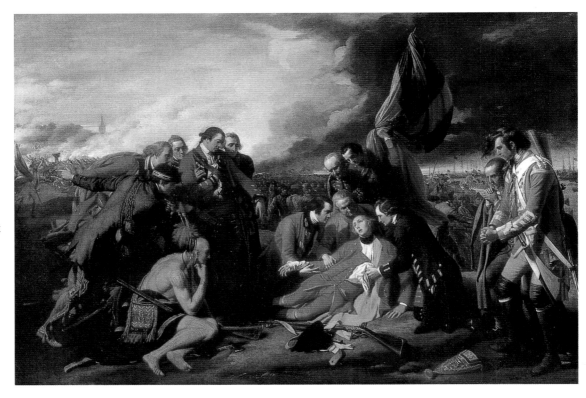

21-4 Benjamin West. *The Death of General Wolfe.* 1770. Oil on canvas, 59½ x 84" (151.1 x 213.4 cm). The National Gallery of Canada, Ottawa

Gift of the Duke of Westminster

in the siege of Quebec during the FRENCH AND INDIAN WAR. When West decided to represent this event 11 years later, two methods were open to him. He could give a factual account, with the maximum of historical accuracy, or he could use "the grand manner," based on Poussin's ideal of history painting (see pages 421–23), with figures in "timeless" classical costume. Although he had been influenced by Mengs and Hamilton, he did not follow them in this painting, because he knew the American scene too well.

Instead, he merged the two approaches. His figures wear contemporary dress, and the figure of the Indian places the scene in the New World. Yet all the attitudes and expressions are "heroic." The composition, in fact, recalls the lamentation over the dead Christ (see fig. 11-33). The artist has dramatized it with Baroque lighting, drama, and brushwork (see fig. 18-1). West thus endowed the death of a modern military hero with both the classical pathos of "noble and serious human actions," as defined by academic theory, and the trappings of a real event. He created an image that expresses an attitude basic to modern times: the shift of allegiance from religion to nationalism. No wonder his picture had countless successors during the nineteenth century.

Copley West's gifted countryman John Singleton Copley of Boston (1738–1815) moved to London just two years before the American Revolution. As New England's outstanding portrait painter, he had adapted the formulas of the British portrait tradition to the cultural climate of his hometown. *Paul Revere*, painted around 1768–70 (fig. 21-5), is deservedly his most famous painting in this vein. Silversmith, printmaker, businessman, and patriot, Revere has acquired legendary status thanks to Henry Wadsworth Longfellow's famous poem about his midnight ride. Copley's painting, in turn, has become virtually an American icon. It has generally been treated as a workingman's portrait, so to speak. However, this is not Revere's working outfit but his best business clothes. Revere looks out at us with astonishing directness, as if he were examining us as intently as we scrutinize him. The thoughtful mood is heightened by the sharp light, which gives him an unusually forceful presence. Revere is a thinker who possesses an active intelligence, and we will recognize the pose of hand on chin as an old device used since antiquity to represent philosophers. Clearly this is no ordinary craftsman. Why, then, did Copley show Revere at a workbench with his engraving tools spread out before him? And why is he holding a teapot as the object of his contemplation and offering it to us for our inspection? Revere's work as a silversmith is not a sufficient explanation, natural as it might seem.

Paul Revere belongs to a type of informal portrait that originated in France in the early eighteenth century and soon became popular as well in England. Reserved originally for artists, writers, and the like, it soon gave rise to a variant showing a sculptor at work in his studio with his tools

France and England fought over possession of North America for 150 years. Tension culminated in a nine-year conflict called the FRENCH AND INDIAN WAR. Waged in New York State, New England, and Quebec, it ended in 1763 when Canada was ceded to England.

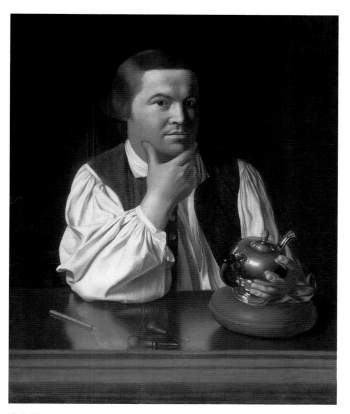

21-5 John Singleton Copley. *Paul Revere*. c. 1768–70. Oil on canvas, 35 x 28¹/₂" (88.9 x 72.3 cm). Museum of Fine Arts, Boston

Gift of Joseph W., William B., and Edward H. R. Revere

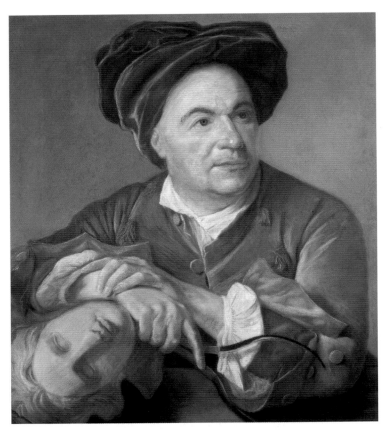

21-6 Francis-Xavier Vispré (attributed to). *Portrait of Louis-François Roubiliac.* c. 1750. Pastel on paper laid on canvas, 24½ x 21½" (62.2 x 54.6 cm). Yale Center for British Art, New Haven

Paul Mellon Collection

teeth, from Revere.) The painting thus stands as a compelling tribute to a fellow artist—and as an invaluable document of Colonial culture.

In Europe, Copley was at last able to attain his ideal of history painting in the manner of West. His most memorable work is *Watson and the Shark* (fig. 21-7). As a young man, Watson had been dramatically rescued from a shark attack while swimming in Havana harbor, but not until he met Copley did he decide to have this gruesome experience memorialized. Perhaps he thought that only a painter newly arrived from America would do full justice to the exotic flavor of the incident. Copley, in turn, must have been fascinated by the task of translating the story into pictorial terms. Following West's example, he made every detail as authentic as possible (here the black man has the same purpose as the Indian in *The Death of General Wolfe*) and utilized all the expressive resources of Baroque painting to invite the viewer's participation. The composition is indebted partially to a hunting scene by Rubens. Copley may also have remembered representations of Jonah and the Whale, which include the elements of his scene, except that the action is reversed. (The prophet is thrown overboard into the jaws of the sea monster.) The shark becomes a monstrous embodiment of evil; the man with the boat hook recalls the Archangel Michael fighting Satan; and the nude youth, resembling a fallen gladiator, flounders helplessly between the forces of doom and salvation. This kind of moral allegory is typical of Neoclassicism as a whole, and despite its charged emotion, the picture has the same logic and clarity found in David's *Death of Socrates.*

Kauffmann One of the leading Neoclassicists in England was the Swiss-born painter Angelica Kauffmann (1741–1807). She spent 15 years in London and became a founding member of the Royal Academy. Kauffmann was among the group that included Reynolds and West, whom she had met in Winckelmann's circle in Rome, where she had been a disciple of Mengs (see page 459). From the antique she developed a delicate style admirably suited to the interiors of Robert Adam (see below),

prominently displayed (fig. 21-6). Sometimes an engraver is seen instead. There is another source as well: moralizing portraits, the descendants of pictures of St. Jerome, that show the sitter holding or pointing to skulls, much as Revere has the teapot in his hand. Copley was surely familiar with such images from the portrait engravings he collected, although the exact sources for the Revere painting remain unknown. Copley transformed Revere from a craftsman into an artist-philosopher, and with good reason. Revere's portrait probably dates from around the time of his first engravings. The painter and the silversmith must have known each other well, for the artist endowed his portrait with a penetrating characterization. (Copley ordered various pieces of silver, and even false

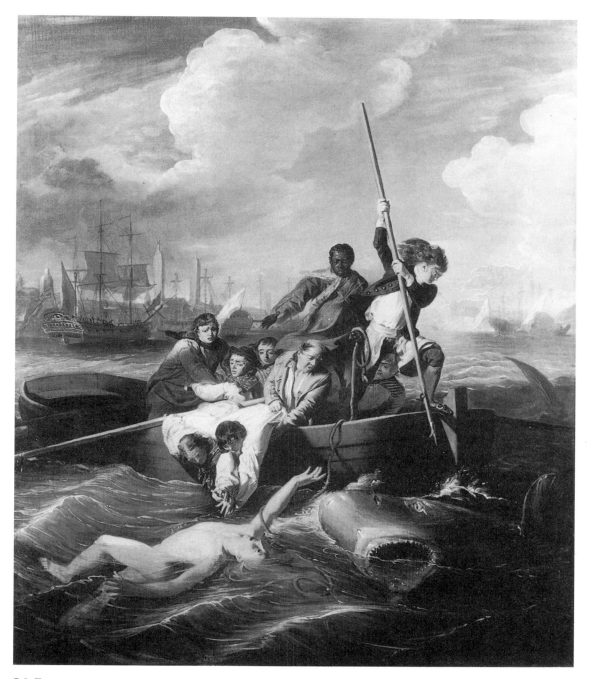

21-7 John Singleton Copley. *Watson and the Shark.* 1778. Oil on canvas, 7'6¼" x 6'1½" (2.29 x 1.84 m). Museum of Fine Arts, Boston

Gift of Mrs. George von Lengerke Meyer

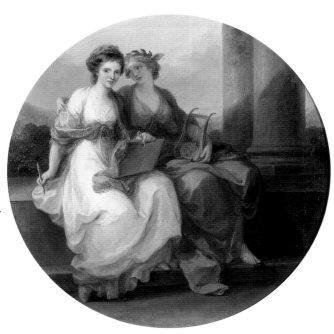

21-8 Angelica Kauffmann. *The Artist in the Character of Design Listening to the Inspiration of Poetry.* 1782. Oil on canvas, diameter 24" (61 cm). The Iveagh Bequest, Kenwood, London

One meaning of the word *original* is that an artist (or writer or musician) created the work in question. An ORIGINAL PLASTER is a three-dimensional work made by an artist from plaster of Paris, a hard-drying substance traditionally carved or cast as sculpture.

The SALONS of France originated in the seventeenth century as infrequent showings of works by members of the Académie Royale de Peinture et de Sculpture. By the early nineteenth century, they had developed into an annual event held in the Salon Carré of the Louvre—hence the name *Salon*. After 1850 the Salon was held at other sites in Paris. Resentment over abuse of the selection process led Napoleon III to create an alternative exhibition, also "official," in 1863: the Salon des Refusés.

which she was often commissioned to decorate. Kauffmann's most ambitious works are narrative paintings, of which the artist John Henry Fuseli observed, "Her heroines are herself." *The Artist in the Character of Design Listening to the Inspiration of Poetry* (fig. 21-8) combines both aspects of her art. The subject must have held particular meaning for her, for it is eloquent testimony to women's struggle to gain recognition in the arts. The artist has assumed the guise of Design, suggesting her strong sense of identification with the muse. The painting became the prototype of the allegorical "friendship" pictures showing two female figures that remained popular into the Romantic era.

Sculpture

The history of Neoclassical sculpture does not simply follow that of painting. Neoclassicism stands out far more clearly in sculpture than in painting, where it is sometimes hard to distinguish from Romanticism. Unlike painters, Neoclassical sculptors were overwhelmed by the authority granted since Winckelmann to ancient statues, which were praised as supreme manifestations of the Greek genius. Most of these works were in fact mechanical Roman copies of no great distinction after Greek originals (see figs. 5-17 and 5-22). (Goethe, upon seeing the newly discovered late Archaic sculpture from Aegina, pronounced it clumsy and inferior; see fig. 5-14.)

When Winckelmann published his essay advocating the imitation of Greek works, enthusiasm for classical antiquity was already well established among the intellectuals of the Enlightenment. In Rome from 1760 on, the restoring of ancient sculpture and its sale, especially to wealthy visitors from abroad, was a flourishing business. To these patrons, classical statues belonged to a different world. They were admired as embodiments of an aesthetic ideal, undisturbed by the demands of time and place. To enter this world, modern sculptors set themselves the goal of creating "modern classics"—sculpture demanding to be judged on a basis of equality with its ancient predecessors. This was not just a matter of style and subject matter. It meant that sculptors had to hope that critical acclaim would establish such works as classics in their own right and attract buyers. The ORIGINAL PLASTER enabled them to present major works to the public without investing in expensive marble or bronze. Plaster sculpture thus became a feature at the SALONS, the exhibitions sponsored by the French Academy, where success was crucial for young artists. Without the original plaster, the Neoclassical revolution in sculpture would have been impossible.

If Paris was the artistic capital of the Western world during the second half of the eighteenth century, Rome became the birthplace and spiritual home of Neoclassicism. As we have seen, however, the new style was pioneered by the resident foreigners from north of the Alps rather than by Italians. That Rome should have been an even stronger magnet for sculptors than for painters is hardly surprising. The city offered an abundance of sculptural monuments but only a meager choice of ancient painting. (It also had many skilled artisans in both marble and bronze.) In the shadow of these monuments, Northern sculptors trained in the Baroque tradition awakened

to a new conception of what sculpture ought to be. They paved the way for Antonio Canova, whose success as the creator of modern classics was the ultimate fulfillment of their ambitions (see pages 498–99).

Houdon Jean-Antoine Houdon (1741–1828), unlike most of his contemporaries, built his career on portrait sculpture. He would have been glad to accept state commissions had they been available. Nevertheless, he soon discovered his special gift for portraits, for which there was a growing demand. Indeed, portraiture proved the most viable field for Neoclassical sculpture. How else could modern artists rise above the quality of the Greek and Roman classics? Houdon's portraits retain the keen sense of individual character introduced by Coysevox (see fig. 19-11), and they established entirely new standards of physical and psychological realism. Houdon, more than any other artist of his time, knew how to give visible form to Enlightenment ideals while still relying on Rococo devices. His portraits have an apparent lack of style that is deceptive. Houdon had an uncanny ability to make all his sitters into Enlightenment personalities while remaining conscientiously faithful to their individual features. He even managed this on the rare occasions when he had to make portrait busts of people long dead, or when he had to work from a death mask only.

With Voltaire, he was more fortunate. Houdon modeled him from life a few weeks before the famous author's death in May 1778, and then made a death mask as well. From these studies he created *Voltaire Seated* (fig. 21-9), which was immediately acclaimed as towering above all others of its kind. The original plaster has not survived, but a terracotta cast from it, retouched by Houdon, offers a close approximation. As contemporary critics quickly pointed out, the *Voltaire Seated* was a "heroicized" likeness. The sculptor enveloped the frail old man in a Roman toga and even added some hair he no longer had so as to justify the classical headband. Yet the effect is not disturbing, for Voltaire wears the toga as casually as a dressing gown. His facial expression and the turn of his head, so reminiscent of Rococo portraiture (compare fig. 20-7, of

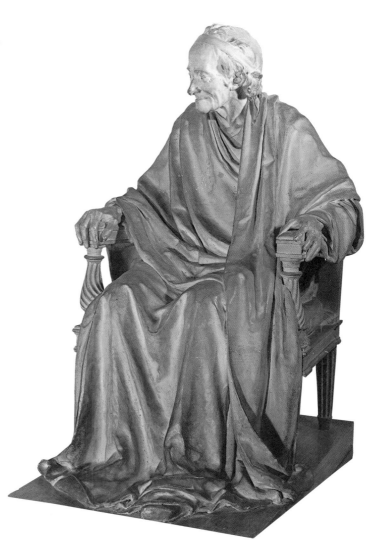

21-9 Jean-Antoine Houdon. *Voltaire Seated.* 1781. Terra-cotta model from original plaster, height 47" (119.4 cm). Musée Fabre, Montpellier, France

about the same time), suggest the atmosphere of an intimate conversation. Thus Voltaire is not merely cast in the role of classical philosopher—he becomes the modern counterpart of one, a modern classic in his own right! In him, we recognize ourselves. Voltaire is the image of modern life: unheroic, skeptical, with his own idiosyncratic mixture of rationality and emotion. That is surely why Voltaire strikes us as so "natural." We are, after all, the heirs of the Enlightenment, which coined this ideal type.

Architecture

ENGLAND

The Palladian Revival England was the birthplace of Neoclassicism in architecture, as it had been in the forefront of painting and sculpture. The earliest sign of this attitude was the Palladian revival. It was sparked by the publication of the treatise *Vitruvius Brittanicus* (1715–17; 1725) by Colin Campbell (1676–1729), which advocated a return to the style of Palladio and Inigo Jones and rejected that of Wren. However, it was the wealthy amateur Richard Boyle, Lord Burlington (1694–1753), who emerged as the leader of the movement in the 1720s. To accomplish his designs, he employed his friend William Kent (c. 1685–

Neoclassical Music

The leading representative of Neoclassicism in music was CHRISTOPH WILLIBALD GLÜCK (1714–1787). Glück wrote two operas, *Orfeo ed Euridice* (1762) and *Alceste* (1767), with the poet Raniero Calzabigi (1714–1795). They sought to correct the excesses of Italian opera through "a beautiful simplicity" and to "confine music to its proper function of serving the poetry for the expression and the situation of the plot." Though originally produced in Vienna, the two operas enjoyed greater success in Paris, where classicism was an uninterrupted tradition. Glück's operas have a nobility and depth of feeling that hark back to Claudio Monteverdi, and a classicism and pageantry worthy of Jean-Baptiste Lully and Jean-Philippe Rameau. The subject of both works is the immortality of love, which conquers even death. Alceste, who was willing to die so that her husband, King Admetes, could live, was seen as a paradigm of conjugal love.

CARL PHILIPP EMANUEL BACH (1714–1788), a son of Johann Sebastian Bach, served for nearly 30 years at the Berlin court of Frederick the Great, himself a very able composer. Unlike his illustrious father, the younger Bach loathed counterpoint. The widespread reaction against the complexities of counterpoint may be likened to the call for natural morality by Bach's exact contemporary, the philosopher Jean-Jacques Rousseau. Bach nevertheless adopted a conservative style that suited his patron's taste. Upon being appointed music director of Hamburg, one of the most important posts in Germany, he felt free to pursue a direct, expressive style that sometimes shows a debt to his predecessor there, Georg Philipp Telemann. His first Hamburg symphonies exemplify *Sturm und Drang* (Storm and Stress) in music: they are full of extremes, with brooding, sighing slow movements sandwiched between dynamic fast ones characterized by irregular rhythms and startling emotional outbursts. Their limitation, and it is a significant one, is the composer's disregard for form, which prevented him from developing them further.

Sturm und Drang also influenced the middle symphonies written by FRANZ JOSEPH HAYDN (1732–1809) in 1771–74. He spent almost his entire career at the estate of the Esterházys south of Vienna, where he had a small but excellent ensemble of instrumentalists and singers. Haydn became the most famous composer of his era and was called to Paris (1785–86) and London (1790, 1794), where he created symphonies of unrivaled sophistication and richness. He was no less a master of the string quartet, of which he wrote many, all marked by unprecedented variety, formal mastery, and refined feeling. The late piano sonatas had a marked influence on the "lesser" ones of his most celebrated pupil, Ludwig von Beethoven, as did his oratorios—*The Creation* (1798), based on Milton's *Paradise Lost*, and *The Seasons* (1801), adapted from James Thomson's poem (1726–30) of the same name.

Haydn became a close friend of WOLFGANG AMADEUS MOZART (1756–1791), despite their great differences in age, temperament, and outlook. A child prodigy, Mozart received a rigorous training from his father, Leopold (1719–1787), who took him on tour through the great courts of Europe. Mozart failed in his efforts to gain a major court appointment; deprived of this measure of security, he became a prolific composer for the open market, putting the stamp of his individual genius on everything he wrote. His finest quartets are the six dedicated to Haydn, who declared him the greatest composer alive, while the late symphonies blaze new territory that foreshadow those of the young Beethoven. His numerous concertos for piano, of which he was a virtuoso, combine enchanting lyricism with brilliant technical display.

Mozart was a supreme vocal composer, and it is the singing quality of the human voice that underlies his mature work, regardless of instrument. He was also a master of compositional technique, including counterpoint, and his compositions depend for much of their success on their formal perfection. Indeed, for Mozart, form was the vehicle of expression, which it served to contain, so that there was an ideal, "classical" balance between the two. He was fully sympathetic with the Enlightenment. Its philosophy both informs and burdens his operas, including his acknowledged masterpieces, *The Marriage of Figaro* (1786) and *Don Giovanni* (1787). Both are a new type of comic opera, called OPERA BUFFA to distinguish it from traditional serious operas (*opera seria*), but unlike others of their kind, they have a wonderful humanity and substantial content, thanks in part to the librettos by Mozart's collaborator, Lorenzo Da Ponte (1749–1838).

1748), a painter-decorator among his considerable entourage of artists and writers. (Their number included the poet Alexander Pope, who urged a classical reform of literature.)

Palladio appealed to the English partly because his designs for villas were well suited to English country houses and partly because his style accorded with the Rule of Taste promoted by the Enlightenment philosopher Anthony Ashley Cooper, Third Earl of Shaftesbury. What distinguishes the Palladian revival from earlier classicisms, however, is less its external appearance than its motivation. Instead of merely reasserting the superior authority of the ancients, it claimed to satisfy the demands of reason, and thus to be more "natural" than the Baroque. At the time, the Baroque style was identified with papist Rome by English Protestants, with absolutist France by George I, and with TORY policies by the WHIG opposition. Thus began an association between Neoclassicism and liberal politics that was to continue through the French Revolution. The appeal to reason found support in Palladio himself, who decried abuses "contrary to natural reason" on the grounds that "architecture, as well as all other arts, being an imitation of nature, can suffer nothing that either alienates or deviates from that which is agreeable to nature."

This rationalism helps to explain the abstract, segmented look of Chiswick House on Burlington's estate (fig. 21-10). Adapted by Burlington and Kent from the Villa Rotonda (see fig. 14-17), as well as other Italian sources, it is compact, simple, and geometric—the antithesis of the Baroque pomp. The concept was not new to England. It had been used on a larger scale just a couple of years earlier at Mereworth Castle by Campbell. Chiswick is at once bolder and more rigorous, yet less derivative than Mereworth. Campbell himself acknowledged Burlington as "not only a great Patron of all Arts, but the first Architect." The exterior surfaces of Chiswick are flat and unbroken, the ornament is meager, and the temple **portico** juts out abruptly from the blocklike body of the structure. The interior, probably by Kent, is more luxurious, in the manner of Jones, but it has a clarity that looks forward to the work of Robert Adam (see below).

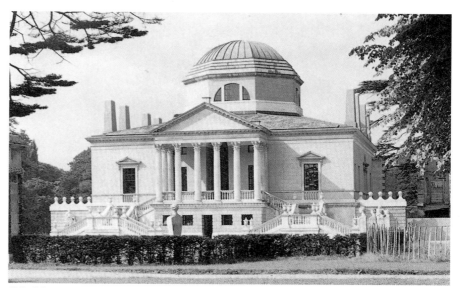

21-10 Lord Burlington and William Kent. Chiswick House, near London. Begun 1725

FRANCE

The Rationalist Movement The rationalist movement came somewhat earlier in France so far as theory is concerned, but was first realized in actual buildings only in the middle years of the century. It was made up of several factions that were united only by their rejection of the Rococo as heavy and ornate.

Structural Rationalism was initiated by the pro-Greek rigorists, who were theorists rather than practicing architects. The first, Abbé Jean-Louis de Cordemoy (active 1706–12), argued in his *New Treatise on All Architecture* (1708; 1714) for a simple, clear system based on freestanding columns surmounted by an entablature and stripped of all extraneous ornament. He therefore warned against the unnecessary decorative use of classical elements. In addition, he was important for helping to initiate the French fascination with the Gothic by calling for an architecture combining classical forms and Gothic construction principles. This idea had first been introduced, although cautiously, by the great classicist Claude Perrault himself.

The central figure, however, was the Jesuit Abbé Marc-Antoine Laugier (1713–1769), a true philosopher of the Enlightenment whose faith in reason

TORY and *WHIG* are the terms applied, since the seventeenth century, to Britain's two chief political parties. *Tory* was originally a name for Irish outlaws. Later, it became associated with the political supporters of James II (1633–1701), the Roman Catholic Stuart king. The name *Whig* was used for those who opposed James II's succession to the Crown. Today's Conservative party members are called Tories; Liberal party followers are Whigs.

was complete. In his *Essay on Architecture* (1753), he followed Vitruvius in accepting that the beautiful in architecture, as in art, must proceed from nature. And like Jean-Jacques Rousseau, he believed that early people lived in an idyllic state of harmony with nature. They built huts of trees using a simple post-and-lintel method that Laugier believed to be the forerunner of the columns and entablatures found in Classical Greek architecture, where every element performed a clear role and ornament was held to a minimum He therefore totally rejected the Roman use of arches, pilasters, and compound orders. Despite his insistence on clarity and logic, Laugier, too, was fascinated by the lightness, gracefulness, and spaciousness of Gothic architecture. He proposed a union of these two ideal systems in which glass would fill the voids between columns. The Franciscan theologian Carlo Lodoli (1690–1761) of Venice was an even purer structuralist. He argued that beauty must proceed not from aesthetics but from the dictates of materials, specifically stone. To him the Greek orders, and by extension Roman and Renaissance architecture, were dishonest because they substituted marble for wood. Thus the only true models of masonry architecture were Stonehenge and Egyptian temples.

The actual attack on the Rococo style began in 1737 with a treatise written by the architect Jacques-François Blondel (1705–1774), the leader of the traditionalists. He argued for a return to the French classical style of Perrault and Mansart out of nostalgia for the age of Louis XIV. The offensive was joined eight years later by the theorist Abbé Jean-Bernard Leblanc, whose *Letters from England* (1745) endorsed a Neoclassical style under the influence of Lord Burlington's ideas. The antiquarians, centering on the collector the comte de Caylus, attracted the younger generation of French architects who returned from studies in Rome during the 1740s and '50s filled with new ideas based on antiquity and the Renaissance. The most prominent was Jean-Laurent Legeay (c. 1710– c. 1786), a visionary who influenced first Piranesi in Rome (see page 448) and then a generation of architects in Paris after being appointed to a

position at the Academy in 1742. The archaeological Neoclassicists of the 1760s proved even more radical. Chief among them was Charles-Louis Clérisseau (1721–1820), a pupil of Blondel who was also inspired by Piranesi and Johann Winckelmann. They believed that the Romans had perfected the Greek orders by extending and combining them in boldly imaginative ways.

It is characteristic of the Enlightenment that utility and necessity replaced beauty, which came to be measured by reason, not aesthetics. However, practicing architects found it impossible to adhere to such an approach in every respect, and they mounted a vigorous counteroffensive. The net result was that French architecture in the 1750s and '60s was dominated by the conscious return to the Style of Louis XIV, but "corrected" and overlaid with new ideas of such boldness that they provided the foundation for modern architecture.

Soufflot The first great monument of the rationalist movement was the Panthéon in Paris (fig. 21-11) by Jacques-Germain Soufflot (1713– 1780). It was begun in 1757 as the Church of Ste-Geneviève, but was secularized during the Revolution. The architect owed his position to his close relationship with the marquis de Marigny, the brother of Louis XV's mistress, Madame du Pompadour, with whom he toured Italy in 1749–51. Upon his return, he settled in Lyons, the home of Laugier, where he quickly established himself among the leading architects of the day. As with so much else in eighteenth-century France, the Church of Ste-Geneviève looks back to the preceding century, in this case Hardouin-Mansart's Church of the Invalides (see fig. 19-9). The huge east portico, however, is modeled directly on Perrault's Louvre facade (see fig. 19-5), as well as ancient Roman temples. (Soufflot had spent seven years studying architecture in Italy as a winner of the French Academy's Prix de Rome at the beginning of his career.) The plan, unusual for France, is in the shape of a Greek cross. Although Hardouin-Mansart's Invalides also uses a Greek-cross plan (see fig. 19-10), the overall shape strongly suggests a debt to Wren's initial proposal for St. Paul's in London (see page 432).

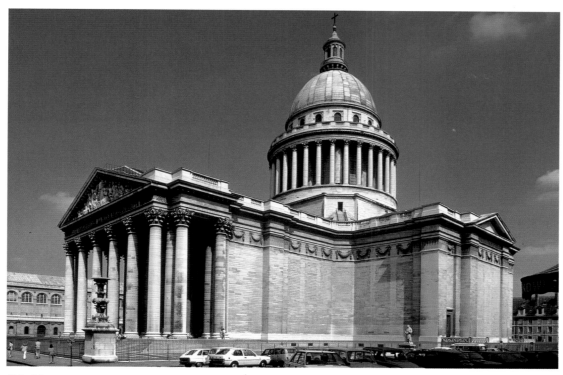

21-11 Jacques-Germain Soufflot. The Panthéon (Ste-Geneviève), Paris. 1757–92

From the beginning, Soufflot intended his church to have long arms and to treat the interior as a classical colonnade surmounted by an entablature rather than as a traditional arcade. He eventually resolved to enlarge the dome. This decision posed formidable problems of vaulting, which he solved with characteristic ingenuity. Interestingly enough, the dome in its final form is also derived from Wren's St. Paul's (see fig. 19-14), not Hardouin-Mansart's Invalides as one might expect, which further indicates England's new importance for Continental architects. Although he never crossed the Channel, Soufflot had personal ties to England and could easily have known Wren's designs from engravings issued in 1726 and 1756. The English connection also helps to explain why the smooth, sparsely decorated surfaces are more akin to those of Chiswick House (which was published by its co-designer, William Kent, in his book on Inigo Jones of 1727) than to any French building. It is an indication of the appeal Chiswick exercised to French rationalists that Voltaire had admired it

during his English sojourn of 1721–26.

From this coolly precise exterior we would never suspect that Soufflot also had a strong interest in Gothic churches. He admired them, not for the seeming miracles they perform but for their structural elegance—a rationalist version of Guarini's point of view (see fig. 17-12). Ste-Geneviève fulfills Soufflot's ideal, conceived early in his career, "to combine the classic orders with the lightness so admirably displayed by certain Gothic buildings." In this regard, he was responding partly to Laugier and other theorists who advocated a union of these seemingly incompatible styles. Soufflot studied Gothic architecture and its proportions in detail. He even constructed a special device to test the strength of stone in order to understand the Gothic structural system, which he used to support the massive dome. However, the buttresses at the four corners remain completely hidden from view by a **parapet** in order not to disturb the insistent classicism inside and out.

Ste-Geneviève remains the great architectural

statement of the rationalist movement. Unfortunately, the windows were walled in at the suggestion of the critic-theorist Antoine Quatremère de Quincy (1755–1849) in 1791–93 to make the building more "appropriate" for a national monument. The remodeling destroyed the light-filled interior and emphasized the abstract severity of the facade. Soon after being rededicated as the Panthéon, it received the ashes of the Enlightenment philosophers Voltaire and Rousseau, and eventually those of the author Victor Hugo. As the Panthéon, the building underwent numerous modifications during the nineteenth century that reflect the turbulent politics of the era. At the direction of Napoleon, Soufflot's pupil Jean-Baptiste Rondelet (1743–1829) redesigned the marble flooring and made changes to the crypt so that it could accommodate the remains of military heroes. Under the Restoration the building was reconsecrated as a church, and a fresco, *The Apotheosis of Louis XVIII,* was added to the dome by Baron Gros (see page 479). Finally, during the July Monarchy it was restored to its role as the Panthéon, and the pediment was replaced in the 1830s with an entirely new one by Pierre-Jean David d'Angers (1788–1856) representing *The Nation Distributing Laurel Wreaths to Great Men with the Help of Liberty and History.*

NEOCLASSICISM AND THE ANTIQUE

The mid-eighteenth century was greatly stirred by two experiences: the rediscovery of Greek art as the original source of classical style, and the excavations at Herculaneum and Pompeii in 1738 and 1748, which for the first time revealed the daily life of the ancient Romans and the full range of their arts and crafts. Richly illustrated books about the Akropolis at Athens, the temples at Paestum, and the finds at Herculaneum and Pompeii were published in England and France. Archaeology caught everyone's imagination. From this came a new style of interior decoration. The Greek phase of this revival proved necessarily limited, as only a narrow range of household furnishings was known at second hand from vase paintings and sculpture. When they wanted to work in a Greek style, designers turned chiefly to architecture, whose vocabulary could be readily adapted to large pieces of furniture, where it was combined with Roman elements. Thus it was, for the most part, a classicism of particulars.

Adam The Neoclassical style was epitomized by the work of the Englishman Robert Adam (1728–1792). His friendship with Piranesi in Rome reinforced Adam's goal of arriving at a personal style based on the antique without slavishly imitating it, but he was also influenced by Clérisseau. His genius is seen most fully in the interiors he designed in the 1760s for palatial homes, which take the style of Lord Burlington and William Kent as their point of departure. Most are remodelings of or additions to existing homes. Because Adam commanded an extraordinarily wide vocabulary, including the Gothic, each room is different in both shape and design. Yet the syntax, which treats classicism with remarkable richness and flexibility, remains distinctive to him. The library wing he added to Kenwood (fig. 21-12) shows Adam at his finest. It is covered with a barrel vault connected at either end to an apse that is separated by a screen of Corinthian columns. The basic scheme, though Roman in origin, comes from Palladio (see pages 343–44). Amazingly, it had been anticipated more than 40 years earlier by Johann Fischer von Erlach (see pages 444–45), who no doubt used the same source.

Adam was concerned above all with movement, but this idea must be understood not in terms of Baroque dynamism or Rococo ornamentation but as the careful balance of varied shapes and proportions. The play of semicircles, half-domes, and arches lends an air of festive grace. The library thus provides an apt setting for "the parade, the convenience, and the social pleasures of life," since it was also a room "for receiving company." This intention was in keeping with Adam's personality, which was at ease with the aristocratic circles in which he moved. The room owes much of its charm to the paintings

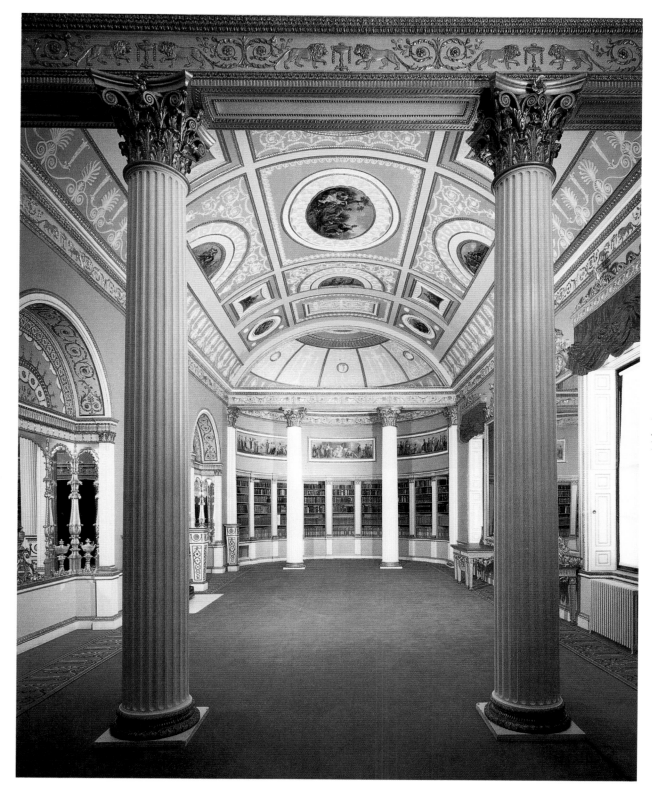

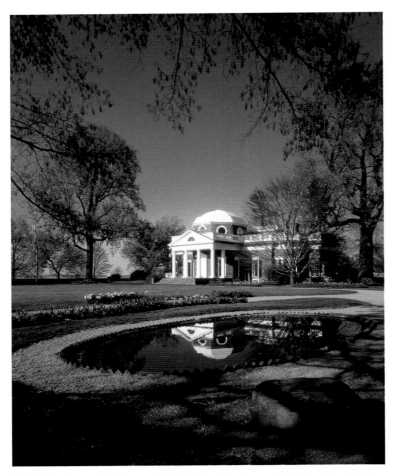

21-13 Thomas Jefferson. Monticello, Charlottesville, Virginia. 1770–84; 1796–1806

before going to Rome) but with a characteristically Neoclassical insistence on planar surfaces, symmetry, and geometric precision.

Jefferson Meanwhile, the Palladianism launched by Lord Burlington spread overseas to the American Colonies, where it became known as the Georgian style. An example of great distinction is the house of Thomas Jefferson (1743–1826), Monticello (fig. 21-13). Built of brick with wood trim, it is not so doctrinaire in design as Chiswick House. (Note the numerous windows.) It nevertheless stands as a monument to the Enlightenment ideals of order and harmony, with which Jefferson was fully in sympathy. The original plan was adapted from a book of English designs, then gradually modified as Jefferson was exposed to other treatises. The scheme of about 1770 featured an Ionic portico placed over a Doric one and surmounted by a pediment. However, the building was remodeled during Jefferson's presidency, and in its final form Monticello has a facade inspired by Palladio (compare fig. 14-17). The house has a clear separation between the private quarters in the wings and the public areas for receiving and entertaining visitors.

Instead of using the Corinthian order favored by Lord Burlington, Jefferson chose the Roman Doric, which Adam had helped to legitimize, although the late eighteenth century came to favor the heavier and more austere Greek Doric. Jefferson was linked indirectly to Adam through Clérisseau, whom he came to know while serving as the American ambassador to France in 1784–88 and whose help he sought in designing the state capitol of Virginia in Richmond in 1785. Jefferson thought out every detail of Monticello, including its relation to the rest of the plantation. Thus the building is carefully placed in its setting, thanks to Jefferson's study of landscape gardening during a visit to England.

by Antonio Zucchi (1762–1795), later the husband of Angelica Kauffmann, who also worked for Adam, and to the **stucco** ornament by Adam's plasterer Joseph Rose, which was adapted from newly discovered Roman examples. The color, too, was in daring contrast to the stark white that was widely preferred for interiors at the time. The effect, stately yet intimate, echoes the delicacy of Rococo interiors (Adam had stayed in Paris in 1754

ROMANTICISM

O f all the "isms" found in Western art of the past two centuries, Romanticism has always been the most difficult to define. It deserves to be termed an "ism" only because its followers (or at least some of them) thought of themselves as being part of a movement. However, they did not leave us anything approaching a definition. Romanticism, it seems, was a certain state of mind rather than the conscious pursuit of a goal or a style. If we try to analyze this state of mind, it breaks down into a series of attitudes, none of which, taken individually, is unique to Romanticism. It is only their particular combination that seems characteristic of the Romantic movement.

How did Romanticism come about? The Enlightenment, paradoxically, liberated not only reason but also its opposite. It helped to create a new wave of emotionalism that lasted for the better part of a half-century and came to be known as Romanticism. The word derives from the late-eighteenth-century vogue for medieval tales of adventure (such as the legends of King Arthur or the Holy Grail), called "romances" because they were written in a Romance language, not Latin. This interest in the long-neglected "Gothick" past was the sign of a general trend. Those who shared a revulsion against the established social order and religion—against established values of any sort—could either try to found a new order based on their faith in the power of reason, or they could seek release in a craving for emotional experience.

Their common goal was a desire to "return to nature." The rationalists revered nature as the ultimate source of reason, while the Romantics worshiped it as unbounded, wild, and ever-changing. The Romantics believed that evil would disappear if people were only to behave "naturally" and give their impulses free rein. In the name of nature, they acclaimed liberty, power, love, violence, classical civilization, the Middle Ages, or anything else that aroused them, although actually they exalted emotion as an end in itself. This attitude has motivated some of the noblest, as well as vilest, acts of the modern era. In its most extreme form, Romanticism could be expressed only through direct action, not through works of art. No artist, then, can be a wholehearted Romantic, for the creation of a work of art demands some detachment, self-awareness, and discipline. What William Wordsworth, the great Romantic poet, said of poetry in 1798—that it is "emotion recollected in tranquility"—applies also to the visual arts.

To cast fleeting experience into permanent form, Romantic artists needed a style. But since they were in revolt against the old order, this could not be the established style of the time. It had to come from some phase of the past to which they felt linked by "elective affinity" (another Romantic concept). Romanticism thus favored the revival not of one style but of a potentially unlimited number of styles. In fact, the rediscovery and use of forms that previously had been neglected or scorned evolved into a stylistic principle in itself. Revivals became the "style" of Romanticism in art, as it did, to a lesser degree, in literature and music.

Seen in this context, Neoclassicism was simply the first phase of Romanticism, a revival that continued all the way through the nineteenth century and thus ultimately came to represent conservative taste. Perhaps it is best, then, to think of them as two sides of the same modern coin. If we maintain the distinction between them, it is because, until about 1800, Neoclassicism overshadowed the other Romantic revivals, and because the Enlightenment was dedicated to the cause of liberty as against the cult of the individual, represented by the Romantic hero.

Painting

It is one of the many contradictions of Romanticism that, despite the desire for unhindered freedom of individual creativity, it became art for the rising professional and commercial class. The upper middle class dominated nineteenth-century society and replaced state commissions and aristocratic patronage as the most important source of support for artists. Painting remains the greatest creative achievement of Romanticism in the visual arts because, being less expensive, it was less dependent than architecture or sculpture on public approval. It held a greater appeal for the individualism of the Romantic artist as well. Moreover, it could better accommodate the themes and ideas of Romantic literature. Romantic painting was not essentially illustrative. Nevertheless, literature, past and present, became a more important source of inspiration for painters than ever before. It provided a new range of subjects, emotions, and attitudes. Romantic writers, in turn, often saw nature with a painter's eye. Many had a strong interest in art criticism and theory. Some, notably the German poet Johann Wolfgang von Goethe and the French novelist Victor Hugo, were capable draftsmen. And William Blake cast his visions in both pictorial and written form (see page 492). Art and literature thus have a complex relationship within the Romantic movement.

SPAIN

Goya We begin with the great Spanish painter Francisco Goya (1746–1828), David's contemporary and the only artist of the age who may be called a genius without hesitation. When Goya first arrived in Madrid in 1766, he found both Mengs and Tiepolo working there. He was much impressed with Tiepolo (see page 447), whom he must have recognized immediately as the greater of the two artists. (Spain had produced no painters of significance for more than a century.) Goya's early works are in a delightful late Rococo vein that reflects the influence of Tiepolo, as well as the French masters of the Rococo. He ignored the growing Neoclassical trend during his brief visit to Rome five years later. In the 1780s, however,

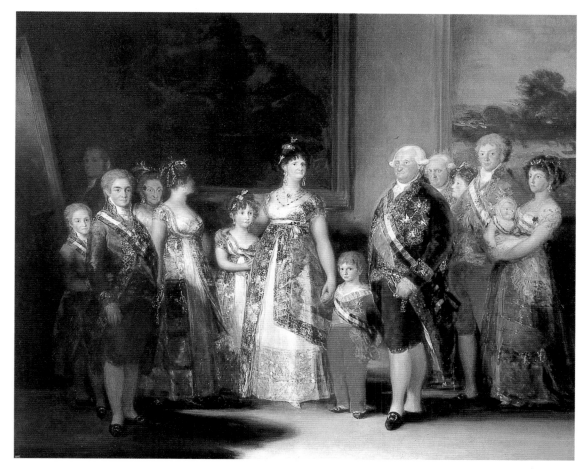

22-1 Francisco Goya. *The Family of Charles IV.* 1800. Oil on canvas, 9'2" x 11' (2.79 x 3.35 m). Museo del Prado, Madrid

Goya became more of a libertarian. He surely sympathized with the French Revolution, and not with the king of Spain, who had joined other monarchs in war against the young Republic. Yet he was highly regarded at court, where he was appointed painter to the king in 1799. Goya now abandoned the Rococo for a Neo-Baroque style based on Velázquez and Rembrandt, the masters he had come to admire most. It is this Neo-Baroque style that announces the arrival of Romanticism.

The Family of Charles IV (fig. 22-1), Goya's largest royal portrait, echoes Velázquez's *Maids of Honor* (see fig. 17-18). The entire clan has come to visit the artist, who is painting in one of the picture galleries of the palace. As in Veláz-quez's painting, shadowy canvases hang behind the group and the light pours in from the side. The brushwork has a sparkle, the color a radiance,

rivaling that of *The Maids of Honor.* Although Goya does not use the Caravaggesque Neoclassicism of David, his painting has more in common with David's work than we might think. Like David, he practices a revival style and, in his way, is equally devoted to the unvarnished truth: he uses the Neo-Baroque of Romanticism to unmask the royal family.

Psychologically, *The Family of Charles IV* is almost shockingly modern. No longer shielded by the polite conventions of Baroque court por-traiture, the inner being of these individuals has been laid bare with pitiless honesty. They are like a collection of ghosts. We see the frightened children, the bloated king, and—in a master stroke of sardonic humor—the grotesquely vulgar queen, posed like Velázquez's Princess Margarita. (Note the left arm and the turn of the head.)

A brilliant military strategist with an insatiable appetite for glory, grandeur, and empire, NAPOLEON Bonaparte (1769–1821) dominated European life from about 1802 to 1815. After a decade of astonishing military successes, he came to power in 1799 as First Consul of France. By 1804 he had himself crowned Emperor Napoleon I of France. He held that title until his final military defeat at Waterloo (in Belgium) in 1815 at the hands of allied British, Dutch, and German forces and the Prussian army. Napoleon and his first wife, Joséphine de Beauharnais (1763–1814), were ardently fond of the Neoclassical style, which under their influence would come to include Egyptian motifs. Napoleon was, in fact, the first European to direct an archaeological exploration in Egypt.

How could Goya get away with this seeming caricature? Was the royal family so dazzled by the splendid painting of their costumes that they failed to realize what he had done to them? Goya, we realize, must have painted them as they saw themselves, while unveiling the deeper truth for all the world to see.

When NAPOLEON's armies occupied Spain in 1808, Goya and many other Spaniards hoped that the conquerors would bring the liberal reforms so badly needed. The barbaric behavior of the French troops crushed that dream and generated a popular resistance of equal savagery. Many of Goya's works from 1810 to 1815 reflect this bitter experience. The greatest is *The Third of May, 1808* (fig. 22-2), one of a pair of large paintings done in 1814 at the artist's request for the newly restored king, Ferdinand VII. The canvas

represents the execution of a group of rioters who rebelled against the French forces. It is doubtful that Goya witnessed the incident, since he made little attempt at topographical accuracy. In characteristically Romantic fashion, he has taken liberties with the scene for the sake of a higher, "poetic" truth. Here the blazing color, the broad, fluid brushwork, and the dramatic nocturnal light are more emphatically Neo-Baroque than ever. The picture has all the emotional intensity of religious art, but these martyrs are dying for Liberty, not the Kingdom of Heaven. Nor are their executioners the agents of Satan but of political tyranny. They are a formation of faceless killers, completely indifferent to their victims' defiance and despair. The same scene was to be repeated countless times in modern history. With the prophecy of genius, Goya created an image that

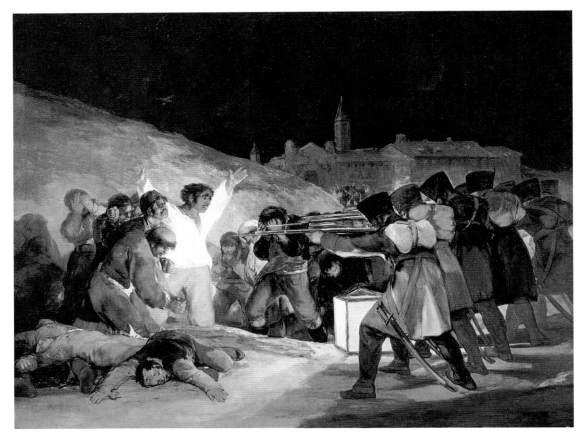

22-2 Francisco Goya. *The Third of May, 1808.* 1814. Oil on canvas, 8'9" x 13'4" (2.67 x 4.06 m). Museo del Prado, Madrid

has become a terrifying symbol of our era.

After the defeat of Napoleon, the Spanish monarchy brought a new wave of repression, and Goya withdrew more and more into a private world. Finally, in 1824, he went into voluntary exile. After a brief stay in Paris, Goya settled in Bordeaux, where he died. His importance for the Neo-Baroque Romantic painters of France is affirmed by Delacroix, the greatest of them all (see pages 483–87), who said that the ideal style would be a combination of Michelangelo's and Goya's art. Later, Édouard Manet (see pages 514–17) turned to him as a source as well.

FRANCE

By 1795 Neoclassicism in France had largely run its course and rapidly lost its purity and rigor. Within a few years French Romantic painting began to emerge among the Primitif faction of Jacques-Louis David's studio. These rebellious students simplified his severe Neoclassicism still further by turning to the linear designs of Greek and Etruscan vase painting, and to the unadorned style of the Italian Early Renaissance. At the same time, they undermined it by preferring subjects whose appeal was primarily emotional rather than intellectual. Their sources were not the classical authors such as Horace or Ovid but the Bible, Homer, Ossian (the legendary Gaelic bard whose poems were forged by James Macpherson in the eighteenth century), and Romantic literature— anything that excited the imagination.

Gros With its exciting glamour and adventurous conquests in remote parts of the world, the reign of Napoleon (which lasted from 1799 to 1815, with one interruption) gave rise to French Romanticism. David became an ardent admirer of Napoleon and executed several large pictures glorifying the emperor. As a portrayer of the Napoleonic myth, however, he was partially eclipsed by artists who had been his students. Some of them found the style of David too confining and fostered a Baroque revival to capture the excitement of the age. Antoine-Jean Gros (1771–1835), David's favorite pupil, shows us Napoleon as a Christ-like leader and healer (fig. 22-3, page 480).

During the siege of Jaffa on the Mediterranean coast in 1799, the bubonic plague broke out. To calm the panic that followed, the general entered the pesthouse and walked fearlessly among the patients— an event that soon became legendary. The painting is a carefully calculated piece of propaganda, which ignores the fact that Napoleon had ordered the execution of hundreds of prisoners during the epidemic.

The central group is a play on the Doubting of Thomas (see fig. 12-8), but now the roles are reversed. This simple but ingenious device raises Napoleon to an almost godlike status even before he became emperor toward the end of 1804, the year the picture was painted. The focus is on the general's courage in touching the sick and the dying. (Note the officer covering his face with a kerchief against the odor.) Many of them are paraphrased from Michelangelo's *Last Judgment* (see fig. 13-10). The burning ruins in the background heighten the apocalyptic aura of the scene. But what really excited the artist's imagination was the alien surroundings. Napoleon's conquests opened up Egypt and the Near East for the first time in centuries and led to the European colonization of North Africa. *Napoleon in the Pesthouse at Jaffa, 11 March 1799* is one of the first symptoms of Orientalism: the Romantic fascination with the Arab world that preoccupied European artists and writers throughout most of the nineteenth century. The artist cannot resist dwelling on the foreign costumes and architecture, which curiously paraphrases the classical setting in an early canvas by his master, David.

After Napoleon's empire collapsed, David spent his last years in exile in Brussels. There his major works were playfully amorous subjects, which were drawn from ancient myths and legends and painted in a coolly sensuous Neo-Mannerist style he had developed in Paris. He turned his pupils over to Gros, whom he urged to return to Neoclassical orthodoxy. Much as Gros respected his teacher's doctrines, his emotional nature drew him to the color and drama of the Baroque. He remained torn between academic principles and his pictorial instincts. Consequently, he never achieved David's authority and ended his life by suicide.

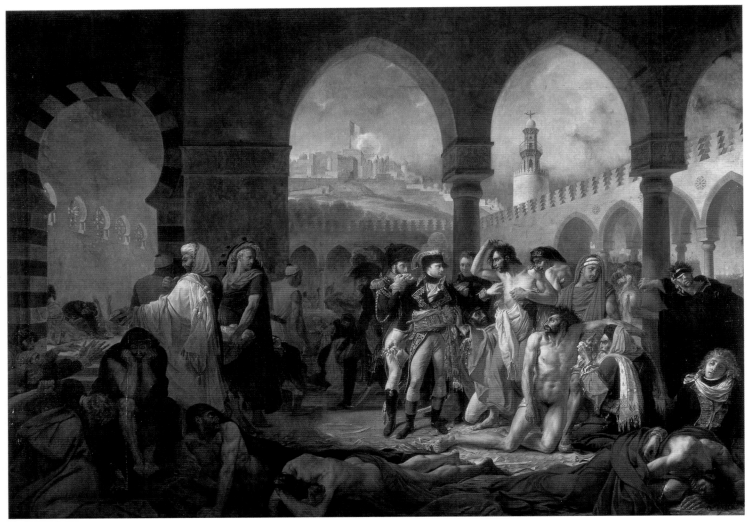

22-3 Antoine-Jean Gros. *Napoleon in the Pesthouse at Jaffa, 11 March 1799.* 1804. Oil on canvas, 17'5½" x 23'7½" (5.32 x 7.20 m). Musée du Louvre, Paris

Géricault The Neo-Baroque trend initiated in France by Gros aroused the imagination of many talented younger artists. The chief heroes of Théodore Géricault (1791–1824), apart from Gros, were Michelangelo and the great Baroque masters. He painted his most ambitious work, *The Raft of the "Medusa"* (fig. 22-4), in response to a political scandal and a modern tragedy of epic proportions. The *Medusa*, a government vessel, had foundered off the West African coast with hundreds of people on board. Only a handful were rescued, after many days on a makeshift raft that had been set adrift by the ship's heartless captain and officers. The event attracted Géricault's attention because, like many French liberals, he opposed the monarchy, which was restored after Napoleon. He went to extraordinary lengths in trying to achieve a maximum of authenticity. He interviewed survivors, had a model of the raft built, even studied corpses in the morgue. This search for uncompromising truth is like David's, and *The Raft of the "Medusa"* is indeed remarkable for its powerfully realistic

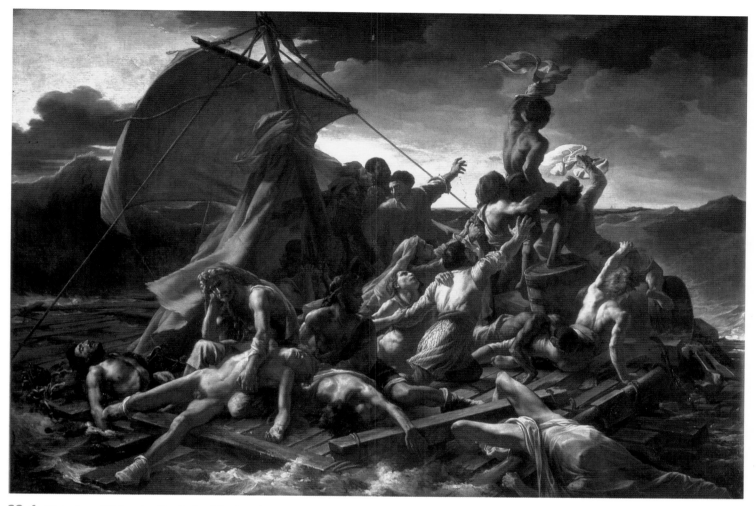

22-4 Théodore Géricault. *The Raft of the "Medusa."* 1818–19. Oil on canvas, 16'1" x 23'6" (4.90 x 7.16 m). Musée du Louvre, Paris

detail. Yet these preparations were subordinate in the end to the spirit of heroic drama that dominates the canvas.

Géricault depicts the moment when the rescue ship is first sighted. From the bodies of the dead and dying in the foreground, the composition is built up to a climax in the group that supports the frantically waving black man. Thus the forward surge of the survivors parallels the movement of the raft itself. In 1820 the artist took the monumental canvas on a traveling exhibition to England, in the hope that this theme of "man against the elements" would have strong appeal across the Channel, where Copley had painted *Watson and the Shark* 40 years before (see fig. 21-7).

Ingres The leadership of David's school ultimately fell to his pupil Jean-Auguste-Dominique Ingres (1780–1867). In 1806 Ingres went to Italy and remained for 18 years, so that he largely missed out on the formation of Romantic painting in France, although he painted two portraits of Napoleon before he left. After his return he became the high priest of the Davidian tradition, which he defended from the attacks of younger artists. What had been a revolutionary style only half a century earlier now became rigid dogma, endorsed by the government and backed by the weight of conservative opinion.

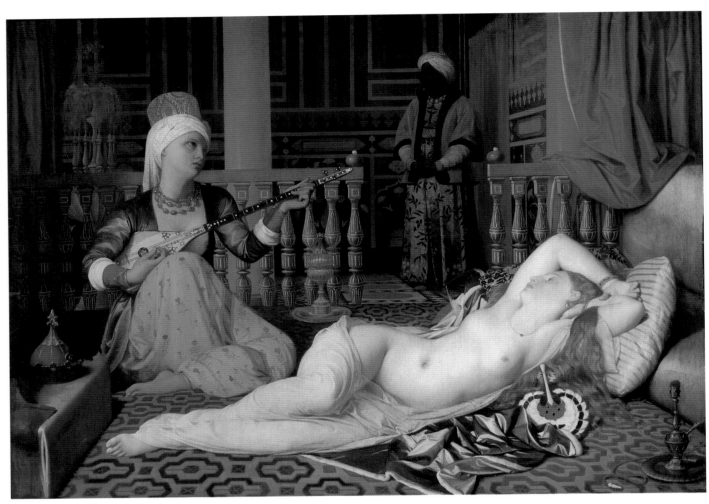

22-5 Jean-Auguste-Dominique Ingres. *Odalisque with a Slave.* 1839–40. Oil on canvas, 28³/₈ x 39¹/₂" (72.1 x 100.3 cm). Fogg Art Museum, Harvard University Art Museums, Cambridge, Massachusetts

Grenville L. Winthrop Bequest

Ingres is usually called a Neoclassicist, and his opponents Romantics. Actually, both factions stood for aspects of Romanticism after 1800: the Neoclassical phase, with Ingres as the last important survivor, and the Neo-Baroque, announced in France by Gros. Indeed, the two seem so interrelated that we should prefer a single name for both if a suitable one could be found. (*Romantic Classicism,* which is appropriate only to the classical camp, has not won wide acceptance.) The two sides seemed to revive the old quarrel between Poussinistes and Rubénistes (see page 437). The original Poussinistes had never quite practiced what they preached, and Ingres's views, too, were far more doctrinaire than his pictures.

Ingres always held that drawing was superior to painting, yet his canvas *Odalisque with a Slave* (fig. 22-5) reveals an exquisite sense of color. Instead of merely tinting his design, he sets off the petal-smooth limbs of this oriental Venus (*odalisque* is a Turkish word for a harem slave girl) with a dazzling array of transparent tones and rich textures. The poetic mood, filled with the enchantment of the *Thousand and One Nights,* is as important as the finely balanced composition in holding the picture together. The exotic subject

is characteristic of the Romantic movement. Despite Ingres's professed worship of Raphael, this nude hardly embodies a classical ideal of beauty. Her elongated proportions, languid grace, and strange mixture of coolness and voluptuousness remind us of Parmigianino's figures (compare fig. 14-3). Whether he admitted it or not, Ingres was just as Romantic as his great rival, Eugène Delacroix, only in a different way (compare fig. 22-8).

History painting as defined by Poussin remained Ingres's lifelong ambition, but he had great difficulty with it. Portraiture, which he pretended to dislike, was his strongest gift and his steadiest source of income. He was, in fact, the last great professional in a field soon to be dominated by the camera. Ingres's portrait of Louis Bertin (fig. 22-6) at first glance looks like a kind of "superphotograph," but this impression is deceptive. The painting endows the sitter with a massive presence and forceful personality. Bertin's pose is shifted slightly to the left, his jacket open to lend the figure greater weight. The position of his powerful hands has been adjusted to convey an almost lionlike strength.

22-6 Jean-Auguste-Dominique Ingres. *Louis Bertin*. 1832. Oil on canvas, 46 x 37$^1/_2$" (116.8 x 95.3 cm). Musée du Louvre, Paris

Ingres further uses the Caravaggesque Neoclassicism he had inherited from David to introduce slight changes of light and to selectively emphasize certain features in the face, which now has an almost frightening intensity.

Only Ingres among the Romantics could unify psychological depth and physical accuracy so completely. His followers focused on physical accuracy alone, competing vainly with the camera. The Neo-Baroque Romantics, in contrast, emphasized the psychological aspect to such a degree that their portraits tended to become records of the artist's private emotional relationship with the sitter. These are often interesting and moving, but they are no longer portraits in the proper sense of the term.

Delacroix The year 1824 was crucial for French painting. Géricault died after a riding accident. The first showing in Paris of works by the English Romantic painters, especially John Constable, was a revelation to many French artists (see pages 492–93). Ingres returned to France from Italy and had his first public success. And Eugène Delacroix (1798–1863) established himself as the foremost Neo-Baroque Romantic painter. For the next quarter-century he and Ingres were bitter rivals, and their polarity, fostered by supporters, dominated the artistic scene in Paris.

To critics, who had recently begun to struggle with the problem of defining Romanticism in art, Delacroix seemed the first indisputably Romantic painter, and his work helped to crystallize the issues. As a result, Romanticism, which previously had been identified largely with the French author Madame de Staël, now became virtually synonymous with modernism. Delacroix occupied a position at its artistic center comparable to that of Hector Berlioz in music and Victor Hugo and Stendhal in literature. Delacroix, like his model Rubens, is an extremely challenging artist, so that it is not easy to take the full measure of his accomplishments. Although he studied with a pupil of David, his early paintings reflect his admiration for Gros (who nevertheless called Delacroix's *Massacre at Chios* "the massacre of painting" when it was exhibited in 1824) and Géricault, whom he knew well.

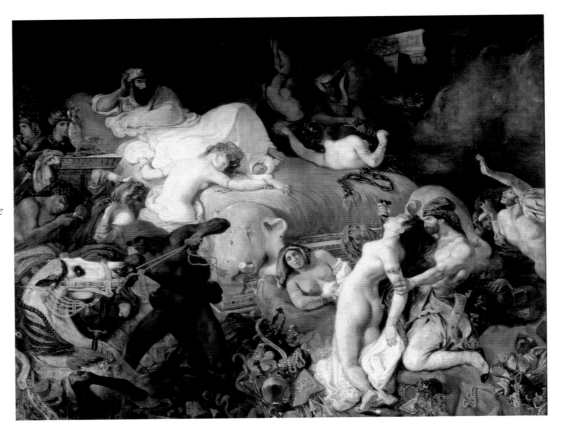

22-7 Eugène Delacroix. *The Death of Sardanapalus.* 1827. Oil on canvas, 12'1½" x 16'2⅞" (3.69 x 4.95 m). Musée du Louvre, Paris

The first work to show him as a mature master is *The Death of Sardanapalus* (fig. 22-7), inspired by Lord Byron's drama in free verse of 1821. Delacroix was above all a literary painter. (He also became the most original—and controversial—illustrator of the age.) If the military hero inspired the early Romantics, it was the cultural hero who touched the imagination of the generation that arose in the mid-1820s. The glamorous days of Napoleon and his empire were now only a memory, so that Delacroix had either to go to some remote place or turn to exotic history and literature for the kind of subject that excited his imagination. He often chose those writers favored by other Romantic artists: Dante, Shakespeare, Goethe, Scott. But he was inspired above all by Byron, the archetype of the Romantic, whose valiant death as commander of a regiment at Missolonghi in 1824 during the Greek war of independence from the Turks was mourned by Delacroix as a tragedy. The artist's fascination with all things English was fired by the flood of literature that began to be published in French translations in 1816. It was fur-

ther kindled by his friendship with Géricault and Gros's pupil Richard Bonington (1802–1828), who also helped to awaken his interest in the Orient. This enthusiasm was cemented when Delacroix, who had learned English as a schoolboy, visited London in 1825.

His journal records that when stuck for a subject, he would turn to the same authors again and again for inspiration. "I should want to spread out some good thick, fat paint on a brown or red canvas. What I would need, then, in finding a subject is to open a book that can inspire me and let its mood guide me. There are those that never fail. The same with engravings. Dante, Lemartine, Byron, Michelangelo." Exactly this sort of thing seems to have happened with the *Sardanapalus*, which, strangely enough, does not illustrate the final scene in Lord Byron's play. It instead evokes the hero's death as the artist imagined it. However, Delacroix's vision of the Orient was here based almost entirely on Byron's poetry.

The picture has the apocalyptic intensity of Michelangelo's *Last Judgment* (see fig. 13-10), the

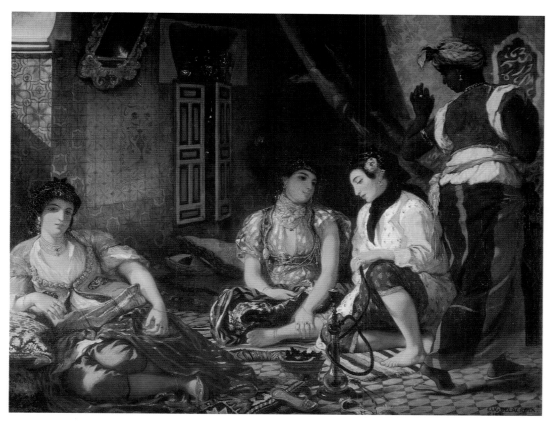

22-8 Eugène Delacroix. *Women of Algiers*. 1834. Oil on canvas, 70⅞ x 90⅛" (180 x 229 cm). Musée du Louvre, Paris

nearly superhuman power of Rubens's *Raising of the Cross* (see fig. 18-1), and the extraordinary freedom of Velázquez's late works (see fig. 17-18). Such sources have been combined into an intoxicating mixture of sensuousness and cruelty. As in Rubens's painting, the sea of writhing figures is loosely organized along a rising diagonal. In both, virtually every square inch is covered with action, save for a glimpse onto the distant background. The rich color and fluid brushwork show Delacroix to be a Rubéniste of the first order. Earlier he had maintained the primacy of line to enclose form. Here he is more concerned with setting up linear rhythms across the canvas, which requires him to adjust contours in response to each other. As a result, there is a ceaseless movement in which the main organizing role is played by the cascades of red cloth. No wonder the painting was severely criticized by conservatives for its poor draftsmanship and inconsistent space, for it violates every classical rule. Delacroix realized its flaws, but was willing to sacrifice everything for the sake of effect. While we do not quite accept the scene as authentic,

we revel in the sheer splendor of the painting.

Delacroix's sympathy with the Greeks did not prevent him from sharing the enthusiasm of fellow Romantics for the Orient. He was enchanted by a visit in 1832 to North Africa, where he found a living counterpart of the violent, chivalric, and picturesque past evoked in Romantic literature. His sketches from this trip supplied him with a large repertory of subjects: harem interiors, street scenes, lion hunts. It is fascinating to compare his *Women of Algiers* (fig. 22-8) with Ingres's *Odalisque with a Slave* (see fig. 22-5). In his version, Ingres also celebrates the exotic world of the Near East—alien, seductive, and violent—but how different the result! Delacroix's work is based on studies made during an actual visit to a harem in Algiers. The painting has an authenticity even in the details that is clearly missing in Ingres's aromatic confection, although the Arab women were carefully posed using a model in Delacroix's studio and the costumes were reworked. No less important, the intense colors and bright light of North Africa made an indelible impression on the artist, whose palette underwent a major change.

SPEAKING OF

oriental

Oriental derives from the Latin *orisi*, which means "to rise," and was thus long employed in the Western world to describe the East, the area in which the sun comes up. In the nineteenth century, Europeans responding to Orientalism invested the Middle East with several false stereotypes. It was seen as a sensual paradise, full of mysterious, enticing pleasures but also as primitive and ripe for colonization by the "superior" Western nations. More recently, the term was extended to include China, Japan, and other East Asian countries. *Oriental* is not an accurate designation of a person or locale; it is always better to cite the specific geographical area being referred to.

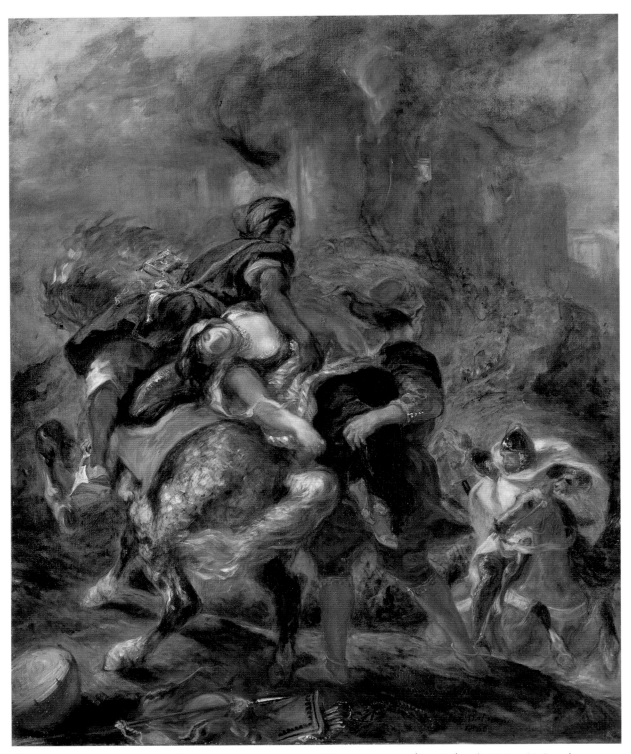

22-9 Eugène Delacroix. *The Abduction of Rebecca.* 1846. Oil on canvas, 39½ x 32¼" (100.3 x 81.9 cm).
The Metropolitan Museum of Art, New York

Delacroix's creativity reached its peak in the years around 1840. During this extraordinarily fertile period, he established many of the great themes that would preoccupy him for the rest of his career. Thereafter he introduced only a few new subjects. Among them is *The Abduction of Rebecca* (fig. 22-9). Taken from Sir Walter Scott's novel *Ivanhoe,* it shows the beautiful Jewish woman being taken from the burning castle of Front-de-Boeuf by two Saracen slaves of the Knight Templar Bois-Gilbert. Although Delacroix harbored doubts about the literary quality of Scott's work, it provided the violent subjects so dear to his own Romantic sensibility, and he treated it often. The scene is similar to Eastern combats inspired by Lord Byron's poems. What mattered to the artist was its exotic quality.

The painting shows Delacroix at the height of his powers. It is the direct outgrowth of the change initiated by the *Women of Algiers*. The color is lighter and more expressive. Above all, the brushwork has a nervous energy that animates the entire surface. Not since Rubens have we seen such a virtuosity. How did he achieve it? Ironically, at the very moment that his inventiveness seemed to wane, he turned his attention to the formal qualities of art. He arrived, in a word, at pure painting.

When it was exhibited at the Salon of 1846, the painting was favorably reviewed by the young critic Charles BAUDELAIRE: "The admirable thing about *The Abduction of Rebecca* is the perfect ordering of its colors, which are intense, close-packed, aligned, and logical; the result of this is a thrilling effect. With almost all painters who are not colorists, you will always notice vacuums, that is to say great holes, produced by tones which are below the level of the rest, so to speak. Delacroix's painting is like nature: it has a *horror vacuii*."

Baudelaire devoted a long section of his Salon review to Delacroix, whose art he worshiped and understood more deeply than any other critic of the day. Discussing one of the artist's important state commissions, he noted perceptively, "Delacroix had decorations to paint, and he solved the great problem. He discovered pictorial unity without doing harm to his trade as a colorist. We have the Palais Bourbon to bear witness to this extraor-

dinary *tour de force*." This commission, which occupied the artist between 1838 and 1847, brought him into renewed contact with the tradition of Western art. His work now showed a preference for classical and biblical themes, without abandoning his earlier subjects. He was, as Baudelaire observed, that rarity in the nineteenth century: an artist who could paint moving religious works, even though he was not a believer himself.

The time frame of the Bourbon Palace decorations coincides with a general crisis of tradition that gripped French art beginning in about 1840 and climaxed eight years later, when revolution was in the air everywhere. Delacroix came to be seen, with Ingres, as the last great representative of the mainstream of European painting. Baudelaire put it best: "Delacroix is the latest expression of progress in art. Heir to the great tradition . . . and a worthy successor of the old masters, he has even surpassed them in his command of anguish, passion and gesture! But take away Delacroix, and the great chain of history is broken and slips to the ground. It is true that the great tradition has been lost, and that the new one is not yet established." There is every indication that Delacroix himself was aware of his new status. Delacroix nevertheless stands at the head of a new tradition, one that Baudelaire could not yet have foreseen. Not only did the Impressionists take his palette and technique as their point of departure, but he became, in effect, the founder of what came to be called Expressionism. Thus the course of modern art is unthinkable without him.

Daumier The later work of Delacroix reflects the attitude that eventually doomed the Romantic movement: its growing detachment from contemporary life. History, literature, the Bible, and the Near East were the realms of the imagination where he sought refuge from the turmoil of the INDUSTRIAL REVOLUTION. Honoré Daumier (1808–1879), one of the few Romantic artists who did not shrink from reality, remained practically unknown as a painter in his day. A biting political cartoonist, he contributed satirical drawings to various Paris weeklies for most of his career. Nearly all of Daumier's cartoons were done with

French poet, critic, and translator Charles-Pierre BAUDELAIRE (1821–1867) was among the most astute of nineteenth-century critics. Well ahead of his time, he was writing Symbolist poetry before Symbolism (see chapter 24) was a recognized movement. His best-known work and only published book of poetry, *Les fleurs du mal* (Flowers of Evil, 1857), is modern in looking for goodness in the morbid and perverse.

The changeover from a small-scale, agriculturally based economy to one based on the large-scale, mechanized production and sale of manufactured goods is known as the INDUSTRIAL REVOLUTION. This great shift began in England in the late eighteenth century and spread through most of western Europe and the United States in the middle of the nineteenth century; it continued elsewhere thereafter, right up to the present. The most profound effects have been urbanization, the rise of capitalism, and the need for specialization.

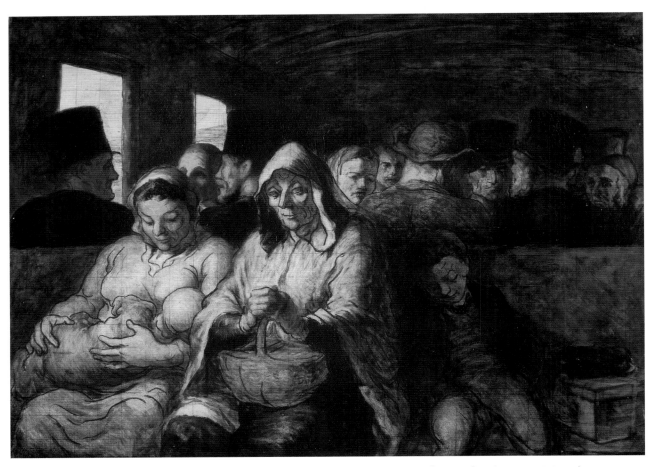

22-10 Honoré Daumier. *The Third-Class Carriage.* c. 1862. Oil on canvas, 25³/₄ x 35¹/₂" (65.4 x 90.2 cm). The Metropolitan Museum of Art, New York

Bequest of Mrs. H. O. Havemeyer, 1929. The H. O. Havemeyer Collection

lithography. He turned to painting in the 1840s but found no public for his work. Only a few friends encouraged him and, a year before his death, arranged his first solo exhibition. Thus his pictures had little impact during his lifetime.

Daumier's mature paintings have the full pictorial range of the Neo-Baroque. Their subjects vary widely. Many show aspects of everyday urban life that also occur in his cartoons, now viewed with a painter's eye rather than from a satirist's angle. In *The Third-Class Carriage* (fig. 22-10), Daumier's forms reflect the compactness of Jean-François Millet's (compare fig. 22-12), but are painted so freely that they must have seemed raw and "unfinished" even by Delacroix's standards. The power of the image derives from this very freedom. Daumier's concern is not for the visible surface of reality but for the emotional meaning behind it. *The Third-Class Carriage* captures a peculiarly modern human condition: "the lonely crowd." The only thing these people have in common is the fact that they are traveling together in a railway car. Although they are physically crowded, they take no notice of one another, for each is alone with his or her own thoughts. Daumier explores this state with an insight into character and a breadth of human sympathy worthy of Rembrandt, whose work he admired.

French Landscape Painting Thanks to the cult of nature, landscape painting became the most characteristic form of Romantic art. While it arose out of the Enlightenment, the Romantic landscape lies outside the descriptive and emotional range of the eighteenth century. The Romantics believed that God's laws could be seen written in nature. Their faith, known as PANTHEISM, was based not on rational thought but on subjective experience, and the appeal to the emotions rather than the intellect made those lessons all the more compelling. In order to express the feelings inspired by nature, the Romantics transcribed landscape as faithfully as possible, in contrast to the Neoclassicists, who forced landscape to conform to prescribed ideas of beauty and linked it to historical subjects. At the same time, the Romantics felt free to modify nature's appearance as a means of evoking heightened states of mind in accordance with dictates of the imagination, the only standard they ultimately recognized. Landscape inspired the Romantics with passions so exalted that only in the hands of the greatest history painters could the human figure equal nature in power.

Corot The first and undeniably greatest French Romantic landscape painter was Camille Corot (1796–1875). In 1825 he went to Italy for two years and explored the countryside around Rome, like a latter-day Claude Lorraine. What Claude recorded in his drawings—the quality of a particular place at a particular time—Corot made into paintings, small canvases done on the spot in an hour or so (fig. 22-11). In size and immediacy, these quickly executed pictures are analogous to Constable's oil sketches, yet they stem from different traditions. Whereas Constable's view of nature, which emphasizes the sky as "the chief organ of sentiment," is derived from Dutch seventeenth-century landscapes, Corot's instinct for architectural clarity and stability recalls Poussin and Claude. But he, too, insists on "the truth of the moment." His exact observation and his readiness to seize upon any view that attracted him during his excursions show the

PANTHEISM (from the Greek *pan*, "all," and *theos*, "god") is the belief that God and the universe are ultimately identical, and that everything that exists is therefore a divine unity. Although the term itself was first used in 1705 by the British author John Toland, the idea has an ancient, wide-ranging history. Two of the world's major religions, Hinduism and Buddhism, draw upon the pantheistic view, as does the work of many philosophers (among them, Lao-tzu, Plato, Baruch Spinoza, and Paul Tillich) and authors (including Ralph Waldo Emerson, Walt Whitman, and D. H. Lawrence).

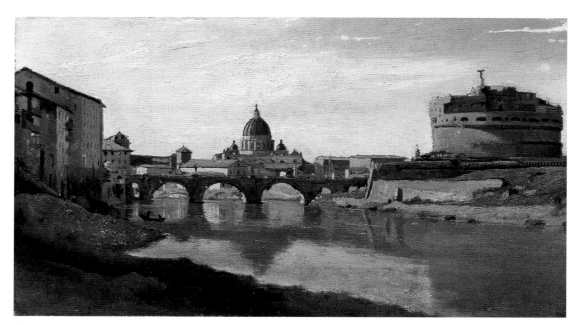

22-11 Camille Corot. *View of Rome: The Bridge and Castel Sant'Angelo with the Cupola of St. Peter's.* 1826–27. Oil on paper mounted on canvas, 10$\frac{1}{2}$ x 17" (26.7 x 43.2 cm). Fine Arts Museums of San Francisco

Museum Purchase, Archer M. Huntington Fund

same commitment to direct visual experience that we find in the English artist. The Neoclassicists had also painted oil sketches outdoors. Unlike them, Corot did not transform his sketches into idealized pastoral visions. His willingness to accept them as independent works of art marks him unmistakably as a Romantic.

Millet Corot's early fidelity to nature was an important model for the Barbizon School, although he was not actually a member. This group of younger painters, centering on Théodore Rousseau (1812–1867), settled in the village of Barbizon on the edge of the forest of Fontainebleau near Paris to paint landscapes and scenes of rural life. Enthused by Constable, whose work had been exhibited in Paris in 1824, they turned to the Northern Baroque

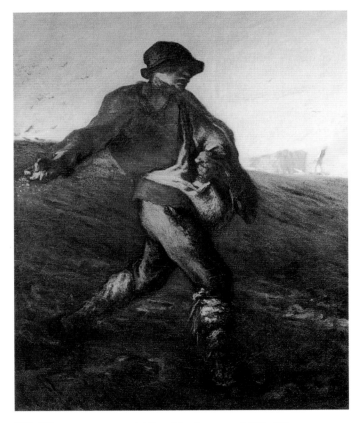

22-12 Jean-François Millet. *The Sower.* c. 1850. Oil on canvas, 40 x 32¹/₂" (101.6 x 82.6 cm). Museum of Fine Arts, Boston

Gift of Quincy Adams Shaw through Quincy A. Shaw, Jr., and Mrs. Marion Shaw Haughton

landscape as an alternative to the Neoclassical tradition. Their paintings are filled with a simple reverence that admirably reflects the rallying cry of the Romantics—sincerity.

Jean-François Millet (1814–1875) became a member of the Barbizon School the same year that the REVOLUTION OF 1848 swept across France and the rest of Europe. Although he was no radical, *The Sower* (fig. 22-12) was championed by liberal critics, because it was the very opposite of the Neoclassical history paintings endorsed by the establishment. Millet's archetypal image nonetheless has a self-consciously classical flavor that reflects his admiration for Poussin. Blurred in the hazy atmosphere, this "hero of the soil" is a timeless symbol of the unending labor that the artist viewed as the peasant's inescapable lot. (Could Millet have known the pathetic sower from the October page of *Les Très Riches Heures du Duc de Berry*? Compare fig. 11-40.) Ironically, the painting monumentalizes a rural way of life that was rapidly disappearing as a result of the Industrial Revolution. For that very reason, however, the peasant was seen as the chief victim of the evils arising from the Machine Age.

Bonheur The Barbizon School generally advocated a return to nature as a way of fleeing the social ills brought on by industrialization and urbanization. Despite their conservative outlook, these artists were raised to a new prominence in French art by the revolution of 1848. That same year Rosa Bonheur (1822–1899), also an artist who worked outdoors, received a French government commission that led to her first great success. This painting, *Plowing in the Nivernais* (fig. 22-13), was exhibited the following year, after a winter spent making studies from life. It established Bonheur as a leading painter of animals, and she eventually became the most famous woman artist of her time. The theme of humanity's union with nature had already been popularized in the country romances of the French writer George Sand, among others. Bonheur's picture shares Millet's reverence for peasant life, but the real subject here, as in all her work, is the animals within the landscape. She depicts them with a

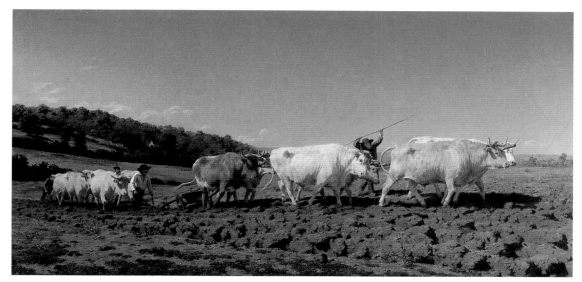

22-13 Rosa Bonheur. *Plowing in the Nivernais.* 1849. Oil on canvas, 69 x 104" (175.3 x 264.2 cm). Musée d'Orsay, Paris

convincing naturalism that later placed her among the most influential realists.

ENGLAND

Fuseli England was as precocious in fostering Romanticism as it had been in promoting Neoclassicism. In fact, one of its first representatives, John Henry Fuseli (1741–1825), was a contemporary of West and Copley. This Swiss-born painter (originally named Füssli) had an extraordinary impact on his time, more perhaps because of his adventurous and forceful personality than the quality of his work. Ordained a minister at 20, he left the Church by 1764 and went to London in search of freedom. Encouraged by Reynolds, he spent the 1770s in Rome, where he met Gavin Hamilton and studied classical art. Yet Fuseli based his style on Michelangelo and the Mannerists, not on Poussin and the antique. A German acquaintance of those years described him as "extreme in everything, Shakespeare's painter." Shakespeare and Michelangelo were indeed his twin gods. He even envisioned a Sistine Chapel with Michelangelo's figures transformed into Shakespearean characters. The Sublime would be the common denominator for "classic" and "Gothic" Romanticism (see page 493). This concept marks Fuseli as a transitional figure. He espoused many of the same Neoclassical theories as Reynolds, West, and Kauffmann (he translated Winckelmann's writings into English) but bent their rules virtually to the breaking point.

We see this mixture in *The Nightmare* (fig. 22-14). The sleeping woman, more Mannerist than Michelangelesque in proportions, is Neoclassical in style. The grinning devil and the luminescent horse, however, come from the demon-ridden world of

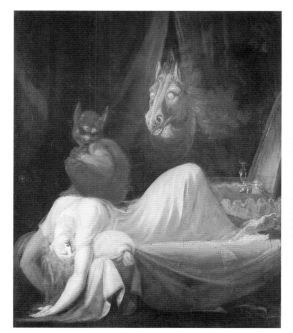

22-14 John Henry Fuseli. *The Nightmare.* c. 1790. Oil on canvas, 29 1/2 x 25 1/4" (74.9 x 64.1 cm). Freies Deutsches Hochstift-Frankfurter Goethe-Museum, Frankfurt

medieval folklore, while the Rembrandtesque lighting reminds us of Reynolds (compare fig. 20-10). Here the Romantic quest for terrifying experiences leads not to physical violence but to the dark recesses of the mind.

What was the genesis of *The Nightmare*? Nightmares often have strong sexual overtones, sometimes openly expressed, at other times disguised. We know that Fuseli originally conceived the subject not long after his return from Italy. He had fallen violently in love with a friend's niece who soon married a merchant, much to the artist's distress. We may see in the picture a projection of his "dream girl," with the demon taking the artist's place while the impassioned horse, a well-known erotic symbol, looks on.

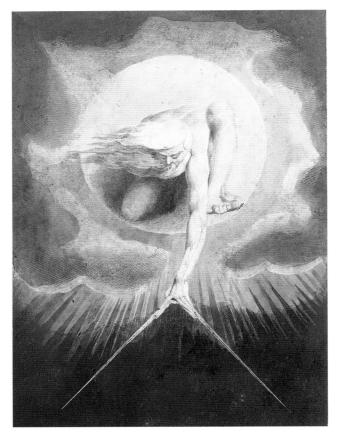

22-15 William Blake. *The Ancient of Days*, frontispiece to *Europe, A Prophesy.* 1794. Metal relief etching, hand-colored, $9^{1}/_{8}$ x $6^{5}/_{8}$" (23.3 x 16.9 cm). Library of Congress, Washington, D.C.

Lessing J. Rosenwald Collection

Blake Fuseli later befriended the poet-painter William Blake (1757–1827), who had an even greater creativity and stranger personality than his own. A recluse and visionary, Blake produced and published his own books of poems with engraved text and hand-colored illustrations. Although he never left England, he acquired a large repertory of Michelangelesque and Mannerist motifs from engravings, as well as through the influence of Fuseli. He also had a tremendous admiration for the Middle Ages and came closer than any other Romantic artist to reviving pre-Renaissance forms. (His books were meant to be the successors of illuminated manuscripts.)

These elements are all present in Blake's memorable image *The Ancient of Days* (fig. 22-15). The muscular figure, radically foreshortened and fitted into a circle of light, is taken from Mannerist sources, while the symbolic compasses come from medieval representations of the Lord as Architect of the Universe. We might therefore expect the Ancient of Days to signify Almighty God. In Blake's esoteric mythology, however, he stands for the power of reason, which the poet regarded as destructive, since it stifles vision and inspiration. To Blake, the "inner eye" was all-important; he felt no need to observe the visible world around him.

Constable It was in landscape rather than in narrative scenes that English Romantic painting reached its fullest expression. During the eighteenth century, landscape paintings consisted largely of imaginary scenes conforming to Northern and Italian Baroque examples. John Constable (1776–1837) admired both Ruisdael and Claude, yet he opposed all flights of fancy. Landscape painting, he believed, must be based on observable facts and aim at "embodying a pure apprehension of natural effect." Toward that end, he painted countless oil sketches outdoors. They were not the first such studies. However, Constable was more concerned than his predecessors with the intangible qualities—sky, light, and atmosphere—rather than the concrete details of the scene. Often the land serves as no more than a foil for the ever-changing drama overhead, which he studied with a meteorologist's accuracy.

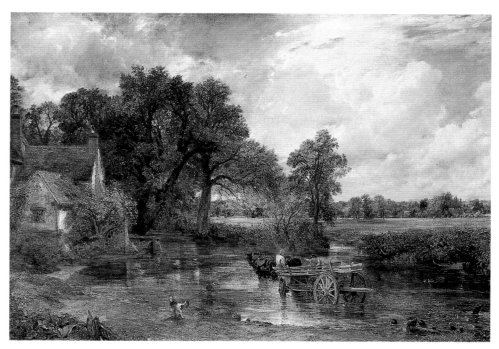

22-16 John Constable. *The Haywain.* 1821. Oil on canvas, 51¼ x 73" (130.2 x 185.4 cm). The National Gallery, London

All of Constable's pictures show familiar views of the English countryside. It was, he later claimed, the scenery around his native Stour Valley that made him a painter. Although he painted the final versions in his studio, he prepared them by making oil studies based on sketches from nature. The sky, to him, was a mirror of those sweeping forces so dear to the Romantic view of nature. It remained "the key note, standard scale, and the chief organ of sentiment." In *The Haywain* (fig. 22-16), he has caught a particularly splendid moment. A great expanse of wind, sunlight, and clouds plays over the spacious landscape. The earth and sky have become vehicles of sentiment imbued with the artist's poetic attitude. At the same time, there is an intimacy in this monumental composition that reveals Constable's deep love of the countryside. This new, personal note is characteristically Romantic. Since Constable has painted the landscape with such conviction, we see the scene through his eyes and accept it as real, even though it looks back to paintings by Ruisdael (see pages 415–16).

Turner Joseph Mallord William Turner (1775–1851) arrived at a style that Constable disdainfully but accurately described as "airy visions, painted with tinted steam." Turner began as a watercolorist, and the use of translucent tints on white paper may help to explain his obsession with colored light. Like Constable, he made extensive studies from nature (though not in oils), but the scenery he selected satisfied the Romantic taste for THE PICTURESQUE and THE SUBLIME—mountains, the sea, or places linked with historic events. In his full-scale pictures he often changed these views so freely that they became unrecognizable.

Many of Turner's landscapes are linked with literary themes and bear such titles as *The Destruction of Sodom,* or *Snowstorm: Hannibal Crossing the Alps,* or *Childe Harold's Pilgrimage: Italy.* When they were exhibited, he would add appropriate quotations from ancient or modern authors to the catalogue. Sometimes he would make up some lines himself and claim to be "citing" his own unpublished poem "Fallacies of Hope." These canvases are nevertheless

THE PICTURESQUE and THE SUBLIME are both aesthetic concepts developed in the eighteenth century. The former was employed to describe landscape scenes that were less idealized than those of the previous century. Such views, often showing dreamy vistas intended to evoke pleasant bucolic memories, were quite often used as models by the landscape designers of the period. Conversely, works calling upon the Sublime often inspired awe, for they depicted all that was grand, wild, and extraordinary in nature. The Romantics in particular appreciated how such works could fire the imagination.

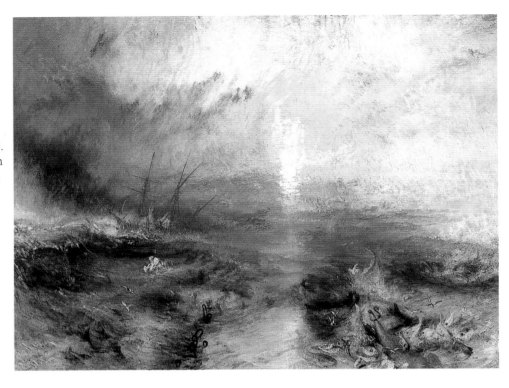

22-17 Joseph Mallord William Turner. *The Slave Ship.* 1840. Oil on canvas, 35³/₄ x 48" (90.8 x 121.9 cm). Museum of Fine Arts, Boston

Henry Lillie Pierce Fund (Purchase)

John RUSKIN (1819–1900) dominated English Victorian aesthetics through the power of his writings and lectures. His career as an author, critic, and professor of art history at Oxford University was devoted to showing the affective relationship between morality and art. He favored an essentially religious aesthetic, believing it to be nobler and more significant than the sensory and sensual perception of works of art. Among Ruskin's reasons for opposing the Industrial Revolution was the belief that art is essentially spiritual (therefore it had reached its greatest heights in Gothic art and architecture) and that any mechanization of art making would defile the whole art enterprise.

the opposite of history painting as defined by Poussin. The titles indeed indicate "noble and serious human actions," but the tiny figures, who are lost in the seething violence of nature, suggest the ultimate defeat of all endeavor—"the fallacies of hope."

The Slave Ship (fig. 22-17) is one of Turner's most spectacular visions and illustrates how he translated his literary sources into "tinted steam." First entitled *Slavers Throwing Overboard the Dead and Dying—Typhoon Coming On*, the painting has several levels of meaning. Like Géricault's *Raft of the "Medusa"* (see fig. 22-4), which had been exhibited in England in 1820, it has to do, in part, with a specific incident that Turner had recently read about.

When an epidemic broke out on a slave ship, the captain threw his human cargo overboard because he was insured against the loss of slaves at sea, but not by disease. Turner also thought of a relevant passage from James Thomson's poem *The Seasons* that describes how sharks follow a slave ship during a typhoon, "lured by the scent of steaming crowds, or rank disease, and death."

But what is the relation between the slaver's action and the typhoon? Are the dead and dying slaves being cast into the sea against the threat of the storm, perhaps to lighten the ship? Is the typhoon nature's retribution for the captain's greed and cruelty? Of the many storms at sea that Turner painted, none has quite this apocalyptic quality. A cosmic catastrophe seems about to engulf everything, not merely the "guilty" slaver but the sea itself, with its crowds of fantastic and oddly harmless-looking fish.

While we still feel the force of Turner's imagination, most of us enjoy the tinted steam for its own sake rather than as a vehicle of the awesome emotions the artist meant to evoke. Even in terms of the values he himself acknowledged, Turner strikes us as "a virtuoso of the Sublime" led astray by his own enthusiasm. He must have been pleased by praise from the theorist John RUSKIN, who saw in *The Slave Ship* (which he owned) "the true, the beautiful, and the intellectual"—all qualities that raised Turner above older landscape painters in Ruskin's eyes. Still, Turner may have come to

wonder if his tinted steam had its intended effect. Soon after finishing *The Slave Ship,* he read in his copy of Goethe's *Color Theory,* recently translated into English, that yellow has a "gay, softly exciting character," while orange-red suggests "warmth and gladness." These are hardly the emotions aroused by *The Slave Ship* in a viewer, even one who does not know its title. Interestingly enough, Turner soon modified his approach to take Goethe's ideas into account. He even painted a pair of canvases about the Deluge that were meant to illustrate Goethe's theory of positive (light and warm) and minus (dark and cold) colors. They nevertheless differ little from the rest of his work.

GERMANY

Friedrich In Germany, as in England, landscape was the finest achievement of Romantic painting, and the underlying ideas, too, were often strikingly similar. When Caspar David Friedrich (1774–1840), the most important German Romantic artist, painted *The Polar Sea* (fig. 22-18), he may have known of Turner's "Fallacies of Hope." In an earlier picture on the same theme (now lost) he had inscribed the name *Hope* on the crushed vessel. In

any case, he shared Turner's attitude toward human fate. The painting, too, was inspired by a specific event, to which the artist gave symbolic significance: a dangerous moment in William Parry's Arctic expedition of 1819–20.

One wonders how Turner might have depicted this scene. Perhaps it would have been too static for him. Friedrich, however, was attracted by this very immobility. He has visualized the piled-up slabs of ice as a kind of megalithic monument to human defeat built by nature itself. There is no hint of tinted steam—the very air seems frozen— nor any subjective handwriting. We look right through the paint-covered surface at a reality that seems created without the painter's intervention. This technique, impersonal and exacting, is peculiar to German Romantic painting. It stems from the early Neoclassicists, but the Germans, whose tradition of Baroque painting was weak, adopted it more wholeheartedly than the English or the French. Friedrich learned this approach at the Royal Academy in Copenhagen, and although in his hands it yielded extraordinary effects, the results proved disappointing for most German artists, who lacked his lofty imagination.

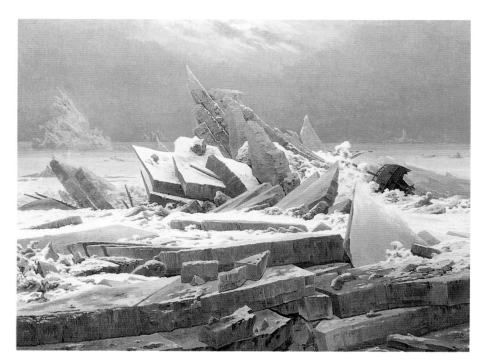

22-18 Caspar David Friedrich. *The Polar Sea.* 1824. Oil on canvas, 38$\frac{1}{2}$ x 50$\frac{1}{2}$" (97.8 x 128.3 cm). Kunsthalle, Hamburg

UNITED STATES

Painting after the American Revolution was dominated by followers of Benjamin West, who took every young artist from the New World under his wing. Strangely enough, the only ones to enjoy much success were portraitists such as Gilbert Stuart (1755–1828). Using the fashionable conventions of Reynolds, they conferred the aura of established aristocracy on the Federalists, who were only too eager to forget the recent Revolutionary past enshrined by the history painters. What Americans wanted was an art based not on the past but on the present. Romantic painting in the United States rode the tidal wave of nationalism fostered by JACKSONIAN DEMOCRACY. Collectors now began to support artists who could articulate their vision of the United States. For perhaps the only time in the country's history, artists, patrons, and intellectuals shared a common point of view.

It was at this time that Americans began to discover landscape painting. Before then, settlers were far too busy carving out homesteads to pay much attention to the poetry of nature's moods. The attitude toward landscape began to change only as the surrounding wilderness was gradually tamed. The spread of civilization allowed Americans for the first time to see nature as the escape from urban life that had long inspired European painters. As in Europe, the contribution of the poets proved essential to shaping American ideas about nature. By 1825 they were calling on artists to depict the wilderness as the most distinctive feature of the New World and its emerging culture. Pantheism virtually became a national religion during the Romantic era. While it could be frightening, nature was everywhere, and was believed to play a special role in determining the American character. Led by Thomas Cole (1801–1848), the founder of the Hudson River School, which flourished from 1825 until the Centennial celebration in 1876, American painters elevated the forests and mountains to symbols of the United States.

Cole Like many early American landscapists, Cole came from England, where he was trained as an engraver, but he learned the basics of painting from an itinerant artist in the Midwest. After a summer sketching tour up the Hudson River, he invented the means of expressing the elemental power of the country's primitive landscape by

Andrew Jackson (1767–1845), the seventh president of the United States, is often credited with instituting the movement toward greater public participation in government known as JACKSONIAN DEMOCRACY. With roots on the frontier and military experience fighting the British, this popular hero was greatly appreciated by everyday citizens but was generally reviled by those in power. While Jackson was the first president to permit the public to enter the White House, he is now usually regarded by historians as more of a champion of capitalism and the rising middle class than of the "common people."

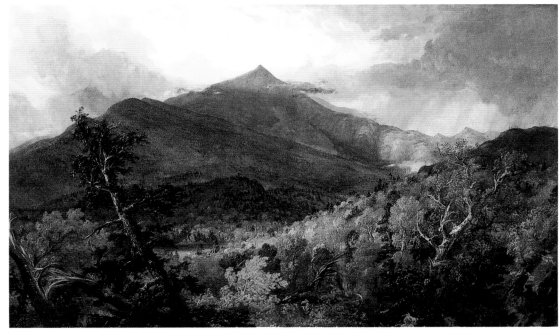

22-19 Thomas Cole. *View of Schroon Mountain, Essex County, New York, after a Storm.* 1838. Oil on canvas, 39 3/8 x 63" (100 x 160 cm). The Cleveland Museum of Art

Hinman B. Hurlbut Collection

transforming the formulas of the English picturesque into Romantic hymns based on the direct observation of nature. Because he also wrote poetry, Cole was uniquely able to create a visual counterpart to the literary ideas of the day. His painting *View of Schroon Mountain, Essex County, New York, after a Storm* (fig. 22-19) shows the peak rising majestically like a pyramid from the forest below. It is treated as a symbol of permanence surrounded by death and decay, signified by the autumnal foliage, passing storm, and dead trees. Stirred by Sublime emotion, the artist has heightened the dramatic lighting behind the mountain, so that the broad landscape becomes a revelation of God's eternal laws.

Bingham *Fur Traders Descending the Missouri* (fig. 22-20) by George Caleb Bingham (1811–1879) shows this close identification with the land in a different way. The picture, both a landscape and a **genre** scene, is full of the vastness and silence of the wide-open spaces. The two trappers in their dugout canoe, gliding downstream in the misty sunlight, are entirely at home in this idyllic setting. Bingham portrays the United States as a benevolent Eden in which settlers assume their rightful place. Rather than being dwarfed by a vast and often hostile continent, these hardy pioneers live in an ideal state of harmony with nature, symbolized by the waning daylight. The picture carries us back to the innocent era of Mark

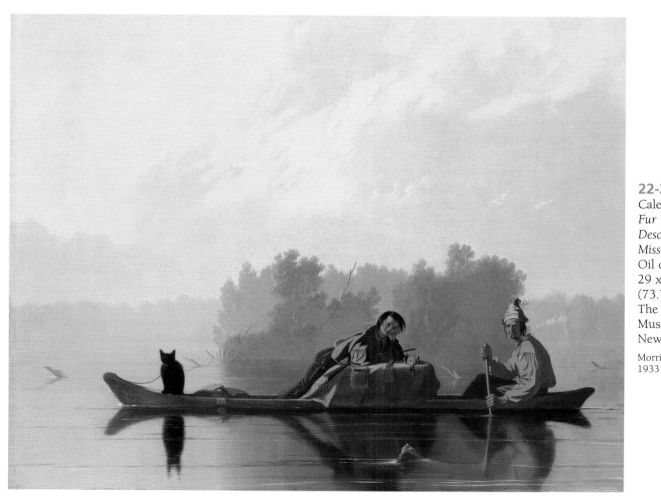

22-20 George Caleb Bingham. *Fur Traders Descending the Missouri.* c. 1845. Oil on canvas, 29 x 36½" (73.7 x 92.7 cm). The Metropolitan Museum of Art, New York

Morris K. Jesup Fund, 1933

Twain's Tom Sawyer and Huckleberry Finn. It reminds us of how much Romantic adventurousness went into the westward expansion of the United States. The scene owes much of its haunting charm to the silhouette of the black cub chained to the prow and its reflection in the water. This masterstroke adds a note of primitive mystery that we shall not meet again until the work of Henri Rousseau (see page 551).

Sculpture

In attempting to define Romanticism in sculpture, we are immediately struck by an extraordinary fact. In contrast to the abundance of theoretical writings that accompanied Neoclassical sculpture from Winckelmann on, there exists only one piece of writing that sets forth a general theory of sculpture from the Romantic point of view: Baudelaire's essay of 1846, "Why Sculpture Is Boring," which occupies only a few pages of his long review of the Salon of that year. Actually, Baudelaire was less concerned with the state of French sculpture at that moment, which struck him as deplorable, than he was with the limitations of sculpture as a medium. To him, there can be no such thing as Romantic sculpture. Every piece of sculpture is a "fetish" whose objective existence prevents the artist from making it a vehicle for expressing his subjective view of the world, his personal sensibility. Sculpture can overcome this limitation only if it is placed in the service of architecture, where it becomes part of a larger whole, such as a Gothic cathedral. As soon as it is detached from this context, sculpture returns to its primitive status.

Fortunately, Baudelaire's theory was not taken at face value by either artists or patrons. It does, however, suggest the difficulty Romantic sculptors had in finding a self-image they could live with. The unique virtue of sculpture—its solid, space-filling reality (its "idol" quality)—was not compatible with the Romantic temperament. To defy established society, its values and institutions, was easier for writers and painters than for sculptors. The rebellious and individualistic urges of

Romanticism could find expression in rough, small-scale sketches but rarely survived the laborious process of translating the sketch into a permanent, finished monument.

ITALY

Canova At the beginning of the Romantic era, we find an adaptation of the Neoclassical style to new ends by sculptors. They were led by Antonio Canova (1757–1822), who was not only the greatest sculptor of his generation but also the most famous artist of the Western world from the 1790s until long after his death. Both his work and his personality became a model for every sculptor during those years. Canova's meteoric rise led to numerous commissions. The tomb of Maria Christina, archduchess of Austria, in the Church of the Augustinians in Vienna (fig. 22-21) is remarkable as much for its "timeless" beauty as for its gently melancholy sentiment. It was commissioned by her husband soon after her death in 1798. Its framework had been anticipated in a monument to Titian planned by Canova several years before. This ensemble, in contrast to the tombs of earlier times (such as fig. 12-6), does not include the real burial place. Moreover, the deceased appears only in a portrait medallion framed by a snake biting its own tail (a symbol of eternity) and sustained by two floating genii. Presumably, but not actually, the urn carried by the woman in the center contains her ashes. This is an ideal burial service performed by mostly allegorical figures: a mourning winged **genius** on the right, and the group about to enter the tomb on the left, who represent the Three Ages of Life. The slow procession, directed away from the beholder, stands for "eternal remembrance." All references to Christianity are conspicuously absent.

Canova must have known of Pigalle's tomb for the maréchal de Saxe (see fig. 20-2), which looks forward to it in so many respects. The differences are equally striking, however. Canova's design looks surprisingly like a very high relief. Most of the figures are seen in strict profile, so that they seem to hug the wall plane despite the deep space. Gestures are kept to a minimum, and the allegorical trappings that clutter Pigalle's monument have been swept away, so that nothing distracts us from the

22-21 Antonio Canova. Tomb of the Archduchess Maria Christina. 1798–1805. Marble, life-size. Augustinerkirche, Vienna

solemn ritual being acted out before us. It is this intense concentration that distinguishes Canova's Romantic classicism from the Baroque classicism of Pigalle.

FRANCE

It was in France that the main development of Romantic sculpture took place. Although the doctrine of the Academy came to be broadened and modified in the course of time, it lasted until Rodin late in the century. Its core belief was that the human body is nature's noblest creation and hence the sculptor's noblest subject. Translated into practice, this idea meant that every student of sculpture received a rigorous training. The course of study was especially demanding at the Paris École des Beaux-Arts. In 1819 the École opened as the successor to both the Académie Royale de Peinture et Sculpture and the Académie Royale d'Architecture under the Académie des Beaux-Arts, which in turn was part of the Institut de France. Since the level of teaching at the École was far higher in sculpture than it was in painting, the limitations of the academic sculptural tradition became apparent only much later.

The Romantic reaction against the ideal of the "modern classic" asserted itself in the sculpture sections of the French Salons after the Revolution of 1830, which brought about the fall of the restored Bourbon regime. However, antiacademic tendencies did not become dominant until the last two decades of the century, when Michelangelo, Rodin's ideal, at last won out over Canova. What ultimately destroyed the modern classic was the cult of the fragmentary and the unfinished.

That the Romantic "rebellion" started so much later in sculpture than in painting also attests to how closely the medium was linked to politics in nineteenth-century France. Artists were often passionately involved in politics, but because the state remained the largest single source of commissions for sculptors, their fortunes were more directly affected than those of the painters by changes in regime. French sculpture was by no means dominated by its social and political environment. Yet, to the extent that it was a public art, sculpture responded to the pressure of these forces, directly or indirectly, far more than did painting. It was shaped by them in varying degrees, depending on local circumstances. Thus we cannot understand its development without reference to the changing politics around it.

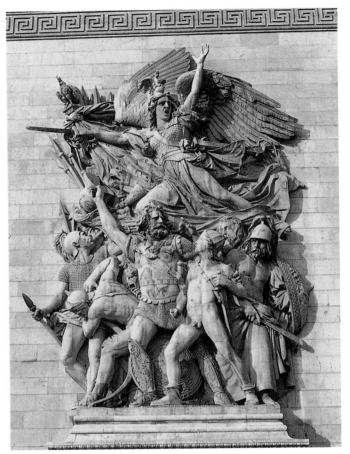

22-22 François Rude. *La Marseillaise.* 1833–36. Stone, approx. 42 x 26' (12.80 x 7.93 m). Arc de Triomphe, Paris

Rude François Rude (1784–1855), who enthusiastically took Napoleon's side after the emperor's return in 1815 from exile on the island of Elba, sought refuge in Brussels from Bourbon rule, as had David, whom he knew and revered. After returning to Paris in 1827, Rude must have felt that artistically he had reached a dead end and decided to strike out in fresh directions. He acquired a new interest in the French Renaissance tradition of the School of Fontainebleau and Giovanni Bologna (see page 342), which would eventually lead him back to Claus Sluter (see pages 239–40). This rediscovery of national sculptural traditions, so characteristic of Romantic revivalism, was part of a new wave of nationalism, which was also illustrated by a passion for historical portraits as "morally elevating for the public."

These concerns are seen in Rude's masterpiece, *The Departure of the Volunteers of 1792,* commonly called *La Marseillaise* (fig. 22-22). It was carved for Napoleon's unfinished Arc de Triomphe on the Place de l'Étoile. The new king, Louis-Philippe, and his energetic minister of the interior, Adolphe Thiers, saw the triumphal arch's completion as an opportunity to demonstrate that his government was one of national reconciliation. Hence the sculptural program had to offer something to every segment of the French political spectrum. Rude received a commission for one of the four groups that flank the opening. He raised his subject—the French people rallying to defend the Republic against attack from abroad—to the level of mythic splendor. The volunteers surge forth, some nude, others in classical armor, inspired by the great forward movement of the winged genius of Liberty above them.

No wonder the work aroused an emotional response that made people identify the group with the national anthem itself. *La Marseillaise* brings to mind certain paintings by Delacroix and, in fact, its ultimate source is pictorial. For Rude, the group had a deeply felt personal meaning: his father had been among those volunteers. When the arch was officially unveiled in 1836, there was almost unanimous agreement that Rude's group made the other three pale into insignificance. Despite its great public acclaim, *La Marseillaise* failed to gain Rude the official honors he so clearly deserved. He found himself more and more in opposition to the regime, and his most important works between 1836 and 1848 were direct expressions of his Bonapartist political beliefs.

Carpeaux Besides bringing Rude into prominence, the Salons of the early 1830s served as showcases for sculptors still in their twenties. What separated them from the generation of their teachers was that none was old enough to have experienced the Napoleonic era. As it happened, there was not a single first-rate artist in this group. We look equally in vain for a major talent among the French sculptors born during the second decade of the century. The third decade, in contrast, saw the birth of several important sculptors. Of these, the best known was Jean-Baptiste Carpeaux (1827–1875). Carpeaux's masterpiece came at the end of the

SECOND EMPIRE, which succeeded the short-lived SECOND REPUBLIC in 1852. In 1861 Carpeaux's old friend the architect Charles Garnier began the Paris Opéra (see pages 505–6) and entrusted him with one of the four sculptural groups across the facade. *The Dance* (fig. 22-23) perfectly matches Garnier's Neo-Baroque architecture. (The plaster model in our illustration is both livelier and more precise than the final stone group, present in fig. 22-28, lower right.)

The group created a scandal after its unveiling in 1869. The nude bacchantes dancing around the winged male genius in the center were denounced as drunk, vulgar, and indecent—and small wonder. Carpeaux's enormous figures (they are 15 feet tall) look undressed rather than nude, because of their naturalism, so that we do not accept them as inhabiting the realm of mythology. Public opinion insisted that the group be replaced. After the war with Germany ended in 1871, the old complaints were forgotten and *The Dance* was recognized as a masterpiece. It is as obviously superior to the other three Opéra groups by more conservative sculptors as Rude's *Marseillaise* is to its neighbors on the Arc de Triomphe. (Carpeaux had studied for a while with Rude.) *The Dance* established the Beaux-Arts style in sculpture for the rest of the century, much as Garnier's Opéra did in architecture (see page 506).

Bartholdi The late nineteenth century offered enormous opportunities for official commissions to sculptors. It is a safe guess that the great majority of monuments in the Western world were produced, or at least begun, between 1872 and 1905. The most ambitious of these was the Statue of Liberty (or, to use its official title, *Liberty Enlightening the World*) by Auguste Bartholdi (1834–1904). This monument (fig. 22-24, page 502) in memory of French support for America during the War of Independence was a gift of the French people, not of the government. Its enormous cost was raised by public subscription, which took ten years. The sculpture was placed on a tall pedestal built with funds raised by the American public.

Bartholdi developed the Statue of Liberty from a previous concept for a gigantic lighthouse in the

22-23 Jean-Baptiste Carpeaux. *The Dance.* 1867–69. Plaster model, approx. 15' x 8'6" (4.57 x 2.64 m). Musée de l'Opéra, Paris

Charles-Louis Napoleon Bonaparte (1808–1873), nephew of Napoleon I, came to power after King Louis-Philippe was ousted in the Revolution of 1848. Napoleon ran for election as president of the SECOND REPUBLIC, and he won on a relatively liberal platform. In 1851 he assumed dictatorial powers; by 1852 he converted the Second Republic to the SECOND EMPIRE, taking the title Napoleon III, emperor of France. An effective champion of domestic reform and liberalization, he nevertheless failed to prepare France against military threats. The Prussians crushed France in the Franco-Prussian War of 1870. Napoleon III was captured and removed from office.

form of a woman holding a lamp that was intended to be erected at the northern entry to the Suez Canal. All he had to do was exchange the Egyptian headdress for a radiant crown and the lantern for a torch. The final work shows an austere, classically draped young woman holding the torch in her raised right hand and a tablet in her left. She steps on the broken shackles of tyranny with her left foot, on which her weight rests. The right leg (the free one, in accordance with the rules of classical **contrapposto**) is set back, so that the figure seems to be advancing when viewed from the side but looks stationary from the front. As a piece of sculpture, the Statue of Liberty is less original than one might think. It derives from a well-established ancestry reaching back to Canova and beyond. Its conservatism, however, was Bartholdi's conscious choice. He sensed that only a "timeless" statue could embody the ideal he wanted to glorify.

22-24 Auguste Bartholdi. *Liberty Enlightening the World (The Statue of Liberty).* 1875–84. Copper sheeting over metal armature, height of figure 151'6" (46 m). Liberty Island, New York Harbor

The figure, which stands more than 150 feet tall, presented severe structural problems that called for the skills of an architectural engineer. Bartholdi found the ideal collaborator in Gustave Eiffel, the future builder of the Eiffel Tower (see fig. 23-28). The project took more than a decade to complete. The Statue of Liberty was inaugurated at last in the fall of 1886. Its fame as the symbol—one is tempted to say "trademark"—of the United States has been worldwide ever since.

Architecture

Given the individualistic nature of Romanticism, we might expect the range of revival styles to be widest in painting, the most personal and private of the visual arts, and narrowest in architecture, the most communal and public. Yet the opposite is true. Painters and sculptors were unable to abandon Renaissance habits of representation and never really revived medieval art or ancient art before the Classical Greek era. Architects were not subject to this limitation, however. Consequently, the revival styles lasted longer in architecture than in the other arts, because it was free to draw on a wider range of sources.

THE CLASSICAL REVIVAL

The "Greek revival" phase of Neoclassicism was pioneered on a small scale in England, but was quickly taken up everywhere. The Greek Doric was believed to embody more of the "noble simplicity and calm grandeur" of Classical Greece than did the later, less "masculine" orders. Yet, the Greek Doric was also the least flexible order and the most difficult to adapt to modern purposes. Hence, only rarely could Greek Doric architecture furnish a direct model for Neoclassical structures. We instead find variations of it combined with elements taken from the other Greek orders.

Schinkel The Altes Museum (Old Museum; fig. 22-25) by Karl Friedrich Schinkel (1781–1841) is a spectacular example of the Greek revival. The main entrance resembles a Doric temple seen from the side (see fig. 5-8), but with Ionic columns strung across a Corinthian order (compare fig. 5-10). The facade and plan are derived in bits and pieces from a contemporary treatise by the French architect Jean-Nicolas Durand (1760–1834), a professor at the recently established engineering school in Paris. Durand reduced classical architecture to a set of geometric formulas based on function and economy. Schinkel's building, however, has none of Durand's uninspired utilitarianism. On the contrary, it is notable for its bold, unified design and refined proportions.

Schinkel, an architect of great ability, began as a painter in the style of Caspar David Friedrich (see page 495). He then worked as a stage designer before being appointed to the Berlin public-works office, which he later headed. (He owed his appointment to Wilhelm von Humboldt, the Prussian statesman and Minister of Education, who was a friend of Goethe. Thus he knew how to instill architecture

22-25 Karl Friedrich Schinkel. Altes Museum, Berlin. 1824–28

with Romantic associations and a theatrical flair worthy of Piranesi. Schinkel's first love was the Gothic, but although most of his public buildings are in a Neoclassical style, they retain a strong element of the Picturesque. He could admire both styles because he shared the Enlightenment belief in the moral and educational functions of architecture. (Schinkel was the tutor and friend of Crown Prince Friedrich Wilhelm, an amateur architect who wanted to combine Greek and Gothic architecture into a new style expressing his dream of a united Germany.)

Here the measured rhythm of the monumental facade establishes a contemplative mood appropriate to viewing the art of antiquity. The Altes Museum expresses the veneration of ancient Greece in the land of Winckelmann and Mengs. To the poet Goethe, Greece remained the peak of civilization. The Altes Museum testifies, furthermore, to the informed attitude that gave rise to art museums, galleries, and academies on both sides of the Atlantic during the nineteenth century. At the same time, the Greek style served the imperial ambitions of Prussia, which emerged as a major power at the Congress of Vienna in 1815 following the defeat of Napoleon. The imposing grandeur of the Altes Museum proclaims Berlin as the new Athens, with Kaiser Wilhelm III as a modern Perikles.

THE GOTHIC REVIVAL

It is characteristic of Romanticism that at the time architects launched the classical revival, they also started a Gothic revival. The appeal of the Gothic was chiefly as a means for creating picturesque effects and expressing Romantic feeling. After 1800 the choice between classical and Gothic modes was often resolved in favor of Gothic. Nationalist sentiments, strengthened by the Napoleonic wars, became important factors. England, France, and Germany each believed that Gothic expressed its national genius. The French theorist Eugène Viollet-le-Duc (1814–1879), a structural rationalist at heart, preferred it because it was "true according to the program and true according to the methods of construction." Certain English writers, notably John Ruskin (1819–1900), regarded Gothic as superior for ethical or religious reasons on the grounds that it was "honest" and "Christian."

Walpole England was central to the Gothic revival, as it was to the development of Romantic literature

22-26 Horace Walpole, with William Robinson and others. Strawberry Hill, Twickenham, England. 1749–77

and painting. Gothic forms had never wholly disappeared in England. They were used on occasion for special purposes, even by Sir Christopher Wren (see pages 432–33), but these were survivals of an authentic, if outmoded, tradition. The conscious revival was begun by William Kent in the 1730s, partly at the prompting of Robert Walpole, one of the most important politicians of the day. It soon became linked with the cult of the Picturesque and with the vogue for medieval (and pseudomedieval) romances.

Horace Walpole (1717–1797), Robert's son, started the medieval craze with the publication in 1764 of his novel *The Castle of Otranto: A Gothic Story.* It was in this spirit that he enlarged and "gothicized" Strawberry Hill, his country house outside London (fig. 22-26). The process, which began midway in the eighteenth century, took more than 25 years and involved Walpole's circle of friends. Those who worked on the project included John Chute (1701–1776), William Robinson (c.1720–1775), Richard Bentley (1708–1782), Thomas Pitt (c. 1737–1793), and Robert

Adam, who was responsible for the round tower. The rambling structure has a studied irregularity, due mainly to Chute, that is decidedly picturesque. Inside, however, most of the elements were faithfully copied or adapted from authentic Gothic sources. Although Walpole associated the Gothic with the pathos of the Sublime, he acknowledged that the house was "pretty and gay." This playfulness, so free of dogma, gives Strawberry Hill its special charm. Gothic here is still an "exotic" style. It appeals because it is strange. But for that very reason it must be "translated," like a medieval romance or like the Chinese motifs that crop up in Rococo decoration.

Barry and Pugin The largest monument of the Gothic revival is the Houses of Parliament in London (fig. 22-27), designed by Sir Charles Barry (1785–1860) and A. N. Welby Pugin (1812–1852). As the seat of government and a focus of patriotic feeling, it presents a curious mixture: repetitious symmetry governs the main body of the structure and picturesque irregularity its silhouette. The

building is a contradiction in terms. It imposes Pugin's Gothic vocabulary, inspired by the English Perpendicular style (compare fig. 11-11), onto the classically conceived structure by Barry, with results that satisfied neither. Nevertheless, the Houses of Parliament admirably convey the grandeur of Victorian England at the height of its power.

NEO-RENAISSANCE AND NEO-BAROQUE ARCHITECTURE

Garnier The stylistic alternatives were continually increased for architects by other historical revivals. When the Renaissance, then the Baroque, returned to favor by midcentury, the revival movement had come full circle: Neo-Renaissance and Neo-Baroque replaced the Neoclassical. This final phase of Romantic historicism dominated French architecture during the years 1850–75 and lingered through 1900. It is epitomized in the Paris Opéra (fig. 22-28), designed by Charles Garnier (1825–1898). He had graduated from the École des Beaux-Arts and won the Prix de Rome, which enabled him to spend six years studying in Italy and Greece. The Opéra was the culmination of Baron

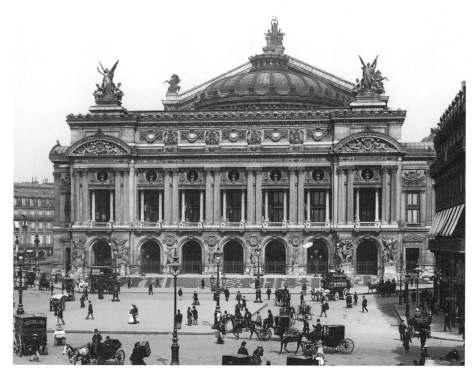

22-28 Charles Garnier. The Opéra, Paris. 1861–74. Photographed in the early 20th century

Georges-Eugène HAUSSMANN's plan to modernize Paris under Napoleon III. It is the focal point for a series of main avenues that converge on it from all sides. Although the building was not completed until after the fall of the Second Empire, its extravagance typified the Beaux-Arts style of the new Paris at its height.

The building is a masterpiece of eclecticism. The massing of the main entrance for those arriving on foot is reminiscent of Lescot's Square Court of the Louvre (see fig. 16-15). But the paired columns of the facade, "quoted" from Perrault's east front of the Louvre (see fig. 19-5), are combined with a smaller order in a fashion first suggested by Michelangelo. The rear entrance consists of a temple front. On the east side is the emperor's entrance with a sweeping staircase, and on the west side a carriage entrance. The Opéra used the latest building materials and techniques, including iron. The stagecraft, too, was state of the art. Garnier nevertheless went to great lengths to conceal the technology, which for him remained a means, not a principle.

The Opéra consciously suggests a palace of the arts combined with a temple of the arts. The theatrical effect captures the festive air of a crowd gathering before the opening curtain. Its Neo-Baroque quality derives more from the abundance of sculpture—including Carpeaux's *Dance* (see fig. 22-23)—and ornament than from its architectural vocabulary. The whole building looks "overdressed," its luxurious vulgarity so naive as to disarm all criticism. It reflects the taste of the capitalist tycoons, newly rich and powerful, who saw themselves as the heirs of the old aristocracy and thus found the styles predating the French Revolution more appealing than Neoclassical or Neo-Gothic.

Photography

Is photography art? The fact that we still pose the question testifies to the continuing debate. The answers have varied with the changing definition and understanding of art. In itself, photography is simply a medium, like oil paint or pastel, used to make art and has no inherent claim to being art. What distinguishes any art from a craft is *why*, not *how*, it is done. But photography shares creativity with art because, by its very nature, it necessarily involves the imagination. Any photograph, even a casual snapshot, represents both an organization of experience and the record of a mental image. The subject and style of a photograph thus tell us about the photographer's inner and outer worlds. Furthermore, photography participates in the same seek-and-find process as painting or sculpture. Photographers may not realize what they respond to until after they see the image in printed form.

Like woodcut, etching, engraving, and **lithography**, photography is a form of printmaking that depends on mechanical processes. In contrast to the other graphic mediums, photography has always been tainted as the product of a new technology. Apart from pushing a button or lever, setting up special effects, or creating them in the darkroom, no active intervention is required of the artist's hand to guide an idea. For this reason, the camera has usually been considered to be little more than a recording device. Photography, however, is by no means a neutral medium. Its reproduction of reality is never completely faithful. Whether we realize it or not, the camera alters appearances. Photographs therefore reinterpret the world around us, making us see it in new terms.

Photography and painting represent parallel responses to their times and have generally expressed the same worldview. Sometimes the camera's power to extend our way of seeing has been realized first by the painter's creative vision. The two mediums nevertheless differ fundamentally in their approach. Painters communicate their understanding through techniques that represent their cumulative response over time, whereas photographers recognize the moment when the subject before them corresponds to the mental image they have formed of it.

It is hardly surprising that photography and art have enjoyed an uneasy relationship from the start. Artists have generally treated the photograph as a preliminary sketch, a convenient source of ideas or record of motifs to be fleshed out and incorporated into a finished work. Academic

painters found the detail provided by photographs to be in keeping with their own precise naturalism. Many other kinds of artists have used photographs, without always admitting it. Photography has in turn been heavily influenced throughout its history by the painter's mediums. Photographs are often still judged by how well they imitate paintings and drawings. To understand photography's place in art history, we must recognize the medium's particular strengths and inherent limitations.

THE FOUNDERS OF PHOTOGRAPHY

In 1822 the French inventor Joseph-Nicéphore Niépce (1765–1833) succeeded in making the first permanent photographic image, although his earliest surviving example (fig. 22-29) dates from four years later. He then joined forces with a younger man, Louis-Jacques-Mandé Daguerre (1789–1851), who had invented an improved camera. After ten more years of chemical and mechanical research, the **daguerreotype**, using positive exposures, was unveiled publicly in 1839, and the age of photography was born. The announcement spurred the Englishman William Henry Fox Talbot (1800–1877) to complete his own photographic process, involving a paper negative from which positives could be made, which he had been pursuing independently since 1833.

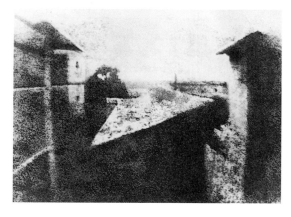

22-29 Joseph-Nicéphore Niépce. *View from His Window at Le Gras.* 1826. Heliograph, 6½ x 7⅞" (16.5 x 20 cm). Gernsheim Collection, Harry Ransom Research Center, University of Texas at Austin

What motivated the earliest photographers? They were searching for an artistic medium, not for a practical device. Although Niépce was a research chemist rather than an artist, his achievement was an outgrowth of his efforts to improve the lithographic process. Daguerre was a skilled painter, and he probably turned to the camera to heighten the illusionism of his huge painted **dioramas**, which were the sensation of Paris during the 1820s and 1830s. Fox Talbot saw in photography a substitute for drawing, as well as a means of reproduction, after he used a **camera obscura** as a tool to sketch landscapes while on a vacation. The interest that all of the founders had in the artistic potential of the medium they had created is reflected in their photographs. Daguerre's first picture, for example, imitated a type of still life originated by Chardin.

That the new medium should have a mechanical aspect was particularly appropriate. It was as if the Industrial Revolution, having forever altered civilization's way of life, now had to invent its own method for recording itself, although the transience of modern existence was not captured by "stopping the action" until the 1870s. Photography underwent a rapid series of improvements, including better lenses, glass-plate negatives, and new chemical processes, which provided faster emulsions and more stable images. Because many of the initial limitations of photography were overcome around midcentury, it would be misleading to tell the early history of the medium in terms of technological developments, important though they were.

The basic mechanics and chemistry of photography had been known for a long time. The camera obscura, a box with a small hole in one end, dates back to antiquity. In the sixteenth century, it was widely used for visual demonstrations. The camera was fitted with a mirror and then a lens in the Baroque period, which saw major advances in optical science culminating in NEWTONIAN PHYSICS. By the 1720s it had become an aid in drawing architectural scenes. At the same time, the discovery was made that silver salts were light-sensitive.

Why, then, did it take another hundred years for someone to put this knowledge together?

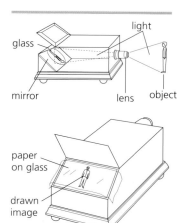

camera obscura

Much of the answer lies in the nature of scientific revolutions. As a rule, they combine old technologies and concepts with new ones in response to changing worldviews that they, in turn, influence. Photography was neither inevitable in the history of technology nor necessary to the history of art; yet it was an idea whose time clearly had come. If we try for a moment to imagine that photography had been invented a hundred years earlier, we will find this to be impossible simply on artistic, let alone technological, grounds. The early eighteenth century was too devoted to fantasy to be interested in the literalness of photography. Rococo portraiture, for example, was more concerned with providing a flattering image than an accurate likeness. Hence the camera's straightforward record would have been totally out of place. Even in architectural painting, extreme liberties were often taken with topographical truth (see pages 447–48).

The invention of photography was a response to the artistic urges and historical forces that underlie Romanticism. Much of the impulse came from a quest for the True and the Natural. The desire for "images made by Nature" can already be seen in the late-eighteenth-century vogue for silhouette portraits (traced from the shadow of the sitter's profile), which led to attempts to record such shadows on light-sensitive materials. David's harsh realism in *The Death of Marat* (see fig. 21-3) had already proclaimed the cause of unvarnished truth. So did Ingres's *Louis Bertin* (see fig. 22-6), which established the standards of physical reality and character portrayal that photographers would follow.

PORTRAITURE

Like lithography, which was invented in 1797, photography met the growing demand for images of all kinds. By 1850 large numbers of the middle class were having their likenesses painted, and it was in portraiture that photography found its readiest acceptance. Soon after the daguerreotype was introduced, photographic studios sprang up everywhere, especially in America, and multi-image cartes de visites, invented in 1854 by Adolphe-Eugène Disdéri, became ubiquitous. Anyone could have a portrait taken cheaply and easily. In the process, the average person became memorable. Photography thus became an outgrowth of the democratic values fostered by the American and French revolutions. There was also keen competition among photographers to get the famous to pose for portraits.

Nadar Gaspard-Félix Tournachon (1820–1910), better known as Nadar, managed to attract most of France's leading personalities to his studio. Like many early photographers, he started out as a painter but came to prefer the lens to the brush. He initially used the camera to capture the likenesses of the 280 sitters whom he caricatured in an enormous lithograph, *Le Panthéon Nadar.* The actress Sarah Bernhardt posed for him several times, and his photographs of her (fig. 22-30) are the direct ancestors of modern glamour photography. With her romantic pose and expression, she is a counterpart to the soulful maidens found throughout nineteenth-century painting. Nadar

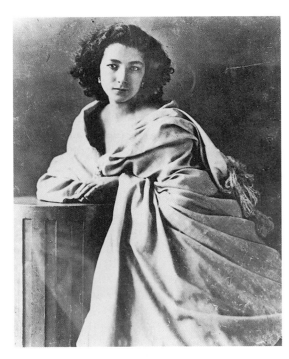

22-30 Nadar. *Sarah Bernhardt.* 1859. George Eastman House, Rochester, New York

has treated her in remarkably sculptural terms. Indeed, the play of light and sweep of drapery are reminiscent of the sculptured portrait busts that were so popular with collectors at the time.

THE RESTLESS SPIRIT AND STEREOPHOTOGRAPHY

Early photography reflected the outlook and temperament of Romanticism. Indeed, the entire nineteenth century had a pervasive curiosity and an abiding belief that everything could be discovered. While this fascination sometimes showed a serious interest in science—witness Charles DARWIN's voyage on the *Beagle* from 1831 to 1836—it typically took the form of a restless quest for new experiences and places. Photography had a remarkable impact on the imagination of the period by making the rest of the world widely available in visual form, or by simply revealing it in a new way. Sometimes the search for new subjects was close to home. Nadar, for example, took aerial photographs of Paris from a hot-air balloon. This feat was wittily parodied by Daumier (see pages 487–88) in a lithograph whose caption, *Nadar Elevating Photography to the Height of Art,* expresses the prevailing skepticism about the aesthetics of the new medium.

A love of the exotic was fundamental to Romantic escapism, and by 1850 photographers began to cart their equipment to faraway places. The unquenchable thirst for vicarious experiences accounts for the great popularity of stereoscopic photographs. Invented in 1849, the two-lens camera produced two photographs comparable to the slightly different images perceived by our two eyes. When seen through a special viewer called a stereoscope, stereoptic photographs fuse to create a remarkable illusion of three-dimensional depth. Two years later, stereoscopes became the rage at the Crystal Palace exposition in London (see pages 536–37). Countless thousands of double-views, such as that in figure 22-31, were taken over the next 50 years. Virtually every corner of the earth became accessible to practically any household, with a vividness second only to being there.

Stereophotography was an important breakthrough. Its binocular vision marked a major

22-31 *Czar Cannon outside the Spassky Gate, Moscow* (cast 1586; presently inside the Kremlin). Second half of 19th century. Stereophotograph
Courtesy Culver Pictures

departure from perspective in the pictorial tradition and demonstrated for the first time photography's potential to enlarge human vision. Nevertheless, this success waned, except for special uses. People were simply too accustomed to viewing pictures as if with one eye. Later on, when the halftone plate was invented in the 1880s for reproducing images on a printed page, stereophotographs revealed another drawback. As our illustration demonstrates, they were unsuitable for illustrations. From then on, it was single-lens photography that was closely linked with the mass media of the day.

PHOTOJOURNALISM

Fundamental to the rise of photography was the nineteenth-century sense that the present was already history in the making. Only with the advent of the Romantic hero did great acts, other than martyrdom, become popular subjects for contemporary painters and sculptors. It is hardly surprising that photography was invented a year after the death of Napoleon, who had been the subject of more paintings than any previous secular leader. At about the same time, Géricault's *Raft of the "Medusa"* (see fig. 22-4) signaled a decisive shift in the Romantic attitude toward representing contemporary events. This outlook brought with it a new kind of photography: photojournalism.

English scientist Charles Robert DARWIN (1809–1882) shook the world in 1859 when he published *On the Origin of Species.* In this work, he theorized that evolution proceeds by natural selection, that the fittest specimens of life survive and reproduce, and that the human species arose in this way from less evolved forms of life.

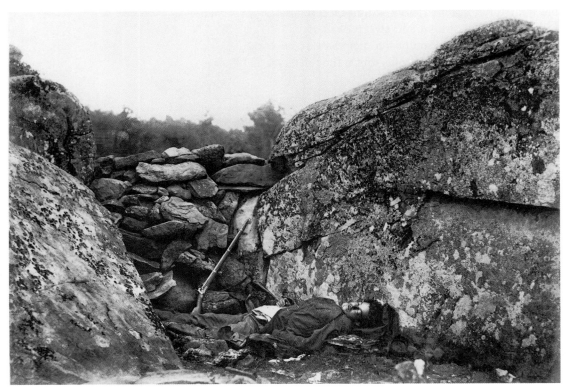

22-32 Alexander Gardner. *Home of a Rebel Sharpshooter, Gettysburg.* July 1863. Wet-plate photograph. Chicago Historical Society

Gardner Its first great representative was Mathew Brady (1823–1896), who covered the Civil War in the United States. Other wars had already been photographed, but Brady and his 20 assistants were able to bring home the horrors of that war with unprecedented directness, despite using cameras too slow and cumbersome to show actual combat. *Home of a Rebel Sharpshooter, Gettysburg* (fig. 22-32) by Alexander Gardner (1821–1882), a former assistant of Brady who formed his own photographic team in 1863, is a landmark in the history of art. Never before had both the grim reality and, above all, the significance of death on the battlefield been conveyed so fully in a single image. Compared with the heroic act celebrated by Benjamin West (see fig. 21-4), this tragedy is as anonymous as the slain soldier himself. The photograph is all the more convincing for having the same harsh realism found in David's *Death of Marat* (see fig. 21-3), and the limp figure, hardly visible between the rocks framing the scene, is no less moving. In contrast, the paintings and engravings by the artists—such as Winslow Homer (see pages 526–27)—who illustrated the war for periodicals were mostly genre scenes that kept the reality of combat safely at arm's length.

REALISM AND IMPRESSIONISM

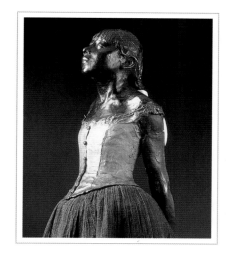

"Can Jupiter survive the lightning rod?" asked Karl Marx, not long after the middle of the nineteenth century. The question suggests that the ancient god of thunder and lightning was now threatened by science. In 1846 the French poet and art critic Charles Baudelaire addressed the same problem when he called for paintings that expressed "the heroism of modern life":

> To prove that our age is no less fertile in sublime themes than past ages, we may assert that since all centuries and all peoples have had their own form of beauty, so inevitably we have ours . . . just as we have our own particular emotions, so we have our own beauty.
>
> The pageant of fashionable life and the thousands of floating existences—criminals and kept women—which drift about in the underworld of a great city . . . all prove to us that we have only to open our eyes to recognize our heroism. . . .
>
> The life of our city is rich in poetic and marvellous subjects. We are enveloped and steeped as though in an atmosphere of the marvellous; but we do not notice it.
>
> The *nude*—that darling of the artists, that necessary element of success—is just as frequent and necessary today as it was in the life of the ancients; in bed, for example, or in the bath, or in the anatomy theater. The themes and resources of painting are equally abundant and varied; but there is a new element—modern beauty.

Painting

FRANCE

Courbet and Realism At the time of Baudelaire's statement, only one painter was willing to make an artistic doctrine of his demand: his friend Gustave Courbet (1819–1877). Courbet was born in Ornans, a village near the French-Swiss border, and remained proud of his rural background. He had begun as a Neo-Baroque Romantic in the early 1840s. By 1848, under the impact of the revolutionary upheavals then sweeping through Europe, he had come to believe that the Romantic emphasis on feeling and imagination was merely an escape from the realities of the time. Truth and sincerity became the rallying cry of the Realists, their motto Baudelaire's motto, "It is necessary to be of one's time." Modern artists must rely on direct experience—they must be Realists. "I cannot paint an angel because I have never seen one," Courbet wrote.

As a descriptive term, *realism* is not very precise. For Courbet, it meant something akin to the realism of Caravaggio (see pages 384–86). As an admirer of Rembrandt, Courbet had, in fact, strong links with the Caravaggesque tradition. Moreover, his work, like Caravaggio's, was denounced for its supposed vulgarity and lack of spiritual content. What ultimately defines Courbet's Realism, however, and distinguishes it from Romanticism, is his devotion to radical (as against merely liberal) politics. His SOCIALIST views were the result of his close friendship with the theorist Pierre-Joseph Proudhon, ten years his senior, who was from the same region in southern France, and they colored his entire outlook. Although Socialism did not determine the specific content or appearance of Courbet's pictures, it does help to account for his choice of subject matter and style, which went against the grain of tradition.

Burial at Ornans (fig. 23-1), from 1849, fully embodies Courbet's programmatic Realism. Here is a picture that disregards the academic hierarchy by treating an apparent genre scene with the same seriousness and monumentality as a history painting. In addition it was executed with a heavy **impasto** that violated accepted standards of finish, so that it had a hostile reception from the public and

most critics. Courbet asked 50 people to pose for him in his studio. He painted them life-size, solidly and matter-of-factly. The canvas is much larger than anything by Millet, and with none of his overt pathos or sentiment (compare fig. 22-12). Its nearest relatives are Dutch group portraits of the seventeenth century. *Burial at Ornans* rivals Rembrandt's *Night Watch* (see fig. 18-10) in scale and ambition. Courbet has adopted the Dutch master's dark palette and thick brushwork as well. The picture consciously avoids any trace of Baroque dynamism, however. It has instead a classical gravity worthy of Masaccio and Raphael (see figs. 12-14 and 13-14).

In contrast to other funerary scenes, such as El Greco's *Burial of Count Orgaz* (see fig. 14-11), this is not the apotheosis of a great man or woman. In fact, the identity of the deceased is never revealed—nor is it important—although the painting is sometimes said to have been inspired by the funeral of Courbet's grandfather. It is not even a religious scene, let alone one about death. The real subject is the gathering as social ritual, to which the burial itself seems almost incidental. The composition is divided into three groups of clergy, men, and women, each of whom is carefully observed. Many of the faces are partially obscured, however, so that they remain as anonymous as the person they have come to mourn. The artist's main intention was to record the dress and customs of his hometown. By rigorously excluding anything that might distract our attention, he prevents us from reading any further significance into the painting. Yet, strangely enough, it has a grandeur and solemnity that are deeply moving, precisely because of the factual presentation. In this way, *Burial at Ornans* fulfills Baudelaire's "heroism of modern life."

During the 1855 PARIS EXPOSITION, where works by Ingres and Delacroix were prominently displayed, Courbet brought attention to his pictures by organizing a private exhibition in a large shed and by distributing a "manifesto of Realism." The show, which included *Burial at Ornans*, centered on another huge canvas, titled *Studio of a Painter: A Real Allegory Summarizing My Seven Years of Life as an Artist* (fig. 23-2). (Fittingly enough, the two paintings now hang opposite each other in the

Socialism is the name of an economic and social doctrine that advocates state ownership and control of the basic means of production, together with the egalitarian distribution of wealth. A SOCIALIST, therefore, is one who believes in socialism. In France in the mid-nineteenth century, socialism was a sincerely considered alternative to monarchy, empire, and unstable republics, and the goal of ending economic and social oppression by one class or group over another paralleled the impulse that fueled the Revolution of 1848 in Paris.

The Exposition Universelle (PARIS EXPOSITION) of 1855 was the first of a long series of French international expositions, but not the first such world's fair. In 1851 Queen Victoria and Prince Albert of England had inaugurated the very first international exhibition in the newly built Crystal Palace in London (see fig. 23-27). The Paris expositions were showcases for, among other goods and products, the work of officially favored French painters and sculptors.

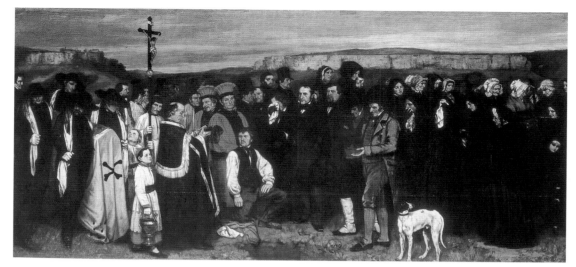

23-1 Gustave Courbet. *Burial at Ornans.* 1849. Oil on canvas, 10'3½" x 21'9½" (3.13 x 6.64 m). Musée d'Orsay, Paris

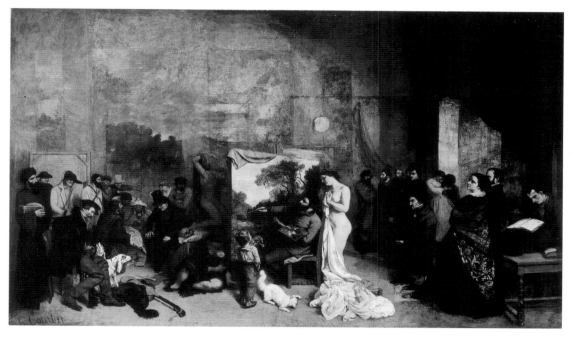

23-2 Gustave Courbet. *Studio of a Painter: A Real Allegory Summarizing My Seven Years of Life as an Artist.* 1854–55. Oil on canvas, 11'10" x 19'7" (3.61 x 5.97 m). Musée d'Orsay, Paris

Musée d'Orsay in Paris.) "Real allegory" is something of a teaser. Allegories, after all, are unreal by definition. Courbet meant either an allegory couched in the terms of his particular Realism, or one that did not conflict with the "real" identity of the figures or objects embodying it.

The framework is familiar. Courbet's composition clearly belongs to the type seen in Velázquez's *Maids of Honor* and Goya's *Family of Charles IV* (see figs. 17-18 and 22-1). But now the artist has moved to the center, and the visitors here are his guests, not royal patrons who enter whenever they wish. He has invited them specially for a purpose that becomes evident only upon further thought. The picture does not yield its full meaning unless we take the title seriously and consider Courbet's relation to this assembly.

There are two main groups. On the left are "the people." They are types rather than individuals, drawn largely from the artist's hometown: hunters,

peasants, workers, a priest, a young mother with her baby. On the right we see groups of portraits representing the Parisian side of Courbet's life: clients, critics, intellectuals. (The man reading is Baudelaire.) All of these people are strangely passive, as if they are waiting for something to happen. Some are quietly conversing among themselves, others seem lost in thought. Yet hardly anyone looks at Courbet. They are not his audience, but a representative sampling of his social environment.

Only two people watch the artist at work: a small boy, intended to suggest "the innocent eye," and the nude model. What is her role? In a more conventional picture, we would identify her as Inspiration, or Courbet's Muse, but she is no less "real" than the others here. Courbet probably meant her to be Nature, or that undisguised Truth which he proclaimed to be the guiding principle of his art. (Note the emphasis on the clothing she has just taken off.) Significantly enough, the center group is lighted by clear, sharp daylight, but the background and the side figures are veiled in semidarkness. This device underlines the contrast between the artist—the active creator—and the world around him that waits to be brought to life.

Manet and the "Revolution of the Color Patch" Courbet's *Studio* helps us to understand a picture that shocked the public even more: *Luncheon on the Grass* (*Le Déjeuner sur l'Herbe*) (fig. 23-3), showing a nude young woman next to two gentlemen in frock coats, by Édouard Manet (1832–1883). Manet was the first artist to grasp Courbet's full importance; his *Luncheon* is, among other things, a tribute to the older artist. There is a long tradition of such outdoor picnic scenes stretching back to a work by Titian in the Louvre that Manet copied while an art student. He nevertheless offended contemporary morality by placing the nude and nattily attired figures in an outdoor setting without allegorical intent. Even worse, the neutral title offered no "higher" significance. People assumed that Manet had intended to represent an actual

23-3 Édouard Manet. *Luncheon on the Grass (Le Déjeuner sur l'Herbe).* 1863. Oil on canvas, 7' x 8'10" (2.13 x 2.69 m). Musée d'Orsay, Paris

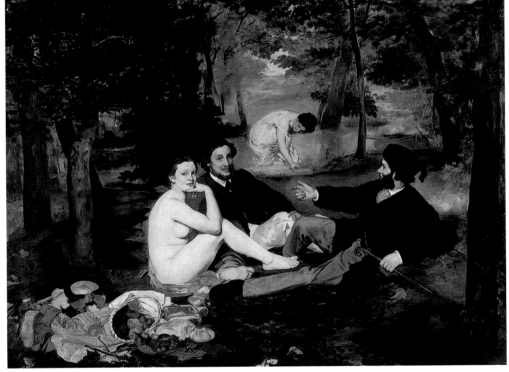

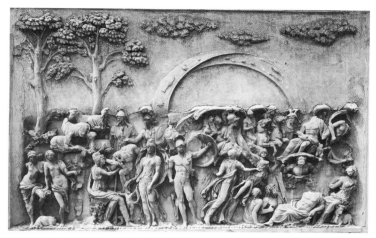

23-4 Marcantonio Raimondi, after Raphael. *The Judgment of Paris.* c. 1520. Engraving, 11⅝ x 17¼" (29.5 x 43.8 cm). The Metropolitan Museum of Art, New York

Rogers Fund, 1919

23-5 *River-Gods.* Panel from Roman sarcophagus. 3rd century A.D. Villa Medici, Rome

Given anonymously

event; yet the group has too formal a pose for that. Not until many years later was the source of these figures discovered: a group of classical deities from an engraving after Raphael that was in turn derived from a Roman sarcophagus, which belonged at the time to Cardinal della Valle and was later hung on a wall overlooking the garden of the Villa Medici in Pincio (figs. 23-4, 23-5). In both we see the Judgment of Paris to the left, and to the right Mars accompanying Venus to Olympia, where they are greeted by Zeus holding his thunderbolt. While Raphael has taken obvious liberties with the composition, the debt is obvious enough. Had Manet's contemporaries known of this origin in the revered figure of Raphael, the *Luncheon* might have seemed a less disreputable kind of outing to them. The girl washing in the distance was inspired by Watteau's painting *Diana Bathing.* (Manet originally titled his canvas *The Bath,* which would have shocked the public even more.)

For us, the main effect of comparing the *Luncheon* with its sources is to make the cool, formal quality of Manet's figures even more obvious. The unembarrassed gaze and frank realism of the nude are not simply a witty parody of classical art. Far more than Courbet's *Studio, Luncheon on the Grass* fulfills all the conditions set down by Baudelaire.

By borrowing freely from the past and clothing his figures in modern urban dress, Manet both updated tradition and gave fresh meaning to the nude. These, he seems to say, are the gods and goddesses of today, and they are no less worthy of our attention—or respect—than those of the past. Nevertheless, the scene fits neither everyday experience nor mythology. Perhaps the meaning of the canvas lies in this very denial of plausibility. For that reason, Manet could be championed by two seemingly opposite literary giants: the Realist novelist Émile Zola, who found in the artist's paintings a counterpart to his own writings (see page 539); and the Symbolist poet Stéphane Mallarmé, who appreciated Manet's economy and artfulness.

As a visual manifesto of artistic freedom, the *Luncheon* is much more revolutionary than Courbet's *Studio.* It asserts the painter's privilege to combine whatever elements he pleases for aesthetic effect alone. The nudity of the model is "explained" by the contrast between her warm, creamy flesh tones and the cool black and gray of the men's attire. To put it another way, the world of painting has "natural laws" that are different from those of everyday reality, and the painter's first loyalty is to his canvas, not to the outside world. Here begins an

attitude that became a bone of contention between progressives and conservatives for the rest of the century. It was later summed up in the doctrine of "art for art's sake" (see page 554). Manet himself refrained from such controversies. His work nevertheless attests to his lifelong devotion to "pure painting": to the belief that brushstrokes and color patches themselves—not what they stand for—are the artist's primary reality. From among the painters of the past, he found that Hals, Velázquez, and Goya had come closest to this ideal. He admired their broad, open technique and their preoccupation with light and color values. Many of his canvases are, in fact, "pictures of pictures": they translate into modern terms those older works that particularly fascinated him. Yet he always filtered out the expressiveness or symbolism of his models, to avoid distracting the viewer's attention from the pictorial structure. His paintings invariably have an emotional reserve that can easily be mistaken for emptiness unless we understand its purpose.

Courbet is said to have remarked that Manet's pictures were as flat as playing cards. Looking at *The Fifer* (fig. 23-6), we can see what he meant. Painted three years after the *Luncheon,* it has very little modeling, no depth, and hardly any shadows. (There are a few but it takes a real effort to find them.) The figure looks three-dimensional only because its contour renders the forms in realistic foreshortening. Otherwise Manet avoids all the methods invented since Giotto's time for transforming a flat surface into a pictorial space. The undifferentiated light gray background seems as near to us as the figure, and just as solid. If the fifer stepped out of the picture, he would leave a hole, like the cutout shape of a stencil.

Here, then, the canvas itself has been redefined. It is no longer a "window," but a screen made up of flat patches of color, like a child's jigsaw puzzle. How radical a step this is can be readily seen if we compare *The Fifer* to Delacroix's *Death of Sardanapalus* (see fig. 22-7) and to a Cubist work such as Picasso's *Three Dancers* of 1925 (see fig. 25-19). The structure of Manet's painting obviously resembles that of Picasso's, whereas Delacroix's still follows the "window"

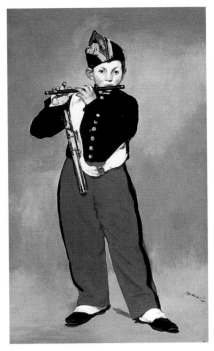

23-6 Édouard Manet. *The Fifer.* 1866. Oil on canvas, 63 x 38¼" (160 x 97.2 cm). Musée d'Orsay, Paris

tradition of the Renaissance. The revolutionary qualities of Manet's art could already be seen in the *Luncheon,* even if they were not yet so obvious. The three figures lifted from Raphael's group of river-gods form a unit nearly as shadowless and stencil-like as *The Fifer.* They would be more at home on a flat screen, and the **chiaroscuro** of their present setting, inspired by the landscapes of Courbet, no longer fits them.

What brought about this "revolution of the color patch"? We do not know, and Manet himself surely did not reason it out beforehand. It is tempting to think that he was spurred to create the new style by the challenge of photography. The "pencil of nature," then known for a quarter-century, had demonstrated the objective truth of Renaissance perspective, but it also established a standard of representational accuracy that no handmade image could hope to rival. Painting needed to be rescued from competition with the

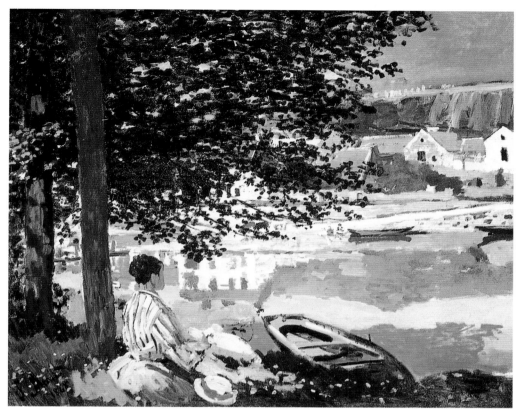

23-7 Claude Monet. *On the Bank of the Seine, Bennecourt.* 1868. Oil on canvas, 32¹/₈ x 39⁵/₈"
(81.6 x 100.7 cm). The Art Institute of Chicago

Mr. and Mrs. Potter Palmer Collection

camera. Manet accomplished this task by insisting that a painted canvas is, above all, a material surface covered with pigments—that we must look at it, not through it. Unlike Courbet, he gave no name to the style he had created. When his followers began calling themselves Impressionists, he refused to adopt the term for his own work. His aim was to be accepted as a Salon painter, a goal that eluded him until late in life.

Monet and Impressionism The word *Impressionism* was coined in 1874, after a hostile critic had looked at a picture entitled *Impression: Sunrise* by Claude Monet (1840–1926). It certainly fits Monet better than it does Manet. Monet had adopted Manet's concept of painting and applied it to landscapes done outdoors. Monet's *On the Bank of the Seine, Bennecourt* of 1868 (fig. 23-7)

is flooded with sunlight so bright that conservative critics claimed it made their eyes hurt. In this flickering network of color patches, shaped like mosaic **tesserae**, the reflections on the water are as real as the banks of the Seine. Even more than *The Fifer,* Monet's painting is a "playing card." Were it not for the woman and the boat in the foreground, the picture would be just as effective upside down. The mirror image here serves a purpose opposite that of earlier mirror images (compare fig. 15-8). Instead of adding to the illusion of real space, it strengthens the unity of the actual painted surface. This inner coherence sets the painting apart from Romantic "impressions" such as Constable's *Haywain* (see fig. 22-16) or Corot's *View of Rome* (see fig. 22-11), even though all three of these works share the same on-the-spot immediacy.

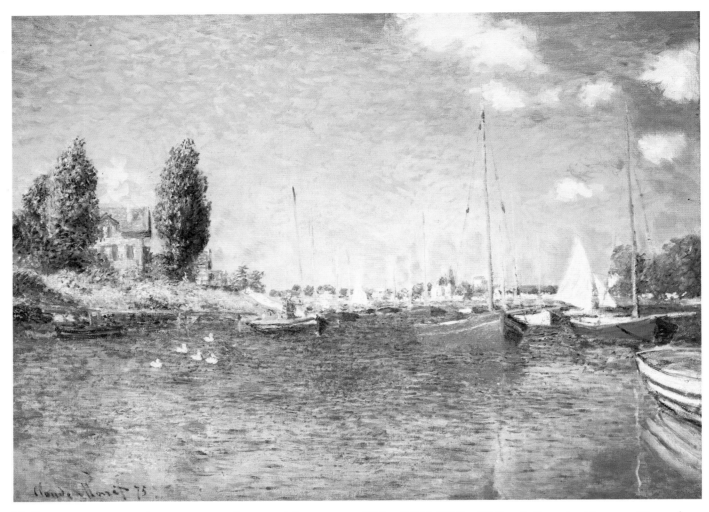

23-8 Claude Monet. *Red Boats, Argenteuil.* 1875. Oil on canvas, 23½ x 31⅝" (59.7 x 80.3 cm). Fogg Art Museum, Harvard University Art Museums, Cambridge, Massachusetts

In the late 1860s and early 1870s Monet and his friend Auguste Renoir worked closely together to develop Impressionism into a fully mature style, one that proved ideally suited to painting outdoors. Monet's *Red Boats, Argenteuil* (fig. 23-8) captures to perfection the intense sunlight along the Seine near Paris, where the artist was spending his summers. Now the flat brushstrokes have become flecks of paint, which convey an extraordinary range of visual effects. The amazingly free brush weaves a tapestry of rich color inspired by the late paintings of Delacroix (compare fig. 22-9). Despite its

spontaneity, Monet's technique retains an underlying logic in which each color and brushstroke has its place. As an aesthetic, then, Impressionism was hardly the straightforward realism it first seems. It nevertheless remained an intuitive approach, even in its color, although the Impressionists were familiar with many of the optical theories that were to provide the basis for Seurat's Divisionism (see page 541).

Renoir The Impressionist painters answered Baudelaire's call to artists to capture the "heroism of

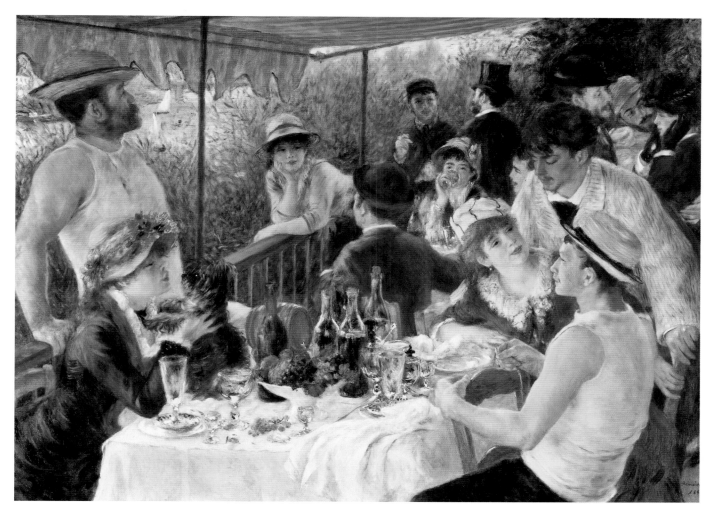

23-9 Auguste Renoir. *Luncheon of the Boating Party, Bougival.* 1881. Oil on canvas, 51 x 68" (129.5 x 172.7 cm). The Phillips Collection, Washington, D.C.

modern life" by depicting its dress and its pastimes. Scenes from the world of entertainment—dance halls, cafés, concerts, the theater—were favorite subjects for them. These carefree views of bourgeois pleasure are flights from the cares of daily life. Although he helped to create the Impressionist landscape style, Auguste Renoir (1841–1919) began as a figure painter who took Manet as his point of departure, and his finest works after 1875 focus on people. *Luncheon of the Boating Party, Bougival* (fig. 23-9) is filled with the joy of life. The painting is a masterly orchestration of color and light aided by the lively brushwork. (Note the reflections on the glasses and bottles.) The group of merrymakers, all friends of the artist, has an air of spontaneity worthy of Steen or Hogarth (compare figs. 18-15 and 20-8). Yet the composition is actually controlled by a strong underlying geometry. This firm structure lends stability to the apparent informality and fixes the viewer's position, so that we become participants in the festive gathering. Thus we have no difficulty imagining ourselves leaning against a railing and observing the scene with the same casualness as the man in the straw hat. (The young woman with a dog was soon to become Renoir's wife.)

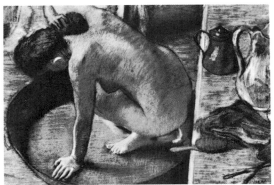

23-11 Edgar Degas. *The Tub*. 1886. Pastel, 23¹/₂ x 32³/₈" (59.7 x 82.3 cm). Musée d'Orsay, Paris

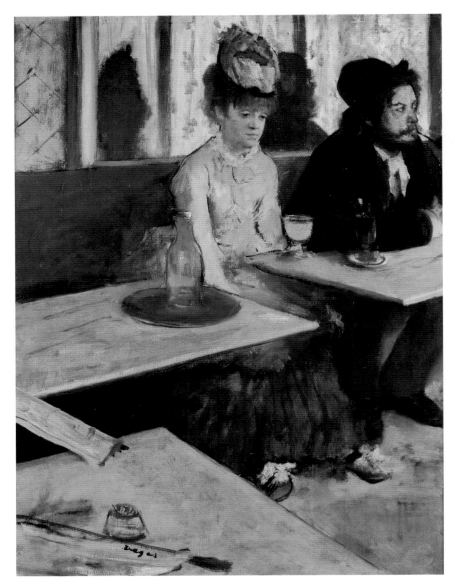

23-10 Edgar Degas. *The Glass of Absinthe*. 1876. Oil on canvas, 36 x 27" (91.3 x 68.7 cm). Musée d'Orsay, Paris

Degas Edgar Degas (1834–1917), a wealthy aristocrat by birth, had a deep understanding of human character that lends significance even to seemingly casual scenes such as *The Glass of Absinthe* (fig. 23-10). He makes us look steadily at the disenchanted pair in his café scene, but out of the corner of our eye, so to speak. The design of this picture at first seems as unstudied

as a snapshot. (Degas practiced photography, although it was not yet capable of capturing an instant on the fly.) However, a longer look shows us that everything here dovetails precisely. The zigzag of empty tables between us and the unfortunate couple reinforces their brooding loneliness, for example. Compositions as boldly calculated as this set Degas apart from other Impressionists. The artist had been trained in the tradition of Ingres, whom he greatly admired, and did not abandon his early loyalty to draftsmanship. When he joined the Impressionists, he always stood slightly outside the movement by refusing to adopt its name.

The Tub (fig. 23-11), of a decade later, is another oblique view, but now severe, almost geometric, in design. The tub and the crouching woman, both strongly outlined, form a circle within a square, and the rest of the rectangular format is filled by a shelf so sharply tilted that it almost shares the plane of the picture. Yet on this shelf Degas has placed two pitchers that are hardly foreshortened at all. (Note how the curve of the small one fits the handle of the other.) Here the tension between the "two-D" surface and "three-D" depth comes close to the breaking point. *The Tub* is Impressionist only in its shimmering, luminous colors. Its other qualities are more characteristic of the 1880s, the first Post-Impressionist decade, when many artists showed a renewed concern with problems of form (see chapter 24).

Morisot The Impressionists' ranks included several women of great ability. The subject matter of Berthe Morisot (1841–1895), a member of the group from its beginning, was the world she knew: the domestic life of the French upper middle class, which she depicted with rare sympathy. Morisot's early paintings, centering on her mother and her sister Edma, were directly influenced by Manet, whose brother she later married. Her mature work is altogether different in character.

Morisot's characteristic themes are women and children, sometimes alone, sometimes together. Usually her figures are engrossed in reading or lost in thought, but they always stay in their private world. Morisot's pictures at first convey a subtle sense of alienation through activities undertaken together, yet not shared—of experiences encountered in a world from which they remain isolated. Later it is human relationships that are the real subjects of her canvases, even when a single figure is shown, for the artist is always present in a subtle way.

The Cradle (fig. 23-12) shows Edma looking tenderly at her daughter Blanche. Although asleep, the infant is now her mother's sole object of attention. For Morisot it is the maternal bond that fascinates—and that was not fulfilled until the birth of her own daughter, Julie, in 1878. Morisot applied her brushwork with a sketchlike brevity that omits unessential details, yet conveys a complete impression of the scene through the careful balance of the compositional elements. The serene painting radiates an air of tenderness free of the sentimentality that often affects genre paintings of the period.

Cassatt Surprisingly, Americans responded to the new style sooner than Europeans did and became the first patrons of the Impressionists. At a time when no French museum would have them, Impressionist works entered public collections in the United States. American painters such as James Abbott McNeill Whistler (see below) and Mary Cassatt (1845–1926) were among the earliest followers of Manet and his circle. Cassatt joined the Impressionists in 1877 and became a tireless champion of their work. She had received

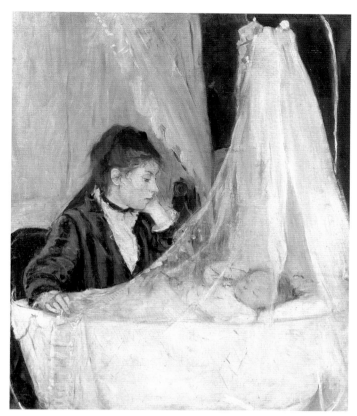

23-12 Berthe Morisot. *The Cradle*. 1872. Oil on canvas, 22 x 18¹/₈" (55.9 x 46 cm). Musee d'Orsay, Paris

a standard academic training in her native Philadelphia but had to struggle to overcome traditional barriers. Although painting was viewed as an unsuitable occupation for a woman, Cassatt, like Morisot, was able to pursue her career as an artist because she was independently wealthy. She helped to gain early acceptance for Impressionist paintings in the United States through her social contacts with wealthy private collectors. Although she never married or had children, maternity provided the thematic and formal focus of most of her work. Cassatt developed a highly accomplished individual style. *The Bath* (fig. 23-13, page 522) is a masterpiece from her mature period. The oblique view, simplified color forms, and flat composition show the impact of her mentor, Degas, as well as her study of Japanese prints. Despite the complexity of its design, the painting has a directness that lends simple dignity to motherhood.

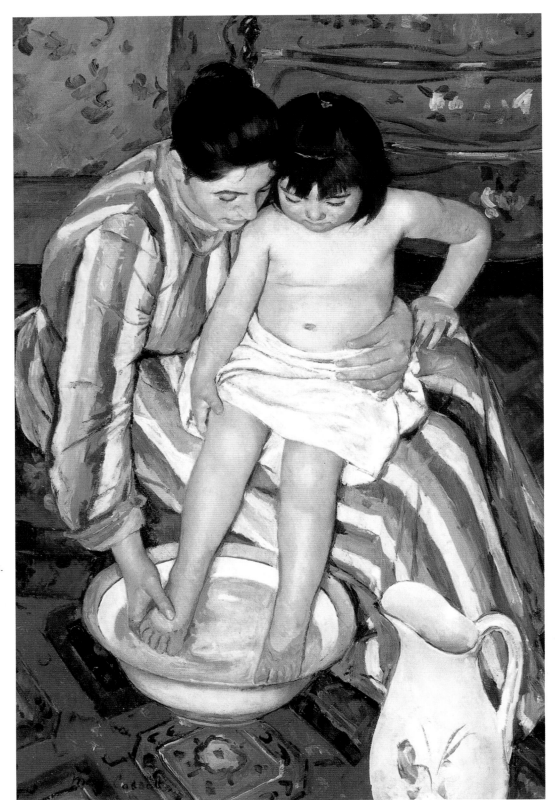

23-13 Mary Cassatt. *The Bath.*
1891–92. Oil on canvas,
39^1/$_2$ x 26" (100.3 x 66 cm).
The Art Institute of Chicago

Robert A. Waller Collection

Monet's Later Works By the mid-1880s, Impressionism had become widely accepted. Its technique was imitated by conservative painters and practiced as a fusion style by a growing number of artists worldwide. Ironically, the movement now underwent a deep crisis. Manet died in 1883. Renoir, already beset by doubts, moved toward a more classical style. Racked by internal dissension fostered by Degas, the group held its last show in 1886. Among the major figures of the movement, only Monet remained faithful to the Impressionist view of nature. Although his work became more subjective over time, he never ventured into fantasy, nor did he forsake the basic approach of his earlier landscapes.

About 1890 Monet began to paint pictures in series, showing the same subject under different conditions of light and atmosphere. These tended increasingly to resemble Turner's "airy visions, painted with tinted steam," as Monet concentrated on the effects of colored light. (He had visited London in 1870 and knew Turner's work; see pages 493–95.) His *Water Lilies* (fig. 23-14) is a fascinating sequel to *On the Bank of the Seine, Bennecourt*

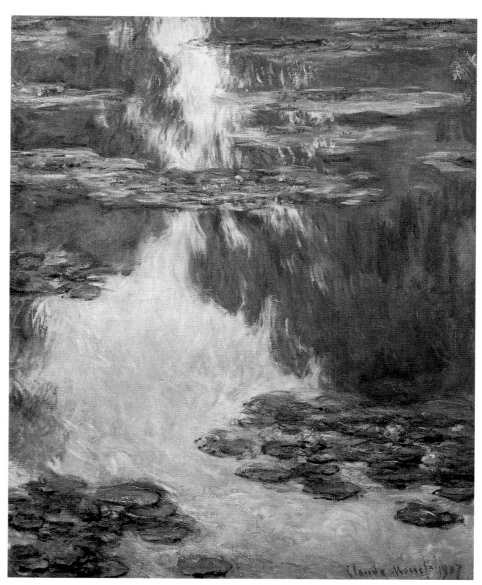

23-14 Claude Monet. *Water Lilies*. 1907. Oil on canvas, 36¹/₂ x 29" (92.7 x 73.7 cm). Kawamura Memorial Museum of Art, Sakura City, Chiba Prefecture, Japan

(see fig. 23-7), painted almost 40 years earlier. The surface of the pond now takes up the entire canvas, so that the effect of a weightless screen is stronger than ever. The artist's brushwork, too, has greater variety and a more individual rhythm. While the scene is still based on nature, this is no ordinary landscape but one entirely of his making. On the estate at Giverny, given to him late in life by the French government, Monet created a self-contained world for purely personal and artistic purposes. The subjects he painted there are as much reflections of his imagination as they are of reality. They convey a very different sense of time as well. Instead of the single moment captured in *On the Bank of the Seine,* his *Water Lilies* summarizes a shifting impression of the pond in response to the changing water as breezes play across it.

ENGLAND

The Pre-Raphaelites By the time Monet came to admire his work, Turner's reputation was at a low in his own country. In 1848 the painter and poet Dante Gabriel Rossetti (1828–1882) helped found an artists' society called the Pre-Raphaelite Brotherhood. The Pre-Raphaelites' basic aim was to do battle against the frivolous art of the day by producing "pure transcripts . . . from nature" and by having "genuine ideas to express." As the name of the society proclaims, its members took their inspiration from the "primitive" masters of the fifteenth century. To that extent, they belong to the Gothic revival, which had long been an important aspect of the Romantic movement. What set the Pre-Raphaelites apart from the Romantics was an urge to reform the ills of modern civilization through their art. In this desire they were aroused by Chartism, a democratic working-class movement that reached its peak in the revolutionary year 1848.

Rossetti himself was not concerned with social problems, however; he thought of himself as a reformer of aesthetic sensibility. The vast majority of his work consists of watercolors or pastels showing women taken from literary sources, but all bear a striking resemblance to his wife, Elizabeth Siddal. *Beata Beatrix* (fig. 23-15), created as a memorial to Siddal, imposes her features on the beloved of his

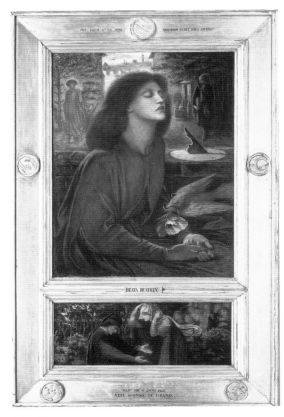

23-15 Dante Gabriel Rossetti. *Beata Beatrix.* 1872. Oil on canvas, 34½ x 27¼" (87.5 x 69.3 cm); predella 10½ x 27¼" (26.5 x 69.3 cm). The Art Institute of Chicago

Charles L. Hutchinson Collection

namesake, the Italian poet Dante, whose account of her death inspired the painting. Rossetti explained the program in considerable detail: "The picture illustrates the 'Vita Nuova,' embodying symbolically the death of Beatrice as treated in that work. The picture is not intended at all to represent death, but to render it under the semblance of a trance. . . . I have introduced . . . the figures of Dante and Love passing through the street and gazing ominously on one another, conscious of the event; while the bird, a messenger of death, drops the poppy between the hands of Beatrice. She, through her shut lids, is conscious of a new world." In this version, the artist has expressed the hope of seeing his beloved Elizabeth again by adding a second panel showing Dante and Beatrice meeting in

paradise and inscribing the dates of their deaths on the frame. For all its apparent spirituality, the painting has an aura of repressed eroticism that is the hallmark of Rossetti's work. It exerted a powerful influence on other Pre-Raphaelites as well.

Morris William Morris (1834–1896) started out as a Pre-Raphaelite painter but soon shifted his interest to "art for use": domestic architecture and interior decoration such as furniture, tapestries, and wallpapers. He wanted to displace the shoddy products of the machine age by reviving the handicrafts of the preindustrial past, an art "made by the people, and for the people, as a happiness to the maker and the user."

Morris was an apostle of simplicity. Architecture and furniture ought to be designed in accordance with the nature of their materials and working processes. Surface decoration likewise must be flat rather than illusionistic. His interiors (fig. 23-16) are total environments that create an effect of quiet intimacy. Despite Morris's self-proclaimed championship of the medieval tradition, he did not imitate its forms directly but instead sought to capture its spirit. His achievement was to invent the first original system of ornament since the Rococo.

Through the many enterprises he sponsored, as well as his skill as a writer and publicist, Morris became a tastemaker without peer in his day. Toward the end of the century, his influence had spread throughout Europe and the United States. Nor was he content to reform the arts of design alone. He saw them, rather, as a lever by which to reform modern society as a whole. As a result, he played an important part in the early history of Fabianism, a gradualist variety of socialism invented in England as an alternative to the revolutionary socialism of the Continent.

UNITED STATES

Whistler James Abbott McNeill Whistler (1834–1903) came to Paris from America in 1855 to study painting. Four years later he moved to London, where he spent the rest of his life, but he visited France during the 1860s and was in close touch with the rising Impressionist movement. *Arrangement in Black and Gray: The Artist's Mother* (fig. 23-17), his best-known painting, reflects the influence of

23-16 William Morris (Morris & Co.). Green Dining Room. 1867. Victoria & Albert Museum, London

Crown copyright reserved

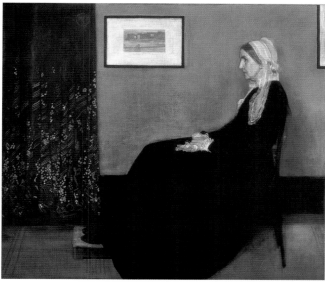

23-17 James Abbott McNeill Whistler. *Arrangement in Black and Gray: The Artist's Mother.* 1871. Oil on canvas, 57 x 64½" (144.8 x 163.8 cm). Musée d'Orsay, Paris

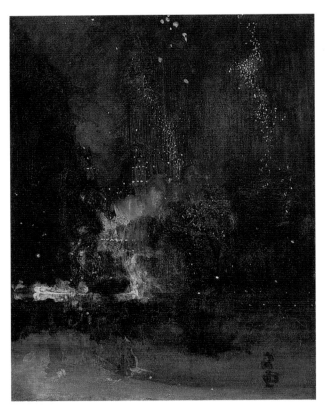

23-18 James Abbott McNeill Whistler. *Nocturne in Black and Gold: The Falling Rocket.* c. 1874. Oil on panel, 23³/₄ x 18³/₈" (60.2 x 46.8 cm). The Detroit Institute of Arts

Gift of Dexter M. Ferry, Jr.

Manet in its emphasis on flat areas, while the likeness has the austere precision of Degas. Its fame as an icon of motherhood would have horrified Whistler, who wanted the canvas to be appreciated for its formal qualities alone.

A witty, sharp-tongued advocate of "art for art's sake," he thought of his pictures as comparable to pieces of music and often called them "symphonies" or "nocturnes." The boldest example, painted about 1874, is *Nocturne in Black and Gold: The Falling Rocket* (fig. 23-18). Without an explanatory subtitle, we would have real difficulty making out the subject. No French painter had yet dared to produce a picture so "nonrepresentational," so reminiscent of Turner's "tinted steam" (see fig. 22-17). It was this canvas, more than any other, that prompted John Ruskin to accuse Whistler of "flinging a pot

of paint in the public's face." (Since the same critic had highly praised Turner's *Slave Ship,* we must conclude that what Ruskin admired was not the tinted steam itself but the Romantic feeling behind it.) During Whistler's successful suit for libel, he offered a definition of his aims that seems particularly relevant to *The Falling Rocket:* "I have perhaps meant rather to indicate an artistic interest alone in my work, divesting the picture from any outside sort of interest. . . . It is an arrangement of line, form, and color, first, and I make use of any incident of it which shall bring about a symmetrical result." The last phrase has special significance, since Whistler acknowledges that in using chance effects, he does not look for resemblances but for a purely formal harmony. While he rarely practiced what he preached to quite the same extent as he did in *The Falling Rocket,* his statement reads like a prophecy of American abstract painting (see fig. 25-35).

Homer After the Civil War, the United States underwent unprecedented industrial growth, immigration, and westward expansion. These changes led to not only a new range of social and economic problems but also a different outlook and taste. As the United States became more like the Old World, Americans traveled abroad in growing numbers and found their cultural models in Europe, particularly France, which led to a new cosmopolitanism in art. There was an equally dramatic shift in the attitude toward nature. The uneasy balance between civilization and nature shifted once and for all in favor of progress by the end of the Centennial Celebration in 1876.

Winslow Homer (1836–1910) was a pictorial reporter during the Civil War and continued as a magazine illustrator until 1875. He went to Paris in 1866, but although he left too soon to feel the full impact of Impressionism, French art had an important effect on his work. *Snap the Whip* (fig. 23-19) conveys a nostalgia for a simpler era of America before the Civil War (see fig. 22-20). The sunlit scene might be called pre-Impressionist. Its fresh delicacy lies halfway between Corot and Monet (compare figs. 22-11 and 23-7). The air of youthful innocence relies equally

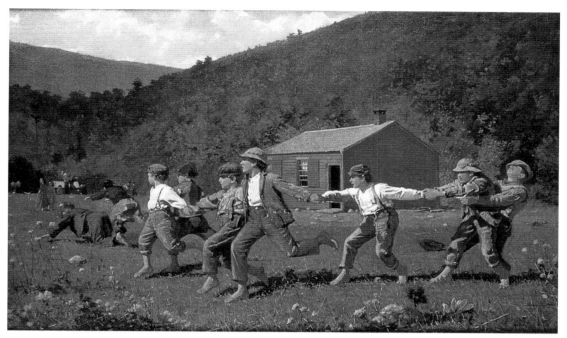

23-19 Winslow Homer. *Snap the Whip*. 1872. Oil on canvas, 22¼ x 36½" (56.5 x 92.7 cm). The Butler Institute of Art, Youngstown, Ohio

on the composition, which was inspired by the bacchanals then popular in French art (compare Carpeaux's *Dance*, fig. 22-23).

Eakins Thomas Eakins (1844–1916) arrived in Paris from Philadelphia about the same time as Homer. He went home four years later, after receiving a conventional academic training but with decisive impressions of Velázquez and Courbet. Elements from both these artists are combined in *William Rush Carving His Allegorical Figure of the Schuylkill River* (fig. 23-20, page 528; compare figs. 17-18 and 23-2). Eakins had encountered stiff opposition for advocating traditional life studies at the Pennsylvania Academy of the Fine Arts. To him, Rush was a hero for basing his 1809 statue for the Philadelphia Water Works on the nude model, although the figure itself was draped in a classical robe. Eakins no doubt knew contemporary European paintings of sculptors carving from the nude; these were related to the theme of PYGMALION and GALATEA, popular at the time among academic artists. Conservative critics nevertheless denounced

the picture for its nudity, despite the presence of the chaperon knitting quietly to the right. Today the painting's declaration of unvarnished truth seems a courageous fulfillment of Baudelaire's demand for pictures that express the "heroism of modern life."

Tanner Thanks in large part to Eakins's enlightened attitude, Philadelphia became the leading center of minority artists in the United States. Eakins encouraged women and blacks to study art seriously at a time when professional careers were closed to them. African-Americans had no chance to enter the arts before Emancipation, and after the Civil War the situation improved only gradually. Henry O. Tanner (1859–1937), the first important black painter, studied with Eakins in the early 1880s. Tanner's masterpiece, *The Banjo Lesson* (fig. 23-21, page 528), painted after he moved permanently to Paris, bears Eakins's unmistakable influence. Avoiding the mawkishness of similar subjects by other American painters, the scene is rendered with the same direct realism as *William Rush Carving His Allegorical Figure of the Schuylkill River*.

In Greek mythology, PYGMALION was a Greek sculptor, the king of Crete, and a misogynist. The exception to his detestation of women was a sculpture he carved of the goddess Aphrodite; he fell in love with it and married the sculpted Aphrodite after the goddess endowed it with life. The Pygmalion story involving GALATEA (see page 317) inspired a comedy published in 1871 by W. S. Gilbert, later the librettist of the Gilbert and Sullivan comic operas popular since the late nineteenth century.

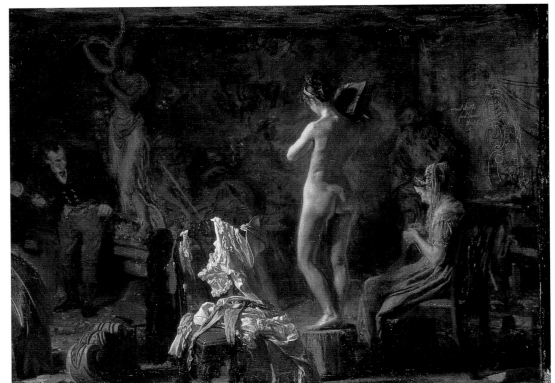

23-20 Thomas Eakins.
*William Rush Carving His
Allegorical Figure of the Schuylkill
River.* 1877. Oil on canvas,
20¹/₈ x 26¹/₂" (51.1 x 67.3 cm).
Philadelphia Museum of Art

Given by Mrs. Thomas Eakins and Miss
Mary A. Williams

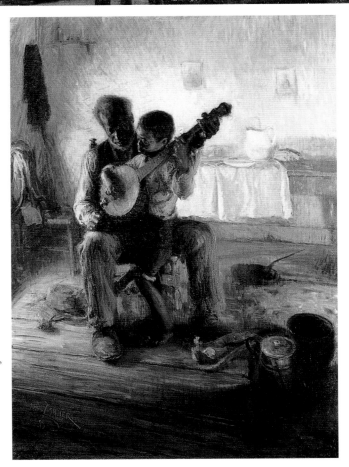

23-21 Henry O. Tanner.
The Banjo Lesson. c. 1893.
Oil on canvas, 48 x 35"
(121.9 x 88.9 cm). Hampton
University Museum, Hampton,
Virginia

Sculpture

Impressionism, it is often said, revitalized sculpture no less than painting. The statement is at once true and misleading. Although Auguste Rodin and Edgar Degas redefined sculpture during the 1880s, it was impossible to reproduce the effect of such pictures as *On the Bank of the Seine* in three dimensions and without color.

Rodin Auguste Rodin (1840–1917), the first Western sculptor of genius since Bernini, experienced one rejection after another early in his career. Not until 1880 was he at last given a major commission: the entrance of the École des Arts Décoratifs in Paris. Rodin developed it into an ambitious ensemble called *The Gates of Hell,* which, characteristically, he never finished. The symbolic program was inspired by Dante's *Inferno,* but it was equally indebted to Baudelaire's *Flowers of Evil.* Its common denominator is a tragic view of the human condition: guilty passions, desire forever unfulfilled here and in the beyond, the vain hope of happiness. The perceptive critic Gustave Geffroy, writing of *The Gates* in 1889, defined their subject as the endless reenactment of the sufferings of Adam and Eve. Indeed, Rodin had tried in 1881 to persuade the government to let him flank *The Gates* with statues of the first man and woman.

The Gates of Hell served as the framework for countless smaller pieces that were eventually made into independent works. Rodin had always thought that the sculptor's noblest task was to show the nude human form. And he continued to believe that the sculptor's purpose was to create "new classics." To him, however, this idea meant works that were free from the dictates of the patron and demanded to be judged on their own terms—without regard to traditional standards of beauty and ugliness.

The most famous of these separate fragments is *The Thinker* (fig. 23-22). The figure was intended for the lintel of *The Gates,* where it could contemplate the panorama of despair below. It derives partly from a statue by Carpeaux of another subject from *The Inferno,* Ugolino and his sons. The ancestry of *The Thinker* can be traced back much

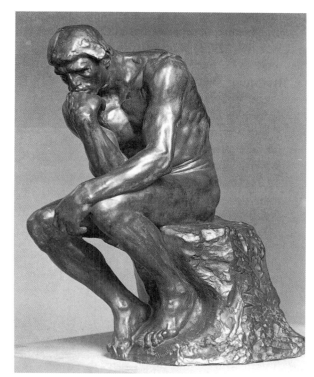

23-22 Auguste Rodin. *The Thinker.* 1879–89. Bronze, height 27¹/₂" (69.8 cm). The Metropolitan Museum of Art, New York

Gift of Thomas F. Ryan, 1910

further, however. It descends indirectly from depictions of Adam in the first phase of Christian art. It also includes the action-in-repose of Michelangelo's superhuman bodies (see fig. 13-11) and the tension in Puget's *Milo of Crotona* (see fig. 19-12, especially the feet).

Who is *The Thinker?* In the context of *The Gates of Hell,* he was originally conceived as a generalized image of Dante (see page 251), the poet who in his mind's eye sees what goes on all around him. Once Rodin decided to detach him from *The Gates,* he became *The Poet-Thinker,* and finally just *The Thinker.* But what kind of thinker? Partly Adam, no doubt (although there is also a different Adam by Rodin, another "outgrowth" of *The Gates*); partly PROMETHEUS; and partly the brute imprisoned by the passions of the flesh. Rodin wisely refrained from giving him a specific name, for the statue fits no established type. In

PROMETHEUS was a descendant of the Titans, the 12 primeval deities of Greece. A great benefactor of humans, he is even thought in some legends to have created them, using clay and water. When he stole fire from heaven to give it to his protégés, Prometheus angered Zeus, who chained him to a rock in the mountains, where an eagle fed on his liver. He was eventually rescued—some say by Hercules, others say by revealing an important secret to Zeus.

this new image of a man, form and meaning are one, instead of separated as in Carpeaux's *Dance* (see fig. 22-23). Carpeaux's naked figures pretend to be nude. *The Thinker*, by contrast, is a true nude, like those of Michelangelo: it is no longer bound to the undressed model.

Unlike Michelangelo, Rodin was by instinct a modeler, not a carver, although we have a number of excellent marbles by his hand. His greatest works, for the most part, were meant to be cast in bronze. (Even these, however, reveal their full strength only when we see them in plaster casts made directly from Rodin's originals.) What Rodin accomplished is strikingly visible in *The Thinker*. The welts and wrinkles of the vigorously creased surface produce, in polished bronze, an ever-changing pattern of reflections. But is this effect borrowed from Impressionist painting? Does Rodin actually dissolve three-dimensional form into flickering patches of light and dark? The fiercely exaggerated shapes pulsate with sculptural energy, and they retain this quality under whatever conditions the piece is viewed. Because the sculptor modeled his figures in wax or clay, he could not have calculated in advance the reflections on the bronze surfaces of the casts made from these models. His working method was thus intended not to capture elusive optical effects but to emphasize the process of "growth"—the miracle of dead matter coming to life in the artist's hands. As the color patch for Manet and Monet is the primary reality, so are the malleable lumps from which Rodin builds his forms. By insisting on this "unfinishedness," he rescued sculpture from mechanical reproduction just as Manet rescued painting from photographic realism.

The *Monument to Balzac* was Rodin's last, as well as most daring and controversial, creation (fig. 23-23). The sculpture was rejected by the writers' association that had commissioned it, and remained in plaster for many years. He had been asked at the insistence of the author Émile Zola to take over the project when the first sculptor died after producing only a sketch. Rodin declared it to be "the sum of my whole life. . . . From the day of its conception, I was a changed man." Outward appearance did not pose a problem (Balzac's features were well known). But Rodin wanted far more than that. He was searching for a way to cast Balzac's whole personality into visible form, without the addition of allegorical figures, which were the usual props of monuments to genius. The final version gives no hint of the many alternative solutions he tried. (More than 40 have survived.) The element common to them all is that Balzac is standing, in order to express the virile energy Rodin saw in his subject.

The final sculpture shows the writer clothed in a long dressing gown—described by his contemporaries as a "monk's robe"—which he liked to

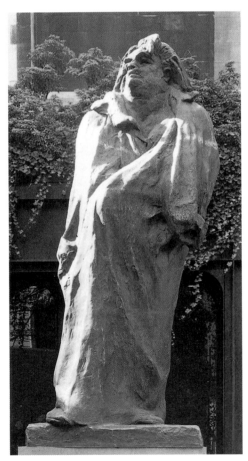

23-23 Auguste Rodin. *Monument to Balzac.* 1897–98. Bronze (cast 1954), height 9'3" (2.82 m). The Museum of Modern Art, New York

Presented in Memory of Curt Valentin by His Friends

wear while working at night. Here was a "time-less" costume that permitted Rodin to conceal and simplify the contours of the body. Seized by a sudden creative impulse, Balzac awakens in the middle of the night. Before he settles down to record his thoughts on paper, he hastily throws the robe over his shoulders without putting his arms through the sleeves. But, of course, Balzac is not about to write. He looms before us with the awesome power of a phantom, completely unaware of his surroundings. The entire figure leans backward to stress its isolation from the viewer. The statue is larger than life, physically and spiritually: it has an overpowering presence. Like a huge monolith, the man of genius towers above the crowd. He shares "the sublime egotism of the gods" (as the Romantics put it). From a distance we see only the great bulk of the figure. The head thrusts upward—one is tempted to say, erupts—with elemental force from the mass formed by the shroudlike cloak. When we are close enough to make out the features clearly, we sense beneath the disdain an inner agony that stamps *Balzac* as the kin of *The Thinker*.

To this day, *Balzac* remains a startling sight. Rodin had indeed reached the outer limits of his art, as he himself realized. The question remains, Why did he never have the sculpture cast in bronze, even though a wealthy private collector offered to pay for it? A possible answer is suggested by its compact shape, which certainly lent itself to a marble statue; it may be that he visualized the monument as one all along.

Degas The fundamental difference between painting and modeling is illustrated by the fact that only Degas among the Impressionists produced sculpture. He made dozens of small-scale wax figurines that explore the same themes as his paintings and drawings. (Renoir's late sculptures were actually done by an assistant according to his instructions and thus do not qualify.) They are private works made for his own interest. Few of them were exhibited during the artist's lifetime, and none were cast until after his death in1917.

During the 1870s there was a growing taste for casts made from artists' working models. It reflected the same appreciation for spontaneity and inspi-

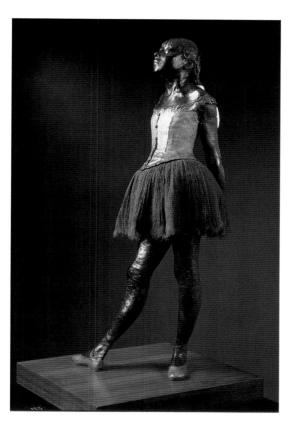

23-24 Edgar Degas. *The Little Fourteen-Year-Old Dancer.* 1878–80. Bronze with gauze tutu and satin hair ribbon, height 38" (96.5 cm). Norton Simon Art Foundation, Pasadena, California

ration found in drawings and oil sketches, which had long appealed to collectors. This preference, which dates back to Rodin's ideal, Michelangelo, was essentially an outgrowth of the Romantic cult of originality, not of Impressionism. It was felt that quick, unfinished, even fragmentary works conveyed the force of the artist's vision more directly than any finished piece could. For the first time sculptors felt free to violate time-honored standards of naturalism and craftsmanship for statuettes, and to leave the impress of their fingers on the soft material as they molded it. Nevertheless, when Degas showed the wax original of *The Little Fourteen-Year-Old Dancer* at the Impressionist exhibitions of 1880 and 1881, the public was scandalized by its lack of traditional finish and its uncompromising observance of unvarnished truth. (The response from critics was less harsh.) The sculpture, reproduced here in a posthumous cast (fig. 23-24), is nearly as rough in texture as the slightly smaller nude study from life on which it is based.

Instead of sculpting her costume, Degas used real cotton and silk, a revolutionary idea for the time but something the Romantics, with their insistent naturalism, must often have felt tempted to do. Degas was intrigued by the tension between the concrete surface and the abstract but powerfully directional forces beneath it. The ungainliness of the young adolescent's body is subtly emphasized by her pose, that of a dancer at "stage rest." In Degas's hands it becomes an extremely stressful one, so full of sharply contrasting angles that no dancer could maintain it for more than a few moments. Yet, rather than awkwardness, the statuette conveys a simple dignity and grace that are irresistible. The openness of the stance, with hands clasped behind the back and legs pointing in opposite directions, demands that we walk around the dancer to arrive at a complete image of it. As we view the sculpture from different angles, the surface provides a constantly shifting impression of light akin to that in Degas's numerous paintings and pastels of the ballet.

Architecture

For more than a century, from the mid-eighteenth to the late nineteenth, architecture had been dominated by a succession of "revival styles" (see pages 502–6). This term, we will recall, does not mean that earlier forms were slavish copies. The best work of the time has both individuality and high distinction. Moreover, as we have seen, each successive phase of revivalism mirrored a different facet of Neoclassical and Romantic thought. Yet the architecture of the past, however freely interpreted, proved in the long run to be inadequate to the practical demands of the Industrial Age (see box, pages 534–35). The problem became one not simply of how to utilize a host of new materials and techniques, including cast iron, in the most utilitarian of structures such as factories and warehouses, but also how to apply them to the stores, apartments, libraries, and other city buildings that formed the bulk of construction.

The French philosopher Auguste Comte (1798–1857) was the founder of a system of thought known as POSITIVISM, which rejected speculation and metaphysics as ways to arrive at truth, relying instead upon objective observation and scientific experimentation. Comte, a reformer, aimed to use the principles of science to create a harmonious society. His doctrine dominated nineteenth-century philosophical thought and is still influential in the school of philosophy known as logical positivism.

Labrouste A famous early example is the Bibliothèque Ste-Geneviève in Paris by Henri Labrouste (1801–1875). He entered the École des Beaux-Arts in 1819, the year it opened, and was quickly recognized for his brilliance. In 1824 he won the Prix de Rome and spent five years in Italy studying classical architecture on a government stipend. Labrouste's radical ideas established him among the leaders of the younger generation after his return during the turbulent year 1830, when the French government was overthrown. The Bibliothèque Ste-Geneviève was his first important commission, and it made his reputation.

The exterior (fig. 23-25) represents the early Beaux-Arts style at its finest. It conforms to the historicism prevalent at midcentury. The facade is drawn chiefly from Italian Renaissance banks, libraries, and churches, but the two-tiered elevation also looks back to Perrault's east front of the Louvre (see fig. 19-5). At the last minute, Labrouste hit on the brilliant idea of inscribing the names of great writers around the facade to identify the building as a library. (The letters were originally painted red for legibility.) What led him to use this simple but ingenious device was the library's location just behind Soufflot's church of Ste-Geneviève, which, it will be recalled, had been secularized during the French Revolution and renamed the Panthéon (see fig. 21-11). Labrouste, in effect, has turned his library into a pantheon as well—but one dedicated to literary and intellectual, not national, heroes. The facade is thus an expression of Auguste Comte's POSITIVISM, in which the rows of names act like so many rows of newsprint, with embossed decoration, to denote the library as the setting for human activity.

The reading room (fig. 23-26), by contrast, recalls the nave of a French Gothic cathedral (compare fig. 11-7). The combination of the classical and the Gothic again pays homage to Soufflot, whose goal was to combine them. Barrel vaults supported by columns, although derived from Romanesque churches, had been introduced into Renaissance libraries and soon became a common feature of reading rooms. Barrel-vaulted libraries enjoyed renewed popularity in England and on

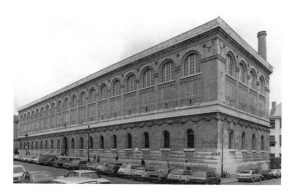

23-25 Henri Labrouste. Bibliothèque
Ste-Geneviève, Paris. 1843–50

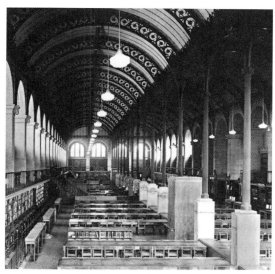

23-26 Henri Labrouste. Reading Room,
Bibliothèque Ste-Geneviève

the Continent during the 1830s. To Labrouste, barrel vaults undoubtedly looked "Gothic." (The term *Romanesque* had not yet been coined.) They had the further advantage of acquiring literary associations through the addition of the classical columns. In this way he united the two main systems of Western architecture, thereby fulfilling the program of Soufflot and the Structural Rationalists.

Labrouste's enthusiasm for the Gothic arose from his contact with the writer Victor Hugo, who consulted him on technical questions for his novel *Notre-Dame de Paris* (The Hunchback of Notre-Dame). Hugo believed that architecture was originally a form of writing, which had reached its zenith in the Greek and Gothic eras. In a similar vein, Labrouste once wrote that the Temple of Hera at Paestum (see fig. 5-8) had been "covered with painted notices, serving as a book." Hugo, and most likely Labrouste himself, was strongly influenced by the Socialist followers of the comte de Saint-Simon. They regarded Greek and Gothic architecture as ideal "organic" phases, to be succeeded by a third one expressing a new social philosophy, moral values, and religious beliefs. Such egalitarian ideas, further shaped by Charles Fourier, were appropriate to the library, which was for general use by the public. But why did Labrouste choose cast-iron columns and arches? Cast iron was not necessary to provide support for the two barrel roofs—this function could have been filled using other materials. Rather, it was essential to the com-

pletion of the building's symbolic program. With the Bibliothèque Ste-Geneviève he announced that technology would provide the new tradition to succeed the Classical and the Gothic.

Labrouste boldly left the interior iron skeleton uncovered, rather than disguising it. His solution does not fully integrate the two systems but lets them coexist. The iron supports, shaped like **Corinthian columns**, are as slender as the new material permits. Their collective effect is that of a space-dividing screen that denies their structural importance. To make them appear weightier, Labrouste has placed them on tall pedestals of solid masonry, instead of directly on the floor. Aesthetically the arches presented greater difficulty, since there was no way to make them look as powerful as their masonry ancestors. Here Labrouste has gone to the other extreme, perforating them with lacy scrolls as if they were pure ornament, so that the vaulting has a fanciful and delicate quality. This daring architectural (as against merely structural) use of exposed iron members created a sensation and placed Labrouste in the forefront of French architecture, although it had already been tried 30 years earlier in England. The reading room featured another innovation as well. It was the first of its kind to be lit by gas, making it usable at night.

After about 1780, in the world of commercial architecture we find the gradual introduction of new materials and techniques that were to have a profound effect on architectural style by 1900. Of these by far the most important was iron, which was used as early as the fourth millennium B.C. and began to be made on a large scale beginning in the fourteenth century. Pig iron, smelted in blast furnaces, can be poured into molds to make cast iron, which has relatively high amounts of carbon and impurities (slag), so that it is brittle. Wrought iron, introduced around 1820, is soft and malleable (hence its name) but, having less carbon and slag, possesses greater tensile strength, making it ideal for bolts, ties, and trusses. Steel is an even stronger alloy of iron and small amounts of carbon that is also ductile and corrosion-resistant. (Technically, most nineteenth-century steel was really a form of wrought iron, since it lacked other elements, such as nickel, chromium, and aluminum, which were added after 1900 for greater hardness.) It was handmade until the 1850s, when the Englishman Henry Bessemer and the American William Kelly independently invented a commercial process to remove the impurities by introducing oxygen, which also heated the iron in a converter of steel lined with silica. The open-hearth furnace, devised in 1864 by William and Frederick Siemens, used regenerative preheating of air to smelt a combination of iron ore and pig iron at extremely high temperatures. The only major advances since then have been the basic-oxygen process and the electric furnace.

CAST IRON was first mass-produced for rails by Abraham Darby in 1767. Fires at textile mills led to the use of cast-iron pillars in the 1780s, then beams during the following decade. Cast-iron columns were also introduced in churches as early as the 1780s; soon the structural elements of churches were being built almost entirely of iron—for example, St. George at Merseyside, erected in 1812–13 by the architect Thomas Rickman and iron founder John Cragg, which uses an extremely sophisticated structural system, including

Thomas Rickman and John Cragg. Interior, St. George's Church, Everton, Liverpool, England. 1812–13

tension rods to tie it together (see illustration). Cast iron has the advantage of being stronger and more fire-resistant than wood, but it is subject to corrosion and, being an excellent heat conductor, expands and contracts, thereby causing condensation that further contributes to the problem of rust. Iron and steel proved especially useful for bridge spans. The first iron bridge was built in 1777–79 at Coalbrookdale by Abraham Darby III from a design by the architect Thomas F. Pritchard. Construction was greatly improved during the first half of the nineteenth century by the introduction of new truss systems and the riveted I beam. Within a few decades of their first appearance, iron columns and arches became the standard means of supporting roofs over the large spaces required by railroad stations. The first railway shed, built in 1830, was a modest structure using straight beams; the arch became an important form only in the 1840s, as rail lines became increasingly common, first throughout Europe, then in America, and large terminals began to be erected.

Because it can be manufactured with great consistency, iron can be used in predictable ways that can be calculated by using standard mathematical formulas. This property gave rise to new structural systems (notably those by James Bogardus in the 1840s and '50s) that are extremely stable yet lightweight, though they almost always remained completely hidden from view. Technology produced a fundamental change in the practice of architecture, which became increasingly dependent on engineering. As a consequence, the tradition of artists and gifted amateurs practicing as architects was over by 1880. The triumph of the iron age was announced at the world's fair held in Paris in 1889 by the Hall of Machines, designed by Charles Dutert with the engineering team of Contamin, Pierron, and Charton, which is seen behind the Eiffel Tower in figure 23-28. The tower itself was a miracle of engineering, manufacturing, and construction. In addition to being extremely lightweight, it was precast so precisely that no fabrication or cutting was done on the site, only riveting, and planned so carefully

that not a single worker was killed. (Interestingly enough, Eiffel added the arches at the base, similiar to those on his bridges, to assure the viewer that the tower would stand, though they were not structurally necessary.) By this time, iron was already being rapidly supplanted by STEEL. Steel mills sprang up everywhere after 1865 to serve the rail industry, but it was not until the 1880s that long rolled-steel beams began to be produced in large quantities, thanks to the widespread use of the open-hearth furnace. This innovation in turn made possible steel-frame construction, essential to skyscrapers, whose potential was first explored during the same decade in New York and Paris, and then in Chicago.

The difficulty with iron and steel is that they rust and can be damaged by fire. To overcome these limitations, they were embedded in concrete, to make FERROCONCRETE, which is fire- and water-resistant, but has low tensile strength and is subject to erosion. Ferroconcrete thus unites the best of both materials. CONCRETE is made by heating limestone and clay until they almost fuse, then grinding and mixing them with water and stone, sand, or gravel. Used widely by the Romans, it was rediscovered in 1774 by John Smeaton of England. PORTLAND CEMENT, which is stronger and more durable, was invented in 1824 by another Englishman, Joseph Aspdin. The process of making it is similar to that of concrete but uses different materials. Lime, silica, alumina, sulfates, and iron oxide are heated until they nearly coalesce before being ground up and mixed with gypsum. Though a concrete house was built as early as 1837 by J. B. White of England,

cement did not become widely adopted until the 1850s and '60s, when it was employed for sewer systems. It nevertheless remained too expensive for large-scale use before the early 1900s.

Ferroconcrete incorporating tension rods was first patented in 1856 by François Coignet. Iron beams were substituted in patents issued in 1867 and 1878 to Joseph Monier, whose system was improved further by Gustav Adolf Wayss in his important publication of 1887. In 1892 the Belgian François Hennebique replaced iron with steel and enclosed girders in cement for the first time to protect them from fire and corrosion, as well as from the chemical fumes found in factories. Equally important, he combined all supports, walls, and ceilings into a single unit using hooked connections that was far more stable. The final step was taken in the early 1900s by Eugène Freyssinet, who recalculated all the formulas for reinforced concrete and in the process invented PRESTRESSED CONCRETE, which enables curved supports to carry much greater loads and counteracts deterioration of the concrete itself under pressure.

As important as these developments were, modern architecture would not have been possible without others that we now take for granted. PLATE GLASS was introduced in the 1820s, followed by the cheaper SHEET GLASS around 1835. The repeal of the excise tax on glass in 1845 in England finally made sheet glass an affordable material on a large scale. Used in conjunction with cast iron, ever-larger panes of glass gave rise to the modern storefront, which became ubiquitous after midcentury. Massive

windows, used serially, were also incorporated first into department stores and eventually skyscrapers from the late 1870s onward. Equally essential to the skyscraper was the invention of the PASSENGER ELEVATOR by Elisha Otis in 1857. The humble BRICK became an important building material in the 1850s with the advent of the modern kiln, which produced it cheaply in vast quantities. Other amenities included gas lighting (1840s), toilets (c. 1870), electricity (1880s), telephones (1880s), and central heat (1890s).

Finally, we should mention RUBBER. It was at first limited chiefly to waterproofing as the result of a process for applying it to fabrics devised by Samuel Peale in 1791, though it was the chemist Charles Mackintosh who opened the first factory in Glasgow in 1823. Its widespread use as insulation and for other applications was made possible only in 1839, when Charles Goodyear, relying on the work of the German chemist Friedrich Ludersdorf and the American chemist Nathaniel Hayward, discovered VULCANIZATION, which involved cooking the rubber with sulfur to prevent it from melting in hot weather and becoming brittle in cold. Synthetic rubber was initially developed in Germany during World War I because natural rubber was hard to come by, but it was not commercially viable until after 1930, when the chemistry of polymers was finally understood through the efforts of Wallace Hume Carothers of the United States and Hermann Staudinger of Germany. The result was the production of neoprene (1931), Buna (1935), butyl rubber (1940), and GR-S (Government Rubber-Styrene, used in World War II).

Steel is a compound of iron that is less brittle, just as hard, and even stronger than iron. STRUCTURAL STEEL construction is the use of steel, mostly in the form of beams that are bolted and welded together to form the skeleton to which various kinds of wall and floor building materials are attached. FERROCONCRETE (*ferrum* is Latin for "iron"), or reinforced concrete, is concrete strengthened by steel rods and sometimes steel plates embedded within it. The steel brings tensile strength (the ability to resist the downward forces of gravity and weight) to the otherwise brittle concrete.

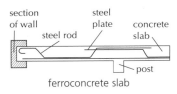

section of wall steel plate concrete slab

steel rod

post

ferroconcrete slab

Although iron was later replaced by STRUCTURAL STEEL and FERROCONCRETE, Labrouste's wedding of historicism and engineering proved so satisfying that most libraries, railroad stations, and the like were indebted to the Bibliothèque Ste-Geneviève for the remainder of the century.

The authority of historical modes nevertheless had to be broken if the industrial era was to produce a truly contemporary style. It proved extraordinarily persistent, however. Labrouste, pioneer though he was of cast-iron construction, could not think of architectural supports as anything but columns having proper capitals and bases, rather than as metal rods or pipes. The "architecture of conspicuous display" practiced by Garnier (see pages 505–6) was divorced, even more than were the previous revival styles, from the needs of the present. It was only in structures that were not considered architecture at all that new building materials and techniques could be explored without these restrictions.

Paxton Within a year of the completion of the Bibliothèque Ste-Geneviève, the Crystal Palace (fig. 23-27) was built in London. A pioneering achievement far bolder in conception than Labrouste's library, the Crystal Palace was designed to house the first of the great international expositions that continue into our day. Its designer, Sir Joseph Paxton (1801–1865), was an engineer and builder of greenhouses. The Crystal Palace was, in fact, a gigantic greenhouse—so large that it enclosed some old trees growing on the site—with its iron skeleton freely on display. In exhibition buildings, ease and cost of construction were paramount, since they were not intended to stay up for very long. Paxton's design was such a success that it set off a wave of similar buildings for commercial purposes, such as public markets. However, the notion that products of engineering might have beauty, not just utility, made very slow headway, even though it found supporters from the mid-nineteenth century on.

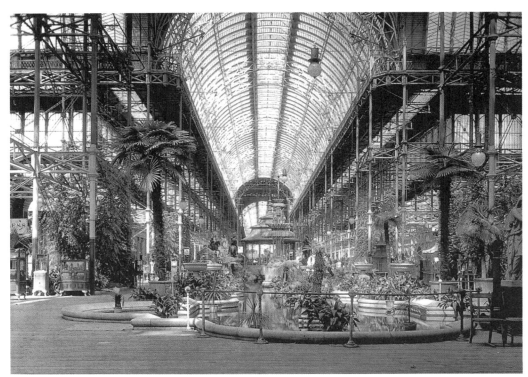

23-27 Sir Joseph Paxton. The Crystal Palace, London. 1851; reerected in Sydenham 1852; destroyed 1936

Hence most such buildings were adorned with decorations that follow the eclectic taste of the period.

Eiffel Only rarely could an engineering feat express the spirit of the times. What was needed for products of engineering to be accepted as architecture was a structure that would capture the world's imagination through its bold conception. The breakthrough came with the Eiffel Tower, named after its designer, Gustave Eiffel (1832–1923). As shown in a contemporary photograph (fig. 23-28), it was erected at the entrance to the Paris World's Fair of 1889, where it served as a triumphal arch of science and industry. It has become such a visual cliché beloved of tourists—much like the Statue of Liberty, which also involved Eiffel (see fig. 22-24)—that we can hardly appreciate what a revolutionary impact it had at the time. The tower, with its frankly technological aesthetic, so dominates the city's skyline that it provoked a storm of protest by the leading intellectuals of the day. Eiffel used the same principles of structural engineering that he had already applied successfully to bridges. Yet the tower is so novel in appearance and so daring in construction that nothing quite like it has ever been built, before or since.

The Eiffel Tower owed much of its success to the fact that for a small sum anyone could take its elevators to see a view of Paris that was previously reserved for the privileged few able to afford hot-air balloon rides. It thus helped to define a distinctive feature of modern architecture, one that it shares with modern technology as a whole: it acts on large masses of people, without regard to social or economic class. Although this capacity, which was shared only by the largest churches and public buildings of the past, has also served the aims of extremists at both ends of the political spectrum, modern architecture has tended by its very nature to function as a vehicle of democracy. We can readily understand, then, why the Eiffel Tower quickly became a popular symbol of Paris itself. It could do so, however, precisely because it serves no practical purpose whatsoever.

23-28 Gustave Eiffel. The Eiffel Tower, Paris. 1887–89

POST-IMPRESSIONISM, SYMBOLISM, AND ART NOUVEAU

The three movements that came to prominence after 1884—Post-Impressionism, Symbolism, and Art Nouveau—bore complex, shifting relationships to one another. At face value, they had little in common other than the time span they shared between the mid-1880s and 1910. Post-Impressionism encompassed a wide range of styles, from the cerebrally analytical to the highly expressive. As such, it could be readily adapted to different outlooks. Symbolism was not a style at all but an intensely private worldview based on the literary movement of the same name. It was free to adopt any style that suited its purposes, including Post-Impressionism. Art Nouveau, by contrast, was both a style and an attitude toward life and art, intimately linked to the Aesthetic Movement and the Arts and Crafts Movement. The factors that united Post-Impressionism, Symbolism, and Art Nouveau were a desire to be new and the profound social and economic changes brought on by the Industrial Revolution, no matter how diverse their responses.

Painting

POST-IMPRESSIONISM

In 1882, just before his death, Manet was made a chevalier of the Legion of Honor by the French government. This event marks the turn of the tide: Impressionism had gained wide acceptance among artists and the public—but, by the same token, it was no longer a pioneering movement. When the Impressionists held their last group show four years later, the future already belonged to the "Post-Impressionists." This colorless label designates a group of artists who passed through an Impressionist phase in the 1880s but became dissatisfied with the style and pursued a variety of directions. Because they did not have a common goal, it is difficult to find a more descriptive term for them than *Post-Impressionists*. They certainly were not "anti-Impressionists." Far from trying to undo the effects of the "Manet revolution," they wanted to carry it further. Thus Post-Impressionism is in essence just a later stage, though a very important one, of the development that had begun in the 1860s with such pictures as Manet's *Luncheon on the Grass* (see fig. 23-3).

Cézanne Paul Cézanne (1839–1906), the oldest of the Post-Impressionists, was born in Aix-en-Provence, near the Mediterranean coast, where he formed a close friendship with the writer Émile ZOLA, later a champion of the Impressionists. A man of intensely emotional temperament, Cézanne went to Paris in 1861 imbued with enthusiasm for the Romantics. Delacroix was his first love among painters, and he never lost his admiration for him. Cézanne quickly grasped the nature of the Manet revolution as well. After passing through a Neo-Baroque phase, he began to paint bright outdoor scenes, but he did not share his fellow Impressionists' interest in "slice-of-life" subjects, in movement, and in change. Instead, his goal was "to make of Impressionism something solid and durable, like the art of the museums."

This quest for the "solid and durable" can be seen in Cézanne's **still lifes**, such as *Still Life with Apples* (fig. 24-1). Not since Chardin have simple everyday objects assumed such importance in a

24-1 Paul Cézanne. *Still Life with Apples.* 1879–82. Oil on canvas, 17¹⁄₈ x 21¹⁄₄" (43.5 x 54 cm). Ny Carlsberg Glyptotek, Copenhagen

painter's eye. The ornamental backdrop is integrated with the three-dimensional shapes, and the brushstrokes have a rhythmic pattern that gives the canvas its shimmering texture. We also notice another aspect of Cézanne's style that may puzzle us at first. The forms are deliberately simplified and outlined with dark colors, and the perspective is incorrect for both the fruit bowl and the horizontal surfaces, which seem to tilt upward. Yet the longer we study the picture, the more we realize the rightness of these apparently arbitrary distortions. When Cézanne took these liberties with reality, his purpose was to uncover the permanent qualities beneath the accidents of appearance. All forms in nature, he believed, are based on abstractions such as the cone, the sphere, and the cylinder. This order underlying the external world was the true subject of his pictures, but he had to interpret it to fit the separate, closed world of the canvas.

To apply this method to landscape became the greatest challenge of Cézanne's career. From 1882 on, he lived in isolation near Aix-en-Provence, exploring its environs as Claude Lorraine and Corot

After establishing himself as a journalist in Paris, Émile-Édouard-Charles-Antoine ZOLA (1840–1902) turned to writing what he called naturalist fiction. In most of his novels, he explored the hard side of people's lives, especially the social ills afflicting the lower classes. Zola was an outspoken critic on issues ranging from art to politics. In one famous published letter addressed to the president of France, known as *J'accuse* (I Accuse; 1898), Zola defended Alfred Dreyfus, a Jewish captain in the French army who had been falsely accused and convicted of divulging military secrets.

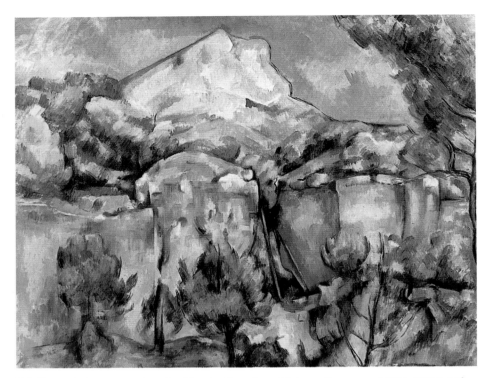

24-2 Paul Cézanne. *Mont Ste-Victoire Seen from Bibémus Quarry.* c. 1897–1900. Oil on canvas, 25½ x 31½" (64.8 x 80 cm). The Baltimore Museum of Art

The Cone Collection, formed by Dr. Claribel Cone and Miss Etta Cone of Baltimore, Maryland

had explored the Roman countryside. One motif seemed almost to obsess him: the distinctive shape of the mountain called Mont Ste-Victoire. Its craggy profile looming against the blue Mediterranean sky appears in a long series of compositions culminating in the monumental late works such as that in figure 24-2. There are no hints of human presence here; houses and roads would only disturb the lonely grandeur of the view. Above the wall of rocky cliffs that bar our way like a chain of fortifications, the mountain rises in triumphant clarity, infinitely remote, yet as solid and palpable as the shapes in the foreground. For all its architectural stability, the scene is alive with movement. But the forces at work here have been brought into equilibrium, subdued by the greater power of the artist's will. This disciplined energy, distilled from the trials of a stormy youth, gives the mature style of Cézanne its enduring strength.

Seurat Georges Seurat (1859–1891) shared Cézanne's aim to make Impressionism "solid and durable," but he went about it very differently. His goal, he once stated, was to make "modern people, in their essential traits, move about as if on friezes, and place them on canvases organized by harmonies of color, by directions of the tones in harmony with the lines, and by the directions of the lines." Seurat's career was as brief as those of Masaccio, Giorgione, and Géricault, and his achievement just as astonishing. Although he participated in the last Impressionist show, it is an indication of the Post-Impressionist revolution that thereafter he exhibited with an entirely new group, the SOCIETY OF INDEPENDENTS.

Seurat devoted his main efforts to a few very large paintings, spending a year or more on each of them and making endless series of preliminary studies before he felt sure enough to tackle

The SOCIETY OF INDEPENDENTS (Société des Artistes Indépendents) was formed in 1884 to organize exhibitions (Salons des Indépendents) open to any artist who paid the required fee. Besides Seurat, founding members included Paul Signac (1863–1935) and Odilon Redon (1840–1916); all three were opposed to the aims of academic art.

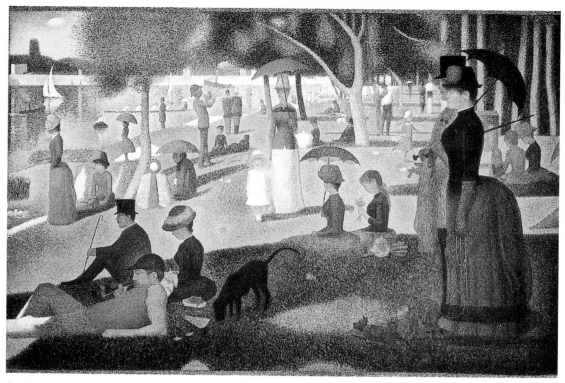

24-3 Georges Seurat. *A Sunday Afternoon on the Island of La Grande Jatte.* 1884–86. Oil on canvas, 6'10" x 10'1¹/₄" (2.08 x 3.08 m). The Art Institute of Chicago

Helen Birch Bartlett Memorial Collection

the definitive version. *A Sunday Afternoon on the Island of La Grande Jatte* of 1884–86 (fig. 24-3) had its genesis in this painstaking method. The subject is the sort that had long been popular among Impressionist painters. Impressionist, too, are the brilliant colors and the effect of intense sunlight. Otherwise, the picture is the very opposite of a quick "impression." The firm, simple contours and the relaxed, immobile figures give the scene a timeless stability that recalls Piero della Francesca (see fig. 12-17). Even the brushwork demonstrates Seurat's passion for order and permanence: the canvas surface is covered with systematic, impersonal dots of brilliant color that were supposed to merge in the beholder's eye and produce intermediary tints more luminous than anything obtainable from pigments mixed on the palette. This procedure was variously known as Neo-Impressionism, Pointillism, or Divisionism (the term preferred by Seurat). The

actual result, however, did not conform to the theory. Looking at the painting from a comfortable distance (seven to ten feet for the original), we find that the mixing of colors in the eye remains incomplete. The dots do not disappear but are as clearly visible as the **tesserae** of a mosaic (compare figs. 8-9 and 8-10). Seurat himself must have liked this unexpected effect, which gives the canvas the quality of a shimmering, translucent screen. Otherwise, he would have reduced the size of the dots.

The painting has a dignity and simplicity suggesting a new classicism, but it is a distinctly modern classicism based on scientific theory. Seurat adapted the laws of color discovered by Eugène Chevreul, O. N. Rood, and David Sutter, as part of a comprehensive approach to art. Like Degas, he had studied with a follower of Ingres, and his theoretical interests grew out of this experience. He came to believe that art must be based on a system. With the help

of his friend Charles Henry (who was, like Rood and Sutter, an American), he formulated a series of artistic "laws" based on early experiments in the psychology of visual perception. These principles helped him to control every aesthetic and expressive aspect of his paintings. But, as with all artists of genius, Seurat's theories do not really explain his pictures. It is the pictures, rather, that explain the theories.

Strange as it may seem, color was an adjunct to form in Seurat's work—the very opposite of the Impressionists' technique. The bodies have little weight or bulk. Modeling and foreshortening are reduced to a minimum, and the figures appear mostly in either strict profile or frontal views, as if Seurat had adopted the rules of ancient Egyptian art. Moreover, he has fitted them together within the composition as tightly as the pieces of a jigsaw puzzle. So exactly are they fixed in relation to one another that not a single one could be moved by even a millimeter. Frozen in time and space, they act out their roles with ritualized gravity, in contrast to the joyous abandon of the relaxed figures in Renoir's *Luncheon of the Boating Party* (see fig. 23-9), who are free to move about in the open air. Thus, despite the period costumes, we read this cross section of Parisian society as timeless. Small wonder, then, that the picture remains so spellbinding more than a century after it was painted.

Seurat's forms achieve a machinelike quality through rigorous abstraction. This is the first expression of a peculiarly modern outlook that would lead to Futurism (see page 573). Seurat's systematic approach to art has the internal logic of modern engineering, which he and his followers hoped would transform society for the better. This social consciousness was allied to a form of anarchism descended from the thinking of Courbet's friend Pierre-Joseph Proudhon and contrasts with the general political indifference of the Impressionists. The fact that Seurat shares the same subject matter as the Impressionists serves only to emphasize further the fundamental difference in attitude.

Van Gogh While Cézanne and Seurat were converting Impressionism into a more severe, classical style, Vincent van Gogh (1853–1890) moved in the opposite direction. He believed that Impressionism did not provide artists with enough freedom to express their emotions. Since this was his main concern, he is sometimes called an Expressionist, although that term ought to be reserved for certain twentieth-century painters (see chapter 25). Van Gogh, the first great Dutch painter since the seventeenth century, did not become an artist until 1880; he died only ten years later, so his career was even briefer than Seurat's. His early interests were in literature and religion. Profoundly dissatisfied with the values of industrial society and imbued with a strong sense of mission, he worked for a while as a lay preacher among poverty-stricken coal miners in Belgium. This intense feeling for the poor dominates the paintings of his pre-Impressionist period, 1880–85.

In 1886 Van Gogh went to Paris, where his brother, Theo, who owned a gallery devoted to modern art, introduced him to Degas, Seurat, and other leading French artists. Their effect on him was electrifying: his pictures now blazed with color, and he even experimented briefly with the Divisionist technique of Seurat. This Impressionist phase, however, lasted less than two years. Although it was vitally important for his development, he had to integrate it with the style of his earlier years before his genius could fully unfold. Paris had opened his eyes to the sensuous beauty of the visible world and had taught him the pictorial language of the color patch, but painting continued to be nevertheless a vessel for his personal emotions. To investigate this spiritual reality with the new means at his command, he went to Arles, in the south of France. There, between 1888 and 1890, he produced his greatest pictures.

Like Cézanne, Van Gogh now devoted his main energies to landscape painting, but the sun-drenched Mediterranean countryside evoked a very different response in him. He saw it filled with ecstatic movement, not architectural stability and permanence. In *Wheat Field and Cypress Trees* (fig. 24-4), both earth and sky pulsate with an overpowering turbulence. The wheat field resembles a stormy sea, the trees spring flamelike from the ground, and the hills and clouds heave with the same undulant motion.

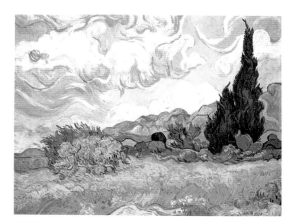

24-4 Vincent van Gogh. *Wheat Field and Cypress Trees.* 1889. Oil on canvas, 28½ x 36" (72.4 x 91.4 cm). The National Gallery, London

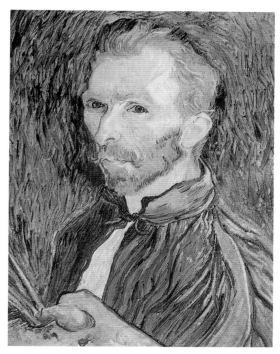

24-5 Vincent van Gogh. *Self-Portrait.* 1889. Oil on canvas, 22½ x 17" (57.2 x 43.2 cm). Collection Mrs. John Hay Whitney, New York

The dynamism contained in every brushstroke makes of each one not merely a deposit of color but an incisive graphic gesture. The artist's personal "handwriting" is here—an even more dominant factor than in the canvases of Daumier (compare fig. 22-10). To Van Gogh himself, it was the color, not the form, that determined the expressive content of his pictures. The letters he wrote to his brother include many eloquent descriptions of his choice of hues and the emotional meanings he attached to them. He had learned about Impressionist color, but his personal color symbolism probably stemmed from discussions with Paul Gauguin (see below), who stayed with Van Gogh at Arles for several months. (Yellow, for example, meant faith or triumph or love to Van Gogh, while carmine was a spiritual color, cobalt a divine one; red and green, on the other hand, stood for the terrible human passions.) Although he acknowledged that his desire "to exaggerate the essential and to leave the obvious vague" made his colors look arbitrary by Impressionist standards, he nevertheless remained deeply committed to the visible world.

The colors of *Wheat Field and Cypress Trees* are stronger, simpler, and more vibrant than those of Monet's *On the Bank of the Seine, Bennecourt* (see fig. 23-7), but they are in no sense "unnatural."

They speak to us of that "kingdom of light" Van Gogh had found in the South and of his mystic faith in a creative force animating all forms of life—a faith no less ardent than the sectarian Christianity that he had espoused in his early years. His *Self-Portrait* (fig. 24-5) will remind us of Albrecht Dürer's (see fig. 16-3), and with good reason: the missionary had now become a prophet. Van Gogh's luminous head, with its emaciated features and burning eyes, is set off against a whirlpool of darkness. "I want to paint men and women with that something of the eternal which the halo used to symbolize," the artist had written, groping to define for his brother the human essence that was his aim in pictures such as this one. At the time of the *Self-Portrait,* he had already begun to suffer fits of a mental illness that made painting increasingly difficult for him. Despairing of a cure, Van Gogh committed suicide a year later, for he felt very deeply that art alone made his life worth living.

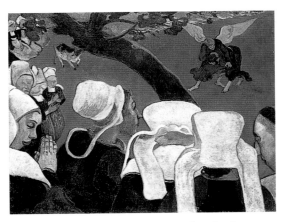

24-6 Paul Gauguin. *The Vision after the Sermon (Jacob Wrestling with the Angel)*. 1888. Oil on canvas, 28³⁄₄ x 36¹⁄₂" (73 x 92.7 cm). The National Galleries of Scotland, Edinburgh

Gauguin and Symbolism The quest for religious experience also played an important part in the work, if not in the life, of another great Post-Impressionist, Paul Gauguin (1848–1903). He began as a prosperous stockbroker in Paris and an amateur painter and collector of modern pictures. At the age of 35, he became convinced that he must devote himself entirely to art. He abandoned his business career, separated from his family, and by 1889 was the central figure of a new movement called Synthetism or Symbolism.

Gauguin was originally a follower of Cézanne and once owned one of his still lifes. He then developed a style that, though less intensely personal than Van Gogh's, was in some ways an even bolder advance beyond Impressionism. Gauguin believed that Western civilization was spiritually bankrupt because industrial society had forced people into an incomplete life dedicated to material gain while their emotions lay neglected. To rediscover for himself this hidden world of feeling, Gauguin left Paris in 1886 to live among the peasants of Brittany at Pont-Aven in western France. There, two years later, he met the young painters Émile Bernard (1868–1941) and Louis Anquetin (1861–1932), who had rejected Impressionism and had begun to evolve a new style, which they called Cloisonism because its strong outlines and brilliant color

resembled an enamel technique called cloisonné. Gauguin incorporated their approach into his own and emerged as the most forceful member of the Pont-Aven group, which quickly came to center on him.

The Pont-Aven style was first developed fully in the works Gauguin and Bernard painted at Pont-Aven during the summer of 1888. Gauguin noticed particularly that religion was still part of the everyday life of the country people, and in pictures such as *The Vision after the Sermon (Jacob Wrestling with the Angel)* (fig. 24-6), he tried to depict their simple, direct faith. Here at last is what no Romantic artist had achieved: a style based on pre-Renaissance sources. Modeling and perspective have given way to flat, simplified shapes outlined heavily in black, and the brilliant colors are equally unnatural. This style, inspired by folk art and medieval stained glass, is meant to re-create both the imagined reality of the vision and the trancelike rapture of the peasant women. The painting fulfills the goal of Synthetism: by treating the canvas in this decorative manner, the artist has turned it from a straightforward representation of the external world into a projection of an internal idea without using narrative or literal symbols. Yet we sense that, while he tried to share this experience, Gauguin remained an outsider. He could paint pictures *about* faith but not *from* faith.

Two years later, Gauguin's search for the unspoiled life led him even farther afield. He went to Tahiti—he had already visited Martinique in 1887—as a sort of missionary in reverse, to learn from the natives instead of teaching them. Although he spent most of the rest of his life in the South Pacific, he never found the unspoiled Eden he was seeking. Indeed, he often had to rely on the writings and photographs of those who had recorded its culture before him. Nevertheless, his Tahitian canvases conjure up an ideal world filled with the beauty and meaning he sought so futilely in real life.

His greatest work in this vein is *Where Do We Come From? What Are We? Where Are We Going?* (fig. 24-7), painted as a summation of his art shortly before he was driven by despair to attempt suicide. Even without the suggestive title, we would recognize the painting's allegorical purpose from

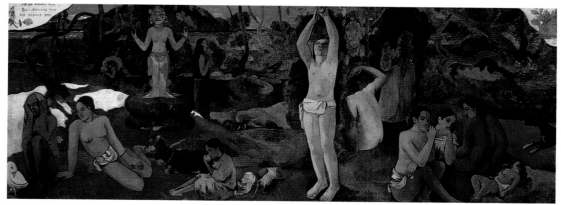

24-7 Paul Gauguin. *Where Do We Come From? What Are We? Where Are We Going?* 1897. Oil on canvas, 4'6³/₄" x 12'3¹/₂" (1.38 x 3.75 m). Museum of Fine Arts, Boston

Arthur Gordon Tompkins Residuary Fund

its monumental scale, the carefully thought-out poses and placement of the figures within the tapestrylike landscape, and their pensive air. Although Gauguin intended the surface to be the sole conveyer of meaning, we know from his letters that the huge canvas represents an epic cycle of life. The scene unfolds from right to left, beginning with the sleeping girl, continuing with the beautiful young woman (a Tahitian Eve) in the center picking fruit, and ending with "an old woman approaching death who seems reconciled and resigned to her thoughts." In effect, the picture constitutes a variation on the Three Ages of Man. The enigmatic Maori god overseeing everything acts as a figure of death. The real secret to the central mystery of life, Gauguin tell us, lies in this primitive Eden, not in some mythical past.

The renewal of Western art and Western civilization as a whole, Gauguin believed, must come from outside its traditions. He advised other Symbolists to shun Graeco-Roman forms and to turn instead to Persia, the Far East, and ancient Egypt for inspiration. This idea itself was not new. It stems from the Romantic myth of the NOBLE SAVAGE, which had been propagated by the thinkers of the Enlightenment more than a century earlier, and its ultimate source is the age-old belief in an earthly paradise where people once lived, and might one day live again, in a state of nature and innocence. No artist before Gauguin had

gone as far to put this doctrine of "primitivism"— as it was called—into practice. His pilgrimage to the South Pacific had more than a purely private meaning: it symbolized the end of the 400 years of expansion that had brought most of the globe under Western domination. Colonialism, once so cheerfully—and so ruthlessly—pursued by the empire builders, was becoming unbearable.

Toulouse-Lautrec The decadent world Gauguin sought to escape provided the subject matter for Henri de Toulouse-Lautrec (1864–1901), an artist of superb talent who led a dissolute life in the night spots and brothels of Paris and died of alcoholism. He was a great admirer of Degas, and indeed, his painting *At the Moulin Rouge* (fig. 24-8, page 546) recalls the zigzag pattern of Degas's *Glass of Absinthe* (see fig. 23-10); yet this view of the well-known nightclub is no Impressionist "slice of life." Toulouse-Lautrec sees through the cheerful surface of the scene, viewing performers and customers with a pitilessly sharp eye for character— including his own: he is the tiny bearded man next to the very tall one in the back of the room. The large areas of flat color, however, and the emphatic, smoothly curving outlines reflect the influence of Gauguin. The Moulin Rouge that Toulouse-Lautrec shows here has an atmosphere so joyless and oppressive that we may wonder if the artist did not regard it as a place of evil.

The idea of the NOBLE SAVAGE goes back to the seventeenth century, but it came into its own in the Romantic era, especially in the philosophical writings of Jean-Jacques Rousseau (1712–1778). Essentially an expression of longing for simpler times, the concept refers to peoples uncorrupted by civilization whose outlook was simple, pure, and emotionally direct and who chose to live under just and reasonable laws.

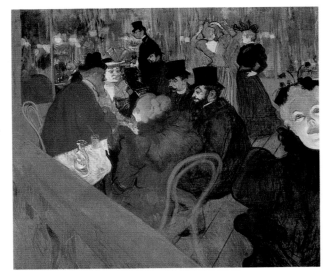

24-8 Henri de Toulouse-Lautrec. *At the Moulin Rouge.* 1893–95. Oil on canvas, 48³/₈ x 55¹/₂" (122.9 x 141 cm). The Art Institute of Chicago

Helen Birch Bartlett Memorial Collection

SYMBOLISM

Van Gogh's and Gauguin's discontent with Western civilization was part of a sentiment widely shared at the end of the nineteenth century. It reflected an intellectual and moral upheaval that rejected the modern world and its rational materialism in favor of irrational states of mind. A self-conscious preoccupation with decadence, evil, and darkness pervaded the artistic and literary climate. Even those who saw no escape from the problems of modern life analyzed their predicament in fascinated horror. Yet, somewhat paradoxically, this very awareness proved to be a source of strength, for it gave rise to the remarkable movement known as Symbolism.

Symbolism in art was at first an outgrowth of a literary movement that arose in 1885–86, with Jean Moréas and Gustave Kahn at its helm. Reacting against the naturalism (the matter-of-fact observation of life) of Zola, they reasserted the primacy of subjective ideas and championed the so-called *poètes maudits* ("doomed poets") Stéphane Mallarmé and Paul Verlaine. There was a natural sympathy between the Pont-Aven painters and the Symbolist poets, and in a long article defining Symbolism published in April 1892, the writer G. Albert Aurier insisted on Gauguin's leadership. Nevertheless, unlike Post-Impressionism, which embodies several stylistic tendencies, Symbolism

was a general outlook, one that allowed for a wide variety of styles—whatever would embody its peculiar frame of mind.

The Nabis Gauguin's Symbolist followers called themselves Nabis, from the Hebrew word for "prophet." They were less remarkable for their creative talent than for their ability to spell out and justify the aims of Post-Impressionism in theoretical form. One of them, Maurice Denis, made the statement that was to become the first article of faith for modernist painters of the twentieth century: "A picture—before being a warhorse, a female nude, or some anecdote—is essentially a flat surface covered with colors in a particular order." He added that "every work of art is a transposition, a caricature, the passionate equivalent of a received sensation." The theory of equivalents gave the Nabis their independence from Gauguin. "We supplemented the rudimentary teaching of Gauguin by substituting for his oversimplified idea of pure colors the idea of beautiful harmonies, infinitely varied like nature; we adapted all the resources of the palette to all the states of our sensibility; and the sights which caused them became to us so many signs of our own subjectivity. We sought equivalents, but equivalents in beauty!"

Vuillard We can now understand why paintings by the Nabis soon came to look so different from Gauguin's. These artists became involved with decorative projects that participated in the late nineteenth century's retreat into a world of beauty. The pictures of the 1890s by Édouard Vuillard (1868–1940), the most gifted member of the Nabis, combine the flat planes and emphatic contours of Gauguin (see fig. 24-6) with the shimmering Divisionist "color mosaic" and the geometric surface organization of Seurat (see fig. 24-3). Most of them are domestic scenes, small in scale and intimate in effect, such as *The Suitor* (formally called *Interior at l'Étang-la-Ville*) (fig. 24-9). This seemingly casual view of his mother's corset-shop workroom has a delicate balance of two-dimensional and three-dimensional effects, probably derived from the flat patterns of the fabrics themselves.

The picture's quiet magic makes us think of Vermeer and Chardin (compare figs. 18-16 and 20-6), whose subject matter, too, was the snug life of the middle class. In both subject and treatment, the painting has counterparts as well in Symbolist literature and theater: the poetry of Verlaine, the novels of Mallarmé, and the productions of Aurélian Lugné-Poë, for whom Vuillard designed stage sets. The painting evokes a host of feelings through purely formal means that could never be conveyed by naturalism alone. The Nabis established an important precedent for the works painted by Henri Matisse a decade later (see fig. 25-1). By then, however, the movement had disintegrated, as its members became more conservative. Vuillard himself turned more to naturalism, and he never recaptured the delicacy and daring of his early canvases.

Moreau The Symbolists discovered that there were some older artists, descendants of the Romantics, whose work, like their own, placed inner vision above the observation of nature. One of these was Gustave Moreau (1826–1898), a recluse who admired Delacroix. Moreau created a world of personal fantasy that has much in common with the medieval reveries of some of the English Pre-Raphaelites. *The Apparition (Dance of Salome)* (fig. 24-10) shows one of his favorite themes: the head of John the Baptist, in a blinding radiance of light, appears to Salome, whose seductive dance has brought about his death. Her odalisquelike sensuousness, the stream of blood pouring from the severed head, the mysterious space of the setting (suggestive of an exotic temple rather than of the palace where the murder took place) all summon up the dreams of oriental splendor and cruelty so dear to the Romantic imagination, combined with an insistence on the reality of the supernatural.

Only late in life did Moreau achieve a measure of recognition. Suddenly, his art was in tune with the times. During his last six years, he even held a professorship at the conservative École des Beaux-Arts, the successor of the official art academy founded under Louis XIV (see page 425). There he attracted the most gifted students, among them such future modernists as Matisse and Georges Rouault.

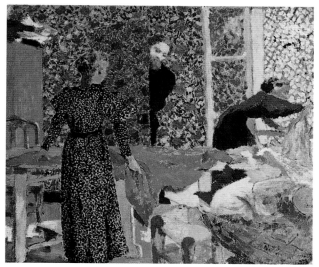

24-9 Édouard Vuillard. *The Suitor (Interior at l'Étang-la-Ville)*. 1893. Oil on millboard panel, 12½ x 14" (31.8 x 35.6 cm). Smith College Museum of Art, Northampton, Massachusetts

Purchased, Drayton Hillyer Fund, 1938

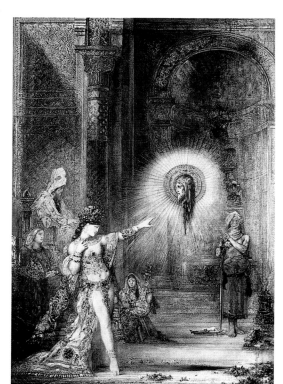

24-10 Gustave Moreau. *The Apparition (Dance of Salome)*. c. 1876. Watercolor, 41¾ x 28⅜" (106 x 72 cm). Musée du Louvre, Paris

Beardsley How prophetic Moreau's work was of the taste prevailing at the end of the century is evident from a comparison with Aubrey Beardsley (1872–1898), a gifted young English artist whose black-and-white drawings were the very epitome of an elegantly "decadent" taste prevalent at the end of the century. They include an illustration for Oscar Wilde's *Salomé* (fig. 24-11) that might well be the final scene of the drama depicted by Moreau: Salome has taken up John's severed head and triumphantly kissed it. Beardsley's erotic meaning is plain: Salome is passionately in love with John and has asked for his head because she could not have him in any other way. Although Moreau's intent remains ambiguous, the thematic parallel between the two works is striking. There are formal similarities as well, such as the "stem" of trickling blood from which John's head rises like a flower. But Beardsley's *Salomé* cannot be said to derive from Moreau's. The sources of his style are English—specifically, the art of the Pre-Raphaelites (see fig. 23-15)—with a strong element of Japanese influence.

Redon Another solitary artist whom the Symbolists discovered and claimed as one of their own was Odilon Redon (1840–1916). Like Moreau, he had a haunted imagination, but his imagery was even more personal and disturbing. Outstanding at etching and lithography, he drew inspiration

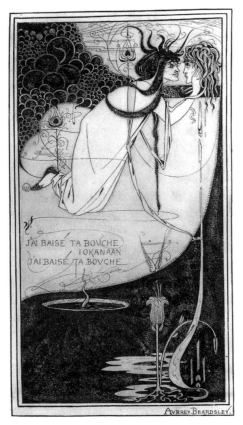

24-11 Aubrey Beardsley. *Salomé.* 1892. Pen drawing, 10^{15}/$_{16}$ x 5^{13}/$_{16}$" (27.8 x 14.8 cm). Aubrey Beardsley Collection, Manuscripts Division, Department of Rare Books and Special Collections, Princeton University Library, New Jersey

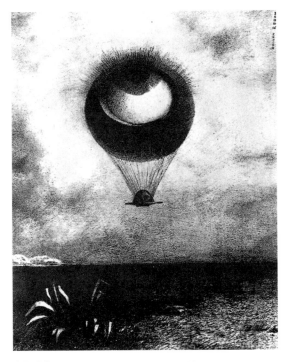

24-12 Odilon Redon. *The Eye like a Strange Balloon Mounts toward Infinity,* from the series Edgar A. Poe. 1882. Lithograph, 10^{1}/$_{4}$ x 7^{11}/$_{16}$" (25.9 x 19.6 cm). The Museum of Modern Art, New York

Gift of Peter H. Deitsch

from Goya as well as Romantic literature. The lithograph shown in figure 24-12 is one of a set Redon issued in 1882 and dedicated to Edgar Allan Poe, the American author, who had been dead for 33 years. Poe's tormented life and his equally tortured imagination made him the very model of the *poète maudit,* and his works, excellently translated by Baudelaire and Mallarmé, were greatly admired in France. Redon's lithographs do not illustrate Poe. They are, rather, "visual poems" in their own right, evoking the macabre, hallucinatory world of Poe's imagination. In our example, the artist has revived an ancient device, the single eye representing the all-seeing mind of God. But, in contrast to the traditional form of the symbol, Redon shows the whole eyeball removed from its socket and converted into a balloon that drifts aimlessly in the sky. Disquieting visual paradoxes of this kind were to be exploited on a large scale by the Dadaists and Surrealists in the following century (see figs. 25-16 and 25-25).

Munch A macabre quality pervades the early work of Edvard Munch (1863–1944), a gifted artist who came to Paris from Norway in 1889 and based his starkly expressive style on those of Toulouse-Lautrec, Van Gogh, and Gauguin. He then settled in Berlin, where his works generated such controversy when they were exhibited in 1892 that a number of young radicals broke from the artists' association and then formed the Berlin Secession. The group took its name from a similar one that had been founded in Munich earlier that year. The Secession quickly became a loosely allied international movement that spread to Austria and Belgium, where it had close ties to Art Nouveau (see page 554).

The Scream (fig. 24-13) is an image of fear, the terrifying, unreasoned fear we feel in a nightmare. Unlike Fuseli (see fig. 22-14), Munch visualizes this experience without the aid of frightening apparitions, and his achievement is the more persuasive for that very reason. The rhythm of the long, wavy lines seems to carry the echo of the scream into every corner of the picture, making of earth and sky one great sounding board of fear.

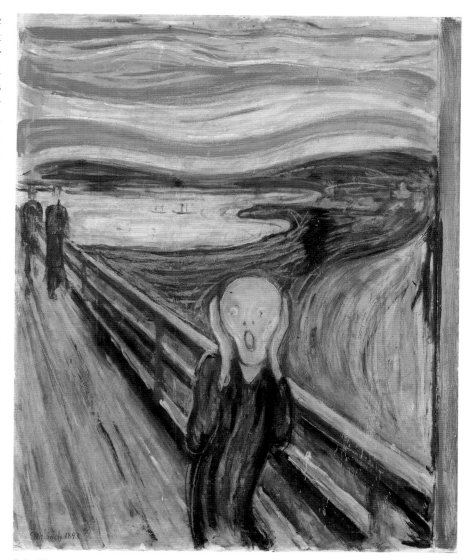

24-13 Edvard Munch. *The Scream.* 1893. Tempera and casein on cardboard, 36 x 29" (91.4 x 73.7 cm). Nasjonalgalleriet, Oslo

Picasso's Blue Period When he arrived in Paris from his native Spain in 1900, Pablo Picasso (1881–1973) felt the spell of the same artistic atmosphere that had generated the style of Munch. His so-called Blue Period (the term refers to the prevailing color of his canvases as well as to their mood) consists almost exclusively of pictures of beggars, derelicts, and other outcasts or victims of society whose pathos reflects the artist's own sense of isolation. Yet these figures, such as that

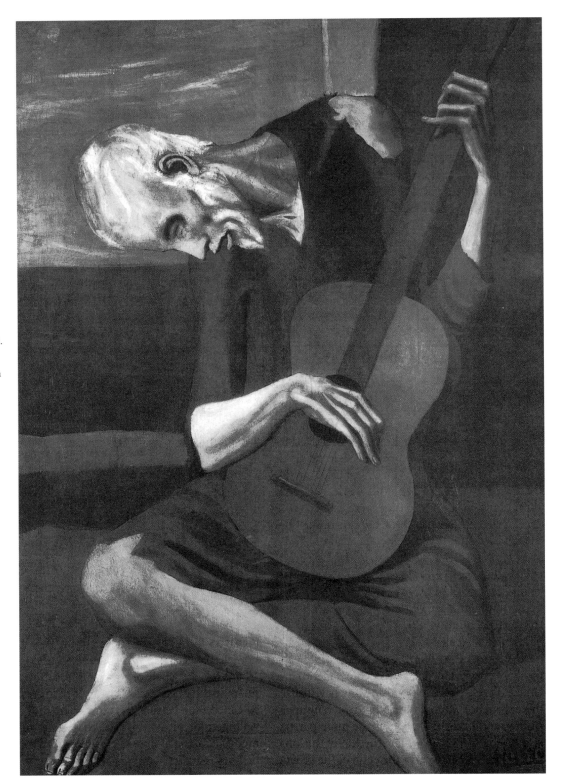

24-14 Pablo Picasso. *The Old Guitarist.* 1903. Oil on panel, 47³/₈ x 32¹/₂" (120.3 x 82.6 cm). The Art Institute of Chicago

Helen Birch Bartlett Memorial Collection

in *The Old Guitarist* (fig. 24-14) of 1903, convey poetic melancholy more than outright despair. The aged musician accepts his fate with a resignation that seems almost saintly, and the attenuated grace of his limbs reminds us of El Greco (compare fig. 14-11). *The Old Guitarist* is a strange amalgam of Mannerism and the art of Gauguin and Toulouse-Lautrec, imbued with an aura of gloom characteristic of the artist's work at this time.

Rousseau A few years later, Picasso and his friends discovered a painter who until then had attracted no attention, although he had been exhibiting his work since 1886. He was Henri Rousseau (1844–1910), a retired customs collector who had started to paint in his middle age without training of any sort. His ideal—which, fortunately, he never achieved—was the arid academic style of Ingres's followers. Rousseau is that paradox, a folk artist of genius. His painting *The Dream* (fig. 24-15) depicts an enchanted world that needs no explanation, and indeed none is possible. Perhaps for that very reason its magic becomes believably real to us. Rousseau himself described the scene in a little poem:

Yadwigha, peacefully asleep
Enjoys a lovely dream:
She hears a kind snake charmer
Playing upon his reed.
On stream and foliage glisten
The silvery beams of the moon.
And savage serpents listen
To the gay, entrancing tune.

Here at last was the innocent directness of feeling that Gauguin thought was so necessary for the age. Picasso and his friends were the first to recognize this quality in Rousseau's work. They revered him as the godfather of twentieth-century painting.

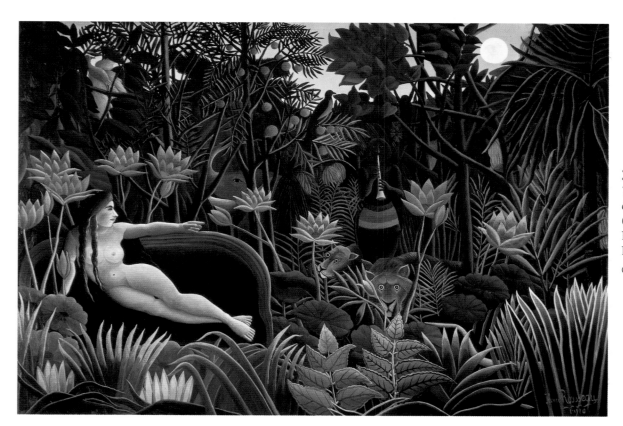

24-15 Henri Rousseau. *The Dream.* 1910. Oil on canvas, 6'8½" x 9'9½" (2.05 x 2.96 m). The Museum of Modern Art, New York

Gift of Nelson A. Rockefeller

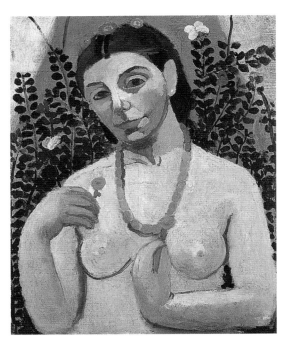

24-16 Paula Modersohn-Becker. *Self-Portrait.* 1906. Oil on canvas, 24 x 19³/₄" (61 x 50.2 cm). Öffentliche Kunstsammlung Basel, Kunstmuseum, Switzerland

forms parallels the experiments of Picasso, which were to culminate in his first Cubist works (see pages 569–70).

Sculpture

Maillol No tendencies equal to Post-Impressionism appear in sculpture until about 1900. Sculptors in France of a younger generation had by then been trained under the dominant influence of Rodin and were ready to go their own ways. The finest of these, Aristide Maillol (1861–1944), began as a Symbolist painter, although he did not share Gauguin's anti-Greek attitude. Maillol might be called a classical primitivist. Admiring the simplified strength of early Greek sculpture, he rejected its later phases. The *Seated Woman* (fig. 24-17) evokes memories of the Archaic and Severe styles (compare figs. 5-11 and 5-16) rather than of Praxiteles. The solid forms and clearly defined volumes also recall Cézanne's statement that all natural forms

The German poet Rainer Maria RILKE (1875–1926) produced a body of introspective, often rapturous poetry and prose that pushed the German language beyond its earlier limits of nuance and has influenced poets and writers ever since. His two most famous works of poetry are *The Duino Elegies* and *The Sonnets to Orpheus* (both 1923, after he had met and worked with Rodin). His much-studied novel *The Notebooks of Malte Laurids Brigge* (1910) is a symbolic recasting of the Old Testament story of the Prodigal Son.

Modersohn-Becker The inspiration that Gauguin had traveled so far to find was discovered by Paula Modersohn-Becker (1876–1907) in the small village of Worpswede, near her family home in Bremen, Germany. Among the artists and writers who congregated there was the Symbolist lyric poet Rainer Maria RILKE, Rodin's friend and briefly his personal secretary. Rilke had visited Russia and had been deeply impressed with what he viewed as the purity of Russian peasant life. His influence on the colony at Worpswede certainly affected Modersohn-Becker, whose last works are direct precursors of modern art. Her gentle but powerful *Self-Portrait* (fig. 24-16), painted in 1906, the year before her early death, presents a transition from the Symbolism of Gauguin and his followers, which she absorbed during several stays in Paris, to Expressionism (see chapter 25). The color has the intensity of Matisse and the Fauves, but at the same time, Modersohn-Becker's deliberately simplified treatment of

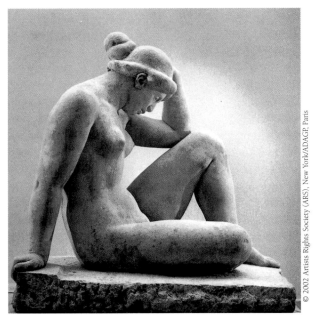

24-17 Aristide Maillol. *Seated Woman* (*La Méditerranée*). c. 1901. Stone, height 41" (104.1 cm). Collection Oskar Reinhart, Winterthur, Switzerland

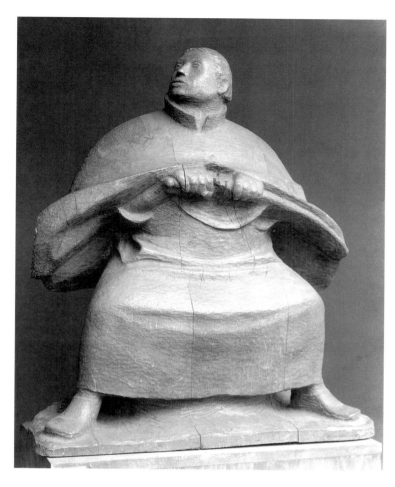

24-18 Ernst Barlach. *Man Drawing a Sword.* 1911. Wood, height 31" (78.7 cm). Private collection

are based on abstractions such as the cone, the sphere, and the cylinder. But the most notable quality of the figure is its harmonious, self-sufficient repose, which the outside world cannot disturb. A statue, Maillol thought, must above all be "static," structurally balanced like a piece of architecture. It must further represent a state of being that is detached from the stress of circumstance, with none of the restless, thrusting energy of Rodin's work. In this respect, the *Seated Woman* is the exact opposite of *The Thinker* (see fig. 23-22). Maillol later gave it the title *La Méditerranée* (The Mediterranean) to suggest the source from which he drew the timeless serenity of his figure.

Barlach Ernst Barlach (1870–1938), an important German sculptor who reached maturity in the years before World War I, is the very opposite of Maillol: he is a "Gothic primitivist." What Gauguin had experienced in Brittany and the tropics— the simple humanity of a preindustrial age—Barlach found by going to Russia. His figures, such as *Man Drawing a Sword* (fig. 24-18), embody elementary emotions—wrath, fear, grief—that seem imposed upon them by invisible presences. When they act, they appear to be sleepwalkers, unaware of their own impulses. To Barlach human beings are humble creatures at the mercy of forces beyond their control, never in control of their fate. Characteristically, these figures do not fully emerge from the material substance (often, as here, a massive block of wood) of which they are made. Their clothing is like a hard chrysalis that hides the body, as in medieval sculpture. Barlach's figures nevertheless communicate an unforgettable mute intensity.

Architecture

ART NOUVEAU

During the 1890s and early 1900s, a movement now usually known as Art Nouveau (New Art) arose throughout Europe and the United States. It takes its name from a shop opened in Paris in 1895 by the entrepreneur Siegfried Bing, who employed most of the leading designers of the day and helped to disseminate their work everywhere. By that time, however, the movement had already been in full force for several years. Art Nouveau has various other names as well: it is called Jugendstil (literally, "Youth Style") in Germany and Austria, Stile Liberty (after the well-known London store that helped to launch it) in Italy, and Modernista in Spain.

Like Post-Impressionism and Symbolism, Art Nouveau is not easy to characterize. It was primarily a new style of decoration based on sinuous curves, nominally inspired by Rococo forms, that often suggest organic shapes. Its favorite pattern was the whiplash line, its typical shape the lily. Yet there was also a severely geometric side that in the long run proved of even greater significance. The ancestor of Art Nouveau was the ornament of William Morris (see page 525), but the movement was also related to the styles of Whistler, Gauguin, Beardsley, and Munch, among others. In turn, it was allied to such diverse outlooks as AESTHETICISM, ART FOR ART'S SAKE, socialism, and Symbolism.

The avowed goal of Art Nouveau was to raise the crafts to the level of the fine arts, thereby abolishing the distinction between them. In this respect, it was meant to be a "popular" art, available to everyone. Yet it often became so extravagant as to be affordable only by the wealthy. Art Nouveau had a profound impact on public taste, and its influence on the applied arts can be seen in wrought-iron work, furniture, jewelry, glass, typography, and even women's fashions. Historically, Art Nouveau may be regarded as a prelude to modernism, but its excessive refinement was perhaps a symptom of the malaise that afflicted the Western world at the end of the nineteenth century. Hence it is uniquely worthy of our attention as Western culture passes through the similar transition of postmodernism.

As a style of decoration, Art Nouveau did not lend itself easily to architectural designs on a large scale. Indeed, wags aptly called it book-decoration architecture, after the origin of its designs, which were best suited to two-dimensional surface effects. But in the hands of architects of greatness, Art Nouveau undermined the authority of the revival styles once and for all.

Gaudí The most remarkable instance of Art Nouveau in architecture is the Casa Milá in Barcelona (fig. 24-19), a large apartment house by Antoní Gaudí (1852–1926). It shows an almost maniacal avoidance of all flat surfaces, straight lines, and symmetry of any kind, so that the building looks as if it had been freely modeled of some malleable substance, although it is in fact made of cut stone. The roof and softly rounded openings have the rhythmic motion of a wave, and the chimneys seem to have been squeezed from a pastry tube. The Casa Milá expresses one person's fanatical devotion to the ideal of "natural" form, one that scarcely could be developed further. It is a tour de force of old-fashioned artisanship, an attempt at architectural reform through aesthetics rather than engineering.

Mackintosh Gaudí represents one extreme of Art Nouveau architecture. The Scot Charles Rennie Mackintosh (1868–1928) represents another. Although they stood at opposite poles, both strove for the same goal—a contemporary style independent of the past. Mackintosh's basic outlook is so pragmatic that at first glance his work hardly seems to belong to Art Nouveau at all. The north facade of the Glasgow School of Art (fig. 24-20) was designed as early as 1896 but might be mistaken for a building done 30 years later. Huge, deeply recessed studio windows have replaced the walls, leaving only a framework of massive, unadorned cut-stone surfaces except in the center bay. This bay, however, is "sculptured" in a style not unrelated to Gaudí's, despite its preference for angles over curves. Another Art Nouveau feature is the spare grillwork fashioned of wrought iron.

AESTHETICISM, which was a movement—and almost a cult—by the end of the nineteenth century, took the position that seeking beauty should be the highest aim of art and literature, and that no artist should create with moral or instructive purposes. Aestheticism is thus very close to ART FOR ART'S SAKE, the European and American doctrine which holds that art's only goal and justification is its creation and the perfection of its technical execution. Aestheticism was influenced by the German Romantics, especially Johann Wolfgang von Goethe (1749–1832). Art for art's sake has been a fairly constant intention since the last decades of the nineteenth century.

Van de Velde One of the founders of Art Nouveau was the Belgian Henri van de Velde (1863–1957). Trained as a painter, Van de Velde fell under the influence of William Morris. He became a designer of posters, furniture, silverware, and glass, then after 1900 worked mainly as an architect. It was he who founded the Weimar School of Arts and Crafts in Germany, which became famous after World War I as the Bauhaus (see pages 634–36). His most ambitious building, the theater he designed in Cologne for an exhibition sponsored by the Werkbund (Arts and Crafts Association) in 1914 (fig. 24-21), makes a telling contrast to the Paris Opéra (see fig. 22-28), completed only 40 years earlier. Whereas the older building tries to evoke the splendors of the Louvre Palace, Van de Velde's exterior is a tautly stretched "skin" that both covers and reveals the individual units of which the internal space is composed.

The Werkbund Exhibition was a watershed in the development of modern architecture. It

provided a showcase for a whole generation of young German architects who were to achieve prominence after World War I (see chapter 27). Many of the buildings they designed for the fairgrounds anticipate ideas of the 1920s.

THE UNITED STATES

The search for a modern architecture first began in earnest around 1880. It required wedding the ideas of William Morris and a new machine aesthetic, tentatively explored some 15 years earlier in the decorative arts, to new construction materials and techniques. The process itself took several decades, during which architects experimented with a variety of styles. It is significant that the symbol of their quest was the SKYSCRAPER and that it first arose in Chicago, then a burgeoning metropolis not yet encumbered by allegiance to the styles of the past. The Chicago fire of 1871 had also opened enormous opportunities to architects from older cities such as Boston and New York.

Sullivan Chicago was home to Louis Sullivan (1856–1924), although his first skyscraper, the Wainwright Building, was erected in St. Louis (fig. 24-22) in 1890–91. The building is **monumental**, but in a very untraditional way. Its exterior—in the slender, continuous brick **piers** that rise between the windows from the base to the attic—both reflects and expresses the internal steel skeleton. The collective effect is that of a vertical grating encased by the corner piers and by the emphatic horizontals of attic and mezzanine. Although many possible "skins" could be stretched over the structural frame, what is important aesthetically is that we immediately feel that this wall is derived from the skeleton underneath and that it is not self-sustaining. *Skin* is perhaps too weak a term to describe this brick sheathing. To Sullivan, who often thought of buildings as analogous to the human body, it was more like the "flesh" and "muscle" that are attached to the "bone," and like them is capable of a variety of expressive effects. When he insisted that "form follows function," he understood the relationship as flexible rather than rigid.

Paradoxically, Sullivan's buildings are based on a lofty idealism and are adorned with a type

The SKYSCRAPER was developed in the United States in the last quarter of the nineteenth century: the Home Insurance Building in Chicago (William Le Baron Jenney, 1883) was the first to possess the steel-skeleton construction characteristic of the form. Early in the twentieth century, New York eclipsed Chicago as the skyscraper capital of the world, with such structures as the Flatiron Building (D. H. Burnham, 1902), the Woolworth Building (Cass Gilbert, 1913), and the Empire State Building (Shreve, Lamb and Harmon, 1931). The tallest skyscraper in the United States today is the Sears Tower in Chicago (110 stories, 1,454 feet high).

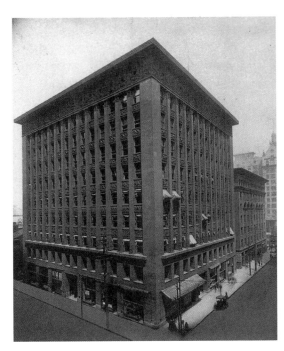

24-22 Louis Sullivan. Wainwright Building, St. Louis, Missouri. 1890–91. Destroyed

of ornamentation that remain firmly rooted in the nineteenth century, even as they point the way toward twentieth-century architecture. From the beginning, Sullivan's geometry carried a spiritual meaning that centered on birth, flowering, decay, and regeneration. It was tied to a highly original style of decoration in accordance with his theory that ornament must give expression to structure—not by reflecting it literally but by interpreting the same concepts through organic abstraction. The soaring verticality of the Wainwright Building, for example, stands for growth, which is elaborated by the vegetative motifs of the moldings along the cornice and between the windows.

Photography

DOCUMENTARY PHOTOGRAPHY

During the second half of the nineteenth century, the press played a leading role in the social

movement that brought the harsh realities of poverty to the public's attention. The camera became an important instrument of reform through the photo-documentary, which tells the story of people's lives in a pictorial essay. The press reacted to the same conditions that had stirred Courbet, and its factual reportage likewise fell within the realist tradition—only its response came a quarter-century later. Hitherto, photographers had been content to present a romanticized image of the poor like that in genre paintings of the day. The first photodocumentary was John Thomson's illustrated sociological study *Street Life in London,* published in 1877. To take his pictures, however, Thomson had to pose his figures.

Riis The invention of gunpowder flash ten years later allowed Jacob Riis (1849–1914) to rely for the most part on the element of surprise. Riis was a police reporter in New York City, where he learned at first hand about the crime-infested slums and their appalling living conditions. He kept up a vigorous campaign of illustrated newspaper exposés, books, and lectures that in some cases led to major revisions of the city's housing codes and labor laws.

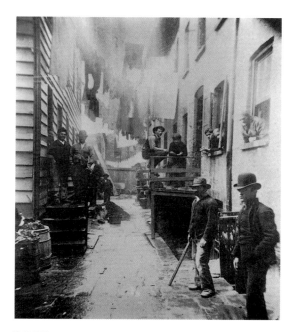

24-23 Jacob Riis. *Bandits' Roost.* c. 1888. Gelatin-silver print. Museum of the City of New York

The unflinching realism of his photographs has lost none of its force. Certainly it would be difficult to imagine a more nightmarish scene than *Bandits' Roost* (fig. 24-23). With good reason, we sense a pervasive air of danger in the eerie light, for the notorious gangs of New York City's Lower East Side sought their victims by night, killing them without hesitation. The motionless figures seem to look us over with the practiced casualness of hunters coldly sizing up potential prey.

PICTORIALISM

The raw subject matter and realism of documentary photography had little impact on art and were shunned by most other photographers as well. England, through such organizations as the Photographic Society of London, founded in 1853, became the leader of the movement to convince doubting critics that photography, by imitating painting and printmaking, could indeed be art. To Victorian England, art above all had to have a high moral purpose or noble sentiment, preferably expressed in a classical style.

Rejlander *The Two Paths of Life* (fig. 24-24, page 558) by Oscar Rejlander (1818–1875) fulfills these ends by presenting an allegory clearly descended from Hogarth's *Rake's Progress* (see fig. 20-8). This tour de force, almost three feet wide, combines 30 negatives through composite printing. A young man (in two images) is choosing between the path of virtue or of vice, the latter represented by a half-dozen nudes. The picture created a sensation in 1857, and Queen Victoria herself purchased a print. Rejlander, however, never enjoyed the same success again. The most adventurous photographer of his time, he soon turned to other subjects less in keeping with prevailing taste.

Cameron The photographer who pursued ideal beauty with the greatest passion was Julia Margaret Cameron (1815–1879). An intimate of leading poets, scientists, and artists, she took up photography at age 48, when given a camera, and went on to create a remarkable body of work. Although in her own day Cameron was known for her allegorical and narrative pictures, she is now remembered

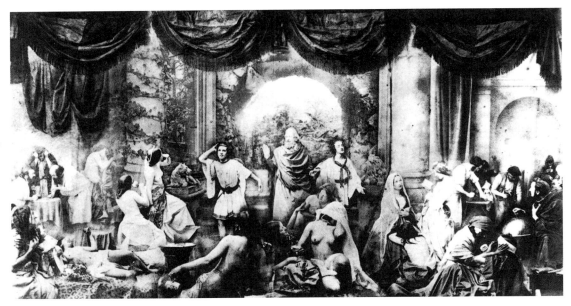

24-24 Oscar Rejlander. *The Two Paths of Life.* 1857. Combination albumen print, 16 x 31" (40.6 x 78.7 cm). George Eastman House, Rochester, New York

24-25 Julia Margaret Cameron. *Ellen Terry, at the Age of 16.* c. 1863. Carbon print, diameter 9½" (24 cm). The Metropolitan Museum of Art, New York

Alfred Stieglitz Collection, 1949

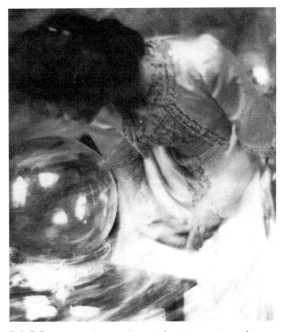

24-26 Gertrude Käsebier. *The Magic Crystal.* c. 1904. Platinum print. Royal Photographic Society, Bath

primarily for her portraits of the men who shaped Victorian England. Many of her finest photographs, however, are of the women who were married to her closest friends. An early study of the actress Ellen Terry (fig. 24-25) has the lyricism and grace of the Pre-Raphaelite aesthetic that shaped Cameron's style (compare fig. 23-15).

PHOTO-SECESSION

The issue of whether photography could be art came to a head in the early 1890s with the Secession movement (see page 549), which was spearheaded in 1893 by the founding in London of the Linked Ring, a rival group to the Royal Photographic Society of Great Britain. In seeking a pictorialism independent of science and technology, the

Secessionists steered a course between idealism and naturalism by imitating every form of late Romantic art that did not involve narrative. Equally antithetical to their aims were Realist and Post-Impressionist painting, then at their zenith. In the group's art-for-art's-sake approach to photography, the Secession had much in common with Whistler's aestheticism.

To resolve the dilemma between art and mechanics, the Secessionists tried to make their photographs look as much like paintings as possible. Rather than resorting to composite or multiple images, however, they exercised total control over the printing process, chiefly by adding special materials to their printing paper to create different effects. Pigmented gum brushed on coarse drawing paper yielded a warm-tone, highly textured print that in its way approximated Impressionist painting. Paper impregnated with platinum salts was especially popular among the Secessionists for the clear grays it produced. The subtlety and depth of the platinum print lend a remarkable ethereality to *The Magic Crystal* (fig. 24-26) by the American photographer Gertrude Käsebier (1854–1934), in which spiritual forces almost visibly sweep across the photograph.

Steichen Through Käsebier and another American photographer, Alfred Stieglitz, the Linked Ring had close ties with the United States, where Stieglitz opened his Photo-Secession gallery in New York in 1905. Among his protégés was the young Edward Steichen (1879–1973), whose photograph of Rodin in his studio (fig. 24-27) is without doubt the finest achievement of the entire Photo-Secession movement. The head in profile contemplating *The Thinker* expresses the essence of the confrontation between the sculptor and his

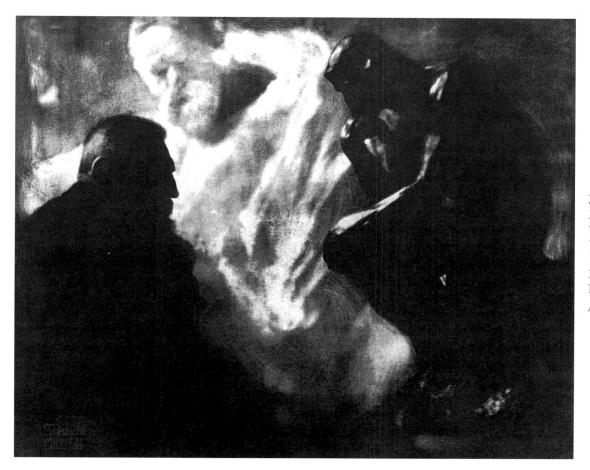

24-27 Edward Steichen. *Rodin with His Sculptures "Victor Hugo" and "The Thinker."* 1902. Gum print, 12³/₄ x 14¹/₄" (32.4 x 36.3 cm). The Art Institute of Chicago

Alfred Stieglitz Collection

work of art. His brooding introspection hides the inner turmoil evoked by the ghostlike monument to Victor Hugo, which rises dramatically like a **genius** in the background. Not since *The Creation of Adam* by Michelangelo (see fig. 13-9), who was Rodin's ideal artist, have we seen a more telling use of space or an image that penetrates the mystery of creativity so deeply.

MOTION PHOTOGRAPHY

An entirely new direction was charted by the Englishman Eadweard Muybridge (1830–1904), the father of motion photography. He wedded two different technologies, devising a set of cameras capable of photographing action at successive points. Photography had grown from such marriages; another instance had occurred earlier when Nadar used a hot-air balloon to take aerial shots of Paris. After some trial efforts, Muybridge managed in 1877 to produce a set of pictures of a trot-ting horse that forever changed artistic depictions of the horse in movement. Of the 100,000 photographs he devoted to the study of animal and human locomotion, the most remarkable were those taken from several vantage points at once (fig. 24-28). The idea was surely in the air, for the art of the period occasionally shows similar experiments, but Muybridge's photographs must nevertheless have come as a revelation to artists. The simultaneous views present an entirely new treatment of motion across time and space that challenges the imagination. Like a complex visual puzzle, they can be combined in any number of ways that are endlessly fascinating. Muybridge's photographs convey a peculiarly modern sense of dynamics, reflecting the new tempo of life in the Machine Age. However, because the gap was then so great between scientific fact on the one hand and visual perception and artistic representation on the other, their far-reaching aesthetic implications were to be realized only later.

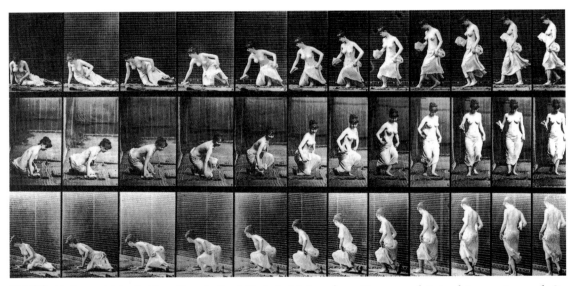

24-28 Eadweard Muybridge. *Female Semi-Nude in Motion,* from *Human and Animal Locomotion,* vol. 2, pl. 271. 1887. George Eastman House, Rochester, New York

TWENTIETH-CENTURY PAINTING

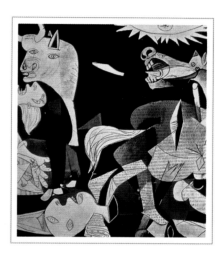

In our account of art in the modern era, we have already discussed a succession of "isms": Neoclassicism, Romanticism, Realism, Impressionism, Post-Impressionism, Divisionism, and Symbolism. There are many more to be found in twentieth-century art, but they may make us feel that we cannot hope to understand the art of our time unless we become familiar with numerous obscure doctrines. Actually we can disregard all but the most important "isms." Like the terms we have used for the styles of earlier periods, they are merely labels to help us sort things out. If an "ism" fails the test of usefulness, we need not keep it. Thus we can disregard many of the "isms" in contemporary art. The movements they designate either cannot be seen very clearly as separate or have so little importance that they are of interest only to the specialist. It has always been easier to invent new labels than to create a movement in art that truly deserves a new name.

Still, we cannot do without "isms" altogether. Since the start of the modern era, the Western world (and, increasingly, the rest of the world) has faced the same basic problems everywhere, and local artistic traditions have steadily given way to international trends. We can distinguish three main currents, each made up of a number of "isms," that began among the Post-Impressionists and developed further in the early twentieth century: Expressionism, Abstraction, and Fantasy. Expressionism stresses artists' emotional attitude toward themselves and the world; Abstraction focuses on the formal structure of the work of art; and Fantasy

explores the realm of the imagination, especially its spontaneous and irrational sides. Feeling, order, and imagination, however, are present in every work of art. Without imagination, art would be deadly dull; without order, it would be chaotic; and without feeling, it would leave us unmoved.

These currents are not mutually exclusive, and we shall find them interrelated in many ways. An artist's work often belongs to more than one, which may in turn embrace a wide range of approaches, from the realistic to the completely nonrepresentational (or "nonobjective"). Our three currents, then, do not correspond to specific styles but to general attitudes. They represent parallel responses to the realization, intuitive as well as intellectual, that after 1900 people were living in a different age. Expressionism is concerned mainly with the human community; Abstraction is interested in the structure of reality; and Fantasy is occupied with the labyrinth of the mind. We shall also find that Realism, which is concerned with the appearance of the world around us, has continued to exist independently of the other three, especially in the United States, where art has often pursued a separate course. These strands bear a shifting relation to one another that reflects the complexity of modern life. To be understood, they must be seen in their proper historical context. Beginning in the mid-1930s, the distinction between them begins to break down. And therefore it is no longer meaningful to trace their evolutions separately after 1945.

In examining twentieth-century art, we shall find it anything but tidy. We quickly discover that the visual arts are like soldiers marching to different drummers. A purely chronological approach would reveal just how out of step they have generally been with one another, but at the cost of losing sight of the internal development of each. Does this mean that the other visual arts have shared none of the same concerns as painting? No, that is not the case either. Expressionism, Abstraction, and Fantasy can be found as well in sculpture, architecture, and photography before 1945. However, they are present in different measure and do not always carry the same meaning. For that reason, the parallels between them should not be overemphasized.

Painting before World War I

THE FAUVES

The twentieth century may be said to have begun five years late so far as painting is concerned. Between 1901 and 1906, several comprehensive exhibitions of the work of Van Gogh, Gauguin, and Cézanne were held in Paris as well as Germany. For the first time the achievements of these masters became available to a broad public. The young painters who had grown up in the "decadent," morbid mood of the 1890s were deeply impressed by what they saw. Several of them formulated a radical new style, full of the violent color of Van Gogh and the bold distortions of Gauguin, which they manipulated freely for pictorial and expressive effects. When their work first appeared in 1905, it so shocked the conservative critic Louis Vauxcelles that he dubbed these artists Fauves (wild beasts), a label they wore with pride. It was not a common program that brought them together, but their shared sense of liberation and experimentation. As a movement, Fauvism included a number of loosely related individual styles, and the group dissolved after a few years. Most of its members were unable to sustain their inspiration or to adapt successfully to the challenges posed by Cubism. Fauvism was nevertheless a decisive breakthrough. It constituted the first unquestionably modern movement of the twentieth century in both style and attitude, one to which every important painter before World War I admitted a debt.

Matisse The leader of the Fauves was Henri Matisse (1869–1954), the oldest of the founders of twentieth-century painting. *The Joy of Life* (fig. 25-1), probably the most important picture of his long career, sums up the spirit of Fauvism better than any other single work. It obviously derives its flat planes of color, the heavy, undulating outlines, and the "primitive" flavor of its forms from Gauguin (see fig. 24-7). Even its subject suggests the vision of humanity in a state of nature that Gauguin had sought in Tahiti. But we soon realize that Matisse's figures are not "noble savages" under the

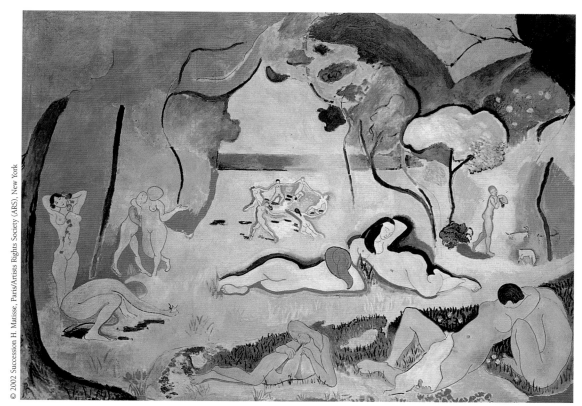

25-1 Henri Matisse. *The Joy of Life*. 1905–6. Oil on canvas, 5'8¹⁄₂" x 7'9³⁄₄" (1.74 x 2.38 m). The Barnes Foundation, Merion, Pennsylvania

spell of a native god. The subject is a pagan scene in the classical sense: a bacchanal like Titian's (compare fig. 13-17). The poses of the figures have a classical origin for the most part, and behind the apparently careless draftsmanship lies a profound knowledge of the human body. (Matisse, a pupil of Gustave Moreau, had been trained in the academic tradition.) What makes the picture so revolutionary is its radical simplicity, its "genius of omission." Everything that possibly can be has been left out or stated only indirectly. The scene nevertheless retains the essentials of three-dimensional form and spatial depth. What holds the painting together is its firm underlying structure, which reflects Matisse's admiration for Cézanne.

Painting, Matisse seems to say, is not a representation of observed reality but the rhythmic arrangement of line and color on a flat plane. He explores how far the image of nature can be pared down

without destroying its basic properties and thus reducing it to mere surface ornament. "What I am after, above all," Matisse once explained, "is expression. . . . [But] . . . expression does not consist of the passion mirrored upon a human face. . . . The whole arrangement of my picture is expressive. The placement of figures or objects, the empty spaces around them, the proportions, everything plays a part." What, we wonder, does *The Joy of Life* express? Exactly what its title says. Whatever his debt to Gauguin, Matisse was never stirred by the same discontent with the decadence of Western civilization. He instead shared the untroubled outlook of the Nabis, with whom he had previously associated, and the canvas owes its decorative quality to their work (compare fig. 24-9). Matisse was concerned above all with the act of painting. This to him was an experience so joyous that he wanted to transmit it to the beholder.

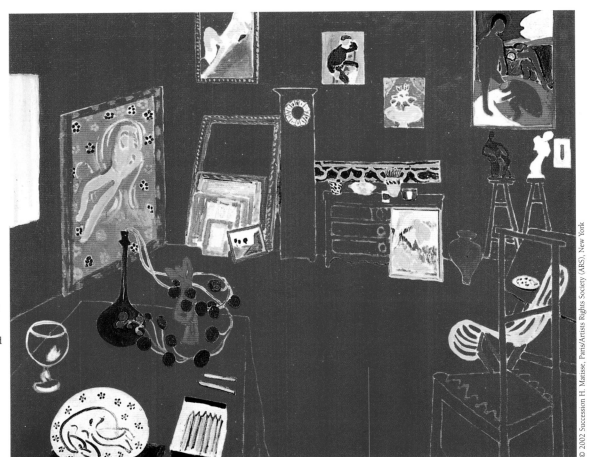

25-2 Henri Matisse. *The Red Studio.* 1911. Oil on canvas, 5'11¼" x 7'2¼" (1.81 x 2.19 m). The Museum of Modern Art, New York

Mrs. Simon Guggenheim Fund

Matisse's "genius of omission" is seen again in *The Red Studio* (fig. 25-2). By reducing the number of tints to a minimum, he makes color an independent structural element. The result is to emphasize the radical new balance he struck between the two-dimensional and three-dimensional aspects of painting. Matisse spreads the same flat red color on the tablecloth and wall as on the floor, yet he distinguishes the horizontal from the vertical planes with complete assurance, using only a few lines. Equally bold is Matisse's use of pattern, seemingly casual yet perfectly calculated. He harmonizes the relation of each element with the rest of the picture by repeating a few basic shapes, hues, and decorative motifs around the edges of the canvas. Cézanne had pioneered this integration of surface ornament into the design of a picture (see fig. 24-1), but here Matisse makes it a mainstay of his composition.

Rouault For Georges Rouault (1871–1958), the other important member of the Fauves, expression still had to include "the passion mirrored upon a human face," as it had in the past. Rouault was the true heir of Van Gogh's and Gauguin's concern for the corrupt state of the world. However, he hoped for spiritual renewal through a revitalized Catholic faith. His pictures, whatever their subject, are personal statements of that ardent hope. Trained in his youth as a stained-glass worker, he was better prepared than the other Fauves to share Gauguin's enthusiasm for medieval art. Rouault's later work, such as *The Old King* (fig. 25-3), has glowing colors and broad, black-bordered shapes inspired by Gothic stained-glass windows (compare fig. 11-29). Within this framework he retains a good deal of pictorial freedom, which he uses to express his profound understanding of the human condition. The old king's face conveys a mood

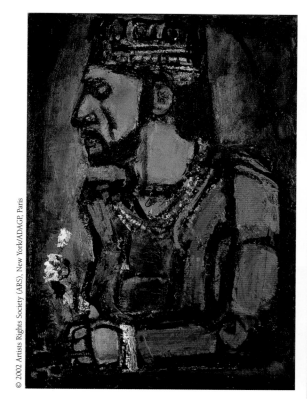

25-3 Georges Rouault. *The Old King*. 1916–37. Oil on canvas, 30¼ x 21¼" (76.8 x 54 cm). The Carnegie Museum of Art, Pittsburgh

Patrons Art Fund

of resignation and inner suffering that reminds us of Rembrandt, Daumier, and Van Gogh.

GERMAN EXPRESSIONISM

Fauvism had a decisive influence on the Expressionist movement, which arose at the same time in Germany. Because Expressionism had deep historical roots that made it especially appealing to the Northern mind, it lasted far longer there. It also proved broader and more varied than in France. For these reasons, Expressionism is sometimes applied to German art alone, but such a limit ignores its close ties to Fauvism and the numerous similarities between them. German Expressionism was characterized by greater emotional extremes and a more spontaneous approach, while Fauvism was for the most part less openly neurotic and morbid. But the two movements were not separated by any fundamental difference in style or content.

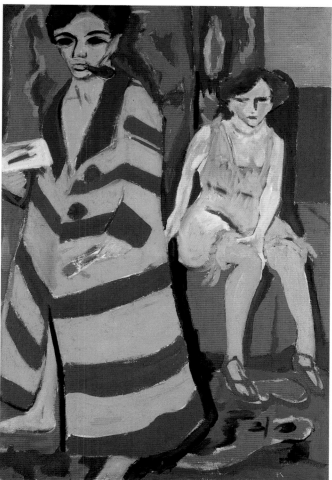

25-4 Ernst Ludwig Kirchner. *Self-Portrait with Model*. 1907. Oil on canvas, 59¼ x 39⅜" (150.5 x 100 cm). Kunsthalle, Hamburg

Die Brücke Expressionism in Germany began with Die Brücke (The Bridge), a group of like-minded painters who lived in Dresden in 1905. Through its bohemian lifestyle, Die Brücke cultivated the sense of imminent disaster that is one of the hallmarks of the modern avant-garde. Their early work not only reveals the direct impact of Van Gogh and Gauguin but also shows elements derived from Munch, who was then living in Berlin and who deeply impressed the German Expressionists. It was an exhibition of Matisse that proved decisive, however. *Self-Portrait with Model* (fig. 25-4) by Ernst Ludwig Kirchner (1880–1938), the group's leader, reflects Matisse's simplified, rhythmic line

and loud color. Yet the contrast between the coldly aloof artist and the brooding model, who looks as if she has been violated, has a peculiar expressiveness that comes from Munch, whose work was often fraught with a palpable sexual tension.

Kokoschka Another Expressionist of highly individual talent was the Austrian painter Oskar Kokoschka (1886–1980), who began his career as a member of the Vienna Secession (see page 549). In 1910 he was invited to Berlin by Herwarth Walden, the publisher of *Der Sturm* (The Storm), an art journal that soon attracted members of Die Brücke and Der Blaue Reiter (see below). Kokoschka's most memorable work, *The Bride of the Wind* (fig. 25-5), celebrates his love for Alma Mahler, the "muse" who inspired so many of Germany's and Austria's leading cultural figures. (Besides the composer-conductor Gustave Mahler, she married the poet Franz Werfel and the architect Walter Gropius.) Based on Romantic paintings of Dante's tragic lovers Paolo and Francesca, it was originally conceived as *Tristan and Isolde* after Wagner's opera but received its present title from the poet

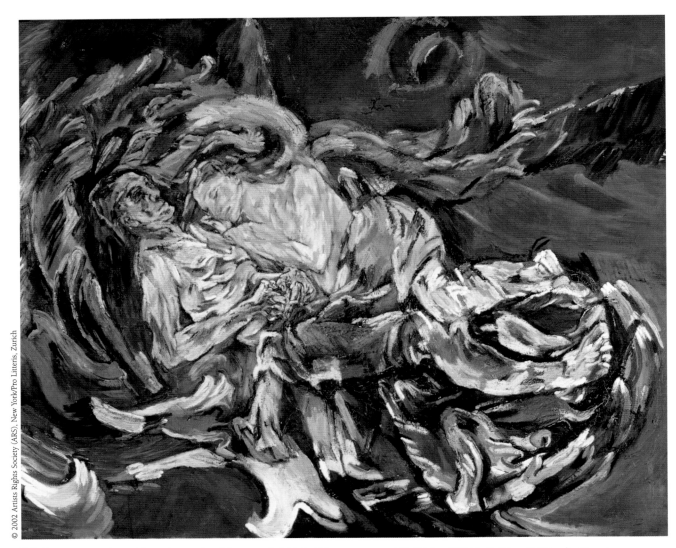

© 2002 Artists Rights Society (ARS), New York/Pro Litteris, Zurich

25-5 Oskar Kokoschka. *The Bride of the Wind.* 1914. Oil on canvas, 5'11¼" x 7'2⅝" (1.81 x 2.20 m). Kunstmuseum, Öffentliche Kunstsammlung Basel, Switzerland

Georg Trakl. The awesome canvas is a monument to the power of love: echoing the impassioned brushwork, the entire universe resounds in a great chord of exaltation at the pair's embrace. Its ecstatic vision achieves that state of mind when "one's perception reaches out towards the Word, towards awareness of the vision," which was Kokoschka's ideal. "It is love, delighting to lodge itself in the mind."

Kandinsky The most daring and original step beyond Fauvism was taken in Germany by a Russian, Vassily Kandinsky (1866–1944). He was the leading member of a group of Munich artists called Der Blaue Reiter (The Blue Rider) after one of his early paintings. Formed in 1911, it was a loose alliance united only by its mystical tendencies. Kandinsky began to discard representation as early as 1910 and abandoned it altogether several years later. Using the rainbow colors and the free, dynamic brushwork of the Fauves, he created a completely nonobjective style charged with extraordinary energy. These works have titles as abstract as their forms: our example, one of the most striking, is called *Sketch I for "Composition VII"* (fig. 25-6).

Perhaps we should avoid the term *abstract,* because it is often taken to mean that the artist has analyzed and simplified visible reality into geometric forms. (Compare Cézanne's assertion that all natural forms are based on the cone, sphere, and cylinder.) Kandinsky did indeed derive his shapes from the world around him—in landscapes that he freely invented—but by transforming rather than reducing them.

Kandinsky's aim is made clear in the first part of his book *Concerning the Spiritual in Art,* written in 1910 but published only in 1912. His intention was to charge form and color with a "purely spiritual meaning," one that expressed his deepest feelings, by eliminating all resemblance to the physical world. To him, the only reality that mattered was the artist's inner reality. Thus Kandinsky regarded the Symbolists as his ancestors. Like Gauguin, he wanted to create an art of spiritual renewal. But in contrast to Rouault, he had no specific spiritual program, although his views were similar to those of the theosophist Rudolf Steiner, who influenced many early-twentieth-century artists in Germany.

Kandinsky, like Steiner, believed that humanity had lost touch with its spirituality through attachment to material things, and he wanted to rekindle a dreamlike consciousness through his art.

The second part of the book is concerned exclusively with the formal aspects of painting, above all color. Kandinsky studied the color theories of Seurat and his followers (see pages 540–42), as did many other Expressionists, but the meaning he gave to specific hues was no less individual than Van Gogh's (see pages 542–43). Kandinsky's theory of color relationships is strikingly similar to the tonal relationships spelled out in *Theory of Harmony* (1911) by the Expressionist composer Arnold Schoenberg, an ally of Der Blaue Reiter with whom the artist was in close contact.

What does all this have to do with Kandinsky's paintings themselves? The character of his art is best summed up by his later statement: "Painting is the vast, thunderous clash of many worlds, destined, through a mighty struggle, to erupt into a totally new world, which is creation. And the birth of a creation is much akin to that of the Cosmos. There is the same vast and cataclysmic

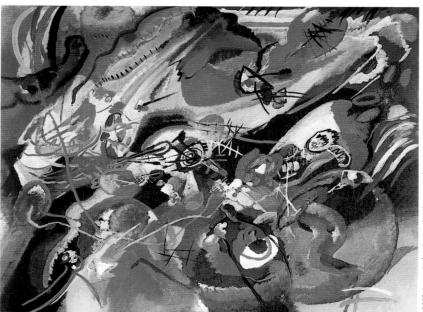

25-6 Vassily Kandinsky. *Sketch I for "Composition VII."* 1913. Oil on canvas, 30³/₄ x 39³/₈" (78 x 100 cm). Private collection

quality belonging to that mighty symphony—the Music of the Spheres."

Kandinsky's antinaturalism was inherent in Expressionist theory from the very beginning. Whistler, too, had spoken of "divesting the picture from any outside sort of interest." He even anticipated Kandinsky's "musical" titles (see fig. 23-18). But it was the liberating influence of the Fauves that permitted Kandinsky to put this approach into practice.

How valid is the analogy between painting and music? Although Kandinsky was careful to acknowledge the differences between the two art forms, he sought a painting style that, like music, was absolute, because it was divorced entirely from the "objective," material realm. While acknowledging that music can say far more than words, Schoenberg (who was also a competent painter) wrote, "I cannot unreservedly agree with the distinction between color and pitch. I find that a note is perceived by its color, one of whose dimensions is pitch. Color, then, is the great realm, pitch one of its provinces. . . . If the ear could discriminate between differences of color, it might be feasible to invent melodies that are built of colors." When a painter like Kandinsky carries such an approach through so completely, does he really lift his art to another plane? Kandinsky's advocates like to point out that representational painting has a "literary" content, and they object to such dependence on another art. But they do not explain why the "musical" content of nonobjective painting should be superior. They believe music is a higher art than literature or painting because it is inherently nonrepresentational. This point of view has an ancient tradition that goes back to Plato and includes Plotinus, St. Augustine, and their medieval successors.

The case is difficult to argue, and it does not matter whether this theory is right or wrong, for the proof of the pudding is in the eating, not in the recipe. Kandinsky's—or any artist's—ideas are not important to us unless we are convinced of the importance of the work itself. The painting reproduced here impresses us with its radiant freshness and vitality, even though we may be uncertain what exactly the artist has expressed.

Hartley Americans became familiar with the Fauves through exhibitions from 1908 on. After the pivotal Armory Show of 1913, which introduced the latest European art to New York, there was a growing interest in the German Expressionists as well. The driving force behind the modernist movement in the United States was the photographer Alfred Stieglitz (see pages 647–49), who almost single-handedly supported many of its early members. To him modernism meant abstraction and its related concepts. Among the most important works by the Stieglitz group are the canvases painted by Marsden Hartley (1887–1943)

25-7 Marsden Hartley. *Portrait of a German Officer.* 1914. Oil on canvas, 68¼ x 41⅜" (173.4 x 105.1 cm). The Metropolitan Museum of Art, New York

The Alfred Stieglitz Collection, 1949

in Munich during the early years of World War I under the direct influence of Kandinsky. *Portrait of a German Officer* (fig. 25-7) is a masterpiece of design from 1914, the year Hartley was invited to exhibit with Der Blaue Reiter. He had already been introduced to Futurism and several offshoots of Cubism, which he used to discipline Kandinsky's supercharged surface. The emblematic image is an allusion to Hartley's lover, who was killed during World War I. It includes the insignia, epaulets, Maltese cross, and other details from an officer's uniform of the day.

ABSTRACTION

The second of our main currents is Abstraction. When discussing Kandinsky, we said that the term is usually taken to mean the process (or the result) of analyzing and simplifying observed reality into geometric shapes. Literally it means "to draw away from, to separate." Actually, abstraction goes into the making of any work of art, whether the artist knows it or not, since even the most painstakingly realistic portrayal can never be an entirely faithful replica. The process was not conscious and controlled, however, until the Early Renaissance, when artists first analyzed the shapes of nature in terms of mathematical bodies (see pages 290–91). Cézanne and Seurat revived this approach and explored it further. They are the direct ancestors of the abstract movement in twentieth-century art. The difference, as one critic has noted, is that, for the latter, abstraction has been both a premise and a goal, not simply a reductive refinement. Abstraction has been the most distinctive and consistent feature of modern painting, to which even its most outspoken opponents have responded.

CUBISM

Picasso's *Demoiselles d'Avignon* It is difficult to imagine the birth of modern abstraction without Pablo Picasso. About 1905 he gradually abandoned the melancholy lyricism of his Blue Period (see fig. 24-14) for a more robust style that was stimulated as much by the Fauves as by the retrospective exhibitions of the great Post-Impressionists. Picasso shared Matisse's enthusiasm for Gauguin and Cézanne, but he viewed these masters very differently. In 1907 he produced his own counterpart to *The Joy of Life,* a monumental canvas (fig. 25-8, page 570) so challenging that it outraged even Matisse. (They nevertheless remained lifelong friends and rivals who learned much from each other's example.) The title, *Les Demoiselles d'Avignon* (The Young Ladies of Avignon), which came from Picasso's friend André Salmon, does not refer to the town of that name, but to Avignon Street in a notorious section of Barcelona near where the artist grew up. When Picasso started the picture, it was to be a temptation scene in a brothel, but he ended up with a composition of five nudes and a still life. But what nudes! Their savage aggressiveness makes Matisse's generalized figures in *The Joy of Life* (see fig. 25-1) seem incredibly innocent.

The three on the left are angular distortions of classical figures, but the violently dislocated features and bodies of the other two have all the "barbaric" qualities of ethnographic art. Following Gauguin's lead, the Fauves had discovered African and Oceanic sculpture, and had introduced Picasso to it. Nonetheless it was Picasso, not the Fauves, who used primitivist art as a battering ram against the classical conception of beauty. Not only the proportions but also the organic integrity of the human body are denied here, so that the canvas (in the apt description of one critic) "resembles a field of broken glass."

Picasso, then, has destroyed a great deal. What has he gained in the process? Once we recover from the initial shock, we begin to see that the destruction is quite methodical. Everything—the figures as well as their setting—is broken up into angular wedges or facets. These, we will note, are not flat, but shaded in a way that gives them a certain three-dimensionality. We cannot always be sure whether they are concave or convex. Some look like chunks of solidified space, others like fragments of translucent bodies. They constitute a unique kind of matter, which imposes a new continuity on the entire canvas. *Les Demoiselles,* unlike *The Joy of Life,* can no longer be read as an image of the external world. Its world is its own, analogous to nature but constructed along different principles. Picasso's revolutionary "building material," made up of voids and solids, is hard to describe

SPEAKING OF

primitive and *primitivism*

This is an especially "vexed term" in that today the word carries negative connotations from the past, when it was used with some disdain to refer to peoples and cultures that had developed differently from Anglo-American culture. The term actually means "early," but has been employed to describe that which is violent, crude, ignorant, and naive, particularly when speaking of cultures unfamiliar to the one who uses the word. On the other hand, *primitivism* is the name of the tendency to elevate, even idealize, some of these traits.

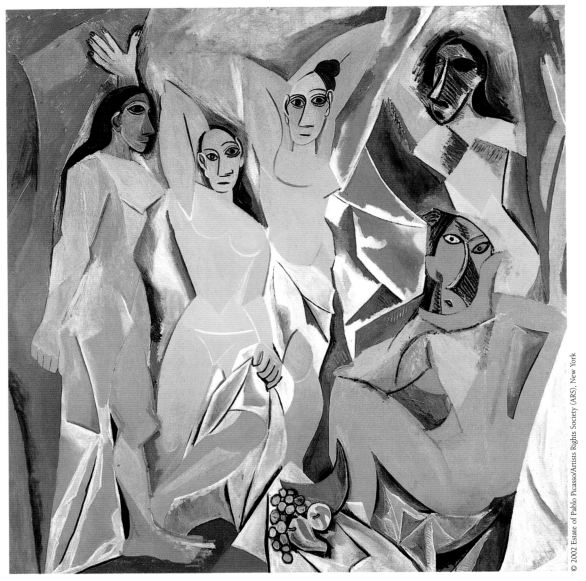

25-8 Pablo Picasso. *Les Demoiselles d'Avignon.* 1907. Oil on canvas, 8' x 7'8" (2.44 x 2.34 m). The Museum of Modern Art, New York

Acquired through the Lillie P. Bliss Bequest

precisely. After seeing an exhibition of paintings by Picasso's friend Georges Braque (see below) in 1909, Louis Vauxcelles, the same critic who named Fauvism, dubbed the new style Cubism after Matisse described them as consisting of little cubes.

Analytic Cubism That *Les Demoiselles* owes anything to Cézanne may at first seem incredible. How-

ever, Picasso had studied Cézanne's late work (such as fig. 24-2) with great care and found in Cézanne's abstract treatment of volume and space the structural units from which to derive the faceted shapes of Analytic (or Facet) Cubism. The link is clearer in *Portrait of Ambroise Vollard* (fig. 25-9), which Picasso painted three years later. (Vollard was one of the leading print publishers and dealers

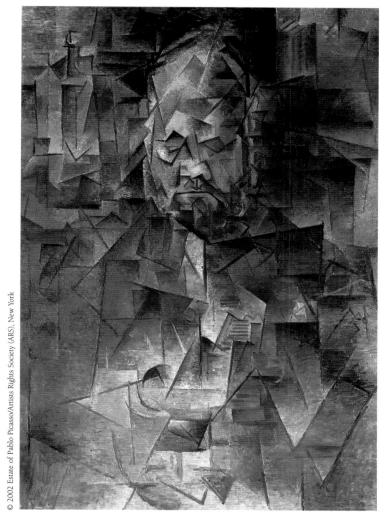

25-9 Pablo Picasso. *Portrait of Ambroise Vollard.* 1910. Oil on canvas, 36$\frac{1}{4}$ x 25$\frac{5}{8}$" (92 x 65 cm). The Pushkin State Museum of Fine Arts, Moscow

of the time.) The facets are now small and precise, more like prisms, and the canvas has the balance and refinement of a fully mature style.

Contrasts of color and texture, so pronounced in *Les Demoiselles,* are now reduced to a minimum. The subdued tonality of the picture approaches monochrome, so as not to compete with the design. The structure has become so complex and systematic that it would seem entirely calculated if the "imprismed" sitter's face did not emerge with such dramatic force. Indeed, this is as commanding a portrait as Ingres's *Louis Bertin* (see fig. 22-6), one that fully conveys the power of Vollard's complex personality. There is no trace of the "barbaric" distortions in *Les Demoiselles;* they had served their purpose. Cubism had become an abstract style within the purely Western sense, but it was not any more removed from observed reality. Picasso may have been playing an elaborate game of hide-and-seek with nature, but he still needed the visible world to stimulate his creative powers. The nonobjective realm held no appeal for him, then or later.

Synthetic Cubism By 1910 Cubism was well established as an alternative to Fauvism. Picasso had been joined by a number of other artists, notably Georges Braque (1882–1963), who had started out as a Fauve painter and then helped to create Cubism. The two collaborated so closely that their work at that time is difficult to tell apart. Both of them (it is not clear to whom the main credit belongs) initiated the next phase of Cubism, which was even bolder than the first. Usually called Synthetic Cubism because it puts forms back together, it is also known as Collage Cubism, after the French word for "pasteup," the technique that started it all. Within a year, Picasso and Braque were producing still lifes composed almost entirely of cut-and-pasted scraps of material, with only a few painted lines added to complete the design. In *Le Courrier* by Braque (fig. 25-10), we recognize strips of imitation wood graining, part of a tobacco wrapper with a contrasting stamp, half the masthead of a newspaper, and a bit of newsprint made into a playing card (the ace of hearts).

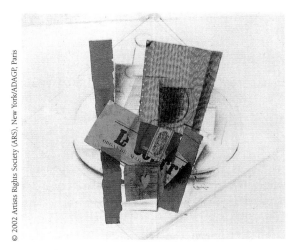

25-10 Georges Braque. *Newspaper, Bottle, Packet of Tobacco (Le Courrier)*. 1914. Collage of charcoal, gouache, pencil, ink, and pasted paper on cardboard, 20⅝ x 25" (52.4 x 63.5 cm). Philadelphia Museum of Art

A. E. Gallatin Collection

Why did Picasso and Braque suddenly prefer the contents of the wastepaper basket to brush and paint? They wanted to explore their new concept of the picture as a tray on which to "serve" the still life, and found the best way was to put real things on the tray. The ingredients of a collage play a double role. They have been shaped and combined, then drawn or painted upon to give them a representational meaning. Yet they do not lose their original identity as scraps of material— they remain "outsiders" in the world of art. Their function is both to represent (to be a part of an image) and to present (to be themselves). Thus they give the collage a self-sufficiency that no Analytic Cubist picture can possibly have. A tray, after all, is a self-contained area, detached from the rest of the physical world. Unlike a painting, it cannot show more than is actually on it.

The difference between the two phases of Cubism may also be defined in terms of picture space. Analytic Cubism retains a certain depth, so that the painted surface acts as a window through which we still perceive the remains of the perspective space of the Renaissance. Although fragmented and redefined, this space lies behind the picture plane and has no visible limits. Potentially, it may even contain objects that are hidden from our view. In Synthetic Cubism, on the contrary, the picture space lies in front of the plane of the "tray." Space is not created by illusionistic devices, such as **modeling** and **foreshortening**, but by the overlapping of layers of pasted materials. The integrity of the nonperspective space is not affected when, as in *Le Courrier,* the apparent thickness of these materials and their distance from each other are increased by a bit of shading here and there. Synthetic Cubism, then, offers a basically new concept of space, the first since Masaccio. It is a true landmark in the history of painting.

Before long Picasso and Braque discovered that they could maintain this new pictorial space without the use of pasted materials. They only had to paint as if they were making collages. World War I, however, put an end to their collaboration and delayed the further development of Synthetic Cubism, which therefore reached its height in the following decade.

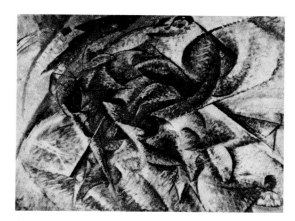

25-11 Umberto Boccioni. *Dynamism of a Cyclist.* 1913. Oil on canvas, 27⅝ x 37⅜" (70 x 95 cm). Collection Gianni Mattioli, Milan

Futurism As originally conceived by Picasso and Braque, Cubism was a formal discipline of subtle balance applied to traditional subjects: still life, portraiture, the nude. Other painters, however, saw in the new style a strong kinship with the geometric precision of engineering that made it uniquely attuned to the dynamism of modern life. The short-lived Futurist movement in Italy represents this attitude. In 1909–10 its disciples, led by the poet Filippo Tommaso Marinetti, issued a series of manifestos violently rejecting the past and exalting the beauty of the machine.

At first they used techniques developed from Post-Impressionism to convey the surge of industrial society, but these were otherwise static compositions, still dependent upon representational images. By adopting the simultaneous views of Analytic Cubism in *Dynamism of a Cyclist* (fig. 25-11), Umberto Boccioni (1882–1916), the most original of the Futurists, was able to communicate the energy of rapid pedaling across time and space far more tellingly than if he had actually depicted the human figure. In traditional art the subject could be seen in only one time and place. Boccioni was partly inspired by the motion photography of Eadweard Muybridge and his successors (see page 560). But in the flexible vocabulary provided by Cubism, he found the means of expressing what Albert Einstein had defined in 1905 in his SPECIAL THEORY OF RELATIVITY—the twentieth century's new sense of time, space, and energy. Moreover, Boccioni suggests the unique quality of the modern experience. With his pulsating movement, the cyclist has become an extension of his environment, from which he is now indistinguishable.

Futurism literally died out in World War I. Its leading artists were killed by the same vehicles of destruction they had glorified only a few years earlier in their revolutionary manifestos, but their legacy was soon taken up in France, the United States, and, above all, Russia.

Cubo-Futurism As its name implies, Cubo-Futurism took its style from Picasso and Braque, and based its theories on Futurist tracts. The movement arose in Russia a few years before World War I as the result of close contacts with the leading European art centers. The Russian Futurists were, above all, modernists. They welcomed industry, which was spreading rapidly throughout Russia, as the foundation of a new society and the means for conquering that old Russian enemy, nature. Unlike the Italian Futurists, however, the Russians rarely glorified the machine, least of all as an instrument of war.

Central to Cubo-Futurist thinking was the concept of *zaum,* a term that has no counterpart in English. Invented by Russian poets, *zaum* was a "trans-sense" (as opposed to the Dadaists' "non-sense"; see page 584) language based on new word forms and syntax. In theory *zaum* could be understood universally, since it was thought that meaning was implicit in the basic sounds and patterns of speech. When applied to painting, *zaum* provided the artist with complete freedom to redefine the style and content of art. The picture surface was now seen as the sole conveyer of meaning through its appearance. Hence the subject of a work of art became its visual elements and their formal arrangement. However, because Cubo-Futurism was concerned with means, not ends, it failed to provide the actual content that is found in modernism. The Cubo-Futurists were more important as theorists than as artists, but they provided the springboard for later Russian movements.

In his SPECIAL THEORY OF RELATIVITY (originally published in "On the Electrodynamics of Moving Bodies," while he was a doctoral candidate in Zurich) the brilliant physicist Albert Einstein (1879–1955) put forth his theory for understanding the nature of measurement and interaction of space and time. To the end of his days, Einstein sought a unified field theory that would explain all major phenomena encompassed in the field of physics.

The new world envisioned by the Russian modernists redefined the roles of man and woman, and it was in Russia that women emerged as artistic equals in a way that was not achieved in Europe or America until considerably later. The finest painter among the Cubo-Futurists was Liubov Popova (1889–1924), who studied in Paris in 1912 and visited Italy in 1914. The combination of Cubism and Futurism that she absorbed abroad is seen in *The Traveler* (fig. 25-12). The treatment of forms remains essentially Cubist, but the painting shares the Futurist obsession with representing dynamic motion in time and space. The jumble of image fragments creates the impression of objects seen in rapid succession. The tumultuous interaction of forms with their environment across the plane threatens to extend the painting into the surrounding space. At the same time, the strong modeling draws attention to the surface and

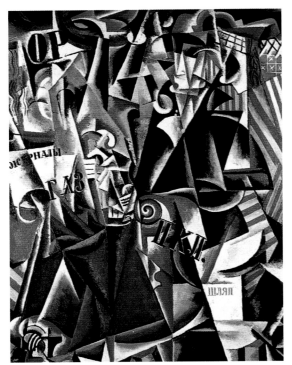

25-12 Liubov Popova. *The Traveler.* 1915. Oil on canvas, 56 x 41¹/₂" (142.2 x 105.4 cm). Norton Simon Art Foundation, Pasadena, California

gives it a relieflike quality that is enhanced by the vigorous texture.

SUPREMATISM

The first purely Russian art of the twentieth century was Suprematism. It was devised by Kazimir Malevich (1878–1935), who wanted to reduce painting to a "supreme" reality based on geometry, because it is an independent abstraction—hence the movement's name. According to the artist, Suprematism was also a philosophical color system constructed in time and space. His space was an intuitive one, with both scientific and mystical overtones. The flat plane replaces volume, depth, and perspective as a means of defining space. Each side or point represents one of the three spatial dimensions, while the fourth stands for the fourth dimension: time. Like Einstein's formula $E=mc^2$ for the theory of relativity, Suprematism has an elegant simplicity that belies the intense effort required to synthesize a complex set of ideas and reduce them to a fundamental "law." The relationship between art and science is closer than we might think, for despite the differences in approach, they are united by the imagination. In fact, the key to solving the theory of relativity came to Einstein in the form of a visual image.

When it first appeared in 1915 in Malevich's painting of a black quadrilateral within a white border, Suprematism had much the same impact on Russian artists that Einstein's theory had on scientists. It unveiled a world never seen before, one that was unmistakably modern. Malevich later began to tilt his quadrilaterals and to simplify his paintings still further in search of the ultimate work of art. These efforts culminated in *Suprematist Composition: White on White* (fig. 25-13), his most famous composition, which limits art to its fewest possible components. It is tempting to dismiss such a radical extreme as an absurd reduction. Seen in person, however, the canvas is surprisingly persuasive. The shapes, created by two subtly different shades of white, have a visionary purity that makes other paintings seem needlessly complex.

The heyday of Suprematism was over by the early 1920s. In response to the growing diversity and fragmentation of Russian art, its followers

25-13 Kazimir Malevich. *Suprematist Composition: White on White.* 1918. Oil on canvas, 31¼ x 31¼" (79.4 x 79.4 cm). The Museum of Modern Art, New York

defected to other movements, above all to the Constructivism led by Vladimir Tatlin (see page 611).

FANTASY

Our third current, Fantasy, follows a less clear-cut course than the other two, since it depends on a state of mind more than on any particular style. The one thing all painters of fantasy have in common is the belief that imagination, "the inner eye," is more important than the outside world. We must be careful how we use the term *fantasy*. It originated in psychoanalytic theory and meant something very different in the early twentieth century than it does now. It was thought of as mysterious and profound, anything but the lighthearted and superficial view we take of it today.

Why did private fantasy come to loom so large in early-twentieth-century art? There were several causes. First, the rift that developed between reason and imagination in the wake of the rationalism of the Enlightenment tended to dissolve the heritage of myth and legend that had been the common channel of private fantasy in earlier times.

Second, the artists had greater freedom—and insecurity—within society, giving them a sense of isolation and favoring an introspective attitude. Finally, the Romantic cult of emotion prompted the artist to seek out subjective experience and to accept its validity. This process took considerable time. We saw the trend beginning at the end of the eighteenth century in the art of Goya and Fuseli (see figs. 22-2 and 22-14). In early-nineteenth-century painting, private fantasy was still a minor current, but by 1900 it had become a major one, thanks to Symbolism on the one hand and the naive vision of artists such as Henri Rousseau on the other.

De Chirico The heritage of Romanticism can be seen most clearly in the pictures painted in Paris just before World War I by the Italian artist Giorgio de Chirico (1888–1978), such as *Mystery and Melancholy of a Street* (fig. 25-14). Illuminated by the cold light of the full moon, this deserted square, with its tilted perspective and rapidly diminishing arcades, has all the poetry of Romantic reverie. It also has a strangely sinister

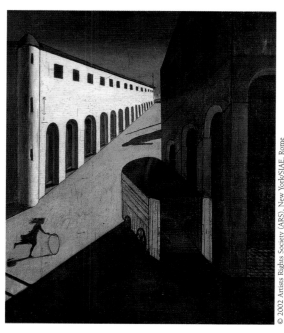

25-14 Giorgio de Chirico. *Mystery and Melancholy of a Street.* 1914. Oil on canvas, 34¼ x 28½" (87 x 72.4 cm). Private collection

air. This is an "ominous" scene in the full sense of the term: everything here suggests an omen, a portent of unknown and disquieting significance. The artist himself could not fully explain the incongruities in these paintings—the empty furniture van or the girl with the hoop—that trouble and fascinate us. De Chirico called this *metaphysical painting:* "We who know the signs of the metaphysical alphabet are aware of the joy and the solitude which are enclosed by a portico, by the corner of a street, or even in a room, on the surface of a table, or between the sides of a box. . . . The minutely accurate and prudently weighed use of surfaces and volumes constitutes the canon of the metaphysical aesthetic." Later, after he had returned to Italy, De Chirico adopted a conservative style and disowned his early works, as if embarrassed at having put his dream world on display. He nevertheless secretly continued to paint copies to meet commercial demand.

Chagall The power of nostalgia, so evident in *Mystery and Melancholy of a Street,* also domi- nates the work of Marc Chagall (1887–1985), a Russian Jew who went to Paris in 1910. *I and the Village* (fig. 25-15) weaves dreamlike memories of Russian folk tales, Jewish proverbs, and the look of Russia into a glowing Cubist vision:

> But please defend me against people who speak of "anecdote" and "fairy tales" in my work. A cow and woman to me are the same—in a picture both are merely elements of a composition [which] have different values of plasticity, but not different poetic values. In the large cow's head in *I and the Village* I made a small cow and woman milking visible through its muzzle because I needed that sort of form, there, for my composition. Whatever else may have grown out of these compositional arrangements is secondary. The fact that I made use of cows, milkmaids, roosters, and provincial Russian architecture as my source forms is because they are part of the environment from which I spring. . . .

The experiences of Chagall's childhood were so important to him that his imagination shaped and reshaped them for years.

Duchamp In Paris shortly before World War I we encounter another artist of fantasy, the French painter Marcel Duchamp (1887–1968). After basing his early style on Cézanne, he created a dynamic version of Analytic Cubism similar to Futurism by superimposing successive phases of movement on one another, much as in multiple-exposure photography. Yet Duchamp's development soon took a far more disturbing turn. In *The Bride* (fig. 25-16) from 1912, we look in vain for any resemblance, however remote, to the human form. What we see instead is a mechanism that seems part motor, part distilling apparatus. It is beautifully engineered to serve no purpose whatsoever. The title cannot be irrelevant: by lettering it right onto the canvas, Duchamp has emphasized its importance. Yet it remains truly puzzling. Evidently the artist intended the machine as a kind of modern fetish that acts as a metaphor of human sexuality. He satirizes the

25-15 Marc Chagall. *I and the Village.* 1911. Oil on canvas, 6'3⅝" x 4'11½" (1.92 x 1.51 m). The Museum of Modern Art, New York

Mrs. Simon Guggenheim Fund

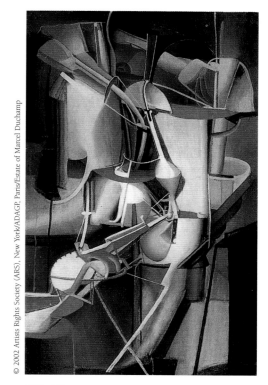

25-16 Marcel Duchamp. *The Bride.* 1912. Oil on canvas, 35¹/₈ x 21³/₄" (89.2 x 55.3 cm). Philadelphia Museum of Art

Louise and Walter Arensberg Collection

scientific outlook on humanity by "analyzing" the bride until she is reduced to a complicated piece of plumbing that seems totally dysfunctional, physically and psychologically. Thus the picture represents the negative counterpart of the glorification of the machine so stridently proclaimed by the Futurists. We may further see in Duchamp's pessimistic outlook a response to the gathering forces that were soon to be unleashed in World War I and topple the political order that had been created a hundred years earlier at the Congress of Vienna following Napoleon's final defeat.

REALISM

The Ash Can School In the United States, the first wave of change was initiated by the Ash Can School, which flourished in New York just before World War I. Centering on Robert Henri (1865–1929), who had studied with a pupil of Thomas Eakins at the Pennsylvania Academy, this group of artists consisted mainly of former illustrators for Philadelphia and New York newspapers. They were fascinated with the teeming life of the city slums and found an endless source of subjects in the everyday urban scene, to which they brought a reporter's eye for color and drama. Despite the socialist philosophy that many of them shared, theirs was not an art of social commentary but one that felt the pulse of the city, in which they discovered vitality and richness while ignoring poverty and squalor. To capture these qualities they relied on rapid execution, inspired by Baroque and Post-Impressionist painting, which lends their canvases a sense of directness and spontaneous observation.

Bellows Although not among its founders, George Bellows (1882–1925) became the leading representative of the Ash Can School in its heyday. His masterpiece, *Stag at Sharkey's* (fig. 25-17), shows why. No painter in America had expressed such heroic energy. *Stag at Sharkey's* continues the Realist tradition of Eakins's *William Rush Carving His Allegorical Figure of the Schuylkill River* (see fig. 23-20). Both place us in the scene as if we were present and use the play of light to pick out the figures against a dark background. Bellows's paintings were fully as shocking as Eakins's had been. Most late-nineteenth-century American artists had all but ignored urban life in favor of landscapes and genteel interiors. Compared with such pictures, the subjects and surfaces of the Ash Can School pictures had a disturbing rawness.

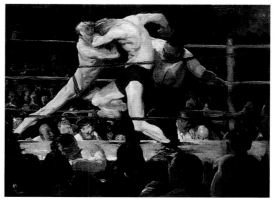

25-17 George Bellows. *Stag at Sharkey's.* 1909. Oil on canvas, 36¹/₄ x 48¹/₄" (92.1 x 122.6 cm). The Cleveland Museum of Art

Hinman B. Hurlbut Collection

THE ARMORY SHOW

The Ash Can School was quickly eclipsed by the rush toward a more radical modernism set off by the Armory Show. Held in New York in 1913, it was an outgrowth of the Independents Show three years earlier, which had showcased the talents of a group of rising young artists known as THE EIGHT. The Armory Show was intended to foster a "new spirit in art" by introducing the public to the latest trends in Europe and the United States. The exhibition began with a survey of French painting from the Romantics to the Post-Impressionists and featured the Symbolists. The modern section was also heavily French, with a strong emphasis on Matisse and Picasso. There were curious lapses as well: German Expressionism was poorly represented and Futurism was omitted completely. The selection of sculpture was haphazard at best. American art, which made up by far the largest part of the exhibition, included works by members of the Ash Can School, the Stieglitz group, and the Eight. While it failed to promote the interests of its organizers, the Armory Show did succeed in its goal of introducing a new cosmopolitanism into the American art scene. It also proved a success with collectors, who bought an astonishing number of works from the exhibition.

Painting between the Wars

THE FOUNDERS

As we examine painting between the wars, we shall find anything but an orderly progression. World War I had completely disrupted the evolution of modernism, and its end unleashed an unprecedented outpouring of art after a four-year creative lull. The responses were equally varied. Because they were already fully formed artists, the founders of modern painting—Picasso, Braque, Matisse, Kirchner, and Kandinsky—followed very different paths from those who had not yet reached maturity by 1914. Responding only to the dictates of their imaginations, they broke the rules they had established earlier; hence their development defies convenient categories. Rather than a simple linear development, we must think in terms of multiple layers of varying depths that bear a shifting relation to one another.

Picasso We begin with Picasso, whose genius towers over the period. As a Spanish national living in Paris, he was not involved in World War I, unlike many French and German artists who served in the military and even lost their lives. This was a time of quiet experimentation that laid the foundation for Picasso's art of the next several decades. The results did not become fully apparent, however, until the early 1920s, following a period of intense development. *Three Musicians* (fig. 25-18) shows the fruit of that labor. It utilizes the "cut-paper style" of Synthetic Cubism so consistently that we cannot tell from the reproduction whether it is painted or pasted. The canvas revives a favorite theme of the artist's early years, the Italian commedia dell'arte. The shapes are locked together as tightly as the pieces of a jigsaw puzzle to create a colorful, almost jaunty composition. Nevertheless, the effect is by no means lighthearted. On the contrary, the painting is a haunting evocation of the tragic mood following World War I. The somber palette invests the scene with grave solemnity. These musicians wear mysterious masks, like those of a primitive rite, which lend them a peculiar anonymity that is almost frightening, and the piece they play must be anything but joyous.

By now, Picasso was internationally famous. Cubism had spread throughout the Western world. It influenced not only other painters but sculptors and even architects. Picasso himself was already striking out in a new direction. Soon after the invention of Synthetic Cubism, he had begun to do drawings in a realistic manner reminiscent of Ingres's. By 1920 he was working simultaneously in two separate styles: the Synthetic Cubism of the *Three Musicians* and a Neoclassical style with strongly modeled, heavy-bodied figures. To many of his admirers, this seemed a kind of betrayal, but in retrospect the reason for Picasso's double-track approach is clear. Having reached the limits of Synthetic Cubism, he wanted to resume contact with the classical tradition. In fact, Picasso had never entirely abandoned the

THE EIGHT were American painters, most of them Realists, who showed together in a 1908 exhibition that proved to be crucial in establishing American Realism as a popular and authentic alternative to the academic aestheticism that held sway. The artists were founder Robert Henri, George Luks, William J. Glackens, John Sloan, Everett Shinn, Ernest Lawson, Arthur B. Davies, and Maurice Prendergast.

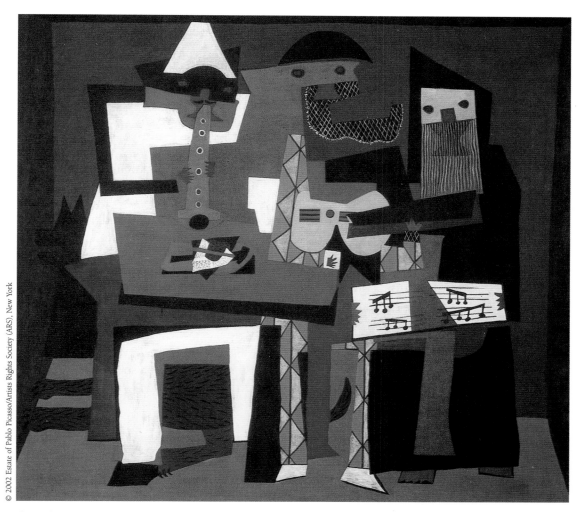

25-18 Pablo Picasso. *Three Musicians*. Summer 1921. Oil on canvas, 6'7" x 7'3¾" (2 x 2.23 m). The Museum of Modern Art, New York

Mrs. Simon Guggenheim Fund

"art of the museums." He was part of a much broader return to classicism by artists who felt a need to reaffirm their belief in an orderly world following the cataclysmic upheavals of World War I.

A few years later the two tracks of Picasso's style began to converge into an extraordinary synthesis that was to become the basis of his art. *Three Dancers* of 1925 (fig. 25-19, page 580) shows how he accomplished this seemingly impossible feat. Structurally the picture is pure Synthetic Cubism. It even includes painted imitations of specific materials, such as patterned wallpaper and samples of various fabrics cut out with pinking shears. The figures, a wildly fantastic version of a classical scheme (compare the dancers in Matisse's *Joy of Life,* fig. 25-1), are an even more violent assault on convention than the figures in *Les Demoiselles d'Avignon* (see fig. 25-8). Human anatomy is here simply the raw material for Picasso's incredible inventiveness. Limbs, breasts, and faces are handled with the same freedom as the fragments of external reality in Braque's *Le Courrier* (see fig. 25-10). Their original identity no longer matters. Breasts may turn into eyes, profiles merge with frontal views, shadows become substance, and

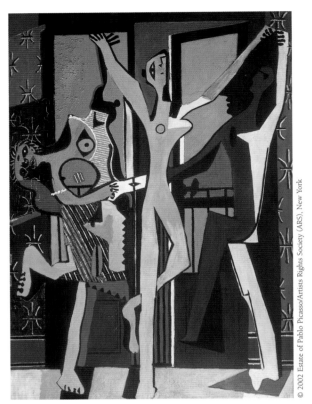

25-19 Pablo Picasso. *Three Dancers*. 1925. Oil on canvas, 7'1½" x 4'8¼" (2.15 x 1.43 m). The Tate Gallery, London

vice versa in an endless flow of metamorphoses. They are "visual puns," offering wholly unexpected possibilities of expression—humorous, grotesque, macabre, even tragic.

Three Dancers marks a transition to Picasso's experiment with Surrealism (see pages 584–85). He had been in close contact with the Surrealists since 1923; his art, in turn, was a point of departure for them. He nevertheless denied that he was affected by Surrealism until a decade later, and with good reason. His prodigious imagination notwithstanding, Picasso did not practice automatism; hence his work did not arise spontaneously from the subconscious. Instead, the paintings of the 1920s addressed formal concerns in the free transformation of objects, which was worked out with great care.

Although Picasso never developed into a true follower of Surrealism, the impact of his fellow Spaniard Joan Miró (see pages 585–86) can be seen in the biomorphism of his mural *Guernica* (fig. 25-20). Picasso did not show any interest in politics during World War I or the 1920s, but the

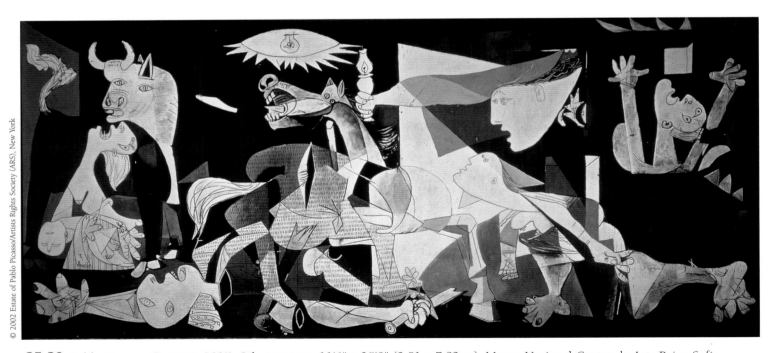

25-20 Pablo Picasso. *Guernica*. 1937. Oil on canvas, 11'6" x 25'8" (3.51 x 7.82 m). Museo Nacional Centro de Arte Reina Sofía, Madrid. On permanent loan from the Museo del Prado, Madrid

SPANISH CIVIL WAR stirred him to ardent partisanship with the Loyalists. The mural, executed in 1937 for the Pavilion of the Spanish Republic at the Paris International Exposition, has truly monumental grandeur. It was inspired by the terror-bombing of Guernica, the ancient capital of the Basques in northern Spain. The painting does not represent the event itself. Rather, it evokes the agony of total war with a series of powerful images.

The destruction of Guernica was the first demonstration of the technique of saturation bombing, which was later used on a huge scale during World War II. The mural was thus a prophetic vision of doom. The symbolism of the scene resists exact interpretation, despite several traditional elements: the mother and her dead child are descendants of the Pietà (see fig. 11-24), the woman with the lamp recalls the Statue of Liberty (see fig. 22-24), and the dead fighter's hand, still clutching a broken sword, is a familiar emblem of heroic resistance (compare fig. 22-22). We also sense the contrast between the menacing, human-faced bull, which we know Picasso intended to represent the forces of brutality and darkness, and the dying horse, which stands for the people. He insisted, however, that the mural was not a political statement about fascism, though "there is a deliberate appeal to people, a deliberate sense of propaganda. . . ." These figures owe their terrifying eloquence to what they are, not to what they mean. The anatomical dislocations, fragmentations, and transformations, which in the *Three Dancers* seemed fantastic, now express the stark reality of unbearable pain. The ultimate test of the validity of collage construction (shown here in superimposed flat "cutouts" restricted to black, white, and gray) is that it could express such overpowering emotions.

Matisse From 1911 on, Matisse was influenced increasingly by Cubism, but after the war he, like Picasso, returned to the classical tradition. The lessons he absorbed from Cubism nevertheless had a far-reaching effect on his style. Their impact can be seen in *Decorative Figure against an Ornamental Background* (fig. 25-21). The painting has a new richness. At the same time, there is an underlying discipline resulting from his study of

Cubism. The carpet provides a firm geometric structure for organizing the composition, so that everything has its place, although the system itself is entirely intuitive. Only in this way could Matisse control all the elements of his complex picture. It is among the finest in a long series of odalisques (harem girls) that Matisse painted during the 1920s and 1930s. In them the artist emerges as the heir of the French tradition, which he had assimilated through his teacher Gustave Moreau (see page 547). The visual splendor would be worthy of Delacroix himself. Yet in the calm pose and strong contours of the figure, Matisse reveals himself to be a classicist at heart, more akin to Ingres than to the Romantics (compare figs. 22-5 and 22-8). The picture also has overtones of Degas (see fig. 23-11), who had been trained by a disciple of Ingres and thus formed an important link in the chain of tradition. It breathes the classical serenity of the *Seated Woman* by Matisse's friend Maillol (see fig. 24-17), who early in his career

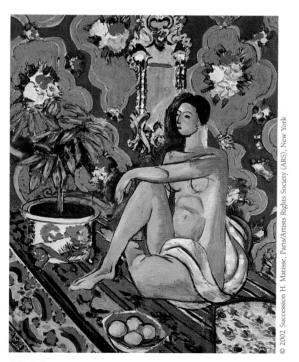

25-21 Henri Matisse. *Decorative Figure against an Ornamental Background.* 1927. Oil on canvas, 51 1/8 x 38 1/2" (129.9 x 97.8 cm). Musée National d'Art Moderne, Paris

Between 1936 and 1939, the SPANISH CIVIL WAR was fought over the survival of the second Spanish republic, founded when the monarchy was overthrown in 1931. The Nationalists, opposed to the republic, included monarchists, Catholics, and fascist Falangists; the Republicans, or Loyalists, counted among their ranks socialists, Communists, and Basque and Catalan separatists. Many volunteers from other countries, forming groups called the International Brigades, took part in the struggle. The Nationalists were ultimately successful, and an authoritarian government was established under their leader, Generalissimo Francisco Franco.

had also been inspired by Gauguin. Nevertheless, Matisse's is a distinctly modern classicism.

ABSTRACTION

Picasso's abandonment of strict Cubism signaled the broad retreat from abstraction after 1920. The utopian ideals associated with modernism, which abstraction embodied, had been largely dashed by "the war to end all wars." In retrospect, abstraction can be seen as a necessary phase through which modern painting had to pass, but it was not essential to modernism as such, even though it was the dominant tendency of the twentieth century.

Léger The Futurist spirit continued to find followers on both sides of the Atlantic, however. Buoyant with optimism and pleasurable excitement, *The City* (fig. 25-22) by the Frenchman Fernand Léger (1881–1955) creates a vision of a mechanized utopia that is inspired by his Communist political views. This beautifully controlled industrial landscape is stable without being static and reflects the clean geometric shapes of modern machinery. In this instance, the term *abstraction* applies more to the choice of design elements and their manner of combination than to the shapes themselves, which

are "prefabricated," except for the two figures on the staircase, who hardly differ from their surroundings.

Demuth The modern movement in the United States proved short-lived. One of the few artists to continue working in an abstract vein after World War I was Charles Demuth (1883–1935). A member of the Stieglitz group (see pages 647–49), he had been friendly with Duchamp and the exiled Cubists in New York during World War I. A few years later, under the impact of Futurism, he developed a style known as Precisionism to depict urban and industrial architecture. Influences from all of these movements appear in *I Saw the Figure 5 in Gold* (fig. 25-23). The title is taken from the poem "The Great Figure" by Demuth's friend William Carlos Williams, whose name also forms part of the design as "Bill," "Carlos," and "W. C. W." In the poem the figure 5 appears on a red fire truck, but in the painting it has become the dominant feature, repeated three times to reinforce its echo in our memory as the fire truck rushes

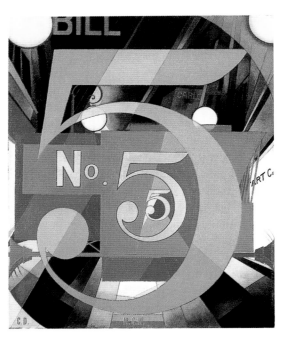

25-23 Charles Demuth. *I Saw the Figure 5 in Gold.* 1928. Oil on composition board, 36 x 29³⁄₄" (91.4 x 75.6 cm). The Metropolitan Museum of Art, New York

The Alfred Stieglitz Collection, 1949

25-22 Fernand Léger. *The City.* 1919. Oil on canvas, 7'7" x 9'9" (2.31 x 2.98 m). Philadelphia Museum of Art

A. E. Gallatin Collection

on through the night:

> Among the rain
> and lights
> I saw the figure 5 in gold
> on a red
> firetruck
> moving
> tense
> unheeded
> to gong clangs
> siren howls
> and wheels rumbling
> through the dark city.

Mondrian The most radical abstractionist of the twentieth century was the Dutch painter Piet Mondrian (1872–1944). Nine years older than Picasso, he arrived in Paris in 1912 as a mature Expressionist in the tradition of Van Gogh and the Fauves. Under the influence of Analytic Cubism, his work soon underwent a complete change, and within the next decade Mondrian developed an entirely nonrepresentational style that he called Neo-Plasticism. The short-lived movement as a whole is also known as De Stijl, after the Dutch magazine advocating his ideas, which were formulated with Theo van Doesburg (1883–1931) and Bart van der Leck (1876–1958). Mondrian became the center of the abstract movement in Paris; in 1919, after spending the war years in the Netherlands, he returned to the city and remained there until the onset of World War II. Indeed, the School of Paris in the 1930s was made up largely of foreigners like him—especially the Abstraction-Création group, which included artists of every outlook. As a result, the differences between the various movements soon became blurred, although Mondrian himself remained true to his principles.

Composition with Red, Blue, and Yellow (fig. 25-24) shows Mondrian's style at its most severe. He restricts his design to horizontals and verticals and his palette to the three primary colors (red, yellow, and blue) plus black and white. Representation is completely eliminated. Yet his canvases remain paintings in every sense of the term. Mondrian never hid his brushwork or the texture of the canvas, and the

25-24 Piet Mondrian. *Composition with Red, Blue, and Yellow.* 1930. Oil on canvas, 20" (50.8 cm) square. Private collection

Courtesy of the Mondrian Estate/Holtzman Trust/MBI NY

pigments have surprising density. Like Kandinsky, Mondrian was affected by THEOSOPHY, albeit the distinctive Dutch branch founded during World War I by the mathematician M. J. H. Schoenmaekers. Unlike Kandinsky, however, he did not strive for pure, lyrical emotion. His goal, he asserted, was "pure reality," which he defined as equilibrium "through the balance of unequal but equivalent oppositions"—especially between line and color. *Plastic* for Mondrian, as for many other early-twentieth-century artists, meant the formal structural relationships underlying both art and nature. The term *Neo-Plasticism* itself was coined by Schoenmaekers, for whom yellow symbolized the vertical movement of the sun's rays; blue, the horizontal line of the earth's orbit around the sun; and red, the union of both. For all their analytic calm, Mondrian's paintings are highly idealistic. He believed, "When we realize that equilibrated relationships in society signify what is just, then we shall realize that in art, likewise, the demands of life press forward when the spirit of the age is ready."

Perhaps we can best understand what Mondrian meant by *equilibrium* if we think of his work as "abstract collage" that uses black bands and colored rectangles instead of recognizable fragments of chair caning and newsprint. He was interested solely in visual relationships and wanted no distracting elements or accidental associations. By establishing the "right" relationship among his

THEOSOPHY (from the Greek *theos*, "divine," and *sophos*, "wisdom") is any religious and philosophical system that seeks knowledge of God and of the universe in relation to God. In Mondrian's time, the most influential theosophist was Madame (Helena Petrovna) Blavatsky (1831–1891), a Russian-born medium, mystic, and occultist who founded the Theosophical Society in New York in 1875. Its worldwide program included the study of all Eastern religions and a keen interest in latent mental and intuitional faculties, as well as a search for a universal and unifying spiritual principle.

bands and rectangles, he transformed them as thoroughly as Braque altered the bits of pasted paper in *Le Courrier* (see fig. 25-10). How did he discover the "right" relationship? And how did he determine the shape and number for the bands and rectangles? In Braque's collage the ingredients are to some extent "given" by chance. Apart from his self-imposed rules, however, Mondrian constantly faced the problem of unlimited possibilities. He could not change the relationship of the bands to the rectangles without changing the bands and rectangles themselves. When we consider his task, we begin to realize its infinite complexity.

Looking again at *Composition with Red, Blue, and Yellow,* we find that when we measure the various units, only the proportions of the canvas itself are truly rational, an exact square. Mondrian has arrived at all the rest "by feel" and must have undergone endless trial and error. How often, we wonder, did he change the dimensions of the red rectangle to bring it and the other elements into self-contained equilibrium? Strange as it may seem, Mondrian's exquisite sense for nonsymmetrical balance is so specific that critics well acquainted with his work have no difficulty in distinguishing fakes from genuine pictures. People who work with nonfigurative shapes, such as designers, architects, and typographers, are likely to be most sensitive to this quality. Mondrian has had a greater influence on them than on painters (see page 634).

FANTASY

Dada Out of despair over the mechanized mass killing of World War I, a number of artists in Zurich and New York, including Duchamp, simultaneously launched a protest movement called Dada (or Dadaism), which then spread to other cities in Germany and France. The term *dada,* which means "hobbyhorse" in French, was reportedly picked at random from a dictionary, although it had actually been used as the title of a Symbolist journal. As an infantile, all-purpose word, however, it perfectly fitted the spirit of the movement. Dada has often been called nihilistic, and it was indeed the very prototype of an avant-garde movement. Its declared purpose was to make clear to the public at large

that all established values—political, moral, and aesthetic—had been rendered meaningless by the catastrophe of the Great War. Dada's program was closely linked to Communism, which it hoped would overthrow bourgeois society and substitute a proletarian paradise. Such political activism was the norm: between 1915 and 1950 most avant-garde artists on both sides of the Atlantic, even Picasso, were associated with Communism or socialism at one time or another.

During its short life (c. 1915–22) Dada preached "non-sense" and antiart with a vengeance. As Hans Arp wrote, "Dadaism carried assent and dissent ad absurdum. In order to achieve indifference, it was destructive." Duchamp once "improved" a reproduction of Leonardo's *Mona Lisa* with a mustache and the abbreviation *LHOOQ*, which makes an off-color pun when pronounced in French. Not even modern art was safe from the Dadaists' assaults. One example exhibited a toy monkey inside a frame with the title *Portrait of Cézanne*. Yet Dada was not a completely negative movement. In its calculated irrationality there was also liberation, a voyage into unknown provinces of the creative mind. The only law respected by the Dadaists was that of chance, and the only reality, that of the imagination.

Ernst Although their most characteristic art form was the readymade (see page 612), the Dadaists adapted the collage technique of Synthetic Cubism to their purposes. Figure 25-25 by the German Dadaist Max Ernst (1891–1976), an associate of Duchamp, is largely composed of snippets from illustrations of machinery. The caption pretends to enumerate these mechanical ingredients, which include (or add up to) "1 Piping Man." Actually there is also a "piping woman." These offspring of Duchamp's prewar *Bride* (see fig. 25-16), staring at us blindly through their goggles, are subtly but deeply haunting.

Surrealism In 1924, after Duchamp's retirement from Dada, a group led by the poet André Breton founded Dada's successor, Surrealism, which also took up Communism. They defined their aim as "pure psychic automatism . . . intended to express

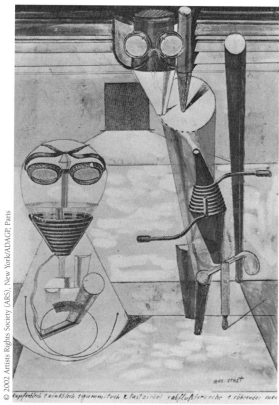

25-25 Max Ernst. *1 Copper Plate 1 Zinc Plate
1 Rubber Cloth 2 Calipers 1 Drainpipe Telescope
1 Piping Man.* 1920. Collage, 12 x 9" (30.5 x 22.9 cm).
Estate of Hans Arp

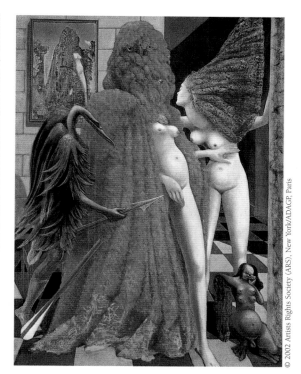

25-26 Max Ernst. *La Toilette de la Mariée.* 1940.
Oil on canvas, 51 x 37⅞" (129.5 x 96.2 cm).
Peggy Guggenheim Collection, Venice

. . . the true process of thought . . . free from the
exercise of reason and from any aesthetic or moral
purpose." Surrealist theory was filled with concepts
borrowed from psychoanalysis, and its rhetoric
cannot always be taken seriously. The notion that
a dream can be transferred by "automatic hand-
writing" directly from the unconscious mind to
the canvas did not work in practice. It was impos-
sible to bypass the conscious awareness of the artist
altogether. Some degree of control was unavoidable.

Ernst's Decalcomania

Surrealism gave rise to
several novel techniques for stimulating and exploit-
ing chance effects. Ernst, the most inventive mem-
ber of the group, often combined collage with "frottage."
(Frottage involves making rubbings from pieces
of wood, pressed flowers, and other relief sur-
faces. It is the process we all know from the chil-
dren's pastime of rubbing with a pencil on a
piece of paper covering, say, a coin.) In *La Toi-
lette de la Mariée* (fig. 25-26), he produced fasci-
nating shapes and textures by "decalcomania."
(The technique uses pressure to transfer oil paint
to the canvas from some other surface. This pro-
cedure is a variant of one recommended by Leo-
nardo da Vinci.) Ernst relied on chance effects
produced by his stains, but he developed them
further into an extraordinary wealth of images. The
end result has some of the qualities of a dream, but
it is a dream born of a strikingly romantic imag-
ination.

Miró

Surrealism had an even more boldly imag-
inative branch. Some works by Picasso, such as

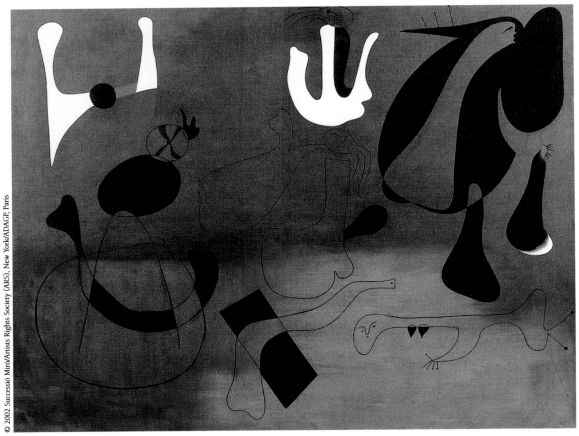

25-27 Joan Miró. *Composition.* 1933. Oil on canvas, 51¼ x 63½" (130.2 x 161.3 cm). Wadsworth Atheneum, Hartford, Connecticut

Ella Gallup Sumner and Mary Catlin Sumner Collection

Three Dancers (see fig. 25-19), have affinities with it, and its greatest representative was also Spanish: Joan Miró (1893–1983), who painted the striking *Composition* in figure 25-27. His style has been labeled "biomorphic abstraction," since his forms are fluid and organic rather than geometric. "Biomorphic concretion" might be a more suitable name. Like the sculptures of Hans Arp (see fig. 26-10), the shapes in Miró's pictures have their own vigorous life. They seem to change before our eyes, expanding and contracting like amoebas until they approach human individuality closely enough to please the artist. Their spontaneous "becoming" is the very opposite of abstraction as we defined it above (see page 569). Once he conceived his forms, however, Miró subjected them to a formal discipline no less rigorous than that of Picasso. In fact, he began as a Cubist and turned to Surrealism only in 1924, five years after moving to Paris.

Klee Miró's work shows the impact of the German-Swiss painter Paul Klee (1879–1940). Klee in turn had been decisively influenced early in his career by Der Blaue Reiter and shared many of the same ideas as his friend Kandinsky. He was fascinated with music, for example, and was himself a talented violinist. His theories of art also have much in common with Kandinsky's. (They were colleagues at the Bauhaus during the 1920s; see pages 634–36.) Klee nevertheless went in the opposite direction. Instead of seeking a higher reality, he wanted to illuminate a deeper one from within the

imagination. Thus natural forms were essential to his work, but as pictorial metaphors conveying hidden meaning rather than as representations of nature. He was affected, too, by Cubism, but Egyptian and ethnographic art—and especially the drawings of small children—held an equally strong interest for him.

During World War I he molded these elements into a pictorial language that was marvelously economical and precise. *Twittering Machine* (fig. 25-28), a delicate pen-and-ink drawing tinted with watercolor, demonstrates the unique flavor of Klee's art. With a few simple lines, he has created a ghostly mechanism that mocks both our faith in the miracles of the Machine Age and our sentimental appreciation of bird song. It is the quality of the line itself that evokes the raspy sound made by this strange device. The little contraption is not without its sinister aspect: the heads of the four wiry birds look like fishing lures, which might entrap any real birds that flew too near. It thus condenses into one striking invention a complex set of ideas about present-day civilization.

The title has an essential role. It is characteristic of the way Klee worked that the picture, no matter how appealing, does not reveal its full content unless the artist tells us what it means. The title, in turn, needs the picture. The witty concept of a twittering machine does not kindle our imagination until we are shown such a thing. This interdependence is familiar to us from cartoons, but Klee lifts it to the level of high art without giving up the playful character of these verbal-visual puns. To him art was a language of signs, of shapes that are images of ideas: as the shape of the letter *S* is the image of a specific sound or an arrow is the image of a one-way street. He also realized that in any conventional system the sign is no more than a "trigger." The instant we see it, we automatically give it meaning without stopping to consider its shape. Klee wanted his signs to be perceived as visual facts and also to act as "triggers." Toward the end of his life, he became absorbed in the study of ideographs of all kinds, such as hieroglyphics, hex signs, and the mysterious markings in prehistoric caves. These simplified representational images appealed to him

because they had the twin quality he strove for in his own graphic language.

How did Klee create the *Twittering Machine*? His writings confirm what we can sense from the drawing itself. He started with a point, which grew organically into a line that became a plane and then evolved into spaces; taken together they define the form. This process, although based on "pure artistic craftsmanship," gives the drawing its air of fresh inspiration and accounts for its whimsical character. He admitted as much: "The legend of the childishness of my drawing must have originated from those linear compositions of mine in which I tried to combine a concrete image . . . with the pure representation of the linear element. Always combined with the more subconscious dimensions of the picture."

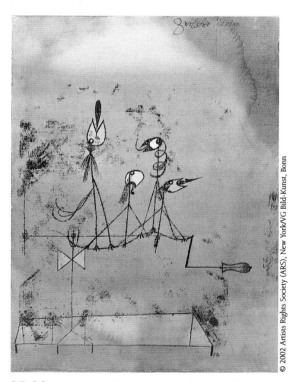

25-28 Paul Klee. *Twittering Machine.* 1922. Watercolor and pen and ink on oil-transfer drawing on paper, mounted on cardboard, 25¼ x 19" (64.1 x 48.3 cm). The Museum of Modern Art, New York

Purchase

EXPRESSIONISM

Kollwitz The experience of World War I filled German artists with a deep anguish at the state of modern civilization, which found its principal outlet in Expressionism. The work of Käthe Kollwitz (1867–1945) consists almost exclusively of prints and drawings that are comparable to those of Kokoschka, whom she admired. Her graphics had their sources in the nineteenth century. Munch was an early inspiration, as was her friend Ernst Barlach. However, Kollwitz pursued a resolutely independent course by devoting her art to themes of inhumanity and injustice. To articulate her social and ethical concerns, she adopted an intensely expressive yet naturalistic style that is as unrelentingly bleak as her choice of subjects. Gaunt mothers and exploited workers provided many of Kollwitz's themes, but her most impassioned statements were reserved for war. World War I, which cost her oldest son his life, made her an ardent pacifist. Her lithograph *Never Again War!* (fig. 25-29) is an unforgettable image of protest.

Grosz George Grosz (1893–1959), a painter and graphic artist who had studied in Paris in 1913, joined the Dadaist movement in Berlin after the end of the war. Inspired by the Futurists, he developed a dynamic form of Cubism for his bitter and often savage satires, which expressed the disillusionment of his generation. In *Germany, a Winter's Tale* (fig. 25-30), the city of Berlin forms the kaleidoscopic and chaotic background for several large figures, which are superimposed on it as in a collage. They include the marionette-like "good citizen" at his table and the sinister forces that molded him: a hypocritical clergyman, a brutal general, and an evil schoolmaster. This, Grosz tells us, is the decadent world of the bourgeoisie that he, like many German intellectuals, hoped would be overthrown by Communism. His bitter parodies are counterparts to the Expressionist

25-29 Käthe Kollwitz. *Never Again War!* 1924. Lithograph, 37 x 27 1/2" (94 x 70 cm). Courtesy Galerie St. Étienne, New York

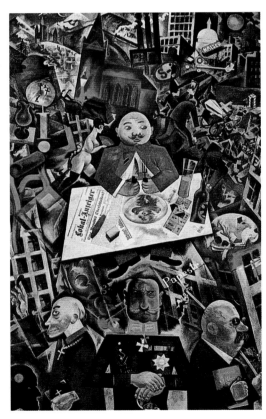

25-30 George Grosz. *Germany, a Winter's Tale.* 1918. Formerly Collection Garvens, Hannover, Germany. Whereabouts unkown

dramas of Georg Kaiser and also participate in the nihilism of the early Dadaist plays by Berthold Brecht, who shared a Marxist outlook.

Beckmann Max Beckmann (1884–1950), a descendant of Die Brücke artists, did not become an Expressionist until after he had lived through World War I, which filled him with such despair at the state of modern civilization that he took up painting to "reproach God for his errors." His **trip-tych** *Departure* (fig. 25-31) reflects his admiration for Grünewald (compare figs. 16-1 and 16-2), but the two wings show a nightmarish world crammed with puppetlike figures, as disquieting as those in Bosch's hell (see fig. 15-7). The right panel incorporates a blind man holding a fish, a lantern that illuminates nothing, and a mad musician, while the left one shows a scene of almost unimaginable torture. What are we to make of these brutal images? We know from letters written by the artist and a close friend that they represent life itself as endless misery filled with all kinds of physical and spiritual pain. The woman trying to make her way in the dark with the aid of the lamp is carrying the corpse of her memories, evil deeds, and failures, from which no one can ever be free so long as life beats its drum. The center panel signifies the departure from life's illusions to the reality behind appearances. The crowned figure seen from behind recalls the mythical Fisher King from the legend of the Holy Grail, whose health and that of his land are restored by Parsifal.

Departure proved remarkably prophetic. It was completed when the artist was on the verge of leaving his homeland under Nazi pressure. The topsy-turvy quality of the two wing scenes, full of mutilations and meaningless rituals, well captures the flavor of Hitler's Germany. The stable design of the center panel, in contrast, with its expanse of blue sea and its sunlit brightness, conveys

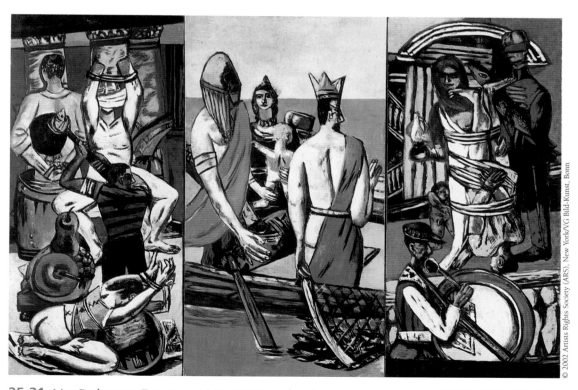

25-31 Max Beckmann. *Departure*. 1932–33. Triptych, oil on canvas, center panel 7'13/4" x 3'93/8" (2.15 x 1.15 m), side panels each 7'13/4" x 3'31/4" (2.15 x 1 m). The Museum of Modern Art, New York
Given anonymously (by exchange)

the hopeful spirit of an embarkation for distant shores. After living through World War II in occupied Holland under the most difficult conditions, Beckmann spent the final three years of his life in America.

REALISM

O'Keeffe After 1920 in the United States, most of the original members of the Stieglitz group concentrated on landscapes, which they treated in representational styles derived from Expressionism. Their work, tinged with Romantic nostalgia, was part of a widespread conservative reaction on both sides of the Atlantic. The most important representative of naturalism in American art during the 1920s was Georgia O'Keeffe (1887–1986). Throughout her long career, she covered a wide range of subjects and styles. She, too, practiced a form of organic abstraction indebted to Expressionism, but she also adopted the Precisionism of Charles Demuth (see pages 582–83),

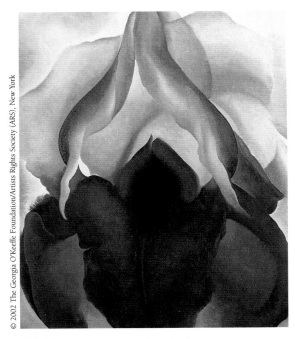

25-32 Georgia O'Keeffe. *Black Iris III.* 1926. Oil on canvas, 36 x 29⁷⁄₈" (91.4 x 75.9 cm). The Metropolitan Museum of Art, New York

The Alfred Stieglitz Collection, 1949

so that she is sometimes considered an abstract artist. Her work often combined aspects of both approaches: as she absorbed a subject into her imagination, she would alter and simplify it to convey a personal meaning. O'Keeffe nevertheless remained a realist at heart. *Black Iris III* (fig. 25-32) is the kind of painting for which she is best known. The image is marked by a strong sense of design unique to her. The decorative quality of the flower is deceptive, however. Observed close-up and magnified to large scale, it is a thinly disguised symbol of female sexuality.

American Scene Painting The dominance of realism during the 1930s signaled the retreat of progressive art everywhere in response to the economic depression and social turmoil that gripped both Europe and the United States. Often realism was linked to the reassertion of traditional values. Most American artists split into two camps, the Regionalists and the Social Realists. The Regionalists wanted to revive idealism by updating the American myth, which was largely defined, however, in Midwestern terms. The Social Realists, by contrast, captured the dislocation and despair of the Depression era and were often concerned with social reform. Although bitterly opposed to each other, both movements drew freely on the Ash Can School (see page 577).

Hopper The one artist who appealed to all factions, including that of the few remaining abstractionists, was a former pupil of Robert Henri, Edward Hopper (1882–1967). He focused on what has since become known as the "vernacular architecture" of American cities—storefronts, movie houses, all-night diners—which no one else had thought worthy of an artist's attention. *Early Sunday Morning* (fig. 25-33) finds a haunting sense of loneliness in the familiar elements of an ordinary street. Its quietness, we realize, is temporary; there is hidden life behind these facades. We almost expect to see one of the window shades raised as we look at them. Apart from its poetic appeal, the picture also has remarkable formal discipline. We note the careful placement of the fireplug and barber pole, the subtle variations in the treatment of

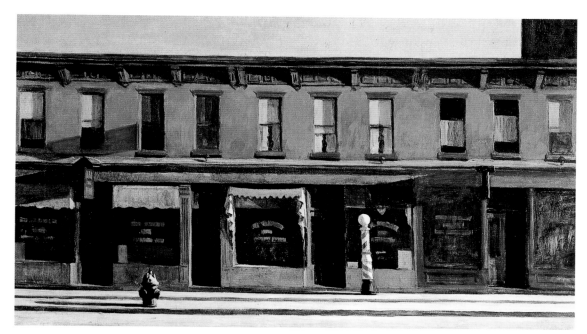

25-33 Edward Hopper. *Early Sunday Morning.* 1930. Oil on canvas, 35 x 60" (88.9 x 152.4 cm). Whitney Museum of American Art, New York

the row of windows, and the precisely calculated slant of sunlight. The delicate balance of verticals and horizontals shows Hopper's awareness of Mondrian.

Painting since World War II

ACTION PAINTING

Having survived the most serious economic calamity and the greatest threat to civilization in all of history, the world now faced a potentially even greater danger: nuclear holocaust. This central fact conditioned the entire COLD WAR era, which came to an end only with the gradual collapse of Communism in Russia beginning in 1985. Ironically, it was also a period of unprecedented prosperity in the West, but not in much of the rest of the world, with the notable exception of Japan.

The painting that prevailed for about 15 years following the end of World War II arose in direct response to the anxiety brought on by these dramatic changes. The term *Abstract Expressionism* is often applied to this style, which was initiated by artists living in New York City. Under the influence of Surrealism and existentialist philosophy, Action painters, the first of the Abstract Expressionists, developed a new approach to art. Painting became a counterpart to life itself. It was seen as an ongoing process in which artists faced considerable risks and overcame the dilemmas confronting them through a series of conscious and unconscious decisions in response to both internal and external demands. The Color Field painters in turn fused the energetic gestures and intense hues of the Action painters in broad forms of poetic color that sometimes reflected the influence of Eastern spirituality. In a sense, Color Field Painting resolved the conflicts expressed by Action Painting. They are, however, two sides of the same coin, separated by the thinnest differences of approach.

Gorky Arshile Gorky (1904–1948), an Armenian who came to America at 16, was the pioneer of the movement and the single most important influence on its other members. It took him 20 years, painting first in the manner of Cézanne, then in

The term *COLD WAR*, describing any conflict that is primarily political and economic rather than military, is most often used for the post–World War II relationship between the Western democracies (particularly the United States) and the Communist Soviet Union. Tension was highest in the 1960s, as the nuclear arms race escalated, Soviet missile installations were discovered in Cuba, and the Berlin Wall was built. By the late 1980s the cold war was over: Germany was reunified as the Berlin Wall was opened, and the Soviet Union was well on its way to being dissolved.

the vein of Picasso, to arrive at his mature style. We see it in *The Liver Is the Cock's Comb* (fig. 25-34), his greatest work. The enigmatic title suggests Gorky's close contact with the Surrealists during the war. A personal mythology underlies Gorky's work; each form represents a private symbol within this self-contained realm. Everything here is in the process of turning into something else. The treatment reflects his own experience in camouflage, gained from a class he conducted during the war. The biomorphic shapes clearly owe much to Miró, while their spontaneous handling and the glowing color reflect Gorky's enthusiasm for Kandinsky (see figs. 25-27 and 25-6). The differences are equally striking. The dynamic interlocking of the forms, their aggressive power of attraction and repulsion, are unique to Gorky.

Pollock The most important of the Action painters proved to be Jackson Pollock (1912–1956). His huge canvas entitled *Autumn Rhythm: Number 30, 1950* (fig. 25-35) was executed mainly by pouring and spattering the colors, instead of applying them with a brush. The result, especially when viewed at close range, suggests both Kandinsky and Ernst (compare figs. 25-6 and 25-26). Kandinsky's nonrepresentational Expressionism and the Surrealists' exploitation of chance effects were indeed the main sources of Pollock's work, but they do not account for his revolutionary technique and the emotional appeal of his art. Why did Pollock "fling a pot of paint in the public's face," as Ruskin had accused Whistler of doing? It was surely not to be more abstract than his predecessors, for the strict control implied by abstraction is exactly what Pollock

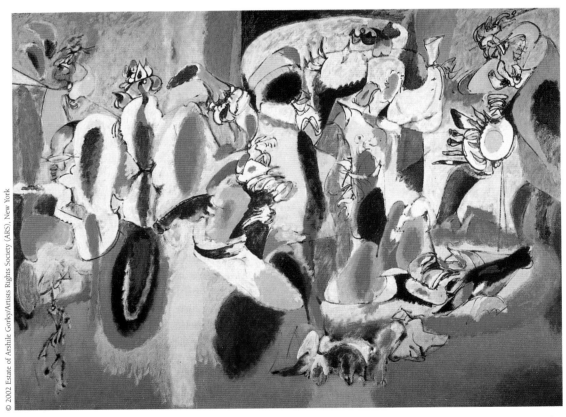

25-34 Arshile Gorky. *The Liver Is the Cock's Comb.* 1944. Oil on canvas, 6'1¹⁄₄" x 8'2" (1.86 x 2.49 m). Albright-Knox Art Gallery, Buffalo, New York

Gift of Seymour H. Knox, 1956

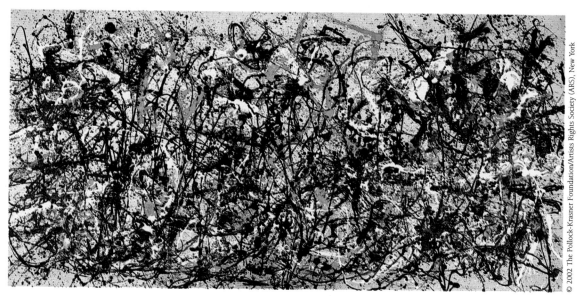

25-35 Jackson Pollock. *Autumn Rhythm: Number 30, 1950.* 1950. Oil on canvas, 8'8" x 17'3" (2.64 x 5.26 m). The Metropolitan Museum of Art, New York

George A. Hearn Fund, 1957

relinquished when he began to dribble and spatter. Rather, he came to regard paint itself not as a passive substance to be manipulated at will but as a storehouse of pent-up forces for him to release.

The actual shapes visible in our illustration were largely determined by the internal dynamics of his material and his process: the viscosity of the paint, the speed and direction of its impact upon the canvas, its interaction with other layers of pigment. The result is a surface so alive, so sensuously rich, that all earlier American painting looks pale in comparison. Pollock did not simply "let go" and leave the rest to chance when he "aimed" the paint at the canvas instead of "carrying" it on the tip of his brush. He released the forces within the paint by giving it a momentum of its own. He himself was the source of energy for these forces, and he "rode" them as a cowboy might ride a wild horse, in a frenzy of psychophysical action. He did not always stay in the saddle; yet the thrill of this contest, which strained his entire being, was worth the risk. Our simile, though crude, points up the main difference between Pollock and his predecessors: his total commitment to the act of painting. Thus he preferred to work on huge canvases that provided a "field of combat" large enough for him to paint not merely with his arms but with the motion of his whole body.

The term *Action Painting* conveys the essence of this approach far better than does *Abstract Expressionism.* Although Pollock gave up a good deal of control over his medium, this loss was more than offset by a gain: the new continuity and expansiveness in the creative process, which gave his work its distinctive mid-twentieth-century stamp. Pollock's drip technique, however, was not in itself essential to Action Painting, and he stopped using it in 1953.

Krasner Lee Krasner (1908–1984), who was married to Pollock, never abandoned the brush, although she was unmistakably influenced by her husband. She struggled to establish her artistic identity and emerged from his shadow only after undergoing several changes in direction and destroying much of her early work. Following Pollock's death, she succeeded in doing what he had been attempting to do for the last three years of his life: to reintroduce the figure into Abstract Expressionism while retaining its automatic handwriting. The

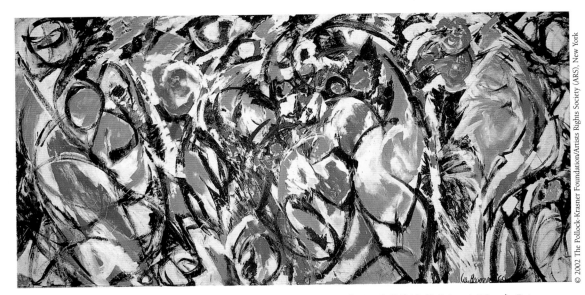

25-36 Lee Krasner. *Celebration*. 1959–60. Oil on canvas, 7'8¹/₄" x 16'4¹/₂" (2.34 x 4.99 m). Private collection

potential had always been there in Pollock's work: we can easily imagine wildly dancing people in *Autumn Rhythm*. In *Celebration* (fig. 25-36), Krasner defines these rudimentary shapes from within the tangled network of lines by using the broad gestures of Action Painting to suggest human forms without actually depicting them.

De Kooning The work of Willem de Kooning (1904–1997), another prominent member of the group and a close friend of Gorky, always retains a link with the world of images, whether or not it has a recognizable subject. In some paintings, such as *Woman II* (fig. 25-37), the image emerges from the jagged welter of brush-strokes. De Kooning shares with Pollock the furious energy of the painting process, the sense of risk, of a challenge successfully—but barely—met. The picture looks as if it had been executed in one afternoon. In reality, the artist worked on the canvas for two years and constantly repainted it until he got it right. What are we to make of his wildly distorted *Woman II*? She was actually in-tended as a caricature of modern movie stars such as Marilyn Monroe, but the result is anything but humorous. It is as if the flow of psychic impulses

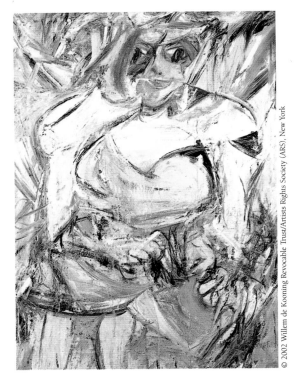

25-37 Willem de Kooning. *Woman II*. 1952. Oil on canvas, 59 x 43" (149.9 x 109.2 cm). The Museum of Modern Art, New York

in the process of painting has unleashed this nightmarish specter from deep within the artist's subconscious. For that reason, he has sometimes been accused of being a woman-hater, a charge he denied. Rather, his figure is like a primordial goddess, cruel yet seductive, who represents the primitive side of our makeup. De Kooning shared with Beckmann an Old World horror of empty space, which to him signified the existential void. Only after he moved to Long Island from the confines of New York City was he able to overcome this deep-seated anxiety.

EXPRESSIONISM IN EUROPE

Action Painting marked the international coming-of-age for American art. The movement had a powerful impact on European art, which in those years had nothing to show of comparable force and conviction. One French artist, however, was of such amazing originality as to constitute a movement all by himself: Jean Dubuffet, whose first exhibition soon after the Liberation electrified and antagonized the Paris art world.

Dubuffet As a young man, Dubuffet (1901–1985) had formal instruction in painting, but he responded neither to the various trends he saw around him nor to the art of the museums. All struck him as divorced from real life, and he turned to other pursuits. Only in middle age did he experience the breakthrough that permitted him to discover his creative gifts. Dubuffet suddenly realized that for him true art had to come from outside the ideas and traditions of the artistic elite, and he found inspiration in the art of children and the insane. The distinction between "normal" and "abnormal" struck him as no more justifiable than established notions of "beauty" and "ugliness." Not since Duchamp (see pages 576–77) had anyone attempted so radical a critique of art.

Dubuffet made himself the champion of what he called *l'art brut* (art in the raw), but he created a paradox. While extolling the directness and spontaneity of the amateur as against the refinement of professional artists, he became a professional artist himself. Duchamp's questioning of established values had led him to cease artistic activity altogether,

but Dubuffet became incredibly prolific, second only to Picasso in output. Compared with the work of Paul Klee, who had first used the style of children's drawings (see pages 586–87), Dubuffet's art is "raw" indeed. Its stark immediacy, its explosive, defiant presence, are the opposite of Klee's discipline and economy. Did Dubuffet perhaps fall into a trap of his own making? If his work merely imitated the *art brut* of children and the insane, would not these self-chosen conventions limit him as much as those of the artistic elite?

We may be tempted to think so on first sight of *Le Métafisyx* (fig. 25-38) from his Corps de Dames series. Even De Kooning's wildly distorted *Woman II* (see fig. 25-37) seems gentle when matched against this shocking assault on our inherited cultural sensibilities. The paint is as heavy and opaque as a rough coating of plaster, and the lines describing the blocklike body are scratched into the surface like graffiti made by an untrained hand. Appearances are deceiving, however. The fury and concentration of attack in Dubuffet's demonic

25-38 Jean Dubuffet. *Le Métafisyx,* from the Corps de Dames series. 1950. Oil on canvas, 45³/₄ x 35¹/₄" (116.2 x 89.5 cm). Private collection

female is by no means "something any child can do." In an eloquent statement the artist explained the purpose of images such as this: "The female body . . . has long . . . been associated with a very specious notion of beauty which I find miserable and most depressing. Surely I am for beauty, but not that one. . . . I intend to sweep away everything we have been taught to consider—without question—as grace and beauty [and to] substitute another and vaster beauty, touching all objects and beings, not excluding the most despised. . . . I would like people to look at my work as an enterprise for the rehabilitation of scorned values, and . . . a work of ardent celebration."

Bacon The English artist Francis Bacon (1909–1992) was allied not with Abstract Expressionism, although he was clearly related to it, but with the Expressionist tradition. For his power to translate sheer anguish into visual form he had no equal among twentieth-century artists except perhaps Rouault (see pages 564–65). Bacon often derived his imagery from other artists. He freely combined several sources while transforming them in order to give them new meaning. *Head Surrounded by Sides of Beef* (fig. 25-39) reflects Bacon's obsession with Velázquez's portrait of Pope Innocent X, a picture that haunted him for years. It is, of course, no longer Innocent X we see here but a screaming ghost, inspired by a scene from Sergei Eisenstein's film *Alexander Nevsky,* that is materializing out of a black void. The two glowing sides of beef are taken from a painting by Rembrandt. Knowing the origin of the imagery does not help us to understand it, however. Nor does comparison with earlier works such as Grünewald's *Crucifixion,* Fuseli's *Nightmare,* or Munch's *Scream,* which are its ancestors (see figs. 16-1, 22-14, and 24-13). Bacon was a gambler, a risk-taker, in real life as well as in the way he worked. What he wanted were images that, in his own words, "unlock the deeper possibilities of sensation." Here he competes with Velázquez, but on his own terms, which are to set up an almost unbearable tension between the shocking violence of his vision and the luminous beauty of his brushwork.

COLOR FIELD PAINTING

By the late 1940s, a number of artists began to transform Action Painting into a style called Color Field Painting, in which the canvas is stained with thin, translucent color washes. These may be oil or even ink, but the favored material quickly became acrylic, a plastic suspended in a polymer resin, which can be thinned with water so that it flows freely.

Rothko In the mid-1940s Mark Rothko (1903–1970) worked in a style derived from the Surrealists, then adopted the gestures of early Action Painting, using blocklike colored forms that act like characters in a dream. Within a few years, however, he sought maximum concentration for greatest clarity. Toward 1947 his forms began to fuse, until he subdued the aggressiveness of Action Painting so completely that his pictures radiated the purest contemplative stillness. *White and Greens in Blue* (fig. 25-40) consists of three rectangles with blurred edges on a blue field. The darker forms seem immersed in the blue ground, so that the white rectangle stands out all the more vividly.

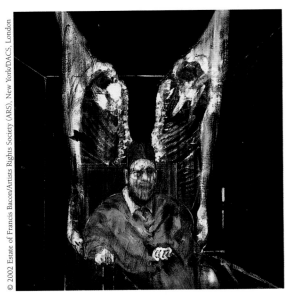

25-39 Francis Bacon. *Head Surrounded by Sides of Beef.* 1954. Oil on canvas, 50³/₄ x 48" (129 x 122 cm). The Art Institute of Chicago

Harriott A. Fox Fund

The canvas is very large, almost eight and one-half feet high, and the thin washes of color permit the texture of the cloth to be seen in places.

This description hardly begins to touch the essence of the work or its mysterious power to move us. The reasons are to be found in the delicate equilibrium of the shapes, their strange interdependence, and the subtle variations of hue, which seem to immerse the beholder in the monumental painting. For those attuned to the artist's special vision, the experience can be akin to a trancelike rapture. Yet Rothko sought to convey not a mystical experience but his melancholy outlook, for he possessed a philosophical cast of mind. The overarching theme of his work is the tragedy of the human condition in the face of inevitable death. The import is inescapable in several series painted toward the end of his life, which ended in suicide. The bold, simplified forms and somber colors are intended as universal symbols. They express the meaning of life by condensing the drama of human existence to its very essence.

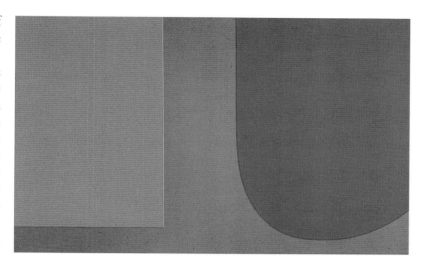

25-41 Ellsworth Kelly. *Red Blue Green*. 1963. Oil on canvas, 7'8" x 11'4" (2.34 x 3.45 m). Museum of Contemporary Art, San Diego, La Jolla, California

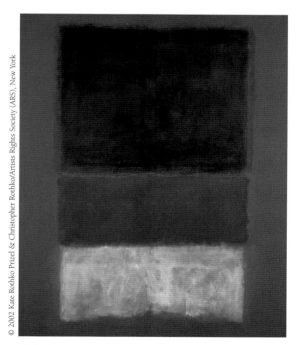

25-40 Mark Rothko. *White and Greens in Blue*. 1957. Oil on canvas, 8'4" x 6'10" (2.5 x 2.1 m). Collection of Mr. and Mrs. Paul Mellon, Virginia

MINIMALISM

Kelly Many artists who came to maturity in the 1950s turned away from Action Painting altogether in favor of "hard-edge" painting. *Red Blue Green* (fig. 25-41) by Ellsworth Kelly (born 1923), an early leader of this movement, abandons Rothko's impressionistic softness. Instead, flat areas of color are contained within carefully delineated forms as part of the formal investigation of color and design for its own sake. This radical abstraction of form is known as Minimalism, which implies an equal reduction of content. It was a quest for basic elements representing the fundamental aesthetic values of art, without regard to issues of content. Minimalism was a necessary, even valuable phase of modern art. At its most extreme, it reduced art not to an eternal essence but to an arid simplicity. In the hands of a few artists of genius like Kelly, however, it yielded works of unequaled formal perfection.

Stella The ancestry of Minimalism can be traced back to Mondrian. Thus Frank Stella (born 1936) began as an admirer of Mondrian, then soon evolved an even more self-contained style. Unlike Mondrian (see pages 583–84), Stella did not concern himself with the vertical-horizontal balance that

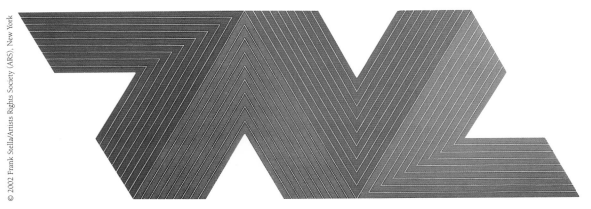

25-42 Frank Stella. *Empress of India.* 1965. Metallic powder in polymer emulsion on canvas, 6'5" x 18'8" (1.96 x 5.69 m). The Museum of Modern Art, New York

Gift of S. I. Newhouse, Jr.

From 1955 to 1965, in a decade of nonviolent protests often met by violent responses, the CIVIL RIGHTS MOVEMENT sought to gain for black Americans the guarantees of equality provided for in the Constitution but not in fact universally enforced. Starting with a boycott of buses in Montgomery, Alabama, and inspired by the charismatic leadership of Martin Luther King, Jr., the movement expanded to include student-led sit-ins, voter registration drives, and a huge march on Washington, D.C., in 1963. The Civil Rights Act of 1964 prohibited discrimination in every public place covered by interstate commerce, as well as in public schools and employment.

connects the older artist's work to the world of nature. Logically enough, he also abandoned the traditional rectangular format, to make quite sure that his pictures bore no resemblance to windows. The shape of the canvas had now become an indispensable part of the design. In one of his largest works, the majestic *Empress of India* (fig. 25-42), this shape is determined by the thrust and counterthrust of four huge chevrons. They are identical in size and shape but sharply different in color and in their relationship to the whole. The paint, moreover, contains powdered metal, which gives it an iridescent sheen. This is yet another way to stress the impersonal precision of the surfaces and to remove the work from any comparison with the "handmade" look of easel pictures. In fact, *Empress of India* is hardly a picture in the traditional sense. It demands to be thought of as an object, sufficient in itself.

AFRICAN-AMERICAN PAINTING

Following World War II, blacks began to attend art schools in growing numbers, at the very time that Abstract Expressionism marked the maturation of American art. The CIVIL RIGHTS MOVEMENT helped them to establish their artistic identities and to seek appropriate styles for expressing them. The turning point proved to be the assassinations of Malcolm X in 1965 and Martin Luther King, Jr., in 1968, which led to an unprecedented outpouring of African-American art.

Since then, black artists have pursued three major tendencies. Mainstream abstractionists, particularly those of the older generation, tend to be concerned primarily with seeking a personal aesthetic. They maintain that there is no such thing as African-American, or black, art, only good art. Consequently they have been denounced by activist artists. Stirred by social consciousness as well as by political ideology, the latter have adopted highly expressive representational styles to communicate a black perspective to the people in their communities. Mediating between these two approaches is a more decorative form that frequently incorporates African, Caribbean, and even Mexican motifs. Abstraction has proved the most fruitful path because it allows black artists to achieve a universal, not only an ethnic, statement. No hard-and-fast rules separate these alternatives, however, and artists have often combined aspects of each into their work.

Bearden The most successful synthesis was achieved by Romare Bearden (1911–1988). Although he got his start in the 1930s, it was not until the mid-1950s that he decided to devote his career entirely to art. Over the course of his long life, he pursued interests in mathematics, philosophy, and music that enriched his work. Bearden was affected by

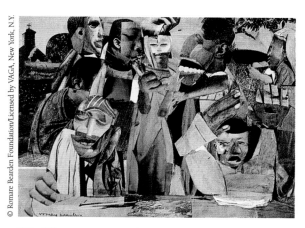

25-43 Romare Bearden. *The Prevalence of Ritual: Baptism.* 1964. Collage of photochemical reproduction, synthetic polymer, and pencil on paperboard, 9¹/₈ x 12" (23.2 x 30.5 cm). Hirshhorn Museum and Sculpture Garden, Smithsonian Institution, Washington, D.C.

Gift of Joseph H. Hirshhorn, 1966

Abstract Expressionism, but, dissatisfied with the approach, he abandoned it in favor of a collage technique. Abstraction, however, remained the underpinning of his art. His reputation was established during the mid-1960s by photomontages such as *The Prevalence of Ritual: Baptism* (fig. 25-43). Bearden's aim, as he put it, was to depict "the life of my people as I know it, passionately and dispassionately as Brueghel. My intention is to reveal through pictorial complexities the life I know." He had a full command of the resources of Western and African art. Our example is as complex as Picasso's *Guernica* (see fig. 25-20), but it is couched in the forms of tribal masks. No wonder Bearden's work appeals to people of all races. His widespread popularity was a breakthrough that inspired other African-American artists.

OP ART

A trend that arose in the mid-1950s was known as Op Art because of its concern with optics: the physical and psychological process of vision. Op Art has been devoted primarily to optical illusions. All representational art from the Old Stone Age onward has been involved with optical illusion in one sense or another. What is new about Op Art is that it is rigorously nonrepresentational. It evolved partly from hard-edge abstraction. At the same time, it seeks to extend the realm of optical illusion in every possible way by taking advantage of the new materials and processes supplied by science, including laser technology. Much Op Art consists of constructions or "environments" (see page 625) that are dependent for their effect on light and motion and cannot be reproduced satisfactorily in a book.

Because of its reliance on science and technology, Op Art's possibilities appear to be unlimited. The movement nevertheless matured within a decade of its inception and developed little thereafter. The difficulty lies primarily with its subject. Op Art seems overly cerebral and systematic, more akin to the sciences than to the humanities. It often involves the viewer with the work of art in a truly novel, dynamic way. But its effects, although undeniably fascinating, involve a relatively narrow range of interests. Only a handful of artists have enriched it with the variety and expressiveness necessary for great art.

Anuszkiewicz Op Art in America was founded by Josef Albers (1888–1976), an important teacher and theorist, who left Germany after Hitler closed the Bauhaus school at Dessau (see page 636). His gifted pupil Richard Anuszkiewicz (born 1930) developed his art by relaxing the self-imposed restrictions of Albers's color system and introducing new geometric shapes. In *Entrance to Green* (fig. 25-44), the ever-decreasing series of rectangles creates a sense of infinite recession toward the center. This rhythm is counterbalanced by the color pattern, which brings the center close to us by the gradual shift from cool to warm tones as we move inward from the periphery. Surprising for such a theoretical work is its expressive intensity. The resonance of the colors within the strict geometry heightens the optical push-pull. Remarkably, the painting can be likened to

25-44 Richard Anuszkiewicz. *Entrance to Green.* 1970. Acrylic on canvas, 9 x 6' (2.74 x 1.83 m). Collection the artist

a modern icon, for it is capable of producing an almost mystical effect in the viewer.

POP ART

Other artists who made a name for themselves in the mid-1950s rediscovered what the public continued to take for granted despite all efforts to persuade otherwise: that a picture is not "essentially a flat surface covered with colors," as Maurice Denis had insisted, but an image wanting to be recognized. If art was by its very nature representational, then the modern movement, from Manet to Pollock, had been based on a delusion, no matter how impressive its achievements. Painting, it seemed, had been on a kind of voluntary starvation diet for the past hundred years, feeding upon itself rather than on the world around us. It was time to give in to the "image-hunger" that had built up. The public at large had never suffered from this craving, since its appetite for images was abundantly supplied by photography, advertising, magazine illustrations, and comic strips.

The artists who felt this way seized on the products of commercial art catering to popular taste. Here, they realized, was an essential aspect of the twentieth century's visual environment that had been entirely disregarded as vulgar and antiaesthetic by the representatives of "highbrow" culture. It was a presence that cried out to be examined. Only Duchamp and some of the Dadaists, with their contempt for all orthodox opinion, had dared to enter this realm (see page 584). It was they who now became the patron saints of Pop Art, as the new movement came to be called.

Pop Art began in London in the mid-1950s with the Independent Group of artists and intellectuals. They were fascinated by the impact on British life of the American mass media, which had been flooding England since the end of World War II. It is not surprising that the new art had a special attraction for America and that it reached its fullest development there during the following decade. In retrospect, Pop Art in the United States was an expression of the optimistic spirit of the 1960s, which began with the election of John F. Kennedy and ended at the height of the Vietnam War. Unlike Dada, Pop Art was not motivated by despair or disgust at contemporary civilization. It viewed commercial culture as its raw material, an endless source of pictorial subject matter, rather than as an evil to be attacked. Nor did Pop Art share Dada's aggressive attitude toward the established values of modern art.

Johns The work of Jasper Johns (born 1930), one of the pioneers of Pop Art in America, raises questions that go beyond the boundaries of the movement. Johns began by painting such familiar objects as flags, targets, numerals, and maps. His *Three Flags* (fig. 25-45) presents an intriguing problem: just what is the difference between image and reality? We instantly recognize the Stars and Stripes, but if we try to define what we actually see here, we find that the answer escapes us. The flags, instead of waving or flopping, stand at attention, as it were, rigidly aligned with each other in a kind of reverse perspective. There is movement of another sort as well. The reds, whites, and blues are not areas of solid color but are subtly modulated and surprisingly painterly. Can we really say, then, that this is an image of three flags? Clearly no such flags can exist anywhere except in the artist's head. The more we think about it, the more we begin to recognize the picture as a feat of the imagination, which is probably the last thing we expected to do when we first looked at it.

Lichtenstein Revolutionary though it was, Johns's use of flags, numerals, and similar elements as pictorial themes had to some extent been anticipated 30 years earlier by Charles Demuth in *I Saw the Figure 5 in Gold* (see fig. 25-23). Roy Lichtenstein (1923–1997), in contrast, turned to comic strips—or, more precisely, to the standardized imagery of the traditional strips devoted to violent action and sentimental love rather than to those bearing the stamp of an individual creator. His paintings, such as *Drowning Girl* (fig. 25-46), are greatly enlarged copies of single frames, including the speech balloons, the impersonal, simplified black outlines, and the dots used for printing color on cheap paper.

These pictures are perhaps the most paradoxical in all of Pop Art. Unlike any other paintings

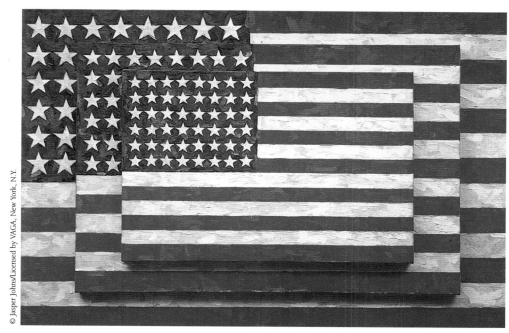

25-45 Jasper Johns. *Three Flags*. 1958. Encaustic on canvas, 30⅞ x 45½ x 5" (78.4 x 115.6 x 12.7 cm). Whitney Museum of American Art, New York

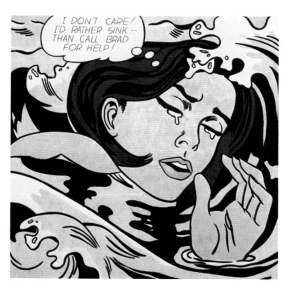

25-46 Roy Lichtenstein. *Drowning Girl*. 1963. Oil and synthetic polymer paint on canvas, 5'7⅝" x 5'6¾" (1.72 x 1.69 m). The Museum of Modern Art, New York

Philip Johnson Fund and Gift of Mr. and Mrs. Bagley Wright

past or present, they cannot be accurately reproduced in this book, for they then become indistinguishable from actual comic strips. Enlarging a design meant for an area only a few inches square to one several hundred times larger gave rise to a host of problems: how, for example, to draw the girl's nose so it would look "right" in comic-strip terms, or how to space the colored dots so they would have the proper weight in relation to the outlines.

Clearly, Lichtenstein's picture is not a mechanical copy but an interpretation. In fact, it is excerpted from the original panel. It nevertheless remains faithful to the spirit of the original, because of the countless changes and adjustments the artist has introduced. How is it possible for images of this sort to be so instantly recognizable? Why are they so "real" to millions of people? What fascinated Lichtenstein about comic strips—and what he made us see for the first time—are the rigid conventions of their style, as firmly set and as remote from life as those of Byzantine art.

Warhol Andy Warhol (1928–1987) used this very quality in ironic commentaries on modern society. A former commercial artist, he made the viewer consider the aesthetic qualities of everyday images, such as soup cans, that we readily overlook. He did much the same thing with the subject of death, an obsession of his. In SILK-SCREENED pictures of electric chairs and gruesome traffic accidents, dying was reduced to the same banality as in the mass media. Warhol had an uncanny understanding of how newspapers and television shape our view of people and events, how they create their own reality and larger-than-life figures. He became a master at manipulating the media to project a public image that disguised his true character. These themes come together in his *Gold Marilyn Monroe* (fig. 25-47). Set against a gold background, like a Byzantine

icon, the famous movie star becomes a modern-day Madonna. Yet Warhol conveys a sense of the tragic personality that lay behind her glamorous facade. The color, lurid and off-register like a reproduction in a sleazy magazine, makes us realize that she has been reduced to a cheap commodity. Through mechanical means, she is rendered as impersonal as the Virgin that stares out from the thousands of icons produced by hack artists through the ages.

PHOTOREALISM

Although Pop Art was sometimes referred to as "the new realism," the term hardly seems to fit the painters we have discussed. To be sure, they remained true to their sources. However, their material was rather abstract: flags, numerals, lettering, signs, badges, comic strips. A later offshoot of Pop Art was the trend called Photorealism because of its fascination with camera images. Photographs had been used by nineteenth-century painters soon after the "pencil of nature" was invented (one of the earliest to do so, surprisingly, was Delacroix), but they were no more than convenient substitutes for reality. For the Photorealists, in contrast, the photograph itself became the reality on which to build their pictures.

Estes The acknowledged grand master of Photorealism is Richard Estes (born 1936). His work is marked by its technical perfection, which turns Photorealism into a form of Magic Realism, a tendency that has flourished periodically since the late nineteenth century. This ability, however precise, is no better than that of any competent illustrator; nor does it distinguish Estes from the Precisionists, who often used photographs as the basis for their paintings. What, then, is the key to his success? It lies in his choice of subject and composition. Estes has a preference for storefronts of an earlier time that evoke nostalgic memories. In this respect he is like an archaeologist of modern urban life. His best paintings, such as *Food Shop* (fig. 25-48), show the same uncanny ability to strike a responsive chord as Hopper's *Early Sunday Morning* (see fig. 25-33). The more we look at it, the more we realize that the gridlike composition is as subtly balanced as a painting by Mondrian (compare fig. 25-24). Unlike the photograph on

© 2002 Andy Warhol Foundation for the Visual Arts/Artists Rights Society (ARS), New York

25-47 Andy Warhol. *Gold Marilyn Monroe.* 1962. Synthetic polymer paint, silk-screened, and oil on canvas, 6'11¼" x 4'7" (2.12 x 1.39 m). The Museum of Modern Art, New York

Gift of Philip Johnson

25-48 Richard Estes. *Food Shop*. 1967. Oil on linen, 65⅝ x 48½" (166.7 x 123.2 cm). Museum Ludwig, Cologne

which it was based, Estes's canvas shows everything in uniformly sharp focus and defines details lost in the shadows. In this way Estes makes his humble storefront an arresting visual experience fully worthy of our attention.

Feminism Photorealism was part of the resurgence of realism that marked American painting in the 1970s. This tendency took on a wide range of themes and techniques, from the most personal to the most detached, depending on the artist's vision of objective reality and its subjective significance. Such flexibility made realism a sensitive vehicle for the feminist movement, which came to the fore in the same decade. Beyond organizing groups dedicated to a wider recognition for women artists, feminism in art has shown little of the unity that initially characterized the social movement. Many feminists, for example, turned to "traditional" women's crafts, particularly textiles, or incorporated crafts into a collage approach known

as Pattern and Decoration. In painting, however, the majority pursued different forms of realism for a variety of artistic ends.

Flack Women artists such as Audrey Flack (born 1931) have used realism to explore the world around them and their relation to it from a personal as well as a feminist viewpoint. Like most of Flack's paintings, *Queen* (fig. 25-49, page 604) is an extended allegory. The queen is the most powerful figure on the chessboard, yet she remains expendable in defense of the king. Equally apparent is the meaning inherent to the queen of hearts, but here the card also refers to the passion for gambling in Flack's family, represented by photos of the artist and her mother in the open locket. The contrast of youth and age is central to *Queen*. The watch is a traditional emblem of life's brevity, and the dewy rose stands for the transience of beauty, which is further conveyed by the makeup on the dressing table. The suggestive shapes of the bud and the

25-49 Audrey Flack. *Queen.* 1975–76. Acrylic on canvas, 6'8" (2.03 m) square. Private collection

Courtesy Louis K. Meisel Gallery, New York

two fruits can also be regarded as symbols of feminine sexuality.

Queen is successful not so much for its statement, no matter how interesting, as for its imagery. Flack creates a purely artistic reality by superimposing two separate photographs. Critical to the illusion is the gray border, which acts as a framing device and also establishes the central space and tonal value of the painting. The objects that seem to project from the picture plane are shown in a different perspective from those on the tilted tabletop behind. The picture space is made even more active by the play of colors within the neutral gray zone.

Late Modernism

NEO-EXPRESSIONISM AND NEO-ABSTRACTION

The art we have looked at since 1945, although distinctive to the postwar era, is so closely related to what came before it that it was clearly cut from the same cloth, and we do not hesitate to call it modernist. At long last, however, twentieth-century painting, to which everything from Abstract Expressionism to Photorealism made such a vital contribution, began to lose vigor. The first sign of decline came in the early 1970s with the widespread use of "Neo-" to describe the latest tendencies, which came and went in rapid succession and are all but forgotten today. Only one of these movements has made a lasting contribution: Neo-Expressionism, which arose toward the end of the '70s and became the dominant current of the 1980s. Imagery of all kinds completely overshadowed the tendency called Neo-Abstraction (also known as "Neo-Geo"). Indeed, abstraction itself was declared all but dead by critics. In its place was left a feeble imitation, which indicated that modern art had turned its back on the mainstream. And despite the fact that Neo-Expressionism is deeply rooted in modernism, it, too, represents the end of the tradition we have traced in this chapter.

25-50 Anselm Kiefer. *To the Unknown Painter.* 1983. Oil, emulsion, woodcut, shellac, latex, and straw on canvas, 9'2" (2.79 m) square. The Carnegie Museum of Art, Pittsburgh

Richard M. Scaife Fund; A. W. Mellon Acquisition Endowment Fund

Kiefer The German artist Anselm Kiefer (born 1945) is the direct heir to Northern Expressionism, but rather than investigating personal moods he confronts moral issues posed by Nazism that have been evaded by other postwar artists in his country. By exploring the major themes of German Romanticism from a modern perspective, he has attempted to reweave the threads broken by history. That tradition, which began as a noble ideal based on a similar longing for a mythical past, ended as a perversion at the hands of Hitler and his followers. It is both fitting and ironic that Kiefer adopted Expressionism, as some of the most important Expressionists (notably Kirchner) had begun as admirers of Hitler before being condemned as "decadent."

To the Unknown Painter (fig. 25-50) is a powerful statement of the human and cultural catastrophe presented by World War II. Conceptually as well as compositionally, it was inspired by the paintings of Caspar David Friedrich (see page 495), of which it is a worthy successor. To express the tragic scope of the war, Kiefer works on an epic scale. Painted in jagged strokes of predominantly earth and black tones, the charred landscape is made tangible by the inclusion of pieces of straw. Amid this destruction stands a somber ruin. It is shown in woodcut to proclaim Kiefer's allegiance to the German Renaissance and to Expressionism. The fortresslike structure is a suitable monument for heroes in recalling the tombs and temples of ancient civilizations (see figs. 2-5 and 3-1). But instead of being dedicated to soldiers who died in combat, it is a memorial to the painters whose art was also a casualty of war.

25-51 Elizabeth Murray. *More than You Know.* 1983. Oil on ten canvases, 9'3" x 9' x 8" (2.82 m x 2.74 m x 20.3 cm). The Edward R. Broida Collection

Courtesy PaceWildenstein Gallery, New York

Murray Neo-Abstraction has yielded less impressive results than Neo-Expressionism thus far. The greatest successes have come from artists who have invested Neo-Abstraction with the personal meaning of Neo-Expressionism. Elizabeth Murray (born 1940) has emerged since 1980 as the leader of this crossover style in the United States. *More than You Know* (fig. 25-51) makes a fascinating comparison with Flack's *Queen* (see fig. 25-49), for both are packed with autobiographical references. While it is at once simpler and more abstract than Flack's painting, Murray's composition seems about to fly apart under the pressure of barely contained emotions. The table will remind us of the one in Picasso's *Three Musicians* (see fig. 25-18), a painting she referred to in other works from the same time. The contradiction between the flattened collage perspective of the table and chair, on the one hand, and the allusions to the distorted three-dimensionality of the surrounding room, on the other, creates a disquieting pictorial space. The more we look at the painting, the more we begin to realize how eerie it is. Indeed, it seems to radiate an almost unbearable tension. The table threatens to turn into a figure, surmounted by a skull-like head, that moves with the explosive force of Picasso's *Three Dancers* (see fig. 25-19). What was Murray thinking of? She has said that the room reminds her of the place where she sat with her ill mother. At the same time, the demonic face was inspired by Munch's *Scream* (see fig. 24-13), while the sheet of paper recalls Vermeer's paintings of women reading letters (see fig. 18-16), which to her express a combination of serenity and anxiety.

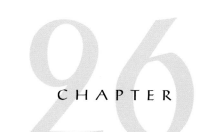

TWENTIETH-CENTURY SCULPTURE

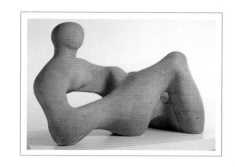

Sculpture, the most conservative of the arts throughout most of the nineteenth century, found it difficult to escape tradition. Modern sculpture thus remained far less adventurous on the whole than painting, which often influenced it. The American sculptor David Smith (see page 618) even claimed that modern sculpture was created by the painters, and to a remarkable degree he was right. Sculpture has successfully challenged the leadership of painting only by pursuing a separate path.

We shall find that twentieth-century sculpture followed essentially two tracks: primitivism and abstraction, although they were not mutually exclusive and are often found in combination. Primitivism was most common before 1945. After World War II, abstraction became the dominant—but hardly exclusive—mode. Primitivism should be understood here not simply as sculpture inspired by ethnographic art, which attracted many painters and sculptors during the early decades of the century. Instead, it should be broadened to include any piece that emphasizes the "idol" quality of sculpture.

Based on Judeo-Christian values, the dictionary definition of *idol* is an image, usually a false god, used as an object of worship. This view, however, is far too narrow. The critic Baudelaire came closer to the truth when he identified primitive sculpture as fetish: something worshiped for its magical powers or inhabited by a spirit. While few works of modern sculpture are objects of devotion, a surprising number of them retain the quality of a fetish. They seem to possess a nearly magical energy, often with sexual overtones, as if conjured up by a demonic force within the artist.

Sculpture before World War I

FRANCE

Matisse Some of the most important experiments in sculpture were conducted by Matisse. During the years 1907–14, he was inspired by ethnographic sculpture. There had been a growing interest in "primitive" art on the part of Gauguin and other painters even before the first major public collections began to be formed in 1890. *Reclining Nude I* (fig. 26-1) is a counterpart to Matisse's painting *Blue Nude* from the same year, which partakes of its "savage" element. Sculpture was a natural complement to Matisse's pictures. It allowed him to investigate problems of form that in turn provided important lessons for his canvases. The bulging distortions in *Reclining Nude* create an astonishing muscular tension. Yet the artist was concerned above all with what he called **arabesque**, and it is the rhythmic contours that define the nude. We will recognize the statuette's kinship with the reclining figures in *The Joy of Life* (see fig. 25-1), which were also conceived in outline. Now, however, these rhythms are explored in the round and manipulated for expressive effect. Remarkably, Matisse accomplished this aim without diminishing the fundamentally classical character of the nude.

Brancusi Sculpture remained only a sideline for Matisse. Perhaps for that reason, Expressionism was much less important in sculpture than in painting. This fact may seem surprising, since the rediscovery of ethnographic art by the Fauves might have been expected to have a strong impact on sculptors. But the only one who shared this interest was Constantin Brancusi (1876–1957), a Romanian who went to Paris in 1904. However, he was fascinated with the formal simplicity and coherence of primitive carvings rather than with their untamed expressiveness.

This concern is evident in *The Kiss* (fig. 26-2), executed in 1909 and now placed over a tomb in a Parisian cemetery. The compactness and self-sufficiency of the group are a radical step beyond Maillol's *Seated Woman* (see fig. 24-17), to which it is related, much as the Fauves are to Post-Impressionism. Brancusi has a "genius of omission" not unlike Matisse's. And his attitude toward art

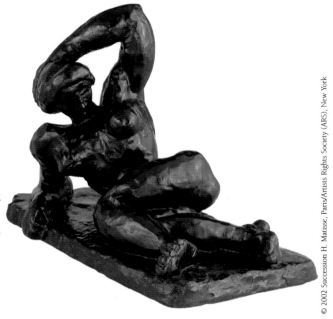

26-1 Henri Matisse. *Reclining Nude I.* 1907. Bronze, height 13⁹/₁₆ x 19⁵/₈ x 11" (34.5 x 49.9 x 28 cm). The Baltimore Museum of Art

The Cone Collection, formed by Dr. Claribel Cone and Miss Etta Cone of Baltimore, Maryland

© 2002 Succession H. Matisse, Paris/Artists Rights Society (ARS), New York

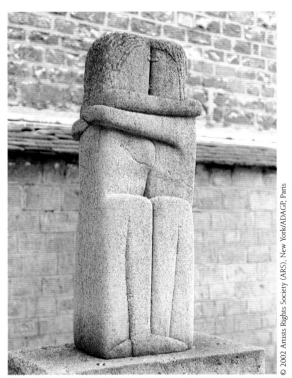

© 2002 Artists Rights Society (ARS), New York/ADAGP, Paris

26-2 Constantin Brancusi. *The Kiss.* 1909. Stone, height 35¹/₄" (89.5 cm). Tomb of T. Rachevskaia, Montparnasse Cemetery, Paris

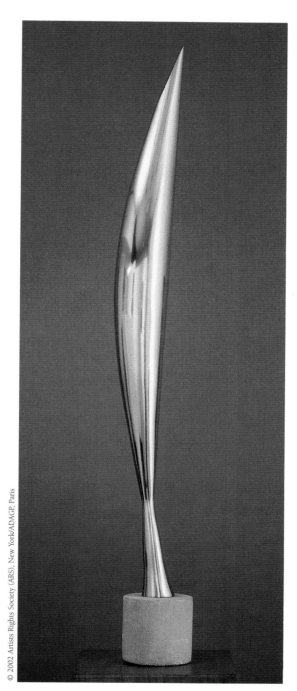

© 2002 Artists Rights Society (ARS), New York/ADAGP, Paris

26-3 Constantin Brancusi. *Bird in Space.* 1928 (unique cast). Bronze, 54 x 8¹/₂ x 6¹/₂" (137.2 x 21.6 x 16.5 cm). The Museum of Modern Art, New York

Given anonymously

expresses the same optimistic faith so characteristic of early modernism: "Don't look for mysteries," he said. "I give you pure joy." To him a monument was a permanent marker, like the steles of the ancients—an upright slab, symmetrical and immobile— and he disturbed this basic shape as little as possible. The embracing lovers are differentiated just enough to be separately identifiable, and seem more primeval than primitive. Innocent and anonymous, they are a timeless symbol of generation. Herein lies the genius of Brancusi: he posed the first successful alternative to Rodin, whose authority overwhelmed the creativity of many younger sculptors. In the process, Brancusi gave modern sculpture its independence.

Brancusi's work took another daring step about 1910, when he began to produce nonrepresentational pieces in marble or metal. (He reserved his "primeval" style for wood and stone.) They fall into two groups: variations on the egg shape and soaring, vertical "bird" motifs. In concentrating on two basic forms of such uncompromising simplicity, Brancusi strove for essences, not for Rodin's illusion of growth. He was fascinated by the contrast of life as potential and as kinetic energy—the self-contained perfection of the egg, which hides the mystery of all creation, and the pure dynamics of the creature released from this shell. *Bird in Space* (fig. 26-3) is the culmination of Brancusi's art. It began as the figure of a mythical bird that talks, which he gradually simplified until it was no longer the abstract image of a bird. Rather, it is flight itself, made visible and concrete. "All my life I have sought the essence of flight," Brancusi stated, and he repeated the motif in variants of ever-greater refinement. Its disembodied quality is emphasized by the high polish, which gives the surface the reflectivity of a mirror and thus establishes a new continuity between the molded space and the surrounding free space.

Duchamp-Villon In the second decade of the century a number of artists tackled the problem of body-space relationships with the formal tools of Cubism. This was no simple task, since Cubism was a painter's approach, more suited to shallow relief and not easily adapted to objects in the round.

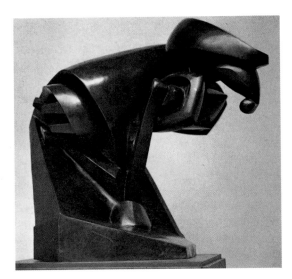

26-4 Raymond Duchamp-Villon. *The Great Horse.* 1914. Bronze, height 39¼" (99.7 cm). The Art Institute of Chicago

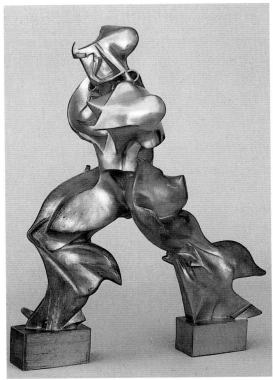

26-5 Umberto Boccioni. *Unique Forms of Continuity in Space.* 1913 (cast 1931). Bronze, 43⅞ x 34⅞ x 15¾" (111.4 x 88.6 x 40 cm). The Museum of Modern Art, New York

Most of the Cubist painters attempted at least a few sculptures, but the results were generally timid. Picasso's tentative efforts at sculpture attest to the difficulties he faced, yet they were of fundamental importance. His attempts to translate the Analytic Cubism seen in *Portrait of Ambroise Vollard* (see fig. 25-9) into three-dimensional form succeeded only partially in breaking up the solid surface. Precisely because its facets are ambiguous in density and location, Cubism in painting afforded an infinitely richer experience both visually and expressively.

The boldest solution to the problems posed by Analytic Cubism in sculpture was achieved by the sculptor Raymond Duchamp-Villon (1876–1916), an older brother of Marcel Duchamp, in *The Great Horse* (fig. 26-4). He began with abstract studies of the animal, but his final version is an image of "horsepower." The body has become a coiled spring, and the legs resemble piston rods. These quasi-mechanical shapes have a dynamism that is entirely convincing, because they are so far removed from their anatomical models.

ITALY

Boccioni In 1912 the Futurists suddenly became absorbed with making sculpture, which they wanted to redefine as radically as painting. They used "force-lines" to create an "arabesque of directional curves" as part of a "systematization of the interpenetration of planes." Hence, as Umberto Boccioni declared, "We break open the figure and enclose it in environment." His running figure titled *Unique Forms of Continuity in Space* (fig. 26-5) is as breathtaking in its complexity as Brancusi's *Bird in Space* is simple. Boccioni has attempted to represent not the human form but the imprint of its motion upon the surrounding air. The figure itself remains concealed behind its "garment" of atmospheric turbulence. The picturesque statue recalls the famous Futurist

statement that "the roaring automobile is more beautiful than the *Winged Victory*," although it obviously owes more to the *Winged Victory* (the *Nike of Samothrace;* see fig. 5-25) than to the design of motor cars. (In 1913 fins and streamlining were still to come.)

Sculpture between the Wars

RUSSIA

Tatlin In Analytic Cubism, concave and convex were treated as equivalents. All volumes, whether positive or negative, were "pockets of space." The Constructivists, a group of Russian artists led by Vladimir Tatlin (1895–1956), applied this principle to relief sculpture and arrived at what might be called three-dimensional collage. Eventually the final step was taken of making the works freestanding. According to Tatlin and his followers, these "constructions" were actually four-dimensional. Since they implied motion, they also implied time. Suprematism (see page 574) and Constructivism were therefore closely related, and in fact overlapped, for both had their origins in Cubo-Futurism. They were nonetheless separated by a fundamental difference in approach. For Tatlin, art was not the Suprematists' spiritual contemplation but an active process of formation that was based on material and technique. He believed that each material dictates specific forms that are inherent in it, and that these laws must be followed if the work of art is to be valid according to the laws of life itself. In the end, Constructivism won out over Suprematism because it was better suited to the temperament of Russia after the REVOLUTION OF 1917, when great deeds, not great thoughts, were needed.

Cut off from artistic contact with Europe during World War I, Constructivism developed into a uniquely Russian art that was little affected by the return of some of the country's most important artists, such as Kandinsky and Chagall. The Russian Revolution galvanized the modernists, who celebrated the overthrow of the old regime with a creative outpouring throughout Russia. Tatlin's model for a *Monument to the Third International* (fig. 26-6) captures the dynamism of the technological utopia envisioned under Communism. Pure energy is expressed as lines of force that establish new time-space relationships. The work also implies a new social structure, for the Constructivists believed in the power of art literally to reshape society. This extraordinary tower revolving at three speeds was conceived on an enormous scale, complete with Communist party offices. Like other such projects, however, it was wildly impractical in a society still recovering from the ravages of war and revolution and was never built.

Constructivism subsequently proceeded to a Productivist phase, which ignored any contradiction between true artistic creativity and purely utilitarian production. After the movement was suppressed as "bourgeois formalism," a number of its members

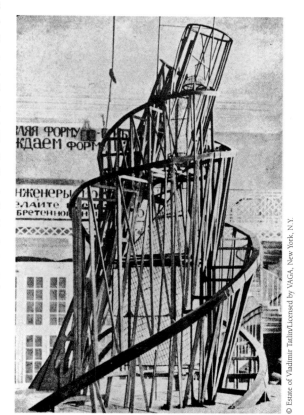

26-6 Vladimir Tatlin. *Project for "Monument to the Third International."* 1919–20. Wood, iron, and glass, height 20' (6.10 m). Destroyed; contemporary photograph

Preceded by a long period of civil unrest, the REVOLUTION OF 1917 was the final violent outburst that ended the rule of the czars. Workers' riots in Petrograd (St. Petersburg) and Moscow and the seizing of the Duma (parliament) led to the abdication of Nicholas II in March. In October, the Bolsheviks, led by Vladimir I. Lenin, brought down the provisional government and established the first Soviet Communist state. The Third International (1919–43), known as the Comintern, was a congress convened by the Communists for the purpose of establishing themselves as the leaders of the worldwide socialist movement.

emigrated to the West, where they joined forces with the few movements still espousing abstraction.

FRANCE

Lipchitz Contrary to what one might have expected, the everyday materials of Synthetic Cubism proved of far greater interest to painters than to the Cubist sculptors, who maintained a traditional loyalty to bronze. After World War I sculptors in France largely deserted abstraction and abandoned Expressionism altogether. Only the Lithuanian-born Jacques Lipchitz (1891–1973), a friend of both Picasso and Matisse, continued to explore the possibilities offered by Cubism. He also shared in Brancusi's prime-valism, and in the mid-1920s he achieved a remarkable synthesis of these two tendencies. With its intently staring eyes, *Figure* (fig. 26-7) is a haunting evocation in Cubist terms of African sculpture. Consisting of two interlocking figures, it creates a play of open and closed forms that relieves Brancusi's austere simplicity through arabesque rhythms akin to those of Matisse. Not surprisingly, the patron who commissioned it as a garden sculpture found it difficult to live with *Figure*. No other sculptor at the time was able to rival Lipchitz for sheer power, and he set an important example for the generation of sculptors that reached maturity a decade later (see pages 616–17).

Duchamp Lipchitz's disciplined abstraction was the very opposite of Dada, which fostered non-traditional approaches that have both enriched and confounded modern sculpture ever since. Playfulness and spontaneity are the motives behind the readymades of Duchamp, which he created by shifting the context of everyday objects from the utilitarian to the aesthetic. The artist would put his signature and a provocative title on found ("readymade") objects, such as bottle racks, and exhibit them as works of art. *In Advance of the Broken Arm* (fig. 26-8) pushed the spirit of readymades even further. Duchamp "re-created" the lost original version of 1915 with this one made in 1945. Some of Duchamp's examples consist of combinations of found objects. These "assisted" readymades approach the status of constructions or three-dimensional collage. This technique, later baptized "assemblage"

(see pages 622–23), proved to have unlimited possibilities, and numerous artists have explored it since World War II, especially in junk-ridden America.

Surrealism Readymades are certainly extreme demonstrations of a principle: that artistic creation depends neither on established rules nor on manual craft. The principle itself was an important discovery, although Duchamp abandoned readymades after only a few years. The Surrealist contribution to sculpture is harder to define. It was difficult to apply the theory of "pure psychic automatism" to painting, but still harder to live up to it in sculpture. How could solid, durable materials be given shape without the sculptor being consciously aware of the process?

Oppenheim A breakthrough came in 1930, when the Surrealists met in response to a growing crisis caused in part by André Breton's insistence on tying the movement to Leon Trotsky's Communist faction. They issued a new manifesto drafted by Breton that called for the "profound and veritable occultation of Surrealism." It further required "uncovering the strange symbolic life of the most ordinary and clearly defined objects." The result was a new class of Surrealist object. Neither readymade nor sculpture, it constituted a kind of three-dimensional collage. However, it was assembled not out of aesthetic concerns using traditional techniques but according to "poetic affinity" following dictates of the subconscious. *Object* (fig. 26-9) by Meret Oppenheim (1913–1985), one of several gifted women associated with the movement, created a sensation when it was exhibited in 1936. Like others of its kind, it was intended to be repulsive and unsettling in the extreme, yet proves all the more fascinating for that very reason.

Arp Perhaps the purest form of Surrealist sculpture was created by Hans Arp (1887–1966). Around 1930 he began to translate his reliefs, which arose from his experiments with collage, into three-dimensional forms. They evolved a few years later into the Human Concretion series (fig. 26-10, page 614), a term that aptly describes their character

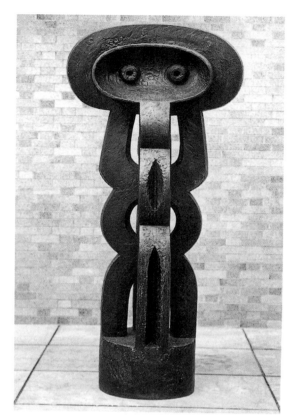

26-7 Jacques Lipchitz. *Figure.* 1926–30 (cast 1937). Bronze, height 7'1¼" (2.17 m). The Museum of Modern Art, New York

Van Gogh Purchase Fund

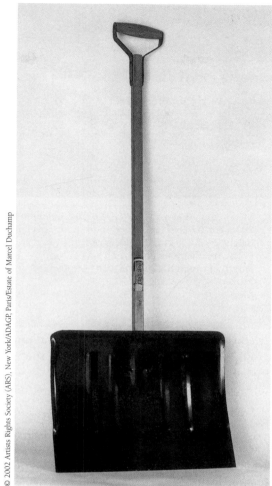

26-8 Marcel Duchamp. *In Advance of the Broken Arm.* 1945, from the original of 1915. Snow shovel, length 46¾" (118.8 cm). Yale University Art Gallery, New Haven, Connecticut

Gift of Katherine S. Dreier for the Collection Société Anonyme

26-9 Meret Oppenheim. *Object.* 1936. Fur-covered teacup, saucer, and spoon; diameter of cup 4¾" (12.1 cm); diameter of saucer 9⅜" (23.8 cm); length of spoon 8" (20.3 cm). The Museum of Modern Art, New York

Purchase

26-10 Hans Arp. *Human Concretion.* 1935. Original plaster, 19¹/₂ x 18³/₄ x 25¹/₂"
(49.5 x 47.6 x 64.7 cm). The Museum of Modern Art, New York
Gift of the Advisory Committee

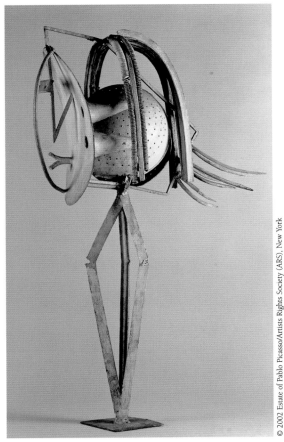

26-11 Pablo Picasso. *Head of a Woman.* 1930–31.
Painted iron, sheet metal, springs, and colanders,
39³/₈ x 14¹/₂ x 23¹/₄" (100 x 37 x 59 cm). Musée
Picasso, Paris

(see also page 586). In contrast to Brancusi's abstractions, which reduce things to their absolute essence, Arp's biomorphic forms seem to grow organically as they are built up during the modeling process. The concretions were almost always done first in clay or plaster. Many were later carved in marble and wood, or sometimes cast in bronze, by skilled artisans, and are notable for their technical perfection. They have influenced countless sculptors ever since.

Picasso As in painting, Picasso's genius was the driving force for much of the sculpture during the 1930s. The painter developed a serious interest in three-dimensional forms in 1928, and for the next five years he concentrated intensely on making sculptures of all sorts. They demonstrate an amazing variety that testifies to his fertile imagination. *Head of a Woman* (fig. 26-11) is an especially appeal-

ing example of his work from this period. This arresting figure, made from a colander and other discarded materials, shows Picasso's fascination with the "primitive" quality of ethnographic sculpture. Its kinship with the head in *Girl before a Mirror* of about the same time (see fig. 7) suggests why the artist turned to sculpture in the first place. On the one hand, his painted shapes have a solidity that practically demands translation into three-dimensional form. On the other, his work is so full of startling transformations that the process of metamorphosis involved in sculpture became highly intriguing. Here there can be little doubt that Picasso's involvement with Surrealism stimulated

26-12 Alexander Calder. *Lobster Trap and Fish Tail.* 1939. Painted steel wire and sheet aluminum, approx. 8'6" x 9'6" (2.59 x 2.89 m). The Museum of Modern Art, New York

Commissioned by the Advisory Committee for the stairwell of the Museum

his imagination and allowed him to approach sculpture without preconceived ideas. As he put it, "One should be able to take a bit of wood and find it's a bird."

Calder Surrealism in the early 1930s produced still another important development: the mobile sculpture of the American Alexander Calder (1898–1976). Called mobiles for short, they are delicately balanced constructions of metal wire, hinged together and weighted so as to move with the slightest breath of air. Unpredictable and ever-changing, such mobiles incorporate the fourth dimension as an essential element. They may be of any size, from tiny tabletop models to the huge *Lobster Trap and Fish Tail* (fig. 26-12). KINETIC SCULPTURE

had been conceived first by the Constructivists. Their influence is evident in Calder's earliest mobiles, which were motor-driven and tended toward abstract geometric forms. Calder was also affected early on by Mondrian, whose use of primary colors he adopted. Like Mondrian, he initially thought of his constructions as self-contained miniature universes. But it was his contact with Surrealism that made him realize the poetic possibilities of "natural" rather than fully controlled movement. He borrowed biomorphic shapes from Miró and began to conceive of mobiles as counterparts to organic structures: flowers on flexible stems, foliage quivering in the breeze, marine animals floating in the sea. Infinitely responsive to their environment, they seem amazingly alive.

Kinetics is the branch of science devoted to the relation between motion and the forces acting on the objects in motion. KINETIC SCULPTURE can be powered to move or, like Calder's mobiles, can move in response to invisible air currents. Other forms include works constructed so that their appearances change drastically in relation to the movement of the viewer or because of the serial lighting of parts. Even some paintings are classified as kinetic art, notably those of the Op Art style, which create a sense of movement through their optical instability.

26-13 Henry Moore. *Recumbent Figure.* 1938. Green Hornton stone, length approx. 54" (137.2 cm). The Tate Gallery, London

ENGLAND

Two English sculptors represent the culmination of the modern sculptural tradition before 1945: Henry Moore (1898–1986) and Barbara Hepworth (1903–1975). The presence of Kokoschka, Mondrian, Gropius, and other émigrés helped give rise to modern art in England during the mid-1930s, when Moore and Hepworth were emerging as mature artists. As a result, they absorbed the full spectrum of earlier twentieth-century sculpture but in different measure, reflecting their contrasting personalities. The two were closely associated as leaders of the modern movement in England and influenced each other. Moore was the more boldly inventive artist, but Hepworth may well have been the better sculptor.

Moore *Recumbent Figure* (fig. 26-13), perhaps Moore's finest sculpture, retains both a classical motif—one thinks of a reclining river-god (see fig. 23-5)—and a primeval look. The design is in complete harmony with the natural striations of the stone, as if the forms had resulted from slow erosion over a thousand years. Through biomorphic abstraction, Moore has evoked the essence of the human figure with striking success. If we were to follow the natural temptation to run our hand over the sculpture, the swelling forms would seem filled with inner life. Moore was originally inspired by a Mayan statue of the rain spirit Chac Mool. Interestingly enough, the nearest relative of Brancusi's *Kiss* is a Pre-Columbian pottery figurine group—which the artist cannot have known, however, since it was a later discovery. The coincidence nevertheless underscores the fundamental kinship between Brancusi and Moore. Moore's figure also suggests an awareness of Arp's Human Concretions from about the same time (see fig. 26-10). The difference is that Arp suggests anatomical forms without specifically referring to them, as Moore does. The undulating effect is not unlike the arabesques achieved by Matisse in *Reclining Nude I* (see fig. 26-1). Moore also takes liberties with the human figure that would be unthinkable without Picasso (compare fig. 25-20). In this way, Moore weaves the

26-14 Barbara Hepworth. *Sculpture with Color (Deep Blue and Red)*. 1940–42. Wood, painted white and blue, with red strings, on a wooden base, 11 x 10¼" (27.9 x 26 cm). Collection Alan and Sarah Bowness, London

strands of early modern sculpture into a seamless unity of incomparable beauty and subtlety.

Hepworth Hepworth was the leading woman sculptor of the twentieth century. In common with Moore's, her sculpture had a biomorphic foundation, but her style became more abstract after her marriage to the painter Ben Nicholson, her association with the Constructivist Naum Gabo, and her contact in Paris with Brancusi and Arp. For a time she was practicing several modes at once under these influences. At the onset of World War II, she moved to St. Ives in Cornwall, where she initiated an individual style that emerged in the early 1940s. *Sculpture with Color (Deep Blue and Red)* flawlessly synthesizes painting and sculpture, Surrealist biomorphism and organic abstraction, the molding of space and the shaping of mass (fig. 26-14). Carved from wood and immaculately finished, it transforms the shape of an egg into a timeless ideal that has the lucid perfection of a classical head, yet also the elemental expressiveness of a prim-

itive mask. Hepworth's egg shape undoubtedly owes something to Brancusi's, although their work is very different. The colors accentuate the play between the interior and exterior of the hollowed-out form, while the strings, a device first used by Moore, seem to suggest a life force within. As a result of its open forms, *Sculpture with Color* enters into an active relationship with its surroundings.

Hepworth was concerned with the relationship of the human figure in a landscape, but in an unusually personal way. After transferring to a house that overlooked St. Ives Bay, she wrote, "I was the figure in the landscape and every sculpture contained to a greater or lesser degree the ever-changing forms and contours embodying my own response to a given position in that landscape. I used colour and strings in many of the carvings of this time. The colour in the concavities plunged me into the depth of water, caves, or shadows deeper than the carved concavities themselves. The strings were the tension I felt between myself and the sea, the wind or the hills."

Sculpture since 1945

PRIMARY STRUCTURES AND ENVIRONMENTAL SCULPTURE

Like painting, sculpture since 1945 has been characterized by epic proportions. Indeed, scale became fundamental for a sculptural movement that extended the scope—the very concept—of sculpture in an entirely new direction. *Primary Structure*, the most suitable name suggested for this type, conveys its two chief characteristics: extreme simplicity of shapes and a kinship with architecture. Another term, *Environmental Sculpture* (not to be confused with the mixed-medium "environments" of Pop Art), refers to the fact that many Primary Structures are designed to envelop the viewer, who is invited to enter or walk through them. It is this space-defining function that distinguishes Primary Structures from all previous sculpture and relates them to architecture. They are the modern successors, in steel and concrete, to such prehistoric monuments as Stonehenge (see figs. 1-5 and 1-6).

Smith Most Primary Structures are not Environmental Sculptures but freestanding works independent of the sites that contain them. Primary Structures and Environmental Sculptures nevertheless share the same massive scale and economy of form. The artist who played the most influential role in defining them was David Smith (1906–1965). During the last years of his life he developed a singularly impressive form of Primary Structure in his Cubi series. Figure 26-15 shows three of these against the open sky and rolling hills of the artist's farm at Bolton Landing, New York. (All are now in major museums.) Only two basic components are employed: cubes and cylinders. Yet Smith created a seemingly endless variety of configurations. The units that make up the structures are balanced one upon the other as if they were held in place by magnetic force, so that each sculpture represents a fresh triumph over gravity. Unlike many members of the Primary Structure movement, Smith executed these pieces himself, welding them of sheets of stainless steel whose shiny surfaces he finished by hand. As a result, his work displays an "old-fashioned" subtlety of touch that reminds us of the polished bronzes of Brancusi.

Bladen The sculptors of Primary Structures often limited themselves to the role of designer and left the execution to others, in order to emphasize the

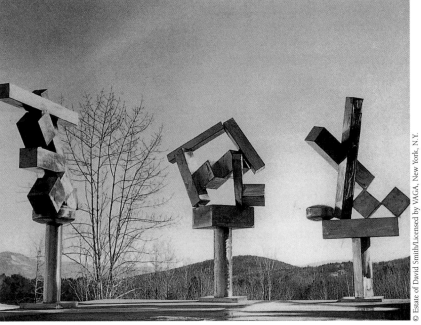

26-15 David Smith. Cubi series (at Bolton Landing, New York). Stainless steel. Left: *Cubi XVIII*. 1964. Height 9'8" (2.95 m). Museum of Fine Arts, Boston. Center: *Cubi XVII*. 1963. Height 9' (2.74 m). Dallas Museum of Fine Arts. Right: *Cubi XIX*. 1964. Height 9'5" (2.87 m). The Tate Gallery, London

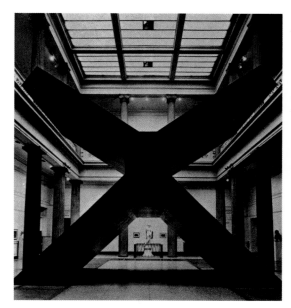

26-16 Ronald Bladen. *The X* (in the Corcoran Gallery, Washington, D.C.). 1967. Painted wood, later constructed in steel, 22'8" x 24'6" x 12'6" (6.91 x 7.47 x 3.81 m)

Courtesy Fischbach Gallery, New York

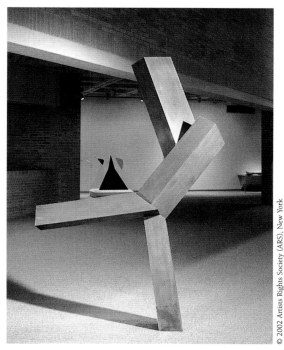

26-17 Joel Shapiro. *Untitled.* 1989–90. Bronze, 8'5½" x 3'6" x 6'6" (2.58 x 1.07 x 1.98 m). North Carolina Museum of Art, Raleigh

Purchased with funds from various donors, by exchange

impersonality and repeatability of their invention. If no patron could be found to foot the bill for carrying out these costly structures, they remained on paper, like unbuilt architecture. Sometimes such works reached the mock-up stage. *The X* (fig. 26-16), by the Canadian Ronald Bladen (1918–1988), was originally built with painted wood substituting for metal for an exhibition inside the two-story hall of the Corcoran Gallery in Washington, D.C. Its commanding presence, dwarfing the Neoclassical colonnade of the hall, seems doubly awesome in such a setting. *The X* was later constructed of painted steel as an outdoor sculpture.

MINIMALISM AND POST-MINIMALISM

A younger generation of Minimalists, Bladen among them, carried the implications of Primary Structures to their logical conclusion. In search of the ultimate unity, they reduced their geometry to the fewest possible components and used mathematical formulas to establish precise relationships. They further eliminated any hint of personal expression by contracting out the work to industrial fabricators.

Shapiro A number of sculptors gradually began to move away from Minimalism without entirely renouncing it. This trend is called Post-Minimalism to denote its continuing debt to the earlier style. Its leading representative is Joel Shapiro (born 1941). After producing small pieces having great conceptual intensity and aesthetic power, he suddenly began to make sculptures of simple wood beams that refer to the human figure but do not directly represent it. They assume active "poses," some standing awkwardly off-balance, others dancing or tumbling, so that they charge the space around them with energy. Shapiro soon began casting them in bronze, which retains the texture of the rough wood grain (fig. 26-17). These pieces are hand-finished with a beautiful patina by skilled artisans to reassert the traditional craftsmanship of sculpture. By freely rearranging the vocabulary of David Smith, who experimented with a similar figure before his death, Shapiro gave Minimalist sculpture a new lease on life. Nevertheless, his work remains one of the few successful attempts

at reviving contemporary sculpture, which as a whole has found it difficult to chart a new direction.

AFRICAN-AMERICAN SCULPTURE

Minimalism and Post-Minimalism were a decisive influence on a group of talented African-American sculptors who came to maturity in the 1960s. Their work has helped to make the late twentieth century the first great age of African-American art. While these sculptors show a variety of styles, subjects, and approaches, all address the black experience in America within a contemporary abstract aesthetic. Thus they have the advantage over African-American painters, who have often been burdened by representationalism and traditional styles.

Puryear Martin Puryear (born 1941), the leading black sculptor on the scene today, draws on his experience with the woodworkers of both Sierra Leone in western Africa, where he spent several years in the Peace Corps, and Sweden, where he attended the Royal Academy. Puryear manages to weld these very different sources into a personal style of seamless unity. He adapts African motifs and materials to the modern Western tradition by relying on careful craftsmanship to bridge the gap. His forms, at once bold and refined, have an elegant simplicity that contrasts the natural and man-made, the finished and unfinished. They may evoke a saw, bow, fishnet, anthill, or in this case a basket (fig. 26-18)—whatever his memory suggests—each restated in whimsical fashion.

EARTH ART

The ultimate medium for Environmental Sculpture is the earth itself, since it provides complete freedom from the limitations of the human scale. Some designers of Primary Structures have, logically enough, turned to earth art, inventing projects that stretch over many miles. These latter-day successors to the mound-building Native Americans of Neolithic times (see fig. 1-7) have the benefit of modern earth-moving machinery, but this advantage is more than outweighed by the problem of cost and the difficulty of finding suitable sites on our crowded planet.

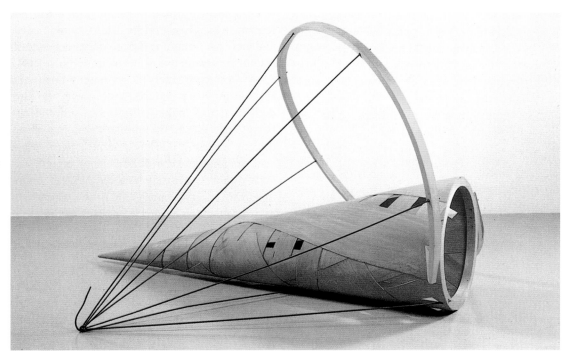

26-18 Martin Puryear. *The Spell.* 1985. Pine, cedar, and steel, 4'8" x 7' x 5'5" (1.42 x 2.13 x 1.65 m). Collection the artist

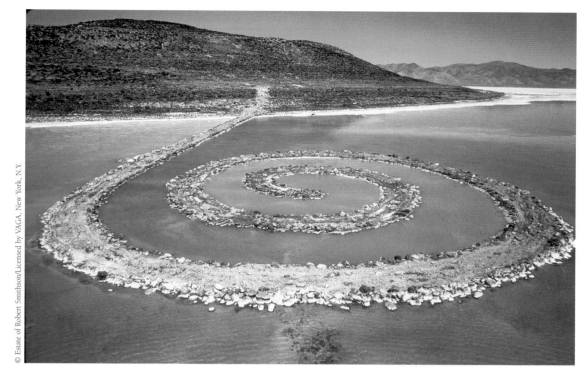

26-19 Robert Smithson. *Spiral Jetty.* As built in 1970. Total length 1,500' (457.2 m); width of jetty 15' (4.57 m). Great Salt Lake, Utah

Smithson Their projects have been carried out mostly in remote regions of the western United States, so that the finding is itself often difficult. *Spiral Jetty,* the work of Robert Smithson (1938–1973), jutted out into the Great Salt Lake in Utah (fig. 26-19) and is now partly submerged. Its appeal rests in part on the Surrealist irony of the concept: a spiral jetty is as self-contradictory as a straight corkscrew. But it can hardly be said to have grown out of the natural formation of the terrain. No wonder it has not endured long, nor was it intended to. The process by which nature is reclaiming *Spiral Jetty,* already twice submerged, was integral to Smithson's design from the start. The project nevertheless lives on in photographs. How can such a thing be called art? To Smithson, "The strata of the Earth is a jumbled museum. When one scans the ruined sites of prehistory one sees a heap of wrecked maps that upsets our present art historical limits . . . there is only an uncertain disintegrating order that transcends the limits of rational separations. The brain itself resembles an eroded rock from which ideas and ideals leak."

MONUMENTS

On a large scale, most Primary Structures are obviously monuments. But just as obviously they are not monuments commemorating or celebrating anything except their designer's imagination. They offer no ready frame of reference, nothing to be reminded of, even though the original meaning of "monument" is "reminder." Part of the problem confronting the monument maker in our era is that, unlike a century ago, there is so little worth commemorating in the first place—no event, no cause unites our fragmented world, despite the momentous changes going on everywhere—and no artistic vocabulary that we readily agree on. Monuments in the traditional sense thus died out when contemporary society lost its sense of what ought to be publicly remembered; yet the belief in the possibility of such monuments has not been abandoned altogether.

Noguchi Most recent "monuments" are wholly secular, wedded to the here and now, so that they fail to move us. The few that touch our deepest

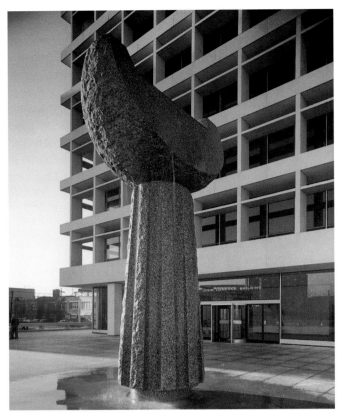

26-20 Isamu Noguchi. Fountain for the John Hancock Insurance Company, New Orleans. 1961–62. Granite, height 16' (4.88 m)

in a Japanese temple sits atop a grooved column recalling the primitive Doric of ancient Greece, where the Western sculptural tradition of which Noguchi felt himself a part originated. Except for the flat faces on either side of the capital, the finish has been left rough, out of the age-old Japanese respect for the natural materials and unadorned simplicity in the crafts. It gives the fountain a primeval look that emphasizes the stone's origin in the earth, for which Noguchi manifested an Eastern veneration. The contrast with the sleek modern lines of the Hancock building could hardly be greater. Yet the placement of the fountain shows not only a Japanese sensitivity to space but a fundamental understanding of the logic of modern architecture that Japanese critics recognized as distinctly Western.

CONSTRUCTIONS AND ASSEMBLAGE

Constructions present a difficult problem. If we agree to restrict the term *sculpture* to objects made of a single substance, then we must put "assemblages" (constructions using mixed mediums) in a class of their own. This is probably a useful distinction, because of their kinship with readymades. But what of Picasso's *Bull's Head* (see fig. 2)? Is it not an instance of assemblage, and have we not called it a piece of sculpture? Actually, there is no inconsistency here. The *Bull's Head* is a bronze cast, even though we cannot tell this by looking at a photograph of it. Had Picasso wished to display the actual handlebars and bicycle seat, he would surely have done so. Since he chose to have them cast in bronze, it must have been because he wanted to "dematerialize" the components of the work by having them reproduced in a single material. Apparently he felt it necessary to clarify the relation of image to reality in this way—the sculptor's way—and he almost always used the same procedure whenever he worked with readymade objects.

Nevertheless, we must not apply the "single-material" rule too strictly. Calder's mobiles, for instance, often combine metal, string, wood, and other substances. Yet they do not strike us as being assemblages, because these materials are not allowed to assert their separate identities. Conversely, an object may deserve to be called an assemblage

emotions have generally been inspired by profound religious beliefs and philosophical ideas. The search for meaning absorbed the Japanese-American sculptor Isamu Noguchi (1904–1988). Influenced early on by the Surrealists, as well as by Brancusi, he did not confront Eastern culture until a prolonged stay in Japan in 1952 that proved decisive to his formation. From then on, he developed into one of the most varied sculptors of this century whose rich imagination fed on both heritages. His role in mediating between East and West was of incalculable importance. To the Japanese he introduced modern Western ideas of style; to Americans he made traditional Japanese concepts of art comprehensible at a time when there was a growing fascination with Zen Buddhism.

We see this union in Noguchi's fountain for the John Hancock Insurance Company in New Orleans (fig. 26-20). Like much of Zen thought, it is an elegantly simple statement of a paradoxical idea. A "capital" rather like the wood-beam supports

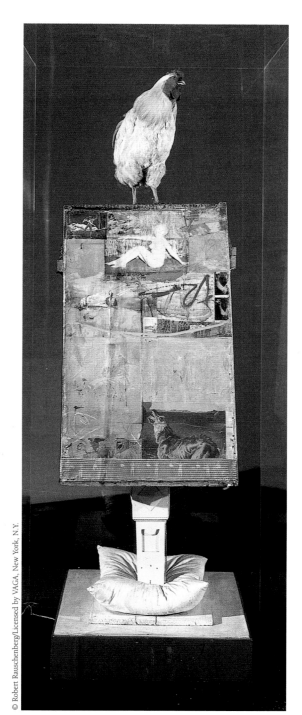

even though composed of essentially the same material. Such is often true of works known as "junk sculpture." These are made of fragments of old machinery, parts of wrecked automobiles, and similar discards, which constitute a broad class that can be called sculpture, assemblage, or environment, depending on the work itself.

Rauschenberg Robert Rauschenberg (born 1925) pioneered assemblage as early as the mid-1950s. Much like a contemporary composer making music out of the noises of everyday life, he constructed works of art from the trash of urban civilization. *Odalisk* (fig. 26-21) is a box covered with an assortment of pasted images—comic strips, photos, clippings from picture magazines—held together only by the network of brushstrokes the artist has painted on them. The box perches on a foot improbably anchored to a pillow on a wooden platform and is topped by a stuffed chicken.

The title is a witty blend of *odalisque* and *obelisk*. It refers both to the nude girls among the collage of clippings as modern "harem girls" and to the shape of the construction as a whole, for the box shares its verticality and slightly tapering sides with real obelisks. Rauschenberg's unlikely "monument" has at least some qualities in common with its predecessors: compactness and self-sufficiency. We will recognize in this improbable juxtaposition the same ironic intent found in the readymades of Duchamp, whom Rauschenberg had come to know well in New York.

Nevelson Although it is almost always made entirely of wood, the work of Louise Nevelson (1900–1988) must be classified as assemblage, and when extended to a monumental scale, it acquires the status of an environment (see page 625). Before Nevelson, there had not been any important American women sculptors in the twentieth century. Sculpture had traditionally been reserved for men because of the manual labor involved. Thanks to the women's suffrage movement in the second half of the nineteenth century, Harriet Hosmer (1830–1908) and her "White Marmorean Flock" (as the novelist Henry James called her and her followers in Rome) had succeeded in legitimizing sculpture as a medium

26-21 Robert Rauschenberg. *Odalisk*. 1955–58. Construction, 6'9" x 2'1" x 2'1" (205.7 x 63.5 x 63.5 cm). Museum Ludwig, Cologne

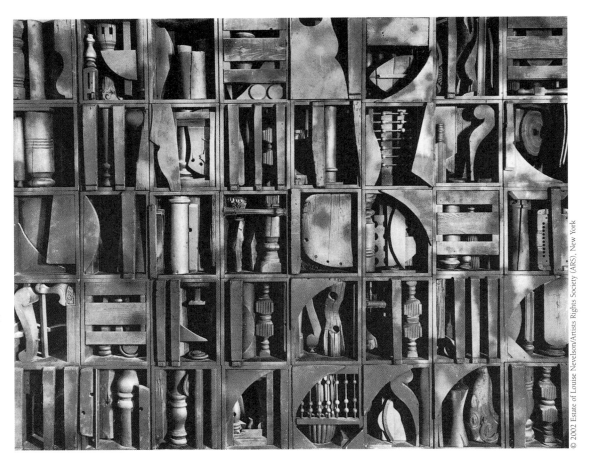

26-22 Louise Nevelson. *Black Chord.* 1964. Painted wood, 8' x 10' x 11½" (2.44 x 3.05 x .29 m). Collection Joel Ehrenkranz

for women. This school of sculpture waned, however, when the sentimental, idealizing Neoclassical style fell out of favor after the Philadelphia Centennial of 1876.

In the 1950s Nevelson rejected external reality and began to construct a private one from her collection of found pieces of wood, both carved and rough. At first these self-contained realms were miniature cityscapes, but they soon grew into large environments of freestanding "buildings," complete with decorations that were inspired by the sculpture on Mayan ruins. Nevelson's work generally took the form of large wall units that flatten her architecture into reliefs (fig. 26-22). Assembled from individual compartments, the whole is always painted a single color, usually a matte black to suggest the shadowy world of dreams. Each unit is elegantly designed and is itself a metaphor of thought or experience. While the organization is governed by

an inner logic, the statement remains an enigmatic monument to the artist's imagination.

Chase-Riboud Nevelson's success has encouraged other American women to become sculptors. Barbara Chase-Riboud (born 1939), a prizewinning novelist and poet who lives in Paris and Rome, belongs to a generation of remarkable black women who have made significant contributions to several of the arts at once. She is heir to a unique American tradition. It is a paradox that whereas black women almost never carve in traditional African cultures, in America they found their first artistic outlet in sculpture. They were attracted to it by the example set by Harriet Hosmer at a time when abolitionism and feminism were closely allied liberal causes.

Chase-Riboud received her initial training in her native Philadelphia. The monumental sculpture

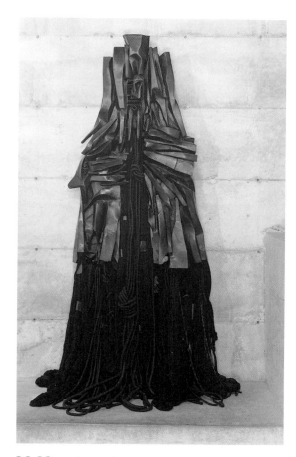

26-23 Barbara Chase-Riboud. *Confessions for Myself.* 1972. Bronze, black paint, and black wool, 10' x 3'4" x 1' (3.05 x 1.02 x .30 m). University of California, Berkeley Art Museum

Purchased with funds from the H. W. Anderson Charitable Foundation

she developed in the early 1970s, after graduating from Yale University, makes an indelible impression. In *Confessions for Myself* (fig. 26-23) she has envisioned a demonic archetype of awesome power. Her highly individual aesthetic uses the principle of assemblage to combine bronze, either polished or with a black patina, and braided fiber. Similar qualities can be found in cast-bronze figures from Benin and in carved wooden masks by the Senufo tribe, which are sometimes decorated with textiles. *Confessions for Myself* can be compared to a poem: each form is like a strophe that contributes to the total meaning of the work. Nor

is the analogy an accident, for Chase-Riboud's growth as an artist coincided with her development as a poet. The title in this case comes from one of the poems that she wrote around the same time. She began *Confessions for Myself* with it in mind, which accounts for the extremely personal nature of the work. Her sculpture expresses a distinctly ethnic sensibility and feminist outlook. At the same time, she is like an archaeologist, peeling back layer after layer of personal memory to reveal a meaning from deep within our collective subconscious. Thus she achieves a universality in keeping with her cosmopolitan view of art and life. Chase-Riboud has found wider acceptance in Europe than in the United States, because her work does not meet popular stereotypes of black art and transcends barriers of race and culture.

ENVIRONMENTS AND INSTALLATIONS

A number of artists associated with Pop Art have also turned to assemblage because they find the flat surface of the canvas too confining. In order to bridge the gap between image and reality, they often introduce three-dimensional objects into their pictures. Some even construct full-scale models of everyday things and real-life situations, utilizing every conceivable kind of material in order to embrace the entire range of their physical environment, including people, in their work. These "environments" combine the qualities of painting, sculpture, collage, and stagecraft. Being three-dimensional, they can claim to be considered sculpture. However, environments form a separate category, distinct from both painting and sculpture, because they combine different materials ("mixed mediums") and blur the borderline between image and reality. The differences are underscored by "installations," which are environments expanded into room-size settings.

Segal George Segal (1924–2000) created three-dimensional life-size environments showing people and objects in everyday situations. The subject of *Cinema* (fig. 26-24, page 626) is ordinary enough to be instantly recognizable: a man changing the letters on a movie theater marquee. The relation of image and reality is far more subtle and complex

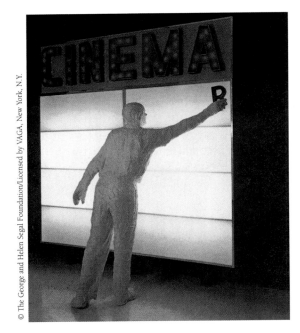

26-24 George Segal. *Cinema.* 1963. Plaster, metal, Plexiglas, and fluorescent light, 9'10" x 8' x 3'3" (2.99 x 2.44 x .99 m). Albright-Knox Art Gallery, Buffalo, New York

Gift of Seymour H. Knox

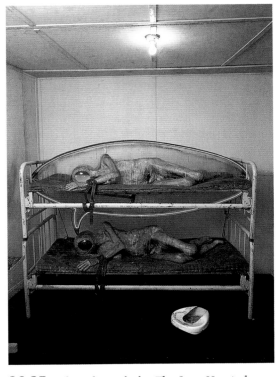

26-25 Edward Kienholz. *The State Hospital.* 1966. Mixed mediums, 8 x 12 x 10' (2.44 x 3.66 x 3.05 m). Moderna Museet, Stockholm

than the scene first suggests. The man's figure is cast from a live model by a technique of Segal's invention and retains its ghostly white-plaster surface. Thus it is one crucial step removed from our world of daily experience. The neon-lit sign has been carefully designed to complement and set off the shadowed figure. Moreover, the scene is brought down from its normal place high above the entrance to the theater, where we might have seen it in passing, and is shown at eye level, isolated from its natural context, so that we grasp it completely for the first time.

Kienholz Some environments can have a shattering impact on the viewer. This is certainly true of *The State Hospital* (fig. 26-25) by the West Coast artist Edward Kienholz (1927–1994), which shows a cell in a ward for senile patients with a naked old man strapped to the lower bunk. He is the victim of physical cruelty, which has reduced what little mental life he had in him

almost to the vanishing point. His body is hardly more than a skeleton covered with leathery, discolored skin, and his head is a glass bowl with live goldfish, of which we catch an occasional glimpse. The horrifying realism of the scene is completed by the sense of smell. When the work was displayed at the Los Angeles County Museum of Art, it emitted a sickly hospital stench. But what of the figure in the upper bunk? It almost duplicates the one below, with one important difference: it is a mental image, since it is enclosed in the outline of a comic-strip balloon rising from the goldfish bowl. It represents, then, the patient's awareness of himself. The abstract devices of the balloon and the metaphoric goldfish bowl are both alien to the realism of the scene; yet they play an essential part in it, for they help to break the grip of horror and pity. They make us think as well as feel. Kienholz's means may be Pop, but his goal is that of Greek tragedy. He has no equal as a witness to the unseen miseries beneath the surface of modern life.

CONCEPTUAL ART

Conceptual Art has the same "patron saint" as Pop Art: Marcel Duchamp. It arose during the 1960s out of the Happenings staged by Allan Kaprow (born 1927) and Jean Tinguely (1925–1991), in which the event itself became the art. Conceptual Art challenges our definition of art more radically than Pop, insisting that the leap of the imagination, not the execution, is art. According to this view, works of art can be dispensed with altogether, since they are incidental by-products of the imaginative leap. So too can galleries and, by extension, even the artist's public. The creative process need only be documented in some way. Sometimes the documentation is in verbal form, but more often it is by still photography, video, or cinema exhibited within an installation.

Conceptual Art, we will recognize, is akin to Minimalism as a phenomenon of the 1960s, but instead of abolishing content, it eliminates aesthetics from art. This deliberately antiart approach, stemming from Dada (see page 584), poses a number of stimulating paradoxes. As soon as the documentation takes on visible form, it begins to come perilously close to more traditional forms of art (especially if it is placed in a gallery, where it can be seen by an audience). In fact, it is almost impossible to divorce the imagination fully from aesthetic matters.

Kosuth We see this dilemma in *One and Three Chairs* (fig. 26-26) by Joseph Kosuth (born 1945), which is clearly indebted to Duchamp's readymades (see fig. 26-8). It "describes" a chair by combining in one installation an actual chair, a full-scale photograph of that chair, and a printed dictionary definition of the word *chair*. Whatever the Conceptual artist's intention, this making of the work of art, no matter how minimal the process, is as essential as it was for Michelangelo. In the end, all art is the final document of the creative process, because without execution, no idea can ever be fully realized. Without such "proof of performance," the Conceptual artist becomes like the emperor wearing new clothes that no one else can see. And, in fact, Conceptual Art has embraced all of the mediums in one form or another.

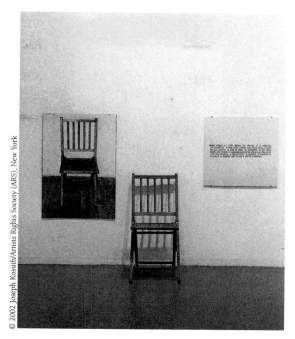

26-26 Joseph Kosuth. *One and Three Chairs.* 1965. Wooden folding chair, photographic copy of chair, and photographic enlargement of dictionary definition of *chair;* chair, $32^3/_8$ x $14^7/_8$ x $20^7/_8$" (82.2 x 37.8 x 53 cm); photo panel, 36 x $24^1/_8$" (91.5 x 61.1 cm); text panel, 24 x $24^1/_8$" (61 x 62.2 cm). The Museum of Modern Art, New York

Larry Aldrich Foundation Fund

PERFORMANCE ART

Performance Art, which originated in the early decades of the twentieth century, belongs for the most part to the history of theater. However, the form that arose in the 1970s combines aspects of Happenings and Conceptual Art with installations. In reaction to Minimalism, artists now wanted to reassert their presence by becoming, in effect, living works of art. The results have relied mainly on the shock value of irreverent humor or explicit sexuality. Nonetheless, Performance Art emerged as perhaps the most characteristic art form of the 1980s.

Beuys The German artist Joseph Beuys (1921–1986) managed to overcome these limitations, but he, too, was a controversial figure who incorporated an element of parody into his work. Life for Beuys was a creative process in which everyone is an artist. To him art was capable of transforming society itself and thus acquired a political mission as well. Beuys assumed the guise of a modern-day shaman intent on healing the spiritual crisis of contemporary life caused, he believed, by the rift between the arts and sciences. To find the common denominator behind such divisions, he created objects and scenarios which, though often baffling at face value,

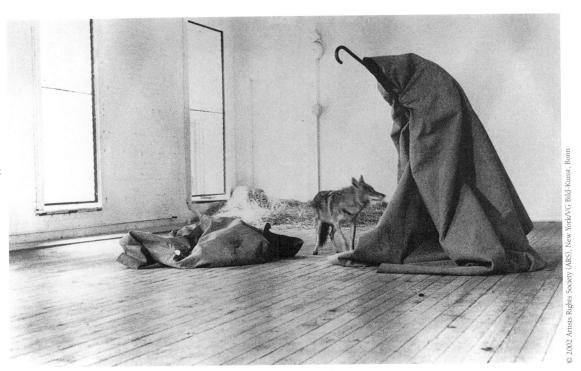

26-27 Joseph Beuys. *Coyote: I Like America and America Likes Me.* Photo of performance at Rene Block Gallery, New York. 1974

Photograph © 1974 Caroline Tisdall, Courtesy Ronald Feldman Fine Arts, New York

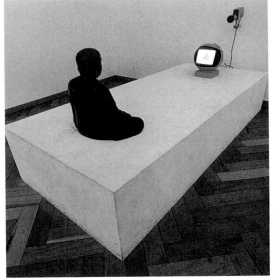

26-28 Nam June Paik. *TV Buddha.* 1974. Video installation with statue. Stedelijk Museum, Amsterdam

sacred to the American Indian but persecuted by the white man. His goal in this "dialogue" was to ease the trauma caused to an entire nation by the schism between the two opposing worldviews. That the attempt was inherently doomed to failure does not in any way reduce the sincerity of this act of conscience.

Paik The notes and photographs that document Beuys's performances hardly do them justice. His chief legacy today lies perhaps in the stimulation he provided his many students, including Anselm Kiefer (see page 605), and collaborators, among them Nam June Paik (born 1932). The sophisticated video displays of the Korean-born Paik fall outside the scope of this book; but his installation with a Buddha contemplating himself on television (fig. 26-28) is a memorable image uniquely appropriate to our age, in which the fascination with electronic mediums often seems to have replaced spirituality as the focus of modern life.

were meant to be accessible to the imagination. In 1974 Beuys spent one week caged up in a New York gallery with a coyote (fig. 26-27), an animal

TWENTIETH-CENTURY ARCHITECTURE

Modernism in twentieth-century architecture has meant first and foremost an aversion to historicism and to decoration for its own sake. Instead it favors a clean functionalism that expresses the Machine Age, with its insistent rationalism. In this regard, it can be considered the successor to classicism and, more specifically, the tradition of Structural Rationalism (see pages 469–70). Yet modern architecture demanded far more than a reform of architectural vocabulary and grammar. A new philosophy was needed to take full advantage of the new building techniques and materials that the engineer had made available to the architect. The leaders of modern architecture have been vigorous and eloquent thinkers, in whose minds architectural theory is closely linked with ideas of social reform to meet the challenges posed by industrial civilization. To them architecture's ability to shape human experience brings with it the responsibility to play an active role in molding modern society for the better. Architecture since 1900 has nevertheless been characterized as much by conservative countermovements and dead ends as by modernism, although it is the latter that defines the age. Moreover, modernism has created as many problems as it has solved, from faulty structures caused by engineering errors to inhuman buildings based on abstract ideals.

Architecture before World War I

EARLY MODERNISM

Wright The first indisputably modern architect was Frank Lloyd Wright (1867–1959), Louis Sullivan's great disciple. If Sullivan, Gaudí, Mackintosh, and Van de Velde could be called the Post-Impressionists of architecture, Wright took architecture to its Cubist phase. This is certainly true of his brilliant early style, which he developed between 1900 and 1910 and which had broad international influence. In the beginning Wright's main activity was the design of suburban homes in the upper Midwest. These were known as Prairie Style houses because their low, horizontal lines were meant to blend with the flat landscape around them.

The last, and most successful, residence in this series is Robie House of 1909 (figs. 27-1, 27-2). The exterior, so unlike anything seen before, instantly proclaims the building's modernity. However, its

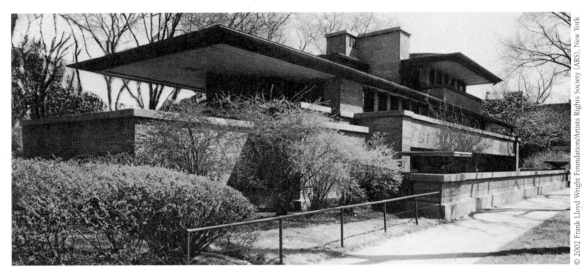

27-1 Frank Lloyd Wright. Robie House, Chicago. 1909

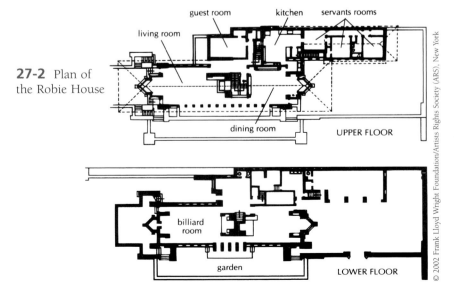

27-2 Plan of the Robie House

"Cubism" is not merely a matter of the clean-cut rectangular elements composing the structure but also of Wright's handling of space. Robie House is designed as a number of "space blocks," similar to the building blocks the architect played with as a child, arranged around a central core, the chimney. Some of the blocks are closed and others are open, but all are defined with equal precision. Thus the space that has been architecturally shaped includes the balconies, terrace, court, and garden, as well as the house itself. As in Analytic Cubism, voids and solids are regarded as equivalents, and the entire complex enters into an active and dramatic relationship with its surroundings. Wright did not aim simply to design a house but to create a complete environment. He even took command of the details of the interior.

Wright acted out of a conviction that buildings have a profound influence on those who live, work, or worship in them, thus making the architect, consciously or unconsciously, a molder of people.

Deutscher Werkbund In Europe modern architecture developed more slowly and unevenly, and it came to maturity only on the eve of World War I, which effectively halted its further growth for nearly a decade. Central to the early development of modernism in Germany was the Deutscher Werkbund (Artisans Community). This alliance of "the best representatives of art, industry, crafts and trades" was founded in 1907 to upgrade the quality and value of German goods to the level of England's. The leader was Hermann Muthesius (1861–1927), whose mission was to translate the Arts and Crafts Movement into a machine style using the most advanced techniques of industrial design and manufacturing. Its membership consisted of 12 leading industrial firms and a like number of artists, designers, and architects from Germany and Austria. The way was led by Peter Behrens (1869–1940), the chief architect and designer for the electrical firm A.E.G., whose three disciples became the founders of modern architecture: Walter Gropius, Ludwig Mies van der Rohe, and Le Corbusier.

Gropius The first to cross that threshold fully was Gropius (1883–1969), who came from a well-known family of architects. The Fagus Shoe Factory (fig. 27-3), designed in 1911 with his partner Adolf

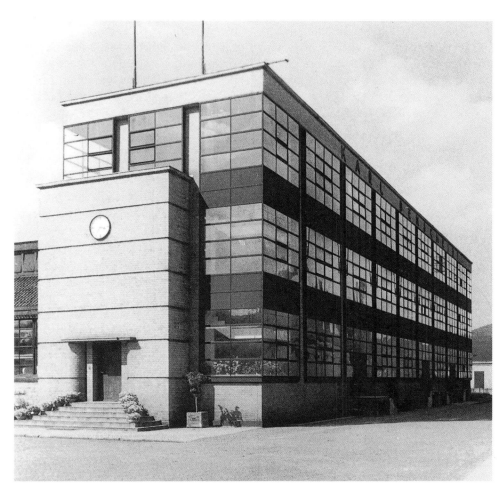

27-3 Walter Gropius and Adolf Meyer. Fagus Shoe Factory, Alfeld, Germany. 1911–14

Meyer (1881–1929), represents the critical step toward modernism in European architecture. The most dramatic feature is the walls, which are a nearly continuous surface of glass. This radical innovation had been possible ever since the introduction of the structural-steel skeleton several decades before, which relieved the wall of any load-bearing function. Sullivan had approached it, but he could not yet free himself from the traditional notion of the window as a "hole in the wall." Far more radically than Sullivan or Behrens, Gropius frankly acknowledged, at last, that in modern architecture the wall is no more than a curtain or climate barrier, which may consist entirely of glass if maximum daylight is wanted. Only in the classical entrance did he give a nod to the past.

Sant'Elia The UTOPIAN side of modernist architecture was added by the Futurist Antonio Sant'Elia (1888–1916). He declared that "we must invent and reconstruct the Futurist city as an immense, tumultuous yard and the Futurist house as a gigantic machine." The Central Station project for his Città Nuova (New City, fig. 27-4) is treated in terms of circulation patterns that determine the relationships between buildings. They establish a restless perpetual motion that fulfills the Futurist vision announced in Boccioni's work (see figs. 25-11 and 26-5). But it is the enormous scale, dwarfing even the largest complexes of the past, that makes this a uniquely modern conception. It even includes a runway for airplanes. (The scheme is not as impractical as it may seem; the design anticipates the huge Fiat-Lingotto automobile factory in Turin by Giacomo Matté-Trucco just two years later.)

Although Sant'Elia's style remained basically Secessionist, his program was resolutely forward-looking: "Modern structural materials and our scientific concepts do not lend themselves to the disciplines of historical styles. . . . We no longer feel ourselves to be the men of the cathedrals and ancient moot halls, but men of the Grand Hotels, railway stations, giant roads. . . . The house of cement, iron and glass, without carved or painted ornament, rich only in the inherent beauty of its lines and modelling, extraordinarily brutish in its mechanical simplicity . . . must rise from the brink of a tumultuous abyss. . . ."

EXPRESSIONISM

Taut The Werkbund exhibition of 1914, which featured Van de Velde's theater (see fig. 24-21), was a showcase for a whole generation of young German architects who were to achieve prominence after World War I. Many of the buildings they designed for the fairgrounds anticipate ideas of the 1920s. Among the most adventurous is the staircase of the "Glass House" (fig. 27-5) by Bruno Taut (1880–1938). It was made magically translucent by the use of glass bricks, then a novel material. The structural-steel skeleton was as thin and unobtrusive as the great strength of the metal permits. The use of glass was inspired, oddly enough, not by technology but by the widespread mystical interest in crystal. This enthusiasm was started by the poet Paul Schneebart, whose aphorisms, such as "Colored glass destroys hatred," ring the Glass House.

Taut's mysticism was shared by the Expressionist movement. After the war he helped to establish the short-lived Workers' Council for Art, whose

UTOPIA (from the Greek ou, "not," and topas, "place"; thus, literally, "nowhere") was coined by Sir Thomas More, who used it as the title of his influential book, originally published in Latin in 1516. More's Utopia was an ideal state entirely ruled by reason, and thus free of poverty and pain. Although in practice unattainable, his vision has inspired generations of writers, artists, and social reformers, from H. G. Wells (A Modern Utopia) to Karl Marx and Friedrich Engels, the socialist and Communist theorists. Some works such as George Orwell's Nineteen Eighty-Four are set in dystopias, the oppressive, terrifying reverse of utopias.

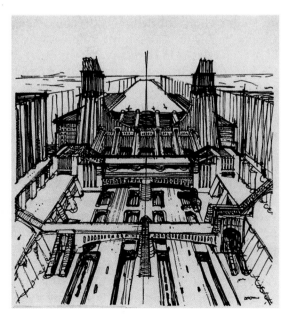

27-4 Antonio Sant'Elia. Central Station project for Città Nuova (after Banham). 1914

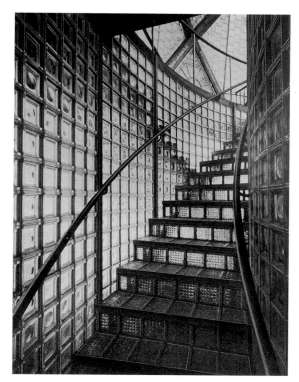

27-5 Bruno Taut. Staircase of the "Glass House," Werkbund Exhibition, Cologne. 1914

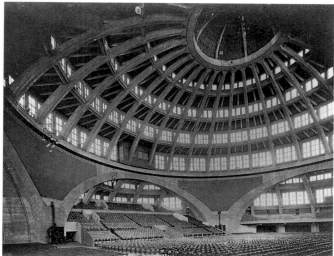

27-6 Max Berg. Interior of the Centennial Hall, Breslau, Germany. 1912–13

members included painters of Die Brücke (see pages 565–66). Its purpose was to unite all the arts under the umbrella of architecture. Through his journals *The Glass Chain* and *Early Light,* Taut became the center of a loose network of architects, including Behrens, Gropius, Erich Mendelsohn (1887–1953), and even Mies van der Rohe, who had the same fascination with crystalline glass. To Taut, architecture "consists exclusively of powerful emotions and addresses itself exclusively to the emotions." We may call this approach Expressionism, because it stresses the artist's feelings toward himself and the world (see pages 561–62). Does modern architecture not incorporate the spontaneous and irrational qualities of Fantasy as well? Indeed it does. But because the modern architect shares the Expressionist's primary concern with the human community, rather than the labyrinth of the imagination, Fantasy plays a much smaller role than Expressionism, which has incorporated it.

Berg The romantic side of Expressionist architecture is best seen in the Centennial Hall (fig. 27-6) built by Max Berg (1870–1948) in Breslau to celebrate Germany's liberation from Napoleon in 1812. Berg, for the first time, has taken full advantage of reinforced concrete's incredible flexibility and strength. The vast scale is not simply an engineering marvel but a visionary space. Ultimately the interior looks back to the Pantheon (see fig. 7-3), but with the solids and voids reversed, so that we are reminded of nothing so much as the interior of Hagia Sophia (see fig. 8-12). That Centennial Hall further recalls the soaring spirituality of a Gothic cathedral (such as our fig. 11-3) is not a coincidence. Berg shared with Rouault an intense Christian religiosity. Little is known of his later years, during which he abandoned his profession.

Architecture between the Wars

By the onset of World War I, the stage was set for a modern architecture. But which way would it go? Would it follow the impersonal standard of the machine aesthetic advocated by Muthesius

or the artistic creativity espoused by Van de Velde? Ironically, the issue was decided by Van de Velde's choice of Behrens's disciple Walter Gropius as his successor at Weimar in 1915, when Van de Velde was forced to resign because he was not a German. However, the war effectively postponed the evolution of modern architecture for nearly a decade. When this development resumed in the 1920s, the outcome of the issues posed at the Cologne Werkbund exhibition in 1914 was no longer clearcut. Rather than a simple linear progression, we find a complex give-and-take between modernism and competing tendencies representing traditional voices and alternative visions. This varied response has its parallel in the art of the period, which largely rejected abstraction in favor of Fantasy, Expressionism, and Realism.

DE STIJL

Rietveld The work of Frank Lloyd Wright attracted much attention in Europe through German publications of 1910 and 1911 featuring his buildings. Among the first to recognize its importance were some young Dutch architects who, a few years later, joined forces with Mondrian in the De Stijl movement (see page 583). Among their most important experiments is Schröder House (fig. 27-7), which was tacked on to an existing apartment house in 1924 by Gerrit Rietveld (1888–1964). The facade looks like a Mondrian painting transposed into three dimensions, for Rietveld has used the same rigorous abstraction and refined geometry (compare fig. 25-24). The arrangement of floating panels and intersecting planes is based on Mondrian's principle of dynamic equilibrium: the balance of unequal but equivalent oppositions, which expresses the mystical harmony of humanity with the universe. Steel beams, rails, and other elements are painted in bright primary colors to define the composition.

Unlike the elements of a painting by Mondrian, the exterior parts of Schröder House look as if they can be shifted at will, although in fact they fit as tightly as the interlocking pieces of a jigsaw puzzle. Not a single element could be moved without destroying the delicate balance of the whole. Inside, however, the living quarters can be reconfigured through a system of sliding partitions that fit neatly together when moved out of the way. This flexible treatment of the living quarters was devised with the owner, Truss Schröder, herself an artist, to suit her individual lifestyle. The decentralized plan also incorporates a continuous, "universal" space, which is given a linear structure by the network of panel dividers.

Schröder House proclaims a utopian ideal widely held in the early twentieth century. The machine would hasten humanity's spiritual development by liberating us from nature, with its conflict and imperfection, and by leading us to the higher order of beauty reflected in the architect's clean, abstract forms. The harmonious design of Schröder House owes its success to the insistent logic of this aesthetic, which we respond to even without being aware of its ideology. The design, far from being impersonal, is remarkably intimate. This effect is achieved not simply through the small scale but also through the architect's allegiance to traditional materials and craftsmanship, even though they were equated by De Stijl with the self-indulgent materialism of the past.

THE INTERNATIONAL STYLE

The Bauhaus Schröder House was recognized immediately as one of the classic statements of modern architecture. The De Stijl architects represented the most advanced ideas in European architecture in the early 1920s. They had a decisive influence on so many architects abroad that the movement soon became international. The

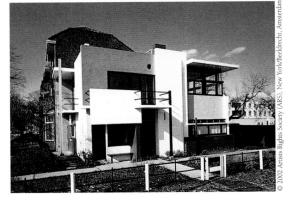

27-7 Gerrit Rietveld. Schröder House, Utrecht, the Netherlands. 1924

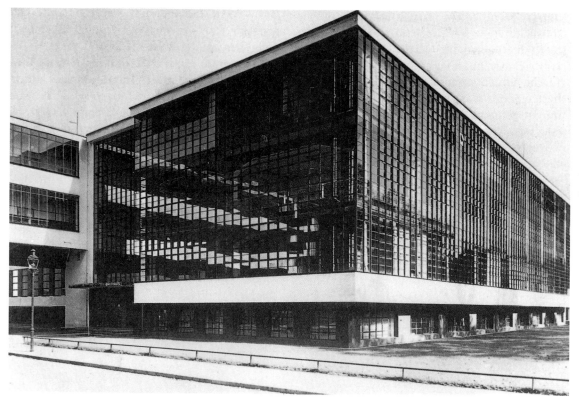

largest and most complete example of this International Style of the 1920s is the group of buildings created in 1925–26 by Walter Gropius for the Bauhaus in Dessau, the famous German art school of which he was the director. The most dramatic is the Shop Block, which is a fully mature statement of the principles announced 14 years earlier in Gropius's Fagus Shoe Factory (see fig. 27-3). The structure is a four-story box with walls of continuous glass (fig. 27-8) that produce a surprising result. Since the glass walls reflect as well as transmit light, their appearance depends on the interplay between the two. They respond to any change of conditions outside and inside. Thus they lend a strange quality of life to the structure. In this way the facade serves a similar purpose to that of the mirrorlike finish of Brancusi's *Bird in Space* (see fig. 26-3).

More important than this individual structure is the complex as a whole and what it stood for. The Bauhaus was the result of merging two separate schools, one devoted to art and the other to crafts.

This union happened in Weimar in 1919—the same year the national assembly established the republican government there known as the Weimar Republic. Hence the Bauhaus occupied a politically sensitive position from the beginning. Initially it tried to fulfill the goals of the Arts and Crafts Movement, but the traditional attitudes toward the two branches were too different for this romantic dream to succeed. A deep split developed between the Workshop Masters, who were responsible for practical crafts, and the Masters of Form, such as Kandinsky and Klee, who were invited by the artist Johannes Itten (1888–1967) in the early 1920s to teach theory. The curriculum was given a far more rational and pragmatic basis by the arrival of László Moholy-Nagy, a Hungarian follower of Tatlin's Constructivism (see page 611), who replaced Itten in 1922, and then of the painter Josef Albers. Also important was the visit in 1921 of Theo van Doesburg, a founder of the De Stijl movement (see page 583), whose ideas galvanized faculty and students alike. But it was the move to Dessau that

proved decisive. The city invited the school to transfer there in 1925, when it was closed down for a while by Weimar during a period of political turmoil.

The definitive character of the Bauhaus is reflected in Gropius's design. The plan consists of three major blocks (fig. 27-9) for classrooms, shops, and studios, which were interconnected; there was also a student center. The curriculum embraced all the visual arts, linked by the root concept of "structure" (*Bau*). It included, in addition to an art school, departments of industrial design under Marcel Breuer (1902–1981), graphic art under Herbert Bayer (1900–1985), and architecture, whose chief representative was Mies van der Rohe (see below), the Bauhaus's last director.

Gropius's buildings at Dessau incorporate elements of De Stijl and Constructivism, just as the school accommodated a range of temperaments and approaches. The Shop Block proclaims the Bauhaus's frankly practical approach. The complex as a whole promoted a remarkable community spirit based on a utopian socialist dream. The Bauhaus at Dessau was thus entirely different in character from the factionalism Gropius had inherited from Van de Velde at Weimar. The program embodied Gropius's tolerant yet unified vision. Not surprisingly, the school did not last long after his departure in 1928 to pursue architecture full time. His hand-picked successor, Hannes Meyer (1889–1954), who had been the first architect appointed to the faculty, was forced to resign in 1930 because

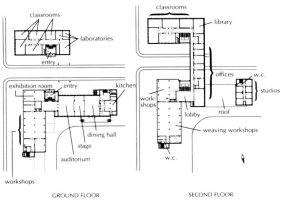

27-9 Plan of the Bauhaus

of his MARXIST leanings, even though he had prevented the formation of a Communist student cell. Mies van der Rohe tried vainly to revive the school's fortunes, but it was shut down by the Dessau parliament in 1932. By then, most of its leaders had left. After a final attempt to reopen it as a private school in Berlin, the Bauhaus was closed by the Nazis in 1933.

Mies van der Rohe Ludwig Mies van der Rohe (1886–1969) followed a highly varied path. As a young architect in Berlin, where he worked several years for Behrens, he started out as a Neoclassicist under the sway of the Schinkel school (see pages 502–3), then became a Structural Rationalist after meeting the Dutch architect Hendrik Berlage (1856–1934) in 1912. Following the war, he joined the radical November Group, which was allied with Taut's Workers Council for Art, and as a result became an Expressionist. He also came into contact with De Stijl and Constructivism. In 1927, as vice-director of the Deutscher Werkbund, Mies van der Rohe was charged with organizing the highly experimental Weissenhof Estate exhibition in Stuttgart. Held in response to the need for vast amounts of inexpensive but comfortable housing in Germany during the Weimar Republic, it became a showcase for all the leading modernist architects of the day. As a result, Mies van der Rohe became a convert to rationalization and standardization as the most effective means to attain that end. However, he never achieved the spartan functionalism of the leftist New Objectivity movement.

In 1929 Mies van der Rohe designed the prophetic German Pavilion for the International Exposition in Barcelona (fig. 27-10). Unfortunately it was dismantled soon after the fair closed. The pavilion, which proceeded from ideas he began to develop around 1923, was a daringly low-slung structure elevated on a marble base, with enclosed courtyards at the front and rear. It was even more radically simple in appearance than Wright's Robie House (see figs. 27-1 and 27-2), out of which it had clearly developed. Its walls were constructed of different-colored marble slabs, arranged with great precision like so many dominoes in a grid system. Here is the great spiritual counterpart to

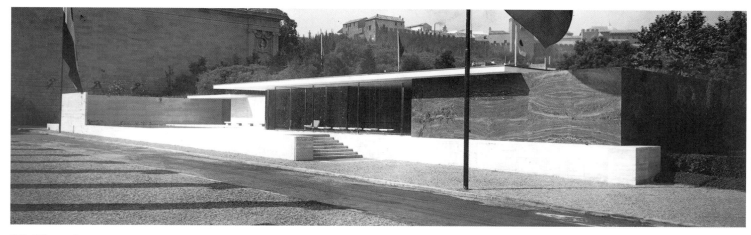

27-10 Ludwig Mies van der Rohe. German Pavilion, International Exposition, Barcelona. 1929

Mondrian among contemporary designers, possessed of the same "absolute pitch" in determining proportions and spatial relationships. Flooded with light from the great expanse of windows, the pavilion's interior was wonderfully open and fluid, yet with a sparse cleanness that still seems irrepressibly modern.

Le Corbusier In France, the most distinguished representative of the International Style during the 1920s was the Swiss-born architect Le Corbusier (Charles Édouard Jeanneret, 1886–1965). His training under Peter Behrens and Auguste Perret (see below), from whom he acquired a preference for reinforced concrete, made him a disciple of Structural Rationalism. His style was further shaped by his experience as a painter. In 1918 he and the artist Amédée Ozenfant (1886–1966) cofounded the movement known as Purism, which advocated a machine aesthetic similar to that of Le Corbusier's friend Fernand Léger, whose canvases during those years reflect the same attitude (see fig. 25-22). Le Corbusier worked with his cousin Pierre Jeanneret (1896–1967) from 1922 until 1940, when the latter joined the French resistance against the Nazis. Before 1940 he built only private houses—from necessity, not choice— but these are as important as Wright's Prairie Style houses. Le Corbusier called them *machines à habiter* (machines to live in). This

term was intended to suggest his admiration for the clean, precise shapes of machinery, not the Futurist desire for "mechanized living."

Le Corbusier evidently wanted to imply that his houses were so different from conventional homes as to constitute a new species. Such is indeed our impression as we approach the most famous of them, Villa Savoye at Poissy-sur-Seine (fig. 27-11, page 638), built in 1928–29. It is an outgrowth of the "Dom-Ino" houses he developed during World War I. The structure resembles a low, square box resting on stilts. These pillars of reinforced concrete (called pilotis) form part of the structural skeleton and reappear to divide the "ribbon windows" running along each side of the box. The flat, smooth surfaces deny all sense of weight. They stress Le Corbusier's preoccupation with abstract "space blocks," which he derived in part from designs by Adolf Loos (1870–1933) of the early 1920s. This simple structure contains living spaces that are open as well as closed, separated by glass walls. Views of the sky and the surrounding landscape can be seen everywhere. Yet we enjoy complete privacy, since we cannot be seen from the ground unless we stand next to a window. The functionalism of Villa Savoye is governed by a "design for living," not by mechanical efficiency. It fulfills Le Corbusier's statement that "architecture is the masterly, correct, and magnificent play of masses brought together in light. . . . Cubes,

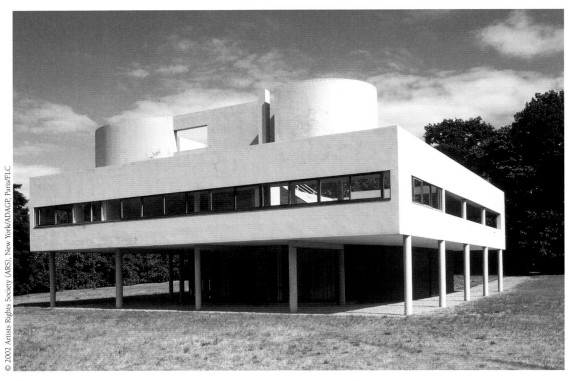

27-11 Le Corbusier. Villa Savoye, Poissy-sur-Seine, France. 1928–29

cones, cylinders, and pyramids are the primary forms which light reveals to advantage. . . . These are . . . the most beautiful forms."

Aalto Although its style and philosophy were codified about 1930 by a committee of Le Corbusier and his followers, the International Style was by no means monolithic. Soon all but the most purist among them began to depart from this standard. One of the first to break ranks was the Finnish architect Alvar Aalto (1898–1976), whose Villa Mairea (fig. 27-12) reads at first glance like a critique of Le Corbusier's Villa Savoye of a decade earlier. Like Rietveld's Schröder House, Villa Mairea was designed for a woman artist. Her second-story studio, covered with wood slats, dominates the view of the house from three directions. This time, however, the architect was given a free hand by his patron, and the building is a summation of ideas he had been developing for nearly ten years.

Aalto adapted the International Style to the tra-ditional architecture, materials, lifestyle, and landscape of Finland. He took an approach opposite to Le Corbusier's in order to arrive at a similar end. Aalto's primary concern was human needs, both physical and psychological, which he sought to

27-12 Alvar Aalto. Villa Mairea, Noormarkku, Finland. 1937–38

harmonize with functionalism. The modernist heritage, which extends back to Wright, is unmistakable in his vocabulary of forms and massing of elements. Yet everywhere there are romantic touches that add a warmth missing from Villa Savoye. Wood, brick, and stone are employed in combination throughout the interior and exterior, in contrast to Le Corbusier's pristine classicism. Free forms are introduced at several places to add an element of playfulness, as well as to break up the cubic geometry and smooth surfaces of the International Style.

Aalto's importance is undeniable, but his place in twentieth-century architecture remains unclear. His inclusion of nationalist elements in Villa Mairea has been interpreted both as a rejection of modernism and as a fruitful regional variation on the International Style. Today his work can be seen as a forerunner of Late Modernist architecture (see pages 641–42).

The Skyscraper in the United States

The United States, despite its early position of leadership, did not share the exciting growth that took place in European architecture during the 1920s. The impact of the International Style did not begin to be felt in America until the very end of the decade. A pioneer example is the Philadelphia Savings Fund Society Building of 1931–32 (fig. 27-13) by George Howe (1886–1954) and William E. Lescaze (1896–1969). It is the first skyscraper built anywhere to incorporate many of the features conceived in Europe after the end of World War I. The skyscraper was a compelling attraction to modernist architects in Europe as the embodiment of the idea of America, and during the 1920s Gropius and Mies van der Rohe designed several prototypes that were remarkably advanced for their time. Yet none was erected, while those constructed in the United States were sheathed in a variety of revivalist styles. (The Gothic was preferred.)

Although they quickly became the most characteristic form of American architecture, even the skyscrapers of the 1930s—when many of the most famous ones, such as the Empire State Building, were built—are in the tradition of Sullivan and

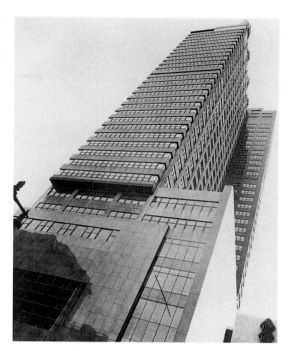

27-13 George Howe and William E. Lescaze. Philadelphia Savings Fund Society Building, Philadelphia. 1931–32

do little to develop the Wainwright Building (see fig. 24-22) except to make it bigger. Despite the fact that it is not entirely purist, the skyscraper of Howe and Lescaze is a landmark in the history of architecture. Remarkably enough, it was not to be surpassed for more than 20 years (compare fig. 27-15). The only building of comparable importance is Raymond Hood's McGraw-Hill Building in New York, which was built at the same time.

EXPRESSIONISM

Architecture between the wars is sometimes labeled Expressionist if it does not conform to the International Style. Such a view is valid only insofar as it represents the assertion of the right of the individual to express a personal point of view against the norms of modernism. The International Style based its ideals on standardization for the sake of universality. As such, it represents the triumph of classicism and Structural Rationalism. In reality, however, it was never the dominant approach after 1917, any more than abstraction was in painting.

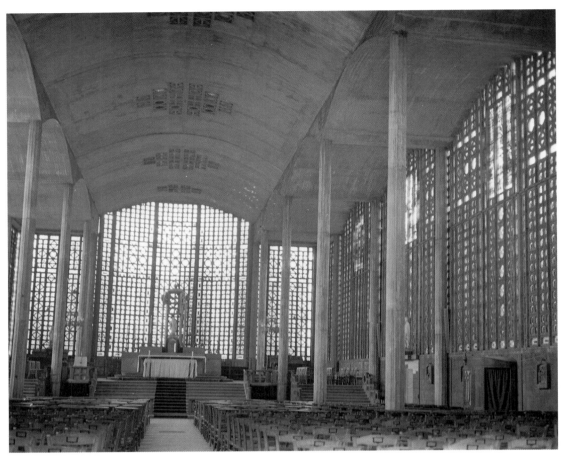

27-14 Auguste Perret. Notre Dame, Le Raincy, France. 1923–24

It seems best, then, to limit Expressionism in architecture following World War I to the few years around 1920.

Perret Early in the century, Auguste Perret (1874–1954) had been among the first to make effective use of recent advances in reinforced concrete and to define its architectural character. Perret was a pupil of the last great French academicians, so that he was a Structural Rationalist from the beginning. For him, concrete provided the means to reconcile classical form and Gothic structural authenticity. His greatest achievement must nevertheless be labeled Expressionist: the Church of Notre Dame, built as a war memorial at Le Raincy outside Paris (fig. 27-14). Perret's design is an astonishingly successful translation of medieval architectural forms into unadorned ferroconcrete.

The structure is supported entirely by grooved classical columns, so that the "walls" become vast expanses of glass, like the stained-glass windows of Gothic cathedrals (see fig. 11-1). In this way, Perret created a modern-day counterpart to Souflot's Panthéon (see fig. 21-11). This feat is not important in itself. It could, after all, readily be dismissed as mere historicism. Yet Perret has brilliantly solved one of the most difficult problems facing the modern architect: how to express traditional spirituality in our secular Machine Age using a twentieth-century vocabulary. Le Raincy is so pivotal that nearly all later church architecture in the West is indebted to its example, no matter how different the results.

Architecture since 1945

HIGH MODERNISM

Following the rise of the Nazis, the best German architects, whose work Hitler condemned as "un-German," came to the United States and greatly encouraged the development of American architecture. Gropius was appointed chairman of the architecture department at Harvard University, where he had an important educational influence. Mies van der Rohe, his former colleague at Dessau, settled in Chicago as a practicing architect. Following the war, they were to realize the dream of modern architecture, contained in germinal form in their buildings of the 1930s but never fully implemented. We may call the style that dominated architecture for 25 years after World War II High Modernism. It was indeed the culmination of the developments that had taken place during the first half of the twentieth century.

Even at its zenith High Modernism never arrived at a single, universal style. Nevertheless, its unified spaces embodied a harmonious vision that developed in a consistent way as the style was used in countless buildings throughout the world. Like the International Style before it, High Modernism permitted considerable local variation within established guidelines, although this development led almost inevitably to its decline.

Mies van der Rohe The crowning achievement of American architecture in the postwar era was the modern skyscraper, defined largely by Mies van der Rohe. The Seagram Building in New York (fig. 27-15), designed with his disciple Philip Johnson (born 1906), carries the principles announced in Gropius's design for the Bauhaus to their ultimate conclusion. It uses the techniques developed by Sullivan and Wright, Mies van der Rohe's great predecessors in Chicago, to extend the structure to an enormous height. Yet the building looks like nothing before it. Although not quite a pure box, it illustrates Mies van der Rohe's famous saying that "less is more." This alone does not explain the difference, however. Mies van der Rohe discovered the perfect means to articulate the skyscraper in the I beam, its basic structural member, which rises continuously

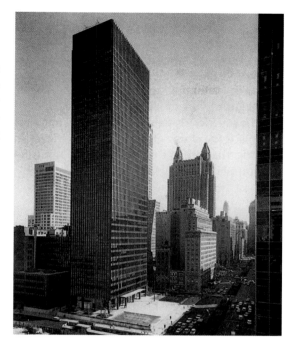

27-15 Ludwig Mies van der Rohe and Philip Johnson. Seagram Building, New York. 1954–58

along nearly the entire height of the facade. (The actual skeleton of the structure remains completely hidden from view.) The effect is as soaring as the **responds** inside a Gothic cathedral (compare fig. 11-3)—and with good reason, for Mies van der Rohe believed that "structure is spiritual." He achieved it through the lithe proportions, which create a perfect balance between the play of horizontal and vertical forces. This harmony expresses the idealism, social as well as aesthetic, that underlies High Modernism in architecture.

LATE MODERNISM

Since 1970 architecture has been obsessed with breaking the tyranny of the cube—and the High Modernism it stands for. Consequently a wide range of tendencies has arisen, representing almost every conceivable point of view. Like so much else in contemporary art, architecture has become theory-bound. Yet once the dust has settled, we may simplify its bewildering categories, with their equally confusing terminology, into Late Modernism, Post-modernism, and Deconstructivism (see chapter 29).

They are separated only by the degree to which they challenge the basic principles of High Modernism.

Rogers and Piano Late Modernism began innocently enough as an attempt to introduce greater variety of form and material, but it ended in the segmentation of space and use of "high-tech" finishes that are the hallmarks of late-twentieth-century buildings. Among the freshest results of Late Modernism is the Centre Georges Pompidou, the national arts and cultural center in Paris, which rejects the formal beauty of the International Style without abandoning its functionalism (fig. 27-16). Selected in an international competition, the design by the Anglo-Italian team of Richard Rogers (born 1933) and Renzo Piano (born 1937) looks like a building turned inside-out. The architects have eliminated any trace of Mies van der Rohe's elegant facades (see fig. 27-15) by exposing the building's inner mechanics while dis-

guising the underlying structure. The interior itself has no fixed walls, so that temporary dividers can be arranged to meet any need. This stark utilitarianism, sometimes termed Productivism, expresses a populist sentiment widespread in France. The exterior is enlivened by eye-catching colors, each keyed to a different function. The festive display is as vivacious and imaginative as Léger's *City* (see fig. 25-22), which, with Paris's Eiffel Tower (see fig. 23-28), can be regarded as the Pompidou Center's true ancestor.

NEO-EXPRESSIONISM

It can be argued that Late Modernism fulfills the agenda mapped at the beginning of the century, when architecture pursued not one but several paths. There is a certain truth to this ironic notion. Since 1985 architecture has also seen the rise of Neo-Expressionism and Neo-Modernism, which can be regarded as counterparts of the similarly

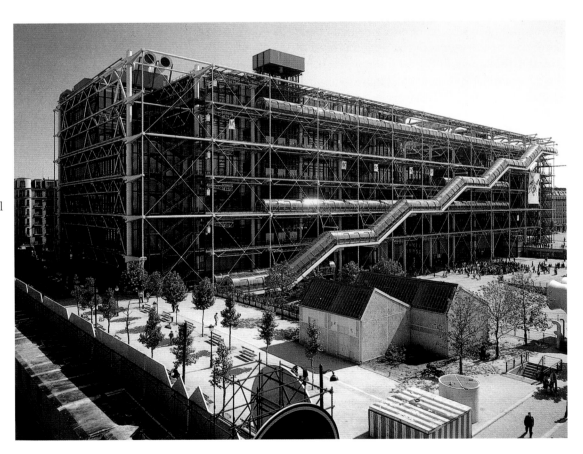

27-16 Richard Rogers and Renzo Piano. Centre National d'Art et Culture Georges Pompidou, Paris. 1971–77

27-17 Santiago Calatrava. TGV (Train à Grande Vitesse) Super Train Station, Satolas, Lyons. 1988–94

named movements in painting (see page 604). They have helped to make architecture the most vibrant and innovative of all art forms on the scene today, in contrast to painting and sculpture, which seem adrift. Indeed, the architecture of the past 15 years is among the richest in variety and quality of any period since the Baroque. There are at present more than two dozen great architects at work around the world. (See also pages 662–67.)

Calatrava Neo-Expressionism utilizes the same high-tech materials and techniques as Late Modernism but creates fantasies that are more sculptural than architectural. Thus architecture has replaced sculpture as the giver of contemporary form. Santiago Calatrava (born 1951), Spanish-born but Swiss-based, has created literally a flight of fancy for the futuristic TGV Station at Satolas, Lyons (fig. 27-17), which suggests some sort of mechanized prehistoric creature out of a science-fiction movie. The entrance to the central hall gives the appearance of the Concorde supersonic plane constructed on a birdlike skeleton but with a tail echoing the French Super Train (Train à Grande Vitesse). Through this seemingly mixed metaphor, the structure helps to link the railroad station with a nearby airport.

NEO-MODERNISM

Neo-Modernism looks back consciously to the modernist tradition created by Gropius, Mies van der Rohe, and Le Corbusier. Within it we may discern three separate, yet closely related, strands. The first is a revival of Structural Rationalism that is especially characteristic of Italian architects, such as Mario Botta (born 1943) and Aldo Rossi (1931–1997), as well as the Frenchman Jean Nouvel (born 1945). The second is a conscious return on the part of certain English architects, most notably Nicholas Grimshaw (born 1939), to the functional engineering of Paxton's Crystal Palace (see fig. 23-27). And the third, taken up by a new school of Dutch architects, among whom Rem Koolhaas (born 1944) is the best known, questions the legacy of High Modernism and tries to give it new life by reconsidering its potential in light of present-day realities. The theories and approaches of these three overlap not only with each other, but also with those of the Postmodernists, so that in recent years there has been a gradual merging of previously separate tendencies.

27-18 Rem Koolhaas. Foyer of the Netherlands Dance Theater, Amsterdam. 1987

Koolhaas An issue that concerns all schools is how to deal with the problem of unplanned urban growth and its attendant blight, although each has faced it somewhat differently. Unlike earlier architects, they have generally avoided attempting to cure social ills, since the utopian schemes put forward by the High Modernists were generally failures. Instead, they have been interested primarily in making significant architectural statements under the difficult conditions imposed by the sites themselves.

Koolhaas and his OMA group have focused on modern chaos theory and the "culture of conges-

tion" epitomized by New York City, which has led to a recent preoccupation with size. For him, it is the architect's role to resist chaos and instead find a new modernism reflecting urban existence in our time, which is full of paradoxes and contradictions. For that reason, Koolhaas combines "architectural specificity with programmatic instability," in which goals are treated in terms of strategy. Far from rejecting modernism, Koolhaas builds on it, while discarding many of its underlying assumptions. Although he has been influenced by Frank Gehry and the Deconstructionists (see page 667), especially in his preference for standard industrial building supplies, he has scorned the return to the style of the early Russian moderns as imitative and irrelevant to our age.

What all this theorizing in effect means is a new functionalism in which the facade is no more than an envelope that coexists with its surroundings, thereby disguising the purposes and spaces it encloses. In fact, Koolhaas's exteriors are deceptively bland. The real action takes place inside. If the Neo-Expressionists and the Sculptural Architects (see pages 665–66) are masters of form, Koolhaas is the master of interior space. The facade of the Netherlands Dance Theater, which is grafted onto an existing concert hall, is extremely modest. However, the foyer (fig. 27-18) is that rarity in modern architecture: a genuinely engaging interior, although it deliberately breaks no new ground as such. Despite Koolhaas's importance as a theorist, his design refrains from the didacticism that made High Modernism seem so cold and barren. He instead rescues modernism from itself and invests it with a new humanism—the feature it most conspicuously lacked—through the use of festive colors and dynamic space strikingly reminiscent of Léger's paintings (compare fig. 25-22). It is this kind of thoughtful reappraisal of the modernist legacy that offers perhaps the best hope for its continued vitality.

TWENTIETH-CENTURY PHOTOGRAPHY

During the nineteenth century, photography struggled to establish itself as art but failed to find an identity. Only under extraordinary conditions of political upheaval and social reform did it address the most basic subject of art, which is life itself. To create an independent vision, photography combined the aesthetic principles of the Secession and the documentary approach of photojournalism with lessons learned from motion photography. At the same time, modern painting, with which it soon became allied, forced a decisive change in photography. Modernism undermined the theoretical assumptions of photography and challenged its credentials as art. Like the other arts, photography responded to the three main artistic currents of the early twentieth century: Expressionism, Abstraction, and Fantasy. But because it has concentrated for the most part on the world around us, modern photography has generally followed a separate course marked by realism. We must therefore discuss twentieth-century photography primarily in terms of different schools and how they have dealt with those often-conflicting currents.

Modern photography was aided by technological advances. It must be emphasized, however, that these innovations have increased but not dictated the photographer's options. George Eastman's invention of the handheld camera in 1888 and the advent of 35mm photography with the Leica camera in 1924 made it easier to take pictures that had been difficult but by no means impossible to take with the traditional view camera. Surprisingly, color photography did not have such a revolutionary importance as might be expected. Color, in fact, had little impact on the content, outlook, or aesthetic of photography until the 1930s, even though it removed the last barrier cited by nineteenth-century critics of photography as art.

The First Half-Century

THE PARIS SCHOOL

Atget Modern photography began quietly in Paris with Eugène Atget (1856–1927), who turned to the camera only in 1898 at the age of 42. From then until his death, he toted his heavy equipment around Paris to record the city in all its variety. Atget was all but ignored by the art photographers, for whom his commonplace subjects had little interest. He himself was a humble man whose studio sign read simply, "Atget—Documents for Artists." His patrons included the founders of modern art: Braque, Picasso, Duchamp, and Man Ray (see below), to name only the best known. It is no accident that these artists were also admirers of Henri Rousseau. Rousseau and Atget shared a naive vision, although Atget found inspiration in unexpected corners of his environment rather than in magical realms of the imagination.

Atget's pictures are characterized by a subtle intensity and technical perfection that heighten the reality, and hence the significance, of even the most mundane subjects. Few photographers have equaled his ability to compose simultaneously in two- and three-dimensional space. Like *Pool, Versailles* (fig. 28-1), his scenes are often desolate, bespeaking a strange and haunted outlook. The viewer has the peculiar sensation that time has been frozen by the majestic composition and the photographer's obsession with textures. While Atget's work is related to the journalistic tradition of Nadar, Brady, and Riis (see pages 508–9, 510, and 557), it is distinctly different from earlier photography. This departure can be explained only in relation to late-nineteenth-century art. His pictures of neighborhood shops and street vendors, for example, are nearly identical with slightly earlier paintings by minor realists whose names are all but forgotten. Moreover, his photographs are directly related to a strain of Magic Realism that was a forerunner of Surrealism. Indeed, Atget has sometimes been called a Surrealist. While this label is misleading, it is easy to understand why he was rediscovered by Man Ray, the Dada and Surrealist artist-photographer.

Cartier-Bresson The greatest photographer of the Paris school is Henri Cartier-Bresson (born 1908). The son of a wealthy thread manufacturer, he studied under a Cubist painter in the late 1920s

28-1 Eugène Atget. *Pool, Versailles.* 1924. Albumen-silver print, 7 x 9³/₈" (17.8 x 23.9 cm). The Museum of Modern Art, New York

Abbott-Levy Collection. Partial gift of Shirley C. Burden

before taking up photography in 1932. Strongly affected at first by Atget, Man Ray, and the CINEMA, he soon developed into the most influential photojournalist of his time. His purpose and technique are nevertheless those of an artist, and his photographs have a nearly universal appeal.

Cartier-Bresson is the master of what he has termed "the decisive moment." This to him means the instant recognition and visual organization of an event at the most intense moment of action and emotion in order to reveal its inner meaning, not simply to record its occurrence. Unlike other members of the Paris school, Cartier-Bresson seems at home anywhere in the world and always in sympathy with his subjects. His photographs show an interest in composition for its own sake, derived from modern abstract art. He also has a fascination with motion, which he invests with all the dynamism of Futurism and the irony of Dada.

The key to his work is his use of space to establish relations that are suggestive and often astonishing. Although he deals with reality, Cartier-Bresson is a Surrealist at heart and has admitted as much. The results can be disturbing, as in *Mexico, 1934* (fig. 28-2). By omitting the man's face, Cartier-Bresson prevents us from identifying the meaning of the gesture, yet we respond to its tension no less powerfully.

THE UNITED STATES

Stieglitz The founder of modern photography in the United States was Alfred Stieglitz, and he remained the dominant figure throughout his long life (1864–1946). From his involvement with the Photo-Secession onward (see pages 558–59), he was a tireless spokesman for photography-as-art, which he defined more broadly than did other members of the movement. He backed up his words by publishing the magazine *Camera Work*. He also supported the other pioneers of American photography by exhibiting their work in his New York galleries, especially the first one, known as "291." Most of his early work follows Secessionist conventions by treating photography as a pictorial equivalent to painting. During the

From Eadweard Muybridge's serial photographs of horses (c. 1867) to Thomas A. Edison's kinetograph, a camera employing celluloid film (1889), to the first public screenings of movies in New York (1896), the early CINEMA developed rapidly. Simple ten-minute movies showing a continuous action from one vantage point soon gave way to more sophisticated dramatic stories, as artists such as D. W. Griffith and Sergei Eisenstein experimented with close-ups, editing, and camera movement. Sound was introduced in 1927, color in the 1930s, and wide screens in the 1950s.

28-2 Henri Cartier-Bresson. *Mexico, 1934.* 1934. Gelatin-silver print. Whereabouts unknown

mid-1890s, however, he took some pictures of street scenes that are forerunners of his mature photographs.

His classic statement, and the one he regarded as his finest photograph, is *The Steerage* (fig. 28-3). Taken in 1907 on a trip to Europe, it captures the feeling of a voyage by letting the shapes and composition tell the story. The scene is divided visually by the gangway in order to emphasize the contrasting activities of the observers on the upper deck and the people below in steerage, which was reserved for the cheapest fares. What it lacks in obvious sentiment it makes up for by remaining true to life.

This kind of "straight" photography is deceptive in its simplicity: the image mirrors the feelings that stirred Stieglitz. For that reason, *The*

28-3 Alfred Stieglitz. *The Steerage.* 1907. Chloride print, $4^3/_8$ x $3^5/_8$" (11.1 x 9.2 cm). The Art Institute of Chicago

Alfred Stieglitz Collection

Steerage marks an important step in his evolution and a turning point in the history of photography. Its importance emerges only in comparison with earlier photographs such as Steichen's *Rodin* (see fig. 24-27) and Riis's *Bandits' Roost* (see fig. 24-23). *The Steerage* is a pictorial statement independent of painting on the one hand and free from social commentary on the other. It represents the first time that documentary photography achieved the level of art in the United States.

Stieglitz's straight photography shaped the American school. It is therefore ironic that Stieglitz, with Steichen's encouragement, became America's first champion of abstract art. He attacked the Ash Can school (see page 577), whose paintings were often similar in subject and appearance to his photographs. The resemblance is misleading, however. For Stieglitz, photography was less a means of recording things than of expressing his experience and philosophy of life, much as a painter does.

This attitude culminated in his Equivalents. In 1922 Stieglitz began to photograph clouds to show that his work was independent of subject and personality. A remarkably lyrical cloud photograph from 1930 (fig. 28-4) corresponds to a state of mind waiting to find expression rather than merely responding to the moonlit scene. The study of clouds is as old as Romanticism itself, but no one before Stieglitz had made them a major theme in photography.

As in Käsebier's *Magic Crystal* (see fig. 24-26), *Equivalent* evokes unseen forces that also make it a counterpart to Kandinsky's *Sketch I for "Composition VII"* (see fig. 25-6).

Weston Stieglitz's concept of the Equivalent opened the way to "pure" photography as an alternative to straight photography. The leader of this new approach was Edward Weston (1886–1958), who was decisively influenced by Stieglitz. During the 1920s Weston pursued abstraction and realism as separate paths, but by 1930 he united them in images that are wonderful in their design and miraculous for their detail.

Pepper (fig. 28-5) is a splendid example of Weston's photography. The image is anything but a straightforward record of this familiar fruit. Like Stieglitz's Equivalents, it makes us see the ordinary with new eyes. The pepper is shown with incredible sharpness and so close up that it seems larger than life. Thanks to the tightly cropped composition, we are forced to contemplate the familiar form anew. *Pepper* has the sensuousness of *Black*

28-4 Alfred Stieglitz. *Equivalent*. 1930. Chloride print. The Art Institute of Chicago

Alfred Stieglitz Collection

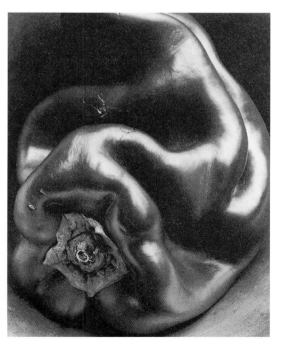

28-5 Edward Weston. *Pepper*. 1930. Center for Creative Photography, Tucson, Arizona

Iris III by O'Keeffe (see fig. 25-32), which lends the Equivalent a new meaning. Every undulation is revealed by the dramatic lighting. The shapes suggest the female nude, a subject that Weston also pioneered in photography.

Adams To achieve uniform detail and depth, Weston worked with the smallest possible camera lens openings. His success led to the formation in 1932 of the West Coast society known as Group f/64, for the smallest aperture. Among its founders was Ansel Adams (1902–1984), who soon became the foremost nature photographer in the United States. His landscapes hark back to nineteenth-century American painting and photography.

Adams was a meticulous technician, beginning with the composition and exposure and continuing through the final print. His famous work *Moonrise, Hernandez, New Mexico* (fig. 28-6) is a perfect marriage of straight and Equivalent pho-

tography. The image came from pure chance and could never be repeated. The key to the photograph lies in the low cloud that divides the scene into three zones, so that the moon appears to hover effortlessly in the early evening sky. As in all of Adams's pictures, there is a full range of tonal nuances, from clear whites to inky blacks.

Bourke-White Stieglitz was among the first to photograph skyscrapers, the new architecture that came to dominate America's growing cities. In turn he championed the Precisionist painters (see page 582), who began to depict urban and industrial architecture around 1925 under the inspiration of Futurism. Several of them soon took up the camera as well. Thus painting and photography once again became closely linked. Both responded to the revitalized economy after World War I, which led to unprecedented industrial expansion on both sides of the Atlantic.

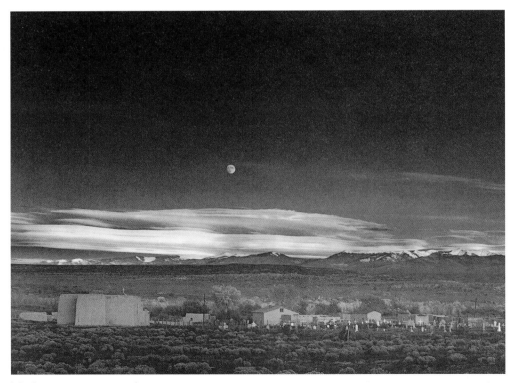

28-6 Ansel Adams. *Moonrise, Hernandez, New Mexico.* 1941. Gelatin-silver print, 15 x 18½" (38.1 x 47 cm). The Museum of Modern Art, New York

Gift of the photographer

During the GREAT DEPRESSION that followed, photography continued to grow with the new mass-circulation magazines that ushered in the great age of photojournalism and, with it, of commercial photography. In the United States, most of the important photographers were employed by the leading journals and corporations.

Margaret Bourke-White (1904–1971) was the first staff photographer hired by *Fortune* magazine and then by *Life* magazine, both published by Henry Luce. Her cover photograph of Fort Peck Dam in Montana for the inaugural November 23, 1936, issue of *Life* remains a classic example of the new photojournalism (fig. 28-7). The decade witnessed enormous building campaigns. With her keen eye for composition, Bourke-White drew a visual parallel between the dam and the massive constructions of ancient Egypt (compare fig. 2-15). (This idea had already appeared in a painting of 1927 by Charles Demuth, *My Egypt*.) In addition to their architectural power, Bourke-White's columnar forms have a remarkable sculptural quality. They loom like colossal statues at the entrance to a temple, so that they assume a nearly human presence.

But unlike the pharaoh's, with their passive time-lessness, these "guardian figures" have the peculiar alertness of Henry Moore's abstract sculpture (see fig. 26-13). Bourke-White's rare ability to suggest multiple levels of meaning made this cover and her accompanying photo essay a landmark in photojournalism.

VanDerZee The nature of the HARLEM RENAISSANCE, which flourished in the 1920s, was hotly debated by black critics even in its own day. While its achievement in literature is beyond dispute, the photography of James VanDerZee (1886–1983) is often regarded as the chief contribution of the Harlem Renaissance to the visual arts. Much of his work is commercial and variable in quality, yet it remains of great documentary value. The best examples provide a compelling portrait of the era. VanDerZee had a keen understanding of settings as reflections of people's sense of place in the world, and he used them to bring out each sitter's character and dreams. *At Home* (fig. 28-8) shows VanDerZee's unique ability to capture the pride of African-Americans during a period when their dreams

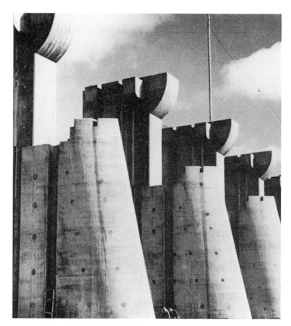

28-7 Margaret Bourke-White. *Fort Peck Dam, Montana*. 1936. Time-Life, Inc.

28-8 James VanDerZee. *At Home*. 1934. James VanDerZee Estate

seemed on the verge of being realized. Posed in imitation of fashionable photographs of white society, it is a portrait of the wife of the Reverend George Wilson Becton, taken two years after the popular pastor of the Salem Methodist Church in Harlem was murdered.

GERMANY

During the late 1920s and early 1930s, photography achieved a degree of excellence that has not been surpassed. Fostered by the invention of superior German cameras and the boom in publishing everywhere, this German version of straight photography emphasized materiality at a time when many other photographers were turning away from the real world. The intrinsic beauty of things was brought out through the clarity of form and structure. This approach accorded with Bauhaus principles of design.

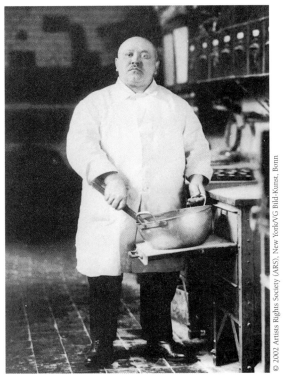

28-9 August Sander. *Pastry Cook, Cologne.* 1928. August Sander Archiv/SK-Stiftung Kultur, Cologne, Germany

Sander August Sander (1876–1964), whose *Face of Our Time* was published in 1929, concealed his intentions behind a disarmingly straightforward facade. The 60 portraits provide a devastating survey of Germany during the rise of the Nazis, who later suppressed the book. Clearly proud of his position, the man in Sander's *Pastry Cook, Cologne* (fig. 28-9) is the very opposite of the timid figure in Grosz's *Germany, a Winter's Tale* (see fig. 25-30). Despite their curious resemblance, this "good citizen" seems oblivious to the evil that Grosz has depicted so vividly. While the photograph passes no individual judgment, in the context of the book the chef's lack of concern stands as a strong indictment of the era as a whole.

THE HEROIC AGE OF PHOTOGRAPHY

The period from 1930 to 1945 can be called the heroic age of photography. During those years photographers demonstrated moral courage as well as physical bravery in responding to the challenges of their times. Physical bravery was illustrated by World War II photographers such as Robert Capa (1913–1954), who was as fearless as Civil War photographer Mathew Brady (see page 510). In the United States, staff photographers of the Farm Security Administration under Roy Stryker compiled a comprehensive photodocumentary archive of rural America during the Depression. While the FSA photographers presented a balanced and objective view, most of them were also reformers whose work responded to the social problems they confronted daily in the field.

Lange A concern for people and a sensitivity to their dignity made Dorothea Lange (1895–1965) the finest documentary photographer of the time in America. At a pea-pickers' camp in Nipomo, California, Lange discovered 2,500 nearly starving migrant workers and took several pictures of a young widow with her children. (She was identified much later as Florence Thompson, who resented all the attention the photographs received.) When *Migrant Mother, California* (fig. 28-10) was published in a news story about their plight, the

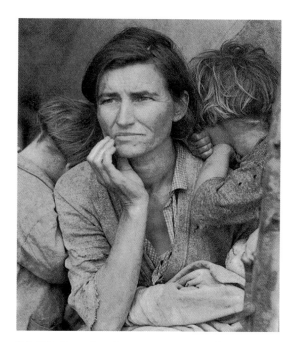

28-10 Dorothea Lange. *Migrant Mother, California.* 1936. Gelatin-silver print. Library of Congress, Washington, D.C.

government rushed in food, and eventually migrant relief camps were opened. More than any Social Realist or Regionalist painting (see page 590), *Migrant Mother, California* has come to stand for that entire era. Unposed and uncropped, this photograph has an unforgettable immediacy no other medium can match.

FANTASY AND ABSTRACTION

"Impersonality," the very disadvantage that had prevented the acceptance of photography in the eyes of many critics, became a virtue in the 1920s. Precisely because photographs are produced by mechanical devices, the camera's images now seemed to some artists the perfect means for expressing the modern era. This change in attitude did not stem from the Futurists. Contrary to what might be expected, they never fully grasped the camera's importance for modern art, despite the influence of motion photography on their paintings (see page 560). The new view of photography arose as part of the Berlin Dadaists' assault on traditional art. Toward the end of World War I, the Dadaists "invented" the **photomontage** and the **photogram**. (Actually, these processes had been practiced early in the history of photography.) In the service of antiart these two modes lent themselves equally well to fantasy and to abstraction, despite the differences between them.

Photomontages Photomontages are simply pieces of photographs cut out and recombined into new images. Composite negatives originated with the art photography of Rejlander (see page 557), but by the 1870s they were already being used in France to create witty impossibilities that are the ancestors of Dada photomontages. Like *1 Piping Man* (see fig. 25-25) by Max Ernst (who, not surprisingly, became a master of the genre), Dadaist photomontages utilize the collage techniques of Synthetic Cubism to ridicule social and aesthetic conventions.

These imaginative parodies destroy all pictorial illusionism. They therefore stand in direct opposition to straight photographs, which use the camera to record and probe the meaning of reality. Dada photomontages might be called "ready-images," after Duchamp's readymades. Like other collages, they are literally torn from popular culture and given new meaning. Although the photogram relies more on the laws of chance, the Surrealists later claimed that the photomontage was a form of automatic handwriting on the grounds that it responds to a stream of consciousness.

Posters Photomontages were soon incorporated into posters. In Germany, posters became a double-edged sword in political propaganda, used by Hitler's sympathizers and enemies alike. The most bitter anti-Nazi commentaries were created by John Heartfield (1891–1968), who changed his name from the German Herzfeld as a sign of protest. His horrific poster of a Nazi victim crucified on a swastika (fig. 28-11, page 654) appropriates a Gothic image of humanity punished for its sins on the wheel of divine judgment. Obviously Heartfield was not concerned about reinterpreting the original meaning in his montage, which communicates its new message to powerful effect.

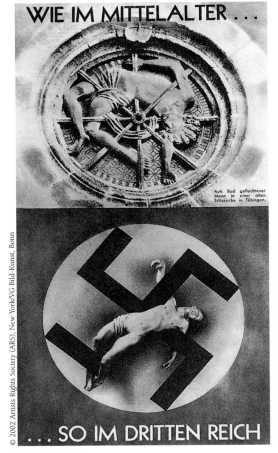

28-11 John Heartfield. *As in the Middle Ages, So in the Third Reich.* 1934. Poster, photomontage. Akademie der Künste, John Heartfield Archiv, Berlin

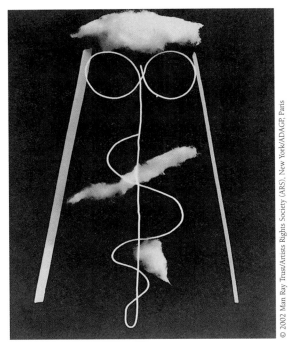

28-12 Man Ray. *Untitled (Rayograph).* 1928. Gelatin-silver print, 15 1/2 x 11 5/8" (39.4 x 29.5 cm). The Museum of Modern Art, New York

Gift of James Thrall Soby

Photograms The photogram does not take pictures but makes them. Objects are placed directly onto photographic paper and exposed to light. This technique was not new. Fox Talbot (see page 507) had used it to make negative images of plants, which he called photogenic drawings. The Dadaists' photograms, however, like their photomontages, were intended to alter nature's forms, not to record them, and to substitute impersonal technology for the handwork of the individual. Since the results in the photogram are so unpredictable, making one involves even greater risks than does a photomontage.

Man Ray Man Ray (1890–1976), an American working in Paris, was not the first to make photograms, but his name is most closely linked to them through his Rayographs. Fittingly enough, he discovered the process by accident. The amusing face in figure 28-12 was made according to the laws of chance by dropping a string, two strips of paper, and a few pieces of cotton onto the photographic paper, then coaxing them here and there before making the exposure. The resulting image is a witty creation that shows the playful, spontaneous side of Dada and Surrealism as against Heartfield's grim satire.

Photography since 1945

THE UNITED STATES

White Photography after World War II was marked by abstraction for nearly two decades, particularly in the United States. Minor White (1908–1976) closely approached the spirit of Abstract Expressionism. An associate of Adams and Weston, he was decisively influenced by Stieglitz's concept of the Equivalent. During his most productive period, from the mid-1950s to the mid-1960s, White used the alchemy of the darkroom to transform reality into a mystical metaphor. His *Ritual Branch* (fig. 28-13) evokes a primordial image. What it shows is not as important as what it stands for, but the meaning we sense there remains elusive.

Frank The birth of a new form of straight photography in the United States was due to Robert Frank (born 1924). His book *The Americans*, compiled from a cross-country journey made in 1955–56, created a sensation upon its publication in 1959. It expressed the same restlessness and alienation as *On the Road* by his traveling companion, the BEAT author Jack Kerouac, published in 1957. As this friendship suggests, words have an important role in Frank's photographs,

28-13 Minor White. *Ritual Branch.* 1958. Gelatin-silver print, 10 3/8 x 10 5/8" (26.4 x 27 cm). The International Museum of Photography at George Eastman House, Rochester, New York

Rejecting traditional standards in their behavior and art, the members of the 1950s BEAT generation turned for inspiration to their own personal experiences, often fueled by experimentation with drugs and elements of Eastern mysticism. Beat writers such as Kerouac, the novelist William Burroughs (*Naked Lunch*), and the poet Allen Ginsberg (*Howl*) cultivated a style that combined the cadences of everyday speech with the syncopated rhythms of bebop and jazz. The "hippies" of the 1960s derived much of their lifestyle and social outlook from the Beats.

28-14 Robert Frank. *Santa Fe, New Mexico.* 1955–56. Gelatin-silver print. Collection PaceWildenstein Gallery, New York

which are as loaded in meaning as Demuth's *I Saw the Figure 5 in Gold* (see fig. 25-23). Yet Frank's social point of view is often hidden behind a facade of seeming neutrality. It is a shock when we recognize the ironic intent of *Santa Fe, New Mexico* (fig. 28-14). The gas pumps face the sign SAVE in the barren landscape like members of a religious cult vainly seeking salvation at a revival meeting. Frank, who later turned to film, holds up an image of American culture that is as sterile as it is joyless. Even spiritual values, he tells us, become meaningless in the face of vulgar materialism.

ENGLAND

Brandt Fantasy gradually reasserted itself on both sides of the Atlantic in the mid-1950s. Photographers first manipulated the camera for the sake of extreme visual effects by using special lenses and filters to alter appearances, sometimes virtually beyond recognition. Since about 1970, however, they have turned mainly to printing techniques, with results that are frequently even more startling.

Manipulation of photography was pioneered by Bill Brandt (1904–1983). Though regarded as the quintessential English photographer, he was born in Germany and did not settle in London until 1931. He decided on a career in photography during

28-15 Bill Brandt. *London Child.* 1955

Copyright Mrs. Noya Brandt. Courtesy Edwynn Houk Gallery, Chicago

psychoanalysis and was apprenticed briefly to Man Ray. Brandt remained a Surrealist who altered visual reality in search of a deeper one, charged with mystery. His work was marked consistently by a literary, even theatrical, cast of mind that drew on the cinema for some of its effects. His early photo-documentaries were often staged as re-creations of personal experience to make social commentaries based on Victorian models. Brandt's fantasy images show a strikingly romantic imagination. Yet there is an oppressive anxiety implicit in his landscapes, portraits, and nudes. *London Child* (fig. 28-15) has the haunting mood of novels by the Brontë sisters, Charlotte, Emily, and Anne. At the same time, this is a classic dream image filled with troubling psychological overtones. The spatial dislocation, worthy of De Chirico, suggests a person who is alienated from both herself and the world.

ARTISTS AS PHOTOGRAPHERS

Hockney The most recent demonstrations of photography's power to extend our vision have come, fittingly enough, from artists. The photographic collages that the English painter David Hockney (born 1937) began making in 1982 are like revelations. They overcome the traditional limitations of a unified image, fixed in time and place, by closely approximating how we actually see. In *Gregory Watching the Snow Fall, Kyoto, Feb. 21, 1983* (fig. 28-16), each frame is similar to a movement of the eye: it contains a piece of visual data that must be stored in our memory and synthesized by the brain. Just as we process only essential information, so there are gaps in the matrix of the image, which becomes more fragmentary toward its edges, though without the loss of sharpness experienced in vision itself.

The collage, with its unusual shape, is a masterpiece of design. The scene appears to bow oddly as it comes toward us. This ebb and flow is more than simply the result of optical physics. In the perceptual process, space and its corollary, time, are not linear but fluid. Hockney includes his own feet as reference points to establish our position clearly. As a result, he helps us to realize that vision is less a matter of looking outward than an egocentric act that defines the viewer's

28-16 David Hockney. *Gregory Watching the Snow Fall, Kyoto, Feb. 21, 1983*. 1983. Photographic collage, 43$\frac{1}{2}$ x 46$\frac{1}{2}$" (110.5 x 118.1 cm). Collection the artist

© 1983 David Hockney

visual and psychological relationship to the surrounding world. Hockney has recorded his friend several times to suggest his reactions to the serene landscape outside the door.

Hockney's picture shows a clear awareness of earlier twentieth-century art. It combines the faceted views of Picasso (see fig. 25-9) and the dynamic energy of Popova (see fig. 25-12). *Gregory Watching the Snow Fall* is nonetheless a distinctly contemporary work, for it also incorporates the fascinating effects of Photorealism and the illusionistic potential of Op Art. Hockney later explored the implications of these photo collages, such as continuous narrative. Some of his photographs have even shown an object or scene simultaneously from multiple vantage points to let us see it completely for the first time.

Leonard Contemporary photographers have often turned to fantasy as autobiographical expression. Both the image and the title of *Romanticism Is Ultimately Fatal* (fig. 28-17) by Joanne Leonard (born

1940) suggest a meaning that is personal in its reference; it was made during the breakup of her marriage. We will recognize in this disturbing vision something of the tortured eroticism of Fuseli's *Nightmare* (see fig. 22-14). The clarity of the presentation turns the apparition at the window into a real

28-17 Joanne Leonard. *Romanticism Is Ultimately Fatal,* from Dreams and Nightmares series. 1982. Positive transparency selectively opaqued with collage, 9$\frac{3}{4}$ x 9$\frac{1}{4}$" (24.8 x 23.5 cm). Collection M. Neri, Benicia, California

and terrifying personification of despair: rather than a romantic knight in shining armor, this is a grim reaper.

Wojnarowicz Even more shocking is *Death in the Cornfield* (fig. 28-18) by David Wojnarowicz (1954–1992). Gifted with a singularly bizarre imagination, he was obsessed with the horrific, which is found throughout his work, both artistic and literary. At the time of this photograph, Wojnarowicz was already suffering from AIDS, which claimed his life two years later. Of the countless images devoted to this dread disease by painters and photographers, none so fully captures its nightmarish terror. The macabre costume, made by Wojnarowicz himself, makes the figure an awesome demon of death from some primitive tribal ritual that appears out of nature as if by magic. Like Munch's *Scream* (fig. 24-13), here is an expression of irrational fear so gripping in its power as to lift personal suffering to a universal plane. It serves as an unforgettable reminder of how many people, not just in the art world, have been touched by the loss of cherished friends and colleagues to AIDS.

28-18 David Wojnarowicz. *Death in the Cornfield.* 1990. Silver print, 26 x 38" (66 x 96.5 cm)
Courtesy of P.P.O.W. Gallery, New York

CHAPTER 29

POSTMODERNISM

We began Part Four with a discussion of modernism. It is appropriate that we end, for now, with its opposite: postmodernism. We live in the "postmodern" era. But, if modern is what is today, how can we live in postmodern times? The term itself suggests the peculiar nature of postmodernism, which seeks out incongruity. To resolve this contradiction, we must understand *modern* in a dual sense: modernity and modernism. Postmodernism is a trend that not only supersedes modernism but is also opposed to the world order as it exists today and to the values that created it.

What, then, is postmodernism and when did it begin? Generally speaking, postmodernism is characterized by a pervasive skepticism that rejects modernism as an ideal which defines twentieth-century culture. In challenging tradition, however, it deliberately refuses to provide a new meaning or impose a different order in its place. Postmodernism represents a generation consciously *not* in search of its identity. Hence it is not a unified movement at all, but a loose collection of tendencies that reflect a new sensibility. Taken together, these pieces provide a jigsaw puzzle of our times. Each country has a somewhat different outlook and vocabulary; nevertheless, all have developed some form of postmodernism. We must therefore paint a broad picture, one that will provide us with a general idea of postmodernism's unique character. Our treatment of postmodern art is likewise intended to be suggestive in discussing representative examples, while admittedly omitting much that is of interest.

As the prefix *post* suggests, our world is in a state of transition. Although the term *postmodern* was coined by a historian in the late 1940s to denote a late stage of the civilization initiated by the Renaissance, it has been used mainly by literary critics since the mid-1960s,

a significant fact in itself. We may indeed trace the first postmodern symptoms back to that time; in hindsight they appear to have been mostly a late phase of modernism, without making a decisive break from the mainstream of the twentieth century.

What is the difference between modernism and postmodernism? Postmodernism springs from post-industrial society, which is moving rapidly into the Information Age. According to postmodern theorists, the political, economic, and social structures that have governed the Western world since the end of World War II are either changing, undergoing attack from within, or breaking down altogether. This institutional erosion has resulted in a corresponding spiritual crisis that reflects the chaos of people's lives.

A related phenomenon of the Information Age is its obsession with meaning—and also with the lack of it. A symptom of this obsession has been the active presence of two theories: **semiotics** and **deconstruction**. Nearly all branches of culture have come under the spell of semiotics—the study of signs—also known as semiology. Semiotics is a fundamental part of any area of human activity that involves symbols, among them philosophy, linguistics, science, sociology, anthropology, communications, psychology, literature, cinema, and art. Semiotics in turn has been undermined from within by deconstruction, which is undoubtedly postmodernism's most powerful attack on the old order. As the term suggests, deconstruction is destructive, not constructive. In literature, for example, it tears a text apart by using that text against itself, until it "deconstructs" itself. For our purposes it is not the theories that count, no matter how interesting or seductive, but their effect on postmodern art.

Postmodernism is a product of the disillusion and alienation afflicting the middle class. At the same time, bourgeois culture has exhausted its possibilities by absorbing its old enemy, the avant-garde, whose mission was ended by its very success. During the 1950s the media made the avant-garde so popular that the middle class accepted it and began to hunger for ceaseless change for its own sake. By the following decade, modernism was reduced to a "capitalist" mode of expression by large corporations, which adopted it not just in architecture but in the painting and sculpture that decorate it.

Celebrating the death of modernism, postmodernism regards it as not only arrogant in its claim to universality but also responsible for the evils of contemporary civilization. Democracy, based on Enlightenment values, is looked on as a force of oppression to spread the West's dominance around the world. In common with most earlier avant-garde movements (including EXISTENTIALISM), postmodernism is antagonistic to humanism, which it dismisses as bourgeois. Reason, with its hierarchies of thought, is abandoned in order to liberate people from the established order. This rejection opens the way for nontraditional approaches, especially those from the Third World, that emphasize emotion, intuition, fantasy, contemplation, mysticism, and even magic. In this view, Western science is no better than any other system, since it has failed to solve today's problems. And because scientific reality does not conform to human experience, it seems irrelevant in daily life.

Postmodernism has all the classic earmarks of a self-appointed avant-garde, despite the fact that it vigorously disavows any such connection. The relativism and anarchism of postmodernism are patently subversive in their intent. This nihilism reflects the prevailing skepticism of the late twentieth century, when very little was deemed to have any significance or worth.

Postmodernism makes no attempt to provide new answers to replace the old certitudes it destroys. It instead substitutes pluralism in the name of multicultural diversity, since no one aesthetic is better than any other. Pluralism leads inevitably to eclecticism, with which it is virtually interchangeable. Not only are the two functions of each other, they become ends in themselves.

By the same token, postmodernism does not try to make the world a better place. In its resolute antimodernism, it is socially and politically ambivalent at best, self-contradictory at worst. Its operating principle is anarchism, but to the extent that it does offer an alternative, postmodernism espouses any new doctrine as superior to the one it seeks to displace. In the end, postmodernism remains

essentially a form of cultural activism motivated by intellectual theory, not political causes, to which it is ill suited.

Postmodern Art

Although art since 1980 has been called postmodern, not all of it fits under this umbrella. We shall find that the participation of the visual arts in the postmodern adventure has varied greatly and taken some surprising turns. The traditional mediums of painting and sculpture have played a secondary role. They are closely identified with the modernist tradition and are therefore spurned as tools of the ruling class. Meanwhile, nontraditional forms, such as installation and photography, have come to the forefront and become highly politicized in the process.

We are, in a sense, the new Victorians. More than a century ago, Impressionism underwent a similar crisis, from which Post-Impressionism emerged as the direction for the next 20 years. Behind its complex rhetoric, postmodernism can be seen as a strategy for sorting through the past while making a decisive break with it that will allow new possibilities to emerge. Having received a rich heritage, artists are faced with a wide variety of alternatives. The principal feature of the new art is eclecticism. Another indication of the state of flux is the re-emergence of many traditional European and regional American art centers.

Much of the basis for postmodern art can be traced back to Conceptualism, which led the initial attack on modernism (see page 627). Indeed, it has been argued that the beginnings of postmodernism can be dated to the rise of Conceptualism in the mid-1960s. The two, however, are products of two distinctly different generations. Furthermore, Conceptualism was itself derived from Dada, which has provided an "antimodern" alternative since early in the twentieth century. In the context of the 1960s, it was simply part of that ongoing dialogue, in which Pop Art also participated. That date, moreover, seems too early for the onset of what is fundamentally a late-twentieth-century phenomenon.

Installations and performance art have been around since the 1960s as well. What has changed is the content of these art forms as part of a larger shift in viewpoint. Focused as it was on matters of art, early Conceptualism seems almost innocent in hindsight. Postmodernists, in contrast, attack modern art as part of a larger offensive against contemporary society. They are far more issue-oriented than their predecessors, and their work cuts across a much wider range of concerns than ever before.

The principal manifestation of postmodernism is APPROPRIATION, which looks back self-consciously to earlier art. It does so both by imitating previous styles and by taking over specific motifs or even entire images. Artists, of course, have always borrowed from tradition, but rarely so systematically as now. Such plundering is nearly always a sign of deepening cultural crisis, suggesting bankruptcy. (The same thing is going on in popular culture, with its constant "retro" revivals.) Since it is not tied to any system, postmodernism is free to adopt earlier imagery and to alter its meaning radically by placing it in a new context. The traditional importance assigned to the artist and object is furthermore de-emphasized in this approach, which stresses content and process over aesthetics. The other chief characteristic of postmodernism is the merging of art forms. Thus there is no longer a clear difference between painting, sculpture, and photography, and we maintain the distinction mostly as a matter of convenience.

Postmodernism is undeniably a fascinating phenomenon. Yet it has a fatal flaw: it has produced art that is less memorable than it is "symptomatic" of our age. But for that very reason it is worthy of our interest. Although it has an anti-intellectual side, postmodernism is preoccupied with theory. As a result, art (and, along with it, art history) has become theory-bound. Despite a growing body of writing and criticism, however, it lags far behind literature and poetry in developing a postmodern approach. Compared with language, the visual arts are traditionally poor vehicles for theory. Perhaps they have become so word-oriented of late because they are attempting to keep up with other disciplines.

In contrast to copying or imitation, APPROPRIATION is the deliberate inclusion of "borrowed" images by other artists in a new work of art, some of it electronic. Appropriation raises all kinds of questions about intellectual property rights and originality and has been an area of heated debate since the mid-1980s.

Architecture

POSTMODERNISM

Postmodernism in art was first coined to denote an eclectic mode of architecture that arose around 1980. Because it is a style, we shall capitalize it to distinguish it from the larger phenomenon of postmodernism, to which it is closely related. As the term implies, Postmodernism represents a broad rejection of mainstream twentieth-century architecture. Although it uses the same construction techniques, Postmodernism rejects not only the vocabulary of Gropius and his followers, but also the social and ethical ideals implicit in their lucid proportions. Looking at the Seagram Building (see fig. 27-15), we can well understand why. As a statement, it is so overwhelming in its authority that it prohibits deviation, and so cold that it lacks appeal. The Postmodernist critique was, then, essentially correct. In its search for universal ideals, the International Style failed to communicate with people, who neither understood nor liked it. Postmodernism is an attempt to reinvest architecture with the human meaning so clearly absent from High Modernism. It does so by appropriating premodernist architecture.

The chief means of introducing greater expressiveness has been to adopt elements from historical styles rich with association. All traditions are assumed to have equal validity, so that they can be combined at will. In the process, the compilation itself becomes a conscious parody characterized by ironic wit. This eclectic historicism is nevertheless highly selective in its sources. They are restricted mainly to various forms of classicism (notably Palladianism; see pages 343–44) and some of the more exotic strains of Art Deco, which provided a genuine alternative to modernism during the 1920s and 1930s. Architects have repeatedly searched the past for fresh ideas. What counts is the originality of the final result.

Graves The Public Services Building in Portland, Oregon (fig. 29-1), by Michael Graves (born 1934) is a characteristic example of Postmodernism. Elevated on a pedestal, it mixes classical, Egyptian, and assorted other motifs in a whimsical building-block paraphrase of Art Deco, which shared an equal disregard for historical propriety. In this way, Graves relieves the building of the monotony imposed by the tyranny of the cube that afflicts so much modern architecture. Although the lavish sculptural decoration intended for it was never added, the exterior has a surprising warmth that continues inside. At first glance, it is tempting to dismiss the Public Services Building as mere historicism. To do so, however, ignores the fact that no earlier structure looks at all like it. What holds this historical mix together is the architect's style. It is based on a mastery of abstraction that is as systematic and personal as Mondrian's. Indeed, Graves first earned recognition in 1969 as a skilled Late Modernist.

Today Postmodern buildings are found everywhere. They are instantly recognizable by their keyhole arches, round "Palladian" windows, and other relics from the architectural past. They are also marked by their luxuriance. Postmodernism may be characterized as architecture for the rich that has since been translated downward to the

29-1 Michael Graves. Public Services Building, Portland, Oregon. 1980–82

middle class. Its aura of wealth suggests the ego-centricity and hedonism that spawned the "me" generation of the 1980s, one of the most prosperous and extravagant decades in recent history. Nevertheless, the retrospective eclecticism of Postmodernism soon became dated through the repetitious quotation of standard devices that were reduced to self-parodies lacking both wit and purpose. In a larger sense, however, this quick passage reflects the restless quest for novelty and, more important, a new modernism that has yet to emerge to replace the old.

Stirling The Postmodernists criticize Late Modernism for its commitment to the "tradition of the new" and its consequent lack of integrity in invention and usage. Moreover, they maintain, Late Modernism lacks both pluralism and a complex relation to the past, so that it fails to transform meaning. We may test this proposition for ourselves by comparing the Pompidou Center (see fig. 27-16) with the Neue Staatsgalerie in Stuttgart (fig. 29-2), which was immediately recognized as a classic example of Postmodernism. The latter has the grandiose scale befitting a "palace" of the arts, but instead of the monolithic cube of the Pompidou Center, English architect James Stirling (1926–1992) incorporates a greater variety of shapes within more complex spatial relationships. There is also an openly decorative quality that will remind us, however indirectly, of Garnier's Paris Opéra (see fig. 22-28). The similarity does not stop there. Stirling has likewise resorted to a form of historicism through paraphrase that is far more subtle than Garnier's opulent revivalism, but no less self-conscious. The prim Neoclassical masonry facade, for example, is punctured by a narrow arched window recalling Italian Renaissance forms (compare fig. 12-11) and by a rusticated portal that has a distinctly Mannerist look. At the same time, there is an exaggerated quoting of modernism through the use of such "high-tech" materials as painted metal (compare fig. 27-7).

This eclecticism is more than a veneer—it lies at the heart of the building's success. The site, centering on a circular sculpture court, is designed along the lines of ancient temple complexes from Egypt through Rome, complete with a monumental

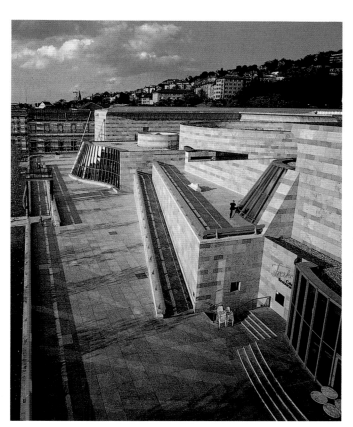

29-2 James Stirling, Michael Wilford and Associates. Neue Staatsgalerie, Stuttgart, Germany. Completed 1984

entrance stairway. This plan enables Stirling to solve a wide range of practical problems with ingenuity and to provide a stream of changing views that fascinate and delight the visitor. The results have been compared to the Altes Museum of Karl Friedrich Schinkel (see fig. 22-25), among the most classical structures of the nineteenth century. By comparison, the Pompidou Center is a far more radical building!

DECONSTRUCTIVISM

Although it claims to deal with meaning, in the end Postmodernist historicism addresses mainly the decorative veneer of the International Style. Spurred by more revolutionary theories, Deconstructivism, another tendency that began to gather momentum about 1980, goes much farther in challenging its substance. The term *Deconstructivism* combines *Constructivism* and *deconstruction*. Strictly speaking, there can be no architecture of deconstruction, because building puts things together

instead of taking them apart. Deconstructivism nevertheless follows similar principles and is symptomatic of postmodernism as a whole. It dismembers modern architecture, then reassembles it again in new ways.

Like Postmodernism, it does so through appropriation. Deconstructivism returns to one of the earliest sources of modernism: the Russian avant-garde. The Russian experiment in architecture proved short-lived, and few of its ideas ever made it beyond the laboratory stage. However, recent architects have been inspired anew by the bold sculpture of the Constructivists and the graphic designs of the Suprematists. They seek to violate the integrity of modern architecture by subverting its internal logic, which the Russians themselves did little to undermine. Nevertheless, Deconstructivism does not abandon modern architecture and its principles altogether, and remains an architecture of the possible based on structural engineering. Although it claims Michelangelo, Bernini, and Guarini as its ancestors, Deconstructivism goes far beyond anything that can be found in earlier architecture. We will find little common ground among its practitioners. The main devices they have in common are superimpositions of clashing systems or layers of space, and distortions from within that subvert the normal vocabulary and purposes of modern architecture.

Tschumi One of the first architects to be influenced by deconstruction was Bernard Tschumi (born 1944). The most complete embodiment of his Deconstructivism is the Parc de la Villette in Paris (figs. 29-3, 29-4), for which the founder of deconstruction, Jacques Derrida, later wrote an essay in the brochure explaining the project. The park's program had to include a variety of functions (workshop, baths, gymnasium, playground, concert facilities) and other parks and buildings already on the site. Tschumi's design is directly based on this fact. It presents an intelligent solution to what could have been a hopelessly complex problem that would have overwhelmed any traditional approach.

To describe the Parc de la Villette, we must resort to the coded terminology of Deconstructivism

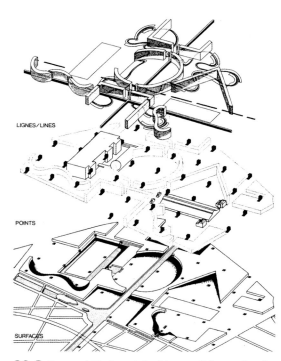

29-3 Bernard Tschumi Architects. Scheme for the Pavilions, Parc de la Villette, Paris. 1982

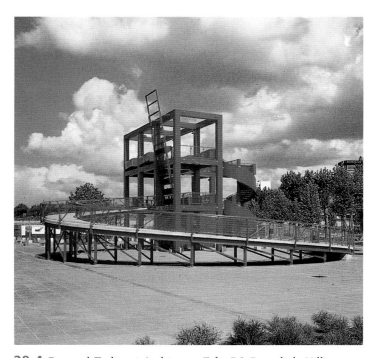

29-4 Bernard Tschumi Architects. *Folie P6,* Parc de la Villette, Paris. 1983

itself. The architect began by laying out the grounds in a simple abstract grid to provide a strong yet flexible conceptual framework for change, improvisation, and substitution. He then subverted it by superimposing two other grid systems on it, so as to prevent any dominant hierarchy or clear relation between the program and the solution (fig. 29-3). This multiple grid is deliberately antifunctional, anticontextual, and infinite. (In principle, it could be extended in any direction indefinitely.)

Tschumi creates highly unorthodox relationships through decentralization, fragmentation, combination, and superimposition of elements, so that the architecture appears to serve no purpose. He further supplants form, function, and structure with contiguity, substitution, and permutation. To undermine the traditional rules of composition, hierarchy, and order, he uses crossprogramming (using space for a different purpose than intended), transprogramming (combining two incompatible programs and spaces), and disprogramming (combining two programs to create a new one from their contradictions). The functions are dispersed through a series of buildings (*folies*) whose components, appearance, and uses are interchangeable. The play between free and rigid form leads to ambiguity, disorder, impurity, imperfection. The result denies any inherent meaning to the forms, structure, or organization.

What does all this theory have to do with the actual experience? Surprisingly little. The ensemble is meant to induce a sense of disassociation, both within and between its elements. This disjointedness conveys an unstable programmatic madness (*folie*) through a form of cinematic montage inspired by the films of the Russian Sergei Eisenstein and others. However, the visitor is hardly aware of this effect. On the contrary, the system creates an order and rhythm of its own, whether Tschumi intended it or not. We are left only with a feeling of enchantment, which suggests the more playful meaning of *folie,* not just madness. The *folies* themselves resemble large-scale sculptures extended almost to the breaking point (fig. 29-4). Yet the tension between the reality of the built structures and their "impossibility" results in an architecture of rare vitality. It is especially fitting that two of the most captivating *folies* are for use by children.

Although the architect insists that he was not expressing himself, this effect is perhaps the ultimate test of the park's success. Tschumi himself acknowledges the fact indirectly by speaking of affirmative deconstruction—a self-contradiction if ever there was one!

Postmodernism vs. Deconstructivism Try as their disciples might to deny it, Postmodernism and Deconstructivism are really two sides of the same postmodernist coin, which has pushed modern architecture to its limits. As a style, Postmodernism challenges it from the outside, while Deconstructivism as an approach corrupts it from within. It is a measure of how firmly postmodern thinking had taken hold of contemporary architecture that in 1988 Philip Johnson—who helped to design the interior of the Seagram Building (see fig. 27-15) and was himself the architect of one of the most controversial Postmodern buildings (the AT&T Building in New York)—declared modern architecture dead and mounted an exhibition of Tschumi and other Deconstructivists. This sort of reevaluation has gone on before. Postmodernism is a transition much like Art Nouveau at the turn of the century, which provided part of the foundation for modern architecture. It is a necessary part of the process that will redefine architecture as we have come to know it.

ARCHITECTURE AFTER POSTMODERNISM: WHAT'S NEXT

If postmodernism is inherently a paradox, what are we to call the phase that follows it? We are tempted to name it the New Modernism, except that the term *Neo-Modernism* already means the same thing, even if it implies something altogether different. Because this new initiative is still unfolding, perhaps it is best not to confuse matters further by trying to pin a tag on it prematurely. The lack of a label does not mean, however, that a new direction cannot be discovered. On the contrary, there is a clear tendency toward convergence between Neo-Expressionism and Deconstructivism, despite the extraordinary variety that has characterized architecture around the world

over the past decade or so. We may call it Sculptural Architecture. Such a merging is less strange than it may seem at first glance. After all, Neo-Expressionism is the most self-consciously sculptural of any form of architecture, while Deconstructivism takes as its point of departure Russian Constructivism, which was primarily a sculptural movement, albeit one with a strong architectural bent. Moreover, we may see this union as bridging the gap between Abstraction and Expressionism, which developed in modernist architecture during the early 1920s.

Reconciliation does not imply compromise, however. It does suggest what the late-nineteenth-century art historian Alois Riegl called "the will to form." It is as if contemporary architecture is seized by an urge to create sculpture on a scale that surpasses even the grandiose dreams of environmental sculptors. In addition, the architects who are pursuing this direction are a different breed from their predecessors. Not that they are youngsters. Most were born between 1943 and 1953; they are, in other words, baby boomers. But although they are very conscious of everything that has come before them, they think—and even talk—differently.

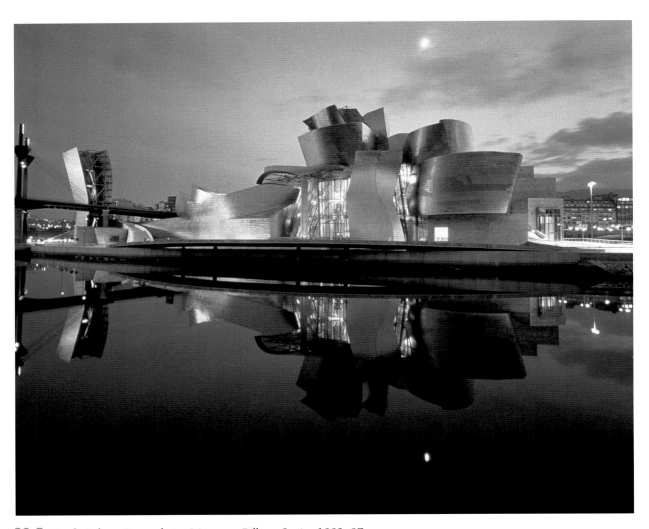

29-5 Frank Gehry. Guggenheim Museum, Bilbao, Spain. 1992–97

Gehry The oldest and most radical of these sculptural Postmodernists is Frank Gehry (born 1929), a Los Angeles architect who has always been a maverick in his sense of design and choice of materials. His earlier work was emphatically Deconstructivist, but the more recent buildings can only be described as assemblages of miscellaneous parts. What is undoubtedly his finest achievement is the Guggenheim Museum in Bilbao, Spain, which opened in 1997 (fig. 29-5). Situated strategically on a bend of the river that runs through the city, it is part cultural institution and part urban renewal project. It replaces an abandoned lumber mill. In accord with the director's wishes, the galleries vary greatly in shape in order to provide different viewing experiences appropriate to the various kinds of art they hold. Once the main functional requirements had been determined, the building was conceived in a series of drawings. Often resembling abstract doodles, they were then translated into usable form by employing the latest computer-aided design programs. Throughout the long development process, Gehry experimented with a number of shapes, many of which were incorporated into the final design.

The result is certainly as innovative and controversial as Frank Lloyd Wright's original Guggenheim Museum in New York (see figs. 13 and 14). The Bilbao Guggenheim is a structure of such dazzling complexity that no single photograph can begin to suggest its ever-changing views. As one critic observed, from head-on it looks like a collision between two ships. Seen from above, the museum appears to unfold like a flower, but it also includes fish, snake, boot, and sail forms. Indeed, the main body is clad in a skin of specially fabricated, ultra-thin titanium tiles suggesting the scales of a serpent or denizen of the deep. It has such organic vitality that it almost seems to take on a life of its own, especially when viewed from the side, as in our illustration. The building ends in a tower that is actually a piece of architectural sculpture rather than a functional piece of architecture. All told, the Bilbao Guggenheim is probably the most exciting building of the 1990s. It became an instant classic, defining the spirit of the decade much as the Pompidou Center (see fig. 27-16) did for the 1980s.

Sculpture

In our introductions to Romantic sculpture and Modern Sculpture (see pages 498 and 607), we discussed Baudelaire's essay "Why Sculpture Is Boring" from his review of the Salon of 1846. It is time to return to the discussion by asking, "Why is contemporary sculpture so boring?" Over the past 20 years, it has simply run out of things to say using the vocabulary of abstraction that sustained it throughout most of the later twentieth century. As a result, it is now an empty shell. One sign of this vacuum is that it is the painters who have lately produced the most sculpture, so that sculpture has once more become a subservient art even without being attached to buildings. At the same time, sculpture has no place in Postmodernism, where it has been replaced by installations on the one hand (see below), while its form-giving function has been usurped by architecture on the other (see page 664).

Above all, contemporary sculpture has lost its "idol" quality, in the full meaning of the term. Baudelaire meant not simply its solid, space-filling reality but above all its role as a fetish—an object to be worshiped for its demonic power, the symbol of something mysterious and profound. His belief that sculpture, because of its three-dimensionality, prevents the artist from expressing his or her unique point of view is essentially a theoretical concern and is highly debatable in actual practice. But how is it possible to endow sculpture with the status of a fetish in this postmodern age, with its belief in nothing except the pervasive flaws of Western civilization? It can be done, but only by rediscovering the power of myth and using it to invest sculpture with new meaning.

One of the few artists who has accomplished this seemingly impossible task is Audrey Flack. She gave up painting (see fig. 25-49) some 20 years ago, after having achieved everything she wanted to in that medium, and reinvented herself as an artist by turning to sculpture. As a Photorealist, Flack turned to traditional naturalism. An avowed feminist, she has used the art, history, and mythology of the past to invent the new ideal woman of the twenty-first century. Through a personal alchemy, her figures are

powerful but beautiful mythological beings, filled with a magic force yet magnetic in their appeal. It would be easy to dismiss her work as an obsolete throwback to academic sculpture except for one thing: its undeniable power, which is gripping in a way that few sculptors today can match.

INSTALLATIONS

Traditional sculpture has been of little significance in Postmodernism, because the emphasis on form in recent architecture has usurped its position.

© 2002 Artists Rights Society (ARS), New York/VG Bild-Kunst, Bonn

29-6 Ilya Kabakov. *The Man Who Flew into Space from His Apartment*, from *Ten Characters*. 1981–88. Mixed-media installation at Ronald Feldman Fine Arts, New York, 1988

Courtesy Ronald Feldman Fine Arts

In fact, sculpture seems almost out of place when it does make an appearance. Instead, installations have become the focal point of the movement. They are the epitome of the Deconstructionist idea of the world as "text." Because their intent can never be fully known even by their authors, "readers" are free to interpret them in light of their own experience. The installation artist creates a separate world that is a self-contained universe, at once alien and familiar. Left to their own devices to wander this microcosm, viewers bring their own understanding to bear on the experience in the form of memories that are evoked by the novel environment. In effect, they help to write the "text." In themselves, installations are empty vessels. They may contain anything that the "author" and "reader" wish to put into them. Hence they serve as a ready means for expressing social, political, or personal concerns, especially those that satisfy the postmodern agenda. The installation as text can also become deliberately literal: it is often linked to a written text that makes the program explicit.

Kabakov Russian artists seem to have a special genius for installations. Cut off for decades from contemporary art in the West, they developed mostly provincial forms of painting and sculpture. Yet that very isolation allowed them to create a unique brand of Conceptual Art that in turn provided the foundation for their installations. The first to gain international acclaim was Ilya Kabakov (born 1933), who now lives in New York. *Ten Characters* was a suite of rooms like those of a seedy communal apartment, each inhabited by an imaginary person with an "unusual idea, one all-absorbing passion belonging to him alone." The most spectacular cubicle was *The Man Who Flew into Space from His Apartment* (fig. 29-6). Its occupant achieved his dream of flying into space by being hurled from a catapult suspended by springs while the ceiling and roof were blown off at the precise moment of launching. Like the other rooms, it was accompanied by a dark text worthy of Fyodor DOSTOYEVSKY, reflecting the Russian talent for storytelling. The installation was more than an elaborate realization of this bizarre fantasy. The extravagant clutter was a bitter commentary

on the peculiar dilemmas of life in the former Soviet Union—its tawdry reality, its broken dreams, the pervasive role of central authority.

Hamilton Kabakov was inspired in part by the example of Joseph Beuys (see pages 627–28), who was also an influence on the American installation artist Ann Hamilton (born 1956). Her work is about loss, be it from personal tragedy or distortion of a natural relationship. Unlike Beuys, she seeks only to raise issues, not to resolve them—a matter that is left to the visitor—yet she uses many of the same means. Her installations involve all of the senses through the use of unusual materials, often in disturbing ways, in order to present a paradox that lies at the center of each work. She exercises these choices through a train of free association until the idea crystallizes.

Hamilton's installations are labor-intensive—obsessively, even ritualistically, so. Thus *parallel lines* for the 1991 São Paulo Bienal (fig. 29-7) began with assistants coating the walls of one gallery with soot from burning candles, then attaching sequentially numbered copper tags to the floor. (This interest in seriality is also basic to Conceptual Art.) Finally, a huge bundle of candles was placed in the room, so as to dominate it. A second room, covered entirely in the same copper tags, held nothing but two glass library cases containing turkey carcasses that were slowly devoured by beetles.

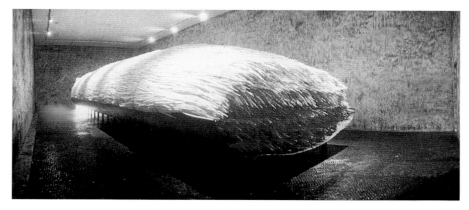

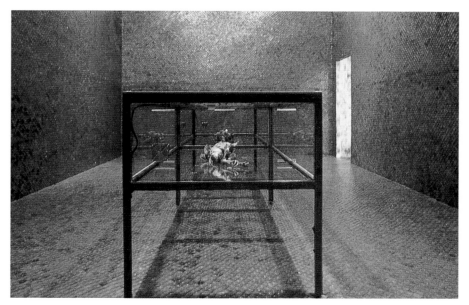

29-7 Ann Hamilton. *parallel lines.* Two parts of an installation in two rooms, São Paolo Bienal, September–December 1991. Mixed mediums

Courtesy Richard Ross

This assault on the viewer's senses and values was intended to pose a number of questions. What is collected, why, and by whom? What is the moral difference between showing candles made by people from the fat of dead animals and exhibiting a dead bird with beetles carrying out their natural role as scavengers? Although death was treated matter-of-factly, there was a strangely mournful air to the entire installation, which invited viewers to think about these matters and to arrive at their own conclusions.

Osorio An artist who believes in taking his installations directly to the community is Pepón Osorio (born 1955). A native of Puerto Rico who resides in New York City, he has used taxicabs literally as vehicles for mobile installations of urban Latino culture. *Badge of Honor* (fig. 29-8) was the result of a rare collaboration: it was placed first in downtown Newark, then at the Newark Museum, which originally commissioned it, in order to blur the traditional distinction between life and art. The installation consisted of two adjoining chambers, one a stark jail cell, the other a typical teenage boy's room whose garishness reflects the American Dream as well as the Baroque opulence that is part of the Latin heritage. These theatrically treated spaces formed the setting for a dialogue projected on opposite walls between a man in prison and his son. Although imaginary, the conversation drew on Osorio's experience as a social worker. Rather than seeming contrived, it managed to bridge the gap between father and son by expressing their feelings with convincing honesty. In the process, the stark contrast between the two rooms disappeared as well. Both emerged as empty because of the tear in the fabric of the family, yet rich because of the strong bond between the boy and his father. The impact on viewers was overwhelming. The installation addressed a serious social problem that affects many minority families. It did so with a dignity made all the more compelling by Osorio's artistry, which was unerring in its appeal to his audience.

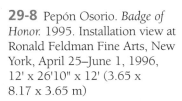

29-8 Pepón Osorio. *Badge of Honor.* 1995. Installation view at Ronald Feldman Fine Arts, New York, April 25–June 1, 1996, 12' x 26'10" x 12' (3.65 x 8.17 x 3.65 m)

Courtesy Ronald Feldman Fine Arts, New York

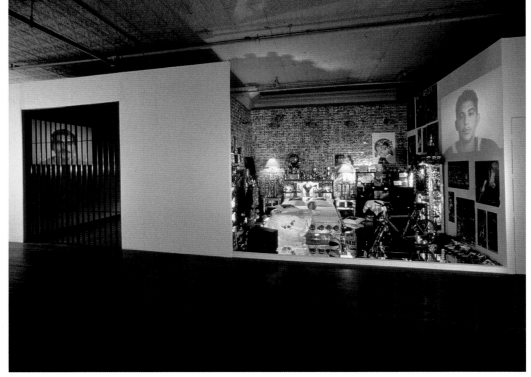

Painting

Painting, like sculpture, is a traditional medium that does not lend itself well to postmodernism. Indeed, most of what passes as Postmodern painting is really Late Modernism in disguise; in any event, there is no fixed boundary between the two. To the extent that it can be said to exist at all, however, Postmodern painting is an outgrowth of Conceptualism, Pop Art, and Neo-Expressionism. However, it differs from them in a fundamental respect. Now painting acts as a deconstructed text gutted of all significance, except for whatever we choose to add through free association from our own experience.

How did painting come to be so barren? Traditional approaches such as allegory require a shared culture. But this common bond is hardly possible in the postmodern age. Our civilization is more fractured than ever, despite the concept of the "global village." Deconstruction, moreover, proclaims the death of both the author and subject matter as unnecessary remnants of humanism, thus rendering meaning null and void. It argues instead that representation in its broadest sense is both unnecessary and undesirable on the grounds that it strives to re-create a fraudulent reality and therefore can never provide an authentic experience. Such an attitude is not confined to deconstruction, however. It is inherent in postmodernism as a whole.

Penck A group of postmodern artists from the former German Democratic Republic have helped to make Germany the leading school of painting in the West today. Perhaps the most interesting among them is A. R. Penck (born 1939). Penck is the pseudonym adopted by Ralf Winkler from a famous geologist whose specialty was the Ice Age. Before emigrating to the West in 1980, the artist lived in East Germany during the cold war, a political "ice age" of its own. The "primitive" and "childish" quality in *The Demon of Curiosity* (fig. 29-9), with its colorful directness, is deceptive. Although largely self-taught, Penck uses a fluid technique that is, in fact, very sophisticated.

But what are we to make of the picture's content?

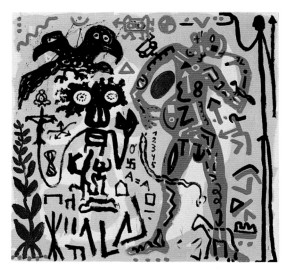

29-9 A. R. Penck. *The Demon of Curiosity.* 1982. Acrylic on canvas, 9'2¼" x 9'2¼" (2.8 x 2.8 m). The Rivendell Collection of Late-Twentieth-Century Art on permanent loan to the Center for Curatorial Studies, Bard College, Annandale-on-Hudson, New York

Courtesy Michael Werner Gallery, New York and Cologne

At first glance, it seems as bewildering as rock engravings in prehistoric caves. Upon closer inspection, we realize that the artist's "code" can be broken, at least enough for us to understand the basic meaning. The demon, as fierce as anything conjured up by Gauguin (compare fig. 24-7), is surmounted by a bird looking both ways that signifies inquisitiveness, to which the small crucified figure at the left has been sacrificed. The figures swim in a sea of hexlike signs, letters, and numbers, symbolizing knowledge, which fills up the man to the point where he seems literally "pregnant (or at least bloated) with meaning." The painting reflects Penck's fascination with cybernetics, the science of information systems. To him the artist is a kind of scientist, and he sees little difference between the two.

Tansey If Penck follows in the footsteps of artists such as Klee by inventing a personal form of pictographs, Mark Tansey (born 1949) uses the Roman

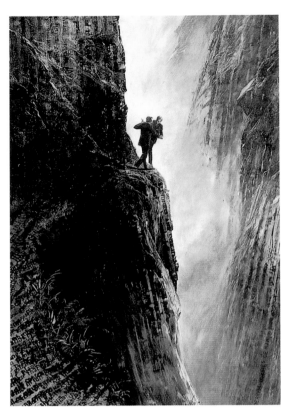

29-10 Mark Tansey. *Derrida Queries de Man.* 1990. Oil on canvas, 6'11" x 4'7" (2.13 x 1.4 m)

Courtesy Curt Marcus Gallery, New York

alphabet to accomplish the seemingly impossible. He constructs representational images that are literally made up of texts following the principles of deconstruction. *Derrida Queries de Man* (fig. 29-10) shows the founder of deconstruction with his chief American disciple, Paul de Man. If we look closely, we see that the landscape is made up of typeset lines that merge to form the steep cliffs. Here the texture of the paint bridges the gap between text and illustration by embedding the idea within the image. In this sense, the painting functions as an illustration of a metaphor. But what is it saying? Certainly it makes a serious point about the relation between content, picture, and reality. Yet it does so with surprising wit, beginning with the very idea of building a painting out of words. And, in a gesture of supreme irony, Tansey has appropriated the image from a famous illustration showing the apparent death of the fictional detective Sherlock Holmes at the hands of his archenemy, Professor Moriarty. By preventing a literal reading of the painting, this astonishing juxtaposition opens up new lines of questioning for the viewer that can never be fully resolved.

Photography

Photography, too, has taken up the theme of image as "text." Given the close association of words and photographs in Conceptual Art, such a move was inevitable. It was aided, however, by the new importance attached to semiotics, which has opened up fruitful new avenues of investigation for the artist. How do signs acquire public meaning? What is the message? Who originates it? What (and whose) purpose does it serve? Who is the audience? What are the means of spreading the idea? Who controls the media?

Photographers, especially in the United States, raise these questions in order to challenge our assumptions about the world we live in and the social order it imposes. Unlike Joanne Leonard or David Hockney (see figs. 28-16 and 28-17), postmodern photographers are "re-photographers," who for the most part do not take their own pictures but appropriate them from other mediums. To convey their message, these new Conceptualists often follow the formula of placing image and text side by side (compare fig. 26-26). Sometimes their pictures are intended as counterparts to paintings and are enlarged on an unprecedented scale, using commercial processes developed for advertisements, which may also serve as sources. Here it is the choice of image that matters, since the act of singling it out and changing its location to a gallery wall constitutes the comment. In both cases, however, we are asked to base our judgment on the message. The means of delivery deliberately shows so little individuality that it is often impossible to tell the work of one artist from another. In the process, the message often becomes equally forgettable.

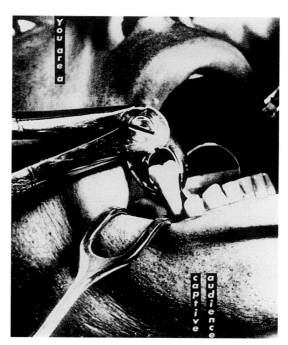

29-11 Barbara Kruger. *You Are a Captive Audience*. 1983. Gelatin-silver print, 48 x 37³/₄" (122 x 96 cm)

Courtesy the artist and Annina Nosei Gallery, New York

Kruger That is not a problem with Barbara Kruger (born 1945), whose pictures are instantly recognizable for their confrontational approach. Her work is like a sharp blow to the solar plexus: the message is direct, the response immediate, especially the first time around. *You Are a Captive Audience* (fig. 29-11) illustrates her style. The image usually involves a tightly cropped close-up in black and white taken from a magazine or newspaper. It is further blown up as crudely as possible to monumental proportions, so that the viewer cannot escape its presence or the message, which is stenciled in white letters against a red background. As in our example, the joining of unrelated text and image is clearly intended for radical ends. The challenging statement is intended to provoke acute anxiety by playing on people's latent fears in our society of being controlled by nameless forces, especially such large, impersonal power centers as the government, the military, or corporations.

Kruger's image is characteristic of life in the postmodern era. In the brave new world of postmodernism, the individual is no longer anchored in time or space. Both have been made obsolete in life, as they have been in science. They are beyond normal human comprehension and are based on assumptions subject to doubt. Traditional definitions of time and space, moreover, were founded on hierarchies of thought that served the purposes of colonialism. However, the new "hyper-space" created by global communication makes it impossible to position oneself within customary boundaries. Deprived of traditional guidelines, the postmodernist drifts aimlessly in a sea without meaning or reality. To the extent that the world makes any sense, it is at the local level, where the limited scale makes understanding possible in human terms.

Just as time and space have lost all meaning, so has history. In the end, however, postmodernism cannot escape the very laws of history it claims to deny. As a parody of modernity, it has its parallels—indeed, its origins—in the avant-garde of a hundred years ago. The same "decadence" and nihilism can be found toward the end of the nineteenth century in the Symbolist movement, with its apocalyptic vision of despair.

	1750–1775	1775–1800	1800–1825
Political History	Seven Years' War (1756–63); French and Indian War, French defeated in Battle of Quebec 1759 Catherine the Great (ruled 1762–96) extends Russian power to Black Sea	American Revolution 1775–85; Constitution adopted 1789 French Revolution 1789–97; Reign of Terror under Maximilien Robespierre 1793 Consulate of Napoleon 1799	Louisiana Purchase 1803 Napoleon crowns himself emperor 1804; exiled to St. Helena 1815 War of 1812 Greeks declare independence 1822
Religion and Literature	Thomas Gray's *Elegy* 1750 Denis Diderot's *Encyclopédie* 1751–72 Jean-Jacques Rousseau (1712–1778), French philosopher and writer	Edward Gibbon's *Decline and Fall of the Roman Empire* 1776–87 Thomas Paine's *The Rights of Man* 1790 William Wordsworth and Samuel Taylor Coleridge, *Lyrical Ballads*, 1798	Johann Wolfgang von Goethe's *Faust* (part I) 1808 George Gordon Byron's *Childe Harold's Pilgrimage* 1812–18 John Keats (1795–1821), English poet Jane Austen (1775–1817), English novelist Walter Scott's Waverly novels (1814–25)
Science and Technology	Benjamin Franklin's experiments with electricity c. 1750 James Watt patents steam engine 1769 Coke-fed blast furnaces for iron smelting perfected c. 1760–75	Power loom 1785; cotton gin 1792 Edward Jenner's smallpox vaccine c. 1798	Lewis and Clark expedition to Pacific 1803–6 First voyage of Fulton's steamship 1807 George Stephenson's first locomotive 1814 Michael Faraday discovers principle of electric dynamo 1821
Painting	Greuze, *The Village Bride* (21-1) West, *The Death of General Wolfe* (21-4) 21-1	Copley, *Watson and the Shark* (21-7) David, *The Death of Socrates* (21-2); *The Death of Marat* (21-3) Gros, *Napoleon at Jaffa* (22-3)	Goya, *The Family of Charles IV* (22-1) Ingres, *Odalisque* (22-5) Goya, *The Third of May, 1808* (22-2) Géricault, *The Raft of the "Medusa"* (22-4) Constable, *The Haywain* (22-16) Friedrich, *The Polar Sea* (22-18) 22-5
Sculpture		Houdon, *Voltaire* (21-9)	Canova, *Tomb of the Archduchess Maria Christina* (22-21)
Architecture	Walpole, Strawberry Hill, Twickenham (22-26) Soufflot, The Panthéon, Paris (21-11)	Jefferson, Monticello, Charlottesville (21-13)	
Photography	21-11	21-13	

1825–1850	1850–1875	1875–1890
Queen Victoria crowned 1837	Louis Napoleon takes title of emperor 1852	Peak of colonialism worldwide 1876–1914
U.S. treaty with China opens ports 1844	Russia abolishes serfdom 1861	First pogroms in Russia 1881–82
Famine in Ireland, mass emigration 1845	U.S. Civil War (1861–65) ends slavery; Abraham Lincoln assassinated 1865	
U.S. annexes western land areas 1845–60	Franco-Prussian War 1870–71	
Revolution of 1848; fails in Germany, Hungary, Austria, Italy; France sets up Second Republic (Louis Napoleon)	Benjamin Disraeli British prime minister 1874–80	

Aleksandr Pushkin (1799–1837), Russian writer	Herman Melville's *Moby-Dick* 1851	Mark Twain's *Tom Sawyer* 1876
Victor Hugo (1802–1885), French writer	Harriet Beecher Stowe's *Uncle Tom's Cabin* 1851	Henrik Ibsen (1828–1906), Norwegian dramatist
Ralph Waldo Emerson (1803–1882), American essayist	Walt Whitman's *Leaves of Grass* 1855	Émile Zola (1840–1902), French novelist
Charles Dickens's *Oliver Twist* 1838	Gustave Flaubert's *Madame Bovary* 1856	Oscar Wilde (1854–1900), Irish writer
George Eliot (1819–1880), English novelist	Charles Baudelaire (1821–1867), French poet	Henry James (1843–1916), American novelist
Karl Marx's *Communist Manifesto* 1848	Leo Tolstoy's *War and Peace* 1864–69	
Edgar Allan Poe (1809–1849), American poet	Fyodor Dostoyevsky's *Crime and Punishment* 1866	
	Karl Marx's *Das Kapital* 1867–94	

Erie Canal opened 1825	Charles Darwin publishes *On the Origin of Species* 1859	Alexander Graham Bell patents telephone 1876
First railway completed (England) 1825	Henry Bessemer patents tilting converter for turning iron into steel 1860	Thomas Alva Edison invents phonograph 1877; invents electric light bulb 1879
Cyrus Hall McCormick invents reaper 1831	Louis Pasteur develops germ theory 1864	First internal combustion engines for gasoline 1885
Daguerreotype process of photography introduced 1839	Gregor Mendel publishes experiments in genetics 1865	
Samuel F. B. Morse perfects telegraph 1844	Nobel invents dynamite 1867	
	First transcontinental railroad in America 1869	
	Suez Canal opened 1869	

Delacroix, *The Death of Sardanapalus* (22-7)	Millet, *The Sower* (22-12)	Moreau, *The Apparition* (24-10)
Corot, *View of Rome* (22-11)	Daumier, *The Third-Class Carriage* (22-10)	Renoir, *Le Moulin de la Galette* (23-9)
Ingres, *Louis Bertin* (22-6)	Manet, *Luncheon on the Grass* (23-3)	Degas, *The Glass of Absinthe* (23-10)
Turner, *Slave Ship* (22-17)	Homer, *Snap the Whip* (23-19)	Eakins, *William Rush Carving His Allegorical Figure of the Schuylkill River* (23-20)
Bingham, *Fur Traders Descending the Missouri* (22-20)	Monet, *On the Bank of the Seine, Bennecourt* (23-7)	Cézanne, *Still Life with Apples* (24-1)
Bonheur, *Plowing in the Nivernais* (22-13)	Whistler, *Arrangement in Black and Gray: The Artist's Mother* (23-17); *Nocturne in Black and Gold* (23-18)	Seurat, *Sunday Afternoon on the Island of La Grande Jatte* (24-3)
Courbet, *Burial at Ornans* (23-1)		Degas, *The Tub* (23-11)
		Morisot, *The Cradle* (23-12)
		Gauguin, *Vision after the Sermon (Jacob Wrestling with the Angel)* (24-6)
		Van Gogh, *Self-Portrait* (24-5); *Wheat Field and Cypress Trees* (24-4)

23-1

Rude, *"La Marseillaise,"* Arc de Triomphe, Paris (22-22)	Carpeaux, *The Dance* (22-23)	Degas, *The Little Fourteen-Year-Old Dancer* (23-24)
		Rodin, *The Thinker* (23-22)

23-24

Barry and Pugin, The Houses of Parliament, London (22-27)	Paxton, The Crystal Palace (23-27)	
Labrouste, Bibliothèque Ste-Geneviève, Paris (23-26)	Garnier, The Opéra, Paris (22-28)	

Niépce, *View from His Window at Le Gras* (22-29)	Rejlander, *The Two Paths of Life* (24-24)	Muybridge, *Female Semi-Nude in Motion* (24-28)
	Nadar, *Sarah Bernhardt* (22-30)	Riis, *Bandits' Roost* (24-23)
	Gardner, *Home of a Rebel Sharpshooter, Gettysburg* (22-32)	
	Cameron, *Ellen Terry, at the Age of Sixteen* (24-25)	
	Czar Cannon outside the Spassky Gate, Moscow (22-31)	

| **1825–1850** | **1850–1875** | **1875–1890** |

	1890–1910	1910–1925	1925–1950
Political History	First Zionist Congress called by Theodor Hertzl 1897 Spanish-American War 1898; U.S. gains Philippines, Guam, Puerto Rico, annexes Hawaii President Theodore Roosevelt (1901–9) proclaims Open Door policy; 8,800,000 immigrate to U.S. 1901–10 Internal strife, reforms in Russia 1905	Revolution in China, republic established 1911 First World War 1914–18; U.S. enters 1917 Bolshevik Revolution 1917 Mahatma Gandhi agitates for Indian independence, starting in 1919 Woman Suffrage enacted in U.S. 1920; in England 1928; in France 1945 Benito Mussolini's Fascists seize Italian government 1922	Adolf Hitler seizes power in Germany 1933 Franklin Delano Roosevelt proclaims New Deal 1933 Spanish Civil War 1936–39; won by Franco Hitler annexes Austria 1938; invades Poland 1939 Second World War 1939–45 Atomic bomb dropped on Hiroshima 1945 Israel gains independence 1948 Communists under Mao win in China 1949 India gains independence 1949
Religion and Literature	G. B. Shaw (1856–1950), British writer Emily Dickinson (1830–1886), poetry published 1890, 1891 Marcel Proust (1871–1922), French novelist W. B. Yeats (1865–1939), Irish poet André Gide (1869–1951), French novelist Gertrude Stein (1874–1946), American writer	T. S. Eliot (1888–1964), British poet James Joyce (1882–1941), Irish writer Eugene O'Neill (1888–1953), American dramatist D. H. Lawrence (1885–1930), English novelist	Virginia Woolf (1882–1941), English author William Faulkner (1897–1962), American novelist Ernest Hemingway (1898–1961), American writer Bertolt Brecht (1898–1956), German dramatist Jean-Paul Sartre (1905–1980), French philosopher Albert Camus (1913–1960), French novelist
Science and Technology	Guglielmo Marconi invents wireless telegraphy 1895 Marie and Pierre Curie discover radium 1898 Max Planck formulates quantum theory 1900 Sigmund Freud's *Interpretation of Dreams* 1900 Wright brothers' first flight with power-driven airplane 1903 Albert Einstein's Special Theory of Relativity 1905 Henry Ford begins assembly-line automobile production 1909	First radio station begins regularly scheduled broadcasts 1920	First regularly scheduled TV broadcasts in U.S. 1928 Motion pictures with sound appear in theaters 1928 Atomic fission demonstrated on laboratory scale 1942 Penicillin discovered 1943 Computer technology developed 1944
Painting	Cassatt, *The Bath* (23-13) Toulouse-Lautrec, *At the Moulin Rouge* (24-8) Beardsley, *Salomé* (24-11) Munch, *The Scream* (24-19) Tanner, *The Banjo Lesson* (23-21) Cézanne, *Mont Ste-Victoire Seen from Bibémus Quarry* (24-2) Matisse, *The Joy of Life* (25-1) Picasso, *Les Demoiselles d'Avignon* (25-8)	Matisse, *The Red Studio* (25-2) Picasso, *Portrait of Ambroise Vollard* (25-9) Duchamp, *The Bride* (25-16) Braque, *Le Courrier* (25-10) Boccioni, *Dynamism of a Cyclist* (25-11) Kandinsky, *Sketch I for "Composition VII"* (25-6) De Chirico, *Mystery and Melancholy of a Street* (25-14) Rouault, *The Old King* (25-3) Léger, *The City* (25-22) Picasso, *Three Musicians* (25-18) Klee, *Twittering Machine* (25-28) O'Keeffe, *Black Iris III* (25-32)	Picasso, *Three Dancers* (25-19) Demuth, *I Saw the Figure 5 in Gold* (25-23) Hopper, *Early Sunday Morning* (25-33) Mondrian, *Composition with Red, Blue, and Yellow* (25-24) Beckmann, *Departure* (25-31) Miró, *Composition* (25-27) Ernst, *La Toilette de la Mariée* (25-26) Gorky, *The Liver Is the Cock's Comb* (25-34) 25-19
Sculpture	Rodin, *Monument to Balzac* (23-23) Maillol, *Seated Woman (La Méditerranée)* (24-17) Brancusi, *The Kiss* (26-2) 26-2	Boccioni, *Unique Forms of Continuity in Space* (26-5) Duchamp-Villon, *The Great Horse* (26-4) Duchamp, *In Advance of the Broken Arm* (26-8) Tatlin, *Project for "Monument to the Third International"* (26-6) Brancusi, *Bird in Space* (26-3)	Moore, *Recumbent Figure* (26-13) Calder, *Lobster Trap and Fish Tail* (26-12) Picasso, *Bull's Head* (2) Hepworth, *Sculpture with Color (Deep Blue and Red)* (26-14) 27-11
Architecture	Sullivan, Wainwright Building, St. Louis (24-22) Gaudí, Casa Milá, Barcelona (24-19) Wright, Robie House, Chicago (27-1, 27-2)	Van de Velde, Theater, Werkbund Exhibition, Cologne (24-21) Rietveld, Schröder House, Utrecht (27-7)	Gropius, The Bauhaus, Dessau (27-8) Le Corbusier, Villa Savoye, Poissy-sur-Seine (27-11) Aalto, Villa Mairea, Noormarkku (27-12)
Photography	Kasebier, *The Magic Crystal* (24-26) Steichen, *Rodin with His Sculptures "Victor Hugo" and "The Thinker"* (24-27) Stieglitz, *The Steerage* (28-3)	Atget, *Pool, Versailles* (28-1) Man Ray, *Untitled (Rayograph)* (28-12)	Sander, *Pastry Cook, Cologne* (28-9) Stieglitz, *Equivalent* (28-4) Weston, *Pepper* (28-5) Cartier-Bresson, *Mexico, 1934* (28-2) Lange, *Migrant Mother, California* (28-10)

Korean War 1950–53
African colonies gain independence after 1957
Fidel Castro takes over Cuba 1959
Sit-ins protest racial discrimination in U.S. 1960
Berlin Wall built 1961
John F. Kennedy assassinated 1963
Lyndon Johnson begins massive U.S. intervention in
Vietnam 1965

Great Proletarian Cultural Revolution in China 1965–68
Russia invades Czechoslovakia 1968
Massacre of student demonstrators at Kent State University,
1970
Civil war in Pakistan gains independence for People's
Republic of Bangladesh 1972–73
Vietnam War ends 1973
Richard Nixon resigns presidency 1974
Iranian Revolution 1979

Mikhail Gorbachev begins implementing reform policy in U.S.S.R. 1985
Tiananmen Square massacre 1989
Breakup of Soviet Union into independent states 1989–90
Berlin Wall demolished; reunification of Germany 1990
Persian Gulf War 1991
Civil war erupts in the states of the former Yugoslavia 1991–92
South Africa holds first multiracial elections 1994
Palestinians gain self-rule from Israel in Jericho and Gaza 1994
Clinton impeachment; Panama Canal ceded by U.S. 1999
World Trade Center towers in New York destroyed in aerial attack 2001

Samuel Beckett (1906–1989), Irish author
Jean Genet (1910–1986), French dramatist
Lawrence Durrell (1912–1990), English novelist
Jack Kerouac's *On the Road* 1957
Jorge Luis Borges (1899–1986), Argentinian author
John Steinbeck awarded Nobel Prize 1962
Betty Friedan's *The Feminine Mystique* 1963

Gabriel García Márquez's *One Hundred Years of Solitude*
1970
First non-Italian pope elected since Adrian VI in 1522—
Pope John Paul II (from Poland) 1978

Alice Walker's *The Color Purple* 1982
Salman Rushdie's *The Satanic Verses* 1989; death threats by
outraged Islamic fundamentalists force him into hiding
Popular acceptance of CD-ROM encyclopedias and reference works
Pope John Paul II visits Sarajevo (1997), Cuba (1998), Nigeria (1998),
Mexico City (1999), and Poland (1999)

Genetic code cracked 1953
First hydrogen bomb (atomic fusion) exploded 1954
Sputnik, first satellite, launched 1957
First manned space flight 1961
First manned landing on the moon 1969

First orbiting laboratory (Skylab) 1973
Viking I and II space probes land on Mars 1976
Personal computers available 1978
Voyager I space probe orbits Jupiter 1979

AIDS virus recognized 1981
First artificial heart implanted 1982
New office technology: facsimile machine, modem, rapid development
of software programs, fiber-optic technology 1990s
Hubble space telescope launched 1990
Human origins pushed back to 4 million years ago, tool-making to
2$\frac{1}{2}$ million years ago 1996
Cloning of sheep Dolly by scientists at Roslin Institute 1997

Pollock, *Autumnal Rhythm: Number 30, 1950* (25-35)
Dubuffet, *Le Métafisyx* (25-38)
De Kooning, *Woman, II* (25-37)
Rothko, *White and Greens in Blue* (25-40)
Johns, *Three Flags* (25-45)
Krasner, *Celebration* (25-36)
Warhol, *Gold Marilyn Monroe* (25-47)
Lichtenstein, *Drowning Girl* (25-46)
Kelly, *Red Blue Green* (25-41)
Stella, *Empress of India* (25-42)

Anuszkiewicz, *Entrance to Green* (25-44)
Estes, *Food Shop* (25-48)
Flack, *Queen* (25-49)

25-49

Penck, *The Demon of Curiousity* (29-9)
Kiefer, *To the Unknown Painter* (25-50)
Murray, *More Than You Know* (25-51)
Tansey, *Derrida Queries de Man* (29-10)

29-8

Rauschenberg, *Odalisk* (26-21)
Segal, *Cinema* (26-24)
Smith, *Cubi* series (26-15)
Nevelson, *Black Cord* (26-22)
Kosuth, *One and Three Chairs* (26-26)

Kienholz, *The State Hospital* (26-25)
Bladen, *The X* (26-16)
Smithson, *Spiral Jetty,* Great Salt Lake, Utah (26-19)
Chase-Riboud, *Confessions for Myself* (26-23)

Shapiro, *Untitled* (26-17)
Kabakov, *The Man Who Flew Into Space from His Apartment* (29-6)
Restored Sistine ceiling unveiled, 1992
Hamilton, *parallel lines* (29-7)
Osorio, *Badge of Honor* (29-8)

Mies van der Rohe, Seagram Building, New York (27-15)
Wright, Solomon R. Guggenheim Museum, New York (13, 14)

Rogers and Piano, Centre
National d'Art et de Culture
Georges Pompidou, Paris (27-16)

29-5

Graves, Public Service Building, Portland (29-1)
Tschumi, Parc de la Villette, Paris (29-3, 29-4)
Stirling, Neue Staatsgalerie, Stuttgart (29-2)
Koolhaus, Netherlands Dance Theater, Amsterdam (27-18)
Calatrava, TGV Station, Lyon (27-17)
Gehry, Guggenheim Museum, Bilbao (29-5)

Brandt, *London Child* (28-15)
Frank, *Santa Fe, New Mexico* (28-14)
White, *Ritual Branch* (28-13)

Leonard, *Romanticism Is Ultimately Fatal* (28-17)
Hockney, *Gregory Watching the Snow Fall, Kyoto,
Feb. 21, 1983* (28-16)
Kruger, *You Are a Captive Audience* (29-12)
Wojnarowicz, *Death in the Cornfield* (28-18)

1950–1965 **1965–1980** **1980–2002**

GLOSSARY

Cross-references are indicated by words in SMALL CAPITALS.

ABACUS. The uppermost element of a CAPITAL, often a flat, square slab.

ABSTRACT. Having little or no reference to the appearance of natural objects; pertaining to the nonrepresentational art styles since 1900; also the reduction of figures and objects to geometric shapes.

ACRYLIC. Plastic binder MEDIUM for PIGMENTS that is soluble in water, developed about 1960.

AISLE. A side passageway of a BASILICA or church, separated from the central NAVE by a row of COLUMNS or PIERS.

ALTARPIECE. A painted or carved work of art placed behind and above the altar of a Christian church. It may be a single panel or a DIPTYCH, TRIPTYCH, or polyptych (with more than three panels) having hinged wings.

AMBULATORY. A passageway to the outside of the NAVE that forms a walkway around the APSE of a church.

AMPHORA. Greek vase having an egg-shaped body, a narrow, cylindrical neck, and two curving handles joined to the body at the shoulder and neck.

ANDACHTSBILD. German for "devotional image." A late medieval image, either painted, engraved, or carved, that was designed to inspire pious feelings in the viewer as he or she contemplated it.

ANIMAL STYLE. A type of artistic design, popular in western Asia and Europe in the ancient and medieval periods, characterized by animal-like forms in intricate linear patterns.

APSE. A large architectural niche facing the NAVE of a BASILICA or church, usually at the east end. In a church with a TRANSEPT, the apse begins beyond the CROSSING.

ARABESQUE. A type of linear ornamentation characterized by flowing, organic shapes, often in the form of interlaced vegetal, floral, and animal MOTIFS.

ARCADE. A series of ARCHES and their supports.

ARCH. A structural member, often semicircular, used to span an opening; it requires support from walls, PIERS, or COLUMNS, and sometimes BUTTRESSING.

ARCHAIC. A relatively early style, such as Greek sculpture of the seventh and sixth centuries B.C.; or any style adopting characteristics of an earlier period.

ARCHITRAVE. The main horizontal beam, and the lowest part, of an ENTABLATURE.

ARCHIVOLT. The molding framing the face of an ARCH, often highly decorated.

ARTS AND CRAFTS MOVEMENT. A late-nineteenth-century design movement centered in England that developed in reaction to the influence of industrialization. Its supporters promoted a return to hand-craftsmanship.

ASSEMBLAGE. Two or more "found" objects put together as a construction. See READYMADE.

ATMOSPHERIC PERSPECTIVE. Means of showing distance or depth in a painting by lightening the tones of objects that are far away from the PICTURE PLANE and by reducing in gradual stages the contrast between lights and darks.

ATRIUM. In ancient architecture, a room or courtyard with an open roof; or the vestibule, usually roofed, in an Early Christian church.

ATTIC. A low upper story placed above the main CORNICE or ENTABLATURE of a building and often decorated with windows and PILASTERS.

BANQUET PIECE. See BREAKFAST PIECE.

BAPTISTERY. A building or part of a church, often round or octagonal, in which the sacrament of baptism is administered. It contains a baptismal font, a receptacle of stone or metal for water used in the rite.

BARREL VAULT. A semicylindrical VAULT.

BASE. The lowest element of a COLUMN, PIER, wall, or DOME.

BASILICA. During the Roman period, a large meeting hall, its exact form varying according to its specific use as an official public building. The term was used by the Early Christians to refer to their churches. An Early Christian basilica had an oblong PLAN, a flat timber ceiling, a trussed roof, a NAVE, and an APSE. The entrance was on one short side, and the apse projected from the opposite side, at the far end of the building.

BAYS. Compartments into which a building may be subdivided, usually formed by the space between consecutive architectural supports.

BELVEDERE. Italian for "beautiful view." Any tower-like structure, whether FREESTANDING or attached to a building, constructed to command a view; also a building situated on a hill for the same purpose.

BLACK-FIGURE. A type of Greek vase painting, practiced in the seventh and sixth centuries B.C., in which the design was painted mainly in black against a lighter-colored background, usually the natural clay.

BLIND ARCADE. An arcade in which the arches and supports are attached to a wall and have only a decorative purpose.

BOOK OF HOURS. A book for individual private devotions with prayers for different hours of the day; often elaborately ILLUMINATED.

BREAKFAST PIECE. A STILL LIFE depicting food, drink, and table settings in disorder, as after a meal. This was a popular subject among seventeenth-century Dutch painters and may have been related to the VANITAS tradition.

BURIN. An ENGRAVING tool made of a pointed steel rod and a wooden handle.

BUTTRESS. A masonry support that counteracts the THRUST exerted by an ARCH or a VAULT. See FLYING BUTTRESS, PIER BUTTRESS.

CAMERA OBSCURA. Latin for "dark room." A darkened enclosure or box with a small opening or lens on one wall through which light enters to form an inverted image on the opposite wall. The principle had long been known but was not used as an aid in picture making until the sixteenth century.

CAMPANILE. Italian for "bell tower." A FREESTANDING tower erected adjacent to a church; a common element in late medieval and Renaissance church building.

CAPITAL. The crowning member of a COLUMN, PIER, or PILASTER on which the lowest element of the ENTABLATURE rests.

CARTOON. From the Italian *cartone*, meaning "heavy paper." A preliminary SKETCH or DRAWING made to be transferred to a wall, panel, or canvas as a guide in painting a finished work.

CARVING. The cutting of a figure or design out of a solid material such as stone or wood, as contrasted to the additive technique of MODELING; also a work executed in this technique.

CARYATID. Greek for "priestess at Caryae." A carved and draped figure, generally a woman, used in place of a COLUMN as an architectural support.

CASTING. A method of reproducing a three-dimensional object or RELIEF. Casting in bronze or another metal is often the final stage in the creation of a piece of SCULPTURE; casting in plaster is a convenient and inexpensive way of making a copy of an original.

CATACOMB. An underground place of burial consisting of tunnels and niches for tombs; most common during Early Christian times.

CATHEDRAL. The principal church of a territory, presided over by a bishop, usually in the leading city of his jurisdiction; known as the bishop's "see."

CELLA. The main chamber of a temple that housed the cult image in Near Eastern, Greek, and Roman temples.

CENTRAL-PLAN CHURCH. The standard design used for churches in Eastern Orthodox Christianity, in which symmetrical chambers radiate from a central primary space.

CHANCEL. See CHOIR.

CHAPEL. A compartment in a church containing an altar dedicated to a saint.

CHEVET. In Gothic architecture, the entire eastern end of a church, including the CHOIR, APSE, AMBULATORY, and radiating CHAPELS.

CHIAROSCURO. Italian for "light and dark." In painting, a method of MODELING form primarily by the use of light and shade.

CHOIR. In a church, the space reserved for the clergy and singers, set off from the NAVE by steps and occasionally by a screen.

CHOIR SCREEN. An element of church architecture, often decorated with sculpture, that is used to separate the CHOIR from the NAVE or TRANSEPT.

CLASSICAL. Used generally to refer to the art of the Greeks and the Romans.

CLASSICAL ORDERS. The three most common Greek and Roman ORDERS are the DORIC, IONIC, and CORINTHIAN.

CLERESTORY. A row of windows piercing the NAVE walls of a BASILICA or church above the level of the side AISLES.

CLOISTER. An open courtyard surrounded by a covered ARCADE. Cloisters are usually associated with spiritual or scholarly reflection and are often attached to monasteries, churches, or universities.

COFFER. A recessed, geometrically shaped ceiling panel. A ceiling decorated with these panels is said to be "coffered."

COLLAGE. A composition made by pasting cut-up textured materials, such as newsprint or wallpaper,

to form all or part of a work of art; may be combined with painting or drawing or with three-dimensional objects.

COLONNADE. A series of COLUMNS placed at regular intervals.

COLOR. The choice and treatment of the HUES in a painting.

COLOSSAL ORDER. An ORDER built on a large scale, extending over two or more stories.

COLUMN. A vertical architectural support, usually consisting of a BASE, a rounded SHAFT, and a CAPITAL.

COMPOSITION. The arrangement of FORM, COLOR, LINE, space, and MASS in a work of art.

COMPOUND PIER. A PIER with COLUMNS, PILASTERS, or SHAFTS attached.

CONTRAPPOSTO. Italian for "set against." The disposition of the parts of the body so that the weight-bearing, or engaged, leg is distinguished from the raised, or free, leg, resulting in a shift in the axis between the hips and shoulders. Used first by Greek sculptors as a means of showing movement in a figure.

CORBELING. A space-spanning technique in which each layer of stone increasingly tapers inward to form an ARCH or a VAULT.

CORINTHIAN COLUMN. First appeared in fifth-century-B.C. Greece, apparently as a variation of the IONIC COLUMN. The CAPITAL differentiates the two: the Corinthian capital has an inverted bell shape, decorated with acanthus leaves, stalks, and VOLUTE scrolls.

CORINTHIAN ORDER. The most ornate CLASSICAL ORDER, distinguished by a fluted COLUMN, a bell-shaped CAPITAL decorated with acanthus-leaf carvings, and a decorated ENTABLATURE. Widely used by the Romans.

CORNICE. A crowning, projecting architectural feature, especially the uppermost part of an ENTABLATURE.

CROSSING. In a cross-shaped church, the area where the NAVE and TRANSEPT intersect.

CRYPT. A VAULTED space beneath the main floor of a church, usually below the CHOIR, used as a burial or relic chamber.

CUPOLA. A rounded, domed roof or ceiling.

DAGUERREOTYPE. Originally, a photograph on a silver-plated sheet of copper that had been treated with fumes of iodine to form silver iodide on its surface and, after exposure, was developed by fumes of mercury. The process, invented by L.-J.-M. Daguerre and made public in 1839, was modified and accelerated as daguerreotypes gained worldwide popularity.

DECONSTRUCTION. A method of linguistic analysis derived from SEMIOTICS and developed in France in the late 1960s by Jacques Derrida among others. Its rejection of extratextual reality for judging a piece of literature and its embrace of multiple conflicting interpretations had a profound impact on the visual arts in the 1990s.

DIORAMA. A large scenic painting placed in a specially designed building and illuminated to give it a lifelike appearance.

DIPTYCH. A painting or RELIEF executed on two panels joined by a hinge.

DOME. A large, curved roof element supported by a circular wall (DRUM) or square BASE.

DORIC COLUMN. The Doric column stands without a BASE directly on top of the stepped platform of a temple. Its shaft has shallow FLUTES.

DORIC ORDER. The CLASSICAL ORDER characterized by a fluted COLUMN without a BASE and with an undecorated CAPITAL and plain ENTABLATURE.

DRAWING. SKETCH, design, or representation by LINES. Drawings are usually made on paper with pen, pencil, charcoal, pastel, chalk, and the like.

DRESSED STONE. Stone that is evenly cut and laid and is smoothly finished; generally used for architectural exteriors.

DRUM. Cylindrical wall supporting a DOME; or one of several sections composing the SHAFT of a COLUMN.

DRYPOINT. A graphic-arts process in which a pointed needle is used to directly inscribe the design into a copper or zinc plate. The INCISING creates a ragged edge that produces a soft line in the print, the distinguishing quality of a drypoint. Also, a print made by this process.

ECHINUS. The cushionlike slab below the ABACUS of a Doric capital; also, the molding below the VOLUTES on an Ionic CAPITAL.

ELEVATION. Architectural drawing of a face of a building.

EMBOSSING. A technique in metalwork used to make designs stand out in RELIEF.

ENAMELING. The process of fusing colored glass to metal by firing in a kiln.

ENCAUSTIC. Method of painting in colors mixed with wax and applied with a brush, usually while the mixture is hot. The technique was practiced in ancient times and in the Early Christian period, and has been revived by some modern painters.

ENGAGED COLUMN. A COLUMN that is part of a wall or projects from it only slightly; such columns often have purely decorative purposes.

ENGRAVING. A graphic-arts process in which a design is INCISED in reverse on a copper plate; this is coated with printer's ink, which remains in the incised lines when the plate is wiped off. Damp paper is placed on the plate, and both are put into a press; the paper soaks up the ink and produces a print of the original. Also, a print made by this process.

ENTABLATURE. The upper part of an architectural ORDER consisting of an ARCHITRAVE, FRIEZE, and CORNICE.

ENTASIS. The slight swelling of the SHAFT of a COLUMN. Entasis creates an optical illusion that makes the column appear consistent and straight from bottom to top when viewed from ground level.

ETCHING. Like ENGRAVING, etching is an INCISING graphic-arts process. However, the design is drawn in reverse with a needle on a plate thinly coated with wax or resin. The plate is placed in a bath of nitric acid, which etches the lines to receive ink. The coating is then removed, and the prints are made as in engraving. Also, a print made by this process.

EUCHARIST. The sacrament of holy communion, the celebration in commemoration of the Last Supper; also the consecrated bread and wine used in the rite.

FACADE. The front face of a building.

FLUTE. Vertical channel on a column SHAFT.

FLYING BUTTRESS. An ARCH that springs from the upper part of the PIER BUTTRESS of a Gothic church, spans the AISLE roof, and abuts the upper NAVE wall to receive the THRUST from the nave VAULTS; it transmits this thrust to the solid pier buttresses.

FORESHORTENING. Method of representing objects as if seen at an angle and receding or projecting into space.

FORM. The external shape or appearance of a representation, considered apart from its COLOR or material.

FREESTANDING. Used to refer to a work of SCULPTURE IN THE ROUND, that is, in full three-dimensionality; also, not attached to architecture and not sculpted in RELIEF.

FREESTANDING COLUMN. A COLUMN that is detached from a wall, usually having a structural purpose.

FRESCO. A technique of wall painting known since antiquity. PIGMENT is mixed with water and applied to a freshly plastered area of a wall. The result is a particularly long-lasting form of painted decoration.

FRIEZE. In CLASSICAL ORDERS, the element of the ENTABLATURE that rests on the ARCHITRAVE and is immediately below the CORNICE. Also, any decorated horizontal band.

GABLE. Triangular part of a wall, enclosed by the lines of a sloping roof.

GALLERY. In church architecture, an elevated story above the NAVE and usually open to it.

GENIUS (pl. genii). A winged, seminude, usually male figure, often purely decorative but frequently representing the guardian spirit of a person or place or personifying an abstract concept.

GENRE. French for "kind" or "sort." A work of art, usually a painting, showing a scene from everyday life that is represented for its own sake.

GLAZE. In ceramics, a thin coating of glass fused to a ceramic surface by firing in a kiln. The result is a decorative and waterproof surface. In oil painting, a thin, translucent layer of paint applied over a dry underlayer, which produces a luminous effect.

GOSPELS, GOSPEL BOOK. Contains the four books of the New Testament that tell the life of Christ, attributed to the evangelists Matthew, Mark, Luke, and John. Often elaborately illustrated.

GROIN. The sharp edge formed by the intersection of two VAULTS.

GROIN VAULT. VAULT formed by the intersection at right angles of two BARREL VAULTS of equal height and diameter so that the GROINS form a diagonal cross.

GROUNDLINE. In pictures or RELIEFS, a LINE that indicates the field of ground upon which figures are placed (GROUND PLANE). Multiple groundlines may be used in a single work of art to indicate spatial depth.

GROUND PLAN. An architectural drawing that shows the outline shape of a building just above ground level, together with its space-defining interior parts.

GROUND PLANE. In pictures or RELIEFS, the surface upon which figures and objects appear to stand.

GUILD. An association of artisans or craftspeople organized to educate its members and promote their products. Guilds were most common and powerful during the Middle Ages and Early Renaissance. Their members were ranked according to experience, from lowest to highest: apprentice, journeyman, and master.

GUTTAE. Small, peglike projections below the FRIEZE in the ENTABLATURE of the DORIC ORDER.

HALO. The projection of light surrounding the head or body of a figure, indicating divinity, holiness, or spiritual eminence.

HERALDIC. Relating to a system of elaborate symbols

used to designate family membership. Heraldic symbols were often employed to decorate the homes and armor of noble families.

HIEROGLYPHICS. Greek for "sacred writing." The characters and picture-writing used by the ancient Egyptians.

HIGH RELIEF. See RELIEF.

HORAE. The Greek goddesses of the seasons.

HUE. The particular shade of a COLOR.

ICON. A panel painting of Christ, the Virgin, or saints; regarded as sacred, especially by Eastern Christians.

ILLUMINATION. A painting technique combining rich PIGMENTS, gold, and other precious metals to produce dazzling color effects. A term used generally for describing painting in manuscripts. Illuminated manuscripts may contain separate ornamental pages, marginal illustrations, ornament within the text, entire MINIATURE paintings, or any combination of these.

ILLUSIONISM. The effort of an artist to represent the visual world.

ILLUSTRATION. The representation of an idea, scene, or text by visual means.

IMPASTO. From the Italian, meaning "in paste." Paint, usually OIL PAINT, applied thickly and showing the marks of the brush or other application tool.

INCISING. Technique of cutting into a hard surface with a sharp instrument to create a linear image.

IONIC COLUMN. The Ionic column stands on a molded BASE. The SHAFT normally has FLUTES more deeply cut than DORIC flutes. The Ionic CAPITAL is identified by its pair of spiral, scroll-like ornaments.

IONIC ORDER. The CLASSICAL ORDER distinguished by its fluted COLUMN, volute CAPITAL, molded ARCHITRAVE, and ENTABLATURE.

JAMB. Side of a doorway or window frame.

KEYSTONE. The stone at the center of an ARCH that locks the other stones in place.

KORE. ARCHAIC-period Greek statue of a draped maiden.

KOUROS. ARCHAIC-period Greek statue of a standing nude youth.

KRATER. An ancient Greek vessel used to hold a mixture of wine and water. A large body and wide mouth were standard features, but within these parameters kraters were produced in many different styles.

LANTERN. Small structure above a roof or DOME with open or windowed walls to allow in light and air; also the tower above the CROSSING of a church.

LATIN CROSS. Cross with three arms of equal length and one longer arm. Beginning with Romanesque architecture, the standard plan in Christian church building.

LINE. Mark made by a moving tool, such as a pen or pencil; more generally, an outline, contour, or silhouette.

LINEAR PERSPECTIVE. See SCIENTIFIC PERSPECTIVE.

LINTEL. A horizontal architectural element upheld by upright posts or COLUMNS to form an opening.

LITHOGRAPHY. A graphic-arts process in which a design is drawn with a grease pencil on a limestone or zinc surface, which is then wetted and inked. A damp paper is pressed against this surface, transferring the final image.

LOGGIA. A covered GALLERY or ARCADE open to the air

on at least one side. It may stand alone or be part of a building.

LOW RELIEF. See RELIEF.

LUNETTE. A semicircular zone, either painted or sculpted, usually above a window or doorway.

MANDORLA. Italian for "almond." An almond-shaped radiance of light surrounding a holy figure.

MARTYRIUM. A church, chapel, or shrine built over the grave of a martyr or upon the site of a great miracle.

MASS. The expanse of COLOR that defines a painted shape; the three-dimensional volume of a sculpted or architectural form.

MASTABA. Aboveground tomb building with a flat roof and inward-sloping walls, linked by a deep shaft to an underground burial chamber. A tomb form popular in ancient Egypt.

MEDIUM. The material with which an artist works, such as marble, OIL PAINT, TERRA-COTTA, or WATERCOLOR.

METOPE. An oblong or square panel found as an element of the ENTABLATURE of the DORIC ORDER. It is located on the FRIEZE between the TRIGLYPHS.

MINIATURE. A painting or drawing in an ILLUMINATED manuscript; also a very small portrait, sometimes painted on ivory.

MOBILE. A type of sculpture made of parts that can be set in motion by the movement of air currents.

MODELING. An additive sculptural process in which a malleable material is molded into a three-dimensional form. In painting or DRAWING, the means by which the three-dimensionality of a form is suggested on a two-dimensional surface, usually through variations of COLOR and the play of lights and darks.

MONUMENTAL. Derived from "monument," a work whose purpose is commemorative. Frequently used to describe works that are larger than life-size; also employed for those giving the impression of great size, whatever their actual dimensions.

MOSAIC. A design formed by embedding small pieces of colored stone or glass in cement. In antiquity, large mosaics were used chiefly on floors; from the Early Christian period on, mosaic decoration was increasingly used on walls and vaulted surfaces.

MOTIF. A distinctive and recurrent feature or theme, shape, or figure in a work of art.

MURAL. A wall painting. See FRESCO.

MUTULE. In the DORIC ORDER, the projecting flat block above the TRIGLYPH.

NARTHEX. The vestibule at the main entrance of a BASILICA or church.

NAVE. The central aisle of a BASILICA or church; also, the section of a church between the main entrance and the CHOIR.

OIL PAINTING. Though known to the Romans, this technique was not systematically used until the fifteenth century. In the oil technique of early Flemish painters, pigments were mixed with drying oils and fused while hot with hard resins; the mixture was then diluted with other oils.

ORDER. In architecture, a CLASSICAL system of proportion and interrelated parts. These include a COLUMN, usually with a BASE, SHAFT, and CAPITAL, and an ENTABLATURE with an ARCHITRAVE, FRIEZE, and CORNICE.

PAINTING MEDIUMS. See ACRYLIC, ENCAUSTIC, FRESCO, OIL PAINTING, TEMPERA, and WATERCOLOR.

PALETTE. The range of COLORS chosen by an artist for use in a particular painting.

PANTHEON. A temple dedicated to all the gods, or one housing tombs of the illustrious dead of a nation or memorials to them.

PARAPET. A low protective wall or barrier along the edge of a platform, roof, bridge, or similar structure.

PASSION. Events surrounding Jesus Christ's death, resurrection, and ascension to heaven.

PASTEL. Powdered PIGMENTS mixed with gum and molded into sticks for drawing; also a picture or SKETCH made with this type of crayon.

PEDIMENT. Triangular section above the ENTABLATURE on the face of a building. The pediments at either end of a temple often contained high RELIEF or FREESTANDING SCULPTURE.

PENDENTIVES. Among the supports for a DOME, the triangular segments of a wall leading from the square base to the circular DRUM.

PERISTYLE. COLONNADE (or ARCADE) around a building or open court.

PERSPECTIVE. See ATMOSPHERIC PERSPECTIVE and SCIENTIFIC PERSPECTIVE.

PHOTOGRAM. A shadowlike picture made by placing opaque, translucent, or transparent objects between light-sensitive paper and a light source and developing the latent photographic image.

PHOTOMONTAGE. A photograph in which prints, in whole or in part, are combined to form a new image. A technique much practiced by the Dada group in the 1920s.

PICTORIAL SPACE. In pictures or RELIEFS, the illusion of depth created by devices such as multiple GROUNDLINES and PERSPECTIVE.

PICTURE PLANE. The imaginary plane suggested by the actual surface of a painting, drawing, or relief.

PIER. A vertical architectural element, usually rectangular in section; if used with an ORDER, often has a BASE and CAPITAL of the same design.

PIER BUTTRESS. An exterior PIER in Romanesque and Gothic architecture, buttressing the THRUST of the VAULTS within.

PIETÀ. In painting or SCULPTURE, a representation of the Virgin Mary mourning the dead Jesus, whom she holds.

PIGMENT. A dry, powdered substance that, when mixed with a suitable liquid, or vehicle, gives COLOR to paint. See ACRYLIC, ENCAUSTIC, FRESCO, OIL PAINTING, TEMPERA, and WATERCOLOR.

PILASTER. A flat, vertical attached element having a CAPITAL and BASE, projecting slightly from a wall. Has a decorative rather than a structural purpose.

PLAN. The schematic representation of a three-dimensional structure, such as a building or monument, on a two-dimensional plane.

PLASTIC. Describes a form that is molded or modeled.

PODIUM. The tall base upon which an Etruscan or Roman temple rests; also, in later structures, a ground floor made to resemble such a base.

POLYCHROMY. The decoration of architecture or sculpture in multiple colors.

PORTAL. A doorway, gate, or entrance of imposing size. In Romanesque and Gothic churches, portals may be elaborately decorated.

PORTICO. A roofed porch supported by COLUMNS.

POST AND BEAM. A system or unit of construction consisting solely of vertical and horizontal elements. See LINTEL.

POST-AND-LINTEL CONSTRUCTION. A space-

spanning technique in which two or more vertical beams (posts) support a horizontal beam (LINTEL).

PREDELLA. The long and narrow horizontal panel beneath the main scene on an ALTARPIECE. The panel is often painted or sculpted to correspond with the altarpiece's overall theme.

PROGRAM. In art history, the conceptual theme of the subject matter and symbolism behind a complex work of painting and sculpture, such as the Sistine Chapel ceiling, or Gauguin's *Where Do We Come From? What Are We? Where Are We Going?*

PROPORTION. The relation of the size of any part of a figure or object to the size of the whole. For architecture, see ORDER.

PYLON. In Egyptian architecture, the entranceway set between two broad, oblong towers with sloping sides.

QUATREFOIL. A decorative MOTIF composed of four lobes; often used in Gothic art and architecture.

READYMADE. A manufactured object exhibited as being aesthetically pleasing. When two or more accidentally "found" objects are placed together as a construction, the piece is called an ASSEMBLAGE.

RED-FIGURE. A type of Greek vase painting in which the design is outlined in black and the background painted in black, leaving the figures and the reddish color of the baked clay after firing. This style replaced the BLACK-FIGURE style toward the end of the sixth century B.C.

RELIEF. Forms in SCULPTURE that are carved from a background block, to which they remain attached. Relief may be hollowed to create sunken relief, modeled shallowly to produce low relief, or modeled deeply to produce high relief; in very high relief, the sculpture will project almost entirely from its background.

REPRESENTATIONAL. As opposed to ABSTRACT, a portrayal of an object in recognizable form.

RESPOND. A projecting and supporting architectural element, often a PIER, that is bonded with another support, usually a wall, to carry one end of an ARCH.

RHYTHM. The regular repetition of a particular form; also, the suggestion of motion by recurrent forms.

RIB. A projecting arched member of a VAULT.

RIBBED VAULT. A compound masonry vault, the GROINS of which are marked by projecting stone RIBS.

ROSE WINDOW. Round windows decorated with STAINED GLASS and TRACERY, frequently incorporated into FACADES and TRANSEPTS of Gothic churches.

RUSTICATION. Masonry or brickwork having beveled joints and a roughened surface intended to resemble large, square blocks.

SACRISTY. A room near the main altar of a church where the vessels and vestments required for services are kept.

SARCOPHAGUS (pl. sarcophagi). A coffin made of stone, marble, or TERRA-COTTA, and less frequently, of metal. Sarcophagi are often decorated with paintings or RELIEFS.

SCALE. Generally, the relative size of any object in a work of art, often used with reference to human scale.

SCIENTIFIC PERSPECTIVE. A mathematical system for representing three-dimensional objects and space on a two-dimensional surface. All objects are represented as seen from a single viewpoint.

SCULPTURE. A three-dimensional form, usually in a solid material. Traditionally, two basic techniques have been used: subtractive—CARVING in a hard material such as marble; and additive—MODELING in a soft material such as clay or wax. See FREE-STANDING and RELIEF.

SCULPTURE IN THE ROUND. See FREESTANDING.

SECTION. Architectural drawing representing the vertical arrangement of a building's interior.

SEMIOTICS. The study of signs and symbols— language being foremost among them—in an effort to deduce the underlying nature and bias of the message being conveyed.

SFUMATO. The gentle gradation from light to dark TONES, softening the appearance of painted images.

SHAFT. A cylindrical form; in architecture, the part of a COLUMN or PIER intervening between the BASE and the CAPITAL. Also, a vertical enclosed space.

SKETCH. A rough DRAWING representing the main features of a composition; often used as a preliminary study.

SPANDREL. The triangular surface formed by the outer curve of an ARCH and its rectangular frame.

STAINED GLASS. The technique of filling architectural openings with glass colored by fused metallic oxides; pieces of this glass are held in a design by strips of lead.

STELA (pl. stelae). A vertical stone slab decorated with a combination of images in RELIEF and inscriptions; often used as a grave marker.

STILL LIFE. A painting or drawing of an arrangement of inanimate objects.

STUCCO. A mixture of lime, sand, and other materials that can be used as a general ground in FRESCO painting or as a final covering for a wall surface. The mixture can also be manipulated for use as decorative MOLDING.

SUNKEN RELIEF. See RELIEF.

TEMPERA. A painting process in which PIGMENT is mixed with an emulsion of egg yolk and water or egg and oil. Tempera, the basic technique of medieval and Early Renaissance painters, dries quickly, permitting almost immediate application of the next layer of paint.

TERRA-COTTA. Clay, MODELED or molded and baked until very hard. Used in architecture for functional and decorative purposes, as well as in pottery and SCULPTURE. Terra-cotta may have a painted or glazed surface.

TESSERA (pl. tesserae). A small piece of colored glass or stone used to create a MOSAIC.

THRUST. The downward and outward pressure exerted by an ARCH or VAULT and requiring BUTTRESSING.

TONALITY. The soft or garish impression given by a COLOR or range of colors.

TONE. A reference to the COLOR, darkness, depth, or brightness of a PIGMENT.

TRACERY. Ornamental stonework in elaborate intersecting patterns, used either in windows or on wall surfaces.

TRANSEPT. In a cross-shaped church, the arm forming a right angle with the NAVE, usually inserted between the latter and the CHOIR or APSE.

TRANSUBSTANTIATION. In the EUCHARISTIC rite, the changing of the bread and wine into the body and blood of Christ, while their outward appearances remain the same.

TREFOIL. A decorative MOTIF composed of three lobes.

TRIFORIUM. An ARCADE running along the walls of a church above the NAVE and usually pierced by three openings per BAY.

TRIGLYPH. A vertical block with V-cut channels. The triglyph is located specifically on the FRIEZE between the METOPES.

TRIPTYCH. A painting or RELIEF executed on three panels that are often hinged so that the two outer panels fold like doors in front of the central panel.

TRIUMPHAL ARCH. A massive, FREESTANDING ornamental gateway; originally developed by the ancient Romans to honor a military victory. Also, a MONUMENTAL arch inside a structure.

TRUMEAU. A central post supporting the LINTEL of a large doorway, as in a Romanesque or Gothic PORTAL, where it was frequently decorated with sculpture.

TYMPANUM. The semicircular panel between the LINTEL and ARCH of a medieval PORTAL or doorway; a church tympanum frequently contains RELIEF sculpture.

VANISHING POINT. In PERSPECTIVE, the point at which parallel lines seem to meet and disappear.

VANITAS. A STILL LIFE in which the objects represent the transience of life. A popular subject in seventeenth-century Dutch painting.

VAULT. An arched architectural covering made of brick, stone, or concrete.

VEDUTA. A painting, drawing, or print of an actual city.

VELLUM. Thin, bleached calfskin that can be written, printed, or painted upon.

VOLUTE. A decorative spiral scroll, seen most commonly in IONIC CAPITALS.

VOTIVE. An object created as an offering to a god or spirit.

VOUSSOIRS. Wedge-shaped stones forming an ARCH.

WATERCOLOR. PIGMENTS mixed with water instead of oil or another medium; also, a picture painted with watercolor, often on paper.

WESTWORK. The elaborate west entrance of Carolingian, Ottonian, and Romanesque churches, composed of exteriors with towers and multiple stories and an interior with an entrance vestibule, a CHAPEL, and GALLERIES overlooking a NAVE.

WOODCUT. A printing process in which a design or lettering is carved in RELIEF on a wooden block; the areas intended not to print are hollowed out.

ZIGGURAT. An elevated platform, varying in height from several feet to the size of an artificial mountain, built by the Sumerians to support their shrines.

BOOKS FOR FURTHER READING

This list includes standard works and the most recent and comprehensive books in English. Books with material relevant to several chapters are cited only under the first heading.

INTRODUCTION

Broude, Norma, and Mary D. Garrard, eds. *Feminism and Art History: Questioning the Litany.* Harper & Row, New York, 1982.

Holt, Elizabeth Gilmore, ed. *A Documentary History of Art.* 3 vols. Vols. 1 and 2, Princeton University Press, Princeton, 1981–86; vol. 3, Yale University Press, New Haven, 1986.

Kostof, Spiro. *A History of Architecture: Settings and Rituals.* 2nd ed. Oxford University Press, New York, 1995.

Panofsky, Erwin. *Meaning in the Visual Arts.* Reprint of 1955 ed. University of Chicago Press, Chicago, 1982.

Taylor, Joshua C. *Learning to Look: A Handbook for the Visual Arts.* 2nd ed. University of Chicago Press, Chicago, 1981.

Trachtenberg, Marvin, and Isabelle Hyman. *Architecture: From Prehistory to Post-Modernism.* 2nd ed. Harry N. Abrams, New York, 2002.

Part One THE ANCIENT WORLD

1 PREHISTORIC ART IN EUROPE AND NORTH AMERICA

Sandars, Nancy K. *Prehistoric Art in Europe.* Reprint of 1985 2nd integrated ed. Pelican History of Art. Yale University Press, New Haven, 1992.

2 EGYPTIAN ART

Malek, Jaromir. *Egyptian Art.* Phaidon, London, 1999.

Panofsky, Erwin. *Tomb Sculpture: Four Lectures on Its Changing Aspects from Ancient Egypt to Bernini.* Reprint of 1969 ed. Harry N. Abrams, New York, 1992.

Smith, William S., and William K. Simpson. *The Art and Architecture of Ancient Egypt.* Rev. ed. Pelican History of Art. Yale University Press, New Haven, 1999.

3 ANCIENT NEAR EASTERN ART

Frankfort, Henri. *The Art and Architecture of the Ancient Orient.* 5th ed. Pelican History of Art. Yale University Press, New Haven, 1997.

4 AEGEAN ART

Graham, James. *The Palaces of Crete.* Rev. ed. Princeton University Press, Princeton, 1987.

Hampe, Roland, and Erika Simon. *The Birth of Greek Art: From the Mycenaean to the Archaic Period.* Oxford University Press, New York, 1981.

5 GREEK ART

Boardman, John, ed. *The Oxford History of Classical Art.* Oxford University Press, New York, 1993.

Lawrence, Arnold W. *Greek Architecture.* 5th ed., rev. Pelican History of Art. Yale University Press, New Haven, 1996.

Osborne, Robin. *Archaic and Classical Greek Art.* Oxford History of Art. Oxford University Press, New York, 1998.

Pollitt, Jerome. *Art and Experience in Classical Greece.* Cambridge University Press, New York, 1989.

———. *Art in the Hellenistic Age.* Cambridge University Press, New York, 1986.

———, ed. *Art of Greece, 1400–31 B.C.: Sources and Documents.* 2nd ed. Prentice Hall, Englewood Cliffs, N.J., 1990.

Richter, Gisela M. A. *A Handbook of Greek Art.* 9th ed. Da Capo, New York, 1987.

Stewart, Andrew F. *Greek Sculpture: An Exploration.* 2 vols. Yale University Press, New Haven, 1990.

6 ETRUSCAN ART

Brendel, Otto J. *Etruscan Art.* 2nd ed. Pelican History of Art. Yale University Press, New Haven, 1995.

Spivey, Nigel. *Etruscan Art.* World of Art. Thames and Hudson, London, 1997.

7 ROMAN ART

Brilliant, Richard. *Roman Art from the Republic to Constantine.* Phaidon, London, 1974.

Elsner, Jaś. *Imperial Rome and Christian Triumph.* Oxford History of Art. Oxford University Press, New York, 1998.

Kleiner, Diana. *Roman Sculpture.* Yale University Press, New Haven, 1992.

Ling, R. *Roman Painting.* Cambridge University Press, New York, 1991.

Macdonald, William L. *The Architecture of the Roman Empire.* Rev. ed. 2 vols. Yale University Press, New Haven, vol. 1, 1982; vol. 2, 1987.

Pollitt, Jerome. *The Art of Rome and Late Antiquity: Sources and Documents.* Prentice Hall, Englewood Cliffs, N.J., 1983.

Strong, Donald E. *Roman Art.* 2nd ed. Pelican History of Art. Yale University Press, New Haven, 1992.

Part Two THE MIDDLE AGES

Calkins, Robert G. *Monuments of Medieval Art.* Reprint of 1979 ed. Cornell University Press, Ithaca, 1985.

8 EARLY CHRISTIAN AND BYZANTINE ART

Beckwith, John. *Early Christian and Byzantine Art.* 2nd (integrated) ed. Pelican History of Art. Penguin, New York, 1979.

Cormack, Robin. *Byzantine Art.* Oxford History of Art. Oxford University Press, New York, 2000.

Demus, Otto. *Byzantine Art and the West.* New York University Press, New York, 1970.

Kitzinger, Ernst. *Byzantine Art in the Making: Main Lines of Stylistic Development in Mediterranean Art, 3rd–7th Century.* Harvard University Press, Cambridge, 1995.

Krautheimer, Richard, and Slobodan Curčić. *Early Christian and Byzantine Architecture.* 4th ed. Pelican History of Art. Yale University Press, New Haven, 1992.

Lowden, John. *Early Christian and Byzantine Art.* Phaidon, London, 1997.

Macdonald, William L. *Early Christian and Byzantine Architecture.* The Great Ages of World Architecture. Braziller, New York, 1965.

Mango, Cyril. *The Art of the Byzantine Empire, 312–1453: Sources and Documents.* Reprint of 1972 ed. University of Toronto Press, Toronto, 1986.

Mathews, Thomas F. *Byzantium from Antiquity to the Renaissance.* Perspectives. Harry N. Abrams, New York, 1998.

Snyder, James. *Medieval Art: Painting, Sculpture, Architecture, 4th–14th Century.* Harry N. Abrams, New York, 1989.

9 EARLY MEDIEVAL ART

Conant, Kenneth J. *Carolingian and Romanesque Architecture, 800–1200.* 4th ed. Pelican History of Art. Yale University Press, New Haven, 1993.

Davis-Weyer, Caecilia, ed. *Early Medieval Art, 300–1150: Sources and Documents.* Reprint of 1971 ed. University of Toronto Press, Toronto, 1986.

Dodwell, C. R. *The Pictorial Arts of the West, 800–1200.* New ed. Pelican History of Art. Yale University Press, New Haven, 1993.

Mayr-Harting, Henry. *Ottonian Book Illumination: An Historical Study.* 2 vols. Oxford University Press, New York, 1991–93.

Pevsner, Nikolaus. *An Outline of European Architecture.* Reprint of 1972 ed. Penguin, London, 1990.

Sekules, Veronica. *Medieval Art.* Oxford History of Art. Oxford University Press, New York, 2001.

10 ROMANESQUE ART

Bowie, Fiona, and Oliver Davies, eds. *Hildegard of Bingen: Mystical Writings.* Crossroad, New York, 1990.

Focillon, Henri. *The Art of the West in the Middle Ages.* Ed. Jean Bony. 2 vols. Reprint of 1963 ed. Cornell University Press, Ithaca, 1980.

Hearn, M. F. *Romanesque Sculpture: The Revival of Monumental Stone Sculpture in the Eleventh and Twelfth Centuries.* Cornell University Press, Ithaca, 1981.

Schapiro, Meyer. *Romanesque Art.* Braziller, New York, 1993.

Stoddard, Whitney S. *Art and Architecture in Medieval France: Medieval Architecture, Sculpture, Stained Glass, Manuscripts, the Art of the Church Treasuries.* Harper & Row, New York, 1972.

11 GOTHIC ART

Bony, Jean. *French Gothic Architecture of the Twelfth and Thirteenth Centuries.* California Studies in the History of Art. University of California Press, Berkeley, 1983.

Frisch, Teresa G. *Gothic Art, 1140–c. 1450: Sources and Documents.* Reprint of 1971 ed. University of Toronto Press, Toronto, 1987.

Krautheimer, Richard, and Trude Krautheimer-Hess. *Lorenzo Ghiberti.* Princeton University Press, Princeton, 1982.

Meiss, Millard. *Painting in Florence and Siena after the Black Death: The Arts, Religion, and Society in the Mid-Fourteenth Century.* Princeton University Press, Princeton, 1978.

Pope-Hennessy, John. *Italian Gothic Sculpture.* 3rd ed. Oxford University Press, New York, 1986.

Simson, Otto Georg von. *The Gothic Cathedral: Origins of Gothic Architecture and the Medieval Concept of Order.* 3rd ed. Bollingen Series. Princeton University Press, Princeton, 1988.

White, John. *Art and Architecture in Italy, 1250–1400.* 3rd ed. Pelican History of Art. Yale University Press, New Haven, 1993.

Part Three THE RENAISSANCE THROUGH THE ROCOCO

12 THE EARLY RENAISSANCE IN ITALY

Borsook, Eve. *The Mural Painters of Tuscany: From Cimabue to Andrea del Sarto.* 2nd ed., rev. and enl. Oxford University Press, New York, 1980.

Burckhardt, Jacob C. *The Civilization of the Renaissance in Italy.* Penguin Classics. Penguin, Harmondsworth, England, 1990.

Gilbert, Creighton E. *Italian Art, 1400–1500: Sources and Documents.* Reprint of 1980 ed. Northwestern University Press, Evanston, Ill., 1992.

Gombrich, E. H. *Norm and Form.* 4th ed. Studies in the Art of the Renaissance. University of Chicago Press, Chicago, 1985.

Hartt, Frederick, and David G. Wilkins. *History of Italian Renaissance Art: Painting, Sculpture, Architecture.* 5th ed. Harry N. Abrams, New York, 2003.

Heydenreich, Ludwig Heinrich, and Wolfgang Lotz. *Architecture in Italy, 1400–1500.* Rev. ed. Pelican History of Art. Yale University Press, New Haven, 1996.

Huse, Norbert, and W. Wolters. *The Art of Renaissance Venice: Architecture, Sculpture, and Painting, 1460–1590.* University of Chicago Press, Chicago, 1990.

Janson, H. W. *The Sculpture of Donatello.* 2 vols. Princeton University Press, Princeton, 1979.

Pope-Hennessy, John. *Donatello, Sculptor.* Abbeville Press, New York, 1993.

———. *Italian Renaissance Sculpture.* 3rd ed. Oxford University Press, New York, 1986.

Seymour, Charles, Jr. *Sculpture in Italy, 1400–1500.* Pelican History of Art. Penguin, Harmondsworth, England, 1966.

Wilde, Johannes. *Venetian Art from Bellini to Titian.* Clarendon Press, Oxford, 1981.

13 THE HIGH RENAISSANCE IN ITALY

Clark, Kenneth. *Leonardo da Vinci.* Rev. and introduced by Martin Kemp. Penguin, New York, 1993.

Freedberg, Sydney J. *Painting in Italy, 1500–1600.* 3rd ed. Pelican History of Art. Yale University Press, New Haven, 1993.

———. *Painting of the High Renaissance in Rome and Florence.* New rev. ed. 2 vols. Hacker Art Books, New York, 1985.

Hibbard, Howard. *Michelangelo.* 2nd ed. Harper & Row, New York, 1985.

Klein, R., and H. Zerner. *Italian Art, 1500–1600: Sources and Documents.* Reprint of 1966 ed. Northwestern University Press, Evanston, Ill., 1989.

Pope-Hennessy, John. *Italian High Renaissance and Baroque Sculpture.* 3rd ed. 3 vols. Oxford University Press, New York, 1986.

———. *Raphael.* New York University Press, New York, 1970.

Rosand, David. *Painting in Sixteenth-Century Venice: Titian, Veronese, Tintoretto.* Cambridge University Press, New York, 1997.

14 THE LATE RENAISSANCE IN ITALY

Shearman, John K. G. *Mannerism.* Reprint of 1967 ed. Style and Civilization. Penguin, Harmondsworth, England, 1986.

15 "LATE GOTHIC" PAINTING, SCULPTURE, AND GRAPHIC ARTS

Cuttler, Charles D. *Northern Painting from Pucelle to Bruegel: Fourteenth, Fifteenth, and Sixteenth Centuries.* Rev. and updated printing. Holt, Rinehart, and Winston, New York, 1972.

Hind, Arthur M. *A History of Engraving and Etching from the Fifteenth Century to the Year 1914.* Reprint of 3rd rev. ed. Dover, New York, 1963.

———. *An Introduction to a History of Woodcut.* 2 vols. Houghton Mifflin, Boston, 1935.

Ivins, W. M., Jr. *How Prints Look: Photographs with Commentary.* Rev. and exp. ed. Beacon Press, Boston, 1987.

Panofsky, Erwin. *Early Netherlandish Painting.* 2 vols. Harvard University Press, Cambridge, 1971.

Snyder, James. *Northern Renaissance Art: Painting, Sculpture, the Graphic Arts, from 1350 to 1575.* Harry N. Abrams, New York, 1985.

16 THE RENAISSANCE IN THE NORTH

Blunt, Anthony. *Art and Architecture in France, 1500–1700.* 5th ed. Pelican History of Art. Yale University Press, New Haven, 1999.

Osten, Gert von der, and Horst Vey. *Painting and Sculpture in Germany and the Netherlands, 1500–1600.* Pelican History of Art. Penguin, Harmondsworth, England, 1969.

Panofsky, Erwin. *The Life and Art of Albrecht Dürer.* 4th ed. Princeton University Press, Princeton, 1971.

Stechow, W. *Northern Renaissance Art, 1400–1600: Sources and Documents.* Northwestern University Press, Evanston, Ill., 1989.

17 THE BAROQUE IN ITALY AND SPAIN

Brown, Jonathan. *The Golden Age of Painting in Spain.* Yale University Press, New Haven, 1991.

Enggass, Robert, and Jonathan Brown. *Italy and Spain, 1600–1750: Sources and Documents.* Reprint of 1970 ed. Northwestern University Press, Evanston, Ill., 1992.

Held, Julius, and Donald Posner. *Seventeenth and Eighteenth Century: Baroque Painting, Sculpture, Architecture.* Harry N. Abrams, New York, 1971.

Hibbard, Howard. *Bernini.* Reprint of 1965 ed. Penguin, Harmondsworth, England, 1982.

Wittkower, Rudolf. *Art and Architecture in Italy, 1600–1750.* 4th ed. Pelican History of Art. Yale University Press, New Haven, 2000.

18 THE BAROQUE IN FLANDERS AND HOLLAND

Brown, Christopher. *Van Dyck.* Cornell University Press, Ithaca, 1983.

Haak, B. *The Golden Age: Dutch Painters of the Seventeenth Century.* Harry N. Abrams, New York, 1984.

Hulst, Roger-Adolf d'. *Jacob Jordaens.* Cornell University Press, Ithaca, 1982.

Rosenberg, Jakob, Seymour Slive, and E. H. ter Kuile. *Dutch Art and Architecture, 1600–1800.* 3rd ed. Pelican History of Art. Yale University Press, New Haven, 1997.

Schama, Simon. *The Embarrassment of Riches: An Interpretation of Dutch Culture in the Golden Age.* University of California Press, Berkeley, 1988.

Schwartz, Gary. *Rembrandt, His Life, His Paintings.* Penguin, New York, 1991.

Scribner, Charles, III. *Peter Paul Rubens.* Masters of Art. Harry N. Abrams, New York, 1989.

Stechow, Wolfgang. *Dutch Landscape Painting of the Seventeenth Century.* Reprint of 1966 ed. Cornell University Press, Ithaca, 1991.

White, Christopher. *Peter Paul Rubens: Man and Artist.* Yale University Press, New Haven, 1987.

19 THE BAROQUE IN FRANCE AND ENGLAND

Blunt, Anthony. *Nicolas Poussin.* 2 vols. Princeton University Press, Princeton, 1967.

Waterhouse, Ellis Kirkham. *Painting in Britain, 1530 to 1790.* 5th ed. Pelican History of Art. Penguin, Harmondsworth, England, 1994.

20 ROCOCO

Conisbee, Philip. *Chardin.* Bucknell University Press, Lewisburg, Pa., 1986.

———. *Painting in Eighteenth-Century France.* Cornell University Press, Ithaca, 1981.

Levey, Michael. *Painting and Sculpture in France, 1700–1789.* New ed. Pelican History of Art. Yale University Press, New Haven, 1993.

———. *Rococo to Revolution: Major Trends in Eighteenth-Century Painting.* Reprint of 1966 ed. The World of Art. Thames and Hudson, New York, 1985.

Part Four THE MODERN WORLD

Arnason, H. H., and Marla Prather. *History of Modern Art.* 4th ed., rev. and enl. Harry N. Abrams, New York, 1998.

Brown, Milton W., et al. *American Art: Painting, Sculpture, Architecture, Decorative Arts, Photography.* Prentice Hall, Englewood Cliffs, N.J., 1979.

Chipp, Herschel B., ed. *Theories of Modern Art: A Source Book by Artists and Critics.* University of California Press, Berkeley, 1968.

Fineberg, Jonathan. *Art since 1940: Strategies of Being.* 2nd ed. Harry N. Abrams, New York, 1999.

Janson, H. W. *Nineteenth-Century Sculpture.* Harry N. Abrams, New York, 1985.

Rosenblum, Naomi. *A World History of Photography.* Rev. ed. Abbeville Press, New York, 1989.

Taylor, Joshua. *The Fine Arts in America.* University of Chicago Press, Chicago, 1979.

21 NEOCLASSICISM

Boime, Albert. *The Academy and French Painting in the Nineteenth Century.* New ed. Yale University Press, New Haven, 1986.

Honour, Hugh. *Neoclassicism.* Reprint of 1968 ed. Penguin, London, 1991.

———. *Romanticism.* Harper & Row, New York, 1979.

Rosenblum, Robert. *Transformations in Late Eighteenth Century Art.* Princeton University Press, Princeton, 1967.

Vaughan, William. *German Romantic Painting.* 2nd ed. Yale University Press, New Haven, 1994.

22 ROMANTICISM

Clark, Kenneth. *The Romantic Rebellion: Romantic versus Classic Art.* Harper & Row, New York, 1973.

Daval, Jean-Luc. *Photography, History of an Art.* Skira and Rizzoli, New York, 1982.

Licht, Fred. *Goya: The Origins of the Modern Temper in Art.* Harper & Row, New York, 1983.

23 REALISM AND IMPRESSIONISM

Clark, T. J. *The Painting of Modern Life: Paris in the Art of Manet and His Followers.* Reprint of 1984 ed. Princeton University Press, Princeton, 1989.

Fried, Michael. *Courbet's Realism.* University of Chicago Press, Chicago, 1990.

Herbert, Robert L. *Impressionism: Art, Leisure, and Parisian Society.* Reprint of 1988 ed. Yale University Press, New Haven, 1995.

Nochlin, Linda. *Impressionism and Post-Impressionism, 1874–1904: Sources and Documents.* Prentice Hall, Englewood Cliffs, N.J., 1966.

———. *Realism and Tradition in Art, 1848–1900: Sources and Documents.* Prentice Hall, Englewood Cliffs, N.J., 1966.

Pool, Phoebe. *Impressionism.* World of Art. Thames and Hudson, London, 1985.

Rewald, John. *The History of Impressionism.* 4th rev. ed. New York Graphic Society, Greenwich, Conn., 1973.

24 POST-IMPRESSIONISM, SYMBOLISM, AND ART NOUVEAU

Hamilton, George Heard. *Painting and Sculpture in Europe, 1880–1940.* 6th ed. Pelican History of Art. Yale University Press, New Haven, 1993.

Rewald, John. *Post-Impressionism: From Van Gogh to Gauguin.* 3rd ed. Museum of Modern Art, New York, 1978.

Sutter, Jean, ed. *The Neo-Impressionists.* New York Graphic Society, Greenwich, Conn., 1970.

25 TWENTIETH-CENTURY PAINTING

Gray, Camilla. *The Russian Experiment in Art, 1863–1922.* Rev. and enl. by Marian Burleigh-Motley. World of Art. Thames and Hudson, New York, 1986.

Livingstone, Marco. *Pop Art: A Continuing History.* Harry N. Abrams, New York, 1990.

Rosenblum, Robert. *Cubism and Twentieth-Century Art.* Rev. ed. Harry N. Abrams, New York, 1976.

Sandler, Irving. *The Triumph of American Painting: A History of Abstract Expressionism.* Harper & Row, New York, 1979.

26 TWENTIETH-CENTURY SCULPTURE

Elsen, A. *Origins of Modern Sculpture.* Braziller, New York, 1974.

Lucie-Smith, E. *Sculpture since 1945.* Universe Books, New York, 1987.

Read, Herbert. *Modern Sculpture: A Concise History.* The World of Art. Reprint of 1964 ed. Thames and Hudson, London, 1987.

27 TWENTIETH-CENTURY ARCHITECTURE

Curtis, William J. R. *Modern Architecture since 1900.* 2nd ed. Prentice Hall, Englewood Cliffs, N.J., 1987.

Kultermann, Udo. *Architecture in the Twentieth Century.* Van Nostrand Reinhold, New York, 1993.

28 TWENTIETH-CENTURY PHOTOGRAPHY

Coke, V. D. *The Painter and the Photograph: From Delacroix to Warhol.* Rev. ed. University of New Mexico Press, Albuquerque, 1972.

Green, J. *American Photography: A Critical History, 1945 to the Present.* Harry N. Abrams, New York, 1984.

Krauss, R. *L'Amour Fou: Photography and Surrealism.* Abbeville Press, New York, 1985.

Sontag, S. *On Photography.* Farrar, Straus & Giroux, New York, 1973.

29 POSTMODERNISM

Jencks, Charles. *Architecture Today.* 2nd ed. Academy Editions, London, 1993.

———. *Post-Modernism: The New Classicism in Art and Architecture.* Rizzoli, New York, 1987.

———. *What Is Post-Modernism?* 3rd ed. St. Martin's Press, New York, 1989.

Norris, Christopher, and Andrew Benjamin. *What Is Deconstruction?* St. Martin's Press, New York, 1988.

Rosenau, Pauline Marie. *Post-Modernism and the Social Sciences: Insights, Inroads, and Intrusions.* Princeton University Press, Princeton, 1992.

Note: Page numbers in *italics* refer to illustrations.

LIST OF CREDITS

The author and the publisher wish to thank the libraries, museums, galleries, and private collectors for permitting the reproduction of works of art in their collections and for supplying the necessary photographs. Photographs from other sources are gratefully acknowledged below. All numbers refer to figure numbers unless otherwise noted.

Photograph Credits

Adros Studio, Rome: 10-18; AKG, London: 9-6; Alison Frantz Collection, American School of Classical Studies, Athens: 5-10; Alinari/Art Resource, N.Y.: 5-23, 6-3, 7-10, 7-12, 7-14, 8-2, 11-13, 12-1, 12-9, 12-11, 17-10, 17-11, 17-16; © The Americans, Robert Frank, Courtesy Pace/MacGill Gallery, NY: 28-14; Antwerp Cathedral, Belgium: 18-1; Araldo di Luca, courtesy Ikona, Rome: p. 125, 7-11; Arcaid/David Churchill, Kingston upon Thames, U.K.: 22-26; The Art Archive, London: 12-22, 14-4, 19-13, 22-4; ARXIU MAS, Barcelona: 14-11, 17-18; Ashmolean Museum, Oxford, England: 4-1; James Austin, UK: 21-11; Bayerisches Staatsbibliothek, Munich: 9-14, p. 263 left; "The Bayeux Tapestry 11th by special permission of the City of Bayeux": 10-1; Jean Bernard, Aix-en-Provence: 11-7, 11-19; Bildarchiv Preussischer Kulturbesitz/Jörg Anders, Berlin: 5-24, p. 365; Bildarchiv Preussischer Kulturbesitz, Berlin: p. 47, 2-12, 2-13, 3-9, 15-9, 22-25; Black Star, New York: 26-2; Joachim Blauel, Munich, Germany: 13-19, 16-3, 16-7, 18-2, 18-9; Boltin Picture Library: 2-14; The British Museum, Library: 13-6; The British Museum, London: 8-14, p. 262 left; © 2002 Jutta Brüdern, Braunschweig: 9-11; Martin Buhler, Basel: 24-16; Bundesdenkmalsamt, Vienna: 22-21; Cameraphoto-Arte, Venice: 14-9; Canali Photobank, Italy: pp. 34-37, 5-3, 5-6, 5-8, 5-17, 6-5, 6-6, 7-16, 7-17, 7-18, p. 145 bottom, 8-3, 8-4, 8-7, 8-8, 8-9, 8-10, 10-9, 11-14, 11-26, 11-27, 11-28, 11-33, 11-35, 11-36, p. 262 center, pp. 264-267, p. 270, 12-2, 12-4, 12-7, 12-8, 12-12, 12-13, 12-16, 12-21, 13-7, 13-12, 13-13, 13-15, 14-1, 14-2, 14-7, 14-10, 14-15, 14-16, 15-6, 16-9, p. 382, 17-1, 17-2, 17-4, 17-5, 17-6, 17-7, 17-9, 17-14, p. 450 left, p. 450 center, p. 451 left; Carnegie Museum of Art, Pittsburgh, gift of Mrs. Horace Binney Hare: p. 420; Carnegie Museum of Art, Pittsburgh, Richard M. Scaifer Fund and A. W. Mellon Acquisition Endowment Fund: 25-50; © Center for Creative Photography, Arizona Board of Regents, Tucson, Arizona: 28-5; Peter Clayton, Hemel Hempstead: 2-9, 2-10, 2-11; Cliché Arch. Phot.c.Centre des Monuments Nationaux, Paris: 10-4, 10-11, 22-23; Collection Museum of Contemporary Art, San Diego, Gift of Dr. and Mrs. Jack Farris © Ellsworth Kelly 1963, photographer: Philipp Scholz Rittermann: 25-41; Collection of Whitney Museum of American Art, Purchase, with funds from Gertrude Vanderbilt Whitney: 31.426: 25-33; © Jean Clothes, SYGMA, New York: p. 40, 1-1; Colorphoto Hans Hinz, Allschwill-Basel: 1-2; The Conway Library/Courtauld Institute of Art, University of London: 11-18; Deutsches Archäologisches Institut, Baghdad: 3-1; Jean Dieuzaide (Photo YAN), Toulouse: 10-2, 10-10; Dom-und Diözesanmuseum/Hermann Wehmeyer, Hildesheim: 9-13; Stephan Drechsel, AKG, London: 11-12; Dumbarton Oaks, Washington, D.C.: © Byzantine Visual Resources; 8-16; Éditions Gaud Molenay, France: 11-9; English Heritage Photographic Library: 1-6, 21-12; English Heritage Photographic Library, London/The Iveagh Bequest, Kenwood, London: 21-8; Erika Barahona Ede, Bilbao: p. 659, 29-05; © Peter Aarons/Esto: 29-1; Ezra Stoller © Esto: 26-20, 27-15; © Peter Mauss/Esto: 29-4; Fine Arts Museums of San Fransisco, Museum purchase, Archer M. Huntington Fund, 1935.2: 22-12; Fotocielo, Rome: 17-8; Foto Grassi, Siena: 11-31; Foto Marburg/Art Resource, N.Y.: 10-5, 11-4, 11-16, 11-20, 11-22, 23-25, 23-26, 23-27, 27-3, 27-6; Foto Mayer, Vienna: 15-11; Fototeca Unione, American Academy, Rome: 7-1; Foto Zwicker-Berberich, Gerchsheim/Würzburg, Germany: p. 434, 20-7; H. Frankfurt, The Art and Architecture of the Ancient Orient: 3-2; French National Tourist Board, London: 22-22; © The Frick Collection, New York: 12-23, 18-11, p. 451 top; Gabinetto Fotografico Nazionale, Rome: 17-13; Gianfranco Gorgoni, New York: 26-19; Lauros/Giraudon, Paris: 23-28; Dr. Reha Günay, Istanbul: 8-19; H. N. A. Archive, N.Y: 7-5, 9-12, 10-1, 10-12, 12-10; Gift of Julius H. Haass in memory of his brother Dr. Ernest W. Haass Photograph © 1996 The Detroit Institute of Arts: 18-13; Hedrich-Blessing/Bill Engdahl Chicago: 27-1; © 1993 Her Majesty Queen Elizabeth II: 20-13; Henri Cartier-Bresson, Magnum Photos, New York: 28-2; Hirmer Fotoarchiv, Munich: 1-3, 2-5, 4-5, 5-13, 5-14, 5-18, 5-19, 5-25, 6-1, 7-13, p. 145 left, 8-6, 13-11; The Huntington Library, Art Collections and Botanical Gardens, San Marino, California/SuperStock: 20-10; Timothy Hursley, Courtesy House & Garden, May 1905 by Condé Nast Publishers, Inc.: 29-2; Iraq Museum Baghdad, and The Oriental Institute Museum of the University of Chicago: 3-3; Jahrbuch des Deutsches Werkbundes, (1915): 24-21, 27-3; Jonis Jan Bos Fotografie: p. 629, 27-18; Courtesy Ilya and Emila Kabakov: 29-6; A. F. Kersting, London: 10-6, 19-5; G. E. Kidder Smith: 27-12; Ernst Ludwig Kirchner, Dr. Wolfgang and Ingeborg Henze-Ketterer: 25-4; Kurf Lange, Oberstodorf, Allgaau, Germany: 2-1, 2-2; Jacques Lathion, Oslo: 24-13; Lautman Photography, Washington, D.C.: p. 458, 21-13; William Lescaze, N.Y.: 27-13; Erich Lessing, Art Resource, N.Y.: 8-15; Library of Congress, Washington, D.C.: 22-15; Library, Getty Research Institute, Los Angeles, Wim Swaan Photograph Collection (96.P21): 2-6, 2-7, 2-15, p. 196, 10-8, 11-4, 11-10, 17-12, 19-6, 19-7, 20-11, p. 451 right; Lichtbildwerstätte Alpenland, Vienna: 8-5, 9-7, 14-8, 14-14, 14-18, p. 365, 16-13, 16-14; Tony Linck, Fort Lee, N.J.: 1-7; Jannes Linders, Rotterdam: 27-7; Mary Boone Gallery, N.Y.: 29-11; Courtesy McKee Gallery: 26-18; © 2002 The Metropolitan Museum of Art, N.Y., All Rights Reserved: p. 53, 5-1, 5-11, 7-19, p. 145 top, 14-6, 15-1, 15-2, 15-13, 17-19, 18-12, 19-2, 20-1, 20-5, 20-14, 21-2, p. 475, 22-9, 22-10, 22-20, 23-4, 25-7, 25-23, 25-32, 25-35; By license of Ministro dei Beni Culturali, ICCD, Roma, IKONA Roma: 23-5; Ministry of Public Buildings and Works, London: 1-5; Ministry of Works, London: 21-10; MoMA/Scala/Art Resource, N.Y.: pp. 452–455, 23-23, 25-2, 25-8, 25-13, 25-15, 25-18, 25-31, 25-36, 25-46, 25-47, 26-2, 26-5, 26-7, 26-9, 26-10, 26-26, 27-8, 27-9, 27-10, 28-1, 28-4, 28-6, 28-12; Musée Royal des Beaux-Arts, Antwerp, Belgium: 15-10; Musées Royaux d'Art et d'Historie, Brussels: 18-6; Museo Archeologico Nazionale, Naples: 5-5; Museo Nacional Centro de

Arte Reina Sofia, Madrid: p. 561; Museum Boymans-van Beuningen, Rotterdam, The Netherlands: p. 403; Museum of Fine Arts, Boston. Harvard-Museum of Fine Arts Expedition: p. 144 left; Ann Münchow, Aachen: 9-5; National Buildings Record, London: 11-11, 19-14, 22-27; National Gallery of Art, Washington, Andrew W. Mellon Collection, Photograph © 2001 Board of Trustees: 8-18; National Gallery of Art, Washington, Samuel H. Kress Collection, Photograph © 2001 Board of Trustees: 7-4; Richard Nickel, Chicago: 24-22; Nikos Kontos Courtesy Ekdotike Athenon: 8-13, p. 152; Nippon Television Network Corporation, Tokyo: 13-8, 13-9, 13-10; Norton Simon Art Foundation, Pasadena, CA.: p. 511; © Takashi Okamura, Shizuoka City, Japan: 11-29, 11-41, 12-5, 12-6, 12-15; The Oriental Institute of the University of Chicago: 3-11; Oroñoz, Madrid: 24-19; Oroñoz, Madrid © 2002 Museo del Prado: 13-17, 16-11; Pedicini/Editoriale Museum, Rome: 7-3; Luciano Pedicini, Napoli, IKONA, Roma: 13-18; Photographie Bulloz, Paris: 10-13, 16-16; Photographie Giraudon, Paris: 9-8, 11-17, 11-40, 13-4, 16-1, 16-2, 16-15, 20-2, 21-8; Photograph by Robert E. Mates © The Solomon R. Guggenheim Foundation, New York: 25-26; Photographie Roger-Viollet, Paris: 19-8, 22-28, 27-14; Photo M.A.S (Arxiu MAS) Barcelona © 2002 Museo del Prado: 15-5, 15-7, 18-3, 22-1, 22-2; The Pierpont Morgan Library/Art Resource, N.Y.: 9-9; Erich Pollitzer, New York: 24-5; Pontificia Commissione di Archeologia Sacra, Rome: 8-1; Port Authority of N.Y.: 22-24; President and Fellows of Harvard College, Harvard University/Michael Nedzweski: 22-5; Private Collection: 25-38; Antonio Quattrone, courtesy Olivetti, Florence: 12-14; Quattrone, Florence: 12-19, p. 323, 14-3, 14-5; Réunion des Musées Nationaux/Art Resource, N.Y.: p. 64, 3-6, 3-7, 5-4, 11-34, 12-20, p. 299, 13-1, 13-3, 16-8, 18-5, 19-12, 20-3, 20-4, 20-6, p. 450 right, p. 451 center, 21-1, 22-3, 22-6, 22-7, 22-8, 22-13, 23-1, 23-2, 23-3, 23-6, 23-10, 24-10, 25-21; Rheinisches Bildarchiv, Cologne: 9-10, p. 262 right, p. 263 center, 19-1, 25-48, 26-21; Richard Ross: 29-7; Ekkehard Ritter, Vienna: 10-19; Jean Roubeck, Paris: 10-3, 11-3, 11-21; Ronald Sheridan's Ancient Art and Architecture Collection, Harrow-on-the-Hill, Middlesex, U.K.: 8-17, 11-25; Routhier, Studio Lourmel, Paris: 23-11; Sachsische Landesbibliothek, Deutsche Fotothek, Dresden: 11-23; Scala/Art Resource, N.Y.: 11-32, 11-37, 12-17, 13-14, 13-16; Haldor Soehner, Munich: 14-12; Soprintendenza Archaeologica Art Etruria Meridionale, Tarquinia: p. 118, 6-2; Christian Smith/Tropix Photographic Library, Meols, Wirral, England: p. 534; G. E. Kidder Smith: 7-2, 7-15; Spectrum Color Library, London: 27-17; Studio Remy, Dijon, France: 11-39; Studio Kontos Photography, Athens: p. 76, 4-2, 4-3, 4-4, 4-6, p. 84, 5-2, 5-9, 5-12, 5-16, 5-26, p. 144 center, p. 144 right, p. 145 center; B. Adolph Studley, Pennsburg, Pennsylvania: 24-18; Mark Tansey courtesy Gagosian Gallery: 29-10; Tate Gallery, London: p. 607, 26-13; Marvin Trachtenberg, New York: 8-12, 11-15, 19-9, 20-12, 27-11, 27-16; Marvin Trachtenberg, Institute of Fine Arts, New York University, N.Y.: 11-1, 14-17; Robert Villani: 27-2; © Eike Walford, Hamburg: 22-18; Clarence Ward, Oberlin: 11-2; Collection of Whitney Museum of American Art, 50th Anniversary Gift of the Gilman Foundation, Inc., The Lauder Foundation, A. Alfred Taubman, an anonymous donor, and purchase 80.32: 25-45; Widener Collection, photograph © 2001 Board of Trustees, National Gallery of Art, Washington: 12-18; D. G. Wilkins: 12-3; Yale Center for British Art, Paul Mellon Collection: 19-3.

Artists Copyrights

© Peter Aarons/Esto. All rights reserved: 29-1; Photograph by Ansel Adams Copyright © 1997 by the Trustees of the Ansel Adams Publishing Rights Trust. All Rights Reserved: 28-6; © 2002 Artists Rights Society (ARS), New York/ADAGP, Paris: 24-17, 25-3, 25-6, 25-10, 25-15, 25-22, 25-38, 26-2; © 2002 Artists Rights Society (ARS) New York/ADAGP, Paris/Estate of Marcel Duchamp: 25-16, 26-8; © 2002 Artists Rights Society (ARS) New York/ADAGP, Paris/FLC: 27-11; © 2002 Artists Rights Society (ARS), New York/Beeldrecht, Amsterdam: 27-7; © 2002 Artists Rights Society (ARS), New York/ProLitteris, Zürich: 25-5, 26-9; © 2002 Artists Rights Society (ARS), New York/SIAE, Rome: 25-14; © 2002 Artists Rights Society (ARS), New York/VG Bild-Kunst, Bonn: 25-25, 25-26, 25-28, 25-29, 25-31, 26-10, 26-27, 29-6; © 2002 Estate of Francis Bacon/Artists Rights Society (ARS), New York/DACS, London: 25-39; © 2002 The Barnes Foundation, Merion, All Rights Reserved: 25-1; © 2002 Romare Bearden Foundation, NY/Licensed by VAGA, New York: 25-43; © 2002 Estate of Alexander Calder/Artists Rights Society (ARS), New York: 26-12; © 2002 Estate of Arshile Gorky/Artists Rights Society (ARS), New York: 25-35; © Hepworth Estate, Alan Bowness, London: 26-14; © David Hockney, Los Angeles: p. 645, 28-16; © 2002 Joseph Hosuth/Artists Rights Society (ARS), New York: 26-26; © 2002 Estate of Jasper Johns/Licensed by VAGA, New York: 25-45; © Anselm Kiefer: 25-50; © 2002 Man Ray Trust/Artists Rights Society (ARS), NY/ADAGP, Paris: 28-12; © 2002 Succession H. Matisse, Paris/Artists Rights Society (ARS), New York: 25-1, 25-2, 25-21, 26-1; © Peter Mauss/Esto. All rights reserved: 29-4; © 2002 Mondrian/Holtzman Trust, c/o Beeldrecht/Artists Rights Society (ARS), New York: 25-24; © The Henry Moore Foundation: p. 607, 26-13; © 2002 Estate of Louise Nevelson/Artists Rights Society (ARS), New York: 26-22; © 2002 The Georgia O'Keeffe Foundation/Artists Rights Society (ARS), New York: 25-32; © 2002 Estate of Pablo Picasso/Artists Rights Society (ARS), New York: p. 561, 25-8, 25-9, 25-18, 25-19, 25-20, 26-11; © 2002 The Pollock-Krasner Foundation/Artists Rights Society (ARS), New York: 25-35, 25-36; © 2002 Robert Rauschenberg/Licensed by VAGA, New York: 26-21; © 2002 Kate Rothko Prizel & Christopher Rothko/Artists Rights Society (ARS), New York: 25-40; © 2002 The George and Helen Segal Foundation/Licensed by VAGA, New York: 26-24; © 2002 Joel Shapiro/Artists Rights Society (ARS), New York: 26-17; © 2002 Estate of David Smith/Licensed by VAGA, New York: 26-15; © 2002 Robert Smithson/Licensed by VAGA, New York: 26-19; © 2002 Frank Stella/Artists Rights Society (ARS), New York: 25-42; © 2002 Estate of Vladimir Tatlin/Licensed by VAGA, New York: 26-6; © 2002 Andy Warhol Foundation for the Visual Arts/(ARS), New York: 25-47; © 2002 Frank Lloyd Wright Foundation/(ARS), New York: 27-1, 27-2.